GARDNER'S
ART
through the
AGES

ELEVENTH EDITION

VOLUME **I**

FRED S. KLEINER

CHRISTIN J. MAMIYA

RICHARD G. TANSEY

HARCOURT COLLEGE PUBLISHERS

Fort Worth Philadelphia San Diego New York Orlando Austin San Antonio
Toronto Montreal London Sydney Tokyo

PUBLISHER	Earl McPeek
EXECUTIVE EDITOR	David Tatom
ACQUISITIONS EDITOR	John R. Swanson
MARKET STRATEGIST	Steve Drummond
DEVELOPMENTAL EDITOR	Stacey Sims
PROJECT EDITOR	Kathryn M. Stewart
ART DIRECTOR	Linda Beaupré
PRODUCTION MANAGER	Diane Gray

Cover image: God as architect of the world (detail), folio 1 verso of a moralized Bible, from Paris, France, ca. 1220–1230. Ink, tempera, and gold leaf on vellum, 13 1/2″ × 8 1/4″. Österreichische Nationalbibliothek, Vienna.

ISBN: 0-15-507085-1
Library of Congress Catalog Card Number: 00-104141

Address for Domestic Orders
Harcourt College Publishers, 6277 Sea Harbor Drive, Orlando, FL 32887-6777
800-782-4479

Address for International Orders
International Customer Service
Harcourt, Inc., 6277 Sea Harbor Drive, Orlando, FL 32887-6777
407-345-3800
(fax) 407-345-4060
(e-mail) hbintl@harcourt.com

Address for Editorial Correspondence
Harcourt College Publishers, 301 Commerce Street, Suite 3700, Fort Worth, TX 76102

Web Site Address
http://www.harcourtcollege.com

Harcourt College Publishers will provide complimentary supplements or supplement packages to those adopters qualified under our adoption policy. Please contact your sales representative to learn how you qualify. If as an adopter or potential user you receive supplements you do not need, please return them to your sales representative or send them to: Attn: Returns Department, Troy Warehouse, 465 South Lincoln Drive, Troy, MO 63379.

Printed in the United States of America

0 1 2 3 4 5 6 7 8 9 048 9 8 7 6 5 4 3 2 1

Harcourt College Publishers

IN MEMORIAM

Richard G. Tansey

WE NOTE WITH DEEP SORROW the death of our good friend and esteemed colleague Richard G. Tansey.

Through six previous editions of *Art through the Ages* he probably introduced more students to the discipline

of art history than any other author or teacher, establishing himself as one of the greatest art-historical

educators of the twentieth century. While we mourn his passing, we celebrate his life, remembering his

keen intellect, wide learning, sharp wit, and unfailing generosity. With the publication of this new edition

his influence will endure in another century, indeed in another millennium.

We dedicate the eleventh edition of *Art through the Ages* to him.

PREFACE

THE CLASSIC FOR A NEW AGE

HELEN GARDNER'S VISION In the mid 1920s, Helen Gardner had a vision — to provide students with a textbook that would introduce them to the artistic legacy of not only Europe and the United States, but of the entire globe. In 1926, Harcourt Brace and Company published that vision — Helen Gardner's *Art through the Ages.* For seventy-five years, from just before the introduction of the Model A automobile through the computer revolution and the dawn of a new millennium, Helen Gardner's book has been the most widely read introduction to the history of art in the English language. At the beginning of the twenty-first century, to mark the seventy-fifth anniversary of the initial publication, Harcourt College Publishers offers the eleventh edition of *Gardner's Art through the Ages,* the classic for a new age.

The fundamental belief that guided Helen Gardner, and one that we share, is that the history of art is essential to a liberal education. The study of art history has as its aim the appreciation and understanding of works of high aesthetic quality and historical significance produced throughout the world and across thousands of years of human history. We think that the most effective way to tell the story of art through the ages, especially for those who are studying art history for the first time, is to organize the vast array of artistic monuments according to the civilizations that produced them and to consider each work in roughly chronological order. Not only has this approach stood the test of time, but it is the most appropriate for narrating the *history* of art. We believe that the enormous variation in the form and meaning of paintings, sculptures, buildings, and other artworks is largely the result of the constantly changing historical, social, economic, religious, and cultural context in which artists and architects worked. A historically based narrative is therefore best suited for a global history of art.

NEW AUTHOR TEAM A new team of authors has revised every chapter of Helen Gardner's pioneering work, rewriting many chapters almost in their entirety. Fred S. Kleiner, Professor of Art History and Archaeology at Boston University and former Editor-in-Chief of the *American Journal of Archaeology,* worked with Richard G. Tansey on the tenth edition. Although Professor Tansey passed away before his work on the eleventh edition could begin, his contributions to *Art through the Ages* over the last thirty years are evident on every page and they remain an enduring legacy. His name appropriately remains on the title page of this book. Christin J. Mamiya, Professor of Art History at the University of Nebraska — Lincoln, joins the author team with this new edition. Professor Mamiya, whose special research interests include Pop art, has revised all of the chapters on modern and contemporary art, in addition to updating and revising the coverage of Renaissance and Baroque art. Professor Kleiner has reworked the chapters on ancient art that he contributed to the tenth edition and has revised all the chapters on the Middle Ages.

FEATURES OF THE ELEVENTH EDITION

REORGANIZATION The eleventh edition of *Art through the Ages* is the most extensively reviewed in the book's history and maintains the Gardner reputation of being the authoritative and up-to-date choice for introducing students to the history of art. We have, however, made many changes to this classic work. As before, the book is available both in a one-volume clothbound and a two-volume paperback edition, but we have divided the history of art into thirty-four chapters, six more than in the tenth edition. A reevaluation of the treatment of the art and architecture of the eighteenth and nineteenth centuries led us to reorganize those chapters. With the collaboration of four contributing authors, we have also rethought our coverage of Asian, African, Oceanic, and pre-Columbian art. Robert L. Brown (University of California — Los Angeles), Virginia E. Miller (Univeristy of Illinois — Chicago), and Quitman Eugene Phillips (University of Wisconsin — Madison) revised the chapters on India and Southeast Asia; the native arts of the Americas; and China, Korea, and Japan, respectively. George Corbin (Lehman College of the City University of New York) revised the chapter on Africa first contributed by Herbert Cole in the tenth edition, expanding and updating the material to meet the requirements of the new edition. He also revised the coverage of

Oceanic art, which now has a chapter of its own. For the first time we devote two chapters each to India, China and Korea, Japan, Africa, and the native arts of the Americas. The chapters on early Asian art follow that on Greece. Discussion of the ancient arts of the Americas and Africa follow the chapters on Byzantium and Islam. We treat later developments in Asian art after the chapter on seventeenth- and eighteenth-century Europe, and the later arts of the Americas, Oceania, and Africa after the discussion of the rise of modernism in the West.

This new organization has allowed us to interweave the narrative of the western and non-European traditions more effectively and to present a global history of art that highlights the interactions between geographically distant and culturally distinct societies. An important additional advantage of the new scheme is that in the two-volume paperbound version of this book, chapters on Asian, African, and pre-Columbian art and architecture now appear in both volumes and can be covered in both semesters of a two-semester course.

TRADITION AND INNOVATION The new author team has also revised the eleventh edition to reflect the latest art historical research emphases, while maintaining the traditional strengths that have made all the previous editions of *Art through the Ages* so successful. While sustaining attention to style, chronology, iconography, and technique, we pay greater attention than ever before to function and context. We consider artworks with a view toward their purpose and meaning in the society that produced them at the time at which they were produced. We also address the very important role of patronage in the production of art and examine the role of the individuals or groups who paid the artists and influenced the shape the monuments took. We give greater attention to the role of women and women artists in societies worldwide over time. Throughout, we have aimed to integrate the historical, political, and social context of art and architecture with the artistic and intellectual aspects. Consequently, we now often treat painting, sculpture, architecture, and the so-called minor arts together, highlighting how they all reflect the conventions and aspirations of a common culture, rather than treating them as separate and distinct media.

ENHANCED ILLUSTRATION PROGRAM The eleventh edition of Helen Gardner's classic text contains more illustrations, more illustrations in color, and more full-page illustrations than any previous edition. More than fourteen hundred photographs, plans, and drawings appear in the book, including more than sixty-five full-page photos (at least one in every chapter). Over sixty-eight percent of the photographs are in color—the highest percentage of color illustrations in any art history survey textbook. Harcourt College Publishers has printed these photographs using a five-color production process and high-quality paper.

NEW MONUMENTS Throughout the eleventh edition, we have also introduced dozens of new monuments. We have tried in our choice of artworks and buildings to reflect the increasingly wide range of interests of scholars today, while not rejecting the traditional list of "great" works or the very notion of a "canon." Recent discoveries, such as the world's oldest paintings, in the Chauvet Cave in France, are illustrated, as are recently cleaned works, like Leonardo da Vinci's *Last Supper* in Milan, Italy. The expanded selection of works encompasses every artistic medium and almost every era and culture. Some are famous works that have never appeared before in *Art through the Ages*. Many, however, are rarely illustrated works of high artistic and historical interest that significantly enrich the character of the traditional art history survey—for example, the costly vestments worn by Byzantine patriarchs and Ottoman emperors.

NEW BOXED ESSAYS To include important background information and other material designed to enhance understanding, every chapter of *Art through the Ages* now features boxed discussions focusing on selected themes and issues in the history of art. The boxes allow us to maintain a clear narrative thread throughout the text while providing students with concise information about terminology, technique, and iconography; an appreciation of the cultural and historical context of art and architecture; and an introduction to some of the major scholarly and ethical controversies of the new millennium. We present these short essays in six broad categories.

Architectural Basics provide students with a sound foundation for the understanding of all discussions of architecture. These discussions are concise primers, with drawings and diagrams of the major aspects of design and construction. The information included is essential to an understanding of architectural technology and terminology. The boxes address questions of how and why various forms developed, the problems architects confronted, and the solutions they used to resolve them. Topics discussed include how the Egyptians built the pyramids, the orders of classical architecture, the revolutionary nature of Roman concrete construction, the origin and development of the Islamic mosque, and the construction of Gothic cathedrals.

Materials and Techniques essays explain the various media artists employed from prehistoric to modern times. Since materials and techniques often influence the character of works of art, these discussions also contain essential information on why many monuments look the way they do. Hollow-casting bronze statues, fresco painting, Chinese silk, Andean weaving, Islamic tilework, embroidery and tapestry, woodblock prints, and perspective are among the many subjects treated.

Written Sources present and discuss key historical documents illuminating important monuments of art and architecture and the careers of some of the world's leading artists, architects, and patrons. The passages we quote permit voices from the past to speak directly to the reader, providing vivid and unique insights into the creation of artworks in all media. Examples include Saint Bernard of Clairvaux's treatise on sculpture in medieval churches, Sinan the Great's commentary on the mosque he built for Selim II,

Vasari's biographies of Renaissance artists, as well as texts that bring the past to life, such as eyewitness accounts of the volcanic eruption that buried Roman Pompeii and of the fire that destroyed Canterbury Cathedral in medieval England.

Religion and Mythology boxes introduce students to the principal elements of the world's great religions, past and present, and to the representation of religious and mythological themes in painting and sculpture of all periods and places. These discussions of belief systems and iconography give readers a richer understanding of some of the greatest artworks ever created. The topics include the gods and goddesses of Egypt, Mesopotamia, Greece, and Rome; the life of Jesus in art; Buddha and Buddhism; Muhammad and Islam; and Aztec religion.

Art and Society essays treat the historical, social, political, cultural, and religious context of art and architecture. In some instances, specific monuments are the basis for a discussion of broader themes, as when we use the Hegeso stele to serve as the springboard for an exploration of the role of women in ancient Greek society. In other cases, we discuss how people's evaluation today of artworks can differ from those of the society that produced them, as when we examine the problems created by the contemporary market for undocumented archeological finds. Other subjects include Egyptian mummification, the art of freed Roman slaves, the Mesoamerican ballgame, the shifting fortunes of Vincent van Gogh, Japanese court culture, and Native American artists.

Art in the News boxes present accounts of the latest archeological finds and discussions of current controversies in the history of art. Among the discoveries and issues we highlight are the excavation of the tomb of the sons of the pharaoh Ramses and the restoration of Michelangelo's frescoes in the Sistine Chapel.

SPECIAL VOLUME TWO REVIEW MATERIAL Since many students taking the second half of a year-long introductory art history survey course will only have the second volume of the paperbound edition of *Art through the Ages*, we have provided a new feature not found in any other textbook currently available: a special set of Volume II boxes on *Art and Society before 1300*. These discussions immediately follow the Preface and Introduction to Volume II and provide concise primers on religion and mythology and on architectural terminology and construction methods in the ancient and medieval worlds—information that is essential for understanding the history of art after 1300, both in the West and the East. The subjects of these special boxes are the Gods and Goddesses of Mount Olympus; the Life of Jesus in Art; Buddhism and Buddhist Iconography; Classical Architecture; and Medieval Churches.

MAPS AND TIMELINES The eleventh edition of *Art through the Ages* includes new or revised maps and timelines at the beginning of every chapter. We have taken great care to make sure that every site discussed in the text appears on our maps. These maps vary widely in both geographical and chronological scope. Some focus on a small region or even a single city, while others encompass a vast territory and occasionally bridge two or more continents. Several maps plot the art-producing sites of a given area over hundreds, even thousands, of years. In every instance, our aim has been to provide readers with maps that will easily allow them to locate the places where works of art originated or were found and where buildings were erected. To this end we have regularly placed the names of modern nations on maps of the territories of past civilizations. The maps, therefore, are pedagogical tools and do not constitute a historical atlas. A historical timeline does, however, accompany each map. At the top is a time rule and the names of historical periods. The central zone features thumbnail photographs of significant monuments in chronological order. The third zone lists important historical figures and major political, cultural, and religious events.

LANGUAGE, GLOSSARY, BIBLIOGRAPHY A group of college students has carefully read many chapters of the revised text of the eleventh edition to assure ease of comprehension and liveliness of expression. The new author team has also provided more frequent headings and subheadings in the text to act as guides for both initial reading and subsequent reviewing for examinations. In addition, in order to aid our readers in mastering the vocabulary of art history, we have italicized and defined all art historical terms and other unfamiliar words at their first occurrence in the text—and at later occurrences too, whenever the term has not been used again for several chapters. Definitions of all terms introduced in the text appear once more in the Glossary at the back of the book, which, for the first time, includes pronunciations. We have also included a pronunciation guide to artists' names, a refined and revised version of that popular feature of the tenth edition. *Art through the Ages* also has a comprehensive bibliography of books in English, including both general works and a chapter-by-chapter list of more focused studies.

PHOTO CAPTIONS The captions to our more than 1400 illustrations contain a wealth of information, including the name of the artist or architect, if known; the formal title (printed in italics), if assigned, description of the work, or name of the building; the findspot or place of production of the object or location of the building; the date; the material or materials used; the size; and the present location if the work is in a museum or private collection. We urge readers to pay attention to the scales provided on all plans and to all dimensions given in the captions. The objects we illustrate vary enormously in size, from colossal sculptures carved into mountain cliffs and paintings that cover entire walls or ceilings to tiny figurines, coins, and jewelry that one can hold in the hand. Note too the location of the monuments discussed. Although many buildings and museums may be in cities or countries that a reader may never visit, others are likely to be close to home. Nothing can substitute for walking through a building, standing in the presence of a statue, or inspecting the brushwork of a painting close up. Consequently, we have made a special effort to illustrate artworks in geographically wide-ranging public collections.

ACKNOWLEDGMENTS

A work as extensive as a global history of art could not be undertaken or completed without the counsel of experts in all areas of world art. For contributions to the eleventh edition in the form of extended critiques of the tenth edition or of the penultimate drafts of the eleventh edition chapters, as well as other assistance of various sorts, we wish to thank Trudi Abram, California State University—Northridge; Catherine Asher, University of Minnesota, Frederick Asher, University of Minnesota, Paul Bahn; Barbara Barletta, University of Florida; Marina Belozerskaya, Radcliffe Institute for Advanced Study; Roberta Bernstein, State University of New York—Albany; Jonathan Best, Wesleyan University; Philip Betancourt, Temple University; Alan Birnholz, State University of New York—Buffalo; Robert Bianchi; Barbara Blackmun, San Diego Mesa College; Ann Marie Bouche, Princeton University; Arthur Bourgeois, Governors State University; Celeste Brusati, University of Michigan; Kathleen Burke-Kelly, Glendale Community College; Walter B. Cahn, Yale University; Anne-Marie Carr, Southern Methodist University; Derrick Cartwright, Musée d'Art Américain—Giverny; Hipolito Chacon, University of Montana; Pramrod Chandra, Harvard University; Michael Charlesworth, University of Texas—Austin; Petra Chu, Seton Hall University; John Clarke, University of Texas—Austin; Adam Cohen, University of California—Berkeley; Jadviga de Costa Nunes, Muhlenburg College; Jeffrey Collins, University of Washington; Joan Coutu, University of Waterloo; Tom Cummins, University of Chicago; Kathy Curnow, Cleveland State University; Anthony Cutler, Pennsylvania State University; Nancy DeGrummond, Florida State University; Walter Denny, University of Massachusetts—Amherst; Marilyn Dunn, Loyola University; Susan Erickson, University of Michigan—Dearborn; Kate Ezra, Columbia College; Betsy Fahlman, Arizona State University; Claire Farago, University of Colorado—Boulder; James Farmer, Virginia Commonwealth University; Peter Fergusson, Wellesley College; Phyllis Floyd, Michigan State University; Mitchell Frank, University of Toronto; Vivien Fryd, Vanderbilt University; Christopher Fulton, Southern Methodist University; Mark Graham, Auburn University; Anthony Gully, Arizona State University; Peter Bacon Hales, University of Illinois—Chicago; Catherine Harding; University of Victoria; Mary Beth Heston, College of Charleston; Jeanne Hokin, Arizona State University; Jeffrey Hughes, Webster University; Susan Huntington, Ohio State University; Carol Ivory, Washington State University; dele jegede, Indiana State University; Amelia Jones, University of California—Riverside; Christy Junkerman, San Jose State University; Deborah Kahn, Boston University; Richard Karberg, Cuyahoga Community College—East Campus; Karl Kilinski, Southern Methodist University; Joni L. Kinsey, University of Iowa; Phyllis Kozlowski, Moraine Valley Community College; David Ludley, Clayton College State University; Rita Parham McCaslin; Sheila McTighe, Columbia University; Patricia Mainardi, City University of New York; Joanne Mannell-Noel, Montana State University; Lynn R. Matteson, University of Southern California; Mark Meadow, University of California—Santa Barbara; Walter Melion, Johns Hopkins University; Arline Meyer, Ohio State University; Anne Mochon, University of Masschusetts—Amherst; Larry Nees, University of Delaware; Mary Pardo, University of North Carolina—Chapel Hill; Robert S. Petersen, Eastern Illinois University; Robert Poor, University of Minnesota; JoAnn Quillman, Louisiana State University; Nancy Ramage, Ithaca College; Ingrida Raudzens, Salem State College; Louise Rice, Duke University; Howard Risatti, Virginia Commonwealth University; Lilien F. Robinson, George Washington University; Mark Rose, *Archaeology Magazine;* Patricia Rose, Florida State University; Christopher D. Roy, The University of Iowa; John Russell, Massachusetts College of Art; Ray Silverman, Michigan State University; Jeffrey Smith, University of Texas—Austin; Jack Spalding, Fordham University; Kristine Stiles, Duke University; Melinda Takeuchi, Stanford University; Roberta Tarbell, Rutgers University—Camden campus; Elizabeth ten Grotenhuis, Boston University; Jan Newstrom Thompson, San Jose State University; Thomas Toone, Utah State University; Bailey Van Hook, Virginia Polytechnic Institute and State University; Richard Vinograd, Stanford University; Deborah Waite, University of Hawaii; Josephine Withers, University of Maryland; Marcilene Wittmer, University of Miami; Mimi Yiengpruksawan, Yale University; and Paul Zimansky, Boston University. Innumerable other instructors and students have also sent us helpful reactions, comments, and suggestions for ways to improve the book. We are grateful for their interest and their insights.

Among those at Harcourt College Publishers who worked with us to make the new edition of *Art through the Ages* the best ever are the president, Ted Buchholz; senior vice president, editorial, Chris Klein; vice president, publisher, Earl McPeek; executive editor, David Tatom; acquisitions editor, John Swanson; technology specialists, Diane Drexler and Sarah Davis Packard; our developmental editors, Helen Triller, Stacey Sims, and Michelle Vardeman; our copy editor, Kay Kaylor; our senior vice president of production, Tim Frelick; senior project editor, Kathryn Stewart; our photo editors, Carrie Ward, Susan Holtz, and Elsa Peterson, all under the in-house supervision of Shirley Webster; our assistant manager of art and design, senior art director, Linda Beaupré; our senior production manager, Diane Gray, and our manager of manufacturing, Lisa Kelly. We are also grateful to the marketing staff for their dedication to making the book successful: Roland Hernandez, senior vice president, marketing; Pat Murphree, executive product manager for marketing avenues; Steve Drummond, executive market strategist; Laura Brennan, market strategist; Mekelle Douglas, marketing coordinator; and Van Strength and Laura Lashley of the Marketing Intelligence Group. Recognition and thanks are also due to our proofreader, Carolyn Crabtree and our indexer, Linda Webster. We take special pleasure in thanking Helen Triller, who has been associated with *Art through the Ages* since the ninth edition. Only those who have worked with Helen on a daily basis can appreciate how important her efforts, expertise, and experience have been to the continuing success of this book.

Among family and friends who have provided various kinds of support, we single out Luraine Tansey, whose contributions to several editions have been chronicled in successive prefaces, and Alex Kleiner, who, to our amazement and delight, was always able to figure out how to make compatible the several different software programs and hardware systems the six authors and many editors used during the preparation of a very long and complex manuscript. We also owe a deep debt of gratitude to our colleagues at Boston University and the University of Nebraska—Lincoln, and to the thousands of students and the scores of teaching fellows in our art history courses over many years in Boston and Lincoln, and at the University of Virginia and Yale University. From them we have learned much that has helped determine the form and content of the eleventh edition.

Fred S. Kleiner
Christin J. Mamiya

GARDNER'S
ART
through the
AGES

ELEVENTH EDITION

ANCILLARY PACKAGE

IN ADDITION TO THE WEALTH OF FEATURES IN THE ELEVENTH EDITION OF *Art through the Ages,* A VARIETY OF ANCILLARIES ARE AVAILABLE TO COMPLEMENT THE TEXTBOOK. CONTACT HARCOURT COLLEGE PUBLISHERS FOR INFORMATION ON HOW TO OBTAIN THESE ITEMS.

WEB SITE Readers are urged to venture beyond the printed page and explore *Art through the Ages* on the Internet at **http://www.harcourtcollege.com/arts/gardner.** This unique resource provides a collection of hundreds of additional images of the works discussed, timelines that chart developments across cultures and over longer periods of time, tips for researching art history on the Internet, and a teaching assistant's guide. It also includes a pronunciation guide, a glossary, self-assessment quizzes, and links to hundreds of other useful sites, all continuously updated. In addition, the thirty-six maps presented in the book have been prepared in an electronic format for access on the Web site.

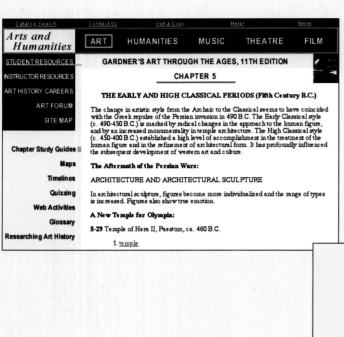

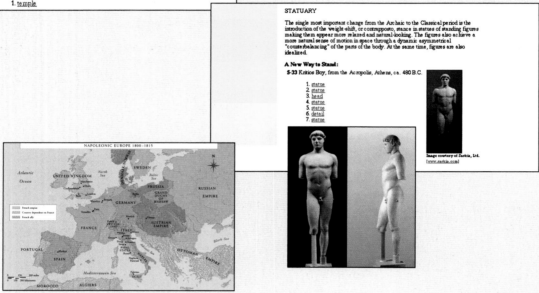

ONLINE COURSE MATERIALS For the first time, a text-specific online course is also available for adoption with *Gardner's Art through the Ages.* Prepared by Linda Scalera Woodward and Deborah Ellington of North Harris College, the course includes chapter-by-chapter learning modules with assignments, discussion questions, Web links and activities, and self-tests. Harcourt College Publishers also offers a variety of other options for WebCT or other course management tool use from free access to a blank WebCT template or basic online testing to customized course creation using materials provided by the instructor.

SLIDE SETS Harcourt College Publishers has assembled three new slide sets for use with the eleventh edition of *Gardner's Art through the Ages.* A full set of 300 images, available in separate parts for Volume I and Volume II, is composed of slides not offered with the tenth edition. Approximately twenty-five percent of the slides illustrate artworks and buildings new to the eleventh edition. A second set contains 50 slides exclusively of works discussed for the first time in the new edition, and a final set of 100 slides consists of plans, sections, diagrams, and maps directly from the textbook.

HARCOURT VIDEO AND CD-ROM ART LIBRARY This extensive library of videos and CD-ROMs contains selections from every era along with a variety of media including architecture and photography. Videos and CD-ROMs are available covering civilizations from around the globe. Examples include *The Caves of Altamira; The Body of Christ in Art; Ancient Treasures: Imperial Art of China;* and *Bauhaus: The Face of the 20th Century.*

GREAT ARTISTS CD-ROM This CD-ROM focuses on eight major artists— William Blake, El Greco, Leonardo da Vinci, Pablo Picasso, Rembrandt, Vincent van Gogh, J.M.W. Turner, and Jean-Antoine Watteau. It includes 1,000 full-color images, 20 minutes of video, biographies of the artists, 500,000 words of descriptive text, 100 music and video clips, an examination of the artists' materials and methods.

PRINT ANCILLARIES A comprehensive package of teaching and study aids accompanies the eleventh edition of *Gardner's Art through the Ages.* The *Study Guide* by Kathleen Cohen (San Jose State University) contains chapter-by-chapter drills on the identification of styles, terms, iconography, major art movements, geographical locations, time periods, and specific philosophical, religious, and historical movements as they relate to particular works of art examined in the textbook. Self-quizzes and discussion questions enable students to evaluate their grasp of the material. Lilla Sweatt (San Diego State University) is the author of the *Instructor's Manual,* which includes sample lecture topics for each chapter, a testbank of questions in formats ranging from matching to essay, studio projects, and lists of resources. A computerized testbank, consisting of questions from the Instructor's Manual, has been created for textbook users. An Internet guide, *Art H.I.T.S. on the Web* is also available with the book. It provides a general introduction to using the World Wide Web and covers Web browsers, search engines, the creation of personal homepages, and presents guidelines for conducting art historical research online as well as for navigating the Gardner Web site.

CONTENTS

CHAPTER 14

CHAPTER 15

CHAPTER 16

CHAPTER 17

CHAPTER 18

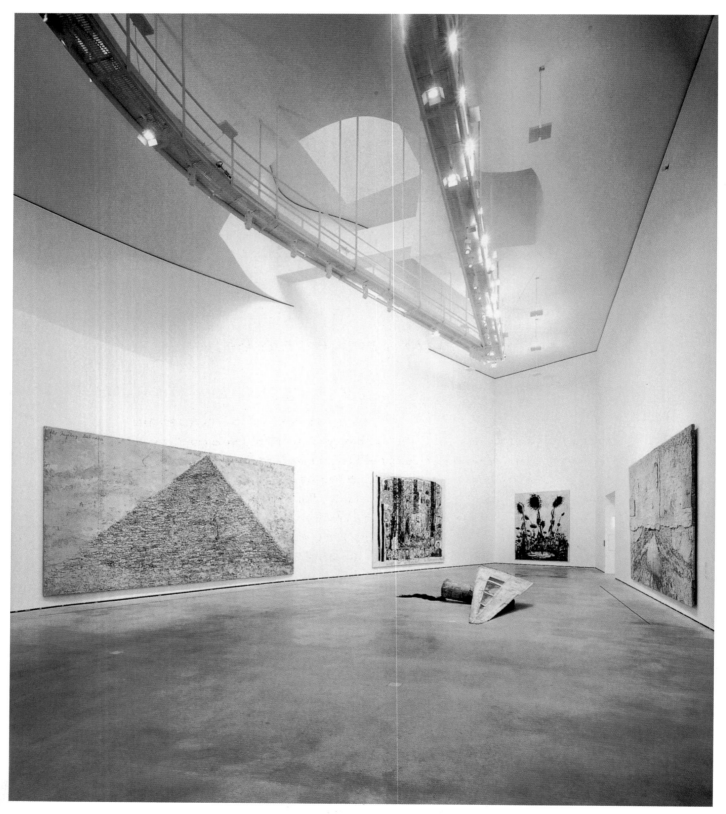

Intro-1 FRANK GEHRY, interior of Guggenheim Museum, Bilbao, Spain, 1997.

INTRODUCTION

THE SUBJECTS AND VOCABULARY
OF ART HISTORY

ART, HISTORY, AND THE HISTORY OF ART

PEOPLE DO NOT OFTEN JUXTAPOSE THE terms *art* and *history*. They tend to think of history as the record and interpretation of past human actions, particularly social and political actions. Most think of art, quite correctly, as part of the present—as objects people can see and touch. People cannot, of course, see or touch history's vanished human events. But a visible and tangible artwork is a kind of persisting event. One or more artists made it at a certain time and in a specific place, even if no one now knows just who, when, where, or why. Although created in the past, an artwork continues to exist in the present, long surviving its times. The first painters and sculptors died thirty thousand years ago, but their works remain, some of them exhibited in glass cases in museums built only a few years ago.

Modern museum visitors can admire these relics of the remote past and the countless other objects humankind has produced over the millennia without any knowledge of the circumstances that led to the creation of those works. An object's beauty or sheer size can impress people, the artist's virtuosity in the handling of ordinary or costly materials can dazzle them, or the subject depicted can move them. Viewers can react to what they see, interpret the work in the light of their own experience, and judge it a success or a failure. These are all valid responses to a work of art. But the enjoyment and appreciation of artworks in museum settings (FIG. **Intro-1**) are relatively recent phenomena, as is the creation of artworks solely for museum-going audiences to view.

Today, it is common for artists to work in private studios and to create paintings, sculptures, and other objects commercial art galleries will offer for sale. Usually, someone the artist has never met will purchase the artwork and display it in a setting the artist has never seen. But although this is not a new phenomenon in the history of art—an ancient potter decorating a vase for sale at a village market stall also probably did not know who

would buy the pot or where it would be housed—it is not at all typical. In fact, it is exceptional. Artists created a high percentage of the paintings, sculptures, and other objects exhibited in museums today for specific patrons and settings and to fulfill a specific purpose. Often, no one knows the original contexts of those artworks. Although people may appreciate the visual and tactile qualities of these objects, they cannot understand why they were made or why they look the way they do without knowing the circumstances of their creation. *Art appreciation* does not require a knowledge of the historical context of an artwork (or a building). *Art history* does.

Thus, a central aim of art historians is to determine the original context of artworks. They seek to achieve a full understanding not only of why these "persisting events" of human history look the way they do but also why the artistic "events" happened at all. What unique set of circumstances gave rise to the erection of a particular building or led a specific patron to commission an individual artist to fashion a singular artwork for a certain place? The study of history is therefore vital to art history. And art history is often very important to the study of history. Art objects and buildings are historical documents that can shed light on the peoples who made them and on the times of their creation in a way other historical documents cannot. Furthermore, artists and architects can affect history by reinforcing or challenging cultural values and practices through the objects they create and the structures they build. Thus, the history of art and architecture is inseparable from the study of history, although the two disciplines are not the same. In the following pages, we outline some of the distinctive subjects art historians address and the kinds of questions they ask, and explain some of the basic terminology art historians use when answering their questions. Armed with this arsenal of questions and words, the reader will be ready to explore the multifaceted world of art through the ages.

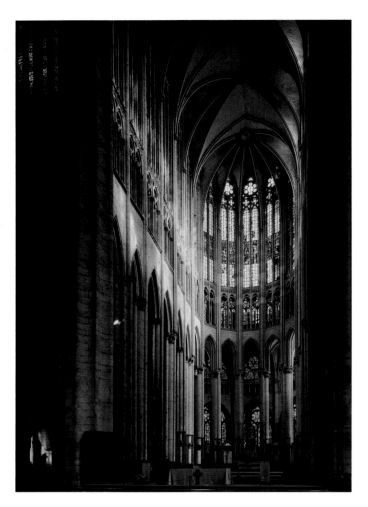

Intro-2 Choir of Beauvais Cathedral, Beauvais, France, rebuilt after 1284.

ART HISTORY IN THE TWENTY-FIRST CENTURY

Art historians study the visual and tangible objects humans make and the structures humans build. They traditionally have classified such works as architecture, sculpture, the pictorial arts (painting, drawing, printmaking, and photography), and the craft arts, or arts of design. The craft arts comprise utilitarian objects, such as ceramic and metal wares, textiles, jewelry, and similar accessories of ordinary living. Artists of every age have blurred the boundaries between these categories, but this is especially true today, when *multimedia* works abound.

From the earliest Greco-Roman art critics on, scholars have studied objects that their makers consciously manufactured as "artworks" and to which the artists assigned formal titles. But today's art historians also study a vast number of objects whose creators and owners almost certainly did not consider artworks. Few ancient Romans, for example, would have regarded a coin bearing their emperor's portrait as anything but money. Today, an art museum may exhibit that coin, and scholars may subject it to the same kind of art historical analysis as a portrait by an acclaimed Renaissance or modern sculptor or painter.

The range of objects art historians study is constantly expanding and now includes, for example, computer-generated images, whereas in the past almost anything produced using a machine would not have been regarded as "art." Most people still consider the performing arts—music, drama, and dance—as outside art history's realm because these arts are temporal, rather than spatial and static, media. But, recently, even this distinction between "fine art" and performance art has become blurred. Art historians, however, generally ask the same kinds of questions about what they study, whether they employ a restrictive or an expansive definition of art.

The Questions Art Historians Ask

HOW OLD IS IT? Before art historians can construct a history of art, they must be sure they know the date of each work they study. Thus, an indispensable subject of art historical inquiry is *chronology*, the dating of art objects and buildings. If researchers cannot determine a monument's age, they cannot place the work in its historical context. Art historians have developed many ways to establish, or at least approximate, the date of an artwork.

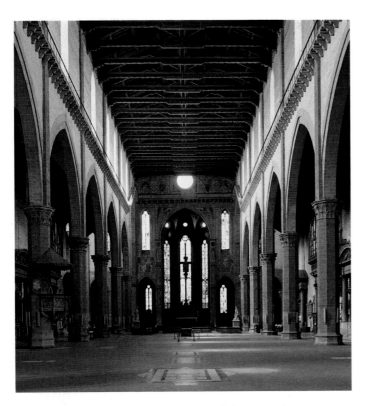

Intro-3 Interior of Santa Croce, Florence, Italy, begun 1294.

Physical evidence often reliably indicates an object's age. The material used for a statue or painting—bronze, plastic, or oil-based pigment, to name only a few—may not have been invented before a certain time, indicating the earliest possible date someone could have fashioned the work. Or artists may have ceased using certain materials—such as specific kinds of inks and papers for drawings and prints—at a known time, providing the latest possible dates for objects made of such materials. Sometimes the material (or the manufacturing technique) of an object or a building can establish a very precise date for an artwork or a building. Studying tree rings, for instance, usually can determine within a narrow range the date of a wood statue or a timber roof beam.

Documentary evidence also can help pinpoint the date of an object or building when a dated written document mentions the work. For example, official records may note when church officials commissioned a new altarpiece—and how much they paid to which artist.

Visual evidence, too, can play a significant role in dating an artwork. A painter might have depicted an identifiable person or a kind of hairstyle, clothing, or furniture fashionable only at a certain time. If so, the art historian can assign a more accurate date to that painting.

Stylistic evidence is also very important. The analysis of *style*—an artist's distinctive manner of producing an object, the way a work looks—is the art historian's special sphere. Unfortunately, because it is a subjective assessment, stylistic evidence is by far the most unreliable chronological criterion.

Still, art historians sometimes find style a very useful tool for establishing chronology.

WHAT IS ITS STYLE? Defining artistic style is one of the key elements of art historical inquiry, although the analysis of artworks solely in terms of style no longer dominates the field the way it once did. Art historians speak of several different kinds of artistic styles.

Period style refers to the characteristic artistic manner of a specific time, usually within a distinct culture, such as "Archaic Greek" or "Early Italian Renaissance." But many periods do not display any stylistic unity at all. How would historians define the artistic style of the 1990s in North America? Far too many crosscurrents existed in that decade for anyone to describe a period style of the late twentieth century—even in a single city such as New York.

Regional style is the term art historians use to describe variations in style tied to geography. Like an object's date, its *provenance,* or place of origin, can significantly determine its character. Very often two artworks from the same place made centuries apart are more similar than contemporaneous works from two different regions. To cite one example, usually only an expert can distinguish between an Egyptian statue carved in 2500 B.C. and one made in 500 B.C. But no one would mistake an Egyptian statue of 500 B.C. for a Greek or Olmec (Mexican) one of the same date.

Considerable variations in a given area's style are possible, however, even during a single historical period. In late medieval Europe during the so-called Gothic age, French architecture differed significantly from Italian architecture. The interiors of Beauvais Cathedral (FIG. **Intro-2**) and Santa Croce in Florence (FIG. **Intro-3**) typify the architectural styles of France and Italy, respectively, at the end of the thirteenth century. The rebuilding of the choir of Beauvais Cathedral began in 1284. Construction commenced on Santa Croce only ten years later. Both structures employ the characteristic Gothic pointed arch, yet they contrast strikingly. The French church has towering stone vaults and large expanses of stained-glass windows, while the Italian building has a low timber roof and small, widely separated windows. Because the two contemporaneous churches served similar purposes, regional style mainly explains their differing appearance.

Personal style, the distinctive manner of individual artists or architects, often decisively explains stylistic discrepancies among monuments of the same time and place. In 1930 the American painter GEORGIA O'KEEFFE produced a series of paintings of flowering plants. One of them was *Jack-in-the-Pulpit IV* (FIG. **Intro-4**), a sharply focused close-up view of petals and leaves. O'Keeffe captured the growing plant's slow, controlled motion while converting the organic form into a powerful abstract composition of lines, shapes, and colors (see our discussion of art historical vocabulary in the next section). Only a year later, another American artist, BEN SHAHN, painted *The Passion of Sacco and Vanzetti* (FIG. **Intro-5**), a stinging commentary on social injustice inspired by the trial and execution of two Italian anarchists, Nicola Sacco and Bartolomeo Vanzetti. Many people believed Sacco and Vanzetti had been unjustly convicted of killing two men in a holdup in 1920. Shahn's painting compresses time in a symbolic representation of the trial and its aftermath. The

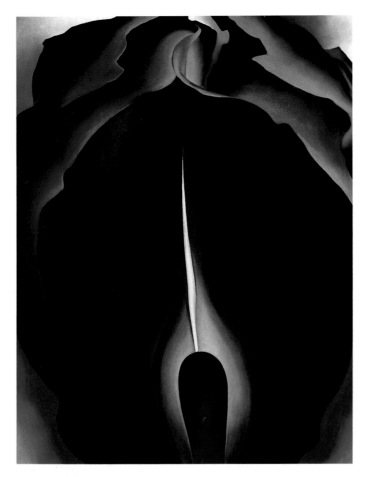

Intro-4 GEORGIA O'KEEFFE, *Jack-in-the-Pulpit IV,* 1930. Oil on canvas, 3′ 4″ × 2′ 6″. Formerly in the collection of Georgia O'Keeffe.

two executed men lie in their coffins. Presiding over them are the three members of the commission (headed by a college president wearing academic cap and gown) who declared the original trial fair and cleared the way for the executions. Behind, on the wall of a columned government building, hangs the framed portrait of the judge who pronounced the initial sentence. Personal style, not period or regional style, sets Shahn's canvas apart from O'Keeffe's. The contrast is extreme here because of the very different subjects the artists chose. But when two artists depict the same subject, the results also can vary widely. The *way* O'Keeffe painted flowers and the *way* Shahn painted faces are distinctive and unlike the styles of their contemporaries. (See the "Who Made It?" discussion on page xxii.)

The different kinds of artistic styles are not mutually exclusive. For example, an artist's personal style may change dramatically during a long career. Art historians then must distinguish among the different period styles of a particular artist, such as the "Blue Period" and the "Cubist Period" of the prolific twentieth-century artist Pablo Picasso.

WHAT IS ITS SUBJECT? Another major concern of art historians is, of course, subject matter, encompassing the story, or *narrative;* the scene presented; the action's time and place; the persons involved; and the environment and its details. Some artworks, such as modern abstract paintings, have

no subject, not even a setting. But when artists represent people, places, or actions, viewers must identify these aspects to achieve complete understanding of the works. Art historians traditionally separate pictorial subjects into various categories, such as religious, historical, mythological, *genre* (daily life), portraiture, *landscape* (a depiction of a place), *still life* (an arrangement of inanimate objects), and their numerous subdivisions and combinations.

Iconography—literally, the "writing of images"—refers both to the *content,* or subject of an artwork, and to the study of content in art. By extension, it also includes the study of *symbols,* images that stand for other images or encapsulate ideas. In Christian art, two intersecting lines of unequal length or a simple geometric cross can serve as an emblem of the religion as a whole, symbolizing the cross of Jesus Christ's crucifixion. A symbol also can be a familiar object the artist

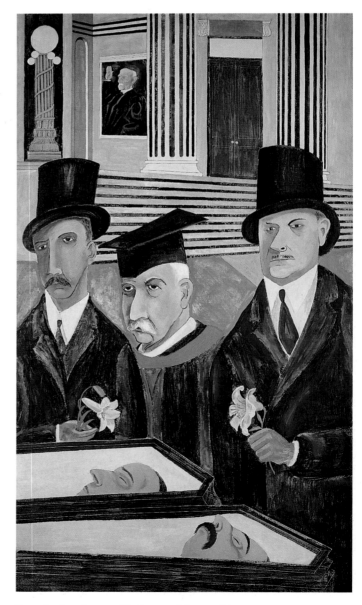

Intro-5 BEN SHAHN, *The Passion of Sacco and Vanzetti,* 1931–1932. Tempera on canvas, 7′ $\frac{1}{2}$″ × 4′. Whitney Museum of American Art, New York (gift of Edith and Milton Lowenthal in memory of Juliana Force).

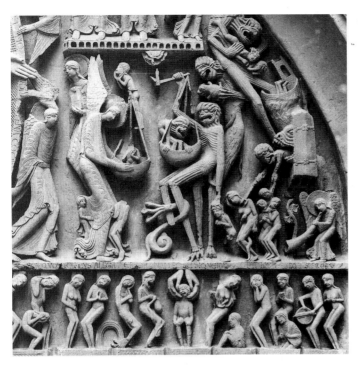

Intro-6 The weighing of souls, detail of west tympanum of Saint-Lazare, Autun, France, ca. 1130.

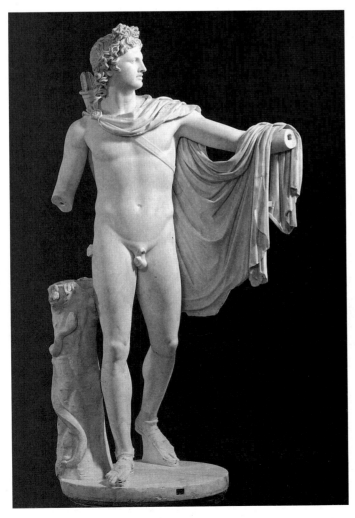

Intro-7 *Apollo Belvedere,* Roman copy or variation of a Greek statue of the mid-fourth century B.C. Marble, approx. 7′ 4″ high. Vatican Museums, Rome.

imbued with greater meaning. A balance or scale, for example, may symbolize justice or the weighing of souls on Judgment Day (FIG. **Intro-6**).

Artists also may depict figures with unique *attributes* identifying them. The Greek god Apollo (FIG. **Intro-7**), an archer, almost always carries a bow and quiver of arrows. In Asian art, the Buddha (FIG. **Intro-8**) has an *urna* (a coil of hair between the brows sometimes shown as a dot), an *ushnisha* (bump on top of the skull), and elongated earlobes as distinguishing marks. In Christian art, Saint Peter—and only Peter—carries the keys to the kingdom of Heaven.

Throughout the history of art, artists also used *personifications*—abstract ideas codified in bodily form. Worldwide, people visualize Liberty as a robed woman with a torch because of the fame of the colossal statue set up in New York

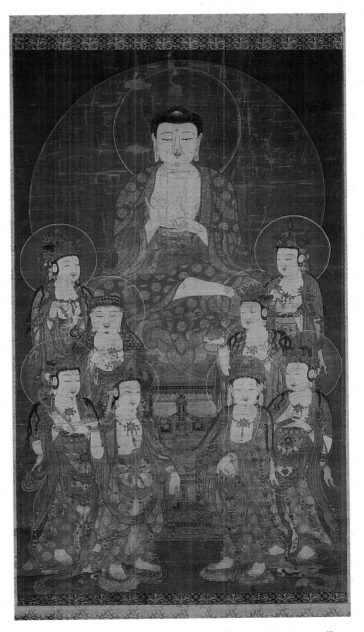

Intro-8 Buddha Amitabha and eight great Bodhisattvas (hanging scroll), Koryo dynasty, from Korea, fourteenth century. Ink, colors, and gold on silk, approx. 4′ 11½″ × 2′ 11″. Asian Art Museum of San Francisco, San Francisco (Avery Brundage Collection).

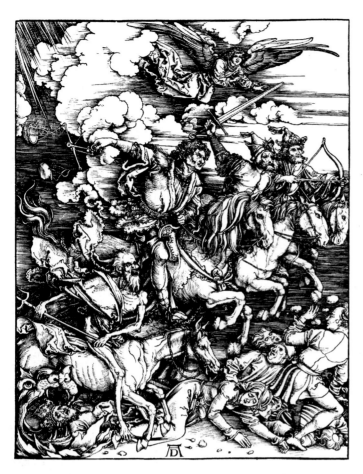

Intro-9 ALBRECHT DÜRER, *The Four Horsemen of the Apocalypse,* ca. 1498. Woodcut, approx. 1′ 3¼″ × 11″. Metropolitan Museum of Art, New York (gift of Junius S. Morgan, 1919).

City's harbor in the nineteenth century. *The Four Horsemen of the Apocalypse* (FIG. **Intro-9**) is a terrifying late-fifteenth-century depiction of the fateful day at the end of time when, according to the Bible's last book, Death, Famine, War, and Pestilence will cut down the human race. The artist, AL-BRECHT DÜRER, personified Death as an emaciated old man with a pitchfork. Dürer's Famine swings the scales that will weigh human souls (compare FIG. Intro-6), War wields a sword, and Pestilence draws a bow.

Even without considering style and without knowing a work's maker, informed viewers can determine much about the work's period and provenance by iconographical and subject analysis alone. In *The Passion of Sacco and Vanzetti* (FIG. Intro-5), for example, the two coffins, the trio headed by an academic, and the robed judge in the background are all pictorial clues revealing the painting's subject. The work's date must be after the trial and execution, probably while the event was still newsworthy. And because the two men's deaths caused the greatest outrage in the United States, the painter/social critic was probably American.

WHO MADE IT? If Ben Shahn had not signed his painting of Sacco and Vanzetti, an art historian could still assign, or *attribute,* the work to him based on knowledge of the artist's personal style. Although signing (and dating) works is quite common (but by no means universal) today, in the his-

tory of art countless works exist whose artists remain unknown. Since personal style can play a large role in determining an artwork's character, art historians often try to attribute anonymous works to known artists. Sometimes they attempt to assemble a group of works all thought to be by the same person, even though none of the objects in the group is the known work of an artist with a recorded name. Art historians thus reconstruct the careers of people such as "the Andokides Painter," the anonymous ancient Greek artist who painted the vases the potter Andokides produced. Scholars attribute works based on internal evidence, such as the distinctive way an artist draws or carves drapery folds, earlobes, or flowers. It requires a keen, highly trained eye and long experience to become a *connoisseur,* an expert in assigning artworks to "the hand" of one artist rather than another. Attribution is, of course, subjective and ever open to doubt. At present, for example, international debate rages over attributions to the famous Dutch painter Rembrandt.

Sometimes a group of artists works in the same style at the same time and place. Art historians designate such a group as a *school.* "School" does not mean an educational institution. The term only connotes chronological, stylistic, and geographic similarity. Art historians speak, for example, of the Dutch school of the seventeenth century and, within it, of subschools such as those of the cities of Haarlem, Utrecht, and Leyden.

WHO PAID FOR IT? The interest many art historians show in attribution reflects their conviction that the identity of an artwork's maker is the major reason the object looks the way that it does. For them, personal style is of paramount importance. But in many times and places artists had little to say about what form their work would take. They toiled in obscurity, doing the bidding of their *patrons,* those who paid them to make individual works or employed them on a continuing basis. The role of patrons in dictating the content and shaping the form of artworks is also an important subject of art historical inquiry.

In the art of portraiture, to name only one category of painting and sculpture, the patron has often played a dominant role in deciding how the artist represented the subject, whether the patron or another person, such as a spouse, son, or mother. Many Egyptian pharaohs and some Roman emperors, for example, insisted artists depict them with unlined faces and perfect youthful bodies no matter how old they were when portrayed. In these cases, the state employed the sculptors and painters, and the artists had no choice but to depict their patrons in the officially approved manner. This is why Augustus, who lived to age seventy-six, looks so young in his portraits (FIG. **Intro-10**). Although Roman emperor for more than forty years, Augustus demanded artists always represent him as a young, godlike head of state.

All modes of artistic production reveal the impact of patronage. Learned monks provided the themes for the sculptural decoration of medieval church portals. Renaissance princes and popes dictated the subjects, sizes, and materials of artworks destined, sometimes, for buildings constructed according to their specifications. An art historian could make a very long list along these lines, and it would indicate that throughout the history of art, patrons have had diverse tastes

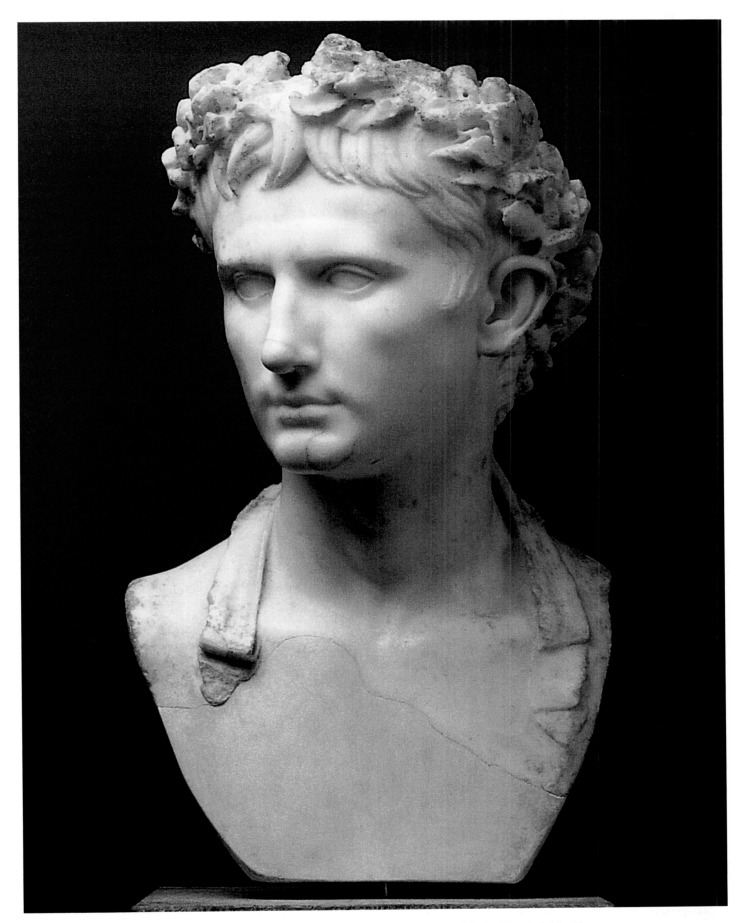

Intro-10 Augustus wearing *corona civica* (civic crown), early first century A.D. Marble, approx. 1′ 5″ high. Glyptothek, Munich.

and needs and demanded different kinds of art. Whenever a patron contracts an artist or architect to paint, sculpt, or build in a prescribed manner, personal style often becomes a very minor factor in how the painting, statue, or building looks. In such cases, knowing the patron's identity reveals more to art historians than does the identity of the artist or school. The portrait of Augustus illustrated here was the work of a virtuoso sculptor, a master wielder of hammer and chisel. But scores of similar portraits of that emperor exist today. They differ in quality but not in kind from this one. The patron, not the artist, determined the character of such artworks. Augustus's public image never varied.

The Words Art Historians Use

Like all specialists, art historians have their own specialized vocabulary. That vocabulary consists of hundreds of words, but certain basic terms are indispensable for describing artworks and buildings of any time and place, and we use those terms throughout this book. They make up the essential vocabulary of *formal analysis,* the visual analysis of artistic form. We define the most important of these art historical terms here. For a much longer list, consult the Glossary in this book's end material.

FORM AND COMPOSITION *Form* refers to an object's shape and structure, either in two dimensions (for example, a figure painted on a canvas) or in three dimensions (such as a statue carved from a marble block). Two forms may take the same shape but may differ in their color, texture, and other qualities. *Composition* refers to how an artist organizes (composes) forms in an artwork, either by placing shapes on a flat surface or arranging forms in space.

MATERIAL AND TECHNIQUE To create art forms, artists shape *materials* (pigment, clay, marble, gold, and many more) with *tools* (pens, brushes, chisels, and so forth). Each of the materials and tools available has its own potentialities and limitations. Part of all artists' creative activity is to select the medium and instrument most suitable to the artists' purpose—or to pioneer the use of new media and tools, such as bronze and concrete in antiquity and cameras and computers in modern times. The processes artists employ, such as applying paint to canvas with a brush, and the distinctive, personal ways they handle materials constitute their *technique.* Form, material, and technique interrelate and are central to analyzing any work of art.

LINE *Line* is one of the most important elements defining an artwork's shape or form. A line can be understood as the path of a point moving in space, an invisible line of sight or a visual *axis.* But, more commonly, artists and architects make a line concrete by drawing (or chiseling) it on a *plane,* a flat and two-dimensional surface. A line may be very thin, wirelike, and delicate, it may be thick and heavy, or it may alternate quickly from broad to narrow, the strokes jagged or the outline broken. When a continuous line defines an object's outer shape, art historians call it a *contour* line.

One can observe all of these line qualities in Dürer's *Four Horsemen of the Apocalypse* (FIG. Intro-9). Contour lines define

the basic shapes of clouds, human and animal limbs, and weapons. Within the forms, series of short broken lines create shadows and textures. An overall pattern of long parallel strokes suggests the dark sky on the frightening day when the world is about to end.

COLOR Light reveals all colors. *Light* in the world of the painter and other artists differs from natural light. Natural light, or sunlight, is whole or *additive* light. As the sum of all the wavelengths composing the visible *spectrum,* it may be disassembled or fragmented into the spectral band's individual colors. The painter's light in art—the light reflected from pigments and objects—is *subtractive* light. Paint pigments produce their individual colors by reflecting a segment of the spectrum while absorbing all the rest. "Green" pigment, for example, subtracts or absorbs all the light in the spectrum except that seen as green, which it reflects to the eyes.

Hue is the property giving a color its name. Although the spectrum colors merge into each other, artists usually conceive of their hues as distinct from one another. Color has two basic variables—the apparent amount of light reflected and the apparent purity. A change in one must produce a change in the other. Some terms for these variables are *value* or *tonality* (the degree of lightness or darkness) and *intensity* or *saturation* (the purity of a color, its brightness or dullness).

A *color triangle* (FIG. **Intro-11**) clearly shows the relationships among the six main colors. Red, yellow, and blue, the *primary colors,* are the vertexes of the large triangle. Orange, green, and purple, the *secondary colors* resulting from mixing pairs of primaries, lie between them. Colors opposite each other in the spectrum—red and green, purple and yellow, and orange and blue here—are *complementary colors.* They "complement," or complete, each other, one absorbing colors the other reflects. When painters mix complementaries in the right proportions, a neutral tone or gray (theoretically, black) results.

TEXTURE *Texture* is the quality of a surface (such as rough or shiny) that light reveals. Art historians distinguish between *actual* textures, or the surface's tactile quality, and *represented* textures, as when painters depict an object as hav-

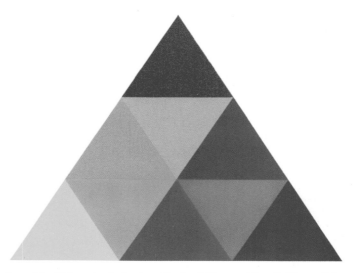

Intro-11 Color triangle developed by Josef Albers and Sewell Sillman. Yale University Art Gallery, New Haven.

ing a certain texture, even though the paint is the actual texture. Sometimes artists combine different materials of different textures on a single surface, juxtaposing paint with pieces of wood, newspaper, fabric, and so forth. Art historians refer to this *mixed-media* technique as *collage.* Texture is, of course, a key determinant of any sculpture's character. People's first impulse is usually to handle a piece of sculpture—even though museum signs often warn "Do not touch!" Sculptors plan for this natural human response, using surfaces varying in texture from rugged coarseness to polished smoothness. Textures are often intrinsic to a material, influencing the type of stone, wood, plastic, clay, or metal sculptors select.

SPACE, MASS, AND VOLUME *Space* is the bounded or boundless "container" of objects. For art historians, space can be *actual,* the three-dimensional space occupied by a statue or a vase or contained within a room or courtyard. Or it can be *illusionistic,* as when painters depict an image (or illusion) of the three-dimensional spatial world onto a two-dimensional surface.

Mass and *volume* describe three-dimensional space. In both architecture and sculpture, mass is the bulk, density, and weight of matter in space. Yet the mass need not be solid. It can be the exterior form of enclosed space. "Mass" can apply to a solid Egyptian pyramid or wooden statue, to a church, synagogue, or mosque—architectural shells enclosing sometimes vast spaces—and to a hollow metal statue or baked clay pot. Volume is the space that mass organizes, divides, or encloses. It may be a building's interior spaces, the intervals between a structure's masses, or the amount of space occupied by three-dimensional objects such as sculpture, pottery, or furniture. Volume and mass describe both the exterior and interior forms of a work of art—the forms of the matter of which it is composed and the spaces immediately around the work and interacting with it.

PERSPECTIVE AND FORESHORTENING *Perspective* is one of the most important pictorial devices for organizing forms in space. Throughout history, artists have used various types of perspective to create an illusion of depth or space on a two-dimensional surface. The French painter CLAUDE LORRAIN employed several perspectival devices in *Embarkation of the Queen of Sheba* (FIG. **Intro-12**), a painting of a biblical episode set in a seventeenth-century European harbor

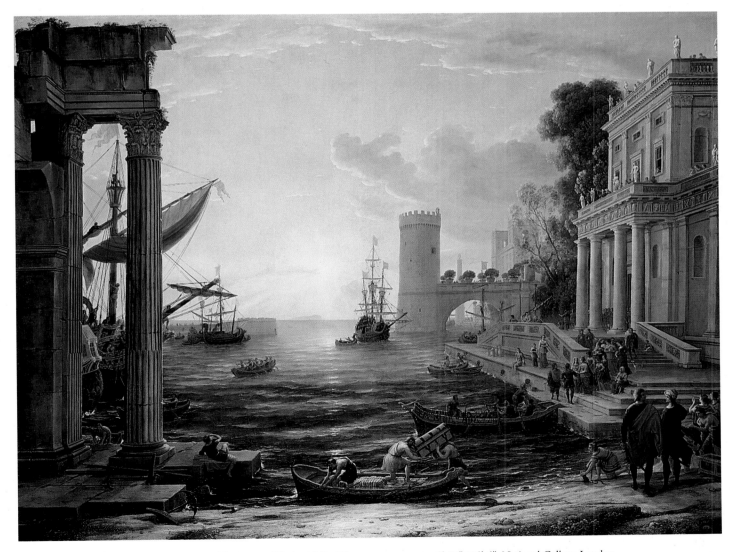

Intro-12 CLAUDE LORRAIN, *Embarkation of the Queen of Sheba,* 1648. Oil on canvas, approx. 4′ 10″ × 6′ 4″. National Gallery, London.

with a Roman ruin in the left foreground. For example, the figures and boats on the shoreline are much larger than those in the distance. Decreasing an object's size makes it appear farther away from viewers. Also, the top and bottom of the port building at the painting's right side are not parallel horizontal lines, as they are in an actual building. Instead, the lines converge beyond the structure, leading viewers' eyes toward the hazy, indistinct sun on the horizon. These perspectival devices—the reduction of figure size, the convergence of diagonal lines, and the blurring of distant forms—have been familiar features of Western art since the ancient Greeks. But it is important to note at the outset that all kinds of perspective are only pictorial conventions, even when one or more types of perspective may be so common in a given culture that they are accepted as "natural" or "true" means of representing the natural world.

In *Red Plum Blossoms* (FIG. **Intro-13**) a Japanese landscape painting, OGATA KORIN used none of these Western perspective conventions. He showed the plum tree as seen from a position on the ground, while viewers look down on the stream from above. Less concerned with locating the tree and stream in space than with composing shapes on a surface, the painter played the water's gently swelling curves against the jagged contours of the branches and trunk. Neither the French nor the Japanese painting can be said to "correctly" project what

viewers "in fact" see. One painting is not a "better" picture of the world than the other. The artists simply approached the problem of picture-making differently.

Artists also represent single figures in space in varying ways. When PETER PAUL RUBENS painted *Lion Hunt* (FIG. **Intro-14**) in the early seventeenth century, he used *foreshortening* for all the hunters and animals, that is, he represented their bodies at angles to the picture plane. When in life one views a figure at an angle, the body appears to contract as it extends back in space. Foreshortening is a kind of perspective. It produces the illusion that one part of the body is farther away than another, even though all the forms are on the same surface. Especially noteworthy in *Lion Hunt* are the gray horse at the left, seen from behind with the bottom of its left rear hoof facing viewers and most of its head hidden by its rider's shield, and the fallen hunter at the canvas's lower right corner, whose barely visible legs and feet recede into the distance.

The artist who carved the portrait of the ancient Egyptian official Hesire (FIG. **Intro-15**) did not employ foreshortening. That artist's purpose was to present the various human body parts as clearly as possible, without overlapping. The lower part of Hesire's body is in profile to give the most complete view of the legs, with both the heels and toes of the foot visible. The frontal torso, however, allows viewers to see its full shape, including both shoulders, equal in size, as in na-

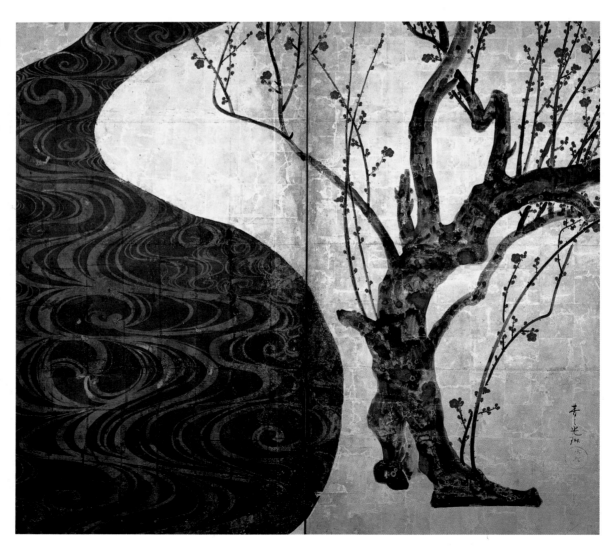

Intro-13 OGATA KORIN, *Red Plum Blossoms,* Edo period, ca. 1710–1716. One of a pair of twofold screens. Ink, color, and gold leaf on paper, 5′ 1$\frac{5}{8}$″ × 5′ 7$\frac{7}{8}$″. Museum of Art, Atami.

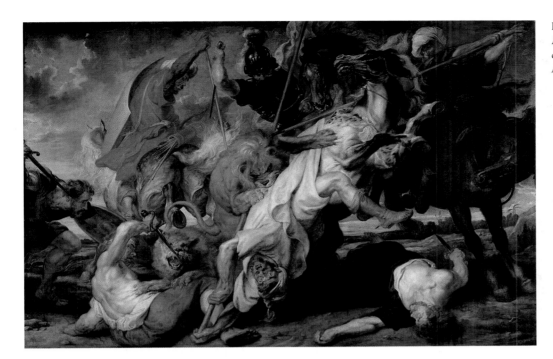

Intro-14 Peter Paul Rubens,
Lion Hunt, 1617–1618. Oil on
canvas, approx. 8′ 2″ × 12′ 5″.
Alte Pinakothek, Munich.

ture. (Compare the shoulders of the hunter on the gray horse
or those of the fallen hunter in *Lion Hunt*'s left foreground.)
The result, an "unnatural" ninety-degree twist at the waist,
provides a precise picture of human body parts. Rubens and
the ancient sculptor used very different means of depicting
forms in space. Once again, neither is the "correct" manner.

PROPORTION AND SCALE *Proportion* concerns the
relationships (in terms of size) of the parts of persons, build-
ings, or objects. "Correct proportions" may be judged intu-
itively ("that statue's head seems the right size for the body").
Or proportion may be formalized as a mathematical relation-
ship between the size of one part of an artwork or building
and the other parts within the work. Proportion in art implies
using a *module,* or basic unit of measure. When an artist or ar-
chitect uses a formal system of proportions, all parts of a
building, body, or other entity will be fractions or multiples of
the module. A module might be a column's diameter, the
height of a human head, or any other component whose di-
mensions can be multiplied or divided to determine the size
of the work's other parts.

In certain times and places, artists have formulated *canons,*
or systems, of "correct" or "ideal" proportions for representing
human figures, constituent parts of buildings, and so forth. In
ancient Greece, many sculptors formulated canons of propor-
tions so strict and all-encompassing that they calculated the
size of every body part in advance, even the fingers and toes,
according to mathematical ratios (FIG. Intro-7). The ideal of
human beauty the Greeks created based on "correct" propor-
tions influenced the work of countless later artists in the
Western world and endures to this day. Proportional systems
can differ sharply from period to period, culture to culture,
and artist to artist. Part of the task art history students face is
to perceive and adjust to these differences.

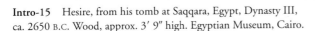

Intro-15 Hesire, from his tomb at Saqqara, Egypt, Dynasty III,
ca. 2650 B.C. Wood, approx. 3′ 9″ high. Egyptian Museum, Cairo.

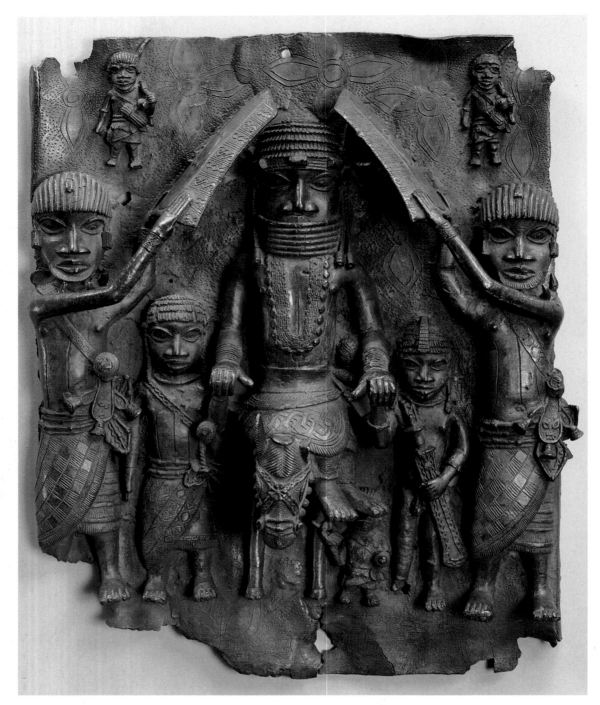

Intro-16 King on horseback with attendants, from Benin, Nigeria, ca. 1550–1680. Bronze, 1′ 7½″ high. Metropolitan Museum of Art, New York (Michael C. Rockefeller Memorial Collection, gift of Nelson A. Rockefeller).

In fact, many artists have used *disproportion* and distortion deliberately for expressive effect. In the medieval French depiction of the weighing of souls on Judgment Day (FIG. Intro-6), the devilish figure yanking down on the scale has distorted facial features and stretched, lined limbs with animal-like paws for feet. Disproportion and distortion make him appear "inhuman," precisely as the sculptor intended.

In other cases, artists have used disproportion to focus attention on one body part (often the head) or to single out a group member (usually the leader). These intentional "unnatural" discrepancies in proportion constitute what art historians call *hierarchy of scale,* the enlarging of elements considered the most important. On a bronze plaque from Benin, Nigeria (FIG. **Intro-16**), the sculptor enlarged all the heads for

emphasis and also varied the size of each figure according to its social status. Central, largest, and therefore most important is the Benin king, mounted on horseback. The horse has been a symbol of power and wealth in many societies from prehistory to the present. That the Benin king is disproportionately larger than his horse, contrary to nature, further aggrandizes him. Two large attendants fan the king. Other figures of smaller size and status at the Benin court stand on the king's left and right and in the plaque's upper corners. One tiny figure next to the horse is almost hidden from view beneath the king's feet.

CARVING AND CASTING Sculptural technique falls into two basic categories, *subtractive* and *additive. Carving* is a

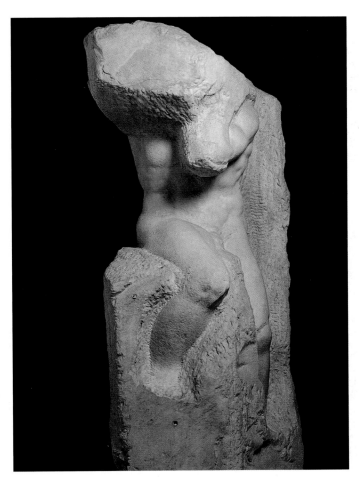

Intro-17 MICHELANGELO, unfinished captive, 1527–1528. Marble, 8′ 7½″ high. Accademia, Florence.

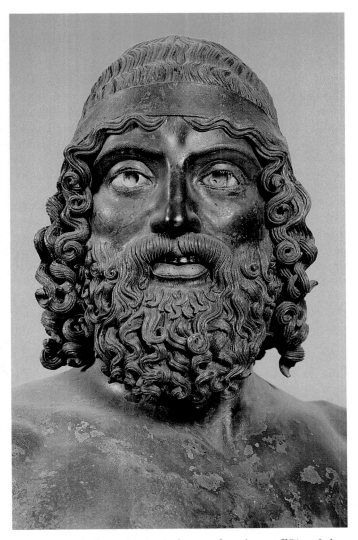

Intro-18 Head of a warrior, detail of a statue from the sea off Riace, Italy, ca. 460–450 B.C. Bronze, statue approx. 6′ 6″ high. Archeological Museum, Reggio Calabria.

subtractive technique. The final form is a reduction of the original mass of a block of stone, a piece of wood, or another material. Wooden statues were once tree trunks, and stone statues began as blocks pried from mountains. In an unfinished sixteenth-century marble statue of a bound slave (FIG. **Intro-17**) by MICHELANGELO, the stone block's original shape is still visible. Michelangelo thought of sculpture as a process of "liberating" the statue within the block. All sculptors of stone or wood cut away (subtract) "excess material." When they finish, they "leave behind" the statue—in our example, a twisting nude male form whose head Michelangelo never freed from the stone block.

In additive sculpture, the artist builds up the forms, usually in clay around a framework, or *armature.* Or a sculptor may fashion a *mold,* a hollow form for shaping, or *casting,* a fluid substance such as bronze. The ancient Greek sculptor who made the bronze statue of a warrior found in the sea near Riace, Italy, cast the head (FIG. **Intro-18**), limbs, torso, hands, and feet in separate molds and then *welded* them (joined them by heating). Finally, the artist added features, such as the pupils of the eyes (now missing), in other materials. The warrior's teeth are silver and his lower lip is copper.

RELIEF SCULPTURE Statues that exist independent of any architectural frame or setting and that viewers can walk around are *freestanding* sculptures, or sculptures "in the round," whether the piece was carved (FIG. Intro-7) or cast (FIG. Intro-18). In *relief sculptures,* the subjects project from the background but remain part of it. In *high relief* sculpture, the images project boldly. In some cases, such as the weighing-of-souls relief at Autun (FIG. Intro-6), the relief is so high that not only do the forms cast shadows on the background, but some parts are actually in the round. The scale's arms are fully detached from the background in places—which explains why some pieces broke off centuries ago. In *low relief,* or *bas-relief,* such as the wooden relief of Hesire (FIG. Intro-15), the projection is slight. In a variation of both techniques, *sunken relief,* the sculptor cuts the design into the surface so that the image's highest projecting parts are no higher than the surface itself. Relief sculpture, like sculpture in the round, can be produced either by carving or casting. The plaque from Benin (FIG. Intro-16) is a good example of bronze-casting in high relief. Artists also can make reliefs by hammering a sheet of metal from behind, pushing the subject out from the background in a technique called *repoussé.*

ARCHITECTURAL DRAWINGS Buildings are groupings of enclosed spaces and enclosing masses. People experience architecture both visually and by moving through and

around it, so they perceive architectural space and mass together. These spaces and masses can be represented graphically in several ways, including as plans, sections, elevations, and cutaway drawings.

A *plan,* essentially a map of a floor, shows the placement of a structure's masses and, therefore, the spaces they bound and enclose. A *section,* like a vertical plan, depicts the placement of the masses as if the building were cut through along a plane. Drawings showing a theoretical slice across a structure's width are *lateral sections.* Those cutting through a building's length are *longitudinal sections.* Illustrated here is the plan and half of the lateral section of Bourges Cathedral (FIG. **Intro-19**), a French Gothic church similar in character to Beauvais Cathedral (FIG. Intro-2). The plan shows not only the building's shape and the location of the piers dividing the aisles and supporting the vaults above but also the pattern of the crisscrossing vault *ribs.* The lateral section shows both the main area of the church and the vaults below the floor.

Other types of architectural drawings appear throughout this book. An *elevation* drawing is a head-on view of an external or internal wall. A *cutaway* combines an exterior view with an interior view of part of a building in a single drawing.

This overview of the art historian's vocabulary is not exhaustive, nor have artists used only painting, drawing, sculpture, and architecture as media over the millennia. Ceramics, jewelry, textiles, photography, and computer art are just some of the numerous other arts. All of them involve highly specialized techniques described in distinct vocabularies. These are considered and defined where they arise in the text.

Art History and Other Disciplines

By its very nature, the work of art historians intersects with that of others in many fields of knowledge, not only in the humanities but also in the social and natural sciences. To "do their job" well today, art historians regularly must go beyond the boundaries of what the public and even professional art historians of previous generations traditionally have considered the specialized discipline of art history. Art historical research in the twenty-first century is frequently *interdisciplinary* in nature. To cite one example, in an effort to unlock the secrets of a particular statue, an art historian might conduct archival research hoping to uncover new documents shedding light on who paid for the work and why, who made it and when, where it originally stood, how its contemporaries viewed it, and a host of other questions. Realizing, however, that the authors of the written documents often were not objective recorders of fact but observers with their own biases and agendas, the art historian may also use methodologies developed in fields such as literary criticism, philosophy, sociology, and gender studies to weigh the evidence the documents provide.

At other times, rather than attempting to master many disciplines at once, art historians band together with other specialists in *multidisciplinary* inquiries. Art historians might call in chemists to date an artwork based on the composition of the materials used or might ask geologists to determine which quarry furnished the stone for a particular statue. X-ray technicians might be enlisted in an attempt to establish whether or not a painting is a forgery. Of course, art historians often

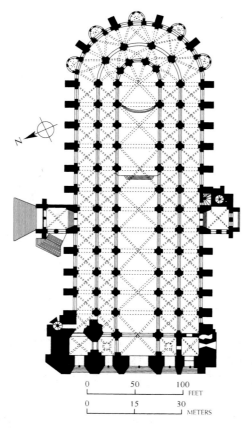

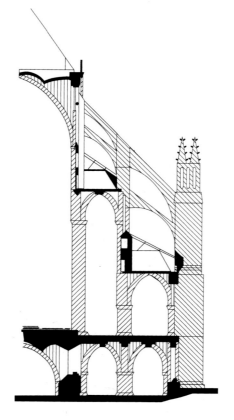

Intro-19 Plan *(left)* and lateral section *(right)* of Bourges Cathedral, Bourges, France, 1195–1255.

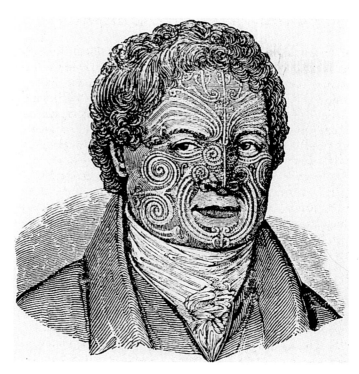 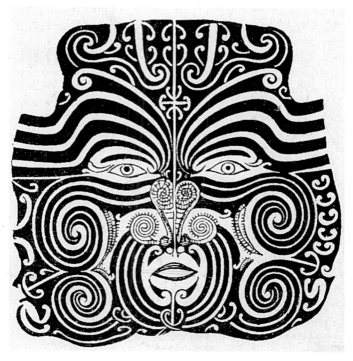

Intro-20 JOHN SYLVESTER *(left)* and TE PEHI KUPE *(right)*, portraits of Maori chief Te Pehi Kupe, 1826. From *The Childhood of Man,* by Leo Frobenius (New York: J. B. Lippincott, 1909).

contribute their expertise to the solution of problems in other disciplines. A historian, for example, might ask an art historian to determine—based on style, material, iconography, and other criteria—if any of the portraits of a certain king were made after his death. That would help establish the ruler's continuing prestige during his successors' reigns. (Some portraits of Augustus, FIG. Intro-10, the Roman Empire's founder, postdate his death by decades, even centuries.)

DIFFERENT WAYS OF SEEING

The history of art can be a history of artists and their works, of styles and stylistic change, of materials and techniques, of images and themes and their meanings, and of contexts and cultures and patrons. The best art historians analyze artworks from many viewpoints. But no art historian (or scholar in any other field!), no matter how broad-minded in approach and no matter how experienced, can be truly objective. Like artists, art historians are members of a society, participants in its culture. How can scholars (and museum visitors and travelers to foreign locales) comprehend cultures unlike their own? They can try to reconstruct the original cultural contexts of artworks, but they are bound to be limited by their distance from the thought patterns of the cultures they study and by the obstructions to understanding their own thought patterns raise—the assumptions, presuppositions, and prejudices peculiar to their own culture. Art historians may reconstruct a distorted picture of the past because of culture-bound blindness.

A single instance underscores how differently people of diverse cultures view the world and how various ways of seeing can cause sharp differences in how artists depict the world.

We illustrate two contemporaneous portraits of a nineteenth-century Maori chieftain side by side (FIG. Intro-20)—one by an Englishman, JOHN SYLVESTER, and the other by the New Zealand chieftain himself, TE PEHI KUPE. Both reproduce the chieftain's facial tattooing. The European artist included the head and shoulders and underplayed the tattooing. The tattoo pattern is one aspect of the likeness among many, no more or less important than the fact the chieftain is dressed like a European. Sylvester also recorded his subject's momentary glance toward the right and the play of light on his hair, fleeting aspects that have nothing to do with the figure's identity.

By contrast, Te Pehi Kupe's self-portrait—made during a trip to Liverpool, England, to obtain European arms to take back to New Zealand—is not a picture of a man situated in space and bathed in light. Rather, it is the chieftain's statement of the supreme importance of the design that symbolizes his rank among his people. Remarkably, Te Pehi Kupe created the tattoo patterns from memory, without the aid of a mirror. The splendidly composed insignia, presented as a flat design separated from the body and even from the head, is Te Pehi Kupe's image of himself. Only by understanding the cultural context of each portrait can viewers hope to understand why either looks the way it does.

As noted at the outset, the study of the context of artworks and buildings is one of the central aims of art history. Our purpose in writing *Art through the Ages* is to present a history of art and architecture that will help readers understand not only the subjects, styles, and techniques of paintings, sculptures, buildings, and other art forms created in all parts of the world for thirty millennia but also their cultural and historical contexts. That story now begins.

PREHISTORIC EUROPE AND THE NEAR EAST

35,000 B.C. 25,000 B.C. 15,000 B.C. 12,000 B.C.

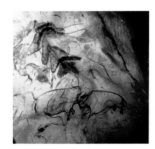

Chauvet Cave
Vallon-Pont-d'Arc
ca. 30,000–28,000 B.C.

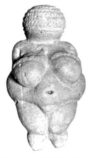

Venus of Willendorf
ca. 28,000–25,000 B.C.

Painted plaque
Apollo 11 Cave, Namibia
ca. 23,000 B.C.

Hall of the Bulls, Lascaux
ca. 15,000–13,000 B.C.

Bison with turned head
La Madeleine
ca. 12,000 B.C.

Neanderthal era, ca. 35,000 B.C.

Emergence of Cro-Magnons, ca. 32,000 B.C.

First Paleolithic paintings and sculptures, ca. 30,000 B.C.

1

THE BIRTH OF ART

AFRICA, EUROPE, AND THE NEAR EAST
IN THE STONE AGE

7000 B.C.	6000 B.C.	4000 B.C.	2000 B.C.

*Human skull with restored
features, Jericho
ca. 7000–6000 B.C.*

*Deer hunt mural, Çatal Hüyük
ca. 5750 B.C.*

*Stonehenge, Salisbury Plain
ca. 2550–1600 B.C.*

Final recession of ice and onset of
temperate climate, ca. 9000 B.C.

Neolithic begins in the Near East, ca. 8000 B.C.

Earliest farming communities, ca. 7000 B.C.

Neolithic begins in Europe, ca. 4000 B.C.

WHAT IS ART?

OUT OF AFRICA Humankind seems to have originated in Africa in the very remote past. From that great continent also comes the earliest evidence of human recognition of abstract images in the natural environment, if not the first examples of what people generally call "art." In 1925, explorers of a cave at Makapansgat in South Africa (see map, Chapter 15, page 414) discovered bones of *Australopithecus,* a predecessor of modern humans who lived some three million years ago. Associated with the bones was a waterworn reddish brown jasperite pebble (FIG. **1-1**) that bears an uncanny resemblance to a human face. The nearest known source of this variety of ironstone is twenty miles away from the cave. One of the early humans who took refuge in the rock shelter at Makapansgat must have noticed the pebble in a streambed and, awestruck by the "face" on the stone, brought it back for safekeeping.

Is the Makapansgat pebble art? In modern times, many artists have created works people universally consider art by removing objects from their normal contexts, altering them, and then labeling them. In 1917, for example, Marcel Duchamp took a ceramic urinal, set it on its side, called it *Fountain* (see FIG. 33-41), and declared his "ready-made" worthy of exhibition among more conventional artworks. But the artistic environment of the past century cannot be projected into the remote past. For art historians to declare a found object such as the Makapansgat pebble an "artwork," it must have been modified by human intervention beyond mere selection—and it was not. In fact, evidence indicates that not until three million years later, around 30,000 B.C., did humans *intentionally manufacture* sculptures and paintings. That is when the story of art through the ages really begins.

PALEOLITHIC ART

Africa

The several millennia following 30,000 B.C. saw a powerful outburst of artistic creativity. The artworks produced range from simple shell necklaces to human and animal forms in ivory, clay, and stone to monumental paintings, engravings, and relief sculptures covering the huge wall surfaces of caves. Scholars attribute this breakthrough to the emergence of Cro-Magnon peoples (named after a site in France), who replaced Neanderthals (a German site) during the Old Stone Age. These peoples of the *Paleolithic* (from the Greek *paleo,* "old," and *lithos,* "stone") period took the remarkable steps that transformed humankind from makers of simple stone tools to artists. The Cro-Magnons seem to have been the first to go beyond the *recognition* of human and animal forms in the natural environment to the *representation* (literally, the presenting again—in different and substitute form—of something observed) of humans and animals. The immensity of this achievement cannot be exaggerated.

PAINTED ANIMALS OF GREAT ANTIQUITY Some of the earliest paintings yet discovered come from Africa, and, like the treasured pebble in the form of a face found at Makapansgat, the oldest African paintings were portable objects. Between 1969 and 1972, scientists work-

1-1 Waterworn pebble resembling a human face, from Makapansgat, South Africa, ca. 3,000,000 B.C. Reddish brown jasperite, approx. $2\frac{3}{8}''$ wide.

ing in the Apollo 11 Cave in Namibia (see map, Chapter 15, page 414) found seven fragments of stone plaques with paint on them, including four or five recognizable images of animals. In most cases, including the example we illustrate (FIG. **1-2**), the species is uncertain, but the forms are always carefully rendered. One plaque depicts a striped beast, possibly a zebra. The charcoal used to sketch the Namibian animals has been dated to around 23,000 B.C.

Like every artist in every age in every medium, the painter of the Apollo 11 plaque had to answer two questions before beginning work: *What* shall be my subject? *How* shall I represent it? In Paleolithic art, the almost universal answer to the first question was an animal—bison, mammoth, ibex, and horse were most common. In fact, Paleolithic painters and sculptors depicted humans infrequently and men almost never. In equally stark contrast to today's world, Paleolithic artists also

1-2 Animal facing left, from the Apollo 11 Cave, Namibia, ca. 23,000 B.C. Charcoal on stone, approx. $5'' \times 4\frac{1}{4}''$. State Museum of Namibia, Windhoek.

agreed on the best answer to the second question. Virtually every animal in every Paleolithic, *Mesolithic* (Middle Stone Age), and *Neolithic* (New Stone Age) painting was presented in the same manner—in strict profile. The profile was the only view of an animal wherein the head, body, tail, and all four legs can be seen. A frontal view would have concealed most of the body, and a three-quarter view would not have shown either the front or side fully. Only the profile view is completely informative about the animal's shape, and this is why the Stone Age painter always chose it. A very long time passed before artists placed any premium on "variety" or "originality," either in subject choice or in representational manner. These are quite modern notions in the history of art. The aim of the earliest painters was to create a convincing image of the subject, a kind of pictorial definition of the animal capturing its very essence, and only the profile view met their needs.

Western Europe

THE FIRST SCULPTURES IN EUROPE Even older than the Namibian painted plaques are some of the first sculptures and paintings of western Europe, although examples of still greater antiquity may yet be found in Africa, bridging the gap between the Makapansgat pebble and the Apollo 11 painted plaques. One of the earliest sculptures discovered to date is an extraordinary ivory statuette (FIG. 1-3), which may be as old as 30,000 B.C., from a cave at Hohlenstein-Stadel in Germany. Carved out of mammoth ivory and nearly a foot tall—a truly huge image for its era—the statuette represents something that existed only in the vivid imagination of the unknown artist who conceived it. It is a human (whether male or female is debated) with a feline head.

Such composite creatures with animal heads and human bodies (and vice versa) were common in the art of the ancient Near East and Egypt (compare, for example, FIGS. 2-10 and 3-39). In those civilizations, surviving texts usually allow historians to name the figures and describe their role in contemporary religion and mythology. But for Stone Age representations, no one knows what the artists had in mind. The animal-headed humans of Paleolithic art sometimes have been called sorcerers and described as magicians wearing masks. Similarly, Paleolithic human-headed animals have been interpreted as humans dressed up as animals. In the absence of any Stone Age written explanations—this is a time before writing, before (or *pre*-) history—researchers only can speculate on the purpose and function of a statuette such as that from Hohlenstein-Stadel.

Art historians are certain, however, that such statuettes were important to those who created and revered them, because manufacturing an ivory figure, especially one a foot tall, was a very difficult process. First, a tusk had to be removed from the dead animal by cutting into the ivory where it joined the head. The artist then cut the tusk to the desired size and rubbed it into its approximate final shape with sandstone. Finally, the sculptor used a sharp stone blade to carve the body, limbs, and head, and a stone *burin* (a pointed engraving tool) to *incise* (scratch) lines into the surfaces, as on the Hohlenstein-Stadel creature's arms. All this probably required at least several days of skilled work.

WOMEN IN PALEOLITHIC ART The composite feline-human from Germany is exceptional for the Stone Age.

1-3 Human with feline head, from Hohlenstein-Stadel, Germany, ca. 30,000–28,000 B.C. Mammoth ivory, $11\frac{5}{8}''$ high. Ulmer Museum, Ulm.

The vast majority of prehistoric sculptures depict either animals or humans. In the earliest art, humankind consists almost exclusively of women as opposed to men, and the artists almost invariably showed them nude, although scholars generally assume that in life both women and men wore garments covering parts of their bodies. When archeologists first discovered Paleolithic statuettes of women, they dubbed them "Venuses," after the Greco-Roman goddess of beauty and love, whom artists usually depicted nude (see FIG. 5-60). The nickname is inappropriate and misleading. Not only does no evidence exist for named gods and goddesses in human form during the Old Stone Age, but also it is doubtful these figurines represented deities of any kind.

One of the oldest and the most famous of the prehistoric female figures is the tiny (only slightly more than four inches tall) limestone figurine of a woman that long has been known as the *Venus of Willendorf* (FIG. 1-4) after its findspot in Austria. Its cluster of almost ball-like shapes is unusual, the result in part of the artist's response to the natural shape of the stone selected for carving. The anatomical exaggeration has suggested to many that this and similar statuettes served as fertility images. But other Paleolithic stone women of far more slender proportions exist, and the meaning of these images is as elusive as everything else about Paleolithic art. Yet the preponderance of female over male figures in the Old Stone Age seems to indicate a preoccupation with women, whose childbearing capabilities insured the survival of the species.

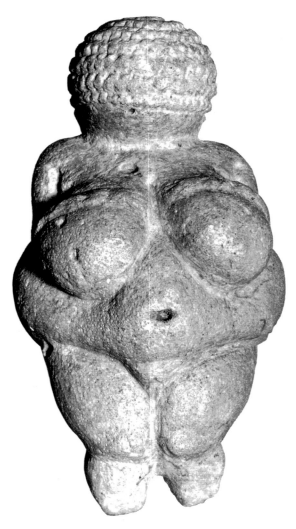

1-4 Nude woman *(Venus of Willendorf)*, from Willendorf, Austria, ca. 28,000–25,000 B.C. Limestone, approx. $4\frac{1}{4}''$ high. Naturhistorisches Museum, Vienna.

One thing at least is clear. The *Venus of Willendorf* sculptor did not aim for naturalism in shape and proportion. As with most Paleolithic figures, the sculptor did not carve any facial features. Here the artist suggested only a mass of curly hair or, as some researchers have recently argued, a hat woven from plant fibers—evidence for the art of textile manufacture at a very early date. In either case, the emphasis is on female fertility. The breasts of the Willendorf woman are enormous, far larger than the tiny forearms and hands that rest upon them, and the middle of the body bulges out even more than it does in actual pregnancies. The artist also took pains to scratch into the stone the outline of the pubic triangle. Sculptors often omitted this detail in other early figurines, leading some scholars to question the nature of these figures as fertility images. Whatever the purpose of such statuettes, the artists' intent seems not to have been to represent a specific woman but womanhood.

A ROCK SHELTER IN FRANCE Because precision in dating is impossible for the Paleolithic era, art historians usually can be no more specific than assigning a range of several thousand years to each artifact. But probably later in date than the *Venus of Willendorf* is another female figure (FIG. **1-5**), from Laussel in France. The Willendorf and

Hohlenstein-Stadel figures were sculpted *in the round* (that is, they are *freestanding* objects). The Laussel woman is one of the earliest *relief sculptures* known. The artist employed a stone chisel to cut into the relatively flat surface of a large rock and create an image that projects from its background.

Today the Laussel relief is exhibited in a museum, divorced from its original context, a detached piece of what once was a much more imposing monument. When the relief was discovered, the Laussel woman (who is about $1\frac{1}{2}$ feet tall, much larger than the Willendorf statuette) was part of a great stone block that measured about 140 cubic feet. The carved block stood in the open air in front of a Paleolithic rock shelter. Such shelters were a common type of dwelling for early humans, along with huts and the mouths of caves. The Laussel relief is one of many examples of open-air art in the Old Stone Age. The popular notions that early humans dwelled exclusively in caves and that all Paleolithic art comes from mysterious dark caverns are false.

After the Laussel sculptor chiseled out the female form and etched the details with a sharp burin, red ocher was applied to the body. (The same color is also preserved on parts of the *Venus of Willendorf*.) Contrary to modern misconceptions about ancient art, artists frequently painted stone sculptures in antiquity, not only in prehistoric times and in the ancient Near East and Egypt but in the Greco-Roman era as well. The Laussel woman has the same bulbous forms as the earlier Willendorf figurine, with a similar exaggeration of the breasts, abdomen, and hips. The head is once again featureless, but the arms have

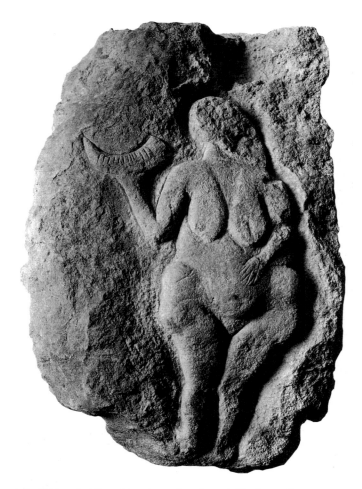

1-5 Woman holding a bison horn, from Laussel, Dordogne, France, ca. 25,000–20,000 B.C. Painted limestone, approx. 1'6" high. Musée d'Aquitaine, Bordeaux.

1-6 Reclining woman, rock-cut relief, La Magdelaine cave, Tarn, France, ca. 12,000 B.C. Approx. half life-size.

taken on greater importance. The left arm rests on the pregnant midsection and draws attention to it, and the raised right hand holds a bison horn. The meaning of the horn is debated.

WOMEN AND BISON IN FRENCH CAVES Relief sculptures of nude women also adorned the walls of caves. Some of the most remarkable are the rock-cut reliefs, about half life-size, found in a cave at La Magdelaine in France. We illustrate one of the reliefs here (FIG. **1-6**). This sculpture is typical of many Paleolithic reliefs in that the artist used the natural contours of the stone wall as the basis for the representation. Old Stone Age artists frequently and skillfully used the caves' naturally irregular surfaces—the projections, recessions, fissures, and ridges—to help give the illusion of real

presence to their forms. Once an appropriate rock formation was selected, the sculptor then accentuated the outlines and added internal details to the figure with a stone chisel. The La Magdelaine woman reclines with extended arms and her left leg crossed over her right one. She lacks a head, but the sculptor carefully delineated her large breasts and pubic triangle.

Other Paleolithic artists created reliefs by building up forms out of clay rather than by cutting into stone blocks or stone walls. Sometime twelve thousand to seventeen thousand years ago in the low-ceilinged circular space at the end of a succession of cave chambers at Le Tuc d'Audoubert, a master sculptor modeled a pair of bison in clay against a large, irregular free-standing rock (FIG. **1-7**). The two bison, like the much older painted animal from the Apollo 11 Cave in Namibia (FIG. 1-2),

1-7 Two bison, reliefs in cave at Le Tuc d'Audoubert, Ariège, France, ca. 15,000–10,000 B.C. Clay, each approx. 2′ long.

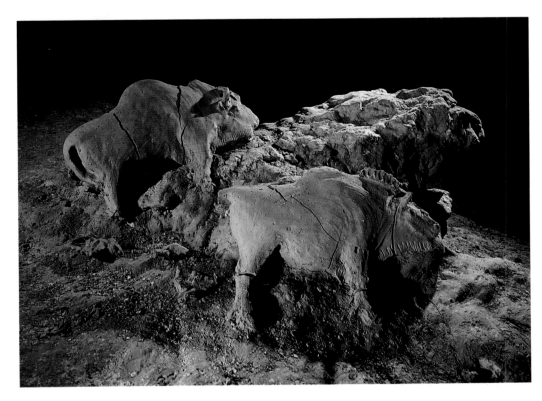

MATERIALS AND TECHNIQUES

Paleolithic Cave Painting

The caves of Altamira (FIG. 1-9), Lascaux (FIGS. 1-11 and 1-13), and other sites in prehistoric Europe had served as underground water channels, a few hundred to several thousand feet long. They are often choked, sometimes almost impassably, by deposits, such as stalactites and stalagmites. Far inside these caverns, well removed from the cave mouths early humans sometimes chose for habitation, hunter-artists painted pictures on the dark walls. For light, they used tiny stone lamps filled with marrow or fat, with a wick, perhaps, of moss. For drawing, they used chunks of red and yellow ocher. For painting, they ground these same ochers into powders they blew onto the walls or mixed with some medium, such as animal fat, before applying. Recent analyses of the pigments used show they comprise many different minerals mixed according to different recipes, attesting to a technical sophistication surprising at so early a date.

Large flat stones served as the painters' palettes. The artists made brushes from reeds or bristles and used a blowpipe of reeds or hollow bones to trace outlines of figures and to put pigments on out-of-reach surfaces. Lascaux has recesses cut into the rock walls seven or more feet above the floor that once probably anchored a scaffolding that supported a platform made of saplings lashed together. This permitted the painters access to the upper surfaces of the caves.

Despite the difficulty of the work, modern attempts at replicating the techniques of Paleolithic painting have demonstrated that skilled artists could cover large surfaces with images in less than a day.

are in strict profile. Each is about two feet long. They are among the largest Paleolithic sculptures known. The sculptor brought the clay from another chamber in the cave complex and modeled it by hand into the overall shape of the animals. The artist then smoothed the surfaces with a spatula-like tool and finally engraved the eyes, nostrils, mouths, and manes with a stone burin. The cracks in the two animals resulted from the drying process and probably appeared within days of the sculptures' completion.

AN ANTLER BECOMES A BISON As already noted, artists fashioned ivory mammoth tusks into human and animal forms from very early times (FIG. 1-3). Prehistoric sculptors also used antlers as a sculptural medium, even though it meant the artists were forced to work on a very small scale. Although only four inches long, one of the finest sculptures of the Paleolithic era is a carved reindeer antler representing a bison (FIG. **1-8**). It was found at La Madeleine in France. As at Le Tuc d'Audoubert, the sculptor incised lines into the surface of this bison's mane with a sharp point. But here the engraving is much more detailed and extends to the horns, eye, ear, nostrils,

mouth, and the hair on the face. Especially interesting is the artist's decision to represent the bison with the head turned. The small size of the reindeer horn fragment may have been the motivation for this space-saving device. Whatever the reason, it is noteworthy that the sculptor turned the neck a full 180 degrees to maintain the strict profile Paleolithic artists insisted on for the sake of clarity and completeness, both in sculpture and in painting.

A LITTLE GIRL DISCOVERS PAINTINGS IN A CAVE The works examined here thus far, whether portable or fixed to rocky outcroppings or cave walls, are all small. They are dwarfed by the "herds" of painted animals that roam the cave walls of southern France and northern Spain, where some of the most spectacular prehistoric art has been discovered. The first examples of cave paintings were found accidentally by an amateur archeologist in 1879 at Altamira, Spain. Don Marcelino Sanz de Sautuola was exploring on his estate a cave where he had already found specimens of flint and carved bone. His little daughter Maria was with him when they reached a chamber some eighty-five feet from the cave's entrance. Because it was dark and the ceiling of the debris-filled cavern was only a few inches above the father's head, the child was the first to discern, from her lower vantage point, the shadowy forms of painted beasts on the cave roof (FIG. **1-9**, a detail of a much larger painting approximately sixty feet long).

Sanz de Sautuola was certain the bison painted on the Altamira ceiling dated back to prehistoric times. Professional archeologists, however, doubted the authenticity of these works, and at the Lisbon Congress on Prehistoric Archeology in 1880, they officially dismissed the paintings as forgeries. But by the close of the century, other caves had been discovered with painted walls partially covered by mineral deposits that would have taken thousands of years to accumulate. Skeptics were finally persuaded that the first paintings were of an age far more remote than they had ever dreamed. Examples of Paleolithic painting now have been found at more than two hundred sites (see "Paleolithic Cave Painting," above). Art historians still regard painted caves as rare

1-8 Bison with turned head, from La Madeleine, Dordogne, France, ca. 12,000 B.C. Reindeer horn, approx. 4″ long. Musée des Antiquités Nationales, Saint-Germain-en-Laye.

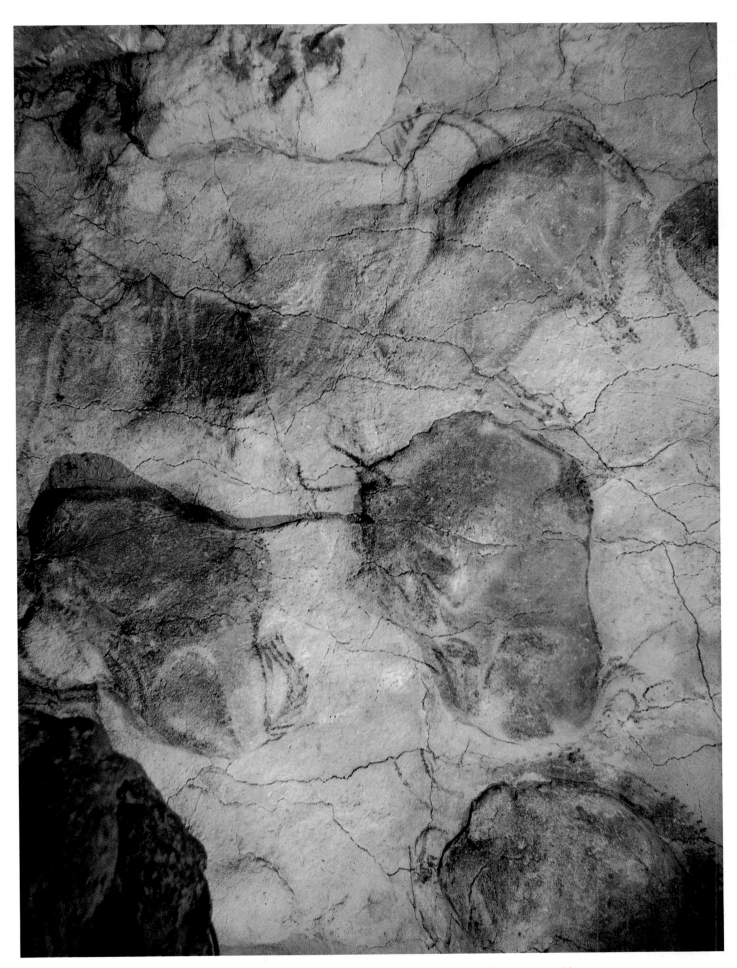

1-9 Bison, detail of a painted ceiling in the Altamira cave, Santander, Spain, ca. 12,000–11,000 B.C. Each bison approx. 8' long.

Animals and Magic in the Old Stone Age

From the moment in 1879 that cave paintings were discovered at Altamira (FIG. 1-9), scholars have wondered why the hunter-artists of the Old Stone Age decided to cover the walls of dark caverns with animal images. Various answers have been given, including that they were mere decoration, but this theory cannot explain the narrow range of subjects or the inaccessibility of many of the paintings. In fact, the remoteness and difficulty of access of many of the cave painting sites and the fact they appear to have been used for centuries are precisely what have led many scholars to suggest that the prehistoric hunters attributed magical properties to the images they painted. According to this argument, by confining animals to the surfaces of their cave walls, the artists believed they were bringing the beasts under their control. Some have even hypothesized that rituals or dances were performed in front of the images and that these rites served to improve the hunters' luck. Still others have stated that the painted animals may have served as teaching tools to instruct new hunters about the character of the various species they would encounter or even to serve as targets for spears!

By contrast, some scholars have argued that the magical purpose of the paintings was not to facilitate the *destruction* of bison and other species. Instead, they believe prehistoric painters created animal images to assure the *survival* of the herds Paleolithic peoples depended on for their food supply and for their clothing. A central problem for both the hunting-magic and food-creation theories is that the animals that seem to have been diet staples of Old Stone Age peoples are not those most frequently portrayed. At Altamira, for example, faunal remains show that red deer, not bison, were eaten.

Other scholars have sought to reconstruct an elaborate mythology based on the cave paintings, suggesting that Paleolithic humans believed they had animal ancestors. Still others have equated certain species with men and others with women and also found sexual symbolism in the abstract signs that sometimes accompany the images. Almost all of these theories have been discredited over time, and art historians must admit that no one knows the intent of these paintings. In fact, a single explanation for all Paleolithic murals, even paintings similar in subject, style, and *composition* (how the motifs are arranged on the surface), is unlikely to apply universally. For now, the paintings remain an enigma.

occurrences, though, because the images in them, even if they number in the hundreds, were created over a period of some twenty thousand years.

The bison at Altamira were painted in Spain thirteen thousand to fourteen thousand years ago, but the artist approached the problem of representing an animal in essentially the same way as the painter of the stone plaque from Namibia (FIG. 1-2), who worked more than ten thousand years earlier. Every one of the Altamira bison is in profile, whether alive and standing or curled up on the ground (probably dead, although this is disputed). To maintain the profile in the latter case, the artist had to adopt a viewpoint above the animal, looking down, rather than the view a person standing on the ground would have.

Art historians often refer to the Altamira animals as a *group* of bison, but that is very likely a misnomer. The several bison in our illustration do not stand on a common *ground line* (a painted or carved baseline on which figures appear to stand in paintings and reliefs), nor do they share a common orientation. They seem almost to float above viewers' heads, like clouds in the sky. And the dead(?) bison are seen in an "aerial view," while the others are seen from a position on the ground. The painting has no setting, no background, no indication of place. The Paleolithic painter was not at all concerned with *where* the animals were or with how they related to one another, if at all. Instead, several *separate* images of a bison adorn the ceiling, perhaps painted at different times, and each is as complete and informative as possible—even if their meaning remains a mystery (see "Animals and Magic in the Old Stone Age," above).

THE BIRTH OF WRITING? That the paintings did have meaning to the Paleolithic peoples who made and ob-

served them cannot, however, be doubted. In fact, signs consisting of checks, dots, squares, or other arrangements of lines often accompany the pictures of animals. Several observers have seen a primitive writing form in these representations of nonliving things, but the signs, too, may have had some other significance. Some look like traps and arrows and, according to the hunting-magic theory, may have been drawn to insure success in capturing or killing animals with these devices. At Pech-Merle in France, the "spotted horses" painted on the cave wall (FIG. **1-10**) may not have spots. Some scholars have argued that the "spots," which appear both within and without the horses' outlines, are painted rocks thrown at the animals.

Representations of human hands also are common. Those around the Pech-Merle horses, and the majority of painted hands at other sites, are "negative," that is, the artist placed one hand against the wall and then painted or blew pigment around it. Occasionally, the artist dipped a hand in paint and then pressed it against the wall, leaving a "positive" imprint. These handprints, too, must have had a purpose. Some scholars have considered them "signatures" of cult or community members or, less likely, of individual artists.

The mural paintings at Pech-Merle also allow some insight into the reason certain subjects may have been chosen for a specific location. One of the horses (at the right in our illustration) may have been inspired by the rock formation in the wall surface resembling a horse's head and neck. Like the reclining woman at La Magdelaine (FIG. 1-6), the Pech-Merle representations may have been created after someone noticed a resemblance between a chance configuration in nature and an animal or person. The artists then "finished" the perceived forms by accentuating the outlines with stone tools, as at La Magdelaine, or by the addition of color, as at Pech-Merle. Art histori-

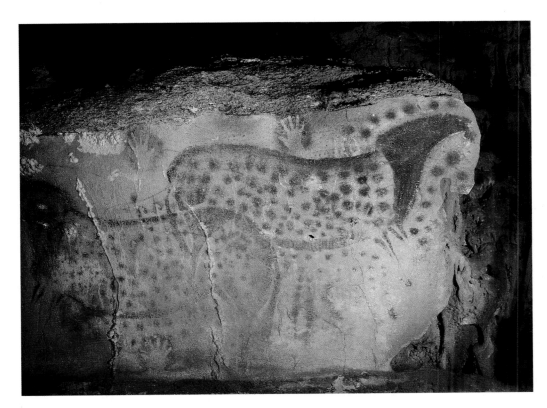

1-10 Spotted horses and negative hand imprints, wall painting in the cave at Pech-Merle, Lot, France, ca. 22,000 B.C. Approx. 11′ 2″ long.

ans also have observed that nearly all horses and hands are painted on concave surfaces, while bison and cattle appear almost exclusively on convex surfaces. What this signifies has yet to be determined.

THE "RUNNING OF THE BULLS" AT LASCAUX

Perhaps the best known Paleolithic caves are those at Lascaux, near Montignac, France, which are extensively decorated. Many of the painted chambers are characteristically hundreds of feet from the entrance. The first chamber one encounters, although even it is far removed from the daylight, is the so-called Hall of the Bulls (FIG. **1-11**). It is also the most magnificent. Not all of the animals depicted are bulls, despite the

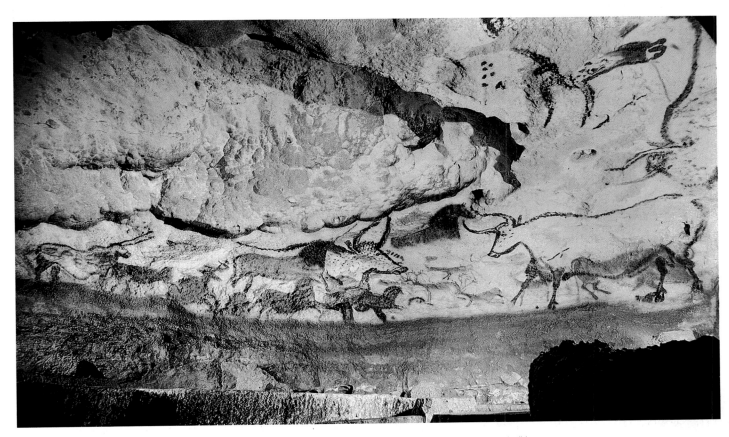

1-11 Hall of the Bulls (left wall), Lascaux, Dordogne, France, ca. 15,000–13,000 B.C. Largest bull approx. 11′ 6″ long.

1-12 Aurochs, horses, and rhinoceroses, wall painting in Chauvet Cave, Vallon-Pont-d'Arc, Ardèche, France, ca. 30,000–28,000 B.C. Approx. half life-size.

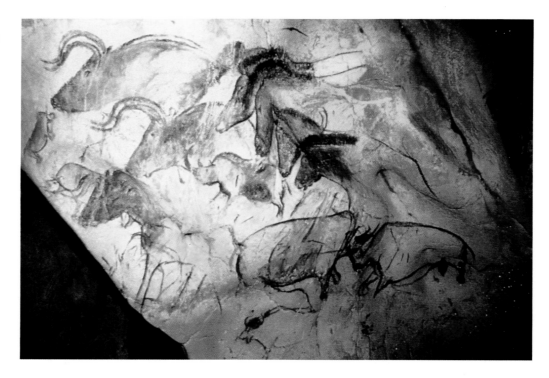

modern nickname of the great circular gallery, and the several species depicted vary in size. Many are represented using colored silhouettes, as in the cave at Altamira (FIG. 1-9) and on the Namibian plaque (FIG. 1-2). Others—such as the great bull at the right in our illustration—were created by outline alone, as were the Pech-Merle horses (FIG. 1-10). On the walls of the Lascaux cave one sees, side by side, the two basic approaches to drawing and painting found repeatedly in the history of art. (Compare, for example, the Greek techniques of *black-figure* [silhouette] and *red-figure* [outline] painting a dozen millennia later in FIG. 5-20.) These differences in style and technique alone suggest that the animals in the Hall of the Bulls were painted at different times, and the modern impression of a rapidly moving herd of beasts was probably not the artists' intent. In any case, the "herd" consists of several different kinds of animals of various sizes moving in different directions.

Another feature of the Lascaux paintings deserves attention. The bulls there show a convention of representing horns that has been called *twisted perspective,* because viewers see the heads in profile but the horns from the front. Thus, the artist's approach is not strictly or consistently *optical* (seen from a fixed viewpoint). Rather, the approach is *descriptive* of the fact cattle have two horns. Two horns are part of the concept "bull." In strict optical-perspective profile, only one horn would be visible, but to paint the animal in that way would, as it were, amount to an incomplete definition of it. This kind of twisted perspective was the norm in prehistoric painting, but it was not universal. In fact, the recent discovery of the world's earliest datable paintings in the Chauvet Cave (FIG. **1-12**) at Vallon-Pont-d'Arc in France, where the painters represented horns in a more natural way, has caused art historians to rethink many of the assumptions they had made about Paleolithic art (see "The World's Oldest Paintings," page 11).

PALEOLITHIC NARRATIVE ART? Perhaps the most perplexing painting in all the Paleolithic caves is the one deep in the well shaft at Lascaux (FIG. **1-13**), where man (as opposed to woman) makes one of his earliest appearances in prehistoric painting. At the left is a rhinoceros, rendered with all the skilled attention to animal detail customarily seen in cave art. Beneath its tail are two rows of three dots of uncertain significance. At the right is a bison, more crudely painted, but the artist quite successfully suggested the bristling rage of the animal, whose bowels are hanging from it in a heavy coil. Between the two beasts is a bird-faced (masked?) man (compare the feline-headed human from Hohlenstein-Stadel, FIG. 1-3) with outstretched arms and hands with only four fingers. The artist depicted the man with far less care and detail than the animals, but made his gender explicit by the prominent penis. Perhaps the painter did not have to strive for a realistic portrayal because the community had no need to create humans for magical or other purposes. The position of the man is also ambiguous. Is he wounded or dead or merely tilted back and unharmed? Do the staff(?) with the bird on top and the spear belong to him? Is it he or the rhinoceros who has gravely wounded the bison—or neither? Which animal, if either, has knocked the man down, if indeed he is on the ground? Are these three images related at all? Art historians can be sure of nothing, but if the painter placed these figures beside each other to tell a story, then this is evidence for the creation of complex *narrative* compositions involving humans and animals at a much earlier date than anyone had imagined only a few generations ago. Yet it is important to remember that even if a story was intended, very few people would have been able to "read" it. The painting, in a deep shaft, is very difficult to reach and could have been viewed only in the flickering light of a primitive lamp.

The World's Oldest Paintings

One of the most spectacular archeological finds of the past century came to light in December 1994 at Vallon-Pont-d'Arc, France, and was announced at a dramatic press conference in Paris on January 18, 1995. The next day, people around the world were startled when they picked up their morning newspapers or turned on their televisions and saw a sampling of pictures of extraordinary Paleolithic cave paintings. Unlike some other recent "finds" of prehistoric art that proved to be forgeries, the paintings in the Chauvet Cave (named after the leader of the exploration team, Jean-Marie Chauvet) seemed to be authentic. But no one, including Chauvet and his colleagues, guessed at the time of their discovery that direct *radiocarbon dating* (a measure of the rate of degeneration of carbon 14 in organic materials) of the paintings would establish that the murals in the cave were more than fifteen thousand years older than those at Altamira (FIG. 1-9). The Chauvet Cave paintings are, in fact, the oldest yet found anywhere, datable around 30,000–28,000 B.C. They have caused scholars to reevaluate the scheme of "stylistic development" from simple to more complex forms that had been nearly universally accepted for decades.

Chauvet and his team have written a moving account of their exploration of the cave. When they encountered the painted wall we illustrate here (FIG. 1-12), this is how they reacted: "There was a moment of ecstasy. . . . Jean-Marie . . . was stammering. Christian [Hillaire] was uttering exclamations of amazement. When Eliette [Brunel Deschamps] and [her daughter] Carole rushed over, they overflowed with joy and emotion in their turn. . . . These were minutes of indescribable madness."[1]

Many species of animals appear on the cave walls, including several ferocious animals that were never part of the Paleolithic human diet, such as lions and bears. Bears, in fact, hibernated in the cave and more than fifty bear skulls are still there. When the bears resided in the cave, it was a dangerous place for anyone to venture into.

Several of the paintings Chauvet's team discovered occupy a special place in the history of art. In the Chauvet Cave, many thousands of years before Lascaux (FIG. 1-11), the horns of the aurochs (extinct long-horned wild oxen) are shown naturalistically, one behind the other, not in the twisted perspective thought to be universally characteristic of Paleolithic art. And the aurochs and horses, although presented in the standard profile view, are incomplete, violating the "rule" that Paleolithic painters always sketched complete forms. Moreover, the two rhinoceroses at the lower right of our illustration appear to confront each other, suggesting to some observers that a narrative was intended, another "first" in either painting or sculpture.

Much research remains to be conducted in the Chauvet Cave, and more paintings have been discovered as work has progressed. But it is already obvious that the assumption that Paleolithic art "evolved" from primitive to more sophisticated representations is wrong. In time, other widely accepted theories probably also will be proven false. This is the frustration—and the excitement—of studying the art of an age so remote that almost nothing remains and almost every new find causes art historians to reevaluate what had previously been taken for granted.

[1] Jean-Marie Chauvet et al., *Dawn of Art: The Chauvet Cave* (New York: Harry N. Abrams, 1996), 48–50.

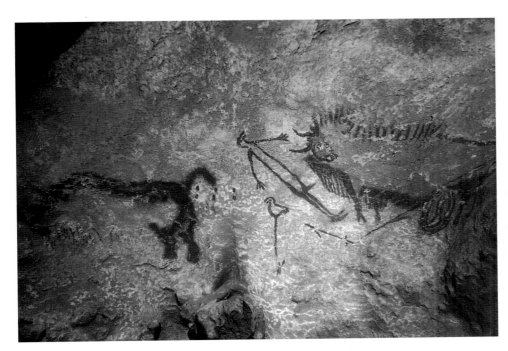

1-13 Rhinoceros, wounded man, and disemboweled bison, painting in the well, Lascaux, Dordogne, France, ca. 15,000–13,000 B.C. Bison approx. 3′ 8″ long.

NEOLITHIC ART

THE ICE RECEDES Around 9000 B.C., the ice that covered much of northern Europe during the Paleolithic period melted as the climate grew warmer. The reindeer migrated north, and the woolly mammoth and rhinoceros disappeared. The Paleolithic gave way to a transitional period, the Mesolithic, when Europe became climatically, geographically, and biologically much as it is today. Then, for several thousand years at different times in different parts of the globe, a great new age, the Neolithic, dawned.

In a supreme intellectual feat, Paleolithic peoples had learned to abstract their world by making pictures of it. By capturing and holding its image, they may have hoped to control it. In the Neolithic period, human beings took a giant stride toward the actual, concrete control of their environment by settling in fixed abodes and domesticating plants and animals. Their food supply assured, many groups changed from hunters to herders, to farmers, and finally to townspeople. Wandering hunters settled down to organized community living in villages surrounded by cultivated fields.

The conventional division of prehistory into the Paleolithic, Mesolithic, and Neolithic periods is based on the development of stone implements. However, a different kind of distinction may be made between an age of food gathering and an age of food production. In this scheme, the Paleolithic period corresponds roughly to the age of food gathering, and the Mesolithic period, the last phase of that age, is marked by intensified food gathering and the taming of the dog. In the Neolithic period, agriculture and stock raising became humankind's major food sources. The transition to the Neolithic occurred first in the ancient Near East.

Ancient Near East

THE DAWN OF CIVILIZATION At one time, researchers proposed that the area known today as the Middle East, the ancient Near East, dried out into desert and semi-desert climates after the last retreat of the glaciers. They suggested that this compelled the inhabitants to move to the fertile valleys of the Nile River in Egypt and the Tigris and Euphrates Rivers in Mesopotamia (parts of modern Syria and Iraq). This view is no longer tenable in light of archeological and ecological findings. The oldest settled communities were found not in the river valleys but in the grassy uplands bordering them. These regions provided the necessary preconditions for the development of agriculture. Species of native plants, such as wild wheat and barley, were plentiful, as were herds of animals (goats, sheep, and pigs) that could be domesticated. Sufficient rain occurred for the raising of crops. Only after village farming life was well developed did settlers, attracted by the greater fertility of the soil and perhaps also by the need to find more land for their rapidly growing populations, move into the river valleys and deltas. There, in addition to systematic agriculture, Neolithic societies originated government, law, and formal religion, as well as writing, measurement and calculation, weaving, metalworking, and pottery.

Based on the information known today, these innovations appear to have occurred first in Mesopotamia and then spread to northern Syria, Anatolia (Turkey), and Egypt at an early

date. Village farming communities such as Jarmo in Iraq and Çatal Hüyük in southern Anatolia date back to the mid-seventh millennium B.C. The remarkable fortified town of Jericho, before whose walls the biblical Joshua appeared thousands of years later, is even older. Archeologists are constantly uncovering surprises, and the discovery and exploration of new sites each year is compelling them to revise their views about the emergence of Neolithic civilization. But two sites known for some time, Jericho on the Jordan River and Çatal Hüyük in Anatolia, offer a reasonably representative picture of the rapid and exciting transformation of human society—and of art—during the Neolithic period.

A STONE TOWER TEN THOUSAND YEARS OLD By 7000 B.C., agriculture was well established in at least three Near Eastern regions: ancient Palestine, Iran, and Anatolia. Although no remains of domestic cereals have been found that can be dated before 7000 B.C., the advanced state of agriculture at that time presupposes a long development. Indeed, the very existence of a town such as Jericho gives strong support to this assumption. The site of Jericho—a plateau in the Jordan River valley with an unfailing spring—was occupied by a small village as early as the ninth millennium B.C. This village underwent spectacular development around 8000 B.C., when a new Neolithic town covering about ten acres was built. Its mud-brick houses sat on round or oval stone foundations and had roofs of branches covered with earth.

As the town's wealth grew and powerful neighbors established themselves, the need for protection resulted in the first known permanent stone fortifications. By approximately 7500 B.C., the town, estimated to have had a population of more than two thousand people, was surrounded by a wide rock-cut ditch and a five-foot-thick wall. Into this wall, which has been preserved to a height of almost thirteen feet, was built a great circular stone tower (FIG. **1-14**),

1-14 Great stone tower built into the settlement wall, Jericho, ca. 8000–7000 B.C.

twenty-eight feet high. Almost thirty-three feet in diameter at the base, the tower has an inner stairway leading to its summit. Not enough of the site has been excavated to determine whether this tower was solitary or one of several similar towers that formed a complete defense system. In either case, a structure such as this, built with only the most primitive kinds of stone tools, was certainly a tremendous technological achievement. It constitutes the beginning of a long history of monumental architecture, which leads from this stone tower in Neolithic Jericho to today's hundred-story skyscrapers of steel, concrete, and glass.

SKULLS WITH RESTORED FACES Around 7000 B.C., the original inhabitants abandoned the Jericho site, but new settlers arrived in the early seventh millennium. They built rectangular mud-brick houses on stone foundations and carefully plastered and painted their floors and walls. Several of the excavated buildings seem to have served as shrines, and the settlers fashioned statuettes of women or goddesses and of animals. Most unusual is a group of human skulls whose features artists "reconstructed" in plaster (FIG. **1-15**). Subtly modeled, with inlaid seashells for eyes and painted hair (including a painted mustache preserved on one specimen), their appearance is strikingly lifelike. The features depicted should, however, be regarded as typical rather than a record of specific faces. The Jericho skulls are not portraits in the modern sense of accurate individual likenesses.

Because the skulls were not only detached from the bodies and given new faces, but also were buried separately, the people of Neolithic Jericho must have attached special sig-

1-16 Schematic reconstruction drawing of a section of Level VI, Çatal Hüyük, Turkey, ca. 6000–5900 B.C. (after J. Mellaart).

nificance to the heads. Some scholars think they attest to belief in an afterlife following the body's death. Whatever their purpose, by their size alone the Jericho heads are distinguished from Paleolithic figurines such as the tiny *Venus of Willendorf* (FIG. 1-4) and even the foot-tall ivory statuette from Hohlenstein-Stadel (FIG. 1-3). They mark the beginning of monumental sculpture in the ancient Near East.

A NEOLITHIC TOWN WITH NO STREETS Remarkable discoveries also have been made in Anatolia. Excavations at Hacilar, Çatal Hüyük, and elsewhere have shown that the central Anatolian plateau was the site of a flourishing Neolithic culture between 7000 and 5000 B.C. Twelve successive building levels excavated at Çatal Hüyük between 1961 and 1965 have been dated between 6500 and 5700 B.C. On a single site, it is possible to retrace, in an unbroken sequence, the evolution of a Neolithic culture over a period of eight hundred years. (Only one of thirty-two acres had been explored before the recent resumption of excavations. The new project promises to expand and perhaps revise the current picture of Neolithic life.)

The source of Çatal Hüyük's wealth was trade, especially in obsidian, a glasslike volcanic stone easily chipped into fine cutting edges and highly valued by Neolithic toolmakers and weapon makers. Along with Jericho, Çatal Hüyük seems to have been one of the first experiments in urban living. The regularity of its plan suggests that the town was built according to some predetermined scheme. A peculiar feature is the settlement's complete lack of streets (FIG. **1-16**); the houses adjoin one another and have no doors. Openings just below the roofs provided access to the interiors. The openings also served as chimneys to ventilate the hearth in the combination living room/kitchen that formed the house's core. Impractical as such an arrangement may appear today, it did offer some advantages. The attached buildings were more stable than freestanding structures and, at the limits of the town site, formed a perimeter wall well suited to defense against human or natural forces. Thus, if enemies managed to breach the exterior wall, they would find themselves not inside the town but above the houses with the defenders waiting there on the roof.

1-15 Human skull with restored features, Jericho, ca. 7000–6000 B.C. Features molded in plaster, painted, and inlaid with shell. Archeological Museum, Amman.

The houses, constructed of mud brick strengthened by sturdy timber frames, varied in size but were of a standard plan. Walls and floors were plastered and painted, and platforms along walls served as sites for sleeping, working, and eating. The dead were buried beneath the floors. A great number of shrines have been found intermingled with standard houses. Varying with the different building levels, the average ratio in the excavated portion of the town is very high, about one shrine to every three houses. Their numbers suggest the important role these shrines played in the life of Çatal Hüyük's inhabitants.

The shrines are distinguished from the house structures by the greater richness of their interior decoration, which consisted of wall paintings, plaster reliefs, animal heads, and *bucrania* (bovine skulls). Bulls' horns, widely thought to be symbols of masculine potency, adorn most shrines, sometimes in considerable numbers. In some rooms they are displayed next to plaster breasts, symbols of female fertility, projecting from the walls. Statuettes of stone or *terracotta* (baked clay) also have been found in considerable numbers at Çatal Hüyük. Most are quite small (two to eight inches high) and primarily depict female figures. Only a few reach twelve inches.

HUNTING DEER IN NEOLITHIC TURKEY

Although at Çatal Hüyük animal husbandry was well established, hunting continued to play an important part in the early Neolithic economy. The importance of hunting as a food source (until about 5700 B.C.) is reflected also in wall paintings, where, in the older shrines, hunting scenes predominate. In style and concept, however, the deer hunt mural at Çatal Hüyük (FIG. **1-17**) is worlds apart from the wall paintings the hunter-artists of Paleolithic times produced. Perhaps what is most strikingly new about the Çatal Hüyük painting and others like it is the regular appearance of the human figure—not only singly but also in large, coherent groups with a wide variety of poses, subjects, and settings. As noted earlier, humans were unusual in Paleolithic cave paintings, and pictorial narratives have almost never been found. Even the "hunting scene" in the well at Lascaux (FIG. 1-13) is doubtful as a narrative. In Neolithic paintings, human themes and concerns and action scenes with humans dominating animals are central.

In the Çatal Hüyük hunt, the group of hunters—and no one doubts it is, indeed, an organized hunting party, not a series of individual figures—shows a tense exaggeration of movement and a rhythmic repetition of basic shapes customary for the era. The painter took care to distinguish important descriptive details—for example, bows, arrows, and garments—and the heads have clearly defined noses, mouths, chins, and hair. The Neolithic painter placed all the

heads in profile for the same reason Paleolithic artists universally chose the profile view for representations of animals. Only the side view of the human head shows all its shapes clearly. However, the Neolithic artist presents the torsos from the front—again, the most informative viewpoint—while the profile view is the choice for the legs and arms. This *composite view* of the human body is quite artificial because the human body cannot make an abrupt ninety-degree shift at the hips. But it is very descriptive of what a human body is—as opposed to what it looks like from a particular viewpoint. The composite view is another manifestation of the twisted perspective of Paleolithic paintings that combined a frontal view of an animal's two horns with a profile view of the head (FIGS. 1-11 and 1-13). Artists overwhelmingly preferred the composite view of the human body for millennia, until the Greeks suddenly and definitively rejected it at the dawn of the Classical age, around 500 B.C. (see Chapter 5).

The technique of painting also changed dramatically since Paleolithic times. The pigments were applied with a brush to a white background of dry plaster. The careful preparation of the wall surface is in striking contrast to the direct application of pigment to the rock face. This was a significant step toward the modern notion of an easel painting with a frame that defines its limits.

THE FIRST LANDSCAPE?

More remarkable still is a painting in one of the older shrines at Çatal Hüyük (FIG. **1-18**) that generally has been acclaimed as the world's first *landscape* (a picture of a natural setting in its own right, without any narrative content). As such, it remained unique for thousands of years. According to radiocarbon dating, the painting was executed around 6150 B.C. In the foreground is a town, with rectangular houses neatly laid out side by side, probably representing Çatal Hüyük itself. Behind the town appears a mountain with two peaks. Art historians think the dots and lines issuing from the higher of the two cones represent a volcanic eruption. They have identified the mountain as the ten thousand six hundred-foot Hasan Dağ. It is located within view of Çatal Hüyük and is the only twin-peaked volcano in central Anatolia. Because the painting appears on a shrine wall, the conjectured volcanic eruption very likely had some religious meaning, but the mural does not necessarily depict a specific historic event. If, however, the Çatal Hüyük painting relates a story, even a recurring one, then it cannot be considered a pure landscape. Nonetheless, this mural is the first depiction of a place devoid of both humans and animals.

The rich finds at Çatal Hüyük give the impression of a prosperous and well-ordered society that practiced a great variety of arts and crafts. In addition to painting and sculpture,

1-17 Deer hunt, detail of a copy of a wall painting from Level III, Çatal Hüyük, Turkey, ca. 5750 B.C.

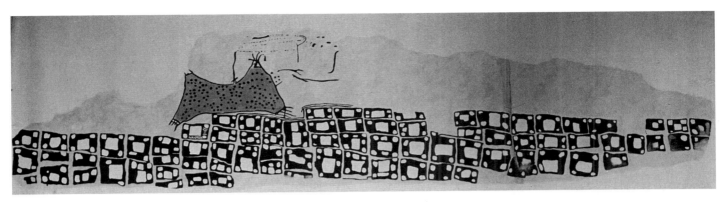

1-18 Landscape with volcanic eruption(?), detail of a copy of a wall painting from Level VII, Çatal Hüyük, Turkey, ca. 6150 B.C.

weaving and pottery were well established, and even the art of smelting copper and lead in small quantities was known before 6000 B.C. The conversion to an agricultural economy appears to have been completed by about 5700 B.C.

Western Europe

A NEOLITHIC ASTRONOMICAL OBSERVATORY In western Europe, where Paleolithic paintings and sculptures abound, no comparably developed towns of the time of Çatal Hüyük have been found. However, in succeeding millennia, perhaps as early as 4000 B.C., the local Neolithic populations in several areas developed a monumental architecture employing massive rough-cut stones. The very dimensions of the stones, some as high as seventeen feet and weighing as much as fifty tons, have prompted historians to call them *megaliths* (great stones) and to designate the culture that produced them *megalithic.*

Sometimes these huge stones were arranged in a circle known as a *cromlech* or *henge,* often surrounded by a ditch. The most imposing today is Stonehenge (FIG. **1-19**) on the Salisbury Plain in southern England. Stonehenge is a complex of rough-cut sarsen (a form of sandstone) stones and smaller "bluestones" (various volcanic rocks). Outermost is a ring, almost one hundred feet in diameter, of large monoliths of sarsen stones capped by *lintels* (a stone "beam" used to span an opening; see FIG. 4-18). Next is a ring of bluestones, which, in turn, encircle a horseshoe (open end facing east) of *trilithons* (three-stone constructions)—five lintel-topped pairs of the largest sarsens, each weighing forty-five to fifty tons. Standing apart and to the east (outside our photograph at the lower right corner) is the "heel-stone," which, for a person looking outward from the center of the complex, would have marked the point where the sun rose at the midsummer solstice.

Stonehenge probably was built in several phases in the centuries before and after 2000 B.C. It seems to have been a kind of astronomical observatory. The mysterious structures were believed in the Middle Ages to have been the work of the magician Merlin of the King Arthur legend, who spirited them from Ireland. Most archeologists now consider Stonehenge a remarkably accurate solar calendar. This achievement is testimony to the rapidly developing intellectual powers of Neolithic humans as well as to their capacity for heroic physical effort.

Impressive as this *prehistoric* achievement is even today, by 2000 B.C. the peoples occupying the Mesopotamian plain between the Tigris and Euphrates Rivers had been erecting multichambered temples on huge platforms for at least a millennium. In the fertile valley of the Nile in Egypt, the great stone pyramids of the pharaohs were already five hundred or more years old when Stonehenge was erected. We now turn to those civilizations, with their written records and *historical* personalities.

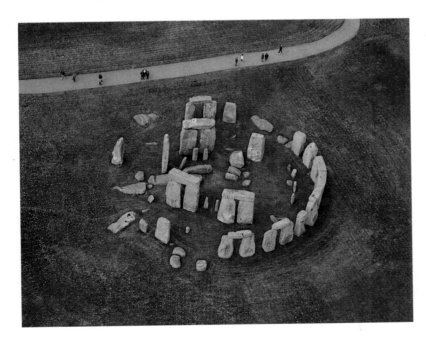

1-19 Stonehenge, Salisbury Plain, Wiltshire, England, aerial view, ca. 2550–1600 B.C. Circle is 97′ diameter; trilithons approx. 24′ high.

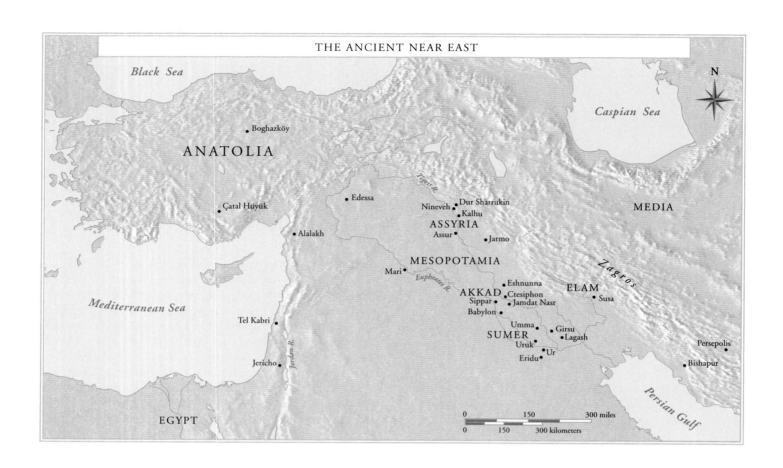

THE ANCIENT NEAR EAST

Black Sea

Caspian Sea

N

ANATOLIA

Boghazköy

MEDIA

Çatal Hüyük

Edessa

Nineveh • Dur Sharrukin
• Kalhu

ASSYRIA

Alalakh

Assur • • Jarmo

Tigris R.

MESOPOTAMIA

Zagros

Mari •

Euphrates R.

AKKAD

ELAM

Eshnunna
• Ctesiphon
Sippar • • Jamdat Nasr
Babylon •

Susa •

Mediterranean Sea

Tel Kabri

Umma •

Girsu
• Lagash

SUMER

Uruk •
Eridu • • Ur

Persepolis

Jericho

Jordan R.

Bishapur

EGYPT

Persian Gulf

| 0 | 150 | 300 miles |
| 0 | 150 | 300 kilometers |

3500 B.C.	3100 B.C.	2900 B.C.	2300 B.C.	2150 B.C.	2000 B.C.	1800 B.C.	1600 B.C.	
URUK		JAMDAT NASR	EARLY DYNASTIC (SUMERIAN)	AKKADIAN DYNASTY	THIRD DYNASTY OF UR (NEO-SUMERIAN)		OLD BABYLONIAN	KASSITES AND MITANNI (MESOPOTAMIA)
								HITTITES (ANATOLIA)
								MIDDLE ELAMITE PERIOD (IRAN)

Female head (Inanna?)
from Uruk
ca. 3200–3000 B.C.

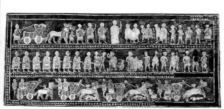

Standard of Ur
ca. 2600 B.C.

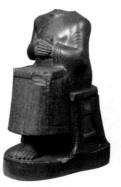

Head of an
Akkadian ruler, from Nineveh
ca. 2250–2200 B.C.

Seated Gudea, from Girsu
ca. 2100 B.C.

Stele of
Hammurabi
ca. 1780 B.C.

Lion Gate, Boghazköy
ca. 1400 B.C.

Invention of the wheel

Development of writing and the
beginnings of recorded history

Flowering of independent city-states

Sargon of Akkad, ca. 2300 B.C.

Naram-Sin, r. ca. 2254–2218 B.C.

Guti invasion, ca. 2150 B.C.

Gudea of Lagash, ca. 2100 B.C.

Hammurabi, r. ca. 1792–1750 B.C.

Sack of Babylon by Hittites,
ca. 1595 B.C.

2

THE RISE OF
CIVILIZATION

THE ART OF THE ANCIENT NEAR EAST

1000 B.C.	900 B.C.		612 B.C.		538 B.C.		330 B.C.	A.D. 224		636
		ASSYRIAN EMPIRE		NEO-BABYLONIAN EMPIRE		ACHAEMENID PERSIAN EMPIRE		GRECO-ROMAN	SASANIAN DYNASTY	

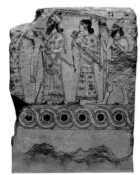

*Ashurnasirpal II and attendants
from Kalhu, ca. 875–860 B.C.*

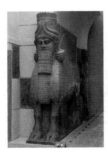

*Lamassu
Citadel of Sargon II
Dur Sharrukin
ca. 720–705 B.C.*

*Ishtar Gate
Babylon, ca. 575 B.C.*

*Palace, Persepolis
ca. 521–465 B.C.*

*Head of Shapur II(?)
ca. A.D. 350*

Darius I, r. 522–486 B.C.

Xerxes, r. 486–465 B.C.

Final defeat of Persians
by the Arabs, A.D. 642

Ashurnasirpal II, r. 883–859 B.C.

Sargon II, r. 721–705 B.C.

Ashurbanipal, r. 668–627 B.C.

Nebuchadnezzar II, r. 604–562 B.C.

Battle of Issus, 331 B.C.

Death of Alexander the Great, 323 B.C.

Augustus, first emperor of Rome, r. 27 B.C.–A.D. 14

Defeat of Valerian by Shapur I, A.D. 260

THE LAND BETWEEN THE RIVERS

When humans first gave up the dangerous and uncertain life of the hunter and gatherer for the more predictable and stable life of the farmer and herder, the change in human society was so astounding, so fundamental, that it justly has been called the Neolithic Revolution. This revolutionary change in the nature of daily life first occurred in Mesopotamia—a Greek word that means "the land between the [Tigris and Euphrates] rivers." Mesopotamia is at the core of the region often called the Fertile Crescent, a land mass that forms a huge arc from the mountainous border between Turkey and Syria through Iraq to Iran's Zagros Mountain range. There humankind first learned how to use the wheel and the plow, how to control floods and construct irrigation canals. The land became an oasis—and the presumed setting for the biblical Garden of Eden.

THE ANCIENT NEAR EAST REDISCOVERED

As the region that gave birth to three of the world's great modern faiths—Judaism, Christianity, and Islam—the Near East long has been of interest to history and religion students. But not until the nineteenth century did systematic excavation open the world's eyes to the extraordinary art and architecture of the ancient Mesopotamians. The great museums of Europe quickly began to fill their galleries with stone reliefs depicting warfare and hunting (FIGS. 2-22, 2-24, and 2-25) and with colossal statues of monstrous human-headed bulls (FIG. 2-21) from the palaces of the Assyrians, rulers of a northern Mesopotamian empire during the ninth to the seventh centuries B.C. In the treasure-hunting spirit of the era, Austen Henry Layard, one of the pioneers of Near Eastern archeology, had specific instructions from the British Museum. He was to obtain as many well-preserved artworks as he could while spending the least possible amount of time and money doing so. Interest heightened with each new discovery, and North American museums also began to collect Near Eastern art.

Nothing that emerged from the Mesopotamian soil attracted as much attention as the treasures Leonard Woolley discovered in the 1920s at the Royal Cemetery at Ur in southern Mesopotamia. The interest in the unearthing of lavish third-millennium B.C. Sumerian burials rivaled the public fascination with the 1922 discovery of the Egyptian boy-king Tutankhamen's tomb (see FIGS. 3-36 to 3-38). The Ur cemetery was filled with gold objects, jewelry, artworks, and musical instruments (FIGS. 2-8 to 2-11). Europe's royalty and elite frequently visited the site. One of the visitors was the mystery writer Agatha Christie, who later married one of the British archeologists working at Ur. Her 1936 *Murder in Mesopotamia* centers on an excavation in Iraq. The discovery of the treasures of ancient Ur put the Sumerians once again in a prominent position on the world stage. They had been absent for four thousand years.

SUMERIAN ART

THE INVENTION OF WRITING
The Sumerians were the people who transformed the vast, flat lower valley between the Tigris and Euphrates into the Fertile Crescent of

the ancient world. Sparsely inhabited before the Sumerians, this area is now southern Iraq. In the fourth millennium B.C., the Sumerians established the first great urban communities and developed the earliest known writing system. The oldest written documents were records of administrative acts and commercial transactions, but the Sumerians also produced great literature. The most famous Sumerian work, the *Epic of Gilgamesh,* antedates Homer's *Iliad* and *Odyssey* by some fifteen hundred years.

At first, around 3400–3200 B.C., the Sumerians made inventories of cattle, food, and other items by scratching *pictographs* (simplified pictures standing for words) into soft clay with a sharp tool, or *stylus.* The clay plaques hardened into breakable, yet nearly indestructible, tablets, accounting for the existence today of thousands of documents dating back nearly five millennia. The Sumerians wrote their pictorial signs from the top down and arranged them in boxes they read from right to left. By 3000–2900 B.C., they had further simplified the pictographic signs by reducing them to a group of wedge-shaped *(cuneiform)* signs. This marked the beginning of writing, as historians strictly define it. By 2600 B.C., cuneiform texts were sophisticated enough to express complex grammatical constructions.

The Sumerian language does not belong to any of the major linguistic groups of antiquity, yet historians do not doubt the Sumerians were a major force in the spread of civilization. Their influence extended widely from southern Mesopotamia, eastward to the Iranian plateau, northward to Assyria, and westward to Syria. Thousands of cuneiform tablets testify to the far-flung network of Sumerian contacts made throughout the ancient Near East. Trade was essential for the Sumerians, because despite their land's fertility, it was poor in such vital natural resources as metal, stone, and wood.

THE FIRST CITY-STATES AND THEIR GODS
Ancient Sumer was not a unified nation but was made up of a dozen or so independent *city-states,* and each was thought to be under the protection of a different one of the Mesopotamian gods (see "The Gods and Goddesses of Mesopotamia," page 19). The Sumerian rulers were the gods' representatives on earth and the stewards of their earthly treasure. The rulers and priests directed all communal activities, including canal construction, crop collection, and food distribution to those who were not farmers. The development of agriculture to the point where only a portion of the population had to produce food made possible such an organization of the labor force. Some members of the community could specialize in activities such as manufacturing, trade, and administration. This type of labor specialization is the hallmark of the first complex urban societies. In the city-states of ancient Sumer, activities that once had been individually initiated became institutionalized for the first time. The community, rather than the family, assumed functions such as defense against enemies and against the caprices of nature. The city-states gained permanent identities as discrete communities ruled by a single person or a council chosen from among the leading families. The city-state was one of the great Sumerian inventions.

The Sumerian city plan reflected the local god's central role in the daily life of the city-state's occupants. The god's temple formed the city's monumental nucleus. It was not only the focus of local religious practice but also served as an administra-

The Gods and Goddesses of Mesopotamia

The Sumerians and their successors in the ancient Near East worshiped numerous deities, mostly nature gods. We list some of the most important of these gods and goddesses here, including all those discussed in this chapter.

Anu Anu, the chief deity of the Sumerians, was the god of the sky and of the city of Uruk, where the ruins of one of the earliest Sumerian temples (FIGS. 2-1 and 2-2) still may be seen.

Enlil Enlil, Anu's son, was the lord of the winds and the earth. He eventually replaced his father as king of the gods.

Inanna Inanna was the Sumerian goddess of love and war. Later known as *Ishtar,* she is the most important female deity in all periods of Mesopotamian history. A sanctuary dedicated to Inanna was constructed at Uruk at a very early date. Amid the ruins, excavators have uncovered fourth-millennium B.C. statues and reliefs (FIGS. 2-3 and 2-4) connected with her worship. Whether or not the goddess herself was represented in human form at that time is uncertain. Inanna/Ishtar is unmistakably depicted with her sacred lion in a mural painting in the eighteenth-century B.C. palace of Zimri-Lim at Mari (FIG. 2-17).

Nanna Nanna, the moon god, also known as *Sin,* was the chief deity of Ur, where his most important shrine was located.

Utu Utu, god of the sun, known later as *Shamash,* was especially revered at Sippar. On a Babylonian stele of ca. 1780 B.C., King Hammurabi presents his law code to Shamash, who is depicted with flames radiating from his shoulders (FIG. 2-16).

Marduk, Nabu, and Adad Marduk was the chief god of the Babylonians. His son Nabu was the god of writing and wisdom. Adad was the Babylonian god of storms. Nabu's dragon and Adad's sacred bull are depicted on the sixth-century B.C. Ishtar Gate at Babylon (FIG. 2-26).

Ningirsu Ningirsu was the local god of Lagash and Girsu. His name means "lord of Girsu." Eannatum, one of the early rulers of Lagash, defeated an enemy army with the god's assistance and commemorated Ningirsu's role in the victory on the so-called *Stele of the Vultures* (FIG. 2-7) of ca. 2600–2500 B.C. Gudea (FIG. 2-15), one of Eannatum's Neo-Sumerian successors, built a great temple about 2100 B.C. in honor of Ningirsu after the god instructed him to do so in a dream.

Ashur Ashur, the local deity of Assur, the city that took his name, became the king of the Assyrian gods. He sometimes is identified with Enlil.

tive and economic center. It was indeed the domain of the god, whom the Sumerians regarded as a great and rich holder of lands and herds, as well as the city-state's protector. The vast temple complex, a kind of city within a city, thus had both religious and secular functions. A temple staff of priests and scribes carried on official business, looking after both the god's and the ruler's possessions.

A MUD-BRICK TOWER TO THE SKY The outstanding preserved example of early Sumerian temple architecture is the five-thousand-year-old White Temple (FIG. **2-1**) at Uruk, the home of the legendary king and hero Gilgamesh. Usually only the foundations of early Mesopotamian temples still can be recognized. The White Temple is a rare exception. Sumerian builders did not have access to stone quarries and instead formed mud bricks for the superstructures of their temples and other buildings. Almost all these structures have eroded over the course of time. The fragile nature of the building materials did not, however, prevent the Sumerians from erecting towering works such as the Uruk temple several centuries before the Egyptians built their stone pyramids. This says a great deal about the Sumerian desire to provide monumental settings for the worship of their deities.

Enough of the Uruk complex remains to permit a fairly reliable reconstruction drawing (FIG. **2-2**). The temple (whose whitewashed walls lend it its modern nickname) stands on top of a high stepped platform, or *ziggurat,* forty feet above

street level in the city center. A stairway (FIG. 2-1) leads to the top but does not end in front of any of the temple doorways, necessitating two or three angular changes in direction. This "bent-axis" approach is the standard arrangement for Sumerian temples, a striking contrast to the linear approach the Egyptians preferred for their temples and tombs (see Chapter 3).

Like other Sumerian temples, the corners of the White Temple are oriented to the cardinal points of the compass. The building, probably dedicated to Anu, the sky god, is of modest proportions (sixty-one by sixteen feet). By design, it did not accommodate large throngs of worshipers but only a select few, the priests and perhaps the leading community members. The temple has several chambers. The central hall, or *cella,* was set aside for the divinity and housed a stepped altar. The Sumerians referred to their temples as "waiting rooms," a reflection of their belief that the deity would descend from the heavens to appear before the priests in the cella. How or if the Uruk temple was roofed is uncertain.

The Sumerian idea that the gods reside above the world of humans is central to most of the world's religions. Moses ascended Mount Sinai to receive the Ten Commandments from the Hebrew God, and the Greeks placed the home of their gods and goddesses on Mount Olympus. The elevated placement of Mesopotamian temples on giant platforms reaching to the sky is consistent with this widespread religious concept. Eroded ziggurats still dominate most of the ruined cities of

2-1 White Temple and ziggurat, Uruk (modern Warka), Iraq, ca. 3200–3000 B.C.

Sumer. The loftiness of the great temple platforms made a profound impression on the peoples of the ancient Near East. The tallest ziggurat of all—at Babylon—was about two hundred and seventy feet high. Known to the Hebrews as the Tower of Babel, it became the centerpiece of a biblical story about the insolent pride of humans (see "Babylon: City of Wonders," page 37).

SCULPTURE IN MARBLE AND GOLD The White Temple at Uruk towers over all other vestiges of that ancient city, but a fragmentary white marble female head (FIG. **2-3**) is also an extraordinary achievement at so early a date. The head is actually only a face with a flat back. Although found in the sacred precinct of the goddess Inanna, the subject is unknown. Many have suggested that it is an image of Inanna, but a mortal woman, perhaps a priestess, may be portrayed. Unlike the life-size Neolithic plastered and painted skulls from Jericho (see FIG. 1-15), human hands fashioned the entire Uruk face. The stone had to be imported and was too costly to use for the full statue. The marble face has drilled holes for attachment to a head and body, probably of wood.

The sculptor refined the features of the goddess or woman. The bright coloration of the eyes, brows, and hair, however, likely overshadowed the soft modeling of the cheeks and mouth. The deep groove at the top anchored a wig, probably made of gold leaf. The hair strands engraved in the metal fell in waves over the forehead and sides of the head. Colored

shell or stone filled the deep recesses for the eyebrows and the large eyes. Often the present condition of an artwork can be very misleading, and the Uruk head is a dramatic example. Its original appearance would have been much more vibrant than the pure white fragment archeologists uncovered.

2-3 Female head (Inanna?), from Uruk (modern Warka), Iraq, ca. 3200–3000 B.C. Marble, approx. 8″ high. Iraq Museum, Baghdad.

2-2 Reconstruction drawing of the White Temple and ziggurat, Uruk (modern Warka), Iraq, ca. 3200–3000 B.C. (after S. E. Piggott).

GIFTS FOR A GODDESS The Sumerians, pioneers in so many areas, also may have been the first to use pictures to tell coherent stories. Sumerian narrative art goes far beyond the Stone Age artists' tentative efforts at storytelling. The so-called *Warka Vase* (FIG. 2-4) from Uruk (modern Warka) is the first great work of narrative relief sculpture known. Found within the Inanna temple complex, it depicts a religious festival in the goddess's honor. The sculptor divided the vase's reliefs into three bands (also called *registers* or *friezes*). The lowest shows sheep and rams above barley and flax and a wavy line representing water. These are the staple commodities of the Sumerian economy. Their inclusion on the vase indicates that Inanna had blessed Uruk's inhabitants with good crops and increased herds. The animals on the *Warka Vase* are in strict profile, consistent with an approach to representation that was then some twenty-five thousand years old. But the organization of the animals (and plants and humans) in a reg-

ister and standing on a *ground line* (the horizontal base of the composition) is new. It marks a significant break with the haphazard figure placement in earlier art. The register format for telling a story was to have a very long future. In fact, artists still employ registers today in modified form in comic books.

A procession of naked men occupies the central band of the stone vase. The men carry baskets and jars overflowing with earth's abundance. They will present their bounty to the goddess as a *votive offering* (gift of gratitude to a deity usually made in fulfillment of a vow) and will deposit it in her temple. The spacing of each figure involves no overlapping. The Uruk men, like the prehistoric deer hunters at Çatal Hüyük (see FIG. 1-17), are a composite of frontal and profile views, with large staring frontal eyes in profile heads. The artist indicated those human bodily parts necessary to communicate the human form and avoided positions, attitudes, or views that would conceal the characterizing parts. For example, if the figures were in strict profile, an arm and perhaps a leg would be hidden. The body would appear to have only half its breadth. And the eye would not "read" as an eye at all, because it would not have its distinctive flat oval shape. Art historians call this characteristic early approach to representation "conceptual," as opposed to "optical," because artists who used it did not record the immediate, fleeting aspect of figures. Instead, they rendered the human body's distinguishing and fixed properties. The fundamental forms of figures and the artist's knowledge of them, not their accidental appearance, directed the artist's hand and dictated the artist's selection of the composite view as the best way to represent the human body.

In the uppermost (and tallest) band is a female figure (not visible in our photograph) with a tall horned headdress. Whether she is Inanna or her priestess is not known. In the portion shown in FIG. 2-4, the food offerings already have been deposited in Inanna's shrine. (The goat and lion are actually animal-shaped vessels—note the spouts on their backs.) An attendant assists an only partially preserved larger figure (at the far right) who is usually, if ambiguously, referred to as a "priest-king" because similar figures appear in other Sumerian artworks as leaders in both religious and secular contexts. On the *Warka Vase,* the attendant carries the leader's broad tasseled belt like a train. The greater height of the "priest-king" indicates his greater importance, a convention called *hierarchy of scale.* Some scholars interpret the scene as a symbolic marriage between the "priest-king" and the goddess, insuring her continued goodwill—and reaffirming the leader's exalted position in society.

STATUETTES OF PERPETUAL WORSHIPERS Further insight into Sumerian religious beliefs and rituals comes from a cache of gypsum statuettes inlaid with shell and black limestone (FIG. 2-5). The figures were reverently buried beneath the floor of a temple at Eshnunna (modern Tell Asmar) when the structure was remodeled. They range in size from well under a foot to about thirty inches tall. The differing heights of the men and women represented may correspond to their relative importance in the community. All of the figures represent mortals, rather than deities, with their hands folded in front of their chests in a gesture of prayer. Many also hold the small beakers the Sumerians used in religious rites. Hundreds of such goblets have been found in the

2-4 Presentation of offerings to Inanna *(Warka Vase),* from Uruk, Iraq, ca. 3200–3000 B.C. Alabaster, 3' $\frac{1}{4}$" high. Iraq Museum, Baghdad.

2-5 Statuettes of worshipers, from the Square Temple at Eshnunna (modern Tell Asmar), Iraq, ca. 2700 B.C. Gypsum inlaid with shell and black limestone, tallest figure approx. 2′ 6″ high. Iraq Museum, Baghdad, and Oriental Institute, University of Chicago.

temple complex at Eshnunna. The men wear belts and fringed skirts. Most have beards and shoulder-length hair. The women wear long robes, with the right shoulder bare. Similar figurines from other sites bear inscriptions giving such information as the name of the donor and the god or even specific prayers to the deity on the owner's behalf. With their heads tilted upward, they wait in the Sumerian "waiting room" for the divinity to appear.

The sculptors of the Eshnunna statuettes employed simple forms, primarily cones and cylinders, for the figures. The statuettes are not portraits in the strict sense of the word, but the sculptors did distinguish physical types. At least one child was portrayed—next to the tallest of the female figures are the remains of two small legs (not visible in the group photo). Most striking is the disproportionate relationship between the oversized eyes and the tiny hands. Scholars have explained the exaggeration of the eye size in various ways. But because the purpose of these votive figures was to offer constant prayers to the gods on their donors' behalf, the open-eyed stares most likely symbolize the eternal wakefulness necessary to fulfill their duty.

Another group of Sumerian votive statuettes comes from the Temple of Ishtar at Mari. Of particular interest is the figure of Urnanshe (FIG. **2-6**), identified by an inscription. His eyes—inlaid with shell and *lapis lazuli* (a rich azure-blue stone imported from Afghanistan)—are unwavering in their intense gaze. Like the other figures in the group, Urnanshe is bare chested, wears a tufted fleece skirt, and holds his arms (now broken) in front of his chest in a gesture of prayer. But he sits on a cushion with legs crossed, and he is beardless, with long straight hair that reaches to the waist, suggesting that he was a *eunuch* (castrated male). Urnanshe was neither priest nor ruler but the official singer at the Mari court. Another, very fragmentary, statuette portrays Urnanshe with a stringed instrument, that is, in his role as musician and singer at religious ceremonies. His statuettes attest that he stands ever ready to serve the goddess as well as his ruler.

2-6 Seated statuette of Urnanshe, from the Ishtar temple at Mari (modern Tell Hariri), Syria, ca. 2600–2500 B.C. Gypsum inlaid with shell and lapis lazuli, 10 $\frac{1}{4}$″ high. National Museum, Damascus.

2-7 Fragment of the victory stele of Eannatum *(Stele of the Vultures)*, from Girsu (modern Telloh), Syria, ca. 2600–2500 B.C. Limestone, full stele approx. 5′ 11″ high. Louvre, Paris.

VICTORY AND VULTURES The city-states of ancient Sumer were often at war with one another, and warfare is the theme of the so-called *Stele of the Vultures* (FIG. **2-7**) from Girsu. A *stele* is a carved stone slab erected to commemorate a historical event or, in some other cultures, to mark a grave (see FIG. 5-55). The Girsu stele presents, in fact, a labeled historical narrative. (It is not, however, the first historical representation in the history of art. That honor belongs—at the moment—to an Egyptian relief, FIG. 3-2, carved more than three centuries earlier.) Although the *Stele of the Vultures* is fragmentary, cuneiform inscriptions almost everywhere on the monument reveal that it celebrates the victory of Eannatum, the *ensi* (ruler; king?) of Lagash, over the neighboring city-state of Umma. The stele has reliefs on both sides and takes its nickname from a fragment with a gruesome scene of vultures carrying off the severed heads and arms of the defeated enemy soldiers. Another fragment shows the giant figure of the local god Ningirsu holding tiny enemies in a net and beating one of them on the head with a mace.

Our illustration depicts Eannatum leading an infantry battalion into battle (above) and attacking from a war chariot (below). The foot soldiers are protected behind a wall of shields and trample naked enemies as they advance. (The fragment showing vultures devouring corpses belongs just to the right in the same register.) Both on foot and in a chariot, Eannatum is larger than anyone else, except Ningirsu on the other side of the stele. He is shown as the fearless general who paves the way for his army. Lives were lost, however, and Eannatum himself was wounded in the campaign. But the outcome was never in doubt because Ningirsu fought with the men of Lagash.

Despite its fragmentary state, the *Stele of the Vultures* is an extraordinary document, not only as a very early effort to record historical events in relief but also for the insight it yields about Sumerian society. Through both words and pictures, it provides information about warfare techniques and the special nature of the Sumerian ruler. Eannatum was greater in stature than other men, and Ningirsu watched over him. According to the text, the ensi was born from the god Enlil's semen, implanted in the womb by Ningirsu. When Eannatum was wounded in battle, it says, the god shed tears for him. He was a divinely chosen ruler who presided over all aspects of his city-state, both in war and in peace. This also seems to have been the role of the ensi in the other Sumerian city-states.

WAR AND PEACE The spoils of war as well as success in farming and trade brought considerable wealth to some of the city-states of ancient Sumer. Nowhere is this clearer than in the so-called Royal Cemetery at Ur, the city that was home to the biblical Abraham. In the third millennium B.C., the leading families of Ur buried their dead in vaulted chambers beneath the earth. Scholars still debate whether these deceased were true kings and queens or simply aristocrats and priests, but they were laid to rest in regal fashion. Archeologists exploring the Ur cemetery uncovered gold helmets and daggers with handles of lapis lazuli, golden beakers and bowls, jewelry of gold and lapis, musical instruments, chariots, and other luxurious items in the graves. A retinue of musicians, servants, charioteers, and soldiers accompanied the "kings and queens" into the afterlife, giving their own lives when their rulers died.

2-8(a) War side of the *Standard of Ur,* from Tomb 779, Royal Cemetery, Ur (modern Tell Muqayyar), Iraq, ca. 2600 B.C. Wood inlaid with shell, lapis lazuli, and red limestone, approx. 8″ × 1′ 7″. British Museum, London.

Not the costliest object found in the "royal" graves, but probably the most significant from the viewpoint of the history of art, is the so-called *Standard of Ur* (FIG. **2-8**). This rectangular box of uncertain function has sloping sides inlaid with shell, lapis lazuli, and red limestone. The excavator, Leonard Woolley, thought the object was originally mounted on a pole and considered it a kind of military standard—hence its nickname. The two long sides of the box have been designated as the "war side" and "peace side," but they may represent the first and second parts of a single narrative. Each is divided into three horizontal bands. The narrative reads from left to right and bottom to top. On the war side, four ass-drawn four-wheeled war chariots mow down enemies, whose bodies appear on the ground in front of and beneath the animals. The gait of the asses accelerates along the band from left to right. Above, a file of foot soldiers gathers up and leads away captured foes. In the uppermost register, soldiers present bound captives (who have been stripped naked to degrade them) to a kinglike figure, who has stepped out of his chariot. His central place in the composition and his greater stature set him apart from all the other figures. Note how his head breaks through the border at the top.

In the lowest band on the peace side, men carry provisions, possibly war booty, on their backs. Above, attendants bring animals, perhaps also spoils of war, and fish for the great banquet depicted in the uppermost register. There, seated dignitaries and a larger-than-life "king" (third from the left) feast, while a lyre player and singer (at the far right, with long straight hair—like Urnanshe, FIG. 2-6) entertain the group. Art historians have interpreted the scene both as a victory celebration and as a banquet in connection with cult ritual. The two are not necessarily incompatible. The absence of an inscription prevents connecting the scenes with a specific event or person, but the *Standard of Ur* undoubtedly depicts figures from the period. The story told in the six registers is another early example of historical narrative.

MUSIC IN THE AFTERLIFE From the "King's Grave" at Ur comes a splendid lyre (FIG. **2-9**) that, in its restored state, resembles the instrument depicted in the feast scene on the *Standard of Ur.* A magnificent bull's head, fashioned of gold leaf over a wooden core with hair, beard, and details of lapis lazuli, caps the instrument's sound box. The sound box itself (FIG. **2-10**) also features bearded, but here humanheaded, bulls in the uppermost of its four inlaid panels. Such

imaginary composite creatures are commonplace in the art of the ancient Near East and Egypt. The man-headed lion known as the Great Sphinx of Gizeh (see FIG. 3-11) is undoubtedly the most famous example. On the Ur lyre, a heroic figure embraces the two man-bulls in a *heraldic composition* (symmetrical around a central figure). His body and that of the scorpion-man in the lowest panel are in composite view. The animals are, equally characteristically, solely in profile:

2-9 Bull-headed lyre (restored) from Tomb 789 ("King's Grave"), Royal Cemetery, Ur (modern Tell Muqayyar), Iraq, ca. 2600 B.C. Gold leaf and lapis lazuli over a wooden core, approx. 5′ 5″ high. University Museum, University of Pennsylvania, Philadelphia.

2-8(b) Peace side of the *Standard of Ur,* from Tomb 779, Royal Cemetery, Ur (modern Tell Muqayyar), Iraq, ca. 2600 B.C. Wood inlaid with shell, lapis lazuli, and red limestone, approx. 8″ × 1′ 7″. British Museum, London.

2-10 Soundbox of the lyre from Tomb 789, Royal Cemetery, Ur (modern Tell Muqayyar), Iraq, ca. 2600 B.C. Wood with inlaid gold, lapis lazuli, and shell, approx. 1′ high. University Museum, University of Pennsylvania, Philadelphia.

the dog wearing a dagger and carrying a laden table, the lion bringing in the beverage service, the ass playing the lyre, the jackal playing the zither, the bear steadying the lyre (or perhaps dancing), and the gazelle bearing goblets. The banquet animals almost seem to be burlesquing the kind of regal feast reproduced on the *Standard of Ur*'s peace side. The meaning of the sound box scenes is unclear. Some scholars have suggested, for example, that the creatures inhabit the land of the dead and that the narrative has a funerary significance. In any event, the Ur lyre's sound box is a very early specimen of the recurring theme in both literature and art of animals acting as people. Later examples include Aesop's fables in ancient Greece, medieval bestiaries, and Walt Disney's cartoon animal actors.

ART IN MINIATURE ON CYLINDER SEALS A banquet is also the subject of a *cylinder seal* (FIG. **2-11**) found in the tomb of "Queen" Pu-abi and inscribed with her name. (Many historians prefer to designate her more conservatively and ambiguously as "Lady" Pu-abi.) The seal is typical of the period, consisting of a cylindrical piece of stone engraved to produce a raised impression when rolled over clay (see "Mesopotamian Cylinder Seals," page 26). In the upper zone, a man and a woman, probably Pu-abi, sit and drink from beakers, attended by servants. Below, male attendants serve two more seated men. Even in miniature and in a medium very different from that of the *Standard of Ur,* the Sumerian artist employed the same figure types and followed the same compositional rules. All the figures are in composite views with large frontal eyes in profile heads, and the seated dignitaries are once again larger in scale to underscore their elevated position in the social hierarchy.

AKKADIAN, NEO-SUMERIAN, BABYLONIAN, AND HITTITE ART

THE FIRST NEAR EASTERN KINGS In 2334 B.C., the loosely linked group of cities known as Sumer came under the domination of a great ruler, Sargon of Akkad. The specific site of the city of Akkad has yet to be located but was in the vicinity of Babylon. The Akkadians were Semitic in origin, that is, they were a Near Eastern people who spoke a language

Mesopotamian Cylinder Seals

Cylinder seals have been unearthed in great numbers at sites throughout Mesopotamia. Generally made of stone—the favorite materials were carnelian, jasper, lapis lazuli, and agate—seals of ivory, glass, and other materials also survive. As the name implies, the seals are cylindrical. Most have a hole drilled lengthwise through the center of the cylinder so that they could be strung and worn around the neck or suspended from the wrist. Cylinder seals were prized possessions, signifying high positions in society, and they frequently were buried with the dead.

Their primary function, however, was not to serve as items of adornment. With this device, the Sumerians (and later peoples of the Near East) sealed and identified their documents and protected storage jars and doors against unauthorized opening. The oldest seals were found with some of the world's earliest written records and served to ratify the accuracy of administrative accounts. Seals and writing developed together in ancient Sumer. Some seals, in fact, bear long cuneiform inscriptions and record the names and titles of rulers, bureaucrats, and deities. Although sealing is increasingly rare, the tradition lives on today whenever a letter is sealed with a lump of wax and then stamped with a monogram or other identifying mark. Customs officials often still seal packages and sacks with official stamps when goods cross national borders.

In the ancient Near East, cylinder seals were decorated with incised designs, producing a raised pattern when the seal was rolled over soft clay. We illustrate a seal from the Royal Cemetery at Ur and a modern impression made from it (FIG. 2-11). Note how cracks in the stone cylinder become raised lines in the impression and how the engraved figures, chairs, and cuneiform characters appear in relief. Continuous rolling of the seal over a clay strip results in a repeating design, as our illustration also demonstrates at the edges.

The miniature reliefs the seals produce are a priceless source of information about Mesopotamian religion and society. Without them, archeologists would know much less about how Mesopotamians dressed and dined; what their shrines looked like; how they depicted their gods, rulers, and mythological figures; and how they fought wars. Clay seal impressions excavated in architectural contexts shed a welcome light on the administration and organization of Mesopotamian city-states. Cylinder seals are also an invaluable resource for art historians, providing them with thousands of examples of Mesopotamian relief sculpture spread over roughly three thousand years.

related to Hebrew and Arabic. Their language—Akkadian—was entirely different from the language of Sumer, but they used the Sumerians' cuneiform characters for their written documents. Under Sargon (whose name means "true king") and his followers, the Akkadians introduced a new concept of royal power based on unswerving loyalty to the king rather than to the city-state. During the rule of Sargon's grandson, Naram-Sin (r. 2254–2218 B.C.), governors of cities were considered mere servants of the king, who, in turn, called himself "King of the Four Quarters"—in effect, ruler of the earth, akin to a god.

IMPERIAL MAJESTY IN COPPER A magnificent copper head of an Akkadian king found at Nineveh (FIG. 2-12) embodies this new concept of absolute monarchy. The harm the head suffered was due to its status as a political artwork. The head is all that survives of a statue that was knocked over in antiquity, perhaps by an enemy of the Akkadians. But the damage to the portrait was not due solely to the statue's toppling. Vandals gouged out the eyes, once inlaid with precious or semiprecious stones. They also broke off the lower part of the beard and mutilated the ears. Nonetheless, the king's majestic serenity, dignity, and authority are evident.

2-11 Banquet scene, cylinder seal *(left)* and its modern impression *(right)*, from the tomb of Pu-abi (tomb 800), Royal Cemetery, Ur (modern Tell Muqayyar), Iraq, ca. 2600 B.C. Lapis lazuli, approx. 2″ high. British Museum, London.

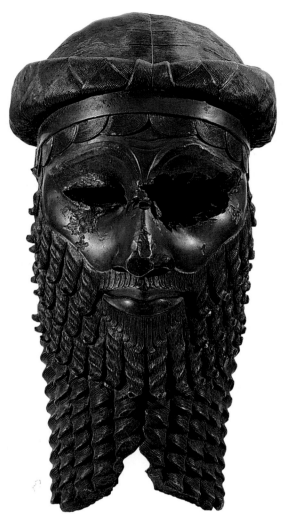

2-12 Head of an Akkadian ruler, from Nineveh (modern Kuyunjik), Iraq, ca. 2250–2200 B.C. Copper, 1' 2⅜" high. Iraq Museum, Baghdad.

honor of Naram-Sin and once by an Elamite king who had captured Sippar in 1157 B.C. and taken the stele as booty back to Susa, where it was found. On the stele, the grandson of Sargon leads his victorious army up the slopes of a wooded mountain. His routed enemies fall, flee, die, or beg for mercy. The king stands alone, far taller than his men, treading on the bodies of two of the fallen Lullubi. He wears the horned helmet—the first time a king appears as a god in Mesopotamian art—and at least three favorable stars (the stele is damaged at the top and broken at the bottom) shine on his triumph.

By storming the mountain, Naram-Sin seems also to be scaling the ladder to the heavens, the same conceit that lies behind the great ziggurat towers of the ancient Near East. His troops march up the mountain behind him in orderly files, suggesting the discipline and organization of the king's forces.

So, too, is the masterful way the sculptor balanced naturalism and abstract patterning. The artist carefully observed and recorded the man's distinctive features—the profile of the nose and the long, curly beard. The sculptor brilliantly communicated the differing textures of flesh and hair—even the contrasting textures of the mustache, beard, and the braided hair on the top of the head. The coiffure's triangles, lozenges, and overlapping disks of hair and the great arching eyebrows that give such character to the portrait reveal that the artist was also sensitive to formal pattern.

No less remarkable is the fact this is a life-size, hollow-cast metal sculpture (see "Hollow-Casting Life-Size Bronze Statues," Chapter 5, page 124), one of the earliest known. The head demonstrates the artisan's sophisticated skill in casting and polishing copper and in engraving the details. The portrait is the first great extant monumental work of hollow-cast sculpture, but it would have been a superb achievement at any date.

A GOD-KING CRUSHES AN ENEMY The godlike sovereignty the kings of Akkad claimed is also evident in the victory stele (FIG. **2-13**) Naram-Sin set up at Sippar. The stele commemorates his defeat of the Lullubi, a people of the Iranian mountains to the east. It is inscribed twice, once in

2-13 Victory stele of Naram-Sin, from Susa, Iran, 2254–2218 B.C. Pink sandstone, approx. 6' 7" high. Louvre, Paris.

RELIGION AND MYTHOLOGY

The Piety of Gudea

One of the central figures of the Neo-Sumerian age was Gudea, ensi of Lagash ca. 2100 B.C. Nearly two dozen portraits of him survive, carved in diorite and polished to a brilliant finish. Gudea's statues all stood in temples where they could render perpetual service to the gods and intercede with the divine powers on his behalf. Although a powerful ruler, Gudea rejected the regal trappings of Sargon of Akkad and his successors in favor of a return to the Sumerian votive tradition of the statuettes from Eshnunna and Mari (FIGS. 2-5 and 2-6). Like the earlier examples, some of Gudea's statues are inscribed with messages to the gods of Sumer. One from Girsu says, "I am the shepherd loved by my king [Ningirsu, the god of Girsu]; may my life be prolonged." Another, also from Girsu, as if in answer to the first, says, "Gudea, the builder of the temple, has been given life."

In fact, Gudea, at great cost, built or rebuilt all the temples where he placed his statues. One characteristic portrait (FIG. 2-15) depicts the pious ruler of Lagash seated with his hands clasped in front of him in a gesture of prayer. As in his other portraits, Gudea has a muscular physique with well-developed arms, and he wears a long garment that leaves his right shoulder bare. The head is unfortunately lost, but the statue is of unique interest because Gudea has a temple plan drawn on a tablet on his lap. The ruler buried accounts of his building enterprises in the temple foundations. The surviving texts describe how the sites were prepared and purified, the materials obtained, and the completed temples dedicated. They also record Gudea's dreams of the gods asking him to erect temples in their honor, promising him prosperity if he fulfilled his duty. In one of these dreams, Ningirsu addresses Gudea:

> When, O faithful shepherd Gudea, thou shalt have started work for me on Erinnu, my royal abode [Ningirsu's new temple], I will call up in heaven a humid wind. It shall bring the abundance from on high. . . . All the great fields will bear for thee; dykes and canals will swell for thee; . . . good weight of wool will be given in thy time.[1]

In our statue, Gudea presents Ningirsu with his plan for the god's new temple. And when the structure was completed and his people enjoyed good harvests and their flocks were plentiful, they knew it was the result of Gudea's piety.

[1] Thorkild Jacobsen, trans., *The Art and Architecture of the Ancient Orient,* by Henri Frankfort, 4th ed. (New Haven: Yale University Press, 1970), 98.

The enemy, by contrast, is in disarray, depicted in a great variety of postures—one falls headlong down the mountainside. The sculptor adhered to older conventions in many details, especially by portraying the king and his soldiers in composite views. Note, too, the frontal placement of Naram-Sin's two-horned helmet on his profile head. But, in other respects, this work shows daring innovation. Here, the sculptor created the first landscape in Near Eastern art since the Çatal Hüyük mural (see FIG. 1-18) and set the figures on successive tiers within that landscape. This was a bold rejection of the standard means of telling a story in a series of horizontal registers, the compositional formula that was the rule not only in earlier Mesopotamian art but also in Egyptian art.

THE RESURGENCE OF SUMER A raid by mountain people, the Guti, brought Akkadian power to an end. The Guti dominated life in central and lower Mesopotamia until the cities of Sumer united in response to the alien presence and established a Neo-Sumerian state ruled by the kings of Ur. This age saw the construction of one of the greatest ziggurats

2-14 Ziggurat (northeastern facade with restored stairs), Ur (modern Tell Muqayyar), Iraq, ca. 2100 B.C.

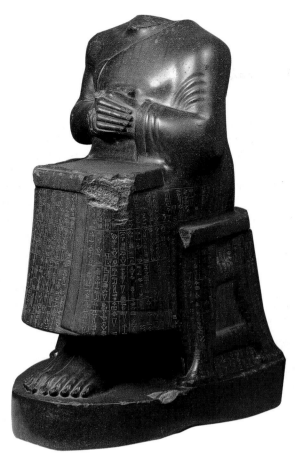

2-15 Seated statue of Gudea holding temple plan, from Girsu (modern Telloh), Iraq, ca. 2100 B.C. Diorite, approx. 2′ 5″ high. Louvre, Paris.

HAMMURABI AND THE RISE OF BABYLON

The resurgence of Sumer was short lived under the kings of what historians refer to as the Third Dynasty of Ur. The last of those kings fell from the attacks of the Elamites, who ruled the territory east of the Tigris River. The following two centuries witnessed the reemergence of the traditional Mesopotamian political pattern of several independent city-states existing side by side. Until Babylon's most powerful king, Hammurabi (r. 1792–1750 B.C.), reestablished a centralized government that ruled southern Mesopotamia, Babylon was one of these city-states. Perhaps the most renowned king in Mesopotamian history, Hammurabi was famous for his conquests. But he is best known today for his law code, which prescribed penalties for everything from adultery and murder to the cutting down of a neighbor's trees (see "Hammurabi's Law Code," page 30).

The code is inscribed on a tall black-basalt stele (FIG. **2-16**) that was carried off as booty to Susa in 1157 B.C., together in Mesopotamia, that at Ur (FIG. **2-14**). It was built about a millennium later than the ziggurat at Uruk (FIGS. 2-1 and 2-2) and is much larger. The base is a solid mass of mud brick fifty feet high. The builders used baked bricks laid in *bitumen,* an asphaltlike substance, for the facing of the entire monument. Three ramplike stairways of a hundred steps each converge on a tower-flanked gateway. From there another flight of steps probably led to the temple proper, which does not survive, even in part.

GUDEA'S DIORITE PORTRAITS The most conspicuous preserved sculptural monuments of the Neo-Sumerian age portray the ensi of Lagash, Gudea. About twenty statues of Gudea survive, showing him seated or standing, hands tightly clasped, head shaven, sometimes wearing a woolen brimmed hat, and always dressed in a long garment that leaves one shoulder and arm exposed (FIG. **2-15**). Gudea was zealous in granting the gods their due, and the numerous statues he commissioned are an enduring testimony to his piety (see "The Piety of Gudea," page 28)—and also to his wealth and pride. All his portraits are of diorite, a rare and costly dark stone that had to be imported. Diorite is also extremely hard and difficult to carve. The prestige of the material—which in turn lent prestige to Gudea's portraits—is evident from an inscription on one of Gudea's statues: "This statue has not been made from silver nor from lapis lazuli, nor from copper nor from lead, nor yet from bronze; it is made of diorite."

2-16 Stele with law code of Hammurabi, from Susa, Iran, ca. 1780 B.C. Basalt, approx. 7′ 4″ high. Louvre, Paris.

Hammurabi's Law Code

In the early eighteenth century B.C., King Hammurabi of Babylon formulated a comprehensive law code for his people. At the time, parts of Europe were still in the Stone Age (see FIG. 1-19). And even in Greece, it was not until more than a thousand years later that Draco provided Athens with its first written set of laws. Hammurabi was following the tradition his Sumerian predecessors established. Two similar earlier law codes survive in part, but Hammurabi's laws are the only ones known in great detail, thanks to the chance survival of a tall and narrow stele depicting Hammurabi receiving the measuring rod and line from the god Shamash (FIG. 2-16). The rod and line symbolize the authority to measure people's lives, that is, to render judgments. The sculptor thus informed viewers that Hammurabi had the god-given authority to enforce the laws spelled out on the stele. The judicial code, written in Akkadian, was inscribed in thirty-five hundred lines of cuneiform characters. Hammurabi's laws governed all aspects of Babylonian life, from commerce and property to murder and theft to marital fidelity, inheritances, and the treatment of slaves.

We list only a small sample of the infractions described and the penalties imposed (which vary with the person's standing in society).

If a man puts out the eye of another man, his eye shall be put out.

If he kills a man's slave, he shall pay one-third of a mina.

If someone steals property from a temple, he will be put to death, as will the person who receives the stolen goods.

If a man rents his boat and the boat is wrecked, the renter shall replace the boat with another.

If a married woman dies before bearing any sons, her dowry shall be repaid to her father, but if she gave birth to sons, the dowry shall belong to them.

If a man's wife is caught in bed with another man, both will be tied up and thrown in the water.

with the Naram-Sin stele (FIG. 2-13). At the top is a relief depicting Hammurabi in the presence of the flame-shouldered sun god, Shamash. The king raises his hand in respect. The god bestows on Hammurabi the authority to rule and to enforce the laws.

The sculptor depicted Shamash in the familiar convention of combined front and side views, but with two important exceptions. His great headdress with its four pairs of horns is in true profile so that only four, not all eight, of the horns are visible. And the artist seems to have tentatively explored the notion of *foreshortening*—a device for suggesting depth by representing a figure or object at an angle, rather than frontally or in profile. The god's beard is a series of diagonal rather than horizontal lines, suggesting its recession from the picture plane.

ISHTAR GRANTS POWER TO A NEW KING While Hammurabi ruled Babylon, King Zimri-Lim (r. 1779–1757 B.C.) controlled the Sumerian city-state of Mari. Zimri-Lim constructed a huge palace complex at Mari, but in 1757 B.C. Hammurabi led an army into the city and destroyed the royal residence. Fortunately, some of the extremely fragile paintings on plaster that adorned the mudbrick palace walls survive. They provide a rare opportunity to study the art of mural painting in Mesopotamia.

The painting we reproduce (FIG. **2-17**) adorned one wall of the palace's main courtyard near the entrance to the throne room suite. At the center, the painter represented the *investiture* of Zimri-Lim, the granting of his right to rule, by the goddess Ishtar. The king approaches Ishtar with his right arm raised in greeting and respect, just as Hammurabi appeared before Shamash (FIG. 2-16). The goddess has one foot on her sacred lion and hands Zimri-Lim the emblems of power, the

rod and line. A god and two other goddesses witness the ceremony. Below, two more goddesses display vases from which plants grow and streams of life-giving water flow. Fish swim freely in the current. The general theme is a venerable one. The gods grant royal authority to their chosen kings and prosperity to their people.

As on Hammurabi's stele, the horned crowns the deities wear are in profile, although the painter showed no interest in foreshortening. In fact, such experiments are very uncommon. Like the bold abandonment of the register format in favor of a tiered landscape on the Naram-Sin stele (FIG. 2-13), innovations in representational modes were exceptional in early eras of the history of art. These occasional departures from the norm testify to the creativity and brilliance of the ancient Near Eastern artists.

A HITTITE FORTRESS IN TURKEY The Babylonian Empire was toppled in the face of an onslaught by the Hittites, an Anatolian people who conquered and sacked Babylon around 1595 B.C. They then retired to their homeland, leaving Babylon in the hands of the Kassites. Remains of the strongly fortified capital city of the Hittites still may be seen near the modern Turkish village of Boghazköy. Constructed of large blocks of heavy stone—a striking contrast to the brick architecture of Mesopotamia—the walls and towers of the Hittites effectively protected them from attack. Still symbolically guarding the gateway to the Boghazköy citadel (FIG. **2-18**) are two huge (seven-foot-high) lions. Their simply carved forequarters project from massive stone blocks on either side of the entrance. These Hittite guardian beasts are early examples of a theme that was to be echoed on many Near Eastern gates. Notable are those of Assyria (FIG. 2-21), one of the greatest empires of the ancient world, and

2-17 Investiture of Zimri-Lim, mural painting from Court 106 of the palace at Mari (modern Tell Hariri), Syria, ca. 1775–1760 B.C. Louvre, Paris.

of the reborn Babylon (FIG. 2-26) in the first millennium B.C. But the idea of protecting a city, palace, temple, or tomb from evil by placing wild beasts or fantastic monsters before an entranceway was not unique to the Near Eastern world. Examples abound in Egypt, Greece, Italy, and elsewhere.

ELAMITE AND ASSYRIAN ART

THE RISE OF SUSA To the east of Sumer, Akkad, and Babylon, in what is western Iran today, a civilization flourished that historians refer to by the biblical name Elam.

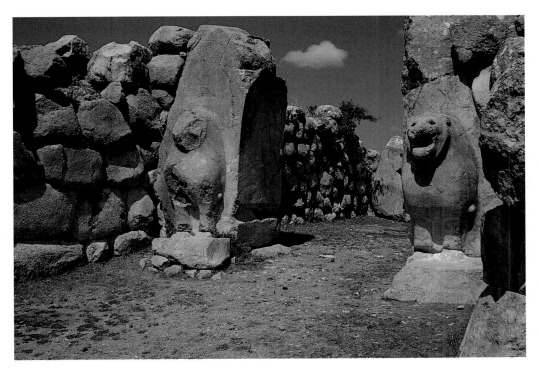

2-18 Lion Gate, Boghazköy, Turkey, ca. 1400 B.C. Limestone, lions approx. 7′ high.

During the second half of the second millennium B.C., Elam reached the height of its political and military power. At this time Elam was strong enough to plunder Babylonia and to carry off the stelae of Naram-Sin and Hammurabi (FIGS. 2-13 and 2-16) and reerect them at its capital city, Susa. The Assyrian king Ashurbanipal finally destroyed the empire of Elam in 641 B.C. when he sacked Susa. The city would rise again to great importance under the Achaemenid Persian Empire.

AN IMMOVABLE PORTRAIT OF A QUEEN

From the ruins of Susa came the life-size bronze-and-copper statue of Queen Napir-Asu (FIG. **2-19**), wife of one of the most powerful Elamite kings, Untash-Napirisha. The statue weighs 3,760 pounds even in its fragmentary and mutilated state, because the sculptor, incredibly, cast the statue with a solid bronze core inside a hollow-cast copper shell. The bronze core increased the cost of the statue enormously, but the queen wished her portrait to be a permanent, immovable votive offering in the temple where it was found. In fact, the

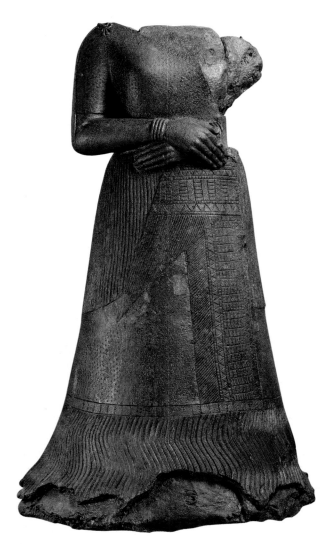

2-19 Statue of Queen Napir-Asu, from Susa, Iran, ca. 1350–1300 B.C. Bronze and copper, 4′ 2¾″ high. Louvre, Paris.

Elamite inscription on the queen's skirt explicitly asks the gods to protect the statue:

> He who would seize my statue, who would smash it, who would destroy its inscription, who would erase my name, may he be smitten by the curse of [the gods], that his name shall become extinct, that his offspring be barren. . . . This is Napir-Asu's offering.[1]

The statue thus falls within the votive tradition going back to the third millennium B.C. and the figurines from Eshnunna and Mari (FIGS. 2-5 and 2-6). In the Elamite statue of Queen Napir-Asu, the Mesopotamian instinct for cylindrical volume is again evident. The portrait's tight silhouette, strict frontality, and firmly crossed hands held close to the body are all enduring characteristics common to the Sumerian statuettes. Yet within these rigid conventions of form and pose, the Elamite artist managed to create refinements that must have come from close observation. The sculptor conveyed the feminine softness of arm and bust, the grace and elegance of the long-fingered hands, the supple and quiet bend of the wrist, the ring and bracelets, and the gown's patterned fabric. The figure presents the ideal in queenly deportment, with just a touch of modesty to lessen the conventional pose's severity. The loss of the head is especially unfortunate.

THE FORTRESS-PALACES OF THE ASSYRIANS

During the first half of the first millennium B.C., a fearsome resurgent force in the Near East, the Assyrians, vanquished the various warfaring peoples that succeeded the Babylonians and Hittites. The Assyrians took their name from Assur, the city on the Tigris River in northern Iraq named for the god Ashur. At the height of their power, the Assyrians ruled an empire that extended from the Tigris to the Nile Rivers and from the Persian Gulf to Asia Minor. Their palaces have been excavated in large part, yielding not only their plans but also statues, mural paintings, and the most extensive series of narrative reliefs in the ancient Near East.

The unfinished royal citadel of King Sargon II (r. 721–705 B.C.) of Assyria built at Dur Sharrukin (FIG. **2-20**) reveals in its ambitious layout the confidence of the Assyrian kings in their all-conquering might. Its strong defensive walls also reflect a society ever fearful of attack during a period of almost constant warfare. The city measures about a square mile in area. The palace, elevated on a mound fifty feet high, covered some twenty-five acres and had more than two hundred courtyards and rooms. As our reconstruction drawing shows, although the palace complex layout had a basic symmetry, the plan is rambling. It embraced a collection of timber-roofed rectangular rooms and halls grouped around square and rectangular courts. Behind the main courtyard, whose sides each measured three hundred feet, were the residential quarters of the king, who received foreign emissaries in the long, high, brightly painted throne room. All visitors entered from another large courtyard, where giant figures of the king and his courtiers lined the walls.

Sargon II regarded his city and palace as an expression of his grandeur. The Assyrians cultivated an image of themselves as merciless to anyone who dared oppose them, although they were forgiving to those who submitted to their will. Sargon, for example, wrote in an inscription, "I built a city with [the labors of] the peoples subdued by my hand, whom Ashur, Nabu, and Marduk had caused to lay themselves at

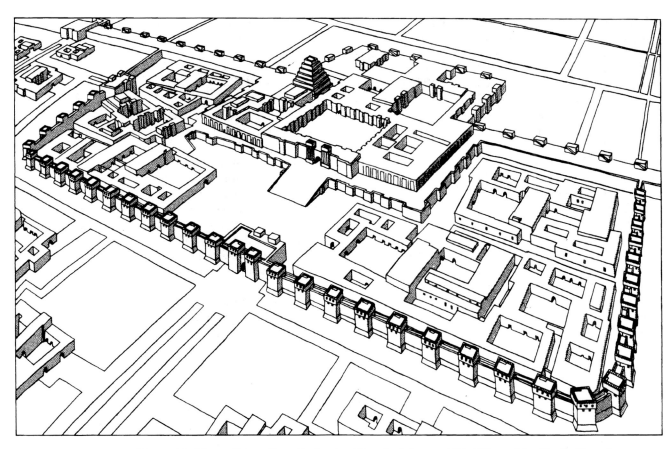

2-20 Reconstruction drawing of the citadel of Sargon II, Dur Sharrukin (modern Khorsabad), Iraq, ca. 720–705 B.C. (after Charles Altman).

my feet and bear my yoke." And in another text, he proclaimed, "Sargon, King of the World, has built a city. Dur Sharrukin he has named it. A peerless palace he has built within it."

In addition to the complex of courtyards, throne room, state chambers, service quarters, and guard rooms that made up the palace, the citadel included a great ziggurat and six sanctuaries for six different gods. The ziggurat at Dur Sharrukin may have had as many as seven stories. Four remain, each eighteen feet high and painted a different color. A continuous ramp spiraled around the building from its base to the temple at its summit. Here, the legacy of the Sumerian bent-axis approach may be seen more than two millennia after the erection of the White Temple on the ziggurat at Uruk (FIG. 2-1).

SARGON'S MONSTROUS GUARDIANS Guarding the gate to Sargon's palace were colossal limestone monsters (FIG. **2-21**), probably called *lamassu* by the Assyrians. These winged, man-headed bulls served to ward off the king's enemies, visible and invisible. The task of moving and installing such immense stone sculptures was so daunting that several reliefs in the palace of Sargon's successor celebrate the feat, showing scores of men dragging lamassu figures with the aid of ropes and sledges.

The Assyrian lamassu sculptures are partly in the round, but the sculptor nonetheless conceived them as high reliefs on adjacent sides of a corner. They combine the front view of the animal at rest with the side view of it in motion.

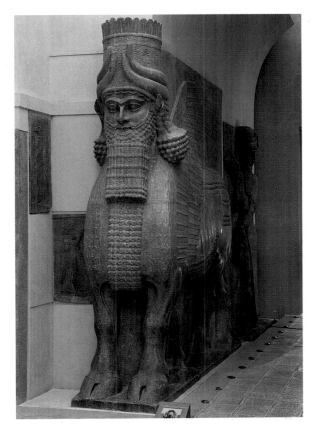

2-21 Lamassu (winged, human-headed bull), from the citadel of Sargon II, Dur Sharrukin (modern Khorsabad), Iraq, ca. 720–705 B.C. Limestone, approx. 13′ 10″ high. Louvre, Paris.

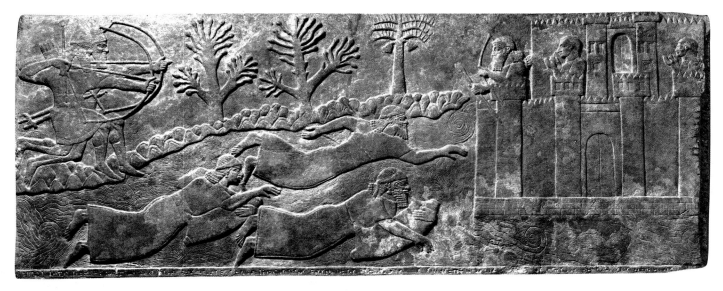

2-22 Assyrian archers pursuing enemies, relief from the Northwest Palace of Ashurnasirpal II, Kalhu (modern Nimrud), Iraq, ca. 875–860 B.C. Gypsum, 2′ 10⅝″ high. British Museum, London.

Seeking to present a complete picture of the lamassu from both the front and the side, the sculptor gave the monster five legs (two seen from the front, four seen from the side). The three-quarter view the modern photographer chose would not have been favored in antiquity. This sculpture, then, is yet another case of early artists providing a "conceptual" picture of an animal or person and of all its important parts, as opposed to an "optical" view of the lamassu as it actually would stand in space.

CHRONICLES OF GREAT DEEDS The Assyrian kings expected their greatness to be recorded in unmistakably exact forms in their palaces. To this end, they commissioned sculptors to produce extensive series of narrative reliefs exalting royal power and piety and recording not only battlefield victories but also the slaying of wild animals. (The Assyrians, like many other societies before and after, regarded prowess in hunting as a manly virtue on a par with success in warfare.) The narrative reliefs of military campaigns and hunting covering Assyrian palace walls have precedents only in Egypt, but in a very different format (see Chapter 3). The degree of documentary detail in the Assyrian reliefs is without parallel in the ancient Near East, even in such narratives as those on the *Stele of the Vultures* (FIG. 2-7) and the *Standard of Ur* (FIG. 2-8). Archeologists have found nothing else comparable made before the Roman Empire (see Chapter 10).

One of the most extensive—and earliest—examples of a cycle of historical narrative reliefs comes from the palace of Ashurnasirpal II (r. 883–859 B.C.) at Kalhu. (The Assyrian kings frequently incorporated Ashur's name into their own.) Throughout the palace, painted gypsum reliefs sheathed the lower parts of the mud-brick walls below brightly colored plaster. Rich textiles on the floors contributed to the luxurious ambience. Every relief celebrated the king and bore an inscription naming Ashurnasirpal and describing his accomplishments.

The example we illustrate (FIG. 2-22) probably depicts an episode that occurred in 878 B.C. when Ashurnasirpal drove his enemy's forces into the Euphrates River. In the relief, two

Assyrian archers shoot arrows at the fleeing foe. Three enemy soldiers are in the water. One swims with an arrow in his back. The other two attempt to float to safety by inflating animal skins. Their destination is a fort where their compatriots await them. The artist showed the fort as if it were in the middle of the river, but it must, of course, have been on land, perhaps at some distance from where the escapees entered the water. The artist's purpose was to tell the story clearly and economically. In art, distances can be compressed and the human actors enlarged so that they stand out from their environment. (Literally interpreted, the defenders of the fort are too tall to walk through its archway.) The sculptor also combined different viewpoints in the same frame, just as the figures are composites of frontal and profile views. Viewers see the river from above while observing the men, trees, and fort from the side. The artist also made other adjustments for clarity. So as not to hide the archers' faces, the sculptor depicted their bowstrings in front of their bodies but behind their heads. The men will snare their own heads in their bows when they launch their arrows! All these liberties with optical reality result, however, in a vivid and easily legible retelling of a decisive moment in the king's victorious campaign. This was the artist's primary goal.

ASSYRIAN COURT RITUAL The Assyrian palace reliefs frequently portrayed the king and his retinue in ceremonial roles or paying homage to the gods. The subjects court sculptors depicted also occupied the painters in the king's employ. Unfortunately, Assyrian paintings, because of their fragile nature, are much rarer today than stone reliefs. A fine example of the painter's art is the *glazed* (painted and then kiln fired to fuse the color with the baked clay) brick from Ashurnasirpal II's Kalhu palace (FIG. **2-23**). It shows the king, taller than everyone else as befits his rank, delicately holding a cup. With it, he will make a *libation* (ritual pouring of liquid) in honor of the protective gods. The artist rendered the figures in outline, lavishing much attention on the patterns of the rich fabrics they wear. The king and the

2-23 Ashurnasirpal II with attendants and soldier, from his palace at Kalhu, Iraq, ca. 875–860 B.C. Glazed brick, 11¾″ high. British Museum, London.

attendant behind him are in consistent profile view, but the rule of showing the eye from the front in a profile head still held. Painted scenes such as this hint at what the Assyrian stone reliefs might have looked like with their original paint intact.

NOBLE ANIMAL ADVERSARIES Two centuries later, sculptors carved hunting reliefs for the Nineveh palace of the conqueror of Elamite Susa, Ashurbanipal (r. 668–627 B.C.). The hunt did not take place in the wild but in a controlled environment, assuring the king's safety and success. In the relief illustrated here (FIG. 2-24), lions released from cages in a large enclosed arena charge the king, who, in his chariot and with his attendants protecting his blind sides, shoots down the enraged animals. The king, menaced by the savage spring of a lion at his back, escapes harm by the quick action of two of his spearmen. They ward off the beast but do not kill it. Only the great king had that privilege. Behind his chariot lies a pathetic trail of dead and dying animals, pierced by what appears to be far more arrows than needed to kill them. A dying lioness (FIG. 2-25), blood streaming from her wounds, drags her hindquarters, paralyzed by arrows that have pierced her spine. The artist ruthlessly depicted the straining muscles, the swelling veins, the muzzle's wrinkled skin, and the flattened ears. Modern sympathies make this scene of carnage a kind of heroic tragedy, with the lions as protagonists. It is unlikely, however, that the king's artists had any intention other than to glorify their ruler by showing the king of men pitting himself against and conquering the king of beasts repeatedly. Depicting Ashurbanipal's beastly foes as possessing not merely strength but courage and nobility as well served to make the king's accomplishments that much grander.

2-24 Ashurbanipal hunting lions, relief from the North Palace of Ashurbanipal, Nineveh (modern Kuyunjik), Iraq, ca. 645–640 B.C. Gypsum, approx. 5′ high. British Museum, London.

2-25 Dying lioness, detail of a relief from the palace of Ashurbanipal, Nineveh (modern Kuyunjik), Iraq, ca. 645–640 B.C. Gypsum, figure approx. 1′ 4″ high. British Museum, London.

2-26 Ishtar Gate (restored), Babylon, Iraq, ca. 575 B.C. Glazed brick. Staatliche Museen, Berlin.

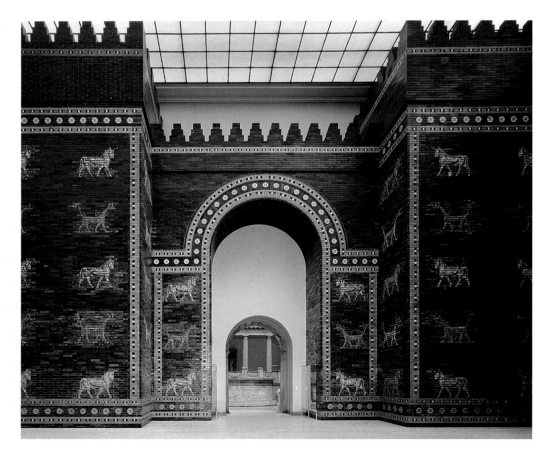

Babylon
City of Wonders

The uncontested list of the Seven Wonders of the ancient world was not codified until the sixteenth century. But already in the second century B.C. a roster of seven must-see monuments—including six of the seven later Wonders—was recorded by Antipater of Sidon, a Greek poet. All of the ancient Wonders were of colossal size and constructed at great expense. Three of them were of great antiquity: the pyramids of Gizeh (see FIG. 3-8), which Antipater described as "man-made mountains," and "the hanging gardens" and "walls of impregnable Babylon."

Babylon was the only site on Antipater's list that could boast two Wonders. Later list makers preferred to distribute the Seven Wonders among seven different cities. Most of these Wonders date to Greek times—the Temple of Artemis at Ephesus, with its sixty-foot-tall columns; Phidias's colossal gold-and-ivory statue of Zeus at Olympia; the grandiose tomb of Mausolus (the "Mausoleum") at Halikarnassos; the Colossus of Rhodes, a bronze statue of the sun god one hundred and ten feet tall; and the three-story lighthouse at Alexandria, perhaps the tallest building in the ancient world. The pyramids are the oldest and the Babylonian gardens the only Wonder in the category of "landscape architecture."

Several ancient texts describe the Babylonian gardens. We quote part of the account of Quintus Curtius Rufus from his history of Alexander the Great written in the mid-first century A.D.:

> On the top of the citadel are the hanging gardens, a wonder celebrated in the tales of the Greeks. . . . Columns of stone were set up to sustain the whole work, and on these was laid a floor of squared blocks, strong enough to hold the earth which is thrown upon it to a great depth, as well as the water with which they irrigate the soil; and the structure supports trees of such great size that the thickness of

their trunks equals a measure of eight cubits [about twelve feet]. They tower to a height of fifty feet, and they yield as much fruit as if they were growing in their native soil. . . . To those who look upon [the trees] from a distance, real woods seem to be overhanging their native mountains.[1]

Not qualifying as a Wonder, but in some ways no less impressive, was Babylon's Marduk ziggurat, the biblical Tower of Babel. According to the Bible, God was angered by humankind's arrogant desire to build a tower to Heaven. The Lord put an end to it by causing the workers to speak different languages, preventing them from communicating with one another. The fifth-century B.C. Greek historian Herodotus describes the Babylonian temple complex:

> In the middle of the sanctuary [of Marduk] has been built a solid tower . . . which supports another tower, which in turn supports another, and so on: there are eight towers in all. A stairway has been constructed to wind its way up the outside of all the towers; halfway up the stairway there is a shelter with benches to rest on, where people making the ascent can sit and catch their breath. In the last tower there is a huge temple. The temple contains a large couch, which is adorned with fine coverings and has a golden table standing beside it, but there are no statues at all standing there. . . . [The Babylonians] say that the god comes in person to the temple [compare the Sumerian notion of the temple as a "waiting room"] and rests on the couch; I do not believe this story myself.[2]

[1] John C. Rolfe, trans., *Quintus Curtius I* (Cambridge: Harvard University Press, 1971), 337–39.

[2] Robin Waterfield, trans., *Herodotus: The Histories* (New York: Oxford University Press, 1998), 79–80.

NEO-BABYLONIAN AND ACHAEMENID PERSIAN ART

The Assyrian Empire was never very secure, and most of its kings had to fight revolts in large sections of the Near East. Assyria's conquest of Elam in the seventh century B.C. and frequent rebellions in Babylonia apparently overextended its resources. During the last years of Ashurbanipal's reign, the empire began to disintegrate. Under his successors, it collapsed from the simultaneous onslaught of the Medes from the east and the resurgent Babylonians from the south. Babylonian kings held sway over the former Assyrian Empire until the Persian conquest.

NEBUCHADNEZZAR'S WONDROUS BABYLON
The most renowned of the Neo-Babylonian kings was

Nebuchadnezzar II (r. 604–562 B.C.), whose exploits the biblical Book of Daniel recounts. Nebuchadnezzar restored Babylon to its rank as one of the great cities of antiquity. The city's famous "hanging gardens" were counted among the Seven Wonders of the ancient world, and its enormous ziggurat was immortalized in the Bible as the Tower of Babel (see "Babylon: City of Wonders," above).

Nebuchadnezzar's Babylon was a mud-brick city, but dazzling blue-glazed bricks faced the most important monuments. Some of the buildings, such as the Ishtar Gate (FIG. 2-26), with its imposing arched opening flanked by towers, featured glazed bricks with molded reliefs of animals, real and imaginary. Glazed bricks had been used earlier (FIG. 2-23), but the surface of the bricks, even of those with figures, was flat. On the surfaces of the Ishtar Gate, laboriously reassembled in Berlin, are the alternating profile figures of the dragon

of Marduk and the bull of Adad. Lining the processional way leading up to the gate were reliefs of Ishtar's sacred lion, glazed in yellow, brown, and red against a blue ground. The Babylonian glazes were opaque and hard. Each brick had to be molded and glazed separately, then set in proper sequence on the wall.

THE TRIUMPH OF PERSIA Although Nebuchad-nezzar, the biblical Daniel's "King of Kings," had boasted that "I caused a mighty wall to circumscribe Babylon . . . so that the enemy who would do evil would not threaten," Cyrus of Persia (r. 559–529 B.C.) captured his city in the sixth century B.C. Cyrus, who may have been descended from an Elamite line, was the founder of the Achaemenid dynasty and traced his ancestry back to a mythical King Achaemenes. Babylon was but one of the Persians' conquests. Egypt fell to them in 525 B.C., and by 480 B.C. the Persian Empire was the largest the world had yet known, extending from the Indus River in southeastern Asia to the Danube River in northeastern Europe. Only the successful Greek resistance in the fifth century B.C. prevented Persia from embracing southeastern Europe as well (see Chapter 5). The Achaemenid line ended with the death of Darius III in 330 B.C., after his defeat at the hands of Alexander the Great (see FIG. 5-69).

PERSIAN GRANDEUR AT PERSEPOLIS The most important source of knowledge about Persian architecture is the palace at Persepolis (FIG. **2-27**), built between 521 and 465 B.C. by Darius I (r. 522–486 B.C.) and Xerxes (r. 486–465 B.C.), successors of Cyrus. Situated on a high plateau, the heavily fortified palace stood on a wide platform overlooking the plain. Alexander the Great razed the palace in

a gesture symbolizing the destruction of Persian imperial power. Some say it was an act of revenge for the Persian sack of the Athenian acropolis in the early fifth century B.C. But even the ruins of the palace complex are impressive.

The dominant structure was a vast columned hall, sixty feet high and more than two hundred feet square. Standing on its own rock-cut podium, this huge royal audience hall, or *apadana,* contained thirty-six colossal columns. The approach to the apadana led through a monumental gateway flanked by Assyrian-inspired colossal man-headed winged bulls. Broad ceremonial stairways provided access to the royal audience hall. Reliefs still decorate the walls of the terrace and stair-cases. They represent processions of royal guards, Persian nobles and dignitaries, and representatives from twenty-three subject nations bringing the king tribute. Every one of the emissaries wears his national costume and carries a typical regional gift for the conqueror.

Traces of color found on similar monuments at other Persian sites suggest that the Persepolis reliefs were painted, and the original effect must have been even more striking than it is today. Still, the absence of color makes it easier to appreciate the highly refined sculptural style. The cutting of the stone is technically superb, with subtly modeled surfaces and crisply chiseled details. Although the reliefs may have been inspired by those in Assyrian palaces, they are different in style. The forms are more rounded and project more from the background. Some of the details, notably the treatment of drapery folds, echo forms characteristic of Archaic Greek sculpture, and Greek influence seems to be one of the ingredients of Achaemenid style.

The impact of Egyptian and Near Eastern art on Greek art of the previous century was so strong that art historians

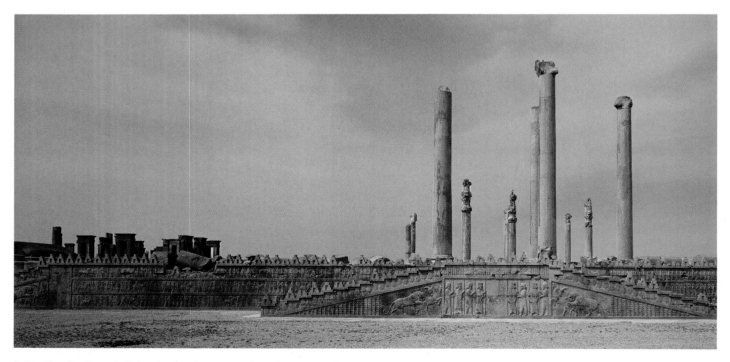

2-27 Royal audience hall *(apadana)* and stairway, palace of Darius I and Xerxes I, Persepolis, Iran, ca. 521–465 B.C.

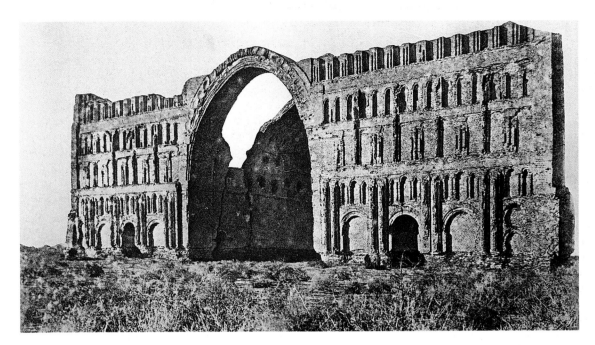

2-28 Palace of Shapur I, Ctesiphon, Iraq, ca. A.D. 250.

commonly apply the term "Orientalizing" to this period of Greek art (see Chapter 5). The detection of Greek elements in late sixth- and early fifth-century B.C. Persian art testifies to the active exchange of ideas and artists among all the Mediterranean and Near Eastern civilizations at this date. A building inscription at Susa, for example, names Ionian Greeks, Medes (who occupied the land north of Persia), Egyptians, and Babylonians among those who built and decorated the palace. Under the single-minded direction of its Persian masters, this heterogeneous workforce, with a widely varied cultural and artistic background, created a new and coherent style that perfectly suited the expression of Persian imperial ambitions.

NEAR EASTERN ART AFTER ALEXANDER

THE NEW PERSIAN EMPIRE With the conquest of Persia by Alexander the Great in 330 B.C., ancient Near Eastern history becomes part of Greek and Roman history. In the third century A.D., however, a new power rose up in Persia to challenge the Romans and sought to force them out of Asia. The new rulers called themselves Sasanians. They traced their lineage to a legendary figure named Sasan, said to be a direct descendant of the Achaemenid kings. Their New Persian Empire was founded in A.D. 224, when the first Sasanian king, Artaxerxes I (r. 211–241), defeated the Parthians (another of Rome's eastern enemies).

A SOARING AUDIENCE HALL The son and successor of Artaxerxes, Shapur I (r. 241–272), succeeded in further extending Sasanian territory. He also erected a great palace at Ctesiphon, the capital his father had established near modern Baghdad in Iraq. Shapur's palace is today in a ruined state, but our photograph (FIG. **2-28**), taken before an 1880 earthquake caused the collapse of the facade's right-hand portion, gives a good idea of its character. The palace's central feature was the monumental *iwan,* or brick audience hall, covered by a *barrel vault* (in effect, a deep arch over an oblong space) that came almost to a point some thirty yards above the ground. The facade to the left and right of the iwan was divided into a series of horizontal bands made up of *blind arcades,* a series of arches without actual openings, applied as wall decoration. A thousand years later, Islamic architects looked at Shapur's palace and especially its soaring iwan and established it as the standard for judging their own engineering feats (see Chapter 13).

SASANIAN SPLENDOR A silver head (FIG. **2-29**), thought by many to portray Shapur II (r. 310–379), suggests the splendor of Sasanian court life. It testifies not only to the wealth of the Sasanian dynasty but also to the superb skills of its court artists. The head is slightly under life-size. The sculptor employed the *repoussé* technique, that is, hammered the shape from a single sheet of metal and pushed the features out from behind. The artist then engraved the details into the silver surface to give form and texture to the hair and beard and to lend the eyes an almost hypnotic stare. Selected portions have mercury gilding to give the metal an even richer look and to add color to the portrait. In this work, an unknown sculptor captured the essence of imperial majesty.

A REVERSAL OF FORTUNES So powerful was the Sasanian army that in A.D. 260 Shapur I even succeeded in capturing the Roman emperor Valerian near Edessa (in

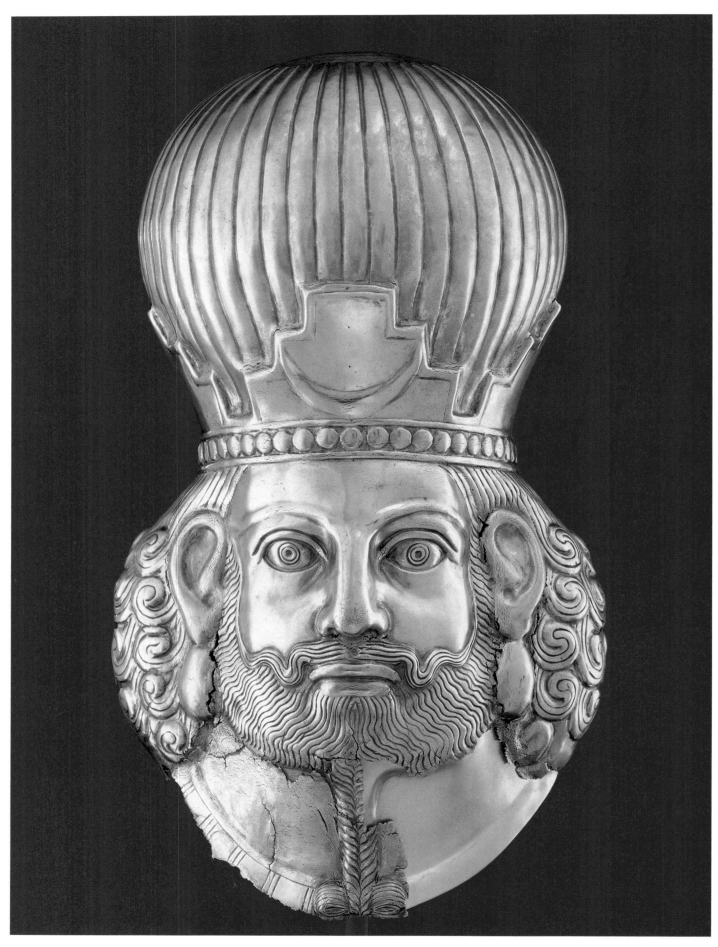

2-29 Head of a Sasanian king (Shapur II?), ca. A.D. 350. Silver with mercury gilding, 1′ 3¾″ high. Metropolitan Museum of Art, New York.

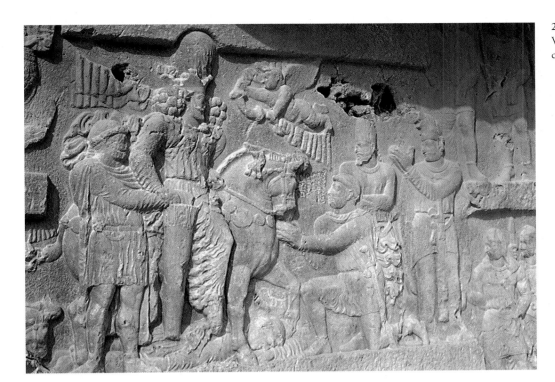

2-30 Triumph of Shapur I over Valerian, rock-cut relief, Bishapur, Iran, ca. A.D. 260.

modern Turkey). His victory over Valerian was so significant an event that Shapur commemorated it in a series of rock-cut reliefs in the cliffs of Bishapur in Iran, far from the site of his triumph. We illustrate a detail of one of the Bishapur reliefs (FIG. **2-30**). Shapur appears larger than life, riding in from the left and wearing the same distinctive tall Sasanian crown the king in the silver portrait wears. The crown breaks through the relief's border and draws the viewer's attention to the king. A Roman soldier's crumpled body lies between the legs of the Sasanian's horse—a time-honored motif (compare the *Standard of Ur,* FIG. 2-8). Here the sculptor probably meant to personify the entire Roman army. At the right, attendants lead in Valerian, who kneels before Shapur and begs for mercy. Above, a *putto*-like

(cherub or childlike) figure borrowed from the repertory of Greco-Roman art hovers above the king and brings him a victory garland. Similar scenes of kneeling enemies before triumphant generals are commonplace in Roman art—but at Bishapur the roles are reversed. This appropriation of Roman compositional patterns and motifs in a relief celebrating the Sasanian defeat of the Romans adds another, ironic, level of meaning to the political message in stone.

The New Persian Empire endured more than four hundred years, until the Arabs drove the Sasanians out of Mesopotamia in 636, just four years after the death of Muhammad, the prophet and founder of Islam. Thereafter, the greatest artists and architects of Mesopotamia worked in the service of Islam. We shall describe their achievements in Chapter 13.

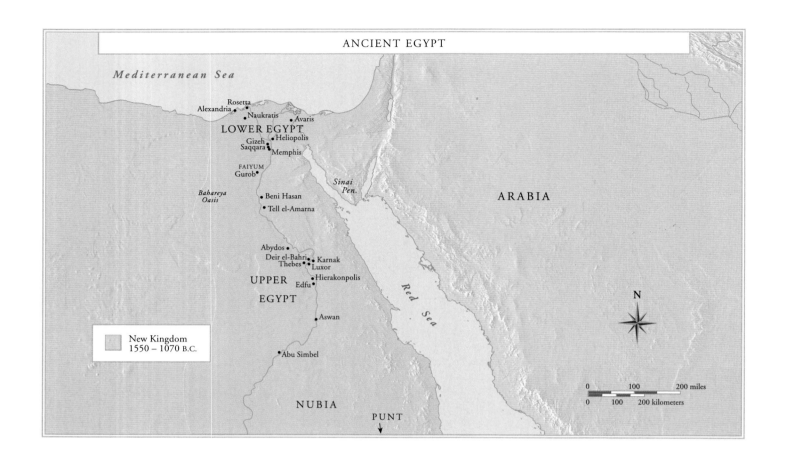

ANCIENT EGYPT

Mediterranean Sea

Rosetta
Alexandria
Naukratis
Avaris

LOWER EGYPT

Gizeh • Heliopolis
Saqqara
Memphis

FAIYUM
Gurob

Bahareya Oasis

Sinai Pen.

Beni Hasan

Tell el-Amarna

ARABIA

Abydos
Deir el-Bahri • Karnak
Thebes • Luxor
• Hierakonpolis

UPPER EGYPT

Edfu

Red Sea

Aswan

N

Abu Simbel

New Kingdom
1550 – 1070 B.C.

0 100 200 miles
0 100 200 kilometers

NUBIA

PUNT
↓

2920 B.C.	2575 B.C.	2134 B.C.	2040 B.C.	1640 B.C.
PREDYNASTIC	EARLY DYNASTIC (DYNASTIES I–III)	OLD KINGDOM (DYNASTIES IV–VIII)		MIDDLE KINGDOM (DYNASTIES XI–XIV)

Palette of King Narmer
ca. 3000–2920 B.C.

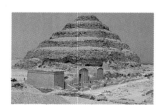

Stepped Pyramid of Djoser
Saqqara
ca. 2630–2611 B.C.

Great Sphinx and Pyramid
of Khafre, Gizeh
ca. 2520–2494 B.C.

Menkaure and
Khamerernebty
ca. 2490–2472 B.C.

Tomb of Amenemhet
Beni Hasan
ca. 1950–1900 B.C.

Union of Upper and Lower
Egypt, ca. 3000–2920 B.C.

Imhotep, first recorded name
of an artist, ca. 2625 B.C.

Sneferu, first pharaoh of the Old
Kingdom, r. 2575–2551 B.C.

Khufu, Khafre, and Menkaure,
builders of the Great Pyramids,
ca. 2551–2472 B.C.

First Intermediate Period,
2134–2040 B.C.

Second
Intermediate
Period,
1640–1550 B.C.

Reunification of Egypt
under Mentuhotep I, 2040 B.C.

3

PHARAOHS AND THE AFTERLIFE

THE ART OF ANCIENT EGYPT

1550 B.C.		1070 B.C.	712 B.C.	332 B.C.	30 B.C.
NEW KINGDOM (DYNASTIES XVIII–XX)			LATE PERIOD (DYNASTIES XXV–XXXI)	GREEK (PTOLEMAIC)	ROMAN

Hatshepsut with
offering jars
ca. 1473–1458 B.C.

Death mask of
Tutankhamen
ca. 1323 B.C.

Temple of Ramses II
Abu Simbel
ca. 1290–1224 B.C.

Mentuemhet
ca. 650 B.C.

Temple of Horus
Edfu
ca. 237–47 B.C.

Ahmose I defeats the Hyksos, 1550 B.C.

Hatshepsut, r. 1473–1458 B.C.

Akhenaton and the Amarna period, 1353–1335 B.C.

Tutankhamen, r. 1333–1323 B.C.

Ramses II, r. 1290–1224 B.C.

Third Intermediate Period, 1070–712 B.C.

Persia conquers Egypt, 525 B.C.

Alexander the Great conquers Persia
and Egypt, 332 B.C.

Ptolemy I, r. 304–284 B.C.

Egypt
becomes
a Roman
province,
30 B.C.

THE LAND OF THE NILE

THE WONDERS OF EGYPT Nearly twenty-five hundred years ago, the Greek historian Herodotus wrote, "Concerning Egypt itself I shall extend my remarks to a great length, because there is no country that possesses so many wonders, nor any that has such a number of works that defy description."[1] Even today, many would agree with this assessment. The ancient Egyptians left to the world a profusion of imposing monuments dating across three millennia. From the cliffs of the Libyan and Arabian Deserts they cut giant blocks of stone, the imperishable material that symbolized the timelessness of their world. The Egyptians then erected grand stone temples to their immortal gods (see "The Gods and Goddesses of Egypt," page 45), set up countless statues of their equally immortal god-kings, and built thousands of tombs to serve as eternal houses of the dead (see "Mummification and the Afterlife," page 46). The solemn and ageless art of the Egyptians expresses the unchanging order that, for them, was divinely established.

The backbone of Egypt was, and still is, the Nile River, which supported all life in that ancient land. Even more than the Tigris and the Euphrates Rivers of Mesopotamia, the Nile, by virtue of its presence, defined the cultures that developed along its banks. Originating deep in Africa, the world's longest river descends through many waterfalls over cliffs to sea level in Egypt, where, in annual flood, it deposits rich soil brought thousands of miles from the African hills. Hemmed in by the narrow valley, which reaches a width of only about twelve miles in its widest parts, the Nile flows through regions that may not have a single drop of rainfall in a decade. Yet crops thrive from the fertilizing silt. In ancient times game also was abundant. The great river that made life possible entered the Egyptians' consciousness as a symbol of life and of the endless cycles of natural processes.

In the time of the *pharaohs,* the ancient Egyptian kings, the land of the Nile consisted of marshes dotted with island ridges. What is now arid desert valley was grassy parkland well suited for hunting and for grazing cattle. Amphibious animals swarmed in the marshes and were hunted through tall forests of papyrus and rushes (FIGS. 3-16 and 3-30). Egypt's fertility was famous. When Egypt became a province of the Roman Empire after Queen Cleopatra's death (r. 51–30 B.C.), it was the granary of the Mediterranean world.

THE BIRTH OF EGYPTOLOGY In the Middle Ages, Egypt's reputation as an ancient land of wonders and mystery lived on. Until the late eighteenth century, people regarded its undeciphered writing and exotic monuments as treasures of occult wisdom, locked away from any but those initiated in the mystic arts. Scholars knew something of Egypt's history from references in the Old Testament, from Herodotus and other Greco-Roman authors, and from preserved portions of a history of Egypt an Egyptian high priest named Manetho wrote in Greek in the third century B.C. Manetho described the succession of pharaohs, dividing them into the still-useful groups called *dynasties,* but his chronology is inaccurate, and the absolute dates of the pharaohs are still debated. The chronologies scholars have proposed for the earliest Egyptian dynasties can vary by as much as two centuries. Exact years cannot be assigned to the reigns of individual pharaohs until 664 B.C. (Dynasty XXVI).[2]

At the end of the eighteenth century, when Europeans rediscovered Egypt, the land of the Nile became the first subject of archeological exploration. In 1799, Napoleon Bonaparte, on a military expedition to Egypt, took with him a small troop of scholars, linguists, antiquarians, and artists. The chance discovery of the famed *Rosetta Stone,* now in the British Museum, gave the eager scholars a key to deciphering Egyptian *hieroglyphic* writing. The stone bears an inscription in three sections: one in Greek, which was easily read; one in *demotic* (Late Egyptian); and one in formal hieroglyphic. Scholars at once suspected that the text was the same in all three sections and that, using Greek as the key, they could decipher the other two sections. More than two decades later, after many false starts, a young linguist, Jean-François Champollion, deduced that the hieroglyphs were not simply pictographs. He proposed that they were the signs of a once-spoken language whose traces survived in Coptic, the later language of Christian Egypt. Champollion's feat established him as a giant in the new field of *Egyptology.*

THE PREDYNASTIC AND EARLY DYNASTIC PERIODS

Painting and Sculpture

THE OLDEST EGYPTIAN ART The Predynastic, or prehistoric, beginnings of Egyptian civilization are chronologically vague. But tantalizing remains from around 3500 B.C. attest to the existence of a sophisticated civilization on the banks of the Nile. A wall painting from the late Predynastic period (FIG. 3-1), found in a tomb at Hierakonpolis, represents what seems to be, at least in part, a funerary scene with people, animals, and large boats. The stick figures and their apparently random arrangement recall the Neolithic painted hunters of Çatal Hüyük (see FIG. 1-17). The boats, symbolic of the journey down the river of life and death, are painted white. They carry cargo of uncertain significance. Also depicted are a heraldic grouping of two animals flanking a human figure (at the lower center) and a man striking three prisoners with a mace (lower left). The heraldic group, a compositional type usually associated with Mesopotamian art (see FIG. 2-10), suggests that influences from Mesopotamia not only had reached Egypt by this time but also already had made the thousand-mile journey up the Nile. The second group, however, is characteristically Egyptian, and the motif was to have a long history in Egyptian painting and sculpture alike.

THE UNIFICATION OF THE TWO EGYPTS In Predynastic times, Egypt was divided geographically and politically into Upper Egypt (the southern, upstream part of the Nile Valley), which was dry, rocky, and culturally rustic, and Lower (northern) Egypt, which was opulent, urban, and populous. The ancient Egyptians began the history of their kingdom with the unification of the two lands. Until recently, this was thought to have occurred during the rule of the First Dynasty pharaoh Menes, identified by many scholars with King Narmer. Narmer's image and name appear on both sides of a ceremonial *palette* (stone slab with a circular depression) found at Hierakonpolis. The palette is one of

The Gods and Goddesses of Egypt

The Egyptian worldview was distinct from that of their neighbors in the ancient Mediterranean and Near Eastern worlds. Egyptians believed that before the beginning of time the primeval waters, called *Nun,* existed alone in the darkness. At the moment of creation, a mound rose out of the limitless waters—just as muddy mounds emerge from the Nile after the annual flood recedes. On this mound the creator god appeared and brought light to the world. In later times, the mound was formalized as a pyramidal stone called the *benben* supporting the supreme god, the sun god, variously worshiped under the name of *Re, Amen,* or *Aton.*

The supreme god also created the first of the other gods and goddesses of Egypt. According to one version of the myth, the creator masturbated and produced *Shu* and *Tefnut,* the primary male and female forces in the universe. They coupled to give birth to *Geb* (Earth) and *Nut* (Sky), who bore Osiris, Seth, Isis, and Nephthys. The eldest, *Osiris* (FIG. 3-39), was the god of order and was revered as the king who brought civilization to Egypt. His brother *Seth* was his evil opposite, the god of chaos. Seth murdered Osiris and cut him into pieces, which he scattered across Egypt. *Isis* (FIG. 3-39), the sister and consort of Osiris, succeeded in collecting Osiris's body parts and with her powerful magic brought him back to life. *Nephthys* (FIG. 3-39), Seth's wife, helped her. With Isis, the resurrected Osiris fathered a son, *Horus,* who avenged his father's death and displaced Seth as king of Egypt. Osiris then became the lord of the underworld. Horus is represented in art either as a falcon, considered the noblest bird of the sky, or as a falcon-headed man (FIGS. 3-2, 3-12, 3-28, and 3-39). All Egyptian pharaohs were identified with Horus while alive and with Osiris after they died.

Other Egyptian deities included *Mut,* the consort of the sun god Amen, and *Khonsu,* the moon god, who was their son. *Thoth,* another lunar deity and the god of knowledge and writing, appears in art as an ibis, a baboon, or an ibis-headed man crowned with the crescent moon and the moon disk (FIG. 3-39). When Seth tore out Horus's falcon-eye *(wedjat),* Thoth restored it. He, too, was associated with rebirth and the afterlife. *Hathor,* the daughter of Re, was a divine mother of the pharaoh, nourishing him with her milk. She appears in Egyptian art as a cow-headed woman or as a woman with a cow's horns (FIGS. 3-2 and 3-28). *Anubis,* a jackal or jackal-headed deity, was the god of mummification and the weigher of hearts in the underworld (FIG. 3-39). *Maat,* daughter of Re, was the goddess of truth and justice. Her feather was used to measure the weight of the deceased's heart to determine if the *ka* (life force) would be blessed in the afterlife.

3-1 People, boats, and animals, detail of a watercolor copy of a wall painting from Tomb 100 at Hierakonpolis, Egypt, Predynastic, ca. 3500–3200 B.C. Egyptian Museum, Cairo.

Mummification and the Afterlife

The Egyptians did not make the sharp distinction between body and soul that is basic to many religions. Rather, they believed that, from birth, a person was accompanied by a kind of other self, the *ka* or life force, which, on the death of the fleshly body, could inhabit the corpse and live on. For the ka to live securely, however, the dead body had to remain as nearly intact as possible. To insure that it did, the Egyptians developed the technique of embalming *(mummification)* to a high art. Their success is evident in numerous well-preserved mummies of kings, princes, and others of noble birth, as well as those of some common persons. The practice endured for thousands of years. In 1996, for example, archeologists discovered an unplundered Roman-period cemetery at Bahareya Oasis containing hundreds of mummies. Systematic excavation began in 1999 and will probably continue for a decade, so rich was the find.

The embalming process was said to have been invented by the god Anubis to preserve the body of the murdered Osiris (see "The Gods and Goddesses of Egypt," page 45). Embalming was first practiced systematically during the Fourth Dynasty, and the process generally lasted seventy days. The first step was the surgical removal of the lungs, liver, stomach, and intestines through an incision in the left flank. The Egyptians believed these organs were most subject to decay. The organs were individually wrapped and placed in four containers known as *Canopic jars* for eventual deposit in the burial chamber with the corpse. (The jars take their name from the mythical Canopus, a Greek sailor who died and was subsequently worshiped in Egypt in the form of a jar.) The brain was extracted through the nostrils and discarded. The Egyptians did not attach any special significance to the brain. But they left in place the heart, necessary for life and regarded as the seat of intelligence.

Next, the body was treated for forty days with natron, a naturally occurring salt compound that dehydrated the body.

Then the corpse was filled with resin-soaked linens, and the embalming incision was closed and covered with a representation of the wedjat eye of Horus, a powerful *amulet* (a device to ward off evil and promote rebirth). Finally, the body was treated with lotions and resins and then wrapped tightly with hundreds of yards of linen bandages to maintain its shape. The Egyptians often placed other amulets within the bandages or on the corpse. The most important were heart *scarabs* (gems in the shape of beetles). Spells written on them assured that the heart would be returned to its owner if it was ever lost. A scroll copy of the *Book of the Dead* (FIG. 3-39) frequently was placed between the legs of the deceased. It contained some two hundred spells intended to protect the mummy and the ka in the afterlife. The mummies of the wealthy had their faces covered with funerary masks (FIG. 3-37). When Egypt became part of the Roman Empire, painted portraits were often substituted (see FIG. 10-63).

Preserving the deceased's body by mummification was only the first requirement for immortality. Food and drink also had to be provided, as did clothing, utensils, and furniture. Nothing that had been enjoyed on earth was to be lacking. Statuettes called *ushabtis* (answerers) also were placed in the tomb. These figurines performed any labor required of the deceased in the afterlife, answering whenever his or her name was called.

Images of the deceased, sculpted in the round and placed in shallow recesses, also were set up in the tomb. They were meant to guarantee the permanence of the person's identity by providing substitute dwelling places for the ka in case the mummy disintegrated. Wall paintings and reliefs recorded, with great animation and detail, the recurring round of human activities. The Egyptians hoped and expected that the images and inventory of life, collected and set up within the tomb's protective stone walls, would insure immortality.

the earliest *historical* (versus prehistorical) artworks preserved (FIG. **3-2**). Although it is no longer regarded as commemorating the foundation of the first of Egypt's thirty-one dynasties around 2920 B.C. (the last ended in 332 B.C.), it does record the unification of Upper and Lower Egypt into the "Kingdom of the Two Lands" at the very end of the Predynastic period.

The *Palette of King Narmer* is an elaborate, formalized version of a utilitarian object commonly used in the Predynastic period. Egyptians prepared eye makeup on such tablets for protecting their eyes against irritation and the sun's glare. The *Palette* is important not only as a document marking the transition from the prehistorical to the historical period in ancient Egypt but also as a kind of early blueprint of the formula for

figure representation that characterized Egyptian art for three thousand years.

On the back of the palette, the king, wearing the high, white, bowling-pin-shaped crown of Upper Egypt and accompanied by an official who carries his sandals, is shown slaying an enemy. The motif closely resembles the group at the lower left of the Hierakonpolis mural (FIG. 3-1) and became the standard pictorial formula signifying the inevitable triumph of the Egyptian god-kings. A falcon with human arms at the top right of Narmer's palette is the symbol of Horus, the king's protector. It faces Narmer and takes captive a man-headed hieroglyph with a papyrus plant growing from it that stands for the land of Lower Egypt. Below the king are two fallen enemies. Two heads of Hathor, a goddess favorably disposed to

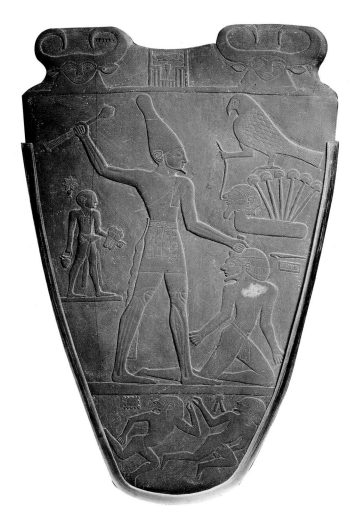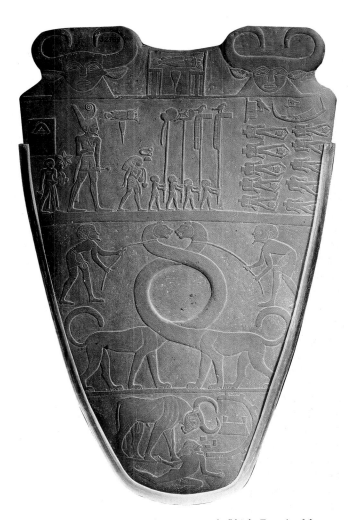

3-2 *Palette of King Narmer* (*left*, back; *right*, front), from Hierakonpolis, Egypt, Predynastic, ca. 3000–2920 B.C. Slate, approx. 2′ 1″ high. Egyptian Museum, Cairo.

Narmer and shown as a cow with a woman's face, are at the top of the palette. Between the Hathor heads is the hieroglyph giving Narmer's name within a frame representing the royal palace, making Narmer's palette the earliest existing labeled work of historical art.

THE PORTRAYAL OF DIVINE KINGS On the front of the palette, the elongated necks of two felines form the circular depression that would have held eye makeup in an ordinary palette not made for display. The intertwined necks of the animals may be another pictorial reference to Egypt's unification. In the uppermost register, Narmer, wearing the red cobra crown of Lower Egypt, reviews the beheaded bodies of the enemy. The dead are seen from above, like the bison lying on the ground on the Altamira cave's ceiling (see FIG. 1-9). The artist depicted each body with its severed head neatly placed between its legs. By virtue of his superior rank, the king, on both sides of the palette, performs his ritual task alone and towers over his own men and the enemy. The king's superhuman strength is symbolized in the lowest band by a great bull knocking down a rebellious city whose fortress walls also are seen in an "aerial view." Specific historical narrative is not the artist's goal in this work. What is im-

portant is the characterization of the king as a deified figure, isolated from and larger than all ordinary men and solely responsible for the triumph over the enemy. Here, at the very beginning of Egyptian history, is evidence of the Egyptian convention of thought, of art, and of state policy that established kings as divine and proclaimed that their prestige was one with the prestige of the gods.

The figure of Narmer on both sides reveals the stereotype of kingly transcendence that, with several slight variations, was repeated, with few exceptions, in subsequent representations of all Egyptian rulers. The artist's portrayal of the king combined profile views of his head, legs, and arms with front views of his eye and torso. As noted in Chapters 1 and 2, this composite view of the human figure also characterized Mesopotamian art and even some Stone Age paintings. Although the human figure's proportions changed, the method of its representation became a standard for all later Egyptian art. The *Palette of King Narmer* established the basic laws that governed art along the Nile for thousands of years. In the Hierakonpolis painting (FIG. 3-1), the artist scattered the figures across the wall more or less haphazardly. On Narmer's palette, the sculptor subdivided the surface into bands and inserted the pictorial elements into their organized setting in a neat

and orderly way. The horizontal lines separating the registers also define the ground supporting the figures, a mode of representation that persisted in hundreds of acres of Egyptian wall paintings and reliefs. This was also the preferred mode for narrative art in the ancient Near East (see Chapter 2).

Architecture

ART AND THE AFTERLIFE Narmer's palette is exceptional among surviving Egyptian artworks because it is commemorative rather than funerary in nature. Far more typical is the Predynastic mural from Hierakonpolis (FIG. 3-1), the earliest known representative of a long tradition of building and decorating the tombs of pharaohs and other important members of Egyptian society. In fact, Egyptian tombs provide the principal, if not the exclusive, evidence for the historical reconstruction of Egyptian civilization. Herodotus described the Egyptians as "religious to excess," and their concern for immortality amounted to near obsession. The overall preoccupation in this life was to insure safety and happiness in the next life. The majority of monuments the Egyptians left behind were dedicated to this preoccupation (see "Mummification and the Afterlife," page 46).

The standard tomb type in early Egypt was the *mastaba* (FIG. **3-3**). The mastaba (Arabic for "bench") was a rectangular brick or stone structure with sloping sides erected over an underground tomb chamber. A shaft connected the burial chamber with the outside, providing the ka with access to the tomb. The form probably was developed from earth or stone mounds that had covered even earlier tombs.

Although mastabas originally housed single burials, as in our example (FIG. 3-3), during the latter part of the Old Kingdom they were used for multiple family burials and became increasingly complex. The central underground chamber was surrounded by storage rooms and compartments whose number and size increased with time until the area covered far surpassed that of the tomb chamber. Built into the superstructure, or sometimes attached to the outside of its eastern face, was the funerary chapel, which contained a statue of the deceased in a small concealed chamber called the *serdab*. The chapel's interior walls and the ancillary rooms were decorated with colored relief carvings and paintings of scenes from daily life intended to magically provide the deceased with food and entertainment.

THE FIRST PYRAMID One of the most renowned figures in Egyptian history is IMHOTEP, the royal builder for King Djoser (r. 2630–2611 B.C.) of the Third Dynasty. Imhotep was a man of legendary powers who served as the pharaoh's chancellor and high priest of the sun god Re, as well as architect. He is the first known artist of recorded history. After his death, Imhotep was revered as a god. Imhotep designed the Stepped Pyramid (FIG. **3-4**) of Djoser at Saqqara, the ancient *necropolis* (Greek for "city of the dead") for Memphis, the capital city Menes founded. Built before 2600 B.C., the pyramid is one of the oldest stone structures in Egypt and the first monumental royal tomb.

Begun as a large mastaba with each of its faces oriented toward one of the cardinal points of the compass, Djoser's tomb was enlarged at least twice before taking on its final shape.

1. Chapel
2. False door
3. Shaft into burial chamber
4. Serdab (chamber for statue of deceased)
5. Burial chamber

3-3 Section *(top)*, plan *(middle)*, and restored view *(bottom)* of typical Egyptian mastaba tombs.

About two hundred feet high, the Stepped Pyramid seems to be composed of a series of mastabas of diminishing size, stacked one on top of another to form a structure that resembles the great ziggurats of Mesopotamia (see FIG. 2-14). Unlike the ziggurats, however, the pyramid Imhotep designed for Djoser is a tomb, not a temple platform, and its dual function was to protect the mummified king and his possessions and to symbolize, by its gigantic presence, his absolute and godlike power. Beneath the pyramid is a network of underground galleries resembling a palace. It was to be Djoser's new home in the afterlife.

Befitting the god-king's majesty, Djoser's pyramid stands near the center of an immense (thirty-seven-acre) rectangular enclosure surrounded by a monumental (thirty-four-foot-high and five thousand four hundred-foot-long) wall of white limestone (FIG. **3-5**). The huge precinct with its protective walls and tightly regulated access stands in sharp contrast to the roughly contemporary Sumerian Royal Cemetery at Ur, where no barriers kept people away from the burial area. Nor did the Mesopotamian cemetery have a temple for the worship of the deified dead. At Saqqara, a funerary temple stands against the northern face of Djoser's pyramid (no. 2 on the plan). Priests performed daily rituals at the temple in celebration of the divine pharaoh.

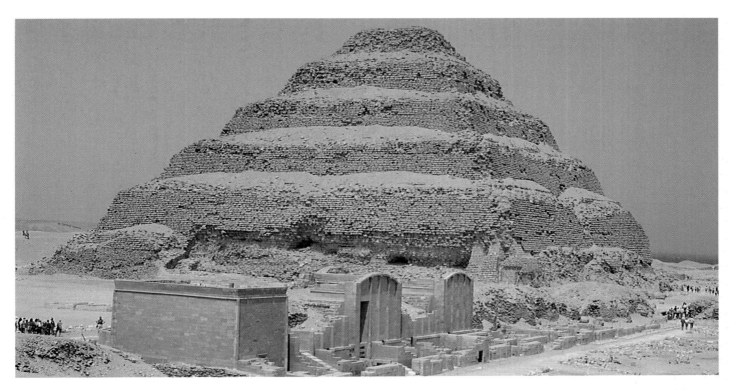

3-4 IMHOTEP, Stepped Pyramid and mortuary precinct of Djoser, Saqqara, Egypt, Dynasty III, ca. 2630–2611 B.C.

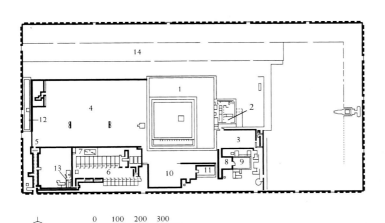

1. Stepped pyramid derived from square-plan mastaba
2. Funerary temple of Djoser
3. Court with serdab
4. Large court with altar and two B-shaped stones
5. Entrance portico
6. Heb-Sed court flanked by sham chapels
7. Small temple
8. Court before North Palace
9. North Palace
10. Court before South Palace
11. South Palace
12. South tomb
13. Royal Pavilion
14. Magazines

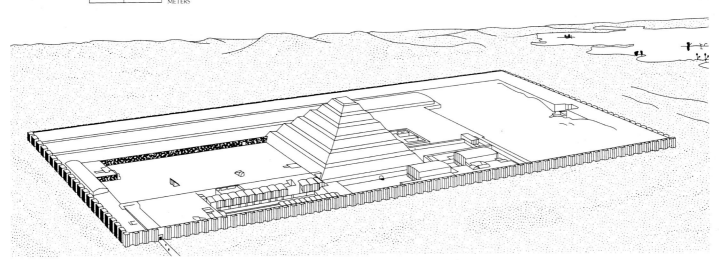

3-5 IMHOTEP, restored plan *(top)* and view *(bottom)* of the mortuary precinct of Djoser, Saqqara, Egypt, Dynasty III, ca. 2630–2611 B.C.

3-6 IMHOTEP, columnar entrance corridor to the mortuary precinct of Djoser, Saqqara, Egypt, Dynasty III, ca. 2630–2611 B.C.

3-7 IMHOTEP, facade of the North Palace of the mortuary precinct of Djoser, Saqqara, Egypt, Dynasty III, ca. 2630–2611 B.C.

Djoser's funerary temple was but one of many buildings arranged around several courts. Most of the others were dummy structures with stone walls enclosing fills of rubble, sand, or gravel (no. 6 on the plan). The buildings imitated in stone masonry various types of temporary structures made of plant stems and mats erected in Upper and Lower Egypt to celebrate the Jubilee Festival. This event perpetually reaffirmed the royal existence in the hereafter.

The translation into stone of structural forms previously made out of plants may be seen in the long entrance corridor to Djoser's funerary precinct (FIG. **3-6**). There, columns that resemble bundles of reeds project from short spur walls on either side of the once-roofed and dark passageway. A person walking through it would have emerged suddenly into a large courtyard and the brilliant light of the Egyptian sun. To the right, the visitor would have seen the gleaming focus of the entire complex, Djoser's pyramid.

The columns flanking the pathway into Djoser's precinct resemble later Greek columns. Architectural historians have little doubt today that the buildings of ancient Egypt had a profound impact on the designers of the first Greek stone columnar temples (see Chapter 5). The upper parts of the Saqqara entrance portico columns are not preserved, but

those of Djoser's North Palace (FIG. **3-7**; no. 9 in FIG. 3-5) still stand. They end in *capitals* ("heads") that take the form of the papyrus blossoms of Lower Egypt. The column shafts resemble papyrus stalks. The later Greek columns also terminate in capitals, although the Greek capitals take a very different form. Greek column shafts are also generally freestanding, but all the columns in the Saqqara complex are *engaged* (attached) to walls. The Egyptian builders seemed not to have realized the full structural potential of stone columns. Still, this is the first appearance of stone columns in the history of architecture. Imhotep's greatest achievement as an architect was to translate the impermanent building types of prehistoric Egypt into lasting stone.

THE OLD KINGDOM

The Old Kingdom is the first of the three great periods of Egyptian history, called the Old, Middle, and New Kingdoms, respectively. Many Egyptologists now begin the Old Kingdom with the first pharaoh of the Fourth Dynasty, Sneferu (r. 2575–2551 B.C.), although the traditional division

of Kingdoms places Djoser and the Third Dynasty in the Old Kingdom. It ended with the demise of the Eighth Dynasty around 2134 B.C. During the Old Kingdom, Egyptian sculptors, painters, and architects codified the modes of representation and methods of construction that would become the rule in the land of the Nile for more than two thousand years.

Architecture

THE GREAT PYRAMIDS AND THE SUN GOD RE

The Egyptians always buried their dead on the west side of the Nile, where the sun sets. At Gizeh, near modern Cairo but on the west side of the river, stand the three pyramids (FIG. **3-8**) of the Fourth Dynasty pharaohs Khufu (r. 2551–2528 B.C.), Khafre (r. 2520–2494 B.C.), and Menkaure (r. 2490–2472 B.C.). Built in the course of about seventy-five years, the Great Pyramids of Gizeh are the oldest of the Seven Wonders of the ancient world (see "Babylon: City of Wonders," Chapter 2, page 37).

The Gizeh pyramids represent the culmination of an architectural evolution that began with the mastaba. The pyramid form did not evolve out of necessity. Kings could have gone on indefinitely stacking mastabas to make their weighty tombs. Rather, scholars have suggested that the kings of the Third Dynasty came under the influence of Heliopolis, a city not far from their royal residence at Memphis. Heliopolis was the seat of the powerful cult of Re, the sun god, whose emblem was a pyramidal stone, the *ben-ben* (see "The Gods and Goddesses of Egypt," page 45). By the Fourth Dynasty, the pharaohs considered themselves the sons of Re and his incarnation on earth. For the pharaohs, it would have been only a small step from their belief that the spirit and power of Re resided in the pyramidal *ben-ben* to the belief that their divine spirits and bodies would be similarly preserved within pyramidal tombs.

Is the pyramid form, then, an invention inspired by a religious demand, rather than the result of a formal evolution? Although interesting, this question is beyond the scope of this book. Of more concern are the remarkable features of the Great Pyramids. Of the three Fourth Dynasty pyramids at

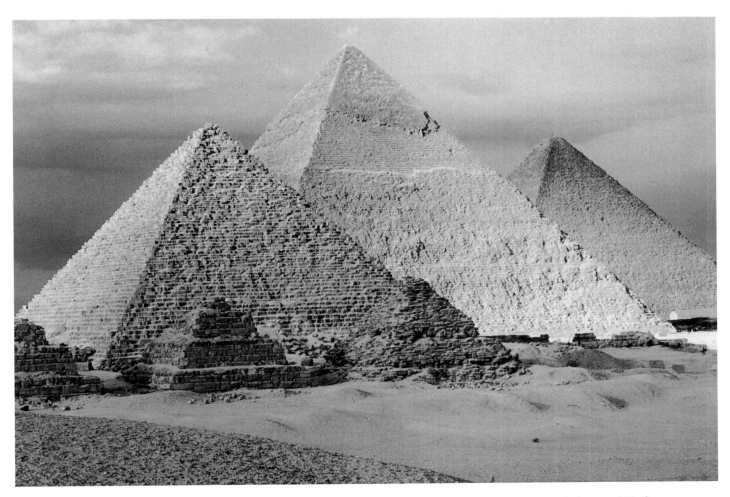

3-8 Great Pyramids, Gizeh, Egypt, Dynasty IV. *From left:* Pyramids of Menkaure, ca. 2490–2472 B.C.; Khafre, ca. 2520–2494 B.C.; and Khufu, ca. 2551–2528 B.C.

ARCHITECTURAL BASICS

Building the Great Pyramids

The three Great Pyramids of Khufu, Khafre, and Menkaure at Gizeh (FIG. 3-8) are the oldest of the Seven Wonders of the ancient world (see "Babylon: City of Wonders," Chapter 2, page 37). The prerequisites for membership in this elite club were colossal size and enormous cost, and the Gizeh pyramids testify to the wealth and pretensions of the Fourth Dynasty pharaohs. But they also attest to Egyptian builders' mastery of stone masonry and to their ability to mobilize, direct, house, and feed a huge workforce engaged in one of the most labor-intensive enterprises ever undertaken.

Like all building projects of this type, the process of erecting the pyramids began with the quarrying of stone, in this case the limestone of the eastern Nile cliffs. Teams of skilled workers had to cut into the cliff faces and remove large blocks of roughly equal size using stone or copper chisels and wooden mallets and wedges. Often, the artisans had to cut deep tunnels into the mountainsides to find high-quality stone free of cracks and other flaws. To remove a block, the workers cut channels on all sides and partly underneath. Then they pried the stones free from the bedrock with wooden levers.

After workers liberated the stones from the cliffs, the rough blocks had to be transported to the building site and *dressed* (shaped to the exact dimensions required, with smooth faces for a perfect fit). Small blocks could be carried on a man's shoulders or on the back of a donkey, but the massive blocks used to construct the Great Pyramids were moved using wooden rollers and sleds. They then were loaded onto boats and floated across the Nile during the seasonal floods. Once

across, the blocks had to be dragged further overland to the tomb site. The artisans dressed the blocks by chiseling and pounding the surfaces and, in the last stage, by rubbing and grinding the surfaces with fine polishing stones. This kind of construction, where carefully cut and regularly shaped blocks of stone are piled in successive rows, or *courses,* is called *ashlar masonry.*

To set the ashlar blocks in place, workers erected great rubble ramps against the core of the pyramid. Their size and slope were adjusted as work progressed and the tomb grew in height. Scholars still debate whether the Egyptians used simple linear ramps inclined at a right angle to one face of the pyramid or zigzag or spiral ramps akin to staircases. Linear ramps would have had the advantage of simplicity and would have left three sides of the pyramid unobstructed. But zigzag ramps placed against one side of the structure or spiral ramps winding around the pyramid would have greatly reduced the slope of the incline and would have made the dragging of the blocks easier. Some scholars have also suggested a combination of straight and spiral ramps. Ropes, pulleys, and levers were used both to lift and to lower the stones, guiding each block into its designated place. Finally, the pyramid was surfaced with a casing of pearly white limestone, cut so precisely that the eye could scarcely detect the joints. A few casing stones still can be seen in the cap that covers the Pyramid of Khafre (FIGS. 3-8, center, and 3-11). They are all that remain after many centuries of people stripping the pyramids to supply limestone for the Islamic builders of Cairo.

Gizeh, that of the pharoah Khufu (FIG. **3-9**) is the oldest and largest. Except for the galleries and burial chamber, it is an almost solid mass of limestone masonry (see "Building the Great Pyramids," above)—a stone mountain built on the same principle as the Stepped Pyramid of King Djoser (FIG. 3-4). In our section drawing of Khufu's tomb, the dotted lines at the base of the structure (no. 2 in FIG. 3-9) indicate the path ancient grave robbers cut into the pyramid. Unable to locate the carefully sealed and hidden entrance, they started some forty feet above the base and tunneled into the structure until they intercepted the ascending corridor. Many royal tombs were plundered almost as soon as the funeral ceremonies had ended. The very conspicuousness of a pyramid was an invitation to looting. The successors of the Old Kingdom pyramid builders had learned this hard lesson. They built few pyramids, and those were relatively small and inconspicuous.

The immensity of the Gizeh pyramids and that of Khufu in particular is indicated by some dimensions. At the base, the length of one side of Khufu's tomb is approximately 775 feet, and its area is some thirteen acres. Its present height is about

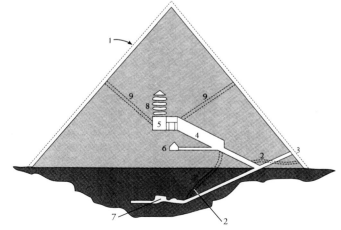

1. Silhouette with original facing stone
2. Thieves' tunnels
3. Entrance
4. Grand gallery
5. King's chamber
6. So-called queen's chamber
7. False tomb chamber
8. Relieving blocks
9. Airshafts(?)

3-9 Section of the Pyramid of Khufu, Gizeh, Egypt.

four hundred and fifty feet (originally four hundred and eighty feet). The structure contains roughly 2.3 million blocks of stone, each weighing an average of two and one-half tons. Napoleon's scholars calculated that the blocks in the three Great Pyramids were sufficient to build a wall one foot wide and ten feet high around France.

The art of the pyramids is inherent not only in their huge size and successful engineering but also in their formal design. Their proportions and immense dignity are consistent with their funerary and religious functions and well adapted to their geographic setting. As with Djoser's Stepped Pyramid, the four sides of each of the Great Pyramids are oriented to the cardinal points of the compass. The simple mass of these monuments dominates the flat landscape to the horizon. But the funerary temples associated with the three Gizeh pyramids are not placed on the north side, facing the stars of the northern sky, as was Djoser's temple. The temples sit on the east side, facing the rising sun and underscoring their connection with Re.

KHAFRE'S TEMPLE AND GUARDIAN SPHINX

From the remains surrounding the Pyramid of Khafre at Gizeh, archeologists have been able to reconstruct an entire funerary complex (FIG. **3-10**). The complex included the pyramid itself with the pharaoh's burial chamber; the *mortuary temple* (temple for the worship of the dead), adjoining the pyramid on the east side, where offerings were made, cere-

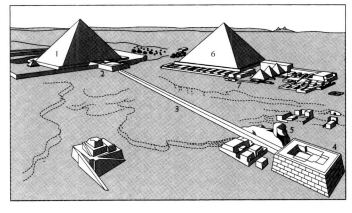

1. Pyramid of Khafre
2. Mortuary temple
3. Covered causeway
4. Valley temple
5. Great Sphinx
6. Pyramid of Khufu
7. Pyramids of the royal family and mastabas of nobles

3-10 Reconstruction drawing of the Dynasty IV Pyramids of Khafre, ca. 2520–2494 B.C., and Khufu, ca. 2551–2528 B.C., Gizeh, Egypt.

monies performed, and cloth, food, and ceremonial vessels stored; the covered *causeway* (raised path) leading down to the valley; and the *valley temple* (vestibule), of the causeway.

Beside the causeway and dominating the temple of Khafre rises the Great Sphinx (FIG. **3-11**). Carved from a spur of

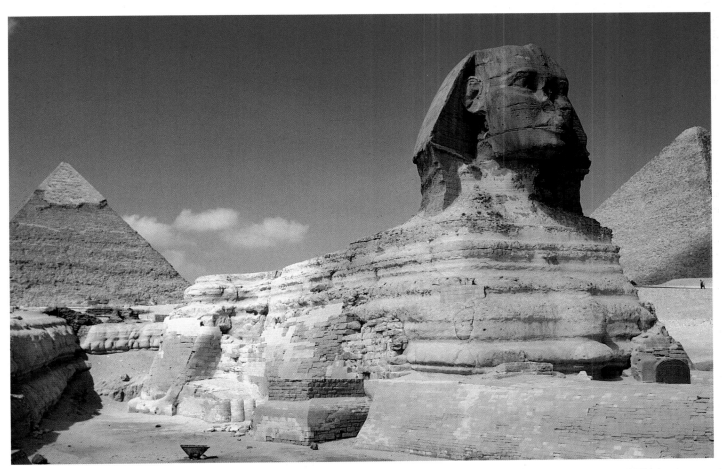

3-11 Great Sphinx (with Pyramid of Khafre in the background at left), Gizeh, Egypt, Dynasty IV, ca. 2520–2494 B.C. Sandstone, approx. 65′ high, 240′ long.

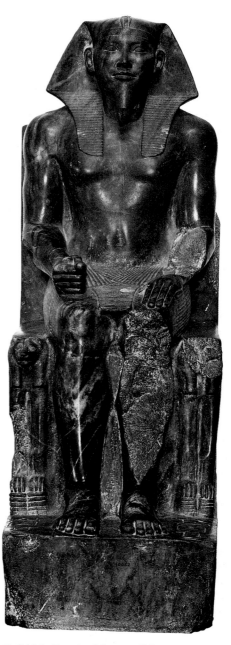

3-12 Khafre (right side and front), from Gizeh, Egypt, Dynasty IV, ca. 2520–2494 B.C. Diorite, approx. 5′ 6″ high. Egyptian Museum, Cairo.

rock, it commemorated the pharaoh and served as an immovable, eternal silent guardian of his tomb. Its role was like that of the later Near Eastern lions and lamassu (see FIGS. 2-18 and 2-21) that stood watch at the entrances to the palaces of their kings. At Gizeh, the rock was cut so that the immense figure of the Sphinx (a *sphinx* is a lion with a human head), adjacent to the valley temple's west front, gives visitors coming from the east the illusion that it rests on a great pedestal. The colossal statue is probably an image of Khafre. It imbues the god-king with the awesome strength and authority of the king of beasts.

Sculpture

STATUES TO SERVE FOR ETERNITY As already noted, in Egyptian tombs statues fulfilled an important function. Sculptors created images of the deceased to serve as

abodes for the ka should the mummies be destroyed. For this reason, an interest in portrait sculpture developed early in Egypt. Thus, too, permanence of style and material was essential. Although sculptors used wood, clay, and other materials, mostly for images of those not of the royal or noble classes, their primary material was stone.

The seated statue of Khafre (FIG. **3-12**) is one of a series of similar statues carved for the pharaoh's valley temple near the Great Sphinx (FIG. 3-10, no. 4). The stone is diorite, an exceptionally hard dark stone brought seven hundred miles down the Nile from royal quarries in the south. (The Neo-Sumerian ruler Gudea [see FIG. 2-15] so admired diorite that he imported it to faraway Girsu.) Khafre's statues are the only organic forms in his temple. They contrast with the structure's geometrically severe flat-planed red granite posts and lintels devoid of decoration. The king wears a simple kilt and sits rigidly upright on a throne formed of two stylized lions'

bodies. Intertwined lotus and papyrus plants—symbol of the united Egypt—are carved between the throne's legs. The falcon-god Horus extends his protective wings to shelter Khafre's head, indicating the pharaoh's divine status. Khafre has the royal fake beard fastened to his chin and wears the royal linen *nemes* headdress with the *uraeus* cobra of kingship on the front. The headdress covers his forehead and falls in pleated folds over his shoulders. (The head of the Great Sphinx is similarly attired but does not have the ceremonial beard.) As befitting a divinity, Khafre is shown with a well-developed, flawless body and a perfect face. The Egyptians considered ideal proportions appropriate for representing imposing majesty, and artists used them quite independently of reality. This generalized anatomy persisted in Egyptian statuary even into the period following Alexander the Great's conquest of Egypt, regardless of the actual age and physique of the pharaoh portrayed.

The seated king is permeated with serenity, reflecting the enduring power of the pharaoh and of kingship in general. The sculptor created this effect, common to Egyptian royal statues, in part by giving the figure great compactness and solidity, with few projecting, breakable parts. The form manifests the purpose: to last for eternity. Khafre's body is attached to the unarticulated slab that forms the back of the king's throne. His arms are held close to the torso and thighs, and his legs are close together and connected to the chair by the stone the artist chose not to remove. The pose is frontal, rigid, and *bilaterally symmetrical* (the same on either side of an axis, in this case the vertical axis). The sculptor suppressed all movement and with it the notion of time.

This repeatable scheme arranges the bodily parts so that they are presented in a totally frontal projection or entirely in profile. The sculptor produced the statue by first drawing the front, back, and two profile views of the pharaoh on the four vertical faces of the stone block. Next, apprentices chiseled away the excess stone on each side, working inward until the planes met at right angles. Finally, the master sculpted the parts of Khafre's body, the falcon, and so forth. The finishing was done by *abrasion* (rubbing or grinding the surface). This *subtractive* method of creating the pharaoh's portrait accounts in large part for the blocklike look of the standard Egyptian statue. Nevertheless, many sculptors, both ancient and modern, have transformed stone blocks into dynamic, twisting human forms (compare FIG. 5-85). Khafre's eternal stillness is a deliberate aesthetic choice.

AN EMOTIONLESS ROYAL EMBRACE The seated statue is one of only a small number of basic formulaic types the sculptors of the Old Kingdom employed to represent the human figure. Another is the image of a person or deity standing, either alone or in groups. Superb examples of the standing type are the joined portrait statues of Menkaure and his queen, Khamerernebty (FIG. **3-13**), which once stood in the valley temple of Menkaure's pyramid complex at Gizeh. Here, too, the statues remain wedded to the stone block from which they were carved, and the sculptor used conventional postures to suggest the timeless nature of these eternal substitute homes for the ka. Menkaure's pose, which is duplicated in countless other Egyptian statues, is rigidly frontal with

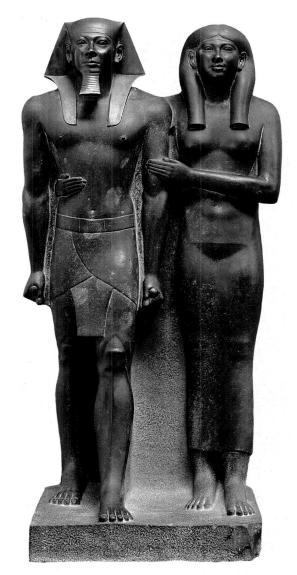

3-13 Menkaure and Khamerernebty, from Gizeh, Egypt, Dynasty IV, ca. 2490–2472 B.C. Slate, approx. 4′ 6½″ high. Museum of Fine Arts, Boston.

arms hanging straight down and close to his well-built body. His hands are clenched into fists with the thumbs forward. His left leg is slightly advanced, but no shift occurs in the angle of the hips to correspond to the uneven distribution of weight. Khamerernebty stands in a similar position. Her right arm, however, circles around her husband's waist, and her left hand gently rests on his left arm. This frozen stereotypical gesture indicates their marital status. The husband and wife show no other sign of affection or emotion and look not at each other but out into space.

PAINTED STATUES AND EGYPTIAN REALISM The timeless quality of the portraits of Khafre, Menkaure, and Khamerernebty is enhanced by the absence of any color but that of the dark natural stone selected for the statues. Many other Egyptian portrait statues, however, were painted, including the striking image of a Fifth Dynasty seated scribe

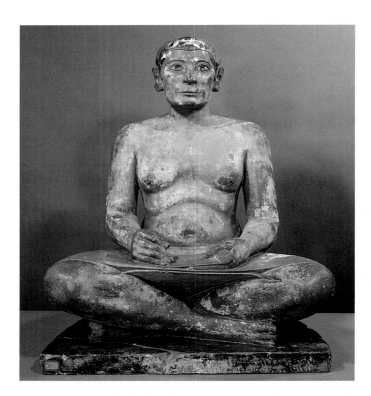

3-14 Seated scribe (Kay?), from his mastaba at Saqqara, Egypt, Dynasty V, ca. 2450–2350 B.C. Painted limestone, approx. 1′ 9″ high. Louvre, Paris.

sometimes identified as Kay (FIG. **3-14**). Despite the stiff upright posture and the frontality of head and body, the color lends a lifelike quality to the statue. But one might argue that this is detrimental to the portrait's success, inasmuch as the color detracts from the statue's role as a timeless image of the deceased placed in his mastaba.

The head displays an extraordinary sensitivity. The sculptor conveyed the personality of a sharply intelligent and alert individual with a penetration and sympathy seldom achieved at such an early date. The scribe sits directly on the ground, not on a throne nor even on a chair. Although he occupied a position of honor in a largely illiterate society, the scribe is a much lower figure in the Egyptian hierarchy than the pharaoh, whose divinity makes him superhuman. In the history of art, especially portraiture, it is almost a rule that as a human subject's importance decreases, formality is relaxed and realism is increased. It is telling that the scribe is shown with sagging chest muscles and a protruding belly. Such signs of age would have been disrespectful and wholly inappropriate in a "portrait" of an Egyptian god-king. The royal statues are never accurate likenesses but are idealized images that proclaim the godlike nature of the divine kings and queens. Their purpose was not to record individual facial features or even the true shapes of bodies. But the scribe's statue is also not a true portrait. Rather, it is a composite of conventional types. In fact, the face's sunken cheeks are difficult to reconcile with the flabby body. Nonetheless, these realistic touches were unthinkable in a pharaonic statue.

A PORTRAIT IN WOOD AND ROCK CRYSTAL A second portrait illustrating this rule of relaxed formality and increased realism is the Fifth Dynasty wooden statue of an official named Ka-Aper (FIG. **3-15**). Like the statue of the seated scribe, Ka-Aper's portrait comes from the deceased's

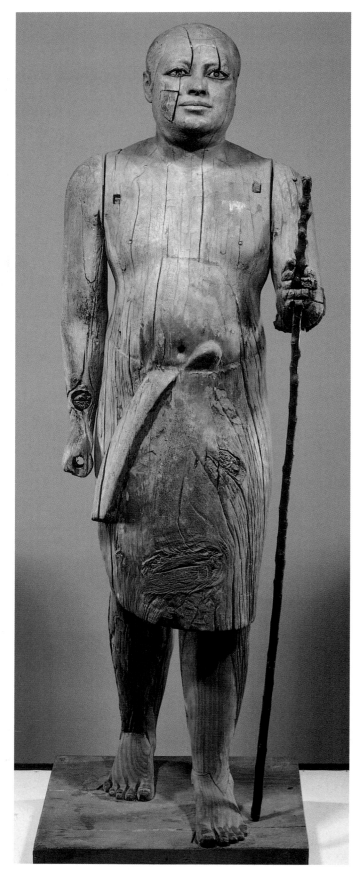

3-15 Ka-Aper, from his mastaba at Saqqara, Egypt, Dynasty V, ca. 2450–2350 B.C. Wood, approx. 3′ 7″ high. Egyptian Museum, Cairo.

simple brick mastaba at Saqqara. Ka-Aper's face is also startlingly alive, an effect the eyes of rock crystal heighten.

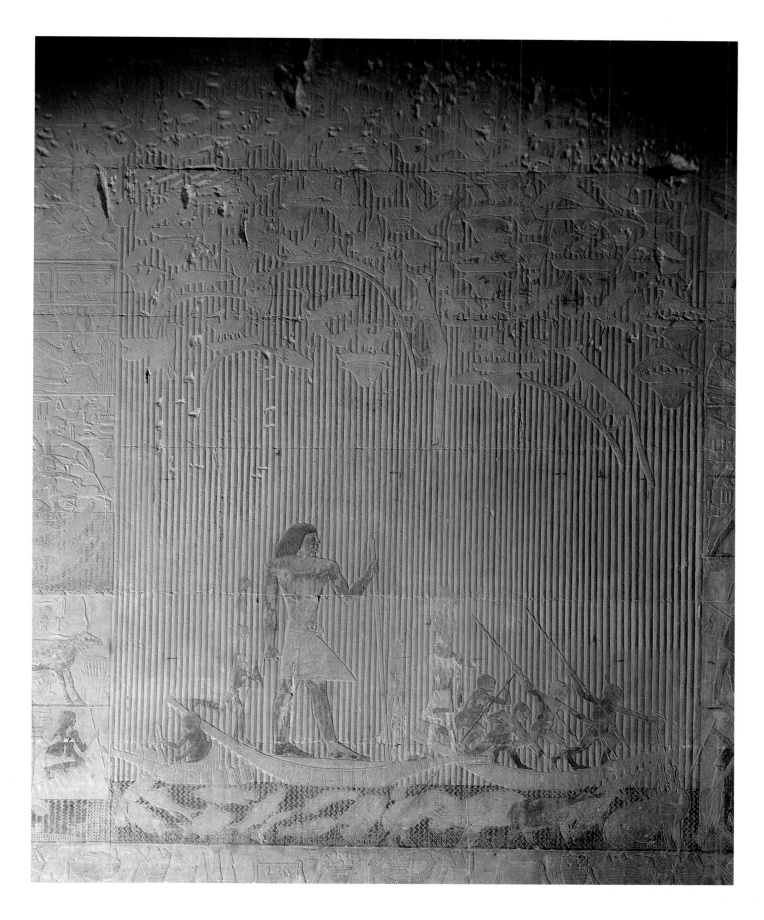

3-16 Ti watching a hippopotamus hunt, relief in the mastaba of Ti, Saqqara, Egypt, Dynasty V, ca. 2450–2350 B.C. Painted limestone, hunting scene approx. 4′ high.

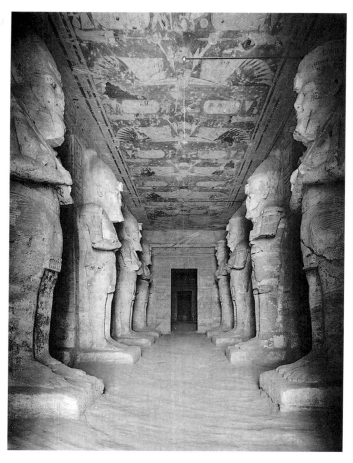

3-23 Interior of the temple of Ramses II, Abu Simbel (now relocated), Egypt, Dynasty XIX, ca. 1290–1224 B.C. Pillar statues approx. 32' high.

colonnaded court and hall into a dimly lit sanctuary. This Egyptian temple plan evolved from ritualistic requirements. Only the pharaohs and the priests could enter the sanctuary. A chosen few were admitted to the great columnar hall. The majority of the people were allowed only as far as the open court, and a high mud-brick wall shut off the site from the outside world. The conservative Egyptians did not deviate from this basic plan for hundreds of years. In fact, the New

Kingdom pylon temple plan's central feature—a narrow axial passageway through the complex—had characterized Egyptian architecture since the Old Kingdom. Axial corridors are also the approaches to the great pyramids of Gizeh (FIG. 3-10) and to the multilevel mortuary temple of Hatshepsut at Deir el-Bahri (FIG. 3-20).

The dominating feature of the statuary-lined approach to a New Kingdom temple was the monumental facade of the pylon, which was routinely covered with reliefs glorifying Egypt's rulers. Inside was an open court with columns on two or more sides, followed by a hall between the court and sanctuary, its long axis placed at right angles to the entire building complex's corridor. This *hypostyle* hall (one with a roof supported by columns) was crowded with massive columns and roofed by stone slabs carried on lintels. The lintels rested on *impost blocks* (stones with the shape of shortened, inverted pyramids) resting on giant capitals. In the hypostyle hall at Karnak (FIGS. **3-25** and **3-26**), the central columns are sixty-six feet high, and the capitals are twenty-two feet in diameter at the top, large enough to hold one hundred people. The Egyptians, who used no cement, depended on the weight of the huge stone blocks to hold the columns in place.

In the Amen-Re temple at Karnak and in many other Egyptian hypostyle halls, the builders made the central rows of columns higher than those at the sides. Raising the roof's central section created a *clerestory*. Openings in the clerestory permitted light to filter into the interior. This method of construction appeared in primitive form as early as the Old Kingdom in the valley temple of the Pyramid of Khafre. Evidently an Egyptian innovation, its significance hardly can be overstated. Before the invention of the lightbulb, illuminating a building's interior was always a challenge for architects. The clerestory played a key role, for example, in Roman basilica and medieval church design and has remained an important architectural feature down to the present.

NEW KINGDOM COLUMNS In the hypostyle hall at Karnak, the columns are indispensable structurally, unlike the rock-cut columns of the tombs at Beni Hasan (FIG. 3-19) and Abu Simbel (FIG. 3-23). But their function as vertical supports is almost hidden by horizontal bands of painted *sunken*

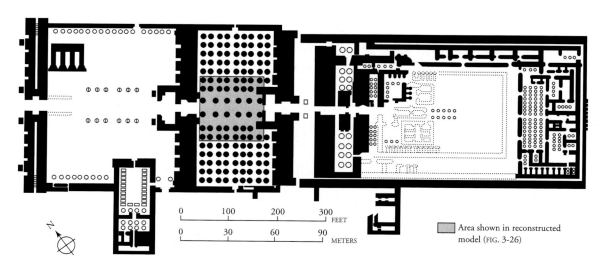

0 100 200 300 FEET
0 30 60 90 METERS

Area shown in reconstructed model (FIG. 3-26)

3-24 Plan of the temple of Amen-Re, Karnak, Egypt, begun fifteenth century B.C. (after Sir Bannister Fletcher). The shaded area in the hypostyle hall corresponds to the model in FIG. 3-26.

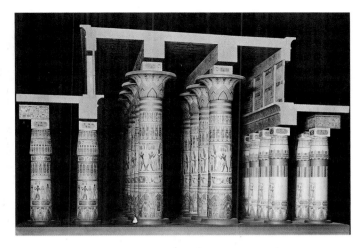

3-26 Model of hypostyle hall, temple of Amen-Re, Karnak, Egypt, Dynasty XIX, ca. 1290–1224 B.C. Metropolitan Museum of Art, New York. (Levi Hale Willard Bequest, 1890).

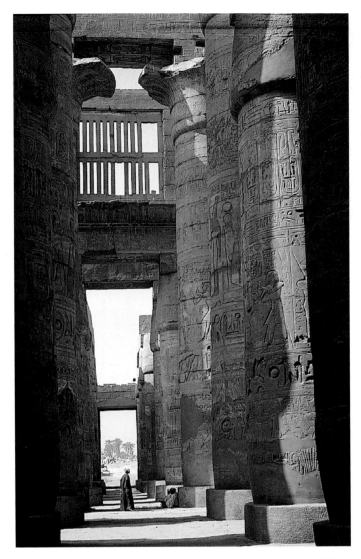

3-25 Hypostyle hall, temple of Amen-Re, Karnak, Egypt, Dynasty XIX, ca. 1290–1224 B.C.

relief sculpture. To create such reliefs, sculptors chisel deep outlines below the stone's surface, rather than cutting back the stone around the figures to make the figures project from the surface. Sunken reliefs preserve the contours of the columns they adorn. Otherwise, the Karnak columns would have had an irregular, wavy profile. But despite this effort to maintain sharp architectural lines, the overwhelming of the surfaces with reliefs suggests that the architects' intention was not to emphasize the columns' functional role. Instead, they used columns as image- and message-bearing surfaces. Most builders, however, even in ancient Egypt, emphasized the column's vertical lines and structural function by freeing the shaft's surfaces from all ornament. The Karnak columns are exceptional in the history of architecture.

Typical New Kingdom columns can be found in the courts and colonnades of the Temple of Amen-Mut-Khonsu at Luxor (FIG. **3-27**). Egyptian columns appear to have originated from an early building technique that used firmly bound sheaves of reeds and swamp plants as roof supports in

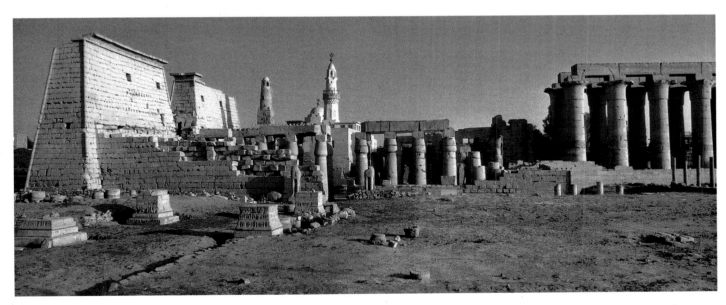

3-27 Temple of Amen-Mut-Khonsu, Luxor, Egypt. *Left:* pylon and court of Ramses II, Dynasty XIX, ca. 1290–1224 B.C.; *right:* colonnaded court of Amenhotep III, Dynasty XVIII, ca. 1390–1353 B.C.

3-28 Temple of Horus, Edfu, Egypt, ca. 237–47 B.C.

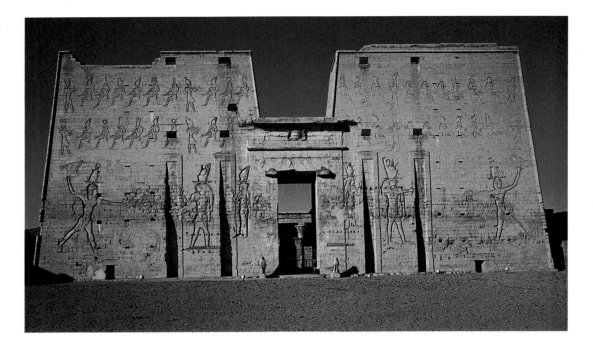

adobe structures. Imhotep first translated such early and relatively impermanent building methods into stone (FIGS. 3-6 and 3-7). Evidence of their swamp-plant origin is still seen in the columns at Karnak and Luxor, which have bud-cluster or bell-shaped capitals resembling lotus or papyrus (the plants of Upper and Lower Egypt).

Egyptian traditions once formulated tended to have very long lives, in architecture as in the other arts. The pylon temple of Horus at Edfu (FIG. **3-28**), built during the third, second, and first centuries B.C., still follows the basic scheme architects worked out more than a thousand years before. The great entrance pylon at Edfu is especially impressive. The broad surface of its massive facade, with its sloping walls, is broken only by the doorway with its overshadowing cornice, moldings at the top and sides, by deep channels to hold great flagstaffs, and by sunken reliefs. The reliefs depict Horus and Hathor witnessing an oversized King Ptolemy XIII (r. 51–47 B.C.) smiting undersized enemies. It is a striking monument to the persistence of Egyptian architectural and sculptural types.

Sculpture and Painting

The patterns the Old Kingdom masters set continued to dominate statuary production in the Nile Valley even under the Roman emperors. Hatshepsut's funerary complex, for example, was bedecked with statues of the female pharaoh that conformed to types established long before, including the standing and seated portrait and the reclining sphinx. The bilateral symmetry of all the poses and the frozen action were unvarying features even when new motifs were introduced.

BLOCK STATUES Extremely popular during the Middle and New Kingdoms were *block statues*. In these works the idea that the ka could find an eternal home in the cubic stone image of the deceased was expressed in an even more

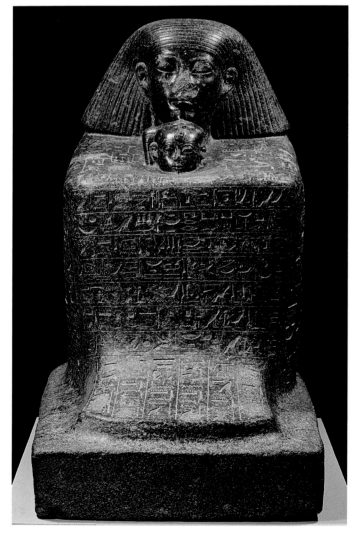

3-29 Senmut with Princess Nefrua, from Thebes, Egypt, Dynasty XVIII, ca. 1470–1460 B.C. Granite, approx. $3'\frac{1}{2}''$ high. Ägyptisches Museum, Berlin.

radical simplification of form than was common in Old Kingdom statuary. A fine example of this genre is the block statue of Senmut and Princess Nefrua (FIG. 3-29). Hatshepsut's chancellor holds the pharaoh's daughter by Thutmose II in his "lap" and envelops the girl in his cloak. The streamlined design concentrates attention on the heads and treats the two bodies as a single cubic block, given over to inscriptions. The polished stone shape has its own simple beauty. With surfaces turning subtly about smoothly rounded corners, it is another expression of the Egyptian fondness for volume enclosed by flat, unambiguous planes. The work—one of many surviving statues depicting Senmut with Hatshepsut's daughter—is also a reflection of the power of Egypt's female ruler. The frequent depiction of Senmut with Nefrua was meant to enhance Senmut's stature through his association with the princess (he was her tutor) and, by implication, with Hatshepsut herself. Toward the end of her reign, however, Hatshepsut believed Senmut had become too powerful, and she had him removed.

A PAINTED TOMB AT THEBES The long life of Egyptian artistic formulas also can be seen in New Kingdom painting. In the Eighteenth-Dynasty Theban tomb of Nebamun, the deceased nobleman, whose official titles were "scribe and counter of grain," is shown standing in his boat, flushing birds from a papyrus swamp (FIG. 3-30).

The hieroglyphic text beneath his left arm says that Nebamun is enjoying recreation in his eternal afterlife. In contrast to the static pose of Ti watching others hunt hippopotami (FIG. 3-16), Nebamun is shown striding forward and vigorously swinging his throwing stick. In his right hand, he holds three birds he has caught. A wild cat, impossibly perched on a papyrus stem just in front of and below him, has caught two more in her claws and is holding the wings of a third in her teeth. Nebamun is accompanied on this hunt by his wife and daughter, who are holding the lotuses they have gathered. The artist scaled down their figures in proportion to their rank. Save for the participation of the deceased and his family in the hunt, formally and conceptually this New Kingdom fowling scene differs little from the hippopotamus hunt in the Old Kingdom tomb of Ti. The painter used the usual conventions to represent the water and the human figures. Cat, fish, and birds, like the Saqqara animals, show a naturalism based on careful observation.

The technique is also that employed in Old Kingdom tombs: *fresco secco* (dry fresco), whereby artists let the plaster dry before painting on it. This procedure, in contrast to true fresco painting on wet plaster (see "Fresco Painting," Chapter 19, page 543), lends itself to slow and meticulous work. It allows the trained professional to express an exact knowledge of the subject.

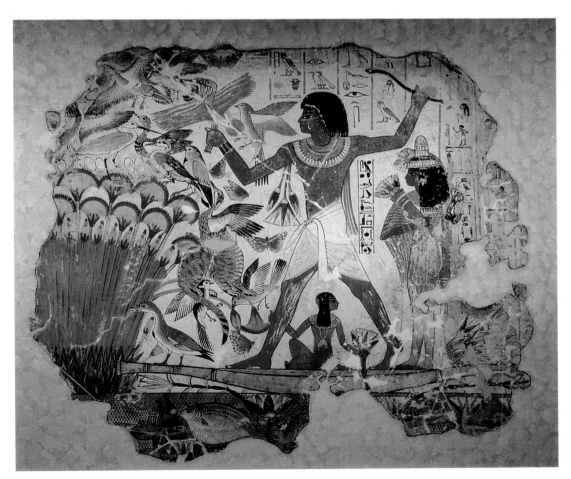

3-30 Fowling scene, from the tomb of Nebamun, Thebes, Egypt, Dynasty XVIII, ca. 1400–1350 B.C. Fresco on dry plaster, approx. 2′ 8″ high. British Museum, London.

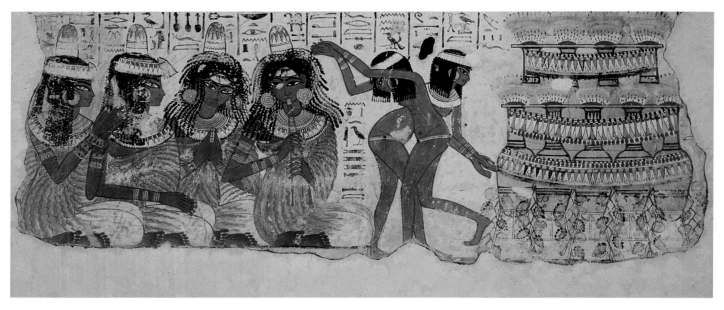

3-31 Musicians and dancers, detail of a fresco from the tomb of Nebamun, Thebes, Egypt, Dynasty XVIII, ca. 1400–1350 B.C. Fragment approx. 1′ × 2′ 3″. British Museum, London.

Another fresco fragment from Nebamun's tomb shows four noblewomen watching and apparently participating in a musicale and dance where two nimble and almost nude dancing girls perform at a banquet (FIG. **3-31**). When Nebamun was buried, his family must have eaten the customary ceremonial meal at his tomb. They would have returned one day each year to partake in a commemorative banquet for the living to commune with the dead. This fresco represents just such a funerary feast, with an ample supply of wine jars at the right. It also shows that New Kingdom artists did not always adhere to the old standards for figural representation. The overlapping of the dancers' figures, their facing in opposite directions, and their rather complicated gyrations were carefully and accurately observed and executed, and the result is also a pleasing intertwined motif. The profile view of the dancers is consistent with their lesser importance than the others in the Egyptian hierarchy. The composite view is still reserved for Nebamun and his family. Of the four seated women, the artist represented the two at the left conventionally, but the other two face the observer in what is a rarely attempted frontal pose. They clap and beat time to the dance, while one of them plays the reeds. The artist took careful note of the soles of their feet as they sat cross-legged and suggested the movement of the women's heads by the loose arrangement of their hair strands. This informality constituted a relaxation of the Old Kingdom's stiff representational rules.

The frescoes in Nebamun's tomb testify to the luxurious life of the Egyptian nobility, filled with good food and drink, fine musicians, lithe dancers, and leisure time to hunt and fish in the marshes. But, as in the earlier tomb of Ti, the scenes should be read both literally and allegorically. Although Nebamun is shown enjoying himself in the afterlife, the artist symbolically asked viewers to recall how he got there. Hunting scenes reminded Egyptians of Horus, the son of Osiris, hunting down his father's murderer, Seth, the god of disorder, thus assuring a happy existence for Nebamun. And music and dance were sacred to Hathor, who aided the dead in their passage to the other world. The sensual women at the banquet are a reference to fertility, rebirth, and regeneration—the conquest of death that made the afterlife possible.

Akhenaton and the Amarna Period

A RELIGIOUS REVOLUTION Not long after Nebamun was laid to rest in his tomb at Thebes, a short but violent upheaval occurred in Egyptian society and in Egyptian art—the only major break in the continuity of their long tradition. In the mid-fourteenth century B.C., the pharaoh Amenhotep IV, later known as Akhenaton (r. 1353–1335 B.C.), abandoned the worship of most of the Egyptian gods in favor of Aton, the universal and only god, identified with the sun disk. He blotted out the name of Amen from all inscriptions and even from his own name and that of his father, Amenhotep III. He emptied the great temples, enraged the priests, and moved his capital downriver from Thebes to a site named for Aton and now called Tell el-Amarna, where he built his own city and shrines. The pharaoh claimed for himself the new and universal god, making himself both the son and sole prophet of Aton. To him alone could the god make revelation. Moreover, in stark contrast to earlier practice, Akhenaton's god was represented neither in animal nor in human form but simply as the sun disk emitting life-giving rays.

A NEW APPROACH TO REPRESENTATION After Akhenaton's death, his new city was largely abandoned, and traditional religion triumphed. But during the brief heretical episode, profound changes occurred in Egyptian art. A colossal statue of Akhenaton from Karnak (FIG. **3-32**), toppled and buried after his death, retains the standard frontal pose of canonical pharaonic portraits. But the effeminate body, with its curving contours, and the long full-lipped face, heavy-lidded eyes, and dreaming ex-

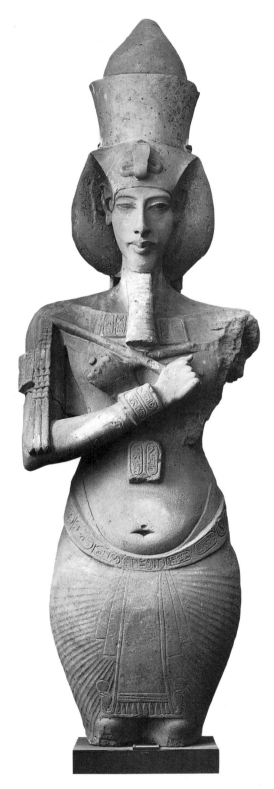

3-32 Akhenaton, from the temple of Amen-Re, Karnak, Egypt, Dynasty XVIII, ca. 1353–1335 B.C. Sandstone, approx. 13' high. Egyptian Museum, Cairo.

pression are a far cry indeed from the heroically proportioned figures of Akhenaton's predecessors (compare FIG. 3-13). Akhenaton's body is curiously misshapen, with weak arms, a narrow waist, protruding belly, wide hips, and fatty thighs. Modern doctors have tried to explain his physique by a variety of illnesses. They cannot agree on a diagnosis, and their premise—that the statue is an accurate depiction of a physical deformity—is probably faulty. Some art histo-

rians think that Akhenaton's portrait is a deliberate artistic reaction against the established style, paralleling the suppression of traditional religion. They argue that Akhenaton's artists tried to formulate a new androgynous image of the pharaoh as the manifestation of Aton, the sexless sun disk. But no consensus exists other than that the style was revolutionary and short lived.

PORTRAITS OF TWO QUEENS The famous painted limestone bust of Akhenaton's queen, Nefertiti (FIG. **3-33**), exhibits a similar expression of entranced musing and an almost mannered sensitivity and delicacy of curving contour. The piece was found in the workshop of the queen's official sculptor, THUTMOSE, and is a deliberately unfinished model very likely by the master's own hand. The left eye socket still lacks the inlaid eyeball, making the portrait a kind of before-and-after demonstration piece. With this elegant bust, Thutmose may have been alluding to a heavy flower on its slender stalk by exaggerating the weight of the crowned head and the length of the almost serpentine neck. Readers might think of those modern descendants of Nefertiti (her name means "The Beautiful One Is Here")—models in fashion magazines, with

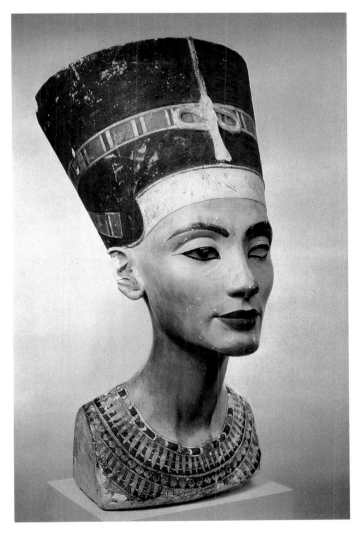

3-33 THUTMOSE, Nefertiti, from Tell el-Amarna, Egypt, Dynasty XVIII, ca. 1353–1335 B.C. Painted limestone, approx. 1' 8" high. Ägyptisches Museum, Berlin.

their gaunt, swaying frames; masklike faces; and enormous shadowed eyes. As modern mannerism shapes living models to its dictates, so the sculptors of Tell el-Amarna may have adjusted their subjects' actual likenesses to their standard of spiritual beauty.

A moving portrait of old age is preserved in the miniature head of Queen Tiye (FIG. **3-34**), mother of Akhenaton. Tiye was the chief wife of Amenhotep III and a commoner by birth. The pharaoh seems to have married her for love rather than for political reasons. The portrait illustrated here was fashioned during her son's reign and was found at Gurob with other objects connected with the funerary cult of Amenhotep III. The beautiful black queen (the Egyptians were a people of mixed race and frequently married other Africans) is shown as an older woman with lines and furrows, consistent with the new relaxation of artistic rules in the Amarna age. The head was carved in yew wood, the heavy-lidded slanting eyes are inlaid with alabaster and ebony, the lips are painted red, and the preserved earring is of gold and lapis lazuli. The present headcloth

is of plaster and linen with small blue beads; it covers what was originally a silver-foil headdress. A gold band still adorns the forehead. The luxurious materials were worthy of a beloved queen.

AN INTIMATE LOOK AT A ROYAL COUPLE
During the last three years of his reign, Akhenaton's co-regent was his half brother, Smenkhkare. A relief from Tell el-Amarna (FIG. **3-35**) may show Smenkhkare and his wife Meritaten in an informal, even intimate, pose that contrasts strongly with the traditional formality in representations of exalted persons. Undulating curves replace rigid lines, and Smenkhkare's pose has no known precedent. The prince leans casually on his staff, one leg at ease, in an attitude that indicates the sculptor's knowledge of the flexible shift of body masses, a principle not fully demonstrated until the fifth century B.C. in Greece. This quite realistic detail accompanies others that show a freer expression of what the artist observed. These include details of costume and departures from the tra-

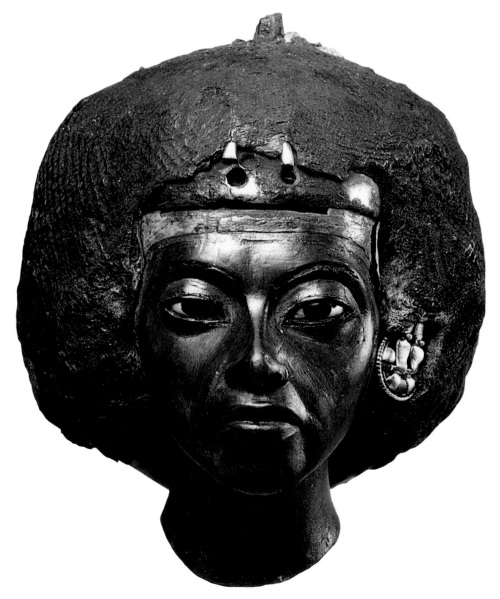

3-34 Tiye, from Gurob, Egypt, Dynasty XVIII, ca. 1353–1335 B.C. Wood, with gold, silver, alabaster, and lapis lazuli, approx. $3\frac{3}{4}''$ high. Ägyptisches Museum, Berlin.

gained world renown not only for their excavator, Howard Carter, but also for the boy king. Tutankhamen was a very minor figure in Egyptian history. The public remembers him today solely because of the chance survival of his tomb's furnishings.

The principal monument in the collection is the enshrined body of the pharaoh himself. The royal mummy reposed in the innermost of three coffins, nested one within the other. The innermost coffin (FIG. **3-36**) was the most luxurious of the three. Made of beaten gold (about a quarter ton of it) and inlaid with such semiprecious stones as lapis lazuli, turquoise,

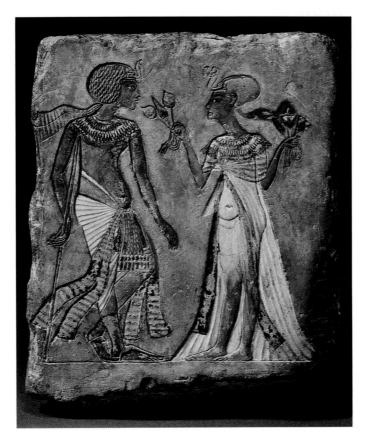

3-35 Smenkhkare and Meritaten(?), from Tell el-Amarna, Egypt, Dynasty XVIII, ca. 1335 B.C. Painted limestone relief, approx. $9\frac{1}{2}''$ high. Ägyptisches Museum, Berlin.

ditional formality, such as the elongated neck and head of Meritaten and the prominent bellies that characterize figures of the Amarna school. The political and religious revolution under Akhenaton was matched by an equally radical upheaval in relief sculpture and painting, as well as in statuary.

The Tomb of Tutankhamen and the Post-Amarna Period

The pharaohs who followed Akhenaton reestablished the cult and priesthood of Amen and restored the temples and the inscriptions. The gigantic temple complexes at Karnak and Luxor (FIGS. 3-25 to 3-27) already examined were dedicated to the renewed worship of the Theban god Amen. When Akhenaton's religious revolution was undone, artists, too, soon returned to the old conservative manner.

TREASURES OF A BOY KING The legacy of the Amarna style may be seen, however, in the fabulously rich art and artifacts found in the largely unplundered tomb of Tutankhamen (r. 1333–1323 B.C.), who was probably Akhenaton's son by a minor wife. Tutankhamen ruled for a decade and died at age eighteen. The treasures of his tomb, which include sculpture, furniture, jewelry, and accessories of all sorts, were uncovered in 1922. The adventure of their discovery

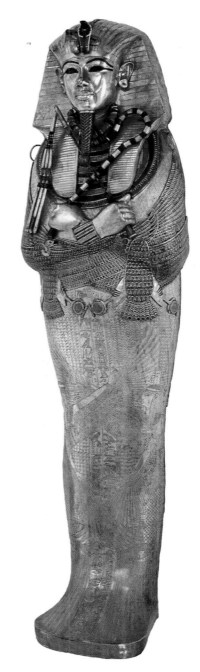

3-36 Innermost coffin of Tutankhamen, from his tomb at Thebes, Egypt, Dynasty XVIII, ca. 1323 B.C. Gold with inlay of enamel and semiprecious stones, approx. 6' 1" long. Egyptian Museum, Cairo.

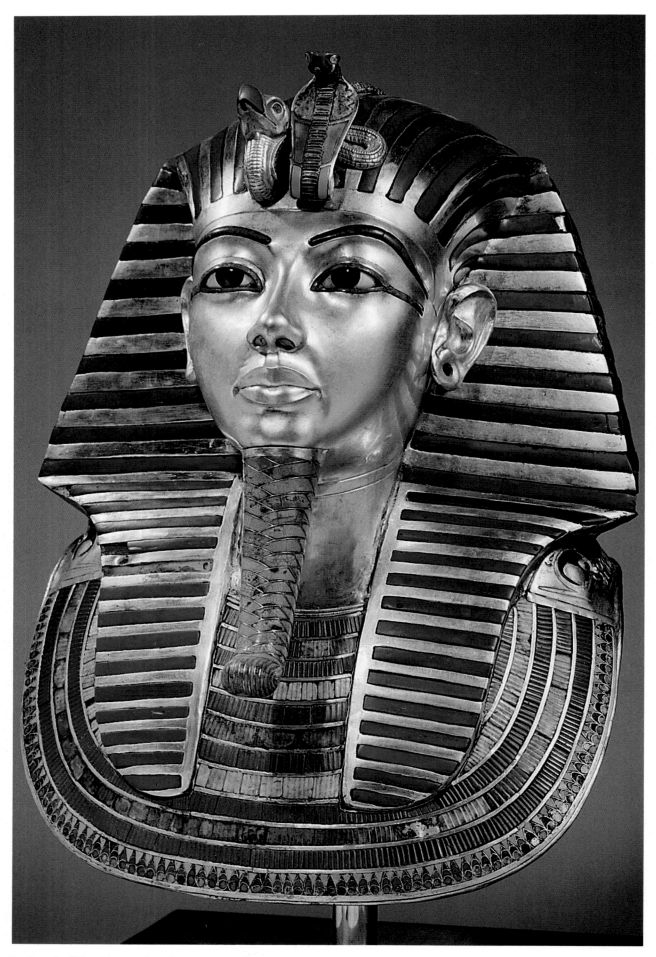

3-37 Death mask of Tutankhamen, from the innermost coffin in his tomb at Thebes, Egypt, Dynasty XVIII, ca. 1323 B.C. Gold with inlay of semiprecious stones, 1'9¼" high. Egyptian Museum, Cairo.

and carnelian, it is a supreme monument to the sculptor's and goldsmith's crafts. The portrait mask (FIG. 3-37), which covered the king's face, is also made of gold with inlaid semiprecious stones. It is a sensitive portrayal of the serene adolescent king dressed in his official regalia, including the nemes headdress and false beard. The general effects of the mask and of the tomb treasures as a whole are of grandeur and richness expressive of Egyptian power, pride, and affluence. One can scarcely imagine what kinds of luxury goods were buried with the truly important pharaohs.

TUTANKHAMEN AS WORLD CONQUEROR Although Tutankhamen probably was considered too young to fight, his position as king required that he be represented as a conqueror. He is shown as such in the panels of a painted chest (FIG. 3-38) deposited in his tomb. The lid panel shows the king as a successful hunter pursuing droves of fleeing animals in the desert, and the side panel shows him as a great warrior. Together, the two panels are a double advertisement of royal power comparable to the later reliefs adorning Assyrian palaces (see FIGS. 2-22 and 2-24). From a war chariot drawn by spirited, plumed horses, Tutankhamen, shown larger than all other figures on the chest, draws his bow against a cluster of bearded Asian enemies, who fall in confusion before him. He slays the enemy, like game, in great numbers. Behind Tutankhamen are three tiers of undersized war chariots, which serve to magnify the king's figure and to increase the count of his warriors. The themes are traditional, but the fluid, curvilinear forms are features reminiscent of the Amarna style. So are the artist's dynamic compositions, with their emphasis on movement and action. This emphasis is seen in the disposition of the hunted, overthrown animals and enemy, who, freed of conventional ground lines, race wildly across the panels.

OSIRIS AND THE *BOOK OF THE DEAD* Tutankhamen's mummy case (FIG. 3-36) shows the boy king in the guise of Osiris, god of the dead and king of the underworld, as well as giver of eternal life. The ritual of the cult of Osiris is recorded in collections of spells and prayers that comprise the so-called *Book of the Dead*. Illustrated papyrus

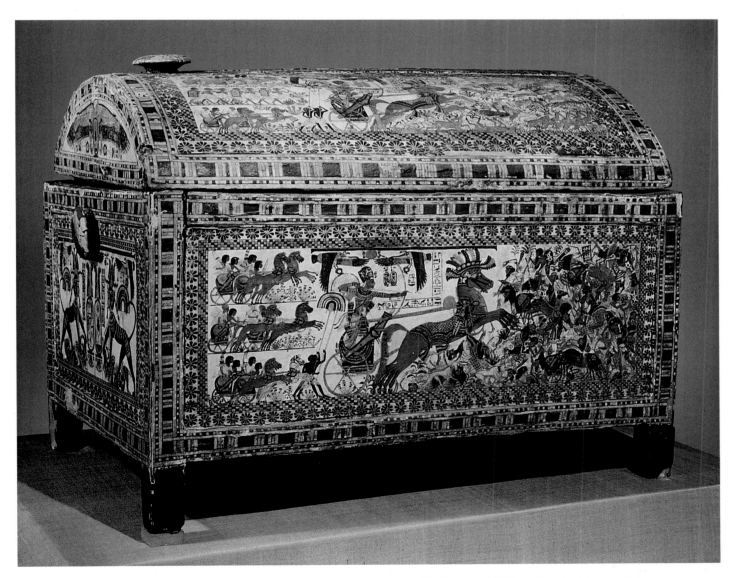

3-38 Painted chest, from the Tomb of Tutankhamen, Thebes, Egypt, ca. 1333–1323 B.C. Wood, approx. 1′ 8″ long. Egyptian Museum, Cairo.

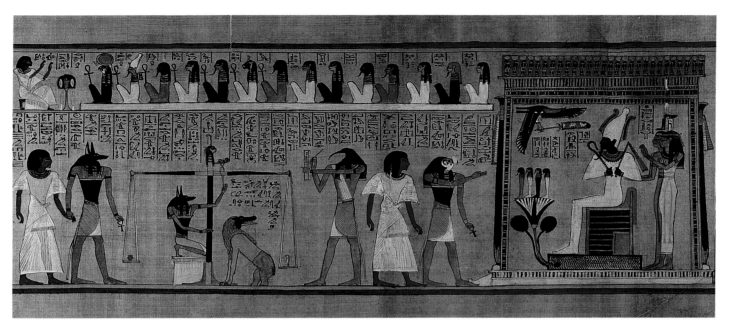

3-39 Last judgment of Hu-Nefer, from his tomb at Thebes, Egypt, Dynasty XIX, ca. 1290–1280 B.C. Painted papyrus scroll, approx. 1′ 6″ high. British Museum, London.

scrolls, some as long as seventy feet, containing these texts were the essential equipment of the tombs of well-to-do persons. The scroll of Hu-Nefer, the royal scribe and steward of the pharaoh Seti I, was found in his tomb in the Theban necropolis. Our illustration (FIG. **3-39**) represents the final judgment of the deceased. At the left, Anubis, the jackal-headed god of embalming, leads Hu-Nefer into the hall of judgment. The god then adjusts the scales to weigh the dead man's heart against the feather of the goddess Maat, protectress of truth and right. A hybrid monster, Ammit, half hippopotamus and half lion, the devourer of the sinful, awaits the decision of the scales. If the weighing had been unfavorable to the deceased, the monster would have eaten his heart on the spot. The ibis-headed god Thoth records the proceedings. Above, the gods of the Egyptian pantheon are arranged as witnesses, while Hu-Nefer kneels in adoration before them. Having been justified by the scales, Hu-Nefer is brought by Osiris's son, the falcon-headed Horus, into the presence of the green-faced Osiris and his sisters Isis and Nephthys to receive the award of eternal life.

THE LATE PERIOD

THE TRIUMPH OF TRADITION In Hu-Nefer's scroll, the figures have all the formality of stance, shape, and attitude of Old Kingdom art. Abstract figures and hieroglyphs alike are aligned rigidly. Nothing here was painted in the flexible, curvilinear style suggestive of movement that was evident in the art of Amarna and Tutankhamen. The return to conser-

vatism was complete. So, in essence, it remained through the last centuries of ancient Egyptian figural art. During this time, Egypt lost the commanding role it once had played in the ancient Near East. The empire dwindled away, and foreign powers invaded, occupied, and ruled the land, until it was taken over by Alexander the Great of Macedon and his Greek successors and, eventually, by the emperors of Rome.

A portrait statue of Mentuemhet (FIG. **3-40**), a rich and powerful man who was Mayor of Thebes and Fourth Priest of Amen during the Twenty-Sixth Dynasty in the seventh century B.C., easily could be mistaken for an Old Kingdom work. The venerable formulas, conventions, and details of representation are all here in summary. The rigidity of the stance, the frontality, and the spareness of silhouette with arms at the side and left leg advanced all recall Old Kingdom statuary (compare FIG. 3-13). Only the double wig, characteristic of the New Kingdom, and the realism of the head, with its rough and almost brutal characterization, differentiate the work from that of the earlier age.

The Late Period pharaohs deliberately referred back to the art of Egypt's classical phase to give their royal image authority. Religious and political motives only partly explain this deliberate archaism, however. As noted throughout this chapter, conservatism was an Egyptian character trait, perhaps the principal trait. The ancient Egyptians' resistance to significant change for almost three millennia is one of the marvels of the history of art. It testifies to the invention of a pictorial style that proved so satisfactory that it endured in Egypt, while everywhere else in the ancient Mediterranean, stylistic change was the only common denominator.

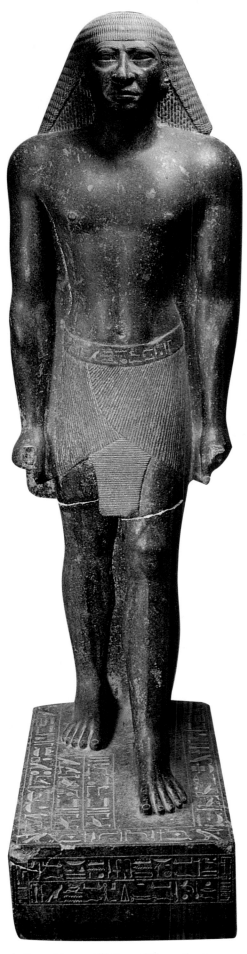

3-40 Mentuemhet, from Karnak, Egypt, Dynasty XXVI, ca. 650 B.C. Granite, approx. 4′ 5″ high. Egyptian Museum, Cairo.

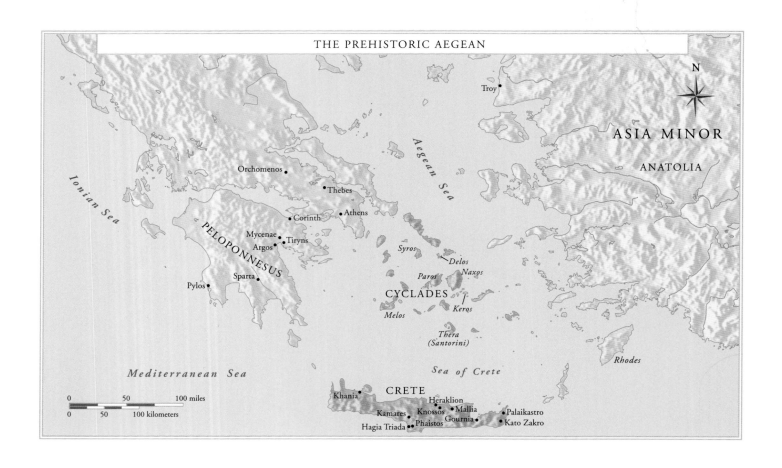

THE PREHISTORIC AEGEAN

Troy

ASIA MINOR

ANATOLIA

Aegean Sea

Ionian Sea

Orchomenos

Thebes

Athens

Corinth

PELOPONNESUS

Mycenae
Tiryns

Argos

Syros

Delos

Paros
Naxos

Sparta

Pylos

CYCLADES

Keros

Melos

Mediterranean Sea

Thera
(Santorini)

Rhodes

Sea of Crete

Khania
CRETE

Heraklion

Mallia

Kamares
Knossos

Gournia
Palaikastro

Hagia Triada
Phaistos

Kato Zakro

	3000 B.C.		2000 B.C.		1700 B.C.	1600 B.C.
CYCLADES	EARLY CYCLADIC		MIDDLE CYCLADIC		LATE CYCLADIC	
CRETE	EARLY MINOAN		MIDDLE MINOAN		LATE MINOAN	
MAINLAND GREECE	EARLY HELLADIC		MIDDLE HELLADIC		LATE HELLADIC (MYCENAEAN)	

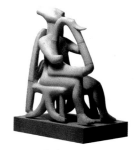

Cycladic lyre player
Keros, ca. 2700–2500 B.C.

Kamares Ware jar
Phaistos, ca. 1800–1700 B.C.

Spring Fresco
Akrotiri, ca. 1650 B.C.

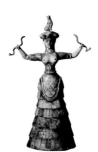

Snake Goddess
Knossos, ca. 1600 B.C.

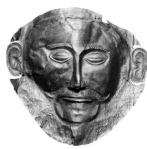

Gold funerary mask
Mycenae, ca. 1600–1500 B.C.

Old Palace period on Crete, ca. 2000–1700 B.C.

Linear A script developed, ca. 1700–1600 B.C.

New Palace period on Crete, ca. 1700–1400 B.C.

Theran eruption, ca. 1628 B.C.

MINOS AND THE HEROES OF HOMER

THE ART OF THE PREHISTORIC AEGEAN

1500 B.C.	1400 B.C.	1300 B.C.	1200 B.C.
			SUB-MINOAN
			SUB-MYCENAEAN

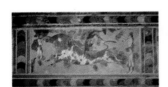

Toreador Fresco
Knossos, ca. 1450–1400 B.C.

Hagia Triada sarcophagus
ca. 1450–1400 B.C.

Citadel, Tiryns
ca. 1400–1200 B.C.

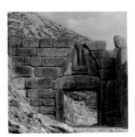

Lion Gate, Mycenae
ca. 1300–1250 B.C.

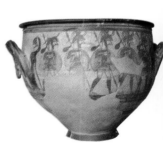

Warrior Vase
Mycenae, ca. 1200 B.C.

Mycenaeans at Knossos, ca. 1450–1400 B.C.

Linear B script developed, ca. 1400–1300 B.C.

Post-palatial period on Crete, ca. 1400–1200 B.C.

Destruction of
Mycenaean palaces,
ca. 1200 B.C.

THE PREHISTORIC AEGEAN REDISCOVERED

HOMER'S TROY

Clan after clan poured out from the ships and huts onto the plain . . . innumerable as the leaves and blossoms in their season . . . the Athenians . . . the men of Argos and Tiryns of the Great Walls . . . troops from the great stronghold of Mycenae, from wealthy Corinth . . . from Knossos . . . Phaistos . . . and the other troops that had their homes in Crete of the Hundred Towns.[1]

So Homer describes in the *Iliad* the might and splendor of the Greek armies poised before the walls of Troy. The Greeks had come to seek revenge against Paris, the Trojan prince who had abducted Helen, wife of King Menelaus of Sparta.

Many consider the *Iliad,* composed around 750 B.C., to be the finest epic poem ever written. It is unquestionably the first great work of Greek literature. Until about 1870, however, Homer's tale was regarded as pure fiction, and scholars discounted the bard as a historian, attributing the profusion of names and places in his writings to the rich abundance of his imagination. The prehistory of Greece remained shadowy and lost, historians believed, in an impenetrable world of myth.

That scholars had done less than justice to the truth of Homer's account was proved by a German amateur archeologist. Between 1870 and his death twenty years later, Heinrich Schliemann uncovered some of the very cities of the heroes Homer celebrated: Troy, Mycenae, and Tiryns. In 1870, Schliemann began work at Hissarlik on the northwestern coast of Turkey, which a British archeologist, Frank Calvert, had postulated was the site of Homer's Troy. Schliemann dug into a vast *tell,* or mound, and found a number of fortified cities built on the remains of one another. One of them had been destroyed by fire in the thirteenth century B.C. This, scholars now generally agree, was the Troy of King Priam and his son Paris, celebrated by Homer some five hundred years later.

Schliemann continued his excavations at Mycenae on the Greek mainland, where, he believed, King Agamemnon, Menelaus's brother, had once ruled. Here his finds were even more startling. A massive fortress-palace; elaborate tombs; and quantities of gold jewelry and ornaments, cups, and inlaid weapons revealed a magnificent civilization far older than the famous vestiges of Classical Greece that had always remained visible in Athens and elsewhere. Further discoveries proved that Mycenae had not been the only center of this fabulous civilization.

KING MINOS'S CRETE The lesson of Schliemann's success in pursuing hunches based on the careful reading of ancient literature was not lost on his successors. Another Greek legend told of King Minos of Knossos on the island of Crete, who had exacted from Athens a tribute of youths and maidens to be fed to the Minotaur, a creature half bull and half man housed in a vast labyrinth. Might this story, too, be based on fact? In 1900, an Englishman, Arthur Evans, began work at Knossos. A short time later he uncovered a palace that did indeed resemble a maze. Evans named the people who had erected it the Minoans, after their mythological king. His initial findings were augmented quickly by additional excavations at Phaistos, Hagia Triada, and other sites, including Gournia, which was explored between 1901 and 1904 by an American archeologist, Harriet Boyd Hawes, one of the first women to direct a major excavation.

More recently, important Minoan remains have been excavated at many other locations on Crete, and contemporary sites have been discovered on other islands in the Aegean, most notably on Santorini (ancient Thera). Art historians now have an array of buildings, paintings, and, to a lesser extent, sculptures that attests to the wealth and sophistication of the people who lived in that once obscure heroic age celebrated in later Greek mythology.

AEGEAN ARCHEOLOGY TODAY Less glamorous than the palaces and works of art, but arguably more important for the understanding of Aegean society, are the many documents archeologists have discovered written in scripts dubbed Linear A and Linear B. The progress made during the past several decades in the deciphering of these texts has provided a welcome corrective to the romanticism that characterized the work of Schliemann and Evans. Scholars have begun to reconstruct Aegean civilization by referring to contemporary records of mundane transactions and not just to Homer's heroic account.

Historians now also know that humans inhabited Greece as far back as the Lower Paleolithic period and that village life was firmly established in Greece in Neolithic times. But the heyday of the ancient Aegean was not until the second millennium B.C., well after the emergence of the river valley civilizations of Egypt and Mesopotamia. Close contact existed at various times between the peoples of the Aegean and the Near East and Egypt, but each civilization manifested an originality of its own.

The Aegean civilizations have long held a special interest for students of the later history of Western art, because they were the direct forerunners of the first truly European civilization, that of Greece. But the art and architecture of the ancient Near East and Egypt also played a major role in the early development of Greek art. And it is also well to remember that the Minoans and Mycenaeans were not Greeks, did not speak Greek, and did not worship Greek gods, even though they inhabited a part of the Mediterranean today incorporated in the modern nation of Greece.

AEGEAN GEOGRAPHY AND AEGEAN ART The sea-dominated geography of the Aegean contrasts sharply with that of the Near East, as does its temperate climate. The situation of Crete and the Aegean Islands at the commercial crossroads of the ancient Mediterranean had a major effect on their prosperity. The sea also provided a natural defense against the frequent and often disruptive invasions that checker the histories of land-bound civilizations such as those of Mesopotamia.

Historians, art historians, and archeologists alike divide the prehistoric Aegean into three geographic areas, and each has a distinctive artistic identity. *Cycladic* art is the art of the Cycladic Islands (those that *circle* around Delos), as well as of the adjacent islands in the Aegean, excluding Crete. *Minoan* art encompasses the art of Crete. *Helladic* art is the art of the Greek mainland (*Hellas* in Greek). Each area is subdivided chronologically into early, middle, and late periods, with the art of the Late Helladic period designated *Mycenaean* after Agamemnon's great citadel of Mycenae.

CYCLADIC ART

"MODERN" SCULPTURE CA. 2500 B.C. Marble was abundantly available in the superb quarries of the Aegean Islands, especially on Naxos and Paros. These same quarries later supplied the master sculptors of classical Greece and Rome with fine marble blocks for monumental statues. But nothing surviving from the classical era is quite like the marble statuettes (FIGS. **4-1** and **4-2**) that date from the Early Cycladic period. These sculptures are much revered today (see "Archeology, Art History, and the Art Market," page 81) because of their striking abstract forms, which call to mind the simple and sleek shapes of some twentieth-century statues (see FIGS. 33-17 and 33-72).

Most of the Cycladic sculptures, like many of their Stone Age predecessors in the Aegean, the Near East, and western Europe (see FIG. 1-4), represent nude women with their arms folded across their abdomens. They vary in height from a few inches to almost life-size. Our example (FIG. 4-1) is about a foot and a half tall and comes from a grave on the island of Syros. The statuette typifies many of these figures. It is almost flat, and the human body is rendered in a highly schematized manner. Large simple triangles dominate the form. Note the shape of the head and the body, which tapers from exceptionally broad shoulders to tiny feet, as well as, of course, the incised triangular pubis. The feet are too fragile to support the figurine. If these sculptures were primarily funerary offerings, as archeologists believe they were, they must have been placed on their backs in the graves—lying down, like the deceased themselves. Whether they represent those buried with the statuettes or fertility figures or goddesses is still debated. As in all such images, the sculptor took pains to emphasize the breasts as well as the pubic area. In the Syros statuette a slight swelling of the belly may suggest pregnancy.

Traces of paint found on some of the Cycladic figurines indicate that at least parts of these sculptures were colored. The now almost featureless faces would have had painted eyes and mouths in addition to the sculptured noses. Red and blue necklaces and bracelets, as well as painted dots on the cheeks, characterize a number of the surviving figurines.

A MUSICIAN PLAYS FOR ALL ETERNITY Male figures also occur in the Cycladic repertoire. The most elaborate of these take the form of seated musicians, such as the lyre player from Keros (FIG. 4-2). Wedged between the echoing shapes of chair and instrument, he may be playing for the deceased in the afterlife, although, again, the meaning of these statuettes remains elusive. The harpist reflects the same preference for simple geometric shapes and large flat planes as the female figures. Still, the artist showed a keen interest in recording the elegant shape of what must have been a prized possession: the harp with its duck-bill or swan-head ornament at the apex of its sound box.

In one instance figurines of both a musician and a reclining woman were placed in a woman's grave. This suggests that the lyre players are not images of dead men, but it does not prove that the female figurines represent dead women. The man might be entertaining the deceased herself, not her image. The musicians also could portray a deity, a forerunner of the Greek god Apollo, whose instrument was the lyre and whose sacred animal was the swan. Given the absence of written documents in Greece at this date, as in prehistoric western Europe and the Near East, art historians cannot be sure of the meaning of many artworks. Some Cycladic figurines have been found in settlements rather than cemeteries, and it is likely, in fact, that the same form took on different meanings in different contexts.

MINOAN ART

Architecture

A PALACE CULTURE EMERGES During the third millennium B.C., both on the Aegean Islands and on the Greek mainland, most settlements were small and consisted only of simple buildings. Only rarely were the dead buried with costly offerings such as the Cycladic statuettes examined in the previous section. The opening centuries of the second millennium (the Middle Minoan period on Crete) are marked, in contrast, by the construction of palaces to house

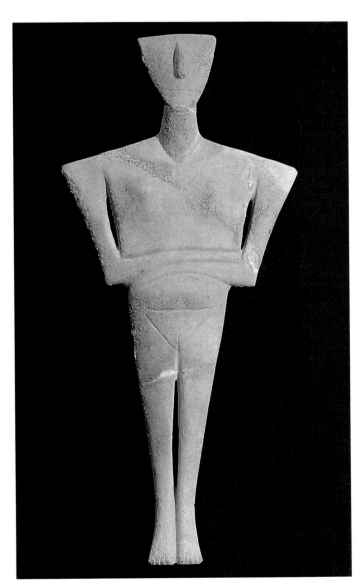

4-1 Figurine of a woman, from Syros (Cyclades), Greece, ca. 2500–2300 B.C. Marble, approx. 1′ 6″ high. National Archeological Museum, Athens.

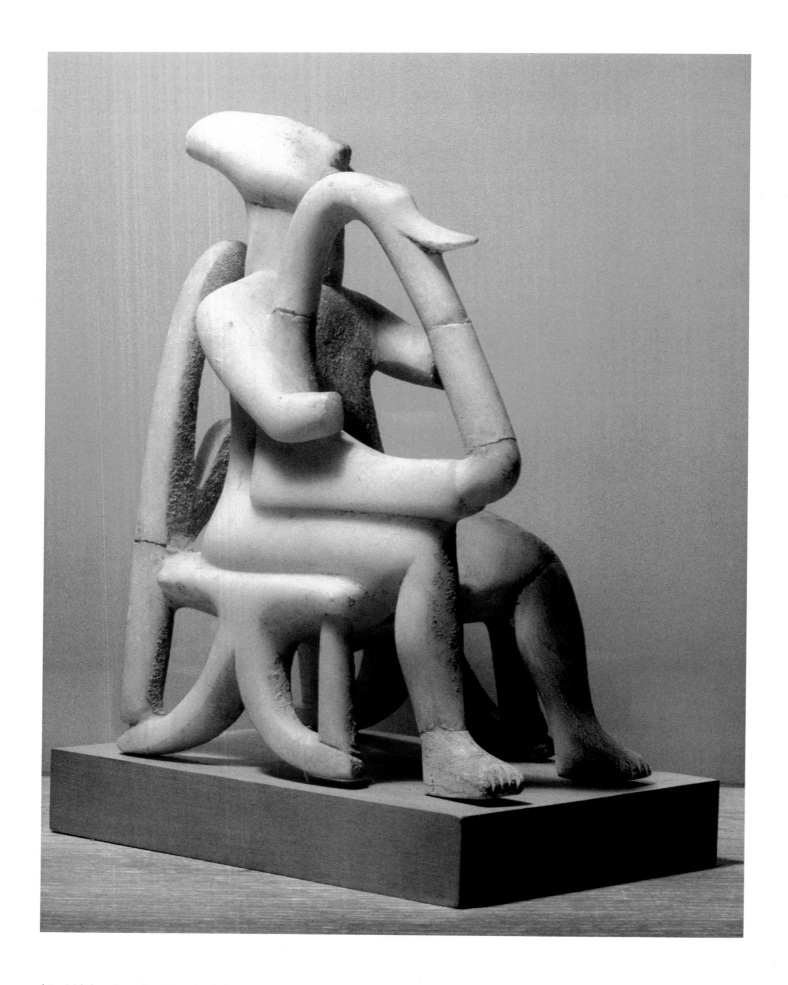

4-2 Male lyre player, from Keros (Cyclades), Greece, ca. 2700–2500 B.C. Marble, approx. 9″ high. National Archeological Museum, Athens.

Archeology, Art History, and the Art Market

One way the ancient world is fundamentally different from the world today is that ancient art is largely anonymous and undated. No equivalent exists in antiquity for the systematic signing and dating of artworks commonplace in the contemporary world. That is why the role of archeology in the study of ancient art is so important. Only the scientific excavation of ancient monuments can establish their context. Exquisite and strikingly "modern" sculptures such as the marble Cycladic figurines we illustrate (FIGS. 4-1 and 4-2) may be appreciated as masterpieces when displayed in splendid isolation in glass cases in museums or private homes. But to understand the role these or any other artworks played in ancient society—in many cases, even to determine the date and place of origin of an object—the art historian must know where the piece was uncovered. Only when the context of an artwork is known can one go beyond an appreciation of its formal qualities and begin to analyze its place in art history—and in the society that produced it.

The extraordinary popularity of Cycladic figurines in recent decades has had unfortunate consequences. Clandestine treasure hunters, anxious to meet the insatiable demands of modern collectors, have plundered many sites and smuggled their finds out of Greece to sell to the highest bidder on the international art market. Entire prehistoric cemeteries and towns have been destroyed because of the high esteem now held for these sculptures. Two British scholars recently calculated that only about ten percent of the known Cycladic marble statuettes come from secure archeological contexts. Many of the rest are probably forgeries, produced mostly after World War II when developments in modern art fostered a new appreciation of these abstract renditions of human anatomy and created a boom in demand for "Cycladica" among collectors. For some categories of Cycladic sculptures—those of unusual type or size—not a single piece with a documented provenance exists. Those groups may be inventions of twentieth-century artisans designed to fetch even higher prices due to their rarity. Consequently, most of the conclusions art historians have drawn about chronology, attribution to different workshops, range of types, and how the figurines were used are purely speculative. The importance of the information the original contexts would have provided cannot be underestimated. That information is, however, probably never recoverable.

kings, priestesses, and their retinues. This first, or Old Palace, period came to an abrupt end around 1700 B.C., when these grand structures were destroyed, probably by an earthquake. Rebuilding began sometime after 1700 B.C., and the ensuing New Palace (Late Minoan) period is the golden age of Crete, an era when the first great Western civilization emerged.

The rebuilt palaces were large, comfortable, and handsome, with ample staircases and courtyards for pageants, ceremonies, and games. They also had storerooms, offices, and shrines that permitted these huge complexes to serve as the key administrative, commercial, and religious centers of Minoan life, as well as royal residences. Archeologists have uncovered their ruins, along with rich treasures of art and artifacts that document the power and prosperity of Minoan civilization. The principal palace sites on Crete are at Knossos, Phaistos, Mallia, Kato Zakro, and Khania. All of the palaces were laid out along similar lines.

THE LABYRINTH OF THE MINOTAUR The largest of the palaces, at Knossos (FIGS. **4-3** and **4-4**), was the legendary home of King Minos. Here the hero Theseus was said to have battled with and defeated the bull-man Minotaur. According to legend, Theseus found his way out of the mazelike palace complex only with the aid of Minos's daughter Ariadne, who had given him a spindle of thread to mark his path through the labyrinth and then safely out again. In fact, the English word *labyrinth* derives from the intricate plan and scores of rooms of the Knossos palace. *Labrys* means "double ax" in Greek, and it is a recurring motif in the Minoan palace, referring to sacrificial slaughter. The *labyrinth* was the "House of the Double Axes," where the Minotaur dwelled.

Our aerial view (FIG. 4-3) reveals that the Knossos palace was a rambling structure built against the upper slopes and across the top of a low hill that rises from a fertile plain. All around the palace proper were mansions and villas, presumably belonging to high officials in the service of the royal house. The great rectangular court (no. 4 in FIG. 4-4), with the palace units grouped around it, had been leveled in the time of the old palace. The manner of the grouping of buildings suggests that the new palace was carefully planned, with the court as the major organizing element.

A secondary organization of the palace plan involves two long corridors. On the west side of the court, a north-south corridor (no. 6) separates official and ceremonial rooms from the magazines (no. 8), where wine, grain, oil, and honey were stored in large jars. On the east side of the court, a smaller east-west corridor (no. 14) separates the living quarters and reception rooms (to the south) from the workers' and servants' quarters (to the north). At the northwest corner of the palace is a theater-like area (no. 5) with steps on two sides that may have served as seats. This form is a possible forerunner of the later Greek theater (see FIG. 5-70). Its purpose is unknown, but it is a feature paralleled in the Phaistos palace.

The grand courtyard is the focus of many Cretan palaces, and, despite the complexity of the plans, these palaces seem to be variations of a common layout. The buildings were well constructed, with thick walls composed of rough, unshaped fieldstones imbedded in clay. Ashlar masonry was used at

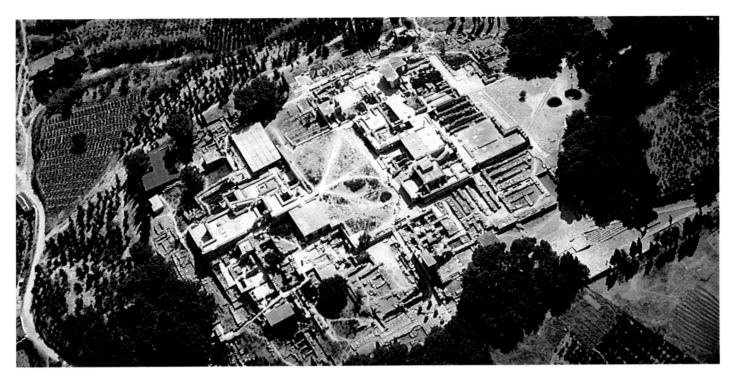

4-3 Aerial view of the palace at Knossos (Crete), Greece, ca. 1700–1400 B.C.

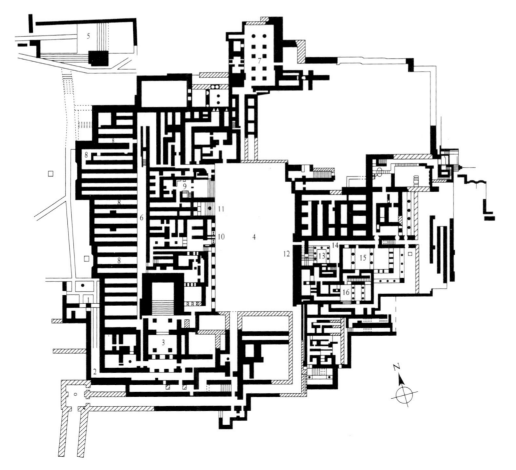

Reconstruction

Earlier { — Existing
structures { ⋯ Reconstruction

1. West porch
2. Corridor of the procession
3. South propylon
4. Central court
5. "Theater area"
6. North-south corridor
7. Pillar hall
8. Magazines
9. Throne room
10. Palace shrine and lower verandas
11. Stepped porch
12. Grand staircase
13. Light well
14. East-west corridor
15. Hall of the Double Axes
 (principal reception room)
16. "Queen's Megaron"

4-4 Plan of the palace at Knossos (Crete), Greece, ca. 1700–1400 B.C.

From a ceremonial scene of uncertain significance comes the famous fragment (FIG. 4-6) dubbed *La Parisienne (The Parisian Woman)* on its discovery because of the elegant dress, elaborate coiffure, and full rouged lips of the young woman (perhaps a priestess or even a goddess) depicted in the fresco. Although the representation is still convention bound (note especially the oversized frontal eye in the profile head), the charm and freshness of the mural are undeniable. The painting method used is appropriate to the lively spirit of the Minoans. Unlike the Egyptians, who painted in *fresco secco* (dry fresco), the Minoans used a *true (wet) fresco* method (see "Fresco Painting," Chapter 19, page 543), which required rapid execution and great skill in achieving quick, almost impressionistic effects. The spirit of *La Parisienne* is in large part from the verve of the artist's hand. The simple, light delicacy of the technique exactly matches the vivacity of the subject.

Liveliness and spontaneity also characterize the so-called *Toreador Fresco* (FIG. 4-7) from the palace at Knossos. Although here, too, only fragments of the full composition have been recovered (the dark patches are original; the rest is a modern restoration), they are extraordinary in their depiction of the dangerous Minoan ceremony of bull-leaping (see "Minoan Paintings Discovered in Egypt," page 84). Despite the modern nickname of the fresco, Minoan bull games were unlike Spanish bullfights. No weapons were used, and the bull was left unharmed, unless it was sacrificed after the games concluded.

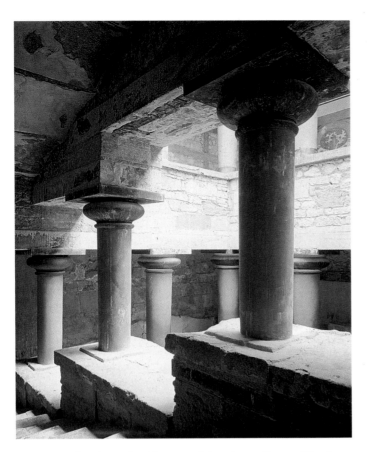

4-5 Stairwell in the residential quarter of the palace at Knossos (Crete), Greece, ca. 1700–1400 B.C.

building corners and around door and window openings. The Minoans also gave thought to such questions as drainage. A remarkably efficient system of terracotta pipes underlies the palace. The bathrooms and toilets in the residential quarter were luxuries at the time.

The Knossos palace was complex not only in plan but also in elevation. It had as many as three stories around the central court and even more on the south and east sides where the terrain sloped off sharply. Interior staircases built around light and air wells (FIG. 4-5) provided necessary illumination and ventilation. Painted Minoan columns, originally fashioned of wood but restored in stone, are characterized by their bulbous, cushionlike capitals, which resemble those of the later Greek Doric order (see "Doric and Ionic Temples," Chapter 5, page 112), and by their distinctive shape. The shafts taper from a wide top to a narrower base—the opposite of both Egyptian and later Greek columns.

Painting

FRESCOES FIT FOR A KING AND QUEEN Mural paintings liberally adorn the palace at Knossos, one of its most striking aspects. The rough fabric of the rubble walls was often coated with a fine white lime plaster and painted with frescoes, which, together with the red shafts and black capitals of the wooden columns, must have provided an extraordinarily rich effect. The frescoes depict many aspects of Minoan life (bull-leaping, processions, and ceremonies) and of nature (birds, animals, flowers, and marine life).

4-6 Minoan woman or goddess *(La Parisienne)*, from the palace at Knossos (Crete), Greece, ca. 1450–1400 B.C. Fragment of a fresco, approx. 10″ high. Archeological Museum, Herakleion.

Minoan Paintings Discovered in Egypt

Knowledge of ancient art and architecture grows daily as archeologists uncover new paintings, sculptures, pots, and other objects, as well as remains of previously unknown buildings. Archeologists infrequently, however, make a truly astounding discovery, but that is what happened when, in the 1980s, an Austrian expedition to Tell el-Daba in the eastern Nile Delta explored a huge palace of the sixteenth century B.C.

Tell el-Daba, ancient Avaris (see map, Chapter 3, page 42), was the capital city of the Hyksos. Until they were driven out around 1530 B.C. by Ahmose, founder of the New Kingdom, the Hyksos ruled the land of the Nile. The palatial complex the Austrians discovered was either built by Ahmose at the beginning of the Eighteenth Dynasty or under the last Hyksos pharaoh and destroyed by Ahmose. The archeologists uncovered the unexpected: pumice from the eruption of the Theran volcano (see "A Volcano Erupts, and the History of Art Is Revised," page 87) and thousands of fragments of Aegean wall paintings.

The most impressive of the Avaris murals depicts bull-leapers seen against a maze background that many believe is a topographical reference to the Minoan palace at Knossos. It is certain that not only is the subject of the painting Aegean but also the costumes, style, and technique—primarily true fresco on lime plaster. No one doubts that Aegean rather than Egyptian artists decorated the palace. One possible explanation for the Avaris paintings is that Ahmose or one of the last Hyksos kings of Egypt married an Aegean princess and that Aegean artists were brought at her request to the Nile to adorn the walls of her new home.

Whatever the final answer to this new archeological and historical riddle, the excavations at Tell el-Daba have demonstrated that contacts between Egypt and the Aegean world were not confined to trade and politics. In fact, painted walls and floors of Aegean style, technique, and subject also have been discovered in recent years in a Canaanite palace at Tel Kabri in northern Israel. Similar finds had been made much earlier at Alalakh in Syria (see map, Chapter 2, page 16, for both sites). Together these startling discoveries provide evidence for a rich international exchange of artists and ideas in the Mediterranean world at the middle of the second millennium B.C. Art historians can no longer study the great civilizations of Egypt, the Near East, and the Aegean in isolation.

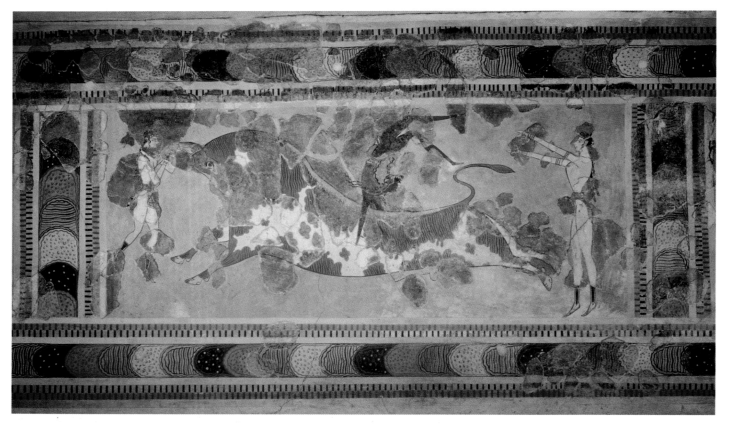

4-7 Bull-leaping *(Toreador Fresco)*, from the palace at Knossos (Crete), Greece, ca. 1450–1400 B.C. Approx. 2′ 8″ high, including border. Archeological Museum, Herakleion.

In the Knossos painting, the young women (with fair skin) and the youth (with dark skin) are depicted according to the widely accepted ancient convention for distinguishing male and female. The young man is shown in the air, having, it seems, grasped the bull's horns and somersaulted over its back in a perilous and extremely difficult acrobatic maneuver. The powerful charge of the bull is brilliantly suggested by the elongation of the animal's shape and the sweeping lines that form a funnel of energy, beginning at the very narrow hindquarters of the bull and culminating in its large sharp horns and galloping forelegs. The human figures also have stylized shapes, with typically Minoan pinched waists, and are highly animated. Although the profile pose with the full-view eye was a familiar convention in Egypt and Mesopotamia, the elegance of the Cretan figures, with their long, curly hair and proud and self-confident bearing distinguishes them from all other early figure styles. The angularity of the figures seen in Egyptian wall paintings is modified by the curving Minoan line that suggests the elasticity of the living and moving being.

FRESCOES BURIED BY A VOLCANO The Minoan figure style also may be seen in the fresco of a young fisherman (FIG. **4-8**) who holds his abundant catch in both hands. The painting is remarkable as a very early monumental study of the nude male figure, a subject that preoccupied later Greek artists for centuries. The fresco is not, however, from Knossos or even from Crete. It was uncovered much more recently in the excavations of Akrotiri on the volcanic island of Santorini (ancient Thera) in the Cyclades, some sixty miles north of Crete. In the Late Cycladic period, Thera was artistically, and possibly also politically, within the Minoan orbit. The extremely well-preserved mural paintings from Akrotiri are invaluable additions to the fragmentary and frequently misrestored frescoes from Crete. The excellent preservation of the Theran paintings is due to an enormous seismic explosion on Santorini that buried Akrotiri in volcanic pumice and ash, making it a kind of Pompeii of the prehistoric Aegean (see "A Volcano Erupts, and the History of Art Is Revised," page 87).

The Akrotiri frescoes decorated the walls of houses, not the walls of a great palace such as that at Knossos, and therefore the number of painted walls from the site is especially impressive. Another fresco from the same room of the same house as that of the fisherman is much smaller but filled with dozens of figures, ships, and buildings. This *Miniature Ships Fresco,* as it has been called, formed a frieze about seventeen inches high at the top of at least three walls of the room. In our detail of the fresco (FIG. **4-9**), a great fleet sails between two ports, perhaps taking part in a sea festival or perhaps engaged in a naval campaign that calls to mind Homer's much later catalog of ships in the *Iliad*. Such a detailed representation of the movement of ships and people from port to port does not appear again until the Column of the Roman emperor Trajan (see FIG. 10-42) almost two millennia later. The details of ship design and sailing are carefully observed in the fresco, as if it were painted by one who knew ships well. Just as closely studied are the placements and poses of sailors, rowers, and passengers.

Little of the conventional stereotyping and repetition that appears in such representations throughout the history of art is evident in the Akrotiri fresco. Instead, the arrangement of

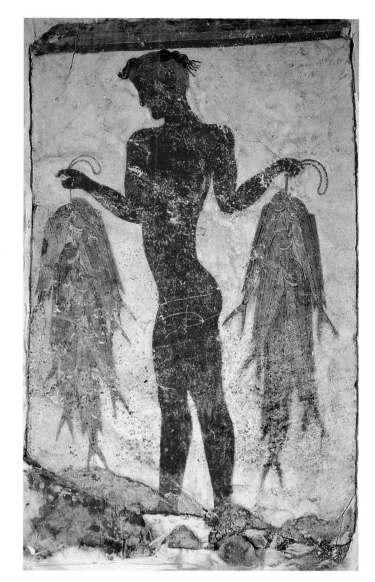

4-8 Young fisherman with his catch, detail of a fresco in Room 5, West House, Akrotiri, Thera (Cyclades), Greece, ca. 1650 B.C. Approx. 4′ 5″ high. National Archeological Museum, Athens.

figures and poses varies significantly according to each person's role—steering, tending to the sail, rowing, or simply sitting and conversing. Dolphins frolic about the ships, and on the left shore (FIG. 4-9, upper left) a lion pursues fleeing deer. The ports—the one at the left encircled by a river represented as arching above it—show quays, houses, and streets occupied by a variety of people attentive to the coming and going of the ships. The whole composition has an openness and lightness that suggest the freedom of movement of a people born to the sea.

THE CELEBRATION OF NATURE The almost perfectly preserved mural paintings (FIG. 4–10) of another room from Akrotiri capture especially well the freshness and vitality of this vision of the Aegean world. In *Spring Fresco,* nature itself is the sole subject, although the artist's aim was not to render the rocky island terrain realistically but, rather, to capture the landscape's essence and to express joy in the splendid

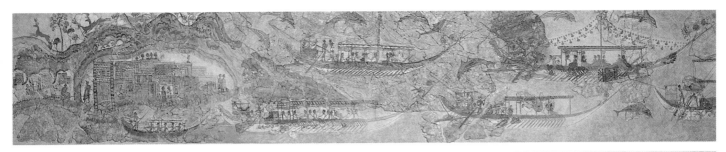

4-9 Flotilla, detail of *Miniature Ships Fresco,* from Room 5, West House, Akrotiri, Thera (Cyclades), Greece, ca. 1650 B.C. Approx. 1′ 5″ high. National Archeological Museum, Athens.

surroundings. The irrationally undulating and vividly colored rocks, the graceful lilies swaying in the cool island breezes, and the darting swallows express the vigor of growth, the delicacy of flowering, and the lightness of birdsong and flight. In the lyrical language of curving line, the artist celebrated the rhythms of spring. This is the first known example of a pure landscape painting, one that not only has no humans but also has no narrative element (compare FIG. 1-18). The *Spring Fresco* represents the polar opposite of the first efforts at mural painting in the caves of Paleolithic Europe, where animals (and occasionally humans) appeared as isolated figures without any indication of setting.

SEA LIFE ON MINOAN POTTERY The love of nature manifested itself in Crete on the surfaces of painted vases

even before the period of the new palaces. During the Middle Minoan period, Cretan potters fashioned sophisticated shapes using newly introduced potters' wheels and decorated their vases in a distinctive and fully polychromatic style. These Kamares Ware vessels, named for the cave on the slope of Mount Ida where they were first discovered, have been found in quantity at Phaistos and Knossos. On our example (FIG. 4-11), as on other Kamares vases, creamy white and reddish-brown decoration is set against a rich black ground. The central motif is a great leaping fish—a forerunner of the diving dolphins of Late Minoan and Late Cycladic murals—and perhaps a fishnet surrounded by a host of curvilinear abstract patterns including waves and spirals. The swirling lines evoke life in the sea, and both the abstract and the natural forms are beautifully adjusted to and integrated with the shape of the vessel.

4-10 Landscape with swallows *(Spring Fresco),* from Room Delta 2, Akrotiri, Thera (Cyclades), Greece, ca. 1650 B.C. Approx. 7′ 6″ high. National Archeological Museum, Athens.

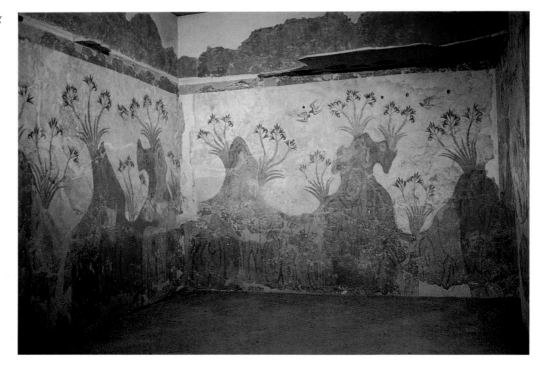

A Volcano Erupts, and the History of Art Is Revised

Today, ships bound for the beautiful Greek island of Santorini, with its picture-postcard white houses, churches, shops, and restaurants, weigh anchor in a bay beneath steep, crescent-shaped cliffs. Until about 20,000 B.C., however, ancient Thera had a roughly circular shape and gentler slopes. Then, suddenly, a volcanic eruption blew out the center of the island, leaving behind the moon-shaped main island and several lesser islands grouped around a bay that roughly corresponds to the shape of the gigantic ancient volcano. The volcano erupted again, thousands of years later, during the zenith of Aegean civilization.

Then, the site of Akrotiri, which Greek excavators gradually are uncovering, was buried by a pumice layer more than a yard deep in some areas and by an even larger volume of volcanic ash *(tephra)* that often exceeds five yards in depth, even after nearly forty centuries of erosion. Whole rooms were filled with tephra, and the walls of some houses were pelted with boulders the volcano spewed forth. Closer to the volcano's cone, the tephra is almost sixty yards deep in places. In fact, the eruption's force was so powerful that ash was blown by the wind and pumice carried by the sea currents throughout the ancient Mediterranean, not only to Crete, Rhodes, and Cyprus but also as far away as Anatolia, Egypt (see "Minoan Paintings Discovered in Egypt," page 84), Syria, and Israel.

Until recently, most scholars embraced the theory Spyridon Marinatos, an eminent Greek archeologist, formulated that the otherwise unexplained demise of Minoan civilization on Crete around 1500 B.C. was the by-product of the volcanic eruption on Thera. According to Marinatos, devastating famine followed the rain of ash that fell on Crete. This view has been reevaluated in the light of new evidence. Archeologists now know that after the eruption, life went on in Crete, if not on Thera. At one Cretan site Theran pumice was collected in conical cups and placed on a monumental stairway, possibly as a votive offering. Archeologists and other scientists, working closely in an impressive and most welcome interdisciplinary research effort, have pinpointed the date of a major climatic event as 1628 B.C. They have studied tree rings at sites in Europe and in North America for evidence of retarded growth and have examined ice cores in Greenland for peak acidity layers. Both kinds of evidence testify to a significant disruption in weather patterns in that year. Today most—but not all—scholars believe the cause of this disruption was the cataclysmic volcanic eruption on Thera.

The revised date of the Theran eruption has profound consequences for the chronology of Aegean art. All the Theran paintings illustrated here (FIGS. 4-8 to 4-10) are now thought to be at least one hundred fifty years older than they were considered not long ago. They predate by many decades the great frescoes from the Knossos palace (FIGS. 4-6 and 4-7). The discovery has implications for the dating of art objects from other areas as well because of the important interconnections between the Aegean, Egypt, and the Near East during the second millennium B.C.

4-11 Kamares Ware jar, from Phaistos (Crete), Greece, ca. 1800–1700 B.C. Approx. 1' 8" high. Archeological Museum, Herakleion.

The sea and the creatures that inhabit it also inspired the Late Minoan Marine Style octopus jar (FIG. **4-12**) from Palaikastro, which is contemporary with the new palaces at Knossos and elsewhere. The tentacles of the octopus reach out over the vessel's curving surfaces, embracing the piece and emphasizing its volume. This is a masterful realization of the relationship between the vessel's decoration and its shape, always a problem for the ceramicist. This later vase differs markedly from its Kamares Ware predecessor in color. Not only is the octopus jar more muted in tone, but the Late Minoan artist also reversed the earlier scheme and placed dark silhouettes on a light ground. This remained the norm for about a millennium in Greece, until about 530 B.C. when, albeit in a very different form, light figures on a dark ground emerged once again as the preferred manner (see FIG. 5-20).

MINOAN FUNERARY RITUALS Midway in size and complexity between the decorated clay vessels and the monumental frescoes of Crete and Thera are the paintings on a Late Minoan limestone sarcophagus (FIG. **4-13**) found at Hagia Triada on the southern coast of Crete. The paintings are closely related in technique, color scheme, and figure style to contemporary palace frescoes, but the subject is foreign to the

4-12 Marine Style octopus jar, from Palaikastro (Crete), Greece, ca. 1500 B.C. Approx. 11″ high. Archeological Museum, Herakleion.

palace repertoire. Befitting the function of the sarcophagus as a burial container, the paintings illustrate the funerary rites in honor of the dead. They provide welcome information about Minoan religion, which still remains obscure despite a century of excavation on Crete. At the right the dead man appears upright in front of his own tomb, like the New Testament's raised Lazarus in medieval art, and watches as three men (note their dark flesh tone) bring offerings to him.

At the left, two light-skinned women carry vessels and pour a libation to the deceased while a male musician plays a lyre. The musician immediately brings to mind the Early Cycladic statuettes of lyre players (FIG. 4-2) deposited in tombs, which may indicate some continuity in funerary customs and beliefs from the Early to the Late Bronze Age in the Aegean.

Sculpture

JOYFUL FARMERS Also from Hagia Triada is the so-called *Harvester Vase* (FIG. **4-14**), probably the finest surviving example of Minoan relief sculpture. Only the upper half of the egg-shaped body and neck of the vessel are preserved. Missing are the lower parts of the harvesters (or, as some think, sowers) and the ground on which they stand. Formulaic scenes of sowing and harvesting were staples of Egyptian funerary art (see FIG. 3-17), but the Minoan artist shunned static repetition in favor of a composition that bursts with the energy of its individually characterized figures. The relief shows a riotous crowd singing and shouting as they go to or return from the fields with the forward movement and lusty exuberance of the youths vividly expressed.

Although most of the figures conform to the age-old convention of combined profile and frontal views, one figure (near the center of our illustration) is singled out from his companions. He shakes a rattle to beat time, and the artist depicted him in full profile with his lungs so inflated with air that his ribs show. This is one of the first instances in the history of art of a sculptor showing a keen interest in the underlying muscular and skeletal structure of the human body. This is not a pictogram for humans, but a painstaking study of human anatomy, a remarkable achievement, especially given the size of the *Harvester Vase*, barely five inches at its greatest diameter. Equally noteworthy is how the sculptor recorded the tension and relaxation of facial muscles with astonishing exactitude. This degree of animation of the human face is without precedent in ancient art.

4-13 Sarcophagus, from Hagia Triada (Crete), Greece, ca. 1450–1400 B.C. Painted limestone, approx. 4′ 6″ long. Archeological Museum, Herakleion.

SNAKE GODDESS OR PRIESTESS? Unlike Mesopotamia and Egypt, Minoan Crete had no temples nor any monumental statues of gods, kings, or monsters, although large wooden images may once have existed. What remains of Minoan sculpture in the round is small in scale, such as the so-called *Snake Goddess* (FIG. **4-15**) from the palace at Knossos. It is one of several similar figurines some scholars believe may represent mortal attendants rather than a deity, although the prominently exposed breasts suggest that these figurines stand in the long line of prehistoric fertility images usually considered divinities. (The woman depicted in the Knossos statuette not only holds snakes in her hands but also supports a leopardlike feline peacefully on her head. This implied power over the animal world also seems appropriate for a deity.) The frontality of the figure is reminiscent of Egyptian and Near Eastern statuary, but the costume is clearly Minoan. The open bodice and flounced skirt worn by Minoan women are frequently depicted in Minoan art. If the statuette represents a goddess, as seems more likely, then it is yet another example of human beings fashioning their gods in their own images.

Scholars dispute the circumstances ending the Minoan civilization, although they now widely believe Mycenaeans had already moved onto Crete and established themselves at Knossos at the end of the New Palace period. From the palace at

4-15 *Snake Goddess*, from the palace at Knossos (Crete), Greece, ca. 1600 B.C. Faience, approx. 1' 1½" high. Archeological Museum, Herakleion.

4-14 *Harvester Vase*, from Hagia Triada (Crete), Greece, ca. 1500 B.C. Steatite, greatest diameter approx. 5". Archeological Museum, Herakleion.

Knossos, these intruders appear to have ruled the island for at least half a century, perhaps much longer. Parts of the palace continued to be occupied until its final destruction around 1200 B.C., but its importance as a cultural center faded soon after 1400 B.C., as the focus of Aegean civilization shifted to the Greek mainland.

MYCENAEAN (LATE HELLADIC) ART

HOMER'S MYCENAEANS The origins of the Mycenaean culture are still debated. The only certainty is the presence of these forerunners of the Greeks on the mainland about the time the old palaces were built on Crete — that is, about the beginning of the second millennium B.C. Doubtless these people were influenced by Crete even then, and some believe the mainland was a Minoan economic dependency for a long time. In any case, Mycenaean power developed on the mainland in the days of the new palaces on Crete, and by 1500 B.C. a distinctive Mycenaean culture was flourishing in Greece. Several centuries later, Homer described Mycenae as "rich in gold." The dramatic discoveries of Schliemann and his successors have fully justified this characterization, even if today's archeologists no longer view the Mycenaeans solely through the heroic eyes of Homer.

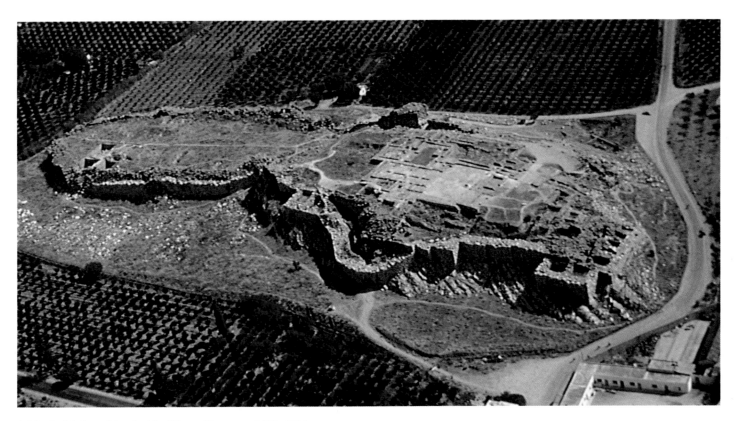

4-16 Aerial view of the citadel at Tiryns, Greece, ca. 1400–1200 B.C.

Architecture

The destruction of the Cretan palaces left the mainland culture supreme. Although this Late Helladic civilization has come to be called Mycenaean, Mycenae was but one of several large citadels. Mycenaean remains also have been uncovered at Tiryns, Orchomenos, Pylos, and elsewhere, and Mycenaean fortification walls have even been found on the Acropolis of Athens. The best-preserved and most impressive Mycenaean remains are those of the fortified palaces at Tiryns and Mycenae. Both were built beginning about 1400 B.C. and burned (along with all the others) between 1250 and 1200 B.C., when the Mycenaeans seem to have been overrun by northern invaders or to have fallen victim to internal warfare.

A CITADEL GIANTS BUILT Homer knew the citadel of Tiryns (FIGS. **4-16** and **4-17**), located about ten miles from Mycenae, as Tiryns of the Great Walls. In the second century A.D., when Pausanias, author of an invaluable guidebook to Greece, visited the site, he marveled at the towering fortifications and considered the walls of Tiryns as spectacular as the pyramids of Egypt. Indeed, the Greeks of the historical age believed mere humans could not have erected such edifices and instead attributed the construction of the great Mycenaean citadels to the mythical *Cyclopes*, a one-eyed race of giants. Historians still refer to the huge roughly cut stone blocks forming the massive fortification walls of Tiryns and other Mycenaean sites as *Cyclopean masonry.*

The heavy walls of Tiryns and other Mycenaean palaces contrast sharply with the open Cretan palaces and clearly reveal their defensive character. Those of Tiryns average about twenty feet in thickness and in one section house a long

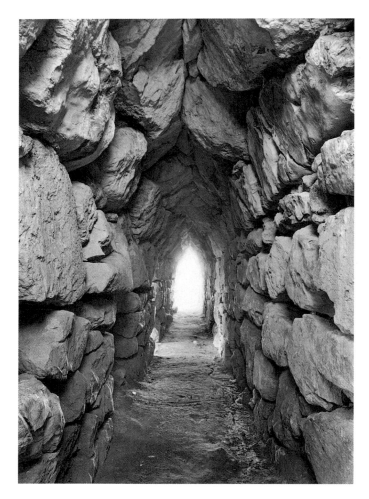

4-17 Corbeled gallery in the walls of the citadel, Tiryns, Greece, ca. 1400–1200 B.C.

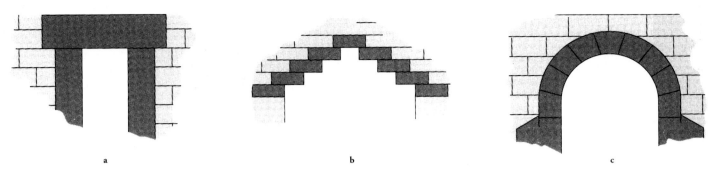

4-18 Three methods of spanning a passageway: (*a*) post and lintel, (*b*) corbeled arch, (*c*) arch.

gallery (FIG. 4-17) covered by a *corbeled vault* (FIG. **4-18b**). Here the large irregular Cyclopean blocks were piled in horizontal courses and then cantilevered inward until the two walls met in a pointed arch. No mortar was used, and the vault is held in place only by the weight of the blocks (often several tons each), by the smaller stones used as wedges, and by the clay that fills some of the empty spaces. This primitive but effective vaulting scheme possesses an earthy dynamism and is very impressive in its crude monumentality. It is easy to see how a later age came to believe that the uncouth Cyclopes were responsible for these massive but unsophisticated fortifications.

Would-be attackers at Tiryns were compelled to approach the palace within the walls (FIG. **4-19**) via a long ramp that forced the (usually right-handed) soldiers to expose their unshielded sides to the Mycenaean defenders above. Then—if

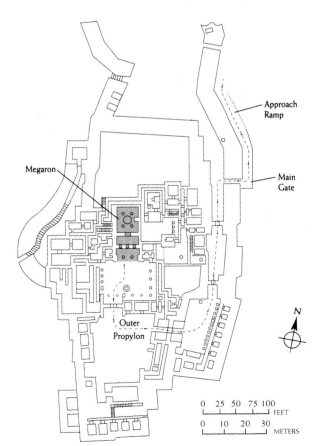

4-19 Plan of the palace and southern part of the citadel, Tiryns, Greece, ca. 1400–1200 B.C.

they got that far—they had to pass through a series of narrow gates that also could be defended easily. Inside, at Tiryns as elsewhere, the most important element in the palace plan was the *megaron,* or reception hall, of the king. The main room of the megaron had a throne against the right wall and a central hearth bordered by four Minoan-style wooden columns serving as supports for the roof. The throne room was preceded by a vestibule with a columnar facade. A variation of this plan later formed the core of some of the earliest Greek temple plans. This fact suggests some architectural continuity during the so-called Dark Ages that followed the collapse of Mycenaean civilization.

THE HOME OF THE CONQUERORS OF TROY
The severity of these fortress-palaces was relieved by frescoes, as in the Cretan palaces, and, at Agamemnon's Mycenae at least, by monumental architectural sculpture. The Lion Gate (FIG. **4-20**) is the outer gateway of the stronghold at Mycenae. It is protected on the left by a wall built on a natural rock outcropping and on the right by a projecting bastion of large blocks. Any approaching enemies would have had to enter this twenty-foot-wide channel and face Mycenaean defenders above them on both sides. The gate itself is formed of two great monoliths capped with a huge lintel (FIG. 4-18a). Above the lintel, the masonry courses form a corbeled arch (FIG. 4-18b), leaving an opening that lightens the weight the lintel carries. This *relieving triangle* is filled with a great limestone slab where two lions carved in high relief stand on the sides of a Minoan-type column. They rest their forepaws on the two altars under the column. The whole design admirably fills its triangular space, harmonizing in dignity, strength, and scale with the massive stones that form the walls and gate. Similar groups appear in miniature on Cretan seals, but the idea of placing monstrous guardian figures at the entrances to palaces, tombs, and sacred places has its origin in Egypt and the Near East (compare, for example, the Great Sphinx of Gizeh, FIG. 3-11, and the later lion and lamassu gates of Assyria, FIGS. 2-18 and 2-21). In fact, at Mycenae the animals' heads were fashioned separately and are lost. It is possible that the "lions" were actually composite beasts in the Eastern tradition, perhaps sphinxes.

A TOMB BENEATH A MOUND The Lion Gate at Mycenae and the towering fortification wall circuit of which it formed a part were constructed at about the presumed date of the Trojan War. At that time wealthy Mycenaeans were laid to rest outside the citadel walls in beehive-shaped tombs (*tholoi;*

4-20 Lion Gate, Mycenae, Greece, ca. 1300–1250 B.C. Limestone, relief panel approx. 9′ 6″ high.

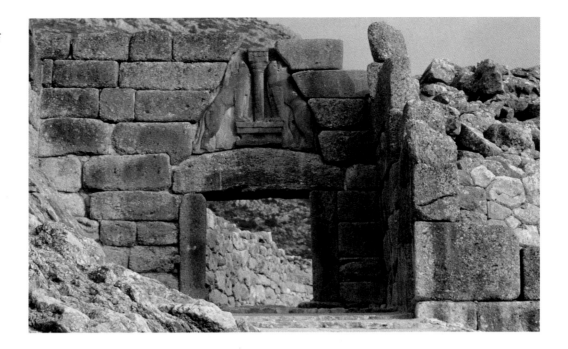

singular, *tholos)* covered by enormous earthen mounds. The best preserved of these is the so-called Treasury of Atreus (FIG. **4-21**), which already in antiquity was mistakenly believed to be the repository of the treasure of Atreus, father of Agamemnon and Menelaus. Approached by a long passageway *(dromos)*, the tomb chamber was entered through a doorway surmounted by a relieving triangle similar to that employed in the roughly contemporary Lion Gate. The tholos is composed of a series of stone corbeled courses laid on a circu-

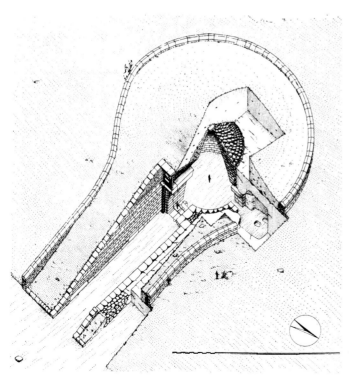

4-21 Cutaway view of the Treasury of Atreus, Mycenae, Greece, ca. 1300–1250 B.C.

lar base and ending in a lofty dome (FIG. **4-22**). The vault probably was built using rough-hewn blocks. After they were set in place, the stonemasons had to finish the surfaces with great precision to conform to both the horizontal and vertical curves of the wall. The principle involved is no different from that of the corbeled gallery of Tiryns (FIG. 4-17). But the problem of constructing a complete dome is much more complicated, and the execution of the vault in the Treasury of Atreus is much more sophisticated than that of the vaulted gallery at Tiryns. About forty-three feet high, this is the largest known vaulted space without interior supports in all antiquity until the Roman Pantheon (see FIG. 10-50), a building constructed almost fifteen hundred years later using a new technology—concrete construction—unknown to the Mycenaeans.

Metalwork, Sculpture, and Painting

TREASURES OF REVERED KINGS The Treasury of Atreus had been thoroughly looted long before its modern rediscovery, but spectacular grave goods have been found elsewhere at Mycenae. Just inside the Lion Gate, but predating it by some three centuries, Schliemann came across what archeologists now designate as Grave Circle A. Here, at a site protected within the circuit of the later walls, Schliemann excavated six deep shafts that had served as tombs for kings and their families. The dead were laid to rest on the floors of these shaft graves with masks covering their faces, recalling the Egyptian funerary practice doubtless familiar to the Mycenaeans. Women were buried with their jewelry and men with their weapons and golden cups.

Among the most spectacular of Schliemann's finds is the beaten *(repoussé)* gold mask illustrated here (FIG. **4-23**), one of several from the royal burial complex. It often has been compared to the fabulous gold mummy mask of Tutankhamen

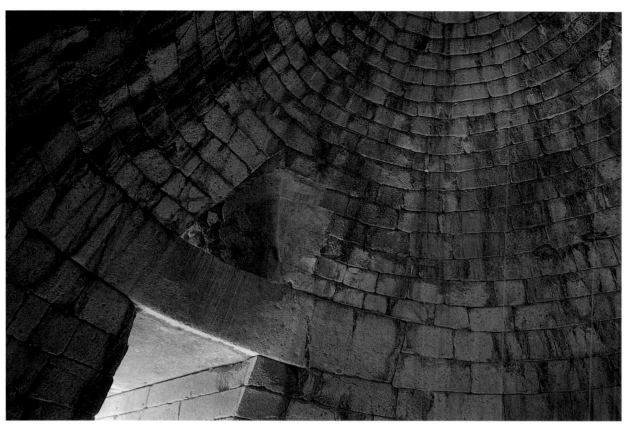

4-22 Vault of the tholos of the Treasury of Atreus, Mycenae, Greece, ca. 1300–1250 B.C. Approx. 43′ high.

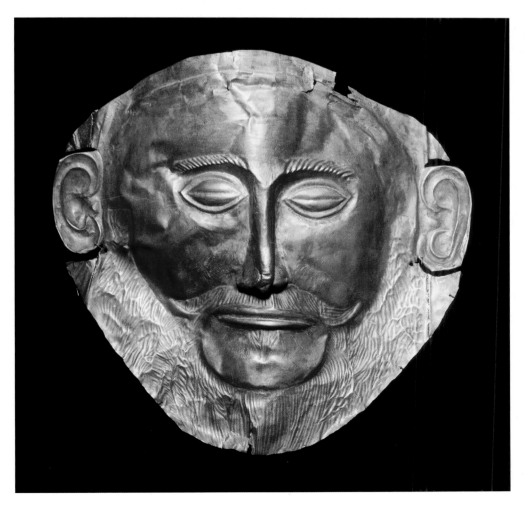

4-23 Funerary mask, from Grave Circle A, Mycenae, Greece, ca. 1600–1500 B.C. Beaten gold, approx. 1′ high. National Archeological Museum, Athens.

4-24 Inlaid dagger blade with lion hunt, from Grave Circle A, Mycenae, Greece, ca. 1600–1500 B.C. Bronze, inlaid with gold, silver, and niello, approx. 9″ long. National Archeological Museum, Athens.

4-25 Head of a sphinx(?), from Mycenae, Greece, ca. 1300–1250 B.C. Painted plaster, approx. $6\frac{1}{2}$″ high. National Archeological Museum, Athens.

4-26 *Warrior Vase*, from Mycenae, Greece, ca. 1200 B.C. Approx. 1′ 4″ high. National Archeological Museum, Athens.

(see FIG. 3-37). The treatment of the human face is, of course, more primitive in the Mycenaean mask. But this was one of the first known attempts in Greece to render the human face at life-size, whereas Tutankhamen's mask stands in a venerable line of monumental Egyptian sculptures going back more than a millennium. It is not known whether the Mycenaean masks were intended as portraits, but different physical types were recorded with care. Youthful faces as well as mature ones were depicted. Our example, with its full beard, must portray a mature man, perhaps a king—although not Agamemnon, as Schliemann wished. If Agamemnon was a real king, he lived some three hundred years after this mask was fashioned. Clearly the Mycenaeans were "rich in gold" long before Homer's heroes fought at Troy.

Also found in Grave Circle A were several magnificent bronze dagger blades inlaid with gold, silver, and *niello* (a black metallic alloy), again attesting to the wealth of the Mycenaean kings, as well as to their warlike nature. The largest and most elaborate of the group (FIG. **4-24**) is decorated with a scene of four hunters attacking a lion that has struck down a fifth hunter, while two other lions flee. The slim-waisted, long-haired figures are Minoan in style, but the subject is borrowed from the repertoire of the ancient Near East. It is likely a Minoan metalworker made the dagger for a Mycenaean patron who admired Minoan art but had different tastes in subject matter than his Cretan counterparts.

A MYCENAEAN SPHINX? Monumental figural art is very rare on the Greek mainland, as on Crete, other than the Minoan-style paintings that once adorned the walls of Mycenaean palaces. The triangular relief of the Lion Gate at Mycenae is exceptional, as is the painted plaster head (FIG. **4-25**) of a woman, goddess, or, perhaps, sphinx found just outside the citadel of Mycenae. The white flesh tone indicates the head is female. The hair and eyes are painted dark blue, almost black, while the lips, ears, and headband are red. The artist decorated the cheeks and chin with red circles surrounded by a ring of

red dots, recalling the facial paint or tattoos recorded on Early Cycladic figurines of women. The large staring eyes give the face a menacing, if not terrifying, expression appropriate for a guardian figure such as a sphinx.

Were it not for this head and one or two other exceptional pieces, art historians might have concluded, wrongly, that the Mycenaeans had no monumental freestanding statuary—a reminder that it is always dangerous to generalize from the fragmentary remains of an ancient civilization. Nonetheless, life-size Aegean statuary must have been rare. After the collapse of Mycenaean civilization and for the next several hundred years, no attempts at monumental statuary are evident until, after the waning of the Dark Ages, Greek sculptors were exposed to the great sculptural tradition of Egypt.

WARRIORS MARCH TO BATTLE One art that did continue throughout the period after the downfall of the Mycenaean palaces was vase painting. One of the latest examples of Bronze Age painting is the *krater* (bowl for mixing wine and water) from Mycenae commonly called the *Warrior Vase* (FIG. **4-26**) after its prominent frieze of soldiers marching off to war. At the left a woman bids farewell to the column of heavily armed warriors moving away from her. The painting on this vase has no indication of setting and lacks the landscape elements that characterized earlier Minoan and Mycenaean art. All the soldiers also repeat the same pattern, a far cry from the variety and anecdotal detail of the lively procession of the Minoan *Harvester Vase* (FIG. 4-14).

This simplification of narrative is paralleled in other painted vases by the increasingly schematic and abstract treatment of marine life. The octopus, for example, eventually became a stylized motif composed of concentric circles and spirals that are almost unrecognizable as a sea creature. By Homer's time, the heyday of Aegean civilization was but a distant memory, and the men and women of Crete and Mycenae—Minos and Ariadne, Agamemnon and Helen—had assumed the stature of heroes of a lost golden age.

THE GREEK WORLD

Rome
Sperlonga
ITALY
Naples
Pompeii
Paestum
N
Riace
Sicily
Gela
Syracuse

Adriatic Sea
Ionian Sea

MACEDONIA
Pella
Mt. Olympus ▲
Corfu

THRACE
Thasos
Samothrace
Troy
ASIA MINOR
Aegean Sea
Pergamon
Cape Artemision
Phokaia
IONIA
Chios
Delphi Chaeronea
Eretria
Ephesos
Thebes
Mt. Pentelicus
Antioch
Sikyon Eleusis
Marathon
Samos
Priene
Corinth
Athens
Miletos
Elis
Anavysos
Didyma
CARIA
Olympia
Mycenae ATTICA
Tegea Argos
Salamis
Delos
Halikarnassos
PELOPONNESOS
Aegina
Paros
Sparta
Siphnos
Knidos
Epidauros
Melos
Thera
Rhodes

Mediterranean Sea
Knossos
Crete
Prinias

0 50 100 miles
0 50 100 kilometers

900 B.C.		700 B.C.		600 B.C.		500 B.C.
GEOMETRIC		ORIENTALIZING		ARCHAIC		

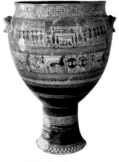

Dipylon krater
ca. 740 B.C.

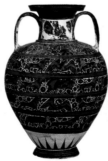

Corinthian amphora
ca. 625–600 B.C.

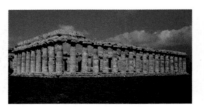

Temple of Hera I
Paestum, ca. 550 B.C.

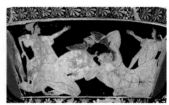

Euphronios, Herakles wrestling
Antaios, ca. 510 B.C.

First Olympic Games, 776 B.C.

Homer, fl. ca. 750–700 B.C.

Greek trading post established at Naukratis, Egypt, ca. 650–630 B.C.

Draco formulates first written law code for Athens, 621 B.C.

Sappho, fl. ca. 600 B.C.

Aeschylus, 525–456 B.C.

Democratic reforms of Kleisthenes, 507 B.C.

5

GODS, HEROES, AND ATHLETES

THE ART OF ANCIENT GREECE

480 B.C.	450 B.C.	400 B.C.	323 B.C.	31 B.C.
EARLY CLASSICAL (SEVERE)	HIGH CLASSICAL	LATE CLASSICAL	HELLENISTIC	

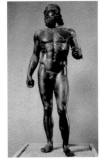

Riace warrior
ca. 460–450 B.C.

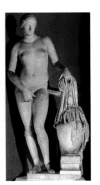

Phidias
Athena Parthenos
ca. 438 B.C.

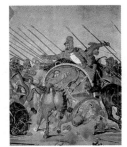

Praxiteles
Aphrodite of Knidos
ca. 350–340 B.C.

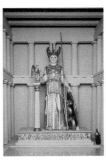

Philoxenos of Eretria
Battle of Issus
ca. 310 B.C.

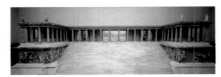

Altar of Zeus
Pergamon
ca. 175 B.C.

Persian Wars, 499–479 B.C.

Sophocles, 496–406 B.C.

Pericles, 490–429 B.C.

Herodotus, ca. 485–425 B.C.

Euripides, 485–406 B.C.

Sack of Athenian Acropolis by Persians, 480 B.C.

Socrates, 469–399 B.C.

Delian League treasury transferred to Athens, 454 B.C.

Peloponnesian War, 431–404 B.C.

Plato, 429–347 B.C.

Aristotle, 384–322 B.C.

Battle of Issus, 333 B.C.

Alexander the Great, r. 336–323 B.C.

Roman conquest of Greece, 146 B.C.

Attalos III wills Pergamene kingdom to Rome, 133 B.C.

Sack of Athens by Sulla, 86 B.C.

Battle of Actium, 31 B.C.

GREEK HUMANISM

"For we are lovers of the beautiful, yet simple in our tastes, and we cultivate the mind without loss of manliness. . . . [We are] the school of Hellas."[1] In the fifth century B.C., the golden age of Athens, the historian Thucydides quoted Pericles, the leader of the Athenians, making this assertion in praise of his fellow citizens, comparing their open, democratic society with the closed barracks state of their rivals, the Spartans. But Pericles might have been speaking in general of Greek culture and its ideal of humanistic education and life. For the Greeks, humanity was what mattered, and humans were, in the words of the philosopher Protagoras, the "measure of all things." This humanistic worldview led the Greeks to create the concept of democracy (rule by the *demos*, the people) and to make seminal contributions in the fields of art, literature, and science. The Greek exaltation of humanity and honoring of the individual are so completely part of the modern Western habits of mind that most people are scarcely aware that these ideas originated in the minds of the Greeks.

GODS AND HUMANS IN GREECE Even the gods of the Greeks (see "The Gods and Goddesses of Mount Olympus," page 99), in marked contrast to the divinities of the Near East, assumed human forms whose grandeur and nobility were not free from human frailty. Indeed, unlike the gods of Egypt and Mesopotamia, the Greek deities differed from human beings only in that they were immortal. It has been said the Greeks made their gods into humans and their humans into gods. Humans, becoming the measure of all things, in turn must represent, if all things in their perfection are beautiful, the unchanging standard of the best. Creating the perfect individual became the Greek ideal.

The Greeks, or *Hellenes,* as they called themselves, appear to have been the product of an intermingling of Aegean peoples and Indo-European invaders. They never formed a single nation but instead established independent city-states or *poleis* (singular, *polis*). The Dorians of the north, who many believe brought an end to Mycenaean civilization, settled in the Peloponnesos. Across the Aegean, the western coast of Asia Minor (modern Turkey) was settled by the Ionians, whose origin is disputed. Some say they were forced out of Greece by the northern invaders and sailed from Athens to Asia Minor. Others hold that the Ionians developed in Asia Minor itself between the eleventh and eighth centuries B.C. out of a mixed stock of settlers. Whatever the origins of the various regional populations, political development differed from polis to polis, although a pattern emerged. Rule was first by kings, then by nobles, and then by tyrants who seized personal power. At last, in Athens, twenty-five hundred years ago, the tyrants were overthrown and democracy was established.

OLYMPIA, HELLAS, AND ATHENS In 776 B.C., the separate Greek-speaking states held their first ceremonial games in common at Olympia. The later Greeks calculated their chronology from these first Olympic Games—the first *Olympiad.* From then on, despite their differences and rivalries, the Greeks regarded themselves as citizens of *Hellas,* distinct from the surrounding "barbarians" who did not speak Greek. The enterprising Hellenes, greatly aided by their indented coasts and island stepping-stones, became a trading and colonizing people who enlarged the geographic and cultural boundaries of Hellas. In fact, today the best preserved of all the grand temples the Greeks erected are found not in Greece proper but in their western colonies in Italy.

Nonetheless, Athens, the capital of Greece today, has justifiably become the symbol of ancient Greek culture. Many of the finest products of Greek civilization were created there. Athens is where the great plays of Aeschylus, Sophocles, and Euripides were performed. And there, in the city's marketplace *(agora),* covered colonnades *(stoas),* and gymnasiums *(palestras),* Socrates engaged his fellow citizens in philosophical argument and Plato formulated his prescription for the ideal form of government in the *Republic.* The rich intellectual life of ancient Athens was complemented by a strong interest in physical exercise, which played a large role in education, as well as in daily life. The Athenian aim of achieving a balance of intellectual and physical discipline, an ideal of humanistic education, is well expressed in the familiar phrase "a sound mind in a sound body."

GREEK ART AND CULTURE REASSESSED The distinctiveness and originality of Greek contributions to art, science, and politics should not, however, obscure the enormous debt Greek civilization owed to the earlier great cultures of Egypt and the Near East. Scholars today increasingly recognize this debt, and the ancient Greeks themselves readily acknowledged borrowing ideas, motifs, conventions, and skills from these older civilizations.

Nor should a high estimation of Greek art and culture blind historians to the realities of Hellenic life and society. The uncritical admiration in the eighteenth and nineteenth centuries of anything Greek has undergone sharp revision in our time. Many modern artists have rejected Greek standards (the late-nineteenth-century French painter Paul Gauguin called Greek art "a lie!"). Even Athenian "democracy" was a political reality for only one segment of the demos. Slavery was regarded as natural, even beneficial, and was a universal institution among the Greeks. Aristotle, the eminent philosopher who tutored Alexander the Great, declared at the beginning of his *Politics:* "It is clear that some are free by nature, and others are slaves."[2] And Greek women were in no way the equals of Greek men. Women normally remained secluded in their homes, emerging usually only for weddings, funerals, and religious festivals. They played little part in public or political life. Despite the fame of the poet Sappho, only a handful of female artists' names are known, and none of their works survive. The existence of slavery and the exclusion of women from public life are both reflected in Greek art. On many occasions freeborn men and women appear with their slaves in monumental sculpture. The symposium (attended only by men and prostitutes) is a popular subject on painted vases.

Although the Greeks invented and passed on to future generations the concept and practice of democracy, most Greek states, even those constituted as democracies, were dominated by wellborn white males, and the most admired virtues were not wisdom and justice but statecraft and military valor. Greek men were educated in the values of Homer's heroes and in the athletic exercises of the palestra. War among the city-states was chronic and often atrocious. Fighting among themselves and incapable of unification, the Greeks eventually fell victim to Macedon's autocracy and Rome's imperialism.

The Gods and Goddesses of Mount Olympus

The names of scores of Greek gods and goddesses appear already in Homer's epic tales of the war against Troy *(Iliad)* and of the adventures of the Greek hero Odysseus on his long and tortuous journey home *(Odyssey)*. Even more are enumerated in the poems of Hesiod, especially his *Theogony (Geneaology of the Gods)* composed around 700 B.C.

The Greek deities most often represented in art are all ultimately the offspring of the two key elements of the Greek universe, Earth *(Gaia/Ge;* we give the names in Greek/Latin form) and Heaven *(Ouranos/Uranus)*. Earth and Heaven mated to produce twelve Titans, including Ocean *(Okeanos/Oceanus)* and his youngest brother *Kronos (Saturn)*. Kronos castrated his father in order to rule in his place, married his sister *Rhea*, and then swallowed all his children as they were born, lest one of them seek in turn to usurp him (see FIG. 28-40). When *Zeus (Jupiter)* was born, Rhea deceived Kronos by feeding him a stone wrapped in clothes in place of the infant. After growing to manhood, Zeus forced Kronos to vomit up Zeus's siblings. Together they overthrew their father and the other Titans and ruled the world from their home on Mount Olympus, Greece's highest peak.

This cruel and bloody tale of the origin of the Greek gods has parallels in Near Eastern mythology and is clearly pre-Greek in origin, one of many Greek borrowings from the Orient. The Greek version of the creation myth, however, appears infrequently in painting and sculpture. Instead the later twelve *Olympian gods and goddesses*, the chief deities of Greece, figure most prominently in art—not only in Greek, Etruscan, and Roman times but also in the Middle Ages, the Renaissance, and down to the present.

THE OLYMPIAN GODS
(AND THEIR ROMAN EQUIVALENTS)

Zeus (Jupiter) King of the gods, Zeus (see FIGS. 5-36 and 29-42) ruled the sky and allotted the sea to Poseidon and the Underworld to Hades. His weapon was the thunderbolt, and with it he led the other gods to victory over the Giants (FIGS. 5-17 and 5-79), who had challenged the Olympians for control of the world.

Hera (Juno) Wife and sister of Zeus, Hera was the goddess of marriage and was often angered by Zeus's many love affairs. Her favorite cities were Mycenae, Sparta, and Argos, and she aided the Greeks in their war against the Trojans.

Poseidon (Neptune) Zeus's brother, Poseidon (see FIGS. 10-62 and 23-17) was one of the three sons of Kronos and Rhea and was lord of the sea. He controlled waves, storms, and earthquakes with his three-pronged pitchfork *(trident)*.

Hestia (Vesta) Daughter of Kronos and Rhea and sister of Zeus, Poseidon, and Hera, Hestia was goddess of the hearth. In Rome, Vesta had an ancient shrine with a sacred fire in the Roman Forum. Her six *Vestal Virgins* were the most important priestesses of the state, drawn only from aristocratic families.

Demeter (Ceres) Third sister of Zeus, Demeter was the goddess of grain and agriculture. She taught humans how to sow and plow. The English word *cereal* derives from *Ceres*.

Ares (Mars) God of war, Ares was the son of Zeus and Hera and the lover of Aphrodite. In the *Iliad* he took the side of the Trojans. Mars, father of the twin founders of Rome, *Romulus* and *Remus* (see FIG. 9-10), looms much larger in Roman mythology and religion than Ares does in Greek.

Athena (Minerva) Goddess of wisdom and warfare, Athena (FIGS. 5-32, 5-44, and 5-79) was a virgin *(parthenos* in Greek) born not from the womb of a woman but from the head of her father, Zeus. Her city was Athens, and her greatest temple was the Parthenon (FIG. 5-42).

Hephaistos (Vulcan) God of fire and of metalworking, Hephaistos fashioned the armor Achilles wore in battle against Troy. He also provided Zeus his scepter and Poseidon his trident and was the "surgeon" who split open Zeus's head when Athena was born. In some accounts, Hephaistos is the son of Hera without a male partner. In others, he is the son of Hera and Zeus. Born lame and, uncharacteristically for a god, ugly, his wife Aphrodite was unfaithful to him.

Apollo (Apollo) God of light and music and a great archer, Apollo (see FIGS. Intro-7, 5-3, 5-57, and 24-63) was the son of Zeus with *Leto/Latona*, daughter of one of the Titans. His epithet *Phoibos* means "radiant," and the young, beautiful Apollo is sometimes identified with the Sun *(Helios/Sol)*.

Artemis (Diana) Sister of Apollo, Artemis (see FIGS. 5-57 and 22-46) was goddess of the hunt and of wild animals. As Apollo's twin, she was occasionally regarded as the Moon *(Selene/Luna)*.

Aphrodite (Venus) Daughter of Zeus and *Dione* (daughter of Okeanos and one of the *nymphs*—the goddesses of springs, caves, and woods), Aphrodite (FIGS. 5-60 and 5-83) was the goddess of love and beauty. In one version of her myth, she was born from the foam *(aphros* in Greek) of the sea (see FIG. 21-27). She was the mother of Eros by Ares and of the Trojan hero *Aeneas* by *Anchises*. Julius Caesar and Augustus traced their lineage to Venus through Aeneas.

Hermes (Mercury) Son of Zeus and another nymph, Hermes (FIGS. 5-58 and 5-62) was the fleet-footed messenger of the gods and possessed winged sandals. He was also the guide of travelers, including the dead journeying to the Underworld, and he carried the *caduceus*, a magical herald's rod entwined by serpents, and wore a traveler's hat, often also shown with wings.

Equal in stature to the Olympians was *Hades (Pluto)*, one of the children of Kronos who fought with his brothers against the Titans but who never resided on Mount Olympus. Hades was the lord of the Underworld and god of the dead.

Other important Greek gods and goddesses are *Dionysos* (*Bacchus*, see FIG. 22-37), the god of wine and the son of Zeus and a mortal woman; *Eros (Amor* or *Cupid)* (see FIGS. 5-48, 5-84, 22-43, and 24-85), the winged child god of love and the son of Aphrodite and Ares; and *Asklepios (Aesculapius)*, son of Apollo and a mortal woman, the Greek god of healing, whose serpent-entwined staff is the emblem of modern medicine.

5-1 Geometric krater, from the Dipylon cemetery, Athens, Greece, ca. 740 B.C. Approx. 3′ 4½″ high. Metropolitan Museum of Art, New York, (Rogers Fund).

THE GEOMETRIC AND ORIENTALIZING PERIODS (NINTH–SEVENTH CENTURIES B.C.)

EMERGENCE FROM THE DARK AGE The destruction of the Mycenaean palaces was accompanied by the disintegration of the Bronze Age social order. The disappearance of powerful kings and their retinues led to the loss of the knowledge of how to cut masonry, to construct citadels and tombs, to paint frescoes, and to sculpt in stone. Even the arts of reading and writing were forgotten. The succeeding centuries, sometimes called the Dark Age of Greece, were characterized by depopulation, poverty, and an almost total loss of contact with the outside world.

Only in the eighth century B.C. did economic conditions improve and the population begin to grow again. This era was in its own way a heroic age, a time when the poleis of Classical Greece took shape; when the Greeks broke out of their isolation and once again began to trade with cities both in the east and the west; when Homer's epic poems, formerly memorized and passed down from bard to bard, were recorded in written form; and when the Olympic Games were established.

Geometric Art

THE HUMAN FIGURE RETURNS TO ART Also during the eighth century the human figure returned to Greek art—not, of course, in monumental statuary, which was exceedingly rare even in Bronze Age Greece, but painted on the surfaces of ceramic pots, which continued to be manufactured after the fall of Mycenae and even throughout the Dark Age.

One of the earliest examples is a huge *krater* (FIG. **5-1**), or mixing bowl, that marked the grave of an Athenian man buried around 740 B.C. At well over a yard tall, this remarkable vase is a considerable technical achievement and testifies both to the potter's skill and to the wealth and position of the deceased's family in the community. The bottom of the great vessel is open, perhaps to permit visitors to the grave to pour libations in honor of the dead, perhaps simply to provide a drain for rainwater, or both. The artist covered much of the surface with precisely painted abstract angular motifs, especially the *meander*, or key, pattern, in horizontal bands of varying height. Most early Greek vases were decorated exclusively with such motifs. The nature of the ornament has led art historians to designate this formative period of Greek art as *Geometric*. The earliest examples of the Geometric style date to the ninth century B.C.

On our krater the artist reserved the widest part of the vase for two bands of human figures and horse-drawn chariots, rather than for abstract ornament. Befitting the vase's function as a grave marker, the scenes depict the mourning for a man laid out on his bier and the grand chariot procession in his honor. In the upper band, the shroud, raised to reveal the corpse, is an abstract checkerboard-like backdrop, and the funerary couch has only two legs because the artist had no interest in suggesting depth or representing space. The human figures and the furniture are as two-dimensional as the geometric shapes elsewhere on the vessel. The painter filled every empty surface with circles and M-shaped ornament, further negating

any sense that the mourners inhabit open space. The figures are silhouettes constructed of triangular (frontal) torsos with attached profile arms, legs, and heads (with a single large frontal eye in the center!), following the age-old convention. The painter distinguished male from female. The deceased's penis grows out of one of his thighs. The mourning women, who tear their hair out in grief, have breasts emerging beneath their armpits. In both cases the artist was concerned with specifying gender, not with anatomical accuracy. Below, the chariots are accompanied by warriors drawn as though they are walking shields, and, in the old conceptual manner, both wheels of the chariots are shown. The horses have the correct number of heads and legs but seem to share a common body, negating any sense of depth. Despite the highly stylized and conventional manner of representation, this vessel marks a significant turning point in the history of Greek art. Not only was the human figure reintroduced into the painter's repertoire, but also the art of storytelling was resuscitated.

A HERO BATTLES A MONSTER Similar schematic figures also appeared in the round at this date, but only at very small scale. One of the most impressive surviving Geometric sculptures is a small solid-cast bronze group (FIG. **5-2**) of a hero, probably Herakles (see "Herakles: Greatest of Greek Heroes," page 103), battling a *centaur* (a mythological beast that was part man, part horse), possibly Nessos, the centaur who had volunteered to carry the hero's bride across a river and then assaulted her. Whether or not the hero is Herakles

5-2 Hero and centaur (Herakles and Nessos?), ca. 750–730 B.C. Bronze, approx. $4\frac{1}{2}''$ high. Metropolitan Museum of Art, New York, (gift of J. Pierpont).

and the centaur is Nessos, the mythological nature of the group is certain. The repertoire of the Geometric artist was not limited to scenes inspired by daily life (and death).

Composite monsters were enormously popular in the ancient Near East and Egypt (see Chapters 2 and 3), and renewed contact with foreign cultures may have inspired such figures in Geometric Greece. The centaur is, however, a purely Greek invention—and one that posed a problem for the artist, who had, of course, never seen such a creature. The Geometric centaur was conceived as a man in front and a horse in back, a rather unhappy and unconvincing configuration that results in the forelegs belonging to a different species than the hindlegs. In our example, the figure of the hero and the human part of the centaur were rendered in a similar fashion. Both are bearded and wear helmets, but (contradictory to nature) the man is larger than the horse, probably to suggest that he will be the victor. Like other Geometric male figures, both painted and sculptured, this hero is nude, in contrast to the Near Eastern statuettes that might have inspired such Greek works. Here, at the very beginning of Greek figural art, one can recognize the Hellenic instinct for the natural beauty of the human figure, which is reflected by the fact Greek athletes exercised without their clothes and even competed nude in the Olympic Games from very early times.

Orientalizing Art

AN OFFERING TO APOLLO One of the masterworks of the early seventh century B.C. is the *Mantiklos Apollo* (FIG. **5-3**), a small bronze statuette dedicated to Apollo at Thebes by an otherwise unknown man named Mantiklos. With characteristic pride in the ability to write, the sculptor (or another) scratched into the thighs of the figure a message from the dedicator to the deity: "Mantiklos dedicated me as a tithe to the far-shooting Lord of the Silver Bow; you, Phoibos [Apollo], might give some pleasing favor in return." Because the Greeks conceived their gods in human form, one cannot be sure whether the figure was meant to represent the youthful Apollo or Mantiklos (or neither). But if the left hand at one time held a bow, then the statuette is certainly an image of the deity. In any case, the purpose of the votive offering is clear. Equally apparent is the increased interest Greek artists at this time had in reproducing details of human anatomy, such as the long hair framing the unnaturally elongated neck, and the pectoral and abdominal muscles, which define the stylized triangular torso. The triangular face has eye sockets that were once inlaid, and the head may have had a separately fashioned helmet on it.

THE GREEKS LOOK EASTWARD The *Mantiklos Apollo* was created when the pace and scope of Greek trade and colonization had accelerated and when Greek artists were exposed more than ever before to Eastern artworks, especially small portable objects such as Syrian ivory carvings. The closer contact had a profound effect on the development of Greek art. Indeed, so many motifs borrowed from or inspired by Egyptian and Near Eastern art entered the Greek pictorial vocabulary at this time that historians have dubbed the seventh century B.C. the *Orientalizing* period.

An elaborate Corinthian *amphora* (FIG. **5-4**), or two-handled storage jar, typifies the new Greek fascination with the Orient. In a series of bands recalling the organization of Geometric painted vases, animals such as the native boar appear beside exotic lions and panthers and composite creatures inspired by Eastern monsters such as the sphinx and lamassu—in this instance the *siren* (part bird, part woman) prominently displayed on the amphora's neck.

The appeal of such vases was not due solely to their Orientalizing animal friezes but also to a new ceramic technique the Corinthians invented, which art historians call *black-figure* painting (see "Greek Vase Painting," page 104). The black-figure painter first put down black silhouettes on the clay surface, as in Geometric times, but then used a sharp, pointed instrument to incise linear details within the forms,

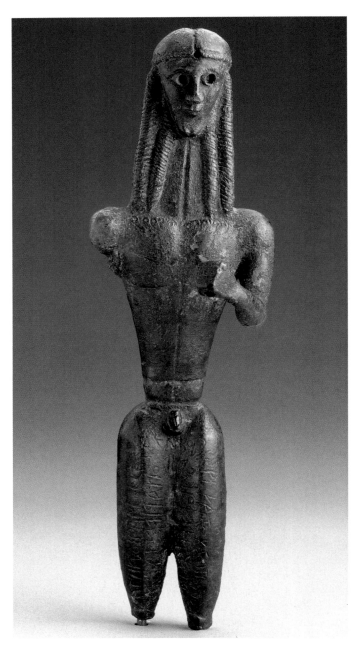

5-3 *Mantiklos Apollo,* statuette of a youth dedicated by Mantiklos to Apollo, from Thebes, Greece, ca. 700–680 B.C. Bronze, approx. 8″ high. Museum of Fine Arts, Boston.

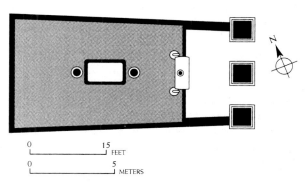

Herakles
Greatest of Greek Heroes

Greek heroes were a class of mortals intermediate between ordinary humans and the immortal gods. Most often the children of gods, some were great warriors, such as those who fought at Troy and were celebrated in Homer's epic poems. Others went from one fabulous adventure to another, ridding the world of monsters and generally benefiting humankind. Many heroes were worshiped after their deaths, and the greatest of them were honored with shrines, especially in the cities most closely associated with them. For example, the bones of Theseus, king of Athens and victor over the Minotaur who inhabited the labyrinthine palace at Knossos (see FIGS. 4-3 to 4-5), were transferred to Athens around 475 B.C. from Skyros, where Theseus had been killed, and deposited in his sanctuary near the city center.

The greatest of all the Greek heroes was *Herakles* (the Roman *Hercules*), born in Thebes and the son of Zeus and Alkmene, a mortal woman. Zeus's wife Hera hated Herakles and sent two serpents to attack him in his cradle, but the infant strangled them. Later, Hera caused the hero to go mad and to kill his wife and children. As punishment he was condemned to perform twelve great labors. In the first, he defeated the legendary lion of Nemea and ever after wore its pelt. The lion's skin and his weapon, a club, are Herakles' distinctive attributes (FIGS. 5-63 and 5-66). His last task was to obtain the golden apples Gaia gave to Hera at her marriage (FIG. 5-32). They grew from a tree in the garden of the Hesperides at the farthest western edge of the Ocean and a dragon guarded them. After completion of the twelve, seemingly impossible, tasks, Herakles was awarded immortality. Athena, who had watched over him carefully throughout his life and assisted him in performing the labors, introduced him into the realm of the gods on Mount Olympus. According to legend, it was Herakles who established the quadrennial Olympic Games.

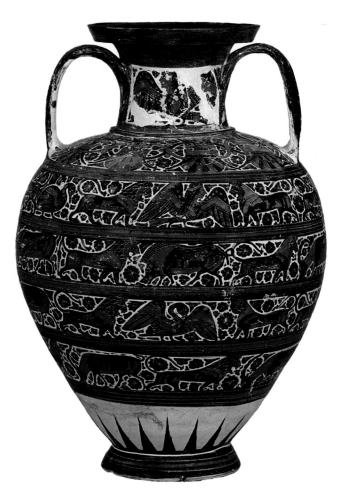

usually adding highlights in purplish red or white over the black figures before firing the vessel. The combination of the weighty black silhouettes with the delicate detailing and the bright polychrome overlay proved to be irresistible, and Athenian painters soon copied the technique from the Corinthians.

THE FIRST GREEK STONE TEMPLES The foundation of the Greek trading colony of Naukratis in Egypt (see map, Chapter 3, page 42) before 630 B.C. brought the Greeks into direct contact with the monumental stone architecture of the Egyptians. Not long after that the first stone buildings since the fall of the Mycenaean kingdoms began to be constructed in Greece. At Prinias on Crete, for example, a stone temple, called Temple A (FIG. 5-5), was built around 625 B.C. to honor an unknown deity. Although the inspiration for the structure came from the East, the form resembles that of a typical Mycenaean megaron, such as that at Tiryns (see FIG. 4-19), with a hearth or sacrificial pit flanked by two columns

5-4 Corinthian black-figure amphora with animal friezes, from Rhodes, Greece, ca. 625–600 B.C. Approx. 1′ 2″ high. British Museum, London.

5-5 Plan of Temple A, Prinias, Greece, ca. 625 B.C.

MATERIALS AND TECHNIQUES

Greek Vase Painting

The techniques Greek ceramicists used to shape and decorate fine vases required a great deal of skill, acquired over many years as apprentices in the workshops of master potters. During the Archaic and Classical periods, when the art of vase painting was at its zenith in Greece, both potters and painters frequently signed their work. These signatures reveal the pride of the artists. They also might have functioned as "brand names" for a large export market. The products of the workshops in Corinth and Athens in particular were much prized and have been found all over the Mediterranean world. The Corinthian amphora illustrated here (FIG. 5-4) was found on Rhodes, an island at the opposite side of the Aegean from mainland Corinth. Athenian *(Attic)* vases were staples in Etruscan tombs in Italy, and all but one of our examples (FIGS. 5-18 to 5-23, 5-57, and 5-58) came from an Etruscan site. Other painted Attic pots have been found as far apart as France, Russia, and the Sudan.

The first step in manufacturing a Greek vase was to remove any impurities found in the natural clay and then to knead it, like dough, to remove air bubbles and make it flexible. The Greeks used dozens of different kinds and shapes of pots, and most were fashioned in several parts. The vessel's body was formed by placing the clay on a rotating horizontal wheel. While an apprentice turned the wheel by hand, the potter pulled up the clay with the fingers until the desired shape was achieved. The handles were shaped separately and attached to the vase body by applying *slip* (liquefied clay) to the joints.

Then a specialist, the painter, was called in, although many potters decorated their own work. (Today most people tend to regard painters as more elevated artists than potters, but in Greece the potters owned the shops and employed the painters.) The "pigment" the painter applied to the clay surface is customarily referred to as *glaze,* but the black areas on Greek pots are neither pigment nor glaze but a slip of finely sifted clay that originally was of the same rich red orange color as the clay of the pot. In the three-phase firing process Greek potters used, the first *(oxidizing)* phase turned both pot and slip red. During the second *(reducing)* phase, the oxygen supply into the kiln was shut off, and both pot and slip turned black. In the final *(reoxidizing)* phase, the pot's coarser material reabsorbed oxygen and became red again, while the smoother, silica-laden slip did not and remained black. After long experiment, Greek potters developed a velvety jet-black "glaze" of this kind, produced in kilns heated to temperatures as high as 950 degrees Celsius (about 1742 degrees Fahrenheit). The firing process was the same whether the painter worked in black-figure or in red-figure. In fact, sometimes both manners were used on the same vase (FIG. 5-20).

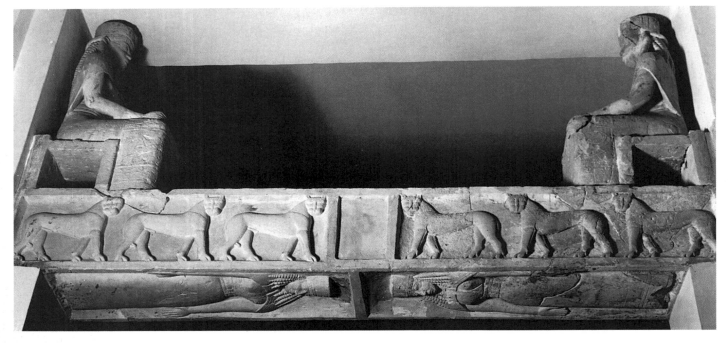

5-6 Lintel of Temple A, Prinias, Greece, ca. 625 B.C. Limestone, approx. 2′ 9″ high; seated goddesses approx. 2′ 8″ high. Archeological Museum, Herakleion.

in the cella. The facade consisted of three great piers; the roof was probably flat.

Above the doorway of the Prinias temple was a huge limestone lintel (FIG. **5-6**), surmounted by confronting statues of seated women, probably goddesses, wearing tall headdresses and capes. Two other similarly dressed, but standing, goddesses are carved in relief on the underside of the block, visible to those entering the temple. On the face of the lintel is a frieze of Orientalizing panthers with frontal heads—the same motif as that on the contemporary Corinthian black-figure amphora (FIG. 5-4). Temple A at Prinias is the earliest known example of a Greek temple with sculptured decoration.

5-7 *Lady of Auxerre*, statue of a goddess or kore, ca. 650–625 B.C. Limestone, approx. 2′ 1½″ high. Louvre, Paris.

GODDESS OR WOMAN? Somewhat earlier and probably also originally from Crete is a limestone statuette of a goddess or maiden (*kore*; plural, *korai*) popularly known as the *Lady of Auxerre* (FIG. **5-7**) after the French town that is her oldest recorded provenance. As with the figure dedicated by Mantiklos, it is uncertain whether the young woman is a mortal or a deity. She wears a long skirt and a cape, as do the Prinias women, but the Auxerre maiden has no headdress, and the right hand placed across the chest is probably a gesture of prayer, indicating that this is a kore. The style is, however, comparable. Characteristic is the triangular flat-topped head framed by long strands of hair that form complementary triangles to that of the face. Also typical are the small belted waist and a fondness for pattern: Note the almost Geometric treatment of the long skirt with its incised concentric squares, once brightly painted. Despite its monumental quality, the statue is only a little more than two feet tall—smaller than the seated goddesses of the Prinias lintel but much larger than the bronze statuettes of the era.

DAEDALUS, MASTER OF ALL ARTS The *Lady of Auxerre* is the masterpiece of a style usually referred to as *Daedalic,* after the legendary artist DAEDALUS, whose name means "the skillful one." In addition to having been a great sculptor, Daedalus was said to have built the labyrinth in Crete to house the Minotaur and also to have designed a temple at Memphis in Egypt (see map, Chapter 3, page 42). The historical Greeks attributed to him almost all the great achievements in early sculpture and architecture before the names of artists and architects were recorded. The story that Daedalus worked in Egypt reflects the enormous impact of Egyptian art and architecture on the Greeks of the aptly named Orientalizing age, as well as on their offspring in the succeeding Archaic period.

THE ARCHAIC PERIOD (SIXTH CENTURY B.C.)

Statuary

GREEK KOUROI AND EGYPTIAN STATUES According to one Greek writer, Daedalus used the same compositional patterns for his statues as the Egyptians used for their own, and the first truly monumental stone statues of the Greeks follow very closely the canonical Egyptian format. A life-size marble *kouros* ("youth;" plural, *kouroi*) in New York (FIG. **5-8**) emulates the stance of Egyptian statues—for example, the portrait of Mentuemhet (see FIG. 3-40) carved only a half century before the Greek statue. In both cases the figure is rigidly frontal with the left foot advanced slightly. The arms are held beside the body, and the fists are clenched with the thumbs forward. This kouros even served a funerary purpose. It is said to have stood over a grave in the countryside somewhere near Athens. Such statues replaced the huge vases (FIG. 5-1) of Geometric times as the preferred form of grave marker in the sixth century B.C. They also were used as votive offerings in sanctuaries. (At one time it was thought that all kouroi were images of Apollo.) The kouros type, because of its generic quality, could be employed in several different contexts.

5-8 Kouros, ca. 600 B.C. Marble, approx. 6' ½" high. Metropolitan Museum of Art, New York.

Auxerre, especially the triangular shape of head and hair and the flatness of the face. Eyes, nose, and mouth all sit on the front of the head, ears were placed on the sides, and the long hair forms a flat backdrop behind the head. In every instance one sees the result of the sculptor's having drawn these features on four independent sides of the marble block, following the same workshop procedure used in Egypt for millennia. The New York kouros also has the slim waist of earlier Greek statues, and the same love of pattern may be discerned. The pointed arch of the rib cage, for example, echoes the V-shaped ridge of the hips, which suggests but does not accurately reproduce the rounded flesh and muscle of the human body.

A SMILING CALF BEARER A generation later than the New York kouros is the statue of a *moschophoros,* or calf bearer (FIG. **5-9**), found on the Athenian Acropolis in frag-

5-9 Calf Bearer *(Moschophoros)*, dedicated by Rhonbos on the Acropolis, Athens, Greece, ca. 560 B.C. Marble, restored height approx. 5' 5". Acropolis Museum, Athens.

Despite the adherence to Egyptian prototypes, Greek kouros statues differ from their Oriental brethren in two important ways. First, they were liberated from their original stone block. The Egyptian obsession with permanence was alien to the Greeks, who were preoccupied with finding ways to represent motion rather than stability in their sculptured figures. Second, the kouroi are nude, and, in the absence of attributes, the monumental marble statues, like the tiny bronze dedicated by Mantiklos (FIG. 5-3), are formally indistinguishable from Greek images of deities with their perfect bodies exposed for all to see.

The New York kouros shares many traits with Greek Orientalizing works such as the *Mantiklos Apollo* and the *Lady of*

ments. Its inscribed base (not visible in our photograph) states that a man whose name has been reconstructed as Rhonbos dedicated the statue. Rhonbos is almost certainly the calf bearer himself bringing an offering to Athena in thanksgiving for his prosperity. He stands in the left-foot-forward manner of the kouroi, but he is bearded and therefore no longer a youth. He wears a thin cloak (which once was set off from the otherwise nude body by paint). No one dressed in such a manner in ancient Athens. The sculptor adhered to the artistic convention of male nudity and attributed to the calf bearer the noble perfection such nudity suggests while also indicating that this mature gentleman is clothed, as any respectable citizen would be in such a context. The Archaic sculptor's love of pattern was paramount once again in the way the difficult problem of representing man and animal together was tackled. The calf's legs and the moschophoros's arms form a bold X that unites the two bodies both physically and formally.

The calf bearer's face differs markedly from those of earlier Greek statues (and those of Egypt and the Near East also) in one notable way: The man smiles—or seems to. From this time on, Archaic Greek statues always smile, even in the most inappropriate contexts (see, for example, FIG. 5-27, where a dying warrior with an arrow in his chest grins broadly at the spectator!). This so-called *Archaic smile* has been variously interpreted, but it is not to be taken literally. Rather, the smile seems to be the Archaic sculptor's way of indicating that the person portrayed is alive. By adopting such a convention, the Greek artist signaled a very different intention from any Egyptian counterpart.

A STATUE FOR A HERO'S GRAVE Sometime around 530 B.C. a young man named Kroisos died a hero's death in battle, and his grave at Anavysos, not far from Athens, was marked by a kouros statue (FIG. **5-10**). The inscribed base invites visitors to "stay and mourn at the tomb of dead Kroisos, whom raging Ares destroyed one day as he fought in the foremost ranks." The statue, with its distinctive Archaic smile, is no more a portrait of a specific youth than is the New York kouros. But two generations later, the Greek sculptor greatly refined the type and, without rejecting the Egyptian stance, rendered the human body in a far more naturalistic manner. The head is no longer too large for the body, and the face is more rounded, with swelling cheeks replacing the flat planes of the earlier work. The long hair does not form a stiff backdrop to the head but falls naturally over the back. Rounded hips replace the V-shaped ridges of the New York kouros.

The original paint survives in part on the Kroisos statue, enhancing the sense of life. All Greek stone statues were painted. The modern notion that classical statuary was pure white is mistaken. The Greeks did not, however, color their statues garishly. The flesh was left in the natural color of the stone, which was waxed and polished, while eyes, lips, hair, and drapery were painted in *encaustic* (see "Iaia of Cyzicus and the Art of Encaustic Painting," Chapter 10, page 289). In this technique the pigment was mixed with wax and applied to the surface while hot.

KORAI FROM THE SACK OF THE ACROPOLIS A stylistic "sister" to the Anavysos kouros is the statue of a

kore wearing a *peplos* (FIG. **5-11**), a simple, long, woolen belted garment that gives the female figure a columnar appearance. Traces of paint are preserved here also. As with the Kroisos statue, this kore was covered by earth for more than two millennia, protecting the painted surface from the destructive effects of exposure to the atmosphere and to bad weather. The *Peplos Kore*, as she is known, was, like the earlier statue of the calf bearer (FIG. 5-9), thrown down by the Persians during their sack of the Acropolis in 480 B.C. (discussed later) and shortly thereafter buried by the Athenians themselves. Before that time, she stood as a votive offering in Athena's sanctuary. Her missing left arm was extended, a break from the frontal compression of the arms at the sides in

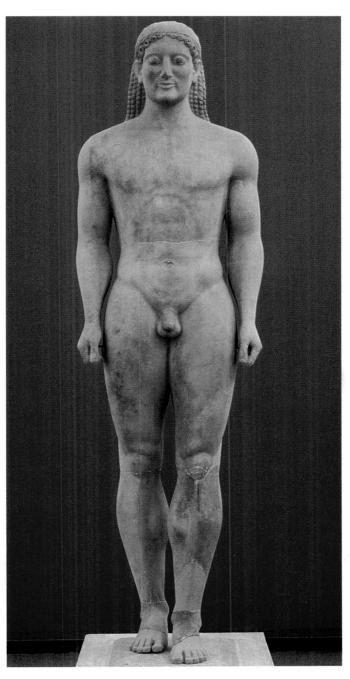

5-10 Kroisos, from Anavysos, Greece, ca. 530 B.C. Marble, approx. 6' 4" high. National Archeological Museum, Athens.

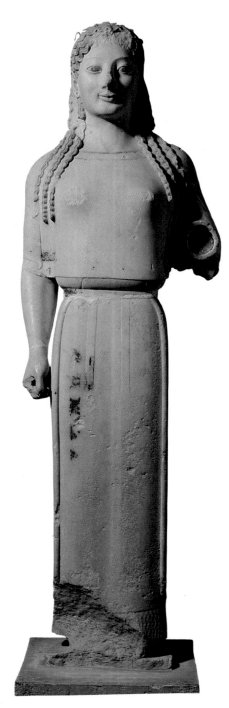

5-11 *Peplos Kore*, from the Acropolis, Athens, Greece, ca. 530 B.C. Marble, approx. 4′ high. Acropolis Museum, Athens.

Egyptian statues. She once held in her hand an attribute that would identify the figure as a maiden or, as some have suggested, a goddess, perhaps Athena herself. Whatever her identity, the contrast with the *Lady of Auxerre* (FIG. 5-7) is striking. Although in both cases the drapery conceals the entire body save for head, arms, and feet, the later sculptor rendered the soft female form much more naturally, sharply differentiating it from the hard muscular body of the kouros.

The *Peplos Kore* is one of the latest peplos-clad dedications on the Acropolis. By the later sixth century, the light linen

Ionian *chiton,* worn in conjunction with a heavier *himation* (mantle), was the garment of choice for fashionable women. Archaic sculptors delighted in rendering the intricate patterns created by the cascading folds of thin, soft material, as may be seen in another kore (FIG. **5-12**) buried on the Acropolis after the Persian destruction. In this statue the asymmetry of the folds greatly relieves the stiff frontality of the body and makes the figure appear much more lifelike than contemporary kouroi. The sculptor achieved added variety by showing the kore grasping part of her chiton in her left hand (unfortunately broken off) to lift it off the ground as she takes a step forward. This is the equivalent of the advanced left foot of the kouroi and is standard for statues of korai. Despite the varied surface treatment of brightly colored garments on the korai, the kore postures are as fixed as those of their male counterparts.

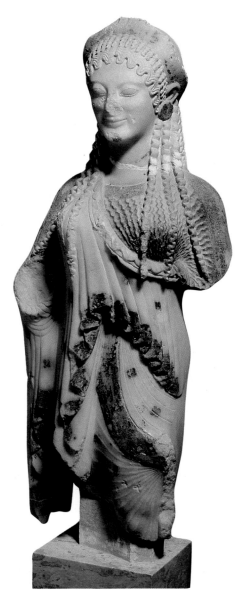

5-12 Kore, from the Acropolis, Athens, Greece, ca. 510 B.C. Marble, approx. 1′ 9½″ high. Acropolis Museum, Athens.

Architecture and Architectural Sculpture

THE CANONICAL TEMPLE TAKES SHAPE Already, in the Orientalizing seventh century B.C., at Prinias, the Greeks had built a stone temple embellished with stone sculptures (FIGS. 5-5 and 5-6). But despite the contemporary Daedalic style of its statues and reliefs, the Cretan temple resembled the megaron of a Mycenaean palace more than anything Greek traders had seen in their travels overseas. In the Archaic age of the sixth century, with the model of Egyptian columnar halls such as that at Karnak (see FIG. 3-25) before them, Greek architects began to build the gable-roofed columnar stone temples that have been more influential on the later history of architecture in the Western world than any other building type ever devised.

Greek architecture and its Roman and Renaissance descendants and hybrids are almost as familiar as modern architecture. The so-called Greek revival European architects instituted in the late eighteenth century led to a wide diffusion of the Greek architectural style. Official public buildings (courthouses, banks, city halls, legislative chambers), designed for impressive formality, especially imitated classical architecture. The ancient Greeks were industrious builders, even though their homes were unpretentious places, they had no monarchs to house royally until Hellenistic times, and they performed religious rites in the open. Their temples were not places the faithful gathered in to worship a deity, as they are for most of the world's modern religions. The altar lay outside the temple at the east end, facing the rising sun, and the temple proper was a shrine for that grandest of all votive offerings to the deities, the cult statue. Both in its early and mature manifestations, the Greek temple was the house of the god or goddess, not of his or her followers.

Figural sculpture played a major role in the exterior program of the Greek temple from early times, partly to embellish the god's shrine, partly to tell something about the deity symbolized within, and partly to serve as a votive offering. But the building itself, with its finely carved capitals and moldings, also was conceived as sculpture, abstract in form and possessing the power of sculpture to evoke human responses. The commanding importance of the sculptured temple, its inspiring function in public life, was emphasized in its elevated site, often on a hill above the city (acropolis means "high city"). As Aristotle stipulated: "The site should be a spot seen far and wide, which gives due elevation to virtue and towers over the neighborhood."[3]

Many of the earliest Greek temples do not survive because they were made of wood and mud brick. Pausanias, who wrote an invaluable guidebook to Greece in the second century A.D., noted that in the even-then ancient Temple of Hera at Olympia, one oak column was still in place. The others had been replaced by stone columns. Archaic and later Greek temples were, however, built of more permanent materials—limestone, in many cases, and, where it was available, marble, which was more impressive (and more expensive). In Greece proper, if not in its western colonies, marble was readily at hand. Bluish white stone came from Hymettus, just east of Athens. Glittering white stone particularly adapted for carving was brought from Pentelicus, northeast of the city. And

from the Aegean Islands, Paros in particular, marble of varying quantities and qualities was supplied.

In its canonical plan the Greek temple (see "Doric and Ionic Temples," page 112) still discloses a close affinity with the Mycenaean megaron (see FIG. 4-19), and, even in its most elaborate form, it retains the latter structure's basic simplicity. In all cases, the Greek scheme's remarkable order, compactness, and symmetry strike the eye first, reflecting the Greeks' sense of proportion and their effort to achieve ideal forms in terms of regular numerical relationships and geometric rules. Whether the plan is simple or more complex, no fundamental change occurs in the nature of the units or of their grouping. Classical Greek architecture, like classical music, has a simple core theme with a series of complex, but always quite intelligible, variations developed from it.

The Greeks' insistence on proportional order guided their experiments with the proportions of temple plans. The earliest temples tended to be long and narrow, with the proportion of the ends to the sides roughly expressible as 1:3. From the sixth century on, plans approached but rarely had a proportion of exactly 1:2. Classical temples tended to be a little longer than twice their width. Proportion in architecture and sculpture, and harmony in music, were much the same to the Greek mind and reflected and embodied the cosmic order (see "Polykleitos's Prescription for the Perfect Statue," page 126).

Sculptural ornament was concentrated on the upper part of the building, in the frieze and pediments. Architectural sculpture, like freestanding statuary, was painted and usually was placed only in the building parts that had no structural function. This is true particularly of the Doric order, where decorative sculpture appears only in the metope and pediment "voids." Ionic builders, less severe in this respect as well, were willing to decorate the entire frieze and sometimes even the lower column drums. Occasionally, they replaced their columns with female figures (caryatids; FIGS. 5-16 and 5-52). By using color, the designer could bring out more clearly the relationships of the structural parts, soften the stone's glitter at specific points, and provide a background to set off the figures.

Although color was used for emphasis and to relieve what might have seemed too bare a simplicity, Greek architecture primarily depended on clarity and balance. To the Greeks, it was unthinkable to use surfaces in the way the Egyptians used their gigantic columns—as fields for complicated ornamentation (see FIG. 3-25). The history of Greek temple architecture is the history of Greek architects' unflagging efforts to find the most satisfactory (that is, what they believed were perfect) proportions for each part of the building and for the structure as a whole.

A TEMPLE FOR HERA IN ITALY The prime example of early Greek efforts at Doric temple design is the unusually well-preserved Archaic temple (FIG. 5-13) erected around 550 B.C. at Paestum (Greek Poseidonia), south of Naples in Italy. The entire peripteral colonnade of this huge (eighty feet by one hundred seventy feet) building is still standing, but most of the entablature, including the frieze, pediment, and all of the roof, has vanished. Called the "Basilica"

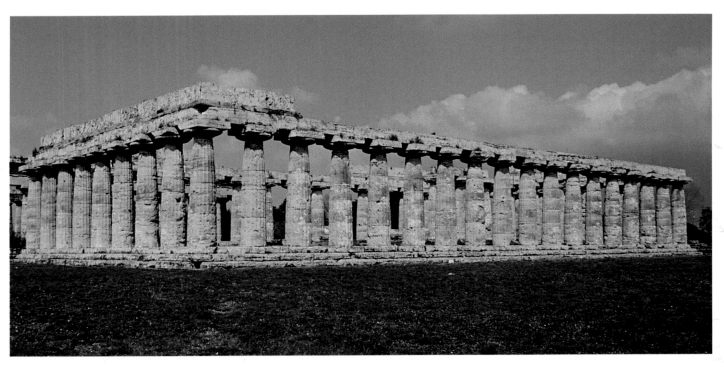

5-13 Temple of Hera I ("Basilica"), Paestum, Italy, ca. 550 B.C.

after the Roman columnar hall building type that early investigators felt it resembled, the structure is now known to be a temple dedicated to Hera. Scholars refer to it as the Temple of Hera I to distinguish it from the later Temple of Hera II (FIG. 5-29), which stands nearby.

The misnomer is partly due to the building's plan (FIG. 5-14), which differs from that of most other Greek temples. The unusual feature, found only in early Archaic temples, is the central row of columns that divides the cella into two aisles. Placing columns underneath the *ridgepole* (the timber beam running the length of the building below the peak of the gabled roof) might seem the logical way to provide inte-

rior support for the roof structure. But it resulted in several disadvantages. Among these was that this interior arrangement allowed no place for a central statue of the deity to whom the temple was dedicated. Also, the peripteral colonnade, in order to correspond with the interior, had to have an odd number of columns (nine in this case) across the building's facade. At Paestum, three columns were also set in antis instead of the canonical two, which in turn ruled out a central doorway for viewing the statue. However, eighteen columns on each side of the Hera I temple resulted in a simple 1:2 ratio of facade and flank columns.

The temple's elevation is characterized by heavy, closely spaced columns with a pronounced swelling *(entasis)* at the middle of the shafts, giving the columns a profile akin to that of a cigar. The shafts are topped by large, bulky, pancakelike Doric capitals, which seem compressed by the overbearing weight of the entablature. If the temple's immense roof were preserved, these columns would seem even more compressed, squatting beneath what must have been a high and massive entablature. The columns and capitals thus express in a vivid manner their weight-bearing function. One structural reason, perhaps, for the heaviness of the design and the narrowness of the spans between the columns might be that the Archaic builders were afraid thinner and more widely spaced columns would result in the superstructure's collapse. In later Doric temples, the columns were placed farther apart, and the forms were gradually refined. The shafts became more slender, the entasis subtler, the capitals smaller, and the entablature lighter. The Greek architects were seeking the ideal proportional relationship among the parts of their buildings. The sculptors of Archaic kouroi and korai were grappling with similar problems contemporaneously. Architecture and sculpture developed in a parallel manner in the sixth century.

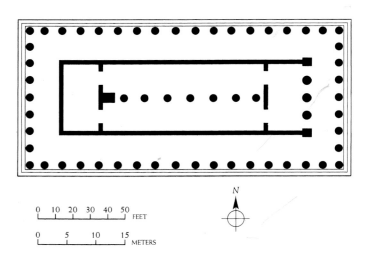

5-14 Plan of the Temple of Hera I, Paestum, Italy, ca. 550 B.C.

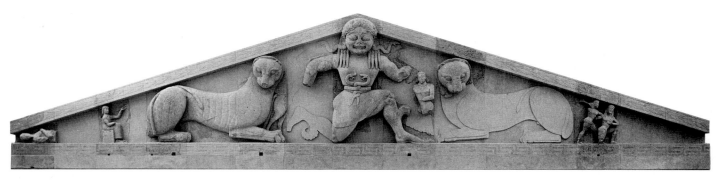

5-15 West pediment from the Temple of Artemis, Corfu, Greece, ca. 600–580 B.C. Limestone, greatest height approx. 9′ 4″. Archeological Museum, Corfu.

A HUGE ISLAND TEMPLE Architects and sculptors were also frequently called on to work together, as at Corfu (ancient Corcyra), where a great Doric temple dedicated to Artemis was constructed early in the sixth century B.C. Corfu is an island off the western coast of Greece and was an important stop on the trade route between the mainland and the Greek settlements in Italy. Prosperity made possible the erection of one of the earliest stone peripteral temples in Greece, one also lavishly embellished with sculpture. The metopes were decorated with reliefs (unfortunately very fragmentary today), and both pediments were filled with huge sculptures (more than nine feet high at the center). The pediments on both ends of the temple appear to have been decorated in an identical manner. The west pediment (FIG. **5-15**) is better preserved.

Designing figural decoration for a pediment was never an easy task because of its awkward triangular shape. Central figures needed to be of great size. By contrast, as the pediment tapered toward the corners, the available area became increasingly cramped. The central figure at Corfu is the *gorgon* Medusa, a demon with a woman's body and bird wings. Medusa also had a hideous face and snake hair, and anyone who gazed at her was turned into stone. She is shown in the conventional Archaic bent-leg, bent-arm, pinwheel-like posture that signifies running or, for a winged creature, flying. To her left and right are two great felines. Together they serve as temple guardians, repulsing all enemies from the sanctuary of the goddess. Similar panthers stand sentinel on the lintel of the seventh-century temple at Prinias (FIG. 5-6). The Corfu felines are in the tradition of the guardian lions of the citadel gate at Mycenae (see FIG. 4-20) and of the sphinx and lamassu figures that stood guard at the entrances to tombs and palaces in Egypt (see FIG. 3-11) and the ancient Near East (see FIGS. 2-18 and 2-21). The triad of Medusa and the felines recalls as well the herald ichuman-beast compositions of Mesopotamia (see FIG. 2-10). The Corfu figures are, in short, still further examples of the Orientalizing manner in early Greek sculpture.

Between Medusa and the great beasts are two small figures—the human Chrysaor at her left and the winged horse Pegasus at her right. Chrysaor and Pegasus are Medusa's children. According to legend, they sprang from her head when it was severed by the sword of the Greek hero Perseus. Their presence here on either side of the living Medusa is therefore a chronological impossibility. The Archaic artist was not interested in telling a coherent story but in identifying the central figure by depicting her offspring. Narration was, however, the purpose of the much smaller groups situated in the pediment corners. To the viewer's right is Zeus, brandishing his thunderbolt and slaying a kneeling giant. In the extreme corner was a dead giant. The *gigantomachy* (battle of gods and giants) was a popular theme in Greek art from Archaic through Hellenistic times and was a metaphor for the triumph of reason and order over chaos. In the pediment's left corner is one of the Trojan War's climactic events. Achilles' son Neoptolemos kills the enthroned King Priam. The fallen figure to the left of this group may be a dead Trojan.

The master responsible for the Corfu pediments was a pioneer, and the composition shows all the signs of experimentation. The lack of narrative unity in the Corfu pediment and the extraordinary scale diversity of the figures eventually gave way to pedimental designs with figures all acting out a single event and appearing the same size. But the Corfu designer already had shown the way. That sculptor realized, for example, that the area beneath the raking cornice could be filled with gods and heroes of similar size if a combination of standing, leaning, kneeling, seated, and prostrate figures were employed in the composition. And the Corfu master discovered that animals could be very useful space fillers because, unlike humans, they have one end taller than the other.

GODS AND GIANTS STRUGGLE AT DELPHI The sixth century B.C. also saw the erection of grandiose Ionic temples on the Aegean Islands and the west coast of Asia Minor. The gem of Archaic Ionic architecture and architectural sculpture is, however, not a temple but a treasury (FIG. **5-16**) the city of Siphnos erected in the Sanctuary of Apollo at Delphi. Greek *treasuries* were small buildings set up for the safe storage of votive offerings. At Delphi many poleis expressed their civic pride by erecting these templelike, but nonperipteral, structures. Athens built one with Doric columns in the porch and sculptured metopes in the frieze. The Siphnians equally characteristically employed the Ionic order for their Delphic treasury. The building was made possible by the wealth from the island's gold and silver mines. In the porch, where one would expect to find fluted Ionic columns, far more elaborate caryatids were employed instead. Caryatids are rare, even in Ionic architecture, but they are unknown in Doric architecture, where they would have been discordant

Doric and Ionic Temples

The *plan* and *elevation* of Greek temples varied with date, geography, and the requirements of individual projects, but all canonical Greek temples have common defining elements that set them apart from both the religious edifices of other civilizations and other kinds of Greek buildings.

Plan The temple core was the *naos* or *cella*, a room with no windows that usually housed the cult statue of the deity. It was preceded by a porch, or *pronaos,* often with two columns between the extended walls (columns *in antis,* that is, between the *antae*). A smaller second room might be placed behind the cella, but in its classical form, the Greek temple had a porch at the rear *(opisthodomos)* set against the blank back wall of the cella. The purpose was not functional but decorative, satisfying the Greek passion for balance and symmetry. A colonnade could be placed across the front of the temple (*prostyle;* FIG. 5-50), across both front and back (*amphiprostyle;* FIG. 5-53), or, more commonly, all around the cella and its porch(es) to form a *peristyle,* as in our diagram (compare FIGS. 5-13 and 5-14). Single (*peripteral*) colonnades are the norm, but double (*dipteral*) colonnades were features of especially elaborate temples (FIG. 5-74).

Elevation The elevation of a Greek temple is described in terms of the platform, the colonnade, and the superstructure

(entablature). In the Archaic period, two basic systems evolved for articulating the three units. These are the so-called *orders* of Greek architecture. The orders are differentiated both in the nature of the details and in the relative proportions of the parts. The names of the orders are derived from the Greek regions where they were most commonly employed. The *Doric* was formulated on the mainland and remained the preferred manner there and in the western colonies of the Greeks. The *Ionic* was the order of choice in the Aegean Islands and on the western coast of Asia Minor. The geographical distinctions are by no means absolute. The Ionic order was, for example, often used in Athens (where, according to some, the Athenians were considered Ionians who never migrated).

In both orders, the columns rest on the *stylobate,* the uppermost course of the platform. Metal *clamps* held together the stone blocks in each horizontal course, while metal *dowels* joined vertically the blocks of different courses. The columns have two or three parts, depending on the order: the *shaft,* which is marked with vertical channels (*flutes*); the *capital;* and, in the Ionic order, the *base.* Greek column shafts, in contrast to their Minoan and Mycenaean forebears, taper gradually from bottom to top. They usually are composed of separate *drums* joined by metal dowels to prevent turning as well as shifting, although instances of *monolithic* (single-piece) columns are known. In the Doric order, the top of the shaft is marked with one or several horizontal lines *(necking)* that furnish the transition to the capital. The capital has two elements. The lower of them (the *echinus*) varies with the order. In the Doric, it is convex and cushionlike, similar to the echinus of Minoan (see FIG. 4-5) and Mycenaean (see FIG. 4-20) capitals. In the Ionic, it is small and supports a bolster ending in scrolllike spirals (the *volutes*). The upper element, present in both orders, is a flat, square block (the *abacus*) that provides the immediate support for the entablature.

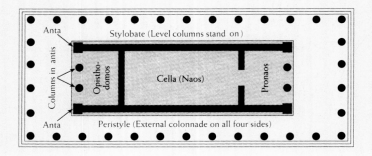

elements in that much more severe order. The Siphnian statue-columns resemble contemporary korai dressed in Ionian chitons and himations (FIG. 5-12).

Another Ionic feature of the Siphnian Treasury is the continuous sculptured frieze on all four sides of the building. The north frieze represents the popular theme of the gigantomachy, but it is a much more detailed rendition than that in the corner of the Corfu pediment. In the section reproduced here (FIG. **5-17**), Apollo and Artemis pursue a fleeing giant at the right, while behind them one of the lions pulling a goddess's chariot attacks a giant and bites into his midsection. The crowded composition was originally enlivened by paint (painted labels identified the various protagonists), and some figures had metal weapons. The effect must have been dazzling. On one of the shields the sculptor inscribed his name (unfortunately lost), a clear indication of pride in accomplishment.

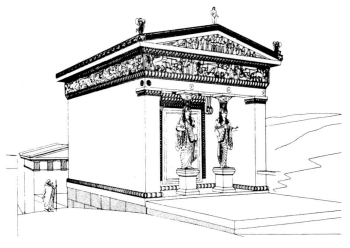

5-16 Reconstruction drawing of the Siphnian Treasury, Delphi, Greece, ca. 530 B.C.

The entablature has three parts: the *architrave* or *epistyle,* the main weight-bearing and weight-distributing element; the *frieze;* and the *cornice,* a molded horizontal projection that together with two sloping *(raking)* cornices forms a triangle that enframes the *pediment.* In the Ionic order, the architrave is usually subdivided into three horizontal bands *(fasciae).* In the Doric order, the frieze is subdivided into *triglyphs* and *metopes,* while in the Ionic the frieze is left open to provide a continuous field for relief sculpture.

Many of the Doric components seem to be translations into stone of an earlier timber architecture. The frieze division into triglyphs and metopes, for example, can be explained best as a stone version of what was originally carpentry. The triglyphs most likely are derived from the ends of crossbeams that rested on the main horizontal support, the architrave. The metopes then would correspond to the voids between the beam ends in the original wooden structure.

The Doric order is massive in appearance, its sturdy columns firmly planted on the stylobate. Compared with the weighty and severe Doric, the Ionic order seems light, airy, and much more decorative. Its columns are more slender and rise from molded bases. The Doric flutes meet in sharp ridges *(arrises),* but the Ionic ridges are flat *(fillets).* The most obvious differences between the two orders are, of course, in the capitals—the Doric, severely plain, and the Ionic, highly ornamental.

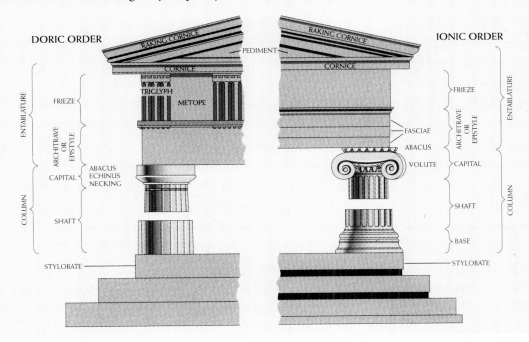

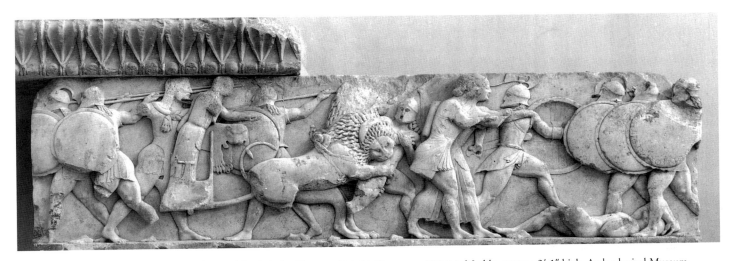

5-17 Gigantomachy, detail of the north frieze of the Siphnian Treasury, Delphi, Greece, ca. 530 B.C. Marble, approx. 2′ 1″ high. Archeological Museum, Delphi.

5-18 KLEITIAS and ERGOTIMOS, *François Vase* (Attic black-figure volute krater), from Chiusi, Italy, ca. 570 B.C. General view *(left)* and detail of centauromachy on other side of vase *(right)*. Approx. 2′ 2″ high. Museo Archeologico, Florence.

Vase Painting

ARTISTS' SIGNATURES Labeled figures and artists' signatures also appear on Archaic painted vases. The masterpiece of this stage of Greek vase painting is the *François Vase* (FIG. **5-18**), named for the excavator who uncovered it (in an enormous number of fragments) in an Etruscan tomb at Chiusi in Italy (see map, Chapter 9, page 230), where it had been imported from Athens. This is in itself a testimony to the esteem held for Athenian potters and painters at this time. In fact, having learned the black-figure technique from the Corinthians, the Athenians had by now taken over the export market for fine painted ceramics.

The *François Vase* (a new kind of krater with volute-shaped handles probably inspired by costly metal prototypes) is signed by both its painter ("Kleitias painted me") and potter ("Ergotimos made me"). In fact, each signed twice! It has more than two hundred figures in six registers. Labels abound, naming humans and animals alike, even some inanimate objects. Only one of the bands was given over to the Orientalizing repertoire of animals and sphinxes. The rest constitute a selective encyclopedia of Greek mythology, focusing on the exploits of Peleus and his son Achilles, the great hero of Homer's *Iliad*, and of Theseus, the legendary king of Athens.

In the detail shown here, Lapiths (a northern Greek tribe) and centaurs battle *(centauromachy)* after a wedding celebration where the man-beasts, who were invited guests, got drunk and attempted to abduct the Lapith maidens and young boys. Theseus, also on the guest list, was prominent among the centaurs' Greek adversaries. Kleitias did not fill the space between his figures with decorative ornament, as did his Geometric predecessors (FIG. 5-1). But his heroes conform to the age-old composite type (profile heads with frontal eyes, frontal torsos, and profile legs and arms). His centaurs are much more believable than their Geometric counterparts (FIG. 5-2). The man-horse combination is top/bottom rather than front/back. The lower (horse) portion has four legs of uniform type, and the upper part of the monster is fully human. In characteristic fashion, the animal section of the centaur is shown in strict profile, while the human head and torso are a composite of frontal and profile views. (Kleitias used a consistent profile for the more adventurous detail of the collapsed centaur at the right.)

EXEKIAS, MASTER OF BLACK-FIGURE The acknowledged master of the black-figure technique was an Athenian named EXEKIAS, whose vases were not only widely exported but copied as well. Perhaps his greatest work is an amphora (FIG. **5-19**), found in an Etruscan tomb at Vulci (see map, Chapter 9, page 230), that Exekias signed as both painter and potter. He did not divide the surface into a series of horizontal bands. Instead, a single large framed panel is peopled by figures of monumental stature. At the left is Achilles, fully armed. He plays a dice game with his comrade Ajax. Out of the lips of Achilles comes the word *tesara* (four); Ajax calls out *tria* (three). Ajax has taken off his helmet, but both men hold their spears. Their shields are nearby, and each man is ready for action at a moment's notice. It is a classic case of "the calm before the storm." The moment Exekias chose to depict is the antithesis of the Archaic penchant for dramatic action. The gravity and tension that will characterize much Classical Greek art of the next century, but are absent in Archaic art, already may be seen here.

Exekias has no equal as a black-figure painter. That may be seen in such details as the extraordinarily intricate engraving of the patterns on the heroes' cloaks (highlighted with delicate touches of white) and in the brilliant composition. The arch formed by the backs of the two warriors echoes the shape of the rounded shoulders of the amphora. The vessel's shape is echoed again in the void between the heads and spears of Achilles and Ajax. Exekias also used the spears to lead the viewer's eyes toward the thrown dice, where the heroes' eyes are fixed. Of course, those eyes do not really look down at the table but stare out from the profile heads in the old manner. For all his brilliance, Exekias was still wedded to many of the old conventions. Real innovation in figure drawing would have to await the invention of a new ceramic painting technique of greater versatility than black-figure, with its dark silhouettes and incised details.

5-19 EXEKIAS, Achilles and Ajax playing a dice game (detail from an Athenian black-figure amphora), from Vulci, Italy, ca. 540–530 B.C. Whole vessel approx. 2′ high. Vatican Museums, Rome.

5-20 ANDOKIDES PAINTER, Achilles and Ajax playing a dice game (Attic bilingual amphora), from Orvieto, Italy, ca. 525–520 B.C. Black-figure side *(left)* and red-figure side *(right)*. Approx. 1′ 9″ high. Museum of Fine Arts, Boston.

"BILINGUAL" PAINTING The birth of this new technique came around 530 B.C., and the person responsible is known as the ANDOKIDES PAINTER, that is, the anonymous painter who decorated the vases signed by the potter Andokides. The differences between the two techniques can best be studied on a series of experimental vases with the same composition painted on both sides, once in black-figure and once in the new technique, *red-figure*. Such vases, nicknamed *bilingual vases,* were produced only for a short time. An especially interesting example is the amphora, now in Boston, by the Andokides Painter (FIG. **5-20**), which features copies of the Achilles and Ajax panel of the bilingual painter's teacher, Exekias.

Neither in black-figure nor red-figure did the Andokides Painter capture the intensity of the model, and the treatment of details is decidedly inferior. Yet the new red-figure technique has obvious advantages over the old black-figure manner. Red-figure is the opposite of black-figure. What was previously black is now red and vice versa. The artist still employs the same black glaze. But instead of using the glaze to create the silhouettes of figures, the painter outlines the figures and then colors the background black. The red clay is reserved for the figures themselves. Interior details are then drawn with the soft brush in place of the stiff metal graver. And the artist can vary the glaze thickness, building it up to give relief to hair curls or diluting it to create brown shades, thereby expanding the chromatic range of the Greek vase painter's craft. The Andokides Painter—many think he was the potter Andokides himself—did not yet appreciate the full potential of his own invention. But he created a technique that, in the hands of other, more skilled artists, helped revolutionize the art of drawing.

EUPHRONIOS, MASTER OF RED-FIGURE One of these younger and more adventurous painters was EUPHRONIOS, whose krater depicting the struggle between Herakles and Antaios (FIG. **5-21**) reveals the exciting possibilities of the new red-figure technique. Antaios was a Libyan giant, a son of Earth, and he derived his power from contact with the ground. To defeat him, Herakles had to lift him up into the air and strangle him while no part of the giant's body touched the earth. But Euphronios did not represent the moment of Herakles' triumph. The two wrestle on the ground, and Antaios still possesses enormous strength. Nonetheless, Herakles has the upper hand. The giant's face is a mask of pain. His eyes roll and his teeth are bared. His right arm is paralyzed, with the fingers limp. Euphronios used diluted glaze to show Antaios's unkempt golden brown hair—intentionally contrasted with the neat coiffure and carefully trimmed beard of the emotionless Greek hero.

The artist also used thinned glaze to delineate the muscles of both figures. But Euphronios was interested not only in rendering human anatomy convincingly. He also wished to show that his figures occupy space. The conventional composite posture for the human figure, which communicates so well the specific parts of the human body, was deliberately rejected

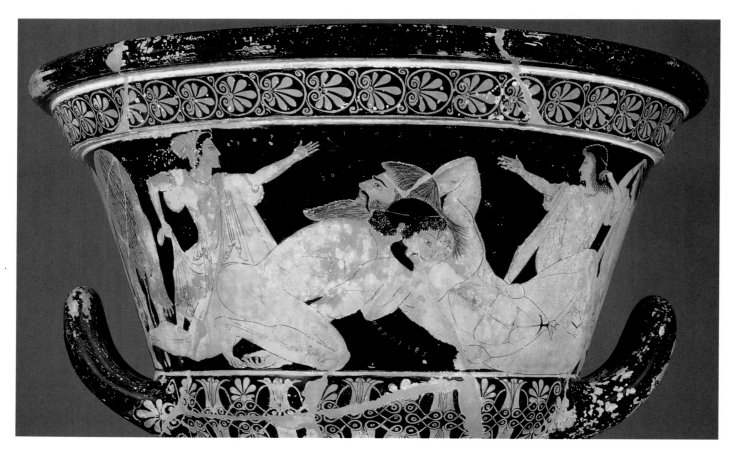

5-21 EUPHRONIOS, Herakles wrestling Antaios (detail of an Attic red-figure calyx krater), from Cerveteri, Italy, ca. 510 B.C. Whole vessel approx. 1' 7" high. Louvre, Paris.

as Euphronios attempted to reproduce how a particular human body is *seen.* He presented, for example, the right thigh of Antaios from the front. The lower leg disappears behind the giant, and one glimpses only part of the right foot. The viewer must make the connection between the upper leg and the foot in the mind. Euphronios did not paint a two-dimensional panel filled with figures in stereotypical postures, as his Archaic and pre-Greek predecessors always did. His panel is a window onto a mythological world with protagonists occupying three-dimensional space. This was a revolutionary new conception of what a picture was supposed to be.

THE RIVALS OF EUPHRONIOS A preoccupation with the art of drawing per se may be seen in a remarkable amphora (FIG. **5-22**) painted by EUTHYMIDES, a contemporary and competitor of Euphronios. The subject is appropriate for a wine storage jar—three tipsy revelers. But the theme was little more than an excuse for the artist to experiment with the representation of unusual positions of the human form. It is no coincidence that the bodies do not overlap, for each is an independent figure study. Euthymides rejected the conventional frontal and profile composite views. Instead, he

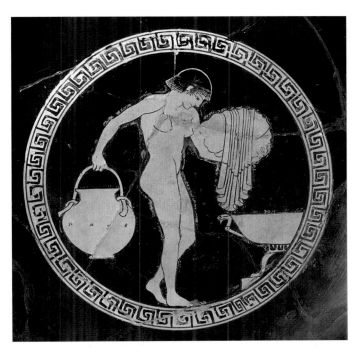

5-23 ONESIMOS, Girl preparing to bathe (interior of an Attic red-figure kylix), from Chiusi, Italy, ca. 490 B.C. Tondo approx. 6″ in diameter. Musées Royaux, Brussels.

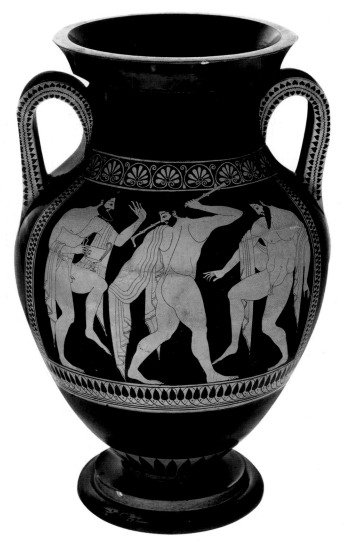

5-22 EUTHYMIDES, Three revelers (Attic red-figure amphora), from Vulci, Italy, ca. 510 B.C. Approx. 2′ high. Staatliche Antikensammlungen, Munich.

painted torsos that are not two-dimensional surface patterns but are *foreshortened,* that is, drawn in a three-quarter view. Most remarkable is the central figure, who is shown from the rear with a twisting spinal column and buttocks in three-quarter view. Earlier artists had no interest in attempting such postures because they are not only incomplete but also do not show the "main" side of the human body. But for Euthymides the challenge of drawing the figure from such an unusual viewpoint was a reward in itself. With understandable pride he proclaimed his achievement by adding to the formulaic signature "Euthymides painted me" the phrase "as never Euphronios [could do]!"

Interest in the foreshortening of the human figure soon extended to studies of nude women, as on the interior of a *kylix* (drinking cup) ONESIMOS painted (FIG. **5-23**). The representation is remarkable not only for the successful foreshortening of the girl's torso and breasts, seen in three-quarter view, but also for its subject. This is neither mythology nor a scene of wealthy noblemen partying. This is a servant girl, not the lady of the house, who has removed her clothes to bathe. Such a genre scene, not to mention female nudity, would never have been portrayed publicly in monumental painting or sculpture of this time. Only in the private sphere was such a subject acceptable.

Aegina and the Transition to the Classical Period

EVOLUTION AND REVOLUTION The years just before and after 500 B.C. were also a time of dynamic transition in architecture and architectural sculpture. Some of the changes were evolutionary in nature, others revolutionary.

Both kinds are evident in the Temple of Aphaia at Aegina (FIG. **5-24**). The temple sits on a prominent ridge with dramatic views out to the sea. The colonnade is forty-five feet by ninety-five feet and consists of six Doric columns on the facade and twelve on the flanks. This is a much more compact structure than the impressive but ungainly Archaic Temple of Hera I at Paestum (FIG. 5-13), even though the ratio of width to length is similar. Doric architects had learned a great deal in the half century that elapsed. The columns of the Aegina temple are more widely spaced and more slender. The capitals create a smooth transition from the vertical shafts below to the horizontal architrave above. Gone are the Archaic flattened echinuses and bulging shafts of the Paestum columns.

5-24 Temple of Aphaia, Aegina, Greece, ca. 500–490 B.C.

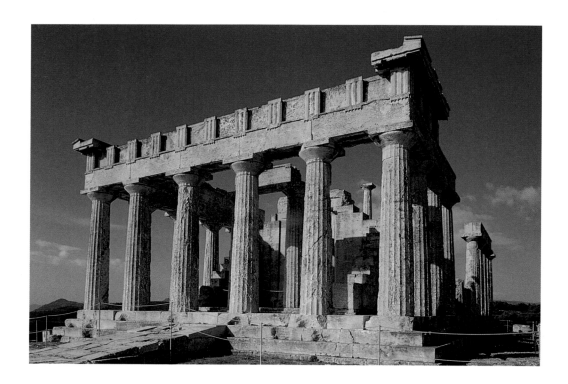

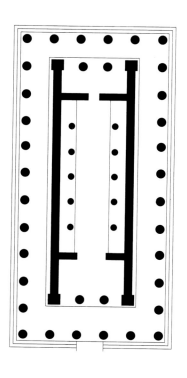

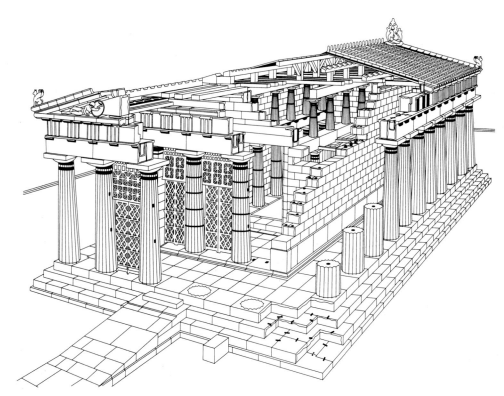

5-25 Plan *(left)* and restored cutaway view *(right)* of the Temple of Aphaia, Aegina, Greece, ca. 500–490 B.C.

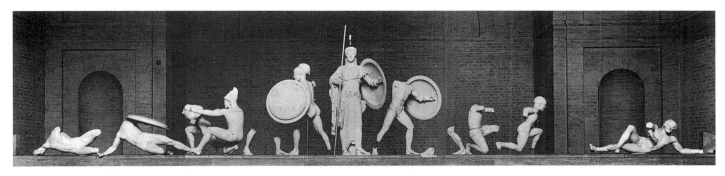

5-26 West pediment of the Temple of Aphaia, Aegina, Greece, ca. 500-490 B.C. Marble, approx. 5′ 8″ high at center. Glyptothek, Munich.

The temple plan and internal elevation (FIG. **5-25**) also were refined. In place of a single row of columns down the cella's center is a double colonnade—and each row has two stories. This arrangement allowed the placement of a statue on the central axis and also gave those gathered in front of the building an unobstructed view through the pair of columns in the pronaos.

Both pediments were filled with life-size statuary (FIG. **5-26**), and the same subject and similar compositions were employed. The theme was the battle of Greeks and Trojans, with Athena at the center of the bloody combat. She is larger than all the other figures because she is superhuman, but the mortal heroes are all carved at the same scale, regardless of their position in the pediment. Unlike the experimental design at Corfu (FIG. 5-15), the Aegina pediments feature a unified theme and consistent size. The latter was achieved by using the whole gamut of bodily postures from upright (Athena) to leaning, falling, kneeling, and lying (Greeks and Trojans).

ARCHAISM YIELDS TO CLASSICISM The sculptures of the Aegina pediments were set in place when the temple was completed around 490 B.C. But the pedimental statues at the eastern end were damaged and replaced with a new group a decade or two later. It is very instructive to compare the earlier and later figures. The west pediment's dying warrior (FIG. **5-27**) was still conceived in the Archaic mode. His torso is rigidly frontal, and he looks out directly at the spectator. In fact, he smiles at us, in spite of the bronze arrow (now missing) that punctures his chest. He is like a mannequin in a store window whose arms and legs have been arranged by someone else for effective display. The viewer has no sense whatsoever of a thinking and feeling human being. The later east pediment's comparable figure (FIG. **5-28**) is radically different. Not only is his posture more natural and more complex, with the torso placed at an angle to the viewer— he is on a par with the painted figures of Euphronios and Euthymides—but he also reacts to his wound as a

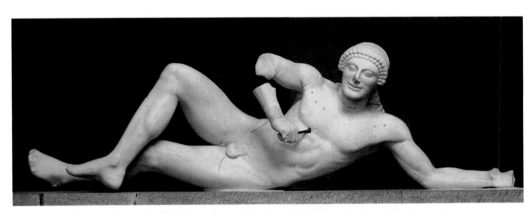

5-27 Dying warrior, from the west pediment of the Temple of Aphaia, Aegina, Greece, ca. 500–490 B.C. Marble, approx. 5′ 2½″ long. Glyptothek, Munich.

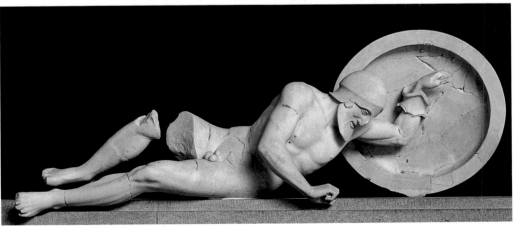

5-28 Dying warrior, from the east pediment of the Temple of Aphaia, Aegina, Greece, ca. 490–480 B.C. Marble, approx. 6′ 1″ long. Glyptothek, Munich.

flesh-and-blood human would. He knows that death is inevitable, but he still struggles to rise once again, using his shield for support. And he does not look out at the spectator. He is concerned with his pain, not with the spectator. Only a decade, perhaps two, separates the two statues, but they belong to different eras. The later warrior is not a creation of the Archaic world, when sculptors imposed anatomical patterns (and smiles) on statues from without. This statue belongs to the Classical world, where statues move as humans move and possess the self-consciousness of real men and women. This was a radical change in the conception of what a statue was meant to be. In sculpture, as in painting, the Classical revolution had occurred.

THE EARLY AND HIGH CLASSICAL PERIODS (FIFTH CENTURY B.C.)

THE AFTERMATH OF THE PERSIAN WARS Art historians reckon the beginning of the Classical* age from a historical event, the defeat of the Persian invaders of Greece by the allied Hellenic city-states. Shortly after Athens was occupied and sacked in 480 B.C., the Greeks won a decisive naval victory over the Persians at Salamis. It had been a difficult war, and at times it had seemed as though Greece would be swallowed up by Asia and the Persian king Xerxes would rule over all. When the Greek city Miletos was destroyed in 494 B.C., the Persians killed the male inhabitants and sold the women and children into slavery. The close escape of the Greeks from domination by Asian "barbarians" nurtured a sense of Hellenic identity so strong that from then on the his-

*Note: In *Art through the Ages* the adjective "Classical," with uppercase *C*, refers specifically to the Classical period of ancient Greece, 480–323 B.C. Lowercase "classical" refers to Greco-Roman antiquity in general, that is, the period treated in Chapters 5, 6, and 10.

tory of European civilization would be distinct from the civilization of Asia, even though they continued to interact.

Typical of the time were the views of the great dramatist Aeschylus, who celebrated, in his *Oresteia,* the triumph of reason and law over barbarous crimes, blood feuds, and mad vengeance. Himself a veteran of the epic battle of Marathon, Aeschylus repudiated in majestic verse all the slavish and inhuman traits of nature that the Greeks at that time of crisis associated with the Persians.

The decades following the removal of the Persian threat are universally considered the high point of Greek civilization. This is the era of the dramatists Sophocles and Euripides, as well as Aeschylus, the historian Herodotus, the statesman Pericles, the philosopher Socrates, and many of the most famous Greek architects, sculptors, and painters.

Architecture and Architectural Sculpture

A NEW TEMPLE FOR OLYMPIA The first great monument of Classical art and architecture is the Temple of Zeus at Olympia, site of the quadrennial Olympic Games. The temple was begun about 470 B.C. and was probably completed by 457 B.C. The architect was LIBON OF ELIS. Today the structure is in ruins, its picturesque tumbled column drums an eloquent reminder of the effect of the passage of time on even the grandest monuments humans have built. Students of art history can get a good idea of its original appearance, however, by looking at a slightly later Doric temple modeled closely on the Olympian shrine of Zeus—the second Temple of Hera at Paestum (FIG. **5-29**). The plans and elevations of both temples follow the pattern of the Temple of Aphaia at Aegina (FIG. 5-25): an even number of columns (six) on the short ends, two columns in antis, and two rows of columns in two stories inside the cella. But the Temple of Zeus was more lavishly decorated than even the Aphaia temple. Statues not only filled both pediments, but also the six metopes of the Doric frieze of the pronaos and the matching six of the opisthodomos were adorned with reliefs.

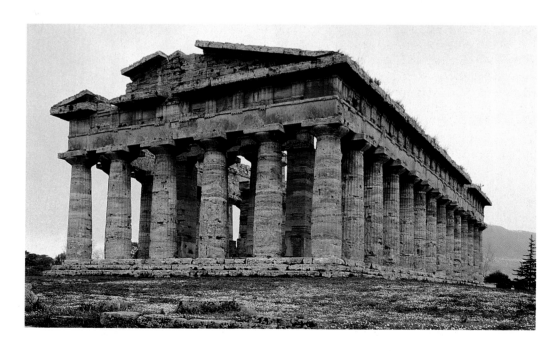

5-29 Temple of Hera II, Paestum, Italy, ca. 460 B.C.

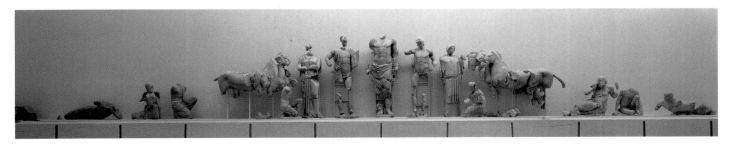

5-30 East pediment from the Temple of Zeus, Olympia, Greece, ca. 470–456 B.C. Marble, approx. 87′ wide. Archeological Museum, Olympia.

TREACHERY IN A CHARIOT RACE The subject of the Temple of Zeus's east pediment (FIG. **5-30**) had deep local significance: the chariot race between Pelops (from whom the Peloponnesos takes its name) and King Oinomaos. The story is a sinister one. Oinomaos had one daughter, Hippodameia, and it was foretold that he would die if she married. Consequently, Oinomaos challenged any suitor who wished to make Hippodameia his bride to a chariot race from Olympia to Corinth. If the suitor won, he also won the hand of the king's daughter. But if he lost, he was killed. The outcome of each race was predetermined, because Oinomaos possessed divine horses his father Ares gave him. Many suitors had been killed, and to insure his victory Pelops resorted to bribing the king's groom Myrtilos to rig the royal chariot so that it would collapse during the race. Oinomaos was killed and Pelops won his bride, but he drowned Myrtilos rather than pay his debt to him. Before he died Myrtilos brought a curse on Pelops and his descendants. This curse led to the murder of Pelops's son Atreus and to events that figure prominently in some of the great Greek tragedies of the day, the three plays known collectively as Aeschylus's *Oresteia:* the sacrifice by Atreus's son Agamemnon of his daughter Iphigeneia; the slaying of Agamemnon by Aegisthus, lover of Agamemnon's wife Clytaemnestra; and the murder of Aegisthus and Clytaemnestra by Orestes, the son of Agamemnon and Clytaemnestra.

The pedimental statues (which faced toward the starting point of all Olympic chariot races) are, in fact, posed like actors on a stage—Zeus in the center, Oinomaos and his wife on one side, Pelops and Hippodameia on the other, and their respective chariots to each side. All are quiet; the horrible events known to every spectator have yet to occur. Only one man reacts—a seer (FIG. **5-31**) who knows the future. He is a remarkable figure. Unlike the gods, heroes, and noble youths and maidens who are the almost exclusive subjects of Archaic and Classical Greek statuary, this seer is a rare depiction of old age. He has a balding, wrinkled head and sagging musculature—and a horrified expression on his face. This is a true show of emotion, unlike the stereotypical "Archaic smile," without precedent in earlier Greek sculpture and not a regular feature of Greek art until the Hellenistic age.

THE TWELVE LABORS OF HERAKLES The metopes of the Zeus temple are also thematically connected with the site, for they depict the twelve labors of Herakles (see "Herakles: Greatest of Greek Heroes," page 103), the legendary founder of the Olympic Games. In the metope illus-

trated here (FIG. **5-32**), Herakles holds up the sky (with the aid of the goddess Athena—and a cushion) in place of Atlas, who had undertaken the dangerous journey to fetch the golden apples of the Hesperides for the hero. The load soon will be transferred back to Atlas, but now each of the very high relief figures in the metope stands quietly with the same serene dignity as the statues in the Olympia pediment.

In both attitude and dress (simple Doric peplos for the women), all the Olympia figures display a severity that contrasts sharply with the smiling and elaborately clad figures of the Late Archaic period. Many art historians call this Early Classical phase of Greek art the "Severe Style."

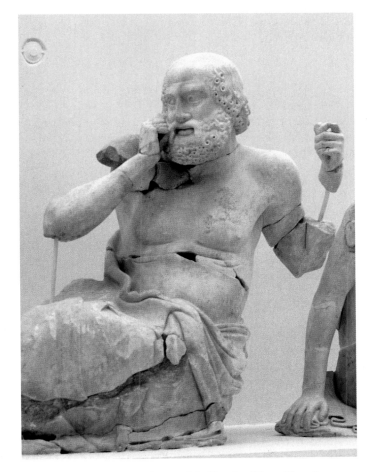

5-31 Seer, from the east pediment of the Temple of Zeus, Olympia, Greece, ca. 470–456 B.C. Marble, approx. 4′ 6″ high. Archeological Museum, Olympia.

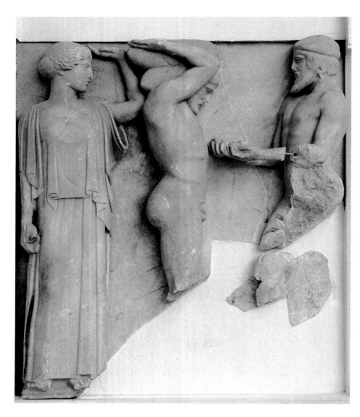

5-32 Athena, Herakles, and Atlas with the apples of the Hesperides, metope from the Temple of Zeus, Olympia, Greece, ca. 470–456 B.C. Marble, approx. 5′ 3″ high. Archeological Museum, Olympia.

Statuary

A NEW WAY TO STAND The Early Classical style is also characterized by a final break from the rigid and unnatural Egyptian-inspired pose of the Archaic kouroi. This change may be seen in the postures of the Olympia figures and in the somewhat earlier statue from the Athenian Acropolis known as the *Kritios Boy* (FIG. **5-33**) because it was once thought to have been carved by the sculptor KRITIOS. For the first time, a sculptor was concerned not simply with representing the body but with portraying how a human being (as opposed to a stone image) actually stands. Real people do not stand in the stiff-legged pose of the kouroi and korai or their Egyptian predecessors. Humans shift their weight and the position of the main bodily parts around the vertical, but flexible, axis of the spine. When humans move, the body's elastic musculoskeletal structure dictates a harmonious, smooth motion of all its elements. The sculptor of the *Kritios Boy* was among the first to grasp this fact and to represent it in statuary. The youth has a slight dip to the right hip, indicating the shifting of weight onto his left leg. His right leg is bent, at ease. Even his head turns slightly to the right, breaking the unwritten rule of frontality dictating the form of virtually all earlier statues. This weight shift, which art historians describe as *contrapposto* (counterbalance), separates Classical from Archaic Greek statuary. When it reappeared, after a long absence, in the sculpture of the later Middle Ages and the Renaissance, it was an unmistakable sign of renewed interest in Classical art.

BRONZE STATUES RESCUED FROM THE SEA The innovations of the *Kritios Boy* were carried even further in the bronze statue of a warrior (FIG. **5-34**) found in the sea near Riace at the "toe" of the Italian "boot." It is one of a pair of statues found in the cargo of a ship that sank in antiquity on its way from Greece probably to Rome, where Greek sculpture was much admired. These statues, now known as the *Riace Bronzes,* were discovered accidentally by a diver. Although they had to undergo several years of cleaning and restoration after nearly two millennia of submersion in salt

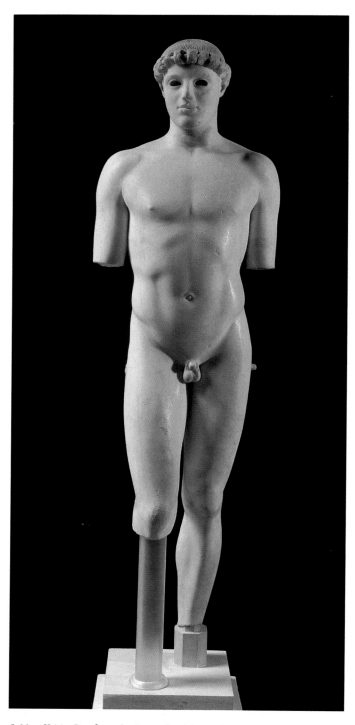

5-33 *Kritios Boy,* from the Acropolis, Athens, Greece, ca. 480 B.C. Marble, approx. 2′ 10″ high. Acropolis Museum, Athens.

the turn of the head and feet in opposite directions as well as a slight twist at the waist are in keeping with the Severe Style. The moment chosen for depiction is not during the frenetic race but after, when the driver quietly and modestly holds his horses still in the winner's circle. He grasps the reins in his outstretched right hand (the lower left arm, cast separately, is missing), and he wears the standard charioteer's garment, girdled high and held in at the shoulders and the back to keep it from flapping. The folds emphasize both the verticality and calm of the figure and recall the flutes of a Greek column. A band inlaid with silver is tied around the head and confines the hair. The eyes are made of glass paste and shaded by delicate bronze lashes.

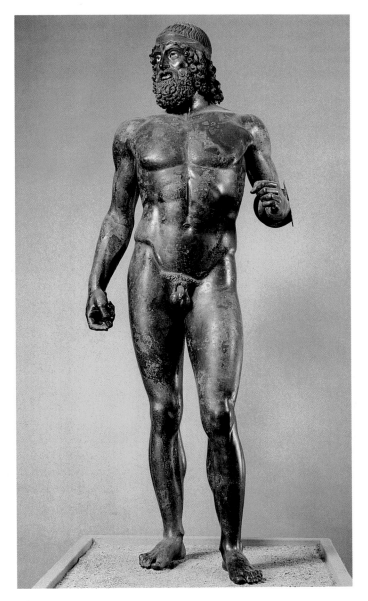

5-34 Warrior, from the sea off Riace, Italy, ca. 460–450 B.C. Bronze, approx. 6′ 6″ high. Archeological Museum, Reggio Calabria.

water, they are nearly intact. The statue shown here lacks only its shield, spear, and wreath. It is a masterpiece of hollow-casting (see "Hollow-Casting Life-Size Bronze Statues," page 124), with inlaid eyes, silver teeth and eyelashes, and copper lips and nipples (see FIG. Intro-18). The weight shift is more pronounced than in the *Kritios Boy*. The warrior's head turns more forcefully to the right, his shoulders tilt, his hips swing more markedly, and his arms are freed from the body. Archaic frontality and rigidity gave way to natural motion in space.

A QUIET VICTOR AND A THUNDERING GOD
The high technical quality of the Riace warrior is equaled in another bronze statue (FIG. **5-35**) set up a decade or two earlier to commemorate the victory of the tyrant Polyzalos of Gela (Sicily) in a chariot race at Delphi. The statue is almost all that remains of an enormous group composed of Polyzalos's driver, the chariot, the team of horses, and a young groom. The charioteer stands in an almost Archaic pose, but

5-35 Charioteer, from a group dedicated by Polyzalos of Gela in the Sanctuary of Apollo, Delphi, Greece, ca. 470 B.C. Bronze, approx. 5′ 11″ high. Archeological Museum, Delphi.

MATERIALS AND TECHNIQUES

Hollow-Casting Life-Size Bronze Statues

Monumental bronze statues such as the Riace warrior (FIG. 5-34), the Delphi charioteer (FIG. 5-35), and the Artemision god (FIG. 5-36) required great technical skill to produce. They could not be manufactured using a single simple mold, as were small-scale Geometric and Archaic figures (FIGS. 5-2 and 5-3). Weight, cost, and the tendency of large masses of bronze to distort when cooling made life-size castings in solid bronze impractical, if not impossible. Instead, large statues were hollow-cast by the *cire perdue* (lost-wax) method. The lost-wax process entailed several steps and had to be repeated many times, because monumental statues were typically cast in parts—head, arms, hands, torso, and so forth.

First, the sculptor fashioned a full-size *clay model* of the intended statue. Then a clay *master mold* was made around the model and removed in sections. When dry, the various pieces of the master mold were put back together for each separate bodily part. Next, a layer of beeswax was applied to the inside of each mold. When the wax cooled, the mold was removed, and the sculptor was left with a hollow *wax model* in the shape of the original clay model. The artist could then correct or refine details, for example, engrave fingernails on the wax hands or individual locks of hair on the head.

In the next stage, a final clay mold *(investment)* was applied to the exterior of the wax model, and a liquid clay core was poured inside the hollow wax. Metal pins *(chaplets)* then were driven through the new mold to connect the investment with the clay core *(a)*. Now the wax was melted out ("lost") and molten bronze poured into the mold in its place *(b)*. When the bronze hardened and assumed the shape of the wax

model, the investment and as much of the core as possible were removed, and the casting process was complete. Finally, the individually cast pieces were fitted together and soldered, surface imperfections and joins smoothed, eyes inlaid, teeth and eyelashes added, attributes such as spears and wreaths provided, and so forth. Such statues were costly to make and much prized.

Two stages of the lost-wax method of bronzecasting (after S. A. Hemingway[1]): *(a)* clay mold (investment), wax model, and clay core connected by chaplets; *(b)* wax melted out and molten bronze poured into the mold.

[1] Sean A. Hemingway, *How Bronze Statues Were Made in Classical Antiquity* (Cambridge, Mass.: Harvard University Art Museums, 1996), 4.

The male human form in motion is, by contrast, the subject of another Early Classical bronze statue (FIG. **5-36**), which, like the Riace warrior, divers found in an ancient shipwreck, this time off the coast of Greece itself at Cape Artemision. The bearded god once hurled a weapon held in his right hand, probably a thunderbolt, in which case he is Zeus. A less likely suggestion is that this is Poseidon with his trident. The pose could be employed equally well for a javelin thrower. Both arms are boldly extended, and the right heel is raised off the ground, underscoring the lightness and stability of hollow-cast monumental statues.

A GREEK STATUE FOR A ROMAN PATRON A bronze statue similar to the Artemision Zeus was the renowned *Diskobolos (Discus Thrower)* by MYRON (FIG. **5-37**), which is known only through marble copies made in Roman times. Even when the original was removed from Greece, as were the Riace and Artemision bronzes, only one community or individual could own it. Demand so far exceeded the supply that a veritable industry was born to meet the Roman call for Greek statuary to display in public places and private villas alike. The copies usually were made in less costly marble. The change in medium resulted in a different surface appearance. In most

cases, the copyist also had to add an intrusive tree trunk to support the great weight of the stone statue and struts between arms and body to strengthen weak points. The copies rarely approach the quality of the originals, and the Roman sculptors sometimes took liberties with their models to conform to their own tastes and needs. Occasionally, for example, a mirror image of the original was created for a specific setting. Nevertheless, the copies are indispensable today. Without them it would be impossible to reconstruct the history of Greek sculpture after the Archaic period.

Myron's *Discus Thrower* is a vigorous action statue, like the Artemision Zeus, but it is composed in an almost Archaic manner, with profile limbs and a nearly frontal chest, suggesting the tension of a coiled spring. Like the arm of a pendulum clock, the right arm of the *Diskobolos* has reached the apex of its arc but has not yet begun to swing down again. Myron froze the action and arranged the body and limbs so that two intersecting arcs were formed, creating the impression of a tightly stretched bow a moment before the string is released. This tension is not, however, mirrored in the athlete's face, which remains expressionless. Once again, as in the later of the two warrior statues from the Aegina pediments (FIG. 5-28), the head is turned away from the spectator. In

5-36 Zeus (or Poseidon?), from the sea off Cape Artemision, Greece, ca. 460–450 B.C. Bronze, approx. 6' 10" high. National Archeological Museum, Athens.

contrast to Archaic athlete statues, the Classical *Diskobolos* does not perform for the spectator but concentrates on the task at hand.

THE QUEST FOR IDEAL FORM One of the most frequently copied Greek statues was the *Doryphoros (Spear Bearer)* by POLYKLEITOS, a work that epitomizes the intellectual rigor of Classical statuary design. The original is lost. We illustrate a marble copy (FIG. **5-38**) that stood in a palestra at Pompeii, where it served as a model for Roman athletes. The *Doryphoros* is the embodiment of Polykleitos's vision of the ideal statue of a nude male athlete or warrior. In fact, it was made as a demonstration piece to accompany a treatise on the subject. *Spear Bearer* is but a modern

5-38 POLYKLEITOS, *Doryphoros (Spear Bearer)*. Roman marble copy from Pompeii, Italy, after a bronze original of ca. 450–440 B.C., 6' 11" high. Museo Nazionale, Naples.

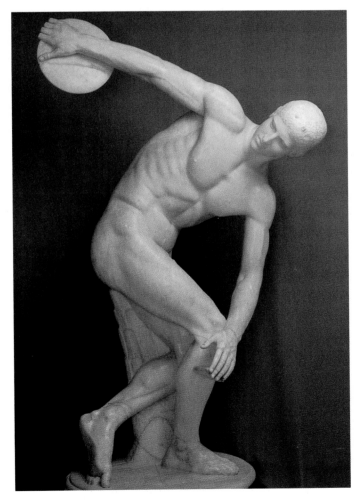

5-37 MYRON, *Diskobolos (Discus Thrower)*. Roman marble copy after a bronze original of ca. 450 B.C., 5' 1" high. Museo Nazionale Romano, Rome.

Polykleitos's Prescription for the Perfect Statue

One of the most influential philosophers of the ancient world was Pythagoras of Samos, who lived during the latter part of the sixth century B.C. A famous geometric theorem still bears his name. Pythagoras also is said to have discovered that harmonic chords in music are produced on the strings of a lyre at regular intervals that may be expressed as ratios of whole numbers—2:1, 3:2, 4:3. He and his followers, the Pythagoreans, believed more generally that underlying harmonic proportions could be found in all of nature, determining the form of the cosmos as well as of things on earth, and that beauty resided in harmonious numerical ratios.

By this reasoning, a perfect statue would be one constructed according to an all-encompassing mathematical formula. In the mid-fifth century B.C., the sculptor Polykleitos of Argos set out to make just such a statue (FIG. 5-38). He recorded the principles he followed and the proportions he used in a treatise titled the *Canon*. His treatise is unfortunately lost, but Galen, a physician who lived during the second century A.D., summarized the sculptor's philosophy as follows: "[Beauty arises from] the commensurability [*symmetria*] of the parts, that is to say, of finger to finger, and of all the fingers to the palm and the wrist, and of these to the forearm, and of the forearm to the upper arm, and of all the other parts to each other, as they are set forth in the *Canon* of

Polykleitos. . . . [The sculptor] supported his treatise [by making] a statue according to [its] tenets, and he called the statue, like the treatise, the *Canon*." This is why Pliny the Elder, writing in the first century A.D., maintained that Polykleitos, "alone of men is deemed to have rendered art itself [that is, the theoretical basis of art] in a work of art."[1]

Polykleitos's belief that a successful statue resulted from the precise application of abstract principles is reflected in an anecdote (probably a later invention) the Roman historian Aelian told:

Polykleitos made two statues at the same time, one which would be pleasing to the crowd and the other according to the principles of his art. In accordance with the opinion of each person who came into his workshop, he altered something and changed its form, submitting to the advice of each. Then he put both statues on display. The one was marvelled at by everyone, and the other was laughed at. Thereupon Polykleitos said, "But the one that you find fault with, you made yourselves; while the one that you marvel at, I made."[2]

[1] J. J. Pollitt, trans., *The Art of Ancient Greece: Sources and Documents* (New York: Cambridge University Press, 1990), 75.

[2] Ibid., 79.

descriptive epithet for the statue. The name assigned to it by Poly-kleitos was *Canon* (see "Polykleitos's Prescription for the Perfect Statue," above).

The *Doryphoros* is the culmination of the evolution in Greek statuary from the Archaic kouros to the *Kritios Boy* to the Riace warrior. The contrapposto is more pronounced than ever before in a standing statue, but Polykleitos was not content with simply rendering a figure that stands naturally. His aim was to impose order on human movement, to make it "beautiful," to "perfect" it. He achieved this through a system of *chiastic,* or cross, balance. What appears at first to be a casually natural pose is, in fact, the result of an extremely complex and subtle organization of the figure's various parts. Note, for instance, how the supporting leg's function is echoed by the straight-hanging arm to provide the figure's right side with the columnar stability needed to anchor the left side's dynamically flexed limbs. If read anatomically, however, the tensed and relaxed limbs may be seen to oppose each other diagonally. That is, the right arm and the left leg are relaxed, and the tensed supporting leg is opposed by the flexed arm, which held a spear. In like manner, the head turns to the right while the hips twist slightly to the left. And although the *Doryphoros* seems to take a step forward, he does not move. This dynamic asymmetrical balance, this motion while at rest, and the resulting harmony of opposites are the essence of the Polykleitan style.

The Athenian Acropolis

ATHENIAN VICTORY AND TYRANNY While Polykleitos was formulating his *Canon* in Argos, the Athenians, under the leadership of Pericles, were at work on one of the most ambitious building projects ever undertaken, the reconstruction of the Acropolis after the Persian sack of 480 B.C. Athens, despite the damage it suffered at the hands of the army of Xerxes, emerged from the war with enormous power and prestige. The Athenian commander Themistocles had decisively defeated the Persian navy off the island of Salamis, southwest of Athens, and forced it to retreat to Asia.

In 478 B.C., in the aftermath of the Persians' expulsion from the Aegean, the Greeks formed an alliance for mutual protection against any renewed threat from the Orient. The new confederacy came to be known as the Delian League, because its headquarters were on the sacred island of Delos, midway between the Greek mainland and the coast of Asia Minor. Although at the outset each league member had an equal vote, Athens was "first among equals," providing the allied fleet commander and determining which cities were to furnish ships and which were instead to pay an annual tribute to the treasury at Delos. Continued fighting against the Persians kept the alliance intact, but Athens gradually assumed a dominant role. In 454 B.C. the Delian treasury was transferred to Athens, ostensibly for security reasons. Pericles, who

was only in his teens when the Persians laid waste to the Acropolis, was by midcentury the recognized leader of the Athenians, and he succeeded in converting the alliance into an Athenian empire. Tribute continued to be paid, but the surplus reserves were not expended for the common good of the allied Greek states. Rather, they were expropriated to pay the enormous cost of executing Pericles' grand plan to embellish the Acropolis of Athens.

The reaction of the allies—in reality the subjects of Athens—was predictable. Plutarch, who wrote a biography of Pericles in the early second century A.D., indicated the wrath the Greek victims of Athenian tyranny felt by recording the protest voiced against Pericles' decision even in the Athenian assembly. Greece, Pericles' enemies said, had been dealt "a terrible, wanton insult" when Athens used the funds contributed out of necessity for a common war effort to "gild and embellish itself with images and extravagant temples, like some pretentious woman decked out with precious stones."[4] This is important to keep in mind when examining those great and universally admired buildings erected on the Acropolis in accordance with Pericles' vision of his polis reborn from the ashes of the Persian sack. They are *not*, as some would wish people to believe, the glorious fruits of Athenian democracy but are instead the by-products of tyranny and the abuse of power. Too often art and architectural historians do not ask how a monument was financed. The answer can be very revealing—and very embarrassing.

THE "OLYMPIAN PERICLES" A number of Roman copies are preserved of a famous bronze portrait statue of Pericles fashioned by KRESILAS, who was born on Crete but who worked in Athens. The portrait was set up on the Acropolis, probably immediately after the leader's death in 429 B.C., and depicted Pericles in heroic nudity. The statue must have resembled that of the Riace warrior (FIG. 5-34) but with the helmet of a *strategos* (general), the position Pericles was elected to fifteen times. The copies, in marble, only reproduce the head. Ours (FIG. **5-39**) is a *herm* (a bust on a square pillar) inscribed "Pericles, son of Xanthippos, the Athenian." Pericles was said to have had an abnormally elongated skull, and Kresilas recorded this feature (while also concealing it) by providing a glimpse through the helmet's eye slots of the hair at the top of the head. This, together with the unblemished features of Pericles' Classically aloof face and, no doubt, his body's perfect physique, led Pliny to assert that Kresilas had the ability to make noble men appear even more noble in their portraits. In fact, he referred to Kresilas's "portrait"—it is not a portrait at all in the modern sense of an individual's likeness—of the Athenian statesman as "the Olympian Pericles," for in this image Pericles appeared almost godlike.[5]

PERICLES' ACROPOLIS, THEN AND NOW The centerpiece of Pericles' great building program on the Acropolis (FIGS. **5-40** and **5-41**) was the Parthenon, or the Temple of Athena Parthenos, erected in the remarkably short period between 447 and 438 B.C. (Work on the great temple's ambitious sculptural ornamentation continued until 432 B.C.) As soon as the Parthenon was completed, construction commenced on a grand new gateway to the Acropolis from the west (the only accessible side of the natural plateau), the Propylaia (FIG. 5-41). Begun in 437 B.C., it was left unfinished in 431 B.C. at the outbreak of the Peloponnesian War between Athens and Sparta. Two later temples, the Erechtheion and the Temple of Athena Nike (FIG. 5-41), built after Pericles' death, were probably also part of the original design. The greatest Athenian architects and sculptors of the Classical period focused their attention on the construction and decoration of these four buildings. More human creative genius concentrated on the Periclean Acropolis than in any other place or time in the history of Western civilization.

That these buildings exist at all today is something of a miracle. The Parthenon, for example, was converted into a Byzantine church and later a Catholic church in the Middle Ages and then, after the Ottoman conquest of Greece, into an Islamic mosque. Each time the building was remodeled for a different religion, it was modified structurally. The colossal statue of Athena inside was removed early on, and the churches had a great curved *apse* at the east end housing the altar, while the mosque had a *minaret* tower used to call the faithful to prayer. In 1687, the Venetians besieged the Acropolis, which at that time was in Turkish hands. One of their rockets scored a direct hit on the ammunition depot the Turks had installed in part of the Parthenon. The resultant explosion blew out the building's center. To make matters worse, the Venetians subsequently tried to remove some of the statues from the Parthenon's pediments. In more than one case,

5-39 KRESILAS, Pericles. Roman marble herm copy after a bronze original of ca. 429 B.C., approx. 6′ high. Vatican Museums, Rome.

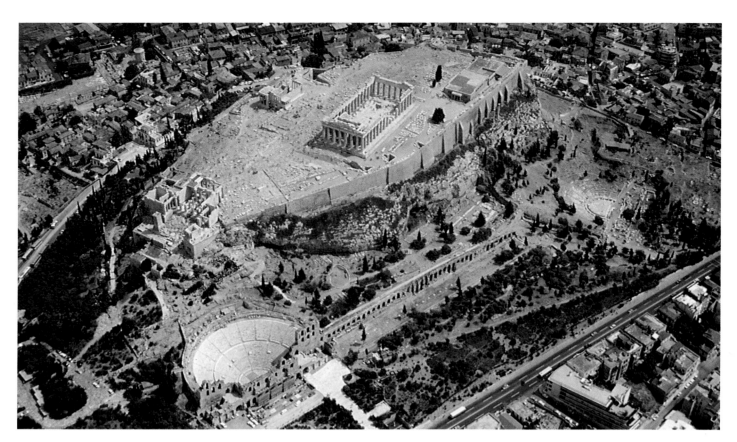

5-40 Aerial view of the Acropolis, Athens, Greece.

statues were dropped and smashed on the ground. Today, a uniquely modern blight threatens the Parthenon and the other buildings of the Periclean age. The corrosive emissions of factories and automobiles are decomposing the ancient marbles. A great campaign has been under way for some time to protect the columns and walls from further deterioration. What little original sculpture remained *in situ* when modern restoration began was transferred to the Acropolis Museum's climate-controlled rooms.

Despite the ravages of time and humanity, most of the Parthenon's peripteral colonnade (FIG. **5-42**) is still standing (or has been reerected), and art historians know a great deal about the building and its sculptural program. The architects were IKTINOS and KALLIKRATES. The statue of Athena (FIG. 5-44) was the work of PHIDIAS, who was also the overseer of the temple's sculptural decoration. In fact, Plutarch claims that Phidias was in charge of the entire Periclean Acropolis project.

MATHEMATICS AND THE IDEAL TEMPLE Just as the contemporary *Doryphoros* by Polykleitos may be seen as the culmination of nearly two centuries of searching for the ideal proportions of the various human bodily parts, so, too, the Parthenon may be viewed as the ideal solution to the Greek architect's quest for perfect proportions in Doric temple design. Its well-spaced columns, with their slender shafts, and the capitals, with their straight-sided conical echinuses, are the ultimate refinement of the bulging and squat Doric columns and compressed capitals of the Archaic Hera temple at Paestum (FIG. 5-13). The Parthenon architects and the *Doryphoros* sculptor were kindred spirits in their belief that beautiful proportions resulted from strict adherence to harmonious numerical ratios, whether they were designing a temple more than two hundred feet long or a life-size statue

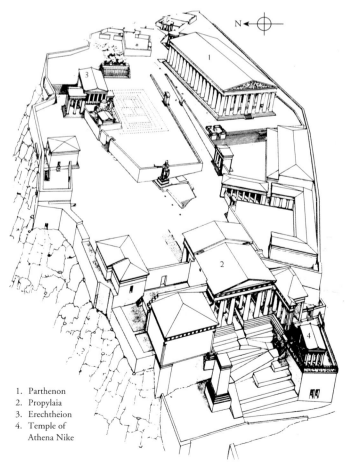

1. Parthenon
2. Propylaia
3. Erechtheion
4. Temple of Athena Nike

5-41 Restored view of the Acropolis, Athens, Greece, seen from the northwest (G. P. Stevens).

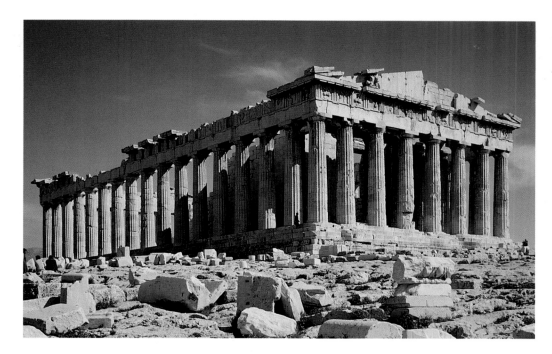

5-42 IKTINOS and KALLIKRATES, Parthenon, the Temple of Athena Parthenos (view from the northwest), Acropolis, Athens, Greece, 447–438 B.C.

of a nude man. For the Parthenon, the controlling ratio for the *symmetria* of the parts may be expressed algebraically as $x = 2y + 1$, where x is the larger number and y is the smaller number. Thus, for example, the temple's short ends have eight columns and the long sides have seventeen: $17 = (2 \times 8) + 1$. The stylobate's ratio of length to width is 9:4 ($9 = [2 \times 4] + 1$), and this ratio also characterizes the cella's proportion of length to width, the distance between the centers of two adjacent column drums (the *interaxial*) in proportion to the columns' diameter, and so forth.

The Parthenon's harmonious design and the mathematical precision of the sizes of its constituent elements tend to obscure the fact this temple, as actually constructed, is quite irregular in shape. Throughout the building are pronounced deviations from the strictly horizontal and vertical lines assumed to be the basis of all Greek post-and-lintel structures. The stylobate, for example, curves upward at the center on both the sides and the facade, forming a kind of shallow dome, and this curvature is carried up into the entablature. Moreover, the peristyle columns lean inward slightly. Those at the corners have a diagonal inclination and are also about two inches thicker than the rest. If their lines were continued, they would meet about one and one-half miles above the temple. These deviations from the norm meant that virtually every Parthenon block and drum had to be carved according to the special set of specifications its unique place in the structure dictated.

This was obviously a daunting task, and a reason must have existed for these so-called refinements in the Parthenon. Some modern observers note, for example, how the curving of horizontal lines and the tilting of vertical ones create a dynamic balance in the building—a kind of architectural contrapposto—and give it a greater sense of life. The oldest recorded explanation, however, may be the correct one. Vitruvius, a Roman architect of the late first century B.C. who claims to have had access to the treatise on the Parthenon Iktinos wrote—again note the kinship with the *Canon* of Polykleitos—maintains that these adjustments were made to compensate for optical illusions. Vitruvius states, for example,

that if a stylobate is laid out on a level surface, it will appear to sag at the center and that the corner columns of a building should be thicker since they are surrounded by light and would otherwise appear thinner than their neighbors.

The Parthenon is "irregular" in other ways as well. One of the ironies of this most famous of all Doric temples is that it is "contaminated" by Ionic elements (FIG. 5-43). Although the cella had a two-story Doric colonnade around Phidias's Athena statue, the back room (which housed the goddess's treasury and the tribute collected from the Delian League) had four tall and slender Ionic columns as sole supports for the superstructure. And while the temple's exterior had a canonical Doric frieze, the inner frieze that ran around the top of the cella wall was Ionic. Perhaps this fusion of Doric and Ionic elements reflects the Athenians' belief that the Ionians of the Cycladic Islands and Asia Minor were descended from Athenian settlers and were therefore their kin. Or it may be Pericles and Iktinos's way of suggesting that Athens was the leader of *all* the Greeks. In any case, a mix of Doric and Ionic features characterizes the fifth-century buildings of the Acropolis as a whole.

LORD ELGIN'S MARBLES The costly decision to incorporate two sculptured friezes in the Parthenon's design is symptomatic. This Pentelic-marble temple was more lavishly decorated than any Greek temple before it, Doric or Ionic (FIG. 5-43). Every one of the ninety-two Doric metopes was decorated with relief sculpture. So, too, was every inch of the five hundred twenty-four-foot-long Ionic frieze. The pediments were filled with dozens of larger-than-life-size statues. Most of the Parthenon's reliefs and statues are today exhibited in a special gallery in the British Museum in London, where they are known popularly as the "Elgin Marbles." Between 1801 and 1803, while Greece was still under Turkish rule, Lord Elgin, the British ambassador to the Ottoman court at Istanbul, was permitted to dismantle many of the Parthenon sculptures and to ship the best-preserved ones to England. He eventually sold them to the British government at a great financial loss to himself. Although he often has been accused of

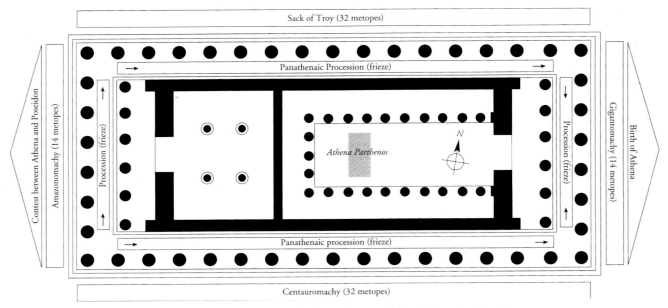

5-43 Plan of the Parthenon, Acropolis, Athens, Greece, with diagram of sculptural program (after A. Stewart), 447–432 B.C.

"stealing" Greece's cultural heritage (the Greek government has long sought the return of the Elgin Marbles to Athens), Lord Elgin must be credited with saving the sculptures from almost certain ruin if they had been left at the site.

PHIDIAS'S GOLD AND IVORY ATHENA One statue that even Elgin could not recover was Phidias's *Athena*

Parthenos, the Virgin, which had been destroyed long before the nineteenth century. Art historians know a great deal about it, however, from descriptions by Greek and Latin authors and from Roman copies. A model in Toronto (FIG. **5-44**) gives a good idea of its appearance and setting. It was a *chryselephantine* statue, that is, fashioned of gold and ivory, the latter used for Athena's exposed flesh. Phidias's statue stood thirty-eight feet tall, and to a large extent the Parthenon was designed around it. To accommodate its huge size, the cella had to be wider than usual. This, in turn, dictated the width of the eight-column facade at a time when six columns were the norm, as at Aegina (FIGS. 5-24 and 5-25).

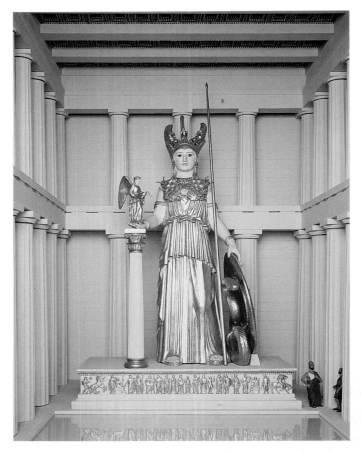

5-44 PHIDIAS, *Athena Parthenos*, in the cella of the Parthenon, Acropolis, Athens, Greece, ca. 438 B.C. Model of the lost statue which was approx. 38′ tall. Royal Ontario Museum, Toronto.

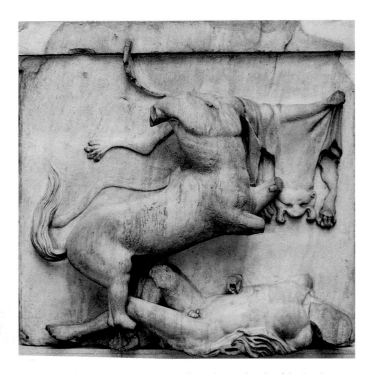

5-45 Lapith versus centaur, metope from the south side of the Parthenon, Acropolis, Athens, Greece, ca. 447–438 B.C. Marble, approx. 4′ 8″ high. British Museum, London.

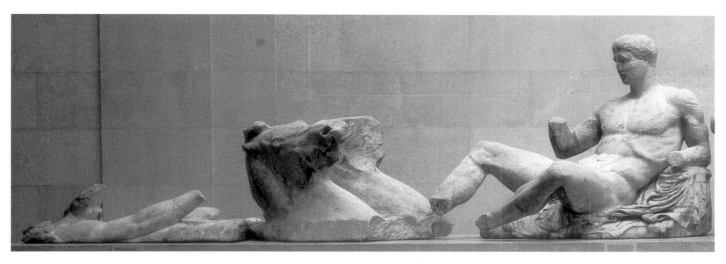

5-46 Helios and his horses, and Dionysos (Herakles?), from the east pediment of the Parthenon, Acropolis, Athens, Greece, ca. 438–432 B.C. Marble, greatest height approx. 4′ 3″. British Museum, London.

Athena was fully armed with shield, spear, and helmet and held Nike (the winged female personification of Victory) in her extended right hand. No one doubts that this Nike referred to the victory of 479 B.C. The memory of the Persian sack of the Acropolis was still vivid, and the Athenians were intensely conscious that by driving back the Persians, they were saving their civilization from the Oriental "barbarians" who had committed atrocities at Miletos. In fact, the *Athena Parthenos* had multiple allusions to the Persian defeat. On the thick soles of Athena's sandals was a representation of a centauromachy. Her shield's exterior was emblazoned with high reliefs depicting the battle of Greeks and Amazons *(Amazonomachy)* when Theseus drove the Amazons out of Athens. And a gigantomachy was painted on the shield's interior. Each of these mythological contests was a metaphor for the triumph of order over chaos, of civilization over barbarism, and of Athens over Persia.

GODS AND HEROES ON THE PARTHENON These same themes were taken up again in the Parthenon's Doric metopes (FIG. 5-43). The best-preserved metopes are those of the south side, which depicted the battle of Lapiths and centaurs, a combat in which Theseus of Athens played a major role. On one extraordinary slab (FIG. **5-45**), a triumphant centaur rises up on its hind legs, exulting over the crumpled body of the Greek it has defeated. The relief is so high that parts are fully in the round; some have broken off. The sculptor knew how to distinguish the vibrant, powerful

form of the living beast from the lifeless corpse on the ground. In other metopes the Greeks have the upper hand, but the full set suggests the battle was a difficult one against a dangerous enemy and that losses as well as victories occurred. The same was true of the war against the Persians.

The subjects of the two pediments were especially appropriate for a temple that celebrated not only Athena but also the Athenians. At the east the birth of Athena was depicted, while at the west was the contest between Athena and Poseidon to determine which one would become the city's patron deity. Athena won, giving her name to the polis and its citizens. It is significant that in the story and in the pediment the Athenians are the judges of the relative merits of the two gods. Here one sees the same arrogance that led to the use of Delian League funds to adorn the Acropolis.

The center of the east pediment was damaged when the apse was added to the Parthenon at the time of its conversion into a church. What remains are the spectators to the left and the right who witnessed Athena's birth on Mount Olympus. At the far left are the head and arms of Helios (the Sun) and his chariot horses rising from the pediment floor (FIG. **5-46**). Next to them is a powerful male figure usually identified as Dionysos or possibly Herakles, who entered the realm of the gods on completion of his twelve labors. At the right are three goddesses, probably Hestia, Dione, and Aphrodite (FIG. **5-47**), and either Selene (the Moon) or Nyx (Night) and more horses, this time sinking

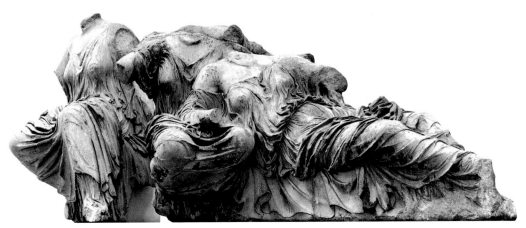

5-47 Three goddesses (Hestia, Dione, and Aphrodite?), from the east pediment of the Parthenon, Acropolis, Athens, Greece, ca. 438–432 B.C. Marble, greatest height approx. 4′ 5″. British Museum, London.

5-48 Details of the Panathenaic Festival procession frieze, from the Parthenon, Acropolis, Athens, Greece, ca. 447–438 B.C. Marble, approx. 3′ 6″ high. Horsemen of north frieze *(top)*, British Museum, London; seated gods and goddesses (Poseidon, Apollo, Artemis, Aphrodite, and Eros) of east frieze *(center)*, Acropolis Museum, Athens; and elders and maidens of east frieze *(bottom)*, Louvre, Paris.

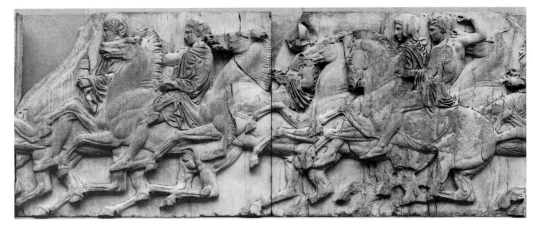

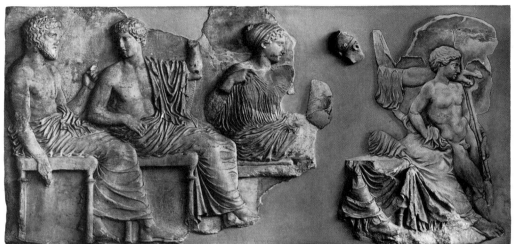

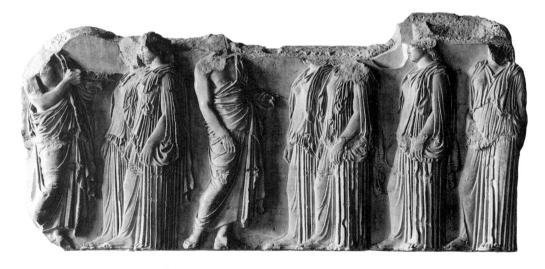

below the pediment's floor. Phidias, who designed the composition even if his assistants executed it, discovered an entirely new way to deal with the awkward triangular frame of the pediment. Its bottom line is the horizon line, and charioteers and their horses move through it effortlessly. The individual figures, even the animals, are brilliantly characterized. The horses of the Sun, at the beginning of the day, are energetic. Those of the Moon or Night, having labored until dawn, are weary.

The reclining figures fill the space beneath the raking cornice beautifully. Dionysos/Herakles and Aphrodite in the lap of her mother Dione are monumental Olympian presences yet totally relaxed organic forms. The sculptors fully understood not only the surface appearance of human anatomy, both male and female, but also the mechanics of how muscles and bones beneath the flesh and garments make the body move. The Phidian school also mastered the rendition of clothed forms. In the Dione-Aphrodite group, the thin and heavy folds of the garments alternately reveal and conceal the main and lesser bodily masses while swirling in a compositional tide that subtly unifies the two figures. The articulation and integration of the bodies produce a wonderful variation of surface and play of light and shade. Not only are the bodies fluidly related to each other, but they are related to the draperies as well, although the latter, once painted, remain distinct from the bodily forms.

ATHENIANS ON ATHENA'S TEMPLE In many ways the most remarkable part of the Parthenon's sculptural program is the inner Ionic frieze (FIG. **5-48**). Scholars still debate the frieze's subject, but most agree that what is represented is the Panathenaic Festival procession that took place every four years in Athens. If this identification is correct, the Athenians judged themselves fit for inclusion in the temple's sculptural decoration. It is another example of the extraordinarily high opinion the Athenians had of their own worth.

The procession began in the *agora* (marketplace) and ended on the Acropolis, where a new peplos was placed on an ancient wooden statue of Athena. That statue (probably similar in general appearance to the *Lady of Auxerre*, FIG. 5-7) was housed in the Archaic temple the Persians razed. The statue had been removed from the Acropolis before the Persian attack for security reasons, and eventually it was installed in the Erechtheion (FIG. 5-51, no. 1). On the Parthenon frieze the procession began on the west, that is, at the temple's rear, the side one first reached after emerging from the gateway to the Acropolis. It then proceeded in parallel lines down the long north and south sides of the building and ended at the center of the east frieze, over the doorway to the cella housing Phidias's statue. It is noteworthy that the upper part of the relief was higher than the lower part so that the more distant and more shaded upper zone was as legible from the ground as the lower part of the frieze. This was another instance of taking optical effects into consideration in the Parthenon's design.

The frieze vividly communicates the procession's acceleration and deceleration. At the outset, on the west side, marshals gather and youths mount their horses. On the north (FIG. 5-48, top) and south, the momentum picks up as the cavalcade moves from the lower town to the Acropolis, accompanied by chariots, musicians, jar carriers, and animals destined for sacrifice. On the east, seated gods and goddesses (FIG. 5-48, center), the invited guests, watch the procession slow almost to a halt (FIG. 5-48, bottom) as it nears its goal at the shrine of Athena's ancient wooden idol. Most remarkable

of all is the role assigned to the Olympian deities. They do not take part in the festival or determine its outcome but are merely spectators. Aphrodite, in fact, extends her left arm to draw her son Eros's attention to the Athenians, just as today a parent at a parade would point out important people to a child. And the Athenian people *were* important — self-important one might say. They were the masters of an empire, and in Pericles' famous funeral oration he painted a picture of Athens that elevated its citizens almost to the stature of gods. The Parthenon celebrated the greatness of Athens and the Athenians as much as it honored Athena.

PROPYLAIA: GATEWAY TO THE ACROPOLIS
Even before all the sculpture was in place on the Parthenon, work began on a new monumental entrance to the Acropolis, the Propylaia (FIG. **5-49**). The architect entrusted with this important commission was MNESIKLES. The site was a difficult one, on a steep slope, but Mnesikles succeeded in disguising the change in ground level by splitting the building into eastern and western sections (FIG. 5-41), each one resembling a Doric temple facade. Practical considerations dictated that the space between the central pair of columns on each side be enlarged. This was the path the chariots and animals of the Panathenaic Festival procession took, and they required a wide ramped causeway. To either side of the central ramp were stairs for pedestrian traffic. Inside, tall, slender Ionic columns supported the split-level roof. Once again an Athenian architect mixed the two orders on the Acropolis. But as with the Parthenon, the Doric order was used for the stately exterior and the Ionic only for the interior. It would have been considered unseemly at this date to combine different kinds of columns on one facade. Later Greek architects were not as reticent (FIG. 5-77).

Mnesikles' full plan for the Propylaia was never executed because of a change in the fortunes of Athens after the outbreak of the Peloponnesian War in 431 B.C. Of the side wings that were part of the original project, only the northwest one was completed. That wing is of special importance in the history of art. In Roman times it housed a *pinakotheke* (picture

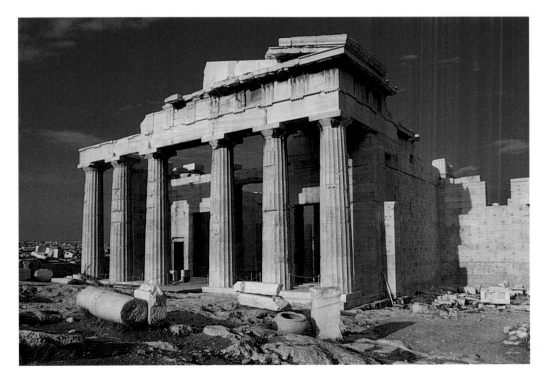

5-49 MNESIKLES, Propylaia (view from the northeast), Acropolis, Athens, Greece, 437–432 B.C.

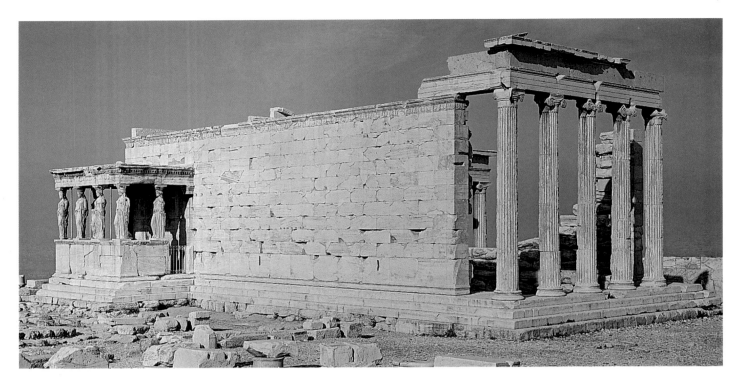

5-50 Erechtheion (view from the southeast), Acropolis, Athens, Greece, ca. 421–405 B.C.

gallery). In it were displayed paintings on wooden panels by some of the major artists of the fifth century B.C. It is uncertain whether or not this was the wing's original function. But if it was, the Propylaia's pinakotheke is the first recorded structure built for the specific purpose of displaying artworks and it is the forerunner of modern museums.

ERECHTHEION: SHRINE OF GODS AND KINGS

In 421 B.C. work finally began on the temple that was to replace the Archaic Athena temple the Persians had razed. The new structure, the Erechtheion (FIG. 5-50), built to the north of the old temple's remains, was, however, to be a multiple shrine. It honored Athena and housed the ancient wooden image of the goddess that was the Panathenaic Festival procession's goal. But it also incorporated shrines to a host of other gods and demigods who loomed large in the city's legendary past. Among these were Erechtheus, an early king of Athens, during whose reign the ancient wooden idol of Athena was said to have fallen from the heavens, and Kekrops, another king of Athens, who served as judge of the contest between Athena and Poseidon. In fact, the site chosen for the new temple was the very spot where that contest occurred. Poseidon had staked his claim to Athens by striking the Acropolis rock with his trident and producing a salt-water spring. The imprint of his trident remained for Athenians of the historical period to see (FIG. 5-51). Nearby, Athena had miraculously caused an olive tree to grow. This tree still stood as a constant reminder of her victory over Poseidon.

The asymmetrical plan of the Ionic Erechtheion is unique for a Greek temple and the antithesis of the simple and harmoniously balanced plan of the Doric Parthenon across the way. Its irregular form reflected the need to incorporate the tomb of Kekrops and other preexisting shrines, the trident mark, and the olive tree into a single complex. The unknown architect responsible for the building also had to struggle with the problem of uneven terrain. The area could not be made level by ter-

racing because that would disturb the ancient sacred sites. As a result, the Erechtheion not only has four sides of very different character, but each side also rests on a different ground level.

Perhaps to compensate for the awkward character of the building as a whole, great care was taken with the Erechtheion's decorative details. The frieze, for example, was given special treatment. The stone chosen was the dark-blue limestone of Eleusis to contrast with the white Pentelic marble of the walls and columns. White relief figures were attached to this dark ground; fragments are now in the Acropolis Museum. The effect was much like that of modern Neoclassical Wedgwood pottery, which, through Roman intermediaries, is ultimately based on the Erechtheion frieze.

1. Shrine housing wooden image of Athena
2. Athena's olive tree
3. Poseidon's trident mark
4. Ruins of Archaic temple

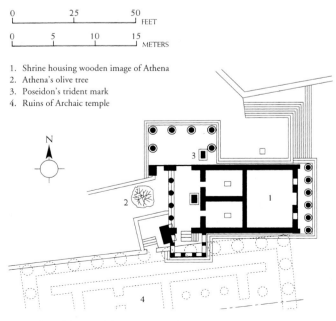

5-51 Plan of the Erechtheion, Acropolis, Athens, Greece, ca. 421–405 B.C.

5-52 Caryatid from the south porch of the Erechtheion, Acropolis, Athens, Greece, ca. 421–405 B.C. Marble, 7′ 7″ high. British Museum, London.

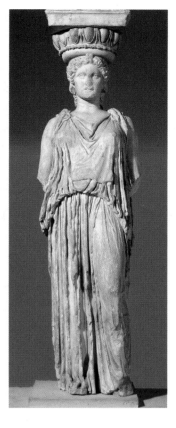

Other details of the Erechtheion's ornament were also much emulated, both in antiquity and in later times. But the temple's most striking and famous feature is its south porch, where caryatids (FIGS. 5-50 and **5-52**) replaced Ionic columns, as they did a century earlier on the Ionic Siphnian Treasury at Delphi (FIG. 5-16). The Delphi caryatids resemble Archaic korai, and their Classical counterparts equally characteristically look like Phidian-era statues. Although they exhibit the weight shift that was standard for the fifth century, the role of the caryatids as architectural supports for the unusual flat roof is underscored by the vertical flutelike drapery folds concealing their stiff, weight-bearing legs. The Classical architect-sculptor successfully balanced the dual and contradictory

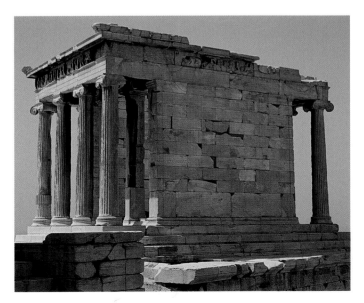

5-53 KALLIKRATES, Temple of Athena Nike (view from the northeast), Acropolis, Athens, Greece, ca. 427–424 B.C.

functions of these female statue-columns. The figures have enough rigidity to suggest the structural column and just the degree of flexibility needed to suggest the living body.

ATHENA, BRINGER OF VICTORY Another Ionic building on the Athenian Acropolis is the little Temple of Athena Nike (FIG. **5-53**), designed by Kallikrates, who worked with Iktinos on the Parthenon (and perhaps was responsible for the Ionic elements of that Doric temple). The temple is amphiprostyle with four columns on both the east and west facades. It stands on what used to be a Mycenaean bastion near the Propylaia and greets all visitors entering Athena's great sanctuary. As on the Parthenon, reference was made here to the victory over the Persians—and not just in the temple's name. Part of its frieze is devoted to a representation of the decisive battle at Marathon that turned the tide against the Persians—a human event, as in the Parthenon's Panathenaic Festival procession frieze. But now a specific occasion was chronicled, not a recurring event anonymous citizens acted out.

Around the building, at the bastion's edge, a parapet was built about 410 B.C. and decorated with exquisite reliefs. The balustrade's theme matched that of the temple proper—Nike (Victory). Her image was repeated dozens of times, always in different attitudes, sometimes erecting trophies bedecked with Persian spoils and sometimes bringing forward sacrificial bulls to Athena. The most beautiful of the reliefs (FIG. **5-54**) shows

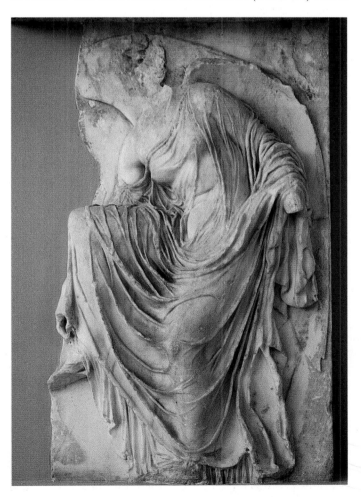

5-54 Nike adjusting her sandal, from the south side of the parapet of the Temple of Athena Nike, Acropolis, Athens, Greece, ca. 410 B.C. Marble, approx. 3′ 6″ high. Acropolis Museum, Athens.

A Greek Woman in Her Father's Home
The Hegeso Stele

In Geometric times huge amphoras and kraters (FIG. 5-1) marked the graves of wealthy Athenians. In the Archaic period, kouroi (FIGS. 5-8 and 5-10) and, to a lesser extent, korai were placed over Greek burials, as were grave stelae ornamented with relief depictions of the deceased. The grave stele of Hegeso (FIG. 5-55) is in this tradition. It was erected at the end of the fifth or beginning of the fourth century B.C. to commemorate the death of Hegeso, daughter of Proxenos, whose names are inscribed on the cornice of the pediment that crowns the stele. Antae at left and right complete the architectural framework.

Hegeso is the well-dressed woman seated on an elegant chair (with footstool). She examines a piece of jewelry (once rendered in paint, not now visible) she has selected from a box a servant girl brings to her. The maid's simple ungirt chiton contrasts sharply with the more elaborate attire of her mistress. The garments of both women reveal the bodily forms beneath them. The faces are serene, without a trace of sadness. Indeed, both mistress and maid are shown in a characteristic shared moment out of daily life. Only the epitaph reveals that Hegeso is the one who has departed.

The simplicity of the scene on the Hegeso stele is, however, deceptive. This is not merely a bittersweet scene of tranquil domestic life before an untimely death. The setting itself is significant—the secluded women's quarters of a Greek house, from which Hegeso rarely would have emerged. Contemporary grave stelae of men regularly show them in the public domain, as warriors. And the servant girl is not so much the faithful companion of the deceased in life as she is Hegeso's possession, like the jewelry box. The slave girl may look solicitously at her mistress, but Hegeso has eyes only for her ornaments. Both slave and jewelry attest to the wealth of Hegeso's father, unseen but prominently cited in the epitaph. (It is noteworthy that the mother's name is not mentioned.) Indeed, even the jewelry box carries a deeper significance, for it probably represents the dowry Proxenos would have provided to his daughter's husband when she left her father's home to enter her husband's home. In ancient Greece's patriarchal society, the dominant position of men is manifest even when only women are depicted.

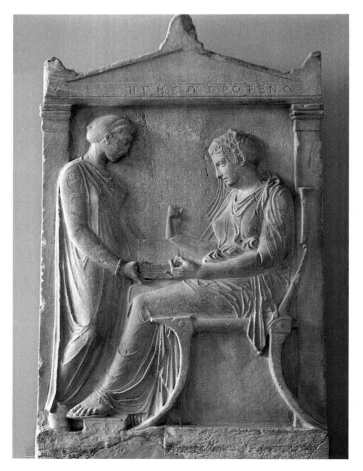

5-55 Grave stele of Hegeso, from the Dipylon cemetery, Athens, Greece, ca. 400 B.C. Marble, 5′ 2″ high. National Archeological Museum, Athens.

Nike adjusting her sandal—an awkward posture rendered elegant and graceful by an anonymous master sculptor. The artist carried the style of the Parthenon pediments (see FIG. 5-47) even further and created a figure whose garments cling so tightly to the body that they seem almost transparent, as if drenched with water. The sculptor was, however, interested in much more than revealing the supple beauty of the young female body. The drapery folds form intricate linear patterns unrelated to the body's anatomical structure and have a life of their own as abstract designs. Deep carving produced pockets of shade to contrast with the polished marble surface and enhance the design's ornamental beauty.

Although the decoration for the great building projects on the Acropolis must have occupied most of the finest sculptors of Athens in the second half of the fifth century B.C., other commissions were available in the city, notably in the Dipylon cemetery. There, around 400 B.C., a beautiful and touching grave stele (FIG. 5-55) in the style of the Temple of Athena Nike parapet reliefs was set up in memory of a woman named Hegeso. Its subject—a young woman in her home, attended by her maid (see "A Greek Woman in Her Father's Home: The Hegeso Stele," above)—and its composition have close parallels in contemporary vase painting.

Painting

POLYCHROMY IN VASE PAINTING Art historians know from ancient accounts that in the Classical period some of the most renowned artists were the painters of monumental wooden panels displayed in public buildings, both secular and religious. Such works are, by nature, perishable,

Greeks did not know how to make them withstand the kiln's heat. Despite the white-ground technique's obvious attractions, the impermanence of the expanded range of colors discouraged its use for everyday vessels, such as drinking cups and kraters. In fact, the full polychrome possibilities of white-ground painting were explored almost exclusively on lekythoi, which were commonly placed in Greek graves as offerings to the deceased. For such vessels designed for short-term use, the white-ground technique's fragile nature was of little concern.

The Achilles Painter's lekythos is decorated with a scene appropriate for its funerary purpose. A youthful warrior takes leave of his wife. The red scarf, mirror, and jug hanging on the wall behind the woman indicate that the setting is the interior of their home. The motif of the seated woman is strikingly similar to that of Hegeso on her grave (FIG. 5-55), but here the woman is the survivor. It is her husband, preparing to go to war with helmet, shield, and spear, who will depart, never to return. On his shield is a huge painted eye, roughly life-size. Greek shields often were decorated with devices such as the horrific face of Medusa, intended to ward off evil spirits and frighten the enemy. This eye undoubtedly was meant to recall this venerable tradition, but it was little more than an excuse for the Achilles Painter to display superior drawing skills. Since the late sixth century B.C., Greek painters had abandoned the Archaic habit of placing frontal eyes on profile faces and attempted to render the eyes in profile. The Achilles Painter's mastery of this difficult problem in foreshortening is on exhibit here.

POLYGNOTOS'S REVOLUTIONARY PAINTINGS

The leading painter of the first half of the fifth century B.C. was POLYGNOTOS OF THASOS, whose works adorned important buildings both in Athens and Delphi. One of these was the pinakotheke of Mnesikles' Propylaia, but the most famous was a portico in the Athenian marketplace that came to be called the Stoa Poikile (Painted Stoa). Descriptions of Polygnotos's paintings make clear that he introduced a revolutionary compositional style, rejecting the scheme used on all the Greek vases examined thus far. Before Polygnotos, figures were situated on a common ground line at the bottom of the picture plane, whether they appeared in horizontal bands or single panels. Polygnotos placed his figures on different levels, staggered in tiers in the manner of Ashurbanipal's lion hunt relief (see FIG. 2-24) of two centuries before. He also incorporated landscape elements into his paintings, making his pictures true "windows onto the world" and not simply surface designs peopled with foreshortened figures. The abandonment of a single ground line by Polygnotos and his followers was as momentous a break from the past as was the rejection of frontality in statuary by Early Classical Greek sculptors.

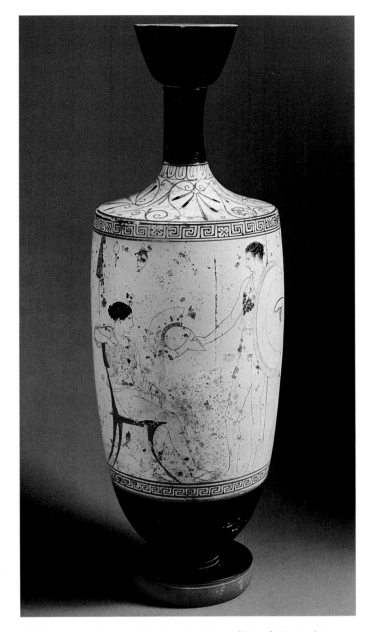

5-56 ACHILLES PAINTER, Warrior taking leave of his wife (Attic white-ground lekythos), from Eretria, Greece, ca. 440 B.C. Approx. 1' 5" high. National Archeological Museum, Athens.

and, unfortunately, all of the great panels of the masters are lost. Nonetheless, one can get some idea of the polychrome nature of those panel paintings by studying Greek vases such as the *lekythos* (flask containing perfumed oil) painted by the so-called ACHILLES PAINTER (FIG. **5-56**) about 440 B.C. The artist here employed the *white-ground* technique, which takes its name from the chalky-white slip used to provide a background for the painted figures. Experiments with white-ground painting date back to the Andokides Painter, but the method became popular only toward the middle of the fifth century B.C.

White-ground is essentially a variation of the red-figure technique. The pot was first covered with a slip of very fine white clay, then black glaze was applied to outline the figures, and diluted brown, purple, red, and white were used to color them. Other colors—for example, the yellow chosen for the garments of both figures on our lekythos—also could be employed, but these had to be applied after firing because the

THE MASSACRE OF NIOBE'S CHILDREN One can visualize Polygnotos's compositions by looking at a red-figure krater (FIG. **5-57**) painted around the middle of the fifth century B.C. by the NIOBID PAINTER. The painter, whose vases are unsigned, was given this modern nickname from this krater, where one side is devoted to the massacre of the Niobids, the children of Niobe, by Apollo and Artemis. Niobe, who had at least a dozen children, had boasted that she was

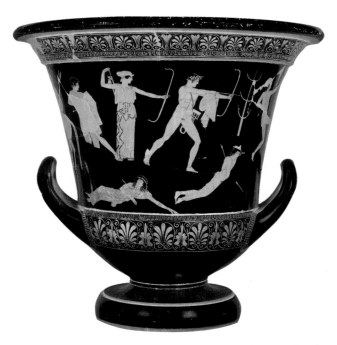

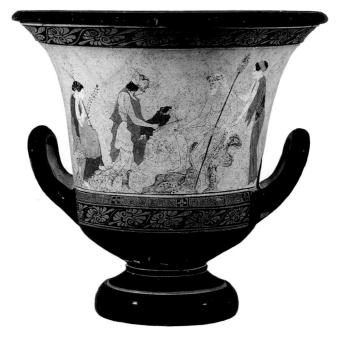

5-57 NIOBID PAINTER, Artemis and Apollo slaying the children of Niobe (Attic red-figure calyx krater), from Orvieto, Italy, ca. 450 B.C. Approx. 1′ 9″ high. Louvre, Paris.

5-58 PHIALE PAINTER, Hermes bringing the infant Dionysos to Papposilenos (Attic white-ground calyx krater), from Vulci, Italy, ca. 440–435 B.C. Approx. 1′ 2″ high. Vatican Museums, Rome.

superior to the goddess Leto, who had only two offspring, Apollo and Artemis. To punish her *hubris* (arrogance) and teach the lesson that no mortal could be superior to a god or goddess, Leto sent her two children to slay all of Niobe's many sons and daughters. On the Niobid Painter's krater, the horrible slaughter occurs in a schematic landscape setting of rocks and trees. The figures are disposed on several levels, and they actively interact with their setting. One slain son, for example, not only has fallen upon a rocky outcropping, but he also is partially hidden by it. His face was drawn in a three-quarter view, something that even Euphronios and Euthymides had not attempted.

WHITE-GROUND LANDSCAPE PAINTING Further insight into the appearance of monumental panel painting of the fifth century B.C. comes from a white-ground krater (FIG. 5-58) by the so-called PHIALE PAINTER. The subject is Hermes handing over his half brother, the infant Dionysos, to Papposilenos ("grandpa-satyr"). The other figures represent the nymphs in the shady glens of Nysa, where Zeus had sent Dionysos, one of his numerous natural sons, to be raised, safe from the possible wrath of his wife Hera. Unlike the decorators of funerary lekythoi, the Phiale Painter used for this krater only colors that could survive the Greek kiln's heat— reds, brown, purple, and a special snowy white reserved for

5-59 Youth diving, painted ceiling of the Tomb of the Diver, Paestum, Italy, ca. 480 B.C. Approx. 3′ 4″ high. Museo Archeologico Nazionale, Paestum.

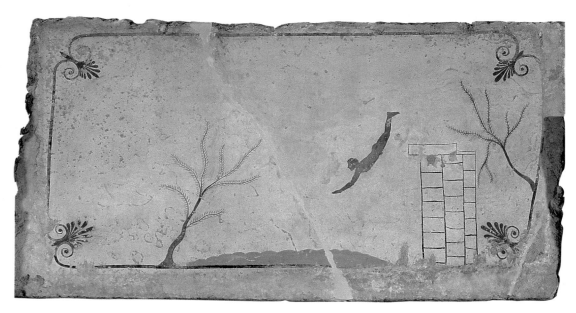

the flesh of the nymphs and for such details as the hair, beard, and shaggy body of Papposilenos. The use of diluted brown wash to color and shade the rocks may reflect the coloration of Polygnotos's landscapes. This vase and the Niobid krater together provide art historians with a shadowy idea of the character and magnificence of Polygnotos's great paintings.

A PLUNGE INTO THE NETHERWORLD Although all of the panel paintings of the masters were lost long ago, some Greek mural paintings are preserved today. A fine early example is in the so-called Tomb of the Diver at Paestum in southern Italy. The four walls of this small, coffinlike tomb are decorated with banquet scenes such as appear regularly on Greek vases. On the tomb's ceiling (FIG. **5-59**), a youth dives from a stone platform into a body of water. The scene most likely symbolizes the plunge from this life into the next. Trees resembling those of the Niobid krater are included within the decorative frame. The theme has no parallels on extant Greek vases, but it appears on an Etruscan tomb wall of the late sixth century B.C. (see FIG. 9-9). The Greek painter of the Tomb of the Diver seems to have been as aware of developments in Etruscan painting in Italy as of the work of contemporaries in mainland Greece.

THE LATE CLASSICAL PERIOD (FOURTH CENTURY B.C.)

POLITICAL UPHEAVAL AND ARTISTIC CHANGE The Peloponnesian War, which began in 431 B.C., ended in 404 B.C. with the complete defeat of a plague-weakened Athens and left Greece drained of its strength. The victor, Sparta, and then Thebes undertook the leadership of Greece, both unsuccessfully. In the middle of the fourth century B.C., a threat from without caused the rival Greek states to put aside their animosities and unite for their common defense, as they had earlier against the Persians. But at the battle of Chaeronea in 338 B.C., the Greek cities suffered a devastating loss and had to relinquish their independence to Philip II, king of Macedon. Philip was assassinated in 336 B.C. and his son, Alexander III, better known simply as Alexander the Great, succeeded him. In the decade before his death in 323 B.C., Alexander led a powerful army on an extraordinary campaign that overthrew the Persian Empire (the ultimate revenge for the Persian invasion of Greece in the early fifth century B.C.), wrested control of Egypt, and even reached India.

The fourth century B.C. was thus a time of political upheaval in Greece, and the chaos had a profound impact on the psyche of the Greeks and on the art they produced. In the fifth century B.C., Greeks had generally believed that rational human beings could impose order on their environment, create "perfect" statues such as the *Canon* of Polykleitos, and discover the "correct" mathematical formulas for constructing temples such as the Parthenon. The Parthenon frieze celebrated the Athenians as a community of citizens with shared values. The Peloponnesian War and the fourth century B.C.'s unceasing strife brought an end to the fifth century B.C.'s serene idealism. Disillusionment and alienation followed. Greek thought and Greek art began to focus more on the individual and on the real world of appearances rather than on the community and the ideal world of perfect beings and perfect buildings.

Sculpture

THE HUMANIZATION OF GREEK SCULPTURE The new humanizing approach to art is immediately apparent in the work of PRAXITELES, one of the great masters of the fourth century B.C. Praxiteles did not reject the themes the sculptors of the High Classical period favored. His Olympian gods and goddesses retained their superhuman beauty, but in his hands they lost some of their solemn grandeur and took on a worldly sensuousness.

Nowhere is this new spirit plainer than in the statue of Aphrodite that Praxiteles made for the Knidians (FIG. **5-60**).

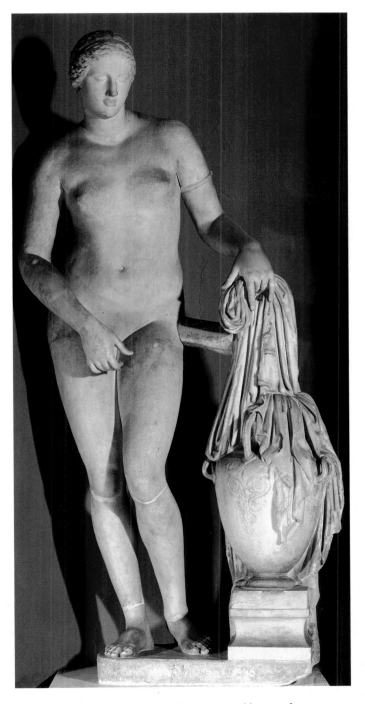

5-60 PRAXITELES, *Aphrodite of Knidos*. Roman marble copy after an original of ca. 350–340 B.C. Approx. 6' 8" high. Vatican Museums, Rome.

The lost original, carved from Parian marble, is known only through copies made for the Romans, but Pliny considered it "superior to all the works, not only of Praxiteles, but indeed in the whole world." It made Knidos famous, and many people sailed there just to see the statue in its round temple (compare FIG. 5-71), where "it was possible to view the image of the goddess from every side." According to Pliny, some visitors were "overcome with love for the statue."[6]

The *Aphrodite of Knidos* caused such a sensation in its time because Praxiteles took the unprecedented step of representing the goddess of love completely nude. Female nudity was exceedingly rare in earlier Greek art and had been confined almost exclusively to paintings on vases designed for household use, such as the kylix of Onesimos (FIG. 5-23) discussed earlier. The women so depicted also tended to be courtesans or slave girls, not noblewomen or goddesses, and no one had dared fashion for a temple a statue of a goddess without her clothes. Moreover, Praxiteles' Aphrodite is not a cold and remote image. In fact, the goddess engages in a trivial act out of everyday life. She has removed her garment, draped it over a large *hydria* (water pitcher), and is about to step into the bath. The motif is strikingly similar to that Onesimos painted.

DEWY EYES AND SENSUOUS LANGUOR Although shocking in its day, the *Aphrodite of Knidos* is not openly erotic (the goddess modestly shields her pelvis with her right hand), but she is quite sensuous. Lucian, writing in the second century A.D., noted that she has a "welcoming look" and a "slight smile" and that Praxiteles was renowned for his ability to transform marble into soft and radiant flesh. Lucian mentions, for example, the "dewy quality of Aphrodite's eyes."[7] Unfortunately, the rather mechanical Roman copies do not capture the quality of Praxiteles' modeling of the stone, but one can imagine the "look" of the *Aphrodite of Knidos* from original works by sculptors who emulated the master's manner.

One of the finest of these is the head of a woman from Chios (FIG. **5-61**) that was once set into a draped statue. This sculptor wielded the chisel in the Praxitelean manner, suggesting the softness of the young girl's face and the "dewy" gaze of the eyes. The sharp outlining of precisely measured bodily parts that characterized the work of Polykleitos and his contemporaries has given way to a smooth flow of flesh from forehead to chin and to a very human sensuousness. In the statues of Praxiteles and his followers, the deities of Mount Olympus still possess a beauty mortals can aspire to, although not achieve, but they are no longer awesome and remote. The Greek gods stepped off their fifth-century B.C. pedestals and entered the fourth-century B.C. world of human experience.

The Praxitelean manner also may be seen in a statue once thought to be by the hand of the master himself but now generally considered a copy of the very highest quality. The statue of Hermes and the infant Dionysos (FIG. **5-62**) found in the Temple of Hera at Olympia brings to the realm of monumental statuary the theme the Phiale Painter had chosen for a white-ground krater (FIG. 5-58) a century earlier. Hermes has stopped to rest in a forest on his journey to Nysa to entrust the upbringing of Dionysos to Papposilenos and the nymphs. Hermes leans on a tree trunk (here it is an integral part of the

5-61 Head of a woman, from Chios, Greece, ca. 320–300 B.C. Marble, approx. 1′ 2″ high. Museum of Fine Arts, Boston.

composition and not the copyist's addition), and his slender body forms a sinuous, shallow S-curve that is the hallmark of many of Praxiteles' statues. He looks off dreamily into space while he dangles a bunch of grapes (now missing) as a temptation for the infant who is to become the Greek god of the vine. This is the kind of tender and very human interaction between an adult and a child that one encounters frequently in real life but that had been absent from Greek statuary before the fourth century B.C.

The superb quality of the carving is faithful to the Praxitelean original. The modeling is deliberately smooth and subtle, producing soft shadows that follow the planes as they flow almost imperceptibly one into another. The delicacy of the marble head's features stand in sharp contrast to the metallic precision of Polykleitos's bronze *Doryphoros* (FIG. 5-38). Even the *Spear Bearer*'s locks of hair were subjected to the fifth-century B.C. sculptor's laws of symmetry and do not violate the skull's perfect curve. One need only compare these two statues to see how broad a change in artistic attitude and intent took place from the mid-fifth to the mid-fourth century B.C. Sensuous languor and an order of beauty that appeals more to the eye than to the mind replaced majestic strength and rationalizing design.

THE PASSIONATE STYLE OF SKOPAS In the Archaic period and throughout most of the Early and High Classical periods, Greek sculptors generally shared common

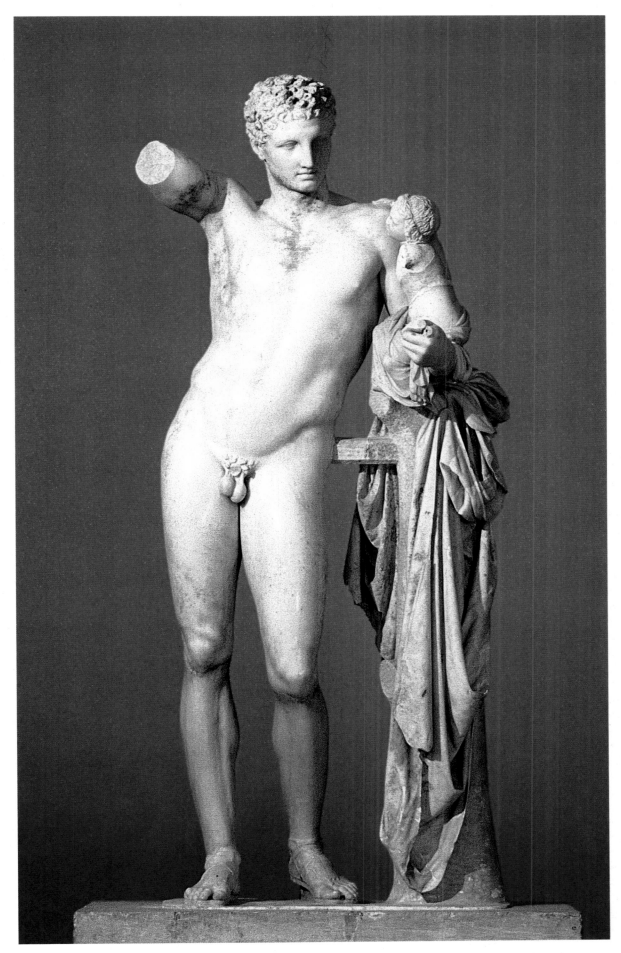

5-62 PRAXITELES, Hermes and the infant Dionysos, from the Temple of Hera, Olympia, Greece. Marble copy after an original of ca. 340 B.C., approx. 7′ 1″ high. Archeological Museum, Olympia.

5-63 Head of Herakles or Telephos, from the west pediment of the Temple of Athena Alea, Tegea, Greece, ca. 340 B.C. Marble, approx. $1'\frac{1}{2}''$ high. (Stolen from) Archeological Museum, Tegea.

goals, but in the Late Classical period of the fourth century B.C., distinctive individual styles emerged. The dreamy, beautiful divinities of Praxiteles had enormous appeal, and, as the head of the woman from Chios (FIG. 5-61) attests, the master had many followers. But other master sculptors pursued very different interests. One of these was SKOPAS OF PAROS, and although his work reflects the general trend toward the humanization of the Greek gods and heroes, his style is marked by intense emotionalism.

Skopas was an architect as well as a sculptor. He designed the Temple of Athena Alea at Tegea. Fragments of the pedimental statues from that temple are preserved, and they epitomize his approach to sculpture, even if they are not by his own hand. One of the heads (FIG. 5-63) portrays a hero wearing a lion-skin headdress. It must be either Herakles or his son Telephos, whose battle with Achilles was the west pediment's subject. The head, like others from the Tegea pediments, is highly dramatic. The hero's head takes an abrupt turn, and his facial expression shows great psychological tension. His large eyes are set deeply into his head. Fleshy overhanging brows create deep shadows. His lips are slightly parted. The passionate face reveals an anguished soul within. Skopas's work broke with the Classical tradition of benign, serene features and prefigured later Hellenistic depictions of unbridled emotion.

An unprecedented psychological intensity also may be seen in a grave stele (FIG. 5-64) found near the Ilissos River in Athens that incorporates the innovations of Skopas. The stele was originally set into an architectural frame similar to that of the earlier Hegeso stele (FIG. 5-55). A comparison between

the two works is very telling. In the Ilissos stele the relief is much higher, with parts of the figures carved fully in the round. But the major difference is the pronounced change in mood. The later work makes a clear distinction between the living and the dead, and depicts overt mourning. The deceased is a young hunter whose features recall those of Skopas's Tegean heroes. At his feet a small boy, either his servant or perhaps a younger brother, sobs openly. The hunter's dog also droops its head in sorrow. Beside the youth an old man, undoubtedly his father, leans on a walking stick and, in a gesture reminiscent of that of the seer at Olympia (FIG. 5-31), ponders the irony of fate that has taken the life of his powerful son and preserved him in his frail old age. Most remarkable of all, the hunter himself looks out at the viewer, inviting sympathy, and creating an emotional bridge between the spectator and the artwork that is inconceivable in the art of the High Classical period.

THE ATHLETES AND HEROES OF LYSIPPOS
The third great Late Classical sculptor, LYSIPPOS OF SIKYON, was so renowned he was selected by Alexander the Great to create his official portrait. (Alexander could afford to employ the best. The Macedonian kingdom enjoyed vast wealth. King Philip hired the leading thinker of his age, Aristotle, as the young Alexander's tutor!)

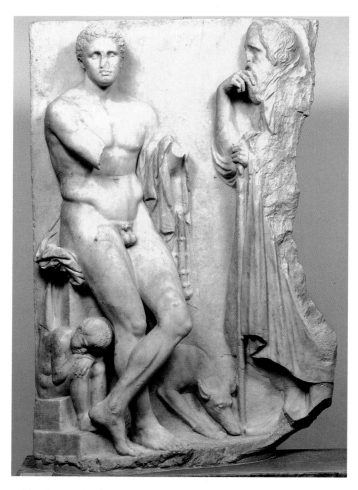

5-64 Grave stele of a young hunter, found near the Ilissos River, Athens, Greece, ca. 340–330 B.C. Marble, approx. 5' 6" high. National Archeological Museum, Athens.

earlier statues by boldly thrusting his right arm forward. To comprehend the action, the observer must move to the side and view the work at a three-quarter angle or in full profile.

To grasp the full meaning of another of Lysippos's works, a colossal statue depicting a weary Herakles (FIG. 5-66), the viewer must walk around it. Once again, the original is lost. The most impressive of the surviving marble copies is nearly twice life-size and was exhibited in the Baths of the emperor Caracalla in Rome (see FIGS. 10-67 and 10-68). Like the marble copy of Polykleitos's *Doryphoros* from the Roman palestra at Pompeii (FIG. 5-38), Lysippos's muscle-bound Greek hero provided inspiration for Romans who came to the baths to exercise. (The statue is signed by the copyist, GLYKON OF ATHENS. Lysippos's name is not mentioned. The educated Roman public did not need a label to identify the famous work.) In the hands of Lysippos, however, the exaggerated muscular development of Herakles is poignantly ironic, for the sculptor depicted the strongman as so weary that he must lean on his club for support. Without that prop Herakles would topple

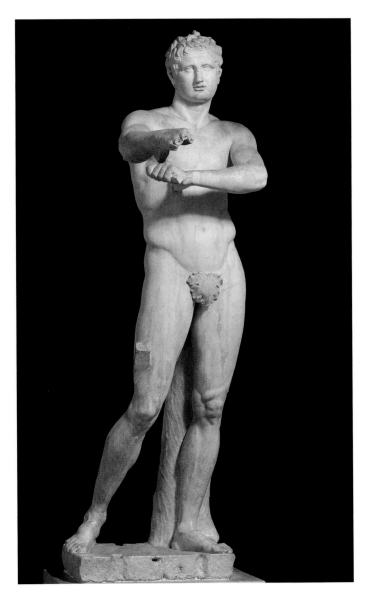

5-65 LYSIPPOS, *Apoxyomenos (Scraper)*. Roman marble copy after a bronze original of ca. 330 B.C., approx. 6′ 9″ high. Vatican Museums, Rome.

Lysippos introduced a new canon of proportions making the bodies more slender than those of Polykleitos—whose own canon continued to exert enormous influence—and the heads roughly one-eighth the height of the body rather than one-seventh, as in the previous century. The new proportions may be seen in one of Lysippos's most famous works, a bronze statue of an *Apoxyomenos* (an athlete scraping oil from his body after exercising), known, as usual, only from Roman copies in marble (FIG. 5-65). A comparison with Polykleitos's *Doryphoros* (FIG. 5-38) reveals more than a change in physique. A nervous energy runs through the *Apoxyomenos* that one seeks in vain in the balanced form of the *Doryphoros*. The *strigil* (scraper) is about to reach the end of the right arm, and at any moment it will be switched to the other hand so that the left arm can be scraped. The weight will shift at the same time and the positions of the legs will be reversed. Lysippos also began to break down the dominance of the frontal view in statuary and encouraged the observer to look at his athlete from multiple angles. The *Apoxyomenos* breaks out of the shallow rectangular box that defined the boundaries of

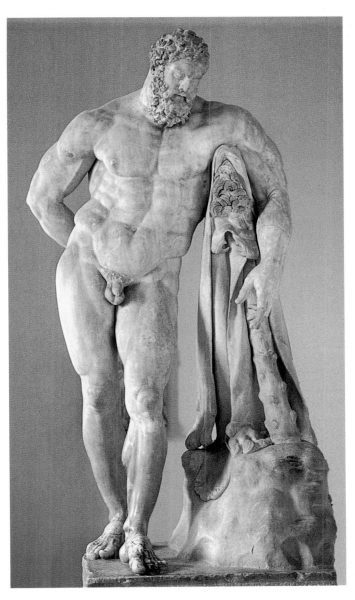

5-66 LYSIPPOS, Weary Herakles *(Farnese Herakles)*. Roman marble copy from Rome, Italy, signed by GLYKON OF ATHENS, after a bronze original of ca. 320 B.C. Approx. 10′ 5″ high. Museo Nazionale, Naples.

over. Lysippos and other fourth-century B.C. artists rejected stability and balance as worthy goals for statuary. Herakles holds the golden apples of the Hesperides in his right hand behind his back—unseen unless one walks around the statue. Lysippos's subject is thus the same as that of the metope of the Early Classical Temple of Zeus at Olympia (FIG. 5-32), but the fourth-century B.C. Herakles is no longer serene. Instead of expressing joy, or at least satisfaction, at having completed one of the impossible twelve labors (see "Herakles: Greatest of Greek Heroes," page 103), he is almost dejected. Exhausted by his physical efforts, he can think only of his pain and weariness, not of the reward of immortality that awaits him. Lysippos's portrayal of Herakles in this statue is perhaps the most eloquent testimony yet to Late Classical sculptors' interest in humanizing the great gods and heroes of the Greeks. In this respect, despite their divergent styles, Praxiteles, Skopas, and Lysippos followed a common path.

Alexander the Great and Macedonian Court Art

ALEXANDER AS EPIC HERO Alexander the Great's favorite book was the *Iliad,* and his own life was very much like an epic saga, full of heroic battles, exotic places, and unceasing drama. Alexander was a man of singular character, an inspired leader with boundless energy and an almost fool-

5-67 Head of Alexander the Great, from Pella, Greece, ca. 200–150 B.C. Marble, approx. 1′ high. Archeological Museum, Pella.

hardy courage. He regularly personally led his army into battle on the back of Bucephalus, the wild and mighty steed only he could tame and ride.

Ancient sources reveal that Alexander believed that only Lysippos had captured his essence in a portrait, and that is why only he was authorized to sculpt the king's image. Lysippos's most famous portrait of the Macedonian king was a full-length heroically nude bronze statue of Alexander holding a lance and turning his head toward the sky. Plutarch reported that on the base was inscribed an epigram stating the statue depicted Alexander gazing at Zeus and proclaiming, "I place the earth under my sway; you, O Zeus, keep Olympus." Plutarch further stated that the portrait was characterized by "leonine" hair and a "melting glance."[8]

The Lysippan original is lost, and because Alexander was portrayed so many times for centuries after his death, it is very difficult to determine which of the many surviving images is most faithful to the fourth-century B.C. portrait. A leading candidate is a second-century B.C. marble head (FIG. 5-67) from Pella, the capital of Macedonia and Alexander's birthplace. It has the sharp turn of the head and thick mane of hair that were key ingredients of Lysippos's portrait. The sculptor's treatment of the features also is consistent with the style of the later fourth century B.C. The deep-set eyes and parted lips recall the manner of Skopas, and the delicate handling of the flesh brings to mind the faces of Praxitelean statues. Although not a copy, this head very likely approximates the young king's official portrait and provides insight not only into Alexander's personality but also into the art of Lysippos.

OPULENCE AT THE MACEDONIAN COURT Alexander's palace has not been excavated, but one can form an idea of the sumptuousness of life at the Macedonian court from the costly objects found in Macedonian graves and from the abundance of mosaics (see "Mosaics," Chapter 11, page 314) uncovered at Pella in the homes of the wealthy. The Pella mosaics are *pebble mosaics.* The floors are formed of small stones of various colors collected from beaches and riverbanks and set into a thick coat of cement. The finest yet to come to light (FIG. **5-68**) has a stag hunt as its *emblema* (central framed panel), bordered in turn by an intricate floral pattern and a stylized wave motif (not shown in our detail). The artist signed his work in the same manner as proud Greek vase painters and potters did "GNOSIS made it." This is the earliest mosaicist's signature known, and its prominence in the design undoubtedly attests to the artist's reputation. The house owner wanted guests to know that Gnosis himself, and not an imitator, had laid this floor.

Gnosis's stag hunt, with its light figures against a dark ground, has much in common with red-figure painting. In the pebble mosaic, however, most of the contour lines and some of the interior details are defined by thin strips of lead or terracotta, while the interior volumes are suggested by subtle gradations of yellow, brown, and red, as well as black, white, and gray pebbles. The musculature of the hunters, and even their billowing cloaks and the animals' bodies, are modeled by shading. Such use of light and dark to suggest volume is rarely seen on Greek painted vases, although examples do exist. Monumental painters, however, commonly used shading. The Greek term for shading was *skiagraphia* (literally,

5-68 GNOSIS, Stag hunt, from Pella, Greece, ca. 300 B.C. Pebble mosaic, figural panel 10′ 2″ high. Archeological Museum, Pella.

shadow painting), and it was said to have been invented by an Athenian painter of the fifth century B.C. named APOLLO- DOROS. Gnosis's emblema, with its sparse landscape setting, probably reflects contemporary panel painting.

THE PERSIAN KING FLEES FROM ALEXANDER
An even better idea of monumental painting during Alexander's time may be gleaned from a mosaic that decorated the floor of one room of a lavishly appointed Roman house at Pompeii. In the *Alexander Mosaic* (FIG. **5-69**), *tesserae* (tiny stones or pieces of glass cut to the desired size and shape) were employed instead of pebbles (see "Mosaics," Chapter 11, page 314). The subject is a great battle between Alexander the Great and the Persian king Darius III, probably the battle of Issus in southeastern Turkey, when Darius fled the battlefield in his chariot in humiliating defeat. The mosaic dates to the late second or early first century B.C. It is widely believed to be a reasonably faithful copy of a famous panel painting of ca. 310 B.C. that PHILOXENOS OF ERETRIA made for King Cassander, one of Alexander's successors.

Philoxenos's painting is notable for its technical mastery of problems that had long fascinated Greek painters. The rearing horse in front of Darius's chariot, for example, is seen in a three-quarter rear view that even Euthymides would have marveled at. The subtle modulation of the horse's rump through shading in browns and yellows is precisely what Gnosis was striving to imitate in his pebble mosaic. Other details are even more impressive. The Persian to the right of the rearing horse has fallen to the ground and raises, backwards, a dropped Macedonian shield to protect himself from being trampled. Philoxenos recorded the reflection of the man's terrified face on the shield's polished surface. Everywhere men, animals, and weapons cast shadows on the ground. Philoxenos and other Classical painters' interest in the reflection of insubstantial light on a shiny surface, and in the

5-69 PHILOXENOS OF ERETRIA, *Battle of Issus,* ca. 310 B.C. Roman copy (the *Alexander Mosaic*) from the House of the Faun, Pompeii, Italy, late second or early first century B.C. Tessera mosaic, approx. 8′ 10″ × 16′ 9″. Museo Nazionale, Naples.

absence of light (shadows), was far removed from earlier painters' preoccupation with the clear presentation of weighty figures seen against a blank background. The Greek painter here truly opened a window into a world filled not only with figures, trees, and sky but also with light. This Classical Greek notion of what a painting should be characterizes most of the history of art in the Western world from the Renaissance on.

Most impressive about the *Battle of Issus*, however, is not the virtuoso details but the psychological intensity of the drama unfolding before the viewer's eyes. Alexander is on horseback leading his army into battle, recklessly one might say, without even a helmet to protect him. He drives his spear through one of Darius's trusted "Immortals," who were sworn to guard the king's life, while the Persian's horse collapses beneath him. The Macedonian king is only a few yards away from Darius, and Alexander directs his gaze at the Persian king, not at the man impaled on his now-useless spear. Darius has called for retreat. In fact, his charioteer is already whipping the horses and speeding the king to safety. Before he escapes, Darius looks back at Alexander and in a pathetic gesture reaches out toward his brash foe. But the victory has slipped out of his hands. Pliny says Philoxenos's painting of the battle between Alexander and Darius was "inferior to none."[9] It is easy to see how he reached that conclusion.

Architecture

A WONDROUS MAUSOLEUM Five of the Seven Wonders of the ancient world were Greek (see "Babylon: City of Wonders," Chapter 2, page 37), but only one Greek Wonder was a tomb. The tomb built at Halikarnassos for Mausolos, the ruler of Caria in Asia Minor from 377 to 353 B.C., was the only funerary monument the ancients considered worthy

of comparison with the pyramids of Egypt (see FIG. 3-8), the solitary Egyptian Wonder. The tomb was erected by Mausolos's wife, Artemisia, and she employed some of the leading sculptors of the day, Skopas among them, to decorate it.

Mausolos's tomb was dismantled long ago, but ancient descriptions permit a reconstruction of the building in general terms. The multistory structure consisted of a high stepped podium, an Ionic colonnade, and a pyramidal roof capped by a colossal marble group of Mausolos in a four-horse chariot. The height of the tomb, including the chariot, was one hundred forty feet. Its fame was so great that already in Roman times *mausoleum* had become a generic term for any grandiose funerary monument. But the tomb, famous as it was, was only one of the triumphs of Greek architects in the fourth century B.C.

THE GREEK THEATER In ancient Greece, plays were not performed repeatedly over months or years as they are today, but only once, during sacred festivals. Greek drama was closely associated with religious rites and was not pure entertainment. At Athens, for example, the great tragedies of Aeschylus, Sophocles, and Euripides were performed in the fifth century B.C. at the Dionysos festival in the theater dedicated to the god on the southern slope of the Acropolis (FIG. 5-40, far right). The finest theater in Greece, however, is at Epidauros (FIG. **5-70**). It was constructed shortly after Alexander the Great was born. The architect was POLYKLEITOS THE YOUNGER, possibly a nephew of the great fifth-century sculptor. His theater is still used for performances of ancient Greek dramas to the delight of tourists and natives alike.

The precursor of the formal Greek theater was a place where ancient rites, songs, and dances were performed. This circular piece of earth with a hard and level surface later be-

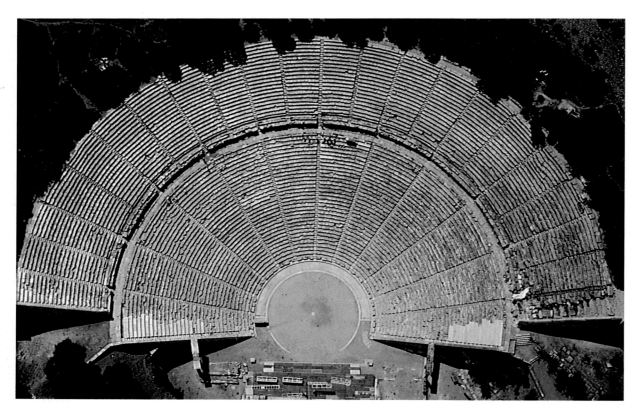

5-70 POLYKLEITOS THE YOUNGER, Theater, Epidauros, Greece, ca. 350 B.C.

5-71 THEODOROS OF PHOKAIA, Tholos, Delphi, Greece, ca. 375 B.C.

5-72 POLYKLEITOS THE YOUNGER, Corinthian capital, from the tholos, Epidauros, Greece, ca. 350 B.C. Archeological Museum, Epidauros.

came the orchestra of the theater. *Orchestra* literally means *dancing place.* The actors and the chorus performed there, and at Epidauros an altar to Dionysos stood at the center of the circle. The spectators sat on a slope overlooking the orchestra—the *theatron,* or *place for seeing.* When the Greek theater took architectural shape, the auditorium (*cavea,* Latin for *hollow place, cavity*) was always situated on a hillside. The cavea at Epidauros, composed of wedge-shaped sections (*cunei,* singular *cuneus*) of stone benches separated by stairs, is somewhat greater than a semicircle in plan. The auditorium is three hundred and eighty-seven feet in diameter, and its fifty-five rows of seats accommodated about twelve thousand spectators. They entered the theater via a passageway between the seating area and the scene building *(skene),* which housed dressing rooms for the actors and also formed a backdrop for the plays. The design is quite simple but perfectly suited to its function. Even in antiquity Polykleitos the Younger's theater was renowned for the harmony of its proportions. Although spectators sitting in some of the seats in the Epidauros theater would have had a poor view of the skene, all had unobstructed views of the orchestra. Because of the open-air cavea's excellent acoustics, everyone could hear the actors and chorus.

CORINTHIAN CAPITALS The theater at Epidauros is situated some five hundred yards southeast of the sanctuary of Asklepios, and Polykleitos the Younger worked there as well. He was the architect of the *tholos,* the circular shrine that probably housed the healing god's sacred snakes. That building lies in ruins today, its architectural fragments removed to the local museum, but one can get an approximate idea of its original appearance by looking at the somewhat earlier and partially reconstructed tholos at Delphi (FIG. **5-71**) designed by THEODOROS OF PHOKAIA. Both tholoi had an exterior colonnade of Doric columns. Within, however, both the Delphi and Epidauros columns (FIG. **5-72**) were crowned by *Corinthian capitals* (see "The Corinthian Capital," page 148), an innovation of the second half of the fifth century B.C.

5-73 Choragic Monument of Lysikrates, Athens, Greece, 334 B.C.

The Corinthian Capital

The *Corinthian capital* (FIG. 5-72) is more ornate than either the Doric or Ionic (see "Doric and Ionic Temples," page 112). It consists of a double row of acanthus leaves, from which tendrils and flowers emerge, wrapped around a bell-shaped echinus. Although this capital often is cited as the Corinthian order's distinguishing feature, strictly speaking, no Corinthian order exists. The new capital type was simply substituted for the volute capital in the Ionic order.

The Corinthian capital was invented during the second half of the fifth century B.C. by the sculptor KALLIMACHOS. Vitruvius recorded the circumstances that supposedly led to its creation:

> A maiden who was a citizen of Corinth . . . died. After her funeral, her nurse collected the goblets in which the maiden had taken delight while she was alive, and after putting them together in a basket, she took them to the grave monument and put them on top of it. In order that they should remain in place for a long time, she covered them with a tile. Now it happened that this basket was placed over the root of an acanthus. As time went on the acanthus root, pressed down in the middle by the weight, sent forth, when it was about springtime, leaves and stalks; its stalks growing up along the sides of the basket and being pressed out from the angles because of the weight of the tile, were forced to form volute-like curves at their extremities. At this point, Kallimachos happened to be going by and noticed the basket with this gentle growth of leaves around it. Delighted with the order and the novelty of the form, he made columns using it as his model and established a canon of proportions for it.[1]

Kallimachos worked on the Acropolis. He made the golden lamp that stood beside the ancient wooden statue of Athena in the Erechtheion. Many scholars believe that a Corinthian column supported the outstretched right hand of the Phidian *Athena Parthenos* (FIG. 5-44) because some of the lost statue's Roman copies have such a column. In any case, the earliest

preserved Corinthian capital dates to the time of Kallimachos. The new type became enormously popular in later Greek and especially Roman times, not only because of its ornate character, but also because it eliminated certain problems of both the Doric and Ionic orders.

The Ionic capital, unlike the Doric, has two distinct profiles—the front and back (with the volutes) and the sides. The volutes always faced outward on a Greek temple, but architects met with a vexing problem at the corners of their buildings, which had two adjacent "fronts." They solved the problem by placing volutes on both outer faces of the corner capitals (as on the Erechtheion, FIG. 5-50, and the Temple of Athena Nike, FIG. 5-53), but the solution was an awkward one.

Doric design rules also presented problems for Greek architects at the corners of buildings. The Doric frieze was organized according to three supposedly inflexible rules: (1) A triglyph must be exactly over the center of each column; (2) a triglyph must be over the center of each intercolumniation; and (3) triglyphs at the corners of the frieze must meet so that no space is left over. But the rules are contradictory. If the corner triglyphs must meet, then they cannot be placed over the center of the corner column (see, for example, the Doric temples at Aegina and Paestum and the Parthenon in Athens, FIGS. 5-24, 5-29, and 5-42).

The Corinthian capital eliminated both problems. Because the capital's four sides have a similar appearance, corner Corinthian capitals do not have to be modified, as do corner Ionic capitals. And because the Ionic frieze is used for the Corinthian "order," architects do not have to contend with metopes or triglyphs.

[1] J. J. Pollitt, trans., *The Art of Ancient Greece: Sources and Documents* (New York: Cambridge University Press, 1990), 193–94.

Consistent with the extremely conservative nature of Greek temple design, architects did not readily embrace the Corinthian capital. Until the second century B.C., Corinthian capitals were employed, as at Delphi and Epidauros, only for the interiors of sacred buildings. The earliest instance of a Corinthian capital on the exterior of a Greek building is the Choragic Monument of Lysikrates (FIG. **5-73**), which is not really a building at all. Lysikrates had sponsored a chorus in a theatrical contest in 334 B.C., and, after he won, he erected a monument to commemorate his victory. The monument consists of a cylindrical drum resembling a tholos on a rectangular base. Engaged Corinthian columns adorn the drum of Lysikrates' monument, and a huge Corinthian capital sits on top of the roof. The freestanding capital once supported the victor's prize, a bronze tripod.

THE HELLENISTIC PERIOD
(323–31 B.C.)

THE GREEK WORLD AFTER ALEXANDER Alexander the Great's conquest of India, the Near East, and Egypt (where the Macedonian king was buried) ushered in a new cultural age that historians and art historians alike call *Hellenistic*. The Hellenistic period is traditionally reckoned from the death of Alexander in 323 B.C. and lasted nearly three centuries, until 31 B.C., when Queen Cleopatra of Egypt and her Roman consort Mark Antony were decisively defeated at the battle of Actium by Antony's rival Augustus. A year later, Augustus made Egypt a province of the Roman Empire. It is said that when Alexander was on his deathbed, his generals, greedy for the lands their young leader had con-

quered, asked, "To which one of us do you leave your empire?" He supposedly answered, "To the strongest."[10] Although probably a later invention, this exchange points out the near inevitability of what followed—the division of Alexander's far-flung empire among his Greek generals and their subsequent naturalization among those they subjugated.

The cultural centers of the Hellenistic period were the court cities of the Greek kings—Antioch in Syria, Alexandria in Egypt, Pergamon in Asia Minor, and others. An international culture united the Hellenistic world, and its language was Greek. Hellenistic kings became enormously rich on the spoils of the East, priding themselves on their libraries, art collections, scientific enterprises, and skills as critics and connoisseurs, as well as on the learned men they could assemble at their courts. The world of the small, austere, and heroic city-state passed away, as did the power and prestige of its center, Athens. A world, or cosmopolitan ("citizen of the world," in Greek), civilization, much like today's, replaced it.

Architecture

NEW ARCHITECTS BREAK OLD RULES Hellenistic culture's greater variety, complexity, and sophistication called for an architecture on an imperial scale and of wide diversity, something far beyond the requirements of the Classical polis, even beyond that of Athens at the height of its power. Building activity shifted from the old centers on the Greek mainland to the opulent cities of the Hellenistic monarchs in Asia Minor—sites more central to the Hellenistic world.

Great scale, a theatrical surprise element, and a willingness to break the rules of canonical temple design characterize one of the Hellenistic period's most ambitious temple projects, the Temple of Apollo at Didyma (FIG. **5-74**). The Hellenistic temple was built to replace the Archaic temple at the site the

Persians had burned down in 494 B.C. when they sacked nearby Miletos. Construction began in 313 B.C. according to the design of two architects who were natives of the area, PAIONIOS OF EPHESOS and DAPHNIS OF MILETOS. So vast was the undertaking, however, that work on the temple continued off and on for more than five hundred years—and still the project was never completed.

The temple was dipteral in plan and had an unusually broad facade of ten huge Ionic columns almost sixty-five feet tall. The sides had twenty-one columns, consistent with the Classical formula for perfect proportions used for the Parthenon—$(2 \times 10) + 1$—but nothing else about the design is Classical. One anomaly immediately apparent to anyone who approached the building was that it had no pediment and no roof—it was *hypaethral,* or open to the sky. And the grand doorway to what should be the temple's cella was elevated nearly five feet off the ground so that it could not be entered. The explanation for these peculiarities is that the doorway served rather as a kind of stage where the oracle of Apollo could be announced to those assembled in front of the temple. The unroofed dipteral colonnade was really only an elaborate frame for a central courtyard that housed a small prostyle shrine that protected a statue of Apollo. Entrance to the interior court was through two smaller doorways to the left and right of the great portal and down two narrow vaulted tunnels that could accommodate only a single file of people. From these dark and mysterious lateral passageways worshipers emerged into the clear light of the courtyard, which contained a sacred spring and was planted with laurel trees in honor of Apollo. Opposite Apollo's inner temple, a stairway some fifty feet wide rose majestically toward three portals leading into the oracular room that also opened onto the front of the temple. This complex spatial planning marks a sharp departure from Classical Greek architecture, which stressed a building's exterior almost as a work of sculpture and left its interior relatively undeveloped.

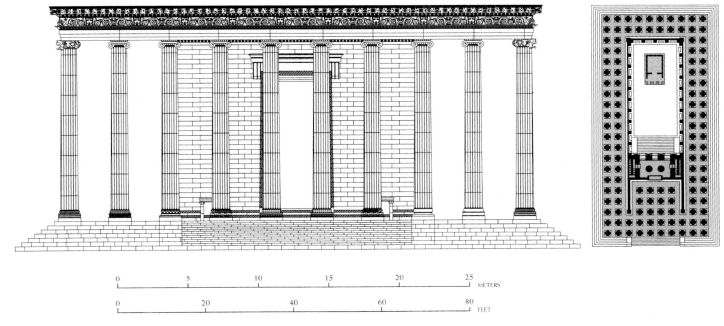

5-74 PAIONIOS OF EPHESOS and DAPHNIS OF MILETOS, Temple of Apollo, Didyma, Turkey, begun 313 B.C. Restored view of facade *(left)* and plan *(right).*

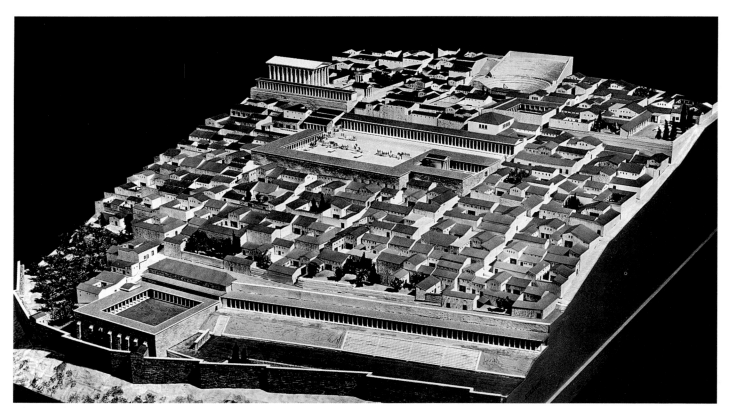

5-75 Model of the city of Priene, Turkey, fourth century B.C. and later. Staatliche Museen, Berlin.

THE IDEAL GREEK CITY When the Persians were finally expelled from the Greek poleis of Asia Minor in 479 B.C., the cities were in near ruin. Reconstruction of Miletos began after 466 B.C., according to a plan laid out by HIPPODAMOS OF MILETOS, whom Aristotle singled out as the father of rational city planning. Hippodamos imposed a strict grid plan on the site, regardless of the terrain, so that all streets would meet at right angles. Such *orthogonal* planning actually predates Hippodamos, not only in Archaic Greece but also in the ancient Near East and Egypt. But Hippodamos was so famous that his name has ever since been synonymous with such urban plans. The so-called *Hippodamian plan* also designated separate quarters for public, private, and religious functions. A "Hippodamian city" was logically, as well as regularly, planned. This desire to impose order on nature and to assign a proper place in the whole to each of the city's constituent parts was very much in keeping with the philosophical tenets of the fifth century B.C. Hippodamos's formula for the ideal city was another manifestation of the same outlook that produced Polykleitos's *Canon* for the human body and Iktinos's treatise on the Parthenon.

An excellent example of Hippodamian planning is the city of Priene (FIG. **5-75**), also in Asia Minor. The city, laid out during the fourth century B.C., had fewer than five thousand inhabitants. (Hippodamos thought ten thousand was the ideal number.) It was situated on sloping ground, so many of the narrow north-south streets were little more than long stairways. Uniformly sized city blocks were nonetheless imposed on the irregular terrain. The central *agora* (marketplace) was allotted six blocks. More than one unit also was reserved for major structures such as the Temple of Athena and the theater.

LIFE IN A GREEK HOME As in any city, ancient or modern, houses occupied most of the area within Priene's walls, rather than civic or religious buildings. Information about the homes of ordinary citizens is scanty, in part because archeologists have been more interested in uncovering grand edifices, such as temples and theaters, and in part because ancient authors usually described only exceptional buildings, not common dwellings. The unpretentious Priene houses (for example, FIG. **5-76**) were typical of later Greek times. They are

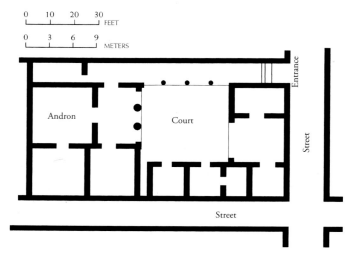

5-76 Plan of House XXXII, Priene, Turkey, fourth century B.C.

rectangular in plan and fit neatly into the Hippodamian grid, but internally they were not laid out symmetrically. A single entrance from the street led to a modest central court, the largest room in the house, surrounded by several smaller roofed units. In the wealthiest homes the courtyard was framed by a peristyle and paved with a pebble mosaic. The house illustrated here has columns (of differing dimensions) on only two sides of the court. Exterior windows were rare, because most houses shared walls with their neighbors, and the court provided welcome light and air to the interior. These courtyards also allowed the collection of rainwater, stored in underground cisterns and used for drinking, cooking, and washing. In most houses a dining room *(andron)* opened onto the court (or onto an anteroom that in turn opened onto the court, as in our example) and was furnished with couches so that the man of the house and his male guests could recline while eating. A kitchen would not be far away. Bedrooms also might open onto the court, but, when a second floor existed, they were normally located upstairs.

PHILOSOPHERS AND STOAS The heart of Priene was its agora, bordered by *stoas*. These covered colonnades, which often housed shops and civic offices, were ideal vehicles for shaping urban spaces, and they were staples of Hellenistic cities. Even the agora of Athens, an ancient city notable for its haphazard, unplanned development, was eventually framed to the east and south by stoas placed at right angles to one another. These new *porticos* joined the famous Classical Painted Stoa (see page 137), where the Hellenistic philosopher Zeno and his successors taught. The *Stoic* school of Greek philosophy took its name from that building.

The finest of the new Athenian stoas was the Stoa of Attalos II (FIG. **5-77**), a gift to the city by a grateful alumnus, the king of Pergamon (r. 159–138 B.C.), who had studied at Athens in his youth. The stoa was meticulously reconstructed under the direction of the American School of Classical Studies at Athens and today has a second life as a museum housing more than six decades of finds from the Athenian agora, as well as the American excavation team's offices. The stoa has two stories, each with twenty-one shops opening onto the colonnade. The facade columns are Doric on the ground level and Ionic on the second story. Such mixing of the two orders on a single facade had occurred even in the Late Classical period. But it became increasingly common in the Hellenistic period, when respect for the old rules of Greek architecture was greatly diminished and a desire for variety and decorative effects often prevailed. Practical considerations also governed the form of the Stoa of Attalos. The columns are far more widely spaced than in Greek temple architecture, to allow for easy access. And the builders left the lower third of every Doric column shaft unfluted to guard against damage from constant traffic.

Pergamon

The kingdom of Attalos II (r. 158–138 B.C.) was one of those born in the early third century B.C. after the breakup of Alexander's empire. Founded by Philetairos, the Pergamene kingdom embraced almost all of western and southern Asia Minor. Upon the death in 133 B.C. of the last of its kings, Attalos III (r. 138–133 B.C.), the kingdom was bequeathed to Rome, which by then was the greatest power in the Mediterranean world. The Attalids enjoyed immense wealth, and much of it was expended on embellishing their capital city of Pergamon, especially its acropolis. Located there were the royal palace, an arsenal and barracks, a great library and theater, an agora, and the sacred precincts of Athena and Zeus.

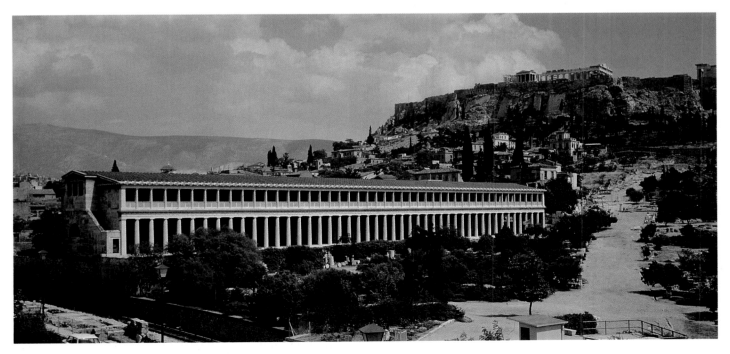

5-77 Stoa of Attalos II, Agora, Athens, Greece, ca. 150 B.C. (Acropolis in the background).

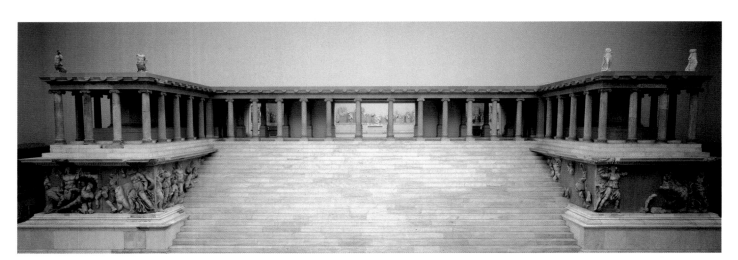

5-78 Reconstructed west front of the Altar of Zeus, from Pergamon, Turkey, ca. 175 B.C. Staatliche Museen, Berlin.

AN EPIC STRUGGLE FOR THE COSMOS The Altar of Zeus, erected on the Pergamene acropolis about 175 B.C., is the most famous of all Hellenistic sculptural ensembles. The monument's west front (FIG. **5-78**) has been reconstructed in Berlin. The altar proper was on an elevated platform and framed by an Ionic stoalike colonnade with projecting wings on either side of a broad central staircase. All around the platform was a sculptured frieze almost four hundred feet long populated by some one hundred larger-than-life-size figures (FIG. **5-79**). The subject is the battle of Zeus and the gods against the giants. It is the most extensive representation Greek artists ever attempted of that epic conflict for control of the world. A similar subject appeared on the shield of Phidias's *Athena Parthenos* and on some of the metopes of the Parthenon, where the Athenians wished to draw a parallel between the defeat of the giants and the defeat of the Persians.

In the third century B.C., King Attalos I (r. 241–197 B.C.) had successfully turned back an invasion by the Gauls in Asia Minor. The gigantomachy of the Altar of Zeus alluded to the Pergamene victory over those barbarians.

A deliberate connection was also made with Athens, whose earlier defeat of the Persians was by then legendary, and with the Parthenon, which already was recognized as a Classical monument—in both senses of the word. The figure of Athena, for example, who grabs the hair of the giant Alkyoneos as Nike flies in to crown her (FIG. 5-79), is a quotation of the Athena from the Parthenon's east pediment. Zeus himself (not illustrated) was based on the Poseidon of the west pediment. But the Pergamene frieze is not a dry series of borrowed motifs. On the contrary, its tumultuous narrative has an emotional intensity that has no parallel to earlier monuments. The battle rages everywhere, even up and down the

5-79 Athena battling Alkyoneos, detail of the gigantomachy frieze, from the Altar of Zeus, Pergamon, Turkey. Marble, approx. 7′ 6″ high. Staatliche Museen, Berlin.

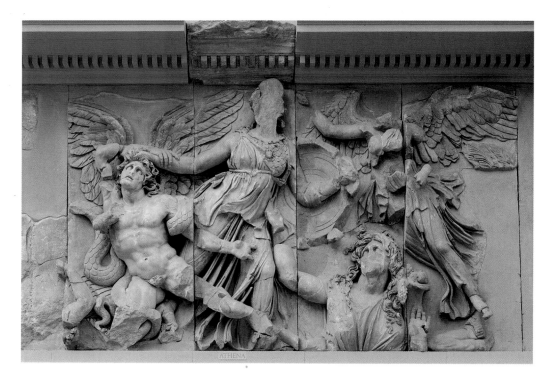

5-80 EPIGONOS(?), Gallic chieftain killing himself and his wife. Roman marble copy after a bronze original from Pergamon, Turkey, ca. 230–220 B.C. Approx. 6′ 11″ high. Museo Nazionale Romano— Palazzo Altemps, Rome.

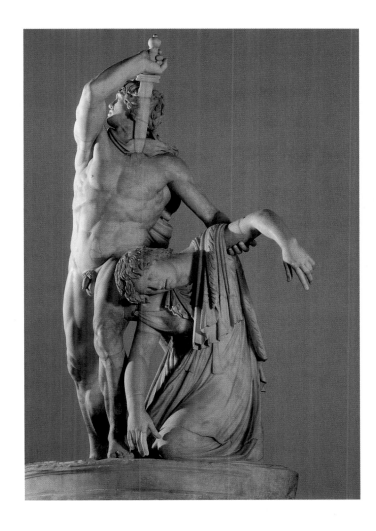

very steps one must ascend to reach Zeus's altar (FIG. 5-78). Violent movement, swirling draperies, and vivid depictions of death and suffering are the norm. Wounded figures writhe in pain, and their faces reveal their anguish. When Zeus hurls his thunderbolt, one can almost hear the thunderclap. Deep carving creates dark shadows. The figures project from the background like bursts of light. These features have been justly termed "baroque" and reappear in seventeenth-century European sculpture (see Chapter 24). One can hardly imagine a greater contrast than between the Pergamene gigantomachy frieze and that of the Archaic Siphnian Treasury at Delphi (FIG. 5-17).

A NOBLE DEATH FOR BARBARIC FOES On the Altar of Zeus, the victory of Attalos I over the Gauls was presented in mythological disguise. In an earlier statuary group set up on Pergamon's acropolis, the defeat of the barbarians was explicitly represented. Roman copies of some of these figures survive (FIGS. **5-80** and **5-81**). The sculptor carefully

5-81 EPIGONOS(?), Dying Gaul. Roman marble copy after a bronze original from Pergamon, Turkey, ca. 230–220 B.C., approx. 3′ $\frac{1}{2}$″ high. Museo Capitolino, Rome.

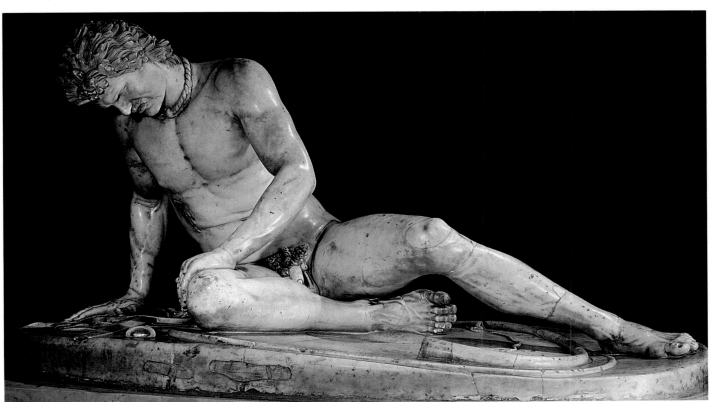

studied and reproduced the distinctive features of the foreign Gauls, most notably their long, bushy hair and mustaches and the *torques* (neck bands) they frequently wore. The Pergamene victors were apparently not included in the group. The viewer saw only their foes and their noble and moving response to defeat.

In what was probably the Attalid group's centerpiece (FIG. 5-80), a heroic Gallic chieftain defiantly drives a sword into his own chest just below the collarbone, preferring suicide to surrender. He already has taken the life of his wife, who, if captured, would have been sold as a slave. In the best Lysippan tradition, the group only can be fully appreciated by walking around it. From one side the observer sees the Gaul's intensely expressive face, from another his powerful body, and from a third the woman's limp and almost lifeless body. The man's twisting posture, the almost theatrical gestures, and the suicidal act's emotional intensity are hallmarks of the Pergamene "baroque" style and were closely paralleled in the later frieze of Zeus's altar.

The third Gaul from this group is a trumpeter who collapses upon his large oval shield as blood pours out of the gash in his chest (FIG. 5-81). He stares at the ground with a pained expression on his face. The Hellenistic figure is reminiscent of the dying warrior from the east pediment of the Temple of Aphaia at Aegina (FIG. 5-28), but the suffering Gaul's pathos and drama are far more pronounced. As in the suicide group and the gigantomachy frieze, the male musculature was rendered in an exaggerated manner. Note the chest's tautness and the left leg's bulging veins—implying that the unseen Attalid hero who has struck down this noble and savage foe must have been an extraordinary man. If this figure is the *tubicen* (trumpeter) Pliny mentioned as the work of the Pergamene master EPIGONOS, then Epigonos may be the sculptor of the entire group and the creator of the dynamic Hellenistic baroque style.

Sculpture

VICTORY IN A FOUNTAIN One of the masterpieces of the Hellenistic baroque style was not created for the Attalid kings but was set up in the Sanctuary of the Great Gods on Samothrace. The *Nike of Samothrace* (FIG. **5-82**) has just alighted on a Greek warship's prow. Her missing right arm was once raised high to crown the naval victor—just like Nike places a wreath on Athena on the Altar of Zeus (FIG. 5-79). But the Pergamene relief figure seems calm by comparison. The Samothracian Nike's wings still beat, and the wind sweeps her drapery. Her himation bunches in thick folds around her right leg, and her chiton is pulled tightly across her abdomen and left leg. The statue's theatrical effect was amplified by its setting. The war galley was displayed in the upper basin of a two-tiered fountain. In the lower basin were large boulders. The fountain's flowing water created the illusion of rushing waves dashing up against the ship. The statue's reflection in the shimmering water below accentuated the sense of lightness and movement. The sound of splashing water added an aural dimension to the visual drama. Art and nature were here combined in one of the most successful sculptures ever fashioned. In the *Nike of Samothrace* and other works in the Hellenistic baroque manner, the Polykleitan con-

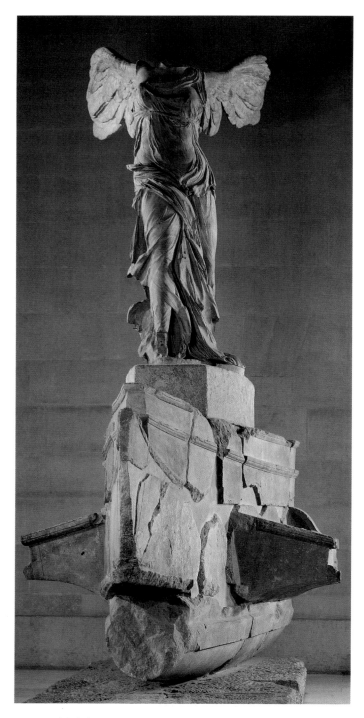

5-82 Nike alighting on a warship (*Nike of Samothrace*) from Samothrace, Greece, ca. 190 B.C. Marble, figure approx. 8′ 1″ high. Louvre, Paris.

ception of a statue as an ideally proportioned, self-contained entity on a bare pedestal was resoundingly rejected. The Hellenistic statues interact with their environment and appear as living, breathing, and intensely emotive human (or divine) presences.

HELLENISTIC EROTICISM Bold steps in redefining the nature of Greek statuary had already been taken in the fourth century B.C. in different ways by Praxiteles, Skopas, and Lysippos. Their distinctive styles continued to influence sculptors throughout the Hellenistic period. The undressing of Aphrodite by Praxiteles, for example, became the norm,

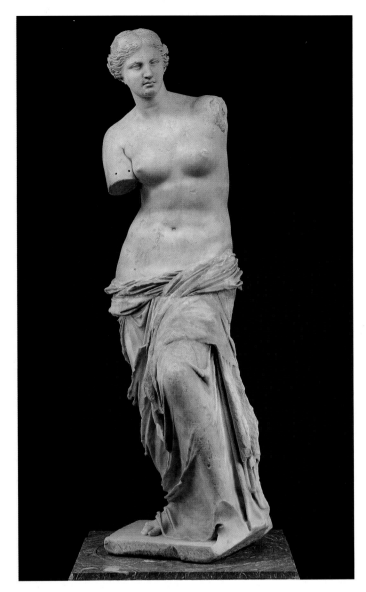

5-83 ALEXANDROS OF ANTIOCH-ON-THE-MEANDER, Aphrodite (*Venus de Milo*), from Melos, Greece, ca. 150–125 B.C. Marble, approx. 6′ 7″ high. Louvre, Paris.

vances of the semihuman, semigoat Pan, the Greek god of the woods. She defends herself with one of her sandals, while her loyal son Eros flies in to grab one of Pan's horns in an attempt to protect his mother from an unspeakable fate. One may wonder about the taste of Dionysios of Berytos (Beirut), who paid to have this statue erected in a businessmen's clubhouse—especially since both Aphrodite and Eros are portrayed as almost laughing—but such groups were commonplace in Hellenistic times. The combination of eroticism and parody of earlier Greek masterpieces was apparently irresistible. These whimsical Hellenistic groups are a far cry from the solemn depictions of the deities of Mount Olympus produced during Classical times.

Also different from earlier periods is the way Eros was represented. In the Hellenistic age he was shown as the pudgy infant Cupid as portrayed in innumerable later artworks, while in earlier Greek art he was depicted as an adolescent (FIG. 5-48, center). In the history of art, babies are all too frequently rendered as miniature adults—often with adult personalities to match their mature bodies. Hellenistic sculptors knew how to reproduce the soft forms of infants and how to portray the spirit of young children in memorable statues.

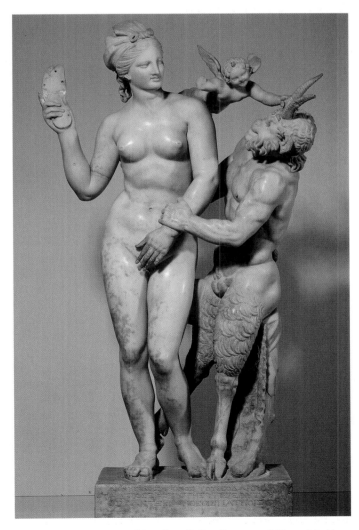

5-84 Aphrodite, Eros, and Pan, from Delos, Greece, ca. 100 B.C. Marble, 4′ 4″ high. National Archeological Museum, Athens.

but Hellenistic sculptors went beyond the Late Classical master and openly explored the nude female form's eroticism. The famous *Venus de Milo* (FIG. **5-83**) is a larger-than-life-size marble statue of Aphrodite found on Melos together with its inscribed base (now lost) signed by the sculptor, ALEXANDROS OF ANTIOCH-ON-THE-MEANDER. In this statue the goddess of love is more modestly draped than the *Aphrodite of Knidos* (FIG. 5-60) but more overtly sexual. Her left hand (separately preserved) holds the apple Paris awarded her when he judged her as the most beautiful goddess of all. Her right hand may have lightly grasped the edge of her drapery near the left hip in a halfhearted attempt to keep it from slipping farther down her body. The sculptor intentionally designed the work to tease the spectator. By so doing he imbued his partially draped Aphrodite with a sexuality that is not present in Praxiteles' entirely nude image of the goddess.

The *Aphrodite of Knidos* was directly quoted in an even more playful and irreverent statue of the goddess (FIG. **5-84**) found on Delos. Here, Aphrodite resists the lecherous ad-

5-85 Sleeping satyr (*Barberini Faun*), from Rome, Italy, ca. 230–200 B.C. Marble, approx. 7′ 1″ high. Glyptothek, Munich.

SLEEP AND INTOXICATION Archaic statues smile at their viewers, and even when Classical statues look away from the viewer they are always awake and alert. Hellenistic sculptors often portrayed sleep. The suspension of consciousness and the entrance into the fantasy world of dreams—the antithesis of the Classical ideals of rationality and discipline—had great appeal to them. A prime example of this newfound interest is a statue of a drunken, restlessly sleeping satyr known as the *Barberini Faun* (FIG. **5-85**). The statue was found in Rome in the seventeenth century and restored (not entirely accurately) by Gianlorenzo Bernini, the great Italian Baroque sculptor (see Chapter 24). Bernini no doubt felt this dynamic statue in the Pergamene manner was the work of a kindred spirit. The satyr, a follower of Dionysos, has consumed too much wine and has thrown down his panther skin upon a convenient rock and then fallen into a disturbed, intoxicated sleep. His brows are furrowed, and one can almost hear him snore.

Eroticism also comes to the fore in this statue. Although men had been represented naked in Greek art for hundreds of years, Archaic kouroi and Classical athletes and gods do not exude sexuality. Sensuality surfaced in the works of Praxiteles in the fourth century B.C. But the dreamy and supremely beautiful Hermes playfully dangling grapes before the infant Dionysos (FIG. 5-62) has nothing of the blatant sexuality of the *Barberini Faun,* whose wantonly spread

legs focus attention on his genitals. Homosexuality was common in the man's world of ancient Greece. (In Plato's *Symposium,* Alcibiades refers to Socrates' almost superhuman ability to resist seduction.) It is not surprising that when Hellenistic sculptors began to explore the human body's sexuality, they turned their attention to both men and women.

A HUMILIATED, BATTERED BOXER Although Hellenistic sculptors tackled an expanded range of subjects, they did not abandon such traditional themes as the Greek athlete. But they often rendered the old subjects in novel ways. This is certainly true of the magnificent bronze statue of a seated boxer (FIG. **5-86**), a Hellenistic original found in Rome and perhaps at one time part of a group. The boxer is not a victorious young athlete with a perfect face and body but a heavily battered, defeated veteran whose upward gaze may have been directed at the man who had just beaten him. Too many punches from powerful hands wrapped in leather thongs—Greek boxers did not use the modern sport's cushioned gloves—have distorted the boxer's face. His nose is broken, as are his teeth. He has smashed "cauliflower ears." Inlaid copper blood drips from the cuts on his forehead, nose, and cheeks. How different is this rendition of a powerful bearded man from that of the noble warrior from Riace (see FIGS. 5-34 and Intro-18) of the Early Classical period! The Hellenistic sculptor appealed not to the intellect but to the emotions

5-86 Seated boxer, from Rome, Italy, ca. 100–50 B.C. Bronze, approx. 4′ 2½″ high. Museo Nazionale Romano, Rome.

when striving to evoke compassion for the pounded hulk of a once-mighty fighter.

THE AGED AND THE UGLY The realistic bent of much of Hellenistic sculpture—the very opposite of the Classical period's idealism—is evident above all in a series of statues of old men and women from the lowest rungs of the social order. Shepherds, fishermen, and drunken beggars are common—the kinds of people who were pictured earlier on red-figure vases but never before were thought worthy of monumental statuary. One of the finest preserved statues of this type (FIG. **5-87**) depicts a haggard old woman bringing chickens and a basket of fruits and vegetables to sell in the market. Her face is wrinkled, her body is bent with age, and her spirit is broken by a lifetime of poverty. She carries on because she must, not because she derives any pleasure from life. Art historians do not know the purpose of such statues, but they attest to an interest in social realism absent in earlier Greek statuary.

Statues of the aged and the ugly are, of course, the polar opposites of the images of the young and the beautiful that dominated Greek art until the Hellenistic age, but they are consistent with the period's changed character. The Hellenistic world was a cosmopolitan place, and the highborn could not help but encounter the poor and a growing number of foreigners (non-Greek "barbarians") on a daily basis. Hellenistic art reflects this different social climate in the depiction of a much wider variety of physical types, including different ethnic types. We already have discussed the sensitive portrayal of Gallic warriors with their shaggy hair, strange mustaches, and golden torques (FIGS. 5-80 and 5-81). Africans, Scythians, and others, formerly only the occasional subject of vase painters, also entered the realm of monumental sculpture in Hellenistic art.

A GREAT ORATOR'S PORTRAIT These sculptures of foreigners and the urban poor, however realistic, are not portraits. Rather, they are sensitive studies of physical types. But the growing interest in the individual beginning in the Late Classical period did lead in the Hellenistic era to the production of true likenesses of specific persons. In fact, one of the great achievements of Hellenistic artists was the redefinition of portraiture. In the Classical period Kresilas was admired for having made the noble Pericles appear even nobler in his portrait (FIG. 5-39). But in Hellenistic times sculptors sought not only to record the actual appearance of their subjects in bronze and stone but also to capture the essence of their personalities in likenesses that were at once accurate and moving.

One of the earliest of these, perhaps the finest of the Hellenistic age and frequently copied in Roman times, was a bronze portrait statue of Demosthenes (FIG. **5-88**) by POLYEUKTOS. The original was set up in the Athenian agora in 280 B.C., forty-two years after the great orator's death. Demosthenes was a frail man and in his youth even suffered from a speech impediment, but he had enormous courage and great moral conviction. A veteran of the disastrous battle against Philip II at Chaeronea, he repeatedly tried to rally opposition to Macedonian imperialism, both before and after Alexander's death. In the end, when it was

5-87 Old market woman, ca. 150–100 B.C. Marble, approx. $4'\frac{1}{2}''$ high. Metropolitan Museum of Art, New York.

clear the Macedonians would capture him, he took his own life by drinking poison.

Polyeuktos rejected Kresilas and Lysippos's notions of the purpose of portraiture and did not attempt to portray a supremely confident leader with a magnificent physique. His Demosthenes has an aged and slightly stooped body. Demosthenes clasps his hands nervously in front of him as he looks downward, deep in thought. His face is lined, his hair is receding, and his expression is one of great sadness. Whatever physical discomfort Demosthenes felt is here joined by an inner pain, his deep sorrow over the tragic demise of democracy at the hands of the Macedonian conquerors.

Hellenistic Art under Roman Patronage

In the opening years of the second century B.C., the Roman general Flaminius defeated the Macedonian army and declared the old poleis of Classical Greece as free once again. They never, however, regained their former glory. Athens, for example, sided with King Mithridates VI of Pontus (r. 120–63 B.C.) in his war against Rome and was crushed by the general Sulla in 86 B.C. Thereafter, it retained some of its earlier prestige as a

5-88 POLYEUKTOS, Demosthenes. Roman marble copy after a bronze original of ca. 280 B.C. 6′ 7½″ high. Ny Carlsberg Glyptotek, Copenhagen.

center of culture and learning, but politically Athens was just another city incorporated into the ever-expanding Roman Empire. Greek artists, however, continued to be in great demand, not only to furnish the Romans with an endless stream of copies of Classical and Hellenistic masterpieces but also to create new statues *à la grecque* for Roman patrons.

GREEK MYTHOLOGY, ROMAN STATUARY One such work is the famous group of the Trojan priest Laocoön and his sons (FIG. **5-89**), which was discovered in Rome in 1506 in the presence of the great Italian Renaissance artist

Michelangelo. The marble group, long believed an original of the second century B.C., was found in the remains of the emperor Titus's (r. A.D. 79–81) palace, exactly where Pliny had seen it more than fourteen centuries before. Pliny attributed the statue to three Rhodian sculptors—ATHANADOROS, HAGESANDROS, and POLYDOROS—who are now generally thought to have worked in the early first century A.D. They probably based their group on a Hellenistic masterpiece depicting Laocoön and only one son. Their variation on the original adds the son at Laocoön's left (note the greater compositional integration of the two other figures) to conform with the Roman poet Vergil's account in the *Aeneid*. Vergil vividly described the strangling of Laocoön and his *two* sons by sea serpents while sacrificing at an altar. The gods who favored the Greeks in the war against Troy had sent the serpents to punish Laocoön, who had tried to warn his compatriots about the danger of bringing the Greeks' Wooden Horse within the walls of their city.

In Vergil's graphic account, Laocoön suffered in terrible agony, and the torment of the priest and his sons is communicated in a spectacular fashion in the marble group. The three Trojans writhe in pain as they struggle to free themselves from the death grip of the serpents. One bites into Laocoön's left hip as the priest lets out a ferocious cry. The serpent-entwined figures recall the suffering giants of the great frieze of the Altar of Zeus at Pergamon, and Laocoön himself is strikingly similar to Alkyoneos (FIG. 5-79), Athena's opponent. In fact, many scholars believe that a Pergamene statue of the second century B.C. was the inspiration for the three Rhodian sculptors.

HOMERIC THEMES IN A ROMAN GROTTO That the work seen by Pliny and displayed in the Vatican Museums today was made for Romans rather than Greeks was confirmed in 1957 by the discovery of fragments of several Hellenistic-style groups illustrating scenes from Homer's *Odyssey.* These fragments were found in a grotto that served as the picturesque summer banquet hall of the seaside villa of the Roman emperor Tiberius (r. A.D. 14–37) at Sperlonga, some sixty miles south of Rome. One of these groups—depicting the monster Scylla attacking Odysseus's ship—is signed by the same three sculptors Pliny cited as the Laocoön group's creators. Another of the groups, installed around a central pool in the grotto, depicted the blinding of the Cyclops Polyphemos by Odysseus and his comrades, an incident also set in a cave in the Homeric epic. The head of Odysseus (FIG. **5-90**) from this theatrical group is one of the finest sculptures of antiquity. The hero's cap can barely contain his swirling locks of hair. Even Odysseus's beard seems to be swept up in the moment's emotional intensity. The parted lips and the deep shadows produced by sharp undercutting add drama to the head, which must have been attached to an agitated body.

At Tiberius's villa in Sperlonga and in Titus's palace in Rome, the baroque school of Hellenistic sculpture lived on long after Greece ceased to be a political force. When Rome inherited the Pergamene kingdom from the last of the Attalids in 133 B.C., it also became heir to the Hellenistic world's artistic legacy. What Rome adopted from Greece it passed on to the medieval and modern worlds. If Greece was peculiarly the inventor of the European spirit, Rome was its propagator and amplifier.

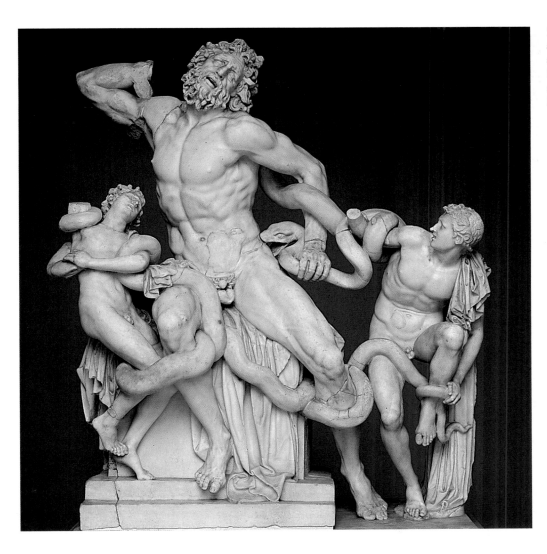

5-89 ATHANADOROS, HAGESANDROS, and POLYDOROS OF RHODES, Laocoön and his sons, from Titus's palace, Rome, Italy, early first century A.D. Marble, approx. 7′ 10½″ high. Vatican Museums, Rome.

5-90 ATHANADOROS, HAGESANDROS, and POLYDOROS OF RHODES, Head of Odysseus, from Tiberius's villa, Sperlonga, Italy, early first century A.D. Marble, approx. 2′ 1″ high. Museo Archeologico, Sperlonga.

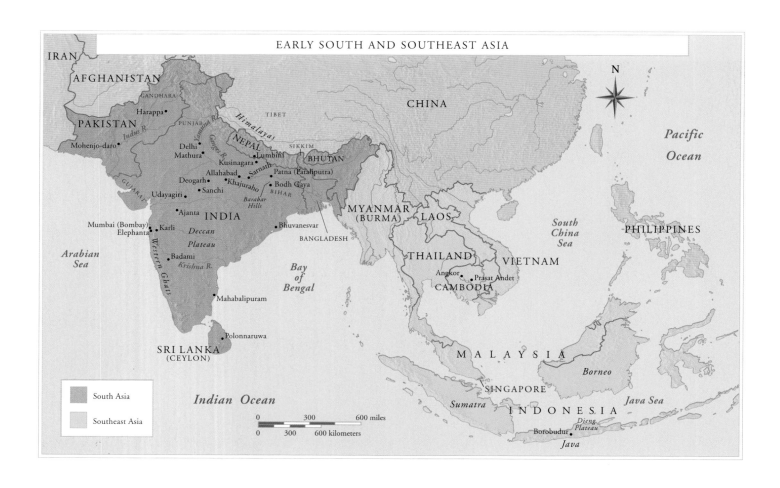

EARLY SOUTH AND SOUTHEAST ASIA

(Map showing Early South and Southeast Asia, with the following labels)

IRAN, AFGHANISTAN, PAKISTAN, GANDHARA, Harappa, PUNJAB, Indus R., Mohenjo-daro, Delhi, Mathura, Ganges R., Yamuna R., Himalayas, NEPAL, TIBET, SIKKIM, Lumbini, BHUTAN, Kusinagara, Sarnath, Allahabad, Patna (Pataliputra), CHINA, Deogarh, Khajuraho, Bodh Gaya, BIHAR, Barabar Hills, Udayagiri, Sanchi, INDIA, MYANMAR (BURMA), LAOS, Ajanta, Bhuvanesvar, BANGLADESH, Mumbai (Bombay), Karli, Deccan Plateau, Elephanta, Western Ghats, Badami, Krishna R., THAILAND, VIETNAM, South China Sea, PHILIPPINES, Pacific Ocean, Arabian Sea, Bay of Bengal, Angkor, Prasat Andet, CAMBODIA, Mahabalipuram, Polonnaruwa, SRI LANKA (CEYLON), MALAYSIA, Borneo, SINGAPORE, Java Sea, Indian Ocean, Sumatra, INDONESIA, Borobudur, Dieng Plateau, Java

South Asia
Southeast Asia

0 300 600 miles
0 300 600 kilometers

	2500 B.C.	1700 B.C.	1000 B.C.	500 B.C.	300 B.C.	185 B.C.	A.D. 1	300
INDIA AND PAKISTAN	URBAN PHASE INDUS CIVILIZATION	VILLAGE PHASE INDUS CIVILIZATION			MAURYA DYNASTY		KUSHAN DYNASTY (NORTHERN INDIA)	
SOUTHEAST ASIA (JAVA AND CAMBODIA)				PRE-ANGKOR KINGDOMS (TO A.D. 802)				

Priest-king(?)
Mohenjo-daro, Pakistan
ca. 2500–1700 B.C.

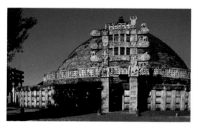

Lion capital, Sarnath, India
third century B.C.

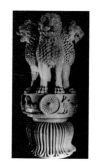

Great Stupa, Sanchi, India
completed first century A.D.

Early Phase Indus Civilization, 5500–2500 B.C.

Ongoing trade between Near East and Indus Valley, Pakistan, 2500–1700 B.C.

Aryan peoples in Punjab compose Vedic texts, Vedas, ca. 1500 B.C.

Upanishads, composed in opposition to Vedic texts, 800–500 B.C.

Sakyamuni Buddha's death, ca. 400 B.C.

Alexander the Great reaches Indus River, Pakistan, 327 B.C.

Maurya dynasty's Ashoka (r. 272–231 B.C.) establishes rule by moral law

Buddhist and Hindu deities first depicted in human form, first century B.C.–first century A.D.

PATHS TO ENLIGHTENMENT

THE ANCIENT ART OF SOUTH AND SOUTHEAST ASIA

300	400	500	600	700	800	900	1000	1200	1300

GUPTA DYNASTY (NORTHERN INDIA) — **LATER HINDU AND BUDDHIST DYNASTIES (NORTHERN INDIA)**

CHALUKYA DYNASTY (TO 1000; CENTRAL INDIA) — **CHANDELLA DYNASTY* (CENTRAL INDIA)**

PALLAVA DYNASTY †(TO 900; SOUTHERN INDIA) — **CHOLA DYNASTY (SOUTHERN INDIA)**

CENTRAL JAVA KINGDOMS (TO 1000) — **ANGKOR KINGDOMS**

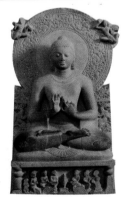

Seated Buddha
Sarnath, India
fifth century

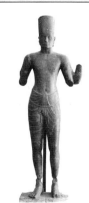

Harihara, Prasat Andet
Cambodia, seventh century

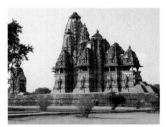

Visvanatha Temple, Khajuraho
India, ca. 1000

Bayon, Angkor Thom
Cambodia, twelfth–thirteenth century

Muslim incursions in South Asia begin, eighth century

Muslim sultanate in Delhi, 1206

Explicit sexual images first appear in Hinduism, ca. ninth century

Jayavarman II (r. 802–850) founds Angkor Dynasty, 802

Note: In view of unreliable written histories for India, specific dates for dynasties are sometimes speculative.

* Chandella dynasty predated its earliest known art and continued beyond the temple construction phase noted here.

† First securely dated Pallava art dates to the sixth century, although historical references refer to the Pallavas earlier.

The South Asian subcontinent, a vast geographic area, includes not only India but also the modern countries of Pakistan, Afghanistan, Nepal, Tibet, Bangladesh, and the island nation of Sri Lanka. Tremendous linguistic and cultural differences among its inhabitants mirror the region's geographic diversity. The people of India speak more than twenty different major languages. Those spoken in the north belong to the Indo-European language family, while those in the south form a completely separate linguistic family called Dravidian. India's art and architecture, produced over some five millennia, are also multicultural. Yet, the material created shares certain themes and characteristics, allowing its organization into categories for comparative discussion. Certainly, the most important attribute is religion. Religious uses and meanings characterize many of the surviving sculptures, paintings, and buildings in India. This chapter discusses the art and architecture of India and Southeast Asia from their beginnings until the thirteenth century. During that time, the two religions of greatest importance were Buddhism and Hinduism.

INDIA AND PAKISTAN

Indus Valley Civilization

In the third millennium B.C., long before the advent of Buddhism and Hinduism, one of the world's earliest important civilizations appeared in South Asia. The Indus Valley civilization spread over a wide geographic area along the Indus River in present-day Pakistan and extended into India as far south as Gujarat and east almost to Delhi. Several large cities, notably Harappa and Mohenjo-daro, attest to a remarkable urban phase for this civilization dating to ca. 2500–1700 B.C. These cities featured streets oriented to compass points, multistoried houses built of brick, and private bathing rooms with elaborate public drainage systems. One intriguing characteristic of the Indus civilization is that archeologists have not yet identified any surviving structures as either temples or palaces. This attribute marks a sharp contrast to the elaborate temple-and-palace architecture of the contemporaneous civilizations of Mesopotamia and Egypt (see Chapters 2 and 3), despite trade between the Indus culture and the ancient Near East.

Archeologists have uncovered a fair number of Indus objects to the west, including discoveries in Bahrain and on the Arabian Peninsula, but have found very few Near Eastern objects at Indus sites. Thus, it appears the Indus civilization traded durable manufactured goods, such as jewelry and stone seals, for nondurable items, perhaps textiles, that have disappeared from the archeological record. Internal trade, also of great importance for the Indus civilization, is one of the explanations for the remarkable cultural consistency among Indus sites.

PRIEST, KING, OR GOD? For such a long-lived civilization, archeologists have discovered surprisingly little art in the Indus Valley, and all of the objects found are small. Sculpture in stone and copper includes only about a dozen examples, the most impressive being the so-called priest-king (FIG. **6-1**). This steatite (a soft local soapstone) sculpture, excavated at Mohenjo-daro, shows a bearded man wearing a headband with a central circular emblem, matched by a similar arm-

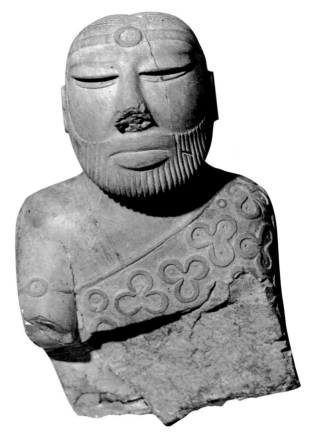

6-1 Priest-king(?), from Mohenjo-daro, Pakistan, ca. 2500–1700 B.C. Steatite, $6\frac{7}{8}''$ high. National Museum of Pakistan, Karachi.

band. A robe decorated with *trefoil* (a cloverlike ornament or symbol with stylized leaves in groups of three) designs covers his left shoulder and goes under his right arm. These designs, as well as the circles of the head- and armbands, originally held colored paste and shell inlays, as did the eyes. The individual depicted has not been identified, although he is clearly an important figure, perhaps a priest, king, or deity.

INDUS SEALS The most common Indus art objects are the so-called seals. Some twenty-five hundred steatite seals with incised designs have been found. They are similar in many ways to the cylinder seals found at contemporaneous sites in Mesopotamia (see "Mesopotamian Cylinder Seals," Chapter 2, page 26). Three impressions taken from typical seal types appear in our illustration (FIG. **6-2**). Each seal measures only one or two inches square and has an animal or tiny narrative carved on its face, along with an as yet untranslated pictographic script. On the back, a boss (circular knob) with a hole permitted insertion of a string. As in the ancient Near East, the Indus peoples sometimes used the seals to make impressions on clay, apparently for securing trade goods wrapped in textiles. Most show no wear, however, so people probably also wore the "seals" on their bodies as a sign of identification or badge of office.

The animals most frequently represented on the seals are male bovines, including the humped zebu (FIG. 6-2, left), as well as such wild animals as the rhinoceros (FIG. 6-2, center) and tiger. Some of the narrative seals appear to show that the Indus peoples worshiped trees, as both Buddhists and Hindus later did. Many scholars have suggested that religious and rit-

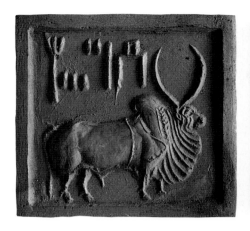

6-2 Seal impressions, from Mohenjo-daro, Pakistan, ca. 2500–1700 B.C. Seals, steatite, each approx. $1\frac{3}{8}'' \times 1\frac{3}{8}''$ square. National Museum, New Delhi.

ual continuities existed between the Indus civilization and later Indian culture.

A BUFFALO MAN IN A YOGIC POSTURE

The most famous of the seals depicts a seated male figure with water buffalo horns (FIG. 6-2, right). The figure's folded legs and his arms resting on the knees suggest a yogic posture, a method for controlling the body and calming the mind used in later Indian religions (compare FIG. 6-14). Yogic postures include many seated, standing, walking, and lying positions. The seal figure assumes a very difficult position with the legs folded under the body so that the heels press together. Although most scholars reject the identification of this seal's figure as a prototype of the Hindu god Shiva, the yogic posture argues that this important Indian religious practice began as early as the Indus civilization.

Aryan Culture

By around 1700 B.C., the urban phase of the Indus civilization had ended. Sculptures, seals, and script all disappeared from production, and the culture returned to one of village life. Very little art survives from the next thousand years, presumably because people used such perishable materials as wood, leather, and cloth. But religious foundations laid during this period defined most later Indian art.

ARYAN PRIESTS AND GODS The earliest language yet identified in South Asia is Sanskrit, the language spoken by the Aryans, a mobile herding people who lived in the Punjab, an area of northwestern India. Scholars do not know for certain whether these people originated in the Punjab or migrated from other areas. However, many researchers no longer accept the view that the Aryans invaded the Punjab, and most have concluded these residents represented a mix of peoples and languages.

Around 1500 B.C., the Aryans composed in Sanskrit the first of four Vedic texts, the Rig-Veda (*veda* means "knowledge"). Each Veda is a compilation of religious learning. The Rig-Veda, a book of hymns meant for priests (called Brahmins) to chant or sing, gives a very different picture of religious life than scholars can glean from earlier Indus archeological finds. The Aryan religion centered on sacrifice, the

ritual enactment of often highly intricate and lengthy ceremonies officiated over by the Brahmin priests. The priests placed materials, such as milk and *soma* (the sacrificial brew), into a fire *(Agni)* that took the sacrifices to the gods in the heavens. If the priests performed the rituals accurately, the gods fulfilled the prayers of those who sponsored the sacrifices. These gods, primarily male, included Indra, Varuna, and Surya, gods associated, respectively, with the rains, the ocean, and the sun. It appears the Aryans did not make images of these deities.

The Rise of Buddhism, Jainism, and Hinduism

SAMSARA, KARMA, MOKSHA, AND NIRVANA The Aryans lived far from the Indus heartland. The new urban phase of Indian civilization, beginning around the sixth century B.C., appeared even farther south, in the Ganges River valley. Here, from 800 B.C. to 500 B.C., religious thinkers composed a variety of reactions against the Vedic rituals in texts called the Upanishads. Among their innovative ideas were *samsara, karma,* and *moksha* (or *nirvana*). Samsara is the belief individuals are born again after death in an almost endless round of rebirths. The type of rebirth can vary. One can be reborn as a human being, an animal, or even a god. A person also can be reborn in a hell. An individual's past actions (karma), either good or bad—recorded without a deity's judgment—determine the nature of future rebirths. The ultimate goal of a person's religious life is to stop the round of rebirths by achieving an ending of all existence, called either moksha (for Hindus) or nirvana (for Buddhists).

BUDDHISM, HINDUISM, AND JAINISM As typical of Indian religions, multiple paths can lead to fulfillment of this goal. One of the greatest Indian religious thinkers, the Buddha, advocated the path of *asceticism,* or self-discipline and self-denial (see "Buddhism and Buddhist Iconography," page 164). The Buddha was not the only religious thinker advocating asceticism as the means to end rebirth. Mahavira, a contemporary of the Buddha, believed in an even more rigorously ascetic system. Because the Indians considered Mahavira a *jina,* or saint, scholars call the religion he founded Jainism in English. The Hindus also support the ascetic path with a

RELIGION AND MYTHOLOGY

Buddhism and Buddhist Iconography

The Buddha, or the Enlightened One, is the title given to Siddhartha Gautama, who also is called Sakyamuni, or the Wise Man of the Sakya Clan. The birth and death dates of this individual, the historical Buddha, are uncertain (different Buddhist sects give different dates). Current scholarship, however, places the Buddha's death around 400 B.C. Written down only many centuries after he died, the Buddha's life story records he was a minor Indian king's son destined to become either a great world conqueror or a great religious leader. He chose the latter. After living in opulence, he abandoned his wife and secular destiny to find enlightenment while meditating (in the yogic tradition) under a Bodhi Tree at Bodh Gaya in eastern India.

THE FOUR NOBLE TRUTHS

The Buddha's insight was that life is pain (*dukha*), including repeated death with each rebirth. Karmic actions of any kind—motivated by desire for love, children, food, power, or things—cause rebirth. The Buddha proposed a way (*marga* or *path*) to stop desire. This insight, formulated as the Four Noble Truths, stipulated that (1) everything is pain; (2) the origin of pain is desire; (3) the extinction of desire is nirvana; and (4) following the path or way the Buddha discovered leads to the ending of pain. In the Buddha's view, usually a person had to become a monk or nun and cultivate specific virtues to achieve nirvana. Some Buddhist sects believe people can attain nirvana within a single lifetime, while others feel it is virtually impossible even after multiple rebirths. At any rate, the Buddha's system is a monastic organization, and most Buddhist art in India is monastic. Laypeople support the monks where Buddhism thrives—giving them all they need to live, including food, clothing, and shelter—and in doing so create merit (or good karma) for their own better rebirth. Ironically, Buddhism died out almost completely in India by about the thirteenth century.

BUDDHISM OUTSIDE INDIA

The Buddha's teachings changed and developed over time and as they spread from India throughout Asia. One general change came with the development of the Mahayana (great vehicle) doctrines during the early centuries of the Christian era. Although formulated for other purposes, the Mahayana doctrines afforded laypeople new ways to achieve spiritual goals. For example, *bodhisattvas* (enlightened beings; see FIGS. 6-12, 7-13, 8-7, 8-8, and FIG. Intro-8), special virtuous Mahayana deities, help people earn merit. Mahayana Buddhists worship the bodhisattvas independently of the Buddha. It is Mahayana Buddhism that spread to China, Korea, and Japan.

Yet another general shift in Buddhism, the development of Tantric teachings, involves secret or esoteric practices. Tantric Buddhism is also important in East Asia and exists today in Tibet as well. One of the earliest forms of Buddhism, Theravada, continues in Sri Lanka and most of mainland South-

east Asia. A Buddha who acquired special importance in East Asia, Amitabha, Buddha of the West (see FIGS. 7-14, 8-8, and 8-15), told followers he could grant salvation through entrance to his Pure Land paradise. Pure Land teachings maintain that people have no hope of attaining enlightenment on their own because of the corruption of their times. They can obtain rebirth in a heavenly realm, however, simply by faith in Amitabha's promise of salvation.

THE BUDDHA IN ART

The earliest Buddhist artists, although often depicting complex narrative scenes, did not show the Buddha in human form. Instead, they used symbols such as the wheel or the tree to suggest his presence. When artists began depicting the Buddha in human form around the first centuries B.C. and A.D., it was as a monk meditating (see FIGS. 6-13, 7-8, and 25-8) or teaching (FIG. 6-15). But they distinguished the Buddha from monks and bodhisattvas by *lakshanas*, bodily attributes or characteristics indicating the Buddha's superhuman nature. These distinguishing marks include an *urna*, or curl of hair between the eyebrows shown as a dot, and a *ushnisha*, a cranial bump shown as hair on the earliest images (FIGS. 6-13 and 6-14) but later as an actual part of the head (see FIG. Intro-8 and FIG. 6-15).

Episodes from the Buddha's life and death are among the most popular subjects in all Buddhist artistic traditions. No single text provides the complete or authoritative narrative of his life. Thus, numerous versions and variations exist, allowing for a rich artistic repertory. Some of the most popular scenes in Buddhist art, the Buddha's birth, enlightenment, first sermon, and death, took place at different locations (Lumbini, Bodh Gaya, Sarnath, and Kusinagara, now Kushinagar, respectively). Illustrations in this chapter depict three of these events. The enlightenment at Bodh Gaya entails several different phases, but most paintings and sculptures present the Buddha seated in meditation (FIGS. 6-13, 7-8, and 25-8) or touching the earth under the Bodhi Tree (see FIG. 7-28).

Depictions of the first sermon show the Buddha teaching, his hands held together in front of his body to indicate the turning of the Wheel of the Law (FIGS. 6-15 and 6-28). A symbolic hand gesture, or *mudra*, also can indicate concepts such as meditation or reassurance. The Buddha set this Wheel rolling with his first sermon, and the Wheel marks with its track the geographic extent of his teaching. Often, artists depicted the Wheel of the Law as an actual wheel flanked by deer, a reference to the Deer Park at Sarnath (FIG. 6-15, on the base below the Buddha). Finally, in scenes of his death (*parinirvana*), artists portrayed the Buddha as lying down (FIG. 6-26).

Indian Buddhists erected monasteries and monuments at all four sites of these key events. Monks and lay pilgrims from throughout the Buddhist world continue to visit these places today.

tradition of wandering, homeless ascetics. But Hinduism (discussed in more detail later; see "Hinduism and Hindu Iconography," page 173) differs from both Buddhism and Jainism in not having a human founder. Indeed, no simple definition of Hinduism is possible, as it is highly individualistic. Hinduism and Buddhism both developed in the late centuries B.C. and early centuries A.D. Unlike the practitioners of the Aryan religion these religions displaced, followers of both Hinduism and Buddhism made and used images of their gods in worship.

Maurya Art and Architecture

Many artistic innovations began during the Maurya dynasty (fourth to second centuries B.C.), including the use of stone, a medium not used for the preceding eighteen hundred years of the Vedic and Upanishadic periods. The dynasty's most famous king, Ashoka (r. 272–231 B.C.), ruled almost all of present-day India, a geographic area not matched in size again until the modern nation of India formed in 1947, after it won independence from Britain. Ashoka's capital was Pataliputra (modern Patna in Bihar state). Today, his palace there lies largely in ruins, but an early visitor to Pataliputra left a glowing description of it. Megasthenes, the ambassador at the Maurya court from the Greek king Seleucus Nicator (ruler of Persia and Babylon at the end of the fourth and the beginning of the third centuries B.C.), detailed the attributes of the Maurya capital. Megasthenes described a walled city with sixty-four gates and five hundred seventy towers, as well as gardens, fishponds, and pillared buildings.

ASHOKA'S PILLARS AND MORAL LAW To rule his vast domains, Ashoka created a unique form of government, rule by *dharma,* or moral law, based largely on the Buddha's teaching (also called dharma). Ashoka had his moral laws inscribed on rocks and tall stone pillars throughout his kingdom in a variety of languages and scripts. The freestanding pillars, usually made of one enormous piece of stone, stood forty feet tall above ground, with another twenty feet buried in the earth. Sculptors placed an elaborate capital, also carved from a single block of stone, above each pillar. The famous lion capital originally topping a pillar at Sarnath (FIG. **6-3**), where the Buddha gave his first sermon, features two pairs of back-to-back lions at the top. They stand on a round abacus decorated with four wheels and four animals carved in relief above a lotus-form capital. The lions once carried a stone wheel, whose fragments still exist, on their backs. The wheel referred to the Buddha's Wheel of the Law but also indicated Ashoka's stature as a *chakravartin,* a universal king whose war chariot marked his secular kingdom with its wheels.

6-3 Lion capital of column erected by Emperor Ashoka (r. 272–231 B.C.), from Sarnath, India. Polished sandstone, 8' high. Archeological Museum, Sarnath.

THE ROCK-CUT CAVES OF THE AJIVIKAS Ashoka supported other religious groups as well as the Buddhists, and sponsored the earliest rock-cut caves for a now-extinct ascetic group, the Ajivikas. One of these caves, the Lomas Rishi, contains a room excavated into the rock with a carved curved wall at one end that copies the shape of a

6-4 Entrance to the Lomas Rishi cave, Barabar Hills, India, mid-third century B.C.

free-standing thatched hut. A carved facade around the cave's door (FIG. 6-4) mimics contemporaneous bent-wood architecture. A brief inscription at the site states that Ashoka gave one of the caves to shelter the Ajivika monks from the monsoon rains. Both Buddhists and Hindus in India used rock-cut architecture extensively until about the tenth century. The horseshoe shape of the Lomas Rishi's facade decoration became one of the most common motifs in all later Indian architecture (FIG. 6-11). This particular example at Lomas Richi has a pointed top, although many other variations of the form are also common.

Buddhist Art and Architecture

After the fall of the Maurya dynasty around the beginning of the second century B.C., a variety of dynasties ruled India, controlling various geographic areas over time but in constant cycles of expansion and collapse. Although art historians often classify Indian art according to dynastic names, time and place, not dynasties, determined artistic styles. Kings in India sponsored the erection of monuments and image making, but the rulers usually did not determine the style of the buildings or art objects. The artists produced art in the traditions they had learned, traditions determined by the times and by where the artists lived. Nor did religion shape artistic styles. The same artists produced both Buddhist and Hindu art in similar styles. More early Buddhist than Hindu art (particularly until the first century A.D.) has survived in India, because the Buddhists constructed large monastic institutions with durable materials such as stone and brick. The Hindus at this time tended to worship in their homes and at small shrines, using wooden images set up under trees.

THE GREAT STUPA AT SANCHI Sanchi, a Buddhist monastery founded during Ashoka's reign, existed for more than a thousand years. It consists of many buildings constructed over the centuries, including *viharas* (celled structures where monks lived), *stupas* (hemispherical monuments enshrining the relics of the Buddha and other important monks), *chaityas* (buildings with rounded, or apsidal, ends for housing stupas), and temples for sheltering images.

Stupas come in many sizes, from tiny handheld objects to huge structures, such as the Great Stupa at Sanchi (FIGS. **6-5** and **6-6**). The Great Stupa in its present form dates from ca. 50 B.C. to A.D. 50. The dome, solid and filled with earth and rubble, stands fifty feet high with a double stairway on the south side leading to an upper-level walkway. Although nineteenth-century excavators did not find any relics in the earthen dome, archeologists assume the builders did bury relics inside this stupa.

6-5 Great Stupa, Sanchi, India, first century B.C. to first century A.D.

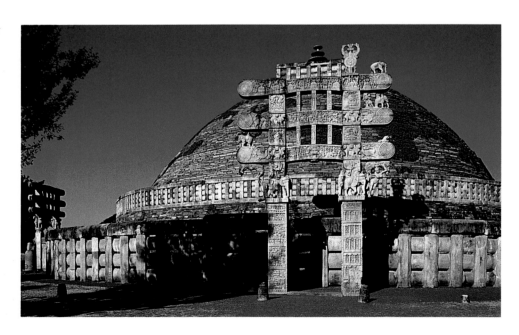

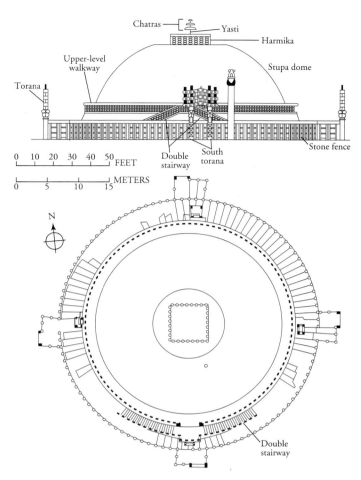

6-6 Exterior diagram and plan of Great Stupa, Sanchi, India, first century B.C. to first century A.D.

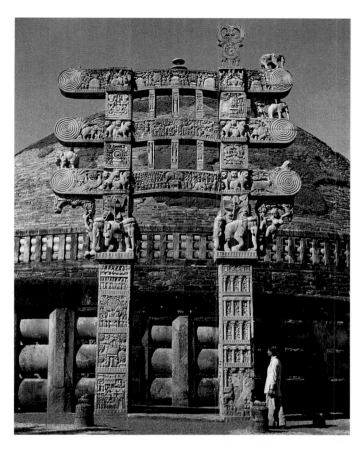

6-7 Eastern gateway, Great Stupa, Sanchi, India, first century B.C. to first century A.D.

Several architectural features of the stupa have symbolic meanings, transforming it into a model of the cosmos. The stupa itself (FIG. 6-6) symbolically represents the world mountain, with the cardinal points marked by gateways, or *toranas.* The *harmika,* positioned atop the stupa dome, is a stone fence or railing that encloses a square area representing one of the Buddhist heavens. At the harmika's center, a *yasti,* or pole, symbolizes the axis of the universe. Three stone disks, or *chatras,* assigned various meanings, crown the yasti. The yasti rises from the mountain-dome and passes through the harmika, thus uniting this world with the paradise above. Enclosing the entire structure is a stone fence, nine to eleven feet tall, its toranas (FIG. 6-7) covered with elaborate relief carvings.

Buddhists worship a stupa by *circumambulation,* walking around it in a clockwise direction so that the body's right side faces the monument. Using a fence or railing to mark off a sacred place or object is common in India, and worshipers of the Great Stupa could enter through a gateway and walk on the lower circumambulation path and then climb the stairs to circumambulate at the second level. Carved onto the different parts of the Great Stupa, more than six hundred brief inscriptions show that the donations of hundreds of individuals made the monument's construction possible. The vast majority of them common laypeople, monks, and nuns, they hoped to accrue merit for future rebirths with their gifts.

THE BUDDHA'S PAST LIVES The reliefs on the four toranas at Sanchi, such as the eastern gateway (FIGS. **6-7** and **6-8**), depict not only the Buddha's life story but also the stories of his past lives *(jatakas)*. In Buddhist belief, everyone has

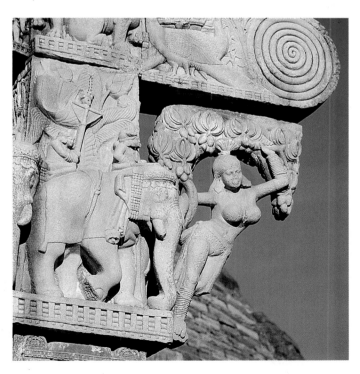

6-8 Yakshi, detail of eastern gateway (FIG. 6-7), Great Stupa, Sanchi, India, first century B.C. to first century A.D.

had innumerable past lives, including Siddhartha. During Siddhartha's past lives, as recorded in the jatakas, he accumulated sufficient merit to achieve enlightenment and become the Buddha. In the life stories recounted in the Great Stupa reliefs, however, the Buddha never appears as a human being. Instead, the artists indicated his presence by using symbols—the form of a wheel, for example. Scholars do not know precisely why early artists avoided portraying the Buddha in human form, but the first such depictions of him appeared around the time of the carving of the Sanchi gateways.

 EROTIC ART IN A MONASTERY Also not clear is the reason an image such as the well-known eastern gateway *yakshi* (FIG. 6-8), an essentially nude and highly erotic female, appears on a monument found within a monastic complex housing celibate monks. Such yakshis, which people worshiped throughout India, are local goddesses associated with fertility and vegetation. It is likely their incorporation into Buddhist monuments stemmed from their popularity with devotees. In the example at Sanchi, the yakshi reaches up to hold onto the mango tree branch above her while pressing her left foot against the trunk, an action intended to bring the tree to flower. Buddhists later adopted this pose, with its rich associations of fertility and abundance, for representing the

Buddha's mother, Maya, giving birth. Thus, the Buddhists adopted pan-Indian symbolism, such as the woman under the tree, to create their own Buddhist iconography.

A MONASTIC HALL CUT OUT OF ROCK Other Buddhist monasteries from the last century B.C. and the first and second centuries A.D. feature viharas (for the monks to sleep in) and chaitya halls (for worship of the stupa) carved out of living rock. The chaitya halls, apsidal structures with pillared *ambulatories* (walking paths), allow worshipers to circumambulate the stupa placed at the back of the hall. The chaitya hall at Karli (FIGS. 6-9 to 6-11), built around A.D. 100 in the Western Ghats (a chain of mountains) near Bombay (present-day Mumbai), is nearly forty-five feet high and one hundred twenty-five feet long. It surpasses in size and grandeur even the rock-cut chamber of the temple of the great Egyptian pharaoh Ramses II (see FIG. 3-23). Inside, the builders affixed curved wooden beams to the rock ceiling in imitation of small wooden models, even though the beams perform no architectural function here. Elaborate capitals atop the rock-cut pillars depict men and women riding on elephants.

A large horseshoe-shaped window dominates the Karli hall's impressive facade. Images of paired men and women

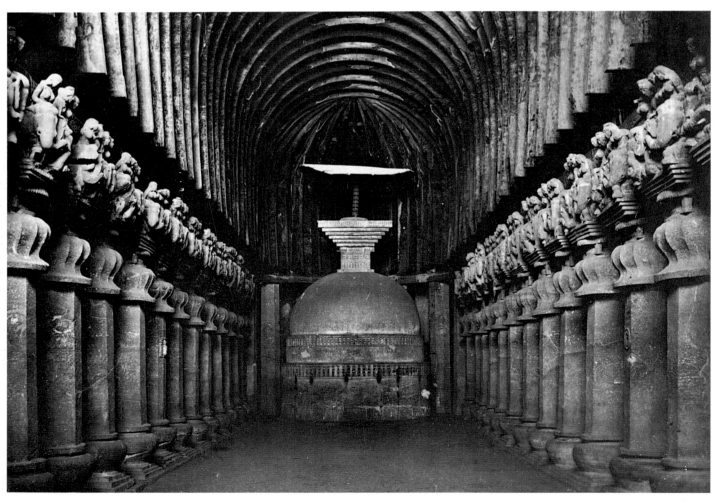

6-9 Interior of chaitya hall, Karli, India, ca. 100.

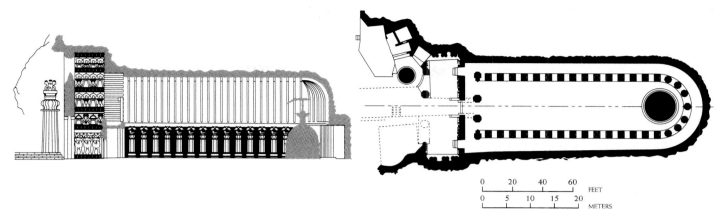

6-10 Section *(left)* and plan *(right)* of chaitya hall, Karli, India, ca. 100.

flank the central doorway. The sculptor inventively placed the couple in our example (FIG. 6-11) in the awkward space of the facade's characteristically horseshoe-shaped false windows.

THE PAINTED CAVES OF AJANTA Buddhist rock-cut architecture appears to have gone out of favor after Karli, only to be revived suddenly some three hundred fifty years later. Several caves at Ajanta, northeast of Bombay, date to the earlier period, but during the second half of the

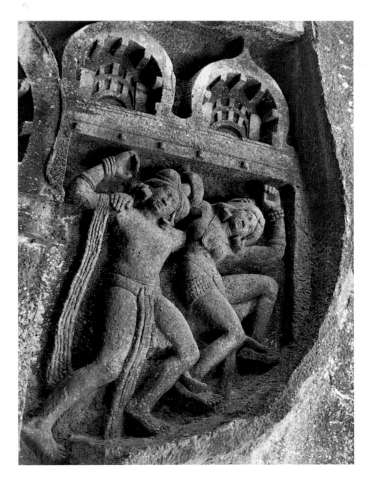

6-11 Loving couple, chaitya hall entrance, Karli, India, ca. 100.

fifth century, a burst of activity at the site produced more than twenty new caves. One reason for their importance is that they retain much of their painted wall decoration. Art historians assume India had a rich painting tradition in ancient times, but because early Indian artists often used perishable materials, such as palm leaf and wood, and because of the tropical climate in much of India, nearly all early Indian painting has been lost. At Ajanta, however, paintings cover the walls, pillars, and ceilings of some of the caves.

The central male individual in one painting (FIG. **6-12**) is a bodhisattva, one of a pair flanking the entrance to the Buddha shrine at the rear center of one of the Ajanta caves. With long, dark hair hanging down below a jeweled crown, he stands holding a lotus flower in his right hand and surrounded by male and female attendants. His face shows great compassion as he gazes downward at the actual worshipers passing through the shrine entrance on their way to the monumental rock-cut Buddha image housed in a cell at the back of the cave. The Ajanta caves provide a tantalizing glimpse of early Indian painting. Significant later examples of paintings in India are rare before the thirteenth century (see Chapter 25).

GANDHARA AND GRECO-ROMAN ART At some point during the first century B.C. or A.D., Indian artists began to depict the Buddha in human form. These images appeared at this time for at least two different reasons. One may be that human Buddha images were not part of the early Indian tradition. Peoples of the Indus and the Vedic periods did not make icons of their chief gods. From the Mauryan period up until the first century B.C., only human images of lesser local gods and goddesses, such as the yakshi depicted on Sanchi's eastern gateway (FIG. 6-8), occur. An additional reason may be the concept of *bhakti* as a path to the deity, which arose in both Buddhist and Hindu thought during the first centuries B.C. and A.D. Bhakti is loving devotion to a particular deity, demonstrated by giving gifts such as food, songs, and flowers to the deity's images. Such gift giving may have stimulated representations of the gods in humanlike forms.

Although researchers cannot pin down an exact place and date for the invention of such Buddha images, they do agree

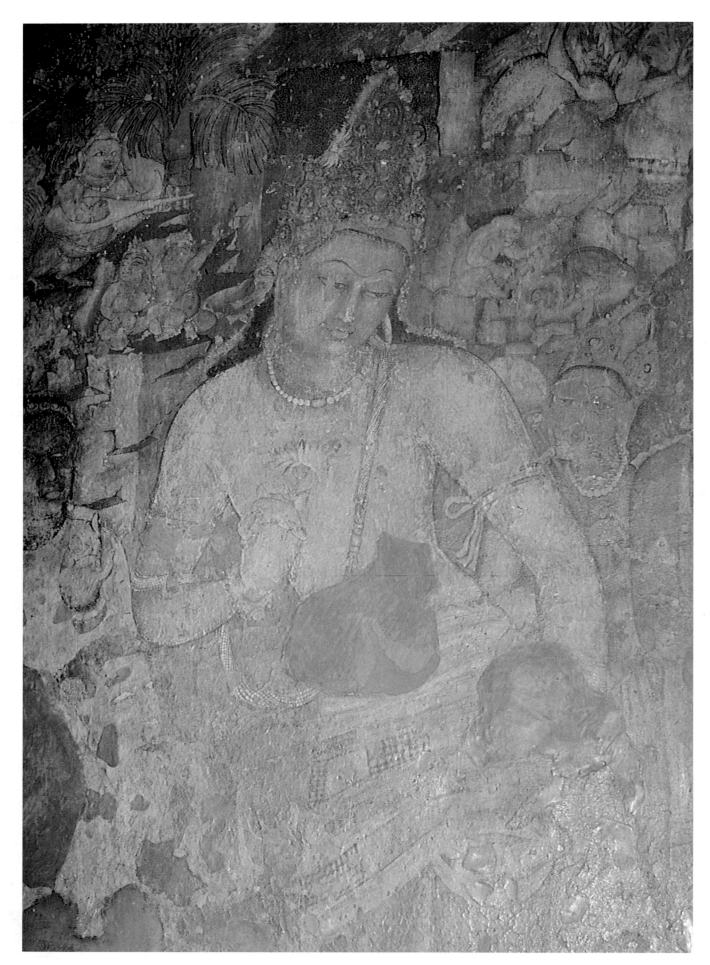

6-12 Bodhisattva, wall fresco in Cave I, Ajanta, India, ca. 450–500.

that, once created, these images became very popular. Among the earliest are those represented by two sculptural styles, one that developed in Gandhara and one at Mathura. Both Gandhara, an area largely in Pakistan today, and Mathura, a city about ninety miles south of Delhi, were important parts of the Kushan empire that ruled much of northern South Asia during the first three centuries A.D.

The Gandhara style (FIG. **6-13**) is, surprisingly, Greco-Roman in character. Gandhara was part of a widespread region of Hellenistic culture and art that stretched across reaches of modern Iran, Russia, Afghanistan, and Pakistan, a legacy of Alexander's incursions in these regions in the fourth century B.C. (see Chapter 5). When Gandharan artists sought models for their Buddha sculptures, they turned to material they were already familiar with—images of deities such as Apollo (see FIG. Intro-7). Thus, they depicted the Buddha with similarly wavy hair, topped by a bun tied with a ribbon. Masking the body underneath, the Buddha's heavy robe emphasizes the elaborate design of the folds, in the Hellenistic-Roman tradition (see FIG. 10-72).

BUDDHIST IMAGERY IN MATHURA Mathura Buddha images (FIG. **6-14**), in contrast, relate more clearly to human images in the Indian tradition—*yakshas,* the male equivalents of the yakshis. Indian artists represented yakshas as bulky, powerful males with broad shoulders and open,

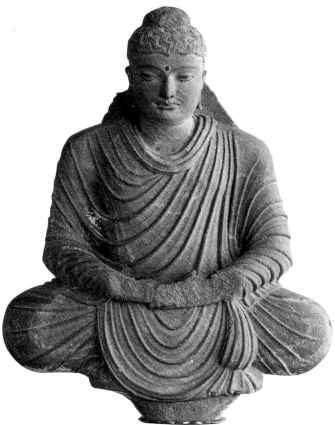

6-13 Seated Buddha, from Gandhara, Pakistan, ca. second to third century. Stone (black schist), 2′ 4 ¾″ high. Yale University Art Gallery, New Haven.

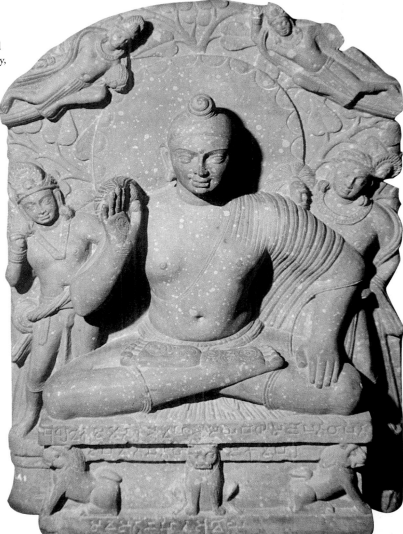

6-14 Seated Buddha, from Mathura, India, second century. Red sandstone, 2′ 3 ½″ high. Archeological Museum, Muttra.

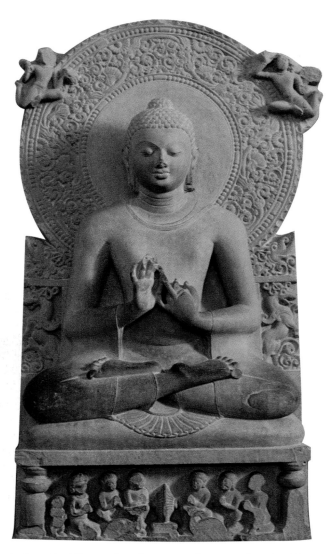

6-15 Seated Buddha preaching first sermon, from Sarnath, India, fifth century. Sandstone, 5' 3" high. Archeological Museum, Sarnath.

staring eyes. The Mathura Buddha images retain these characteristics but wear a monk's robe and sit in a yogic posture with the right hand raised palm-out in a gesture indicating to worshipers they need have no fear. The robe appears almost transparent, revealing the thick, full body beneath.

THE TEACHING BUDDHA OF SARNATH The Gandhara Buddha style (FIG. 6-13) had little impact on India's later art, although in China it served as the model for the earliest Chinese Buddha images (see FIG. 7-8). The Mathura-style image, in contrast, was the source for much of later Buddhist sculpture, developing at Sarnath in the fifth century as one of the most important image styles. The Sarnath Buddha (FIG. 6-15) retains the clinging robe of the earlier Mathura image, revealing a body with a softened build. The Buddha's eyes are downcast, and he holds his hands in front of his body in the Wheel-turning gesture (compare FIG. 6-28), preaching his first sermon, indicated by the tiny Wheel of the Law seen on its edge below the figure. Flanking the Wheel, two now partially broken deer symbolize the Deer Park at Sarnath, where the Buddha delivered his first sermon.

Hindu Art and Architecture

Buddhists and Hindus practiced their religions side by side in India, often at the same site (Mathura, for example). Buddhism and Hinduism are not one-god religions, such as Judaism, Christianity, and Islam. Instead, Buddhists and Hindus approach the spiritual through many gods and varying paths, which permits mutually tolerated differences. Although Hindus worship a multitude of different deities, Vishnu (FIG. 6-16), Shiva (FIGS. 6-17, 6-18, and 6-25), and Devi (or "the Goddess") are the most popular and important (see "Hinduism and Hindu Iconography," page 173).

VISHNU RESCUES THE EARTH The Hindus began to construct cave temples long after the Buddhists did. The earliest, at Udayagiri near Sanchi, constructed ca. A.D. 400, some six hundred years after the first Buddhist examples. Yet, within a century, the Hindu cave temples had reached great size and complexity. Even the earliest Udayagiri caves, although architecturally simple and small, contain monumental relief sculptures showing an already fully developed religious iconography—sometimes with political overtones (see "Myth and History in Indian Sculpture," page 174). The Boar Avatar of Vishnu (sometimes identified as Varaha, using the Sanskrit word for *boar*), carved in a shallow niche of rock at Udayagiri (FIG. 6-16), stands about thirteen feet tall. The

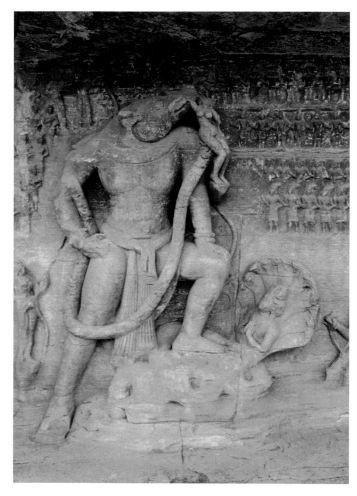

6-16 Boar Avatar of Vishnu, Cave V, Udayagiri, India, ca. 400. Vishnu 12' 8" high.

Hinduism and Hindu Iconography

Hinduism has no simple definition. Indeed, the term creates such controversy that Indians have turned to their law courts in an attempt to determine a definition. The actual practices and beliefs of Hindus vary tremendously, with many paths leading to spiritual goals. The three most important Hindu deities, Shiva, Vishnu, and Devi, all have various forms, and Hindus also worship many other gods. The earliest humanlike Hindu images appeared at the same time as the first Buddha images in human form.

Shiva often takes the form of a *linga* (a phallus or cosmic pillar), which artists have represented in a highly abstracted geometric form since about the sixth century. But Shiva also appears in human form in Hindu art, frequently with multiple arms (FIGS. 6-17 and 6-25) and heads (FIG. 6-18).

The many forms Vishnu assumes include *avatars,* manifestations of the deity incarnated in some visible form while performing a sacred function on earth. In these instances, Vishnu descends to earth to protect it from demons. As the Boar Avatar (FIG. 6-16), for example, he saves the earth from floods.

Devi (or the Goddess) assumes multiple forms, too—both benevolent and destructive. Sometimes linked to the male gods Shiva and Vishnu as consort, she also appears alone when worshiped as the supreme deity.

The stationary images of deities in Hindu temples are often made of stone. Hindus periodically remove movable images, often of bronze, from the temple, particularly during festivals to enable many worshipers to take *darshan* (seeing the deity and being seen by the deity) at one time. In temples dedicated to Shiva, the permanent form is the linga, displayed in the *garbha griha* (womb chamber) or inner sanctuary (FIG. 6-22), where priests attend to the deity.

The Shiva Nataraja (FIG. 6-25) is a movable image, but it would not appear in worship as it does in an art history book. Rather, when Hindus worship the Shiva Nataraja, they dress the image, cover it with jewels, and garland it with flowers. The only bronze part visible is the face, marked with colored powders and scented pastes. Considered the embodiment of the deity, the image is not a symbol of the god but the god itself. All must treat the god/image as a living being. Worship of the deity involves taking care of him as if he were an honored person. Bathed, clothed, given foods to eat, and taken for outings, the image also receives such gifts as songs, lights (lit oil lamps), good smells (incense), and flowers—all things he can enjoy through the senses. The food given to the god is particularly important, as he eats the "essence," leaving the remainder for the worshiper. The food is then *prasada* (grace), sacred because it came in contact with the divine. In an especially religious household, the deity resides as an image and receives the food for each meal before the family eats. When the god resides in a temple, it is then the duty of the priests to feed, clothe, and take care of him.

avatar has a human body and a boar's head. Vishnu assumed this form when he rescued the earth, here personified as a female who clings to the boar's tusk, from a flood. Vishnu stands with one foot resting on the coils of a snake king (identified by the multiple hoods behind his human head), who represents the conquered flood waters. Rows of gods and ascetics form lines to witness the event.

A MANY-ARMED DANCING SHIVA In the sixth century, under the Chalukya kings, Hindu artists carved a series of reliefs in caves at Badami in the Deccan, a plateau area between northern and southern India. One relief (FIG. **6-17**) shows Shiva in the *lalita* or "charming" pose, which he assumes to seduce his consort Parvati. As he dances, his multiple arms swing rhythmically in an arc. Some of the hands hold objects, and others form prescribed *mudras* (symbolic gestures). At the right, a drummer accompanies the dance, while Shiva's son, the elephant-headed Ganesha, tentatively mimics his father. Nandi, Shiva's bull mount, stands at the left.

Artists often represented Hindu deities as part human and part animal (FIG. 6-16) or as figures with multiple body parts (FIG. 6-17). Because these are images of gods, not of human beings, they should not be judged by a standard of human anatomical accuracy. Indeed, these composite and multi-limbed forms indicate that the subjects are not human but more-than-human gods. The Western standard of naturalistic depiction of gods in human form, set by the Greeks

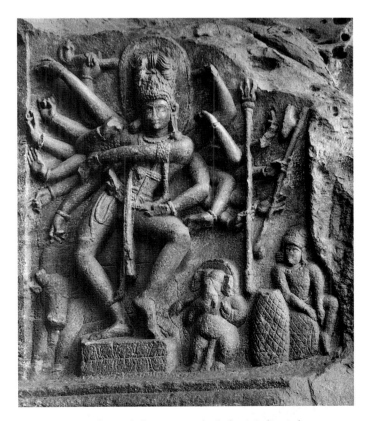

6-17 Dancing Shiva, relief in cave temple, Badami, India, sixth century.

Myth and History in Indian Sculpture

The story of Vishnu's Avatar Varaha rescuing the earth from the flood waters, depicted in the monumental relief at Udayagiri (FIG. 6-16), is a myth, an imaginary or legendary tale. Scholars often contrast mythological narratives with historical ones—that is, narratives based on actual events and personalities. By this definition, mythology, not history, is the almost exclusive subject of early Indian art. Even depictions of the Buddha's life (FIG. 6-15) can be considered mythic, because the artistic representations, as well as the textual narratives of his life, are so far removed from the historical Buddha's lifetime and so filled with the miraculous that it is difficult to label them as historical.

Although in many cultures myth and history can be clearly differentiated, the distinction was much more ambiguous in ancient India. People used the stories of the deities, the myths, as a way of seeing and understanding their world. They interpreted their own actions and lives (that is, "history") in terms of those of the deities (that is, "myth"). This explains in part why it is so difficult to find historical scenes in ancient Indian art.

In the ancient Near East and Egypt, rulers frequently commemorated their victories and other great deeds in stone reliefs (see Chapters 2 and 3), a practice which reached a high point in the ancient world in Roman art (see Chapter 10). But such overtly political artworks featuring historical events and persons appear rarely in ancient Indian art. When Indian kings and powerful elites sponsored religious art, they expected their patronage to gain them merit for future rebirths. But some of their monuments also commemorated contemporary events, such as victories in war. Rather than depicting themselves and the actual events, however, they placed themselves by analogy into a relationship with the deity. Thus, mythic reliefs can have hidden political meaning.

The patron of the Udayagiri Varaha relief, a local king, gave honor in an inscription to Chandragupta II (r. 376–412), the king of the Guptas, the most important and powerful Indian dynasty at the time. The relief's creators apparently dedicated the work to Chandragupta.

Chandragupta consolidated most of northern India into his empire by defeating the last of a group of kings who had ruled that region of India for hundreds of years. At Udayagiri, Varaha's victory in saving the earth parallels Chandragupta's victories. The local king wanted viewers (including perhaps Chandragupta, since inscriptions indicate he actually visited the site) to see Chandragupta as saving his kingdom by ridding it of its enemies much in the way Varaha saved the earth. Certain pictorial clues in the relief reinforce this interpretation. For example, on each side of the niche streams of water (identified by female personifications) meet to form a single stream. The two streams represent the Ganges and Yamuna Rivers, which merge at Allahabad to form the single mighty Ganges that ultimately empties into the ocean in the Bay of Bengal. Allahabad was the capital of the Gupta dynasty. The relief suggests that just as the two great northern rivers unite at Chandragupta's capital, the king united the north under his rule. Thus, the artist clothed contemporary events in mythological guise, as the ancient Greeks frequently did (see Chapter 5).

(see Chapter 5), does not apply to Indian images. Indian artists did not intend to portray accurate anatomy.

SHIVA WITH THREE FACES A third Hindu cave site, just off the coast of Bombay, is on Elephanta, an island named by early Portuguese colonizers who found a life-size stone elephant sculpture there. Perhaps the most impressive of the Elephanta reliefs is a seventeen-foot-high image of Shiva as Mahadeva (FIG. **6-18**), the "Great God" or Lord of Lords, set deep within the cave in a niche once closed off with wooden doors. Two stone door guardians with dwarf attendants flank the niche. Mahadeva appears to emerge out of the dark of the cave as worshipers' eyes become accustomed to the darkness. This image of Shiva has three faces, which show different aspects of the deity. The central face expresses Shiva's quiet, balanced demeanor. The face's clean planes contrast with the richness of the piled hair encrusted with jewels. The two side faces differ significantly. That on the right is female, with framing hair curls. The left face is a grimacing male with a curling mustache who wears a cobra as an earring. The female (Uma) indicates the creative aspect of Shiva, while the fierce male (Bhairava) represents Shiva's destructive side. Shiva holds these two opposing forces in check, and the central face expresses their balance. The cyclic destruction and creation of the universe, which the side faces also symbolize, is part of Indian notions of time, matched by the cyclic pattern of death and rebirth (samsara) and further symbolized by Shiva as Lord of the Dance (FIG. 6-25).

VISHNU'S TOWER TEMPLE AT DEOGARH Although the Hindus excavated many striking cave temples out of living rock (unquarried stone), temples constructed of stone blocks became more important in Hinduism. As with the caves, the Hindus initially built rather small and simple temples but with a fully developed iconography. The Vishnu Temple at Deogarh (FIG. **6-19**) in north central India, erected in the early sixth century, is among the first Hindu temples constructed with stone blocks. (The Hindus built temples in wood, thatch, and mud earlier and continued to do so even after the introduction of stone masonry.) A simple square

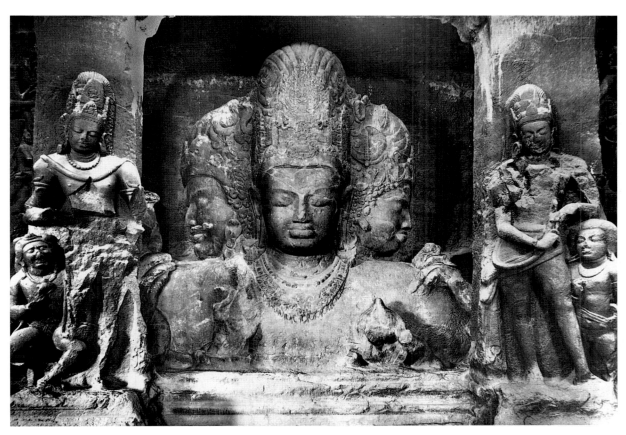

6-18 Shiva as Mahadeva in rock-cut temple, Elephanta, India, sixth century. Shiva 17′ high.

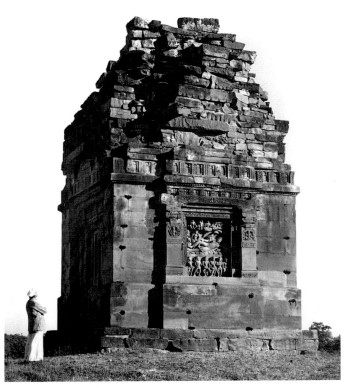

6-19 Vishnu Temple (side view), Deogarh, India, early sixth century.

building on a *plinth* (base) of earth, it has an elaborately decorated doorway at the front and a relief in a niche on each of the other three sides. A small shrine once stood at each corner of the plinth. The temple culminates in a tower (poorly preserved). Inside is a single now-empty room.

Many of the standard elements of later Hindu temple design already appear in the Deogarh temple. Decoration emphasizes the doorway and niches. Much like the guardian figures flanking the niche at Elephanta, sculpted guardians protect both the doorway and the niches at Deogarh, because these are transition areas between the sacred interior and the dangerous outside. Hindus believe Vishnu manifests himself in doorways and niches such as those on the Deogarh temple. That is, he takes a visible form for the benefit of worshipers in a setting accessible to many at once, unlike the small garbha griha or inner sanctuary, where only a small group of priests attends the deity. In much the same way, the three-headed Shiva at Elephanta can be understood as the god manifesting himself in the niche, emerging out of the very mountain where the Elephanta cave was carved. These manifestation places are areas of transition for worshipers and the deity to meet.

THE HINDU TEMPLE AS MOUNTAIN The earliest Hindu temples, such as the Vishnu Temple at Deogarh, usually featured towers. Over time, as temple plans became more complex, the builders constructed higher, more elaborate towers. The towers played an important symbolic role in

6-20 Lingaraja Temple, Bhuvanesvar, India, ca. eleventh to twelfth century.

Linga) at Bhuvanesvar (FIG. **6-20**) in northeastern India dates from the eleventh to twelfth century. The tallest tower here rises some two hundred feet, although the construction method simply overlaps masonry courses. Relief forms replicating the tower's general shape, but in miniature, decorate the structure's spire in numerous repetitions. Carved lions support the crowning member at the top. Various porches and halls lead from the eastern entrance to the temple's inner sanctuary. A multitude of subsidiary shrines surrounds the structure.

The Visvanatha Temple at Khajuraho (FIGS. **6-21** and **6-22**) in northern India is one of more than twenty large and elaborate temples at that site. Visvanatha is another of the many names for Shiva and means "Lord of the Universe." Erected ca. 1000 and dedicated in 1002 by kings of the Chandella dynasty, the temple structure has four towers of different heights, each rising higher than the preceding one with the tallest tower at the rear, in much the same way the foothills of the Himalayas rise to meet their highest peak.

The mountain symbolism applies to interior temple design at Khajuraho as well. As at Bhuvanesvar, porches and *mandapas* (pillared halls; FIG. 6-22) were added to the simple sanctuary of earlier temples. Steps lead to a small open porch that connects to the first of two mandapas that stand in front of the garbha griha. Aligned in a row, each of the four components (porch, each mandapa, and the garbha griha) supports its own tower. At the back, under the tallest of the exterior towers, the usually small and dark inner sanctuary chamber, like a cave, houses the most important manifestation or form of the deity. Thus, temples such as the Visvanatha symbolize constructed mountains with caves, comparable to the actual

the design of Hindu temples. Hindus thought of the temple tower as a mountain peak and of the temple's garbha griha as the cavelike space within the mountain that serves as the deity's home. The highly complex Lingaraja Temple (Royal

6-21 Visvanatha Temple, Khajuraho, India, ca. 1000.

6-22 Plan of Visvanatha Temple, Khajuraho, India, ca. 1000.

cave temples at Elephanta and other Indian sites. In both cases, the god lives within the cave and takes various forms, manifested in sculpture for worshipers. In Hindu temples constructed of stone blocks (rather than rock cut) joined without mortar, the exterior reliefs are the focus of worship. As in Greek temples (see Chapter 5), the interiors of Indian temples are usually too small and cramped for congregational worship.

REGIONAL STYLES IN TEMPLE DESIGN The mountain and cave symbolism is not overt in the early Deogarh Temple (FIG. 6-19), but it has the door decoration, exterior niche reliefs, garbha griha, and tower. Thus, the Deogarh tower, although badly damaged, is an early example of the northern Indian type characterizing the large and highly complex temples at Bhuvanesvar and Khajuraho. The northern Indian towers have a beehive shape with compressed stories topped by a large flat disk with ribbed edges (amalaka).

As with sculptural styles, architectural styles in India vary from region to region. Although the arrangement of a tower over a garbha griha entered through a series of pillared halls and porches is standard, the floor plans, sizes, and ornamentation of these units vary greatly. For example, a high wall surrounds the Lingaraja Temple at Bhuvanesvar (FIG. 6-20), while the Visvanatha Temple at Khajuraho (FIGS. 6-21 and 6-22), like other temples the Chandella kings built, sits on a high plinth. These two distinct treatments separate sacred temples from secular space. In addition, the Lingaraja interior is plain, while relief carvings fill the Visvanatha Temple interior.

SEXUAL IMAGERY AT KHAJURAHO The profusion of carving on the interiors of the Khajuraho temples matches that found on their exteriors (FIG. **6-23**). Ornamental designs cover large areas of the exteriors, while figural reliefs decorate other parts. Scholars can identify few of the figures, numbering in the hundreds, by name, although some are clearly deities such as Shiva, Ganesha, and Vishnu. Most appear human. Pairs of men and women depicted in these reliefs often embrace and sometimes engage in other more

6-23 Sculptures on temple wall, Visvanatha Temple, Khajuraho, India, ca. 1000.

overtly sexual behaviors. The use of amorous couples as a decorative motif, indicating spiritual favor and prosperity, goes back in India to the earliest architectural traditions, both Hindu and Buddhist (FIG. 6-11). Sexuality is a common element in Indian religious symbolism. The mostly nude female under the tree on the eastern gateway at Sanchi (FIG. 6-8) indicates this trait characterized Indian art for centuries.

One explanation appearing to fit some of the sexually explicit images at Khajuraho relates to Tantric practices, rituals that include highly controlled sexual exercises as means to gain spiritual power. Chandella court members practiced Tantric Hinduism, but such an explanation cannot account for all of the images. Despite scholars' ongoing efforts, no one yet fully understands the meaning of the explicit sexual imagery at Khajuraho.

TEMPLES CARVED OUT OF HUGE BOULDERS

In addition to cave temples and masonry temples, Indian architects created a third type of monument—temples carved out of rocky outcroppings (*rathas,* from a word meaning "chariot"), although few examples exist. Rather than excavate a cave, which has an entrance facade but no human-cut exterior structure (FIG. 6-10), Indian architects carved the entire rock, including the temple's exterior. Kings of the Pallava dynasty constructed several such monolithic temples (FIG. **6-24**)

at Mahabalipuram, south of Madras on the Bay of Bengal. Sculpted out of granite boulders that jut out from the sand, they date to the seventh century. The largest of the rathas illustrated (in the foreground), dedicated to Shiva, boasts the typical southern-Indian-style tower resembling a stepped pyramid. The tower ascends in pronounced tiers of cornices decorated with miniature shrines. The lower walls include carved columns and figures of deities inside niches. The ratha to its right, dedicated to Vishnu, has a rectangular plan and a rounded roof, while the next ratha is a smaller example of the southern Indian type. At the end of the row sits a very small temple modeled on a thatched hut and dedicated to Durga, a fierce form of the Goddess. The two largest temples remain unfinished, perhaps because the architect felt that cutting away any more of the rock would collapse the structures under the weight of the stone on top.

SHIVA, LORD OF THE DANCE

In southern India, particularly under the Chola dynasty, which rose to power in 846, artists cast portable representations of deities in solid bronze, some of them large and very heavy. An example of these portable statues (FIG. **6-25**; the holes on the base held poles for carrying the image) represents Shiva performing one of his many cosmic dances. (In another dance described earlier, depicted in the stone relief at Badami, FIG. 6-17, Shiva dances to impress and seduce his wife Parvati.) Here, the

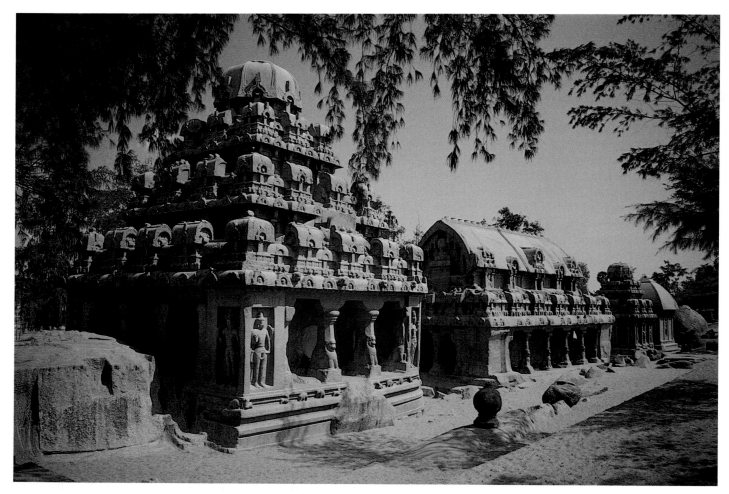

6-24 Rock-cut temples, Mahabalipuram, India, seventh century.

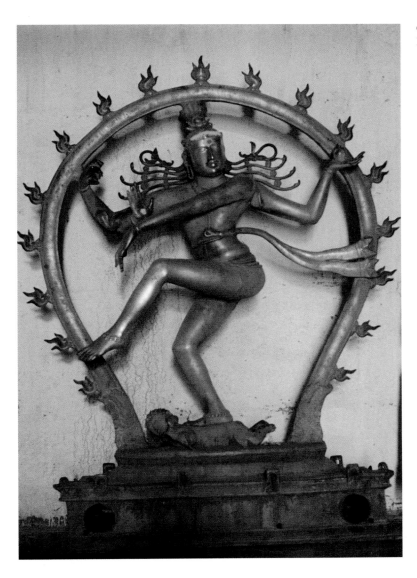

6-25 Shiva as Nataraja, bronze in the Naltunai Isvaram Temple, Punjai, India, ca. 1000.

bronze Shiva dances as Nataraja (Lord of the Dance) by spinning on one leg atop a dwarf representing ignorance, which Shiva stamps out as he dances. Shiva extends all four arms, two of them touching the flaming *nimbus* (light of glory) encircling him. These two upper hands also hold a small drum (at right) and a flame (at left). Shiva creates the universe to the drumbeat's rhythm, while the small fire represents destruction. His lower left hand points to his upraised foot, indicating the foot as the place where devotees can find refuge and enlightenment. Shiva's lower right hand, raised in the fear-not gesture, tells worshipers to come forward without fear. As Shiva spins, his matted hair comes loose and spreads like a fan on both sides of his head.

The Chola dynasty ended in the thirteenth century, a time of political, religious, and cultural change in India. At this point, Buddhism survived in only some areas of India. It soon died out completely there, although the late form of northern Indian Buddhism continued in Tibet and Nepal. At the same time, Islam, present in India as early as the ninth century, spread rapidly over northern India (see Chapter 13). Hindu and Islamic art assumed preeminent roles in India after the thirteenth century (see Chapter 25).

SOUTHEAST ASIA

Southeast Asia is an enormous geographic region of great cultural, ethnic, and linguistic diversity. It includes the modern nations of Myanmar (Burma), Thailand, Laos, Cambodia, Vietnam, Malaysia, and Indonesia, as well as the prosperous city-state of Singapore. For many years, scholars considered the area merely an extension of Indian and Chinese civilizations. Today, however, they recognize Southeast Asian art as one of the most important of the world's artistic traditions.

Sri Lanka

THE EARLY SPREAD OF BUDDHISM Sri Lanka (formerly Ceylon) is an island located at the very tip of the Indian subcontinent. Its pertinence in a discussion of Southeast Asian art stems from its role as a fountainhead of Southeast Asian Theravada Buddhism. Theravada Buddhism, the oldest form of Buddhism, stressing worship of the historical Buddha, began to dominate Burma, Thailand, Laos, and Cambodia in about the thirteenth century. Buddhism arrived in Sri Lanka

Indianization

Visitors to Borobudur in Indonesia (FIG. 6-27) and Angkor Wat in Cambodia (FIG. 6-31) immediately recognize the imagery of Indian art at those sites. In an effort to explain the Indian character of such Southeast Asian monuments, scholars of earlier generations hypothesized that Indian artists constructed and decorated Borobudur and Angkor, indicating colonization of Southeast Asia by Indians. Today, researchers have concluded that such colonization did not occur. In fact, they believe India never dominated these areas of Southeast Asia politically and did not even send military expeditions to them. The cultural transfer during the first millennium A.D. was peaceful and nonimperialistic. It appears to have developed almost as a by-product of trade.

In the early centuries A.D., extensive trade took place among Rome, India, and China, their ships passing Southeast Asia on the monsoon winds. The tribal chieftains of Southeast Asia quickly saw an opportunity to participate, mainly with their own forest products, such as aromatic woods, bird feathers, and spices. Accompanying trade from India were the already complex religions of Buddhism and Hinduism, a written language (Sanskrit), law texts, and images of the gods. The Southeast Asian chiefs initially used the transferred elements as a sort of "cultural vocabulary" to compete with one another and to participate in an Indian world. But the Southeast Asian peoples soon modified the Indian cultural material, including the art, to make it their own, and with astounding results.

as early as the Maurya period (third century B.C.). With the demise of Buddhism in India in about the thirteenth century, Sri Lanka now has the longest-lived Buddhist tradition in the world. The island, however, also has its own rich artistic tradition, one constantly in contact with that of India.

The recumbent stone Buddha image at Gal Vihara near Polonnaruwa (FIG. **6-26**) measures forty-six feet long and serves as an example of the monumental "sleeping Buddhas" popular in Southeast Asia. Although such reclining Buddha images can be interpreted as representing the Buddha's death *(parinirvana)*, worshipers who adhere to Theravadin tradition

tend to interpret them as depictions of the Buddha in meditation while lying down.

Java

Both Hinduism and Buddhism came to Southeast Asia from India (see "Indianization," above). This situation differs from that in China, Korea, and Japan, where only the Buddhist tradition was of any importance in their ancient history (see Chapters 7 and 8). On the island of Java, part of the modern nation of Indonesia, the period from the eighth to the

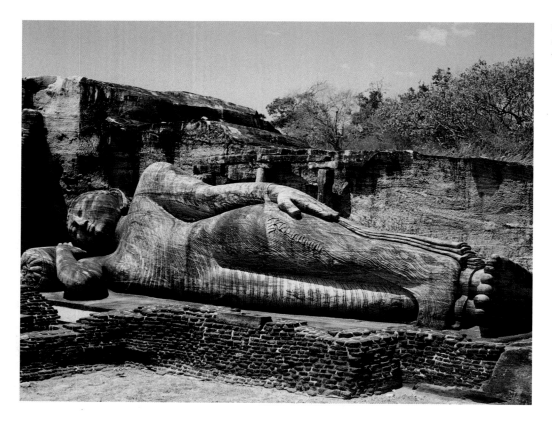

6-26 Buddha, Gal Vihara, Sri Lanka, eleventh to twelfth century. Stone, whole figure 46' long.

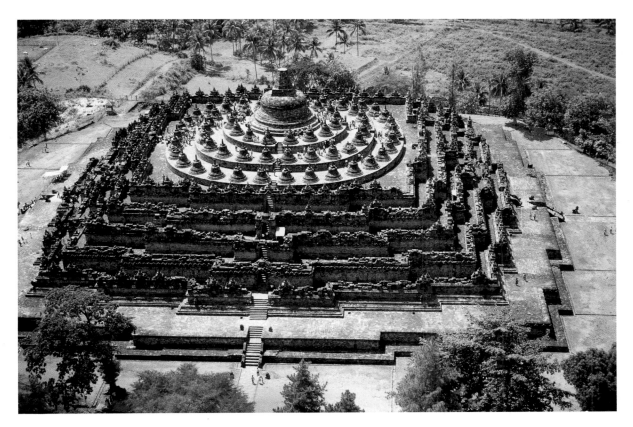

6-27 Stupa, Borobudur, Java, Indonesia, ca. 800.

tenth centuries witnessed the erection of both Hindu and Buddhist monuments. Borobudur (FIGS. **6-27** and **6-28**), a Buddhist monument unique in both form and meaning, is one of the most impressive. Its relationships to Indian art, texts, and Buddhism are clear, yet nothing comparable exists in India.

BUDDHISM ON A COSMIC MOUNTAIN Borobudur is a cosmic mountain on earth, decorated with stupas, Buddha images, and hundreds of relief carvings. Built over a small hill in steps or terraces accessed by four directional stairways, the structure contains literally millions of blocks of volcanic stone. At some point during its construction, the heavy stones caused part of the hill to collapse, requiring the builders to shore up the original foundation with an enormous wall of stone serving as a wide platform. Four square terraces and three circular ones lead to a closed stupa at the top. A *parapet* (wall) flanking each square terrace permits worshipers walking on the terrace to see only the sky. The parapet also prevents people below from seeing those above on higher terraces. Relief carvings cover both the parapet side and the monument side of the path used by worshipers. The architect positioned seventy-two hollow and perforated stupas along the three top circular terraces, each stupa containing a life-size stone image of the Buddha performing the Wheel-turning gesture (FIG. 6-28). Other Buddha images in niches facing out along the top of each parapet perform various other hand gestures.

Extremely large, Borobudur measures about four hundred feet per side at the base and about ninety-eight feet tall. More than five hundred life-size Buddha images, at least a thousand relief panels, and some fifteen hundred stupas of various sizes decorate the massive monument. Worshipers circumambulated the monument, beginning on the lowest terrace and moving

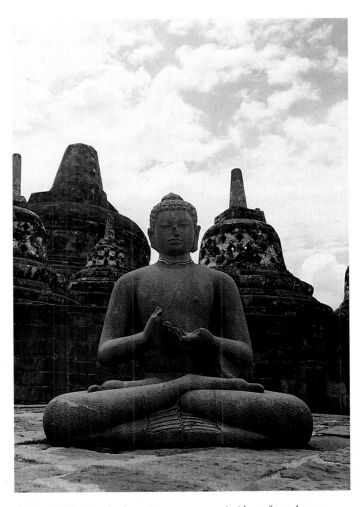

6-28 Buddha in Wheel-turning gesture, once inside perforated stupa, upper circular terrace, Great Stupa, Borobudur, Java, Indonesia, ninth century.

up, terrace by terrace, toward the central stupa at the top. They visually encountered the Buddha and his teachings in the form of numerous images and extensive relief carvings as they progressed. The complex organization of the images and the topics of the reliefs indicate the builder intended worshipers to progress through ever more advanced stages of understanding.

Although scholars cannot give a simple interpretation to such a magnificent conception, they continue to work to unravel the monument's significance. The construction date of about A.D. 800 makes this, in terms of Indian influence, an early monument. Borobudur's sophistication, complexity, and originality, however, underline how completely Southeast Asians absorbed, rethought, and reformulated Indian-related religion and art.

Cambodia

In 802, at about the same time the Javanese built Borobudur, the Khmer King Jayavarman II (r. 802–850) founded the Angkor dynasty, which ruled Cambodia for the next four hundred years and sponsored the construction of hundreds of monuments. For at least two hundred years before the founding of Angkor, the Khmer (the predominant ethnic group in Cambodia) produced Indian-related sculpture of exceptional quality. Images of Vishnu were particularly important during the pre-Angkorian period.

A HALF-VISHNU, HALF-SHIVA STATUE The Harihara from Prasat Andet (FIG. **6-29**) shows Vishnu in his manifestation as half Shiva and half Vishnu (the meaning of *harihara*). The division is vertical, the left side (facing the image) Shiva and the right side Vishnu. The miter-shaped headgear reflects the division most clearly. The Shiva half, embellished with the winding ascetic's locks, contrasts with the kingly Vishnu's plain miter. The halves originally also were distinguished by the now-lost attributes held in the four hands, but otherwise the artist barely differentiated the sides.

The sculpture's broken arms and ankles indicate the vulnerability of a more-than-life-size stone image carved in the round. Unlike almost all stone sculpture in India, carved in relief on slabs or steles, Khmer artists chose to carve their images in the round, placing weight on the ankles and arms extended into space. The Khmer sculptors intended viewers to see their statues from all sides in the statues' positions at the center of the garbha grihas of brick temples.

ANGKORIAN TEMPLE MOUNTAINS The Khmer kings worked for more than four centuries on the construction of the site of Angkor in Cambodia. These kings of the Angkor dynasty built temples of brick, but they also used stone to produce enormous monuments, including Angkor Wat (FIGS. **6-30** and 6-31) and the nearby Bayon (FIGS. 6-34 and 6-35). The temples at Angkor include two major types—temple mountains and temples dedicated to an individual Khmer king's ancestors. The temple mountains, with the major deity residing in the top central shrine, were reserved for worship by the King and the elite. Angkor Wat and the Bayon are both temple mountains, monuments whose purpose was to associate the king with his personal de-

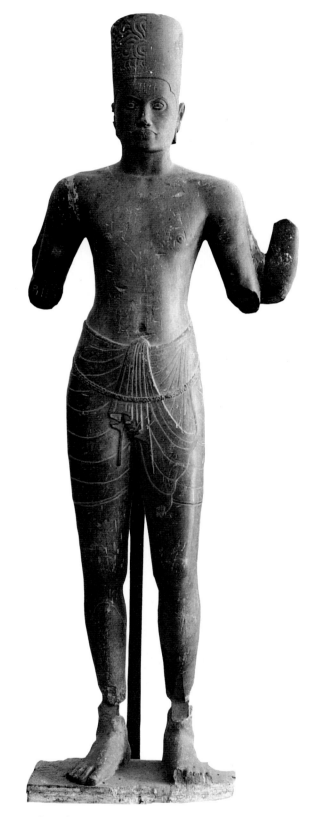

6-29 Harihara, from Prasat Andet, Cambodia, seventh century. Stone, 6′ 3″ high. National Museum, Phnom Penh.

ity (see "Khmer Kingship," page 183). These two temples, however, are unusual in the context of the Angkor kingly tradition, as the kings dedicated Angkor Wat to Vishnu and the Bayon to the Buddha. For hundreds of years before the construction of these two temples, the Khmer kings associated themselves with aspects of Shiva.

Khmer Kingship

The kings of Angkor were exceedingly powerful, and almost all of the art and architecture surviving at Angkor Wat from hundreds of years of building at the site attest to that fact. The Angkor kings not only displayed their power through lofty monuments, elaborate art programs, and ritual splendor, but they also used the monuments and art to generate power initially. Each king built a temple mountain and installed his personal god—Shiva, Vishnu, or the Buddha—on top. He named the image/god with part of his own royal name, implying that the king was a part or portion of the god. When the king died, the Khmer believed the god reabsorbed him, because he had been the earthly portion of the god during his lifetime, so they worshiped the king's image posthumously as the god. This concept of the king approaches an actual deification of the human ruler, familiar in many other societies, such as ancient Egypt (see Chapter 3).

At the end of the thirteenth century, a Chinese official, Zhou Daguan, visited Angkor and recorded what he saw. He described the spectacle when the Khmer king left his palace in Angkor Thom (see plan of Angkor, FIG. 6-30). The entourage began with "young girls of the palace, three to five hundred in number, who wear floral material and flowers in their hair and hold candles in their hands . . . ; even in broad daylight their candles are lit. Then come girls of the palace carrying gold and silver utensils and a whole series of ornaments." After many other groups—including ministers, princes, concubines, wives, and guards—the king came, "standing on an elephant and holding the precious sword in his hand. The tusks of the elephant are sheathed in gold. There are more than twenty white parasols flecked with gold, with handles of gold. . . . Those who see the king must prostrate themselves and touch the ground in front of them."[1] The Khmer king surrounded himself at all times with symbols of his power and glory, placing himself godlike as separate from his people, using displays of art, wealth, and splendor.

[1] G. Coedes, *The Indianized States of Southeast Asia* (Honolulu: East-West Center, 1968), 216.

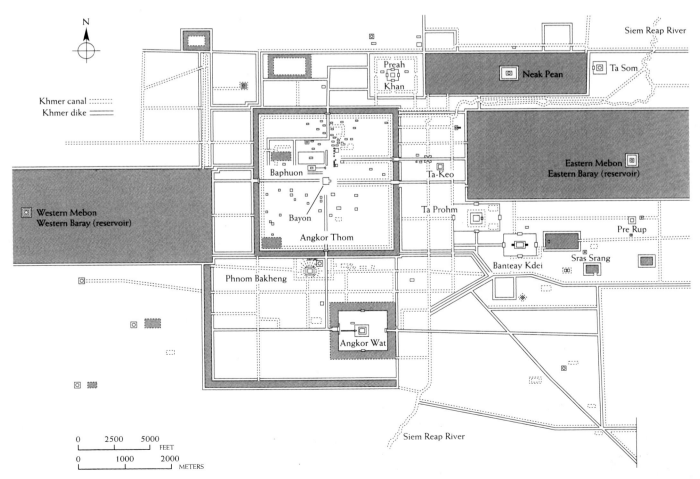

6-30 Overall plan of Angkor site, Cambodia, during the twelfth and thirteenth centuries.

6-31 Angkor Wat, Angkor, Cambodia, twelfth century.

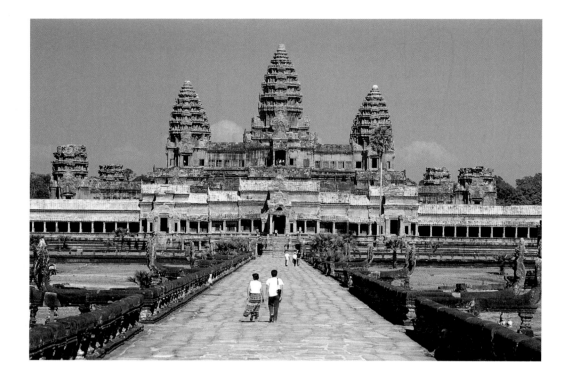

The plan of Angkor (FIG. 6-30) shows the location of Angkor Wat and the Bayon. Angkor Wat, constructed to the south of most of the buildings at Angkor, consists of a temple positioned at the center of a huge rectangle of land delineated by a moat measuring about four thousand nine hundred twenty by four thousand two hundred sixty feet. The Bayon is at the center of another much larger moated and walled area called Angkor Thom in the heart of Angkor. The Khmer kings also built several enormous reservoirs (*barays*) at the site. Scholars continue to debate the use and purpose of the extensive hydraulics at Angkor, but religious and cosmological meanings clearly played a significant role.

A KHMER ROYAL PORTRAIT Suryavarman II (r. 1113–1150) built Angkor Wat (FIGS. **6-31** and **6-32**), which rises, like other temple mountains, in pyramid-like steps,

each level punctuated by tower shrines connected with covered galleries. On the inner wall of the lowest gallery, reliefs depict the king holding court (FIG. 6-32). Suryavarman II sits on an elaborate wooden throne, its bronze legs rising as cobra heads (*nagas*). Kneeling retainers surround the king, holding a forest of umbrellas and fans as emblems of his rank.

A BRONZE VISHNU ON AN ISLAND Khmer craftspeople were masters of bronze casting. The bronze fragment portraying Vishnu lying on the cosmic ocean (FIG. **6-33**), recovered from the Mebon temple on an island in the Western Baray (FIG. 6-30), is more than eight feet long. In complete form, at well over twenty feet long, it was among the largest bronzes of antiquity. Originally, gold and silver inlays and jewels embellished the image, and it wore a separate miter on

6-32 King Suryavarman II holding court, lowest gallery, south side, Angkor Wat, Angkor, Cambodia, twelfth century. Stone.

6-33 Vishnu lying on the cosmic ocean, from Mebon temple on island in Western Baray, Angkor, Cambodia, eleventh century. Bronze, 8' long.

its head. The sleeping Vishnu reproduces the myth of the creation of the universe. The story tells of Vishnu lying on the cosmic ocean, usually represented by a snake but here also literally indicated by the waters of Western Mebon. In the myth, a lotus stem grows from Vishnu's navel, its flower supporting Brahma, the creator god. It appears the bronze Vishnu had a waterspout emerging from his navel, indicating his ability not only to protect the earth and create Brahma and Shiva but also to create the waters.

THE BAYON'S GIANT FACES Jayavarman VII (r. 1181–1219) ruled over much of mainland Southeast Asia and built more during his reign than all of the Khmer kings preceding him in four hundred years. His most important temple, the Bayon, is a complicated and still enigmatic monument constructed with unique circular terraces surmounted by towers carved with huge faces (FIGS. 6-34 and 6-35). Jayavarman

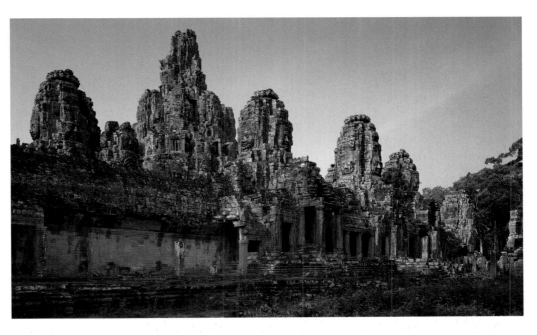

6-34 Tower of the Bayon, Angkor Thom, Cambodia, twelfth to thirteenth century.

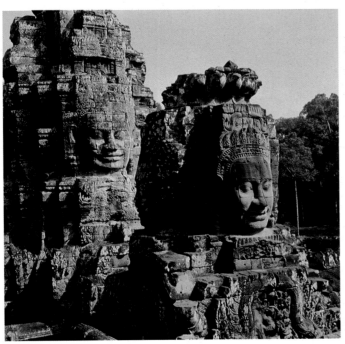

turned to Buddhism from the Hinduism the earlier Khmer rulers embraced. The faces on the Bayon towers perhaps portray a bodhisattva, intended to indicate the watchful compassion emanating in all directions from the capital. Other researchers have proposed that the faces depict Jayavarman or various other deities. Jayavarman's great experiment in religion and art was short lived, but it also marked the point of change in Southeast Asia when Theravada Buddhism began to dominate most of the mainland. Chapter 25 chronicles this important development.

During the first to fourth centuries A.D., Buddhism also traveled to other parts of Asia—to China, Korea, and Japan. Although the artistic traditions in these countries differ greatly from one another, they share, along with the Southeast Asian countries, a tradition of Buddhist art and an ultimate tie with India. Chapters 7 and 8 trace the changes Buddhist art underwent in East Asia, along with the region's other rich artistic traditions.

6-35 Tower of the Bayon, Angkor Thom, Cambodia, twelfth to thirteenth century.

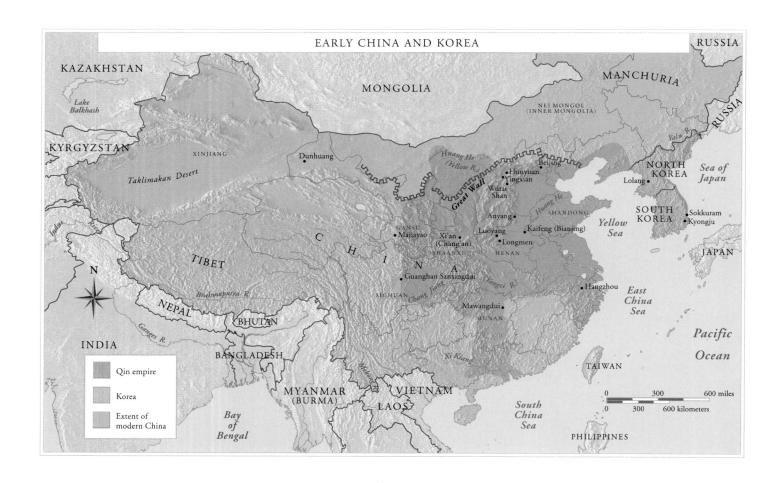

EARLY CHINA AND KOREA

Qin empire

Korea

Extent of modern China

	3000 B.C.		1500 B.C.	1050 B.C.		400 B.C.	221 B.C.	206 B.C.		A.D. 220	589
CHINA	NEOLITHIC		SHANG	ZHOU*			QIN	HAN		PERIOD OF DISUNITY†	
KOREA	POTTERY-PRODUCING CULTURES							THREE KINGDOMS			

Majiayao vases
3000–2500 B.C.

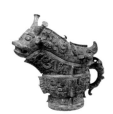

Gong, twelfth
or eleventh century B.C.

Bi (disk)
fourth–third century B.C.

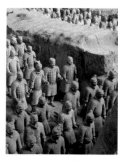

Army of Shi Huangdi
Shaanxi Province, China
ca. 210 B.C.

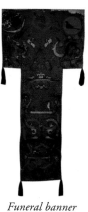

Funeral banner
ca. 168 B.C.

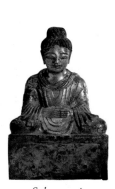

Sakyamuni
Buddha, 338

First evidence of Chinese script, ca. 1400–1200 B.C.

Life of Confucius, ca. 551–479 B.C.

First coins, ca. 500 B.C.

China establishes outposts in
northern Korea, 108 B.C.

Invention of paper, ca. 100 B.C.–100 A.D.

First written evidence of Buddhist
images in China, 193

Buddhism arrives in Korea, 372

Growth of Pure Land sects, 400–500

Xie He, "Six Laws" of painting, ca. 500

* The Warring States period (475–221 B.C.) occurred during this time span also.

† Various short-lived or regional dynasties also developed within the periods
indicated here for major dynasties; mentioned in the text are the Xin, Jin, Zhau,
and Liao, as well as the Northern Wei.

7

DAOISM, CONFUCIANISM, AND BUDDHISM

THE ART OF EARLY CHINA AND KOREA

581		618	688		907	918		960	1000		1127
SUI		TANG				FIVE DYNASTIES		NORTHERN SONG			SOUTHERN SONG
			GREAT SILLA (TO 935)				KORYO PERIOD				

Golden crown
Korea, fifth–sixth century

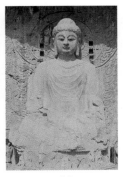

Vairocana Buddha, Longmen
Caves, Luoyang
China ca. 670–680

Sakyamuni Buddha
Sokkuram, Korea, eighth century

Maebyong vase
Korea, ca. 918–1000

Fan Kuan, Travelers among
Mountains and Streams
early eleventh century

Meiping vase
thirteenth century

Earliest cave at Dunhuang, 538–953

Daoist canon distributed by imperial order, 749

Beginnings of woodblock printing, ca. 750

Temporary persecution of Buddhism, 845–847

The new Koryo kingdom founded, 918

Chan Buddhism begins to
flourish, ca. 1200

Mongols invade
Korea, 1231

The Koryo state
ends, 1392

CHINA

A VAST AND ANCIENT LAND China has the unique distinction as the only continuing civilization originating in the ancient world. Vast and varied both topographically and climatically, China's landscape includes sandy plains, mighty rivers, towering mountains, and fertile farmlands. Northern China has a dry and moderate-to-cold climate, whereas southern China is moist and tropical. The nation is also ethnically diverse. Over the centuries, the Chinese took control of areas inhabited originally by non-Chinese people, including Tibetans, the Turkic peoples of Xinjiang (formerly Chinese Turkestan), the Mongols (of Inner Mongolia), the Manchus (of Manchuria), and the Koreans (north of the Yalu River).

China's spoken language varies so much that speakers of its various dialects do not understand one another. However, the written language long has been widely intelligible, permitting people thousands of miles apart to share literary, philosophic, and religious traditions. Distinct regional art styles appeared in China, flourishing especially in the early eras and during times of political fragmentation, but a broad cultural unity also permitted an easy flow of artistic forms and ideas throughout China.

Neolithic China

BORN ON THE YELLOW RIVER China traces its beginnings to the basin of the Huang He, the Yellow River. In this respect, Chinese civilization resembles other great civilizations that developed in areas adjacent to major rivers — the Tigris and Euphrates in Mesopotamia, the Nile in Egypt, and the Indus and Ganges in India (see Chapters 2, 3, and 6). The Chinese archeological record, extraordinarily rich, goes back to Neolithic settlements of around 5000 B.C. New discoveries in recent years have expanded the early record enormously. Archeologists have discovered thousands of Neolithic and later sites and have excavated hundreds of them. Their investigations have revealed a complex aggregation of cultures that, despite a limited technology, produced impressive artworks, especially from jade and clay.

CHINA'S EARLY MASTER POTTERS Even before the invention of the potter's wheel in the fourth millennium B.C., Chinese artists produced high-quality ceramic wares in great variety. Metal had not yet been discovered, and the domestication of animals was in a rudimentary stage, yet the mastery of potter's clay was astonishingly sophisticated in China. The Yangshao culture, among many situated along the

7-1 Neolithic vases, Majiayao culture, from Gansu Province, China, 3000–2500 B.C. Earthenware.

Chinese Earthenwares and Stonewares

China has no rival in the combined length and richness of its ceramic history. Beginning with the makers of the earliest pots in prehistoric villages, ancient Chinese potters showed a flair for shaping carefully prepared and kneaded clay into diverse, often dramatic and elegant vessel forms. Chinese artists continue to produce many of these forms today, inspiring potters around the world.

Until Chinese potters developed true *porcelains* (extremely fine, hard white ceramics; see Chapter 26) in about A.D. 1300, they produced only two types of clay vessels or objects—earthenwares and stonewares. For both types, potters used clays colored by mineral impurities, especially iron compounds ranging from yellow to dark reddish brown.

The clay bodies of *earthenwares* (FIG. 7-1), fired at low temperatures in open pits or simple kilns, remain soft and porous or only partially fused, thus allowing liquids to seep through. Chinese artists also used the low-fire technique to produce terracotta sculptures, even life-size figures of humans and animals (FIG. 7-5). Over time, Chinese potters developed kilns allowing them to fire their clay vessels at much higher temperatures—more than two thousand degrees Fahrenheit. Such temperatures produce *stonewares,* named for their stone-like hardness and density.

Potters in China excelled at the various techniques commonly used to decorate earthenwares and stonewares. Most of these decorative methods depend on changes occurring in the kiln to chemical compounds found in the clay as natural impurities or added to its surface by the artist (see "Greek Vase Painting," Chapter 5, page 104). When fired, many compounds change color dramatically, depending on the conditions in the kiln. For example, if little oxygen remains in a hot kiln, iron oxide (rust) turns either gray or black, while an abundance of oxygen produces a reddish hue.

Potters also can decorate vessels simply by painting their surfaces with ground minerals, such as iron oxides, suspended in water. In one of the oldest decorative techniques, however, potters apply slip (a mixture of clay and water like a fine, thin mud)—by painting, pouring, or dipping—to a clay body not yet fully dry. The natural variety of clay colors can produce a broad, if not bright, palette for decorators, as seen in the Neolithic Majiayao vessels (FIG. 7-1). But potters often also add compounds such as iron oxide to the slip to change or intensify the colors. After vessels have partially dried, potters might incise shapes and lines through the slip down to the clay body to produce designs such as those often seen in later Chinese stonewares (FIG. 7-26).

The slip technique compares with that used by Archaic Greek black-figure painters (see FIGS. 5-4, 5-18, and 5-19). Chinese artists sometimes inlaid designs, too, carving them into plain vessel surfaces and then filling them with slip or soft clay of a contrasting color. Such techniques spread throughout eastern Asia (FIG. 7-29).

To produce a hard, glassy surface after firing, potters coated plain or decorated vessels with a glaze, a finely ground mixture of minerals. Clear or highly translucent glazes best reveal decorated surfaces, while more opaque, richly colored glazes (FIG. 7-18) serve as primary decoration.

Yellow River's middle and upper reaches, was especially prolific in fine *earthenware* pottery (see "Chinese Earthenwares and Stonewares," above) for many centuries. In the third millennium B.C., the potters of Majiayao, in Gansu Province, produced particularly striking vessels (FIG. 7-1) whose sides swell outward into robust forms with smoothly rounded contours. Decoration in red and brown on a cream-colored ground in a variety of geometric motifs—stripes, spirals, zigzags, and netlike patterns—complements their harmonious proportions. The multiplicity of forms suggests the vessels served a wide variety of functions and attests to the diversified needs of this industrious Neolithic community.

Shang Dynasty (ca. 1500–1050 B.C.)

Traditional Chinese histories trace the origins of China deep into the mythological past. However, until about 221 B.C., many smaller states, even in China's central regions, divided its territory. The earliest traditional dynasty confirmed by archeology is the Shang (ca. 1500–1050 B.C.), whose kings ruled from a series of royal capitals in the Yellow River valley and vied for power and territory with the rulers of neighboring states.

ROYAL BURIALS AT ANYANG In 1928, excavations at Anyang in northern China brought to light not only one of the last Shang capitals but also evidence of the dynasty's earlier development. Findings revealed a warlike, highly stratified society. Walls of pounded earth protected Shang cities. Servants, captives, and even teams of chariateers with chariots and horses accompanied Shang kings to their tombs, a practice noted earlier with regard to the Royal Cemetery at Ur (see Chapter 2). The excavated tomb furnishings include weapons and a great wealth of objects in jade, ivory, lacquer, gold, silver, and bronze. Archeologists also discovered numerous inscribed bones and turtle shells once used for divination. The diviners sought answers to inquiries about many topics, including military strategy, royal tours of inspection, aid from ancestors, childbirth, and the meaning of dreams. The script on these objects was basically pictographic but sufficiently developed to express abstract ideas. These fragmentary records have provided information about Shang kings and their affairs.

SHANG BRONZE-CASTING Shang dynasty artists perfected the casting of elaborate bronze vessels in piece molds. Many of these vessels served as containers for ritual offerings in divination ceremonies. The Shang bronzeworkers began the process by producing a solid clay model of the desired object and allowing it to dry to durable hardness. Then they pressed damp clay around it to form a mold that hardened but remained somewhat flexible. At that point, they carefully cut the mold in pieces and removed the mold from the model. Next, the artists shaved the model to reduce its size to form a core for the piece mold. They then reassembled the mold around the model using bronze spacers to preserve a space between the model and the mold—a space equivalent to the layer of wax in the lost-wax method (see "Hollow-Casting Life Size Bronze Statues," Chapter 5, page 124). The Shang bronze casters then added a final clay layer on the outside to hold everything together, leaving open ducts for pouring molten bronze into the space between the model and the mold and for gases to escape. Once the mold had cooled, they broke it apart, removed the new bronze vessel, and cleaned and polished it. Shang bronzes show a skill in casting rivaling that of any other ancient civilization and indicating a long developmental period for achieving such mastery. The great numbers of cast-bronze vessels strongly suggest well-organized workshops, but no records provide a clear picture of such matters or of the place the artists held in their society. Bronze-casting may have been a hereditary occupation.

7-2 Gong of animal forms, from Anyang, China, Shang dynasty, twelfth or eleventh century B.C. Bronze, $6\frac{1}{2}$" high. Asian Art Museum of San Francisco, San Francisco (Avery Brundage Collection).

GONGS IN ANIMAL FORMS Shang bronzes held wine, water, grain, or meat for sacrificial rites. Each vessel's shape matched its intended purpose. Motifs of animal forms were major decorative elements for Shang objects, especially bronzes. They ranged from mere suggestions of animal forms emerging out of linear patterns to identifiable representations of specific creatures. Often, distinct motifs stand out against a background of round or squared spirals ending in hooks. Sometimes these motifs also cover the figures. A major motif is an animal divided in half lengthwise, with the two halves spread out on the vessel body in a bilaterally symmetrical design. The head's two halves, meeting in the center, often also can be read as a complete frontal animal mask with partial bodies at both sides. Such design complexity occurs frequently on Shang vessels, with motifs simultaneously suggesting body parts and independent creatures.

One of the most dramatic Shang vessel forms from Anyang is the *gong,* or covered libation vessel. In the particularly intricate decoration of the gong we illustrate (FIG. **7-2**), the multiple designs and their fields of background spirals integrate so closely with the vessel's form that they are not merely an external embellishment but an integral part of the sculptural whole. Some motifs on the vessel's side may represent the eyes of a tiger and the horns of a ram. (On other Shang vessels, the eyes may be those of a sheep and the horns those of a bull, water buffalo, or deer.) A horned animal forms the front of the lid, and at the rear is a horned head with a bird's beak. Another horned head appears on the handle. Fish, birds, elephants, rabbits, and more abstract composite creatures swarm over the surface against a background of spirals. No broad agreement exists as to the meaning of these animal motifs, but they may represent specific religious concepts. For example,

an animal or bird in the mouth of another animal may signify generation. Or the images may reflect the early Chinese attitude toward the powers of nature and the forces ordering the cosmos. Thus, although the functions of Shang vessels have been determined according to the vessels' shapes, the precise meaning and function of the decor remain uncertain.

AN ANCIENT STATUE OF UNPARALLELED SIZE
More recent excavations in other regions of China have greatly expanded historical understanding of this early period. They suggest that, even as Anyang flourished, so did other major centers with distinct aesthetic traditions. For example, in 1986, pits at Guanghan Sanxingdui, in Sichuan Province, yielded objects in gold, bronze, jade, and clay of types never before discovered. The most dramatic find, a bronze statue (FIG. **7-3**) more than eight feet tall, matches anything from Anyang in masterful casting technique. A stylized human figure stands on a thin platform supported by four legs formed of fantastic animal heads with horns and trunklike snouts. These, in turn, rest on a thick, heavy square base. The statue as a whole tapers gently as it rises, and the figure gradually becomes rounder. Just below the neck, great arms branch dramatically outward, ending in oversized hands that once must have encircled another element of the work. Representations of the human figure on this scale in this period are otherwise unknown. A version of Shang surface decoration, with its squared spirals and hook-pointed curves, complements the somewhat abstract rendering of the body and clothing. The figure's facial features suggest a humanized version of the animal mask seen in other bronzes.

7-3 Standing figure, from Guanghan Sanxingdui, China, Shang dynasty, ca. 1200 B.C. Bronze, 8′ 5″ high, including base. China Cultural Relics Promotional Center, Beijing.

Zhou Dynasty (ca. 1050–256 B.C.)

POLITICAL AND ARTISTIC TRANSITION
Around 1050 B.C., the Zhou, whose dynasty endured until 256 B.C., overthrew the Shang kingdom. The very earliest Zhou art is nearly indistinguishable from that of the Shang, and some artists probably worked for both dynasties. Within a generation, however, changes in vessel shapes already had oc-curred, and by the fourth century B.C. Zhou bronzes featured entirely new designs—scenes of hunting, religious rites, and magic practices. These may relate to the subjects and composi-tions of lost paintings mentioned in Zhou literature. Other materials favored in the late Zhou period were jade and *lac-quer,* a varnishlike substance made from the sap of the Asiatic sumac and used to decorate wood and other organic materials (see FIG. 26-4). Zhou artists produced objects in great quantity to satisfy the elaborate demands of ostentatious feudal courts vying with one another in lavish display. Bronzes inlaid with gold and silver were popular, as were mirrors highly polished on one side and decorated with a variety of motifs on the other. The mirrors, distributed widely, have even been found among the treasures discovered in Japanese tombs.

JADE'S BEAUTY AND PRESTIGE The carving of jade jewelry and ritual objects for burial with the dead, beginning in Neolithic times, reached a peak of technical perfection dur-ing the Zhou dynasty. Among the most common finds in tombs of the period are *bi* disks, which may have symbolized the circle of heaven. One example (FIG. **7-4**), carved in nephrite, like other Chinese jades made before the eighteenth century, features stylized dragons. Nephrite polishes to a more lustrous, slightly buttery finish, while jadeite, the stone pre-ferred in later times, is quite glassy. Both stones come in col-ors other than the well-known green and are tough, hard, and heavy, as well as beautiful. In China, such qualities became

metaphors for the fortitude and moral perfection of superior persons. Jade also became such an important symbol of rank that later, in the Han dynasty, some rulers were buried in jade bodysuits. Working jade involves laborious sawing, drilling, grinding, and polishing, rather than carving or chipping. Jade sculpture demanded great skill and patience from Zhou artists working with simple hand tools. The intricate *piercework* (carving extending entirely through objects) on the dragons along the outer edge and on the elegant forms surrounding the disk's center testifies to the Zhou craftsperson's mastery of the material. The Chinese thought dragons flew between heaven and earth and brought rain, so these animals long have been symbols of good fortune in eastern Asia. They also sym-bolized rulers' power to mediate between heaven and earth.

Qin Dynasty (221–206 B.C.)

SHI HUANGDI AND CHINA'S GREAT WALL
From the late Zhou to the founding of the Qin dynasty, China endured more than two centuries of political and social turmoil during what historians have dubbed the Warring States period (475–221 B.C.). The late Zhou dynasty techni-cally ended in 256, when the line of kings completely failed. The Warring States period began when the dynasty lost its power over most of the territory it ruled. Thus, the periods overlap somewhat. This was also a time of intellectual and artistic upheaval, when conflicting schools of philosophy, in-cluding Legalism, Daoism, and Confucianism, emerged (see "Daoism and Confucianism," page 193).

The political chaos of the Zhou dynasty's last few hundred years ceased temporarily when the powerful armies of the ruler of the state of Qin conquered all rival states. Qin's ruler took the name Cheng, but he is known to history primarily by his title, Shi Huangdi, the First Emperor of China, and be-tween 221 and 210 B.C. he controlled an area equal to about half of modern China, far more than any of the Kings before him. During his reign, he ordered the linkage of active fortifi-cations along his realm's northern border to form the famous Great Wall. The wall defended China against the fierce no-madic peoples of the north, especially the Huns, who eventu-ally made their way to eastern Europe. By sometimes brutal methods, Shi Huangdi consolidated rule through a central-ized bureaucracy and adopted a standardized written lan-guage, weights and measures, and coinage. He also repressed schools of thought other than legalism, which had emerged during the Warring States period and espoused absolute obe-dience to the state's authority and advocated strict laws and punishments. Chinese historians long have condemned Shi Huangdi, but the empire he founded set the stage for the greatly admired Han dynasty and all else thereafter.

ARCHEOLOGISTS UNCOVER AN ARMY In 1974, excavations started at the site of the immense burial mound of the First Emperor of Qin in Shaanxi Province. For its con-struction, the ruler conscripted many thousands of laborers and had the tomb filled with treasure—a task that continued after his death. The mound itself remains unexcavated, but pits uncovered around it have revealed an astonishing collec-tion of artifacts, establishing this site as one of the past cen-tury's greatest archeological discoveries. Excavators have found more than six thousand life-size terracotta figures of soldiers and horses (FIG. **7-5**)—and more recently, bronze horses and

7-4 Bi (disk), late Zhou dynasty, fourth to third century B.C. Nephrite, $6\frac{1}{2}$″ in diameter. Nelson-Atkins Museum, Kansas City.

Daoism and Confucianism

Daoism and Confucianism developed during the Warring States period in the fifth through the third centuries B.C., when political turbulence led to social unrest. Daoism and Confucianism embrace both philosophical systems and religions. Religious Daoism, actually rather distinct from its philosophical counterpart, emerged in part out of ancient folk beliefs, and believers adapted many of Buddhism's ritual forms and trappings. These included elaborate ceremonies, brightly colored icons, and lavish temples. Religious Confucianists embraced and developed traditional rites, especially those dedicated to venerating ancestors, great teachers, and heroic leaders. Their practices, too, borrowed from Buddhism, particularly their emphasis on sacred biography, images, and religious ceremonies.

Philosophical Daoism emerged out of the metaphysical teachings attributed to Laozi (604?–531? B.C.) and Zhuangzi (370?–301? B.C.). Daoist philosophy stresses submission to a universal path, or principle, called the Dao, whose features cannot be described but only suggested through analogies. For example, the Dao is said to be like water, always yielding but eventually wearing away the hard stone that does not yield. For Daoists, strength comes from flexibility and nonstruggle. Daoism stresses an intuitive awareness—nurtured by harmonious contact with nature and fellowship with like-minded individuals—over careful reasoning. Historically, Daoist principles encouraged retreat from ordinary society, rather than constructive moral engagement. They emphasized personal development and producing and appreciating personal expressions in poetry and painting.

Confucius (551–479 B.C.) was born in the state of Lu (roughly modern Shandong Province) to an aristocratic family who had fallen on hard times. From an early age, he showed a strong interest in the rites and ceremonies that helped unite people into an orderly society. As he grew older, he developed a deep concern for the suffering the civil conflict of his day caused. Thus, he adopted a philosophy he hoped would lead to order and stability. Confucius stressed empathy for suffering, morality, ceremony, and virtuous social practices based on respect for hierarchical relationships, such as those between parent and child and ruler and subject. He believed that the "superior person, or gentleman," would be a model of such character and behavior.

Confucius spent much of his adult life trying to find rulers willing to apply his teachings, but he died in disappointment. However, he and his follower Mencius (371?–289? B.C.), who helped develop and spread his ideas, had a profound impact upon Chinese thought and social practice. Chinese traditions of venerating deceased ancestors and outstanding leaders encouraged Confucianism's development as a religion as well as a philosophic tradition. Eventually, Emperor Wu Di (r. 140–87 B.C.) of the Han dynasty established Confucianism as the state's official doctrine. Thereafter, it became the primary subject of the civil service exams required for admission into and advancement within government service.

"Confucian" and "Daoist" are broad, imprecise terms scholars often use to distinguish aspects of Chinese culture stressing social responsibility and order (Confucian) from those emphasizing cultivation of individuals, often in reclusion (Daoist). But the two traditions are frequently difficult to separate in art. For example, a landscape painting may seem to depict the ideal places of retreat for Daoists, but its sense of order and structure also may convey Confucian ideals of cosmic order as the model for humanity.

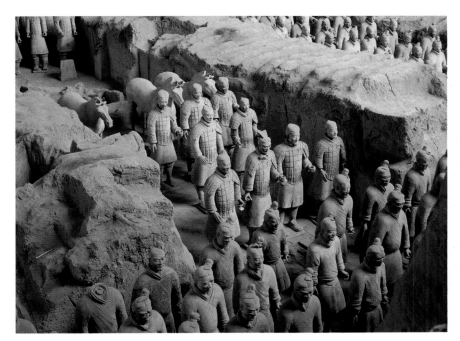

7-5 Army of Emperor Shi Huangdi in pits next to burial mound, Shaanxi Province, China, Qin dynasty, ca. 210 B.C. Painted terracotta, average figure 5′ 10$\frac{7}{8}$″ high.

Silk and the Silk Road

Silk is the finest natural fabric ever produced. It comes from the cocoons of caterpillars called silkworms, raised in China since the third millennium B.C., and the basic procedures probably have not changed much in five thousand years. Farmers today still raise silkworms from eggs, which they place in trays kept in rooms with carefully controlled temperature and humidity levels. The farmers also must grow mulberry trees or purchase the leaves, the silkworms' only food source. Eventually, the silkworms form cocoons out of very fine filaments they extrude as liquids from their bodies. The filaments soon solidify with exposure to air. Before the transformed caterpillars emerge as moths and badly damage the silk, the farmers kill them with steam or high heat. They soften the cocoons in hot water and unwind the filaments onto a reel. The filaments are so fine that workers generally unwind those from five to ten cocoons together to bond into a single strand while still soft and sticky. Later, they twist several strands together to form a thicker yarn and then weave the yarn on a loom to produce silk cloth. Both the yarn and the cloth can be dyed. Workers additionally decorate the cloth by weaving threads of different colors together in special patterns *(brocades)* or by stitching in threads of different colors *(embroidery)*. Many east Asian artists painted directly on plain silk (FIGS. 7-6, 7-9, 7-16, 7-19, and 7-23, and 7-24).

Greatly admired throughout most of Asia, Chinese silk and the secrets of its production gradually spread throughout the ancient world. The Romans knew of silk as early as the second century B.C. and treasured it for garments and hangings. Silk came to the Romans along the ancient fabled Silk Road, actually two major and several minor caravan tracts linking China and the Mediterranean world. The western part, between the Mediterranean region and India, developed first, due largely to the difficult geographic conditions to India's northeast. In central Asia, the caravans had to skirt the Taklimakan Desert, one of the most inhospitable environments on earth, as well as climb high, dangerous mountain passes. Very few traders actually traveled the entire route. Along the way, goods usually passed through the hands of people from many lands, who often only dimly understood the ultimate origins and destinations of what they traded. The Roman passion for silk ultimately led to the modern name for the caravan tracts, but silk was far from the only product traded along the way. Gold, ivory, exotic animals, and all manner of other merchandise precious enough to warrant the risks passed along the Silk Road. Ideas moved along these trade routes as well. Travelers on the Silk Road brought Buddhism to China from India in the first century A.D.

Upheavals in the East associated with the Tang dynasty's end in A.D. 906 and with the rise of Islam in the Middle East (see Chapter 13) caused a long interruption in trade along the Silk Road. Not until the Venetian Marco Polo's time in the thirteenth century did Europeans reopen it.

impressions of chariots. Replicating the emperor's invincible hosts, they served as the immortal imperial bodyguard deployed in trenches outside what researchers believe is a vast underground funerary palace (as yet unexcavated) designed to match the fabulous palace the emperor occupied in life. The historian Sima Qian (136–85 B.C.) described both palaces, but scholars did not take his account seriously until these statues came to light.

Originally in vivid color, the emperor's troops stood in long ranks and files, as if lined up for battle. The terracotta army included cavalry, chariots, archers, lancers, and hand-to-hand fighters. The style of the Qin warriors blends formalism—simplicity of volume and contour, rigidity, and frontality—with sharp realism of detail. Set poses repeat with little or no variation, as if produced from a single mold, but the figures exhibit subtle differences in details of facial features, coiffures, and equipment. Such individualization made the army seem more real and, like the funerary palace, offered the deceased emperor continuity in his passage from this world to the next.

Han Dynasty (206 B.C.–A.D. 220)

Soon after Shi Huangdi's death, the people who had suffered under his reign revolted and founded the Han dynasty in 206 B.C. The Han emperors, ruling China for four centuries, created a new, but equally powerful, centralized government and extended China's southern and western boundaries. Chinese armies penetrated far into Xinjiang and even began to trade indirectly with distant Rome via the fabled Silk Road (see "Silk and the Silk Road," above).

PAINTED SILK IN A NOBLEWOMAN'S TOMB In 1972, archeologists excavated a striking example of Han painting on silk (FIG. **7-6**) in a tomb at Mawangdui in Hunan Province in southern China. The tomb belonged to the wife of the Marquis of Dai. Scholars have not yet determined the function of this T-shaped silk painting, but it may have been used in the funeral ceremonies preceding the woman's burial. Marked by rigorous symmetry and stylized forms, the silk's pictorial field attends less to accurate portrayal than to presenting an iconography of uncertain meaning. Art historians generally agree that the area within the cross at the top of the T represents heaven, most of the vertical section the human realm, and the very bottom the underworld. In the heavenly realm, dragons and immortal beings cavort between and below two orbs—the red sun and its symbol, the raven, on the right and the silvery moon and its symbol, the toad, on the left. Below, the standing figure on the first white platform near the vertical section's center, probably the Marquise of Dai herself, awaits her ascent to heaven, where she can attain im-

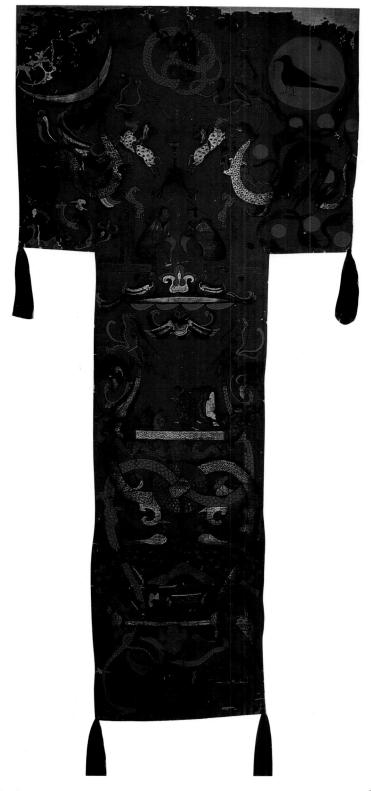

7-6 Funeral banner, from Tomb 1 (tomb of Dai), Mawangdui, China, Western Han dynasty, ca. 168 B.C. Painted silk, 6' 8¾" × 3' ¼". Hunan Provincial Museum, Changsha.

mortality. Nearer the bottom, the artist depicted the Marquise's funeral. Between these two sections, positions a form resembling a bi disk with two intertwining dragons (compare FIG. 7-4). Their tails reach down to the underworld and their heads point to heaven, unifying the whole composition.

Producing lavish funerary objects such as this funeral banner, performing costly and complex funeral rites, and regularly making offerings to ancestors provide dramatic evidence of how important the ideal of continuity through ancestor veneration has been over time in Chinese life.

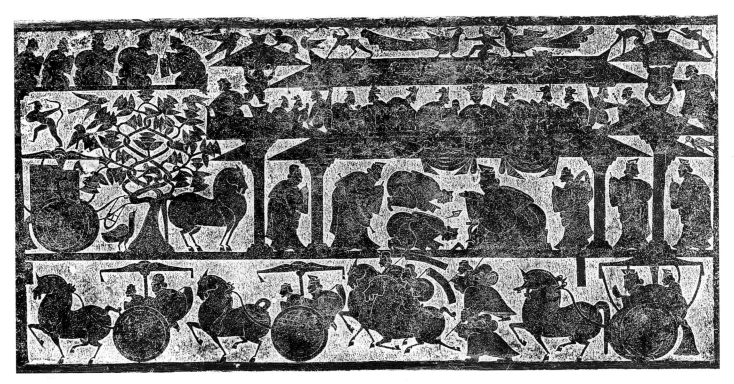

7-7 Mythological scenes, Wu family shrine, Shandong Province, China, late Han dynasty, A.D. 147–168. Rubbing of a stone relief, approx. 5' long.

YI SAVES THE EARTH Among the major information sources about Han pictorial style are the reliefs (FIG. 7-7) at the Wu family shrines in the northeastern Shandong Province, datable between A.D. 147 and 168. Dedicated to deceased male family members, the shrines consist of three walls covered by a pitched roof, but they are not large enough to enter. On the exterior slabs of the walls, scenes from history and folklore combine to suggest the dead ancestor's virtues. The slab shown here includes, at the left, a depiction of the archer-hero Yi saving the earth from scorching by shooting down the nine extra suns, represented as crows in the Fusang tree. (The small orbs below the sun on the Mawangdui banner probably allude to the same story.) The inclusion of the archer's story suggests the deceased's reverence for the past and perhaps implies his own courage.

The story on each relief unfolds in registers, as do those in the ancient Near East, Egypt, and early Greece. Images of flat polished stone stand out against an equally flat, though roughly textured, ground. The curved figures relate to one another by the linear rhythms of their contours. Buildings and trees indicate a setting, but the perspective devices of contemporaneous painting and relief sculpture in the classical world are absent. The artist suggested distance by placing one adjacent figure above another, although some chariot wheels do overlap. Important individuals are larger than their subordinates. Most interesting are the trees, highly stylized as masses of intertwined branches bearing isolated overlarge leaves. Yet within this schematic form, a variation via a twisted branch or broken bough shows how the designer's generalization derived from observing specific trees. It also illustrates how a detail in one element can individualize the whole. This subtle relationship between the specific and the abstract became one of the most important attributes of later Chinese painting.

Period of Disunity (220–589)

BUDDHISM REACHES CHINA For three and a half centuries, from 220 to 589, civil strife divided China into competing states. Scholars variously refer to this era as the Period of Disunity or the period of the Six Dynasties or of the Northern and Southern Dynasties. Buddhism (see "Buddhism and Buddhist Iconography," Chapter 6, page 164) had reached China in the first century A.D., although its first adherents were non-Chinese on the outskirts of the Han empire. Certain practices shared with Daoism, such as withdrawal from ordinary society, helped Buddhism gain an initial foothold among the Chinese. But Buddhism's promise of hope beyond this world's troubles of existence earned it an ever broader audience during the upheavals of the Period of Disunity. In addition, the fully developed Buddhist system of thought attracted intellectuals. Buddhism never fully displaced Confucianism and Daoism, but it did prosper throughout China for centuries and had a profound effect on the further development of the religious forms of those two native traditions.

Pilgrims and missionaries making the hazardous trip along the desert trade routes of central Asia that formed the Silk Road's eastern portion brought Buddhist art to China. Most of the Buddhist art surviving in China from the fourth and fifth centuries originated in the northern states, which non-Chinese peoples ruled. An important early Chinese Buddhist image is the gilded bronze statuette of Sakyamuni Buddha (the historical Buddha; FIG. 7-8), dated by inscription to the year 338. In both style and iconography, this Buddha resembles the prototype conceived and developed at Gandhara, Pakistan (see FIG. 6-13). The Chinese figure recalls its presumed Gandharan models in the flat, relieflike handling of the robe's heavy concentric folds, the ushnisha (cranial bump)

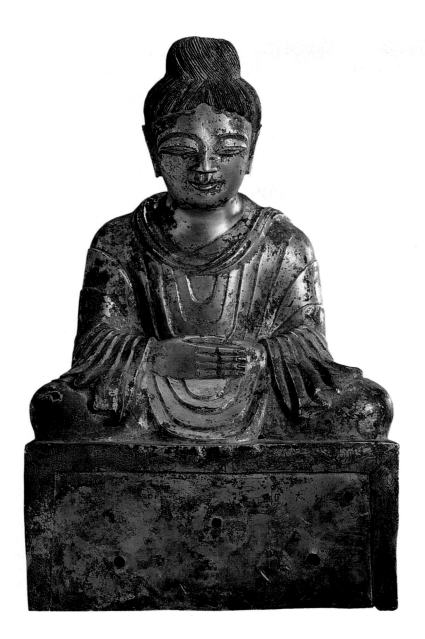

7-8 Sakyamuni Buddha, late Zhau dynasty, Period of Disunity, 338. Gilded bronze, 1' 3$\frac{1}{2}$" high, 9$\frac{5}{8}$" wide. Asian Art Museum of San Francisco, San Francisco (Avery Brundage Collection).

on the head, and the cross-legged position. So new were the icon and its meaning, however, that the Chinese sculptor incorrectly represented the canonical meditation gesture. Here, the Buddha clasps his hands across his stomach. They should be turned palms upward, with thumbs barely touching in front of the torso (see FIG. 6-13).

By the early sixth century, a thinner and more stylized image of the Buddha had emerged in India. These changes in formal approach spread throughout eastern Asia, as an early-seventh-century bronze from Japan (see FIG. 8-6) indicates. The Chinese, too, produced more graceful, slender figures. As Buddhism flourished in China, so did Chinese Buddhist art, especially in great cave complexes built in the Indian fashion (FIG. 6-12). Even before Buddhism's arrival in China, Mahayana and later teachings in southern and central Asia had developed an expanded group of deities. These gods appeared in the Chinese caves, along with the Buddhas.

CHINESE PAINTING Buddhist imagery did not hold exclusive sway in this period, however. Secular arts and objects related to Confucian and Daoist practices and beliefs also flourished. Rulers sought calligraphers and painters to lend distinction to their courts. Several distinctive materials and formats characterize Chinese painting (and by extension painting throughout eastern Asia). The basic requirements are the same as for writing—a round tapered brush, soot-based ink, and a support (surface for painting), usually silk or paper. In some paintings (FIG. 7-25), figural outlines reveal the characteristic Chinese line that elastically widens and narrows to convey not only outline but depth and mass as well. In other works (FIG. 7-16), *iron-wire lines* (thin, unmodulated lines with a suggestion of tensile strength, which are often seen in Buddhist figure painting) define the figures. The Chinese also used richly colored minerals as pigments, finely ground and suspended in a gluey medium, and watery washes of mineral and vegetable dyes.

The formats of Chinese paintings not on walls tend to be more personal and intimate than often common in the West. Artists glued some pictures to silk scrolls for vertical display (unrolled) on appropriate occasions. Other paintings were mounted on long, narrow scrolls viewers unrolled horizontally, section by section. Painters attached still others to fans and to paper leaves in albums.

Xie He's Six Laws

China has a long and rich history of scholarship on painting, preserved today in copies of texts from as far back as the fourth century and in citations to even earlier sources. Few of the first texts on painting survive, but later authors often quoted them, preserving the texts for posterity. China's early invention of printing led to an even greater dispersion of such texts. (Printing was used widely in China by the second century A.D.; it is extremely difficult to set even a rough date for its invention there.) Thus, educated Chinese painters and their clients could steep themselves in a rich art historical tradition.

Perhaps the most famous subject of later commentary is a set of six laws of painting Xie He (active early sixth century) formulated. Scholars still debate the precise meaning of his now cryptic laws formed of only four Chinese characters each. Loosely translated, they read:

1. Animation through spirit resonance
2. Bone method in the use of the brush
3. Fidelity to the object in depiction
4. Conforming to type in applying colors
5. Appropriate planning in placement
6. Transmission by copying ancient models

Interpreting these laws in connection with actual paintings, however difficult, offers valuable insights into what the Chinese valued in painting. The simplest laws to understand are the third, fourth, and fifth, because they show painters' concern for accuracy in rendering forms and colors and for care in composition, concerns common in many cultures. However, separating form and color into different laws gives written expression to some of the distinctive features of painting in China and the rest of eastern Asia. Generally, Chinese painters did not use gradations of color when modeling three-dimensional form. Many paintings are brushed-ink drawings with flat applications of thick pigments, washes of color, or both, sometimes supplemented with simple streaks of shading along edges, such as drapery folds (for example, see FIGS. 7-6, 7-14, and 7-16).

Also noteworthy is the order of the laws, suggesting Chinese painters' primary concern—to convey the vital spirit of their subjects and their own sensitivity to that spirit. Next in importance was the handling of the brush, the careful placement of strokes, especially of ink. Although applying these two laws directly to specific paintings is difficult, Gu Kaizhi's figurative paintings (FIG. 7-9) and others' later landscape paintings (FIG. 7-19) certainly suggest values in painting quite distinct from Western values. The forms of such paintings do not conform to simple visual reality, and their textures result from careful handling of the inked brush, a key element in the training of Chinese painters.

The sixth law also speaks to a standard Chinese painting practice—copying. Chinese painters trained by copying their teachers' and other painters' works. In addition, artists often copied famous paintings as sources of forms and ideas for their own works. Gu Kaizhi's scroll (FIG. 7-9) may, in fact, be a copy of another painting of his era. Many renowned Chinese painters consciously painted works in the manner of famous predecessors. Change and individual development occurred in constant reference to the past, the artists always preserving some elements of it.

The horizontal scroll, or *handscroll,* has a long history as a major format for painting in eastern Asia and was frequently used to present illustrated religious texts. These scrolls, sometimes exceeding fifty feet in length, were unrolled to the left and rerolled from the right, with only a small section exposed. Priests and other teachers often placed large-scale instructional scrolls on special stands and presented them to a small audience. Other scrolls were more intimate in scale and best viewed by only one or two people at a time. In later periods, the horizontal scroll also developed as a format for painting continuous landscapes. Art historians have compared the organization of these paintings to a symphony because of how motifs reappear and moods vary in the different sections. Due to the unrolling/rerolling process, appreciation of the landscape scroll involves memory, as well as vision, and the format encourages leisurely contemplation.

LADY FENG'S HEROISM The painter and essayist Gu Kaizhi (ca. 344–406) is one of the few individual artists from the Period of Disunity to whom art historians have been able to attribute extant paintings with confidence. Gu won respect as a calligrapher and was a friend of important members of the imperial court. A horizontal scroll attributed to Gu Kaizhi, called *Admonitions of the Instructress to the Court Ladies,* contains painted scenes between passages of explanatory text. One of the sections (FIG. **7-9**) depicts a well-known act of heroism, the Lady Feng saving her emperor's life by placing herself between him and an attacking bear. Gu set his figures against a blank background and provided only a minimal setting for the scene. The figures' fluid poses and fluttering drapery ribbons, in concert with individualized facial expressions, convey a clear quality of animation. This style accords well with painting ideals expressed in texts of the time, when representing inner vitality and spirit took precedence over reproducing surface appearances (see "Xie He's Six Laws," above).

Early Chinese Architecture

FLEXIBLE SUPPORT AND MULTIPLE COLORS Chinese architecture did not display dramatic changes in style over the centuries, although striking new forms, such as the pagoda (FIGS. 7-21 and 7-22), developed to serve Buddhist

7-9 Attributed to GU KAIZHI, *Lady Feng and the Bear*, detail of *Admonitions of the Instructress to the Court Ladies*, Period of Disunity, late fourth century. Handscroll, ink and colors on silk, $9\frac{3}{4}'' \times 11' 4\frac{1}{2}''$. British Museum, London.

needs. As in many other ancient cultures, the Chinese used wood to construct their earliest buildings, and those structures do not survive. However, scholars believe that many of the features giving East Asian architecture its specific character—for example, the roof's curving silhouette—may go back to Zhou times. Even the simple buildings depicted on Han stone carvings (FIG. 7-7) reveal a style and a method of construction long basic to China. This lasting characteristic is an ingenious and flexible support system employing columns, beams, and brackets (see "Chinese Construction Methods and Principles," page 200).

The essentials of a Chinese building consist of a rectangular hall covered by a pitched roof with projecting eaves supported by wooden columns and brackets. The walls serve no weight-bearing function but act only as screening elements. The colors of Chinese buildings, predominantly red, black, yellow, and white, are also distinctive. Chinese timber architecture is customarily multicolored throughout, save for certain parts left in natural color, such as white marble

balustrades (a row of vaselike supports with a railing) or roof crests. The builders usually painted the screen walls and the columns red. Chinese designers often chose dazzling combinations of colors and elaborate patterns (FIG. 7-10) for the beams, brackets, eaves, rafters, and ceilings. The builders painted or lacquered the surfaces to protect the timber from rot and wood parasites, as well as to produce an arresting aesthetic, even spiritual, effect.

THE PRECARIOUS TEMPLE OF HUNYUAN A small temple occupying an almost impossible mountainside site at Hunyuan reveals the technical expertise of Chinese architects. The Xuankong Si, or Hanging Temple (FIG. 7-11), built during the Northern Wei dynasty (386–534), seems to hover in the air in front of a huge cliff about to overwhelm it. The building's light, fragile fabric stands in startling contrast to the brutal mass of stone it seems to defy. Though later masonry foundations lend it support at the base, the original builders erected the structure literally from the top down. They fashioned the separate parts beforehand, lifted them to the top of the cliff, and then lowered the architectural pieces, along with

7-11 Xuankong Si (Hanging Temple), Hunyuan, China, Northern Wei dynasty, 386–534. Reconstructed during the Ming dynasty, 1368–1644.

7-10 Console bracket cluster supporting eaves of a bell tower, China.

Chinese Construction Methods and Principles

It is a curious paradox that the architecture of China, the oldest continuing civilization in the world, should be represented by few surviving buildings older than the ninth century. China's conservatism would seem to have made preservation of its ancient monuments one of its first cares. Yet the very flexibility of its construction methods made conservation of individual structures less vital. Buildings easily could be dismantled, moved to another site, or simply replaced. And, unlike bronzes, paintings, and so forth, the Chinese did not consider buildings antiquities of intrinsic "artistic" value, and they obviously could not be preserved in collections. Wars, fires, and earthquakes took tremendous tolls on them. Moreover, many Buddhist temples were destroyed during persecutions. More important than the survival of individual buildings was the survival of the tradition of building.

In Chinese architecture, the builders laid *beams* (no. 1 in our diagram) between columns, decreasing the length of the beams as the structure rose. The beams supported vertical *struts* (no. 2), which in turn supported higher beams and eventually the *purlins* (no. 3) running the length of the building and carrying the roof's sloping *rafters* (no. 4). Unlike the rigid elements of the triangular trussed timber roof common in the West and familiar in North American home construction, the varying lengths of the Chinese structure's cross beams and the variously placed purlins could produce roof lines of different shapes. In addition, the interlocking clusters of brackets could *cantilever* (support with brackets) the roof to allow for broad overhang of the *eaves* (no. 5). Multiplication of the *bays* (compartments) formed by column-beam-bracket construction could extend the building's length to any dimension desired. The proportions of the structural elements could be fixed into modules, allowing for standardization of parts. This made rapid construction of a building possible. The workers fit the parts together without using any adhesive substance, such as mortar or glue. Delicately joined as the parts were, they still could carry easily the heavy tiled roofs of the great Chinese temples and halls (FIGS. 7-15 and 7-22).

The Chinese considered the choice of site for a building a cultivated art. The architect diligently calculated the north-south and east-west axes when situating a building, giving careful thought to the landscape environment for both practical and spiritual reasons. The Chinese favored southern and southeastern orientations for the somewhat milder climatic conditions and for assistance in generating vegetation—the life-giving sun against the deadly northern chill. In conformity with the Chinese belief in *fengshui* (wind and water), water must stop the breath of life, which is scattered by wind. Thus architects must adjust the forces of wind and water when orienting buildings. In the layout of building complexes, the seclusion of the units and the spaces of the enclosure express the conservation of breath. The plans are often symmetrical, the buildings facing each other on both sides of a central axis. The axis functions as a path and visual perspective seen through gateways, towers, halls, and courtyards in a sequence of primarily perpendicular units along it. The qualities of symmetry, regularity, uniformity, and secludedness in the layout, not only of halls and temple complexes but also of whole cities, powerfully express the Chinese respect for tradition and order.

the workers who assembled them while suspended from the cliff. The column-beam-bracket system, braced against the rock face, took advantage of the cliff's resistance to stabilize the stresses. This remarkable structure, though often restored, has withstood numerous earthquakes. The current structure, rebuilt during the Ming dynasty (1368–1644), shows later enhancements. In particular, the decora]tive function of color and the ornamental exaggeration of the turned-up eaves became more conspicuous in later centuries. The Hanging Temple then took on the dramatically horned or winged silhouette distinguishing later Chinese rooflines.

Tang Dynasty (618–906)

CHINA REUNIFIED The emperors of the short-lived Sui dynasty (581–618) succeeded in reuniting China and prepared the way for the brilliant Tang dynasty (618–906). Under the Tang emperors, China entered a period of unequaled magnificence. Chinese armies marched across central Asia, prompting an influx of foreign peoples, wealth, and ideas. Arab traders, Nestorian Christians (members of a sect originating in western Asia), and other travelers journeyed to the Tang's cosmopolitan capital at Chang'an (modern Xi'an), and the Chinese, in turn, ventured westward. The Tang rulers embellished their empire with extravagant wooden structures, but all have disappeared due to intentional and unintentional destruction by fire. Judging from records, however, the Tang buildings were colorfully painted and of colossal size, possessing furnishings of great luxury and elaborate gold, silver, and bronze ornaments.

A ROCK-CUT COSMIC BUDDHA In its first century, the new dynasty continued to support Buddhism and to sponsor great monuments for Buddhist worshipers. One of the most spectacular is the colossal rock-cut figure of Vairocana Buddha (FIG. **7-12**), the personification of the cosmos, carved out of a cliff in the great Longmen Cave complex near Luoyang between 670 and 680. Work at Longmen had begun almost two centuries earlier, during the Period of Disunity, under the rulers of the Tuoba Wei. The one thousand three hundred fifty-two caves, ninety-seven thousand statues, three thousand six hundred inscriptions, and seven hundred eighty-five carved niches at Longmen provide some notion of the powerful attraction of Buddhism to the Chinese.

Chinese raised beam construction (after L. Liu).

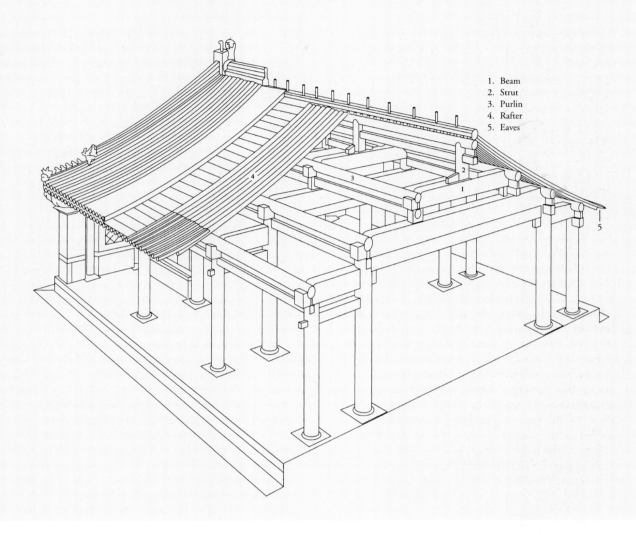

1. Beam
2. Strut
3. Purlin
4. Rafter
5. Eaves

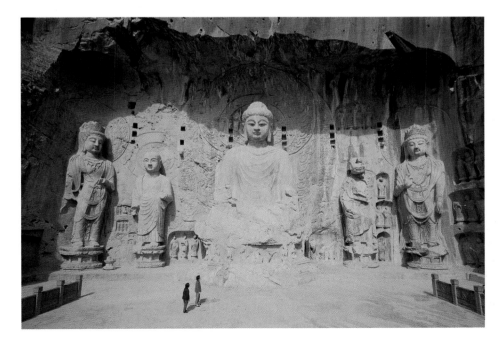

7-12 Vairocana Buddha, Longmen Caves, Luoyang, China, Tang dynasty, ca. 670–680. Natural rock, 50′ high.

The Vairocana Buddha presides over an infinite number of worlds, each with its Buddha, symbolized in his throne's lotus petals. In serene majesty, flanked by Buddhas and bodhisattvas, the Longmen Buddha overwhelms visitors to the site. An almost geometric regularity of contour and smoothness of planes emphasizes the massive figure's volume. The folds of his robes fall in a few concentric arcs. The sculptor suppressed surface detail in the interest of monumental simplicity and dignity. The detailed and deeply channeled drapery of the bodhisattvas at the extreme left and right makes a telling contrast with the carving of Vairocana.

A SINUOUS BODHISATTVA By the end of the seventh century, Buddhist sculpture in China had changed dramatically, influenced by the fluid, sensual style of Buddhist sculpture in India (see FIG. 6-15). Fleshiness increased and drapery began to cling, as if wet, against the body. A marble statue of a bodhisattva (FIG. **7-13**) exemplifies the early Tang style admirably, drawing heavily on Indian prototypes. The figure's hip-tilted pose and revealing drapery accentuate its sinuous beauty, in the Indian tradition. Still, the crisp precision of the carving and the figure's robustness mark the work as Tang Chinese. The swaying pose suggests that this bodhisattva was one of the attendants in a Buddha triad. A *Buddha triad* is a group of three statues with a central Buddha flanked on each side by an attendant bodhisattva. Bodhisattvas had strong appeal in eastern Asia as compassionate beings ready to achieve Buddhahood but dedicated to humanity's salvation. Some received direct worship and became the main subjects of sculpture and painting.

THE BUDDHA OF THE WEST AT DUNHUANG
The westward expansion of the Tang Empire increased the importance of Dunhuang, the westernmost gateway to China on the Silk Road. Dunhuang long had been a wealthy, cosmopolitan trade center; a Buddhist pilgrimage destination; and home to thriving communities of Buddhist monks and nuns of varied ethnicity, as well as to adherents of other religions. More than three hundred sanctuaries cut into the soft rock of the cliffs near Dunhuang, known as the Mogao Buddhist caves, contain walls decorated with paintings. Images of painted unfired clay and stucco also adorn the chambers. The site was dedicated in 366, but the earliest extant caves date to the late fifth century. By the eighth century, wealthy donors sponsored larger and more elaborately decorated caves.

Paradise of Amitabha (FIG. 7-14), on the wall of one of the Dunhuang caves, shows how the splendor of the age and religious teachings could come together in a powerful image. Buddhist Pure Land sects, especially those centered on Amitabha, Buddha of the West, had captured the popular imagination in the Period of Disunity under the Six Dynasties and continued to flourish during the Tang dynasty. Pure Land teachings asserted that individuals had no hope of attaining enlightenment through their own power because of the corruption of the age. Instead, they could obtain rebirth in a realm free from corruption simply through faith in Amitabha's promise of salvation. Richly detailed, brilliantly colored pictures steeped in the Tang dynasty's opulence, such as this one, greatly aided worshipers in gaining faith by visual-

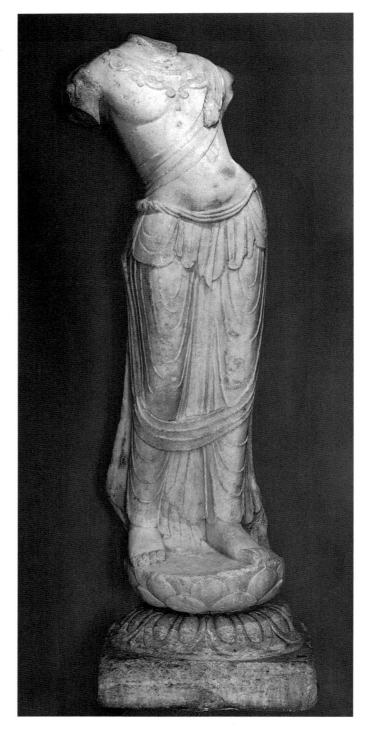

7-13 Bodhisattva, early Tang dynasty, seventh to eighth century. Marble. Charles Uht Collection, New York.

izing the wonders of such a paradise. Amitabha sits in the center of a raised platform, his principal bodhisattvas and lesser divine attendants surrounding him. Before them a celestial dance takes place. The scene's splendor coincides with textual descriptions of Amitabha's Pure Land but with a particularly Chinese visualization. Everything occurs within a setting of Tang-style palace architecture, symmetrically arranged and highly ornate.

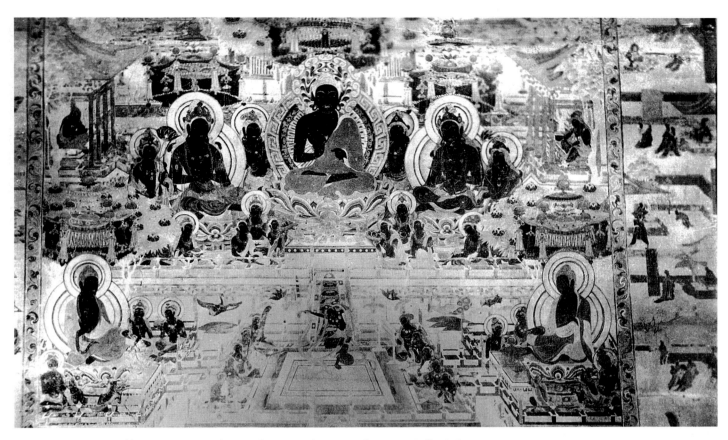

7-14 *Paradise of Amitabha*, Cave 139A, Dunhuang, China, Tang dynasty, ninth century. Wall painting.

THE CHANGING ROLE OF CHINESE ARTISTS

The social circumstances and roles of ancient Chinese artists varied greatly over time and according to specific occupation, but some very general patterns by the time of the Tang dynasty emerge from the historical record. By the seventh century, the great majority of artists served the needs and met the demands of clients ranging from kings to local noblewomen to Buddhist institutions. They often worked under close supervision and also tended to serve collectively. The number of extant Shang (FIG. 7-2) and Zhou bronzes alone suggests the existence of early well-organized workshops. Members may have inherited their occupations, as in later periods. Certainly, workshops (their members locked into their positions as the state's slaves) decorated and furnished great imperial building projects of the Qin and succeeding dynasties. The artists who created the great works at Longmen Caves inherited their occupations, served in workshops, and, until about mid-sixth century, were the state's slaves, unable to accept private commissions without permission.

By the Tang dynasty, however, even artists in the great workshops that carved and painted the Buddhist cave temples had achieved more independent status, although various rulers still sometimes compelled their labor as a form of taxation. Such workshops surely had leaders, but historians know almost nothing about them. A real sense of specific artistic identity only emerges in major records related to calligraphers and to painters such as Gu Kaizhi (FIG. 7-9), who were all men. Scholars know very little about artists in other fields or about women's contributions.

TANG TEMPLES A cutaway cross-section and perspective drawing (FIG. 7-15) of one of the oldest surviving Buddhist temples in China, the Foguang Si near Mount Wutai (Wutai Shan) in northern China, shows the realization of Tang architectural ideals in temples. A complex grid of beams and purlins, and a thicket of interlocking brackets, supports the overhang of the eaves—some fourteen feet out from the column faces—as well as the timbered and tiled roof. China's timber technology reached early maturity in this masterpiece of Tang dynasty architecture.

For all its successes, Buddhism never replaced native Chinese religions, and the Buddhist practice of removing people from their families and from public service to enter monastic

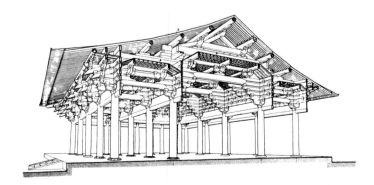

7-15 Schematic cross-section and perspective drawing of Chinese beam-bracketing construction, Foguang Si temple, Wutai Shan, China, Tang dynasty, ca. 857 (after L. Liu).

7-16 Attributed to YAN LIBEN, Tang emperor and attendants, detail of *The Thirteen Emperors*, Tang dynasty, ca. 650. Handscroll, ink and colors on silk, 1' 8¼″ × 1' 5½″. Museum of Fine Arts, Boston (Denman Waldo Ross Collection).

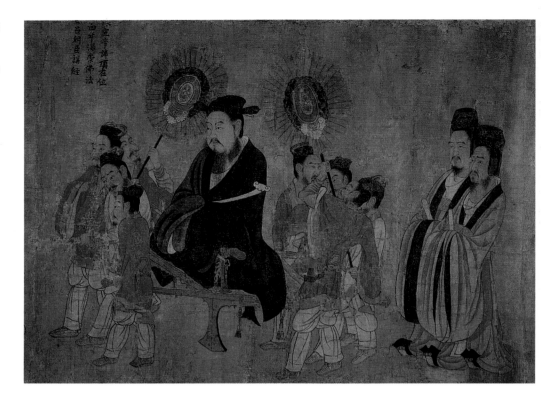

communities conflicted deeply with Confucian values. In 845, the emperor Wuzong instituted a major persecution, destroying four thousand six hundred Buddhist temples and forty thousand shrines and forcing the return of two hundred sixty thousand five hundred monks and nuns to lay life. These policies did not affect Dunhuang, then under Tibetan rule, so it preserves much lost elsewhere, although its painting styles do not fully reflect those of central China. Scholars today also look to survivals of art and architecture in Korea and Japan made during periods of these countries' closest cultural intercourse with China to help fill in the gaps in the visual record.

ART AT THE TANG COURT Chang'an, the Tang capital, was perhaps the greatest city in the world during the seventh and eighth centuries. A brilliant tradition of figurative painting developed at the Tang court that, in its variety and balance, reflected the Tang emperors' worldliness and self-assurance. Indeed, many art historians regard the early Tang dynasty as the golden age of Chinese figurative painting. Glowing accounts by Chinese poets and critics survive, although only a few examples of the paintings remain.

In perfect accord with descriptions of the robust Tang style are the unrestored portions of *The Thirteen Emperors* (FIG. **7-16,** detail), a masterpiece of line drawing and colored washes. YAN LIBEN (d. 673), believed to have been the artist, was a celebrated seventh-century Tang painter and statesman. In the work, each emperor stands or sits in an undefined space, his eminence clearly indicated by his great size relative to his attendants. Simple shading in the faces and the robes gives the figures an added semblance of volume and presence. As a whole, the portrait series offers a pageant of majesty exalting the Tang emperors' power and dignity.

A PRINCESS'S PAINTED TOMB Wall paintings in the tomb of the Tang princess Yongtai permit an analysis of court painting styles unobscured by problems of authenticity and reconstruction. Within the tomb, built in 706 near Chang'an, the figures of palace ladies (FIG. **7-17**) appear as if on a shallow stage. The artist did not provide any indications of background or setting, but intervals between the two rows and the figures' grouping in an oval suggest a consistent ground plane. The women assume a variety of poses, seen in full-face and in three-quarter views, from the front or the back. The device of paired figures facing into and out of the

7-17 Palace ladies, in the tomb of Princess Yongtai, near Chang'an (Xi'an), Tang dynasty, 706. Wall painting.

space of the picture in a near mirror image appears often in paintings of this period and effectively creates depth. Thick, even contour lines describe full-volumed faces and suggest solid forms beneath the drapery, all with the utmost economy. This simplicity of form and line, along with the measured cadence of the poses, results in an air of monumental dignity befitting a daughter of the Tang ruling house.

By the eighth century, China had become an international cultural center, integrating concepts and forms from farther west and affecting developments to the south and east. In particular, Tang artists and craftspeople taught visitors from Korea and Japan, and some even traveled abroad. Thus, fair approximations of the Tang artists' elegant approach to figurative painting, dominated by sweeping brush lines, began to appear elsewhere in eastern Asia (see FIG. 8-8).

GLAZED EARTHENWARE SCULPTURE Tang potters also achieved renown, producing fine wares for ostentatious display. They covered their vessels with colorful lead glazes and invented robust shapes with clearly defined parts—base, body, and neck. Earlier potters often had imitated bronze models, but the Tang artists derived their vessel forms more directly from the clay's plastic character and techniques such as wheel-throwing. Tang ceramicists also produced thousands of earthenware figures of people, domesticated animals, and fantastic creatures for burial in tombs. The depiction of such diverse figures as Greek acrobats and Semitic traders indicates the cosmopolitanism of Tang China. The artists painted some figurines with colored slips and decorated others, such as the spirited, handsomely adorned Neighing Horse (FIG. 7-18), with colorful lead glazes that ran in dramatic streams down the objects' sides when fired.

The horse's popularity as a Chinese art subject reflects the importance the emperors placed on the quality of their stables. More than seven hundred thousand studs in the Tang kingdom attested to their significance for the dynasty's military success and glory. The breed represented here is powerful

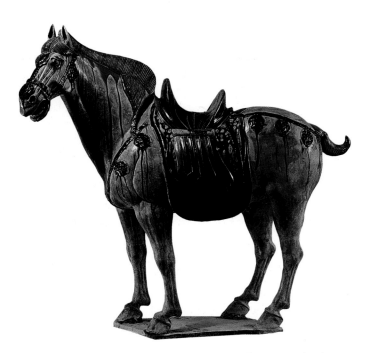

7-18 Neighing Horse, Tang dynasty, eighth to ninth century. Glazed earthenware, 1′ 8″ high. Victoria and Albert Museum, London.

in build. Its beautifully arched neck terminates in a small, elegant head. Richly harnessed and saddled, the horse testifies to its rider's nobility. During the period of Tang power, representing horses in painting and ceramics was a special genre, on equal footing with figural composition and landscape.

Northern Song Dynasty (960–1127)

The last century of Tang rule witnessed the empire's gradual disintegration. When the dynasty finally fell in 906, China once more experienced the ravages of civil war. Conflicting claims between rival states went unresolved until the Song dynasty consolidated the country once again, ruling China from their court at Bianjing (modern Kaifeng in Henan Province). During the interim of internal strife known as the Five Dynasties (907–960), the styles and techniques of painting monumental landscapes evolved rapidly, reaching a peak in the Northern Song period, though figurative painting continued, often as copies of Tang work.

IMAGINARY JOURNEYS IN PAINTED REALMS Landscape painting flourished even before the Tang dynasty. Daoist nature cults and a new appreciation of landscape themes in poetry provided the stimulus for the early development of landscape painting. Indeed, throughout history, landscape painting played a much more important role in China than in the West because landscapes had significance far beyond being sites of human action in great narratives. According to prevailing theory in China, landscapes should evoke both humanity's ideal harmonious relationship with the order of the cosmos and nature's potential to transform the human spirit. The ideal practiced in life meant wandering among streams and mountains, and a shifting, rather than fixed, perspective in painting suggested such a viewing process.

Early descriptive texts on landscape painting by painters and commentators from as early as the fourth century A.D. had a profound impact on Chinese artists in succeeding centuries. Such texts indicate that even then Chinese artists appreciated the almost magical potential of landscape painting to re-create and organize the human experience of nature or to transport viewers to imaginary realms. When the painter ZONG BING (373–443), for example, became too old to continue his mountain wanderings, he re-created favorite landscapes on the walls of his studio so that he could take imaginary journeys. Of the representational power of painting, Zong wrote:

> Nowadays, when I spread out my silk to catch the distant scene, even the form of the Kunlun [Mountain] may be captured within a square inch of space; a vertical stroke of three inches equals a height of several thousand feet. . . . By such means as this, the beauty of the Song and Hua Mountains and the very soul of the Xuanpin [Dark Spirit of the Universe] may all be embraced within a single picture.[1]

Another fifth-century painter, Wang Wei, elaborated on the re-creative potential of landscape painting:

> I unroll a picture and examine it, and reveal mountains and seas unfamiliar to me. The wind scatters in the verdant forests, the torrent overflows in bubbling foam. Ah, how could this be achieved merely by the skillful use of hands and fingers? The spirit must also exercise control over it. For this is the essence of painting.[2]

7-19 Fan Kuan, *Travelers among Mountains and Streams*, Northern Song dynasty, early eleventh century. Hanging scroll, ink and colors on silk, 6′ 9″ × 2′ 5″. National Palace Museum, Taipei.

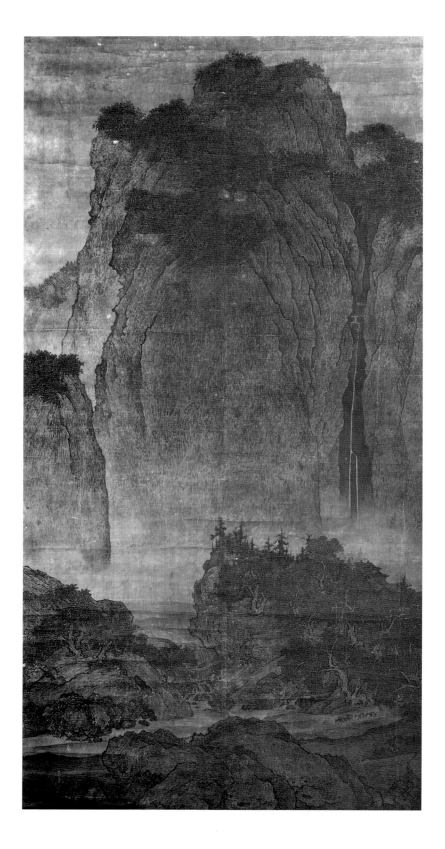

Travelers among Mountains and Streams (FIG. **7-19**), painted by Fan Kuan in the early eleventh century, stands out as a masterpiece of landscape painting. It incorporates the ideals Zong Bing and Wang Wei espoused and illustrates the basic ideals of Chinese painting theory. The picture presents a vertical landscape of massive mountains rising from the distance. The overwhelming natural forms dwarf the human and animal figures, which the artist reduced to minute proportions. Paths and bridges in the middle region vanish, only to reappear and lead spectators on a journey through the landscape—a journey facilitated by shifting perspective points. Fan depicted some elements directly from the side and others obliquely from the top. To appreciate such landscapes fully, viewers must focus not only on the outlines but also on intricate details and on the character of each brush stroke. Numerous "texture strokes" help model massive forms and convey a sense of tactile surfaces. Here, they are small, pale brush marks the Chinese call "raindrop strokes."

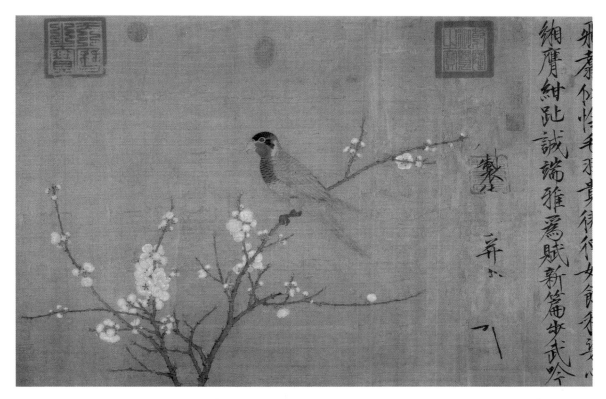

7-20 SONG HUIZONG, *The Five-Color Parakeet*, Northern Song dynasty, ca. 1100–1125. Hanging scroll, ink and color on silk, 1' 8⅞" high. Museum of Fine Arts, Boston.

THE EMPEROR WHO PAINTED BIRDS The Song imperial court employed painters, gathering them into official government bureaus that art historians sometimes refer to collectively as the Imperial Painting Academy. Illustrating lines of poetry by painting served frequently as an examination for entrance into the academy. In general, the court painters produced sophisticated and often brightly colored works, according to the emperors' tastes. Treasured albums held fans these master artists painted. The emperor SONG HUIZONG (1082–1135; r. 1100–1125), an avid art collector and patron, was also an important painter, especially renowned for his meticulous pictures of birds. *The Five-Color*

Parakeet (FIG. **7-20**) bears a poem and signature the emperor handwrote. With little regard for animating his subject, Song rendered almost every feather and plum-blossom petal in sharp, precise lines. The emperor's calligraphy, highly elegant and precise but with dynamic flourishes, enhances the silk painting's beauty.

CHINESE PAGODAS During the Northern Song period, the Liao dynasty briefly ruled part of China. In 1056, the Liao rulers built the great Foguang Si Pagoda at Yingxian (FIGS. **7-21** and 7-22). The *pagoda,* or tower, the building

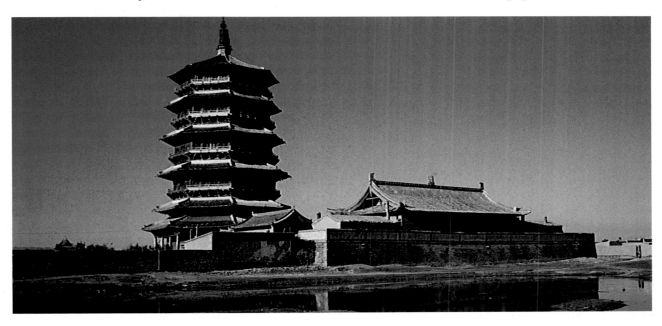

7-21 Foguang Si Pagoda, Yingxian, China, Liao dynasty, 1056.

type most often associated with Buddhism in China and other parts of eastern Asia, is the most eye-catching feature of a temple complex. It somewhat resembles the tall tower form of certain Indian temples (see FIG. 6-20) and its distant ancestor is the Indian stupa (see FIG. 6-5). Like stupas, many early pagodas housed relics and provided a focus for devotion to the Buddha as teacher and to those transmitting the faith. Later pagodas served other functions, such as housing sacred images. The Chinese and Koreans built both stone and brick pagodas, but wooden pagodas were also common and became the standard in Japan.

The Foguang Si Pagoda is two hundred sixteen feet tall and made entirely of wood. As is common with pagodas in other materials, this one is octagonal in plan, although wooden structures more commonly had square plans. Otherwise, its construction is typical. Sixty giant four-tiered bracket clusters carry the floor beams and projecting eaves of the five main stories. The main stories alternate with windowless mezzanines with cantilevered balconies, forming an elevation of nine stories altogether. Along with the open veranda on the ground level and the soaring pinnacle, the balconies visually lighten the building's mass. Our cross-section (FIG. 7-22) shows the symmetrical placement of statues of the Buddha, the colossal scale of the ground-floor statue, and the bewildering intricacy of the beam-and-bracket system at its most ingenious.

Southern Song Dynasty (1127–1279)

In 1127, due to conquests in the north by the Ruzhen, a seminomadic people who had formed an extensive empire,

the Song emperors moved China's capital to the southeast. From then until 1279, the Southern Song court lived out its days amid the tranquil beauty of the city of Hangzhou. Neo-Confucianism, a blend of traditional Chinese thought and selected Buddhist concepts, became the leading philosophy. Accordingly, orthodox Buddhism declined. Buddhist art, however, continued to develop both in the north, where the Ruzhen rulers had established themselves as the Jin dynasty (1115–1234), and in the south. Buddhist sculpture in the Southern Song period added grace and elegance to the Tang style. Like secular paintings, many artworks associated with Chan (*Zen* in Japanese; a meditative school of Buddhism) engaged traditional Chinese notions of intimacy between the human spirit and nature.

TWO SPHERES OF BEING A painting by Zhou Jichang, representing *arhats* giving alms to beggars (FIG. 7-23), expresses this new relationship in Buddhism. Arhats are the Buddha's enlightened disciples who have achieved freedom from rebirth (nirvana) by suppression of all desire for earthly things. More than in earlier paintings, in this work the artist placed the figures in a carefully delineated landscape. He arranged the foreground, middle ground, and background vertically to clarify their positions relative to one another and to the beggars. The arhats move with slow dignity in a plane above the ragged wretches who scramble miserably for the alms their serene benefactors throw down. The extreme differ-

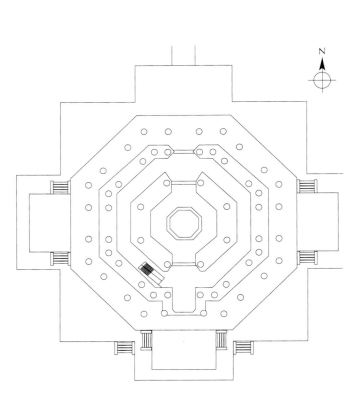

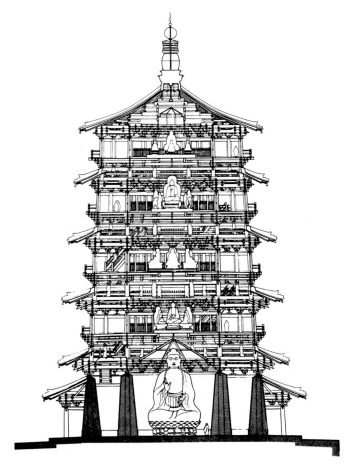

7-22 Plan and cross-section of Foguang Si Pagoda, Yingxian, China, Liao dynasty, 1056 (after L. Liu).

7-23 ZHOU JICHANG, *Arhats Giving Alms to Beggars*, Southern Song dynasty, 1178. Ink and colors on silk, 3′ 8″ × 1′ 9″. Museum of Fine Arts, Boston, General Funds.

MISTY MOUNTAINS AND INFINITE SPACE A landscape can take over the composition entirely in Chinese painting, diminishing or eliminating figures altogether, as in the earlier Northern Song painting (FIG. 7-19). Many Southern Song paintings also feature landscape as a very great presence. Artists adopted a more-or-less conventional system for arranging the landscape elements. A typical Southern Song landscape is basically asymmetrical and composed on a diagonal. It consists of three parts—the foreground weighted in one corner, the middle distance, and the far distance. A field of mist often separates these parts from one another. The painter generally marked the foreground by a rock, which, by its position, emphasizes the distance of the other parts. The middle distance may include a flat cliff or may be given over entirely to mist or water. In the far distance, mountain peaks, usually tinted in pale blue, suggest the infinity of space. The whole composition illustrates how the Song artists used great voids to hold solid masses in equilibrium. The technique is one of China's unique contributions to the art of painting. To this basic composition, which has many variations, the painter frequently added a scholar meditating under a gnarled pine tree and accompanied by an attendant. Such paintings suggest ideals of peace and unity with nature and the Confusian, Daoist, or Buddhist cosmos.

The chief painters in the Southern Song court style were MA YUAN (ca. 1160–1225) and XIA GUI (active ca. 1195–1224). Ma was a master of suggestion, as demonstrated by a small fan-shaped album leaf, *Bare Willows and Distant Mountains* (FIG. **7-24**), a picture of tranquility conveyed in a few sensitively balanced and half-seen shapes. The misty atmosphere, placement of near foreground motifs in one corner, and tall, elegant trees with visible roots are all typical elements in both Ma and Xia's paintings. The

7-24 MA YUAN, *Bare Willows and Distant Mountains*, Southern Song dynasty, thirteenth century. Album leaf, ink and colors on silk, $9\frac{1}{2}″ \times 9\frac{1}{2}″$. Museum of Fine Arts, Boston.

ence in deportment between the two groups distinguishes their status, as do their contrasting features. The arhats' vividly colored attire, flowing draperies, and quiet gestures set them off from the dirt-colored and jagged shapes of the people physically and spiritually beneath them. The landscape's composition—the cloudy platform and lofty peaks of the arhats and the desertlike setting of the beggars—also sharply distinguishes the two spheres of being.

triangular form on the mountain also contains the broad "axe-cut" strokes they preferred. The Ma-Xia style set many standards for later professional painters, in Korea and Japan, as well as in China, who favored bolder treatments over the gentle softness of these two artists.

CHAN BUDDHISM AND ART As orthodox Buddhism lost ground under the Song, the new school of Chan Buddhism gradually gained importance, until it was second only to Neo-Confucianism. The Chan sect traced its semi-legendary origins through a series of patriarchs (the founder and early leaders, joined in a master–pupil lineage). The first patriarch was Bodhidharma, a legendary sixth-century Indian missionary, who performed such feats as crossing a river on a reed to carry the messages of Chan across China. By the time of the Sixth Chan Patriarch, Huineng, who lived during the early Tang period, the religious forms and practices of the school were already well established. Although Chan monks adapted many of the rituals and ceremonies of other sects over the course of time, the Chan ideal was that followers of Chan teachings would repudiate texts, ritual, and charms as instruments of enlightenment. Their focus was to be instead on the cultivation of the mind or spirit of the individual in order to break through the illusions of ordinary reality, especially by means of meditation. In Chan thought, the means of enlightenment lie within the individual, and direct personal experience with some ultimate reality is the necessary step to its achievement. Meditation is a critical practice. In fact, the word "Chan" is a translation of the Sanskrit word for meditation, and Bodhidharma was said to have meditated so long in a cave that his arms and legs withered away. In practice, the Chan monk or pupil seeks direct personal experience with some ultimate reality through meditation. That breakthrough to Chan enlightenment has often been conceived of as a sudden, almost spontaneous act. These beliefs shaped a new art as they developed in China.

CHAN INFLUENCE IN INK PAINTING LIANG KAI (ca. 1140–1210) was a master of an abbreviated, expressive style of ink painting that found great favor among Chan monks in China, Korea, and Japan. He served in the Painting Academy of the imperial court in Hangzhou, and his early works include poetic landscapes typical of the Southern Song. Later in life, he left the court to become a Chan monk and concentrated on figure painting. Surviving works attributed to him include two lively, sketchy pictures of the Sixth Patriarch, Huineng. In one, the patriarch tears up a Buddhist sutra in an expression of the Chan rejection of traditional teachings and emphasis on meditation and personal spiritual development. In the other (FIG. **7-25**), he crouches as he chops bamboo. The performance of even such mundane tasks had the potential to become spiritual exercises. More specifically, this scene represents the patriarch's "Chan moment," when the sound of the blade striking the bamboo resonates within his spiritually attuned mind to propel him through the final doorway to enlightenment. The scruffy, caricature-like representation of the revered figure suggests that Huineng's mind is not burdened by worldly matters, such as physical appearance or signs of social status. However, Liang Kai utilized a variety of brushstrokes in the execution of this deceptively simple picture. Most are pale and wet, ranging from the fine lines of

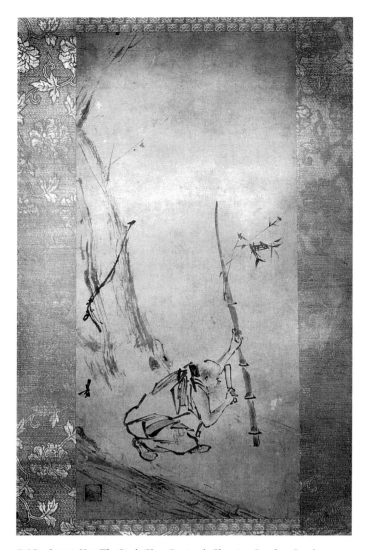

7-25 LIANG KAI *The Sixth Chan Patriarch Chopping Bamboo,* Southern Song dynasty, thirteenth century. Hanging scroll, ink on paper, 2′ 5¼″ high. Tokyo National Museum.

Huineng's beard to the broad texture strokes of the tree. A few darker strokes, which define the vine growing around the tree and the patriarch's clothing, offer visual accents in the painting. This kind of quick and seemingly casual execution of paintings has traditionally been interpreted as a sign of a painter's ability to produce compelling pictures spontaneously as a result of superior training and character, or, in the Chan setting, progress toward enlightenment. Chan and its arts eventually spread to Korea and Japan; in Japan, where it is called Zen, it had an especially extensive, long-term impact on the arts and remains an important sect of Buddhism there today (see Chapter 8).

CIZHOU CERAMICS Northern and Southern Song artists also produced superb ceramics. Some reflect their patrons' interests in antiquities and imitate the powerful forms of the Shang and Zhou bronzes. However, Song ceramics more commonly had elegant shapes with fluid silhouettes. Many featured monochrome glazes, such as the famous celadon wares, also produced in Korea (FIG. 7-29), but a quite different kind of pottery, loosely classed as Cizhou, emerged

in northern China. The example shown (FIG. **7-26**) is a vase of the high-shouldered shape known as *meiping*. Chinese potters developed the subtle techniques of *sgrafitto,* incising the design through a colored slip, during the Northern Song period. They achieved the intricate black-and-white design here by cutting through a black slip (see "Chinese Earthenwares and Stonewares," page 189). The tightly twining vine and flower petal motifs on this vase closely embrace the vessel in a perfect accommodation of surface design to vase shape.

Ancient Chinese culture laid the critical foundations for later East Asian civilization, including that in Korea and Japan. It provided a system of writing; fundamental tenets

and ideals in philosophy and religion; numerous basic technologies; standard aesthetic principles; and the formats, materials, basic forms, and subjects of art and architecture. All of these contributions had attained a high level of development well before Christ's birth on the western side of Asia and many diminished dramatically in importance only in the past century. Chinese transformations of Buddhist forms and thought in the early centuries A.D. added another profound component to east Asian civilization. Without question, the cultural debt of later eastern Asia to early China is extremely large. But evoking, even revering, China's past did not prevent reinterpreting its past as part of a dynamic process of cultural and artistic evolution. The next section traces this reinterpretative process in neighboring Korea.

KOREA

Korea, a small peninsula of the Chinese-Manchurian mainland, faces the islands of Japan. Korea's location made it susceptible to attacks from both directions, and, frequently throughout its long history, these attacks have politically destabilized it. Ethnically, the Koreans are related to the peoples of eastern Siberia and Mongolia, as well as to the Japanese. In the early centuries, the Koreans used Chinese characters to write Korean words, but the Korean language later acquired its own phonetic alphabet. Korean art, although unmistakably derived from Chinese models, is not merely derivative but has, like Korean civilization, a discernible native identity. Furthermore, it frequently mediated the cultural developments passing from the continent into Japan.

Pottery-producing cultures appeared on the peninsula in the Neolithic period between five thousand and three thousand years ago, and bronze work dates back to at least 600 B.C. Historians believe that Chinese refugees, fleeing from dynastic wars, settled in northern Korea as early as the twelfth century B.C. Much later, about 100 B.C., during the Han dynasty, the Chinese established a colony in Korea, Lolang, for centuries an important commercial center. Native kingdoms—Koguryo, Paekche, and Silla—arose in different regions of the peninsula. The centuries of their contemporaneous reigns are known as the Three Kingdoms period (ca. 57 B.C.–A.D. 688). The art of these three states laid the foundation for many of the later developments on the peninsula. Paekche continued a strong pottery tradition, lagging somewhat behind the others in metalwork because of poor mineral resources. The other two kingdoms, in contrast, not only produced fine pottery, but excelled at metalworking as well.

GOLD CROWNS IN SILLA TOMBS Gold has been valued around the world from earliest times for its beauty and resistance to corrosion. Exposure to air, heat. moisture, and most solvents does not affect it. Ancient artists frequently cast gold and other metals, but they also forged them into different shapes by hammering, pulling, twisting, cutting, and punching them. Unlike hard metals, such as iron, gold is naturally soft and easy to forge when only slightly heated. Even early artists could beat it into thin sheets or draw it out into fine wires for cutting and shaping. Tombs of the Silla kingdom have yielded spectacular artifacts, such as gold crowns, revealing the wealth

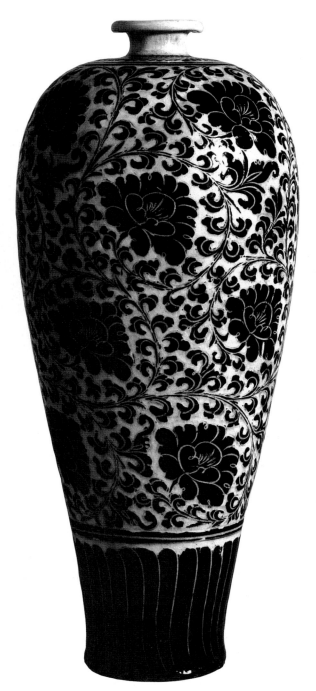

7-26 Meiping vase, Song dynasty, thirteenth century. Stoneware, Cizhou type, with sgraffito decoration, 1' 7½″ high, 7¾″ wide. Asian Art Museum of San Francisco, San Francisco (Avery Brundage Collection).

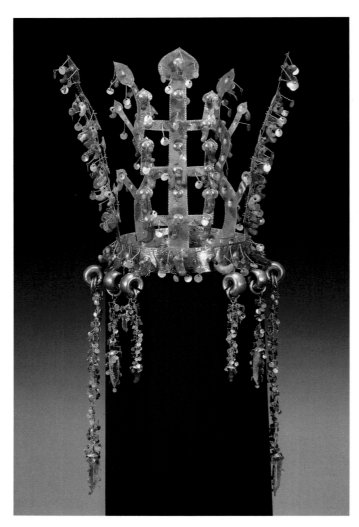

7-27 Crown, from north mound of Tomb 98 at Hwangnamdong, near Kyongju, Korea, Silla kingdom, fifth to sixth century. Gold, $10\frac{3}{4}''$ high. Kyongju National Museum, Kyongju.

and power of the rulers of the three kingdoms. The crown from a tomb at Hwangnamdong (FIG. **7-27**), dated to the fifth or sixth century A.D., attests to the high quality of artisanship among Silla artists. They cut the crown's major elements, the band and the uprights, as well as the myriad spangles adorning them, from sheet gold and embossed these along the edges. Gold rivets and wires secure the whole, as do the comma-shaped pieces of jade further embellishing the crown. Archeologists interpret the uprights as stylized tree and antler forms believed to symbolize life and supernatural power. These magnificent crowns have no counterparts in China, relating instead to Siberian forms.

BUDDHIST ART AND THE THREE KINGDOMS
In A.D. 372, in the Paekche kingdom, Buddhism arrived in Korea from China. Many small gilt bronze statues, very close in style to those produced in China, attest to Buddhism's spread. Korea, in turn, helped spread Buddhism and Buddhist art to Japan, and Japanese works (see FIG. 8-6) reflecting the forms of China and Korea display that continuity.

Aided by China's emperor, the Silla Kingdom conquered the Koguryo and the Paekche kingdoms and unified Korea as Great Silla. Korea's golden age is the era of Great Silla

(688–935), contemporary with the Tang dynasty's brilliant culture in China. The Silla rulers looked upon Buddhism not only as a religion, but also as a protective force. They sponsored the building of temples of magnificent scale in and around their capital of Kyongju to be places of worship and to serve as a supernatural defense against external threats. Unfortunately, none of these monuments survived Korea's turbulent history. However, near the summit of Mount Toham, just east of the city, the splendid granite cave at Sokkuram, with its reliefs and freestanding figures, has survived as the greatest cultural treasure of the period. Scant surviving records suggest that the monument was built under the supervision of Kim Tae-song (the family name appears first), a member of the royal family who served as prime minister. He initiated construction in 742, the year after he resigned his government post, and died in 774 before the project was completed. The records also suggest that Kim intended Sokkuram to honor his parents in his previous life. Certainly the scale of Sokkuram, which is too small for a place of congregation, and its high aesthetic standard support the idea that it was a private chapel for royalty.

The main *rotunda* (circular area under a dome) of the cave measures only about twenty-one feet in diameter. Despite its modest size, the Sokkuram cave project required substantial resources. Unlike some Buddhist caves, the interior wall surfaces and sculpture were not cut from native stone in the

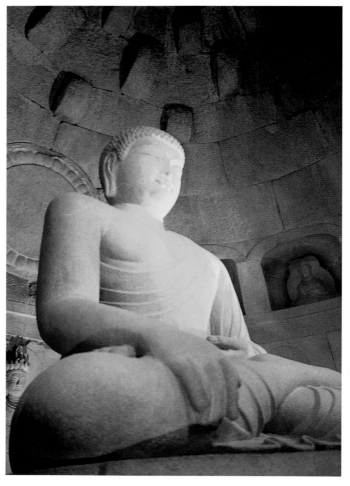

7-28 Sakyamuni Buddha, at entrance to rock chapel, Sokkuram, Korea, Great Silla, eighth century. Granite, about 11′ high.

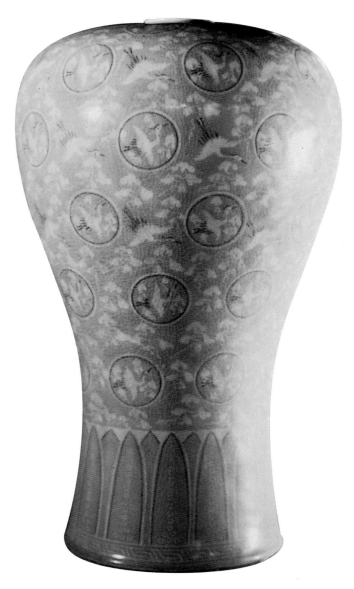

7-29 Maebyong vase, Koryo period, ca. 918–1000. Celadon with inlaid decoration, 1′ 4½″ tall. Kansong Art Museum, Seoul.

majestic image remains faithful to its iconographic prototype. More immediately, the Korean statue draws on the robust, round-faced figures of Tang China (FIG. 7-12), and its drapery is a more schematic version of the fluid type found in Tang sculpture. However, the figure has a distinctly broad-shouldered dignity combined with harmonious proportions that are without close precedents.

CELADON WARE Though Buddhism was the established religion of Korea, Confucianism, introduced from China during the Silla era, increasingly shaped social and political conventions. In the ninth century, the three old kingdoms began to reemerge as distinct political entities, and by 935 the Koryo (from Koguryo) dominated for the next three centuries. The Great Silla and Koryo kingdoms overlap slightly (the period ca. 918–935) because both kingdoms existed as these shifts in power occurred. In 1231, the Mongols, who had invaded China, pushed into Korea, beginning a war lasting thirty years. In the end, the Koryo had to submit to forming an alliance with the invaders.

Koryo potters in the twelfth century produced the famous Korean *celadon* wares, admired worldwide. Highly translucent iron-pigmented glazes, fired in an oxygen-deprived kiln to become gray, pale blue, pale green, or brownish olive, characterize celadon wares. Incised or engraved designs in the vessel alter the glaze's thickness to produce elegant tonal variations.

A vase in the shape known as *maebyong* in Korean (FIG. 7-29; *meiping* in Chinese, FIG. 7-26) probably dates to early in the Koryo period (ca. 918–1000), as evidenced by its simplicity compared with the elaborateness of later celadon design. The artist incised delicate motifs of flying cranes—some flying down and others, in *roundels* (circular motifs), flying up—into the clay's surface and then filled the grooves with white and colored slip. Next, the potter covered the incised areas with the celadon green glaze. Variation in the spacing of the motifs shows the potter's sure sense of the dynamic relationship between ornamentation and ceramic volume.

As noted earlier, ancient Korean art clearly took shape within the larger framework of an East Asian cultural sphere dominated by China. However, sometimes in very subtle ways apparent only to specialists and sometimes in more pronounced ones obvious to anyone, Korea's art and culture also developed distinctively, as Chapter 26 documents.

Ancient China was to later eastern Asia what both Greece and Rome were to Europe. China's achievements in virtually every field, including writing, literature, technology, philosophy, religion, and art, spread beyond even the boundaries of the vast empire it sometimes controlled. Although Buddhism began in India, the Chinese adaptations and transformations of its teachings, religious practice, and artistic forms were those that endured and spread farther east. Chapters 8, 26, and 27 reveal the importance of early Chinese models to the art of both early and later Japan and of later China and Korea while recognizing each area's own distinct history.

process of excavation. Instead, workers assembled hundreds of granite pieces of various shapes and sizes, attaching them with stone rivets instead of mortar. Sculpted images of bodhisattvas, arhats, and ancient Indian gods line the lower zone of the wall. Above, ten niches contain miniature statues of seated bohhisattvas and believers. All of these figures face inward toward the eleven-foot-tall statue of Sakyamuni (FIG. 7-28), the historical Buddha, which dominates the chamber as it sits slightly back from center and faces the entrance. Carved from a single block of granite, the image represents the Buddha as he touched the earth to call it to witness the realization of his enlightenment. Although remote in time and place from the Sarnath Buddha in India (see FIG. 6-15), this

EARLY JAPAN

CHINA	RUSSIA		Hokkaido		N
NORTH KOREA	Sea of Japan		Honshu		
Pyongyang				Pacific	
SOUTH KOREA			NAGANO GUNMA Ina JAPAN	Ocean	
			Mt. Fuji • Tokyo Kamakura		
Korea Strait	Kyoto (Heian) Nara • Ise KAGAWA MIE				
Shikoku					
East China Sea	Kyushu	Philippine Sea			0 200 400 miles / 0 200 400 kilometers

10,500 B.C.	2500 B.C.	1500 B.C.	300 B.C.	A.D. 100	300	552	645	
JOMON	MIDDLE JOMON		YAYOI			KOFUN	ASUKA	HAKUHO

Jomon vessel 2500–1500 B.C.

Dotaku 100–300

Haniwa warrior figure fifth–mid-sixth century

Horyuji kondo Nara, ca. 680

Hunting and fishing

Rice growing and metalworking

Emergence of imperial family

Buddhism officially introduced, 552

SACRED STATUES AND SECULAR SCROLLS

THE ART OF EARLY JAPAN

710	794		1185		1332
NARA	HEIAN		KAMAKURA		

Amida triad
Horyuji, Nara, ca. 710

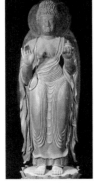

Standing Yakushi
Jingoji, Kyoto, ca. 793

Phoenix Hall
Byodoin, Uji, 1053

Tale of Genji
to mid-twelfth century

Shunjobo Chogen
Todaiji, Nara
early thirteenth century

Transfer of capital to Nara, 710

Transfer of capital to Heian (Kyoto), 794

New sects of Esoteric Buddhism
introduced, ca. 805

Suspension of diplomatic relations
with China, 894

Pure Land Buddhist teachings gain
importance, from tenth century

Warrior clans rise in power, twelfth century

Kamakura shogunate established, 1185

Popular Pure Land sects
emerge, thirteenth century

The Japanese archipelago consists of four main islands and hundreds of smaller ones, a surprising number of them inhabited. Two major distinct population groups lived on the islands by earliest historical times. The great majority of Japan's inhabitants trace their ancestry to one of these two early groups and consider Japan to have been culturally homogeneous throughout its history. Nevertheless, regional differences and the cultural effects of both immigration and imported ideas long have given Japanese art and culture a varied and dynamic character. In early centuries, the islands' mountainous terrain made travel and communication difficult. This tended to produce strong regional variations in dialect, cuisine, and local customs, persisting to some degree even now. Meanwhile, immigration from the Asian continent's eastern edge, the source of Japan's original population, never really has ceased, helping Japan participate in the cultural developments of eastern Asia. All in all, Japan's close proximity to the continent has allowed the island country to reap tremendous benefits, while the sea has helped protect it from outright invasions. But Japanese culture also has had sufficient opportunity to evolve in its own directions, particularly in times of diminished contact with the outside world.

JAPAN BEFORE BUDDHISM

Jomon Period (ca. 10,500–300 B.C.)

POTTERY BEFORE FARMING Japan's earliest distinctive culture is the Jomon, named after the cord *(jo)* markings *(mon)* decorating many of its earthenware vessels. The Jomon people were hunter-gatherers, but the richness of their natural environment enabled them to live surprisingly settled existences. Their villages consisted of pit dwellings—shallow round excavations with raised earthen rims and thatched roofs. Escaping the nomadic existence of many early hunter-gatherers permitted the Jomon people to develop ceramic technology well before agriculture. In fact, archeologists have dated some ceramic sherds found in Japan to before 10,000 B.C.—older than the sherds from any other area of the world.

In addition to rope markings, incised lines and applied coils of clay adorned Jomon pottery surfaces. The most impressive examples come from the Middle Jomon period (2500–1500 B.C.). Much of the population then lived in the mountainous inland region, where local variations in ceramic form and surface treatment flourished. However, all Jomon potters shared a highly developed feeling for modeled, rather than painted, ceramic ornament. Jomon pottery displays such a wealth of coils, striped incisions, and sometimes quasi-figural motifs that the sculptural treatment in certain instances even jeopardizes the vessel's basic functionality. Jomon vessels served a wide variety of purposes, from storage to cooking to bone burial. Some of the most elaborate pots may have served ceremonial functions.

A dramatic example from Miyanomae in Nagano Prefecture (a prefecture is a district with a governor; FIG. **8-1**) shows a characteristically deep and intricate surface modeling and a partially sculpted rim. Jomon pottery contrasts strikingly with China's most celebrated Neolithic earthenwares (see FIG. 7-1) in that the Japanese vessels are extremely thick and heavy. The

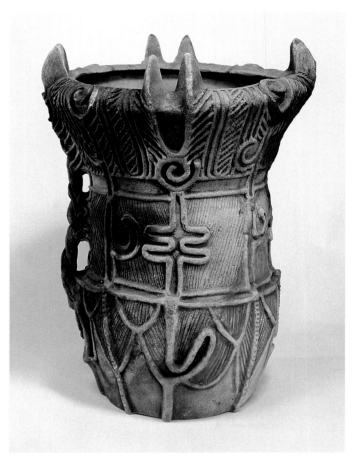

8-1 Vessel, from Miyanomae, Nagano Prefecture, Japan, Middle Jomon period, 2500–1500 B.C. Earthenware, $1' 11\frac{2}{3}'' \times 1' 1\frac{1}{4}''$. Tokyo National Museum, Tokyo.

harder, thinner, and lighter Neolithic Chinese earthenware emphasizes basic ceramic form and painted decoration.

Yayoi (ca. 300 B.C.–A.D. 300) and Kofun (ca. A.D. 330–552) Periods

Jomon culture gradually gave way to Yayoi beginning around 300 B.C. in Kyushu, the southernmost of the main Japanese islands. Increased interaction with and immigration from Korea brought dramatic social and technological transformations. People continued to live in pit dwellings, but their villages grew in size and developed fortifications, indicating a perceived need for defense. Toward the end of this period, near A.D. 300, Chinese visitors noted that Japan had walled towns, many small kingdoms, and a highly stratified social structure. Wet-rice agriculture provided the social and economic foundations for such development.

JAPANESE BRONZES AND HAN CHINA Less sculptural and sometimes polychromed pottery, bronze-casting, and loom weaving help characterize the Yayoi period as a time of tremendous change in material culture as well. Among the most intriguing objects Yayoi artisans produced are the *dotaku,* or bells, treasured ceremonial bronzes based on Han Chinese bell forms but not functional as musical instruments. Cast in clay molds, these bronzes generally featured

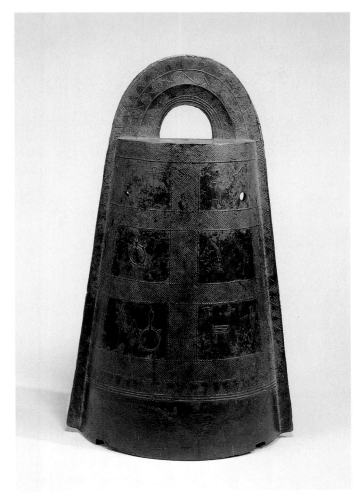

8-2 *Dotaku* (bell) with incised figural motifs, from Kagawa Prefecture, Japan, Late Yayoi period, A.D. 100–300. Bronze, 1′ 4⅞″ high. Tokyo National Museum, Tokyo.

raised decoration. On a few, including the one shown here (FIG. **8-2**) from Kagawa Prefecture, the ornament consists of simple line drawings whose exact meanings scholars still debate. Whatever their meaning, the dotaku engravings are the earliest surviving examples of pictorial art in Japan. The cranes and tortoises, ancient Chinese symbols of longevity, on the bell forms suggest some awareness of Chinese belief systems.

TREASURE-FILLED BURIAL MOUNDS Historians named the succeeding Kofun period (*ko* means "old"; *fun* means "tomb") after the great *tumuli* (pit graves covered by sometimes enormous mounds) that had begun to appear in the third century. These grew dramatically in number and scale in the fourth century, signaling the rise of grand political leaders. The tumuli recall earlier Jomon practices of abandoning the dead on sacred mountains. Important symbolic objects buried with the deceased include examples of items that later became Japanese imperial house regalia—mirrors, swords, and comma-shaped jewels. Numerous bronze mirrors came from China, but the tombs' forms and many of the goods suggest even closer connections with Korea. For example, the comma-shaped jewels closely resemble those found on

Korean Silla crowns (see FIG. 7-27), whose simpler gilt bronze counterparts lay in the Japanese tombs.

CYLINDER-STATUES FOR THE DEAD In association with the great Japanese tumuli, researchers also discovered a very distinctive native element in the earthenware *haniwa,* such as the one from Gunma Prefecture (FIG. **8-3**), placed on and around the pit grave mounds. Compared to the terracotta soldiers and horses buried with the Qin emperor in Shaanxi Province, China (see FIG. 7-5), these statues appear deceptively whimsical as variations on a cylindrical theme (*haniwa* means "clay circle"). Yet haniwa sculptors skillfully adapted the basic clay cylinder into a host of forms, from abstract shapes to objects, animals (such as deer, bears, horses, and monkeys), and human figures familiar in Japanese society at that time—warriors, women nursing babies, shamans, and so forth. These artists altered the shapes of the cylinders,

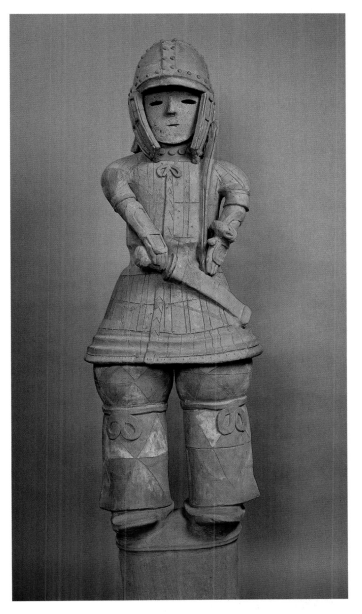

8-3 *Haniwa* (cylindrical) warrior figure, from Gunma Prefecture, Japan, late Kofun period, fifth to mid-sixth century. Low-fired clay, 4′ 1¼″ high. Aikawa Archaeological Museum, Aikawa.

Pre-Buddhist Beliefs and Rituals in Japan

The early beliefs and practices of pre-Buddhist Japan, which form a part of the belief system later called Shinto ("Way of the Gods"), did not derive from the teachings of any individual founding figure or distinct leader. Formal scriptures, in the strict sense, do not exist for these beliefs and practices either. Shintoism developed hand in hand with Japanese society. With the advent of agriculture in the Yayoi period, a variety of religious beliefs and practices arose. These included agricultural rites surrounding planting and harvesting and *shamanism,* the belief a priest, or shaman, can influence the ancestral spirits, gods, and demons who produce good and evil. Villagers venerated and prayed to a multitude of local, sometimes specialized, deities or spirits called *kami.* The early Japanese believed kami existed in mountains, waterfalls, and other impressive features and aspects of nature, as well as in charismatic people. When Buddhism arrived in Japan from the mainland in the sixth century, Shinto practices changed under its influence. Before then, painted or carved images of Shinto deities did not exist.

During the Yayoi period, mastery of farming led to larger villages, increased social stratification, division of labor, and conflict with neighbors. Many precious objects used for ceremonial purposes, such as the bronze dotaku (FIG. 8-2), indicated the wealth and power of a community and its leader. Conquests of nearby territories produced small states, which grew rapidly in the Kofun period. The leaders of one of the Kofun states gained power over a particularly large territory, and their line continues unbroken today as the Japanese imperial successors. (In Japan, "emperor" is a conventional term of respect rather than a characterization of the Japanese ruler's authority over great territories.)

The basic societal unit during the Kofun period was the clan, a local group claiming a common ancestor. Each clan had its own protector kami, to whom members offered prayers in the spring for successful planting and in the fall for good harvests. Clan members built shrines made up of several buildings, such as the one at Ise (FIG. 8-4), for kami. Priests made offerings of grains and fruits at these shrines and prayed on behalf of the clans. Ordinary people might hold festivals in the vicinity but could not actually enter the shrine's sacred buildings and sanctuaries, or smaller shrines. Rituals of divination, water purification, and ceremonial purification at the shrines became popular. Visitors to the shrine area had to wash before entering in a ritual of spiritual and physical cleansing.

Purity was such a critical aspect of Japanese religious beliefs that people would abandon buildings and even settlements if negative events, such as poor harvests, suggested spiritual defilement. Even the early imperial court moved several times to newly built towns to escape impurity and the trouble it caused. Such purification concepts are also the basis for the cyclical rebuilding of the sanctuaries at grand shrines. The actual buildings of the inner shrine at Ise, for example, have been rebuilt every twenty years—at least sixty-one times—with few interruptions. Such rebuilding rids the sacred site of physical and spiritual impurities that otherwise might accumulate. During rebuilding, the old structure remains standing until the architects erect an exact duplicate next to it. In this way, the Japanese have preserved ancient forms with great precision.

emblazoned them with applied ornaments, punched out and drew forth forms, and then painted the haniwa. The Kofun Japanese set these simple sculptures in curving rows around the burial chambers on the exterior of the mounds. The variety of figure types suggests not a protective army such as that guarding the Qin tomb but figures that may have served as a spiritual barrier protecting both the living and the dead from contamination.

AMATERASU'S ANCIENT SHRINE The Kofun shrine of the sun goddess, Amaterasu, at Ise (FIG. **8-4**) in Mie Prefecture, built initially during the fifth century and rebuilt every twenty years since then, is the greatest of all Shinto monuments (see "Pre-Buddhist Beliefs and Rituals in Japan," above). Shrine architecture varies tremendously in Japan. Researchers believe that the Ise shrine preserves some of the very earliest designs. The ultimate source of the main sanctuary's form appears to be early granaries, sometimes represented on bronze mirrors or as clay haniwa. Granaries were among the

most important buildings in Japan's early agrarian society, so architects probably imitated the basic granary forms when designing palaces and shrines. Although not every aspect of the Ise shrine is equally ancient, the inner shrine's three main structures convey some sense of Japanese architecture before Buddhism arrived and before the introduction of more elaborately constructed and adorned buildings.

Aside from the thatched roofs and some metallic decorations, the sole construction material at Ise is wood, fitted together in a *mortise-and-tenon* system, the wallboards slipped into slots in the pillars. Two massive freestanding posts (once great cypress trunks), one at each end of the building, support most of the weight of the *ridgepole,* the beam at the roof's crest. The golden-hued cypress columns and planks contrast in color and texture with the white gravel covering the sacred grounds. The thatched roof contains several aesthetic nuances. The builders browned the thatch by a smoking process and sewed it into bundles. Then they carefully laid it in layers that gradually decrease in number from the eaves to the ridgepole.

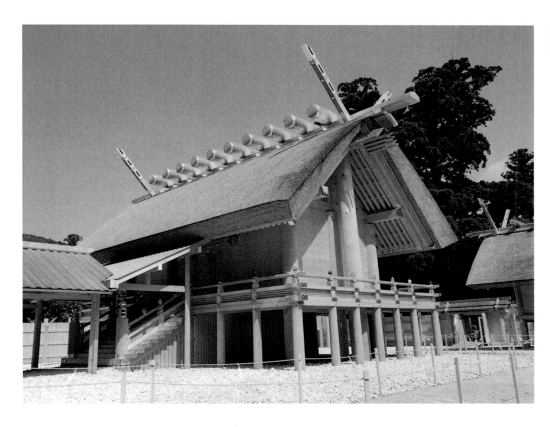

8-4 Main hall, Ise shrine, Ise, Mie Prefecture, Japan, as rebuilt in 1973.

Next, the workers sheared the entire surface smooth to produce a gently changing contour. Finally, they further enhanced the roofline by adding decorative elements that once had a structural function—the *chigi,* or crosspieces, at the gables and cylindrical wooden weights placed at right angles across the ridgepole. The shrine, in its setting, expresses purity and dignity, effectively emphasized by the extreme simplicity of the precisely planned proportions, textures, and architectural forms.

BUDDHIST JAPAN

Asuka (552–645), Hakuho (645–710), and Nara (710–794) Periods

ASUKA JAPAN AND CHINA In A.D. 552, according to traditional interpretation, the ruler of Paekche, one of Korea's Three Kingdoms (see Chapter 7), sent Japan's ruler a gilded bronze figure of the Buddha and *sutras* (Buddhist scriptures) translated into Chinese, the written language of eastern Asia then. This event marked the beginning of the Asuka period, when Japan's ruling elite firmly established major elements of continental culture that had been gradually filtering into Japan. These cultural components included Chinese writing, Confucianism (see "Daoism and Confucianism," Chapter 7, page 193), and Buddhism (see "Buddhism and Buddhist Iconography," Chapter 6, page 164). The Japanese court, ruling from a series of capitals south of modern Kyoto, increasingly adopted the Chinese court's forms and rites. In 710, the Japanese finally established what they meant as a permanent capital at Nara. City planners laid out the new capital on a symmetrical grid closely modeled on the plan of the Chinese

capital of Chang'an. However, Nara remained the capital only until 794.

For half a century after 552, Buddhism met with opposition, but at the end of that time, the new religion was established firmly in Japan. Shinto beliefs and practices continued to have significance, especially as agricultural rituals and imperial court rites. As time passed, Shinto deities even gained new identities as local manifestations of Buddhist deities.

In the arts allied to Buddhist practices, Japan followed Korean and Chinese prototypes very closely, especially in the Asuka, Hakuho, and Nara periods. In fact, early Buddhist architects in Japan adhered so closely to mainland standards (although generally with a considerable time lag) that surviving Japanese temples have helped greatly in the reconstruction of what was almost completely lost on the continent. Buddhist temples served as monasteries as well, because they were homes to monks or nuns and were really building complexes rather than individual structures.

BUDDHIST ARCHITECTURE: PAGODAS In the early Buddhist period, one of the most important building types was the pagoda. Early Japanese examples tended to be simpler than the very elaborate Chinese version, such as the much later Foguang Si (see FIGS. 7-21 and 7-22), and square in plan with a single pillar rising through the center to the top. Like Indian stupas, pagodas were great reliquaries. Under the main pillar, a stone chamber housed relics of important teachers, celebrating the Buddhist faith's historical transmission through the generations.

THE WORLD'S OLDEST WOODEN BUILDING The main building in a Japanese Buddhist temple complex,

the image hall, housed the major sculptural icons and provided a site of worship and prayer. At Horyuji, outside Nara, an important surviving early temple complex, the image hall (FIG. **8-5**) is known as the *kondo* (Golden Hall). The Horyuji kondo dates from around 680, making it the oldest surviving wooden building in the world. Although periodically repaired and somewhat altered (the covered porch is an eighth-century addition; the upper railing dates to the seventeenth century), the structure retains its graceful but muscular forms beneath the additions. The main pillars (not visible in our illustration) decrease in diameter from bottom to top, as in classical architecture. The tapering made an effective transition between the more delicate brackets above and the columns' stout muscularity, but such tapering was a short-lived feature in Japan. Also somewhat masked by the added porch is the harmonious diminishing from the first to the second story. Following Chinese models, the builders used ceramic tiles as roofing material, rather than the thatching of earlier Japanese structures.

AN EARLY BUDDHA TRIAD IN BRONZE

Wood was the mainstay of Buddhist sculpture throughout Japanese history, but bronze also held a significant place. In addition, artists of the Nara period made some surviving works from unfired clay or by using a special lacquer process, both forms supported by a wooden *armature* (framework). Among the earliest extant examples of Japanese Buddhist sculpture is a bronze Buddha triad (FIG. **8-6**). Rescued from a temple destroyed by fire in the seventh century, it became one of the main images in the Horyuji kondo. The central figure in the triad is Shaka (the Indian/Chinese Sakyamuni), the historical Buddha. Behind the main image, a flaming *mandorla* (an almond-shaped nimbus) bears small figures of other Buddhas. The sculptor, Tori Busshi (*busshi* means "maker of Buddhist images"), was a descendant of a Chinese immigrant. Tori's Buddha triad dates to 623 but reflects the style of the early to mid-sixth century in China and Korea. He elongated the heads and gave greater attention to the drapery's elegantly stylized folds than to rendering the physical substance of the bodies or their garments with naturalistic modeling.

THE HEALING BUDDHA OF YAKUSHIJI

Within little more than half a century, however, Japan had begun to leave behind the Asuka period's style in favor of new ideas and forms coming out of Tang China and Korea. More direct relations with China also narrowed the time gap between developments there and their transfer to Japan. In the Yakushi

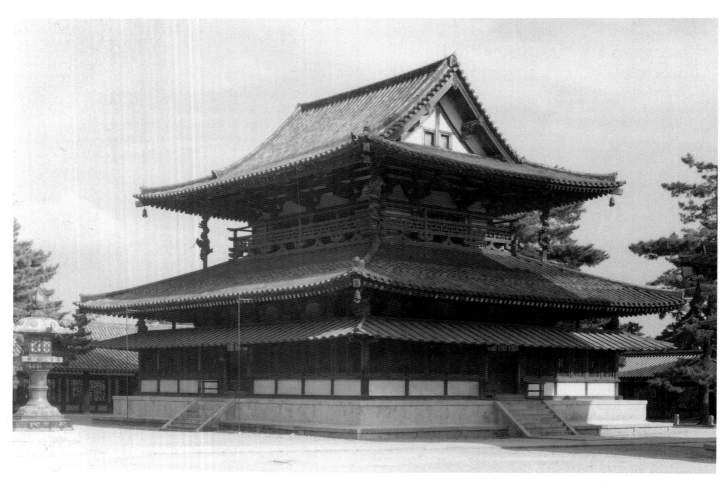

8-5 Horyuji *kondo* (Golden Hall), Nara, Japan, Hakuho period, ca. 680.

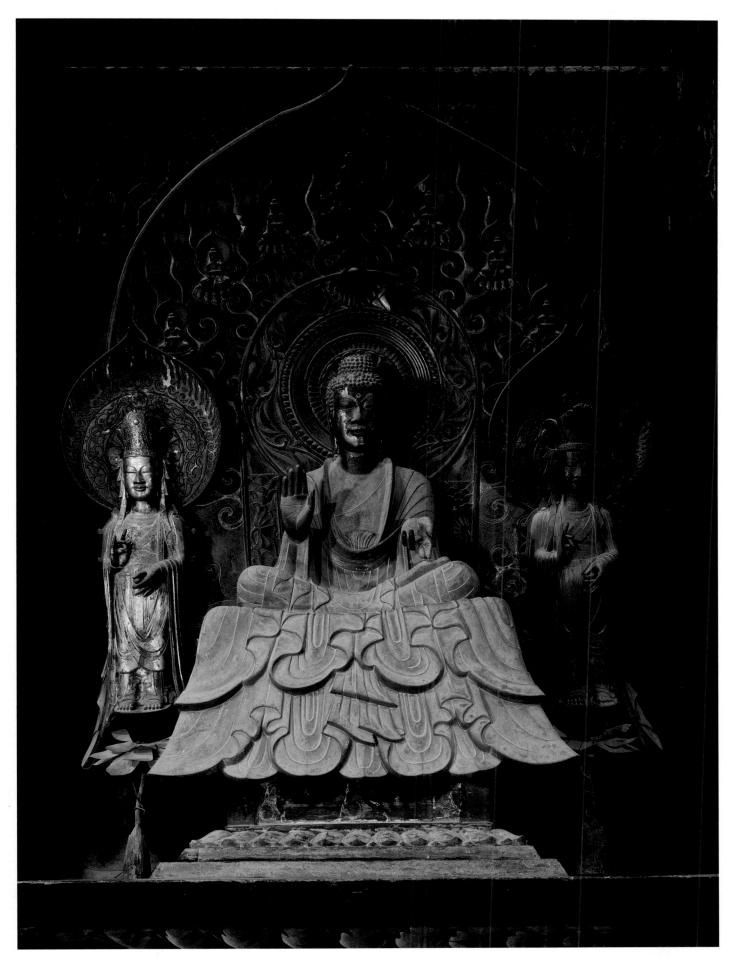

8-6 TORI BUSSHI, Shaka triad, Horyuji kondo, Nara, Japan, Asuka period, 623. Bronze, 5′ 9$\frac{1}{2}$″ high.

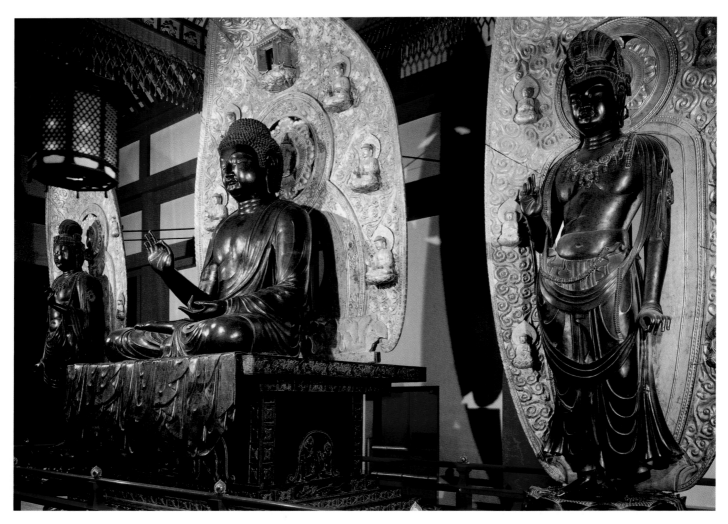

8-7 Yakushi triad, Yakushiji kondo, Nara, Japan, Hakuho period, late seventh or early eighth century. Bronze, central figure 8′ 4″ high.

(Bhaisajyaguru, the Healing Buddha) triad (FIG. **8-7**) in the kondo at the Yakushiji temple of the late seventh century in Nara, the sculptor favored greater anatomical definition and shape-revealing drapery over the dramatic stylizations of the Horyuji statues. The attendant bodhisattvas, especially, reveal the long stylistic trail back through China (see FIG. 7-13) to the sensuous fleshiness of Indian sculpture (see FIG. 6-15). The dark, lustrous surface of the statues—caused by the unusual composition of the cast bronze—makes the figures stand out strikingly from their golden mandorlas.

THE PAINTED WALLS OF HORYUJI Until a disastrous fire in 1949, the interior walls of the Golden Hall at Horyuji preserved some of the finest examples of Buddhist wall painting in eastern Asia, executed around 710, the beginning of the Nara period. The only record of them consists of color photographs. The most important paintings depicted the Buddhas of the four directions. Like the others, Amitabha (Amida in Japanese), the Buddha of the West (FIG. **8-8**), sits enthroned in his Pure Land, attended by bodhisattvas. The exclusive worship of Amida later became a major trend in Japanese Buddhism, and much grander depictions of his paradise appeared, resembling that at Dunhuang in China (see FIG. 7-14). Here, however, the representation is

simple and iconic. Although executed on a dry wall, the painting process involved familiar fresco techniques, such as transferring designs from paper to wall by punching holes in the paper and pushing colored powder through the perforations. As with the Buddha triad at Yakushiji, the mature Tang style, with its echoes of Indian sensuality, survives in this work. The fluid brush lines, thoroughly east Asian, give the figures their substance and life. Such lines belong to a particular type, often seen in Buddhist painting, termed *iron wire* because they are thin and unmodulated with a suggestion of tensile strength. Also, as in many other Buddhist paintings, the lines are red instead of black. The identity of the painters of these pictures is unknown, but some scholars have suggested they were Chinese or Korean rather than Japanese.

THE COSMIC BUDDHA AND THE EMPEROR
During the Nara period, the imperial court sponsored the construction in Nara of the largest wooden building in the world, the Golden Hall at the Todaiji temple, later destroyed and significantly altered in rebuilding. Also known as the Great Buddha Hall, it housed a fifty-three-foot bronze image of the Cosmic Buddha, Vairocana (Roshana in Japanese), inspired by colossal stone statues of this type in China (see FIG. 7-12). However, Todaiji and its Buddha played a special role

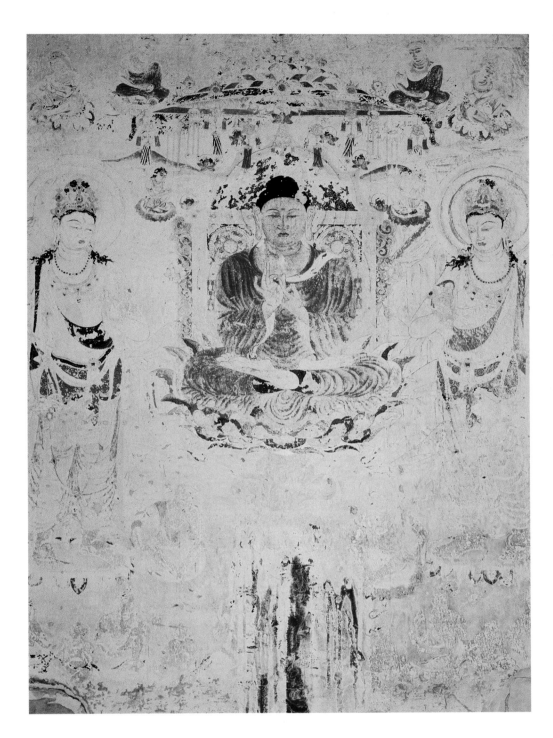

8-8 Amida triad, wall painting (damaged), from Horyuji kondo, Nara, Japan, Hakuho period, ca. 710. Ink and colors, 10′ 3″ × 8′ 6″. Horyuji Treasure House, Nara.

at this juncture in Japanese history. Todaiji was closely linked to the authority of the Japanese imperial throne, and its construction even required signs of the blessing of the Shinto sun goddess, the imperial family's mythical ancestor. The temple served as the administrative center of a network of branch temples built in every province, and the Cosmic Buddha functioned as ideologically similar to the emperor. The consolidation of imperial authority and thorough penetration of Buddhism throughout the country thus went hand in hand. The treasures donated to Todaiji serve today as almost a museum of eighth-century pan-Asian culture. Many of the temple's sculptures are Japanese examples of the finest Tang Chinese art forms.

Heian Period (794–1185)

In 794, possibly to escape the power of the Buddhist priests in Nara, the imperial house moved its capital north to what became its home until modern times. Originally called Heian, it is known today as Kyoto, still one of the great cities of the world for art and culture. In the early Heian period, Japan maintained fairly close ties with China, but from the middle of the ninth century on, relations between Japan and China deteriorated so rapidly that, by that century's end, court-sponsored contacts had ceased. Although never actually isolated, Japanese culture, especially at court, turned much more inward than it had in the preceding few centuries.

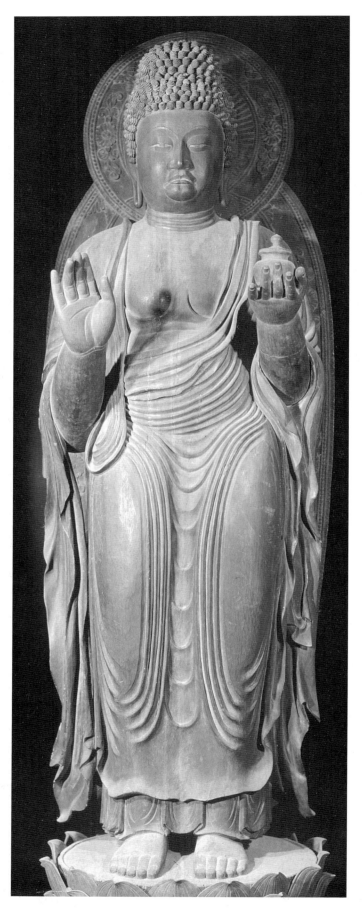

8-9 Standing Yakushi, Jingoji, Kyoto, Japan, Early Heian period, ca. 793. Cypress wood with traces of paint, 5′ 7″ high.

THE CYPRESS BUDDHA OF JINGOJI Distinctive Buddhist images, such as the standing Yakushi (FIG. **8-9**) at the Jingoji temple in Kyoto, survive from the early Heian period. The sculptor carved the statue from a single block of cypress wood, except for the protruding appendages. After the ninth century, artists fashioned large statues from multiple blocks joined together. The second method made carving easier and lessened the dangers of cracking. The Jingoji statue, with stylized drapery folds delineating its massive volumes, reveals a retreat from the naturalism of the eighth century. However, the figure maintains some of the sensuality of the late-seventh- and eighth-century statues to complement its heavy dignity. The narrow, even drapery folds define the swelling forms of the chest, stomach, and thighs. Full lids, nose, and lips lend a sensual gravity to the face.

THE FLOATING PHOENIX HALL OF UJI In the early Heian period, Japanese monks traveled to China and brought back the teachings of various Buddhist sects, especially the Esoteric ones. Esoteric Buddhism embraced a great number of deities, including figures adapted from Hinduism (see "Hinduism and Hindu Iconography," Chapter 6, page 173), Buddhas, and bodhisattvas. Esoteric teachings emphasized rigorous training and study to attain advancement toward enlightenment in this life. However, during the Heian period, belief in the vow of Amida, the Buddha of the West, to save believers through rebirth in his Pure Land also gained great prominence among the Japanese aristocracy. The most important surviving monument in Japan related to Pure Land beliefs is the Phoenix Hall of the Byodoin (FIG. **8-10**), a temple built for Fujiwara Yorimichi (r. 990–1074) on the grounds of his summer villa at Uji. Dedicated in 1053, the Phoenix Hall houses a wooden statue of Amida carved from multiple joined blocks, the dominant approach to wooden sculpture by this time. The building's elaborate winged form evokes images of the Buddha's palace in his Pure Land, as depicted in east Asian paintings (see FIG. 7-14) based on the design of great Chinese palaces. By placing only light pillars on the exterior, elevating the wings, and situating the whole on a reflective pond, the Phoenix Hall builders suggested the floating weightlessness of a celestial architecture. The building's name derives from its overall birdlike shape and from two bronze phoenixes decorating the ridgepole ends. In eastern Asia, these birds were not symbols of rebirth, as in the West, but instead represented imperial might, sometimes associated especially with the empress. The Fujiwara family's authority derived primarily from the marriage of daughters to the imperial line.

TALE OF GENJI Japan's most admired literary classic is *Tale of Genji* (see "Japanese Literature and Court Culture," page 225). Artists probably began producing illustrated copies of this novel soon after its writing in the early eleventh century, but the oldest extant examples are fragments from a deluxe set of early-twelfth-century handscrolls. From textual and physical evidence, scholars have suggested the set originally consisted of about ten handscrolls produced by about five teams of artisans. Each team consisted of a nobleman talented in calligraphy, a chief painter, and assistants. The script is primarily *hiragana,* a sound-based

ART AND SOCIETY

Japanese Literature and Court Culture

During the Nara and Heian periods (710–1185), the Japanese imperial court developed as the center of an elite culture. Both men and women produced literature, paintings, calligraphy, and decorative arts critics generally consider "classical" today. Heian court members, especially those from the great Fujiwara clan dominating the court for a century and a half, compiled the first great anthologies of Japanese poetry and wrote Japan's most influential secular prose.

Japanese poetry and related painting and decorative art emphasize human sentiments intertwined with responses to nature, seasonality, and a body of standard metaphors and symbols. For example, the full moon, flying geese, crying deer, and certain plants symbolize autumn, which in turn evokes somber emotions, fading love, and dying. Such concrete but evocative images frequently appear in paintings.

Even in secular prose, the characters generally speak in poetic form. Exchanging poems was a common Japanese social practice and a frequent preoccupation of lovers.

A lady-in-waiting to an early-eleventh-century empress wrote the best-known and longest-admired work of literature in Japan, *Tale of Genji*. Known as Lady Murasaki, the author is one of many important Heian women writers, including especially diarists and poets. Generally considered the world's oldest full novel, *Tale of Genji* tells of the life and loves of Prince Genji and, after his death, of his heirs. The novel and much of Japanese literature consistently display a sensitivity to the sadness in the world caused by the transience of love and life. Illustrated scrolls of *Tale of Genji* (FIG. 8-11) rely on key poetic motifs and careful compositions to convey such feelings.

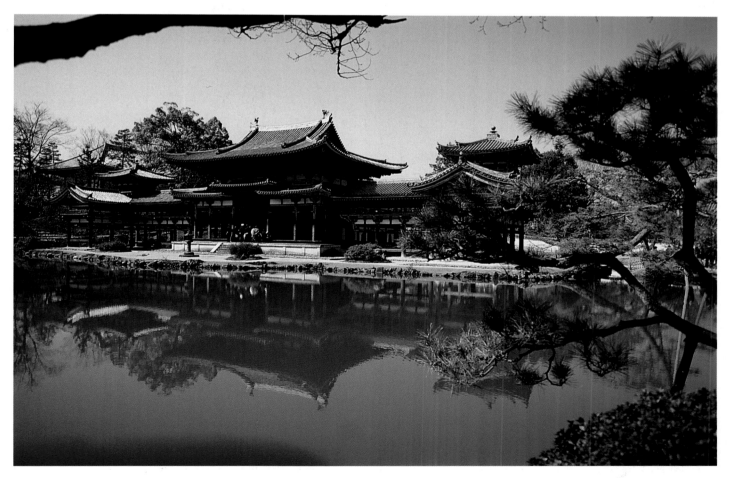

8-10 Phoenix Hall, Byodoin, Uji, Japan, Heian period, 1053.

8-11 Scene from Minori chapter, *Tale of Genji*, late Heian period, first half of twelfth century. Handscroll, ink and color on paper, $8\frac{5}{8}''$ high. Goto Art Museum, Tokyo.

writing system developed in Japan from Chinese characters. Hiragana originally served the needs of women, who were not taught Chinese, but it became the primary script for Japanese court poetry. In these handscrolls, pictures alternate with text, as in Gu Kaizhi's *Admonitions* scrolls (see FIG. 7-9). However, the Japanese work focuses on emotionally charged moments in personal relationships, rather than lessons in exemplary behavior. In the scene illustrated here (FIG. **8-11**), for example, Genji meets with his greatest love, Murasaki (the name given to the novel's otherwise anonymous author), near the time of her death. The bush-clover in the garden identifies the season as Autumn, the season associated with the fading of life and love.

8-12 Detail of The Flying Storehouse, from *The Legends of Mount Shigi*, late Heian period, late twelfth century. Handscroll, ink and colors on paper, $1'\frac{1}{2}''$ high. Chogosonshiji, Nara.

Here, a radically upturned ground plane and strong diagonal lines primarily convey the suggestive, rather than illusionistic, spatial representation. Although this implies an elevated viewpoint, the painter omitted roofs and ceilings to allow a privileged view of the emotionally charged moments typically represented in the interiors. Artists typically represented such moments in the interiors. Flat fields of unshaded color emphasize the painting's two-dimensional character, but rich patterns in the textiles and architectural ornament give a feeling of sumptuousness. The human figures appear constructed of stiff layers of contrasting fabrics, and the artist simplified and generalized the aristocratic faces, using a technique called "line for eye and hook for nose." This lack of individualization may reflect societal restrictions on looking directly on exalted persons, or it may have served to ease viewers' identification with a character in the story. Heian aristocrats tended to participate quite actively in painting and poetry composition, and it is easy to imagine an illustration moving a court member to take on a character's role and write a suitable poem. Several formal features of the *Genji* illustrations—native subjects, bright mineral pigments, lack of emphasis on strong brushwork, and general flatness—were later considered typical of *yamato-e* (native-style painting). In the early Heian period before this example was made, however, yamato-e probably referred only to subject matter.

THE LEGENDS OF MOUNT SHIGI Painted at the end of the Heian period, *The Legends of Mount Shigi* (FIG. **8-12**) represents a different facet of narrative handscroll painting. The stories belong to a genre of pious Buddhist tales devoted to miraculous events involving saintly individuals. Unlike the *Genji* scrolls, short segments of text and pictures do not alternate. Instead, the painters took advantage of the scroll format to present several scenes in a long stretch of unbroken setting. For example, the first scroll shows the same travelers at several stages of their journey through a continuous landscape. This sort of pictorial narration does not survive in China, if it ever existed there.

The *Mount Shigi* scrolls illustrate three miracles associated with a Buddhist monk named Myoren. The first relates the story of the flying storehouse and depicts Myoren's begging bowl lifting the rice-filled storehouse of a wealthy landowner and carrying it off to the monk's hut in the mountains (FIG. 8-12). The painter depicted the gaping landowner, his attendants, and several onlookers in various poses—some grimacing, others gesticulating wildly and scurrying about in frantic astonishment. The artist exaggerated each feature of the painted figures, in striking contrast to the *Genji* scroll figures. In handscroll paintings, only the lower classes generally displayed their feelings or became subjects of humorous caricature.

Kamakura Period (1185–1332)

In the late twelfth century, a series of civil wars between rival warrior families led to the Japanese imperial court's end as a major political and social force. The victors, headed by the Minamoto family, established their *shogunate* (military government) at Kamakura. The imperial court remained in Kyoto as the theoretical source of political authority but without actual power. During the Kamakura period, more frequent and positive contact with China brought with it an appreciation for more recent cultural developments there, ranging from new architectural styles to Zen Buddhism.

A MOVING PORTRAIT OF AN AGED PRIEST Rebuilding in Nara, necessitated by the destructive battles that helped bring the Minamoto to power, presented an early opportunity for architectural experimentation. A leading figure in planning and directing the reconstruction efforts was the priest Shunjobo Chogen (1121–1206), who had made three trips to China between 1166 and 1176. After learning about contemporary Chinese architecture, he oversaw the rebuilding of Todaiji and associated projects under the Minamoto's patronage. His portrait statue (FIG. **8-13**) is one of the most striking examples of the high level of naturalism prevalent in the early Kamakura period. Characterized by finely painted details, a powerful rendering of aging signs, and the inclusion of such personal attributes as prayer beads, the statue of Chogen exhibits the carving skill and style of the Kei school of sculptors (see "Japanese Artists, Workshops, and Patrons," page 228). The Kei school traced its lineage to a famous sculptor of the mid-eleventh century. Its works display fine Heian carving techniques combined with an increased concern for natural volume and detail learned from studying surviving Nara period works and works imported from Song China.

8-13 The priest Shunjobo Chogen, Todaiji, Nara, Japan, Kamakura period, early thirteenth century. Painted cypress wood, 2′ 8⅜″ high.

ART AND SOCIETY

Japanese Artists, Workshops, and Patrons

Until recent times, hierarchically organized male workshops produced most Japanese art. For large projects, some clients assigned an intermediary to oversee the work. Until the late Heian period, major commissions came almost exclusively from the imperial court or the great temples. As warrior families began to gain wealth and power, they, too, extended great commissions—in many cases closely following the aristocrats' precedents in subject and style.

Family-run workshops often created works such as the portrait statue of Chogen (FIG. 8-13), as well as paintings and most other art forms. Many of the master's main assistants and apprentices were relatives. Outsiders of considerable skill sometimes joined workshops, often through marriage. The eldest son most often inherited the master's position, after rigorous training in the necessary skills from a very young age. Therefore, one meaning of the term "school of art" in Japan is a network of workshops tracing their origins back to the same master, a kind of artistic clan. Inside the workshops, the master and senior assistants handled the most important production stages, but those of lower rank helped with the more routine work.

By the Heian period, artists organized in official court bureaus at the imperial palace also cooperated in producing artworks. The most famous of these bureaus created paintings.

Teams of court painters, led by the bureau director, produced pictures such as the scenes in the *Tale of Genji* handscrolls (FIG. 8-11). This system remained vital into the Kamakura period and well beyond. Under the direction of a patron or the patron's representative, the master painter laid out the picture by brushing in the initial outlines and contours. Under his direction, more junior painters applied the colors. Then the master completed the picture by brushing in fresh contours and details such as facial features. Very junior assistants and apprentices assisted in the process by preparing paper, ink, and pigments. Unlike mastership in hereditarily run workshops, competition among several families determined control of the Court Painting Bureau during the Heian and Kamakura periods.

Not all paintings at court came from the Painting Bureau. One aristocratic family of modest court rank became famous for its portraits. Amateur painting was also common among aristocrats of all ranks. As in poetry composition and calligraphy, aristocrats frequently held elegant competitions in painting. Such activities involved both women and men. In fact, court ladies probably played a significant role in developing the painting style seen in the *Genji* scrolls, and a few participated in public projects.

THE BURNING OF THE SANJO PALACE All the painting types flourishing in the Heian period continued to prosper in the Kamakura period. A striking example of narrative handscroll painting is *The Burning of the Sanjo Palace* (FIG. **8-14**), a fragment of a work illustrating some of the battles in the civil wars at the end of the Heian period. Here, viewers see the drama unfold in swift and violent staccato brushwork and vivid flashes of color. At the beginning of the scroll (read from right to left), the eyes focus first on a mass of figures rushing toward a blazing building (not shown here)—

8-14 Detail of *The Burning of the Sanjo Palace,* Kamakura period, thirteenth century. Handscroll, ink and colors on paper, 1′ 4¼″ high; complete scroll, 22′ 10″ long. Museum of Fine Arts, Boston (Fenollosa-Weld Collection).

8-15 *Amida Descending over the Mountains*, Kamakura period, thirteenth century. Hanging scroll, ink and colors on silk, 4′ 3⅛″ × 3′ 10½″. Zenrinji, Kyoto.

the painting's crescendo—and then move at a slowed pace through swarms of soldiers, horses, and bullock carts. Finally, a warrior on a rearing horse arrests viewers' gaze. The horse and rider, however, serve as a "deceptive cadence" (false ending). They are merely a prelude to the single figure of an archer, who picks up and completes the soldiers' mass movement, drawing the turbulent narrative to a quiet close.

AMIDA DESCENDS TO SAVE THE DEAD Buddhism and Buddhist painting remained vital in the Kamakura period. Evangelical monks spread Pure Land beliefs throughout Japan to people from all levels of society, and new Pure Land sects emerged that the lower ranks of society, including peasants, found especially appealing. But elite patrons continued to commission major Pure Land artworks. Pure Land beliefs in Japan stressed the grace of Amida, who, if called on, hastened to believers at the moment of death and conveyed their souls to his Pure Land. Pictures of this scene often hung in the presence of a dying person, who recited Amida's name to insure salvation.

One dramatic version of the scene, which scholars call the "speedy descent," depicts Amida and his host rushing on clouds down a mountainside. The composition provides a powerful image of Amida's dedication to humanity's salvation. In the less dramatic but equally powerful *Amida Descending over the Mountains* (FIG. **8-15**), a gigantic Amida appears to move directly toward viewers. His two main attendant bodhisattvas already made the passage. The grand frontal presen-

tation of Amida gives the painting an iconic quality even as the bodhisattvas' movement maintains the narrative of his descent. Particularly striking in this painting is the way in which Amida's halo resembles a rising moon, an image long admired in Japan for its spiritual beauty.

Striking transformations mark the long history of Japanese art as the country's population received, responded to, and developed new forms and ideas from continental eastern Asia. Early metalwork, Buddhist architecture, and the basic painting formats and media, to name only a few examples, readily reveal Japan's close ties to the continent. However, from earliest times, Japan maintained distinctive aesthetic ideals and preferences. For instance, the dynamic forms of Jomon pottery and haniwa figures suggest the early Japanese derived a deep pleasure from allowing the colors and textures of their raw materials to remain vital in the final objects. This tendency may not have been exclusive to Japanese art and certainly did not dominate in later centuries, but it did remain a vital part of Japan's aesthetic heritage, helping determine what people accepted from the continent and how they adapted it. In the end, however, the most distinctive feature of Japanese art is its great variety. This reflects the people's capacity to embrace radically different aesthetics simultaneously, appreciating their separate contributions to a richly diverse material culture. Chapter 27 shows how this cultural flexibility continued after several decades of upheaval, the Kamakura rulers' downfall in the early fourteenth century (1332), and the establishment of a new shogunate by the end of the century.

ITALY IN ETRUSCAN TIMES

N

Po R.
Villanova
TUSCANY
Florence
Arno R.
Arezzo
L. Trasimene
Chiusi
Perugia
Tiber R.
Vulci
Tarquinia
Veii
Cerveteri
Rome
Palestrina

Corsica

ITALY

Adriatic Sea

Cumae
Paestum

Sardinia

Tyrrhenian Sea

Ionian Sea

GREECE

Mediterranean Sea

Sicily

Syracuse

0 100 200 miles
0 100 200 kilometers

900 B.C.	700 B.C.	600 B.C.	480 B.C.
VILLANOVAN	ORIENTALIZING	ARCHAIC	CLASSICAL

*Regolini-Galassi fibula
Cerveteri, ca. 650–640 B.C.*

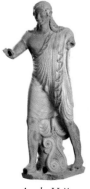

*Apulu, Veii
ca. 510–500 B.C.*

*Tomb of the Leopards
Tarquinia, ca. 480–470 B.C.*

Greek colonization of southern Italy and Sicily
begins, mid-eighth century B.C.

Founding of Rome, 753 B.C.

Tarquinius Priscus, first
Etruscan king of Rome, 616 B.C.

Expulsion of Etruscan
kings from Rome, 509 B.C.

Etruscan naval defeat
by the Greeks at
Cumae, 474 B.C.

ITALY BEFORE THE ROMANS

THE ART OF THE ETRUSCANS

323 B.C. 89 B.C.

HELLENISTIC

Ficoroni Cista
late fourth century B.C.

Tomb of the Reliefs
Cerveteri, third century B.C.

Porta Marzia
Perugia, second century B.C.

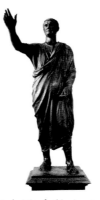

Aule Metele (Arringatore)
early first century B.C.

Destruction of Veii by the Romans, 396 B.C.

Peace between Rome and Tarquinia, 351 B.C.

Roman conquest of Cerveteri, 273 B.C.

Social War and completion of Romanization of Italy, 89 B.C.

WHO WERE THE ETRUSCANS?

"The Etruscans, as everyone knows, were the people who occupied the middle of Italy in early Roman days, and whom the Romans, in their usual neighbourly fashion, wiped out entirely." So opens D. H. Lawrence's witty and sensitive *Etruscan Places* (1929), one of the earliest modern essays that highly values Etruscan art and treats it as much more than a debased form of the art of the contemporary city-states of Greece and southern Italy. ("Most people despise everything B.C. that isn't Greek, for the good reason that it ought to be Greek if it isn't," Lawrence goes on to say!) Today it is no longer necessary to argue the importance and originality of Etruscan art. Deeply influenced by, yet different from, Greek art, Etruscan sculpture, painting, and architecture not only provided the models for early Roman art and architecture but also had an impact on the art of the Greek colonies in Italy.

The heartland of the Etruscans was the territory between the Arno and Tiber Rivers of central Italy. The lush green hills still bear their name—Tuscany, the land of the people the Romans called *Tusci,* the region centered on Florence, birthplace of Renaissance art. So do the blue waters that splash up against the Italian peninsula's western coastline, for the Greeks referred to the Etruscans as *Tyrrhenians* and gave their name to the sea off Tuscany. The origin of the Tusci people—the enduring "mystery of the Etruscans"—is, however, not clear at all. Their language, although written in a Greek-derived script and extant in inscriptions that are still in large part obscure, is unrelated to the Indo-European linguistic family. Ancient historians, as fascinated by the puzzle as are modern scholars, generally felt that the Etruscans emigrated from the east. Herodotus specifically declared that they came from Lydia in Asia Minor and were led by King Tyrsenos—hence their Greek name. But Dionysius of Halicarnassus, a Greek author of the end of the first century B.C., maintained that the Tusci were native Italians. And some modern researchers have theorized that the Etruscans came into Italy from the north.

All of these theories are current today, and no doubt some truth exists in all of them. The Etruscan people of historical times were very likely the result of a gradual fusion of native and immigrant populations. This mixing of peoples occurred between the end of the Bronze Age and the so-called Villanovan era (named after an important northern Italian site and comparable to the Geometric period in Greece). At that time the Etruscans emerged as a people with a culture related to but distinct from those of other Italic peoples and from the civilizations of Greece and the Orient.

During the eighth and seventh centuries B.C., the Etruscans, as highly skilled seafarers, enriched themselves through trade abroad. By the sixth century B.C., they controlled most of northern and central Italy from such strongholds as Tarquinia (ancient Tarquinii), Cerveteri (Caere), Vulci, and Veii. But these cities never united to form a state, so it is improper to speak of an Etruscan "nation" or "kingdom," only of *Etruria,* the territory occupied by the Etruscans. The cities coexisted, flourishing or fading independently. Any semblance of unity among them was based primarily on common linguistic ties and religious beliefs and practices. This lack of political cohesion eventually made the Etruscans relatively easy prey for Lawrence's Roman aggressors.

EARLY ETRUSCAN ART

Orientalizing Art

The great mineral wealth of Etruria—iron, tin, copper, and silver were all successfully mined in antiquity—transformed Etruscan society during the seventh century B.C. The modest Villanovan villages and their agriculturally based economies gave way to prosperous cities engaged in international commerce. Cities such as Cerveteri, blessed with rich mines, could acquire foreign goods, and Etruscan aristocrats quickly developed a taste for luxury items incorporating Eastern motifs. To satisfy the demand, local artisans, inspired by imported goods, produced magnificent items for both homes and tombs. As in Greece at the same time, art historians speak of an Orientalizing period of Etruscan art followed by an Archaic period. And, as in Greece, the local products cannot be mistaken for the foreign models.

A BEJEWELED WOMAN'S TOMB About the middle of the seventh century B.C., a wealthy Etruscan family stocked the so-called Regolini-Galassi Tomb (named for its excavators) at Cerveteri with bronze cauldrons and gold jewelry of Etruscan manufacture and Orientalizing style. The most spectacular of the many luxurious objects in the tomb is a golden *fibula* (clasp or safety pin; FIG. **9-1**) of unique shape used to fasten a woman's gown at the shoulder. The giant fibula is in the Italic tradition, but the five lions that walk across the gold surface were borrowed from the Orient. The technique, also emulating Eastern imports, is masterful, combining hammered relief *(repoussé)* and *granulation* (the fusing of tiny metal balls, or *granules,* to a metal surface). The Regolini-Galassi fibula equals or exceeds in quality anything that might have served as a model.

The jewelry from the Regolini-Galassi Tomb also includes a golden *pectoral* that covered the deceased woman's chest and two gold circlets that may be earrings, although they are large enough to be bracelets. Such a taste for ostentatious display is frequently the hallmark of newly acquired wealth, and this was certainly the case in seventh-century Etruria.

Archaic Art and Architecture

TEMPLES FOR THE ETRUSCAN GODS Etruscan artists looking eastward for inspiration were also greatly impressed by the art and architecture of Greece. But however eager they may have been to emulate Greek works, the distinctive Etruscan temperament always manifested itself. The vast majority of Archaic Etruscan artworks depart markedly from their prototypes. This is especially true of religious architecture, where the design of Etruscan temples superficially owes much to Greece but where the differences far outweigh the similarities. Because of the materials Etruscan architects employed, usually only the foundations of Etruscan temples have survived. These are nonetheless sufficient to reveal the plans of the edifices, and the archeological record is supplemented by the Roman architect Vitruvius's account of Etruscan temple design in his treatise on classical architecture written near the end of the first century B.C.

9-1 Fibula with Orientalizing lions, from the Regolini-Galassi Tomb, Cerveteri, Italy, ca. 650–640 B.C. Gold, approx. 1′ $\frac{1}{2}$″ high. Vatican Museums, Rome.

RELIGION AND MYTHOLOGY

Etruscan Counterparts of Greco-Roman Gods and Heroes

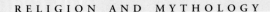

Etruscan	Greek	Roman
Tinia	Zeus	Jupiter
Uni	Hera	Juno
Menrva	Athena	Minerva
Apulu	Apollo	Apollo
Artumes	Artemis	Diana
Hercle	Herakles	Hercules

The typical Archaic Etruscan temple (FIG. **9-2**) resembles the Greek gable-roofed temple, but it was constructed not of stone but of wood and sun-dried brick with terracotta decoration. Entrance was possible only via a narrow staircase at the center of the front of the temple, which sat on a high podium. Columns also were restricted to the building's front, creating a deep porch that occupied roughly half of the podium, setting off one side of the structure as the main side. This was contrary to Greek practice, where the temple's front and rear were indistinguishable and where steps accompanied the peripteral colonnades on all sides. (It is also one of the important features of Etruscan temple design the Romans retained; see Chapter 10.) The Etruscan temple was not meant to be seen as a sculptural mass from the outside and from all directions, as the Greek temple was, but instead was intended to function primarily as an ornate home for grand statues of Etruscan gods. It was a place of shelter, protected by its roof's wide overhang.

Etruscan temples differed in other ways from those of Greece. Etruscan (or *Tuscan*) columns resembled Greek Doric columns, but they were made of wood, were unfluted, and had bases. Because of the lightness of the superstructure they had to support, Etruscan columns were, as a rule, much more widely spaced than Greek columns. Unlike their Greek counterparts, Etruscan temples frequently had three cellas—one

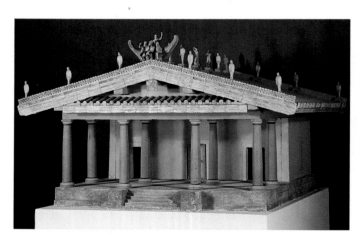

9-2 Model of a typical Etruscan temple of the sixth century B.C., as described by Vitruvius. Istituto di Etruscologia e di Antichità Italiche, Università di Roma, Rome.

9-3 Apulu (Apollo), from the roof of the Portonaccio Temple, Veii, Italy, ca. 510–500 B.C. Painted terracotta, approx. 5′ 11″ high. Museo Nazionale di Villa Giulia, Rome.

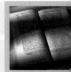

Etruscan Artists in Rome

In 616 B.C., according to the traditional chronology, Tarquinius Priscus of Tarquinia became Rome's first Etruscan king. He ruled for almost forty years. His grandson, Tarquinius Superbus ("the Arrogant"), was Rome's last king, driven out in 509 B.C. by Romans outraged by his tyrannical behavior. Before his expulsion, however, Tarquinius Superbus embarked on a grand program to embellish the modest city of huts Romulus had presided over two centuries before.

The king's most ambitious undertaking was the erection of a magnificent temple on the Capitoline Hill for the joint worship of Jupiter, Juno, and Minerva. For this great commission, he summoned architects, sculptors, and workers from all over Etruria. Rome's first great religious shrine was Etruscan in patronage, in manufacture, and in form. The architect's name is unknown, but several sources preserve the identity of the Etruscan sculptor brought in to adorn the temple. His name was Vulca of Veii. Pliny the Elder describes his works as "the finest images of deities of that era . . . more admired than gold."[1] The Romans entrusted Vulca with making the statue of Jupiter that stood in the central of the Capitoline temple's three cellas. He also fashioned the enormous terracotta statuary group of Jupiter in a four-horse chariot placed on the temple's roof at the highest point directly over the facade's center. The fame of Vulca's red-faced (painted terracotta) portrayal of Jupiter was so great that Roman generals would paint their faces red in emulation of his Jupiter when they paraded in triumph through Rome after a battlefield victory. (One can get an approximate idea of the appearance of this early Jupiter temple and of Vulca's roof statue from the model reproduced in FIG. 9-2.)

One story told about Vulca's chariot group underscores both its tremendous size and the reverent awe later generations held for it. Terracotta statuary normally condenses and contracts in the furnace as the clay's moisture evaporates in the heating process. Vulca's statue swelled instead, and it only could be removed from the furnace by dismantling its walls and lifting off its roof.[2]

Vulca is the only Etruscan artist named by any ancient writer, but the signatures of other Etruscan artists appear on surviving artworks. One of these is Novios Plautios, who also worked in Rome, although a few centuries later (see FIG. 9-12). By then the Etruscan kings of Rome were a distant memory and the Romans had captured Veii and annexed its territory.

[1] Pliny, *Natural History,* 35.157.
[2] Plutarch, *Life of Poplicola,* 13.

for each of their chief gods, Tinia, Uni, and Menrva (see "Etruscan Counterparts of Greco-Roman Gods and Heroes," page 234). And pedimental statuary was exceedingly rare in Etruria. Narrative statuary—in terracotta instead of stone—normally was placed on the peaks of Etruscan temple roofs.

AN EPIC CONTEST ON A ROOFTOP The finest of these rooftop statues to survive today is the life-size image of Apulu (FIG. **9-3**), a brilliant example of the energy and excitement that characterizes Archaic Etruscan art in general. The statue comes from a temple in the Portonaccio sanctuary at Veii. It is but one of a group of at least four painted terracotta figures that adorned the top of the temple's roof. The god confronts Hercle for possession of the Ceryneian hind, a wondrous beast with golden horns that was sacred to Apulu's sister Artumes. The bright paint and the rippling folds of Apulu's garment call to mind the Ionian korai of the Acropolis (see FIG. 5-12). But this vital figure's extraordinary force, huge swelling contours, plunging motion, gesticulating arms, fanlike calf muscles, and animated face are distinctly Etruscan. Some scholars have attributed the Apulu to VULCA OF VEII, the most famous Etruscan sculptor of the time (see "Etruscan Artists in Rome," above). The statue's discovery in 1916 was instrumental in prompting a reevaluation of the originality of Etruscan art.

DINING IN THE AFTERLIFE Although life-size terracotta statuary was known in Greece, this medium was especially favored in Etruria. Another magnificent example of Archaic Etruscan terracotta sculpture is the sarcophagus in the form of a husband and wife reclining on a banqueting couch (FIG. **9-4**) from a tomb in the Cerveteri necropolis. The work was cast in four sections and then joined. It had no parallel in Greece, which, at this date, had no monumental tombs to house such sarcophagi. The Greeks buried their dead in simple graves marked by a stele or a statue. Moreover, although banquets were commonly depicted on Greek vases (which, by the late sixth century B.C., the Etruscans imported in great quantities and regularly deposited in their tombs), only men dined at Greek symposia. The image of a husband and wife sharing the same banqueting couch is uniquely Etruscan (see "The 'Audacity' of Etruscan Women," page 236).

The man and woman on the Cerveteri sarcophagus are as animated as the Apulu of Veii (FIG. 9-3), even though they are at rest. They are the antithesis of the stiff and formal figures encountered in Egyptian tomb sculptures (compare the portraits of Menkaure and Khamerernebty from Gizeh, FIG. 3-13). Also typically Etruscan, and in striking contrast to contemporary Greek statues with their emphasis on proportion and balance, is how the Cerveteri sculptor rendered the upper and lower parts of each body. The legs were only summarily modeled, and the transition to the torso at the waist is

The "Audacity" of Etruscan Women

At the instigation of the emperor Augustus at the end of the first century B.C., Titus Livy wrote a history of Rome from its legendary founding in 753 B.C. to his own day. In the first book of his great work, Livy recounted the tale of Tullia, daughter of Servius Tullius, an Etruscan king of Rome in the sixth century B.C. The princess had married the less ambitious of two brothers of the royal Tarquinius family, while her sister had married the bolder of the two princes. Together, Tullia and her brother-in-law, Tarquinius Superbus, arranged for the murder of their spouses. They then married each other and plotted the overthrow and death of Tullia's father. After the king's murder, Tullia ostentatiously drove her carriage over her father's corpse, spraying herself with his blood. (The Roman road where the evil deed occurred is still called the Street of Infamy.) Livy, while condemning Tullia's actions, nonetheless placed them in the context of the famous "audacity" of Etruscan women.

The independent spirit and relative freedom women enjoyed in Etruscan society similarly horrified (and threatened) other Greco-Roman male authors. The stories the fourth-century B.C. Greek historian Theopompus heard about the debauchery of Etruscan women appalled him. Etruscan women epitomized immorality for Theopompus, but much of what he reported is untrue. Etruscan women did not, for example, exercise naked alongside Etruscan men. But archeological evidence confirms the accuracy of at least one of his "slurs": Etruscan women did attend banquets and recline with their husbands on a common couch (FIGS. 9-4 and 9-8). Aristotle also remarked on this custom. It was so foreign to the Greeks that it both shocked and frightened them. Only men, boys, slave girls, and prostitutes attended Greek symposia. The wives remained at home, excluded from most aspects of public life. In Etruscan Italy, in striking contrast to contemporary Greece, women also regularly attended sporting events with men. This, too, is well documented in paintings and reliefs.

Etruscan inscriptions also reflect the higher status of women in Etruria than in Greece. They often give the names of both the father and mother of the person commemorated (FIG. 9-15), a practice unheard of in Greece (witness the grave stele of "Hegeso, daughter of Proxenos," FIG. 5-55). Etruscan women, moreover, retained their own names and could legally own property independent of their husbands. The frequent inscriptions on Etruscan mirrors and other toilet items (FIG. 9-12) buried with women seem to attest to a high degree of female literacy as well.

9-4 Sarcophagus with reclining couple, from Cerveteri, Italy, ca. 520 B.C. Painted terracotta, approx. 3′ 9½″ high. Museo Nazionale di Villa Giulia, Rome.

9-5 Aerial view of Banditaccia necropolis, Cerveteri, Italy, seventh to second centuries B.C.

9-6 Plan of the Tomb of the Shields and Chairs, Cerveteri, Italy, second half of the sixth century B.C.

unnatural. The Etruscan artist's interest focused on the upper half of the figures, especially on the vibrant faces and gesticulating arms. Gestures are still an important ingredient of Italian conversation today, and the Cerveteri banqueters and the Veii Apulu speak to viewers in a way Greek statues of similar date, with their closed contours and calm demeanor, never do.

HOUSES FOR THE DEAD The exact findspot of the Cerveteri sarcophagus is not known, but the kind of tomb that housed such sarcophagi is well documented. The typical tomb at Cerveteri and in other Etruscan cemeteries took the form of a mound, or *tumulus* (plural *tumuli;* FIG. 9-5), not unlike the Mycenaean Treasury of Atreus (see FIG. 4-21). But whereas the Mycenaean tholos tomb was constructed of masonry blocks and then covered by an earthen mound, each Etruscan tumulus covered one or more subterranean multi-chambered tombs cut out of the dark local limestone called *tufa*. These burial mounds sometimes reached colossal size with diameters in excess of one hundred and thirty feet. They were arranged in cemeteries in an orderly manner along a network of streets and produced the effect of veritable cities of the dead (which is the literal meaning of the Greek word *necropolis*), always located some distance from the cities of the living.

The underground tomb chambers cut into the rock resembled the houses of the living. In the plan of the sixth-century B.C. Tomb of the Shields and Chairs at Cerveteri (FIG. 9-6), for example, the central entrance and the smaller chambers opening onto a large central space mirror the axial sequence of rooms in actual Etruscan houses of the time. (The plan is also similar to that of early Roman houses, which, like Roman

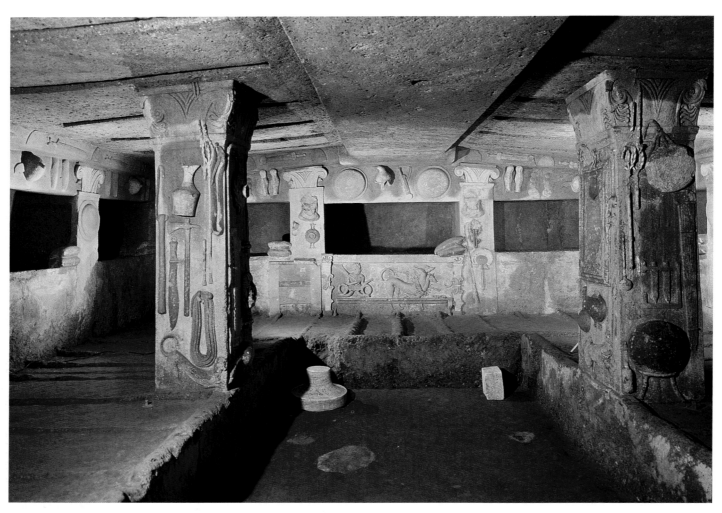

9-7 Interior of the Tomb of the Reliefs, Cerveteri, Italy, third century B.C.

temples, show the deep influence of Etruscan design; see "The Roman House," Chapter 10, page 255.) The effect of a domestic interior was enhanced by cutting out of the rock a series of beds and grand armchairs with curved backs and footstools (clearly visible on the plan), as well as ceiling beams, framed doorways, and even windows. The technique recalls that of the rock-cut Egyptian tombs at Beni Hasan (see FIG. 3-19). One cannot help but notice the very different values of the Etruscans, whose temples no longer stand because they were constructed of wood and mud brick but whose grand subterranean tombs are as permanent as the bedrock itself, versus the Greeks, who employed stone for the shrines of their gods but only rarely built monumental tombs for their dead.

The most elaborate of the Cerveteri underground tombs, in decoration if not in plan, is the so-called Tomb of the Reliefs (FIG. 9-7). Like the much earlier Tomb of the Shields and Chairs, it accommodated several generations of a single family. The walls and piers of this tomb were, as usual, gouged out of the tufa bedrock, but in this instance brightly painted stucco reliefs covered the stone. The stools, mirrors, drinking cups, pitchers, and knives effectively suggest a domestic context, underscoring the connection between Etruscan houses of the dead and those of the living.

A TOMB GUARDED BY PAINTED LEOPARDS
Large underground burial chambers hewn out of the natural

rock were also the norm at Tarquinia. But tumuli do not cover the Tarquinian tombs, and the interiors do not have carvings imitating the appearance of Etruscan houses. In some cases, however, paintings decorate the tomb chamber walls. Painted tombs are statistically rare, the privilege of only the wealthiest Etruscan families. Nevertheless, archeologists have discovered so many at Tarquinia since they began to use periscopes to explore tomb contents from the surface before considering time-consuming and costly excavation that art historians have an almost unbroken record of monumental painting in Etruria from Archaic to Hellenistic times.

A characteristic example dating to the early fifth century B.C. is the Tomb of the Leopards (FIG. 9-8), named for the beasts that guard the painted chamber's interior from their perch within the rear wall pediment. They are reminiscent of the panthers on each side of Medusa in the pediment of the Archaic Greek Temple of Artemis at Corfu (see FIG. 5-15). But mythological figures, whether Greek or Etruscan, are uncommon in Tarquinian murals, and the Tomb of the Leopards has none. Instead, banqueting couples (the men with dark skin, the women with light skin in conformity with the age-old convention) adorn the walls—painted versions of the terracotta sarcophagus from Cerveteri (FIG. 9-4). Pitcher- and cupbearers serve them, and musicians playing double pipes and the seven-stringed lyre entertain them. The banquet takes place in the open air or perhaps in a tent set up for the occasion. In characteristic Etruscan fashion,

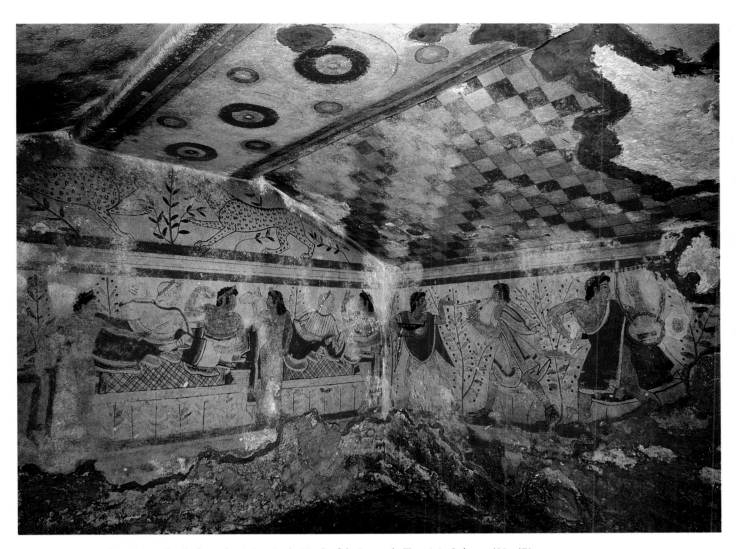

9-8 Banqueters and musicians, detail of mural paintings in the Tomb of the Leopards, Tarquinia, Italy, ca. 480–470 B.C.

the banqueters, servants, and entertainers all make exaggerated gestures with unnaturally enlarged hands. The man on the couch at the far right on the rear wall holds up an egg, the symbol of regeneration. The tone is joyful, a celebration of life, food, wine, music, and dance, rather than a somber contemplation of death.

ETRUSCAN LANDSCAPES In stylistic terms the Etruscan figures are comparable to those on sixth-century Greek vases before Late Archaic painters became preoccupied with the problem of foreshortening. Etruscan painters may be considered somewhat backward in this respect, but in other ways they seem to have outpaced their counterparts in Greece, especially in their interest in rendering nature. In the Tomb of the Leopards, the landscape is but a few trees and shrubs placed between the entertainers (and leopards) and behind the banqueting couches. But elsewhere the natural environment was the chief interest of the Tarquinian painter.

Scenes of Etruscans enjoying the pleasures of nature decorate all the walls of the main chamber of the aptly named Tomb of Hunting and Fishing at Tarquinia. In our detail (FIG. **9-9**), a youth dives off a rocky promontory, while others fish from a boat. On another wall youthful hunters aim their slingshots at brightly painted birds. The scenes of hunting and fishing recall the painted reliefs in the Old Kingdom Egyptian Tomb of Ti (see FIG. 3-16) and the mural paintings from the

New Kingdom Tomb of Nebamun (see FIG. 3-30) and may indicate knowledge of this Egyptian funerary tradition. The multicolored rocks may be compared to those of the Aegean *Spring Fresco* from Thera (see FIG. 4-10), but art historians know of nothing similar in contemporary Greek art save the Tomb of the Diver at Paestum (see FIG. 5-59). The latter is, however, exceptional and from a Greek tomb in *Italy* about a half century *later* than the Tarquinian tomb. In fact, it is likely the Paestum composition emulated older Etruscan designs, undermining the now outdated art historical judgment that Etruscan art was merely derivative and that Etruscan artists never set the standard for Greek artists.

LATER ETRUSCAN ART

The fifth century B.C. was a golden age in Greece but not in Etruria. In 509 B.C., the Romans expelled the last of their Etruscan kings, Tarquinius Superbus (see "Etruscan Artists in Rome," page 235), replacing the monarchy with a republican form of government. In 474 B.C., an alliance of Cumaean Greeks and Hieron I of Syracuse (on Sicily) defeated the Etruscan fleet off Cumae, effectively ending Etruscan dominance of the seas and with it Etruscan prosperity. These events had important consequences in the world of art and architecture. The number of Etruscan tombs, for example, decreased sharply, and the quality of the furnishings declined markedly.

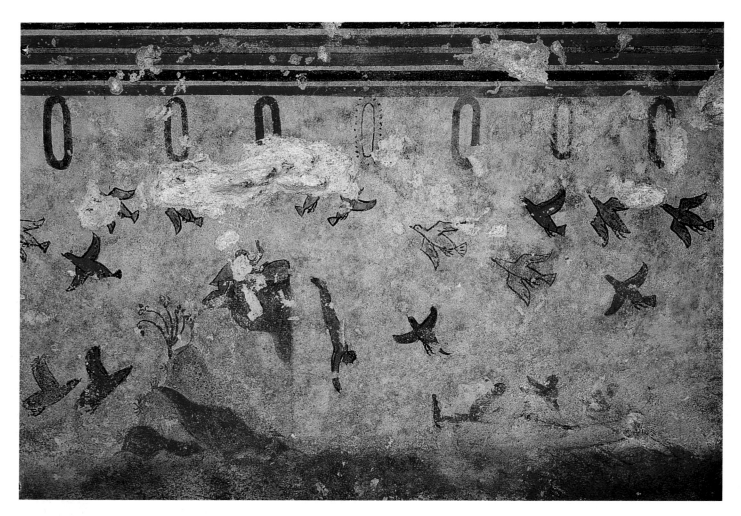

9-9 Diving and fishing, detail of mural paintings in the Tomb of Hunting and Fishing, Tarquinia, Italy, ca. 530–520 B.C.

No longer were tumuli filled with golden jewelry and imported Greek vases or mural paintings of the first rank. But Etruscan art did not cease. Indeed, in the areas Etruscan artists excelled in, especially the casting of statues in bronze and terracotta, they continued to produce impressive works, even if fewer in number.

Classical Art

MYTHICAL ETRUSCAN ANIMALS The best-known of these later Etruscan statues—one of the most memorable portrayals of an animal in the history of world art—is the *Capitoline Wolf* (FIG. **9-10**). The statue is a somewhat larger-than-life-size hollow-cast bronze portrayal of the she-wolf that, according to ancient legend, nursed Romulus and Remus after they were abandoned as infants. When the twins grew to adulthood, they quarreled and Romulus killed his brother. Romulus founded Rome on April 21, 753 B.C. on the Palatine Hill and became the city's king. The statue of the she-wolf seems to have been made, however, for the new Roman Republic after the expulsion of Tarquinius Superbus. It became the new state's totem. The appropriately defiant image has remained the emblem of Rome to this day.

The *Capitoline Wolf* is not, however, a work of Roman art, which had not yet developed a distinct identity, but the product of an Etruscan workshop. (The suckling infants are

additions of Renaissance date and are probably the work of Antonio Pollaiuolo.) The vitality noted in the human figure in Etruscan art is here concentrated in the tense, watchful animal body of the she-wolf, with her spare flanks, gaunt ribs, and taut, powerful legs. The lowered neck and head, alert ears, glaring eyes, and ferocious muzzle capture the psychic intensity of the fierce and protective beast as danger ap-

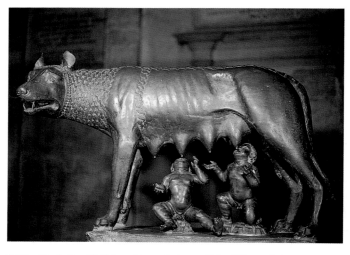

9-10 *Capitoline Wolf,* from Rome, Italy, ca. 500–480 B.C. Bronze, approx. 2′ 7½″ high. Palazzo dei Conservatori, Rome.

9-11 *Chimera of Arezzo*, from Arezzo, Italy, first half of fourth century B.C. Bronze, approx. $2' 7\frac{1}{2}''$ high. Museo Archeologico Nazionale, Florence.

proaches. Not even the great animal reliefs of Assyria (see FIG. 2-25) match, much less surpass, this profound rendering of animal temper.

Another masterpiece of Etruscan animal sculpture, found in 1553 and greatly admired during the Renaissance, is the bronze *Chimera of Arezzo* (FIG. **9-11**), which dates about a century later than the *Capitoline Wolf*. The chimera is a monster of Greek invention with a lion's head and body and a serpent's tail. A second head, that of a goat, grows out of the lion's left side and bears the wound inflicted by the Greek hero Bellerophon, who hunted and slew the composite beast. As rendered by the Etruscan sculptor, the chimera, although injured and bleeding, is nowhere near defeated. Like the earlier she-wolf statue, the chimera's muscles are stretched tightly over its rib cage. It prepares to attack, and a ferocious cry emanates from its open jaws. Some scholars have postulated that the statue was part of a group that originally included Bellerophon, but the chimera could have just as well stood alone. The menacing gaze upward toward an unseen adversary need not have been answered. In this respect, too, the chimera is in the tradition of the guardian nurse of Romulus and Remus.

Etruscan Art and the Rise of Rome

ROME OVERWHELMS ETRURIA At about the time the *Chimera of Arezzo* was fashioned, Rome began to appropriate Etrus-can territory. Veii fell to the Romans in 396 B.C., after a terrible ten-year siege. Peace was concluded with Tarquinia in 351 B.C., but by the beginning of the next century, Tarquinia, too, was annexed by Rome, and Cerveteri was conquered in 273 B.C. Rome's growing power in central Italy is indicated indirectly by the engraved inscription on the

9-12 NOVIOS PLAUTIOS, *Ficoroni Cista,* from Palestrina, Italy, late fourth century B.C. Bronze, approx. $2' 6''$ high. Museo Nazionale di Villa Giulia, Rome.

Ficoroni Cista (FIG. **9-12**). Etruscan artists produced such *cistae* (cylindrical containers for a woman's toilet articles), made of sheet bronze with cast handles and feet and elaborately engraved bodies, in large numbers from the fourth century B.C. forward. Together with engraved bronze mirrors, they were popular gifts for both the living and the dead. The Etruscan bronze cista industry centered in Palestrina (ancient Praeneste), where the *Ficoroni Cista* was found. The inscription on the cista's handle states that Dindia Macolnia, a local noblewoman, deposited the bronze container in her daughter's tomb and that the artist was one NOVIOS PLAUTIOS. According to the inscription, his workshop was not in Palestrina but in Rome, which by this date was becoming an important Italian cultural, as well as political, center.

The engraved frieze of the *Ficoroni Cista* depicts an episode from the Greek story of the expedition of the Argonauts in search of the Golden Fleece. Scholars generally agree that the composition is an adaptation of a lost Greek panel painting, perhaps one on display in Rome—another testimony to the burgeoning wealth and prestige of the city once ruled by Etruscan kings. The Greek source for Novios Plautios's engraving is evident in the figures seen entirely from behind or in three-quarter view, and in the placement of the protagonists on several levels in the Polygnotan manner (see FIG. 5-57).

9-13 *Porta Marzia,* Perugia, Italy, second century B.C.

9-14 Sarcophagus of Lars Pulena, from Tarquinia, Italy, early second century B.C. Tufa, approx. 6′ 6″ long. Museo Archeologico Nazionale, Tarquinia.

THE GATE OF MARS In the third century B.C., the Etruscan city of Perugia (ancient Perusia) formed an alliance with Rome and was spared the destruction Veii, Cerveteri, and other Etruscan towns suffered. Portions of Perugia's ancient walls are still standing, as are some of its gates. One of these, the so-called *Porta Marzia* (Gate of Mars), was dismantled by the Renaissance architect Antonio da Sangallo, but the gate's upper part is preserved, imbedded in a later wall (FIG. **9-13**). The *arcuated* opening is formed by a series of trapezoidal stone *voussoirs* held in place by pressing against each other (compare FIG. 4-18*c*). Such arches were built earlier in Greece as well as in Mesopotamia (see FIG. 2-26), but Italy, first under the Etruscans and later under the Romans, is where arcuated gateways and freestanding ("triumphal") arches became a major architectural type.

The *Porta Marzia* typifies the Etruscan adaptation of Greek motifs by using Hellenic-inspired pilasters to frame the rounded opening. Arches bracketed by engaged columns or pilasters have a long and distinguished history in Roman and later times. In the *Porta Marzia,* sculptured half-figures of Jupiter and his sons Castor and Pollux and their steeds look out from between the fluted pilasters. The divine twins had appeared miraculously on a battlefield in 484 B.C. to turn the tide in favor of the Romans. The presence of these three deities at the *Porta Marzia's* apex already may reflect the new Roman practice of erecting triumphal arches crowned by gilded bronze statues.

TORMENT IN THE UNDERWORLD In Hellenistic Etruria the descendants of the magnificent Archaic terracotta sarcophagus from Cerveteri (FIG. 9-4) were made of local stone and were carved rather than cast. The leading production center was Tarquinia, and that is where the sarcophagus of Lars Pulena (FIG. **9-14**) was fashioned early in the second century B.C. and placed in his family's tomb. The deceased is shown in a reclining position, but he is not at a festive banquet, and his wife is not present. His expression is somber, a far cry from the smiling, confident faces of the Archaic era when Etruria enjoyed its greatest prosperity. Similar heads—realistic but generic types, not true portraits—are found on all later Etruscan sarcophagi and in tomb paintings. They are symptomatic of the economic and political decline of the once-mighty Etruscan city-states.

Also attesting to a gloomy assessment of the future is the theme chosen for the coffin proper. The deceased is shown in the underworld, attacked by two *Charuns* (Etruscan death demons) swinging lethal hammers. Above, on the lid, Lars Pulena exhibits a partially unfurled scroll inscribed with the record of his life's accomplishments. Lacking confidence in a happy afterlife, he dwells instead on the past.

THE END OF THE ETRUSCANS In striking contrast, the portrait of Aule Metele (FIG. **9-15**) is a supremely self-confident image. He is portrayed as a magistrate raising his arm to address an assembly—hence his modern nickname *Arringatore (Orator).* The life-size bronze statue was discovered in 1566 near Lake Trasimene and is yet another Etruscan masterpiece known to Italian Renaissance sculptors. The statue of the orator proves that Etruscan artists continued to be experts at bronze-casting long after the heyday of Etruscan prosperity.

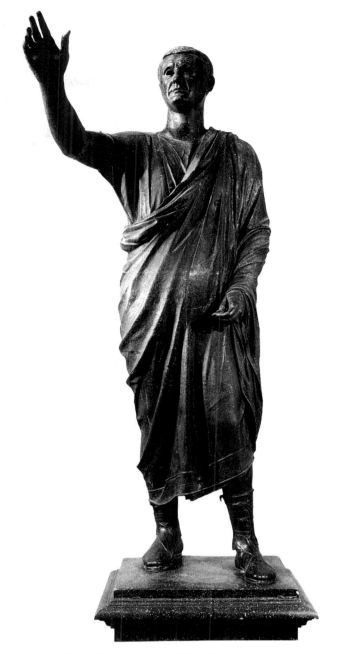

9-15 Aule Metele *(Arringatore, Orator),* from Sanguineto, near Lake Trasimene, Italy, early first century B.C. Bronze, approx. 5′ 7″ high. Museo Archeologico Nazionale, Florence.

The *Arringatore* was most likely produced at about the time that Roman hegemony over the Etruscans became total. The so-called Social War of the early first century B.C. ended in 89 B.C. with the conferring of Roman citizenship on all of Italy's inhabitants. In fact, Aule Metele—his Etruscan name and his father and mother's names are inscribed on his garment's hem—wears the short toga and high laced boots of a Roman magistrate. His head, with its close-cropped hair and signs of age in the face, resembles portraits produced in Rome at the time. This orator is Etruscan in name only. If the origin of the Etruscans remains debatable, the question of their demise has a ready answer. Aule Metele and his compatriots became Romans, and Etruscan art became Roman art.

THE ROMAN WORLD

N

Atlantic Ocean

Thames R.

GERMANY

Rhine R.

Trier

Danube R.

FRANCE

ROMANIA

Danube R.

Black Sea

Nimes

Milan

Venice

ITALY

Carrara

Adriatic Sea

CROATIA

Split

Otricoli

Amiternum

Rome

Naples

Melfi

Taranto

GREECE

Cyzicus

Nicaea

Constantinople
(Istanbul)

Pergamon

TURKEY

Tigris R.

SPAIN

Actium

Delphi

Corinth

Athens

Olympia

Euphrates R.

Carthage

Sicily

Syracuse

SYRIA

Baalbek

Damascus

Timgad

TUNISIA

Mediterranean Sea

Tel Shalem

Jerusalem

Petra

ALGERIA

Lepcis Magna

Alexandria

LIBYA

EGYPT

FAIYUM

Nile R.

0 250 500 miles

0 250 500 kilometers

Tiber R.

Adriatic Sea

Cerveteri

Veii

Primaporta

Rome

Tivoli

Ostia

Palestrina

ITALY

Tyrrhenian Sea

Benevento

Mt. Vesuvius

Naples

Boscoreale

Herculaneum

Nuceria

Boscotrecase

Pompeii

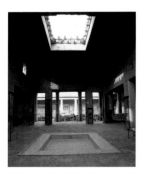

*House of the Vettii, Pompeii
second century B.C.*

*Denarius with portrait
of Julius Caesar, 44 B.C.*

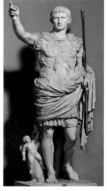

*Portrait of Augustus
from Primaporta, ca. 20 B.C.*

*Colosseum, Rome
ca. A.D. 70–80*

Foundation of Rome by Romulus, 753 B.C.

Expulsion of Etruscan kings from Rome, 509 B.C.

Marcellus brings spoils
of Syracuse to Rome, 211 B.C.

Roman conquest of Greece, 146 B.C.

Rome inherits kingdom of
Pergamon, 133 B.C.

Foundation of Roman
colony at Pompeii, 80 B.C.

Assassination of Julius Caesar, 44 B.C.

Battle of Actium, 31 B.C.

Augustus, r. 27 B.C.–A.D. 14

Vitruvius, *The Ten Books of Architecture*, ca. 25 B.C.

Vergil, 70–19 B.C.

Julio-Claudians, r. 14–68

Flavians, r. 69–96

Eruption of Mount
Vesuvius, A.D. 79

10

FROM SEVEN HILLS TO THREE CONTINENTS

THE ART OF ANCIENT ROME

96	192	337
HIGH EMPIRE	LATE EMPIRE	

Pantheon, Rome
A.D. 118–125

Equestrian statue
of Marcus Aurelius
ca. A.D. 175

Painted portrait of
the Severan family
ca. A.D. 200

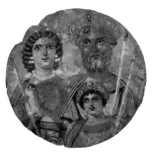

Ludovisi Battle
Sarcophagus
ca. A.D. 250–260

Arch of Constantine
Rome, A.D. 312–315

Trajan, r. 98–117

Hadrian, r. 117–138

Antonines, r. 138–192

Severans, r. 193–235

Soldier emperors, r. 235–284

Diocletian, r. 284–305

Constantine, r. 306–337

Edict of Milan, 313

Dedication of
Constantinople, 330

THE MIGHTY EMPIRE OF ROME

With the rise and triumph of Rome, a single government ruled, for the first time in human history, from the Tigris and Euphrates to the Thames and beyond, from the Rhine and Danube to the Nile. Within the Roman Empire's borders lived people of numerous races, religions, tongues, traditions, and cultures: Britons and Gauls, Greeks and Egyptians, Africans and Syrians, and Jews and Christians, to name only a very few. Of all the ancient civilizations, only the Roman approximates today's world in its multicultural character. Indeed, the Roman world is the bridge—in politics, the arts, and religion—between the ancient and the medieval and modern Western worlds.

ROMAN ART AND THE MODERN WORLD Roman monuments of art and architecture can be found throughout the vast territory the Romans governed and are the most conspicuous and numerous of all the remains of ancient civilization. An extraordinary number of these are part of the fabric of modern life and are not merely ruins that spark the curiosity of tourists, students, and scholars. In Rome, western Europe, Greece, the Middle East, and Africa today, Roman temples and basilicas have an afterlife as churches. The powerful concrete vaults of Roman theaters, baths, circuses, sanctuaries, and office buildings form the cores of modern houses, stores, restaurants, factories, and museums. Bullfights, sports events, operas, and rock concerts occur in Roman arenas and baths. Roman aqueducts continue to supply water to some modern towns. Ships dock in what were once Roman ports, and western Europe's highway system still closely follows the routes of Roman roads.

Even in North America, where no Roman remains exist save for the statues, paintings, mosaics, and other artworks imported by private collectors and museum curators, modern versions of famous Roman buildings such as the Pantheon (FIG. 10-48) may be found in cities and on college campuses. And Roman civilization lives on in the Western world in concepts of law and government, in languages, in calendars—even in the coins used daily. Indeed, Roman art speaks to contemporary Western viewers in a language almost everyone can readily understand. Its diversity and eclecticism foreshadowed the modern world. The Roman use of art, especially portraits and historical relief sculptures, to manipulate public opinion is similar to the carefully crafted imagery of contemporary political campaigns. And the Roman mastery of concrete construction began an architectural revolution still felt today.

FROM VILLAGE TO WORLD CAPITAL The far-flung Roman Empire centered on the city on the Tiber River that, according to legend, Romulus founded as a modest village of huts on April 21, 753 B.C. Nine hundred years later, Rome was the capital of the greatest empire the world had ever known, an empire with some fifty thousand miles of sea routes and expertly engineered highways for travel and commerce. Within its boundaries stood marble and concrete temples, theaters, baths, basilicas, arches, and palaces. Roman walls and ceilings were adorned with paintings and stucco reliefs, the floors covered with marble slabs and mosaics, and the niches and colonnades filled with statues. The imperial city of the second century A.D. awed foreign kings and even later Roman rulers. The historian Ammianus Marcellinus reported that when the emperor Constantius visited Rome in A.D. 357 and entered the Forum of Trajan (FIG. 10-41), he "stopped in his tracks, astonished" and marveled at the Forum's opulence and size, "which cannot be described by words and could never again be attempted by mortal men."[1]

THE REPUBLIC

KINGS, SENATORS, AND CONSULS Our story, however, begins long before Roman art and architecture embodied the imperial ideal of the Roman state, at a time when that "state" encompassed no territory beyond one of its famous seven hills. The Rome of Romulus in the eighth century B.C. comprised only small huts of wood, wattle, and daub, clustered together on the Palatine Hill overlooking what was then uninhabited marshland. In the Archaic period, as discussed in Chapter 9, Rome was essentially an Etruscan city, both politically and culturally. Its greatest shrine, the Temple of Jupiter Optimus Maximus (Best and Greatest) on the Capitoline Hill, was built by an Etruscan king, designed by an Etruscan architect, made of wood and mud brick in the Etruscan manner, and decorated with an Etruscan sculptor's terracotta statuary (see "Etruscan Artists in Rome," Chapter 9, page 235). Rome's earliest monumental art thus was, in all respects, Etruscan art.

In 509 B.C., Tarquinius Superbus, the last of Rome's Etruscan kings, was thrown out and constitutional government was established (see "An Outline of Roman History," page 247). The new Roman Republic vested power mainly in a *senate* (literally, "a council of elders, *senior* citizens") and in two elected *consuls*. Under extraordinary circumstances a *dictator* could be appointed for a specified time and a specific purpose, such as commanding the army during a crisis. All leaders came originally from among the wealthy landowners, or *patricians,* but later also from the *plebeian* class of small farmers, merchants, and freed slaves. Before long, the descendants of Romulus conquered Rome's neighbors one by one: the Etruscans and the Gauls to the north, the Samnites and the Greek colonists to the south. Even the Carthaginians of North Africa, who under Hannibal's dynamic leadership had annihilated some of Rome's legions and almost brought down the Republic, fell before the might of Roman armies.

THE CRAZE FOR GREEK ART For art historians, 211 B.C. was a turning point. An ambitious Roman general made a decision then that had a profound impact on Rome's character. Breaking with precedent, Marcellus, conqueror of the fabulously wealthy Sicilian Greek city of Syracuse, brought back to Rome not only the usual spoils of war—captured arms and armor, gold and silver coins, and the like—but also the city's artistic patrimony. Thus began, in the words of the historian Livy, "the craze for works of Greek art."[2] According to the biographer Plutarch, the Romans, "who had hitherto been accustomed only to fighting or farming," now began "affecting urbane opinions about the arts and about artists, even to the point of wasting the better part of a day on such things."[3] Ships filled with plundered Greek statues and paintings became a frequent sight in the harbor of Ostia at the mouth of the Tiber River.

An Outline of Roman History

MONARCHY (753–509 B.C.)

In the monarchy period, Latin and Etruscan kings reigned, beginning with Romulus and ending with Tarquinius Superbus (exact dates of rule unreliable).

REPUBLIC (509–27 B.C.)

The Republic lasted from the expulsion of Tarquinius Superbus until the bestowing of the title of Augustus on Octavian, the grandnephew of Julius Caesar and victor over Mark Antony in the Civil War that ended the Republic. Some major figures were:

Marcellus, b. 268(?) B.C., d. 208 B.C., consul
Marius, b. 157 B.C., d. 86 B.C., consul
Sulla, b. 138 B.C., d. 79 B.C., consul and dictator
Pompey, b. 106 B.C., d. 48 B.C., consul
Julius Caesar, b. 100 B.C., d. 44 B.C., consul and dictator
Mark Antony, b. 83 B.C., d. 30 B.C., consul

EARLY EMPIRE (27 B.C.–A.D. 96)

The Early Empire began with the rule of Augustus and his Julio-Claudian successors and continued until the end of the Flavian dynasty. Selected emperors and their dates of rule (with names of the most influential empresses in parentheses) are listed in chronological order:

Augustus (Livia), r. 27 B.C.–A.D. 14
Tiberius, r. 14–37
Caligula, r. 37–41
Claudius (Agrippina the Younger), r. 41–54
Nero, r. 54–68

Vespasian, r. 69–79
Titus, r. 79–81
Domitian, r. 81–96

HIGH EMPIRE (A.D. 96–192)

The High Empire began with the rule of Nerva and the Spanish emperors, Trajan and Hadrian, and ended with the last emperor of the Antonine dynasty. The emperors (and empresses) of this period were:

Nerva, r. 96–98
Trajan (Plotina), r. 98–117
Hadrian (Sabina), r. 117–138
Antoninus Pius (Faustina the Elder), r. 138–161
Marcus Aurelius (Faustina the Younger), r. 161–180
Lucius Verus, coemperor, r. 161–169
Commodus, r. 180–192

LATE EMPIRE (A.D. 192–337)

The Late Empire began with the Severan dynasty and included the soldier emperors of the third century, the tetrarchs, and Constantine, the first Christian emperor. Selected emperors (and empresses) were:

Septimius Severus (Julia Domna), r. 193–211
Caracalla (Plautilla), r. 211–217
Severus Alexander, r. 222–235
Trajan Decius, r. 249–251
Trebonianus Gallus, r. 251–253
Diocletian, r. 284–305
Constantine I, r. 306–337

Exposure to Greek sculpture and painting and to the splendid marble temples of the Greek gods increased as the Romans expanded their conquests beyond Italy to Greece itself, which became a Roman province in 146 B.C., and, after 133 B.C., when the last Attalid king of Pergamon willed his kingdom to Rome (see Chapter 5). Nevertheless, although the Romans developed a virtually insatiable taste for Greek "antiques," their own monuments were not slavish imitations of Greek masterpieces. The Etruscan basis of Roman art and architecture was never forgotten, and the statues and buildings of the Roman Republic are highly eclectic, drawing on both Greek and Etruscan traditions. The resultant mix, however, is distinctly Roman.

Architecture

A HARBOR GOD'S ECLECTIC TEMPLE A superb example of Roman eclecticism is the little temple on the east bank of the Tiber known as the Temple of "Fortuna Virilis"

(FIG. **10-1**), actually the Temple of Portunus, the Roman god of harbors. In plan it follows the Etruscan pattern. The high podium is accessible only at the front, with its wide flight of steps. Freestanding columns are confined to the deep porch. But the structure is built of stone (local tufa and travertine), overlaid originally with stucco in imitation of the gleaming white marble temples of the Greeks. The columns are not Tuscan but Ionic, complete with flutes and bases. Moreover, in an effort to approximate a peripteral Greek temple—while maintaining the basic Etruscan plan—the architect added a series of engaged Ionic half-columns around the cella's sides and back. The result was a *pseudoperipteral* temple, and, although it combines Etruscan and Greek elements, the design is uniquely Roman.

A ROUND TEMPLE ON A CLIFF The Romans' admiration for the Greek temples they encountered in their conquests also led to the importation of the round, or tholos temple type, a form unknown in Etruscan architecture, into

10-1 Temple of "Fortuna Virilis" (Temple of Portunus), Rome, Italy, ca. 75 B.C.

Republican Italy. At Tivoli (ancient Tibur), east of Rome, a Greek-inspired temple with a circular plan—variously known as the Temple of "the Sibyl" or of "Vesta" (FIG. **10-2**)—was erected early in the first century B.C. on a dramatic site overlooking a deep gorge. The travertine columns are Corinthian, and the frieze is carved (with garlands held up by oxen heads),

also in emulation of Greek models. But the high podium can be reached only via a narrow stairway leading to the cella door. This arrangement introduced an axial alignment not found in Greek tholoi (see FIG. 5-71), where, as in Greek rectangular temples (for example, FIG. 5-29), steps continue all around the structure. Also in contrast with Greek practice, the cella wall was constructed not of masonry blocks but of a new material of recent invention: concrete (see "The Roman Architectural Revolution: Concrete Construction," page 249).

CONCRETE TRANSFORMS A HILLSIDE The most impressive and innovative use of concrete during the Republic was in the Sanctuary of Fortuna Primigenia (FIG. **10-3**), constructed in the late second century B.C. on a hillside at Palestrina (ancient Praeneste, formerly an Etruscan city). The great size of the sanctuary, spread out over several terraces leading up to a tholos at the peak of an ascending triangle, reflected the Republican taste for colossal Hellenistic designs. The means of construction, however, was distinctly Roman.

The builder used concrete barrel vaults of enormous strength to support the imposing terraces and to cover the great ramps leading to the grand central staircase, as well as to give shape to the shops aligned on two consecutive levels. In this way, the unknown architect transformed the entire hillside into a grandiose complex symbolic of Roman power. This subjection of nature to human will and rational order was the first full-blown manifestation of the Roman imperial spirit. It contrasted with the more restrained Greek practice of simply crowning a hill with sacred buildings, as opposed to converting the hill itself into architecture.

10-3 Reconstruction drawing of the Sanctuary of Fortuna Primigenia, Palestrina, Italy, late second century B.C.

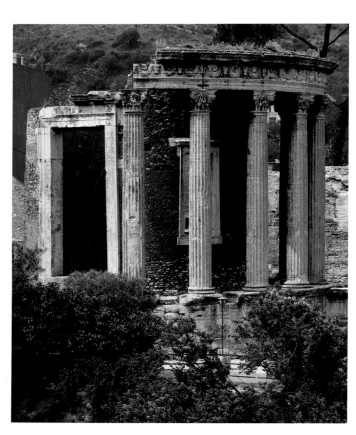

10-2 Temple of "the Sibyl" or of "Vesta," Tivoli, Italy, early first century B.C.

The Roman Architectural Revolution
Concrete Construction

The history of Roman architecture would be very different if the Romans had been content to use the same building materials as the Greeks, Etruscans, and ancient Near Eastern peoples. Instead, the Romans developed concrete construction, causing a revolution in architectural design. Roman *concrete* was made from a changing recipe of lime mortar, volcanic sand, water, and small stones (*caementa,* from which the English word *cement* is derived). The mixture was placed in wooden frames and left to dry and to bond with a brick or stone facing. When the concrete completely dried, the builders removed the wooden molds, leaving behind a solid mass of great strength, though rough in appearance. Afterward, the rough concrete was often covered with stucco or even sheathed with marble *revetment* (facing). Despite this lengthy procedure, concrete walls were much less costly to construct than walls of imported Greek marble or even local tufa and travertine.

The advantages of concrete, however, go well beyond cost. It is possible to fashion concrete shapes that masonry construction cannot achieve, especially huge vaulted and domed rooms without internal supports. The Romans came to prefer these over the Greek and Etruscan post-and-lintel structures. Concrete enabled Roman builders to think of architecture in radical new ways. Roman concrete architecture became an architecture of space rather than of sheer mass.

To cover and give shape to these new "spatial envelopes," the Romans employed a variety of vaulting systems. The most common types were:

Barrel Vaults Also called the *tunnel vault,* the barrel vault is an extension of a simple arch, creating a semicylindrical ceiling over parallel walls. Such vaults were constructed both before and after the Romans using traditional ashlar masonry (see, for example, FIGS. 2-26, 17-3, and 17-34), but those vaults are less stable than concrete barrel vaults. If any of the blocks of a cut-stone vault come loose, the whole may collapse. Also, masonry barrel vaults only can be illuminated by light entering at either end of the tunnel. In concrete barrel vaults, by contrast, windows can be placed at any point, because once the concrete hardens, it forms a seamless sheet of "artificial stone" that may be punctured almost at will. Whether made of stone or concrete, barrel vaults require *buttressing* (lateral support) of the walls below the vaults to counteract their downward and outward thrust.

Groin Vaults *Groin* or *cross vaults* are formed by the intersection at right angles of two barrel vaults of equal size. Besides appearing lighter than the barrel vault, the groin vault needs less buttressing. The barrel vault's thrust is concentrated along the entire length of the supporting wall. The groin vault's thrust, however, is concentrated along the groins, and buttressing is needed only at the points where the groins meet the vault's vertical supports. The system leaves the covered area open, permitting light to enter. Groin vaults, like barrel vaults, can be built using stone blocks—but with the same structural limitations when compared to concrete vaulting.

When a series of groin vaults covers an interior hall, as in our diagram and in FIGS. 10-44, 10-68, and 10-79, the open lateral arches of the vaults form the equivalent of a clerestory of a traditional timber-roofed structure (for example, see FIG. 11-8). Such a *fenestrated* sequence of groin vaults has a major advantage over wooden clerestories. Concrete vaults are relatively fireproof, always an important consideration given that fires were common occurrences (see "The Burning of Canterbury Cathedral," Chapter 17, page 455).

Hemispherical Domes The largest domed space in the ancient world for more than a millennium was the corbeled, beehive-shaped tholos of the Treasury of Atreus at Mycenae (see FIGS. 4-21 and 4-22). The Romans were able to surpass the Mycenaeans by using concrete to construct hemispherical domes, which usually rested on concrete cylindrical *drums*. If a barrel vault is described as a round arch extended in a line, then a hemispherical dome may be described as a round arch rotated around the full circumference of a circle. Masonry domes (compare FIG. 10-73), like masonry vaults, cannot accommodate windows without threatening their stability. Concrete domes can be opened up even at their apex with a circular "eye" *(oculus),* as in our diagram and FIGS. 10-33, 10-49, and 10-50, allowing much-needed light to reach the vast spaces beneath.

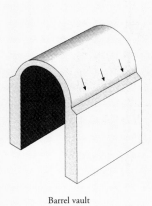

Barrel vault

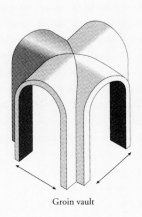

Groin vault

Fenestrated sequence
of groin vaults

Hemispherical dome
with oculus

10-4 Funerary relief with portraits of the Gessii, from Rome(?), Italy, ca. 30 B.C. Marble, approx. 2′ 1½″ high. Museum of Fine Arts, Boston (Archibald Cary Coolidge Fund).

10-5 Relief with funerary procession, from Amiternum, Italy, second half of first century B.C. Limestone, approx. 2′ 2″ high. Museo Nazionale d'Abruzzo, L'Aquila.

Sculpture

THE SOCIAL CONTEXT OF PORTRAITS The patrons of the Roman Republic's great temples and sanctuaries were in almost all cases men from old and distinguished families, often victorious generals who used the spoils of war to finance public works. These aristocratic patricians were fiercely proud of their lineage. They kept likenesses *(imagines)* of their ancestors in wooden cupboards in their homes and paraded them at the funerals of prominent relatives. (Marius, a renowned Republican general who lacked a long and distinguished genealogy, was ridiculed by contemporary Roman patricians as a man who had no ancestral imagines in his home.)

The surviving sculptural portraits of prominent Roman Republican figures, which are uniformly literal reproductions of individual faces, must be seen in this social context. Although their style derives to some degree from Hellenistic and Etruscan, and perhaps even Ptolemaic Egyptian, portraits, Republican portraits are one way the patrician class celebrated its elevated status. Slaves and former slaves could not possess such portraits, because, under Roman law, their parents and grandparents were not people but property. Yet when freed slaves died, they often ordered portraits for their tombs (FIGS. **10-4** and **10-5**)—in a style that contrasts sharply with that favored by freeborn patricians (see "Art for Former Slaves," page 251).

The subjects of Republican patrician portraits are almost exclusively men (and to a lesser extent women) of advanced age, for generally these elders held the power in the state. These patricians did not ask sculptors to make them appear nobler than they were, as Kresilas portrayed Pericles (see FIG. 5-39). Instead, they requested accurate records of their distinctive features, in the tradition of the treasured household imagines.

One of the most striking of these so-called *veristic* (superrealistic) portraits is the head of an unidentified patrician (FIG. **10-6**) found near Otricoli. The sculptor painstakingly recorded each

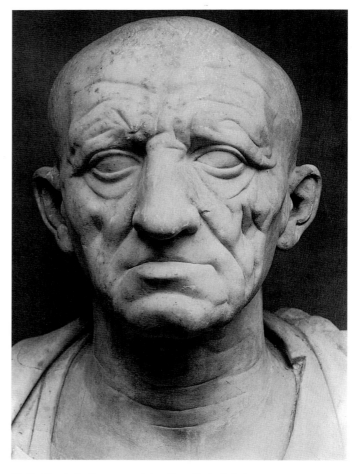

10-6 Head of a Roman patrician, from Otricoli, Italy, ca. 75–50 B.C. Marble, approx. 1′ 2″ high. Museo Torlonia, Rome.

Art for Former Slaves

Historians and art historians alike tend to focus on the lives and monuments of famous individuals, but some of the most interesting remains of ancient Roman civilization are the artworks commissioned by ordinary people, especially former slaves, or *freedmen* and *freedwomen*. Slavery was common in the Roman world, and it is estimated that Italy at the end of the Republic had some two million slaves, or roughly one slave for every three citizens. The very rich might own hundreds of slaves, but slaves could be found in all but the most impoverished households. The practice was so much a part of Roman society that even slaves often became slave owners when their former masters freed them.

The most noteworthy of all the artworks Roman freed slaves paid for are the stone reliefs that regularly adorned their tomb facades. One interesting example (FIG. 10-4) depicts three people, all named Gessius. At the left is Gessia Fausta and at the right Gessius Primus. Both are the freed slaves of Publius Gessius, the freeborn citizen in the center shown wearing a general's *cuirass* (breastplate) and portrayed in the standard Republican superrealistic fashion (FIGS. 10-6 to 10-8). As slaves this couple had no legal standing; they were the property of Publius Gessius. After they were freed, however, in the eyes of the law the ex-slaves became people. These stern frontal portraits proclaim their new status as legal members of Roman society—and their gratitude to Publius Gessius for granting them that status.

As was the custom, the two ex-slaves bear their patron's name, but whether they are sister and brother, wife and husband, or unrelated is unclear. The relief's inscriptions explicitly state that the monument was paid for with funds provided by the will of Gessius Primus and that the work was directed by Gessia Fausta, the only survivor of the three. The

relief thus depicts the living and the dead side by side, indistinguishable except by the accompanying message. This theme is common in Roman art (compare FIGS. 10-46 and 10-57) and proclaims that death does not break bonds formed in life.

More rarely, freed slaves commissioned tomb reliefs that were narrative in character. A relief from Amiternum (FIG. 10-5) depicts the cortege in honor of the deceased, complete with musicians, professional female mourners who pull their hair in a display of feigned grief, and the deceased's wife and children. The deceased is laid out on a bier with a canopy as a backdrop, much like the figures on Greek Geometric vases (see FIG. 5-1). Here, however, the dead man surprisingly props himself up as if still alive, surveying his own funeral. This may be an effigy, like the reclining figures on the lids of Etruscan sarcophagi (see FIGS. 9-4 and 9-14), rather than the deceased himself.

Compositionally, the relief is also not what one would expect. Mourners and musicians stand on floating ground lines, as if on "magic carpets." They are not to be viewed as suspended in space, however, but as situated behind the front row of pallbearers and musicians. This sculptor, in striking contrast to the (usually Greek) artists the patrician aristocracy employed, had little regard for the rules of classical art. Overlapping was studiously avoided, and the figures were placed wherever they fit, so long as they were clearly visible. This approach to making pictures was characteristic of pre-classical art but it had been out of favor for several centuries. One looks in vain for similar compositions in the art commissioned by the consuls and senators of the Roman Republic. In ancient Rome's cosmopolitan world, as today, stylistic tastes often were tied to a person's political and social status.

rise and fall, each bulge and fold, of the facial surface, like a mapmaker who did not want to miss the slightest detail of surface change. The result was a blunt record of the man's features and a statement about his personality: serious, experienced, determined—virtues that were much admired during the Republic.

AN OLD HEAD ON A YOUNG BODY The portrait from Otricoli is in bust form. The Romans believed the head alone was enough to constitute a portrait. The Greeks, by contrast, believed that head and body were inseparable parts of an integral whole, so their portraits were always full length (see FIG. 5-88). In fact, in Republican portraiture veristic heads were often, although incongruently, placed on bodies to which they could not possibly belong.

Such is the case in the portrait of a general (FIG. **10-7**) found at the Sanctuary of Hercules at Tivoli. A typically stern and lined Republican head sits atop a powerful, youthful body. The sculptor modeled the portrait on the statues of heroically nude Greek youths the Romans admired so much—although this patron's modesty dictated that a mantle shield the genitals. By the general's side, and acting as a prop for the heavy marble statue, is a

cuirass, an emblem of his rank. This curious and discordant image nonetheless conveys several messages. The portrait head preserves the patron's appearance, consistent with old Republican values; the cuirass declares he is a military officer; and the Greek-inspired body type proclaims he is a hero. As different as this statue is from the pseudoperipteral Temple of "Fortuna Virilis" (FIG. 10-1), both combine native and imported elements and reveal the eclectic nature of Republican art and architecture.

JULIUS CAESAR BREAKS THE RULES Beginning early in the first century B.C., the Roman desire to advertise distinguished ancestry led to the placement of portraits of illustrious forebears on Republican coins. These ancestral portraits supplanted the earlier Roman tradition (based on Greek convention) of using images of divinities on coins. No Roman, however, dared to place his own likeness on a coin until 44 B.C., when Julius Caesar, shortly before his assassination on the Ides of March, issued coins featuring his portrait and his newly acquired title, *dictator perpetuus* (dictator for life). The *denarius* (the standard Roman silver coin, from which the word *penny* ultimately derives) illustrated here

10-7 Portrait of a Roman general, from the Sanctuary of Hercules, Tivoli, Italy, ca. 75–50 B.C. Marble, approx. 6′ 2″ high. Museo Nazionale Romano-Palazzo Massimo alle Terme, Rome.

10-8 Denarius with portrait of Julius Caesar, 44 B.C. Silver, diameter approx. $\frac{3}{4}''$. American Numismatic Society, New York.

"Rising from the Ashes: The Excavation of Herculaneum and Pompeii," Chapter 28, page 849). Their remains, still being excavated, permit a reconstruction of the art and life of a Roman town of the Late Republic and Early Empire with a completeness far beyond that possible at any other archeological site.

OSCANS, SAMNITES, AND ROMANS Pompeii was first settled by the Oscans, one of the many Italic tribes that occupied Italy during the heyday of the Etruscans. It was taken over toward the end of the fifth century B.C. by the Samnites, who, under the influence of their Greek neighbors, greatly expanded the original town and gave monumental shape to the city center. Pompeii fought with other Italian cities on the losing side against Rome in the Social War, and in 80 B.C. Sulla founded a new Roman colony on the site, with Latin as its official language. The colony's population had grown to between ten and twenty thousand when, in February A.D. 62, an earthquake shook the city, causing extensive damage. When Mount Vesuvius erupted seventeen years later, repairs were still in progress.

AN ARCHEOLOGICAL PARK Walking through Pompeii today is an experience that cannot be approximated anywhere else. The streets, with their heavy flagstone pavements and sidewalks, are still there, as are the stepping stones that enabled pedestrians to cross the streets without having to step in puddles. Ingeniously, the city planners placed these stones in such a way that they could be straddled by vehicle wheels so that supplies could be brought to the shops, taverns, and bakeries. Tourists still can visit the impressive concrete-vaulted rooms of Pompeii's public baths and sit in the seats of its open-air theater and indoor concert hall, even walk among the tombs outside the city's walls. The sights include private homes with magnificently painted walls and pleasant gardens. Some still have their kitchen utensils in place. Pompeii has been called the living city of the dead for good reason.

records Caesar's aging face and receding hairline (FIG. **10-8**) in conformity with the Republican veristic tradition. But placing the likeness of a living person on a coin violated all the norms of Republican propriety. Henceforth, Roman coins, which circulated throughout the vast territories under Roman control, would be used to mold public opinion in favor of the ruler by announcing his achievements both real and fictional.

POMPEII AND THE CITIES OF VESUVIUS

BURIED BY A VOLCANO On August 24, A.D. 79, Mount Vesuvius, a long-dormant volcano whose fertile slopes were covered with vineyards during the Late Republic and Early Empire, suddenly erupted, burying many prosperous towns around the Bay of Naples (the ancient Greek city of Neapolis), among them Pompeii (see "An Eyewitness Account of the Eruption of Mount Vesuvius," page 253). This catastrophe for the inhabitants of the Vesuvian cities became a boon for archeologists and art historians. When the buried cities were first explored in the eighteenth century, they had been undisturbed for nearly seventeen hundred years (see

Architecture

THE HEART OF POMPEII The center of civic life in any Roman town was its *forum*, or public square, usually located at the city's geographic center at the intersection of the main north-south street, the *cardo*, and the main east-west avenue, the *decumanus* (FIG. 10-40). The forum, however, gen-

An Eyewitness Account of the Eruption of Mount Vesuvius

Pliny the Elder, whose *Natural History* is one of the most important sources for Greek art history, was among those who tried to rescue others from danger when Mount Vesuvius erupted. He was overcome by fumes the volcano spewed forth, and died. His nephew, Pliny the Younger, a government official under Trajan, left an account of the eruption and his uncle's demise:

> [The volcanic cloud's] general appearance can best be expressed as being like a pine . . . for it rose to a great height on a sort of trunk and then split off into branches. . . . Sometimes it looked white, sometimes blotched and dirty, according to the amount of soil and ashes it carried with it. . . . The buildings were now shaking with vi-

olent shocks, and seemed to be swaying to and fro as if they were torn from their foundations. Outside, on the other hand, there was the danger of falling pumice-stones, even though these were light and porous. . . . Elsewhere there was daylight, [but around Vesuvius, people] were still in darkness, blacker and denser than any night that ever was. . . . When daylight returned on the 26th—two days after the last day [my uncle] had been seen—his body was found intact and uninjured, still fully clothed and looking more like sleep than death.[1]

[1] Betty Radice, trans., *Pliny the Younger: Letters and Panegyricus,* vol. 2 (Cambridge, Mass.: Harvard University Press, 1969), 427–33.

erally was closed to all but pedestrian traffic. Pompeii's forum (FIGS. **10-9** and **10-10**) lies in the southwest corner of the expanded Roman city but at the heart of the original town. The forum took on monumental form in the second century B.C. when the Samnites erected two-story colonnades inspired by Hellenistic architecture on three sides of the long and narrow plaza. At the north end they constructed a Temple of Jupiter. When Pompeii became a Roman colony in 80 B.C., the Romans converted the temple into a *Capitolium*—a triple shrine of Jupiter, Juno, and Minerva. (For the Roman gods and goddesses and their Greek equivalents, see "The Gods and Goddesses of Mount Olympus," Chapter 5, page 99.) The temple

is of standard Republican type, constructed of tufa covered with fine white stucco and combining an Etruscan plan with Corinthian columns. It faces into the civic square, dominating the area. This is very different from the siting of Greek temples (see FIGS. 5-40 and 5-41), which stood in isolation and could be approached and viewed from all sides, like colossal statues on giant stepped pedestals. The Roman forum, like the Etrusco-Roman temple, has a chief side, a focus of attention.

The area within the porticoes of the forum at Pompeii was empty, except for statues commemorating local dignitaries and, later, Roman emperors. This is where daily commerce was conducted and festivities held. All around the square, behind the

10-9 Aerial view of the forum, Pompeii, Italy, second century B.C. and later.

1. Forum
2. Temple of Jupiter (Capitolium)
3. Basilica

10-10 Plan of the forum, Pompeii, Italy, second century B.C. and later.

10-11 Aerial view of the amphitheater, Pompeii, Italy, ca. 80 B.C.

colonnades, were secular and religious structures, including the town's administrative offices. Most noteworthy is the *basilica* at the southwest corner, the earliest well-preserved building of its kind. Constructed during the late second century B.C., the basilica housed the law court of Pompeii and also was used for other official purposes. In plan (FIG. 10-10) it resembles the forum itself: long and narrow, with two stories of internal columns dividing the space into a central *nave* and flanking *aisles*. This scheme had a long afterlife in architectural history and will be familiar to anyone who has ever entered a Christian church.

A HOME FOR GLADIATORS The forum was an oasis in the heart of Pompeii—an open, airy plaza. Throughout the rest of the city, every square foot of land was developed. At the southeastern end of town, immediately after the Roman colony was founded in 80 B.C., Pompeii's new citizens erected a large amphitheater (FIG. **10-11**). It is the earliest such structure known and could seat some twenty thousand spectators—more than the entire population of the town a century and a half after it was built! The word *amphitheater* means "double theater," and the Roman structures closely resemble two Greek theaters put together, although the Greeks never built amphitheaters. Greek theaters were placed on natural hillsides (see FIGS. 5-40 and 5-70), but supporting an amphitheater's continuous elliptical cavea required building an artificial mountain—and only concrete, unknown to the Greeks, was capable of such a job. In the Pompeii amphitheater a series of radially disposed concrete barrel vaults forms a giant retaining wall that holds up the earthen mound and stone seats. Barrel vaults also form the tunnels leading to the arena, the central area where bloody gladiatorial combats and other boisterous events occurred. (*Arena* is Latin for "sand," which soaked up the contestants' blood.) The Roman amphitheater stands in sharp contrast, both architecturally

and functionally, to the Greek theater, home of refined performances of comedies and tragedies.

A painting (FIG. **10-12**) on the wall of a Pompeian house records an unfortunate incident that occurred in the amphitheater in A.D. 59. A brawl broke out between the Pompeians and their neighbors, the Nucerians, during a contest

10-12 Brawl in the Pompeii amphitheater, wall painting from House I,3,23, Pompeii, Italy, ca. A.D. 60–79. Approx. 5' 7" × 6' 1". Museo Nazionale, Naples.

The Roman House

The Roman house was more than just a place to live. It played an important role in Roman societal rituals. In the Roman world individuals were frequently bound to others in a patron-client relationship whereby a wealthier, better-educated, and more powerful *patronus* would protect the interests of a *cliens,* sometimes large numbers of them. The standing of a patron in Roman society often was measured by clientele size. Being seen in public accompanied by a crowd of clients was a badge of honor. In this system, a plebeian might be bound to a patrician, a freed slave to a former owner, or even one patrician to another. Regardless of rank, all clients were obligated to support their patron in political campaigns and to perform specific services on request, as well as to call on and salute the patron at the patron's home.

A client calling on a patron would enter the typical Roman *domus* (private house) through a narrow foyer (*fauces,* the "throat" of the house), which led to a large central reception area, the *atrium.* The rooms flanking the fauces could open inward, as in our diagram, or outward, in which case they were rented out as shops. The roof over the atrium was partially open to the sky, not only to admit light but also to channel rainwater into a basin *(impluvium)* below. The water could be stored in cisterns for household use. Opening onto the atrium was a series of small bedrooms called *cubicula* (cubicles). At the back were the patron's *tablinum* or "home office," a dining room *(triclinium),* a kitchen, and sometimes a small garden.

Endless variations of the same basic plan exist, dictated by the owner's personal taste and means, the nature of the land plot, and so forth, but all Roman houses of this type were inward-looking in nature. The design shut off the street's noise and dust, and all internal activity was focused on the brightly illuminated atrium at the center of the residence. This basic module (only the front half of the typical house in our diagram) resembles the plan of the typical Etruscan house as reflected in the Tomb of the Shields and Chairs (see FIG. 9-6) and other tombs at Cerveteri. Thus few doubt that the early Roman house, like the early Roman temple, grew out of the Etruscan tradition.

During the second century B.C., when Roman architects were beginning to build stone temples with Greek columns, the Roman house also took on Greek airs. A peristyle garden was added behind the Etruscan-style house, providing a second internal illumination source as well as a pleasant setting for meals served in a summer triclinium. The axial symmetry of the plan meant that on entering the fauces of the house, a visitor could be greeted by a vista through the atrium directly into the peristyle garden (as in FIG. 10-13), which often boasted a fountain or pool, marble statuary, mural paintings, and mosaic floors.

Such houses were not, of course, the norm. While they were typical of Pompeii and other towns, they were very rare in large cities such as Rome, where the masses lived instead in multistory apartment houses, discussed later (FIG. 10-53).

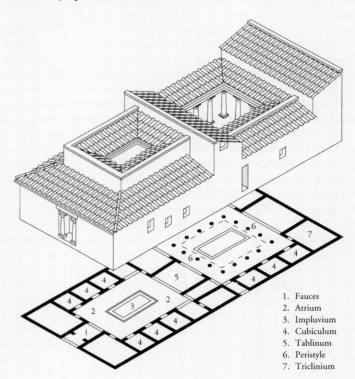

1. Fauces
2. Atrium
3. Impluvium
4. Cubiculum
5. Tablinum
6. Peristyle
7. Triclinium

between the two towns. The fighting left many seriously wounded and led to a decade-long prohibition against such events. The painting shows the cloth awning *(velarium)* that could be rolled down from the top of the cavea to shield spectators from either sun or rain. It also features the distinctive external double staircases (not visible in FIG. 10-11) that enabled large numbers of people to enter and exit the cavea in an orderly fashion.

HOUSES FOR PATRICIANS AND EX-SLAVES At Pompeii, as in modern cities and towns, private homes occupied most of the area. The evidence from Pompeii regarding Roman domestic architecture (see "The Roman House," above) is unparalleled anywhere else and is the most precious by-product of the catastrophic volcanic eruption of A.D. 79. One of the best preserved houses at Pompeii, partially rebuilt and an obligatory stop on every tourist's

10-13 Atrium of the House of the Vettii, Pompeii, Italy, second century B.C., rebuilt A.D. 62–79.

itinerary today, is the House of the Vettii (FIG. **10-13**), an old Pompeian house remodeled and repainted after the earthquake of A.D. 62. Our photograph was taken in the *fauces*. It shows the *impluvium* in the center of the *atrium*, the opening in the roof above, and, in the background, the *peristyle* garden with its marble tables and splendid mural paintings dating to the last years of the Vesuvian city. At that time, the house was owned by two brothers, Aulus Vettius Restitutus and Aulus Vettius Conviva, probably freedmen who had made their fortune as merchants. Their wealth enabled them to purchase and furnish the kind of fashionable town house that in an earlier era would have been owned only by patricians.

One such house, a luxurious Pompeian mansion of the second century B.C., the so-called House of the Faun, epitomizes Livy's "craze for things Greek" that characterized much of Republican art and architecture. The house was named after the Hellenistic-style bronze statue that stood in one of its two atriums. Its walls were covered with First Style murals of Greek type (see page 257), and on the floor of a room opening onto one of two peristyles, excavators found the mosaic of Alexander the Great battling Darius of Persia (see FIG. 5-69), a copy of a fourth-century B.C. Greek panel painting.

Painting

PAINTED WALLS EVERYWHERE The houses and villas around Mount Vesuvius have yielded a treasure trove of mural paintings, the most complete record of the changing fashions in interior decoration found anywhere in the entire

ancient world. The sheer quantity of these paintings tells a great deal about both the prosperity and the tastes of the times. How many homes today, even of the very wealthy, have custom-painted frescoes in nearly every room?

In the early years of exploration at Pompeii and nearby Herculaneum, excavators focused almost exclusively on the figural panels that formed part of the overall mural designs, especially those depicting Greek heroes and famous myths. These were cut out of the walls and transferred to the Naples Archeological Museum. (The painting of the brawl in the amphitheater, FIG. 10-12, suffered this fate.) In time, more enlightened archeologists put an end to the practice of cutting pieces out of the walls, and gave serious attention finally to the mural designs as a whole. Toward the end of the nineteenth century, August Mau, a German art historian, divided the various mural painting schemes into four so-called Pompeian Styles, numbered by their chronological order. Mau's

10-14 First Style wall painting in the fauces of the Samnite House, Herculaneum, Italy, late second century B.C.

classification system, although later refined and modified in detail, still serves as the basis for the study of Roman painting.

THE FIRST STYLE AND GREEK PAINTING The *First Style* also has been called the Masonry Style because the decorator's aim was to imitate costly marble panels using painted stucco relief. In the fauces (FIG. **10-14**) of the Samnite House at Herculaneum, the visitor is greeted at the doorway with the illusion of walls constructed, or at least faced, with marbles imported from quarries all over the Mediterranean. This approach to wall decoration is comparable to the modern practice, employed in private libraries and corporate meeting rooms alike, of using cheaper manufactured materials to approximate the look and shape of genuine wood paneling. The practice is not, however, uniquely Pompeian or Roman. First Style walls are well documented in the Greek world from the late fourth century B.C. on. The use of the First Style in Roman houses of the late second and early first centuries B.C. is yet another example of the Hellenization of Republican architecture.

The finest examples of First Style painting, such as those in the Samnite House, create a stunning illusion of actual marble veneers. (For walls revetted with real marble slabs, see FIGS. 10-50 and 17-15.) Roman wall paintings were true frescoes (see "Fresco Painting," Chapter 19, page 543), with the colors applied while the plaster was still damp, but the surface bril-

liance was achieved by painstaking preparation of the wall. The plaster, mixed with marble dust if the patron could afford it, was laid on in several layers with a smooth trowel. The dried, painted surface was then polished to a marblelike finish.

THE TRIUMPH OF ILLUSIONISM The First Style never went completely out of fashion, but after 80 B.C. a new approach to mural design became more popular. The *Second Style* is in most respects the antithesis of the First Style. Some scholars have argued that the Second Style also has precedents in Greece, but most believe it is a Roman invention. Certainly, the Second Style evolved in Italy and was popular until around 15 B.C., when the Third Style was introduced. Second Style painters aimed not to create the illusion of an elegant marble wall, as First Style painters sought to do. Rather, they wanted to dissolve a room's confining walls and replace them with the illusion of an imaginary three-dimensional world. They did this purely pictorially. The First Style's modeled stucco panels gave way to the Second Style's flat wall surfaces.

DIONYSIAC MYSTERIES AT POMPEII An early example of the new style is the room that gives its name to the Villa of the Mysteries at Pompeii (FIG. **10-15**). This chamber was probably used to celebrate, in private, the rites of the

10-15 Dionysiac mystery frieze, Second Style wall paintings in Room 5 of the Villa of the Mysteries, Pompeii, Italy, ca. 60–50 B.C. Frieze approx. 5′ 4″ high.

10-16 Second Style wall paintings (general view and detail of tholos) from Cubiculum M of the Villa of Publius Fannius Synistor, Boscoreale, Italy, ca. 50–40 B.C. Approx. 8′ 9″ high. Metropolitan Museum of Art, New York.

Greek god Dionysos (Roman Bacchus). Dionysos was the focus of an unofficial mystery religion popular in Italy at this time among women. The precise nature of the Dionysiac rites is unknown, but the figural cycle in this room, illustrating mortals (all female save for one boy) interacting with mythological figures, is thought to provide some evidence for the cult's initiation rites. In these rites young women, emulating Ariadne, daughter of King Minos (see Chapter 4), were united in marriage with Dionysos.

The backdrop for the nearly life-size figures is a series of painted panels imitating marble revetment, just as in the First Style but without the modeling in relief. In front of this marble wall (but actually on the same two-dimensional surface), the painter created the illusion of a shallow ledge on which the human and divine actors move around the room. Especially striking is how some of the figures interact across the corners of the room. Note, for example, the seminude winged woman at the far right of the rear wall who lashes out with her whip across the space of the room at a kneeling woman with a bare back (the initiate and bride-to-be of Dionysos) on the left end of the right wall. Nothing comparable to this room existed in Hellenistic Greece. Despite the presence of Dionysos, satyrs, and other figures from Greek mythology, this is a Roman design.

10-17 Gardenscape, Second Style wall painting, from the Villa of Livia, Primaporta, Italy, ca. 30–20 B.C. Approx. 6′ 7″ high. Museo Nazionale Romano-Palazzo Massimo alle Terme, Rome.

PERSPECTIVE PAINTING IN ANTIQUITY In the early Second Style Dionysiac mystery frieze, the spatial illusionism is confined to the painted platform that projects into the room. But in mature Second Style designs, painters created a three-dimensional setting that also extends beyond the wall. A prime example is a cubiculum (FIG. **10-16**) from the Villa of Publius Fannius Synistor at Boscoreale, near Pompeii, decorated between 50 and 40 B.C. The frescoes were removed soon after their discovery, and today they are part of a reconstructed Roman bedroom in the Metropolitan Museum of Art in New York City. All around the room the Second Style painter opened up the walls with vistas of Italian towns and sacred sanctuaries. Painted doors and gates invite the viewer to walk through the wall into the world the painter created.

Although the Boscoreale painter was inconsistent in applying it, this Roman artist demonstrated a knowledge of *linear (single vanishing-point) perspective,* often incorrectly said to be an innovation of Italian Renaissance artists (see "Depicting Objects in Space: Perspectival Systems in the Early Renaissance," Chapter 21, page 594). In this kind of perspective, all the receding lines in a composition converge on a single point along the painting's central axis to show depth and distance. Ancient writers state that Greek painters of the fifth century B.C. first used linear perspective for the design of Athenian stage sets (hence its Greek name, *skenographia* or *scene painting*). It was most successfully employed in the Boscoreale cubiculum in the far corners, where a low gate leads to a peristyle framing a tholos temple (see detail). Single-vanishing-point perspective was used more consistently and on an even grander scale in the somewhat later Room of the Masks in what was probably the house of the emperor Augustus on the Palatine Hill in Rome. Artists used it less successfully in numerous other Pompeian houses. Linear perspective was a favored tool of Second Style painters seeking to transform the usually windowless walls of Roman houses into "picture-window" vistas that expanded the apparent space of the rooms.

AN EMPRESS'S PAINTED GARDEN The ultimate example of a Second Style picture-window wall was found in the Villa of Livia, wife of the emperor Augustus, at Primaporta, just north of Rome. There, a vaulted, partly underground room was decorated on all sides with lush gardenscapes (FIG. **10-17**). The painter dispensed with the wall entirely, even as a framing element for the landscape. The only architectural element is the flimsy fence of the garden itself. To suggest recession, the painter mastered another kind of perspective, *atmospheric perspective,* indicating depth by the increasingly blurred appearance of objects in the distance. At Livia's villa, the fence, trees, and birds in the foreground are precisely painted, while the details of the dense foliage in the background are indistinct. Among the wall paintings examined so far, only the landscape fresco from Thera (see FIG. 4-10) offers a similar wraparound view of nature. But the Aegean fresco's white sky and red, yellow, and blue rock formations do not create a successful illusion of a world filled with air and light just a few steps away.

THIRD STYLE ELEGANCE AND FANTASY Livia's magnificent verdant gardenscape is the polar opposite of First Style designs, which reinforce, rather than deny, the heavy presence of confining walls with modulated surfaces re-

10-18 Detail of a Third Style wall painting, from Cubiculum 15 of the Villa of Agrippa Postumus, Boscotrecase, Italy, ca. 10 B.C. Approx. 7′ 8″ high. Metropolitan Museum of Art, New York.

producing marble panels. But tastes changed rapidly in the Roman world, as in society today, and not long after the Primaporta villa walls were decorated with gardenscapes, Roman patrons began to favor mural designs that reasserted the primacy of the wall surface. In the *Third Style* of Pompeian painting, artists no longer attempted to replace the walls with three-dimensional worlds of their own creation. Nor did they seek to imitate the appearance of the marble walls of Hellenistic kings. Instead they decorated the walls of their Roman patrons' homes with delicate linear fantasies sketched on predominantly *monochromatic* (one-color) backgrounds.

One of the earliest examples of the new style is a room in the Villa of Agrippa Postumus at Boscotrecase (FIG. **10-18**),

The Roman Illustrated Book

The hundreds of paintings uncovered in the cities Mount Vesuvius buried give the false impression that the history of Roman painting is well documented and that art historians can trace its development decade by decade. But Pompeii, Herculaneum, and the other towns around the Bay of Naples have yielded only frescoes. As in Greece, no Roman paintings on wooden panels have been discovered, save for the special case of Roman Egypt (FIGS. 10-63 and 10-64). Nor has anyone found any of the grand tableaus of battles and beseiged cities that were exhibited in Roman triumphal processions and then displayed in public buildings to perpetuate the memory of a general's great achievements on the state's behalf.

Also apparently lost are virtually all illustrated Roman books, although art historians know they once existed in great numbers. The oldest preserved painted manuscript, itself very incomplete, is the *Vatican Vergil,* which dates from the early fifth century A.D. It originally contained more than two hundred pictures illustrating all of Vergil's works. Today only fifty painted *folios* (pages) of the *Aeneid* and *Georgics* survive.

On the page illustrated here (FIG. 10-19) is a section of text from the *Georgics.* There, Vergil recounts his visit to a modest farm near Tarentum (Taranto, in southern Italy). The farm belongs to an old man from Corycus in Asia Minor. In the framed painted panel at the bottom of the page, the old farmer is seated at the left. His rustic farmhouse is in the background, rendered in a three-quarter view. The farmer speaks about the pleasures of the simple life in the country and on his methods of gardening. His audience is two laborers and, at the far right, Vergil himself in the guise of a farmhand. The style is reminiscent of Pompeian landscapes, with quick touches that suggest space and atmosphere. In fact, the heavy, dark frame has close parallels in the late Pompeian styles of mural painting (FIG. 10-20).

near Pompeii, also a property the imperial family owned. The villa was probably painted just before 10 B.C. Nowhere does the artist use illusionistic painting to penetrate the wall. In place of the stately columns of the Second Style are insubstantial and impossibly thin *colonnettes* supporting featherweight canopies barely reminiscent of pediments. In the center of this delicate and elegant architectural frame is a tiny floating landscape painted directly on the jet-black ground. It is hard to imagine a sharper contrast with the panoramic gardenscape at Livia's villa. On other Third Style walls, landscapes and mythological scenes appear in frames, like modern canvas paintings hung on walls. Never could these framed panels be mistaken for windows opening onto a world beyond the room.

ROMAN PAINTING AND LATIN POETRY Despite the differences in style, the landscapes of the Primaporta and Boscotrecase villas reveal a love of country life and idealization of nature that also appears in the pastoral poetry of Vergil, a contemporary of Livia and Augustus. Horace, another renowned Augustan poet, also proclaimed in one of his odes the satisfaction afforded the city dweller by a villa in the countryside, where life is beautiful, simple, and natural, in contrast with the urban greed for gold and power. A fifth-century A.D. illustrated manuscript of Vergil's verse (FIG. **10-19**) is in the Vatican Library today. It not only contains Vergil's pastoral poems, but provides invaluable evidence about the nature of Roman illustrated books (see "The Roman Illustrated Book," above).

10-19 The old farmer of Corycus, folio 7 verso, from the *Vatican Vergil,* ca. A.D. 400–420. Tempera on parchment, approx. $1' \frac{1}{2}'' \times 1'$. Biblioteca Apostolica Vaticana, Rome.

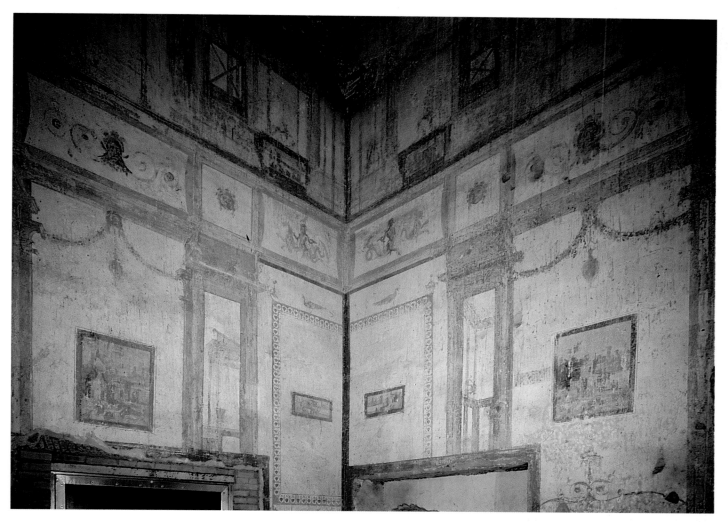

10-20 Fourth Style wall paintings in Room 78 of the *Domus Aurea* of Nero, Rome, Italy, A.D. 64–68.

NERO AND THE FOURTH STYLE In the *Fourth Style,* a taste for illusionism returned once again. This style became popular around the time of the Pompeian earthquake of A.D. 62, and it was the preferred manner of mural decoration when the town was buried in volcanic ash in 79. The earliest examples display a kinship with the Third Style, such as Room 78 (FIG. **10-20**) in the emperor Nero's fabulous *Domus Aurea,* or Golden House, in Rome (see "An Imperial Pleasure Palace: The Golden House of Nero," page 270). All the walls are an austere creamy white. In some areas the artist painted sea creatures, birds, and other motifs directly on the monochromatic background, much like the landscape in the Boscotrecase villa (FIG. 10-18). Landscapes appear here also—as framed paintings in the center of each large white subdivision of the wall. But views through the wall are also part of the design, although the Fourth Style architectural vistas are irrational fantasies. Viewers do not look out on cityscapes or round temples set in peristyles, but at fragments of buildings—columns supporting half-pediments, double stories of columns supporting nothing at all—painted on the same white ground as the rest of the wall. In the Fourth Style, architecture became just another motif in the painter's ornamental repertoire.

PAINTING ON THE EVE OF THE ERUPTION The latest Fourth Style walls conform to the same design principles, but the painters rejected the quiet elegance of the Third Style and early Fourth Style in favor of crowded and confused compositions and sometimes garish color combinations. The Ixion Room (FIG. **10-21**) of the House of the Vettii at Pompeii was decorated in this manner just before the eruption of Mount Vesuvius. The room served as a triclinium in the house remodeled by the Vettius brothers after the earthquake. It opened onto the peristyle seen in the background of FIG. 10-13.

The decor of the dining room is a kind of résumé of all the previous styles, another instance of the eclecticism noted earlier as characteristic of Roman art in general. The lowest zone, for example, is one of the most successful imitations anywhere of costly multicolored imported marbles, despite the fact the illusion is created without recourse to relief, as in the First Style. The large white panels in the corners of the room, with their delicate floral frames and floating central motifs, would fit naturally into the most elegant Third Style design. Unmistakably Fourth Style, however, are the fragmentary architectural vistas of the central and upper zones of the Ixion Room

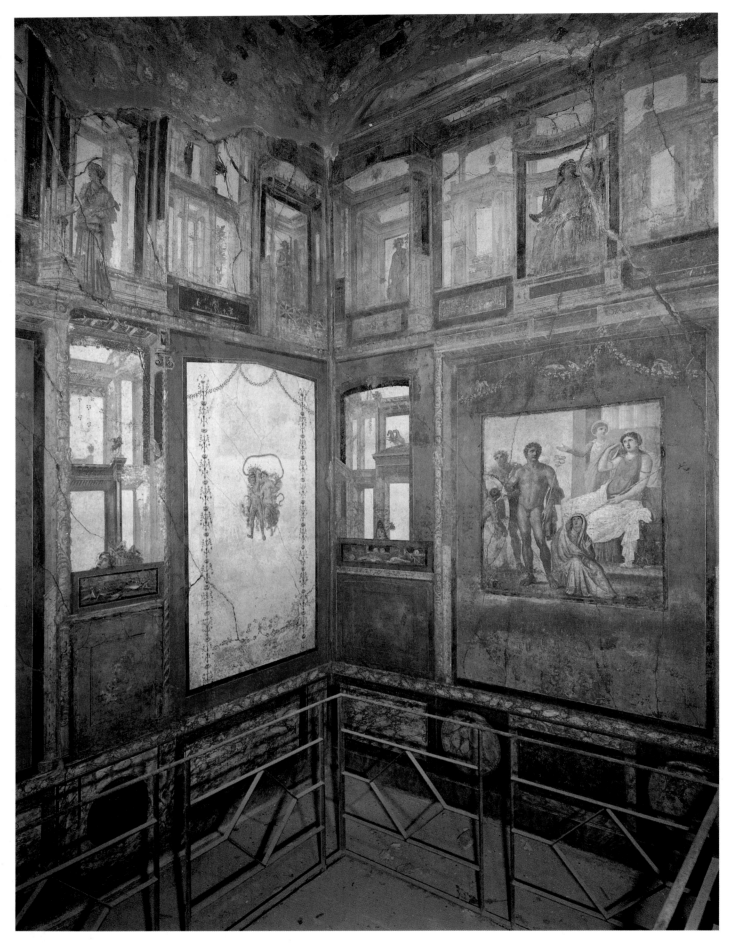

10-21 Fourth Style wall paintings in the Ixion Room (Triclinium P) of the House of the Vettii, Pompeii, Italy, ca. A.D. 70–79.

walls. They are unrelated to one another, do not constitute a unified cityscape beyond the wall, and are peopled with figures that would tumble into the room if they took a single step forward.

GREEK MYTHS ON ROMAN WALLS The Ixion Room takes its nickname from the mythological panel painting at the center of the rear wall (FIG. 10-21). Ixion had attempted to seduce Hera, and Zeus punished him by binding him to a perpetually spinning wheel. The panels on the two side walls also have Greek myths as subjects. The Ixion Room may be likened to a small private art gallery with paintings decorating the walls, as in many modern homes. Scholars long have believed that these and the many other mythological paintings on Third and Fourth Style walls were based on lost Greek panels, although few, if any, can be described as true copies of "Old Masters." These paintings attest to the Romans' continuing admiration for Greek artworks three centuries after Marcellus brought the treasures of Syracuse to Rome.

Mythological figures were on occasion also the subject of Roman mosaics. The House of Neptune and Amphitrite at Herculaneum takes its name from the mosaic shown here (FIG. **10-22**). Statuesque images of the sea god Neptune and his wife Amphitrite, set into an elaborate niche, appropriately preside over the running water of the fountain in the courtyard in front of them. In the ancient world, mosaics were usually confined to floors (as was the *Battle of Issus*, FIG. 5-69), where the tesserae formed a durable as well as decorative surface. In Roman times, however, mosaics also decorated walls and even ceilings, foreshadowing the extensive use of wall and vault mosaics in the Middle Ages (see "Mosaics," Chapter 11, page 314).

The subjects chosen for Roman wall paintings and mosaics were diverse. Although mythological themes were immensely popular, a vast range of other subjects also has been documented. As noted, landscape paintings frequently appear on

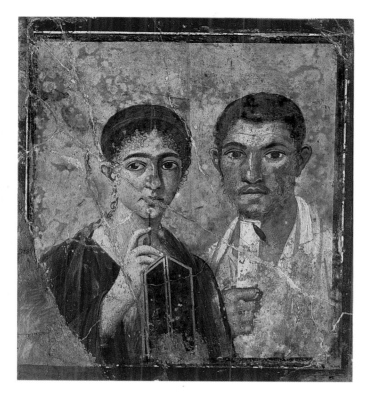

10-23 Portrait of a husband and wife, wall painting from House VII,2,6, Pompeii, Italy, ca. A.D. 70–79. Approx. 1′ 11″ × 1′ 8½″. Museo Nazionale, Naples.

Second, Third, and Fourth Style walls. Paintings and mosaics depicting scenes from history include the *Battle of Issus* mosaic and the mural painting of the brawl in the amphitheater of Pompeii (FIG. 10-12).

PRETENTIOUS PRIVATE PORTRAITS Given the Roman custom of keeping *imagines* of illustrious ancestors in atriums, it is not surprising that painted portraits have been found on the walls of some Pompeian houses. Almost all were cut out of the walls on discovery and brought to Naples, where they hang in the Archeological Museum as if they were independent panels in the tradition of later portraits on canvas. One must go to Naples to see the portrait of a husband and wife illustrated here (FIG. **10-23**), but originally it formed part of a Fourth Style wall of an *exedra* (recessed area) opening onto the atrium of a Pompeian house. The man holds a scroll and the woman a stylus and a wax writing tablet, standard attributes in Roman marriage portraits. They suggest the fine education of those depicted—even if, as was sometimes true, the individuals were uneducated or even illiterate. Such portraits were thus the Roman equivalent of modern wedding photographs of the bride and groom posing in rented formal garments never worn by them before or afterward. By contrast, the heads are not standard types but sensitive studies of the man and woman's individual faces. This is another instance of a realistic portrait placed on a conventional figure type, a recurring phenomenon in Roman portraiture (see "Role-Playing in Roman Portraiture," page 266) first encountered here in the statue of the Republican general found at Tivoli (FIG. 10-7).

10-22 Neptune and Amphitrite, wall mosaic in the summer triclinium of the House of Neptune and Amphitrite, Herculaneum, Italy, ca. A.D. 62–79.

10-24 Still life with peaches, detail of a Fourth Style wall painting, from Herculaneum, Italy, ca. A.D. 62–79. Approx. 1′ 2″ × 1′ 1½″. Museo Nazionale, Naples.

PAINTING THE INANIMATE Roman painters' interest in the likenesses of individual people was matched by their concern for recording the appearance of everyday objects. This explains the frequent inclusion of still-life paintings in the mural schemes of the Second, Third, and Fourth Styles. A still life with peaches and a carafe, a detail of a painted wall from Herculaneum (FIG. **10-24**), demonstrates that Roman painters sought to create illusionistic effects when depicting small objects, as well as architecture and landscape. Here, the method used involves light and shade with scrupulous attention to shadows and to highlights. Undoubtedly, the artist worked directly from an arrangement made specifically for this painting. The fruit, the stem and leaves, and the glass jar were set out on shelves to give the illusion of the casual, almost accidental, relationship of objects in a cupboard.

Art historians have not found evidence of anything like these Roman studies of food and other inanimate objects until the Dutch still lifes of the seventeenth and eighteenth centuries (see FIG. 24-54). The Roman murals are not as exact in drawing, perspective, or rendering of light and shade as the Dutch canvases. Still, the illusion created here marks the furthest advance by ancient painters in representational technique. The artist seemed to understand that the look of things is a function of light. The goal was to paint light as one would strive to paint the touchable object that reflects and absorbs it.

THE EARLY EMPIRE

ANTONY AND CLEOPATRA VANQUISHED The murder of Julius Caesar on the Ides of March, 44 B.C., plunged the Roman world into a bloody civil war. The fighting lasted thirteen years and ended only when Octavian (bet-

ter known as Augustus), Caesar's grandnephew and adopted son, crushed the naval forces of Mark Antony and Queen Cleopatra of Egypt at Actium in northwestern Greece. Antony and Cleopatra committed suicide, and in 30 B.C. Egypt, once the ancient world's wealthiest and most powerful kingdom, became another province in the ever-expanding Roman Empire.

Historians reckon the passage from the old Roman Republic to the new Roman Empire from the day in 27 B.C. when the Senate conferred the majestic title of Augustus (r. 27 B.C.–A.D. 14) on Octavian. The Empire was ostensibly a continuation of the Republic, with the same constitutional offices, but in fact Augustus, who was recognized as *princeps* (first citizen), occupied all the key positions. He was consul and *imperator* (commander in chief, from which comes the word *emperor*) and even, after 12 B.C., *pontifex maximus* (chief priest of the state religion). These offices gave Augustus control of all aspects of Roman public life.

THE PAX ROMANA With powerful armies keeping order on the empire's frontiers and no opposition at home, Augustus brought peace and prosperity to a war-weary Mediterranean world. Known in his own day as the *Pax Augusta* (Augustan Peace), the peace Augustus established prevailed for two centuries. It came to be called simply the *Pax Romana*. During this time the emperors commissioned a huge number of public works throughout the Empire: roads, bridges, forums, temples, basilicas, theaters, amphitheaters, market halls, and bathing complexes, all on an unprecedented scale. And people everywhere were reminded of the source of this beneficence by the erection of imperial portraits and by arches covered with reliefs recounting the emperor's great deeds. These portraits and reliefs often presented a picture of the emperor and his achievements that bore little resemblance to historical fact. Their purpose, however, was not to provide an objective record but to mold public opinion. The Roman emperors and the artists they employed have had few equals in the effective use of art and architecture for propagandistic ends.

Augustus and the Julio-Claudians (27 B.C.–A.D. 68)

THE SON OF A GOD RULES ROME When Octavian inherited Caesar's fortune in 44 B.C., he was not yet nineteen years old. When he vanquished Antony and Cleopatra at Actium in 31 B.C. and became undisputed master of the Mediterranean world, he had not reached his thirty-second birthday. The rule by elders that had characterized the Roman Republic for nearly half a millennium came to an abrupt end. Suddenly Roman portraitists were called on to produce images of a *youthful* head of state. But Augustus was more than merely young. Caesar had been made a god after his death, and Augustus, while never claiming to be a god himself, widely advertised himself as the son of a god. His portraits—produced in great numbers by anonymous artists the state paid—were designed to present the image of a godlike leader, a superior being who, miraculously, never aged. Although Augustus lived until A.D. 14, even official portraits made near the end of his life continued to show

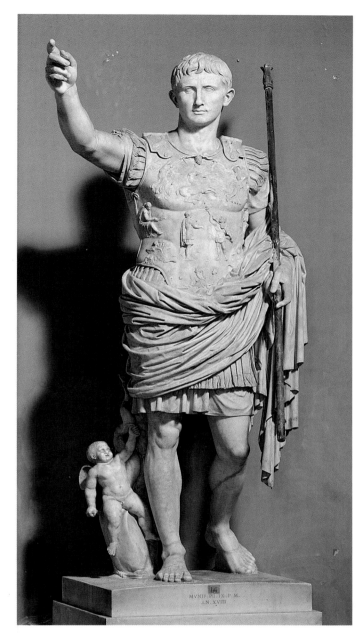

10-25 Portrait of Augustus as general, from Primaporta, Italy, copy of a bronze original of ca. 20 B.C. Marble, 6′ 8″ high. Vatican Museums, Rome.

manner of the orator Aule Metele (see FIG. 9-15). Although the head is that of an individual and not a nameless athlete, its overall shape, the sharp ridges of the brows, and the tight cap of layered hair emulate the Polykleitan style. Current events are referred to on Augustus's cuirass, which depicts the return of captured Roman military standards by the Parthians. The Cupid at his feet serves a very different purpose. Caesar's family, the Julians, traced their ancestry back to Venus, and the inclusion of Venus's son was an unsubtle reminder of Augustus's divine descent. Every facet of the Primaporta statue was designed to carry a political message.

A NEVER-AGING EMPRESS A portrait bust of Livia (FIG. **10-26**) shows that the imperial women of the Augustan age shared the emperor's eternal youthfulness. Although she sports the latest Roman coiffure, with the hair rolled over the forehead and knotted at the nape of the neck, Livia's blemishless skin and sharply defined features derive from images of Classical Greek goddesses. Livia outlived Augustus by fifteen years, dying at age eighty-seven. In her portraits, the coiffure changed with the introduction of each new fashion, but her face remained ever young, as befitted her exalted position in the Roman state.

THE AUGUSTAN PEACE COMMEMORATED On Livia's birthday in 9 B.C., Augustus dedicated the Ara Pacis Augustae (Altar of Augustan Peace), the monument

10-26 Portrait bust of Livia, from Faiyum, Egypt, early first century A.D. Marble, approx. 1′ 1½″ high. Ny Carlsberg Glyptotek, Copenhagen.

him as a handsome youth (see FIG. Intro-10). Such a notion may seem ridiculous today, when television, the internet, magazines, and newspapers portray world leaders as they truly appear, but in antiquity few people had actually seen the emperor. His official image was all most knew. It therefore could be manipulated at will.

The models for Augustus's idealized portraits cannot be found in the veristic likenesses of the Roman Republic. Rather, Classical Greek art inspired the emperor's sculptors. The portrait statue of Augustus (FIG. **10-25**) found at his wife Livia's villa at Primaporta depicts the emperor as general. (Others portray him in different roles. See "Role-Playing in Roman Portraiture," page 266.) It is based closely on Polykleitos's *Doryphoros* (see FIG. 5-38). Here, however, the emperor addresses his troops with his right arm extended in the

Role-Playing in Roman Portraiture

In every town throughout the vast Roman Empire, portraits of the emperors and empresses and their families were displayed—in forums, basilicas, baths, and markets; in front of temples; atop triumphal arches—anywhere a statue could be placed. The statue heads varied little from Britain to Syria. All were replicas of official images, either imported or scrupulously copied by local artists. But the portrait heads were placed on many types of bodies. The type chosen depended on the position the person held in Roman society or the various fictitious guises imperial family members assumed. Portraits of Augustus, for example, show him not only as armed general (FIG. 10-25) but also as recipient of the civic crown for saving the lives of fellow citizens (see FIG. Intro-10), veiled priest, toga-clad magistrate, traveling commander on horseback, heroically nude warrior, and various Roman gods, including Jupiter, Apollo, and Mercury.

Such role-playing was not confined to emperors and princes but extended to their wives, daughters, sisters, and mothers. Statues of Livia (FIG. 10-26) portray her as many goddesses, including Ceres, Juno, Venus, and Vesta. She also appears as the personification of Health, Justice, and Piety. In fact, it was common for imperial women to appear on Roman coins not only as goddesses but also as embodiments of feminine virtue. Faustina the Younger, for example, the wife of Marcus Aurelius and mother of thirteen children, appears as Venus and Fecundity, among many other roles. Julia Domna (FIG. 10-64), Septimius Severus's wife, is Juno, Venus, Peace, and Victory in her portraits.

Ordinary citizens also engaged in role-playing. Some assumed literary pretensions, as in the portrait painting of a Pompeian husband and wife discussed earlier (FIG. 10-23). Others equated themselves with Greek heroes (FIG. 10-61) or Roman deities (FIG. 10-62) on their coffins. The common people followed the lead of the emperors and empresses.

celebrating his most important achievement, the establishment of peace. The altar (FIG. **10-27**) was reconstructed during the Fascist era in Italy in connection with the two thousandth anniversary of Augustus's birth, when Mussolini was seeking to build and head a modern Roman Empire. The altar stands within an almost square wall enclosure adorned with acanthus tendrils in the lower zone and figural reliefs in the upper zone. Four panels on the east and west ends depict carefully selected mythological subjects, including (at the right in our photograph) a relief of Aeneas making a sacrifice. Aeneas was the son of Venus and one of Augustus's forefathers. The connection between the emperor and Aeneas was a key element of Augustus's political ideology for his new golden age. It is no coincidence that the *Aeneid* was written during the rule of Augustus. Vergil's epic poem glorified the young emperor by celebrating the founder of the Julian line.

A second panel (FIG. **10-28**), on the other end of the altar enclosure, depicts a seated matron with two animated babies on her lap. Her identity has been much disputed. She is usually called Tellus (Mother Earth), although some have called her Pax (Peace), Ceres (goddess of grain), or even Venus. Whatever her name, she epitomizes the fruits of the Pax Augusta. All around her the bountiful earth is in bloom, and animals of different species live peacefully side by side. Personifications of refreshing breezes (note their windblown drapery) flank her. One rides a bird, the other a sea creature. Earth, sky, and water were all incorporated into this picture of peace and fertility in the Augustan cosmos.

Processions of the imperial family and other important dignitaries appear on the long north and south sides of the Ara Pacis (FIG. **10-29**). The parallel friezes of the Ara Pacis were clearly inspired to some degree by the Panathenaic procession frieze of the Parthenon (see FIG. 5-48, bottom). This was another instance of Augustan artists using Classical Greek

models. Augustus sought to present his new order as a golden age like that of Athens under Pericles in the middle of the fifth century B.C. The emulation of Classical models thus made a political statement, as well as an artistic one.

Even so, the Roman procession is very different in character from the Greek. On the Parthenon, anonymous figures act out an event that recurred every four years. The frieze stands for *all* Panathenaic Festival processions. The Ara Pacis depicts a specific event—probably the inaugural ceremony of 13 B.C. when work on the altar began—and recognizable contemporary figures. Among those portrayed are children, who restlessly tug on their elders' garments and talk to one another when they should be quiet on a solemn occasion—in short, children who act like children, and not like miniature adults as they frequently do in the history of art. Their presence lends a great deal of charm to the procession, but that is not why children were included on the Ara Pacis when they had never before appeared on any Greek or Roman state monument. Augustus was concerned about a decline in the birthrate among the Roman nobility, and he enacted a series of laws designed to promote marriage, marital fidelity, and raising children. The portrayal of men with their families on the Altar of Peace was intended as a moral exemplar. Once again, the emperor used art to further his own political and social agenda.

ROME BECOMES A MARBLE CITY Augustus's most ambitious project in the capital was the construction of a new forum with a Temple of Mars facing into a rectangular plaza flanked by porticoes. The temple and colonnades were made of white marble from Carrara (ancient Luna), the same source the great sculptors of the Italian Renaissance used. Prior to the opening of these quarries in the second half of the first century B.C., marble had to be imported at great cost from abroad, and it was used sparingly. The ready availability

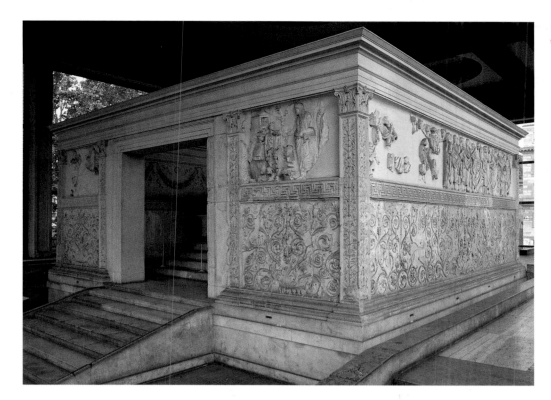

10-27 Ara Pacis Augustae (view from the southwest), Rome, Italy, 13–9 B.C.

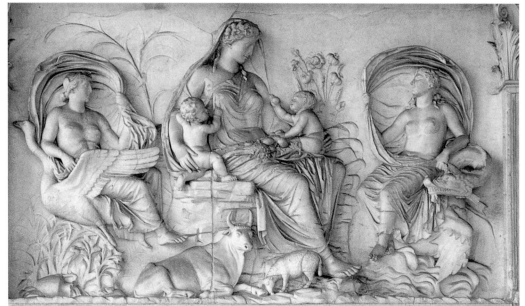

10-28 Female personification (Tellus?), panel from the east facade of the Ara Pacis Augustae, Rome, Italy, 13–9 B.C. Marble, approx. 5′ 3″ high.

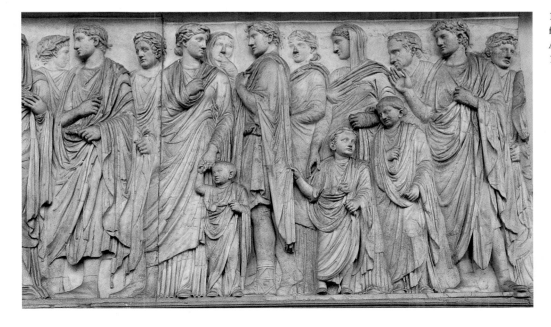

10-29 Procession of the imperial family, detail of the south frieze of the Ara Pacis Augustae, Rome, Italy, 13–9 B.C. Marble, approx. 5′ 3″ high.

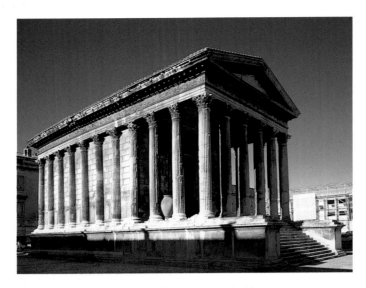

10-30 Maison Carrée, Nîmes, France, ca. A.D. 1–10.

of Italian marble under Augustus made possible the emperor's famous boast that he had found Rome a city of brick and transformed it into a city of marble.

The extensive use of Carrara marble for public monuments (including the Ara Pacis) must be seen as part of Augustus's larger program to make his city the equal of Periclean Athens. In fact, the Forum of Augustus incorporated several explicit references to Classical Athens and to the Acropolis in particular, most notably copies of the caryatids of the Erechtheion (see FIG. 5-52) in the upper story of the porticoes. Roman history also was evoked. The porticoes contained dozens of portrait statues, including images of all the major figures of the Julian family going back to Aeneas. Augustus's forum became a kind of public atrium filled with *imagines*. His family history thus became part of the Roman

state's official history. The Forum of Augustus and those of his successors did serve a practical function by providing alternative areas to the old and overcrowded Republican Forum Romanum for the conduct of state business. Yet they also gave the emperors the opportunity to present their own version of history to the Roman people.

ROMAN GAUL AND THOMAS JEFFERSON The Forum of Augustus is in ruins today, but the conservative Neo-Classical Augustan style it epitomizes may be seen in an exceptionally well-preserved temple at Nîmes (ancient Nemausus) in southern France (ancient Gaul). The so-called Maison Carrée (FIG. **10-30**) dates to the opening years of the first century A.D. Larger than the Temple of "Fortuna Virilis" in Rome (FIG. 10-1), this Corinthian pseudoperipteral temple was patterned on the Temple of Mars in the Forum of Augustus. In fact, many scholars believe that some of the artisans who worked on the Roman temple went immediately afterward to Nîmes to work on the Maison Carrée.

Vitruvius, whose treatise, *The Ten Books of Architecture*, dedicated to Augustus, became the bible of Renaissance architects, preferred the classicizing architectural style of the Maison Carrée and the Forum of Augustus to the newer Roman vaulted concrete technology. The Maison Carrée was also much admired by Thomas Jefferson, who used it as the model for the State Capitol in Richmond, Virginia, which he designed.

THE FRUITS OF THE PAX ROMANA An earlier Augustan project at Nîmes was the construction of the great aqueduct-bridge known today as the Pont-du-Gard (FIG. **10-31**). Throughout the far-flung territories Rome administered, millions of individuals depended on the government for food distribution, water supply and sanitation, and police and firefighters. Second only to food provision, an adequate water supply for the urban population was the most pressing need.

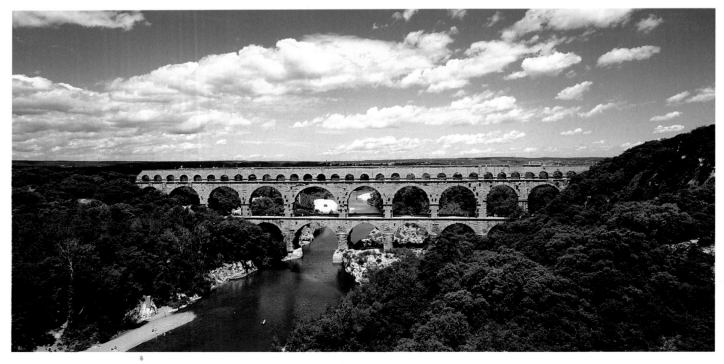

10-31 Pont-du-Gard, Nîmes, France, ca. 16 B.C.

As early as the fourth century B.C., the Romans built aqueducts to carry water from mountain sources to their city on the Tiber River. As Rome's power spread through the Mediterranean world, aqueducts, roads, and bridges were constructed to serve colonies everywhere in the empire.

The Pont-du-Gard demonstrates the skill of Rome's engineers. The aqueduct provided about one hundred gallons of water a day for each inhabitant of Nîmes from a source some thirty miles away. The water was carried over the considerable distance by gravity flow, which required channels built with a continuous gradual decline over the entire route from source to city. The Pont-du-Gard three-story bridge was erected to maintain the height of the water channel where the water crossed the Gard River. Each large arch spans some eighty-two feet and is constructed of uncemented blocks weighing up to two tons each. The bridge's uppermost level consists of a row of smaller arches, three above each of the large openings below. They carry the water channel itself. Their quickened rhythm and the harmonious proportional relationship between the larger and smaller arches reveal that the Roman engineer had a keen aesthetic, as well as practical, sense.

CLAUDIAN RUSTICATION Many aqueducts were required to meet the demand for water in the capital. Under the emperor Claudius (r. A.D. 41–54), a grandiose gate, the Porta Maggiore (FIG. **10-32**), was constructed at the point where two of Rome's water lines (and two intercity trunk roads) converged. Its huge *attic* (uppermost story) bears a wordy dedicatory inscription that conceals the conduits of both aqueducts, one above the other. The gate is the outstanding example of the Roman *rusticated* (rough) masonry style. Instead of using the precisely shaped blocks Hellenic and Augustan architects favored, the designer of the Porta Maggiore combined smooth and rusticated surfaces. These created an exciting, if eccentric, facade with crisply carved

pediments resting on engaged columns composed of rusticated drums. Later architects closely studied the Porta Maggiore, and it profoundly influenced the facade designs of some Renaissance palaces.

NERO'S ARCHITECTURAL REVOLUTION In A.D. 64, when Nero, stepson and successor of Claudius, was emperor (r. A.D. 54–68), a great fire destroyed large sections of Rome. Afterward, the city was rebuilt in accordance with a new code that required greater fireproofing, resulting in the widespread use of concrete, which was both cheap and fire resistant. Increased use gave Roman architects the opportunity to explore the possibilities the still relatively new material opened up.

After the great fire, Nero asked SEVERUS and CELER, two brilliant architect-engineers, to build a grand imperial palace on a huge confiscated plot of fire-ravaged land near the Forum Romanum (see "An Imperial Pleasure Palace: The Golden House of Nero," page 270). The excavated portion of Nero's *Domus Aurea* contains many rooms of uncertain purpose. Their walls are brick-faced concrete, and concrete vaults cover most rooms. The more important rooms seem to have been located on the southern side, where they faced the villa's artificial lake. Traces of rich decorations, with marble paneling and painted and gilded stucco, have been found in some rooms, while others are adorned with frescoes (FIG. 10-20) in the latest style. Structurally, these chambers are unremarkable. One octagonal hall (drawn in FIG. 10-33), however, stands apart from the rest and testifies to Severus and Celer's entirely new approach to concrete architecture.

The ceiling of the octagonal room is a dome that modulates from an eight-sided to a hemispherical form as it rises toward the oculus. Radiating outward from the five inner sides (the other three, directly or indirectly, face the outside) are smaller, rectangular rooms, covered by concrete vaults.

10-32 Porta Maggiore, Rome, Italy, ca. A.D. 50.

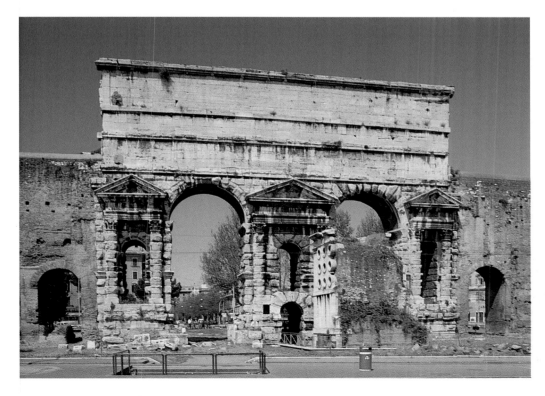

An Imperial Pleasure Palace
The Golden House of Nero

Nero's *Domus Aurea,* or Golden House, was a vast and no-toriously extravagant country villa in the heart of Rome. The second-century A.D. Roman biographer Suetonius de-scribed it vividly:

> The entrance-hall was large enough to contain a huge statue [of Nero in the guise of Sol, the sun god], 120 feet high; and the pillared arcade ran for a whole mile. An enormous pool, like a sea, was sur-rounded by buildings made to resemble cities, and by a landscape garden consisting of ploughed fields, vineyards, pastures, and wood-lands—where every variety of domestic and wild animal roamed about. Parts of the house were overlaid with gold and studded with precious stones and mother-of-pearl. All the dining-rooms had ceil-ings of fretted ivory, the panels of which could slide back and let a rain of flowers, or of perfume from hidden sprinklers, shower upon [Nero's] guests. The main dining-room was circular, and its roof re-volved, day and night, in time with the sky. Sea water, or sulphur water, was always on tap in the baths. When the palace had been decorated throughout in this lavish style, Nero dedicated it, and con-descended to remark: "Good, now I can at last begin to live like a human being!"[1]

Suetonius's description is a welcome reminder that the Ro-man ruins tourists flock to see are but a dim reflection of the magnificence of the original structures. Only in rare instances, such as the Pantheon, with its marble-revetted walls and floors (FIG. 10-50), can visitors experience anything approaching the architects' intended effects. Even there much of the marble paneling is of later date and the gilded bronze is missing from the dome.

[1] Robert Graves, trans., *Suetonius: The Twelve Caesars* (New York: Penguin, 1957; illustrated edition, 1980), 197–98.

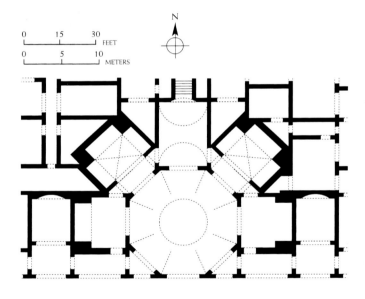

10-33 Severus and Celer, plan *(above)* and section *(below)* of the octagonal hall of the *Domus Aurea* of Nero, Rome, Italy, A.D. 64–68.

These satellite rooms were enlivened by decorative recesses. The middle one contained a waterfall. The architects inge-niously lit the rooms by leaving spaces between their vaulted ceilings and the central dome's exterior. But the most signifi-cant aspect of the design is that here, for the first time, the ar-chitects appear to have thought of the walls and vaults not as limiting space but as shaping it.

Today, the octagonal hall is deprived of its marble and stucco incrustation, and the concrete shell stands bare, but this serves to focus the visitor's attention on the design's spa-tial complexity. When one walks through the rooms, one sees that the central domed octagon is defined not by walls but by eight angled piers. The wide square openings between the piers are so large that the rooms beyond look like extensions of the central hall. The grouping of spatial units of different sizes and proportions under a variety of vaults creates a dy-namic three-dimensional composition that is both complex and unified. The Neronian architects were not only inventive but also progressive in their recognition of the malleable na-ture of concrete, a material not limited to the rectilinear forms of traditional post-and-lintel construction.

The Flavians (A.D. 69–96)

Because of his outrageous behavior, Nero was forced to com-mit suicide in A.D. 68, bringing the Julio-Claudian dynasty to an end. A year of renewed civil strife followed. The man who emerged triumphant in this brief but bloody conflict was Vespasian (r. A.D. 69–79), a general who had served un-der Claudius and Nero. Vespasian, whose family name was Flavius, had two sons, Titus (r. A.D. 79–81) and Domitian (r. A.D. 81–96). The Flavian dynasty ruled Rome for more than a quarter century.

A TRIUMPH OF ROMAN ENGINEERING The Flavians left their mark on the capital in many ways, not the least being the construction of the Colosseum (FIG. **10-34**), the monument that, for most people, still represents Rome more than any other building. In the past it was identified so closely with Rome and its empire that in the early Middle Ages there was a saying, "While stands the Colosseum, Rome shall stand; when falls the Colosseum, Rome shall fall; and when Rome falls—the World."[4] The Flavian Amphitheater, as it was known in its own day, was one of Vespasian's first undertakings after becoming emperor. The decision to build the Colosseum was very shrewd politically. The site chosen was the artificial lake on the grounds of Nero's *Domus Aurea,* which was drained for the purpose. By building the new amphitheater there, Vespasian reclaimed for the public the land Nero had confiscated for his private pleasure and provided Romans with the largest arena for gladiatorial combats and other lavish spectacles that had ever been constructed. The Colosseum takes its name, however, not from its size—it could hold more than fifty thousand spectators—but from its location beside the Colossus of Nero, the huge statue of the emperor portrayed as the sun, at the entrance to his urban villa.

Vespasian, who died in A.D. 79, did not live to see the Colosseum in use. The amphitheater was completed in 80 and formally dedicated by Titus. To mark the opening, games were held for one hundred days, at extravagant cost but to the people's delight. The highlight was the flooding of the arena to stage a complete naval battle with more than three thou-sand participants. Later emperors would compete to see who could put on the most elaborate spectacles, and over the years many thousands of lives were lost in the gladiatorial and animal combats staged in the amphitheater. Many of those who died were Christians, and the Colosseum has never quite outlived its infamy in this respect.

The Colosseum, like the much earlier amphitheater at Pompeii (FIG. 10-11), could not have been built without concrete. The enormous oval seating area is held up by a complex system of corridors covered by concrete barrel vaults. This concrete "skeleton" reveals itself today to anyone who enters the amphitheater. In the centuries following the fall of Rome, the Colosseum served as a convenient quarry for ready-made building materials. Almost all its marble seats were hauled away, exposing the network of vaults below. Hidden in antiquity but visible today are the arena substructures, where were located the waiting rooms for the gladiators, animal cages, and machinery for raising and lowering stage sets as well as animals and humans. Cleverly designed lifting devices brought beasts from their dark dens into the arena's violent light. Above the seats a great velarium, as at Pompeii, once shielded the spectators. It was held up by giant wooden poles affixed to the Colosseum's facade.

The exterior travertine shell is approximately 160 feet high, the height of a modern sixteen-story building. Seventy-six numbered entrances led to the seating area. The relationship of these openings to the tiers of seats within was carefully thought out and resembles that seen in modern sports stadiums. The exterior's decor, however, had nothing to do with

10-34 Aerial view of the Colosseum, Rome, Italy, ca. A.D. 70–80.

10-35 Portrait of Vespasian, from Ostia, Italy, ca. A.D. 69–79. Marble, approx. 1' 4" high. Museo Nazionale Romano-Palazzo Massimo alle Terme, Rome.

VESPASIAN AND THE REVIVAL OF VERISM
Vespasian was an unpretentious career army officer who desired to distance himself from Nero's extravagant misrule. His portraits (FIG. **10-35**) reflect his much simpler tastes. They also made an important political statement. Breaking with the tradition Augustus established of depicting the Roman emperor as an eternally youthful god on earth, Vespasian's sculptors resuscitated the veristic tradition of the Republic, possibly at his specific direction. Although not as brutally descriptive as many Republican likenesses, Vespasian's portraits frankly recorded his receding hairline and aging leathery skin—proclaiming that his values were different from Nero's.

AN ELEGANT FLAVIAN WOMAN Flavian portraits of people of all ages exist, in contrast to Republican times, when only elders were deemed worthy of depiction. A portrait bust of a young woman (FIG. **10-36**), probably a Flavian princess, is a case in point. The portrait is notable for its elegance and delicacy and for the virtuoso way the sculptor rendered the differing textures of hair and flesh. The elaborate Flavian coiffure, with its corkscrew curls punched out by skilled hands using a drill instead of a chisel, creates a dense mass of light and shadow set off boldly from the softly modeled and highly polished skin of the face and swanlike neck. The drill played an increasing role in Roman sculpture in succeeding periods and in time was used even for portraits of men, when much longer hair and full beards were fashionable.

function. The facade is divided into four bands, with large arched openings piercing the lower three. Ornamental Greek orders frame the arches in the standard Roman sequence for multistoried buildings: Tuscan Doric, Ionic, and then Corinthian from the ground up. This sequence is based on the proportions of the orders, with the Tuscan viewed as capable of supporting the heaviest load. The uppermost story is circled with Corinthian pilasters (and between them the brackets for the poles that held up the velarium over the cavea).

The framing of the openings in the Colosseum's facade by engaged columns and a lintel is a variation of the scheme used on the Etruscan *Porta Marzia* at Perugia (see FIG. 9-13). The Romans commonly used this scheme from Late Republican times on. Like the pseudoperipteral temple, which is an eclectic mix of Greek orders and Etruscan plan, this way of decorating a building's facade combined Greek orders with an architectural form foreign to Greek post-and-lintel architecture, namely the arch. Revived in the Italian Renaissance, the motif had a long, illustrious history in classical architecture. The Roman practice of framing an arch with an applied Greek order had no structural purpose, but it added variety to a monotonous surface. It also unified a multistoried facade by casting a net of verticals and horizontals over it.

10-36 Portrait bust of a Flavian woman, from Rome, Italy, ca. A.D. 90. Marble, approx. 2' 1" high. Museo Capitolino, Rome.

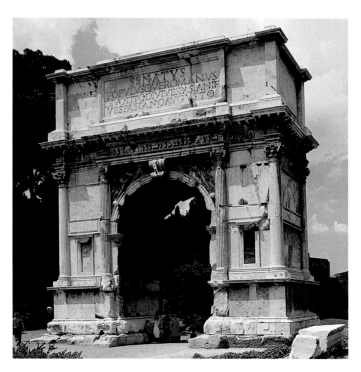

10-37 Arch of Titus, Rome, Italy, after A.D. 81.

A NEW ARCH FOR A NEW GOD When Vespasian's older son, Titus, died in A.D. 81, only two years after becoming emperor, his younger brother, Domitian, succeeded him. Domitian erected an arch (FIGS. **10-37** to **10-39**) in Titus's honor on the Sacred Way leading into the Republican Forum Romanum. This type of arch, the so-called *triumphal arch*, has a long history in Roman art and architecture, beginning in the second century B.C. and continuing even into the era of Christian Roman emperors. The term is something of a misnomer, however, because Roman arches celebrated more than just military victories. Such freestanding arches, usually crowned by gilded bronze statues, commemorated a wide variety of events, ranging from victories abroad to the building of roads and bridges at home.

The Arch of Titus is typical of the early triumphal arch and consists of one passageway only. As on the Colosseum, engaged columns frame the arcuate opening, but their capitals are the *Composite* type, an ornate combination of Ionic volutes and Corinthian acanthus leaves that became popular at about the same time as the Fourth Style in Roman painting. Reliefs depicting personified Victories (winged women, as in Greek art) fill the *spandrels,* the area between the arch's

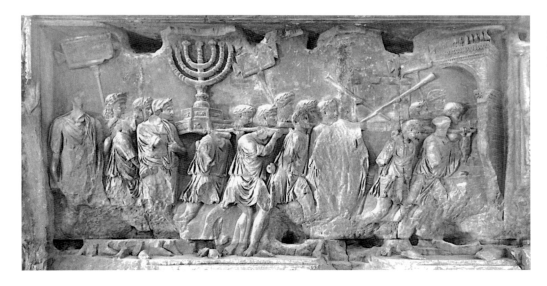

10-38 Spoils of Jerusalem, relief panel from the Arch of Titus, Rome, Italy, after A.D. 81. Marble, approx. 7′ 10″ high.

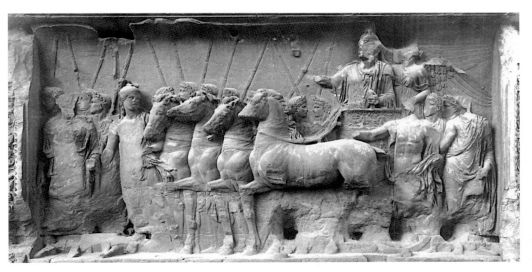

10-39 Triumph of Titus, relief panel from the Arch of Titus, Rome, Italy, after A.D. 81. Marble, approx. 7′ 10″ high.

curve and the framing columns and entablature. A dedicatory inscription stating that the arch was set up to honor the god Titus, son of the god Vespasian, dominates the attic. (Roman emperors normally were proclaimed gods after they died, unless they ran afoul of the Senate; then they were damned. The statues of those who suffered *damnatio memoriae* were torn down and their names were erased from public inscriptions. This was Nero's fate.)

THE SPOILS OF JERUSALEM Inside the passageway of the Arch of Titus are two great relief panels. They represent the triumphal parade of Titus down the Sacred Way after his return from the conquest of Judaea at the end of the Jewish Wars in A.D. 70. One of the reliefs (FIG. 10-38) depicts Roman soldiers carrying the spoils—including the sacred seven-branched candelabrum, the *menorah*—from the Temple in Jerusalem. Despite considerable damage to the relief, the illusion of movement is convincing. The parade moves forward from the left background into the center foreground and disappears through the obliquely placed arch in the right background. The energy and swing of the column of soldiers suggest a rapid march. The sculptor rejected the classicizing low relief of the Ara Pacis (FIG. 10-29) in favor of extremely deep carving, which produces strong shadows. The heads of the forward figures have broken off because they stood free from the block. Their high relief emphasized their different placement in space from the heads in low relief, which are intact. The play of light and shade across the protruding foreground and receding background figures quickens the sense of movement.

The panel on the other side of the passageway (FIG. 10-39) shows Titus in his triumphal chariot. The seeming historical accuracy of the spoils panel—it closely corresponds to the contemporary description of Titus's triumph by the Jewish historian Josephus—gave way in this panel to allegory. Victory rides with Titus in the four-horse chariot and places a wreath on his head. Below her is a bare-chested youth who is probably a personification of Honor (*Honos*). A female personification of Valor (*Virtus*) leads the horses. These allegorical figures transform the relief from a record of Titus's battlefield success into a celebration of imperial virtues. Such an intermingling of divine and human figures occurs on the Villa of the Mysteries frieze at Pompeii (FIG. 10-15), but this was the first known instance of divine beings interacting with humans on an official Roman historical relief. (On the Ara Pacis, FIG. 10-27, Aeneas and "Tellus" appear in separate framed panels and were carefully segregated from the procession of living Romans.) It is well to remember, however, that the Arch of Titus was erected after his death and that its reliefs were carved when Titus was already a god. Soon afterward this kind of interaction between mortals and immortals became a staple of Roman narrative relief sculpture, even on monuments honoring a living emperor.

THE HIGH EMPIRE

THE ROMAN EMPIRE AT ITS PEAK In the second century A.D., under Trajan, Hadrian, and the Antonines, the Roman Empire reached its greatest geographic extent and the height of its power. Rome's might was unchallenged in the

Western world, although the Germanic peoples in Europe, the Berbers in Africa, and the Parthians and Persians in the Near East constantly applied pressure. Within the empire's secure boundaries, the Pax Romana meant unprecedented prosperity for all who came under Roman rule.

Trajan (A.D. 98–117)

THE FIRST SPANISH EMPEROR Domitian's extravagant lifestyle and ego resembled Nero's. He demanded to be addressed as *dominus et deus* (lord and god), angering the senators. When he was assassinated in A.D. 96, the Senate chose the elderly Nerva, one of its own, as emperor. Nerva ruled for only sixteen months, but before he died he established a pattern of succession that lasted for almost a century. He adopted Trajan, a capable and popular general to whom he was unrelated by blood. A Spaniard by birth, Trajan was the first non-Italian to become emperor of Rome. Under Trajan, Roman armies brought Roman rule to ever more distant areas, and the imperial government took on ever greater responsibility for its people's welfare by instituting a number of farsighted social programs. Trajan was so popular he was granted the title *Optimus* (the Best), an epithet he shared with Jupiter (who was said to have instructed Nerva to choose Trajan as his successor). In late antiquity Augustus, the founder of the Roman Empire, and Trajan became the yardsticks for success. The goal of new emperors was to be *felicior Augusto, melior Traiano* (luckier than Augustus, better than Trajan).

A NEW COLONY IN AFRICA In A.D. 100 Trajan founded a new colony for army veterans at Timgad, ancient Thamugadi (FIG. **10-40**), in what is today Algeria. Timgad

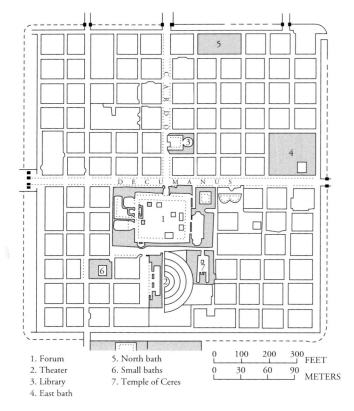

1. Forum 5. North bath
2. Theater 6. Small baths
3. Library 7. Temple of Ceres
4. East bath

0 100 200 300 FEET
0 30 60 90 METERS

10-40 Plan of Timgad (Thamugadi), Algeria, founded A.D. 100.

was built along a major road one hundred miles from the sea. Like other colonies, it became the physical embodiment of Roman authority and civilization for the local population and served as a key to the Romanization of the provinces. The town was planned with great precision, its design resembling that of a Roman military encampment or *castrum*. (Scholars still debate which came first. The castrum may have been based on the layout of Roman colonies.) Unlike the sprawling unplanned cities of Rome and Pompeii, Timgad is a square divided into equal quarters by its two main streets, the *cardo* and the *decumanus*. They cross at right angles and are bordered by colonnades. Monumental gates in the colony's original walls mark the ends of the two avenues. The forum is located at the point where the streets intersect. The quarters are subdivided into square blocks, and the forum and public buildings, such as the theater and baths, occupy areas sized as multiples of these blocks. The Roman plan is a modification of the Hippodamian plan of Greek cities (see FIG. 5-75), though more rigidly ordered.

The fact that most of these colonial settlements were laid out in the same manner, regardless of whether they were in North Africa, Mesopotamia, or England, expresses concretely the unity and centralized power of the Roman Empire at its height. But, even the Romans could not regulate human behavior completely. As the population of Timgad grew sevenfold and burst through the Trajanic settlement walls, rational planning was ignored, and the city and its streets branched out haphazardly.

ROME'S GREATEST FORUM Trajan's major building project in Rome was a huge new forum (FIG. **10-41**), roughly twice the size of the forum Augustus built a century before—even if the enormous market complex next to the forum is excluded. The new forum glorified Trajan's victories in his two wars against the Dacians (who lived in what is now Romania), and was paid for with the spoils of those campaigns. The architect was APOLLODORUS OF DAMASCUS, Trajan's chief military engineer during the Dacian wars, who had constructed a world-famous bridge across the Danube River. Apollodorus's plan incorporated the main features of most early forums (FIG. 10-10), except that a huge basilica, not a temple, dominated the colonnaded open square. The temple (completed after the emperor's death and dedicated to the newest god in the Roman pantheon, Trajan himself) was set instead behind the basilica. It stood at the rear end of the forum in its own courtyard, with two libraries and a giant commemorative column, the Column of Trajan (FIG. 10-42).

One entered Trajan's forum through an impressive gateway resembling a triumphal arch, complete with an attic statuary group of Trajan driving a six-horse chariot while Victory crowns him. Inside the forum were other reminders of Trajan's military prowess. A larger-than-life-size gilded-bronze equestrian statue of the emperor stood at the center of the great court in front of the basilica. Statues of bound Dacians stood above the columns of the forum porticoes.

The Basilica Ulpia (Trajan's family name was Ulpius) was a much larger and far more ornate version of the basilica in the forum of Pompeii(FIG. 10-10). As shown in the model (FIG. 10-41), it had *apses,* or semicircular recesses, on each short end. The nave was flanked by two aisles on each side. In contrast to the Pompeian basilica and later Christian churches, the entrances were on the long side facing the forum. The

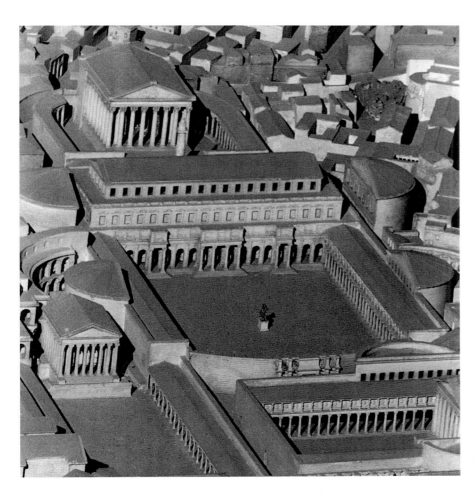

10-41 APOLLODORUS OF DAMASCUS, model of Forum of Trajan, Rome, Italy, dedicated A.D. 112. Museo della Civiltà Romana, Rome.

building was vast: about four hundred feet long (without the apses) and two hundred feet wide. Light entered through *clerestory* windows, made possible by elevating the timber-roofed nave above the colonnaded aisles. In the Republican basilica at Pompeii, light reached the nave only indirectly through aisle windows. The clerestory (used millennia before at Karnak in Egypt, see FIGS. 3-25 and 3-26) was a much better solution. Early Christian architects embraced this feature of the Basilica Ulpia for the design of the first churches (see FIGS. 11-8 and 11-16).

THE COLUMN AND TOMB OF TRAJAN The Column of Trajan (FIG. **10-42**) was probably also the brainchild of Apollodorus of Damascus. The idea of covering the shaft of a colossal freestanding column with a continuous spiral narrative frieze seems to have been invented here, but it was often copied. As late as the nineteenth century, a column inspired by the Column of Trajan was erected in the Place Vendôme in Paris in commemoration of the victories of Napoleon. The type even appeared in Christian settings with reliefs illustrating the life of Christ (see FIG. 16-26).

Trajan's Column is one hundred twenty-eight feet high. Coins indicate that it was once crowned by a heroically nude statue of the emperor. Trajan's portrait was lost in the Middle Ages, and in the sixteenth century a statue of Saint Peter replaced it. The square base, decorated with captured Dacian arms and armor, served as Trajan's mausoleum. His ashes and those of his wife, Plotina, were placed inside it in golden urns.

The six hundred twenty-five-foot band that winds around the column has been likened to an illustrated scroll of the type housed in the neighboring libraries (and held by Lars Pulena on his sarcophagus, see FIG. 9-14). The reliefs depict Trajan's two successful campaigns against the Dacians. The story is told in more than one hundred and fifty episodes in which some twenty-five hundred figures appear. The band increases in width as it winds to the top of the column, so that it is easier to see the upper portions. Throughout, the relief is very low so as not to distort the contours of the shaft. Legibility was enhanced in antiquity by paint, but it still would have been very difficult for anyone to follow the narrative from beginning to end.

Much of the spiral frieze is given over to easily recognizable compositions like those found on coin reverses and on historical relief panels: Trajan addressing his troops, sacrificing to the gods, and so on. The narrative is not a reliable chronological account of the Dacian Wars, as was once thought. The general character of the campaigns was nonetheless accurately recorded. Notably, battle scenes take up only about a quarter of the frieze. As is true of modern military operations, the Romans spent more time constructing forts, transporting men and equipment, and preparing for battle than fighting. The focus is always on the emperor, who appears again and again in the frieze, but the enemy is not belittled. The Romans won because of their superior organization and more powerful army, not because they were inherently superior beings.

SHOPPING IN IMPERIAL ROME On the Quirinal Hill overlooking the forum, Apollodorus built the Markets of Trajan (FIG. **10-43**) to house both shops and administrative offices. The transformation of a natural slope into a multilevel

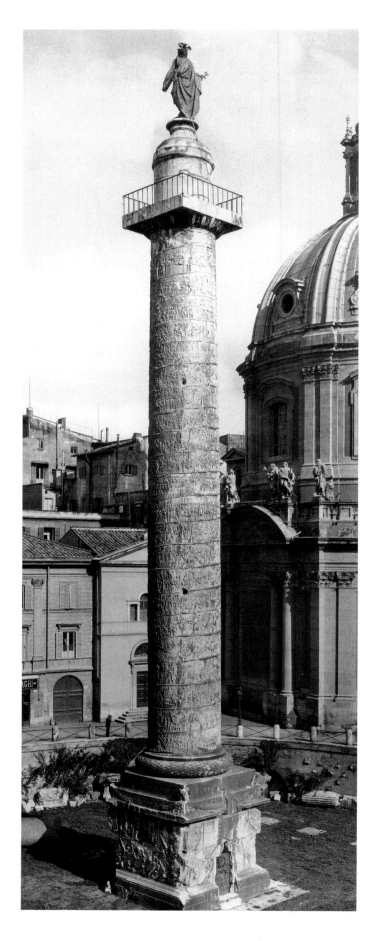

10-42 Column of Trajan, Forum of Trajan, Rome, Italy, dedicated A.D. 112.

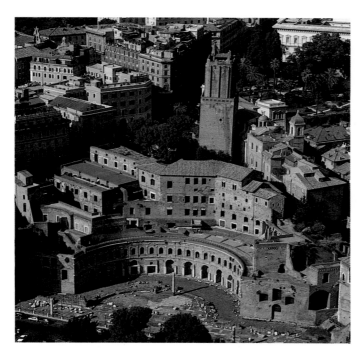

10-43 APOLLODORUS OF DAMASCUS, aerial view of Markets of Trajan, Rome, Italy, ca. A.D. 100–112.

10-44 APOLLODORUS OF DAMASCUS, interior of the great hall, Markets of Trajan, Rome, Italy, ca. A.D. 100–112.

complex was possible here, as earlier at Palestrina (FIG. 10-3), only by using concrete. Trajan's architect was a master of this modern medium as well as of the traditional stone-and-timber post-and-lintel architecture of the forum below.

The basic unit was the *taberna,* a single-room shop covered by a barrel vault. Each taberna had a wide doorway, usually with a window above it that allowed light to enter a wooden inner attic used for storage. The shops were on several levels. They opened either onto a hemispherical facade winding around one of the great exedras of Trajan's forum, onto a paved street farther up the hill, or onto a great indoor market hall (FIG. **10-44**) resembling a modern shopping mall. The hall housed two floors of shops, with the upper shops set back on each side and lit by skylights. Light from the same sources reached the ground-floor shops through arcuate openings beneath the great umbrella-like groin vaults covering the hall (see "The Roman Architectural Revolution: Concrete Construction," page 249).

THE TRIUMPHAL ARCH AS BILLBOARD In A.D. 109 a new road, the Via Traiana, was opened in southern Italy. Several years later a great arch honoring Trajan (FIG. **10-45**) was built at the point where the road entered Benevento (ancient Beneventum). Architecturally, the Arch of Trajan at Benevento is almost identical to Titus's arch on the Sacred Way in Rome (FIG. 10-37), but relief panels cover both facades of the Trajanic arch, giving it a billboardlike function. Every inch of the surface was used to advertise the emperor's achievements. In one panel, he enters Rome after a successful military campaign. In another, he distributes largess to needy children. In still others, he was portrayed as the founder of colonies for army veterans and as the builder of a new port at Ostia, Rome's harbor at the mouth of the Tiber. The reliefs present Trajan as the guarantor of peace and security in the empire, the benefactor of the poor, and the patron of soldiers and merchants alike. In short, the emperor was "all things to all people."

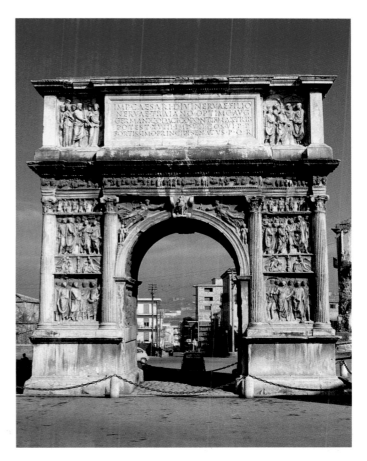

10-45 Arch of Trajan, Benevento, Italy, ca. A.D. 114–118.

10-46 Funerary relief of a circus official, from Ostia, Italy, ca. A.D. 110–130. Marble, approx. 1′ 8″ high. Vatican Museums, Rome.

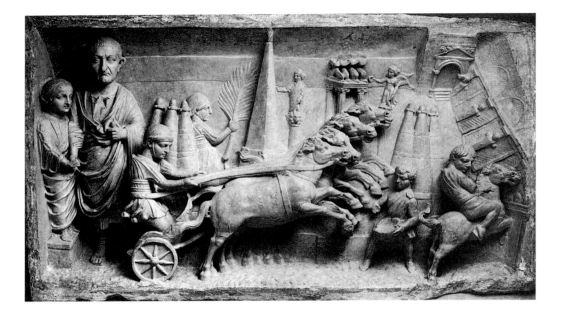

In several of the panels, Trajan freely intermingles with divinities, and on the arch's attic (which may have been completed after his death and deification) Jupiter hands his thunderbolt to the emperor, awarding him dominion over the earth. Such scenes, depicting the "first citizen" of Rome as a divinely sanctioned ruler in the company of the gods, henceforth became the norm, not the exception, in official Roman art.

RACES IN THE CIRCUS MAXIMUS One of Trajan's other benefactions to the Roman people was the restoration of the Circus Maximus, where the world's best horse teams competed in chariot races. A relief that once decorated a circus official's tomb (FIG. **10-46**) gives a partial view of the refurbished racecourse. The relief is not a product of one of the emperor's official sculptural workshops, and it illustrates once again how different the art produced for Rome's huge working class was from the art the state and old aristocratic families commissioned.

The relief shows the Circus Maximus in distorted perspective. Only one team of horses races around the central island, but the charioteer is shown twice, once driving the horses and a second time holding the palm branch of victory. This is an example of *continuous narration;* that is, the same figure appears more than once in the same space at different stages of a story. This is not the first instance of continuous narration, but few earlier examples exist and only much later did this way of telling a story in pictures become common. (The emperor's appearance in different settings in the Column of Trajan's frieze is not an example of continuous narration.)

In fact, the charioteer may appear a third time within the same relief, for he may be, later in life, the toga-clad official who appears at the panel's left end. There the recently deceased official clasps hands with his wife. (The handshake between man and woman is a symbol of marriage in Roman art.) She is of smaller stature (and less important than her husband in this context, for it is *his* career in the circus commemorated on *his* tomb), and she is shown standing on a base. The base indicates that she is not a living person but a statue. The handshake between man and statue is the plebeian

artist's shorthand way of saying the wife died before the husband, that her death had not broken their marriage bond, and that, because the husband has now died, the two will be reunited in the afterlife. The rules of classical design, which still guided the Roman state's artists, were ignored here, as in the funerary relief from Amiternum (FIG. 10-5), also made for a nonelite patron. Before long, however, some of these nonclassical elements appeared in official art as well.

Hadrian (A.D. 117–138)

A GREEK BEARD FOR A ROMAN EMPEROR Hadrian, Trajan's chosen successor and fellow Spaniard, was a connoisseur and lover of all the arts, as well as an author and architect. He traveled widely as emperor, often in the Greek East. Everywhere he went, statues and arches were set up in his honor. More portraits of Hadrian exist today than of any other emperor except Augustus. Hadrian, who was forty-one years old at the time of Trajan's death and who ruled for more than two decades, is always depicted in his portraits as a mature adult who never ages.

A fine example is the fragmentary bronze statue of the emperor wearing a cuirass (FIG. **10-47**) found at Tel Shalem, Israel, several miles south of the ancient city of Scythopolis. The portrait probably was erected toward the end of Hadrian's lifetime, when Rome put down a second Jewish revolt and Judaea was reorganized as a new province called Syria Palaestina. Hadrian's portraits more closely resemble Kresilas's portrait of Pericles (see FIG. 5-39) than those of any Roman emperor before him, and no one doubts that his likenesses were inspired by Classical Greek statuary. The idealizing official portraits of Augustus also were inspired by fifth-century B.C. statues, but the prototypes were images of athletes. The models for Hadrian's artists were statues of mature Greek men. Hadrian himself wore a beard—a habit that, in its Roman context, must be viewed as a Greek affectation. Beards then became the norm for all subsequent Roman emperors for more than a century and a half.

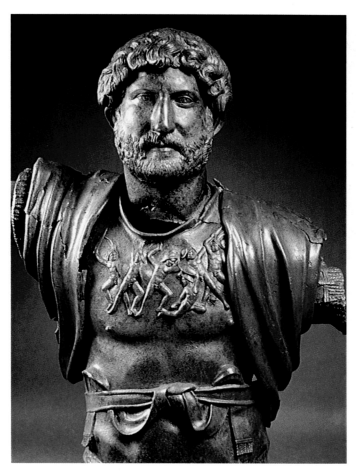

10-47 Portrait bust of Hadrian as general, from Tel Shalem, Israel, ca. A.D. 130–138. Bronze, approx. 2′ 11″ high. Israel Museum, Jerusalem.

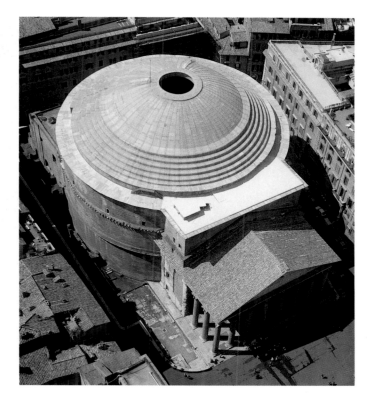

10-48 Aerial view of the Pantheon, Rome, Italy, A.D. 118–125.

THE PANTHEON, TEMPLE FOR ALL GODS
Soon after Hadrian became emperor, work began on the Pantheon (FIG. **10-48**), the temple of all the gods, one of the best-preserved buildings of antiquity. It also has been one of the most influential designs in architectural history. The Pantheon reveals the full potential of concrete, both as a building material and as a means for shaping architectural space. The temple originally was approached from a columnar courtyard, and, like temples in Roman forums, stood at one narrow end of the enclosure. Its facade of eight Corinthian columns—almost all that could be seen from ground level in antiquity—

was a bow to tradition. Everything else about the Pantheon is revolutionary. Behind the columnar porch is an immense concrete cylinder covered by a huge hemispherical dome one hundred forty-two feet in diameter. The dome's top is also one hundred forty-two feet from the floor (FIG. **10-49**). The design is thus based on the intersection of two circles (one horizontal, the other vertical) so that the interior space could be imagined as the orb of the earth and the dome as the vault of the heavens.

If the Pantheon's design is simplicity itself, executing that design took all the ingenuity of Hadrian's engineers. The cylindrical drum was built up level by level using concrete of varied composition. Extremely hard and durable basalt was used in the mix for the foundations, and the "recipe" was gradually modified until, at the top, featherweight pumice replaced stones to lighten the load. The dome's thickness also decreases as it nears the *oculus,* the circular opening thirty feet in diameter that is the only light source for the

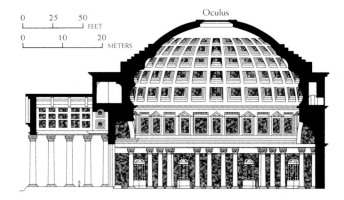

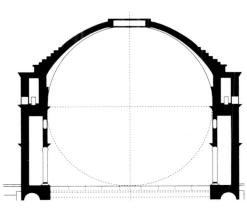

10-49 Longitudinal and lateral sections of the Pantheon, Rome, Italy, A.D. 118–125.

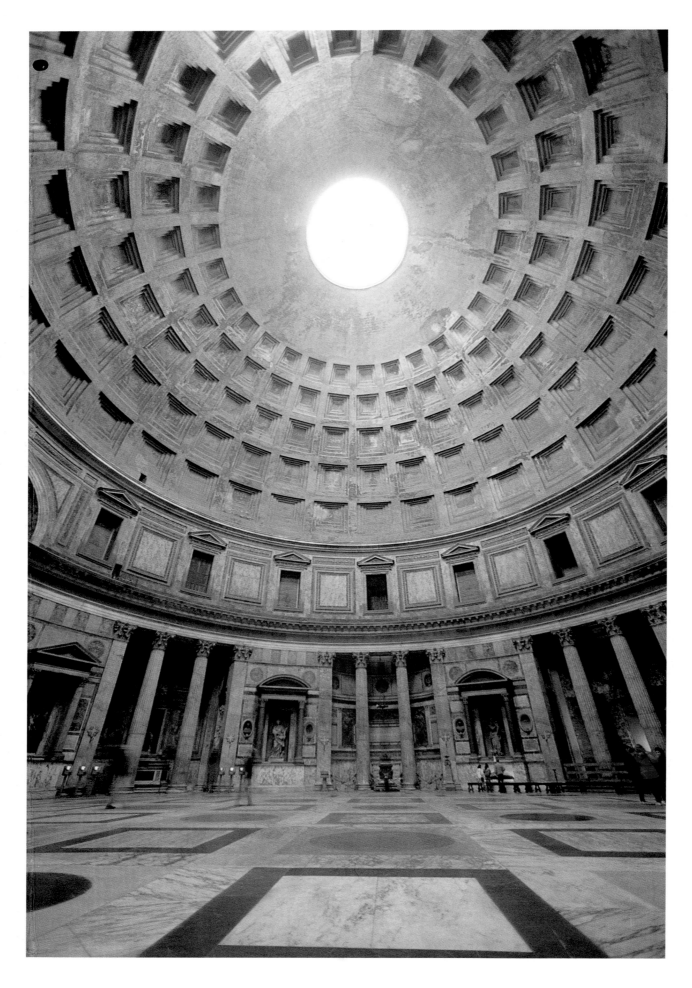

10-50 Interior of the Pantheon, Rome, Italy, A.D. 118–125.

interior (FIG. **10-50**). The dome's weight was lessened, without weakening its structure, through the use of *coffers* (sunken decorative panels). These further reduced the dome's mass and also provided a handsome pattern of squares within the vast circle. Renaissance drawings suggest that each coffer once had a glistening gilded-bronze rosette at its center, enhancing the dome's symbolism as the starry heavens.

Below the dome much of the original marble veneer of the walls, niches, and floor has survived (FIG. 10-50). In the Pantheon visitors can get a sense, as almost nowhere else, of how magnificent the interiors of Roman concrete buildings could be. But despite the luxurious skin of the Pantheon's interior, on first entering the structure one senses not the weight of the enclosing walls but the space they enclose. In pre-Roman architecture, the form of the enclosed space was determined by the placement of the solids, which did not so much shape space as interrupt it. Roman architects were the first to conceive of architecture in terms of units of space that could be shaped by the enclosures. The Pantheon's interior is a single unified, self-sufficient whole, uninterrupted by supporting solids. It encloses visitors without imprisoning them, opening through the oculus to the drifting clouds, the blue sky, the sun, and the gods. In this space, the architect used light not just to illuminate the darkness but to create drama and underscore the interior shape's symbolism. On a sunny day, the light that passes through the oculus forms a circular beam, a disk of light that moves across the coffered dome in the course of the day as the sun moves across the sky itself. Escaping from the noise and torrid heat of a Roman summer day into the Pantheon's cool, calm, and mystical immensity is an experience almost impossible to describe and one that should not be missed.

A WELL-TRAVELED EMPEROR'S RETREAT Although some have suggested that Hadrian himself was the architect of the Pantheon, the amateur builder does not deserve credit for the design. Hadrian was, however, deeply involved with the construction of his own villa at Tivoli, where building activity seems never to have ceased until the emperor's death.

One of the latest projects on the vast estate was the construction of a pool and an artificial grotto, called the *Canopus* and *Serapeum* (FIG. **10-51**), respectively. They commemorated the emperor's trip to Egypt, where he visited a famous temple of the god Serapis on a canal called the Canopus. Nothing about the design, however, derives from Egyptian architecture. The grotto at the end of the pool is made of concrete and has an unusual pumpkin-shaped dome of a type Hadrian designed himself (see "Hadrian: Emperor and Architect," page 282). Yet, in keeping with the persistent eclecticism of Roman art and architecture, the pool was lined with marble copies of famous Greek statues, as one would expect from a lover of Greek art. There is also a Corinthian colonnade at the curved end of the pool, but it is of a type unknown in Classical Greek architecture. Not only does the colonnade lack a superstructure, but it has *arcuated,* as opposed to traditional Greek horizontal, lintels between alternating pairs of columns. This kind of simultaneous respect for Greek architecture—elsewhere on the grounds is a replica of the Temple of Aphrodite at Knidos—and willingness to break Greek design rules typifies much Roman architecture of the High and Late Empire.

A BAROQUE TOMB IN A MOUNTAIN An even more extreme example of what many have called Roman "baroque" architecture (because of the striking parallels with

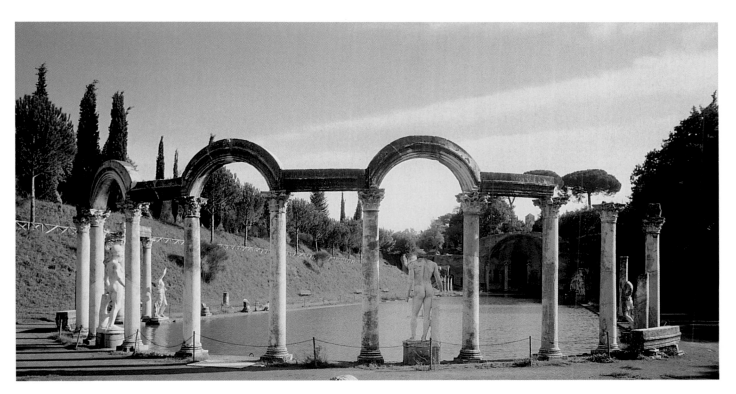

10-51　*Canopus* and *Serapeum*, Hadrian's Villa, Tivoli, Italy, ca. A.D. 130–138.

Hadrian
Emperor and Architect

Dio Cassius, a third-century A.D. senator who wrote a history of Rome from its foundation to his own day, recounted a revealing anecdote about Hadrian and Apollodorus of Damascus, architect of the Forum of Trajan (FIG. 10-41):

> Hadrian first drove into exile and then put to death the architect Apollodorus who had carried out several of Trajan's building projects. . . . When Trajan was at one time consulting with Apollodorus about a certain problem connected with his buildings, the architect said to Hadrian, who had interrupted them with some advice, "Go away and draw your pumpkins. You know nothing about these problems." For it so happened that Hadrian was at that time priding himself on some sort of drawing. When he became emperor he remembered this insult and refused to put up with Apollodorus's outspokenness. He sent him [his own] plan for the temple of Venus and Roma, in order to demonstrate that it was possible for a great work to be conceived without his [Apollodorus's] help, and asked him if he thought the building was well designed. Apollodorus sent a [very critical] reply. . . . [The emperor did not] attempt to restrain his anger or hide his pain; on the contrary, he had the man slain.[1]

The story says a great deal both about the absolute power Roman emperors wielded and about how seriously Hadrian took his architectural designs. But perhaps the most interesting detail is the description of Hadrian's drawings of "pumpkins." These must have been drawings of concrete domes like the one in the *Serapeum* at Hadrian's Tivoli villa (FIG. 10-51). Such vaults were too adventurous for Apollodorus, or at least for a public building in Trajanic Rome, and Hadrian had to try them out later at home at his own expense.

[1] J. J. Pollitt, trans., *The Art of Rome, c. 753 B.C.–A.D. 337: Sources and Documents* (New York: Cambridge University Press, 1983), 175–76.

seventeenth-century Italian buildings) is the second-century A.D. tomb nicknamed Al-Khazneh, the "Treasury" (FIG. **10-52**), at Petra in modern Jordan. It is one of the most elaborate of many tomb facades cut into the sheer rock faces of the local rose-colored mountains. As at Hadrian's villa, classical architectural elements are used here in a purely ornamental fashion and with a studied disregard for classical rules.

The Treasury's facade is more than one hundred and thirty feet high and consists of two stories. The lower story resembles a temple facade with six columns, but the columns are unevenly spaced and the pediment is only wide enough to cover the central four columns. On the upper level, a temple-within-a-temple is set on top of the lower temple. Here the facade and roof split in half to make room for a central tholoslike cylinder, which contrasts sharply with the rectangles and triangles of the rest of the design. On both levels, the rhythmic alternation of deep projection and indentation creates dynamic patterns of light and shade. At Petra, as at Tivoli, the vocabulary of Greek architecture was maintained, but the syntax is new and distinctively Roman. In fact, the design recalls some of the architectural fantasies painted on the walls of Roman houses—for example, the tholos seen through columns surmounted by a broken pediment in the Second Style cubiculum from Boscoreale (FIG. 10-16).

Ostia

THE CROWDED LIFE OF THE CITY The average Roman, of course, did not own a luxurious country villa and was not buried in a grand tomb. Ninety percent of Rome's population of close to one million lived in multistory apartment blocks *(insulae)*. After the great fire of A.D. 64, these were built of brick-faced concrete. The rents were not cheap, since the law of supply and demand in real estate was just as valid in antiquity as it is today. Juvenal, a Roman satirist of the early second century A.D., commented that people willing to give up chariot races and the other diversions Rome had to offer could purchase a fine home in the countryside "for a year's rent in a dark hovel" in a city so noisy that "the sick die mostly from lack of sleep."[5]

10-52 Al-Khazneh ("Treasury"), Petra, Jordan, second century A.D.

10-53 Model of an insula, Ostia, Italy, second century A.D. Museo della Civiltà Romana, Rome.

Conditions were much the same for the inhabitants of Ostia, Rome's harbor city. After its new port opened under Trajan, Ostia's prosperity increased dramatically and so did its population. A burst of building activity began under Trajan and continued under Hadrian and throughout the second century A.D. Many multistory second-century *insulae* (FIG. 10-53) have been preserved at Ostia. Shops occupied the ground floors. Above were up to four floors of apartments. Although many of the insula apartments were large, they had neither the space nor the light of the typical Pompeian private *domus* (see "The Roman House," page 255). In place of peristyles, the insulae of Ostia and Rome had only narrow light wells or small courtyards. Consequently, instead of looking inward, large numbers of glass windows faced the city's noisy streets. Only deluxe apartments had private toilets. Others shared latrines, often on a different floor than the apartment. Still, these insulae were quite similar to modern apartment houses, which also sometimes have shops on the ground floor.

Another strikingly modern feature of these multifamily residences is their brick facades, which were not concealed by stucco or marble veneers. When a classical motif was desired, brick pilasters or engaged columns could be added, but the brick was always left exposed. Ostia and Rome have many examples of apartment houses, warehouses, and tombs with intricate moldings and contrasting colors of brick. In the second century A.D., brick came to be appreciated as attractive in its own right.

PAINTED VAULTS AND MOSAIC PAVEMENTS
Although the decoration of Ostian insulae tended to be more modest than that of the private houses of Pompeii, the finer apartments had mosaic floors and painted walls and ceilings. The painted groin vaults of Ostia are of special interest, because few painted ceilings are preserved in the cities buried by the eruption of Mount Vesuvius, and they are rarely of the vaulted type. Room IV (FIG. 10-54) in the aptly named Insula of the Painted Vaults is typical of painted ceiling design of the second and third centuries A.D. Such designs appear both in

10-54 Ceiling and wall paintings in Room IV of the Insula of the Painted Vaults, Ostia, Italy, early third century A.D.

10-55 Neptune and creatures of the sea, floor mosaic in the Baths of Neptune, Ostia, Italy, ca. A.D. 140.

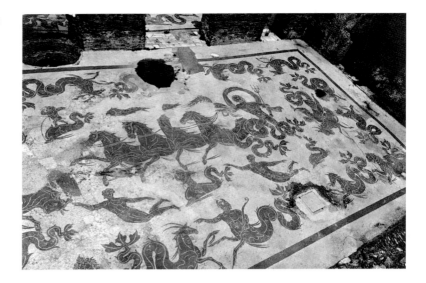

urban buildings and in the underground Christian catacombs (see FIG. 11-3). The groin vault was treated as if it were a dome, with a central oculus-like medallion surrounded by eight wedge-shaped segments resembling wheel spokes. In each segment is a white lunette with delicate paintings of birds and flowers, motifs also common earlier at Pompeii.

The most popular choice for elegant pavements at Ostia in both private and public edifices was the black-and-white mosaic. One of the largest and best preserved examples is in the so-called Baths of Neptune, named for the grand mosaic floor (FIG. **10-55**) with four seahorses pulling the Roman god of the sea across the waves. Neptune needs no chariot to support him as he speeds along, his mantle blowing in the strong wind. All about the god are other sea denizens, positioned so that regardless of which side a visitor enters the room, some figures appear right side up. The artist rejected the complex polychrome modeling of figures seen in Pompeian mosaics such as the *Battle of Issus* (see FIG. 5-69) and used simple black silhouettes enlivened

by white interior lines. Roman black-and-white mosaics were conceived as surface decorations and not as three-dimensional windows and thus were especially appropriate for floors.

TOMBS OF WORKING MEN AND WOMEN Ostian tombs of the second century A.D. were usually constructed of brick-faced concrete, and the facades of these houses of the dead resembled those of the contemporary insulae of the living. These were normally communal tombs, not the final resting places of the very wealthy. Many of them were adorned with small painted terracotta plaques immortalizing the activities of middle-class merchants and professional people. We illustrate two of these plaques (FIG. **10-56**). One depicts a young man selling vegetables from behind a counter (which has been tilted forward so that the observer can see the produce clearly). The other shows a midwife delivering a baby. Because she looks out at the viewer rather than at what she is doing and because almost all these reliefs focus on the livelihoods of the deceased, it is likely the relief commemorates the midwife rather than the mother. Scenes of working men and women such as these appear on Roman funerary reliefs all over western Europe. Centuries later they may have served as the models for some medieval illustrations of the "labors of the months." They were as much, or more, a part

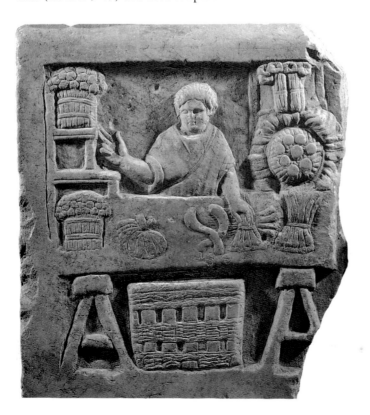

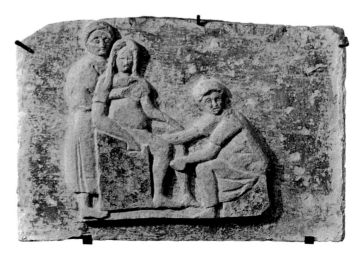

10-56 Funerary reliefs of a vegetable vendor *(left)* and a midwife *(right)*, from Ostia, Italy, second half of second century A.D. Painted terracotta, approx. 1′ 5″ and 11″ high, respectively. Museo Ostiense, Ostia.

of the classical legacy to the later history of art as the monuments Roman emperors commissioned, which until recently were the exclusive interest of art historians.

The Antonines (A.D. 138–192)

SUCCESSION BY ADOPTION Early in A.D. 138, Hadrian adopted the fifty-one-year-old Antoninus Pius (r. A.D. 138–161). At the same time, he required that Antoninus adopt Marcus Aurelius (r. A.D. 161–180) and Lucius Verus (r. A.D. 161–169), thereby assuring a peaceful succession for at least another generation. When Hadrian died later in the year, he was proclaimed a god, and Antoninus Pius became emperor. Antoninus ruled the Roman world with distinction for twenty-three years. After his death and deification, Marcus Aurelius and Lucius Verus became the Roman Empire's first coemperors.

CLASSICAL AND NON-CLASSICAL Shortly after Antoninus Pius's death, Marcus and Lucius erected a memorial column in his honor. This column's pedestal has a dedicatory inscription on one side, and a relief illustrating the *apotheosis* (ascent to the heavens) of Antoninus and his wife Faustina the Elder on the opposite side (FIG. **10-57**). On the adjacent sides are two identical representations of the *decursio,* or ritual circling of the imperial funerary pyre (FIG. **10-58**).

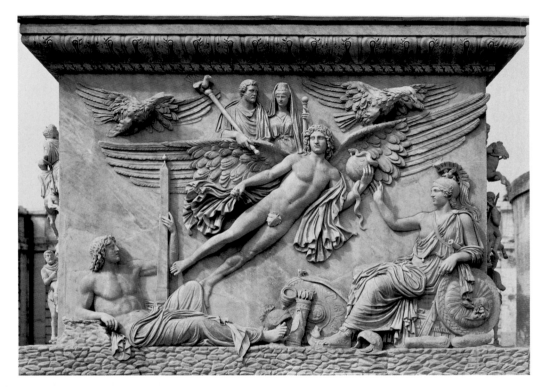

10-57 Apotheosis of Antoninus Pius and Faustina, pedestal of the Column of Antoninus Pius, Rome, Italy, ca. A.D. 161. Marble, approx. 8′ 1½″ high. Vatican Museums, Rome.

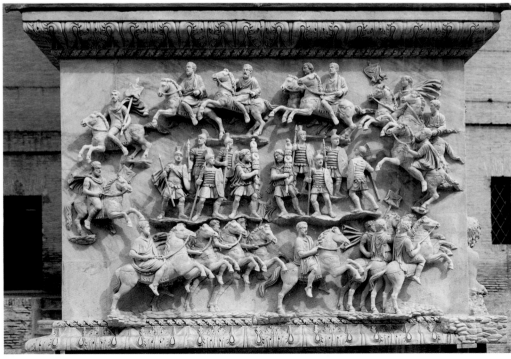

10-58 Decursio, pedestal of the Column of Antoninus Pius, Rome, Italy, ca. A.D. 161. Marble, approx. 8′ 1½″ high. Vatican Museums, Rome.

The two figural compositions are very different. The apotheosis relief remains firmly in the classical tradition with its elegant, well-proportioned figures, personifications, and single ground line corresponding to the panel's lower edge. The Campus Martius (Field of Mars), personified as a youth holding the Egyptian obelisk that stood in that area of Rome, reclines at the lower left corner. Roma (Rome personified) leans on a shield decorated with the she-wolf suckling Romulus and Remus (compare FIG. 9-10). Roma bids farewell to the couple being lifted into the realm of the gods on the wings of a personification of uncertain identity. All this is familiar from earlier scenes of apotheosis. New to the imperial repertoire, however, was the fusion of time the joint apotheosis represents. Faustina had died twenty years before Antoninus Pius. By depicting the two as ascending together, the artist wished to suggest that Antoninus had been faithful to his wife for two decades and that now they would be reunited in the afterlife. This notion had been employed before in the funerary reliefs of freed slaves and the middle class (FIG. 10-46) but had never been used in an elite context.

The decursio reliefs break even more strongly with classical convention. The figures are much stockier than those in the apotheosis relief, and the panel was not conceived as a window onto the world. The ground is the whole surface of the relief, and marching soldiers and galloping horses alike are shown on floating patches of earth. This, too, had not occurred before in imperial art, only in plebeian art (FIG. 10-5). After centuries of following classical design rules, elite Roman artists and patrons finally became dissatisfied with them. When seeking a new direction, they adopted some of the nonclassical conventions of the art of the lower classes.

DISQUIETING ANTONINE PORTRAITS Another break with the past occurred in the official portraits of Marcus Aurelius, although the pompous trappings of imperial iconography were retained. In the sixteenth century, Pope Paul III selected a larger-than-life-size gilded-bronze equestrian statue of the emperor Marcus Aurelius (FIG. **10-59**) as the centerpiece for Michelangelo's new design for the Capitoline Hill in Rome (see FIGS. 22-26 and 22-27). The statue inspired many Renaissance sculptors to portray their patrons on horseback (see FIGS. 21-32 and 21-33). Recently removed from its Renaissance site and painstakingly restored, the portrait owed its preservation throughout the Middle Ages to the fact it was mistakenly thought to portray Constantine, the first Christian emperor of Rome. Most ancient bronze statues were melted down for their metal value, because they were regarded as impious images from the pagan world. Even today, after centuries of new finds, only a very few bronze equestrian statues are known. The type was, however, often used for imperial portraits—an equestrian statue of Trajan stood in the middle of his forum (FIG. 10-41). Perhaps more than any other statuary type, the equestrian portrait expresses the Roman emperor's majesty and authority.

In this portrait, Marcus possesses a superhuman grandeur and is much larger than any normal human would be in relation to his horse. He stretches out his right arm in a gesture that is both a greeting and an offer of clemency. Some evidence suggests that an enemy once cowered beneath the horse's raised right foreleg begging Marcus for mercy. The

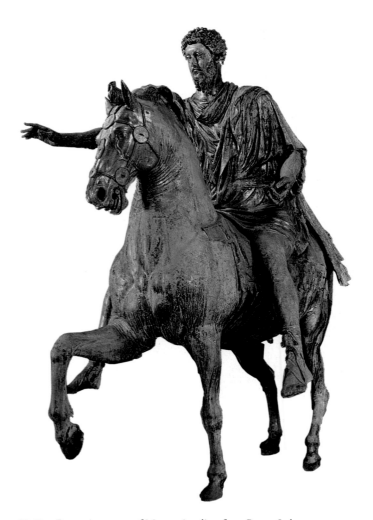

10-59 Equestrian statue of Marcus Aurelius, from Rome, Italy, ca. A.D. 175. Bronze, approx. 11′ 6″ high. Musei Capitolini, Rome.

statue conveys the awesome power of the godlike Roman emperor as ruler of the whole world.

This message of supreme confidence is not, however, conveyed by the statue's portrait head or by the late portraits of the emperor in marble, such as the one illustrated (FIG. **10-60**). The latter is a detail of a panel from a lost arch that probably resembled Trajan's arch at Benevento (FIG. 10-45). The emperor rides in a triumphal chariot, and, like Titus before him (FIG. 10-39), Victory crowns him. The Antonine sculptor, in keeping with contemporary practice, used a drill to render the emperor's long hair and beard and even to accentuate the pupils of his eyes, creating bold patterns of light and shadow across his face. A chisel was used to carve the lines in Marcus's forehead and the deep ridges running from his nostrils to the corners of his mouth.

Portraits of aged emperors were not new (FIG. 10-35), but Marcus's were the first ones where a Roman emperor appears weary, saddened, and even worried. For the first time, the strain of constant warfare on the frontiers and the burden of ruling a worldwide empire show in the emperor's face. The Antonine sculptor ventured beyond Republican verism. The ruler's character, his thoughts, and his soul were exposed for all to see, as Marcus revealed them himself in his *Meditations,* a deeply moving philosophical treatise setting forth the em-

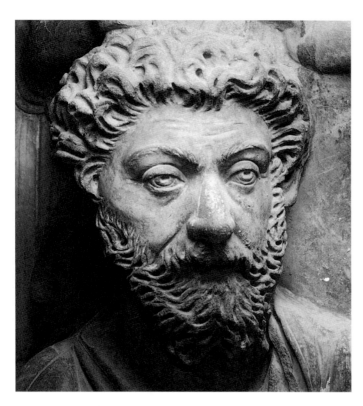

10-60 Portrait of Marcus Aurelius, detail of a relief from a lost arch, Rome, Italy, ca. A.D. 175–180. Marble, approx. life-size. Palazzo dei Conservatori, Rome.

peror's personal worldview. This was a major turning point in the history of ancient art, and, coming as it did when the classical style was being challenged in relief sculpture (FIG. 10-58), it marked the beginning of the end of classical art's domination in the Greco-Roman world.

CREMATION GIVES WAY TO BURIAL Other profound changes also were taking place in Roman art and society at this time. Beginning under Trajan and Hadrian and especially during the rule of the Antonines, Romans began to favor burial over cremation. This reversal of funerary practices may reflect the influence of Christianity and other Eastern religions, whose adherents believed in an afterlife for the human body. Although the emperors themselves continued to be cremated in the traditional Roman manner, many private citizens opted for burial. Thus they required larger containers for their remains than the ash urns that were the norm until the second century A.D. This in turn led to a sudden demand for sarcophagi, which are more similar to modern coffins than any other ancient type of burial container.

ORESTES ON ROMAN SARCOPHAGI Greek mythology was one of the most popular subjects for the decoration of these sarcophagi. In many cases, especially in the late second and third centuries A.D., the Greek heroes and heroines were given the portrait features of the deceased Roman men and women in the marble coffins. These private patrons were following the model of imperial portraiture, where emperors and empresses frequently masqueraded as gods and goddesses and heroes and heroines (see "Role-Playing in Roman Portraiture," page 266). An early example of the type (although it lacks any portraits) is the sarcophagus (FIG. **10-61**) now in Cleveland, one of many decorated with the story of the tragic Greek hero Orestes. All the examples of this type use the same basic continuous-narrative composition. Orestes appears several times: slaying his mother Clytaemnestra and her lover Aegisthus to avenge their murder of his father Agamemnon, taking refuge at Apollo's sanctuary at Delphi (symbolized by the god's tripod at the right), and so forth.

The repetition of sarcophagus compositions indicates that sculptors had access to pattern books. In fact, sarcophagus production was a major industry during the High and Late Empire. Several important regional manufacturing centers existed. The sarcophagi produced in the Latin West, such as the Cleveland Orestes sarcophagus, differ in format from those made in the Greek-speaking East. Western sarcophagi have reliefs only on the front and sides, because they were placed in floor-level niches inside Roman tombs. Eastern sarcophagi have reliefs on

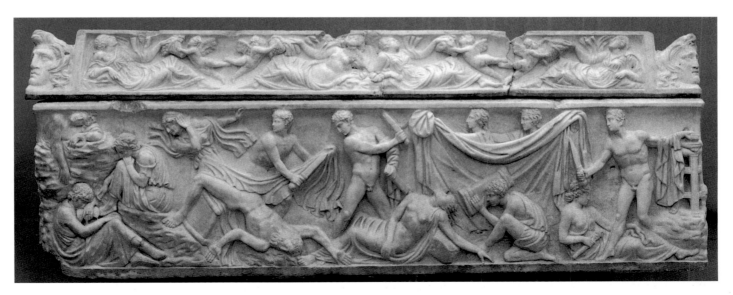

10-61 Sarcophagus with the myth of Orestes, ca. A.D. 140–150. Marble, 2′ 7$\frac{1}{2}$″ high. Cleveland Museum of Art, Cleveland.

10-62 Asiatic sarcophagus with *kline* portrait of a woman, from Melfi, Italy, ca. A.D. 165–170. Marble, approx. 5' 7" high. Museo Nazionale del Melfese, Melfi.

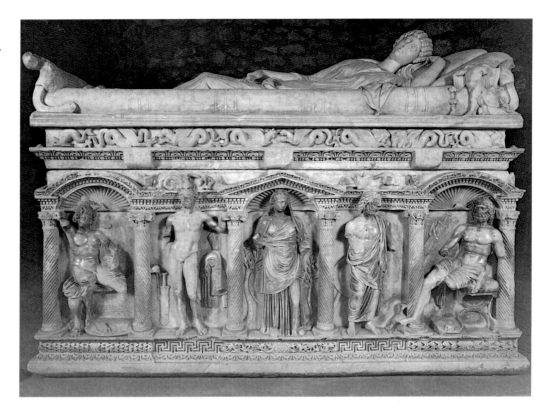

all four sides and stood in the center of the burial chamber. This contrast parallels the essential difference between the Etrusco-Roman and the Greek temple: The former was set against the wall of a forum or sanctuary and approached from the front, while the latter could be reached (and viewed) from every side.

A MORTAL VENUS'S COFFIN An elaborate example of a sarcophagus of the Eastern type (FIG. **10-62**) comes from Melfi in southern Italy. It was manufactured, however, in Asia Minor and attests to the vibrant export market for such luxury items in Antonine times. The decoration of all four sides of the marble box with statuesque images of Greek gods and heroes in architectural frames is distinctively Asiatic. But the lid portrait, which carries on the tradition of Etruscan sarcophagi (see FIGS. 9-4 and 9-14), is also a feature of the most expensive Western Roman coffins. Here the deceased, a woman, reclines on a *kline* (bed). With her are her faithful little dog (only its forepaws remain at the left end of the lid) and Cupid (at the right). The winged infant god mournfully holds a downturned torch, a reference to the death of a woman whose beauty rivaled that of his mother, Venus (who appears in one of the niches on the back of the sarcophagus).

MUMMY PORTRAITS IN ROMAN EGYPT In Egypt, burial had been practiced for millennia. Even after the Kingdom of the Nile was reduced to a Roman province in 30 B.C., Egyptians continued to bury their dead in mummy cases. In Roman times, however, painted portraits on wood replaced the traditional stylized portrait masks (see "Iaia of Cyzicus and the Art of Encaustic Painting," page 289). Hundreds of these mummy portraits have been preserved in the cemeteries of the Faiyum district. One of them (FIG. **10-63**)

10-63 Mummy portrait of a man, from Faiyum, Egypt, ca. A.D. 160–170. Encaustic on wood, approx. 1' 2" high. Albright-Knox Art Gallery, Buffalo (Charles Clifton Fund).

Iaia of Cyzicus and the Art of Encaustic Painting

The names of very few Roman artists are known. Those that are tend to be names of artists and architects who directed major imperial building projects (Severus and Celer, *Domus Aurea;* Apollodorus of Damascus, Forum of Trajan), worked on a gigantic scale (Zenodorus, Colossus of Nero), or made precious objects for famous patrons (Dioscurides, gem cutter for Augustus).

An interesting exception to this rule is IAIA OF CYZICUS. Pliny reported the following about this renowned painter from Asia Minor who worked in Italy during the Republic:

> Iaia of Cyzicus, who remained a virgin all her life, painted at Rome during the time when M. Varro [116–27 B.C.] was a youth, both with a brush and with a cestrum on ivory, specializing mainly in portraits of women; she also painted a large panel in Naples representing an old woman and a portrait of herself done with a mirror. Her hand was quicker than that of any other painter, and her artistry was of such high quality that she commanded much higher prices than the most celebrated painters of the same period.[1]

The *cestrum* Pliny mentioned is a small spatula used in *encaustic* painting, a technique of mixing colors with hot wax and then applying them to the surface. Pliny knew of encaustic paintings of considerable antiquity, including those of Polygnotos of Thasos, a famous fifth-century B.C. Greek painter (see Chapter 5, page 137). The best evidence for the technique comes, however, from Roman Egypt, where mummies were routinely furnished with portraits painted with encaustic on wooden panels (FIG. 10-63).

Artists applied encaustic to marble as well as to wood. According to Pliny, when Praxiteles was asked which one of his statues he preferred, the fourth-century B.C. Greek artist, perhaps the ancient world's greatest marble sculptor, replied: "Those that Nikias painted." This anecdote underscores the importance of coloration in ancient statuary.

[1] J. J. Pollitt, trans., *The Art of Rome, c. 753 B.C.–A.D. 337: Sources and Documents* (New York: Cambridge University Press, 1983), 87.

depicts a man who, following the lead of Marcus Aurelius, has long curly hair and a full beard. Such portraits, which mostly date to the second and third centuries A.D., were probably painted while the subjects were still alive. Art historians use them to trace the evolution of portrait painting after Mount Vesuvius erupted in A.D. 79 (compare FIG. 10-23). Our example is of high quality. Note the refined use of the brush and spatula, soft and delicate modeling, and sensitive portrayal of the calm demeanor of its thoughtful subject.

The Western and Eastern Roman sarcophagi and the mummy cases of Roman Egypt all served the same purpose, despite their differing shape and character. In an empire as vast as Rome's, regional differences are to be expected. As will be discussed later, geography also played a major role in the Middle Ages, when Western and Eastern Christian art differed sharply.

THE LATE EMPIRE

A CIVILIZATION IN TRANSITION By the time of Marcus Aurelius, two centuries after Augustus established the Pax Romana, Roman power was beginning to erode. It was more and more difficult to keep order on the frontiers, and even within the empire the authority of Rome was being challenged. Marcus's son Commodus (r. A.D. 180–192), who succeeded his father, was assassinated, bringing the Antonine dynasty to an end. The economy was in decline, and the efficient imperial bureaucracy was disintegrating. Even the official state religion was losing ground to Eastern cults, Christianity among them, which were beginning to gain large

numbers of converts. The Late Empire was a civilization in transition, a pivotal era in world history, during which the pagan ancient world was gradually transformed into the Christian Middle Ages.

The Severans (A.D. 193–235)

AN AFRICAN RULES THE EMPIRE Civil conflict followed Commodus's death. When it ended, an African-born general named Septimius Severus (r. A.D. 193–211) was master of the Roman world. The new emperor, anxious to establish his legitimacy, adopted himself into the Antonine dynasty, proclaiming himself as Marcus Aurelius's son. It is not surprising, then, that official portraits of Septimius Severus depict him with the long hair and beard of his Antonine "father"—whatever his actual appearance may have been. Many portraits in marble and bronze exist today of the African emperor and of his wife, Julia Domna, the daughter of a Syrian priest, and their two sons, Caracalla and Geta. But only one painted portrait of the family has been found. In fact, the portrait (FIG. **10-64**), discovered in Egypt and painted in *tempera* (pigments in egg yolk) on wood (as were many of the mummy portraits from Faiyum), is the only surviving painted likeness of any Roman emperor. Such portraits, however, must have been quite common all over the empire. Their perishable nature explains their almost total loss.

The Severan family portrait is of special interest for two reasons beyond its mere survival. The emperor's hair is tinged

10-64 Painted portrait of Septimius Severus and his family, from Egypt, ca. A.D. 200. Tempera on wood, approx. 1′ 2″ diameter. Staatliche Museen, Berlin.

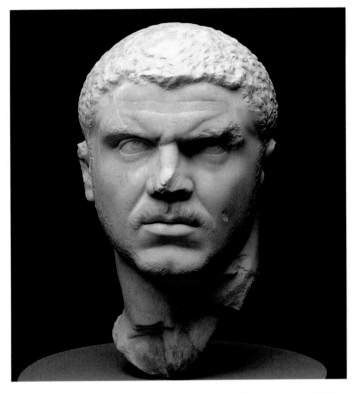

10-65 Portrait of Caracalla, ca. A.D. 211–217. Marble, approx. 1′ 2″ high. Metropolitan Museum of Art, New York.

with gray, suggesting that his marble portraits—which, like all marble sculptures in antiquity, were painted—also may have revealed his advancing age in this way. (The same was very likely true of the marble likenesses of the old and tired Marcus Aurelius.) The group portrait is also notable because the face of the emperor's younger son, Geta, was erased. When Caracalla succeeded his father as emperor, he had his brother murdered and his memory damned. (Caracalla also ordered the death of his own wife, Plautilla.) The painted *tondo* (circular format) portrait from Egypt is an eloquent testimony to that *damnatio memoriae* and to the long arm of Roman authority. This kind of defacement of a political rival's portrait is not new. As noted earlier, for example, Thutmose III of Egypt destroyed the portraits of Hatshepsut after her death (see FIG. 3-21). But the Romans employed damnatio memoriae as a political tool more often and more systematically than any other civilization.

A PORTRAIT OF A RUTHLESS EMPEROR The ruthless character of Caracalla (r. A.D. 211–217) was captured in his portraits. The marble head shown here (FIG. **10-65**) was typical. The sculptor suggested the texture of Caracalla's short hair and close-cropped beard with incisions into the marble surface. Most remarkable, however, is the moving characterization of the emperor's suspicious nature, a further development from the groundbreaking introspection of the portraits of Marcus Aurelius. Caracalla's brow is knotted, and he abruptly turns his head over his left shoulder, as if he suspects danger from behind. The emperor had reason to be fearful. He was felled by an assassin's dagger in the sixth year of his rule. Assassination would become the fate of many Roman emperors during the turbulent third century A.D.

10-66 Chariot procession of Septimius Severus, relief from the Arch of Septimius Severus, Lepcis Magna, Libya, A.D. 203. Marble, approx. 5′ 6″ high. Castle Museum, Tripoli.

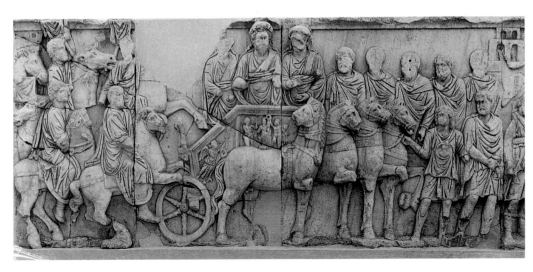

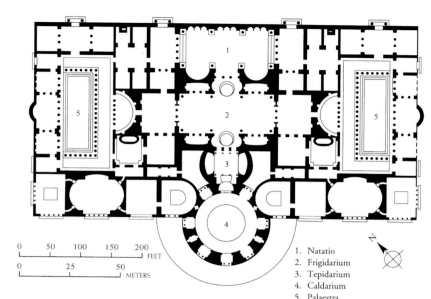

10-67 Plan of the central section of the Baths of Caracalla, Rome, Italy, A.D. 212–216. The bathing, swimming, and exercise areas were surrounded by landscaped gardens, lecture halls, and other rooms, all enclosed within a great concrete perimeter wall.

0 50 100 150 200 FEET
0 25 50 METERS

1. Natatio
2. Frigidarium
3. Tepidarium
4. Caldarium
5. Palaestra

THE NONCLASSICAL STYLE TAKES ROOT The hometown of the Severans was Lepcis Magna, on the coast of what is now Libya. In the late second and early third centuries A.D., imperial funds were used to construct a modern harbor there, as well as a new forum, basilica, arch, and other monuments. The Arch of Septimius Severus, erected in 203 at the intersection of two major streets, had friezes on the attic on all four sides. One of these (FIG. **10-66**) shows the chariot procession of Septimius and his two sons. Unlike the triumph panel from the Arch of Titus in Rome (FIG. 10-39), this relief gives no sense of rushing motion. Rather, it has a stately stillness. The chariot and the horsemen behind it are moving forward, but the emperor and his sons are detached from the procession and face the viewer. Also different is how the figures in the second row have no connection with the ground and are elevated above the heads of those in the first row so that they can be seen more clearly.

Both the frontality and the floating figures were new to official Roman art in Antonine and Severan times, but both appeared long before in the private art of freed slaves (compare FIGS. 10-4 and 10-5). Once embraced by sculptors in the emperor's employ, these non-classical elements had a long afterlife, appearing in medieval art in frontal images of Christ and the saints. As is often true in the history of art, this period of social, political, and economic upheaval was accompanied by the emergence of a new aesthetic.

A GIGANTIC ROMAN HEALTH SPA The Severans were also active builders in the capital. The Baths of Caracalla in Rome (FIGS. **10-67** and **10-68**) were the greatest in a long line of bathing and recreational complexes erected with imperial funds to win the public's favor. Made of brick-faced concrete and covered by enormous vaults springing from thick walls up to one hundred and forty feet high, Caracalla's baths covered an area of almost fifty acres. They dwarfed the typical baths of cities and towns such as Ostia and Pompeii and even Rome itself. The design was symmetrical along a central axis, facilitating the Roman custom of taking sequential plunges in cold-, warm-, and hot-water baths in, respectively, the *frigidarium, tepidarium,* and *caldarium.*

The caldarium of Caracalla's baths was a circular chamber so large that today it seats hundreds of spectators at open-air performances of Italian operas. Its dome was almost as large as the Pantheon's (FIG. 10-50), and the concrete drum that supported it was much taller. Our reconstruction of the frigidarium (FIG. 10-68), which was also the central hall of the baths, shows not only the scale of the architecture and the way light entered through fenestrated groin vaults but also how lavishly

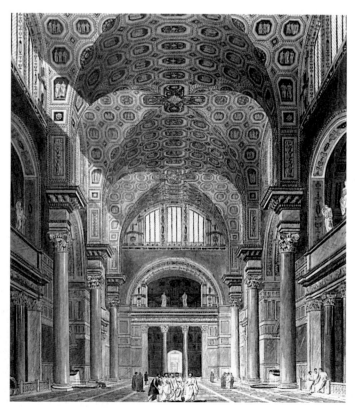

10-68 Reconstruction drawing of the central hall *(frigidarium)* of the Baths of Caracalla, Rome, Italy, A.D. 212–216.

the rooms were decorated. Stuccoed vaults, mosaic floors (both black-and-white and polychrome), marble-faced walls, and colossal statuary were found throughout the complex. Although the vaults themselves collapsed long ago, many of the mosaics and statues are preserved. Among these is the $10\frac{1}{2}$-foot-tall copy of Lysippos's Herakles (see FIG. 5-66), whose muscular body may have inspired Romans of the third century A.D. to exercise vigorously.

Caracalla's baths also had landscaped gardens, lecture halls, libraries, colonnaded exercise courts *(palaestrae)*, and a giant swimming pool *(natatio)*. Archeologists estimate that up to sixteen hundred bathers at a time could enjoy this Roman equivalent of a modern health spa. A branch of one of the city's major aqueducts supplied water, and furnaces circulated hot air through hollow floors and walls throughout the complex.

The Soldier Emperors (A.D. 235–284)

MURDER AND CIVIL WAR The Severan dynasty ended when Severus Alexander (r. A.D. 222–235) was murdered. The next half century was a stormy one. One general after another was declared emperor by his troops, only to be murdered by another general a few years or even a few months later. (In the year 238, two coemperors the Senate chose were dragged from the imperial palace and murdered in

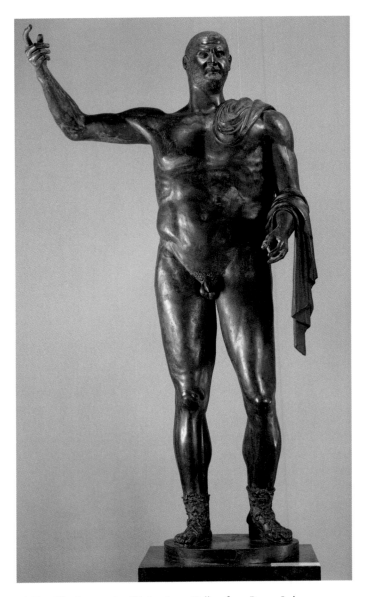

10-70 Heroic portrait of Trebonianus Gallus, from Rome, Italy, A.D. 251–253. Bronze, approx. 7′ 11″ high. Metropolitan Museum of Art, New York (Rogers Fund).

public after only three months in office.) In these unstable times, no emperor could begin ambitious architectural projects. The only significant building activity in Rome during the "soldier emperors" era occurred under Aurelian (r. A.D. 270–275). He constructed a new defensive wall circuit for the capital—a military necessity and a poignant commentary on the decay of Roman power.

SOUL PORTRAITS OF SOLDIER EMPERORS If architects went hungry in third-century Rome, sculptors and engravers had much to do. Great quantities of coins (in debased metal) were produced so that the troops could be paid with money stamped with the current emperor's portrait and not with that of his predecessor or rival. Each new ruler set up portrait statues and busts everywhere to assert his authority.

The sculptured portraits of the third century A.D. are among the most moving ever produced. Following the lead of the sculptors of the Marcus Aurelius and Caracalla portraits,

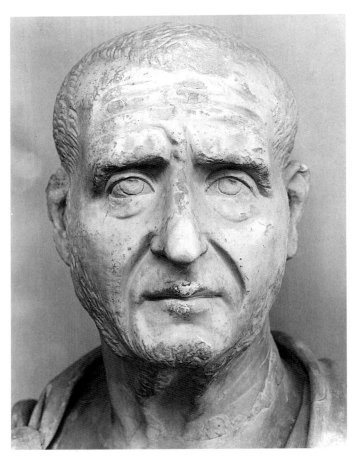

10-69 Portrait bust of Trajan Decius, A.D. 249–251. Marble, approx. 2′ 7″ high. Museo Capitolino, Rome.

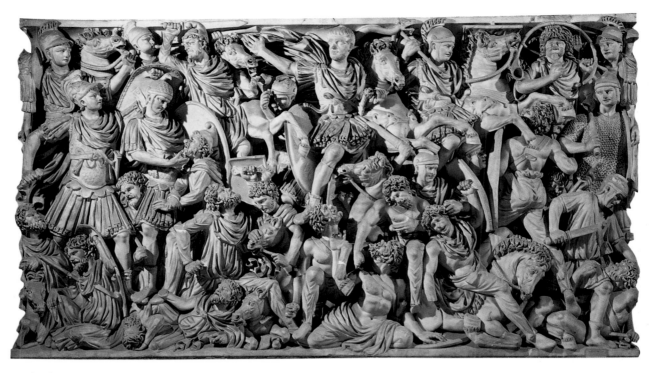

10-71 Battle of Romans and barbarians *(Ludovisi Battle Sarcophagus)*, from Rome, Italy, ca. A.D. 250–260. Marble, approx. 5′ high. Museo Nazionale Romano-Palazzo Altemps, Rome.

artists fashioned likenesses of the soldier emperors that are as notable for their emotional content as they are for their technical virtuosity. Trajan Decius (r. 249–251), for example, whose brief reign is best known for persecution of Christians, was portrayed as an old man with bags under his eyes and a sad expression (FIG. **10-69**). In his eyes, which glance away nervously rather than engage viewers directly, is the anxiety of a man who knows he can do little to restore order to an out-of-control world. The sculptor modeled the marble as if it were pliant clay, compressing the sides of the head at the level of the eyes, etching the hair and beard into the stone, and chiseling the deep lines in the forehead and around the mouth. The portrait reveals the anguished soul of the man—and of the times.

Decius's successor was Trebonianus Gallus (r. A.D. 251–253), another short-lived emperor. A larger-than-life-size bronze portrait (FIG. **10-70**) exists of Trebonianus appearing in heroic nudity, as had so many emperors and generals before him. His physique is not, however, that of the strong but graceful Greek athletes Augustus and his successors admired so much. Instead, his is a wrestler's body with massive legs and a swollen trunk. The heavyset body dwarfs his head, with its nervous expression. In this portrait, the Greek ideal of the keen mind in the harmoniously proportioned body gave way to an image of brute force, an image well suited to the era of the soldier emperors.

BARBARIANS AND PHILOSOPHERS By the third century, burial of the dead had become so widespread that even the imperial family was practicing it in place of cremation. Sarcophagi were more popular than ever. An unusually large sarcophagus (FIG. **10-71**), discovered in Rome in 1621 and purchased by Cardinal Ludovisi, is decorated on the front with a chaotic scene of battle between Romans and one of their northern foes, probably the Goths. The writhing and highly emotive figures were spread evenly across the entire relief, with no illusion of space behind them. This piling of figures was an even more extreme rejection of classical perspective than using floating ground lines on the pedestal of the Column of Antoninus Pius (FIG. 10-58). It underscores the increasing dissatisfaction Late Roman artists felt with the classical style.

Within this dense mass of intertwined bodies, the central horseman stands out vividly. He is bareheaded and thrusts out his open right hand to demonstrate that he holds no weapon. Several scholars have identified him as one of the sons of Trajan Decius. In an age when the Roman army was far from invincible and Roman emperors were constantly felled by other Romans, the young general on the sarcophagus is boasting that he is a fearless commander assured of victory. His self-assurance may stem from his having embraced one of the increasingly popular Oriental mystery religions. On the youth's forehead is carved the emblem of Mithras, the Persian god of light, truth, and victory over death, many of whose shrines have been found at Rome and Ostia.

The insecurity of the times led many Romans to seek solace in philosophy. On many third-century sarcophagi, the deceased assumes the role of the learned intellectual. (Others continued to masquerade as Greek heroes or Roman generals.) One especially large example (FIG. **10-72**) depicts an enthroned Roman philosopher holding a scroll. He is flanked by two standing women (also with portrait features). In the background are other philosophers, students of the central deceased teacher. This type of sarcophagus became very popular for Christian burials, where the wise-man motif was used not only to portray the deceased (see FIG. 11-4) but also Christ flanked by his apostles (see FIG. 11-5). Frontal three-part

10-72 Sarcophagus of a philosopher, ca. A.D. 270–280. Marble, approx. 4′ 11″ high. Vatican Museums, Rome.

compositions, such as on this sarcophagus and on the Severan arch at Lepcis Magna (FIG. 10-66), are also quite common in Early Christian art (see FIGS. 11-5 and 11-17).

A CRITIQUE OF THE PANTHEON The decline in respect for classical art also can be seen in architecture. At Baalbek (ancient Heliopolis) in modern Lebanon, the architect of the Temple of Venus (FIG. **10-73**), following in the "baroque" tradition of the Treasury at Petra (FIG. 10-52), ignored almost every rule of classical design. Although made of stone, the third-century building, with its circular domed cella set behind a gabled columnar facade, was in many ways a critique of the concrete Pantheon (FIG. 10-48), which by then had achieved the status of a "classic." The platform of the Baalbek temple was

scalloped all around the cella. The columns—the only known instance of *five*-sided Corinthian capitals with corresponding pentagonal bases—also supported a scalloped entablature (which served to buttress the shallow stone dome). These concave forms and those of the niches in the cella walls played off against the cella's convex shape. Even the "traditional" facade of the Baalbek temple was eccentric. The unknown architect inserted an arch within the triangular pediment.

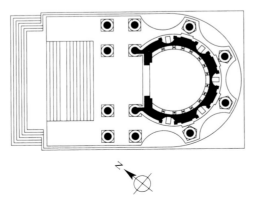

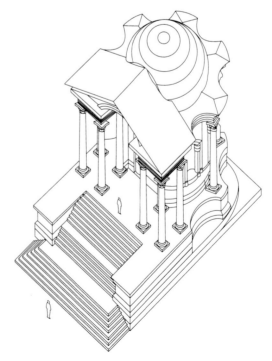

10-73 Plan and reconstruction drawing of the Temple of Venus, Baalbek, Lebanon, third century A.D.

Diocletian and the Tetrarchy
(A.D. 284–306)

POWER SHARED AND ORDER RESTORED In an attempt to restore order to the Roman Empire, Diocletian (r. A.D. 284–305), who was proclaimed emperor by his troops, decided to share power with his potential rivals. In 293, he established the *tetrarchy* (rule by four) and adopted the title of Augustus of the East. The other three tetrarchs were a corresponding Augustus of the West, and Eastern and Western Caesars (whose allegiance to the two Augusti was cemented by marriage to their daughters). Together, the four emperors ruled without strife until Diocletian retired in 305. Without his leadership, the new tetrarchs began fighting among themselves, and the tetrarchic form of government collapsed. The division of the Roman Empire into eastern and western spheres survived, however. It persisted throughout the Middle Ages, setting the Latin West apart from the Byzantine East.

INDIVIDUALITY LOST The four tetrarchs often were portrayed together, both on coins and in the round. Artists did not try to capture their individual appearances and personalities but sought instead to represent the nature of the tetrarchy itself—that is, to portray four equal partners in power. In the two pairs of *porphyry* (purple marble) portraits of the tetrarchs shown here (FIG. **10-74**), it is impossible to name the rulers. Each of the four emperors has lost his identity as an individual and was subsumed into the larger entity of the tetrarchy. All the tetrarchs are identically clad in cuirass and cloak. Each grasps a sheathed sword in the left hand. With their right arms they embrace one another in an overt display of concord. The figures, like those on the decursio relief of the Column of Antoninus Pius (FIG. 10-58), have large cubical heads on squat bodies. The drapery is schematic and the bodies are shapeless. The faces are emotionless masks, as alike as freehand carving can achieve. In this group portrait, carved eight centuries after Greek sculptors first freed the human form from the formal rigidity of the Egyptian-inspired kouros stance, the human figure was once again conceived in iconic terms. Idealism, naturalism, individuality, and personality now belonged to the past.

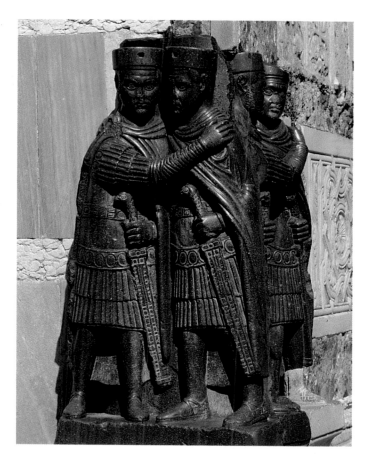

10-74 Portraits of the four tetrarchs, ca. A.D. 305. Porphyry, approx. 4′ 3″ high. Saint Mark's, Venice.

A FORTIFIED IMPERIAL PALACE When Diocletian abdicated in 305, he returned to Dalmatia (roughly the area of the former Yugoslavia), where he was born. There he built a palace (FIG. **10-75**) for himself at Split, near ancient Salona on the Adriatic coast in Croatia. Just as Aurelian had felt it necessary to girdle Rome with fortress walls, Diocletian instructed his architects to provide him with a well-fortified suburban palace. The complex, which covers about ten acres,

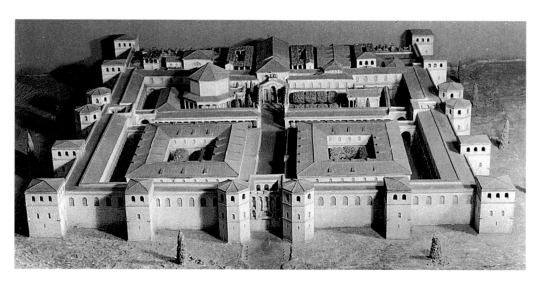

10-75 Model of the Palace of Diocletian, Split, Croatia, ca. A.D. 300–305. Museo della Civiltà Romana, Rome.

was laid out like a Roman castrum, complete with watchtowers flanking the gates. It gave the emperor a sense of security in the most insecure of times.

Within the high walls, two avenues (comparable to the cardo and decumanus in a provincial colony such as Timgad, FIG. 10-40) intersected at the palace's center. Where a city's forum would have been situated, Diocletian's palace had a colonnaded court leading to the entrance to the imperial residence. If admitted to the emperor's private quarters, a visitor passed through a templelike facade with an arch within its pediment, as in the Temple of Venus at Baalbek (FIG. 10-73). This motif's formal purpose was undoubtedly to emphasize the design's central axis, but symbolically it became the "gable of glorification" Diocletian appeared under before those who gathered in the court to pay homage to him. On one side of the court was a Temple of Jupiter; on the other side, Diocletian's mausoleum (left rear in FIG. 10-75), which towered above all the other structures in the complex. The emperor's huge domed tomb was a type that would become very popular in Early Christian times not only for mausoleums but eventually also for churches, especially in the Byzantine East. It is, in fact, used as a church today.

Constantine (A.D. 306–337)

CONSTANTINE AND CHRISTIANITY The shortlived concord among the tetrarchs that ended with Diocletian's abdication was followed by an all-too-familiar period of conflict that ended two decades later with the restoration of one-man rule. The eventual victor was Constantine I ("the Great"), son of Constantius Chlorus, Diocletian's Caesar of the West. After the death of his father, Constantine invaded Italy in 312.

At a battle at the Milvian Bridge at the gateway to Rome, he defeated and killed his chief rival, Maxentius. Constantine attributed his victory to the aid of the Christian god. In 313, he and Licinius, Constantine's coemperor in the East, issued the Edict of Milan, ending the persecution of Christians.

In time, Constantine and Licinius became foes, and in 324 Constantine defeated and executed Licinius near Byzantium (modern Istanbul, Turkey). Constantine was now unchallenged ruler of the whole Roman Empire. Shortly after the death of Licinius, he founded a "New Rome" on the site of Byzantium and named it Constantinople ("City of Constantine"). A year later, in 325, at the Council of Nicaea, Christianity became de facto the official religion of the Roman Empire. From this point on, paganism declined rapidly. Constantinople was dedicated on May 11, 330, "by the commandment of God," and in succeeding decades many Christian churches were erected there. Constantine himself was baptized on his deathbed in 337. For many scholars, the transfer of the seat of power from Rome to Constantinople and the recognition of Christianity mark the beginning of the Middle Ages.

Constantinian art is a mirror of this transition from the classical to the medieval world. In Rome, for example, Constantine was a builder in the grand tradition of the emperors of the first, second, and early third centuries, erecting public baths, a basilica on the Sacred Way leading into the Roman Forum, and a triumphal arch. But he was also the patron of the city's first churches, including Saint Peter's (see FIG. 11-7).

A NEW ARCH WITH OLD RELIEFS After his decisive victory at the Milvian Bridge, Constantine erected a great triple-passageway arch (FIG. **10-76**) in the shadow of the

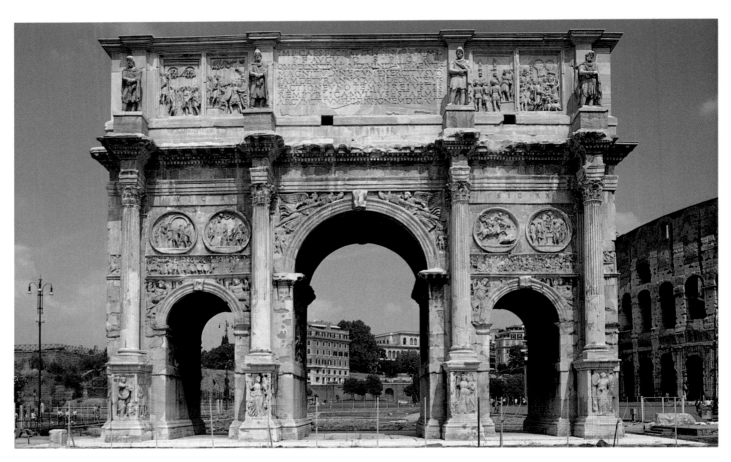

10-76 Arch of Constantine, Rome, Italy, A.D. 312–315 (south side).

10-77 Distribution of largess, detail of the north frieze of the Arch of Constantine, Rome, Italy, A.D. 312–315. Marble, approx. 3' 4" high.

Colosseum to commemorate his defeat of Maxentius. The arch was the largest erected in Rome since the end of the Severan dynasty nearly a century before. Much of the sculptural decoration, however, was taken from earlier monuments of Trajan, Hadrian, and Marcus Aurelius. The columns also date to an earlier era. Sculptors refashioned the second-century reliefs to honor Constantine by recutting the heads of the earlier emperors with the features of the new ruler. They also added labels to the old reliefs, such as *Fundator Quietus* (bringer of peace) and *Liberator Urbis* (liberator of the city), references to the downfall of Maxentius and the end of civil war.

The reuse of statues and reliefs by the Constantinian artists has often been cited as evidence of a decline in creativity and technical skill in the waning years of the pagan Roman Empire. Although such a judgment is in large part deserved, it ignores the fact the reused sculptures were carefully selected to associate Constantine with the "good emperors" of the second century. That message is underscored in one of the new Constantinian reliefs above the arch's lateral passageways. It shows Constantine on the speaker's platform in the Roman Forum, flanked by statues of Hadrian and Marcus Aurelius.

In another Constantinian relief (FIG. **10-77**), the emperor is shown with attendants and distributing largess to grateful citizens who approach him from right and left. Constantine is a frontal and majestic presence, elevated on a throne above the recipients of his munificence. The figures are squat in proportion, like the tetrarchs (FIG. 10-74). They do not move according to any classical principle of naturalistic movement but, rather, with the mechanical and repeated stances and gestures of puppets. The relief is very shallow, the forms were not fully modeled, and the details were incised. The heads were not distinguished from one another. The sculptor depicted a crowd, not a group of individuals. (Constantine's head, which was carved separately and set into the relief, has been lost.) The frieze is less a narrative of action than a picture of actors frozen in time so that the viewer can distinguish instantly the all-important imperial donor (at the center on a throne) from his attendants (to the left and right above) and the recipients of the largess (below and of smaller stature).

This approach to pictorial narrative was once characterized as a "decline of form," and when judged by classical art standards, it was. But the composition's rigid formality, determined by the rank of those portrayed, was consistent with a new set of values. It soon became the preferred mode, sup-

planting the classical notion that a picture is a window onto a world of anecdotal action. Comparing this Constantinian relief with a painted Byzantine icon of the sixth century A.D. (see FIG. 12-15) reveals that the new compositional principles are those of the Middle Ages. They were very different from, but not necessarily "better" or "worse" than, those of classical antiquity. The Arch of Constantine was the quintessential monument of its era, exhibiting a respect for the classical past in its reuse of second-century sculptures while rejecting the norms of classical design in its frieze, paving the way for the iconic art of the Middle Ages.

A COLOSSUS IN A COLOSSAL BASILICA After his victory over Maxentius, Constantine's official portraits broke with tetrarchic tradition as well as with the style of the soldier emperors and resuscitated the Augustan image of an eternally youthful head of state. The head illustrated (FIG. **10-78**) is the most impressive by far of Constantine's preserved portraits. It is eight and one-half feet high, one of several marble fragments of a colossal thirty-foot-tall enthroned statue of the emperor that was composed of a brick core, a wooden torso covered with bronze, and a head and limbs of marble. Constantine's artist modeled the seminude seated portrait on Roman images of Jupiter. The emperor held an orb (possibly surmounted by the cross of Christ), the symbol of global power, in his extended left hand. The nervous glance of third-century portraits is absent, replaced by a frontal mask with enormous eyes set into the broad and simple planes of the head. The emperor's personality is lost in the immense

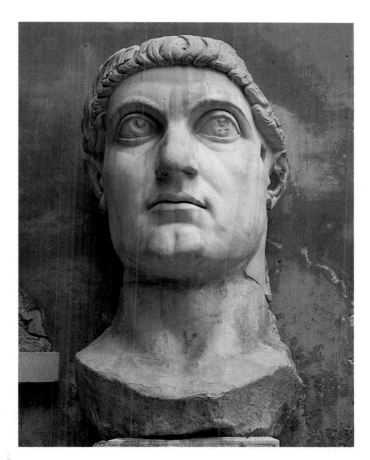

10-78 Portrait of Constantine, from the Basilica Nova, Rome, Italy, ca. A.D. 315–330. Marble, approx. 8' 6" high. Palazzo dei Conservatori, Rome.

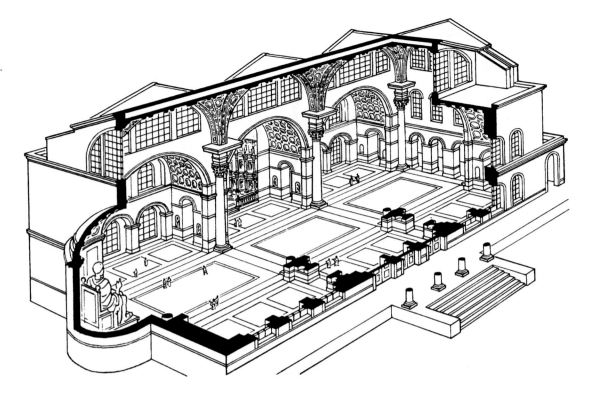

image of eternal authority. The colossal size, the likening of the emperor to Jupiter, the eyes directed at no person or thing of this world—all combine to produce a formula of overwhelming power appropriate to Constantine's exalted position as absolute ruler. To find an image of comparable grandeur and authority, one must go back more than fifteen hundred years to the colossal rock-cut portraits of the Egyptian pharaoh Ramses II (see FIG. 3-22).

Constantine's gigantic portrait sat in the western apse of the Basilica Nova in Rome (FIG. **10-79**), the huge new basilica Maxentius had begun on a site not far from the Arch of Titus. Constantine completed the project after his rival's death. From its position in the apse, the emperor's image dominated the basilica's interior in much the same way enthroned statues of Greco-Roman divinities loomed over awestruck mortals who entered the cellas of pagan temples.

The Basilica Nova ruins never fail to impress tourists with their size and mass. The original structure was three hundred feet long and two hundred fifteen feet wide. Brick-faced concrete walls twenty feet thick supported coffered barrel vaults in the aisles. These vaults also buttressed the groin vaults of the nave, which was one hundred fifteen feet high. The walls and floors were richly marbled and stuccoed and could be readily admired by those who came to the basilica to conduct business, because the groin vaults permitted ample light to enter the nave directly. Our reconstruction (FIG. 10-79) effectively suggests the immensity of the interior, where the great vaults dwarf not only humans but also even the emperor's colossal portrait. The drawing also clearly reveals the fenestration of the groin vaults, a lighting system akin to the clerestory of a traditional stone-and-timber basilica. The lessons learned in the design and construction of buildings such as Trajan's great market hall (FIG. 10-43) and the Baths of Caracalla (FIG. 10-68) were applied here to the Roman basilica.

Although one could argue that the Basilica Nova was the ideal solution to the problem of basilica design with its spacious, well-lit interior and economical, fire-resistant concrete frame, it became the exception rather than the rule. The traditional basilica form exemplified by Trajan's Basilica Ulpia in Rome (FIG. 10-41) remained the norm for centuries.

CONSTANTINE'S GERMAN AUDIENCE HALL
At Trier (ancient Augusta Treverorum) on the Moselle River in Germany, the imperial seat of Constantius Chlorus as Caesar of the West, Constantine built a new palace complex. It included a basilica-like audience hall or Aula Palatina (FIGS. **10-80** and **10-81**) of traditional form and materials. The Trier basilica measures about one hundred ninety feet long and ninety-five feet wide. Its austere brick exterior (FIG. 10-80), with boldly projecting vertical buttresses creating a pattern of alternating voids and solids, characterized much later Roman—and Early Christian—architecture. The building's verticality originally was lessened by horizontal timber galleries, which permitted the servicing of the windows. The brick wall was stuccoed in grayish white. The growing taste for large windows was due to the increasing use of lead-framed panes of window glass. These enabled late Roman builders to give life and movement to blank exterior surfaces.

Inside (FIG. 10-81), the audience hall was also very simple. Its flat, wooden, coffered ceiling is some ninety-five feet above the floor. The interior has no aisles, just a wide space with two stories of large windows that provide ample light. At the narrow north end, the main hall is divided from the semicircular apse (which also has a flat ceiling) by a so-called *triumphal arch*. The Aula Palatina's interior is quite severe, although the arch and apse originally were covered with marble veneer and mosaics to provide a magnificent environment for the enthroned emperor. The design of both the interior and exterior was closely paralleled in many Early Christian basilicas (for example, see FIG. 11-8). The Aula Palatina itself was later converted into a Christian church.

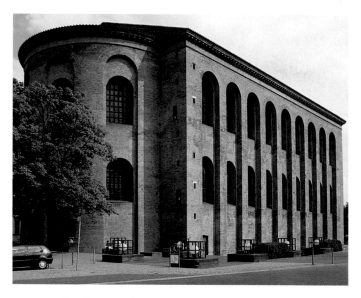

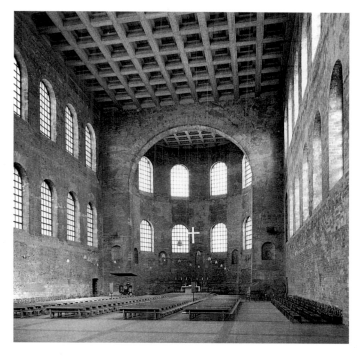

10-80 Aula Palatina (Basilica), Trier, Germany, early fourth century A.D. (exterior).

10-81 Aula Palatina, Trier, Germany, early fourth century A.D. (interior).

PORTRAITS THAT ARE NOT LIKENESSES We close our survey of ancient Roman art with two portraits of Constantine stamped on Roman coins. These images reveal both the essential character of Roman imperial portraiture and the special nature of Constantinian art. The first (FIG. **10-82,** left) was struck shortly after the death of Constantine's father, when Constantine was in his early twenties and his position was still insecure. Here, in his official portrait, he appears considerably older, because he adopted the imagery of the tetrarchs. Indeed, were it not for the accompanying label identifying this Caesar as Constantine, it would be impossible to know who was portrayed.

Eight years later, after the defeat of Maxentius and the issuance of the Edict of Milan, Constantine's portrait (FIG. 10-82, right) was transformed. Clean shaven and looking his actual thirty years of age, the unchallenged Augustus of the West rejected the mature tetrarchic "look" in favor of youth. Eternal youthfulness henceforth characterized all the emperor's portraits until his death more than two decades later (compare FIG. 10-78). These two coins should dispel any uncertainty about the often fictive nature of imperial portraiture and the ability of Roman emperors to choose any official image that suited their needs.

CLASSICAL AND MEDIEVAL The later portrait is also an eloquent testimony to the dual nature of Constantinian rule. The emperor appears in his important role as *imperator* (general), dressed in armor, wearing an ornate helmet, and carrying a shield bearing the enduring emblem of the Roman state—the she-wolf nursing Romulus and Remus (compare FIG. 9-10 and Roma's shield in FIG. 10-57). Yet he does not carry the scepter of the pagan Roman emperor. Rather, he holds a cross crowned by an orb. And at the crest of his helmet, at the front, just below the grand plume, is a disk containing the *Christogram,* the monogram made up of *chi* and *rho,* the initial letters of Christ's name in Greek (compare the shield one of the soldiers holds in FIG. 12-10). Constantine was at once portrayed as Roman emperor and as a soldier in the army of the Lord. The coin, like Constantinian art in general, belonged both to the classical and to the medieval world.

10-82 Coins with portraits of Constantine. Nummus *(left)*, A.D. 307. Billon, diameter approx. 1″. American Numismatic Society, New York. Medallion *(right)*, ca. A.D. 315. Silver. Staatliche Münzsammlung, Munich.

EUROPE AND THE NEAR EAST IN LATE ANTIQUITY

Atlantic Ocean

BRITAIN

GERMANY
Trier•

FRANCE

• Milan •Venice
Ravenna•

Adriatic Sea

SPAIN

ITALY
Rome•

Caspian Sea

Black Sea

Thessaloniki
(Salonica)• •Constantinople
 (Byzantium; Istanbul)

Rossano• GREECE TURKEY

Sicily • Athens

Mediterranean Sea

SYRIA •Dura-Europos

Jerusalem•
Bethlehem•

Jordan R.

Alexandria•

EGYPT

N

0 250 500 miles
0 250 500 kilometers

*Synagogue, Dura-Europos
ca. 245–256*

*Santa Maria Antiqua
sarcophagus, ca. 270*

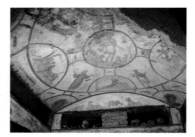

*Catacomb of Saints Peter
and Marcellinus, Rome
early fourth century*

Crucifixion of Christ, 29

Persecution of the Christians under Trajan Decius, 249–251

Persecution of the Christians under
Diocletian, 303–305

Constantine, r. 306–337

Edict of Milan, 313

Foundation of
Constantinople, 324

PAGANS, CHRISTIANS, AND JEWS

THE ART OF LATE ANTIQUITY

337		476	493	526
SUCCESSORS OF CONSTANTINE		ODOACER	THEODORIC	

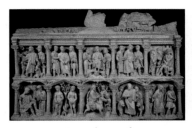

*Sarcophagus of
Junius Bassus, ca. 359*

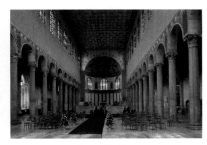

*Santa Sabina
Rome, 422–432*

*Vienna Genesis
early sixth century*

Theodosius I, r. 379–395

Christianity proclaimed state religion of Roman Empire, 380

Theodosius prohibits pagan worship, 391

Honorius, r. 395–423

Honorius moves capital to Ravenna, 404

Fall of Rome to Alaric, 410

Romulus Augustus, last Roman emperor, r. 475–476

Fall of Ravenna to Odoacer, 476

Theodoric at Ravenna, 493–526

THE WORLD OF LATE ANTIQUITY

The Roman Empire was home to an extraordinarily diverse population. In Rome alone on any given day, someone walking through the city's various quarters would have encountered people of an astonishing range of social, ethnic, racial, linguistic, and religious backgrounds. And the multicultural character of Roman society became only more pronounced as the empire grew. The previous chapter focused on the rich legacy of art and architecture bequeathed by the *pagan* Roman world. But during the Late Roman Empire a rapidly growing number of people rejected the emperors' polytheism (belief in multiple gods) in favor of the worship of a single all-powerful god. This chapter addresses the Jewish and Christian art produced under Roman rule. These Late Roman sculptures, paintings, mosaics, and buildings occupy a special place in our account of art through the ages because they formed the foundation of the art and architecture of the Middle Ages.

PAGANS, JEWS, AND CHRISTIANS The powerful religious crosscurrents of late antiquity may be seen in microcosm in a distant outpost of the Roman Empire on a promontory overlooking the Euphrates River in Syria. Called Europos by the Greeks and Dura by the Romans, the town probably was founded shortly after the death of Alexander the Great by one of his successors. By the end of the second century B.C., Dura-Europos was in the hands of the Parthians. The city was captured by Trajan in 115 but reverted to Parthian control shortly thereafter.* In 165, under Marcus

*Note: From this point on, all dates are A.D. unless otherwise indicated.

Aurelius, the Romans retook Dura and placed a permanent garrison there. Dura-Europos fell in 256 to Rome's new enemy in the East, the Sasanians, heirs to the Parthian Empire (see Chapter 2). The Sasanian victory at Dura is an important fixed point in the chronology of late antiquity because the fortified town's population was evacuated and Dura's buildings were left largely intact. This "Pompeii of the desert" has revealed the remains of more than a dozen different cult buildings, including many shrines of the polytheistic religions of the classical and Near Eastern worlds. But the excavators also discovered worship places for the monotheistic creeds of Judaism and Christianity, even though neither were approved religions in the Roman state.

BIBLICAL PAINTINGS ON SYNAGOGUE WALLS
The synagogue at Dura-Europos is remarkable not only for its very existence in a Roman garrison town but also for its extensive cycle of mural paintings (FIG. **11-1**) depicting biblical themes. The building, originally a private house with a central courtyard, was converted into a synagogue during the latter part of the second century. The paintings seem to defy the Bible's Second Commandment prohibiting the making of graven images and surprised scholars when they were first reported. It is now apparent that although the Jews of the Roman Empire did not worship idols as did their pagan contemporaries, biblical stories not only appeared on the painted walls of synagogues such as that at Dura-Europos but also in painted manuscripts. God (YHWH, or Yahweh in the Old Testament), however, never appears in the synagogue paintings or in the illustrated Bibles, except as a hand emerging from the top of the framed panels.

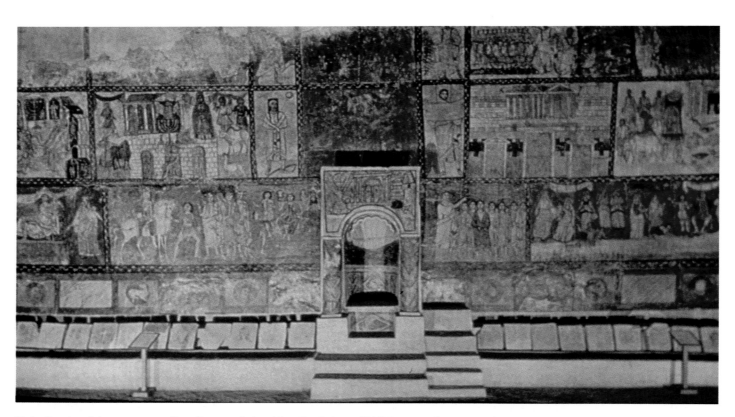

11-1 Interior of the synagogue at Dura-Europos, Syria, with wall-paintings of Old Testament themes, ca. 245–256. Tempera on plaster. National Museum, Damascus.

The style of the Dura murals is also instructive. Even when the subject is a narrative theme, the compositions are devoid of action. The artists tell the stories through stylized gestures, and the figures, which have expressionless features and lack both volume and shadow, tend to stand in frontal rows. This is especially true of the painting just to the right of the niche that housed the sacred Jewish *Torah* (the scroll containing the *Pentateuch,* the first five books of the Hebrew Scriptures). The prophet Samuel is anointing David as the future king of Israel, while his six older brothers look on. The painter drew attention to Samuel by depicting him larger than all the rest. David and his brothers are emotionless and almost disembodied spiritual presences. Their bodies do not even have enough feet! David, however, is distinguished from his brothers by the purple toga he wears. Purple was the color associated with the Roman emperor, and the imperial toga was borrowed here to signify David's royalty. The Dura painting style was characteristic also of much pagan art during the third and fourth centuries. Compare the Dura compositions with the friezes of the earlier Arch of Septimius Severus at Lepcis Magna (FIG. 10-66) and the later Arch of Constantine in Rome (FIG. 10-77). This new Late Antique style characterized much of the art of the Byzantine Empire (see FIGS. 12-10 and 12-11).

BAPTISM IN A SECONDHAND HOUSE The Christian community house at Dura-Europos (FIG. **11-2**) was also a remodeled private residence with a central courtyard. Its meeting hall (created by breaking down the partition between two rooms on the court's south side) could accommodate no more than about seventy people at a time. It had a raised platform at one end where the congregation leader sat or stood. Another room, on the opposite side of the courtyard, had a canopy-covered font for baptismal rites, the all-important ceremony initiating a new convert into the Christian community. Upstairs a communal dining room may have existed for the celebration of the *Eucharist,* when the faithful partook of the bread and wine symbolic of the body and blood of Christ (see "The Life of Jesus in Art," pages 308–309).

Although the baptistery had mural paintings (poorly preserved), the place where Christians gathered to worship at Dura, as elsewhere in the Roman Empire, was a modest secondhand house, in striking contrast to the grand temples of the Roman gods. Without the sanction of the state, Christian communities remained small in number and often attracted the most impoverished classes of society. They found the promise of an afterlife where rich and poor were judged on equal terms especially appealing. Nonetheless, Diocletian was so concerned by the growing popularity of Christianity in the Roman army ranks that he ordered a fresh round of persecutions in 303 to 305, a half century after the last great persecutions under Trajan Decius. The Romans hated the Christians because of their alien beliefs—that their god had been incarnated in the body of a man and that the death and Resurrection of the god-man Christ made possible the salvation and redemption of all. But they also hated them because they refused to pay even token homage to the Roman state's official gods. As Christianity's appeal grew, so, too, did the Roman state's fear of weakening imperial authority. Persecution ended only when the Roman emperor Constantine, after defeating Maxentius at the Milvian Bridge in Rome, came to believe that the Christian god was the source of his power rather than

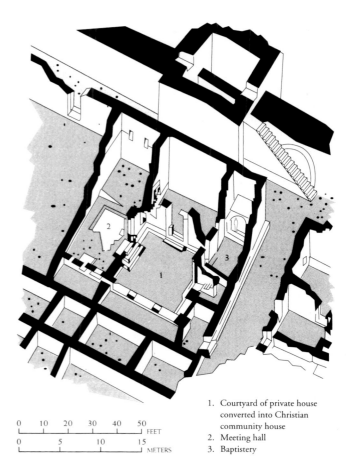

1. Courtyard of private house converted into Christian community house
2. Meeting hall
3. Baptistery

11-2 Reconstruction of the Christian community house at Dura-Europos, Syria, ca. 240–256.

a threat to it (see Chapter 10). A year after that victory, the Edict of Milan brought an end to the official mistreatment of Christians.

THE CATACOMBS AND FUNERARY ART

THE CHRISTIAN "HOLLOWS" OF ROME Very little is known about the art of the first Christians. When we speak of "Early Christian art," we mean the earliest preserved works with Christian subjects, not the art of Christians at the time of Jesus. The most significant Early Christian monuments in Rome are the least conspicuous; they are entirely underground. These *catacombs* are vast subterranean networks of *galleries,* or passageways, and chambers designed as cemeteries for burying the Christian dead, many of them sainted martyrs. To a much lesser extent, the catacombs also housed the graves of Jews and others. The builders tunneled the catacombs out of the tufa bedrock, much like the Etruscans created the underground tomb chambers in the necropolis at Cerveteri (see FIG. 9-7). The catacombs are less elaborate than the Etruscan tombs, but much more extensive. The name derives from the Latin *ad catacumbas,* which means "in the hollows." The catacombs in Rome (others exist elsewhere) comprise galleries estimated to run for sixty to ninety miles—and additional catacombs may be discovered yet. From the second through the fourth centuries, these catacombs were in

constant use. As many as four million bodies may have been buried in them.

In accordance with Roman custom, Christians had to be buried outside a city's walls on private property, usually purchased by a *confraternity,* or association, of Christian families pooling funds. Each of the catacombs was initially of modest extent. First, the builders dug a gallery three to four feet wide around the perimeter of the burial ground at a convenient level below the surface. In the walls of these galleries, they cut openings to receive the bodies of the dead. These openings, called *loculi,* were placed one above another, like shelves. Often, the Christians carved small rooms out of the rock, called *cubicula* (as in Roman houses of the living), to serve as mortuary chapels. Once the original perimeter galleries were full of loculi and cubicula, they cut other galleries at right angles to them. This process continued as long as lateral space permitted. They then dug lower levels connected by staircases. Some catacomb systems extended as deep as five levels. When adjacent burial areas belonged to members of the same Christian confraternity, or by gift or purchase fell into the same hands, the owners opened passageways between the respective cemeteries. The galleries thus spread laterally and gradually acquired a vast extent. After Christianity received official approval, the catacombs fell into disuse except as holy places—monuments to the great martyrs visited by the pious, who could worship in the churches often built directly above the catacombs.

Painting

FRESCOES ON THE DOME OF HEAVEN The frescoes that decorated many cubicula were Roman in style but Christian in subject. The ceiling organization of a cubiculum in the Catacomb of Saints Peter and Marcellinus in Rome (FIG. **11-3**), for example, is similar to the vaulted-ceiling designs in many Roman houses and tombs. Compare the century-earlier frescoed vault in the Insula of the Painted Vaults at Ostia (see FIG. 10-54). In the catacomb, the polygonal frame of the Ostian spoked-wheel design became a large circle, akin to the Dome of Heaven, and inscribed within is the symbol of the Christian faith, the cross. The cross's arms terminate in four *lunettes* (semicircular frames), which also find parallels in the Ostian composition.

The lunettes contain the key episodes from the Old Testament story of Jonah. The sailors throw him from his ship on the left. He emerges on the right from the "whale" (the Greek word is *ketos,* or sea dragon, and that is how the artist represented the monstrous marine creature that swallowed Jonah). And, safe on land at the bottom, Jonah contemplates the miracle of his salvation and the mercy of God. Jonah was a popular figure in Early Christian painting and sculpture, especially in funerary contexts. The Christians honored him as a *prefiguration* (prophetic forerunner) of Christ, who rose from death as Jonah had been delivered from the belly of the ketos, also after three days. (Old Testament miracles prefiguring

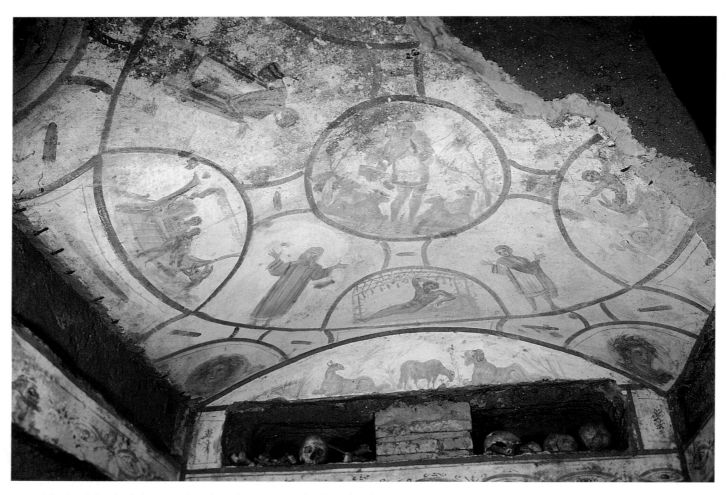

11-3 The Good Shepherd, the story of Jonah, and orants, painted ceiling of a cubiculum in the Catacomb of Saints Peter and Marcellinus, Rome, Italy, early fourth century.

Jewish Subjects in Christian Art

From the beginning, the Old Testament played an important role in Christian life and Christian art, in part because Jesus was a Jew and so many of the first Christians were converted Jews, but also because Christians came to view many of the persons and events of the Old Testament as prefigurations of New Testament persons and events. Christ himself established the pattern for this kind of biblical interpretation when he compared Jonah's spending three days in the belly of the sea monster (usually translated as "whale" in English) to the comparable time he would be entombed in the earth before his Resurrection (Matt. 12:40). In the fourth century Saint Augustine (354–430) confirmed the validity of this approach to the Old Testament when he stated that "the New Testament is hidden in the Old; the Old is clarified by the New."[1]

Thus the Old Testament figured prominently in Early Christian art in all media. Biblical tales of Jewish faith and salvation were especially common in funerary contexts but appeared also in churches and on household objects. The most popular Old Testament stories in Early Christian art are listed here.

Adam and Eve (FIG. 11-5) Eve, the first woman, tempted by a serpent, ate the forbidden fruit of the tree of knowledge. She also fed some to Adam, the first man. As punishment, God expelled Adam and Eve from Paradise. This "Original Sin" ultimately led to Christ's sacrifice on the cross so that all humankind could be saved. Christian theologians often consider Christ the new Adam and his mother, Mary, the new Eve.

Abraham and the Three Angels (see FIGS. 12-8 and 12-34) Sarah, wife of Abraham, the father of the Hebrew nation, was ninety years old and childless when three angels visited Abraham. They announced that Sarah would bear a son, and she later miraculously gave birth to Isaac. Christians believe the Old Testament angels symbolized the Holy Trinity.

Sacrifice of Isaac (FIGS. 11-5 and 12-8) God instructed Abraham to sacrifice Isaac, his only son, as proof of his faith. When it became clear Abraham would obey, the Lord sent an angel to restrain him and provided a ram for sacrifice in Isaac's place. Christians view this episode as a prefiguration of the sacrifice of God's only son, Jesus.

Jonah (FIGS. 11-3 and 11-4) Jonah, an Old Testament prophet, had disobeyed God's command. In his wrath, the Lord caused a storm while Jonah was at sea. Jonah asked the sailors to throw him overboard, and the storm subsided. A sea dragon then swallowed Jonah, but God answered his prayers, and the monster spat out Jonah after three days and nights, foretelling Christ's Resurrection.

Daniel (FIG. 11-5) Daniel, one of the most important Jewish prophets, violated a Persian decree against prayer and the Persians threw him into a den of lions. God sent an angel to shut the lions' mouths, and Daniel emerged unharmed. Like Jonah's story, this is an Old Testament salvation tale, a precursor of Christ's triumph over death.

[1] Augustine, *City of God*, XVI.26.

Christ's Resurrection abound in the catacombs and in Early Christian art in general; see "Jewish Subjects in Christian Art," above.)

A YOUTHFUL CHRIST AND HIS SHEEP A man, a woman, and at least one child occupy the compartments between the Jonah lunettes. They are *orants* (praying figures), raising their arms in the ancient attitude of prayer. Together they make up a cross-section of the Christian family seeking a heavenly afterlife. The cross's central medallion shows Christ as the Good Shepherd, whose powers of salvation are underscored by his juxtaposition with Jonah's story. The motif can be traced back to Archaic Greek art (see FIG. 5-9), but there the pagan calf bearer offered his sheep in sacrifice to Athena. In Early Christian art, Christ is the youthful and loyal protector of the Christian flock, who said to his disciples, "I am the good shepherd; the good shepherd gives his life for the sheep" (John 10:11). In the Christian motif, the sheep on Christ's shoulders is one of the lost sheep he has retrieved, symbolizing a sinner who has strayed and been rescued.

Prior to Constantine, artists almost invariably represented Christ either as the Good Shepherd or as a young teacher. Only after Christianity became the Roman Empire's official religion did Christ take on in art such imperial attributes as the halo, the purple robe, and the throne, which denoted rulership. Eventually artists depicted Christ with the beard of a mature adult, which has been the standard form for centuries, supplanting Early Christian art's youthful imagery.

The style of the catacomb painters was most often a quick, sketchy impressionism that compares unfavorably with the best Roman frescoes. The vast majority of people buried in the catacombs could not afford to employ the best artists. The catacombs were, moreover, very unpromising places for mural decoration. Decomposing corpses spoiled the air, the humidity was excessive, and the lighting (provided largely by oil lamps) was entirely unfit for elaborate compositions or painstaking execution. It is therefore no wonder that painters often completed their frescoes hastily and that the results frequently were of mediocre quality.

Sculpture

COFFINS FOR THE CHRISTIAN FAITHFUL All Christians rejected cremation, and the wealthiest Christian faithful, like their pagan contemporaries, favored impressive marble sarcophagi. Many of these coffins have survived in the catacombs and elsewhere. As expected, the most

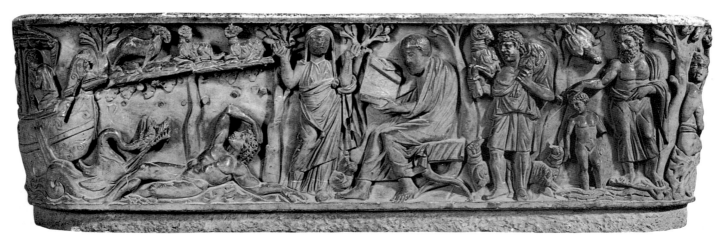

11-4 Sarcophagus with philosopher, orant, and Old and New Testament scenes, Santa Maria Antiqua, Rome, Italy, ca. 270. Marble, 1' 11¼" × 7 '2".

common themes painted on the walls and vaults of the Roman subterranean cemeteries were also the subjects that appeared on Early Christian sarcophagi. Often, the decoration of the marble coffins was a collection of significant Christian themes, just as on the painted ceiling in the Catacomb of Saints Peter and Marcellinus (FIG. 11-3).

On the front of a sarcophagus (FIG. **11-4**) in Santa Maria Antiqua in Rome, the story of Jonah takes up the left third. At the center is an orant and a seated philosopher, the latter a motif borrowed directly from contemporary pagan sarcophagi (see FIG. 10-72). The heads of both the praying

woman and the seated man reading from a scroll are unfinished. Roman workshops often produced sarcophagi before knowing who would purchase them. The sculptors added the portraits at the time of burial, if they added them at all. This practice underscores the universal appeal of the themes chosen. At the right are two different, yet linked, representations of Jesus—as the Good Shepherd and as a child receiving baptism in the Jordan River, though he really was baptized at age thirty (see "The Life of Jesus in Art," pages 308–309). The sculptor suggested the future ministry of the baptized Jesus by turning the child's head toward the Good

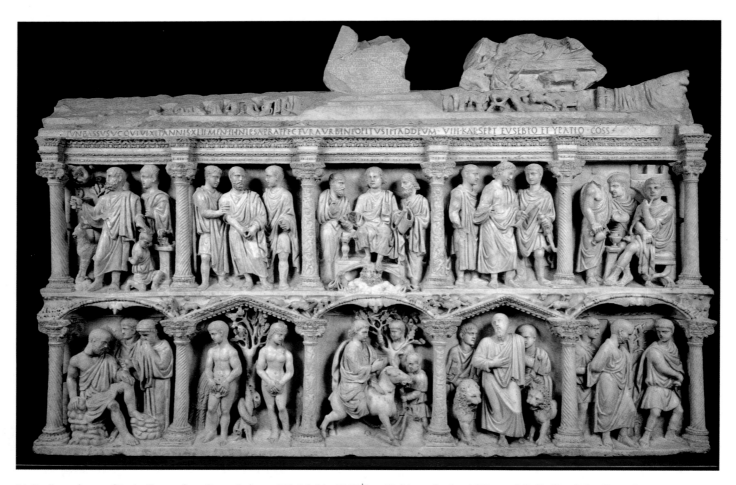

11-5 Sarcophagus of Junius Bassus, from Rome, Italy, ca. 359. Marble, 3' 10½" × 8'. Museo Storico del Tesoro della Basilica di San Pietro, Rome.

Shepherd and by placing his right hand on one of the sheep. Baptism was especially significant in the early centuries of Christianity because so many adults were converted to the new faith in this manner.

A CONVERTED CHRISTIAN'S SARCOPHAGUS One of the Christian converts was the city prefect of Rome, Junius Bassus, who, according to the inscription on his sarcophagus (FIG. **11-5**), was baptized just before his death in 359. The sarcophagus, decorated only on the front in the western Roman manner, is divided into two registers of five compartments, each framed by columns in the tradition of Asiatic sarcophagi (see FIG. 10-62). In contrast to the Santa Maria Antiqua sarcophagus, the deceased does not appear on the body of the coffin. Instead, stories from the Old and New Testaments fill the ten niches. Christ has pride of place and appears in the central compartment of each register: as a youthful teacher enthroned between his chief apostles, Saints Peter and Paul (above), and triumphantly entering Jerusalem on a horselike donkey (below). Both compositions owe a great deal to Roman imperial imagery. In the upper zone, Christ, like an enthroned pagan emperor, sits above a personification of the sky god holding a billowing mantle over his head, indicating that Christ is ruler of the universe. The scene below closely follows the pattern of Roman emperors entering cities on horseback. Appropriately, the scene of Christ's heavenly triumph is situated above that of his earthly triumph.

The Old Testament scenes on the Junius Bassus sarcophagus were chosen for their significance in the early Christian Church. Adam and Eve, for example, are in the second niche from the left on the lower level. Their original sin of eating the apple in the Garden of Eden ultimately necessitated Christ's sacrifice for the salvation of humankind. To the right of the entry into Jerusalem is Daniel, unscathed by flanking lions, saved by his faith. At the upper left, Abraham is about to sacrifice Isaac. Christians believe that this Old Testament story was a parable for God's sacrifice of his own son, Jesus.

The Crucifixion itself, however, does not appear on the Junius Bassus sarcophagus. Indeed, the subject was very rare in Early Christian art, and unknown prior to the fifth century. Christ's divinity and exemplary life as teacher and miracle worker, not his suffering and death at the hands of the Romans, were emphasized. The sarcophagus sculptor, however, alluded to the Crucifixion in the scenes in the two compartments at the upper right depicting Jesus being led before Pontius Pilate for judgment. The Romans condemned Jesus to death but he triumphantly overcame it. Junius Bassus and other Christians, whether they were converts from paganism or from Judaism, hoped for a similar salvation.

AN "IDOL" OF CHRIST Apart from the reliefs on privately commissioned sarcophagi, monumental sculpture became increasingly uncommon in the fourth century. Portrait statues of Roman emperors and other officials continued to be erected, and statues of pagan gods and mythological figures were still made, but their numbers decreased sharply. In his *Apologia,* Justin Martyr, a second-century philosopher who converted to Christianity and was mindful of the Second Commandment's admonition to shun graven images, accused

the pagans of worshiping statues as gods. Christians tended to suspect the freestanding statue, linking it with the false gods of the pagans, so Early Christian houses of worship had no "cult statues." Nor did the first churches have any equivalent of the pedimental statues and relief friezes of Greco-Roman temples.

The Greco-Roman experience, however, was still a living part of the Mediterranean mentality, and many Christians like Junius Bassus were recent converts from paganism who retained some of their classical values. This may account for those rare instances of Early Christian "idols," such as the marble statuette of Christ enthroned shown here (FIG. **11-6**). Less than three feet tall, the sculpture is contemporary with or somewhat later than, and a freestanding version of, the youthful Christ between Saints Peter and Paul on the Junius Bassus sarcophagus (FIG. 11-5). As on the relief, Christ's head is that of a long-haired Apollo-like youth, but the statuary type was one employed for bearded Roman philosophers of advanced age. The remarkably young teacher wears the Roman tunic, toga, and sandals, and holds an unopened scroll in his left

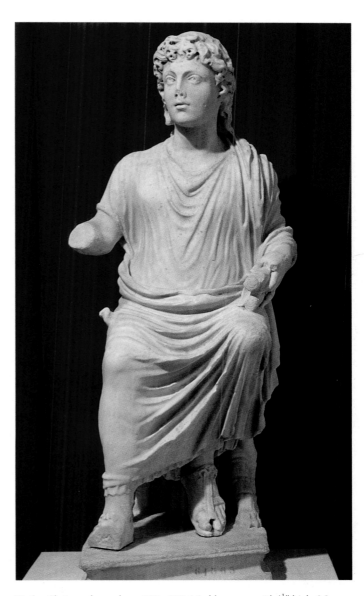

11-6 Christ enthroned, ca. 350–375. Marble, approx. 2′ 4½″ high. Museo Nazionale Romano, Rome.

The Life of Jesus in Art

Christians believe that Jesus of Nazareth was the son of God, the *Messiah* (Savior, *Christ*) of the Jews prophesied in the Old Testament. His life, from his miraculous birth from the womb of a virgin mother through his preaching and miracle working to his execution by the Romans and subsequent ascent to heaven, has been the subject of countless artworks from Roman times through the present day. The primary literary sources for these representations are the Gospels of the New Testament attributed to the four Evangelists, Saints Matthew, Mark, Luke, and John; later apocryphal works; and commentaries on these texts by medieval theologians.

The life of Jesus dominated the subject matter of Christian art to a far greater extent than Greco-Roman religion and mythology ever did classical art. Whereas images of athletes, portraits of statesmen and philosophers, narratives of war and peace, genre scenes, and other secular subjects were staples of the classical tradition, Christian iconography held a near monopoly in the art of the Western world in the Middle Ages.

Although many of the events of Jesus' life were rarely or never depicted during certain periods, the cycle as a whole has been one of the most frequent subjects of Western art, even after the revival of classical and secular themes in the Renaissance. Thus it is useful to summarize the entire cycle here in one place, giving selected references to illustrations of the various episodes, from late antiquity to the seventeenth century. We describe the events as they usually appear in the artworks.

INCARNATION AND CHILDHOOD

The first "cycle" of the life of Jesus consists of the events of his conception, birth, infancy, and childhood.

Annunciation to Mary (see FIGS. 12-33, 19-18, and 21-38) The archangel Gabriel announces to the Virgin Mary that she will miraculously conceive and give birth to God's son Jesus. God's presence at the *Incarnation* is sometimes indicated by a dove, the symbol of the *Holy Spirit*, the third "person" of the *Trinity* with God the Father and Jesus.

Visitation (see FIG. 18-24) The pregnant Mary visits Elizabeth, her older cousin, who is pregnant with the future Saint John the Baptist. Elizabeth is the first to recognize that the baby Mary is bearing is the Son of God, and they rejoice.

Nativity (see FIGS. 19-3 and 19-4), *Annunciation to the Shepherds* (see FIG. 16-28), and *Adoration of the Shepherds* (see FIG. 24-57) Jesus is born at night in Bethlehem and placed in a basket. Mary and her husband Joseph marvel at the newborn in a stable or, in Byzantine art, in a cave. An angel announces the birth of the Savior to shepherds in the field, who rush to Bethlehem to adore the child.

Adoration of the Magi (see FIG. 21-10) A bright star alerts three wise men *(magi)* in the East that the King of the Jews has been born. They travel twelve days to find the *Holy Family* and present precious gifts to the infant Jesus.

Presentation in the Temple In accordance with Jewish tradition, Mary and Joseph bring their first-born son to the temple in Jerusalem, where the aged Simeon, whom God said would not die until he had seen the Messiah, recognizes Jesus as the prophesied Savior of humankind.

Massacre of the Innocents and *Flight into Egypt* King Herod, fearful that a rival king has been born, orders the massacre of all infants in Bethlehem, but an angel warns the Holy Family and they escape to Egypt.

Dispute in the Temple Joseph and Mary travel to Jerusalem for the feast of *Passover* (the celebration of the release of the Jews from bondage to the pharaohs of Egypt). Jesus, only twelve years old at the time, engages in learned debate with astonished Jewish scholars in the temple, foretelling his ministry.

PUBLIC MINISTRY

The public ministry cycle comprises the teachings of Jesus and the miracles he performed.

Baptism (FIG. 11-4) The beginning of Jesus' public ministry is marked by his baptism at age thirty by John the Baptist in the Jordan River, where the dove of the Holy Spirit appears and God's voice is heard proclaiming Jesus as his son.

Calling of Matthew (see FIG. 24-19) Jesus summons Matthew, a tax collector, to follow him, and Matthew becomes one of his twelve *disciples,* or *apostles* (from the Greek for "messenger"), and later the author of one of the four Gospels.

Miracles In the course of his teaching and travels, Jesus performs many miracles, revealing his divine nature. These include acts of healing and the raising of the dead, the turning of water into wine, walking on water and calming storms, and the creation of wondrous quantities of food. In the miracle of loaves and fishes (FIG. 11-17), for example, Jesus transforms a few loaves of bread and a handful of fishes into enough food to feed several thousand people.

Delivery of the Keys to Peter (see FIG. 21-42) The fisherman Peter was one of the first Jesus summoned as a disciple. Jesus chooses Peter as his successor, the rock *(petra)* on which his church will be built, and symbolically delivers to Peter the keys to the kingdom of heaven.

Transfiguration (see FIG. 12-13) Jesus scales a high mountain and, in the presence of Peter and two other disciples, James and John the Evangelist, is transformed into radiant light. God, speaking from a cloud, discloses that Jesus is his son.

Cleansing of the Temple Jesus returns to Jerusalem, where he finds money changers and merchants conducting business in the temple. He rebukes them and drives them out of the sacred precinct.

The Life of Jesus in Art (continued)

PASSION

The Passion (from Latin *passio*, "suffering") cycle includes the episodes leading to Jesus' death, Resurrection, and ascent to heaven.

Entry into Jerusalem (FIG. 11-5) On the Sunday before his Crucifixion (Palm Sunday), Jesus rides triumphantly into Jerusalem on a donkey, accompanied by disciples. He is greeted enthusiastically by crowds of people who place palm fronds in his path.

Last Supper (see FIGS. 20-8, 21-39, 22-3, 22-52, and 23-4) and *Washing of the Disciples' Feet* In Jerusalem, Jesus celebrates Passover with his disciples. During this Last Supper, Jesus foretells his imminent betrayal, arrest, and death and invites the disciples to remember him when they eat bread (symbol of his body) and drink wine (his blood). This ritual became the celebration of *Mass (Eucharist)* in the Christian Church. At the same meal, Jesus sets an example of humility for his apostles by washing their feet.

Agony in the Garden Jesus goes to the Mount of Olives in the Garden of Gethsemane, where he struggles to overcome his human fear of death by praying for divine strength. The apostles who accompanied him there fall asleep despite his request that they stay awake with him while he prays.

Betrayal and Arrest (see FIG. 19-17) One of the disciples, Judas Iscariot, agrees to betray Jesus to the Jewish authorities in return for thirty pieces of silver. Judas identifies Jesus to the soldiers by kissing him, and Jesus is arrested. Later, a remorseful Judas hangs himself from a tree (FIG. 11-21).

Trials of Jesus (FIGS. 11-5 and 11-20) and *Denial of Peter* Jesus is brought before Caiaphas, the Jewish high priest, and is interrogated about his claim to be the Messiah. Meanwhile, the disciple Peter thrice denies knowing Jesus, as Jesus predicted he would. Jesus is then brought before the Roman governor of Judea, Pontius Pilate, on the charge of treason because he had proclaimed himself as King of the Jews. Pilate asks the crowd to choose between freeing Jesus or Barabbas, a murderer. The people choose Barabbas, and the judge condemns Jesus to death. Pilate washes his hands, symbolically relieving himself of responsibility for the mob's decision.

Flagellation and *Mocking* The Roman soldiers who hold Jesus captive whip (flagellate) him and mock him by dressing him as King of the Jews and placing a crown of thorns on his head.

Carrying of the Cross, Raising of the Cross, (see FIG. 24-34) and *Crucifixion* (see FIGS. 11-21, 12-20, 16-16, and 16-27) The Romans force Jesus to carry the cross on which he will be crucified from Jerusalem to Mount Calvary (Golgotha, the "place of the skull," where Adam was buried). He falls three times and gets stripped along the way. Soldiers erect the cross and nail his hands and feet to it. Jesus' mother, John the Evangelist, and Mary Magdalene mourn at the foot of the cross, while soldiers torment Jesus. One of them (the centurion Longinus) stabs his side with a spear. After suffering great pain, Jesus dies. The Crucifixion occurred on a Friday and Christians celebrate the day each year as Good Friday.

Deposition (see FIGS. 20-6 and 22-41), *Lamentation* (see FIGS. 12-27 and 19-9), and *Entombment* (see FIG. 17-33) Two disciples, Joseph of Arimathea and Nicodemus, remove Jesus' body from the cross (the Deposition); sometimes those present at the Crucifixion look on. They take Jesus to the tomb Joseph had purchased for himself, and Joseph, Nicodemus, the Virgin Mary, Saint John the Evangelist, and Mary Magdalene mourn over the dead Jesus (the Lamentation). (When in art the isolated figure of the Virgin Mary cradles her dead son in her lap, it is called a *Pietà* [Italian for *pity;* see FIGS. 18-53 and 20-19]). In portrayals of the Entombment, his followers lower Jesus into a sarcophagus in the tomb.

Descent into Limbo (see FIGS. 12-23 and 12-31) During the three days he spends in the tomb, Jesus, no longer a mortal human but now the divine Christ, descends into Hell, or Limbo, and triumphantly frees the souls of the righteous, including Adam, Eve, Moses, David, Solomon, and John the Baptist. In Byzantine art, this episode is often labeled *Anastasis* (*Resurrection* in Greek), although it refers to events preceding Christ's emergence from the tomb and reappearance on earth.

Resurrection (see FIG. 21-52) and *Three Marys at the Tomb* On the third day (Easter Sunday), Christ rises from the dead and leaves the tomb while the guards outside are sleeping. The Virgin Mary, Mary Magdalene, and Mary, the mother of James, visit the tomb, find it empty, and learn from an angel that Christ has been resurrected.

Noli Me Tangere, Supper at Emmaus, and *Doubting of Thomas* During the forty days between Christ's Resurrection and his ascent to heaven, he appears on several occasions to his followers. Christ warns Mary Magdalene, weeping at his tomb, with the words "Don't touch me" (*Noli me tangere* in Latin), but he tells her to inform the apostles of his return. At Emmaus he eats supper with two of his astonished disciples. Later, Thomas, who cannot believe that Christ has risen, is invited to touch the wound in his side that he received at his Crucifixion.

Ascension (see FIGS. 12-14 and 17-26) On the fortieth day, on the Mount of Olives, with his mother and apostles as witnesses, Christ gloriously ascends to heaven in a cloud.

hand. The piece is unique and, unfortunately, of unknown provenance, so art historians only can speculate about its original context and function. Several third- and fourth-century marble statuettes of Christ as the Good Shepherd and of Jonah also survive, but they, too, are exceptional. Monumental sculpture of Christian character was not significant in the history of art until the twelfth century (Chapter 17).

ARCHITECTURE AND MOSAICS

THE FRUITS OF IMPERIAL PATRONAGE Although some Christian ceremonies were held in the catacombs, regular services took place in private community houses of the type found at Dura-Europos (FIG. 11-2). Once Christianity achieved imperial sanction under Constantine, an urgent need suddenly arose to construct churches. The new buildings had to meet the Christian liturgy's require-ments, provide a suitably monumental setting for the celebration of the Christian faith, and accommodate the rapidly growing numbers of worshipers.

Constantine was convinced the Christian god had guided him to victory over Maxentius, and in lifelong gratitude he protected and advanced Christianity throughout the empire, as well as in the obstinately pagan capital city of Rome. As emperor, he was, of course, obliged to safeguard the ancient Roman religion, traditions, and monuments, and, as noted in Chapter 10, he was (for his time) a builder on a grand scale in the heart of the city. But eager to provide buildings to house the Christian rituals and venerated burial places, especially the memorials of founding saints, Constantine also was the first major patron of Christian architecture. He constructed elaborate basilicas, memorials, and mausoleums not only in Rome (see "Constantine's Gifts to the Churches of Rome," page 311) but also in Constantinople, his "New Rome" in the East; and at sites sacred to Christianity, most notably Bethlehem, the birthplace of Jesus; and Jerusalem, the site of his crucifixion.

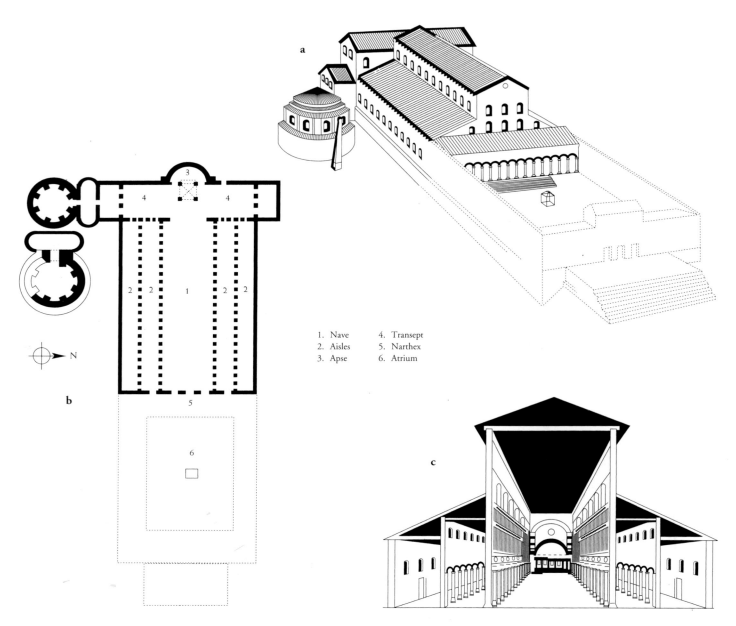

1. Nave 4. Transept
2. Aisles 5. Narthex
3. Apse 6. Atrium

11-7 Restored view (*a*), plan (*b*), and section (*c*) of Old Saint Peter's, Rome, Italy, begun ca. 320. (The restoration of the forecourt is conjectural.)

WRITTEN SOURCES

Constantine's Gifts to the Churches of Rome

Constantine the Great was the first emperor to sponsor the construction of churches in Rome. His generosity went well beyond providing land and erecting edifices. It extended to outfitting the interiors with costly altars, chandeliers, candlesticks, pitchers, goblets, and plates fashioned of gold and silver and sometimes embellished with jewels. The *Book of the Popes,* compiled by an anonymous sixth-century author, provides a vivid picture of the emperor's abundance, enumerating Constantine's donations to Old Saint Peter's (FIG. 11-7) and to the great basilica of Saint John Lateran, the cathedral of Rome adjacent to the emperor's palace. The highlight of the very long list of gifts to the Lateran basilica is

> a ciborium [a *baldacchino,* or domical canopy over an altar, supported by four columns] of hammered silver, which has upon the front the Saviour seated upon a chair, in height 5 feet, weighing 120 lbs., and also the 12 apostles, who weigh each 90 lbs., and are 5 feet in height and wear crowns of purest silver; further, on the back, looking toward the apse are the Saviour seated upon a throne in height 5 feet, of purest silver, weighing 150 lbs., and 4 angels of silver, which weigh each 105 lbs. and are 5 feet in height and have jewels from Alabanda in their eyes and carry spears; the ciborium itself weighs 2025 lbs. of wrought silver; a vaulted ceiling of purest gold; and a lamp of purest gold, which hangs beneath the ciborium, with 50 dolphins of purest gold, weighing each 50 lbs., and chains which weigh 25 lbs.[1]

The description of the silver statues of Christ, the apostles, and angels are especially interesting. They are symptomatic of the triumph of classical taste and tradition over the Christian reluctance to fashion "idols." The marble statuette of Christ already discussed (FIG. 11-6) also may have been made for a patron like Constantine, but of lesser means, who was born a pagan and embraced Christianity only late in life.

[1] Caecilia Davis-Weyer, trans., *Early Medieval Art, 300–1150: Sources and Documents* (Englewood Cliffs, N.J.: Prentice-Hall, 1971), 41.

Rome

CONSTANTINE HONORS SAINT PETER Constantine's dual role as both Roman emperor and champion of the Christian faith was reflected in his decision to locate the new churches of Rome on the city's outskirts to avoid any confrontation between Christian and pagan ideologies. The greatest of Constantine's churches in Rome was Old Saint Peter's (FIG. **11-7**), probably begun as early as 319. The Constantinian structure eventually was replaced by the grand present-day church (see FIG. 24-4), one of the masterpieces of Italian Renaissance and Baroque architecture. Old Saint Peter's stood on the western side of the Tiber River on the spot where Constantine and Pope Sylvester believed Peter, the first apostle and founder of the Roman Christian community, had been buried. Excavations in the Roman cemetery beneath the church have in fact revealed a second-century memorial erected in honor of the early Christian martyr at his reputed grave. The great Constantinian church, capable of housing three to four thousand worshipers at one time, was raised, at immense cost, upon a terrace over the ancient cemetery on the irregular slope of the Vatican Hill. It enshrined one of the most hallowed sites in Christendom, second only to the Holy Sepulcher in Jerusalem, the site of Christ's Resurrection. The project also fulfilled the figurative words of Christ himself, when he said, "Thou art Peter, and upon this rock (in Greek, *petra*) I will build my church" (Matt. 16:18). Peter was Rome's first bishop and also the head of the long line of popes that extends to the present.

BASILICAS BECOME CHURCHES The plan and elevation of Old Saint Peter's resemble those of Roman basilicas and audience halls, such as the Basilica Ulpia in the Forum of Trajan (FIG. 10-41) and the Aula Palatina at Trier (see FIGS. 10-80 and 10-81), rather than the design of any Greco-Roman temple. The Christians, understandably, did not want their houses of worship to mimic the form of pagan shrines, but practical considerations also contributed to their shunning the pagan temple type. The Greco-Roman temple housed only the cult statue of the deity. All rituals took place outside at open-air altars. The classical temple, therefore, could have been adapted only with great difficulty as a building that accommodated large numbers of people within it. The Roman basilica, in contrast, was ideally suited as a place for congregation, and Early Christian architects eagerly embraced it.

Like Roman basilicas, Old Saint Peter's (FIG. 11-7) had a wide central *nave* (three hundred feet long) flanked by *aisles* and ending in an *apse.* It was preceded by an open colonnaded courtyard, very much like the forum proper in the Forum of Trajan but called an *atrium* like the central room in a private house. Worshipers entered the basilica through a *narthex,* or vestibule. When they emerged in the nave, they had an unobstructed view of the altar in the apse, framed by the so-called *triumphal arch* dividing the nave from the area around the altar. A special feature of the Constantinian church was the transverse aisle, or *transept,* an area perpendicular to the nave between the nave and apse. It housed the relics of Saint Peter that hordes of pilgrims came to see. (*Relics* are the body parts, clothing, or any object associated with a saint or Christ himself; see "Pilgrimages and the Cult of Relics," Chapter 17, page 457.) The transept became a standard element of church design in the West only much later, when it also took on, with the nave and apse, the symbolism of the Christian cross.

INSIDE AN EARLY CHRISTIAN BASILICA Unlike pagan temples but comparable to most Roman basilicas and

audience halls, Old Saint Peter's was not adorned with lavish exterior sculptures. Its brick walls were as austere as those of the Aula Palatina at Trier (see FIG. 10-80). Inside, however, were frescoes and mosaics, marble columns (taken from pagan buildings, as was customary at the time), grandiose chandeliers, and gold and silver vessels on jeweled altar cloths for use in the Mass. A huge marble baldacchino supported by spiral columns marked the spot of Saint Peter's tomb beneath the *crossing* of the nave and the transept. The Early Christian basilica may be likened to the ideal Christian, with a somber and plain exterior and a glowing and beautiful soul within.

One can get some idea of the character of the timber-roofed, five-aisled interior of Old Saint Peter's by comparing our section drawing (FIG. 11-7) with the photograph of the interior of Santa Sabina in Rome (FIG. **11-8**). Santa Sabina, built a century later, is a basilican church of much more modest proportions, but it still retains its Early Christian character. The Corinthian columns of Santa Sabina's nave produce a steady rhythm that focuses all attention on the apse within its "triumphal arch," which frames the altar and contains seats for the clergy. In a pagan basilica, the apse was where the enthroned statue of the emperor was displayed, as in the Basilica Nova in Rome (see FIG. 10-79). The seat of episcopal authority thus supplanted the pagan basilica's secular throne. (The word *cathedral* is derived from the Latin *cathedra,* the bishop's chair.) In Santa Sabina, as in Old Saint Peter's, the nave is drenched with light from the clerestory windows piercing the thin upper wall beneath the timber roof. The same light would have illuminated the frescoes and mosaics that commonly adorned the nave, triumphal arch, and apse of Early Christian churches. Outside, Santa Sabina has plain brick walls. They resemble quite closely the exterior of Trier's Aula Palatina (FIG. 10-80).

FROM MAUSOLEUM TO CHURCH The rectangular basilican church design was long the favorite of the Western Christian world, but Early Christian architects also adopted

another classical architectural type: the *central-plan* building. The type is so named because the building's parts are of equal or almost equal dimensions around the center. Roman central-plan buildings were usually round or polygonal domed structures. Byzantine architects developed this form to monumental proportions and amplified its theme in numerous ingenious variations. In the West, the central plan was used generally for structures adjacent to the main basilicas, such as mausoleums, baptisteries, and private chapels, rather than for actual churches, as in the East (see Chapter 12).

A highly refined example of the central-plan design is Santa Costanza in Rome (FIGS. **11-9** and **11-10**), built in the mid-fourth century as the mausoleum for Constantia, the emperor Constantine's daughter. It contained her monumental porphyry sarcophagus, which is now in the Vatican Museums. The mausoleum, later converted into a church, stood next to the basilican church of Saint Agnes, whose tomb was in a nearby catacomb. Santa Costanza has antecedents that can be traced back to the beehive tombs of the Mycenaeans (see FIGS. 4-21 and 4-22), but its immediate predecessors were the domed structures of the Romans, such as the Pantheon (see FIGS. 10-48 to 10-50) and especially imperial mausolea such as Diocletian's at Split (see FIG. 10-75). At Santa Costanza, the interior design of the pagan Roman buildings was modified to accommodate an *ambulatory,* a ringlike barrel-vaulted corridor separated from the central domed cylinder by a dozen pairs of columns. (Twelve is the number of Christ's apostles, and twelve pairs of columns were also a feature of Constantine's centrally planned Anastasis Rotunda in Jerusalem.) It is as if the nave of the Early Christian basilica with its clerestory wall were bent around a circle, the ambulatory corresponding to the basilican aisles.

A PORTRAIT IN A MOSAIC VINEYARD Like Early Christian basilicas, Santa Costanza has a severe brick exterior. Its interior was once adorned with mosaics, although most are lost. Old and New Testament themes ap-

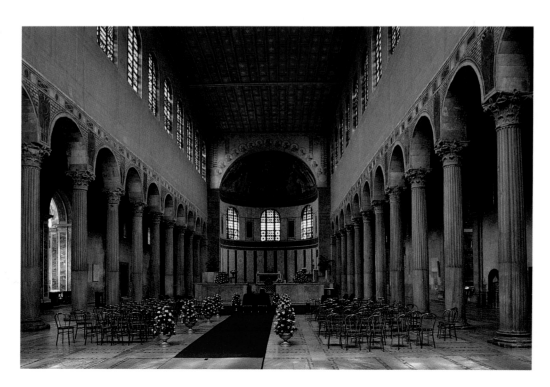

11-8 Interior of Santa Sabina, Rome, Italy, 422–432.

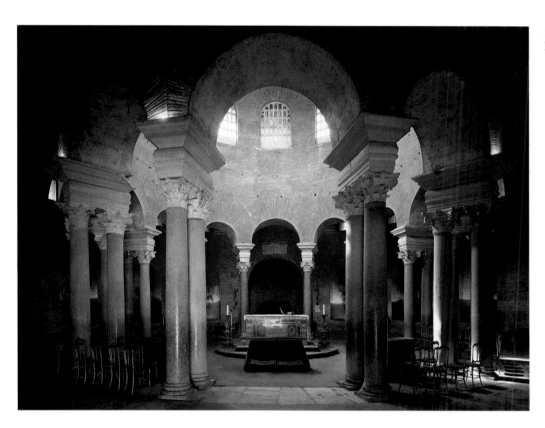

11-9 Interior of Santa Costanza, Rome, Italy, ca. 337–351.

peared side by side, as in the catacombs and on Early Christian sarcophagi. But Santa Costanza also had an abundance of pagan imagery, appropriate for the tomb of an emperor's daughter. In our detail of a mosaic in the ambulatory vault (FIG. 11-11), a portrait bust of Constantia is at the center of a rich vine scroll inhabited by putti and birds. Scenes of putti harvesting grapes and producing wine, echoing the decoration of Constantia's sarcophagus (not shown), surround the portrait.

The surviving mosaics of Santa Costanza, despite their pagan themes, are a reminder of how important a role mosaic decoration played in the interiors of Early Christian buildings (see "Mosaics," page 314). When, under Constantine, Christianity suddenly became a public and official religion in Rome, not only were new buildings required to house the faithful, but wholesale decoration programs for the churches also became necessary. To advertise the new faith in all its diverse aspects—its dogma, scriptural narrative, and symbolism—and to instruct and edify believers, acres of walls in dozens of new churches had to be filled in the style and medium that would carry the message most effectively.

CHRIST AS SUN GOD The earliest known mosaic of explicitly Christian content is the late-third-century vault mosaic (FIG. 11-12) in a small Christian mausoleum not far from Saint Peter's tomb in the Roman cemetery beneath Old Saint Peter's. It depicts Christ in the guise of a familiar pagan deity, Sol Invictus (in Greek, Helios), the Invincible Sun, driving the sun chariot through the golden heavens. All about Christ are vines, as in Constantia's mausoleum (FIG. 11-11). He holds an orb in his left hand, characterizing him as ruler of the universe, another borrowing from the pagan repertory of Roman imperial art. But viewers could easily distinguish the Christian charioteer from the pagan Sol by the halo around his head: The rays suggest the pattern of a cross. This is a far more grandiose

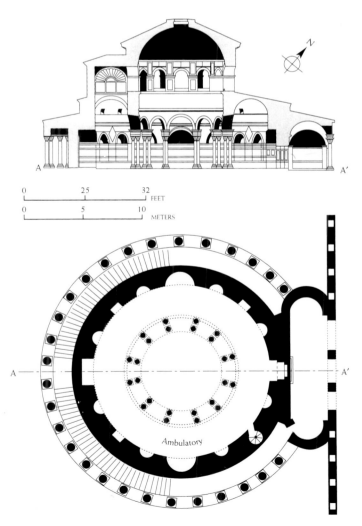

11-10 Longitudinal section (*top*) and plan (*bottom*) of Santa Costanza, Rome, Italy, ca. 337–351.

Mosaics

As an art form, mosaic had a rather simple and utilitarian beginning, seemingly invented primarily to provide an inexpensive and durable flooring. Originally, small beach pebbles were set, unaltered from their natural form and color, into a thick coat of cement. Artisans soon discovered, however, that the stones could be arranged in decorative patterns. At first, these *pebble mosaics* were uncomplicated and were confined to geometric shapes. Generally, the artists used only black and white stones. Examples of this type, dating back to the eighth century B.C., have been found at Gordion in Asia Minor. Eventually, artists arranged the stones to form more complex pictorial designs, and by the fourth century B.C. the technique had developed to a high sophistication level. Mosaicists depicted elaborate figural scenes using a broad range of colors—yellow, brown, and red in addition to black, white, and gray—and shaded the figures, clothing, and setting to suggest volume. Thin strips of lead provided linear definition (see FIG. 5-68).

By the middle of the third century B.C., artists had invented a new kind of mosaic that permitted the best mosaicists to create designs that more closely approximated true paintings. The new technique employed *tesserae* (Latin for "cubes" or "dice"). These tiny cut stones gave the artist much greater flexibility because their size and shape could be adjusted at will, eliminating the need for lead strips to indicate contours and interior details. Much more gradual gradations of color also became possible, and mosaicists finally could aspire to rival the achievements of panel painters (see FIG. 5-69).

In Early Christian mosaics, sparkling tesserae of reflective glass, as opposed to the opaque marble tesserae the Romans preferred, almost immediately became the standard vehicle of expression. Mosaics particularly suited the flat, thin-walled surfaces of the new basilicas, becoming a durable, tangible part of the wall—a kind of architectural tapestry. The mosaics caught the light flooding through the clerestories in vibrant reflection, producing abrupt effects and contrasts and sharp concentrations of color that could focus attention on a composition's central, most relevant features. Mosaics worked in the Early Christian manner were not intended for the subtle tonal changes a naturalistic painter's approach would require. Color was *placed,* not blended. Bright, hard, glittering texture, set within a rigorously simplified pattern, became the rule. For mosaics situated high on the wall, far above the observer's head, the painstaking use of tiny tesserae seen in Roman floor mosaics became meaningless. Early Christian mosaics, designed to be seen from a distance, employed larger stones. The larger tesserae were also set unevenly so that their surfaces could catch and reflect the light. Artists favored simple designs for optimal legibility. For several centuries, mosaic, in the service of Christian theology, was the medium of some of the supreme masterpieces of medieval art.

11-11 Detail of vault mosaic in the ambulatory of Santa Costanza, Rome, Italy, ca. 337–351.

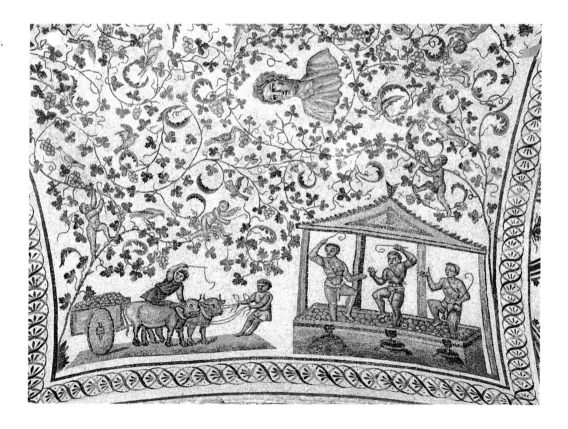

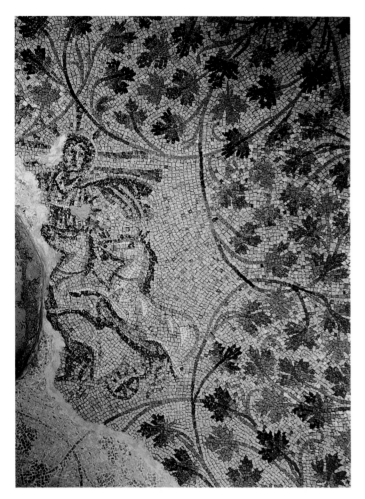

11-12 Christ as Sol Invictus, detail of a vault mosaic in the Mausoleum of the Julii, Rome, Italy, late third century.

conception of Christ than the role of Good Shepherd and a fitting theme for the vaulted ceiling above the deceased. Christ does appear, however, as the caretaker of the Christian flock below, on the west wall of the tomb. On the east wall, in typical Early Christian fashion, is the story of Jonah.

ABRAHAM AND LOT IN A CHURCH NAVE Old Testament themes are the focus of the extensive fifth-century mosaic cycle in the nave of the basilican church of Santa Maria Maggiore in Rome. A characteristic panel of great dramatic power represents the parting of Abraham and his nephew Lot (FIG. **11-13**), as set forth in Genesis, the Bible's opening book. Agreeing to disagree, Lot leads his family and followers to the right, toward the city of Sodom, while Abraham heads for Canaan, moving toward a building (perhaps symbolizing the Christian Church) on the left. Lot's is the evil choice, and the instruments of the evil (his two daughters) are in front of him. The figure of the yet unborn Isaac, the instrument of good (and, as noted earlier, a prefiguration of Christ), stands before his father, Abraham.

The cleavage of the two groups is emphatic, and each group was represented by a shorthand device that could be called a "head cluster," which had precedents in antiquity and had a long history in Christian art. The figures turn from each other in a sharp dialogue of glance and gesture. The wide eyes, turned in their sockets; the broad gestures of enlarged hands; and the opposed movements of the groups all may remind viewers of a silent, expressive chorus that comments on the drama's action only with their hands and bodies. Thus, the complex action of Roman art stiffened into the medieval art of simplified motion, which has great power to communicate without ambiguity.

The artist's placing of the panel's figures in the foreground and disinterest in defining the spatial setting also foreshadowed the

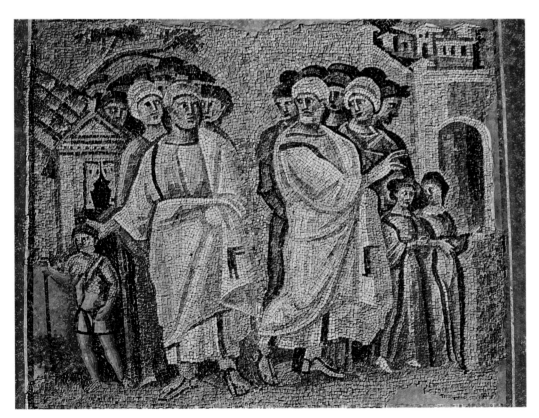

11-13 The parting of Lot and Abraham, mosaic in the nave of Santa Maria Maggiore, Rome, Italy, 432–440.

character of later Christian art. The background town and building are symbolic, rather than descriptive. But within this relatively abstract setting, the figures themselves loom with massive solidity. They cast shadows and were modeled in dark and light to give them the three-dimensional appearance that testified to the artist's heritage of Roman pictorial illusionism. Another century had to pass before Western Christian artists portrayed figures entirely as flat images, rather than as plastic bodies.

Ravenna

NEW CAPITALS FOR A CRUMBLING EMPIRE In the decades following the foundation in 324 of Constantinople, the New Rome in the East, and the death of Constantine in 337, the pace of Christianization of the Roman Empire quickened. In 380 the emperor Theodosius I issued an edict finally establishing Christianity as the state religion. In 391 he enacted a ban against pagan worship. In 394 the Olympic Games, the enduring symbol of the classical world and its values, were abolished. Theodosius died in 395, and imperial power passed to his two sons, Arcadius, who became Emperor of the East, and Honorius, Emperor of the West. The problems that plagued the last pagan emperors, most notably the threat of invasion from the north, did not, however, disappear with the conversion to Christianity.

In 404, when the Visigoths, under their king, Alaric, threatened to overrun Italy from the northwest, Honorius moved the capital of his crumbling empire from Milan to Ravenna, an ancient Roman city (perhaps founded by the Etruscans) near Italy's Adriatic coast, some eighty miles south of Venice. There, in a city surrounded by swamps and thus easily defended, his imperial authority survived the fall of Rome to Alaric in 410. Honorius died in 423, and the reins of government were taken by his half sister, Galla Placidia, whom the Visigoths had captured in Rome in 410. Galla Placidia had married a Visigothic chieftain before returning to Ravenna and the Romans after the chieftain's death six years later. In 476 Ravenna fell to Odoacer, the first Germanic king of Italy, who was overthrown in turn by Theodoric, king of the Ostrogoths, who established his capital at Ravenna in 493. The subsequent history of the city belongs with that of the Byzantine Empire (see Chapter 12).

AN EMPRESS'S MOSAIC-CLAD MAUSOLEUM The so-called Mausoleum of Galla Placidia in Ravenna (FIG. **11-14**) is a rather small *cruciform* (cross-shaped) structure with a dome-covered crossing and barrel-vaulted arms. Dedicated to Saint Lawrence, it was built shortly after 425, almost a quarter century before Galla Placidia's death in 450. The building also housed the sarcophagi of Honorius and Galla Placidia and thus served the double function of imperial mausoleum and martyr's chapel. Originally the building adjoined the narthex of the now greatly altered palace-church of Santa Croce (Holy Cross), which was also cruciform in plan. Although the mausoleum's plan is that of a Latin cross, the cross arms are very short and appear as little more than apselike extensions of a square. The emphasis is on the tall dome-covered crossing. The mausoleum is in essence a central-plan structure. Yet, this small, unassuming building also represents one of the earliest successful fusions of the two basic early church plans, the *longitudinal* (basilican) and the central. It introduced, on a small scale, a building type that had a long his-

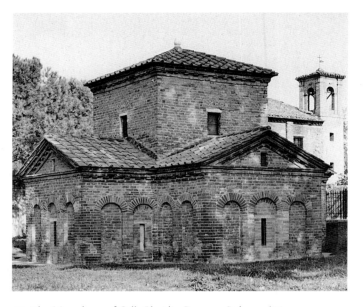

11-14 Mausoleum of Galla Placidia, Ravenna, Italy, ca. 425.

tory in Christian architecture: the basilican plan with a domed crossing.

The mausoleum's unadorned brick shell encloses one of the richest mosaic ensembles in Early Christian art. Mosaics cover every square inch of the interior surfaces above the marble-faced walls. Garlands and decorative medallions resembling snowflakes on a dark blue ground adorn the barrel vaults of the nave and cross arms. The dome has a large golden cross set against a star-studded sky. Representations of saints and apostles cover the other surfaces.

Christ as Good Shepherd is the subject of the lunette above the entrance (FIG. **11-15**). No earlier version of the Good Shepherd is as regal as this one. Instead of carrying a lamb on his shoulders, Jesus sits among his flock, haloed and robed in gold and purple. To his left and right, the sheep are distributed evenly in groups of three. But their arrangement is rather loose and informal, and they occupy a carefully described landscape that extends from foreground to background beneath a blue sky. All the forms have three-dimensional bulk and cast shadows. In short, the panel is full of Greco-Roman illusionistic devices. The mosaicist was still deeply rooted in the classical tradition. Some fifty years later, this artist's successors in Ravenna worked in a much more abstract and formal manner.

THEODORIC'S PALACE-CHURCH Around 504, soon after Theodoric settled in Ravenna, he ordered the construction of his own palace-church, a three-aisled basilica dedicated to the Savior. In the ninth century, the relics of Saint Apollinaris were transferred to this church. The building was rededicated and has been known since that time as Sant'Apollinare Nuovo. The rich mosaic decorations of the interior nave walls (FIG. **11-16**) are in three zones. Only the upper two date from Theodoric's time. Old Testament patriarchs and prophets stand between the clerestory windows. Above them, scenes from Christ's life alternate with decorative panels.

The mosaic depicting the miracle of the loaves and fishes (FIG. **11-17**) illustrates well the stylistic change that occurred since the decoration of the Mausoleum of Galla Placidia. Jesus, beardless, in the imperial dress of gold and purple, and

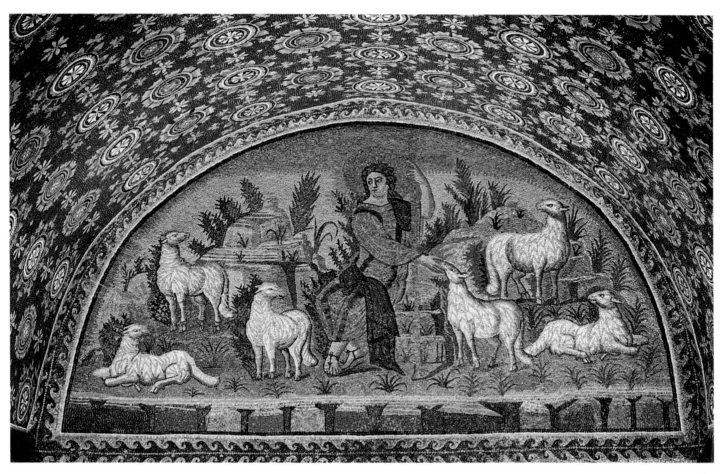

11-15 Christ as the Good Shepherd, mosaic from the entrance wall of the Mausoleum of Galla Placidia, Ravenna, Italy, ca. 425.

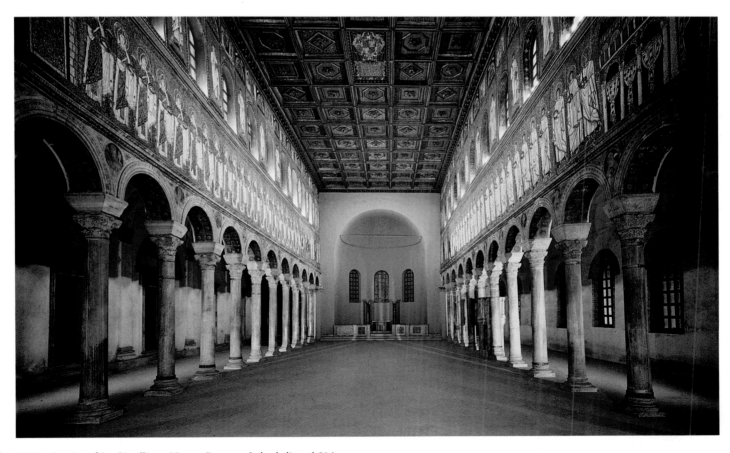

11-16 Interior of Sant'Apollinare Nuovo, Ravenna, Italy, dedicated 504.

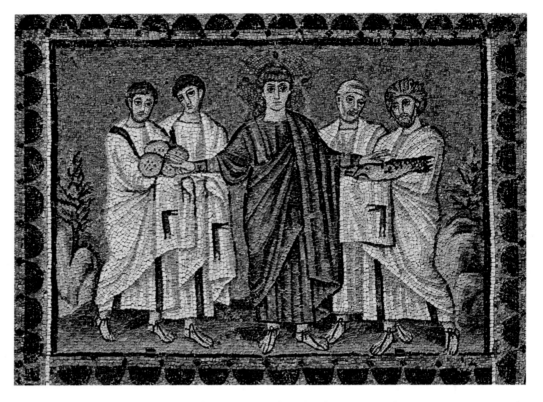

11-17 Miracle of the loaves and fishes, mosaic from the top register of the nave wall (above the clerestory windows) of Sant'Apollinare Nuovo, Ravenna, Italy, ca. 504.

now distinguished by the cross-inscribed *nimbus* (halo) that signifies his divinity, faces directly toward the viewer. With extended arms he directs his disciples to distribute to the great crowd the miraculously increased supply of bread and fish he has produced. The artist made no attempt to supply details of the event. The emphasis is instead on the holy character of it, the spiritual fact that Jesus is performing a miracle by the power of his divinity. The fact of the miracle takes it

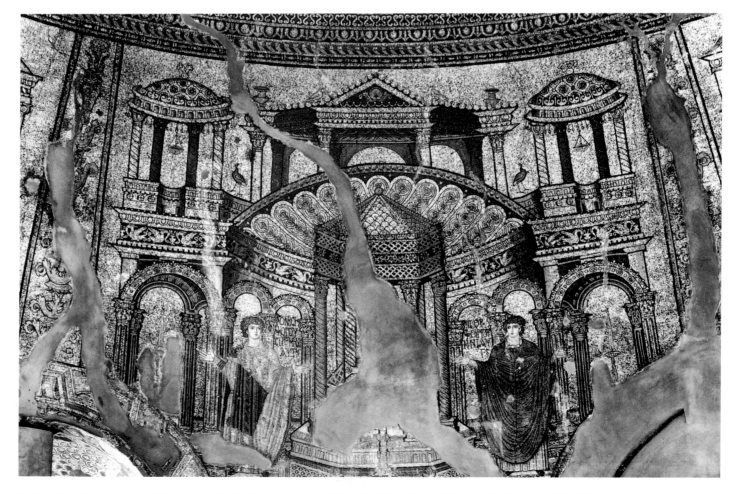

11-18 Saints Onesiphorus and Porphyrius, detail of the dome mosaic, Church of Saint George, Thessaloniki, Greece, ca. 390–450.

Medieval Manuscript Illumination

Rare as medieval books are, they are far more numerous than their ancient predecessors (see "The Roman Illustrated Book," Chapter 10, page 260). The dissemination of manuscripts, as well as their preservation, was aided greatly by an important invention in the Early Imperial period, the codex. The *codex* is much like a modern book, composed of separate leaves *(folios)* enclosed within a cover and bound together at one side. The new format superseded the long manuscript scroll *(rotulus)* the Egyptians, Greeks, Etruscans, and Romans used. (The Etruscan magistrate Lars Pulena, FIG. 9-14; the philosophers on Roman and Early Christian sarcophagi, FIGS. 10-72 and 11-4; and Christ himself in his role as teacher, FIGS. 11-5 and 11-6, all hold rotuli in their hands.) Much more durable *vellum* (calfskin) and *parchment* (lambskin), which provided better surfaces for painting, also replaced the comparatively brittle papyrus used for ancient scrolls. As a result, luxuriousness of ornament became more and more typical of sacred books in the Middle Ages, and at times the material beauty of the pages and their illustrations overwhelm or usurp the spiritual beauty of the text. Art historians refer to the luxurious painted books produced before the invention of the printing press as *illuminated manuscripts,* from the Latin *illuminare,* meaning "to adorn, ornament, or brighten."

Such books were costly to produce and involved many steps. Numerous artisans performed very specialized tasks, beginning with the curing and cutting (and sometimes the dying) of the animal skin, followed by the sketching of lines to guide the scribe and to set aside spaces for illumination, the lettering of the text, the addition of paintings, and finally the binding of the pages and attachment of covers, buckles, and clasps. The covers could be even more sumptuous than the book itself. Many covers survive that are fashioned of gold and decorated with jewels, ivory carvings, and repoussé reliefs (see FIGS. 16-15 and 16-16).

out of the world of time and of incident. The presence of almighty power, not anecdotal narrative, is the important aspect of this scene. The mosaicist told the story with the least number of figures necessary to make its meaning explicit. The artist aligned the figures laterally, moved them close to the foreground, and placed them in a shallow picture box cut off by a golden screen close behind their backs. The landscape setting, which the artist who worked for Galla Placidia so explicitly described, is here merely a few rocks and bushes that enclose the figure group like parentheses. The blue sky of the physical world has given way to the otherworldly splendor of heavenly gold, the standard background color from this point on. Remnants of Roman illusionism appear only in the handling of the individual figures, which still cast shadows and retain some of their former volume. But the shadows of the drapery folds already are only narrow bars. Soon afterward, they disappeared in Christian art.

SAINTS IN A CITY NOT OF THIS WORLD In the eastern Roman Empire, the pace of stylistic change was even more rapid. Many of the features of the Sant'Apollinare Nuovo mosaic may be seen, in more advanced form and created perhaps as much as a century earlier, in the mosaics of the dome of the Church of Saint George at Thessaloniki (Salonica) in northern Greece. The church, of the central-plan type, was originally built around 300 as the mausoleum of Galerius, the tetrarchic Caesar of the East under Diocletian. Its conversion into a church sometime between 390 and 450 (the date is a matter of scholarly controversy) thus parallels the history of the mausoleum of Constantine's daughter, which became Santa Costanza (FIGS. 11-9 to 11-11).

Only part of the mosaic decoration of the Church of Saint George is preserved. The detail we illustrate here (FIG. **11-18**) comes from the lower of two bands of mosaics, which had eight panels. Seven are fairly well preserved. In each one, two saints with their arms raised in prayer stand before two-story architectural fantasies that resemble Roman mural paintings (see FIG. 10-16) and the facades of the rock-cut tombs of Petra (see FIG. 10-52). In this respect, the Thessaloniki mosaics are more closely tied to the classical past than are those of Sant'Apollinare Nuovo. Yet figures and architecture alike have lost almost all substance, and it is increasingly difficult to imagine, for example, rounded torsos and limbs beneath the flat, curtainlike garments worn by Saints Onesiphorus and Porphyrius. A new aesthetic took hold here, one quite foreign to classical art, with its worldly themes, naturalism, perspective illusionism, modeling in light and shade, and proportionality. The formality of the poses and the solemn, priestly demeanor of the Thessaloniki figures, as well as the ethereal golden background, became prominent features of Byzantine art (see Chapter 12). The Saint George dome mosaic seems to have completed the change from the naturalistic images of the pagan floor mosaic, which are literally under the feet and of this world, to the floating images of a celestial world high above the Christian's wondering gaze.

LUXURY ARTS

Illuminated Manuscripts

THE FIRST ILLUSTRATED BIBLES The designers of the Old and New Testament narrative cycles in Santa Maria Maggiore (FIG. 11-13) and Sant'Apollinare Nuovo (FIG. 11-17) must have drawn on a long tradition of pictures in manuscripts that began in pharaonic Egypt (see FIG. 3-39). Richly illustrated texts with Greek, Roman, Hebrew, and Christian themes must have been readily available to the Early Christian

11-19 Rebecca and Eliezer at the well, folio 7 recto of the *Vienna Genesis,* early sixth century. Tempera, gold, and silver on purple vellum, approx. $1'\frac{1}{4}'' \times 9\frac{1}{4}''$. Österreichische Nationalbibliothek, Vienna.

mosaicists. The earliest well-preserved painted manuscript containing biblical scenes is the *Vienna Genesis* (FIG. **11-19**), so called because of its present location. The pages are sumptuous—fine calfskin dyed with rich purple, the same dye used to give imperial cloth its distinctive color, and the text is silver ink (see "Medieval Manuscript Illumination," page 319).

The *Vienna Genesis* represents the somewhat uneasy transition from the scroll to the *codex*, from the old roll format, which favored continuous narrative, to the new bound book, with its series of individual pictures on separate leaves. The *Vienna Genesis* still employs the continuity of a frieze in a scroll, with two or more episodes of a story painted within a single frame. The page we reproduce illustrates the story of Rebecca and Eliezer in the Book of Genesis (24:15–61). When Isaac, Abraham's son, was forty years old, his parents sent their servant Eliezer to find a wife for him. Eliezer chose Rebecca because when he stopped at a well, she was the first woman to draw water for him and his camels. The *Vienna Genesis* scene shows Rebecca at the left, in the first episode of the story, leaving the city of Nahor to fetch water from the well. In the second episode, she gives water to Eliezer and his ten camels, while one already laps water from the well.

The artist painted Nahor as a walled city seen from above, in the manner of the cityscapes on the Santa Maria Maggiore mosaics (FIG. 11-13), which maintained Roman pictorial conventions in widespread use in painting, mosaic, and relief sculpture (for example, on the Column of Trajan, FIG. 10-42). Rebecca walks to the well along the colonnaded avenue of a Roman city. A seminude female personification of a spring is the source of the well water. These are further reminders of the persistence of classical motifs and stylistic modes in Early Christian art. The painter presented the action with all possible simplicity but included convincing touches, such as the drinking camel and Rebecca bracing herself with her raised left foot on the well's rim as she tips up her jug for Eliezer. The figures appear as silhouetted against a blank landscape except for the miniature city and the road to the well. Everything necessary for bare narrative is present and nothing else.

A PURPLE GOSPEL BOOK Closely related to the *Vienna Genesis* is another early-sixth-century manuscript, the *Rossano Gospels*, the earliest preserved illuminated book that contains illustrations of the New Testament. By this time a canon of New Testament iconography had been fairly well established. Like the *Vienna Genesis*, the text of the *Rossano Gospels* is in silver on purple vellum. The Rossano artist, however, attempted with considerable success to harmonize the colors with the purple ground.

The subject of our illustration (FIG. **11-20**), presented with vivid gestures, is the appearance of Jesus before Pilate, who asks the Jews to choose between Jesus and Barabbas (Matt. 27:2–26). In the fashion of continuous narrative, the story's separate episodes appear in the same frame, but without repeating any of the protagonists. The figures are on two levels separated by a simple ground line. In the upper level, Pilate presides over the tribunal. He sits on an elevated dais, following a long-established pattern in Roman art (compare Constantine in the distribution-of-largess frieze on the Arch of Constantine, FIG. 10-77). The people form an arch around Pilate and demand the death of Jesus, while a court scribe

records the proceedings. Jesus (here a bearded adult, as soon became the norm for medieval and later depictions of Christ) and the bound Barabbas appear in the lower level. The painter explicitly labeled Barabbas to avoid any possible confusion so that the picture would be as readable as the text. The haloed Christ and Pilate on his magistrate's dais, flanked by painted imperial portraits, needed no further identification.

Ivory Carving

CHRIST CRUCIFIED AND JUDAS HANGED A century before the pages of the *Rossano Gospels* were illuminated with scenes from the Passion cycle, a Roman or northern Italian sculptor produced a series of panels for an ivory casket dramatically recounting the suffering and triumph of Christ. Ivory carving (see "Ivory Carving in Antiquity and the Early Middle Ages," page 322) was another luxury art much admired in the Early Christian period, and these plaques, now in the British Museum, are among the finest known. The narrative on the box begins with Pilate washing his hands, Jesus carrying the cross on the road to Calvary, and the denial of Peter, all compressed into a single panel. The plaque we illustrate (FIG. **11-21**) is the next in the sequence and shows, at the left, Judas hanging from a tree with his open bag of silver dumped on the ground beneath his feet. The Crucifixion is at the right. The Virgin Mary and Joseph of Arimathea are to the left of the cross. On the other side Longinus thrusts his

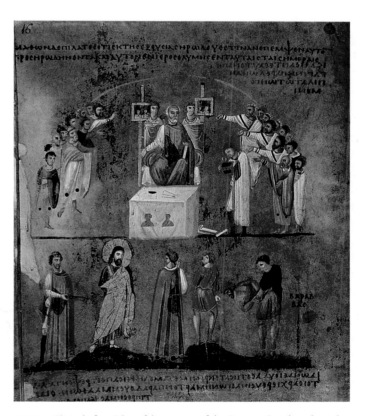

11-20 Christ before Pilate, folio 8 verso of the *Rossano Gospels,* early sixth century. Tempera on purple vellum, approx. 11″ × 10¼″. Diocesan Museum, Archepiscopal Palace, Rossano.

MATERIALS AND TECHNIQUES

Ivory Carving in Antiquity and the Early Middle Ages

Ivory has been prized since the earliest times, when the tusks of Ice Age European mammoths were fashioned into pendants, beads, and other items for bodily adornment, and, occasionally, statuettes (see FIG. 1-3). The primary ivory sources in the historical period are the elephants of India and especially Africa, where the species is larger than the Asian counterpart and the tusks longer, heavier, and of finer grain. African elephant tusks five to six feet in length and weighing ten pounds are common, but tusks of male elephants can be ten feet long or more and weigh well over one hundred pounds. Carved ivories are familiar, if precious, finds at Mesopotamian and Egyptian sites, and ivory objects were manufactured and coveted in the prehistoric Aegean and throughout the classical world. Most frequently employed then for household objects, small votive offerings, and gifts to the deceased, ivory also could be used for grandiose statues such as Phidias's *Athena Parthenos* (see FIG. 5-44).

In the Greco-Roman world, people admired ivory both for its beauty and because of its exotic origin. Elephant tusks were costly imports and Roman generals proudly displayed them in triumphal processions when they paraded the spoils of war before the people. (In FIG. 12-1 a barbarian brings tribute to a Byzantine emperor in the form of an ivory tusk.) Adding to the expense of the material itself was the fact that only highly skilled artisans were capable of working in ivory. The tusks were very hard and of irregular shape, and the ivory workers needed a full toolbox of saws, chisels, knives, files, and gravers close at hand to cut the tusks into blocks for statuettes or thin plaques decorated with relief figures and ornament.

In the late antique and early medieval world, ivory was employed most frequently for book covers (see FIG. 16-15), caskets and chests (FIG. 11-21), and diptychs (see FIGS. 11-22 and 12-2). A *diptych* is a pair of hinged tablets, usually of wood, with a wax layer on the inner sides for writing letters and other documents. (The court scribe recording Jesus' trial in the *Rossano Gospels,* FIG. 11-20, and the woman in a painted portrait from Pompeii, FIG. 10-23, both hold wooden diptychs.) Diptychs fashioned out of ivory generally were created for ceremonial and official purposes: for example, to announce the election of a consul or a marriage between two wealthy families or to commemorate the death of an elevated member of society.

11-21 Suicide of Judas and Crucifixion of Christ, plaque from a casket, ca. 420. Ivory, 3″ × 3⅞″. British Museum, London.

11-22 Priestess celebrating the rites of Bacchus, right leaf of the Diptych of the Nicomachi and the Symmachi, ca. 400. Ivory, $11\frac{3}{4}'' \times 5\frac{1}{2}''$. Victoria and Albert Museum, London.

spear into the side of the "King of the Jews" (*REX IVD* is inscribed above Jesus' head). The two remaining panels show two Marys and two soldiers at the open doors of a tomb with an empty coffin within and the doubting Thomas touching

the wound of the risen Christ. The series is one of the oldest cycles of Passion scenes preserved today. The artist who fashioned the casket helped establish the iconographical types maintained for a millennium for narratives of Christ's life.

On the London ivories, Jesus appears once again as a beardless youth. In the Crucifixion (FIG. 11-21), the earliest known rendition of the subject in the history of art, he exhibits a superhuman imperviousness to pain. The Savior is a muscular, nearly nude, heroic figure who appears virtually weightless. He does not *hang* from the cross; he is *displayed* on it, a divine being who has conquered death. The striking contrast between the powerful frontal unsuffering Jesus on the cross and the limp hanging body of his betrayer with his snapped neck is very effective, both visually and symbolically.

THE ENDURING PAGAN GODS It is important to remember that although after Constantine all the most important architectural projects in Italy were Christian in character, not everyone converted to the new religion, even after Theodosius closed all temples and banned all pagan cults in 391. An ivory plaque (FIG. **11-22**), probably produced in Rome around 400, strikingly exhibits the endurance of pagan themes and patrons and of the classical style. The ivory, one of a pair of leaves of a diptych, commemorates either the marriage of members of two powerful Roman families of the senatorial class, the Nicomachi and the Symmachi, or the passing within a decade of two prominent male members of the two families. Whether their purpose was to celebrate the living or the dead, the Nicomachi and the Symmachi here ostentatiously reaffirmed their faith in the old pagan gods. Certainly, they favored the aesthetic ideals of the classical past, as exemplified by such works as the stately processional friezes of the Greek Parthenon (see FIG. 5-48) and the Roman Ara Pacis (see FIG. 10-29).

The leaf we reproduce, inscribed "of the Symmachi," represents a pagan priestess in front of Jupiter's sacred oak tree. She wears ivy in her hair and seems to be celebrating the rites of both Bacchus and Jupiter at an open-air altar, although scholars dispute the identity of the divinities honored. The other diptych panel, inscribed "of the Nicomachi," shows a priestess honoring Ceres and Cybele. On both panels, the precise yet fluent and graceful line; the easy, gliding poses; and the mood of spiritual serenity reveal an artist who practiced within a still-vital classical tradition that idealized human beauty as its central focus.

The great senatorial magnates of Rome, who resisted the empirewide imposition of the Christian faith at the end of the fourth century probably deliberately sustained the classical tradition. Despite the great changes that had occurred in art during the later third and fourth centuries, classical values lived on. Many artists had turned away from Greco-Roman naturalism to something archaic, abstract, and bluntly expressive—as seen even in official imperial commissions such as the portraits of the tetrarchs (see FIG. 10-74) and the frieze of the Arch of Constantine (see FIG. 10-77). But for other artists and patrons, classical art was still the standard for measuring success. The classical tradition was never fully extinguished in the Middle Ages. It survived in intermittent revivals, renovations, and restorations side by side and in contrast with the opposing, nonclassicizing medieval styles. The rise of classical art to dominance in the Renaissance will be one of the signs of the end of the medieval world.

EUROPE AND THE BYZANTINE EMPIRE CA. 1000

SCOTLAND
KINGDOM OF NORWAY
IRELAND
North Sea
KINGDOM OF SWEDEN
Baltic Sea
Moscow • Vladimir
WALES
KINGDOM OF DENMARK
ENGLAND
DUCHY OF POLAND
RUSSIA
Atlantic Ocean
NORMANDY
FRANCE
HOLY ROMAN EMPIRE
Danube R.
Kiev
KINGDOM OF BURGUNDY
LOMBARDY
Venice
KINGDOM OF HUNGARY
Danube R.
Black Sea
Caspian Sea
KINGDOM OF LEÓN
Ravenna
Adriatic Sea
Balkans
Nerezi
Rome
ITALY
Ohrid
MACEDONIA
Constantinople (Byzantium; Istanbul)
CALIPHATE OF CORDOBA
ARAB DOMINIONS
Thessaloniki
Nicaea
BYZANTINE EMPIRE
Monreale
Sicily
Hosios Loukas
Athens
Tralles
Miletus
Antioch
SYRIA
Zagba
Mediterranean Sea
Cyprus
ARAB DOMINIONS
Jerusalem
Alexandria
EGYPT
Mt. Sinai

0 250 500 miles
0 250 500 kilometers

N

527		726	843
EARLY BYZANTINE		ICONOCLASM	MIDDLE BYZANTINE

*Barberini Ivory
mid-sixth century*

Rabbula Gospels, 586

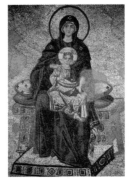

*Virgin and Child icon
Mount Sinai
sixth–seventh century*

*Apse mosaic, Hagia Sophia
Constantinople, 867*

Paris Psalter, ca. 950–970

Fall of Ravenna to Odoacer;
end of Western Roman Empire, 476

Justinian the Great, r. 527–565

Nika riots in Constantinople, 532

Belisarius captures Ravenna, 539

Heraclius defeats Persians, 627

Arabs besiege Constantinople, 717–718

Leo III prohibits image making, 726

Ravenna falls to the Lombards, 751

Restoration of images, 843

Basil I, r. 867–886, founder
of Macedonian dynasty

Turks convert to Islam,
ninth–tenth century

ROME IN THE EAST

THE ART OF BYZANTIUM

1000	1204	1453
	LATE BYZANTINE	

Crucifixion mosaic
Church of the Dormition
Daphni, ca. 1090–1100

Vladimir Virgin
late eleventh–
early twelfth century

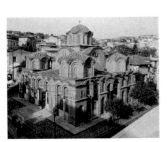

Church of Saint Catherine
Thessaloniki, ca. 1280

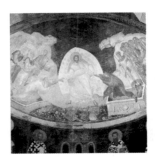

Anastasis, Church of Christ
in Chora, Constantinople
ca. 1310–1320

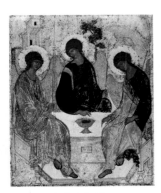

Andrei Rublyev
Trinity icon, ca. 1410

Basil II, r. 980–1001, revival of Byzantine power

Schism between Byzantine and Roman churches, 1054

Norman conquest of Sicily, 1060–1092

Seljuk Turks capture Byzantine Asia Minor, 1073

First Crusade, 1095–1099

Fourth Crusade and the Frankish conquest, 1202–1204

Michael VIII Palaeologus recaptures
Constantinople from the Franks, 1261

Ottoman Turks
capture Constantinople;
end of Byzantine
Empire, 1453

BYZANTIUM: THE NEW ROME

THE EASTERN CHRISTIAN EMPIRE When Constantine I founded a "New Rome" in the East in 324 on the site of the ancient Greek city of Byzantium and called it Constantinople in honor of himself, he legitimately could claim to be ruler of a united Roman Empire. In the fifth century, however, that empire, by then officially a Christian state, fell apart. An Emperor of the West ruled from Ravenna and an Emperor of the East ruled from Constantinople. Though not formally codified, the division of the Roman Empire became permanent. Centralized government disintegrated in the western half and was replaced by warring kingdoms that, during the Middle Ages, formed the foundations of the modern western European nations. The eastern half of the Roman Empire, only loosely connected by religion to the west, and with only minor territorial holdings there, had a long and complex history of its own. Centered at New Rome, the Eastern Christian Empire remained a cultural and political entity for a millennium, until the last of a long list of Eastern Roman emperors, ironically named Constantine XI, died at Constantinople in 1453, vainly defending it against the Ottoman Turks.

Historians call that Eastern Christian Roman Empire "Byzantium," after its capital city's original name, and use the term *Byzantine* to identify whatever pertains to Byzantium—its territory, its history, and its culture. The Byzantine emperors, however, did not use these terms to define themselves. They called their empire "Rome" *(Romania)* and themselves "Romans" *(Romaioi).* Though they spoke Greek and not Latin, the Eastern Roman emperors never relinquished their claim as the legitimate successors to the ancient Roman emperors. Nevertheless, *Byzantium* and *Byzantine,* though inexact terms, have become in modern times the accepted designations for the Eastern Roman Empire, and we shall use them here.

Byzantium preserved its identity throughout alternating periods of good rule and misrule, stability and instability, expansion and contraction, and victory and defeat. When its shrinking borders reduced it to a mere fragment of the once mighty Byzantine Empire, when it became only a small medieval Greek kingdom, an enclave around the city of Constantinople, it still was stubbornly "Rome." As such, it had resisted successive assaults of Sasanian Persians, Arabs, Russians, Serbs, Normans, Franks, Venetians, and others, until it finally was overcome by the surging power of the Ottoman Turks. During the long course of its history, Byzantium was the Christian buffer against the expansion of Islam into central and northern Europe, and its cultural influence was felt repeatedly in Europe throughout the Middle Ages. Byzantium Christianized the Slavic peoples of the Balkans and of Russia, giving them its Orthodox religion and alphabet, its literary culture, and its art and architecture. Byzantium's collapse in 1453 brought the Ottoman Empire into Europe as far as the Danube River, but the effect of Constantinople's fall was felt even further to the west. The westward flight of Byzantine scholars from the Rome of the East introduced the study of classical Greek to Italy and helped inspire there the new consciousness of antiquity that historians call the Renaissance.

THE THEOCRATIC STATE Constantine recognized Christianity at the beginning of the fourth century, Theodosius established it as the Roman Empire's official religion at the end of the fourth century, and Justinian, in the sixth century, proclaimed it New Rome's only *lawful* religion. By that time it was not simply the Christian religion but the *Orthodox* Christian doctrine that the Byzantine emperor asserted as the only permissible faith for his subjects. This Orthodox Christianity was *trinitarian.* Its central article of faith was the trinity of Father, Son, and Holy Spirit (as stated in Roman Catholic, Protestant, and Eastern Orthodox creeds today). All other versions of Christianity were called heresies, especially the *Arian,* which denied the equality of the three aspects of the Trinity, and the *Monophysite,* which denied the duality of the divine and human natures in Jesus Christ. Justinian considered it his first duty not only to stamp out the few surviving pagan cults but also to crush all those who professed any Christian doctrine other than the Orthodox.

The Byzantine emperors were believed to be the earthly vicars of Jesus Christ, whose imperial will was God's will. They alone exercised all temporal and spiritual authority. As sole executives for church and state, the emperors shared power with neither senate nor church council. As theocrats they reigned supreme, combining the functions of both pope and caesar, which the Western Christian world would keep strictly separate. The Byzantine emperors' exalted and godlike position made them quasi-divine. Their church was simply an extension of the imperial court, and the imperial court, with its hierarchies of lesser and greater functionaries converging upward to the throne, was an image of the Kingdom of Heaven.

In practice, the Byzantine emperors' attempt to make real the ideal of absolute political and religious unity was a failure. They ruled over peoples of great ethnic, religious, cultural, and linguistic diversity, with varying histories and institutions—Armenians, Syrians, Egyptians, Palestinians, Jews, and Arabs, as well as Greeks, Italians, Germans, Slavs, and many others. Many of these were heretical Christians, and Byzantine efforts to force Orthodoxy on them in the interest of political and doctrinal unity led to bitter resistance, especially in Monophysite Egypt and Syria. When Islam made its way into the Byzantine Empire in the seventh century, the disaffected peoples of these provinces gave it ready support. While religious intolerance lost the great Eastern provinces, the same rigid Orthodoxy also eventually severed its last ties to the Latin Christianity of the West.

A THRICE GLORIOUS EMPIRE The Byzantine Empire's unity, fragmented from invasions by hostile peoples and hostile creeds, also was regularly disrupted by events at home: palace intrigues, conspiracies and betrayals, bureaucratic corruption, violent religious controversy, civil commotions, rebellions, and assassinations. Yet with characteristic resilience, Byzantium, in three periods of revived energy, recovered from dismal defeats, disunity, and stagnation. At those times intelligent, able, and successful rulers in war and peace guided the state. Under them Byzantium prospered and its culture flourished. These were the periods when the unique stylistic features of Byzantine art and architecture were shaped and refined.

Art historians divide the history of Byzantine art into the three periods of its greatest glory, sometimes referred to as "golden ages." The first, *Early Byzantine,* extends from the age of the emperor Justinian (r. 527–565) to the onset of *Iconoclasm* (the destruction of images used in religious worship)

The Emperors of New Rome

Byzantine art is generally, and properly, considered to belong to the Middle Ages rather than to the ancient world, but the emperors of Byzantium, New Rome, considered themselves the direct successors of the emperors of Old Rome. Although the official state religion was Christianity and all pagan cults were suppressed, the political imagery of Byzantine art displays a striking continuity between ancient Rome and medieval Byzantium. Artists continued to portray emperors sitting on thrones holding the orb of the earth in their hands, battling foes while riding on mighty horses, and receiving tribute from defeated enemies. Official portraits continued to be set up in great numbers throughout the territories Byzantium controlled. But, as was true of the classical world, much of imperial Byzantine statuary is forever lost. However, some of the lost portraits of the Byzantine emperors can be visualized from miniature versions of them on ivory reliefs such as the *Barberini Ivory* (FIG. 12-1) and from descriptions in surviving texts.

One especially impressive portrait in the Roman imperial tradition, melted down long ago, depicted the emperor Justinian on horseback atop a grandiose column. Cast in glittering bronze, like the equestrian statue of Marcus Aurelius (see FIG. 10-59), set up nearly four hundred years earlier, it attested to the continuity between the art of Old and New Rome, where pompous imperial images were commonly displayed at the apex of freestanding columns. (Compare FIG. 10-42, where a statue of Saint Peter has replaced a lost statue of the emperor Trajan.) Procopius, the sixth-century historian who chronicled Justinian's wars and who wrote, at the em-

peror's behest, a treatise on his ambitious building program, described the equestrian portrait:

> Finest bronze, cast into panels and wreaths, encompasses the stones [of the column] on all sides, both binding them securely together and covering them with adornment. . . . This bronze is in color softer than pure gold, while in value it does not fall much short of an equal weight of silver. At the summit of the column stands a huge bronze horse turned towards the east, a most noteworthy sight. . . . Upon this horse is mounted a bronze image of the Emperor like a colossus. . . . He wears a cuirass in heroic fashion and his head is covered with a helmet . . . and a kind of radiance flashes forth from there. . . . He gazes towards the rising sun, steering his course, I suppose, against the Persians. In his left hand he holds a globe, by which the sculptor has signified that the whole earth and sea were subject to him, yet he carries neither sword nor spear nor any other weapon, but a cross surmounts his globe, by virtue of which alone he has won the kingship and victory in war. Stretching forth his right hand towards the regions of the East and spreading out his fingers, he commands the barbarians that dwell there to remain at home and not to advance any further. [1]

Statues such as this are the missing links in an imperial tradition that never really died and that lived on also in the Holy Roman Empire of the Western medieval world (see FIG. 16-11) and in the Renaissance (see FIGS. 21-32 and 21-33).

[1]Cyril Mango, trans., *The Art of the Byzantine Empire, 312–1453: Sources and Documents* (Englewood Cliffs, NJ: Prentice-Hall, 1972), 110–11.

under Leo III in 726. The *Middle Byzantine* period begins with the renunciation of Iconoclasm in 843 and ends with the western Crusaders' occupation of Constantinople in 1204. *Late Byzantine* corresponds to a third golden age in the fourteenth and early fifteenth centuries after the Byzantines recaptured Constantinople in 1261 until its final loss in 1453 to the Ottoman Turks and the conversion of many Christian churches to Islamic mosques.

EARLY BYZANTINE ART (527–726)

THE GOLDEN AGE OF JUSTINIAN The reign of Justinian and his politically astute consort, the Empress Theodora, marks the end of the Late Roman Empire and the beginning of the Byzantine Empire. At this time Byzantine art emerged as a recognizably novel and distinctive style, leaving behind the uncertainties and hesitations of Early Christian artistic experiment. Though still revealing its sources in late antique art, it definitively expressed, with a new independence and power of invention, the unique character of the Eastern Christian culture centered at Constantinople.

Under Justinian, the Roman Empire's power and extent were briefly restored. Justinian's generals, Belisarius and Narses, drove the German Ostrogoths out of Italy, expelled the German Vandals from the African provinces, beat back the Bulgars on the northern frontier, and held the Sasanian Persians at bay on the eastern borders. At home, a dangerous rebellion of political/religious factions in the city was put down, and Orthodoxy triumphed over the Monophysite heresy. In Constantinople alone Justinian built or restored more than thirty churches of the Orthodox faith, and his activities as builder extended throughout the Byzantine Empire. The historian of his reign, Procopius, declared that the emperor's ambitious building program was an obsession that cost his subjects dearly in taxation. But his grand monuments defined the Byzantine style in architecture forever after. Justinian also supervised the codification of Roman law in a great work known as the *Corpus Juris Civilis (Code of Civil Law)*, which became the foundation of the law systems of many modern European nations. Justinian could claim, with considerable justification, to have revived the glory of "Old Rome" in New Rome (see "The Emperors of New Rome," above).

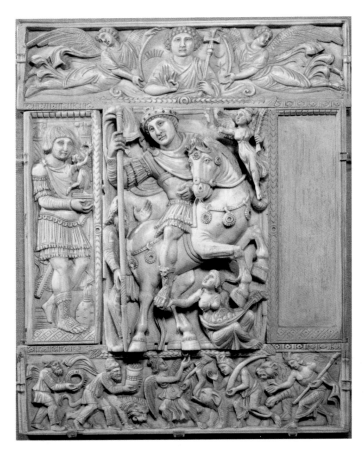

12-1 Justinian as world conqueror, left leaf of a diptych *(Barberini Ivory)*, mid-sixth century. Ivory, 1' 1½" × 10½". Louvre, Paris.

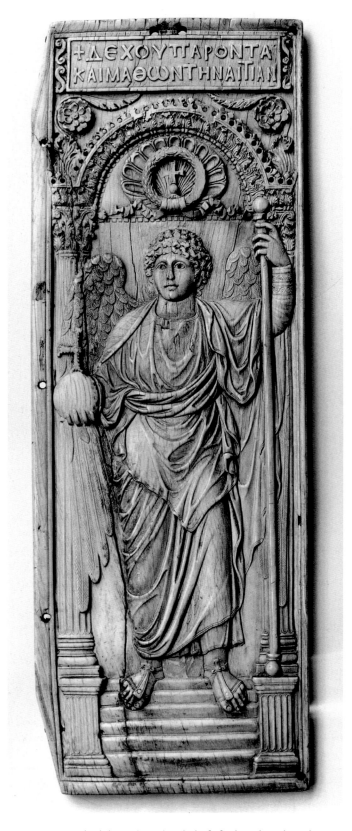

12-2 Saint Michael the Archangel, right leaf of a diptych, early sixth century. Ivory, approx. 1' 5" × 5½". British Museum, London.

Luxury Arts

JUSTINIAN THE CONQUEROR The triumphant image of Justinian's New Rome was set forth for all to see on an ivory plaque known today as the *Barberini Ivory* (FIG. **12-1**). Carved in five parts (one is lost), the *Barberini Ivory* shows at the center an emperor, usually identified as Justinian, riding triumphantly on a rearing horse, while a startled, half-hidden barbarian recoils in fear behind him. The dynamic twisting postures of both horse and rider and the motif of the spear-thrusting equestrian emperor are survivals of the pagan Roman Empire, as are the personifications of bountiful Earth (below the horse) and palm-bearing Victory (flying in to crown the conqueror). Also borrowed from pagan art are the tribute-bearing and clemency-seeking barbarians at the bottom of the plaque. They are juxtaposed with a lion, elephant, and tiger, exotic animals native to Africa and Asia, sites of Justinianic conquest. At the left, a Roman soldier carries a statuette of another Victory, reinforcing the central panel's message.

The source of the emperor's strength, however, comes not from his earthly armies but from God. The uppermost panel depicts two angels holding aloft a youthful image of Christ carrying a cross in his left hand. Christ blesses Justinian with a gesture of his right hand, indicating approval of Justinian's rule. Still conceived in the language of classical art, the *Barberini Ivory* announced Byzantium's theocratic state.

VICTORY BECOMES AN ARCHANGEL Another ivory panel (FIG. **12-2**), created somewhat earlier than the *Barberini Ivory* and likewise carved in the Eastern Christian Empire, perhaps in Constantinople, offers still further evidence of classical art's persistence. The panel, depicting Saint

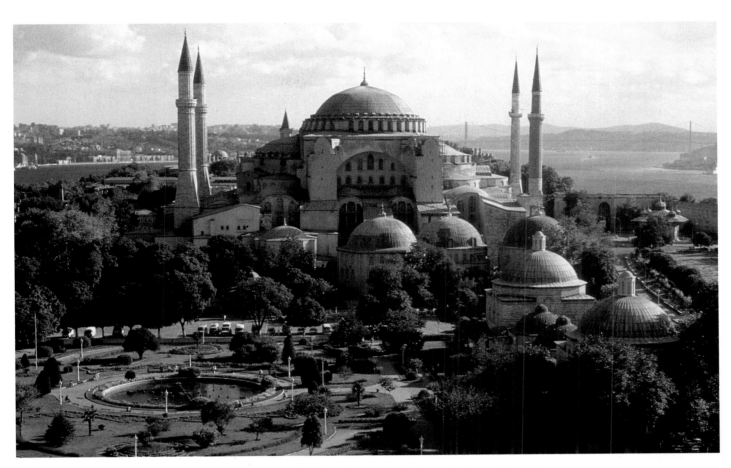

12-3 ANTHEMIUS OF TRALLES and ISIDORUS OF MILETUS, Hagia Sophia, Constantinople (Istanbul), Turkey, 532–537.

Michael the Archangel, is all that is preserved of what was once a hinged diptych in the Early Christian tradition. The prototype of Michael must have been a pagan winged Victory, although Victory was personified as a woman in Greco-Roman art. Instead of carrying the palm branch of victory, as does the Victory on the *Barberini Ivory,* Michael holds forth an orb surmounted by a cross, the symbol of Christianity's triumph. He may have been offering it to a Byzantine emperor depicted on the missing diptych leaf. The flowing classical drapery, the delicately incised wings, and the facial type and coiffure are also of the pre-Christian tradition.

Nonetheless, significant divergences—misinterpretations of or lack of concern for the rules of naturalistic representation—occur here. Subtle ambiguities in the figure's relationship to its architectural setting include such details as the feet hovering above the steps without any real relationship to them and the placement of the upper body, wings, and arms in front of the column shafts while the lower body is behind the column bases at the top of the receding staircase. These details, of course, have little to do with the angel's striking beauty, but they do signify the emergence of a new aesthetic that characterized Byzantine art for centuries. Rejecting the goal of most classical artists to render the three-dimensional world in convincing and consistent fashion and to people that world with fully modeled figures firmly rooted on the ground, the Byzantine artist introduced uncertainties in the spatial setting and rendered figures that seem more to float than to stand.

Architecture and Mosaics

BYZANTIUM'S GREATEST CHURCH The sense of weightlessness, of miraculous suspension in midair, is also characteristic of the most important monument of early Byzantine art, albeit in a very different way. Hagia Sophia (FIG. 12-3), the church of Holy Wisdom, was built in Constantinople for Justinian by ANTHEMIUS OF TRALLES and ISIDORUS OF MILETUS between 532 and 537. It is Byzantium's grandest building and one of the supreme accomplishments of world architecture. Its dimensions are formidable for any structure not made of steel. In plan (FIG. 12-4), it is about two hundred seventy feet long and two hundred forty feet wide. The dome is one hundred eight feet in diameter, and its crown rises some one hundred eighty feet above the pavement. (The first dome collapsed in 558 and was replaced by the present one, greater in height and more stable.) In scale, Hagia Sophia rivals the architectural wonders of pagan and Christian Rome: the Pantheon, the Baths of Caracalla, and the Basilica of Constantine. In exterior view, the great dome dominates the structure, but the building's present external aspects are much changed from their original appearance. Huge buttresses were added to the Justinianic design, and four towering Turkish minarets were constructed after the Ottoman conquest of 1453, when Hagia Sophia became an Islamic mosque. The building was secularized in the twentieth century and is now a museum.

12-4 ANTHEMIUS OF TRALLES and ISIDORUS OF MILETUS, longitudinal section and plan of Hagia Sophia, Constantinople (Istanbul), Turkey, 532–537 (after drawings by Van Nice and Antoniades).

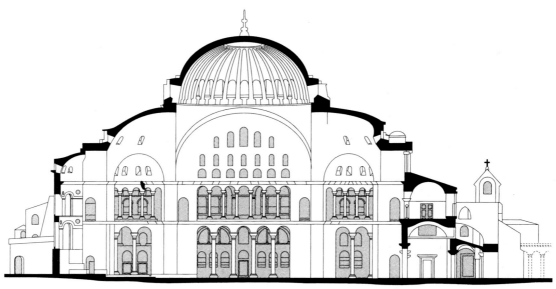

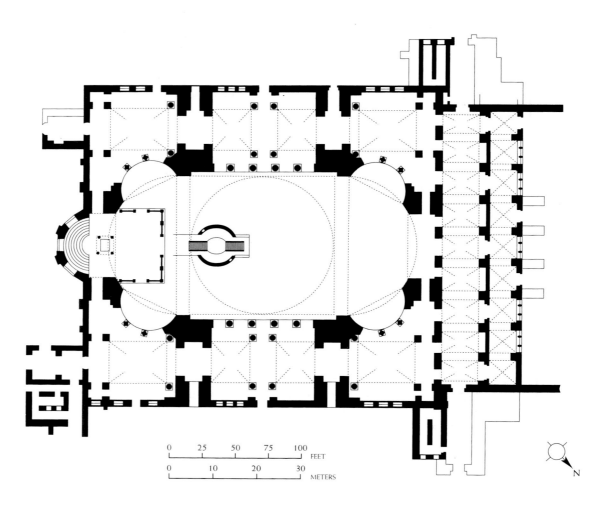

The characteristic Byzantine plainness and unpretentiousness of the exterior (which, in this case, also disguise the great scale) scarcely prepare visitors for the building's interior (FIG. **12-5**), which was once richly appointed. A contemporaneous poet and member of Justinian's court, Paulus Silentiarius, recorded his impressions of Hagia Sophia. His words allow

readers to visualize the original magnificence of the interior, whose walls and floors were clad with colored stones from all over the known world:

Who . . . shall sing the marble meadows gathered upon the mighty walls and spreading pavement. . . . [There is stone] from the green

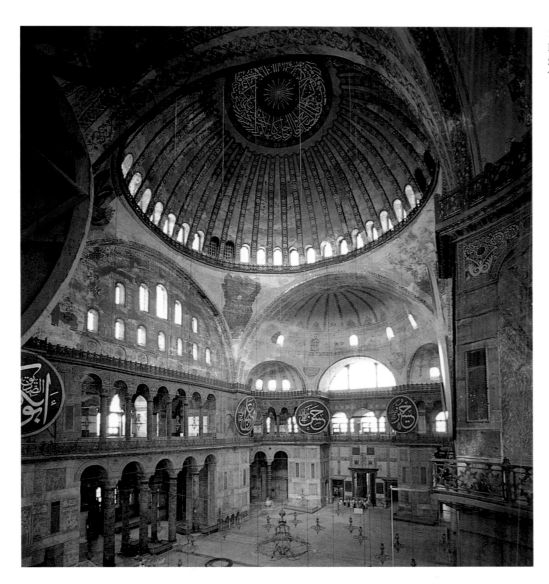

12-5 ANTHEMIUS OF TRALLES and ISIDORUS OF MILETUS, interior of Hagia Sophia, Constantinople (Istanbul), Turkey, 532–537.

flanks of Carystus [and] the speckled Phrygian stone, sometimes rosy mixed with white, sometimes gleaming with purple and silver flowers. There is a wealth of porphyry stone, too, besprinkled with little bright stars. . . . You may see the bright green stone of Laconia and the glittering marble with wavy veins found in the deep gullies of the Iasian peaks, exhibiting slanting streaks of blood-red and livid white; the pale yellow with swirling red from the Lydian headland; the glittering crocus-like golden stone [of Libya]; . . . glittering [Celtic] black [with] here and there an abundance of milk; the pale onyx with glint of precious metal; and [Thessalian marble] in parts vivid green not unlike emerald. . . . It has spots resembling snow next to flashes of black so that in one stone various beauties mingle.[1]

THE MYSTICISM OF LIGHT What distinguishes Hagia Sophia from the equally lavishly revetted and paved interiors of Roman buildings such as the Pantheon (see FIG. 10-50) is the special mystical quality of the light that floods the interior (FIG. 12-5). The soaring canopy-like dome that dominates the inside as well as the outside of the church rides on a halo of light from windows in the dome's base. Visitors to Hagia Sophia from Justinian's time to today have been struck by the light within the church and its effect on the human spirit. The forty windows at the dome's base create the peculiar illusion that the dome is resting on the light that pours through them. The historian Procopius observed that the dome looked as if it were suspended by "a golden chain from Heaven." Said he: "You might say that the space is not illuminated by the sun from the outside, but that the radiance is generated within, so great an abundance of light bathes this shrine all around."[2]

The poet Paulus compared the dome to "the firmament which rests on air" and described the vaulting as covered with "gilded tesserae from which a glittering stream of golden rays pours abundantly and strikes men's eyes with irresistible force. It is as if one were gazing at the midday sun in spring."[3] Thus, Hagia Sophia has a vastness of space shot through with light and a central dome that *appears* to be supported by the light it admits. Light is the mystic element—light that glitters in the mosaics, shines forth from the marbles, and pervades and defines spaces that, in themselves, seem to escape definition. Light seems to dissolve material substance and transform it into an abstract spiritual vision. Pseudo-Diony-

Pendentives and Squinches

Perhaps the most characteristic feature of Byzantine architecture is the placement of a dome, which is circular at its base, over a square, as in the Justinianic church of Hagia Sophia (FIGS. 12-3 to 12-5) and countless later structures (for example, FIGS. 12-19 and 12-22). Two structural devices that are the hallmark of Byzantine engineering made this feat possible: *pendentives* and *squinches*.

In pendentive construction (from the Latin *pendere,* "to hang") a dome rests on what is, in effect, a second, larger dome. The top portion and four segments around the rim of the larger dome are omitted so that four curved triangles, or pendentives, are formed. The pendentives join to form a ring and four arches whose planes bound a square. The dome's weight is thus transferred through the pendentives and arches to the four piers from which the arches spring, instead of to the walls. The first use of pendentives on a monumental scale was in Hagia Sophia in the mid-sixth century, although Near Eastern architects had experimented with them earlier. In Roman and Early Christian central-plan buildings, such as the Pantheon (see FIG. 10-50) and Santa Costanza (see FIGS. 11-9 and 11-10), the domes spring directly from the circular top of a cylinder (see "The Roman Architectural Revolution: Concrete Construction," Chapter 10, page 249).

The pendentive system is a dynamic solution to the problem of setting a round dome over a square or rectangular

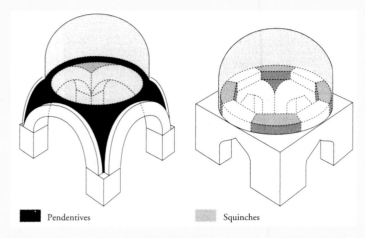

Pendentives **Squinches**

Domes on pendentives *(left)* and squinches *(right).*

space, making possible a union of centralized and longitudinal or basilican structures. A similar effect can be achieved using squinches—arches, corbels, or lintels—that bridge the corners of the supporting walls and form an octagon inscribed within a square. To achieve even greater height, a builder can rest a dome on a cylindrical drum that in turn rests on either pendentives or squinches, but the principle of supporting a dome over a square is the same.

sius, perhaps the most influential mystic philosopher of the age, wrote in *The Divine Names:* "Light comes from the Good and . . . light is the visual image of God." [4]

How was this illusion of a floating "dome of Heaven" achieved? Justinian's architects used *pendentives* (see "Pendentives and Squinches" above) to transfer the weight from the great dome to the piers beneath, rather than to the walls. With pendentives, not only could the space beneath the dome be unobstructed but the walls themselves could be pierced by scores of windows. This created the impression of a dome suspended above, not held up by, walls mortals built. Experts *today* can explain the technical virtuosity of Anthemius and Isidorus, but it remained a mystery to their contemporaries. Procopius communicated the sense of wonderment experienced by those who entered Justinian's great church: "No matter how much they concentrate their attention on this and that, and examine everything with contracted eyebrows, they are unable to understand the craftsmanship and always depart from there amazed by the perplexing spectacle." [5]

THE DOMED BASILICA By placing a hemispherical dome on a square base instead of on a circular base, as in the Pantheon, Anthemius and Isidorus succeeded in fusing two previously independent and seemingly mutually exclusive architectural traditions: the vertically oriented central-plan

building and the longitudinally oriented basilica. Hagia Sophia is, in essence, a domed basilica (FIGS. 12-4 and 12-5) —a uniquely successful conclusion to several centuries of experimentation in Christian church architecture. However, the thrusts of the pendentive construction at Hagia Sophia made other elements necessary: huge wall piers to the north and south and, to the east and west, half-domes, whose thrusts descend, in turn, into still smaller domes covering columned niches that give a curving flow to the design.

The diverse vistas and screenlike ornamented surfaces mask the structural lines. The arcades of the nave and galleries have no real structural function. Like the walls they pierce, they are only part of a fragile "fill" between the huge piers. Structurally, although Hagia Sophia may seem Roman in its great scale and majesty, it does not have Roman organization of its masses. The very fact the "walls" in Hagia Sophia are actually concealed (and barely adequate) piers indicates that the architects sought Roman monumentality as an *effect* and did not design the building according to Roman principles. Using brick in place of concrete marked a further departure from Roman practice and characterizes Byzantine architecture as a distinctive structural style. Hagia Sophia's eight great supporting piers are ashlar masonry, but the screen walls are brick, as are the vaults of the aisles and galleries and the dome and semicircular half-domes known as *conches.*

BYZANTINE LITURGY AND THE EMPEROR The ingenious design of Hagia Sophia provided the illumination and the setting for the solemn liturgy of the Orthodox faith. The large windows along the great dome's rim poured light down upon the interior's jeweled splendor, where priests staged the sacred spectacle. Sung by clerical choirs, the Orthodox equivalent of the Latin Mass celebrated the sacrament of the Eucharist at the altar in the apsidal sanctuary, in spiritual reenactment of Jesus' Crucifixion. Processions of chanting priests, accompanying the patriarch (bishop) of Constantinople, moved slowly to and from the sanctuary and the vast nave. The gorgeous array of their vestments (compare FIG. 12-35) rivaled the interior's polychrome marbles, metals, and mosaics, all glowing in shafts of light from the dome.

The nave of Hagia Sophia, as in all Byzantine churches, was reserved for the clergy not the congregation. The laity, segregated by sex, were confined to the shadows of the aisles and galleries, restrained in most places by marble parapets. The complex spatial arrangement allowed only partial views of the brilliant ceremony. The emperor alone was privileged to enter the sanctuary. When he participated with the patriarch in the liturgical drama, his rule was again sanctified and his person exalted. Church and state were symbolically made one, as in fact they were. The church building was then the earthly image of the court of Heaven, its light the image of God and God's holy wisdom.

At Hagia Sophia, the intricate logic of Greek theology, the ambitious scale of Rome, the vaulting tradition of the Near East, and the mysticism of Eastern Christianity combined to create a monument that is at once a summation of antiquity and a positive assertion of the triumph of Christian faith.

RAVENNA, BYZANTIUM'S SACRED FORTRESS In 493, Theodoric, the Ostrogoths' greatest king, chose the Italian city of Ravenna as the capital of his kingdom, which encompassed much of the Balkans and all of Italy (see Chapter 11). During the short history of Theodoric's unfortunate successors, the importance of the city declined. But in 539, the Byzantine general Belisarius conquered Ravenna for his emperor, Justinian, and led the city into the third and most important stage of its history. Reunited with the Eastern Empire, Ravenna remained the "sacred fortress" of Byzantium, a Byzantine foothold in Italy for two hundred years, until its conquest first by the Lombards and then by the Franks.

Ravenna enjoyed its greatest cultural and economic prosperity during Justinian's reign, at a time when repeated sieges, conquests, and sackings threatened the "eternal city" of Rome with complete extinction. As the seat of Byzantine dominion in Italy, ruled by Byzantine governors, or *exarchs,* Ravenna and its culture became an extension of Constantinople. Its art, miraculously preserved today despite heavy bombing during World War II, even more than that of the Byzantine capital (where relatively little outside of architecture has survived), clearly reveals the transition from the Early Christian to the Byzantine style.

SAN VITALE, MARTYR'S SHRINE San Vitale (FIGS. **12-6** to **12-9**), dedicated by Bishop Maximianus in 547 in honor of Saint Vitalis, who was martyred at Ravenna in the second century, is the most spectacular building in Ravenna. The church is an unforgettable experience for all who have entered it and marveled at its intricate design and magnificent golden mosaics. Construction of San Vitale began under Bishop Ecclesius shortly after Theodoric's death in 526. Julianus Argentarius (Julian the banker) provided the enormous sum of 26,000 gold *solidi* (weighing in excess of three hundred fifty pounds) required to proceed with the work. The church is unlike any of the other Early Christian churches of Ravenna. Indeed, it is unlike any other church in Italy. Although it has a traditional plain exterior and a polygonal apse, San Vitale is not a basilica. It is centrally

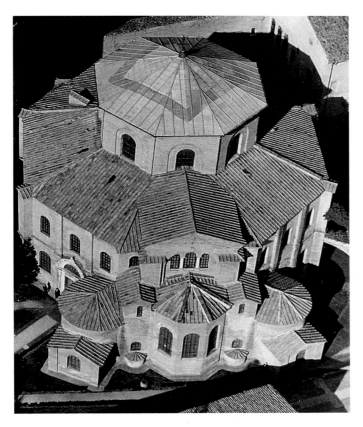

12-6 Aerial view of San Vitale, Ravenna, Italy, 526–547.

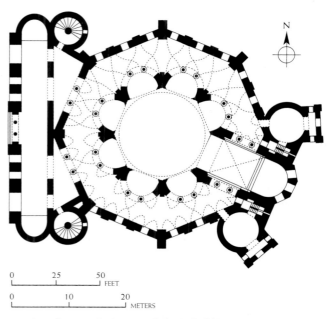

12-7 Plan of San Vitale, Ravenna, Italy, 526–547.

planned, like Justinian's churches in Constantinople, and it seems, in fact, to have been loosely modeled on the earlier Church of Saints Sergius and Bacchus there.

The design features two concentric octagons. The dome-covered inner octagon rises above the surrounding octagon to provide the interior with clerestory lighting (FIG. 12-6). The central space is defined by eight large piers that alternate with curved, columned niches, pushing outward into the surrounding ambulatory (FIG. 12-8) and creating, on the plan (FIG. 12-7), an intricate eight-leafed design. These niches effect a close integration between inner and outer spaces that, otherwise, would have existed simply side by side as independent units. A cross-vaulted choir (FIG. 12-9) preceding the apse interrupts the ambulatory and gives the plan some axial stability. This effect is weakened, however, by the unsymmetrical placement of the narthex (FIG. 12-7), whose odd angle never has been explained fully. (The atrium, which no longer exists, may have paralleled a street that ran in the same direction as the angle of the narthex.) The ambulatory has a second story, the gallery (FIG. 12-8), which was reserved for women and is a typical element of Byzantine churches.

San Vitale's intricate plan and elevation combine to produce an effect of great complexity. The exterior's octagonal regularity is not readily apparent inside. A rich diversity of ever-changing perspectives greets visitors walking through the building (FIGS. 12-8 and 12-9). Arches looping over arches, curving and flattened spaces, and wall and vault shapes seem to change constantly with the viewer's position. Light filtered through alabaster-paned windows plays over the glittering mosaics and glowing marbles that cover the building's complex surfaces, producing a sumptuous effect.

CHURCH AND STATE UNITED The mosaics that decorate San Vitale's choir and apse (FIG. 12-9), like the building itself, must be regarded as one of the climactic achievements of Byzantine art. Completed less than a decade after the Ostrogoths surrendered Ravenna, the apse and choir decorations proclaim the triumph of Justinian and of the Orthodox faith. The sanctuary's multiple panels form a unified composition, whose theme is the holy ratification of the emperor's right to rule.

In the apse vault, the Second Coming was represented. Christ, youthful in the Early Christian tradition, holds a scroll with seven seals (Rev. 5:1) and sits on the orb of the world. The four rivers of Paradise flow beneath him, and rainbow-hued clouds float above. Christ extends a golden wreath of victory to Vitalis, the patron saint of the church, introduced here by an angel. At Christ's left, another angel introduces Bishop Ecclesius, in whose time the church foundations were

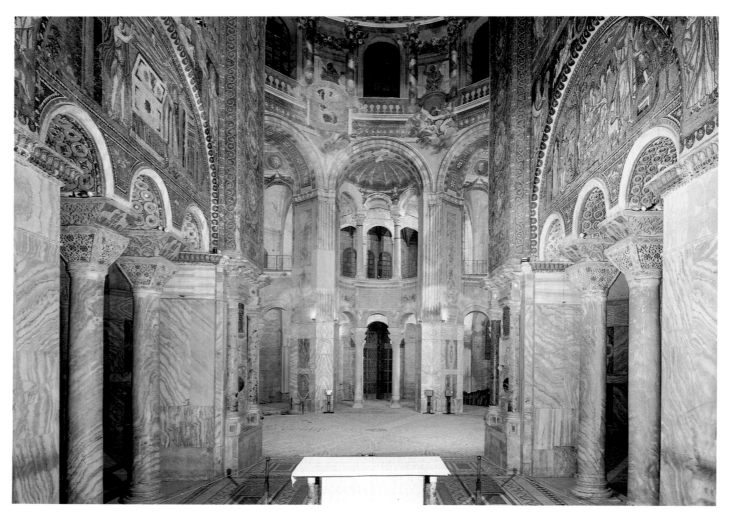

12-8 Interior of San Vitale (view from the apse into the choir), Ravenna, Italy, 526–547.

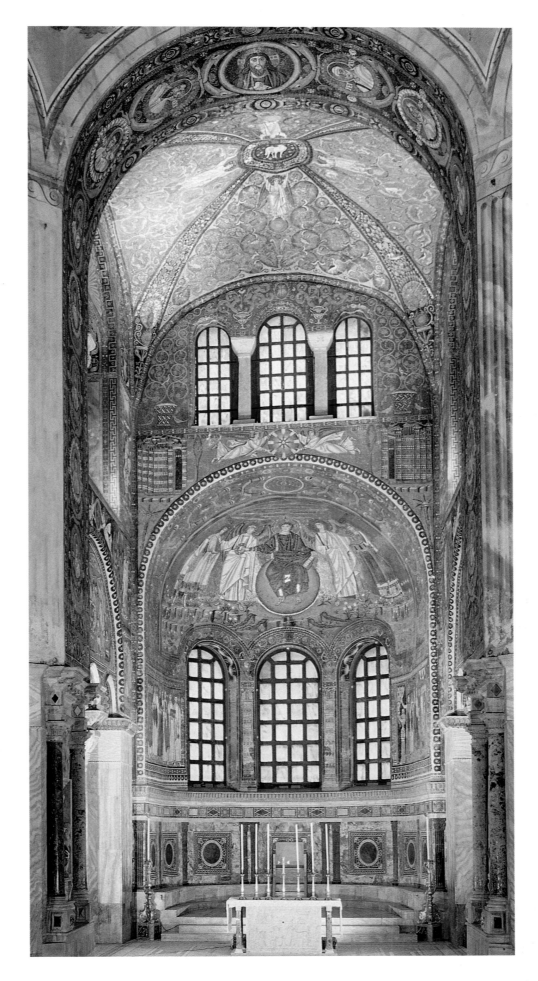

12-9 Choir and apse of San Vitale with mosaic of Christ between two angels, Saint Vitalis, and Bishop Ecclesius, Ravenna, Italy, 526–547.

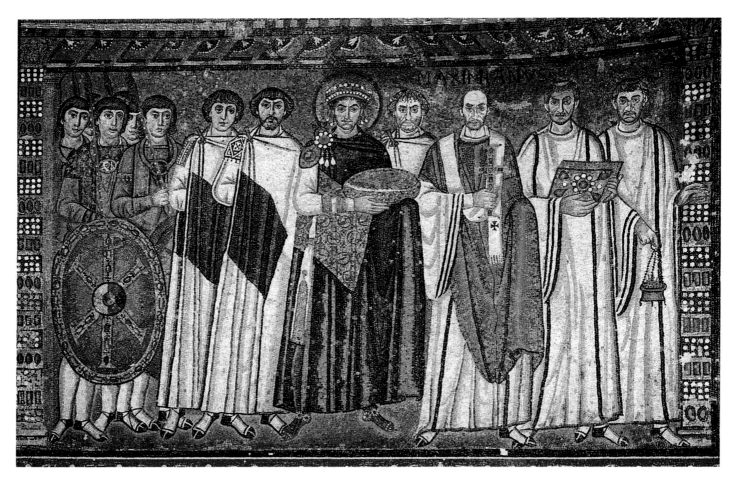

12-10 Justinian, Bishop Maximianus, and attendants, mosaic from the north wall of the apse, San Vitale, Ravenna, Italy, ca. 547.

laid. Ecclesius offers a model of San Vitale to Christ. The arrangement recalls Christ's prophecy of the last days of the world: "And then shall they see the Son of Man coming in the clouds with great power and glory. And then shall he send his angels, and shall gather together his elect from the four winds, from the uttermost part of Heaven" (Mark 13:26–27).

The wreath Christ extends to Saint Vitalis also is extended to Justinian, for he appears, on the Savior's right side, in the dependent mosaic (FIG. **12-10**) on the choir wall just below and to the left of the apse mosaic. Thus, these rites confirmed and sanctified his rule, combining (as was typical of such expressions of the Byzantine imperial ideal) the political and the religious into one, as noted earlier. The laws of the Eastern Church and the laws of the state, united in the laws of God, were manifest in the person of the emperor and in his God-given right.

Justinian's counterpart on the opposite wall of the apse is his empress, Theodora (FIG. **12-11**), one of the most remarkable women of the Middle Ages (see "Theodora: A Most Unusual Empress," page 338). The monarchs are accompanied by their retinues in a depiction of the offertory procession (the part of the liturgy when the bread and wine of the Eucharist are brought forward and presented). Both processions move into the apse, Justinian proceeding from left to right and Theodora from right to left. Justinian, represented as a priest-king, carries a *paten* (large golden bowl) containing the bread, and Theodora carries the golden cup with the wine.

Images and symbols covering the entire sanctuary express the single idea of Christ's redemption of humanity and the reenactment of it in the Eucharist. To the left of the Justinian mosaic (at the right in FIG. 12-8), for example, the lunette mosaic over the two columns of the choir depicts Abraham and the three angels and the sacrifice of Isaac, prefigurations of the Trinity and of the Crucifixion, respectively. The etiquette and protocol of the imperial court fuse in the imperial mosaics with the ritual of the liturgy of the Orthodox Church. The positions of the figures are all-important. They express the formulas of precedence and rank. In his mosaic, Justinian is at the center, and he is distinguished from the dignitaries who accompany him not only by the imperial purple he wears but also by his halo, an indication of his godlike status. At his left (at right in the mosaic) is Bishop Maximianus, the man responsible for San Vitale's completion. The mosaicist stressed the bishop's importance by labeling his figure with the only identifying inscription in the composition. Some have identified the figure behind and between Justinian and Maximianus as Julius Argentarius, the church's benefactor.

The artist divided the figures into three groups: the emperor and his staff (standing for the imperial administration); the clergy; and the army, bearing a shield with the *chi-rho* monogram of Christ. Each group has a leader whose feet precede (by one foot overlapping) the feet of those who follow. The positions of Justinian and Maximianus are curiously am-

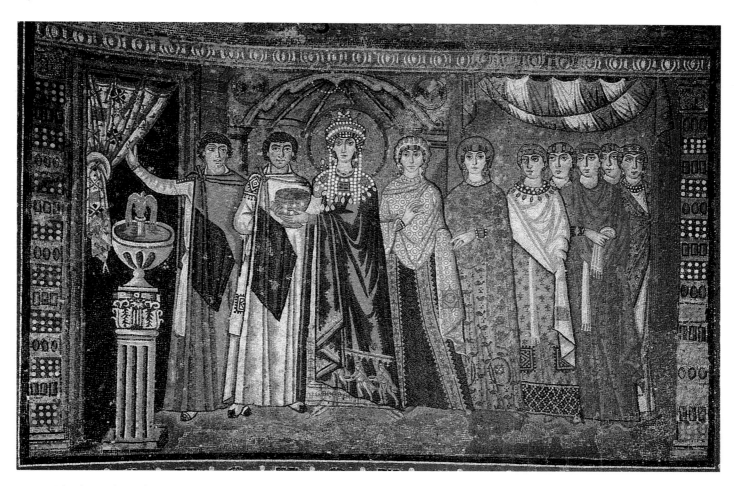

12-11 Theodora and attendants, mosaic from the south wall of the apse, San Vitale, Ravenna, Italy, ca. 547.

biguous. Although the emperor appears to be slightly behind the bishop, the sacred vessel he carries overlaps the bishop's arm. Thus, symbolized by place and gesture, the imperial and churchly powers are in balance. Justinian's paten holding the Eucharist bread, Maximianus's cross, and the attendant clerics' book and censer produce a slow forward movement that strikingly modifies the scene's rigid formality. No background is indicated. The artist expected the observer to understand the procession as taking place in this very sanctuary. Thus, the emperor appears forever as a participant in the sacred rites and as the proprietor of this royal church, the very symbol of his rule of the Western Empire.

THE NEW BYZANTINE AESTHETIC The procession at San Vitale recalls but contrasts with that of Augustus and his entourage on the Ara Pacis (see FIG. 10-29), erected more than half a millennium earlier in Rome. There the fully modeled marble figures have their feet planted firmly on the ground and talk among themselves, unaware of the viewer's presence. Two boys tug on the garments of their elders, while a woman comforts a child by placing her hand on his head. All is anecdote, all very human and of this world, even if the figures themselves conform to a classical ideal of beauty that cannot be achieved. The frontal figures of the Byzantine mosaic, however, hover before viewers, weightless and speechless. Their positions in space are as uncertain as that of Saint Michael on the ivory diptych examined earlier (FIG. 12-2).

Tall, spare, angular, and elegant, the figures have lost the rather squat proportions characteristic of much Early Christian work. The gorgeous draperies fall straight, stiff, and thin from the narrow shoulders. The organic body has dematerialized, and, except for the heads, some of which seem to be true portraits, viewers see a procession of solemn spirits gliding silently in the presence of the sacrament. In this mosaic, the Byzantine world's new aesthetic is revealed. It is very different from that of the classical world but equally compelling. Blue sky has given way to heavenly gold, and matter and material values are disparaged. Byzantine art is an art without solid bodies or cast shadows, with blank golden spaces, and with the perspective of Paradise, which is nowhere and everywhere.

THEODORA IN RAVENNA The portraits of the empress Theodora and her entourage (FIG. 12-11) exhibit the same stylistic traits, but they are represented within a definite architecture, perhaps the narthex of San Vitale. The empress stands in state beneath an imperial canopy, waiting to follow the emperor's procession. An attendant beckons her to pass through the curtained doorway. The fact she is outside the sanctuary in a courtyard with a fountain and only about to enter attests that, in the ceremonial protocol, her rank was not quite equal to her consort's. But the very presence of Theodora at San Vitale is significant. Neither she nor Justinian ever visited Ravenna. Their participation in the liturgy at

Theodora
A Most Unusual Empress

Theodora, wife of Justinian and empress of Byzantium, was not born into an aristocratic family. Her father, who died when she was a child, was the "keeper of bears" for one of the circus *factions* (teams, distinguished by color) at Constantinople. His responsibility was to prepare these animals for bear fights, bear hunts, and acrobatic performances involving bears in a long tradition rooted in ancient Rome. Theodora's mother was an actress, and after the death of her father the young Theodora took up the same career. Acting was not a profession the highborn held in esteem. At Byzantium, actresses often doubled as prostitutes, and the beautiful Theodora was no exception. In fact, actresses were so low on the Byzantine social ladder that the law prohibited senators from marrying them.

Justinian met Theodora when he was about forty years old, she only twenty-five. She became his mistress, but before they could wed, as they did in 525, ignoring all the social norms of the day, Justinian's uncle, the emperor Justin, first had to rewrite the law against senatorial marriages to actresses to permit wedlock with an *ex*-actress. When Justin died in April 527, Justinian was crowned emperor by the patriarch of Con-

stantinople, and Theodora became empress of Byzantium, capping what can be fairly described as one of the most remarkable and improbable "success stories" of any age. By all accounts, even of those openly hostile to the imperial couple, Justinian and Theodora remained faithful to each other for the rest of their lives.

It was not Theodora's beauty alone that attracted Justinian. John the Lydian, a civil servant at Constantinople at the time, described her as "surpassing in intelligence all men who ever lived." As her husband's trusted adviser, she repaid him for elevating her from poverty and disgrace to riches and prestige. During the Nika revolt in Constantinople in 532, when all of her husband's ministers counseled flight from the city, Theodora, by the sheer force of her personality, persuaded Justinian and his generals to hold their ground. The revolt was suppressed.

Byzantine artists immortalized the strong-willed and beautiful Theodora on the mosaic-clad walls of the apse of San Vitale at Ravenna (FIG. 12-11), where she appears as the near equal of her husband.

San Vitale is pictorial fiction. Justinian was represented because he was the head of the Byzantine state, and by his presence he exerted his authority over his territories in Italy. But Theodora's portrayal is more surprising and testifies to her unique position in Justinian's court. Theodora's prominent role in the mosaic program of San Vitale is proof of the power she wielded at Constantinople and, by extension, at Ravenna. In fact, the representation of the Three Magi on the border of her robe suggests she belongs in the elevated company of the three monarchs who approached the newborn Jesus bearing gifts.

THE UNBROKEN BASILICAN TRADITION The Justinianic period in Ravenna closes with the Church of Sant'Apollinare in Classe, a few miles from the city. Here, until the ninth century (when it was transferred to Ravenna), rested the body of Saint Apollinaris, who suffered his martyrdom in Classe, Ravenna's port. The building itself is Early Christian in type, a three-aisled basilica with a plan quite similar to that of Theodoric's palace-church dedicated to the same saint in Ravenna (see FIG. 11-16). As in the earlier church, the building's outside is plain and unadorned, but the interior is decorated with sumptuous mosaics, although in this case they are confined to the triumphal arch and the apse behind it (FIG. **12-12**).

The mosaic decorating the semivault above the apse probably was completed by 549, when the church was dedicated. It shows, against a gold ground, a large medallion with a jeweled cross (symbol of the transfigured Christ). This may represent

the cross Constantine erected on the hill of Calvary to commemorate the martyrdom of Jesus. Visible just above the cross is the hand of God. On either side of the medallion, in the clouds, appear the figures of Moses and Elijah, who appeared before Christ during his Transfiguration. Below these two figures are three sheep, the three disciples who accompanied Christ to the foot of the Mount of the Transfiguration. Beneath, amid green fields with trees, flowers, and birds, stands the church's patron saint, Apollinaris. He is portrayed in the Early Christian manner as an orant with uplifted arms. Accompanying him are twelve sheep, perhaps representing the Christian congregation under the protection of Saint Apollinaris, and forming, as they march in regular file across the apse, a wonderfully decorative base.

On the face of the triumphal arch above, the image of Christ in a medallion appears in the rainbow-streaked heavens, flanked by the four symbolic creatures of the visions of Ezekiel and the Book of Revelation. They stand for the Four Evangelists: the angel for Matthew, the lion for Mark, the ox for Luke, and the eagle for John. (This is not the first appearance of these symbols, which recur throughout medieval art.) The twelve lambs immediately below, issuing from the cities of Bethlehem and Jerusalem, are the Twelve Apostles. The two palms of Paradise in the narrow spandrels of the arch, and the two archangels below them, complete the iconographical program.

BYZANTINE STYLE AND CHRISTIAN DOGMA Comparison of the Early Byzantine Sant'Apollinare in Classe mosaic with the Galla Placidia mosaic (see FIG. 11-15) from

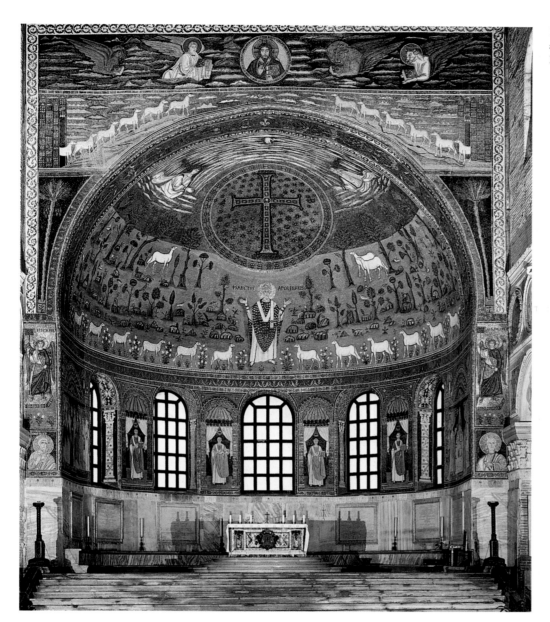

12-12 Saint Apollinaris amid sheep, apse mosaic, Sant'Apollinare in Classe, Ravenna, Italy, ca. 533-549.

the Early Christian period at Ravenna shows how the style and artists' approach to the subject changed during the course of a century. Both mosaics portray a human figure and some sheep in a landscape. But in Classe, in the mid-sixth century, the artist did not try to re-create a segment of the physical world, telling the story instead in terms of flat symbols, lined up side by side. The mosaicist carefully avoided overlapping in what must have been an intentional effort to omit all reference to the three-dimensional space of the material world and physical reality. Shapes have lost the volume seen in the earlier mosaic and instead are flat silhouettes with linear details. The effect is that of an extremely rich, flat tapestry design without illusionistic devices. This new Byzantine style became the ideal vehicle for conveying the extremely complex symbolism of the fully developed Christian dogma.

The Sant'Apollinare in Classe apse mosaic, for example, has much more meaning than first meets the eye. The Transfiguration of Christ—here, into the cross—symbolizes not only his own death, with its redeeming consequences, but also the death of his martyrs (in this case, Saint Apollinaris). The

lamb, also a symbol of martyrdom, appropriately represents the martyred apostles. The whole scene expands above the altar, where the priests celebrated the sacrament of the Eucharist—the miraculous recurrence of the supreme redemptive act. The very altars of Christian churches were, from early times, sanctified by the bones and relics of martyrs (see "Pilgrimages and the Cult of Relics," Chapter 17, page 457). Thus, the mystery and the martyrdom were joined in one concept: The death of the martyr, in imitation of Christ, is a triumph over death that leads to eternal life. The images above the altar present a kind of inspiring vision to the eyes of believers. The way of the martyr is open to them, and the reward of eternal life is within their reach. The organization of the symbolism and the images is hieratic, and the graphic message must have been delivered to the faithful with overwhelming force. Looming above their eyes is the apparition of a great mystery, ordered to make perfectly simple and clear that humankind's duty is to seek salvation. The anonymous artist, working under the direction of the priests, made sure that the devout could read the pictorial message as easily as an

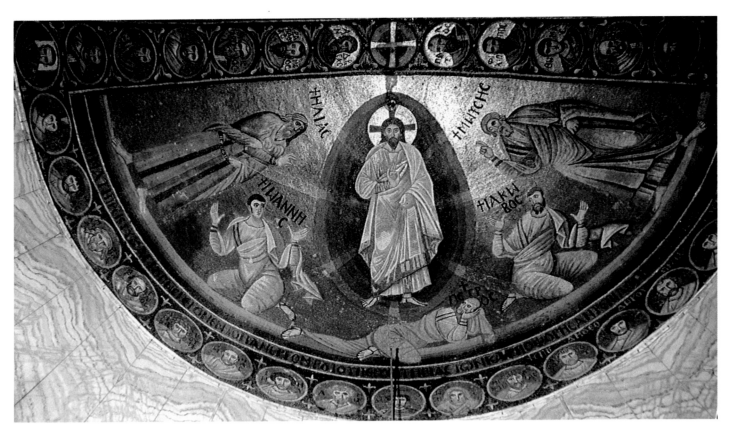

12-13 Transfiguration of Jesus, apse mosaic, Church of the Virgin, monastery of Saint Catherine, Mount Sinai, Egypt, ca. 565.

inscription—in fact, more easily, for many of the faithful were illiterate.

BYZANTIUM IN EGYPT During Justinian's reign, almost continuous building took place, not only in Constantinople and Ravenna but also all over the Byzantine Empire. At Mount Sinai in Egypt, Justinian's builders began work on a major new walled monastery, now called Saint Catherine's, at about the time the mosaicists in Ravenna were completing their pictorial programs for San Vitale and Sant'Apollinare in Classe. The monastic movement began in Egypt in the third century and spread rapidly to Palestine and Syria in the East and as far as Ireland in the West. It began as a migration to the wilderness by those who sought a more spiritual way of life, far from the burdens, distractions, and temptations of town and city. In desert places these refuge seekers lived austerely as hermits, in contemplative isolation, cultivating the soul's perfection. So many thousands fled the cities that the authorities became alarmed—noting the effect on the tax base, military recruitment, and business in general.

By the fifth century, the numbers of these monks were so great that confusion and conflict called for regulation. Individuals were brought together to live according to a rule within a common enclosure, a community under the direction of an abbot (see "Medieval Monasteries and Benedictine Rule," Chapter 16, page 443). The monks typically lived in a walled monastery, an architectural complex that included the monks' residence (an alignment of single cells), a *refectory* (dining hall), a kitchen, storage and service quarters, a guest house for pil-

grims, and, of course, an *oratory* or monastery church (see FIG. 16-20).

Justinian built the fortress monastery at Mount Sinai between 548 and 565 and dedicated its church to the Virgin Mary. In the mid-fifth century, Mary had been officially recognized by the Orthodox Church as the Mother of God (*Theotokos,* "bearer of God" in Greek), putting to rest a controversy about the divine nature of Christ. The new monastery's location was chosen because it was at the foot of the mountain where Moses was believed to have received the Ten Commandments from God and where God first spoke to the Hebrew prophet from a burning bush. Mount Sinai had been an important pilgrimage destination since the fourth century, and Justinian's fortress was intended to protect not only the hermit-monks but also the lay pilgrims during their visits.

The apse mosaic (FIG. **12-13**) in the monastery church at Mount Sinai probably dates to 565, the year of the building's completion, or very shortly thereafter. The subject is the Transfiguration. Jesus appears in a deep-blue egg-shaped *mandorla,* or "glory," flanked by the Old Testament prophets Elijah and Moses. (Other mosaics in the church depict Moses receiving the Law and standing before the burning bush.) At Christ's feet are the disciples John, Peter, and James. Portrait busts of saints and prophets in medallions frame the whole scene. The artist stressed the intense whiteness of Jesus' transfigured, spiritualized form, from which rays stream down on the disciples. The stately figures of Elijah and Moses and the static frontality of Jesus set off the frantic terror and astonishment of the gesticulating dis-

12-14 *Ascension of Christ*, folio 13 verso of the *Rabbula Gospels,* from Zagba, Syria, 586. Approx. 1′ 1″ × 10½″. Biblioteca Medicea-Laurenziana, Florence.

12-15 *Virgin (Theotokos) and Child between Saints Theodore and George,* icon, sixth or early seventh century. Encaustic on wood, 2′ 3″ × 1′ 7⅜″. Monastery of Saint Catherine, Mount Sinai, Egypt.

ciples. This effectively contrasts the eternal composure of heavenly beings with the distraught responses of the earthbound.

The artist swept away all traces of landscape or architectural setting for a depthless field of gold, fixing the figures and their labels in isolation from one another. A rainbow band of colors graduating from yellow to blue bounds the golden field at its base. The figures are ambiguously related to this multicolor ground line. Sometimes they are placed behind it; sometimes they overlap it. The bodies cast no shadows, even though supernatural light streams over them. This is a world of mystical vision, where all substance that might suggest the passage of time or motion through physical space was subtracted so that the devout can contemplate the eternal and motionless world of religious truth.

Painting

BYZANTIUM IN SYRIA One of the essential truths of Christianity is the belief that following his Crucifixion and entombment, Christ rose from the dead after three days and, on the fortieth day, ascended from the Mount of Olives to Heaven. The Ascension is the subject of a full-page painting (FIG. **12-14**) in a manuscript known as the *Rabbula Gospels.* Written in Syriac by the monk Rabbula at the monastery of Saint John the Evangelist at Zagba in Syria, it dates to the year 586. The composition shows Christ (bearded, as became

the norm in Byzantine art) in a mandorla borne aloft by angels, while his mother, other angels, and various apostles look on. The artist set the figures into a mosaic-like frame, and many think a mural painting or mosaic in a Byzantine church somewhere in the Eastern Empire was the model for the Rabbula Ascension.

The account of Christ's Ascension is not part of the accompanying text of the *Rabbula Gospels* but is borrowed from the Book of Acts. And even Acts omits mention of the Virgin's presence at the miraculous event. Here, however, the Theotokos occupies a very prominent position, central and directly beneath Christ. It is an early example of the prominent role the Mother of God played in later medieval art, both in the East and in the West. Frontal, with a nimbus, and posed as an orant, Mary stands apart from the commotion all about her and looks out at the viewer. Other details also depart from the standard texts. Christ, for example, does not rise in a cloud but in a mandorla above a fiery winged chariot carrying the symbols of the Four Evangelists. This page is not therefore an *illustration* of the Gospels but an independent *illumination* presenting one of the central tenets of Christian faith. Similar compositions appear on pilgrims' flasks from Palestine that were souvenir items reproducing important monuments visited. They reinforce the theory that the *Rabbula Gospels* Ascension was based on a lost painting or mosaic in a major church.

Icons and Iconoclasm

Icons ("images" in Greek) are small portable panel paintings depicting Christ, the Virgin, or saints (or a combination of all three, as in FIG. 12-15). Icons survive from as early as the fourth century. From the sixth century on, they became enormously popular in Byzantine worship, both public and private. In Early Christian art the sacred personages of Christianity were often depicted, but in Byzantine icons the focus of attention narrowed to the representation of a particular saint or saints. In Byzantium, Christians considered icons a personal, intimate, and indispensable medium for spiritual transaction with holy figures. Some icons came to be regarded as wonder-working, and believers ascribed miracles and healing powers to them (see FIG. 12-29).

Icons, however, were by no means universally accepted. From the very beginning, many Christians were deeply suspicious of the practice of imaging the divine, whether on portable panels, on the walls of churches, or especially as statues that reminded them of pagan idols. The opponents of Christian figural art had in mind the Old Testament prohibition of images as given by the Lord to Moses in the Second Commandment: "Thou shalt not make unto thee any graven image or any likeness of anything that is in heaven above, or that is in the earth beneath, or that is in the water under the earth. Thou shalt not bow down thyself to them, nor serve them" (Exod. 20:4, 5).

When, early in the fourth century, Constantia, sister of the emperor Constantine, requested an image of Christ from Eusebius, the first great historian of the Christian Church, he rebuked her, referring to the Second Commandment:

> Can it be that you have forgotten that passage in which God lays down the law that no likeness should be made of what is in heaven or in the earth beneath? . . . Are not such things banished and excluded from churches all over the world, and is it not common knowledge that such practices are not permitted to us . . . lest we appear, like idol worshipers, to carry our God around in an image?[1]

Opposition to icons became especially strong in the eighth century, when the faithful often knelt before them in prayer to seek protection or a cure for illness. Icon worship was easy to confuse with idol worship, and this brought about an imperial ban on *all* sacred images. The term for this destruction of holy pictures is *iconoclasm*. The *iconoclasts* (breakers of images) and the *iconophiles* (lovers of images) became bitter and irreconcilable enemies. The anguish of the latter can be read in a graphic description of the deeds of the iconoclasts, written in about 754:

> In every village and town one could witness the weeping and lamentation of the pious, whereas, on the part of the impious, [one saw] sacred things trodden upon, [liturgical] vessels turned to other use, churches scraped down and smeared with ashes because they contained holy images. And wherever there were venerable images of Christ or the Mother of God or the saints, these were consigned to the flames or were gouged out or smeared over.[2]

The consequences of iconoclasm for the history of Byzantine art are difficult to overstate. For more than a century not only did the portrayal of Christ, the Virgin, and the saints cease, but the iconoclasts also systematically destroyed countless works from the early centuries of Christendom. Knowledge of Byzantine art before the revival of image making in the ninth century is therefore very fragmentary. Writing a history of Early Byzantine art presents a great challenge to art historians.

[1]Cyril Mango, trans., *The Art of the Byzantine Empire, 312–1453: Sources and Documents* (Englewood Cliffs, N.J.: Prentice-Hall, 1972), 17–18.

[2]Ibid., 152.

ICONS FOR THE DEVOUT Gospel books such as the *Rabbula Gospels* played an important role in monastic religious life. So, too, did icons, although few early examples survive because of the wholesale destruction of images *(Iconoclasm)* that occurred in the eighth century (see "Icons and Iconoclasm," above). Some of the finest early icons come from Saint Catherine's monastery at Mount Sinai. The one we illustrate (FIG. **12-15**) was painted in encaustic on wood, continuing a tradition of panel painting in Egypt that, like so much else in the Byzantine world, goes back to the Roman Empire (see FIG. 10-63). The Sinai icon represents the enthroned Theotokos and Child with Saints Theodore and George. Behind them, two angels look upward to a shaft of light where the hand of God appears. This format, with minimal variations, remained typical of the compositional features of Byzantine icons for centuries. The foreground figures are strictly frontal and have a solemn demeanor. Background details are few and suppressed. The forward plane of the picture dominates; space is squeezed out. It is a perfect example of Byzantine hieratic style, the mode of grave decorum that suits liturgical ritual. Traces of Greco-Roman illusionism remain in the Virgin's rather personalized features and in her sideways glance, and distant echoes of Hellenistic art endure in the posing of the angels' heads. But the painter rendered the two guardian saints in the new Byzantine manner, especially Saint Theodore, whose piercing eyes command the viewer to witness and revere the miraculous apparition of the Theotokos.

ICONOCLASM (726–843)

BYZANTIUM IN CRISIS The preservation of the Early Byzantine icons at the Mount Sinai monastery is fortuitous but ironic, for opposition to icon worship was especially prominent in the Monophysite provinces of Syria and Egypt. And there, in the seventh century, a series of calamities erupted, indirectly causing the imperial ban on images. The Sasanid Persians, chronically at war with Rome, swept into the eastern provinces early in the seventh century. Between 611 and 617 they captured the great cities of Antioch, Jerusalem, and Alexandria. Hardly had the Byzantine emperor Heraclius pressed them back and defeated them in 627 when a new and overwhelming power appeared unexpectedly on the stage of history. The Arabs, under the banner of the new Islamic religion, conquered not only Byzantium's eastern provinces but also Persia itself, replacing Sasanian Persia in the age-old balance of power with the Christian West. In a few years the Arabs were launching attacks on Constantinople, and Byzantium was fighting for its life.

These were catastrophic years for the Eastern Roman Empire. They terminated once and for all the long story of imperial Rome, closed the Early Byzantine period, and inaugurated the medieval era of Byzantine history. Almost two-thirds of the Byzantine Empire's territory was lost—many cities and much of its population, wealth, and material resources. The shock of these events persuaded the emperor Leo III (r. 717–741) that God had punished the Christian Roman Empire for its idolatrous worship of icons by setting upon it the merciless armies of the infidel. In 726 he formally prohibited the use of images, and for more than a century Byzantine artists produced little new religious figurative art. In place of images, the iconoclasts used symbolic forms already familiar in Early Christian art—the cross (recall the one that crowns the great mosaic of the apse at Sant'Apollinare in Classe, FIG. 12-12), the vacant Throne of Heaven, the cabinet with the scriptural scrolls, and so forth. Stylized floral, animal, and architectural motifs provided decorative fill. In this last respect, iconoclastic art much resembled the contemporaneous *aniconic* (nonimage) art of Islam (see Chapter 13).

MIDDLE BYZANTINE ART (843–1204)

THE RETURN OF THE IMAGE MAKERS In the ninth century, a powerful reaction against iconoclasm set in. The destruction of images was condemned as a heresy, and restoration of the images began in 843. Shortly thereafter, under a new line of emperors, the Macedonian dynasty, art, literature, and learning sprang to life once again. In this great renovation, as historians have called it, Byzantine culture recovered something of its ancient Hellenistic sources and accommodated them to the forms inherited from the Justinianic age.

Basil I (r. 867–886), head of the new dynasty, thought of himself as the restorer of the Roman Empire. He denounced as usurpers the Frankish Carolingian monarchs of the West (see Chapter 16) who, since 800, had claimed the title "Roman Empire" for their realm. Basil bluntly re-

minded their emissary that the only true emperor of Rome reigned in Constantinople. They were not Roman emperors but merely "kings of the Germans." Iconoclasm had forced Byzantine artists westward, where doubtless they found employment at the courts of these Germanic kings. They strongly influenced the character of western European art. But under Basil and his successors, mural painters, mosaicists, book illuminators, ivory carvers, and metalworkers once again received commissions aplenty.

Architecture and Mosaics

UNDOING ICONOCLASM Basil I and his successors undertook the laborious and costly task of refurbishing the churches the iconoclasts defaced and neglected, Hagia Sophia first among them. There, in 867, the Macedonian dynasty dedicated a new mosaic in the apse depicting the enthroned Virgin with the Christ Child in her lap (FIG. **12-16**). In the vast space beneath the dome of the great church, the figures look undersized, but the seated Theotokos is actually more than sixteen feet tall. An accompanying inscription, now fragmentary, announced that "pious emperors" (the Macedonians) had commissioned the mosaic to replace one the "impostors" (the iconoclasts) had destroyed.

12-16 Virgin (Theotokos) and Child enthroned, apse mosaic, Hagia Sophia, Constantinople (Istanbul), Turkey, dedicated 867.

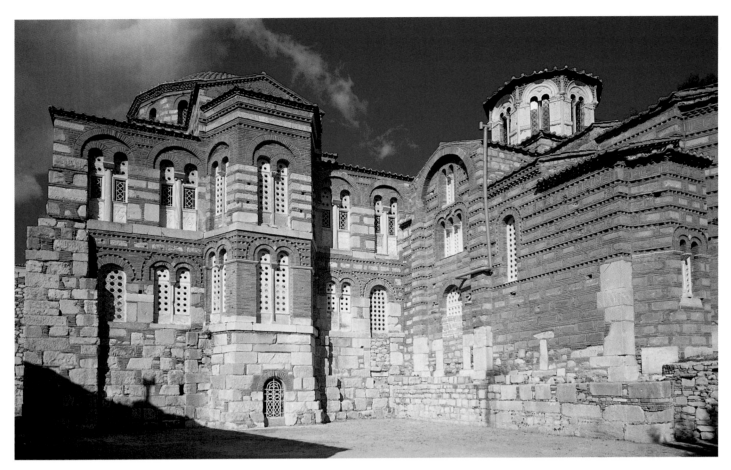

12-17 Monastery churches at Hosios Loukas, Greece *(view from the east).* Katholikon *(left),* first quarter of eleventh century, and Church of the Theotokos *(right),* tenth century.

The original mosaic's subject is uncertain, but the ninth-century work echoes the style and composition of the Early Byzantine Mount Sinai icon of the Theotokos, Christ, and saints (FIG. 12-15). Here, the strict frontality of Mother and (much older) Child is alleviated by the angular placement of the throne and footstool. The mosaicist rendered the furnishings in a perspective that, although imperfect, recalls once more the Greco-Roman roots of Byzantine art. The treatment of the folds of Christ's robes is, by contrast, even more schematic and flatter than in earlier mosaics. These seemingly contradictory stylistic features are not uncommon in Byzantine paintings and mosaics. Most significant about the images in the Hagia Sophia apse is their very existence. The iconophiles had triumphed over the iconoclasts.

NEW CHURCHES FOR THE OLD FAITH Although the new emperors did not wait very long to redecorate the churches of their predecessors, they undertook little new church construction in the decades following the renunciation of iconoclasm in 843. But in the tenth century and through the twelfth, a number of monastic churches arose that are the flowers of Middle Byzantine architecture. They feature a brilliant series of variations on the domed central plan. From the exterior, the typical later Byzantine church building is a domed cube, with the dome rising above the square on a kind of cylinder or drum. The churches are small, vertical, high shouldered, and, unlike earlier Byzantine buildings, have exte-

rior wall surfaces with vivid decorative patterns, probably reflecting the impact of Islamic architecture.

The monastery Church of the Theotokos (FIGS. **12-17**, right, and **12-18**, top) at Hosios Loukas (Saint Luke) in

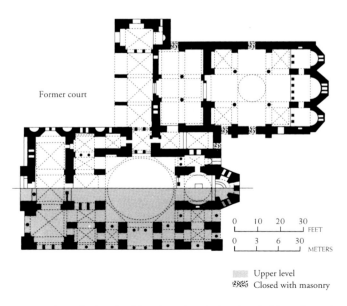

12-18 Plans of Church of the Theotokos *(top)* and Katholikon *(bottom),* Hosios Loukas, Greece, first quarter of eleventh century.

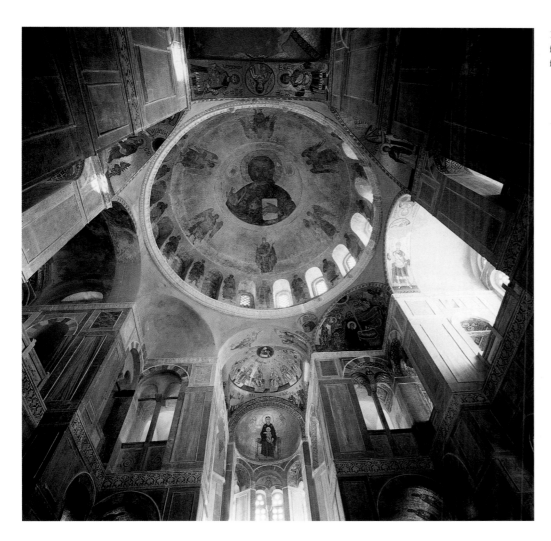

12-19 Interior of Katholikon (view facing east), Hosios Loukas, Greece, first quarter of eleventh century.

Greece, not far from the ancient sanctuary of Apollo at Delphi, dates to the tenth century. One of two churches at the site, it is an outstanding example of church design during this Second Golden Age of Byzantine art and architecture. Light stones framed by dark red bricks—the so-called *cloisonné* technique, a term borrowed from enamel work (see "Cloisonné," Chapter 16, page 429)—make up the walls. The interplay of arcuated windows, projecting apses, and varying roof lines further enhances this surface dynamism. The plan (FIG. 12-18) shows the form of a domed cross in square with four equal-length, vaulted cross arms (the Greek cross). The dome rests on pendentives. Around this unit, and by the duplication of it, Byzantine architects developed bewilderingly involved spaces.

In the adjacent, larger Katholikon (FIGS. 12-17, left, and 12-18, bottom), built in the early eleventh century, the architect placed a dome over an octagon inscribed within a square. The octagon was formed by squinches, which, as noted earlier (see "Pendentives and Squinches," page 332), play the same role as pendentives in making the transition from a square base to a round dome but create a different visual effect on the interior (FIG. **12-19**). This arrangement departs from the older designs, such as Santa Costanza's circular plan (see FIG. 11-10), San Vitale's octagonal plan (FIG. 12-7), and Hagia Sophia's dome on pendentives rising from a square (FIG. 12-4). The

Katholikon's complex core lies within two rectangles, the outermost one forming the exterior walls. Thus, in plan from the center out, a circle-octagon-square-oblong series exhibits an intricate interrelationship that is at once complex and unified.

The interior elevation of the Katholikon reflects its involved plan. Like earlier Byzantine buildings, the church creates a mystery out of space, surface, light, and dark. High and narrow, it forces one's gaze to rise and revolve. The eye is drawn upward toward the dome, but much can distract it in the interplay of flat walls and concave recesses; wide and narrow openings; groin and barrel vaults; single, double, and triple windows; and illuminated and dark spaces. Middle Byzantine architects seem to have aimed for the creation of complex interior spaces that issue into multiple domes in the upper levels. From the exterior, this spatial complexity produces spectacular combinations of round forms that develop dramatically shifting perspectives.

A SECOND GOLDEN AGE FOR MOSAICS Most of the original mosaic decoration of the Hosios Loukas Katholikon does not survive, but at Daphni, near Athens, the mosaics produced during Byzantium's Second Golden Age fared much better. In the monastery Church of the Dormition (from the Latin for *sleep,* referring to the ascension

Eulalios
Painter of Christ

Most of the art of Byzantium, and of the Middle Ages in general, is anonymous. The names of the architect-engineers of Justinian's great sixth-century church of Holy Wisdom in Constantinople (FIG. 12-3) are known. But the mosaicist who adorned its apse (FIG. 12-16) in the ninth century is nameless, even though the homily the patriarch Photius delivered for the building's dedication in 867 survives. The scribe Rabbula signed the *Gospels* he wrote in Syriac in 586, but the identity of the painter of its full-page miniatures (FIG. 12-14) is unknown.

Medieval authors, however, did record the name of Eulalios, a painter who worked in the twelfth century. So great was his fame that more than one writer notes his name and describes his paintings. Eulalios's most important commission was the decoration of the dome of the Church of the Holy Apostles in Constantinople with an image of Christ as Pantocrator. Nicephorus Callistus, an early-fourteenth-century poet, historian, and author of saints' lives, was so struck by Eulalios's portrayal of Christ that he speculated the painter had actually seen the Pantocrator:

> Either Christ himself came down from heaven and showed the exact traits of his face to [the painter] or else the famous Eulalios mounted up to the very skies to paint with his skilled hand Christ's exact appearance.[1]

Nicholas Mesarites, who visited the Church of the Holy Apostles around the year 1200, left a more precise description of Eulalios's Christ:

> [The dome] exhibits an image of the God-man Christ looking down, as it were, from the rim of heaven towards the floor of the church and everything that is in it. . . . His head is in proportion to his body that is represented down to the navel, his eyes are joyful and welcoming to those who are not reproached by their conscience, but to those who are condemned by their own judgment, they are wrathful and hostile. . . . The right hand blesses those who walk a straight path, while it admonishes those who do not and, as it were, checks them and turns them back from their disorderly course. The left hand, with its fingers spread as far apart as possible, supports the Gospel.[2]

It is easy to visualize Eulalios's Pantocrator by comparing Nicholas Mesarites' description with surviving representations of the same theme: for example, the painted dome of the Katholikon at Hosios Loukas (FIG. 12-19), the mosaic dome of the Church of the Dormition at Daphni, and even the apse of the Cathedral at Monreale (FIG. 12-24) in faraway Sicily. All conform to the same basic iconographic type—an image of the stern judge of human worth who strikes fear into all who will come before him.

[1]Cyril Mango, trans., *The Art of the Byzantine Empire, 312–1453: Sources and Documents* (Englewood Cliffs, N.J.: Prentice-Hall, 1972), 231–32.

[2]Ibid., 232.

of the Virgin Mary to Heaven at the moment of her death), the main elements of the late-eleventh-century pictorial program are intact, although the mosaics were restored in the nineteenth century. Gazing down from on high in the central dome is the fearsome image of Christ as *Pantocrator* (literally "ruler of all" in Greek but usually applied to Christ in his role as Last Judge of humankind). It is similar in general appearance to the painting in the dome of the Hosios Loukas Katholikon (FIG. 12-19), which replaced an earlier mosaic. The theme was a common one in churches throughout the Byzantine Empire. The most famous Pantocrator of all was the work of EULALIOS, who decorated the dome of the Church of the Holy Apostles in Constantinople (see "Eulalios: Painter of Christ," above).

On one of the walls below the Daphni dome, beneath the barrel vault of one arm of the Greek cross, an unknown artist depicted Christ's Crucifixion (FIG. **12-20**) in a pictorial style characteristic of the post-iconoclastic Middle Byzantine period. It is a subtle blend of the painterly, Hellenistic style and the later more abstract and formalistic Byzantine style. The Byzantine artist fully assimilated classicism's simplicity, dig-

nity, and grace into a perfect synthesis with Byzantine piety and pathos. The figures have regained the classical organic structure to a surprising degree, particularly compared to figures from the Justinianic period (compare FIGS. 12-9 and 12-10). The style is a masterful adaptation of classical statuesque qualities to the linear Byzantine style.

The Virgin and Saint John flank the crucified Christ. A skull at the foot of the cross indicates Golgotha, the "place of skulls." Nothing else was needed to set the scene. In quiet sorrow and resignation, Mary and John point to Christ as if to indicate the cross's meaning. Symmetry and closed space combine to produce an effect of the motionless and unchanging aspect of the deepest mystery of the Christian religion. The timeless presence is, as it were, beheld in unbroken silence. The picture is not a narrative of the historical event of the Crucifixion, the approach taken by the carver of the Early Christian ivory panel (see FIG. 11-21) examined in the previous chapter. Nor is Christ a triumphant, beardless youth, oblivious to pain and defiant of the laws of gravity. Rather, he has a tilted head and sagging body, and blood spurts from the wound Longinus inflicted on him, although he is not overtly

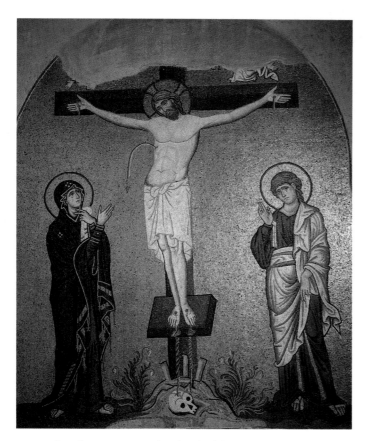

12-20 Crucifixion, mosaic in the Church of the Dormition, Daphni, Greece, ca. 1090–1100.

the four equal arms of the Greek cross. At Saint Mark's the architect elaborated the domes on the exterior, covering them with swelling, wooden, helmetlike forms sheathed in gilded copper. These forms protect the inner masonry domes and contribute to the exuberant composition.

Saint Mark's served both as a martyrium and a palace chapel. In the twelfth century it became the cathedral of Venice. Because of its importance to the city, the doges repeatedly remodeled the eleventh-century structure, and today it is disguised on its lower levels by Romanesque and Gothic additions.

CHRIST TRAMPLES SATAN The interior of Saint Mark's (FIG. 12-22) is, like its plan, Byzantine in effect. Light enters through a row of windows at the bases of all five domes, vividly illuminating a rich cycle of mosaics. Both Byzantine and local artists worked on Saint Mark's mosaics over the course of two centuries. Recent cleaning and restoration on a grand scale have returned the mosaics to their original splendor. It is now possible to experience to the fullest the radiance of mosaic (some forty thousand square feet of it) as it covers, like a gold-brocaded and figured fabric, all the walls, arches, vaults, and domes.

In the vast central dome, eighty feet above the floor and forty-two feet in diameter, Christ reigns in the company of the Four Evangelists, the Virgin Mary, and personifications of Christian virtues. The great arch framing the church crossing bears a narrative of the Crucifixion and Resurrection of Christ and of his liberation from death of the Old Testament

in pain. The Virgin and John point to the figure on the cross as if to a devotional object, sacramental in itself, that the monks are to view in silent contemplation.

VENICE AND BYZANTIUM The revival on a grand scale of church building, featuring vast stretches of mosaic-covered walls, was not confined to the Greek-speaking Byzantine East in the tenth to twelfth centuries. A resurgence of religious architecture and of the mosaicist's art also occurred in areas of the former Western Roman Empire where the ties with Constantinople were the strongest. In the Early Byzantine period, Venice, about eighty miles north of Ravenna on the eastern coast of Italy, was a dependency of that Byzantine stronghold. When the Lombards wrested control of most of northern Italy from Constantinople and Ravenna fell in 751, Venice became an independent power. Its *doges* (dukes) enriched themselves and the city through seaborn commerce, serving as the crucial link between Byzantium and the West.

Venice had long possessed the relics of Saint Mark, and the doges constructed the first Venetian church dedicated to the evangelist in the ninth century. Fire destroyed that church in 976. They then built a second church on the site, but a grandiose new shrine begun in 1063 replaced it. The third Saint Mark's (FIG. 12-21), like its two predecessors, was modeled on the Church of the Holy Apostles at Constantinople, built in Justinian's time. The Constantinopolitan church no longer exists, but its key elements were a cruciform plan with a central dome over the crossing and four other domes over

12-21 Aerial view of Saint Mark's, Venice, Italy, begun 1063.

12-22 Interior of Saint Mark's (view facing east), Venice, Italy, begun 1063.

12-23 *Anastasis*, mosaic from the west vault of Saint Mark's, Venice, Italy, ca. 1180.

worthies. The Anastasis mosaic (FIG. **12-23**) is one of the most originally interpretive, powerfully expressive, and unforgettable scenes in all of Byzantine art. Between his death and Resurrection, Christ, bearing his cross, has descended into Limbo, where he tramples Satan and receives the supplication of the faithful at the left and the witness of Saint John the Baptist and the prophets at the right. He has come to liberate the righteous who had died before his coming.

The composition is boldly asymmetrical. Below an explanatory label in both Latin and Greek, the off-center giant figure of Christ dominates the mosaic by the strength and span of his stride, the direction and intensity of his glance, and the imperious firmness of his seizure of Adam's hand, the focus of the whole design. The hands of Eve and the other Old Testament figures make a pathetic chorus of begging gestures converging to the saving hand of Christ. Swirling draperies leap and spin. The agitated poses and gestures form jagged silhouettes against a featureless golden ground. The insubstantial figures appear weightless and project from their flat field no more than the elegant Latin and Greek letters above them. Nothing here reflects on the world of matter, of solids, of light and shade, of perspective space. This is a masterpiece of emotional, as well as hieratic, abstraction, revealing the mysteries of the Christian Church. The iconography is Byzantine, but the mosaics are the work not of a Byzantine Greek but of a Venetian master, an outstanding member of the great school of mosaicists that flourished at Saint Mark's in the twelfth and thirteenth centuries.

A ROYAL CHURCH IN SICILY Venetian success was matched in the western Mediterranean by the Normans who, having driven the Arabs from Sicily, set up a powerful kingdom there, whose resources matched Venice's. Though they were the enemies of Byzantium, the Normans, like the Venetians, assimilated Byzantine culture and even employed Byzantine artisans. In their Sicilian kingdom, the mosaics of the great basilican church of Monreale, not far from Palermo, are striking evidence of Byzantium's presence. They rival those of Saint Mark's not only in quality but also in their extent. One scholar has estimated that more than one hundred million glass and stone tesserae were required for the Monreale mosaics.

These mosaics were paid for by the Norman king William II, who is portrayed twice, continuing the theme of royal presence and patronage of the much earlier Ravenna portraits of Justinian and Theodora at San Vitale (FIGS. 12-10 and 12-11). In one panel, William, clearly labeled, unlike Justinian or his consort, stands next to the enthroned Christ, who places his hand upon William's crown. In the second, the king kneels before the Virgin and presents her with a model of the Monreale church, a role that at San Vitale Bishop Ecclesius played (FIG. 12-9), rather than the emperor or empress. As in the Ravenna church, the mosaic program commemorates both the piety and power of the ruler who reigns with divine authority.

The apse mosaics (FIG. **12-24**) are especially impressive. The image of Christ as Pantocrator, as ruler and judge of heaven and earth, looms menacingly in the vault, a colossal allusion to William's kingly power and a challenge to all who would dispute the royal right. In Byzantium proper, the Pantocrator's image usually appears in the main dome of centralized churches such as those at Daphni and Hosios Loukas (FIG. 12-19), but the Greek churches are monastic churches and they were not built for the glorification of monarchs. Monreale, moreover, is a basilica—longitudinally planned in the Western tradition. The semidome of the apse, the only

domes but also by the sometimes extravagant furnishings of their churches. In 976, the Venetian doge Pietro Orseolo ordered from Constantinople a set of gold-and-enamel plaques nailed on wood for the second church of Saint Mark in Venice. In 1105, under Doge Ordelafo Falier, the plaques were refashioned into a *pala* (altarpiece, or panel placed behind and over the altar) that was again augmented in 1209 with booty from the Crusaders' sack of Constantinople. The altarpiece was modified once more in 1345. In its final form the Venetian *Pala d'Oro (Golden Pala)* reflects contemporaneous (Gothic) taste in Italy and unites plaques of several different periods featuring narrative scenes from Christ's life and dozens of saints, angels, prophets, and temporal rulers in golden niches surrounded by jewels of many different hues.

Among the figures added in 1105 was Doge Falier and the Byzantine Emperor Alexius I Comnenus (r. 1081–1118) and his wife, the Empress Irene (FIG. **12-25**). The regally attired and haloed gold-and-enamel Irene is a frontal, wafer-thin, weightless figure, a stylistic cousin to the mosaic saints and apostles of Monreale, despite the enormous differences in scale and technique. The presence of Alexius and Irene have suggested to some scholars that the *Pala d'Oro* in its 1105 form was an imperial gift to the Venetian church.

The pendant portraits of the Constantinopolitan rulers carried on a tradition of inserting haloed royal images into church programs that went back to the Early Byzantine

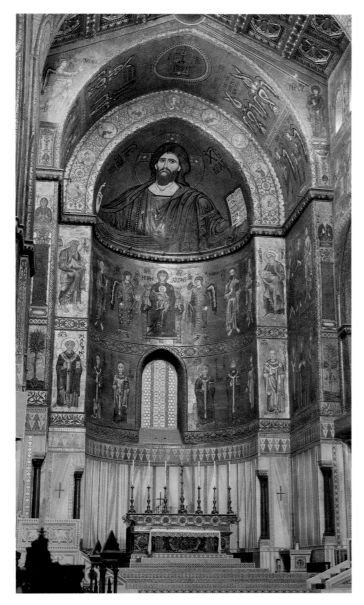

12-24 Pantocrator, Theotokos and Child, angels, and saints, apse mosaic in the cathedral at Monreale, Italy, ca. 1180–1190.

vault in the building and its architectural focus, was the most conspicuous place for the vast image with its politically propagandistic overtones. Below the Pantocrator in rank and dignity, the enthroned Theotokos is flanked by archangels and the Twelve Apostles symmetrically arranged in balanced groups. Lower on the wall (and less elevated in the hierarchy) are popes, bishops, and other saints. The artists observed the stern formalities of style characteristic of Byzantine hieraticism here, far from Constantinople. The Monreale mosaics testify to the stature of Byzantium and of Byzantine art in medieval Italy.

Luxury Arts

EMPRESS IRENE AND SAINT MARK'S The wealth and pretensions of the Venetian dukes and the Norman kings of Sicily are revealed not only by their ambitious building programs with their acres of mosaic-covered walls, vaults, and

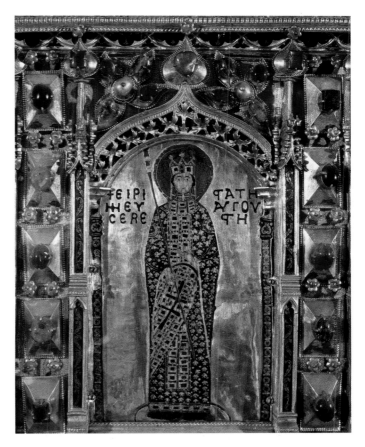

12-25 Empress Irene, detail of the *Pala d'Oro*, Saint Mark's, Venice, Italy, ca. 1105. Gold cloisonné inlaid with precious stones, detail approx. $7'' \times 4\frac{1}{2}''$.

period (FIGS. 12-10 and 12-11). They are reminders once again of the important role the Byzantine empresses played in both life and art and of the commercial, political, and artistic exchanges between Italy and Byzantium in the twelfth century.

DIPTYCH TO TRIPTYCH Costly carved ivories also were produced in large numbers in the Middle Byzantine period, but after iconoclasm the three-part *triptych* replaced the earlier diptych as the standard format for ivory panels. One of the premier examples of this type is the *Harbaville Triptych* (FIG. **12-26**), a portable shrine with hinged wings that was used for private devotion. Such triptychs were very popular—among those who could afford such luxurious items—and they often replaced icons for use in personal prayer. Carved on the wings of the *Harbaville Triptych*, both front and back, are four pairs of full-length figures and two pairs of medallions depicting saints, mostly bishops but including four military saints on the front. A cross dominates the central panel on the back (not illustrated). On the front is a scene of *Deesis*. Saint John the Baptist and the Theotokos appear as intercessors, praying on behalf of the viewer to the enthroned Savior. Below them are five apostles.

The hieratic formality and solemnity associated with Byzantine art, visible in the mosaics of Ravenna and Monreale and in the *Pala d'Oro* enamel plaques, yielded here to a softer, more fluent technique. They may lack true classical contrapposto, but the looser stances of the figures (most stand on bases, like freestanding statues) and three-quarter views of many of the heads relieve the hard austerity of the customary frontal pose. This more natural classicizing spirit was a second, equally important, stylistic current of the Middle Byzantine period. It also surfaced in mural painting and book illumination.

Painting

BYZANTIUM IN THE BALKANS When the emperors lifted the ban against religious images and again encouraged religious painting at Constantinople, the impact was felt far and wide. The style varied from region to region, as expected, but a renewed enthusiasm for picturing the key New Testament figures and events was universal.

In 1164, at Nerezi in Macedonia, Byzantine painters embellished the church of Saint Pantaleimon with murals of great emotional power. One of these represents the Lamentation over the dead Christ (FIG. 12-27). It is an image of passionate grief. The artist captured Christ's friends in attitudes, expressions, and gestures of quite human bereavement. Mary presses her cheek against her dead son's face while Saint John clings to Christ's left hand. Saint Peter and the disciple Nicodemus kneel at his feet. Above, swooning angels hover in a blue sky above a hilly landscape—a striking contrast to the abstract golden world of the mosaics favored for church walls elsewhere in the Byzantine Empire. The artist strove to make utterly convincing an emotionally charged realization of the theme by staging the Gospel story in a more natural setting and peopling it with fully modeled actors. This alternate representational mode, no less Byzantine than the hieratic style of Ravenna or the poignant melancholy of Daphni, found a ready reception in late medieval Italy (compare FIGS. 12-33 and 19-9).

DAVID AS GRECO-ROMAN HARPIST Another example of this classicizing style is a page from a book of the Psalms of David. The so-called *Paris Psalter* (FIG. **12-28**) reasserts the artistic values of the classical past with astonishing authority. Art historians believe the manuscript dates from

12-26 Christ enthroned with saints *(Harbaville Triptych)*, ca. 950. Ivory, central panel $9\frac{1}{2}'' \times 5\frac{1}{2}''$. Louvre, Paris.

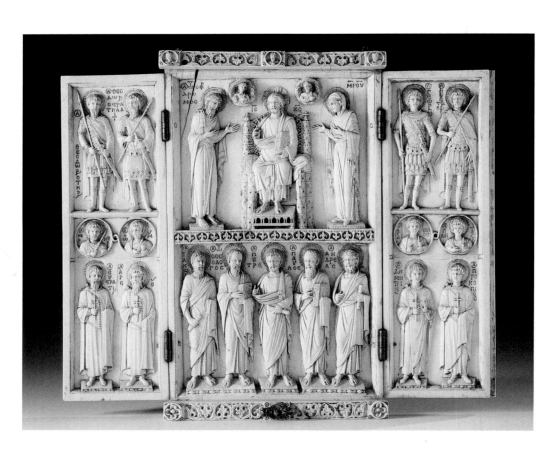

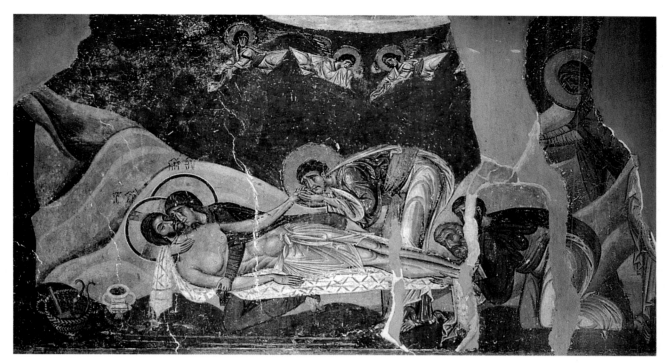

12-27 *Lamentation over the Dead Christ*, wall painting, Saint Pantaleimon, Nerezi, Macedonia, 1164.

the mid-tenth century—the so-called "Macedonian Renaissance," a time of enthusiastic and careful study of ancient Greece's language and literature and of humanistic reverence for the classical past. It was only natural that in art inspiration should be drawn once again from the Hellenistic naturalism of the pre-Christian Mediterranean world.

David, the psalmist, surrounded by sheep, goats, and his faithful dog, plays his harp in a rocky landscape with a town in the background. Similar settings appeared frequently in Pompeian murals. Befitting an ancient depiction of Orpheus, the Greek hero who could charm even inanimate objects with his music, allegorical figures accompany the Old Testament harpist. Melody looks over his shoulder, while Echo peers from behind a column. A reclining male figure points to an inscription that identifies him as representing the mountain of Bethlehem. These allegorical figures do not appear in the Bible. They are the stock population of Greco-Roman painting. Apparently, the artist had seen a work from late antiquity or perhaps earlier and partly translated it into a Byzantine pictorial idiom. In works such as this, Byzantine artists kept the classical style alive in the Middle Ages.

A MIRACLE-WORKING RUSSIAN ICON Nothing in Middle Byzantine art better demonstrates the rejection of the iconoclastic viewpoint than the painted icon's return to prominence. After the restoration of images, such icons multiplied by the thousands to meet public and private demand. In the eleventh century, the clergy began to display icons in hieratic order (Christ, the Theotokos, John the Baptist, and then other saints, as on the *Harbaville Triptych*) in tiers on the *templon*, the columnar screen separating the sanctuary from the main body of a Byzantine church.

One example, the renowned *Vladimir Virgin* (FIG. **12-29**), is a masterpiece of its kind. Descended from works such as the Mount Sinai icon (FIG. 12-15), the *Vladimir Virgin* clearly

12-28 *David composing the Psalms*, folio 1 verso of the *Paris Psalter*, ca. 950–970. Tempera on vellum, 1' 2⅛" × 10¼". Bibliothèque Nationale, Paris.

12-29 Virgin (Theotokos) and Child, icon *(Vladimir Virgin)*, late eleventh to early twelfth century. Tempera on wood, original panel approx. 2′ 6½″ × 1′ 9″. Tretyakov Gallery, Moscow.

reveals the stylized abstraction that centuries of working and reworking the conventional image had wrought. Painted by an artist in Byzantium, the characteristic traits of the Byzantine icon of the Virgin and Child are all present: the sharp sidewise inclination of the Virgin's head to meet the tightly embraced Christ Child; the long, straight nose and small mouth; the golden rays in the infant's drapery; the decorative sweep of the unbroken contour that encloses the two figures; the flat silhouette against the golden ground; and the deep pathos of the Virgin's expression as she contemplates the future sacrifice of her son.

The icon of Vladimir, like most icons, has seen hard service. Placed before or above altars in churches or private chapels, incense and the smoke from candles that burned before or below it blackened its surface. It was frequently repainted, often by inferior artists, and only the faces show the original surface. First painted in the late eleventh or early twelfth century, it was exported to Vladimir in Russia—hence its name—and then, as a wonder-working image, was taken in 1395 to Moscow to protect that city from the Mongols. As the especially sacred picture of their country, the Rus-

sians believed it saved the city of Kazan from later Tartar invasions and all of Russia from the Poles in the seventeenth century. It is a historical symbol of Byzantium's religious and cultural mission to the Slavic world.

LATE BYZANTINE ART (1204–1453)

THE SACK OF CONSTANTINOPLE When rule passed from the Macedonian to the Comnenian dynasty in the later eleventh and the twelfth centuries, three events of fateful significance changed Byzantium's fortunes for the worse. The Seljuk Turks conquered most of Anatolia. The Byzantine Orthodox Church broke finally with the Church of Rome. And the Crusades brought the Latins (a generic term for the peoples of the West) into Byzantine lands on their way to fight for the Cross against the Saracens (Muslims) in the Holy Land (see "The Crusades," Chapter 17, page 473).

Crusaders had passed through Constantinople many times en route to "smite the infidel" and had marveled at its wealth and magnificence. Envy, greed, religious fanaticism (the Latins called the Greeks "heretics"), and even ethnic enmity motivated the Crusaders when, during the Fourth Crusade in 1203 and 1204, the Venetians persuaded them to divert their expedition against the Muslims in Palestine and to attack Constantinople instead. They took the city and atrociously sacked it in a manner so horrible as to be remembered by Greek peoples to this day. Nicetas Choniates, a contemporaneous historian, expressed the feelings of the Byzantines toward the Crusaders: "The accursed Latins would plunder our wealth and wipe out our race. . . . Between us there can be only an unbridgeable gulf of hatred. . . . They bear the Cross of Christ on their shoulders, but even the Saracens are kinder." [6]

The Latins set up kingdoms within Byzantium, notably in Constantinople itself. What remained of Byzantium was split into three small states. The Palaeologans ruled one of these, the kingdom of Nicaea. In 1261, Michael VIII Palaeologus (r. 1259–1282) succeeded in recapturing Constantinople. But his empire was no more than a fragment, and even that disintegrated during the next two centuries. Isolated from the Christian West by Muslim conquests in the Balkans and besieged by Muslim Turks to the east, Byzantium sought help from the West. It was not forthcoming. In 1453, the Ottoman Turks, then a formidable power, captured Constantinople and brought to an end the long history of Byzantium (see Chapter 13). But despite the state's grim political condition under the Palaeologan dynasty, the arts flourished well into the fourteenth century.

Architecture

A MULTIPLICATION OF DOMES Late Byzantine architecture did not depart radically from the characteristic plans and elevations of Middle Byzantine architecture. But the number of domes and drums increased, and their groupings became more and more dramatic. Elevations became narrower and steeper. Wall and drum arcades were more deeply cut back into overlapping arches. The eaves curved rhythmically and varied brick patterns ornamented the external walls.

12-30 Church of Saint Catherine, Thessaloniki, Greece, ca. 1280.

The church of Saint Catherine in Thessaloniki (FIG. **12-30**), second city to Constantinople in rank, shows all these Palaeologan variations on the grand stylistic theme of Middle Byzantine architecture. The plan is an inscribed cross with a central dome and four additional domes at the corners. On the exterior these appear as *cupolas,* drums with shallow caps, the central drum rising a level above the others. Thus the church has a vertical gradation from a rectilinear base to the super-structure's cylindrical volumes, culminating in the dominant central unit. Wall and drum arcades are grouped rhythmically in alternating pairs and triads. Lively patternings face and punctuate the enframements of arches and niches and the scalloped eaves. The intricate harmonizing by alternation and repetition of walls and openings and of verticals, half-circles, and cylinders produces a lively rhythm. The complexity of surfaces and details characteristic of earlier Byzantine building interiors broke out to the exterior in Late Byzantine architecture.

Painting

RESURRECTION AND REDEMPTION A new burst of creative energy also enlivened Late Byzantine painting. Artists produced masterpieces of mural and icon painting rivaling those of the earlier periods. A fresco (FIG. **12-31**) in the apse of the *parekklesion* (side chapel, in this instance a funerary chapel) of the Church of Christ in Chora (now the Kariye Museum, formerly the Kariye Camii mosque) in Constantinople is another striking version of the Anastasis theme, represented earlier at Saint Mark's in Venice (FIG. **12-23**). Here,

the Anastasis is central to a cycle of pictures portraying the themes of human mortality and redemption by Christ and of the intercession of the Virgin, both appropriate for a funerary chapel.

As in the version in Saint Mark's, Christ, trampling Satan and all the locks and keys of his prison house of Hell, raises Adam and Eve from their tombs. Looking on are John the Baptist, King David, and King Solomon on the left. And on the right are the righteous of the Old Dispensation (led by Saint Stephen, first of the martyrs of the New Dispensation). Comparison with the Saint Mark's version, however, reveals sharp differences in composition, expression, and figure style. Christ does not carry the cross and he appears in a luminous mandorla. Formal symmetry has returned, with Christ at the center, his pose and gaze essentially frontal and his hands, free of the cross, reaching out equally to Adam and Eve. Instead of the rough, tormented angularities of the Saint Mark's mosaic, the action is swift and smooth. All tension is erased, the supple motions executed with the grace of a ballet. The figures float and levitate in a spiritual atmosphere, spaceless and without material mass or shadow-casting volume. This same smoothness and lightness can be seen in the modeling of the figures and the subtly nuanced coloration. The jagged abstractions of drapery found in the Saint Mark's figures are gone in a return to the fluent delineation of drapery characteristic of the long tradition of classical illusionism.

ART FOR A SPIRITUAL WORLD It is useful here to compare the Anastasis of the Kariye not only with that of Saint Mark's but also with the Transfiguration mosaic of Saint

12-31 *Anastasis*, apse fresco in the *parekklesion* of the Church of Christ in Chora (now the Kariye Museum), Constantinople (Istanbul), Turkey, ca. 1310–1320.

Catherine's at Mount Sinai (FIG. 12-13). This comparison sets side by side outstanding works from the three great periods of Byzantine art. Despite obvious differences of individual style and expression, all three display an essential conservatism that determined the iconography, composition, figural and facial types, bodily attitudes, and the rendering of space and volume, as well as the human form and its drapery. Throughout its history, Byzantine art looked back to its antecedents, Greco-Roman illusionism as transformed in the age of Justinian. Like their Orthodox religion, Byzantine artists were suspicious of any real innovation, especially that imported from outside the Byzantine cultural sphere. They drew their images from a persistent and conventionalized vision of a spiritual world unsusceptible to change. Byzantine art was not concerned with the systematic observation of material nature as the source of its imaging of the eternal.

Byzantine spirituality was perhaps most intensely felt in icon painting. In the Late Byzantine period the Early Byzantine low chancel screen separating the church sanctuary from its main area developed into an *iconostasis* (icon stand), a high screen with doors. As its name implies, the iconostasis supported tiers of painted devotional images, which began to be produced again in large numbers, both in Constantinople and throughout the diminished Byzantine Empire.

An outstanding example, notable for the lavish use of finely etched silver foil to frame the tempera figure of Christ as Savior of Souls (FIG. **12-32**), dates to the beginning of the fourteenth century. It comes from the church of Saint Clement at Ohrid in Macedonia, where many Late Byzantine icons imported from the capital have been preserved. The Ohrid Christ, consistent with Byzantine art's conservative nature, adhered to an iconographical and stylistic tradition that went back to the earliest icons from the monastery at Mount Sinai. The artist chose not only the standard presentation of the Savior holding a bejeweled Bible in his left hand while he blesses the faithful with his right hand, but also painted the image in the eclectic style familiar to Byzantium. Note especially the juxtaposition of Christ's fully modeled head and neck, which reveal the Byzantine painter's Greco-Roman heritage, with the schematic linear folds of Christ's garment, which do not envelop the figure but rather seem to be placed in front of it.

A PARADE OF ICONS In the Late Byzantine period, icons often were painted on two sides because they were intended to be carried in processions. When they were deposited in the church, they were not mounted on the iconostasis but were exhibited on stands so that worshipers could

12-32 Christ as Savior of Souls, icon from the church of Saint Clement, Ohrid, Macedonia, early fourteenth century. Tempera, linen, and silver on wood, 3′ ¼″ × 2′ 2½″. Icon Gallery of Saint Clement, Ohrid.

view them from both sides. The Ohrid icon of Christ has a painting of the Crucifixion on its reverse. Another double icon from Saint Clement's, also imported from Constantinople, represents the Virgin on the front as Christ's counterpart as Savior of Souls. The Annunciation (FIG. **12-33**) is the subject of the reverse. With a commanding gesture of heavenly authority, the angel Gabriel announces to Mary that she is to be the Mother of God. She responds with a simple gesture conveying both astonishment and acceptance. The gestures and attitudes of the figures are again conventional. Like the highly simplified architectural props, they have a long history in Byzantine art. The tall, elegant figure of the angel, the smooth rhythm of its striding motion, and the delineation and modeling of the drapery reveal its close stylistic kinship to the Christ figure of the Kariye mural (FIG. 12-31). Both exemplify the high artistic achievement of metropolitan Constantinople's narrative art in the Palaeologan revival.

A MASTER ICON PAINTER IN RUSSIA In Russia, icon painting flourished for centuries, extending the life of the style well beyond the collapse of the Byzantine Empire in 1453. Russian paintings usually had strong patterns, firm lines, and intense contrasting colors. All served to heighten the legibility of the icons in the wavering candlelight and clouds of incense that worshipers encountered in church interiors. For many art historians, Russian painting reached a cli-

12-34 ANDREI RUBLYEV, Three angels (Old Testament Trinity), ca. 1410. Tempera on wood, 4′ 8″ × 3 ′9″. Tretyakov Gallery, Moscow.

max in the work of ANDREI RUBLYEV (ca. 1370–1430). His rendition of the three Old Testament angels who appeared to Abraham (FIG. **12-34**) is a work of great spiritual power, as well as an unsurpassed example of subtle line in union with intensely vivid color. These angels were interpreted in Christian thought as a prefiguration of the Holy Trinity after Christ's incarnation. Here they sit about a table, each framed with a halo and sweeping wings, three nearly identical figures distinguished only by their garment colors. The light linear play of the draperies sets off the tranquil demeanor of the figures. Color defines the forms and becomes more intense by the juxtaposition of complementary hues. The intense blue and green folds of the central figure's cloak, for example, stand out starkly against the deep-red robe and the gilded orange of the wings. In the figure on the left, the highlights of the orange cloak are an opalescent blue green. The unmodulated saturation, brilliance, and purity of the color harmonies were the hallmark of Rublyev's style.

Luxury Arts

GOD AND EMPEROR ON PRIESTLY ROBES In Byzantium, other arts also played an indispensable part in the ensemble of a church interior—the carvings and rich metalwork of the iconostasis, serving to frame icons that themselves often were ornamented with precious metals and jewels; the finely wrought, gleaming candlesticks and candelabra; the illuminated books bound in gold or ivory and inlaid with jewels and enamels; and the crosses, croziers, sacred vessels, and processional banners. Each, with its great richness of texture and color, contributed to the total ambience of the Byzantine

12-33 Annunciation, reverse of two-sided icon from the church of Saint Clement, Ohrid, Macedonia, early fourteenth century. Tempera and linen on wood, 3′ $\frac{1}{4}$″ × 2′ 2$\frac{3}{4}$″. Icon Gallery of Saint Clement, Ohrid.

12-35 Large sakkos of Photius, ca. 1417. Satin embroidered with gold and silver thread and silk with pearl ornament, approx. 4′5″ long. Kremlin Armory, Moscow.

church. And amid these opulent inanimate treasures, the solemn clergy celebrated the liturgy of the Orthodox faith in magnificent embroidered and bejeweled robes, adding further to the visual feast.

Fortunately some of these vestments have been reverently preserved through centuries of political and social upheaval in Russia. One of them is the so-called "large *sakkos*" (a magnificent "small sakkos" also exists) or tunic (FIG. **12-35**) of Photius, the early-fifteenth-century Metropolitan (Orthodox bishop) of Russia. It can represent here this whole branch of the "minor arts" and remind readers of how incomplete the story of art through the ages would be if the narrative were confined to monumental works of painting, sculpture, and architecture.

Photius's satin sakkos is embroidered with gold and silver thread and colored silks outlined with pearls. Dozens of religious and secular figures appear in a dazzling array of rectilinear, L-shaped, cruciform, and circular frames. The Crucifixion dominates the center of the front, while below is the Anastasis. All around are various Orthodox Church feasts and figures of saints, as well as Old Testament scenes, including the sacrifice of Abraham, linked with the Crucifixion here as it was in Early Christian times. Also portrayed are the Grand Prince of Moscow, Vasily Dimitrievich, and his wife Sophia Vitovtovna

(labeled in Russian), as well as the future emperor John VIII Palaeologus (r. 1425–1448) and his wife Anna Vasilyevna (named in Greek). Beside John is Photius, "Metropolitan of Kiev and all Russia." Needleworkers most likely embroidered the sakkos between the time of John's marriage in 1416 and Anna Vasilyevna's death in 1418. The couple probably sent the sakkos to Photius as a gift. In fifteenth-century Russia, as in sixth-century Ravenna, the rulers of Byzantium, as the vicars of God on earth, joined the clergy in celebration of the liturgy of the Christian Church.

THE THIRD ROME A third of a century after Photius first donned his sakkos, Constantinople fell to the Ottoman Turks, never to be recovered. With the passing of Byzantium, Russia became the self-appointed heir and the defender of Christendom against the infidel. The court of the tsar (the word is derived from *caesar*) declared: "Because the Old Rome has fallen, and because the Second Rome, which is Constantinople, is now in the hands of the godless Turks, thy kingdom, O pious Tsar, is the Third Rome. . . . Two Romes have fallen, but the Third stands, and there shall be no more."[7] Rome, Byzantium, Russia—the worlds of the caesars of Old Rome, New Rome, and Third Rome were a continuum, where artistic change was slow and the old ways never really died.

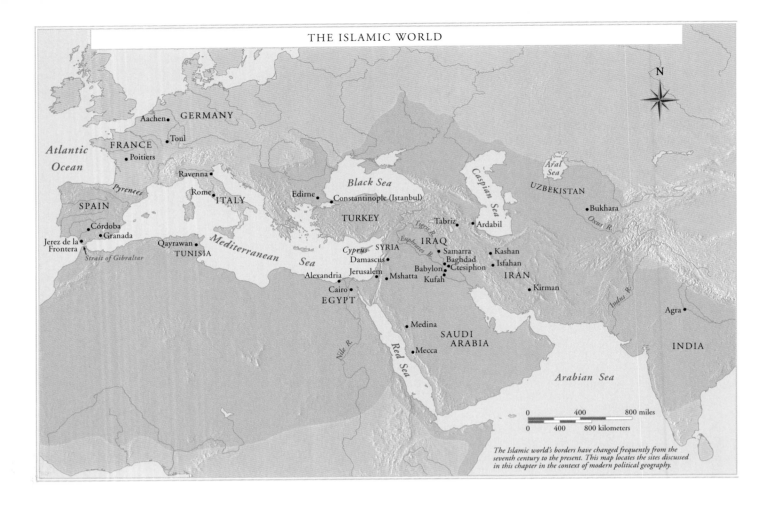

THE ISLAMIC WORLD

The Islamic world's borders have changed frequently from the seventh century to the present. This map locates the sites discussed in this chapter in the context of modern political geography.

	600	700	800	900	1000
SYRIA AND IRAQ		UMAYYAD CALIPHATE	ABBASID CALIPHATE		
SPAIN			UMAYYAD CALIPHATE		
IRAN AND CENTRAL ASIA			SAMANID DYNASTY		
EGYPT				FATIMID DYNASTY	
TURKEY					
INDIA					

Dome of the Rock
Jerusalem, 687–692

Sulayman
Bird ewer, 796

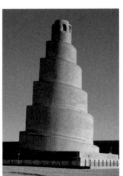

Malwiya minaret
Samarra, 848–852

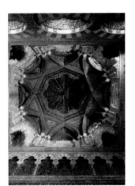

Mihrab dome, Great Mosque
Córdoba, 961–965

Birth of Muhammad in Mecca, ca. 570

Muhammad's first revelation, 610

Muhammad's flight to Mecca (Hijra), 622

Death of Muhammad in Medina, 632

Muslims capture Jerusalem, 638

Muslim conquest of Lower Egypt, 642

Umayyad caliphate established, 661

Muslim armies enter Spain, 711

Charles Martel defeats Muslims at Poitiers, 732

Abbasid caliphate established, 750

Umayyad caliphate established in Spain, 756

Abbasids found Baghdad, 762

Samanid dynasty established in Transoxiana, 819

Fatamid dynasty established in Egypt, 909

Fatamids found Cairo, 969

Fall of Umayyad caliphate in Spain, 1031

13

MUHAMMAD AND THE MUSLIMS

ISLAMIC ART

	1100	1200	1300	1400	1500	1600

NASRID DYNASTY

SELJUK DYNASTY

TIMURID DYNASTY

SAFAVID DYNASTY

MAMLUK DYNASTY

OTTOMAN EMPIRE

MUGHAL DYNASTY

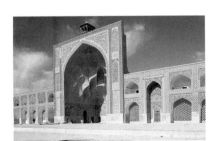

Great Mosque, Isfahan
begun late eleventh century

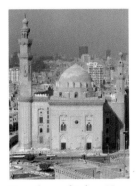

Mausoleum of Sultan Hasan
Cairo, begun 1356

Maqsud of Kashan
Ardabil carpet, 1540

Taj Mahal
Agra, 1632–1647

Seljuk dynasty established in Iran, 1038

First Crusade captures Jerusalem, 1099

Nasrid dynasty established at Granada, 1230

Mamluk dynasty established in Egypt, 1250

Mongols sack Baghdad, 1258

Ottoman Empire founded, 1281

Ottomans capture Constantinople, 1453

Fall of Granada to the Christians, 1492

Safavid dynasty established
in Iran, 1501

Mughal dynasty established
in India, 1526

Ottomans capture
Baghdad, 1534

Muhammad and Islam

Muhammad, founder of Islam and revered as its Prophet, was a native of Mecca on the west coast of Arabia. Born around 570 into a family that traced its roots to Ishmael, the son of the Hebrew prophet Abraham, Muhammad was a merchant in the great Arabian caravan trade. Critical of the polytheistic religion of his fellow Arabs, he was inspired to prophecy. Muhammad preached a religion of the one and only god, Allah, whose revelations he received beginning in 610 and for the rest of his life. Believers in Islam, who yield their will to Allah's will and have professed so, are *Muslims*. Opposition to Muhammad's message among the Arabs was strong enough to prompt the Prophet and his growing number of followers to flee from Mecca to a desert oasis eventually called Medina ("City of the Prophet"). Islam dates its beginnings from this flight in 622, known as the *Hijra* (emigration). (Muslims date events beginning with the Hijra in the same way Christians reckon events from Christ's birth and the Romans before them began their calendar with Rome's founding by Romulus in 753 B.C. The Muslim year is, however, a 354-day year of twelve lunar months, and dates cannot be converted by simply adding 622 to Christian-era dates.) Barely eight years later, in 630, Muhammad returned to Mecca with ten thousand soldiers. He took control of the city, converted the population to Islam, and destroyed all the idols. But he preserved as the Muslim world's symbolic center the small cubical building that had housed the idols, the *Kaaba* (from the Arabic for "cube"). The Arabs associated the Kaaba with the era of Abraham and Ishmael, the common ancestors of Jews and Arabs. Muhammad died in Medina in 632.

The essential meaning of Islam is acceptance of and submission to Allah's will. It broadly includes living according to the rules laid down in the collected revelations communicated through Muhammad during his lifetime. These are recorded in the Quran (Koran), Islam's sacred book, codified by the Muslim ruler Uthman (r. 644–656). *Quran* means "recitations"—a reference to the archangel Gabriel's instructions to Muhammad in 610 to "recite in the name of Allah." The Quran is composed of one hundred fourteen *surahs* (chapters) divided into verses.

The profession of faith in Allah is the first of five obligations binding all Muslims. In addition, the faithful must pray five times daily, facing in Mecca's direction; give alms to the poor; fast during the month of Ramadan; and once in a lifetime—if possible—make a pilgrimage to Mecca. Muslims are guided not only by the revelations in the Quran but also by Muhammad's example. The *Sunna*, collections of the Prophet's moral sayings and anecdotes of his exemplary deeds, are supplemental to the Quran, offering guidance to the faithful on ethical problems of everyday life. The reward for the Muslim faithful is Paradise.

Islam has much in common with Judaism and Christianity. Its adherents think of it as a continuation, completion, and in some sense a reformation of those other great monotheisms. In addition to the belief in one god, Islam incorporates many of the Old Testament teachings, with their sober ethical standards and hatred of idol worship, and those of the New Testament Gospels. Adam, Abraham, Moses, and Jesus are acknowledged as the prophetic predecessors of Muhammad, the final and greatest of the prophets before Allah's coming. Muhammad did not claim to be divine, as did Jesus, and he did not perform miracles. Rather, he was God's messenger, the purifier and perfecter of the common faith of Jews, Christians, and Muslims in one God. Islam also differs from Judaism and Christianity in its simpler organization. Muslims worship God directly, without a hierarchy of rabbis, priests, or saints acting as intermediaries.

In Islam, as Muhammad defined it, religious and secular authority were united even more completely than in Byzantium. Muhammad established a new social order, replacing the Arabs' old decentralized tribal one. In this he was influenced, no doubt, by the examples of the emperors and kings reigning in the lands his people would conquer. He took complete charge of his community's temporal, as well as spiritual, affairs. After Muhammad's death the *caliphs* (from the Arabic for "successor") continued this practice of uniting religious and political leadership in one ruler. But Muslims are divided over the legitimacy of temporal authority. The *Shiites* believe that only the descendants of the Prophet through his daughter Fatima, his only child, and her husband Ali are qualified for the highest political and religious leadership in Islam. The *Sunnites* recognize the legitimacy of the first caliphs, who were followers of Muhammad but not descended from him, and endorse either an elective or a dynastic principle of Islamic leadership.

THE RISE OF ISLAM

OUT OF ARABIA The religion of *Islam* (an Arabic word meaning "submission to God") arose among the peoples of the Arabian peninsula early in the seventh century (see "Muhammad and Islam," above). A distinctive and compelling Islamic tradition of art and architecture quickly followed. The Arabs were nomadic herders and caravan merchants traversing, from ancient times, the wastes and oases of the vast Arabian desert and settling and controlling its coasts. When Islam arose, the Arabs were peripheral to the Byzantine and Persian empires. Yet within little more than a century, the Mediterranean, once ringed and ruled by Byzantium, had become an Islamic lake. And the armies of Islam had conquered the Middle East, long the seat of Persian dominance and influence.

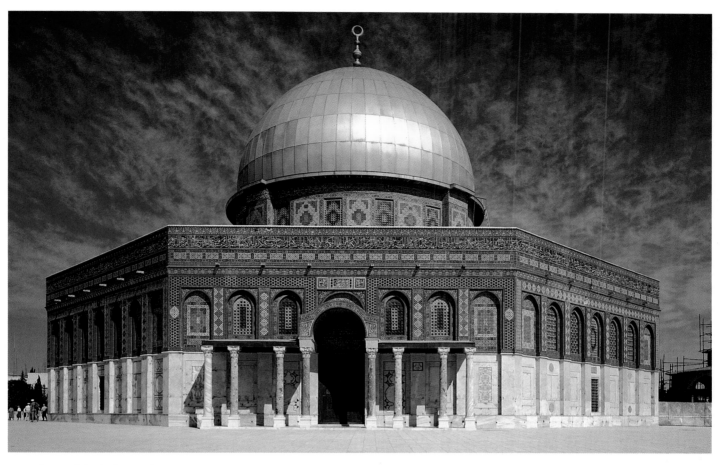

13-1 Dome of the Rock, Jerusalem, 687–692.

The swiftness of the Islamic advance is among the wonders of world history. By 640, Muslim warriors had conquered Syria, Palestine, and Iraq in the name of Islam. In 642, the Byzantine army abandoned Alexandria, marking the Muslim conquest of Lower (northern) Egypt. In 651, Iran was conquered, bringing more than four hundred years of Sasanian rule to an end (see Chapter 2). By 710, all of North Africa had been overrun, and a Muslim army crossed the Strait of Gibraltar into Spain. A victory at Jerez de la Frontera in southern Spain in 711 seemed to open all of western Europe to the Muslims. By 732, they had advanced north to Poitiers in France, where an army of Franks under Charles Martel, the grandfather of Charlemagne, opposed them successfully (see Chapter 16). Although Muslim forces continued to conduct raids in France, they could not extend their control beyond the Pyrenees along the French-Spanish border. But in Spain, the Islamic rulers of Córdoba flourished until 1031, and not until 1492 did Islamic influence and power in the Iberian Peninsula end. That year the Muslims of Granada fell to King Ferdinand and Queen Isabella, the sponsors of Columbus's voyage to the New World. Arab power prevailed in North Africa, the *Maghrib* or Arabic West. In the East, the Muslims reached the Indus River by 751, and only in Anatolia could stubborn Byzantine resistance slow their advance. Relentless Muslim pressure against the shrinking Byzantine Empire eventually caused its collapse in 1453, when the Ottoman Turks conquered Constantinople (see Chapter 12).

The irresistible and far-ranging sweep of Islam from Arabia to India to North Africa and Spain was not due to military might alone. That the initial conquests had effects that endured for centuries can be explained only by the nature of Islamic faith and its appeal to millions of converts. Islam remains today one of the world's great religions, with adherents on all continents. And the sophistication of its civilization has had a profound impact around the globe. Arabic translations of Aristotle and other Greek writers of antiquity were studied eagerly by Christian scholars in the West during the twelfth and thirteenth centuries (see Chapter 18). Arabic love lyrics and poetic descriptions of nature inspired the early French troubadours. Arab scholars laid the foundations of arithmetic and algebra, and their contributions to astronomy, medicine, and the natural sciences have made a lasting impression in the Western world.

EARLY ISLAMIC ART

During the early centuries of Islamic history, the Muslim world's political and cultural center was the Fertile Crescent of ancient Mesopotamia. This crescent-shaped area of cultivable land was strewn with impressive ruins of earlier cultures, from the Sumerians to the Sasanians (see Chapter 2). The caliphs of Damascus (capital of modern Syria) or Baghdad (capital of Iraq) appointed provincial governors to rule the vast territories the Arabs conquered. These governors eventually gained

13-2 Interior of the Dome of the Rock, Jerusalem, 687–692.

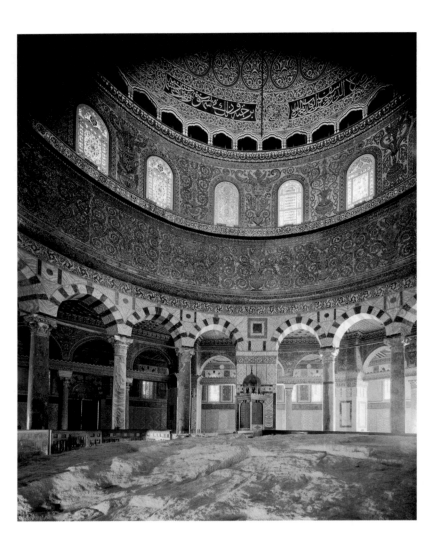

relative independence by setting up dynasties in various territories and provinces: the Umayyads in Syria (661–749) and in Spain (756–1031); the Abbasids in Iraq (749–1258, largely nominal after 945); the Fatimids in Egypt (909–1171); and so on. Despite the Quran's strictures against sumptuousness and attention to worldly pleasures, Islamic rulers often surrounded themselves with luxuries commensurate with their enormous wealth and power. And, like other potentates before and after, they were builders on a grand scale.

Architecture

THE TRIUMPH OF ISLAM IN JERUSALEM The first great achievement of Islamic architecture is in Jerusalem, which the Muslims had taken from the Byzantines in 638. The Dome of the Rock (FIG. **13-1**) was erected by the Umayyad caliph Abd al-Malik (r. 685–705) between 687 and 692. The structure is a monumental sanctuary, an architectural tribute to Islam's triumph. It houses the rock (FIG. **13-2**) from which Muslims believe Muhammad ascended to Heaven during a nocturnal journey recalled in Surah 17 of the Quran. The sanctuary was erected on the traditional site of Adam's burial, of Abraham's preparation for Isaac's sacrifice, and of the Temple of Solomon the Romans destroyed in 70. The Dome of the Rock marked the coming of Islam to the city

that had been, and still is, sacred to both Jews and Christians. The structure rises from a huge platform known as the Noble Enclosure. Even today it dominates the skyline of the holy city.

As Islam took much of its teaching from Judaism and Christianity, so its architects and artists borrowed and transformed design, construction, and ornamentation principles that had been long applied in, and were still current in, Byzantium and the Middle East. The Dome of the Rock is a domed octagon resembling San Vitale in Ravenna (see FIG. 12-6) in its basic design. In all likelihood, it was inspired by a neighboring Christian monument, the rotunda of the Holy Sepulchre, which Constantine the Great began in the fourth century. This rotunda bore a family resemblance to the roughly contemporary mausoleum of Constantine's daughter, now Santa Costanza in Rome (see FIGS. 11-9 and 11-10). The Dome of the Rock is a member of the same extended family. Its double-shelled wooden dome, however, some sixty feet across and seventy-five feet high, so dominates the elevation as to reduce the octagon to function merely as its base. This soaring, majestic unit creates a decidedly more commanding effect than that of late Roman and Byzantine domical structures (for example, FIGS. 11-10 and 12-3). The silhouettes of those domes are comparatively insignificant when seen from the outside. The dominating domed cupola characterized Islamic architecture thereafter and, with the later minaret, still identifies it worldwide.

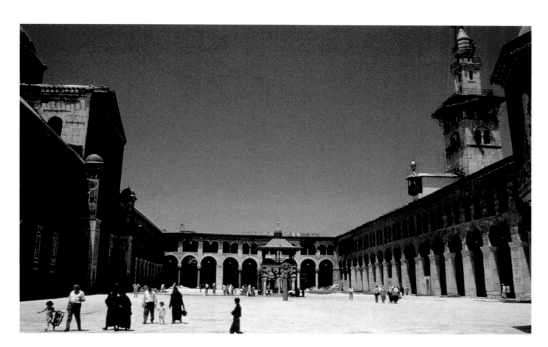

13-3 Great Mosque, Damascus, Syria, 706–715.

13-4 Detail of a mosaic in the courtyard arcade of the Great Mosque, Damascus, Syria, 706–715.

The building's exterior has been much restored. Sixteenth-century and later tiling now replaces the original mosaic. Yet the vivid, colorful patterning that wraps the walls like a textile is typical of Islamic ornamentation. It contrasts markedly with Byzantine brickwork and Greco-Roman sculptured profiling and carved decoration. The interior's rich mosaic ornament (FIG. 13-2) has been preserved. From it one can imagine how the exterior walls originally appeared. Islamic practice does not significantly distinguish interior and exterior decor. The splendor of infinitely various surfaces is given to public gaze both within and outside buildings.

A NEW MOSQUE FOR A NEW CAPITAL The Umayyads transferred their capital from Mecca to Damascus in 661. There, Abd al-Malik's son, the caliph al-Walid (r. 705–715), built an imposing new mosque for the expanding Muslim population where a Byzantine church (formerly a Roman temple) stood. The Umayyads destroyed the church, but they used the Roman precinct walls as a foundation for their own construction. Like the Dome of the Rock, the Great Mosque of Damascus (FIG. 13-3) owes much to the architecture of the Greco-Roman and Early Christian East. The courtyard is bounded by pier arcades reminiscent of Roman aqueducts, and it is constructed of masonry blocks, columns, and capitals salvaged from the Roman and Early Christian structures al-Walid demolished to make way for his mosque. The minarets, two at the southern corners and one at the northern side of the enclosure—the earliest in the Islamic world—are modifications of the preexisting Roman square towers. The grand prayer hall (on the left in our photograph) is on the south side of the courtyard (facing Mecca). Its main entrance is distinguished by a facade with a pediment and arches that recall classical and Byzantine models, respectively. The facade faces into the courtyard, like a Roman forum temple (see FIGS. 10-9 and 10-10), a plan that was maintained throughout the long history of Islamic mosque architecture. The Damascus mosque synthesizes elements received from other cultures into a novel architectural unity, which includes the distinctive Islamic elements of mihrab, mihrab dome, minbar, and minaret (see "The Islamic Mosque," page 364).

An extensive cycle of mosaics covers the walls of the Great Mosque. In our example (FIG. 13-4), a conch shell niche "supports" an arcaded pavilion with a flowering rooftop flanked by structures shown in classical perspective. Like the architectural design, the mosaics owe much to Roman, Early Christian, and Byzantine art (compare FIGS. 10-22 and 11-18). Indeed, some evidence indicates that the Great Mosque mosaics are the work of Byzantine mosaicists.

ARCHITECTURAL BASICS

The Islamic Mosque

Muslim religious architecture is closely related to Muslim prayer, an obligation laid down in the Quran for all Muslims. Prayer as a private act requires neither prescribed ceremony nor a special locale. Only the *qibla*—the direction (toward Mecca) Muslims face while praying—is important. But prayer also became a communal act when the first Muslim community established a simple ritual for it. To celebrate the Muslim sabbath, which occurs on Friday, the community convened once a week for the Friday noonday prayer, probably in the Prophet's house in Medina. The main feature of Muhammad's house was a large square court with two *zullahs,* or shaded areas, along the north and south sides. These zullahs consisted of thatched roofs supported by rows of palm trunks. The southern zullah, wider and supported by a double row of trunks, indicated the qibla. During these communal gatherings, the *imam,* or leader of collective worship, standing on a stepped pulpit known as a *minbar* near the qibla wall, pronounced the *khutba,* a speech that included both a sermon and a profession of the community's allegiance to its leader. The minbar thus represents secular authority even as it serves its function in worship.

These features became standard in the Islamic *mosque* (from Arabic *masjid,* a place for bowing down), where the faithful gathered for the five daily prayers. The *masjid-i jami,* or Friday mosque (also referred to as the congregational or great mosque), was ideally large enough to accommodate a community's entire population for the Friday noonday prayer and khutba. A very important feature both of ordinary mosques and of Friday mosques is the *mihrab,* a semicircular niche usually set into the qibla wall (FIG. 13-9). Often a dome over the bay in front of it signalized its position (FIGS. 13-3, 13-9, and 13-14). The niche was a familiar Greco-Roman architectural feature, generally enclosing a statue. But for Islamic architecture, its origin, purpose, and meaning are still debated. Some scholars believe the mihrab originally may have honored the place where the Prophet stood in his house at Medina when he led the communal prayers. It thus would have been a revered religious memorial. The mihrab also may have symbolized a gateway into Paradise.

In some mosques, the mihrab is preceded by a screened area called the *maqsura,* an area generally reserved for the ruler or his representative. It can be quite elaborate in form (FIG. 13-13). Many mosques, including the very early Great Mosque at Damascus (FIG. 13-3), also have one or more *minarets* (FIGS. 13-3, 13-10, and 13-21), towers for the *muezzin* (crier) to call the faithful to prayer. Early mosques are generally characterized by *hypostyle halls,* prayer halls with roofs supported by a multitude of columns (FIGS. 13-9 and 13-12). Later variations of the early mosque formulation include mosques with four *iwans* (vaulted rectangular recesses), one on each side of the courtyard (FIG. 13-24), and central-plan mosques with a single large dome-covered interior space (FIGS. 13-21 to 13-23), as in Byzantine churches (see Chapter 12).

The mosque's origin is still in dispute, although one prototype may well have been the Prophet's house in Medina. Once the Muslims had firmly established themselves in their conquered territories, they began to build on a large scale, impelled, perhaps, by a desire to create such visible evidence of their power as would surpass in size and splendor that of their non-Islamic predecessors. Today, mosques continue to be erected throughout the world. Despite many variations in design and detail (an adobe-and-wood mosque in Mali, FIG. 15-7, is discussed later in the context of African art) and the employment of modern building techniques and materials unknown in Muhammad's day, the Islamic mosque's essential features are unchanged. All mosques, wherever they are built and whatever their plan, are oriented toward Mecca, and the faithful pray facing the mihrab in the qibla wall.

Characteristically, temples, clusters of houses, trees, and rivers compose the pictorial fields, bounded by stylized vegetal design, familiar in Roman, Early Christian, and Byzantine ornament. No zoomorphic forms, human or animal, appear either in the pictorial or ornamental spaces. This is true of all the mosaics in the Great Mosque as well as the mosaics in the earlier Dome of the Rock (FIG. 13-2). Islamic tradition prohibits the representation of fauna of any kind in sacred places. The world shown in the Damascus mosaics, suspended miragelike in a featureless field of gold, is explained in accompanying inscriptions as an image of Paradise. Many passages from the Quran describe the gorgeous places of Paradise awaiting the faithful—gardens, groves of trees, flowing streams, and "lofty chambers." Indeed, the abundant luxurious images and ornament, floating free of all human reference, create a vision of Paradise appealing to the spiritually oriented imagination, whatever its religion.

AN UMAYYAD DESERT PALACE The Umayyad rulers of Damascus constructed numerous palatial residences throughout the vast territories they governed. The rural palaces were not merely idyllic residences removed from the congestion, noise, and disease of the cities. They seem to have served as nuclei for the agricultural development of conquered territories and possibly as hunting lodges. In addition, the Islamic palaces were symbols of authority over conquered and inherited lands, as well as expressions of their owners' newly acquired wealth.

One of the most impressive Umayyad palaces, despite the fact it was never completed, is at Mshatta in the Jordanian desert (FIGS. 13-5 to 13-7). Its plan (FIG. 13-5) resembles that of Diocletian's palace at Split (see FIG. 10-75), which in turn reflects the layout of a Roman fortified camp. The high walls of the Mshatta palace incorporate twenty-five towers but lack parapet walkways for patrolling guards. The walls, nonethe-

13-5　Plan of the Umayyad palace, Mshatta, Jordan, ca. 740–750 (after Alberto Berengo Gardin).

0　50　100　150　FEET

0　10　20　30　40　50　METERS

1. Entrance gate
2. Mosque
3. Ceremonial courtyard
4. Covered area
5. Audience hall

N

13-6　Detail of the frieze of the Umayyad palace, Mshatta, Jordan, ca. 740–750. Limestone, 16′ 7″ high. Museum für Islamische Kunst, Staatliche Museen, Berlin.

less, offered safety from marauding nomadic tribes and provided privacy for the caliph and his entourage. Visitors entered the palace through a large portal on the south side (FIG. 13-7). To the right was a mosque (the plan shows the mihrab niche in the qibla wall), a necessary element of any isolated palace complex so that the rulers and their guests could fulfill their obligation to pray five times a day. The mosque was sep-

arated from the palace's residential wing and official audience hall by a small open ceremonial courtyard and a large covered area. Most Umayyad palaces also were provided with fairly elaborate bathing facilities that displayed technical features, such as heating systems, adopted from Roman baths. Just as

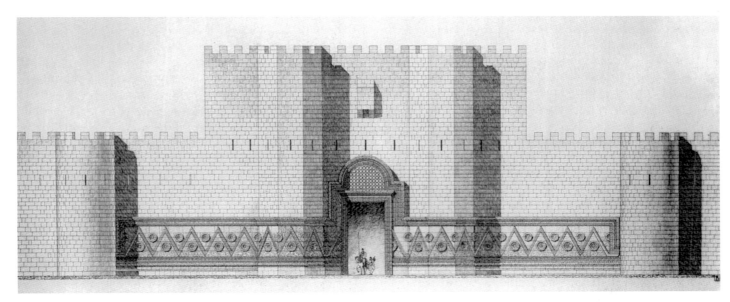

13-7　Reconstruction drawing of the facade of the Umayyed palace, Mshatta, Jordan, ca. 740–750 (after Schulz).

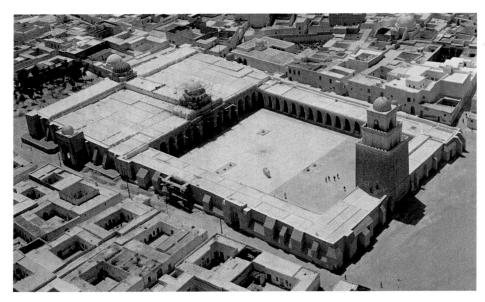

13-8 Aerial view of Great Mosque, Qayrawan, Tunisia, ca. 836–875.

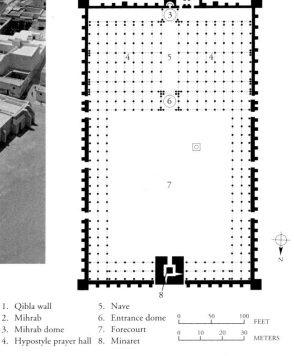

1. Qibla wall
2. Mihrab
3. Mihrab dome
4. Hypostyle prayer hall
5. Nave
6. Entrance dome
7. Forecourt
8. Minaret

13-9 Plan of the Great Mosque, Qayrawan, Tunisia, ca. 836–875.

under the Roman Empire, these baths probably served more than merely hygienic purposes. Indeed, in several Umayyad desert palaces, excavators have uncovered in the baths paintings and sculptures of hunting and other secular themes, including depictions of dancing women—themes traditionally associated with royalty in the Near East. Large halls frequently attached to many of these baths seem to have been used as places of entertainment, as was the case in Roman times. Thus, the bath-spa-social center, a characteristic amenity of Roman urban culture that died out in the Christian world, survived in Islamic culture.

The architectural ornamentation of many of the early Islamic palaces was confined to simply molded stucco and decorative brickwork, but at Mshatta the facade (FIG. 13-7) is enlivened by a richly carved stone frieze. The long band is more than sixteen feet high. Our detail (FIG. 13-6) shows one of a series of triangles framed by elaborately carved moldings. Each triangle contains a large rosette that projects from a field densely covered with curvilinear, vegetal designs. No two triangles were treated the same way, and animal figures appear in some of them. Similar compositions of birds, felines, and vegetal scrolls can be found in Roman, Byzantine, and Sasanian art. The Mshatta frieze, however, has no animal figures to the right of the entrance portal—that is, on the part of the facade corresponding to the mosque's qibla wall.

THE ABBASIDS' ROUND CITY OF PEACE In 750, after years of civil war, the Abbasids, who claimed descent from Abbas, an uncle of Muhammad, overthrew the Umayyad caliphs. The new rulers moved the capital from Damascus to a site in Iraq near the old Sasanian capital of Ctesiphon (see FIG. 2-28). There the caliph al-Mansur (r. 754–775) established a new capital, Baghdad, which he called Madina al-salam, the City of Peace. The city was laid out in 762 at a time astrologers determined as favorable. It was round in plan, about a mile and a half in diameter. The shape signified that the new capital was the center of the uni-

verse. At the city's center was the caliph's palace, oriented to the four compass points.

For almost three hundred years Baghdad was the hub of Arab power and of a brilliant Islamic culture. The Abbasid caliphs were renowned throughout the world and even established diplomatic relations with Charlemagne at Aachen in Germany. The Abbasids lavished their wealth on art, literature, and science and were responsible for the translation of numerous Greek texts that otherwise would have been lost. Many of these works were introduced to the medieval West through their Arabic versions.

A HYPOSTYLE MOSQUE IN TUNISIA Of all the variations in mosque plans, the hypostyle mosque most closely reflects the mosque's supposed origin, Muhammad's house in Medina (see "The Islamic Mosque," page 364). One of the finest hypostyle mosques, still in use today, is the mid-eighth-century Great Mosque at Qayrawan (FIGS. **13-8** and **13-9**) in Abbasid Tunisia. The precinct takes the form of a slightly askew parallelogram of huge scale, some four hundred fifty feet by two hundred sixty feet. Built of stone, its walls have sturdy buttresses, square in profile. The arcaded forecourt is entered through a massive minaret not quite in line with the two domes that fix the axis of the hypostyle prayer hall. The first dome is over the entrance bay. The second, more elaborate one is over the bay that fronts the mihrab set into the qibla wall. The axis is defined by a raised nave flanked by eight columned aisles on either side, space for a large congregation. The nave that connects the entrance dome with the mihrab dome intersects with another nave at right angles to it, running the length of the qibla wall. The resultant **T**-shaped space provides a plan organization and focus often missing from the rambling hypostyle mosque scheme. Inside,

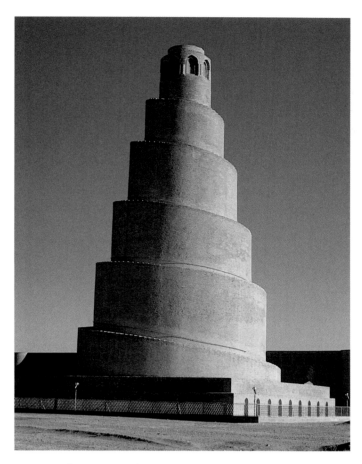

13-10 *Malwiya* minaret of the Great Mosque, Samarra, Iraq, 848–852.

to the right of the mihrab, is the original carved wooden minbar of 862, the oldest known.

THE SPIRAL MINARET OF SAMARRA The three-story minaret of the Qayrawan mosque is square in plan and believed to be a near copy of a Roman lighthouse, but minarets can take a variety of forms. Perhaps the most striking and novel is that of the immense (more than forty-five thousand square yards) Great Mosque at Samarra, the largest mosque in the world. It was erected by the Abbasid caliph al-Mutawakkil (r. 847–861) between 848 and 852. Known as the *Malwiya* ("snail shell" in Arabic) minaret (FIG. **13-10**) and more than 165 feet tall, it now stands alone but originally was linked to the mosque by a bridge. The brick tower is distinguished by its spiral ramp, which increases in slope from bottom to top. Many have compared its form to the ziggurats of ancient Mesopotamia (see FIGS. 2-2 and 2-14), but those rectilinear stepped platforms bear very little resemblance to the Samarran minaret. Some later European depictions of the biblical Tower of Babel (Babylon's ziggurat; see "Babylon: City of Wonders," Chapter 2, page 37) were, however, inspired by the *Malwiya* minaret.

MEMORIALIZING THE DEAD The eastern realms of the Abbasid empire were overseen by dynasties of governors who exercised considerable independence while recognizing the ultimate authority of the Baghdad caliphs. One of these dynasties, the Samanids (r. 819–1005), presided over the eastern frontier beyond the Oxus River (Transoxiana) on the

border with India. In the early tenth century, they erected an imposing domed brick mausoleum at Bukhara in modern Uzbekistan (FIG. **13-11**). Monumental tombs were virtually unknown in the early Islamic period. Muhammad had been opposed to elaborate burials and instructed his followers to bury him in a simple unmarked grave. In time, however, the Prophet's resting place in Medina was enclosed by a wooden screen and covered by a dome. By the ninth century, Abbasid caliphs were laid to rest in dynastic mausoleums.

The Samanid mausoleum at Bukhara is one of the earliest preserved tombs in the Islamic world. It is constructed of baked bricks and takes the form of a cube with slightly sloping sides capped by a dome. The builders painstakingly shaped the bricks to create a vivid and varied surface pattern. Some of the bricks form engaged columns at the corners. A brick *blind arcade* (a series of arches in relief, with blocked openings) runs around all four sides. Inside, the walls are as elaborate as the exterior. The brick dome rests on eight arcuated brick squinches (see "Pendentives and Squinches," Chapter 12, page 332) framed by engaged *colonnettes* (small columns). The dome-on-cube form had a long and distinguished future in Islamic funerary architecture.

THE SPLENDOR OF UMAYYAD CÓRDOBA In 750, only one Umayyad notable, Abd-al-Rahman I, escaped the Abbasid massacre of his clan in Syria. He fled to Spain, where, as noted earlier, the Arabs had overthrown the Christian kingdom of the Visigoths in 711. The Arab military governors of the peninsula accepted the fugitive as their overlord, and he founded the Spanish Umayyad dynasty, which lasted for almost three centuries. The capital of the Spanish Umayyads was Córdoba, which became the center of a brilliant culture rivaling that of the Abbasids at Baghdad and exerting major influence on the civilization of the Christian West.

The jewel of the capital at Córdoba was its Great Mosque, begun in 784 and enlarged several times during the ninth and

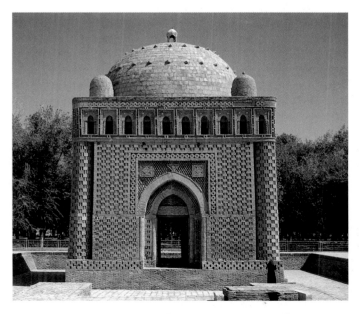

13-11 Mausoleum of the Samanids, Bukhara, Uzbekistan, early tenth century.

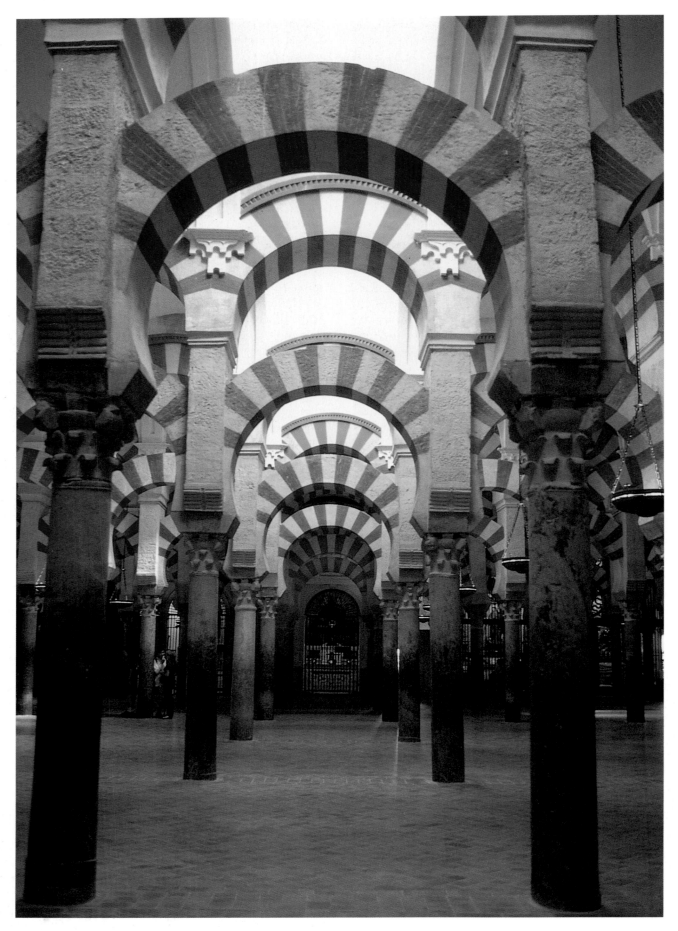

13-12 Prayer hall of the Great Mosque, Córdoba, Spain, eighth to tenth centuries.

tenth centuries. It eventually became the largest mosque in the Islamic West. The additions followed the original style and arrangement of columns and arches, and the builders maintained a striking stylistic unity for the entire building. The hypostyle prayer hall (FIG. **13-12**) has thirty-six piers and five hundred fourteen columns topped by a unique system of double-tiered arches that carried a wooden roof (now replaced by vaults). The lower arches are horseshoe shaped, a form perhaps adapted from earlier Near Eastern architecture or of Visigothic origin. The horseshoe arch quickly became closely associated with Muslim architecture. Visually, these arches seem to billow out like sails blown by the wind, and they contribute greatly to the light and airy effect of the mosque's interior.

The caliph al-Hakam II (r. 961–976) undertook major renovations to the Córdoba mosque. His builders expanded the prayer hall and added a series of domes. They also erected the elaborate screened maqsura (FIG. **13-13**), with its highly decorative multilobed arches, a variation on the two-tiered system of arches in the prayer hall. The area was reserved for the caliph and was connected to his palace by a corridor in the qibla wall. Early Islamic buildings had wooden roofs, and the experiments with arch forms were motivated less by structural necessity than by a desire to create rich and varied abstract patterns. In Córdoba's maqsura the builders further enhanced the magnificent effect of the complex arches by sheathing the walls with marbles and mosaics. The mosaicists and even the tesserae were brought to Spain from Constantinople by al-Hakam II.

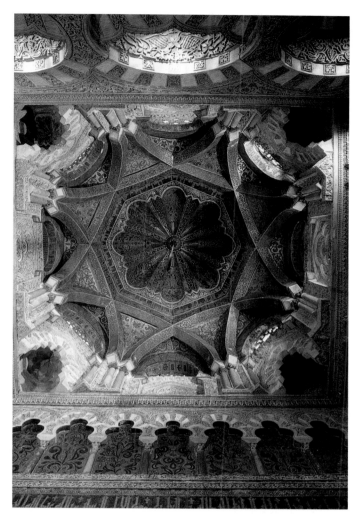

13-14 Dome in front of the mihrab of the Great Mosque, Córdoba, Spain, 961–965.

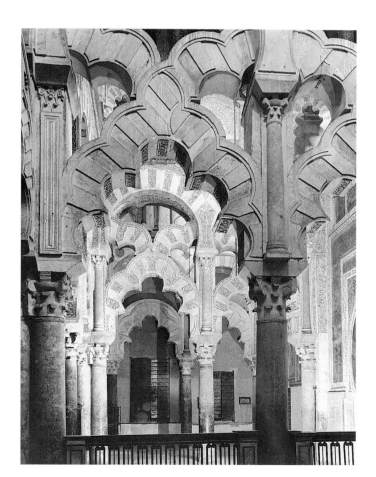

13-13 Maqsura of the Great Mosque, Córdoba, Spain, 961–965.

The same desire for decorative effect inspired the design of the dome that covers the area in front of the mihrab (FIG. **13-14**), one of the four domes built during the tenth century to emphasize the axis leading to the mihrab. The dome rests on an octagonal base of arcuated squinches and is crisscrossed by ribs that form an intricate pattern centered on two squares set at forty-five-degree angles to each other. The mosaic-clad surfaces are the work of the same Byzantine artists responsible for the maqsura's decoration.

Luxury Arts

ISLAMIC DESIGN In the mosaics at Córdoba, as elsewhere in the Islamic world, most of the design elements are based on plant motifs, which are sometimes intermingled with abstract geometric shapes and, in secular settings, with animal figures. But the natural forms often are so stylized that they are lost in the purely decorative tracery of the tendrils, leaves, and stalks. These *arabesques,* as they are often called because they are so characteristic of Islamic ("Arab") art, form a pattern that covers an entire surface, whether that of a small utensil or the wall

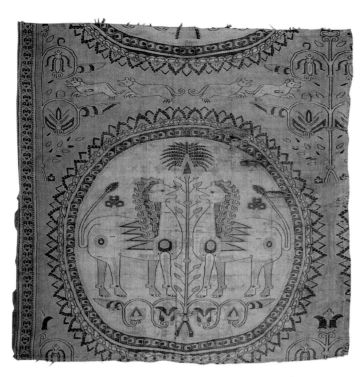

13-15 Confronting lions and palm tree, fragment of a textile from Zandana, Uzbekistan, eighth century. Silk compound twill, 2′ 11″ × 2′ 9½″. Musée Historique de Lorraine, Nancy.

of a building. In all periods of Islamic art, the relationship of one form to another has been more important than the design's totality. The patterns have had no function but to decorate.

This ornamental system offers a potential for unlimited growth, as it permits extension of the designs in any desired direction. Most characteristic, perhaps, is the design's independence of its carrier. Neither its size (within limits) nor its forms are dictated by anything but the design itself. This arbitrariness imparts a certain quality of impermanence to Islamic design, a quality that may reflect the Muslim taste for readily movable furnishings, such as rugs and hangings. Wood is scarce in most of the Islamic world, and the kind of furniture used in the West—beds, tables, and chairs—is rarely found in Muslim structures. Architectural spaces, therefore, are not defined by the type of furniture placed in them. A room's function (eating or sleeping, for example) can change simply by rearranging the carpets and cushions.

ISLAMIC SILK IN A FRENCH CATHEDRAL
Silk textiles and wool carpets are among the glories of Islamic art. Unfortunately, because of their fragile nature and the heavy wear carpets endure, early Islamic textiles are rare today and often fragmentary. Silk thread was also very expensive. Produced by silkworms, which only can flourish in certain temperate regions, silk textiles were manufactured first in China in the third millennium B.C. They were shipped over what came to be called the Silk Road through Asia to the Middle East and Europe (see "Silk and the Silk Road," Chapter 7, page 194).

One of the earliest Islamic silks (FIG. **13-15**) is found today in Nancy, France. Unfortunately, it is fragmentary and its colors,

once rich blues, greens, and oranges, faded long ago. The silk survives because it is associated with the relics of Saint Amon housed in Toul Cathedral. The precious fabric may have been used to wrap the treasures when they were transported to France in 820. It probably dates to the eighth century and comes from Zandana near Bukhara. The design consists of repeated medallions with confronting lions flanking a palm tree. Other animals scamper across the silk between the roundels. Such zoomorphic motifs are foreign to the decorative vocabulary of mosque architecture, but they could be found in Muslim households—even in Muhammad's in Medina. The Prophet, however, was said to have objected to curtains decorated with figures and permitted only cushions adorned with animals or birds.

A SIGNED ZOOMORPHIC EWER The furnishings of Islamic palaces and mosques reflected a love of sumptuous materials and rich decorative patterns. Metal, wood, glass, and ivory were artfully worked into a great variety of objects for the mosque or home. Colored glass was used with striking effect in mosque lamps. Ornate ceramics of high quality were produced in large numbers. Basins, ewers, jewel cases, writing

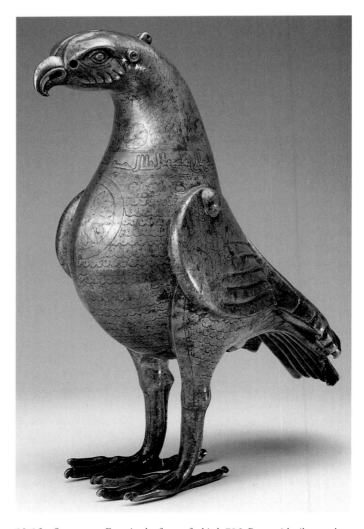

13-16 SULAYMAN, Ewer in the form of a bird, 796. Brass with silver and copper inlay, 1′ 3″ high. Hermitage, Saint Petersburg.

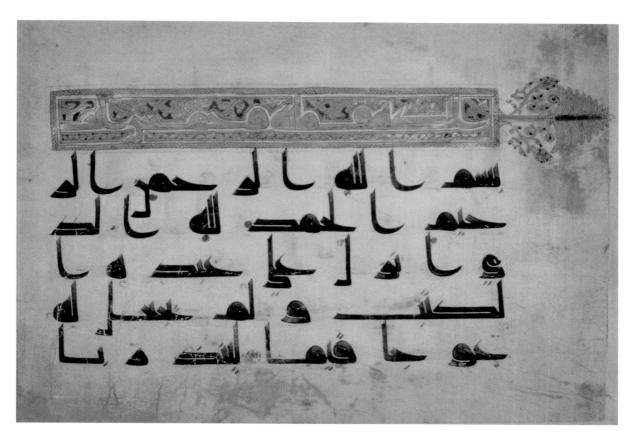

13-17 Quran page with beginning of surah 18, *al-Kahf (The Cave),* ninth or early tenth century. Ink and gold on vellum, $7\frac{1}{4}'' \times 10\frac{1}{4}''$. Chester Beatty Library and Oriental Art Gallery, Dublin.

boxes, and other decorative items were made of bronze or brass, engraved, and inlaid with silver.

One of the most striking examples of the metalworker's art is the cast brass ewer in the form of a bird (FIG. **13-16**) signed by SULAYMAN and dated 796. (The place of origin also was inscribed but is illegible today.) Some fifteen inches tall, the ewer is nothing less than a freestanding statuette. But its utilitarian purpose meant Sulayman did not have to fear accusations of fashioning an idol—the holes between the eyes and beak function as a spout. The decoration on the body, which bears traces of silver and copper inlay, takes a variety of forms. In places, the etched lines seem to suggest natural feathers, but the rosettes on the neck, the large medallions on the breast, and the inscribed collar have no basis in anatomy. Similar motifs can be found in Islamic textiles, pottery, and architectural tiles. The ready adaptability of motifs to various scales and to various techniques again illustrates both the flexibility of Islamic design and its relative independence from its carrier.

THE ART OF THE QURAN In the Islamic world, the art of *calligraphy,* ornamental writing, was more revered even than the art of textiles. The faithful wanted to reproduce the Quran's sacred words in as beautiful a script as human hands could contrive. And these words were displayed not only on the fragile pages of books but also on the walls of buildings. Quotations from the Quran appear, for example, in a mosaic band above the outer ring of columns inside the Dome of the Rock (FIG. 13-2). The practice of calligraphy was itself a holy task and required long and arduous training. The scribe had

to possess exceptional spiritual refinement. An ancient Arabic proverb proclaims, "Purity of writing is purity of soul." Only in China does calligraphy hold so supreme a position among the arts (see "Inscriptions on Chinese Paintings," Chapter 26, page 805).

Arabic script predates Islam. It is written from right to left with certain characters connected by a baseline. Although the chief Islamic book, the sacred Quran, was codified in the mid-seventh century, the earliest preserved Qurans date to the eighth century. Quran pages were either bound into books or stored as loose sheets in boxes. Most of the early examples are written in the script form called *Kufic,* after the city of Kufah, one of the renowned centers of Arabic calligraphy. Kufic script is quite angular, with the uprights forming almost right angles with the baseline. As with Hebrew and other Semitic languages, the usual practice was to write in consonants only. But to facilitate recitation of the Quran, scribes often indicated vowels by red or yellow symbols above or below the line.

All of these features can be seen on a ninth-century or early tenth-century page (FIG. **13-17**) in Dublin that carries the heading and opening lines of surah 18 of the Quran. Five text lines in black ink with red vowels appear below a decorative band incorporating the chapter title in gold and ending in a palm-tree *finial* (a crowning ornament). This approach to page design has parallels at the extreme northwestern corner of the then-known world—in the early medieval manuscripts of the British Isles, where text and ornament are similarly united (see FIG. 16-7). But the stylized human and animal forms that populate those Christian books never appear in Qurans.

LATER ISLAMIC ART

Architecture

THE LAST ISLAMIC STRONGHOLD IN SPAIN
In the early years of the eleventh century, the Umayyad caliphs' power in Spain unraveled, and their palaces fell prey to Berber soldiers from North Africa. The Berbers ruled southern Spain for several generations but could not resist the pressure of Christian forces from the north. Córdoba fell to the Christians in 1236. From then until the final Christian triumph in 1492, the Nasrids, an Arab dynasty that established its capital at Granada, ruled the remaining Muslim territories in Spain.

On a rocky spur at Granada, the Nasrids constructed a huge palace-fortress called the Alhambra ("the Red" in Arabic) because of the rose color of the stone used for its walls and twenty-three towers. By the end of the fourteenth century, the complex, a veritable city with a population of some forty thousand Muslims, included at least a half dozen royal residences. Only two of these fared well over the centuries. They present a vivid picture of court life in Islamic Spain before the final Christian conquest. Paradoxically, the two palaces owe their preservation to their Christian conquerors, who maintained a few of the buildings as trophies commemorating the expulsion of the Muslims.

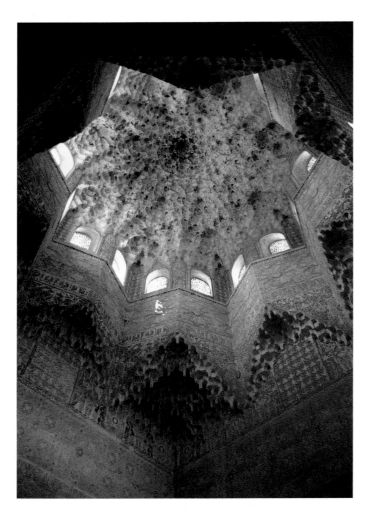

13-18 Muqarnas dome, Hall of the Two Sisters, Alhambra palace, Granada, Spain, 1354–1391.

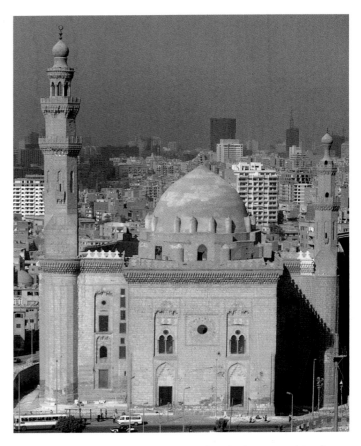

13-19 Madrasa-mosque-mausoleum complex of Sultan Hasan (view from the south with the mausoleum in the foreground), Cairo, Egypt, begun 1356.

PARADISE AND THE DOME OF HEAVEN One of those palaces is the Palace of the Lions, named for the courtyard fountain with marble lions carrying its water basin on their backs. It is an unusual instance of freestanding stone sculpture in the Islamic world. The palace was the residence of Muhammad V (r. 1354–1391), and its courtyards, lush gardens, and luxurious carpets and other furnishings were designed to conjure the image of Paradise. The complex is noteworthy also for its elaborate stucco ceilings and walls, which never fail to impress visitors.

We reproduce a view of the ceiling of the so-called Hall of the Two Sisters (FIG. **13-18**) in the Palace of the Lions. The dome of the square room rests on an octagonal drum supported by squinches and pierced by eight pairs of windows, but its structure is difficult to discern because of the intricate surface decoration. The ceiling is covered with some five thousand *muqarnas* ("stalactites")—tier after tier of nichelike prismatic forms that seem aimed at denying the structure's solidity. The muqarnas ceiling was intended to catch and reflect sunlight. The lofty vault in this hall and others in the palace were meant to symbolize the dome of heaven. The flickering light and shadows create the effect of a starry sky as the sun's rays move from window to window during the day. To underscore the symbolism, the palace walls were inscribed with verses by the court poet Ibn Zamrak, who compares the Alhambra's lacelike muqarnas ceilings to "the heavenly spheres whose orbits revolve."

THE SLAVE SULTANS OF EGYPT In the mid-thirteenth century, the Mongols from east-central Asia conquered much of the eastern Islamic world. The center of Is-

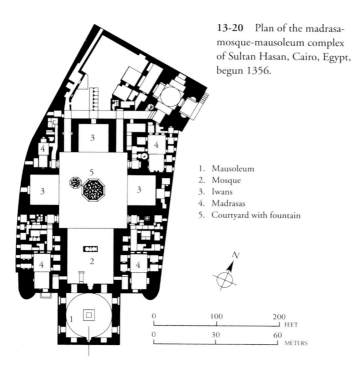

13-20 Plan of the madrasa-mosque-mausoleum complex of Sultan Hasan, Cairo, Egypt, begun 1356.

1. Mausoleum
2. Mosque
3. Iwans
4. Madrasas
5. Courtyard with fountain

lamic power moved from Baghdad to Egypt. The lords of Egypt at the time were former Turkish slaves (*mamluks* in Arabic) who converted to Islam. The capital of the Mamluk *sultans* (rulers) was Cairo, which became the largest Muslim city of the late Middle Ages. The Mamluks were ambitious builders, and Sultan Hasan, although not an important figure in Islamic history, was the greatest of all. He ruled briefly as a child and was deposed but regained the sultanate from 1354 until 1361, when he was assassinated.

Hasan's major building project in Cairo was a huge madrasa complex (FIGS. **13-19** and **13-20**) on a plot of land about eight thousand square yards in area. The *madrasa* ("place of study" in Arabic) is a later Islamic institution, a theological college devoted to the teaching of orthodox Sunni Islamic law. Hasan's complex was so large that it housed not only four such colleges for the study of the four major schools of Islamic law but also a mosque, mausoleum, orphanage, and hospital, as well as shops and baths. Like all Islamic building complexes incorporating religious, educational, and charitable functions, this one was supported by a *waqf,* or endowment. Hasan's waqf consisted of various rental properties. The income from these paid the salaries of attendants and faculty, provided furnishings and supplies such as oil for the lamps or free food for the poor, and supported scholarships for needy students.

The grandiose structure has a large central courtyard with a monumental fountain in the center and four *iwans* (rectangular vaulted recesses) opening onto it, a design used earlier for Iranian mosques (FIG. 13-24). In each corner of the main courtyard (FIG. 13-20), between the iwans, is a madrasa with its own courtyard and four or five stories of rooms for the students. The largest iwan in the complex, on the southeastern side, served as a mosque. Contemporaries believed the soaring vault that covered the iwan-mosque was taller than the arch of the Sasanian palace at Ctesiphon (see FIG. 2-28), which was then one of the most admired engineering feats in the world. Behind the qibla wall stands the sultan's mausoleum, a gigantic version of the Samanid mausoleum at Bukhara (FIG.

13-11). The siting of the dome-covered cube south of the mosque was carefully calculated. The prayers of the faithful facing the mihrab and Mecca, therefore, were directed toward Hasan's tomb. (Only the sultan's two sons are actually buried there. Hasan's body was not returned when he was killed.)

The exterior walls of the complex are crowned by a muqarnas cornice, and the mihrab in the mosque and the walls of Hasan's mausoleum are covered with marble plaques of several colors. But the complex as a whole is relatively austere, characterized by its massiveness and geometric clarity. It presents a striking contrast to the filigreed elegance of the contemporary Alhambra, and testifies to the diversity of regional styles within the Islamic world, especially after the end of the Umayyad and Abbasid dynasties.

THE OTTOMANS COME TO POWER During the ninth and tenth centuries, the Turkic people, of central Asian origin, had been converted to Islam. They moved into Iran and the Near East in the eleventh century, and by 1055 the Seljuk Turkish dynasty had built an extensive, although short-lived, empire that stretched from India to western Anatolia. By the end of the twelfth century, this empire had broken up into regional states, and in the early thirteenth century it came under the sway of the Mongols, led by Genghis Khan. After the Seljuks fell, several local dynasties established themselves in Anatolia, among them the Ottomans, founded by Osman I (r. 1290–1326). Under Osman's successors, the Ottoman state expanded for a period of two and a half centuries throughout vast areas of Asia, Europe, and North Africa to become, by the middle of the fifteenth century, one of the great world powers.

The Ottoman emperors were lavish patrons of architecture. Ottoman builders developed a new type of mosque with a square prayer hall covered by a dome as its core. In fact, the dome-covered square, which had been a dominant form in Iran and was employed for the early-tenth-century mausoleum at Bukhara (FIG. 13-11), became the nucleus of all Ottoman architecture. The combination had an appealing geometric clarity. At first used singly, the domed units came to be used in multiples, a turning point in Ottoman architecture. The resultant Ottoman style is geometric and formalistic, rather than ornamental.

After the Ottoman Turks conquered Constantinople (which they renamed Istanbul) in 1453, they firmly established their architectural code. The new lords of Constantinople were impressed by Hagia Sophia (see FIGS. 12-3 to 12-5), which, in some respects, conformed to their own ideals. They converted the Byzantine church into an Islamic mosque with minarets. But the longitudinal orientation of Hagia Sophia's interior never satisfied Ottoman builders, and Anatolian development moved instead toward the central-plan mosque.

SINAN AND THE CENTRAL-PLAN MOSQUE The first examples of the central-plan mosque were built in the 1520s, eclipsed later only by the works of the most famous Ottoman architect, SINAN (ca. 1491–1588). A contemporary of Michelangelo and with equal aspirations to immortality, Sinan perfected the Ottoman architectural style. By his time, the basic domed unit was universally used. It could be multiplied, enlarged, or contracted as needed, and almost any number of units could be used together. Thus, the typical Ottoman

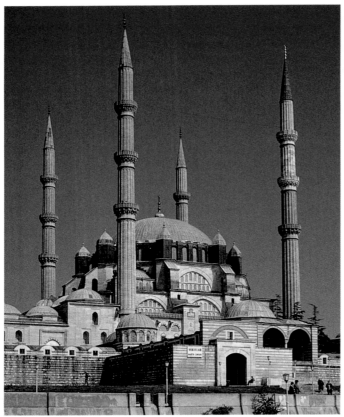

13-21 SINAN, Mosque of Selim II, Edirne, Turkey, 1568–1575.

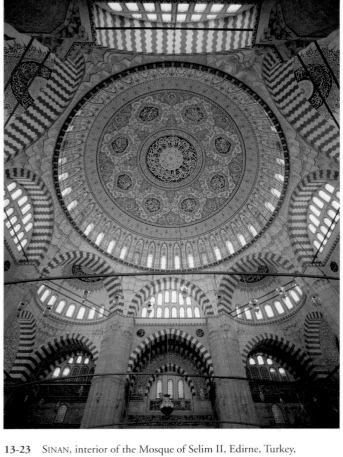

13-23 SINAN, interior of the Mosque of Selim II, Edirne, Turkey, 1568–1575.

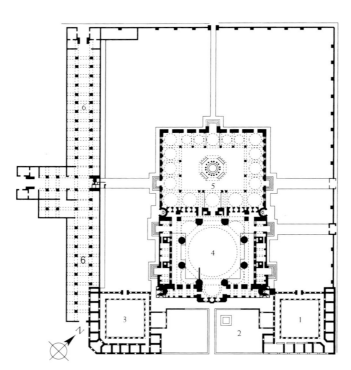

1. Madrasa
2. Cemetery
3. Darül-Kurra (house for the readers of the Quran)
4. Mosque
5. Avlu (courtyard forming summer extension of mosque)
6. Arasta (covered market)

13-22 SINAN, plan of the Mosque of Selim II, Edirne, Turkey, 1568–1575.

building of Sinan's time was a creative assemblage of domical units and artfully juxtaposed geometric spaces. Builders usually erected domes with an extravagant margin of structural safety that since has served them well in earthquake-prone Istanbul and other Ottoman cities. (The sound construction of the Ottoman mosques was vividly demonstrated in August 1999 when a powerful earthquake centered sixty-five miles east of Istanbul toppled hundreds of modern buildings and killed thousands of people but caused no damage to the centuries-old mosques.) Working within this architectural tradition, Sinan searched for solutions to the problems of unifying the additive elements and of creating a monumental centralized space with harmonious proportions.

Sinan's efforts to overcome the limitations of a segmented interior found their ultimate expression in the Mosque of Selim II at Edirne (FIGS. **13-21** to **13-23**), which had been the Ottoman Empire's capital from 1367 to 1472 and remained the imperial residence. There Sinan created a structure that made the mihrab visible from almost any spot in the mosque. The massive dome, effectively set off by four slender pencil-shaped minarets (each more than two hundred feet high, among the tallest ever constructed), dominates the city's skyline (FIG. 13-21). Various dependent structures were placed around the mosque. Most important Ottoman mosques had numerous annexes, including libraries and schools, hospices, baths, soup kitchens for the poor, markets, and hospitals, as well as a cemetery containing the mausoleum of the sultan responsible for building the mosque (compare Hasan's complex

WRITTEN SOURCES

Sinan the Great, the Mosque of Selim II, and Hagia Sophia

Sinan (ca. 1491–1588), called "Sinan the Great," was in fact the greatest Ottoman architect. Born in Anatolia to a Christian family, he was recruited for service in the Ottoman government, converted to Islam, and was trained in engineering and the art of building while in the Ottoman army. His talent was quickly recognized, and he was entrusted with increasing responsibility until, in 1538, he was appointed the chief court architect for Suleyman the Magnificent (r. 1520–1566), a generous patron of art and architecture. Hundreds of building projects, both sacred and secular, have been attributed to Sinan, although he could not have been involved with all that bear his name.

The capstone of Sinan's distinguished career was the mosque (FIGS. 13-21 to 13-23) he designed when he was almost eighty years old for Suleyman's son, Selim II (r. 1566–1574), at Edirne, site of the Ottoman imperial residence. Sa'i Mustafa Çelebi, Sinan's biographer, recorded the architect's achievement in his own words:

> Sultan Selim Khan ordered the erection of a mosque in Edirne. . . . His humble servant [I, Sinan] prepared for him a drawing depicting,

on a dominating site in the city, four minarets on the four corners of a dome. . . . Those who consider themselves architects among Christians say that in the realm of Islam no dome can equal that of the Hagia Sophia; they claim that no Muslim architect would be able to build such a large dome. In this mosque, with the help of God and the support of Sultan Selim Khan, I erected a dome six cubits higher and four cubits wider than the dome of the Hagia Sophia.[1]

Sinan's dome is, in fact, higher than Hagia Sophia's (see FIGS. 12-3 to 12-5) when measured from its base, but its crown is not as far above the pavement as that of the dome of Justinian's church. Nonetheless, Sinan's feat was universally acclaimed as a triumph, and the Mosque of Selim II was considered proof that the Ottomans finally had surpassed the greatest achievement of the Christian emperors of Byzantium in the realm of architecture.

[1]Aptullah Kuran, *Sinan: The Grand Old Master of Ottoman Architecture* (Washington, D.C.: Institute of Turkish Studies, 1987), 168–69.

in Cairo, FIG. 13-20). These utilitarian buildings were grouped around the mosque and axially aligned with it if possible. More generally, they were adjusted to their natural site and linked with the central building by planted shrubs and trees.

The Edirne mosque is preceded by a rectangular court covering an area equal to that of the building (FIG. 13-22). Porticoes formed by domed squares surround the courtyard. Behind it, the building rises majestically to its climactic dome, whose height surpasses that of Hagia Sophia (see "Sinan the Great, the Mosque of Selim II, and Hagia Sophia," above). But it is the organization of this mosque's interior space (FIG. 13-23) that reveals the genius of its builder. The mihrab is recessed into an apselike alcove deep enough to permit window illumination from three sides, making the brilliantly colored tile panels of its lower walls sparkle as if with their own glowing light. The plan of the main hall is an ingenious fusion of an octagon with the dome-covered square. The octagon, formed by the eight massive dome supports, is pierced by the four half-dome-covered corners of the square. The result is a fluid interpenetration of several geometric volumes that represents the culminating solution to Sinan's lifelong search for a monumental unified interior space. Sinan's forms are clear and legible, like mathematical equations. Height, width, and masses are related to one another in a simple but effective ratio of 1:2. The building is generally regarded as the climax of Ottoman architecture. Sinan proudly proclaimed it his masterpiece.

IRANIAN MOSQUES SHEATHED WITH TILES
The Mosque of Selim II at Edirne was erected during a single building campaign under the direction of a single master architect, but many other major Islamic architectural projects were built or remodeled over several centuries. A case in point is the Great Mosque at Isfahan (FIG. 13-24) in Iran. The earliest mosque on the site, of the hypostyle type, was constructed in the eighth century during the caliphate of the Abbasids. But the present edifice was begun in the eleventh century by Sultan Malik Shah I (r. 1072–1092), whose capital was at Isfahan. The later mosque consists of a large courtyard bordered by a two-story arcade on each side. As in the fourteenth-century complex of Sultan Hasan in Cairo (FIG. 13-20), four iwans open onto the courtyard, one at the center of each side. The southwestern iwan leads into a dome-covered room in front of the mihrab. It functioned as a maqsura reserved for the sultan and his attendants. It is uncertain whether this plan, with four iwans and a dome before the mihrab, was employed for the first time in the Great Mosque at Isfahan, but it became standard in Iranian mosque design. In four-iwan mosques the qibla iwan is always the largest. Its size (and the dome that often accompanied it) immediately indicated to worshipers the proper direction for prayer.

We illustrate the Isfahan mosque's northwestern iwan, whose soaring pointed arch frames a tile-sheathed muqarnas vault. The muqarnas ceiling probably was installed in the fourteenth century, and the ceramic-tile revetment on the walls and vault is the work of the seventeenth-century Safavid rulers of Iran. The use of glazed tiles has a long history in the Middle East. Even in ancient Mesopotamia, gates and walls were sometimes covered with colorful baked bricks (see FIGS. 2-23 and 2-26). In the Islamic world, the art of ceramic tilework reached its peak in the sixteenth and seventeenth centuries in Turkey and Iran (see "Islamic Tilework," page 377). Employed as a veneer over a brick core, tiles could sheathe entire buildings, including domes and minarets.

13-24 Courtyard of the Great Mosque, Isfahan, Iran, eleventh to seventeenth centuries.

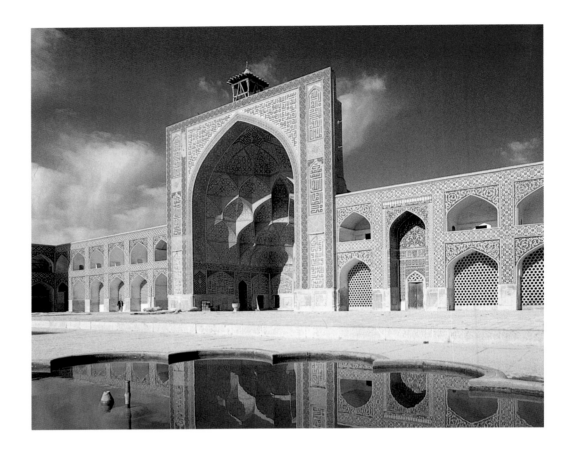

13-25 Dome of the Shah Mosque, Isfahan, Iran, 1611–1638.

MATERIALS AND TECHNIQUES

Islamic Tilework

From the Dome of the Rock (FIGS. 13-1 and 13-2), the earliest major Islamic building, to the present day, mosaics or ceramic tiles have been used to decorate the walls and vaults of mosques, madrasas, palaces, and tombs. The golden age of Islamic tilework was the sixteenth and seventeenth centuries. At that time, Islamic artists used two basic techniques to enliven building interiors with brightly colored tiled walls and to sheathe their exteriors with gleaming tiles that reflected the sun's rays.

In *mosaic tilework* (FIG. 13-26), large ceramic panels of single colors are fired in the potter's kiln and then cut into smaller pieces and set in plaster in a manner similar to the laying of mosaic tesserae of stone or glass (see "Mosaics," Chapter 11, page 314).

Cuerda seca (dry cord) tilework was introduced in Umayyad Spain during the tenth century—hence its Spanish name even in Middle Eastern and Central Asian contexts. Cuerda seca tiles (for example, FIGS. 13-1 and 13-25) are polychrome and can more easily bear complex arabesque patterns as well as Arabic script. They are more economical to use because vast surfaces can be covered with large tiles much more quickly than they can with thousands of smaller mosaic tiles. Polychrome tiles, however, have drawbacks. Because all the glazes are fired at the same temperature, cuerda seca tiles are not as brilliant in color as mosaic tiles. The preparation of the multicolored tiles also requires greater care. To prevent the colors from running together during firing, the potters outline the motifs on cuerda seca tiles with a greasy pigment containing manganese that leaves a matte black line between the colors after firing.

The Shah (or Royal) Mosque in Isfahan, which dates from the early seventeenth century, is widely recognized as one of the masterpieces of Islamic tilework. Our detail (FIG. **13-25**) shows the dome and one minaret of the qibla iwan. Beautifully adjusted to the dome's shape, the design of the spiraling tendrils is at once rich and subtle, enveloping the dome without overpowering it. In contrast to the more general Islamic tendency to disguise structure, the design here enhances the dome's form without obscuring it. On parts of the dome and on the minarets, the cuerda seca tiles are curved to conform to the shape of the architecture, a technological triumph by the Iranian ceramicists.

CERAMIC CALLIGRAPHY We noted earlier the Quran's central importance to the Islamic world and how its verses appeared in the mosaics of the earliest great Islamic building, the Dome of the Rock in Jerusalem (FIG.13-2). Excerpts from the Quran appear on the walls of numerous other Islamic structures in a variety of media. Indeed, some of the masterworks of Arabic calligraphy are found not in manuscripts but on walls. A fourteenth-century mihrab from the Madrasa Imami in Isfahan (FIG. **13-26**) exemplifies the perfect aesthetic union between the calligrapher's art and the system of abstract Islamic ornamentation known as arabesque. The mihrab, now in the Metropolitan Museum of Art in New York, resembles the tiled dome of the Shah Mosque of Isfahan (FIG. 13-25), although it is much earlier in date. The two monuments, though also of greatly different scale, manifest the same design principles.

The pointed arch that immediately enframes the mihrab niche bears an inscription from the early Quran in Kufic, the stately rectilinear script employed for the early Quran page illustrated (FIG. 13-17). The many supple cursive styles that make up the repertoire of Islamic calligraphy are derived

13-26 Mihrab from the Madrasa Imami, Isfahan, Iran, ca. 1354. Glazed mosaic tilework, 11′3″ × 7′6″. Metropolitan Museum of Art, New York.

from Kufic. One of these styles, known as *Muhaqqaq,* fills the mihrab's outer rectangular frame. The mosaic tile ornament on the curving surface of the niche and the *transom* (crosspiece) above the arch are composed of tighter and looser networks of geometric and abstract floral motifs. The mosaic technique is masterful. Every piece had to be sawn to fit its specific place in the mihrab—even the tile inscriptions. The framed inscription in the niche's center—proclaiming that the mosque is the domicile of the pious believer—is smoothly integrated with the subtly varied patterns. The mihrab's outermost inscription—detailing the five pillars of Islamic faith—serves as a fringelike extension, as well as a boundary, for the entire design. The calligraphic and geometric elements are so completely unified that only the practiced eye can distinguish them. The artist transformed the architectural surface into a textile surface, the three-dimensional wall into a two-dimensional hanging, weaving the calligraphy into it as another cluster of motifs within the total pattern.

PARADISE IN INDIA Although Spain had been surrendered to the Christians at the end of the fifteenth century, in the sixteenth and seventeenth centuries Islam remained the leading religion throughout Anatolia, North Africa, the Middle East, and Central Asia, usurping other faiths in many areas. Suleyman the Magnificent, for example, presided over the Ottoman Empire from his capital at Istanbul, formerly Con-

stantinople, the seat of the Christian Byzantine Empire. In India, the Muslim Mughal dynasty held sway over a mixed population of Muslims, Hindus, and Jains (see Chapter 25). The Mughals were fabulously wealthy, and many of their cities and buildings rank among the most impressive achievements of Asian architecture.

The most famous of all the Islamic buildings of India is the fabled Taj Mahal at Agra (FIG. **13-27**). This immense mausoleum was erected by Shah Jahan (r. 1628–1658) as a memorial to his favorite wife, Mumtaz Mahal, but the ruler himself eventually was buried there as well. The central block's dome-on-cube shape is descended from that of the Samanid mausoleum at Bukhara (FIG. 13-11) and also reflects the basic form of the mausoleum of Sultan Hasan in Cairo (FIG. 13-19). But modifications and refinements have converted the earlier massive structures into an almost weightless vision of cream-colored marble. The Agra mausoleum seems to float magically above the tree-lined reflecting pools that punctuate the garden leading to it. The illusion that the marble tomb is suspended above the water is reinforced by the absence of any visible means of ascent to the upper platform. A stairway, in fact, exists, but the architect intentionally hid it from the view of anyone who approaches Mumtaz Mahal's memorial.

The Taj Mahal follows the plan of Iranian garden pavilions, except the building is placed at one end rather than in

13-27 Taj Mahal, Agra, India, 1632–1647.

the center of the formal garden. The tomb is octagonal in plan with arcuated muqarnas niches on each side. The interplay of shadowy voids with gleaming marble walls that seem paper thin creates an impression of translucency. The pointed arches lead the eye in a sweeping upward movement toward the climactic balloon-shaped dome. Carefully related minarets and corner pavilions enhance, and stabilize, this soaring central theme. The architect achieved this delicate balance between verticality and horizontality by strictly applying an all-encompassing system of proportions. The Taj Mahal (without the minarets) is exactly as wide as it is tall, and the height of its dome is equal to the height of the facade. The perfect harmony and balance of dimensions were carried over into the complex as a whole. For example, the bright white mausoleum is flanked by twin red sandstone buildings (not visible in our photograph). One (at the left) is a mosque, but the other is an empty replica, constructed solely to provide compositional symmetry. Rarely has so grand a building been erected just to achieve an aesthetic effect.

Abd al-Hamid Lahori, a court historian who witnessed the construction of the Taj Mahal, compared its minarets to ladders reaching toward Heaven and the surrounding gardens to Paradise. In fact, the gateway to the gardens and the walls of the mausoleum are inscribed with carefully selected excerpts from the Quran and other Islamic texts that confirm the historian's interpretation of the tomb's symbolism. The Taj Mahal was conceived as the Throne of God perched above the gardens of Paradise on Judgment Day. The minarets hold up the canopy of that throne. In Islam, the most revered place of burial is beneath the Throne of God.

Luxury Arts

The Taj Mahal at Agra, the tile-sheathed mosques of Isfahan, Sultan Hasan's madrasa complex in Cairo, and the architecture of Sinan the Great in Edirne are enduring testaments to the brilliant artistic culture of the Mughal, Safavid, Mamluk, and Ottoman rulers of the Muslim world. But these are just some of the most conspicuous public manifestations of the greatness of later Islamic art and architecture. In the smaller-scale, and often private, realm of the luxury arts, Muslim artists also excelled. From the vast array of manuscript paintings, ceramics, textiles, and metalwork, four masterpieces may serve to suggest both the range and the quality of the inappropriately dubbed Islamic "minor arts" of the fourteenth to sixteenth centuries.

A ROYAL CARPET WITH MILLIONS OF KNOTS
The first of these artworks (FIG. **13-28**) is by far the largest, one of a pair of carpets from Ardabil in Iran. They are said to have come from the funerary mosque of Shaykh Safi al-Din (1252–1334), the founder of the Safavid line. Their origin, however, has been questioned, because the carpets are too large (the one we illustrate is almost thirty-five by eighteen feet) to fit into any of the rooms in that shrine. In any case, the carpets were made in 1540, two centuries after the mosque's erection, during the reign of Shah Tahmasp (r. 1524–1576). Tahmasp elevated carpet weaving to a national industry and set up royal factories at Isfahan, Kashan, Kirman, and Tabriz. The name of MAQSUD OF KASHAN is woven into the design of the carpet

we show. He must be the designer who supplied the master pattern to two teams of royal weavers (one for each of the two carpets). The carpet consists of roughly twenty-five million knots (some three hundred forty to the square inch; its twin has even more knots). It has been estimated that it would have taken a single weaver twenty years to complete the work.

The design consists of a central sunburst medallion, representing the inside of a dome, surrounded by sixteen pendants. Mosque lamps (appropriate motifs if the traditional attribution to the Ardabil funerary mosque is correct) are suspended from two pendants on the long axis of the carpet. The lamps are of different sizes, and some scholars have suggested that this is an optical device to make the two appear equal in size when viewed from the end of the carpet at the room's threshold (the bottom end in our illustration). The rich blue background is covered with leaves and flowers attached to a framework of delicate stems that spreads over the whole field. The entire composition presents the illusion of a heavenly dome with lamps reflected in a pool of water full of floating lotus blossoms. No human or animal figures appear, as befits a carpet intended for a mosque, although they can be found on other Islamic textiles used in secular contexts, both earlier (FIG. 13-15) and later.

MINIATURE PAINTINGS OF IRAN'S HISTORY
Shah Tahmasp was also a great patron of miniature painting. Around 1525 he commissioned an ambitious decade-long project to produce an illustrated 742-page copy of the *Shahnama (Book of Kings)*. The *Shahnama* is the Persian national epic poem by Firdawsi (940–1025). It recounts the history of Iran from the Creation until the Muslim conquest. Tahmasp's *Shahnama* contains 258 illustrations by many artists, including some of the most renowned painters of the day. It was eventually presented as a gift to Selim II, the Ottoman sultan who was the patron of Sinan's mosque at Edirne (FIGS. 13-21 to 13-23). The manuscript later entered a private collection in the West and ultimately was auctioned off as a series of individual pages, destroying its integrity—an unfortunate consequence of the esteem for Islamic art throughout the world.

The page we reproduce (FIG. **13-29**) is widely regarded as the greatest of all Persian miniature paintings. It is the work of SULTAN-MUHAMMAD and depicts Gayumars, the legendary first king of Iran, and his court. Gayumars was said to have ruled from a mountaintop when humans first learned to cook food and clothe themselves in leopard skins. In Sultan-Muhammad's representation of the story, Gayumars presides over his court (all the figures wear leopard skins) from his mountain throne. The king is surrounded by light amid a golden sky. His son and grandson are perched on multicolored rocky outcroppings to the viewer's left and right, respectively. The court encircles the ruler and his heirs. Dozens of human faces are portrayed within the rocks themselves. Many species of animals populate the lush landscape. According to the *Shahnama,* wild beasts became instantly tame in the presence of Gayumars. Sultan-Muhammad rendered the figures, animals, trees, rocks, and sky with an extraordinarily delicate touch. The sense of lightness and airiness that permeates the painting is enhanced by its placement on the page—floating, off center (our view is a detail of the full page), on a speckled background of gold leaf. The painter gave his royal patron a singular vision of Iran's fabled past.

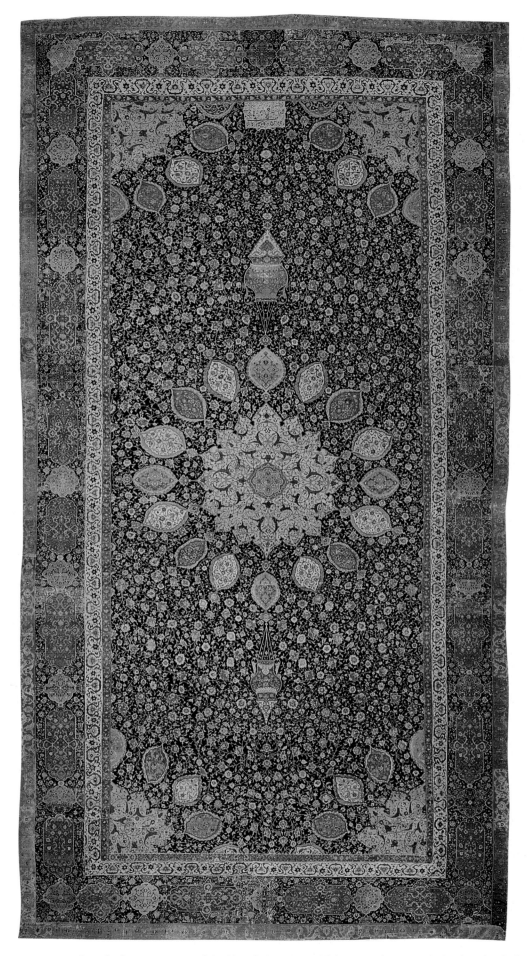

13-28 MAQSUD OF KASHAN, carpet from the funerary mosque of Shaykh Safi al-Din(?), Ardabil, Iran, 1540. Knotted pile of wool and silk, 34′ 6″ × 17′ 7″. Victoria and Albert Museum, London.

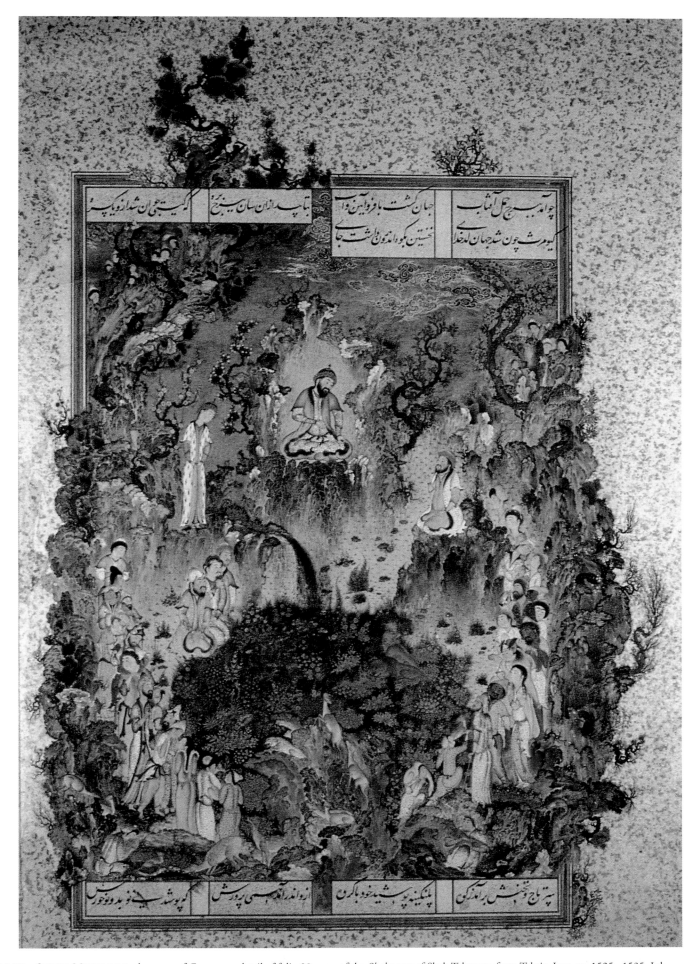

13-29 SULTAN-MUHAMMAD, *the court of Gayumars,* detail of folio 20 verso of the *Shahnama* of Shah Tahmasp, from Tabriz, Iran, ca. 1525–1535. Ink, watercolor, and gold on paper, full page approx. 1′ 1″ × 9″. Prince Sadruddin Aga Khan Collection, Geneva.

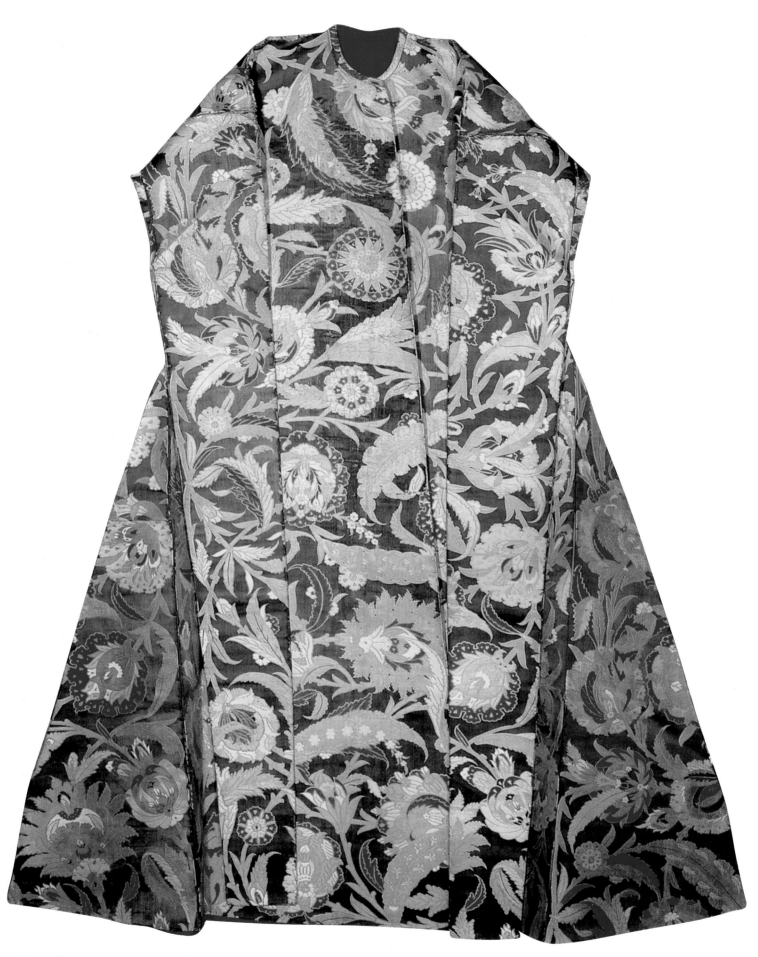

13-30 Ottoman royal ceremonial caftan, from Istanbul, Turkey, ca. 1550. Polychrome silk and gilt-metal thread, 4′ 9″ high. Topkapi Palace Museum, Istanbul.

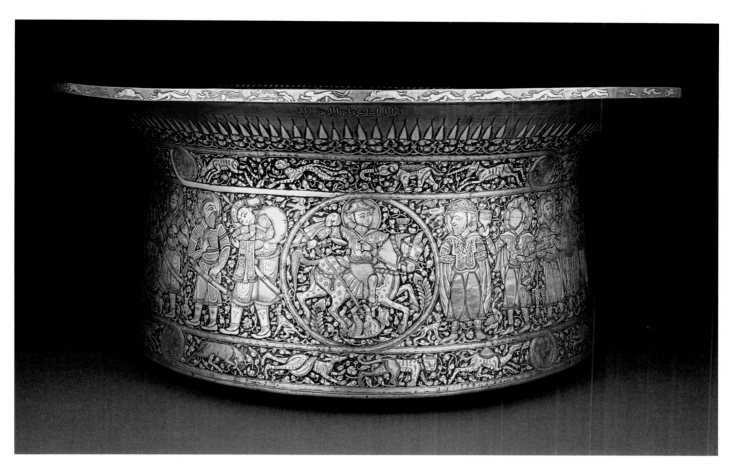

13-31 MUHAMMAD IBN AL-ZAYN, basin *(Baptistère de Saint Louis)*, from Egypt, ca. 1300. Brass inlaid with gold and silver, $8\frac{3}{4}''$ high. Louvre, Paris.

OTTOMAN POMP AND CIRCUMSTANCE When Tahmasp's *Shahnama* was presented to Selim II, the Ottoman sultan would have received the precious gift with due pomp and circumstance, perhaps wearing a ceremonial caftan like the one illustrated (FIG. **13-30**). It was woven of silk thread around 1550, perhaps for Suleyman the Magnificent's son Bayezid. More than a thousand such caftans are preserved in the Ottoman Topkapi Palace, now a museum. But this caftan was one of the most difficult to create on a loom because of its large number of colors and because of the complexity of its floral designs. This kind of distinctive Ottoman design of sinuous curved leaves and complex blossoms is known as *saz,* a Turkish term recalling an enchanted forest. The saz design is never repeated on this garment, a remarkable feat. The designer, nonetheless, made sure the pattern matched across the front opening. Court protocol dictated that Ottoman rulers stood absolutely motionless in the presence of visitors. This explains why the caftan has no fastenings to prevent it from opening. The wearer's arms protruded through slits at the shoulders. The sleeves are ankle length and served only for decoration; they were draped over the back. The rich saz arabesque of the Ottoman robe presents a telling contrast with the Byzantine sakkos of Photius (see FIG. 12-35), which is covered with Jewish and Christian narratives, saints, and Russian royalty, as well as a portrait of Photius himself.

AN ISLAMIC BASIN FOR CHRISTIAN KINGS Figures and animals do adorn one of the most impressive examples of Islamic metalwork known today, a brass basin (FIG. **13-31**) from Egypt inlaid with gold and silver and signed—six times—by the Mamluk artist MUHAMMAD IBN AL-ZAYN. The basin, used for washing hands at official ceremonies, must have been fashioned for a specific Mamluk patron. Some scholars think a court official named Salar ordered the piece as a gift for his sultan, but no inscription identifies him. The central band depicts Mamluk hunters and Mongol enemies. Running animals fill the friezes above and below. Arabesques of inlaid silver fill the background of all the bands and roundels. Figures and animals also decorate the inside and underside of the basin.

The basin has been long known as the *Baptistère de Saint Louis,* but the association with the famous French king (see "Louis IX: The Saintly King," Chapter 18, page 509) is a myth, for he died before the piece was made, The *Baptistère,* nonetheless brought to France long ago and was used in the baptismal rites of newborns of the French royal family as early as the seventeenth century. Like the Zandana silk in Toul Cathedral (FIG. 13-15), Muhammad ibn al-Zayn's basin testifies to the prestige of Islamic art in western Europe. The impact both of such imported items and of the art and architecture of Muslim Spain on European artists and builders of the later Middle Ages is examined in due course. But first this history of art through the ages steps back in time and looks at developments in the Western hemisphere and in sub-Saharan Africa.

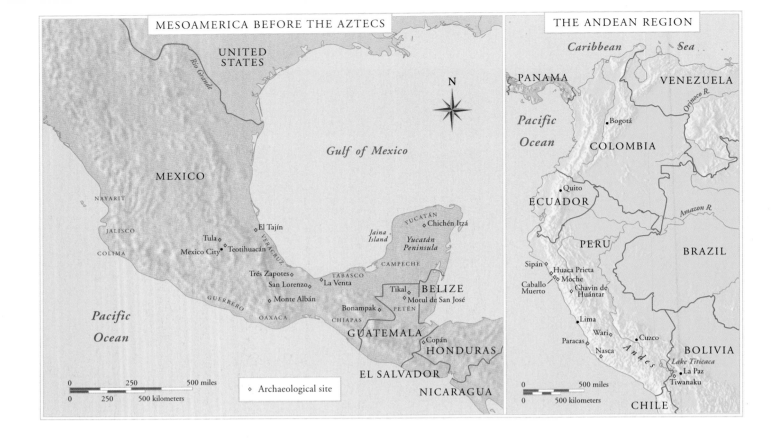

MESOAMERICA BEFORE THE AZTECS

UNITED STATES

Río Grande

MEXICO

Gulf of Mexico

N

NAYARIT

JALISCO

COLIMA

Tula ◇
Mexico City • Teotihuacán ◇
El Tajín ◇

VERACRUZ

Jaina Island

YUCATÁN
◇ Chichén Itzá

Yucatán Peninsula

CAMPECHE

Trés Zapotes ◇
San Lorenzo ◇
Monte Albán ◇

TABASCO
◇ La Venta

Tikal ◇
◇ Motul de San José

BELIZE

GUERRERO

OAXACA

CHIAPAS

Bonampak ◇

PETÉN

Pacific Ocean

GUATEMALA

Copán ◇
HONDURAS

EL SALVADOR

NICARAGUA

0 — 250 — 500 miles
0 — 250 — 500 kilometers

◇ Archaeological site

THE ANDEAN REGION

Caribbean Sea

PANAMA

VENEZUELA

Orinoco R.

Pacific Ocean

• Bogotá

COLOMBIA

• Quito

ECUADOR

Amazon R.

PERU

BRAZIL

Sipán ◇
Caballo Muerto ◇
◇ Huaca Prieta
◇ Moche
◇ Chavín de Huántar

• Lima

Wari •
Paracas ◇
Nasca ◇

Andes

• Cuzco

BOLIVIA

Lake Titicaca
• La Paz
Tiwanaku

0 — 500 miles
0 — 500 kilometers

CHILE

	3000 B.C.	2000 B.C.	1000		B.C. A.D.
MESOAMERICA		PRECLASSIC (FORMATIVE)			
SOUTH AMERICA REGIONAL DEVELOPMENT PERIODS	PRECERAMIC		INITIAL PERIOD	EARLY HORIZON	EARLY INTERMEDIATE PERIOD
SOUTH AMERICA WIDESPREAD HORIZON STYLES			CABALLO MUERTO	CHAVÍN (800–200 B.C.) (SPREAD OF CULTURE 400–200 B.C.) (PARACAS 400 B.C.–A.D. 200) (NASCA 200 B.C.–A.D. 600)	

*Feline head, Huaca de los Reyes
Caballo Muerto, Peru, ca. 1300 B.C*

*Ceremonial ax
La Venta, Mexico
900–400 B.C.*

*Seated figure, Colima, Mexico
ca. 200 B.C.–A.D. 250*

Asian immigrants settle the Americas, 30,000–10,000 B.C.

Beginnings of plant domestication in Mesoamerica, 8000 B.C.

First monumental architecture built in Peru, of adobe and stone, ca. 3000 B.C.

Earliest Andean woven cotton textiles, ca. 2000 B.C.

Earliest Peruvian metallurgy, 2000 B.C.

First Mesoamerican ballcourt built, 1400 B.C.

Caballo Muerto, Peru, 1300 B.C.

Olmec culture spreads throughout Mesoamerica, 900–400 B.C.

Beginnings of Maya civilization, 600 B.C.

Earliest Mesoamerica writing, ca. 500 B.C.

Spread of Chavín culture, 400–200 B.C.

Paracas textiles woven, 400 B.C.–A.D. 200

Shaft-tomb cultures of West Mexico, ca. 200 B.C.–A.D. 250

Teotihuacán founded, 100 B.C.

14

FROM ALASKA TO
THE ANDES

THE ARTS OF ANCIENT AMERICA

300 A.D.			900	1000		1250	
CLASSIC				EARLY POST CLASSIC			
	MIDDLE HORIZON						

MOCHE (1–700) TIWANAKU SITE (100–1000)
 WARI SITE (500–800)

Ear ornament
Sipán, Peru, ca. 300

Temple I, Tikal, Guatemala
ca. 700

Atlantids, Tula, Mexico
ca. 900–1180

Moche burials at Sipán, 100–300

Nasca lines, 500

Abandonment of Teotihuacán, 700

Capture of 18-Rabbit, 738

Bonampak murals, ca. 800

Southern lowland Maya collapse, ca. 900

Ascendance of Chichén Itzá, ca. 900

Toltec domination, 1000

Tula collapses, ca. 1200

AMERICA BEFORE COLUMBUS

Among world cultures, those that flourished in Mexico, Central America, and South America before contact with European explorers were exceptional in several important ways. Some of the native peoples, such as the Maya, had a highly developed writing system and knowledge of mathematical calculation that allowed them to keep precise records and create a sophisticated calendar and a highly accurate astronomy. Although most relied on stone tools, did not use the wheel (except for toys), and had no pack animals but the llama (in South America), these peoples excelled in the engineering arts associated with the planning and construction of cities, civic and domestic buildings, roads and bridges, and irrigation and drainage systems. They mastered complex agricultural techniques using only rudimentary cultivating tools. And they produced distinctive and remarkable sculptures, paintings, and crafts. However, the sixteenth-century European invaders left most of these civilizations in ruins. Others were abandoned to the forces of nature—erosion and the encroachment of tropical forests. But despite the ruined state of many cities, archeologists have reconstructed many of them, and with art historians, reconstructed much of the art and architectural history of the Americas before the Europeans arrived.

THE PEOPLING OF THE AMERICAS The origins of the indigenous peoples of the Americas are still disputed, the debate centering primarily on the date of their arrival from Asia. Many must have crossed the now submerged land bridge called Beringia, which connected the shores of the Bering Strait between Asia and North America, sometime between 30,000 B.C. and 10,000 B.C. Some scholars also have proposed that at least some migrants reached America via boats traveling along the Pacific coast of North America. These Stone Age nomads were hunter-gatherers. They made tools only of bone, pressure-flaked stone, and wood. They had no knowledge of agriculture but possibly some of basketry. They could control fire and probably built simple shelters. For many centuries, they spread out until they occupied the two American continents. But they were always few in number. When the first Europeans arrived at the end of the fifteenth century, the total population of the Western Hemisphere may not have exceeded forty million.

Between 8000 and 2000 B.C., a number of the migrants had learned to domesticate plants like squash and maize (corn). This set the stage for the maize culture that was basic to the early peoples of the Americas. As agriculturalists, the nomads settled down in villages and learned to make clay pottery utensils and lively figurines. Metal technology, although extremely sophisticated when it existed, developed only in the Andean region of South America (eventually spreading north into modern-day Mexico) and generally met only the need for ornament, not for tools. With these skills as a base, many cultures rose and fell over long periods. Several reached a high level of social complexity and artistic achievement by the early centuries of the Christian era.

A CLASH OF CULTURES Because these civilizations abruptly collapsed with the Spanish conquests of the sixteenth century, their cultures have come to be called *pre-Columbian* in reference to Christopher Columbus's arrival in the

Caribbean in 1492, even though he made only brief stops on the mainland. Others—notably Hernán Cortés in Mexico and Francisco Pizarro in Peru—completed the conquest of what people now call Latin America. In the twenty-five years following the European discovery of the "New World," the Spanish monarchs poured money into expeditions that probed the coasts of North and South America, but with little luck in finding the wealth they sought. When brief stops on the coast of Yucatán, Mexico, yielded a small but still impressive amount of gold and other precious artifacts, the Spanish governor of Cuba outfitted yet another expedition. Headed by Cortés, this contingent of Spanish explorers was the first to make contact with the great Aztec emperor Moctezuma. In two short years, with the help of guns, horses, and native allies oppressed by their Aztec overlords, Cortés managed to overthrow the vast and rich Aztec empire. His victory in 1521 opened the door to hordes of Spanish conquistadors seeking their fortunes, to missionaries eager for new converts to Christianity, and to a host of new diseases for which the native Americans had no immunity. The ensuing clash of cultures led to a century of turmoil and an enormous population decline throughout the Spanish king's new domains. Great wealth accrued to Europe, ending only with the independence of most Latin American countries in the early nineteenth century. Although the Spaniards destroyed many impressive buildings and artworks in their zeal to obliterate all traces of pagan beliefs, immediately melting down all the gold and silver objects they captured to form ingots, a surprisingly large body of magnificent artworks in many media still survives. These objects and the ruined cities where they were found serve as haunting reminders of the great civilizations that succeeded one another in the centuries before the Europeans arrived.

MESOAMERICA

GEOGRAPHY AND CLIMATE The term *Mesoamerica* names the region that comprises part of present-day Mexico, Guatemala, Belize, Honduras, and the Pacific coast of El Salvador. Mesoamerica was the homeland of several of the great civilizations that flourished before the European conquest. The principal regions of pre-Columbian Mesoamerica are the Gulf Coast region (Olmec culture); the states of Jalisco, Colima, and Nayarit, collectively known as West Mexico; the Chiapas, Yucatán, Quintana Roo, and Campeche states in Mexico and the Petén area of Guatemala (Maya culture); southwestern Mexico and the state of Oaxaca (Zapotec and Mixtec cultures); and the central plateau surrounding modern-day Mexico City (Teotihuacán, Toltec, and Aztec cultures). These cultures were often influential over extensive areas.

The Mexican highlands are a volcanic and seismic region. In highland Mexico, great reaches of arid plateau land, fertile for maize and other crops wherever water is available, lie between heavily forested mountain slopes, which at some places rise to a perpetual snow level. The moist tropical rain forests of the coastal plains yield rich crops, when the land can be cleared. In Yucatán, a subsoil of limestone furnishes abundant material both for building and carving. This limestone tableland merges with the vast Petén region of Guatemala, which

separates Mexico from Honduras. Yucatán and the Petén, where dense rain forest alternates with broad stretches of grassland, host some of the most spectacular Maya ruins. The great mountain chains of Mexico and Guatemala extend into Honduras and slope sharply down to tropical coasts. Highlands and mountain valleys, with their chill and temperate climates, alternate dramatically with the humid climate of tropical rain forest and coastlines.

LANGUAGE AND CHRONOLOGY The variegated landscape of Mesoamerica may have much to do with the diversity of languages its native populations speak. Numerous languages are distributed among no fewer than fourteen linguistic families. Many of the languages spoken in the preconquest periods survive to this day. Various Mayan languages linger in Guatemala and southern Mexico. The Náhuatl of the Aztecs endures in the Mexican highlands. The Zapotec and Mixtec languages persist in Oaxaca and its environs. Diverse as the languages of these peoples were, their cultures, otherwise, had much in common. The Mesoamerican peoples shared maize cultivation, religious beliefs and rites, myths, social structures, customs, and arts. Yet each is renowned for its particular accomplishments. The Maya, for example, developed a complex writing system. The Mixtecs excelled as master craftsmen in gold and turquoise. The Aztecs were fierce warriors who in a few short years created a vast imperial state.

Archeologists, with ever increasing refinement of technique, have been uncovering, describing, and classifying Mesoamerican monuments for more than a century. Since the 1950s, when linguists made important breakthroughs in deciphering the Maya hieroglyphic script, evidence for a detailed account of Maya history and art has emerged. Many Maya rulers now can be listed by name and the dates of their reigns fixed with precision. Other writing systems, such as that of the Zapotec, who began to record dates at a very early time, are less well understood, but researchers are making rapid progress in their interpretation. The general Mesoamerican chronology is now well established and widely accepted. The standard chronology, divided into three epochs, involves some overlapping of subperiods—the Preclassic (Formative) extends from 2000 B.C. to about A.D. 300; the Classic period runs from about 300 to 900; and the Postclassic begins ca. 900 and ends with the Spanish conquest of 1521.

Preclassic (2000 B.C. – A.D. 300)

THE OLMEC "MOTHER CULTURE" The Olmec culture of the present-day states of Veracruz and Tabasco is known as the "mother culture" of Mesoamerica. Many religious, social, and artistic traditions can be traced to it. Although little is known of its origins, history, or language, the wide diffusion of Olmec institutional forms, monuments, arts, and artifacts reflects the culture's broad influence. Excavations in and around not only the principal Gulf Coast sites of Olmec culture—Tres Zapotes, San Lorenzo, and La Venta—but also in central Mexico and along the Pacific coast from the Mexican state of Guerrero to El Salvador indicate that Olmec influence was far more widespread than scholars

once supposed. The Olmec clearly were the source of the distinctive features subsequent Mesoamerican cultures shared.

Settling in the tropical lowlands of the Gulf of Mexico, the Olmec peoples cultivated a terrain of rain forest and alluvial lowland washed by numerous rivers flowing into the gulf. Here, between approximately 1500 B.C. and 400 B.C., social organization assumed the form later Mesoamerican cultures adapted and developed. The mass of the population—food-producing farmers scattered in hinterland villages—provided the sustenance and labor that maintained a hereditary caste of rulers, hierarchies of priests, functionaries, and artisans. The nonfarming population presumably lived, arranged by rank, within precincts that served ceremonial, administrative, and residential functions, and perhaps also as marketplaces. At regular intervals, the whole community convened for ritual observances at the religious-civic centers of towns such as San Lorenzo and La Venta. These centers were the formative architectural expressions of the structure and ideals of Olmec society.

COLOSSAL RULER PORTRAITS At La Venta, low clay-and-earthen platforms and stone fences enclosed two great courtyards. At the north end of the larger area was a mound almost one hundred feet high. Although now very eroded, its current fluted cone shape resembles a volcano. This early pyramid may have been built to mimic a mountain, held sacred by Mesoamerican peoples as both a life-giving source of water and a feared destructive force. (Volcanic eruptions and earthquakes still wreak havoc in this region.) The La Venta layout is an early form of the temple-pyramid and plaza complex aligned on a north-south axis that characterized later Mesoamerican ceremonial center design.

Four colossal basalt heads weighing about ten tons each and standing between six and eight feet high (FIG. **14-1**) face out from the plaza. Almost as much of an achievement as the

14-1 Colossal head, Olmec, La Venta, Mexico, 900–400 B.C. Basalt, 8′ high.

carving of these huge stones was their transportation across the sixty miles of swampland from the nearest known basalt source. The large heads are hallmarks of Olmec art. Several others have been found at San Lorenzo and Tres Zapotes. Although their identities are uncertain, their individualized features and distinctive headgear and ear ornaments, as well as the later Maya practice of carving monumental ruler portraits, suggest that the Olmec heads portray rulers rather than deities. The Olmec apparently mutilated their own monuments, perhaps for ritual reasons related to the end of a ruler's reign. Sometimes they reshaped sculptures for other uses, turning carved stone thrones into colossal heads, for example. But because both San Lorenzo and, later, La Venta appear to have been violently overthrown, the deliberate defacement of some monuments may represent the vandalism of particularly hostile invaders or Olmec revolutionaries.

JADE JAGUAR-HUMANS The Olmec also carved sculptures in jade, a material they acquired from unknown sources far from their homeland and that all Mesoamerican peoples highly prized. Sometimes the Olmec carved it into ax-shaped polished forms called *celts,* which they then buried as ceremonial offerings under their courtyards or platforms. The celt shape could be modified into a figural form, combining relief carving with incising. Stone-tipped drills and abrasive materials like sand were used to carve jade. Figures represented include crying babies (of unknown significance) and figures combining human and animal features and postures (FIG. **14-2**), notably those of the jaguar, the largest, most powerful, and most elusive of Mesoamerican predators. Archeologists have dubbed these jaguar-human representations "were-jaguars." Although Olmec religious beliefs and practices are little known, such human-animal representations may refer to the belief that religious practitioners known as shamans underwent dangerous transformations to wrest power from supernatural forces and harness it for the community's good.

14-2 Ceremonial ax in the form of a jaguar-human, Olmec, from La Venta, Mexico, 900–400 B.C. Jadeite, 11½″ high. British Museum, London.

WEST MEXICO'S RICH CERAMIC TRADITION Far to the west of the tropical heartland of the Olmec are the Preclassic sites along Mexico's Pacific coast. The pre-Columbian peoples of the modern West Mexican states of Nayarit, Jalisco, and Colima were long thought to have existed at Mesoamerica's geographic and cultural fringes. Recent archeological discoveries, however, have revealed that although the West Mexicans did not produce large-scale stone sculpture, they did build permanent structures. These included tiered platforms and ballcourts (see "The Mesoamerican Ballgame," page 392), architectural features found in nearly all Mesoamerican cultures. Yet West Mexico is best known for its rich tradition of clay sculpture.

Distinctive tombs consisting of shafts as deep as fifty feet with chambers at their base have yielded varied offerings. These include clay sculptures, usually hollow, of humans, plants, animals, and mythological creatures. Archeologists have long neglected West Mexico. Because scientific excavations began only recently, much of what is known about tomb contents derives primarily from the artifacts grave robbers find and sell. Researchers believe, however, that most of these tombs were built and filled with elaborate offerings during the late Preclassic period.

The large ceramic figures found in these tombs exhibit a distinct sense of volume, particularly in the swollen torsos and limbs (FIG. **14-3**). The Colima figures are consistently a highly burnished red orange, in contrast with the distinctive polychrome surfaces of the majority of other West Coast ceramics. The area also is noted for small-scale clay narrative scenes that include modeled houses and temples and numerous solid figurines shown in a variety of lively activities. Art historians have interpreted some of these sculptures as festivals, funerals, and battles. These sculptured scenes provide informal glimpses of daily life found in no other pre-Columbian Mesoamerican cultures. To some degree this viewpoint that West Mexican ceramic sculpture is anecdotal and secular rather than religious may result from scholars' limited knowledge of the region, as well as from the modern Western tendency to separate the religious from the secular. The Mesoamerican belief system does not recognize such a division. Consequently, scholars are unsure whether the figure we illustrate is a shaman with a horn on his forehead (a common indigenous symbol of special powers) or a political leader wearing a shell ornament (often a Mesoamerican emblem of rulership). He could be serving, of course, both roles.

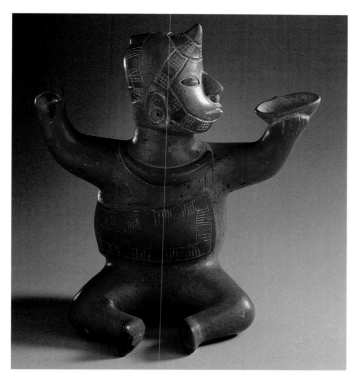

14-3 Seated figure with raised arms, from Colima, Mexico, ca. 200 B.C.–A.D. 250. Clay with orange and red slip, 1′ 1″ high. Los Angeles County Museum of Art, Los Angeles.

Classic (A.D. 300–900)

The era designated as the Classic period in Mesoamerica witnessed the rise to grandeur of several great civilizations. Although these advanced cultures originated in the late Preclassic period, they achieved their unprecedented magnificence in the Classic period.

MESOAMERICA'S FIRST METROPOLIS At Olmec La Venta, the characteristic Mesoamerican temple-pyramid-plaza layout appeared in embryonic form. At the awe-inspiring site of Teotihuacán (FIG. 14-4), northeast of modern Mexico City, the Preclassic scheme underwent a monumental expansion into a genuine city. Teotihuacán was a large, densely populated metropolis that fulfilled a central civic, economic, and religious role for the region and indeed for much of Mesoamerica. The carefully planned area covers nine square miles, laid out in a grid pattern with the axes oriented consistently by sophisticated surveying. The city's orientation, as well as the placement of some of its key pyramids, also appear to have been related to astronomical phenomena.

At its peak, around 600, Teotihuacán may have had as many as two hundred thousand residents. It would have been at that time the sixth largest city in the world. Divided into numerous wardlike sectors, this metropolis must have had a uniquely cosmopolitan character, with Zapotec peoples located in the city's western wards and merchants from

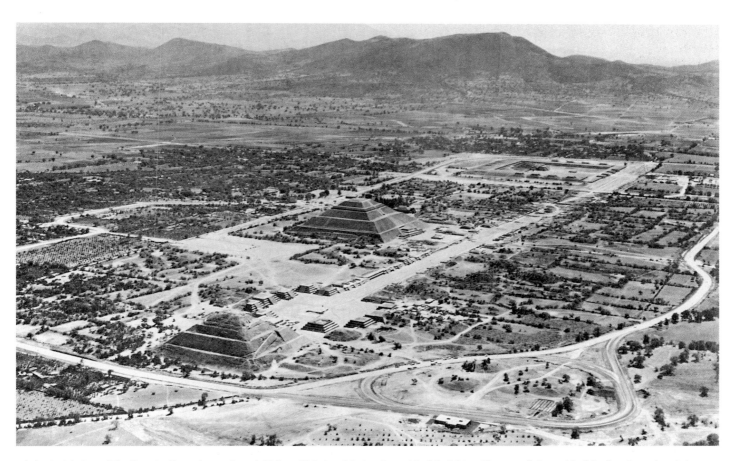

14-4 Aerial view of Teotihuacán (from the northwest), Valley of Mexico, Mexico. Pyramid of the Moon *(foreground)*, Pyramid of the Sun *(center)*, and the Citadel *(center background)*, all connected by the Avenue of the Dead; main structures ca. A.D. 50–200; site ca. 100 B.C.–A.D. 750.

Veracruz living in the eastern wards, importing their own pottery and building their houses and tombs in the style of their homelands. The city's urbanization did nothing to detract from its sacred nature. In fact, it vastly augmented Teotihuacán's importance as a religious center. The Aztecs, who visited Teotihuacán regularly and reverently long after it had been abandoned, gave it its current name, which means "the place of the gods." Because the city's inhabitants left only a handful of undeciphered hieroglyphs and linguists do not yet even know what language they spoke, the names of many major features of the site are unknown. The Avenue of the Dead and the Pyramids of the Sun and Moon are later Aztec designations that do not necessarily relate to these entities' original names.

The grid plan is quartered by a north–south and an east–west axis, each four miles in length. The rational scheme recalls Hellenistic and Roman urban planning (compare FIGS. 5-75 and 10-40). The main north–south axis, the Avenue of the Dead (FIG. 14-4), is one hundred thirty feet wide and connects the Pyramid of the Moon complex with the Citadel, which houses the well-preserved Temple of Quetzalcóatl (discussed later). It is not a continuously flat street but is broken by sets of stairs along its length, giving pedestrians a constantly changing view of the surrounding buildings and landscape. The Pyramid of the Sun, facing west on the east side of the Avenue of the Dead, is the city's centerpiece and its largest structure, rising to a height of more than two hundred feet.

The shapes of the monumental structures at Teotihuacán echo the surrounding mountains. Their imposing mass and scale surpass those of all other Mesoamerican sites. Rubble filled and faced with the local volcanic stone, the pyramids consist of stacked squared platforms diminishing in perimeter from the base to the top, much like the Stepped Pyramid of Djoser in Egyptian Saqqara (see FIG. 3-4). Ramped stairways ascend to crowning temples made of perishable materials such as wood and thatch and therefore now missing at Teotihuacán.

The Teotihuacanos built the Pyramid of the Sun over a cave, which they reshaped and filled with ceramic offerings.

The pyramid may have been constructed to honor a sacred spring within the now-dry cave. Four children were found buried at the corners of the pyramid. The later Aztec sacrificed children to bring rainfall, and Teotihuacán art abounds with references to water, so they may have shared the Aztec preoccupation with rain and agricultural fertility. The city's inhabitants rebuilt the Pyramid of the Moon (currently being excavated) at least five times in Teotihuacán's early history. It may have been positioned to mimic the shape of the mountain behind it known as Cerro Gordo, undoubtedly an important source for life-sustaining streams.

THE TEMPLE OF THE FEATHERED SERPENT
At the south end of the Avenue of the Dead is the great quadrangle of the Citadel (FIG. 14-4). It encloses a smaller pyramidal shrine, the Temple of Quetzalcóatl, the "feathered serpent." Quetzalcóatl was a major god in the Mesoamerican pantheon at the time of the Spanish conquest, hundreds of years after the fall of Teotihuacán. The later Aztecs associated him with wind, rain-bringing clouds, and life. Beneath this structure archeologists recently found a tomb looted in antiquity, perhaps that of a Teotihuacán ruler. The discovery has led them to speculate that like their contemporaries, the Maya, the Teotihuacanos also buried their elite in or under pyramids. Surrounding the tomb both beneath and around the pyramid were the remains of at least a hundred sacrificial victims. Some were adorned with necklaces made of strings of human jaws, both real and sculpted from shell, a reminder that rulership during the Classic period was not necessarily benevolent. Like most other Mesoamerican groups, the Teotihuacanos apparently felt the need to invoke and appease their gods through human sacrifice. The presence of such a large number of victims also may reflect Teotihuacán's militaristic expansion—throughout Mesoamerica, the victors often sacrificed captured warriors.

The temple's sculptured panels (FIG. **14-5**), long protected by subsequent building, are well preserved on the west facade. Massive projecting stone heads of Quetzalcóatl, which alter-

14-5 Detail of Temple of Quetzalcóatl, the Citadel, Teotihuacán, Valley of Mexico, Mexico, third century.

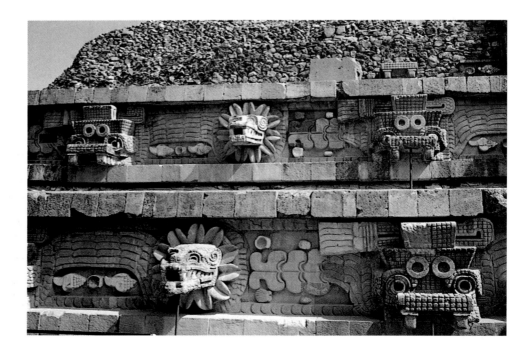

nate with heads of a long-snouted scaly creature with rings on its forehead, decorate each of the temple's six terraces. This remains the first unambiguous representation of the feathered serpent in Mesoamerica. The scaly creature's identity is unclear. Linking these alternating heads are low-relief carvings of feathered-serpent bodies and seashells. The latter reflect Teotihuacán contact with the peoples of the Mexican coasts and also symbolize water, an essential ingredient for the sustenance of an agricultural economy.

BRIGHT MURALS FOR A GREAT CITY

Like those of most pre-Columbian Mesoamerican cities, Teotihucán's buildings and streets were once stuccoed over and brightly painted. In a treatment unique to Teotihuacán, however, elaborate murals covered the walls of the rooms of its elite residential compounds. These images reveal nothing about everyday life at Teotihuacán but consist largely of depictions of deities, ritual activities, and processions of priests, warriors, and even animals. Rendered as flat, repetitive motifs, the figures, although laden with elaborate costumes, are often devoid of individuality. The depiction of volume, spatial relations, or narrative interaction was not a priority.

Experimenting with a variety of surfaces, materials, and techniques over the centuries, Teotihuacán muralists finally settled on applying pigments to a smooth lime-plaster surface coated with clay. They then polished the surface to a high sheen. During one phase of Teotihuacán painting, artists limited themselves to a palette of varying tones of red (largely derived from the mineral hematite), creating subtle contrasts between figure and ground. But most Teotihuacán murals feature vivid hues arranged in flat, carefully outlined patterns.

TEOTIHUACÁN'S BOUNTY-GIVING GODDESS

Once thought a man, the principal god of the city is now known to have been a woman, an earth or nature goddess, depicted here in a mural (FIG. **14-6**). Always shown frontally with her face covered by a jade mask, she is dwarfed by her large feathered headdress and reduced to a bust placed upon a stylized pyramid. She stretches her hands out to provide liquid streams filled with bounty (compare the Sumerian mural at Zimri-Lim's palace, FIG. 2-17), but the stylized human hearts that flank the frontal bird mask in her headdress reflect her dual nature. They remind viewers that the ancient Mesoamericans saw human sacrifice as essential to agricultural renewal.

The influence of Teotihuacán was all-pervasive in Mesoamerica. Colonies were established as far away as the southern borders of Maya civilization, in the highlands of Guatemala, some eight hundred miles from Teotihuacán. Political and economic interaction between Teotihuacán and the Maya in southern Mexico and Guatemala linked the two outstanding Early Classic cultures.

THE CLASSIC MAYA CITY-STATE

Strong cultural influences stemming from the Olmec tradition and from Teotihuacán contributed to the development of Classic Maya culture. As with Teotihuacán, Maya civilization's foundations were laid in the Preclassic period, perhaps by 600 B.C. or even earlier. At that time, the Maya, who occupied the moist lowland areas of Belize, southern Mexico, Guatemala, and Honduras, seem to have abandoned their early somewhat egalitarian pattern of village life and adopted a hierarchical autocratic

society. This system evolved into the typical Maya city-state governed by hereditary rulers and ranked nobility. How and why this happened is still uncertain.

Stupendous building projects signaled the change. Vast complexes of terraced temple-pyramids, palaces, plazas, ballcourts, and residences of the governing elite dotted the Maya area. Unlike the Teotihuacán civilization, no one site ever achieved complete dominance as the single center of power. The new architecture, and the art embellishing it, advertised the power of the rulers, who appropriated cosmic symbolism and stressed their descent from gods to reinforce their claims to legitimate rulership. The unified institutions of religion and kingship were established so firmly, their hold on life and custom was so tenacious, and their meaning was so fixed in the symbolism and imagery of art that the rigidly conservative system of the Classic Maya lasted almost a thousand years. Maya civilization in the southern region collapsed around 900, vanishing more abruptly and unaccountably than it had appeared.

Although the causes of the beginning and end of Classic Maya civilization are obscure, researchers are gradually revealing its history, beliefs, ceremonies, conventions, and daily life patterns. Long romanticized, the Maya now enter the world history stage as believably as the peoples of other great civilizations. No longer viewed as a peaceful, benign society under theocratic rule, the Maya are now seen as flesh-and-blood peoples who glorified their rulers and oppressed the lower classes, who undertook (and broke) strategic political alliances, who waged war, and who practiced human sacrifice. This more accurate picture is the consequence of modern interdisciplinary

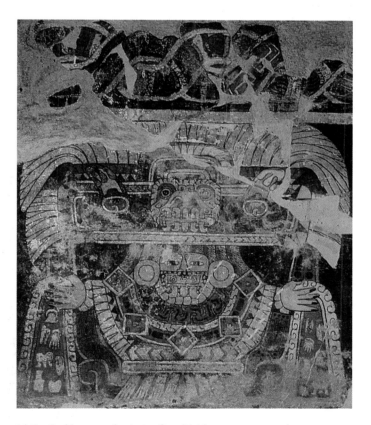

14-6 Goddess, mural painting from Tetitla apartment complex at Teotihuacán, Valley of Mexico, Mexico, 650–750. Pigments over clay and plaster.

The Mesoamerican Ballgame

After witnessing the native ballgame of Mexico soon after their arrival in the sixteenth century, the Spanish conquerors took Aztec ballplayers back to Europe to demonstrate the novel sport. Their chronicles remark on the athletes' great skill, the heavy wagering that accompanied the competition, and the ball itself, made of rubber, a substance they had never seen before.

The game was played throughout Mesoamerica and into the southwestern United States, beginning at least thirty-four hundred years ago, the date of the earliest known ballcourt. The Olmec were apparently avid players. Their very name—a modern invention in the Aztec language—means "rubber people," after the latex-growing region they inhabited. Not only are ballplayers represented in Olmec art, but remnants of sunken earthen ballcourts and even rubber balls have been found at Olmec sites.

The Olmec earthen playing field evolved in other Mesoamerican cultures into a plastered masonry surface, I- or T-shaped in plan, flanked by two parallel sloping or straight walls. Sometimes the walls were wide enough to support small structures on top, as at Copán (FIG. 14-7), while at other sites temples stood at either end of the ballcourt. The largest ballcourt in Mesoamerica measures nearly five hundred feet long, while a site in rubber-rich Veracruz boasts seventeen ballcourts—at last count. Most ballcourts were adjacent to the important civic structures of Mesoamerican cities, such as palaces and temple-pyramids, as at Copán. Teotihuacán is an exception. Archeologists have not found a ballcourt there, but mural paintings at the site illustrate people playing the game with portable markers.

Researchers know surprisingly little about the rules of the ballgame itself—how many players were on the field, how goals were scored and tallied, and how competitions were arranged. Unlike a modern soccer field with its standard dimensions, Mesoamerican ballcourts vary widely in size. Some have stone rings, which a ball conceivably could have been tossed through, set high up on their walls at right angles to the ground, but many courts lack this feature. Alternatively, the ball may have been bounced against the walls and into the end zones. As in soccer, players could not touch the ball with their hands but used their heads, elbows, hips, and legs. They wore thick leather belts, and sometimes even helmets, and padded their knees and arms against the blows of the fast-moving solid rubber ball. Typically, the Maya portrayed ballplayers wearing heavy protective clothing, kneeling, and poised to deflect the ball (FIG. 14-10).

Although widely enjoyed as a competitive spectator sport, the ballgame did not serve solely for entertainment. The ball, for example, may have represented a celestial body such as the sun, its movements over the court imitating the sun's daily passage through the sky. Reliefs on the walls of ballcourts at certain sites make clear that the game sometimes culminated in human sacrifice, probably of captives taken in battle and then forced to participate in a game they were predestined to lose.

Ballplaying also had a role in Mesoamerican mythology. In the ancient Maya epic known as the *Popol Vuh (Council Book)*, first written down in Spanish in the colonial period, a legendary pair of twins is forced to play ball with the evil lords of the Underworld. The brothers lose and are sacrificed. The sons of one twin eventually travel to the Underworld, and, after a series of trials including a ballgame, outwit the lords and kill them. They revive their father, buried in the ballcourt after his earlier defeat at the hands of the Underworld gods. While the younger twins rise to the heavens to become the sun and the moon, the father becomes the god of maize, principal sustenance of all Mesoamerican peoples. The ballgame and its aftermath, then, were a metaphor for the cycle of life, death, and regeneration that permeated Mesoamerican religion.

scholarship. Archeologists, epigraphers (scholars who decipher writing systems), art historians, and ethnographers (those who study contemporary societies) all have contributed to a clearer understanding of ancient Maya culture.

DECODING THE MAYAN SCRIPT Like the decipherment of Egyptian writing early in the nineteenth century, the decoding of the Mayan script has been an exciting intellectual adventure. By the end of the nineteenth century, numbers, dates, and some astronomical information could be read, but little else, leading scholars to conclude the Maya were obsessed with time and religion and uninterested in recording the mundane events of human lives. Two important breakthroughs beginning in the 1950s radically altered the understanding of both Mayan writing and the Maya worldview.

The first was the realization the Maya depicted their rulers (rather than gods or anonymous priests) in their art and noted their rulers' achievements in their texts. The second was that Mayan writing is largely phonetic; that is, the hieroglyphs are made up of signs representing sounds in the Mayan language. Fortunately, the various Mayan languages were recorded in colonial texts and dictionaries and most are still spoken today. Although perhaps only half of the ancient Mayan script can be translated accurately into spoken Mayan, today scholars can at least grasp the general meaning of many more hieroglyphs.

MAYA ASTRONOMY AND CALENDARS The Maya possessed a highly developed knowledge of arithmetic calculation and the ability to observe and record the movements of

not only the sun and moon but also numerous planets. They contrived an intricate but astonishingly accurate calendar, and although their calendric structuring of time was radically different in form from the Western calendar used today, it was just as precise and efficient. With their calendar, the Maya established the all-important genealogical lines of their rulers, which certified their claim to rule, and created the only true written history in ancient America. Although other pre-Columbian Mesoamerican societies also possessed calendars, only the Maya calendar can be translated directly into today's calendrical system.

THE CITY CENTER AS THEATRICAL STAGE
The most sacred and majestic buildings of Maya cities were raised in enclosed, centrally located precincts. The religious-civic transactions that guaranteed the order of the state and the cosmos occurred in these settings. The Maya held dramatic rituals within a sculptured and painted environment, where huge symbols and images proclaimed the nature and necessity of that order. Maya builders designed spacious plazas for vast audiences who were exposed to overwhelming propaganda. The programmers of that propaganda, the ruling families and troops of priests, nobles, and retainers, wore its symbolism in their costumes. In Maya paintings and sculptures, the Maya elite wear extravagant profusions of vividly colorful cotton tex-

tiles, feathers, jaguar skins, and jade, all emblematic of their rank and wealth. On the different levels of the painted and polished temple platforms, the ruling classes performed the offices of their rites in clouds of incense to the music of maracas, flutes, and drums. The Maya transformed the architectural complex at each city's center into a theater of religion and statecraft. In the stagelike layout of a characteristic Maya city center, its principal group, or "site core," was the religious and administrative nucleus for a population of dispersed farmers settled throughout a suburban area of many square miles.

COPÁN'S PLAZAS AND PYRAMIDS Because Copán, on the western border of Honduras, has more hieroglyphic inscriptions and well-preserved carved monuments than any other site in the Americas, it was one of the first Maya sites excavated. It also has proved one of the richest in the trove of architectural, sculptural, and artifactual remains recovered. Archeologists are still exploring the site. Copán's heart is dominated by conspicuous plazas. In our restored view of the city center (FIG. **14-7**), the Great Plaza is to the left and the smaller Middle Plaza is at the center. The latter is enclosed on three sides by the ballcourt (left side of plaza; see "The Mesoamerican Ballgame," page 392), by the towering tiered pyramid (Structure 10L-26) with its steep "Hieroglyphic Stairway," and by the so-called Acropolis, with its

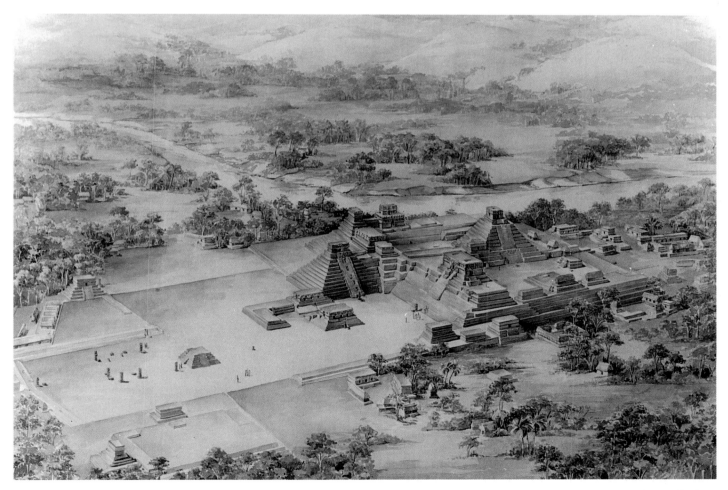

14-7 Reconstruction drawing by Tatiana Proskouriakoff of principal group of ruins at Copán, Maya, Copán Valley, Honduras. Great plaza *(left)*, Middle Plaza with Ballcourt *(two small structures at center)* and Temple of the Hieroglyphic Stairway *(center, slightly above and to right of Ballcourt)*, Acropolis *(right)*, and elite residences *(far right)*; eighth century. Peabody Museum, Harvard University.

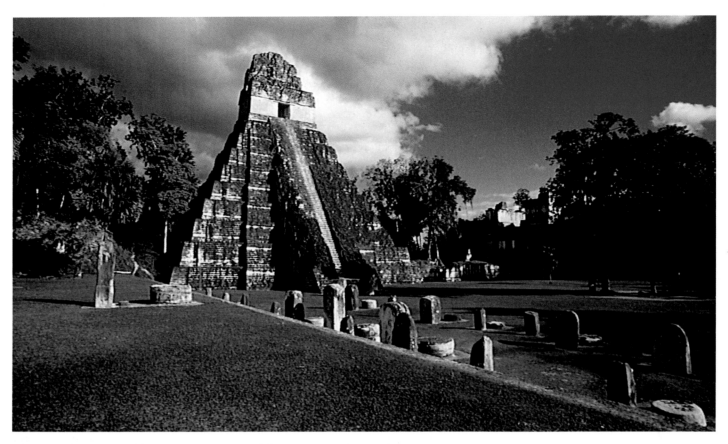

14-8 Temple I (Temple of the Giant Jaguar), Maya, Tikal, Petén, Guatemala, ca. 700.

cluster of pyramids and courtyards on a higher platform to the right of the Hieroglyphic Stairway. Beyond and below the Acropolis to the far right are elite residential buildings. In the Great Plaza the Maya set up tall, sculptured stone stelae (to the left in FIG. 14-7). Carved with the portraits of the rulers who erected them, these stelae also record their names, dates of reign, and notable achievements in glyphs on the front, sides, or back (FIG. 14-9).

A TIKAL RULER'S TEMPLE-PYRAMID TOMB
Another great Maya site of the Classic period is Tikal in Guatemala, some one hundred fifty miles north of Copán. Tikal, one of the oldest and largest of the Maya cities, rises above the thick tropical forest. The city and its suburbs originally covered some seventy-five square miles and served as the ceremonial center of a population of perhaps seventy-five thousand. The Maya did not lay out central Tikal on a grid plan like its contemporary, Teotihuacán. Instead, causeways connected irregular groupings. Modern surveys have uncovered the remains of as many as three thousand separate structures in an area of about six square miles. The site's nucleus, the Great Plaza, is studded with stelae and defined by numerous architectural complexes. The most prominent monuments are the two soaring pyramids that face each other across an open square. The taller pyramid (FIG. **14-8**), Temple I (also called the Temple of the Giant Jaguar after a motif on one of its carved wooden lintels), reaches a height of one hundred forty-four feet. It is the temple-mausoleum of a Tikal ruler, whose body was placed in a vaulted chamber under the pyramid's base. The towering structure, made up of nine sharply

inclining platforms and a narrow stairway, culminates at the summit in a three-chambered temple. The temple is surmounted by an elaborately sculpted *roof comb,* a vertical architectural projection that once bore the ruler's giant portrait modeled in stucco. This structure exhibits most concisely the pre-Columbian Mesoamerican formula for the stepped temple-pyramid and the compelling aesthetic and psychological power of Maya architecture.

MAYA PORTRAITURE The grand pyramids of Copán and Tikal are among the most imposing buildings the Maya erected. But they are only the most eye-catching monuments in cities filled with sculptures and paintings that also played a significant role in glorifying their powerful rulers. Stele D (FIG. **14-9**) in the Great Plaza at Copán (FIG. 14-7, left) represents one of the foremost of the city's rulers, 18-Rabbit (r. 695–738). In a dynastic succession of sixteen rulers, 18-Rabbit was the thirteenth. During his long reign, the city may have reached its greatest physical extent and range of political influence. On Stele D 18-Rabbit wears an elaborate headdress and ornamented kilt and sandals. He holds across his chest a double-headed serpent bar, symbol of the sky and of his absolute power. His features have the quality of a portrait likeness, although highly idealized. The Maya elite, like the Egyptian pharaohs and the rulers of some other ancient societies, tended to have themselves portrayed in a conventionalized manner and as eternally youthful. The dense, deeply carved ornamental details that frame the face and figure in florid profusion stand almost clear of the block and wrap around the sides of the stele. The high relief gives the impres-

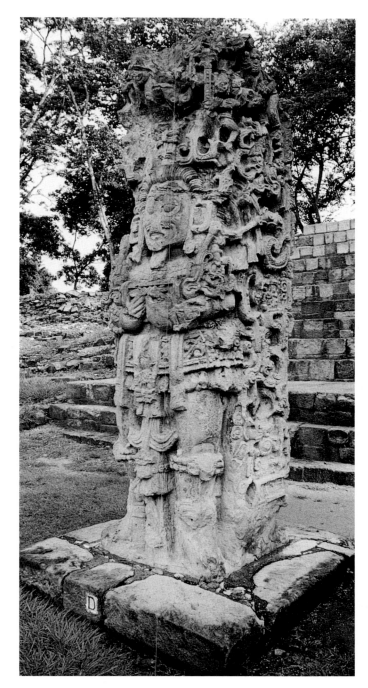

14-9 Stele D portraying the ruler 18-Rabbit, Maya, Great Plaza at Copán, Honduras, 736. Stone, 11′ 9″ high.

sion of a statue in the full round, although a hieroglyphic text is carved on the flat back side of the stele. The stele was originally painted—remnants of red paint are visible on many of the other stelae at Copán. Although a powerful ruler who erected many stelae and buildings at Copán, 18-Rabbit eventually was captured and beheaded by a rival king.

EVERYDAY LIFE IN CLAY SCULPTURE The almost unlimited variety of figural attitude and gesture permitted in the modeling of clay explains the profusion of informal ceramic figurines that, like West Mexican pottery (FIG. 14-3), may illustrate aspects of everyday Maya life. Small-scale free-standing figures in the round, they are remarkably lifelike,

carefully descriptive, and even comic at times. They represent a wider range of human types and activities than is commonly depicted on Maya stelae. Ballplayers (FIG. 14-10), women weaving, older men, dwarves, supernatural beings, and amorous couples, as well as elaborately attired rulers and warriors, comprise the figurine repertory. Many of the hollow figurines are also whistles. They were made in ceramic workshops on the mainland, often with molds, but burials on the island cemetery of Jaina, off the western coast of Yucatán, yielded hundreds of such figures, including the ballplayer we illustrate. Traces of blue remain on the figure's belt, remnants of the vivid pigments that once covered many of these figurines. The Maya used "Maya blue," a combination of a particular kind of clay and indigo, a vegetable dye, to paint both ceramics and murals. This pigment has proven virtually indestructible, unlike the other colors that largely have disappeared over time. Like the larger terracotta figures of West Mexico, these figurines were made to accompany the dead on their inevitable voyage to the Underworld. The excavations at Jaina, however, have revealed nothing more that might clarify the meaning and function of the figures. Male figurines were not found exclusively in the burials of male individuals, for example.

ROYAL RITUALS PORTRAYED ON WALLS The vivacity of the Jaina figurines and their variety of pose, costume, and occupation were reinterpreted in two dimensions at Bonampak (Mayan for "painted walls") in southeastern Mexico. Three chambers in one Bonampak structure contain mural paintings that are vivid vignettes of Maya court life.

14-10 Ballplayer, Maya, from Jaina Island, Mexico, 700–900. Painted clay, 6¼″ high. National Museum of Anthropology, Mexico City.

14-11 Presentation of captives to a Maya ruler, Maya, from Structure 1 at Bonampak, Mexico, late eighth century. Watercolor copy by Antonio Tejeda, housed at Peabody Museum, Harvard University, Cambridge.

The example we illustrate (FIG. **14-11**) shows warriors surrounding captives on a terraced platform. In contrast to Teotihuacán, the figures represented have naturalistic proportions and overlap, twist, turn, and gesture. The artists used fluid and calligraphic line to outline the figures, working with color to indicate both textures and volume. The Bonampak painters combined their pigments—both mineral and organic—with a mixture of water, crushed limestone, and vegetable gums and applied them to their stucco walls in a technique best described as a cross between fresco and tempera.

The Bonampak murals are filled with circumstantial detail. The information given is comprehensive, explicit, and presented with the fidelity of an eyewitness report. The royal personages are identifiable by both their physical features and their costumes, while accompanying inscriptions provide the precise day, month, and year for the events recorded. All the scenes at Bonampak relate the events and ceremonies that welcome a new royal heir (shown as a toddler in some scenes).

They include presentations, preparations for a royal fete, dancing, battle, and the taking and sacrificing of prisoners. On all occasions of state, public bloodletting was an integral part of Maya ritual. The ruler, his consort, and certain members of the nobility drew blood from their own bodies and sought union with the supernatural world. The slaughter of captives taken in war regularly accompanied this ceremony. Indeed, Mesoamerican cultures undertook warfare largely to provide victims for sacrifice. The victors forced many captives to play a fixed and fatal ballgame in courts laid out adjacent to the temples (see "The Mesoamerican Ballgame," page 392). The torture and eventual execution of prisoners served both to nourish the gods and to strike fear into enemies and the general populace.

In the scene we illustrate, depicting the presentation of prisoners to the ruler (FIG. 14-11), the painter arranged the figures in registers that may represent a pyramid's steps. On the uppermost step, against a blue background, is a file of gorgeously appareled nobles wearing animal headgear. Conspicuous

among them on the right are retainers clad in jaguar pelts and jaguar headdresses. The Bonampak ruler himself, in jaguar jerkin and high-backed sandals, stands at the center, facing a crouching victim who appears to beg for mercy. Naked captives, anticipating death, crowd the middle level. One of them, already dead, sprawls at the ruler's feet. Others dumbly contemplate the blood dripping from their mutilated hands. The lower zone, cut through by a doorway into the structure housing the murals, shows clusters of attendants who are doubtless of inferior rank to the lords of the upper zone. The stiff formality of the grandees and the attendants contrasts graphically with the supple imploring attitudes and gestures of the hapless victims. The Bonampak victory was short lived. The murals were never finished, and shortly after the dates written on the walls the site seems to have been abandoned.

PAINTED VASES FOR PALACES AND TOMBS
Vivid narratives also appear on the much smaller surfaces of painted cylinder vases. A rollout view of a typical vase design (FIG. **14-12**) shows a palace scene where an enthroned lord sits surrounded by courtiers and attendants. In this scene, at once regal and intimate, the participants gesture and talk. The elaborate costumes of the Copán stele and the Bonampak paintings are absent. Instead, the figures wear simple loincloths, turbans of wrapped cloth and feathers, and black body paint. The red frame that surrounds the scene suggests an architectural setting. The painter provided a glimpse of the event through the open doorways of a palace.

The horizontal band of hieroglyphs at the top describes the vessel and names the artist. Although this particular name has not been completely deciphered, the names of a handful of Maya vase painters, all male, are now known. (In pre-Columbian art, artists' signatures are almost nonexistent and even on Maya pots are very rare.) Some texts even list the vessel's contents. One pot marked with the glyph for cacao, or chocolate, still contained remnants of the prestigious drink when it was discovered. In our example, the artist may have portrayed himself among the participants. He repeats his name in one of the vertical texts, which refer to both the figures and ritual events. Some artists even recorded their parentage, clearly stating they were of noble birth and high status. Vases such as this one may have been used as drinking and food vessels for noble Maya, but their final destination was the tomb,

where they accompanied the deceased to the Underworld. They likely were commissioned by the deceased before his death or by his survivors and occasionally were sent from distant sites as funerary offerings. (The Maya intermarried with other powerful families to consolidate power between important cities, and both trade and gift exchanges were common.)

Terminal Classic and Early Postclassic (800–1250)

Throughout Mesoamerica, the Classic period ended at different times with the disintegration of the great civilizations. Teotihuacán's political and cultural empire, for example, was disrupted around 600, and its influence waned. In 700 the great city's center was destroyed by fire, possibly at the hands of invaders from the north known as the Toltecs, and within fifty years Teotihuacán was deserted. Around 900, many of the great Maya sites were abandoned to the jungle, leaving a few northern Maya cities to flourish for another century or two before they, too, became depopulated. The Classic culture of the Zapotecs, centered at Monte Albán in the state of Oaxaca, came to an end around 700, and the neighboring Mixtec peoples assumed supremacy in this area during the Postclassic period. Classic El Tajín, later heir to the Olmec in the Veracruz plain, survived the general crisis that afflicted the others but was burned sometime in the twelfth century, again by northern invaders. The war and confusion that followed the collapse of the Classic civilizations broke the great states up into small, local political entities isolated in fortified sites. The collapse encouraged even more warlike regimes and chronic aggression. The militant city-state of Chichén Itzá dominated Yucatán, while in central Mexico the Toltec and the later Aztec peoples, both ambitious migrants from the north, forged empires by force of arms.

THE ASCENDANCY OF CHICHÉN ITZÁ Yucatán, a flat, low limestone peninsula covered with scrub vegetation, lies north of the rolling and densely forested region of the Guatemalan Petén. During the Classic period, Mayan-speaking peoples sparsely inhabited this northern region. For still-debated reasons, when the southern Classic Maya sites were abandoned after 900, the northern Maya continued to build many new temples in this area. A new art style, which can be

14-12 Enthroned Maya lord and courtiers, cylinder vase (rollout view), Maya, from Motul de San José region, Guatemala, 672–830. Ceramic with red, rose, orange, white, and black on cream slip, approx. 8″ high. Dumbarton Oaks Research Library and Collections, Washington.

seen in the buildings at Chichén Itzá, was contemporaneous with the political ascendancy of the Toltec at Tula, a site northwest of Mexico City. Although the two cities share striking similarities in their art and architecture—such as colonnaded structures and an emphasis on sacrificial and militaristic imagery—the nature of their relationship is still poorly understood. But the long-held notion that warriors from Tula actually invaded the Maya site has gradually been abandoned.

The Maya of Chichén Itzá left fewer written records than their cousins to the south, and the surviving texts are brief, limited to the ninth century, and written in a different style from those of Classic sites such as Tikal and Copán. Furthermore, recent hieroglyphic decipherments, as well as the site's art style, which does not focus on single figures but on groups and processions, suggest that rulership at Chichén Itzá may have been shared among nobles rather than passed from father to son.

EXPERIMENTATION IN THE NORTH The northern Maya experimented with building construction and materials to a much greater extent than the Maya farther south. Piers and columns appeared in doorways, and stone mosaics enlivened outer facades. The northern groups also invented a new type of construction, a solid core of coarse rubble faced inside and out with a veneer of square limestone plates.

The design of the structure known as the Caracol ("snail" in Spanish) at Chichén Itzá (FIG. **14-13**, foreground) suggests that the northern Maya were as inventive of architectural form as they were experimental with construction and materials. A cylindrical tower rests on a broad terrace supported, in turn, by a larger rectangular platform measuring one hundred sixty-nine feet by two hundred thirty-two feet. The tower, composed of two concentric walls, encloses a circular staircase that leads to a small chamber near the top of the structure. In plan, the building recalls the cross-section of a conch shell. Because

the conch shell was an attribute of the feathered serpent, and round temples were dedicated to him in central Mexico, this building may have been a temple to Kukulcan, the Maya name for Quetzalcóatl. Windows along the Caracol's staircase and an opening at the summit probably were used for astronomical observation, which has given the building another nickname—the Observatory. Noted astronomers, the Maya tracked celestial events closely, both for practical reasons, such as determining when to plant and the date of the next eclipse, and to foretell and attempt to manipulate the future.

THE SACRED MOUNTAIN RE-CREATED Conspicuous among the other notable structures at Chichén Itzá is the Temple of Kukulkan, which sits upon the summit platform of a great pyramid (FIG. 14-13, background). The Castillo, or "castle," as the entire monument has been long named, is of imposing size—ninety-eight feet high and one hundred eighty-two feet wide at the base—a majestic symbol of a mountain, revered as sacred throughout Mesoamerica and re-created countless times in stone. Steps on four sides of the nine-tiered pyramid converge on the temple level. Painted reliefs throughout the structure relating to the cult of Quetzalcóatl are signatures of central Mexican influence on the northern Maya of Yucatán. The Castillo is a kind of paradigm of Mesoamerican architectural form. Towering above the city's central plaza, the great stepped pyramid's quadripartite (four-part) plan echoes the four sacred directions.

TOLTEC GUARDIANS OF QUETZALCÓATL The name *Toltec,* which signifies "makers of things," generally refers to a powerful tribe of invaders from the north, whose arrival in central Mexico coincided with the great disturbances that must have contributed to the fall of the Classic civilizations. The Toltec capital at Tula flourished from about 900 to 1200. The Toltecs were great political organizers and

14-13 The Caracol *(foreground)* and the Castillo *(background)*, Chichén Itzá, Maya, Yucatán, Mexico, ca. 800–900.

military strategists, dominating large parts of north and central Mexico. They also were respected both as master artisans and farmers, and later peoples such as the Aztec looked back on them admiringly, proud to claim descent from them.

At Tula, four colossal atlantids (male statue-columns) portraying armed warriors (FIG. **14-14**) reflect the grim, warlike regime of the Toltecs. These images of brutal authority stand eternally at attention, warding off all hostile threats. Built up of four stone drums each, the sculptures stand atop of Pyramid B, dedicated to Quetzalcóatl. They wear feathered headdresses and, as breastplates, stylized butterflies, heraldic symbols of the Toltec. In one hand they clutch a bundle of darts and in the other an *atlatl* (spear-thrower), typical weapons of highland Mexico. The figures originally supported a now-missing temple roof. Such an architectural function requires rigidity of pose, compactness, and strict simplicity of contour. The unity and regularity of architectural mass and silhouette here combine perfectly with abstraction of form.

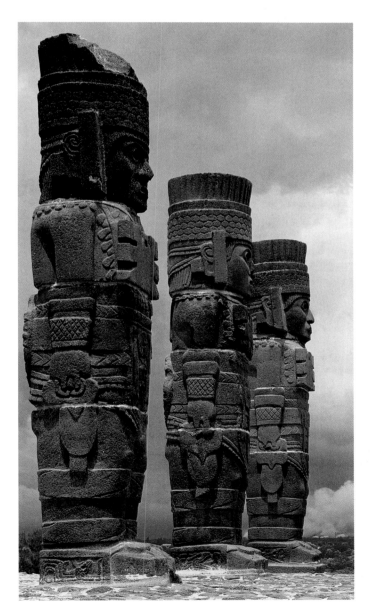

14-14 Colossal atlantids, Pyramid B, Toltec, Tula, Hidalgo, Mexico, ca. 900–1180. Stone, 16' high.

By 1180, the last Toltec ruler abandoned Tula, followed by most of his people. Some years later, the city was catastrophically destroyed, its ceremonial buildings burned to their foundations, its walls thrown down, and the straggling remainder of its population scattered. As with the fate of the other pre-Columbian Mesoamerican civilizations, the exact reasons for the Toltecs' departure and for their city's destruction are unknown. Although the stage was set for the rise of the last great civilization of Mesoamerica, the Aztecs (see Chapter 30), they did not reach the height of their power for another three hundred years.

SOUTH AMERICA

The story of the great cultures of Andean South America is much the same as that of the pre-Columbian peoples of Mesoamerica. Native civilizations jarred against and stimulated one another, produced distinctive architecture and art, and were exterminated in violent confrontations with the Spanish conquistadors. Although long overshadowed by the better-known cultures of Mexico and Central America, those of South America are actually more ancient and in some ways surpass the accomplishments of their northern contemporaries. Andean peoples, for example, mastered metalworking much earlier, and their monumental architecture predates that of the earliest Mesoamerican culture, the Olmec, by more than a millennium.

GEOGRAPHY AND CHRONOLOGY The Central Andean region of South America lies between Ecuador and northern Chile, its western border the Pacific Ocean. It consists of three well-defined geographic zones, running north and south and roughly parallel to one another. The narrow western coastal plain is a hot desert crossed by rivers, creating habitable fertile valleys. Next, the high peaks of the great Cordillera of the Andes hem in plateaus of a temperate climate. The region's inland border, the eastern slopes of the Andes, is a hot and humid jungle.

Highly developed civilizations flourished both on the coast and in the highlands, but their origins are still obscure. As in Mesoamerica, art-producing cultures succeeded one another at irregular intervals but began at least one thousand years earlier. Andean chronology shifts between periods of independent regional development and periods known as "horizons," when a single culture appears to have dominated a broad geographic area for a relatively long period. The peoples of the earliest cultures, unidentified, lived from about 3000 B.C. to 800 B.C. The horizon art and architectural styles are represented by the cultures of Chavín (ca. 800–200 B.C.), Tiwanaku and Wari (ca. A.D. 600–1000), and, finally, the Inca (see Chapter 30), whose dominance of the Andean area was complete but brief, lasting only for the century preceding the Spanish conquest in 1532. Between the horizon periods cultural development did not lag, but it took different forms in widely separated areas. Among the many regional cultures that flourished before the Europeans arrived, the most important are those of the so-called Early Intermediate period (ca. 200 B.C.–A.D. 700), especially the Paracas and Nasca cultures of the south coast of Peru and the Moche in the north.

14-15 Feline head, Huaca de los Reyes mound, Caballo Muerto, Moche Valley, Peru, ca. 1300 B.C. Adobe over cobble core, probably once painted, 5′ 7″ high, 4′ 3″ wide, 2′ deep.

Early Cultures (ca. 3000–800 B.C.)

The discovery of complex ancient communities documented by radiocarbon dating is changing researchers' assessments of early South American cultures. Planned communities boasting organized labor systems and monumental architecture dot the narrow river valleys that drop from the Andes to the Pacific Ocean. In the Central Andes, these early sites began to develop around 3000 B.C., about a millenium before the invention of pottery there ca. 2000 B.C. Carved gourds, possibly imported from Ecuador, and some fragmentary twined cotton textiles survive from this early period. (*Twining* is a nonloom technique like macramé; the weaver twists two threads around each other to form the finished cloth.) They depict composite creatures, such as crabs turning into snakes, as well as doubled and then reversed images, both hallmarks of much of later Andean art.

CEREMONIAL ARCHITECTURE The architecture of the early coastal sites typically consists of large U-shaped flat-topped platforms—some as high as a ten-story building—around sunken courtyards. Many had numerous small chambers on top. Construction materials included both uncut fieldstones and handmade *adobes* (sun-dried mud bricks) in the shape of cones, laid point to point in coarse mud plaster to form walls and platforms. Facades, ornamented with bright multicolored adobe friezes, often displayed human figures with feline or serpentine attributes or great fanged faces of massive proportions. We illustrate a large adobe feline head (FIG. **14-15**), once painted although the color disap-

peared long ago, from the Huaca de los Reyes mound at the site of Caballo Muerto in Peru. Feline and serpentine motifs reappeared throughout Andean pre-Columbian history. Undoubtedly, the early modeled images served as backdrops for large public festivals held within the open-air plazas before them. These great U-shaped complexes almost always faced toward the Andes mountains, source of the life-giving rivers these communities depended on for survival. Mountain worship, which continues in the Andean region to this day, was probably the focus of early religious practices as well.

In the highlands, archeologists also have discovered large ceremonial complexes. In place of the numerous interconnecting rooms found on top of many coastal mounds, the highland complexes have a single small chamber at the top, often with a stone-lined firepit in the center. Researchers believe these pits played a role in a highland fire ritual. Burnt offerings, often of exotic objects such as marine shells and tropical bird feathers, have been found in them.

Chavín (ca. 800–200 B.C.)

Named after the ceremonial center of Chavín de Huántar, located in the northern highlands of Peru, the Chavín culture developed and spread throughout much of the coastal region and the highlands during the first millennium B.C. From recent discoveries at other sites, archeologists have concluded that the Chavín horizon style, once thought the "mother culture" of the Andean region, was in reality the culmination of developments that began some two thousand years earlier elsewhere.

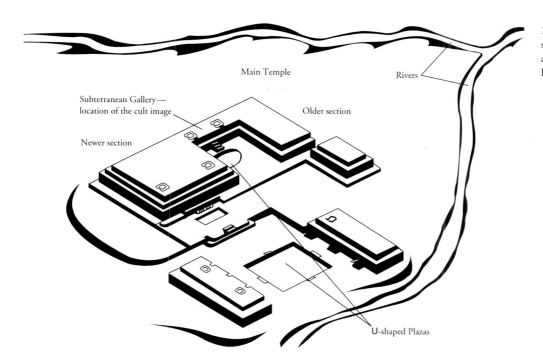

Main Temple

Subterranean Gallery—
location of the cult image

Older section

Newer section

Rivers

U-shaped Plazas

14-16 Reconstructed drawing of plan of sacred center showing temple and associated sunken courtyards, Chavín de Huántar, Peru, first millennium B.C.

A SCULPTURE-FILLED TEMPLE PLATFORM
The main temple of Chavín de Huántar (FIG. **14-16**) is a U-shaped, stone-faced platform facing east toward a nearby river. Although at first glance it appears to be a solid platform with small ruined chambers on top, the temple is penetrated by a labyrinth of narrow passageways, small chambers, and stairways. The few members of Chavín society with access to these rooms must have witnessed secret and sacred ceremonies lit by torches, as no windows light the interior of the temple. The temple's builders may have attempted to re-create in stone the soaring Andean peaks that surround the valley, mountains still highly revered by Andean peoples. The temple is fronted by sunken courts, an arrangement undoubtedly adopted from earlier coastal sites. Modifications to the structure during the centuries have resulted in the asymmetrical shape seen today. The temple complex at Chavín de Huántar is famous for its extensive stone carvings. Consisting largely of low relief on panels, lintels, and columns and some rarer instances of freestanding sculpture, Chavín carving is essentially linear, hardly more than incision. An immense cult image stood in the center of the temple's oldest part. Other examples of sculpture in the round include heads of mythological creatures *tenoned* (attached by stone pegs) into the exterior walls. Although, at first glance, the subjects of Chavín stone carving appear to vary considerably, the artists most consistently emphasized composite creatures that combine feline, avian, reptilian, and human features.

A FROWNING AND SMILING GOD The *Raimondi Stele* (FIG. **14-17**), named after its discoverer, represents the late variant of Chavín stone carving. On the lowest third of the stone is a figure called the "staff god." He appears in various versions from Colombia to northern Bolivia but seldom with the degree of elaboration found at Chavín. In this instance, the squat scowling deity, always depicted holding staffs, gazes upward. An elaborate headdress dominates the upper two-thirds of the slab. Inverting the image reveals that the headdress is composed of a series of fanged jawless faces, each emerging from the mouth of the one above it. Snakes

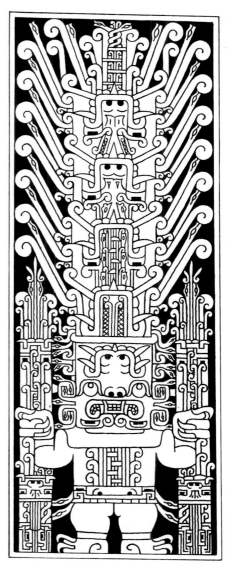

14-17 Drawing of the *Raimondi Stele,* from main temple, Chavín de Huántar, Peru, first millennium B.C. Incised green diorite, 6′ high. Instituto Nacional de Cultura, Lima, Peru.

Andean Weaving

When the Inca first encountered the Spanish conquistadors, they were puzzled by the Europeans' lust for gold and silver. Finely woven cloth was infinitely more precious to the Inca than mere metal. Textiles and clothing dominated every aspect of their existence. Storing textiles in great warehouses, their leaders demanded cloth as tribute, gave it as gifts, exchanged it during diplomatic negotiations, and even burned it as a sacrificial offering. Although both men and women participated in cloth production, the Inca rulers selected women from around the empire and sequestered them for life to weave exclusively for the rulers.

Andean peoples began making textiles at least four thousand years ago. They spun into yarn the cotton grown in five different shades on the warm coast and fur sheared from highland camelids (domesticated llamas and alpacas and the wild vicuña) and then wove the yarn into cloth. Rare tropical bird feathers and small plaques of gold and silver were sometimes sewn onto cloth destined for the nobility. Andean weavers mastered nearly every textile technique known today, many executed with a simple device known as a *backstrap loom*. Such looms are still in use in the Andes. The women stretch the long *warp* (vertical) threads between two pieces of wood, one tied to a stationary object. A belt or backstrap, attached to the other piece, goes around the waist of the seated weaver, who controls the tension of the warp threads by leaning forward and back. The weaver passes the *weft* (horizontal) threads over and under the warps and pushes them tightly against each other to produce the finished cloth. In ancient textiles, the sturdy cotton often formed the warp, while the wool, which can be dyed brighter colors, served to create complex designs in the weft. *Embroidery* (see "Embroidery and Tapestry," Chapter 17, page 485), sewing threads onto a finished ground cloth to form contrasting designs, was the specialty of the Paracas culture (FIG. 14-18).

The dry deserts of coastal Peru have preserved not only numerous textiles from different periods but also hundreds of finely worked baskets containing spinning and weaving implements. These tools are invaluable sources of information about Andean textile production processes. The baskets found in documented contexts came from women's graves, attesting to both the close identity between weaving and women and the reverence for the cloth-making process.

A special problem all weavers confront is that they must visualize the entire design in advance and cannot easily change it during the weaving process. No records exist of how Andean weavers learned, retained, and passed on the elaborate patterns they wove into cloth, but Moche pottery (from a northern site discussed later) depicts weavers at work, apparently copying designs from finished models. From the earliest times, religious and political elites throughout the Andes must have tightly controlled the production of fine cloth. However, the inventiveness of individual weavers, within strict guidelines, is evident in the endless variety of colors and patterns in surviving pre-Columbian textiles.

Some motifs, such as the figures, animals, and birds embroidered on Paracas fabrics (FIG. 14-18), derived from the natural world, but most Andean textile designs are highly abstract and geometric, reflecting the right-angled relationship of warp and weft. Some of the abstract designs are actually highly stylized figures (FIG. 14-24), but many others, including those woven into fine Inca tunics during the Spanish conquest, still cannot be read with certainty. Colonial sources state only that the type and quality of clothing and accessories the Andean peoples wore reflected ethnic identity and social rank.

abound. They extend from the deity's belt; comprise part of the staffs; serve as whiskers and hair for the deity and the headdress creatures; and, finally, form a *guilloche* (an architectural ornament that imitates braided ribbon) at the apex of the composition. The *Raimondi Stele* clearly illustrates the Andean artistic tendency toward both multiplicity and dual readings. Upside down, the frowning god's face turns into not one but two smiling faces.

Chavín iconography spread widely throughout the Andean region through portable media such as goldwork, textiles, and ceramics. For example, more than three hundred miles from Chavín on the south coast of Peru, archeologists have discovered cotton textiles with imagery recalling Chavín sculpture. Painted staff-bearing female deities, apparently local manifestations or consorts of the highland staff god, decorate these large cloths, which may have served as wall hangings in temples. The ceramic vessels of the north coast of Peru, contemporaneous with both Huaca de los Reyes and later Chavín, are identified easily by their massive chambers, spout, surface relief, and burnished dark colors—brown, black, or grey. The motifs are much like those found on Chavín stone carvings. The stirrup spout, in which a spout emerges from a semicircular handle on top of the vessel (FIG. 14-21), became popular at this time and continued to be a commonly used North Coast form until the advent of the Spaniards.

Paracas (400 B.C. – A.D. 200)

Several coastal traditions developed during the period between about 500 B.C. and A.D. 600. Together they exemplify the great variations within Peruvian art styles. The Paracas culture, which flourished as early as the fifth century B.C., occupied a desert peninsula and a nearby river valley on the south coast of Peru.

FLYING FIGURES ON A FUNERARY MANTLE Outstanding among the Paracas arts are the funerary textiles (FIG. **14-18**) used to wrap the bodies of the dead in multiple layers. More than a thousand examples survive. The dry desert

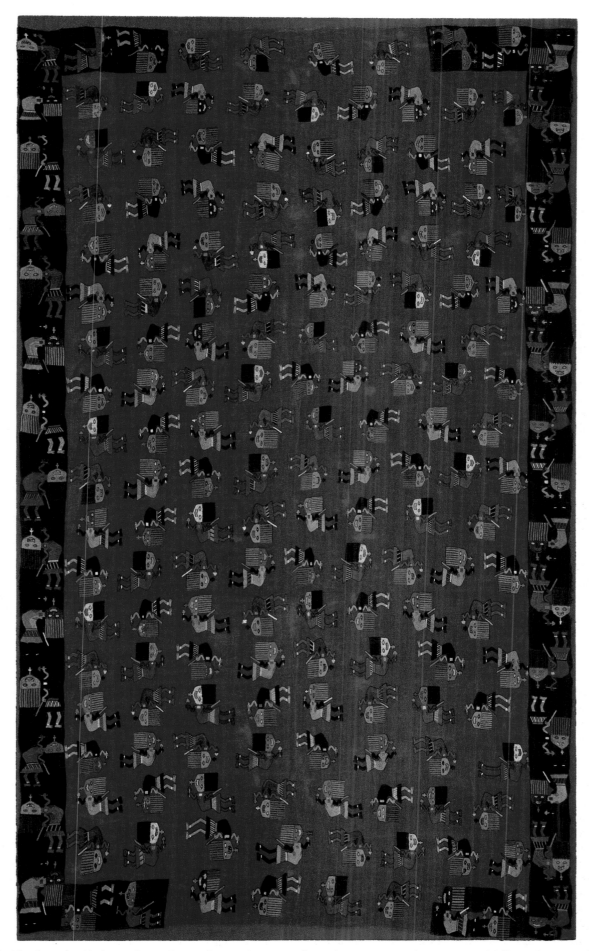

14-18 Embroidered mantle with shaman figures, Paracas, from southern coast of Peru, first century A.D. Plain weave camelid fiber with stem-stitch embroidery embroidered with camelid wool, 4′ 7$\frac{7}{8}$″ × 7′ 10$\frac{7}{8}$″. Museum of Fine Arts, Boston (William A. Paine Fund).

climate preserved the textiles, buried in shaft tombs beneath the sands. These textiles are among the enduring masterpieces of Andean art (see "Andean Weaving," page 402). Most are of woven cotton with designs embroidered onto the fabric in alpaca or vicuña wool (imported from the highlands, where these animals are herded in large numbers). The weavers used more than one hundred fifty vivid colors, the majority derived from plants. The motifs of the grave mantles have a symbolism not yet deciphered. Most distinctive is a flying figure with prominent eyes, who is repeated scores of times over the surface of the mantle we illustrate. The flying or floating beings on these cloths variously carry batons and fans (as they do here), plants, and sometimes the skulls or severed heads of enemies. Their flowing hair and the slow kicking motion of their legs suggest airy, hovering movement. Despite endless repetition of the figure, variations of detail occur throughout each textile, notably in the figures' positions and in subtle color changes. Furthermore, the mantles often had sewn borders of contrasting color, although with similar designs. Feline, bird, and serpent motifs also appear on some of the textiles, but the human figure, real or mythological, predominates. Art historians have interpreted the flying figure as a Paracas shaman dancing or flying during an ecstatic trance such as those shamans experienced in rites to cure individual illness or to insure the fertility of the community's crops.

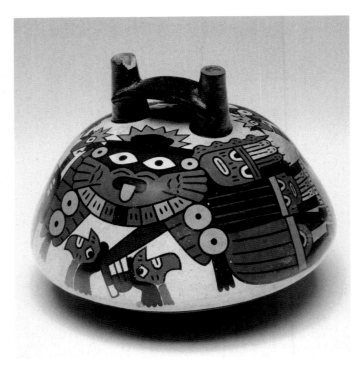

14-19 Bridge-spouted vessel depicting ceremonial figure, Nasca, from Nasca River valley, Peru, ca. 50–200. Ceramic, approx. $5\frac{1}{2}''$ high. Art Institute of Chicago, Chicago (Kate S. Buckingham Endowment).

Nasca (200 B.C.–A.D. 600)

The culture now called Nasca is named after the Nasca River valley of the south coast of Peru. The Nasca were renowned for their pottery. Thousands of their ceramic vessels survive and usually have round bottoms, double spouts connected by bridges, and smoothly burnished polychrome surfaces (FIG. **14-19**). The subjects vary greatly, with emphasis on plants, animals, and composite mythological creatures, partly human and partly animal. The painters commonly represented ritual impersonators, some of whom, like the Paracas flying figures, hold trophy heads and weapons. In the example we illustrate, two such costumed figures fly around the vessel. The painter reduced their bodies and limbs to abstract appendages and focused on the heads. The figures wear a multicolored necklace, a whiskered gold mouthpiece, circular disks hanging from the ears, and a rayed crown on the forehead. Masks or heads with streaming hair, possibly more trophy heads, flow over the impersonators' backs, increasing the sense of motion.

IMMENSE DRAWINGS ON THE NASCA PLAIN
Polychrome pottery is not the sole source of Nasca's fame. Some eight hundred miles of lines, drawn in complex networks on the dry surface of the Nasca Plain in southwestern Peru, have long attracted world attention as mysterious and gigantic artworks. Nasca artists traced out about three dozen images of birds, fish, and plants on the plain. Our illustration (FIG. **14-20**) shows a hummingbird with a wingspan of more than two hundred feet. The Nasca artists also drew geometric forms, such as trapezoids, spirals, and straight lines running for miles. Uniformly, the Nasca Lines, as the immense drawings are called, appear light on a dark ground. The Nasca produced the effect by scraping aside the sun-darkened desert pebbles to reveal the lighter layer of whitish clay and calcite beneath. The near-rainless environment has preserved the drawings for centuries, but modern highways and off-road vehicles have damaged many of the Nasca Lines.

Given the huge size and bewildering intricacy of the patterns, speculation continues as to the source, construction, and meaning of the Nasca Lines. Although they are best seen from the air, they are also visible from the Andean foothills and the great coastal dunes. The lines were constructed quite easily from available materials and with some rudimentary geometry. A small group of workers have made modern reproductions of them with relative ease. The lines seem to be paths laid out using simple stone-and-string methods. Some lead in traceable directions across the deserts of the Nasca River drainage, while others are punctuated by many shrine-like nodes, like the knots on a cord. The lines converge at central places usually situated close to water sources and seem to be associated with water supply and irrigation. They may have marked pilgrimage routes for those who journeyed to local or regional shrines on foot. Although astronomical functions have been proposed for the lines, this theory has not been convincingly demonstrated. Altogether, the vast arrangement of the Nasca Lines is a system—not a meaningless maze but a traversable map that plotted out the whole terrain of the Nasca material and spiritual concerns. Remarkably, until quite recently similar ritual pathways were made and used in association with shrines in highland Bolivia, demonstrating the tenacity of the Andean indigenous belief systems.

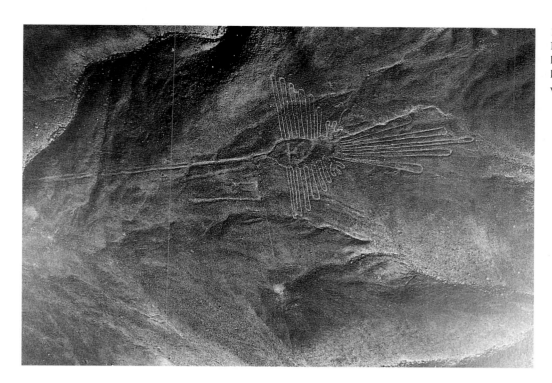

14-20 Drawing of a hummingbird on Nasca Plain, Nasca, Peru, ca. 500. Dark layer of pebbles, scraped aside to reveal lighter clay and calcite beneath; 27' wide, 200' wingspan, and 459' length.

Moche (A.D. 1–700)

The Moche occupied a series of river valleys on the north coast of Peru around the same time the Nasca flourished to the south, but the Moche left behind more impressive architectural remains. Their ceremonial architecture consisted of immense pyramidal platforms that, due to the scarcity of stone, they constructed of adobe and then plastered and painted in bright colors. In the lower Moche River valley, the remains of the Temple of the Sun, which the Moche made of millions of adobe bricks, provide some idea of the scale of such construction.

MOCHE DAILY LIFE Among the most famous art objects the ancient Peruvians produced are the Moche ceramic vessels, predominantly flat-bottomed stirrup-spouted jars, generally decorated with a bichrome (two-color) slip. Although the Moche hand made early vessels without the aid of a potter's wheel, they fashioned later ones in two-piece molds. Thus, numerous near-duplicates survive. Moche potters continued to refine the stirrup spout, making it an elegant slender tube, much more slender than the Chavín prototype. This refinement may be seen in one of the famous Moche portrait bottles (FIG. **14-21**). It may depict the face of a warrior, a ruler, or even a royal retainer whose image may have been buried with many other pots to accompany his dead master. Among ancient civilizations, only the Greeks and the Maya surpassed the Moche in the information recorded on their ceramics. Moche pots illustrate architecture, metallurgy, weaving, the brewing of *chicha* (fermented maize beer), human deformities and diseases, and even sexual acts.

TREASURES OF THE LORDS OF SIPÁN Elite men, along with retinues of sacrificial victims, appear to be the occupants of several rich Moche tombs excavated near the little village of Sipán on the arid northwest coast of Peru.

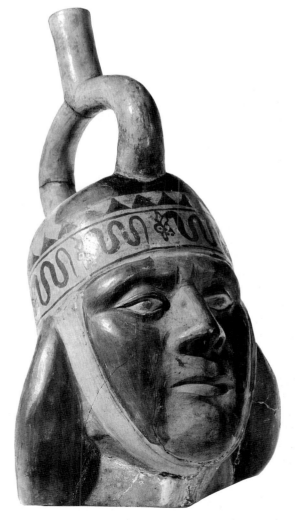

14-21 Portrait bottle, Moche, from northcoast Peru, fifth to sixth century. Painted clay, $11\frac{1}{2}''$ high. American Museum of Natural History, New York.

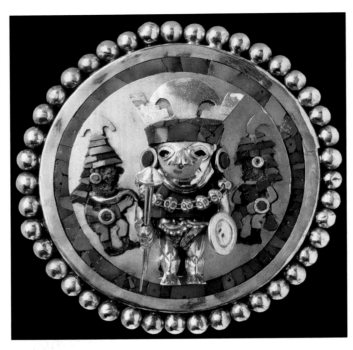

14-22 Ear ornament, from a tomb at Sipán, Moche, Peru, ca. 300. Gold and turquoise, approx. $4\frac{4}{5}''$. Bruning Archeological Museum, Lambayeque.

Looted and unlooted tombs have yielded a treasure of golden artifacts and more than a thousand ceramic vessels. The tombs' discovery in the late 1980s made a great stir in the archeological world, contributing significantly to the knowledge of Moche culture. Located beneath a large adobe platform adjacent to two high but greatly eroded pyramids, the tombs had escaped the attention of village grave robbers for many years. The splendor of the funeral trappings that adorned the body of one of the dead, the so-called Lord of Sipán; the quantity and quality of the sumptuous accessories; and the bodies of the retainers buried with him indicate he was a personage of the highest rank. Indeed, he may have been one of the warrior-priests so often pictured on Moche ceramic wares and murals (and in this tomb on a golden pyramid-shaped rattle) assaulting his enemies and participating in sacrificial ceremonies.

An ear ornament of turquoise and gold found in one tomb shows a warrior-priest clad much like the dead man (FIG. 14-22). Represented frontally, he carries a war club and shield and wears a necklace of owls' heads. The figure's bladelike crescent-shaped helmet is a replica of the large golden one buried with the warrior-priest. The ear ornament of the jewelry image is a simplified version of the piece itself. The removable nose guard and the golden chin guard also match those the deceased wore. Two retainers, with similar helmets and ear ornaments, appear in profile.

Though the Andean cultures did not develop a system of writing, they had an advanced knowledge of metallurgy long before the Mesoamericans, who must have received it via Central America as late as the tenth century. Treasure of silver and gold, of course, lured the Spanish invaders to the Americas, and the wildcat plundering of pre-Columbian tombs by grave robbers, both foreign and domestic, continues to scatter precious artifacts worldwide. The value of the Sipán find is incalculable for what it reveals about elite Moche culture.

Tiwanaku (100–1000)

The bleak highland country surrounding Lake Titicaca in southeastern Peru and southwestern Bolivia contrasts markedly with the warm valleys of the coast. Isolated in these mountains, at an altitude of twelve thousand five hundred feet, another culture developed semi-independently of the coastal cultures, beginning in the first centuries of the Christian era and ending about 1000. This culture has been named Tiwanaku, after the principal archeological site on the southern shores of the lake in Bolivia. The Tiwanaku art style then spread to the adjacent coastal area as well as to other highland areas, eventually extending from southern Peru to northern Chile.

THE GATEWAY OF THE SUN Tiwanaku was an important ceremonial center, although today it is largely in ruins. The inhabitants constructed buildings with the region's fine stone—sandstone, andesite, and diorite—bringing much of it from great distances. Among these impressive structures is the imposing Gateway of the Sun (FIG. 14-23), a huge monolithic block of andesite pierced by a single doorway and crowned with a sculptured lintel. Moved in ancient times from its original location within the site, the gateway now forms part of an enormous walled platform, leading nowhere. The central figure, rigidly frontal, stands on a terraced step holding a staff in each hand. From the enormous blocklike head project rays that terminate in circles and puma heads. The form recalls that of the *Raimondi Stele* (FIG. 14-17) in its frontality and in the symmetrical staffs, as well as in the geometric conventions used for human and animal representation. The "staff-god"—possibly a sky and weather deity rather than the sun deity the rayed head suggests—appears in art throughout the Tiwanaku horizon, associated, as here,

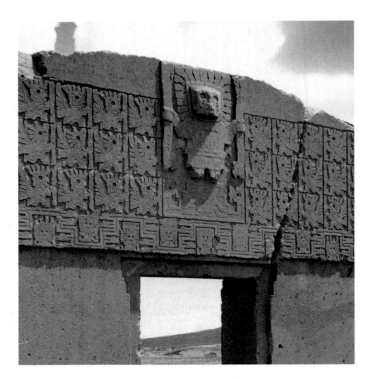

14-23 Detail of Gateway of the Sun, Tiwanaku, Bolivia, ca. 375–700.

with smaller-scale attendant figures. Carved in high relief on this lintel, the god stands out prominently against the low-relief rows of condor impersonators and winged men with weapons who run toward the center. Each of the running figures fills a square panel, giving an effect of movement, which quickens slightly the composition's otherwise static formality. A border of *frets* (an ornamental pattern of contiguous straight lines joined usually at right angles) interspersed with masklike heads forms a kind of supporting lower step. Because of the distortion of the bodily proportions, the suppression of detail, and the intricate flat relief, the Gateway imagery is difficult to decipher today. But artists once had painted the carved surface, inlaid the eyes of the figures with turquoise, poured molten gold into the recesses, and hammered sheet gold over the raised surfaces.

Wari (500–800)

The flat, abstract, and repetitive figures surrounding the central figure on the Gateway of the Sun recall woven textile designs. Indeed, the people of the Tiwanaku culture, like those of Paracas, were consummate weavers, although many fewer textiles survive from the damp highlands. However, from a contemporaneous Peruvian culture known as Wari, which

dominated parts of the dry coast, many examples of weaving, especially tunics, have been recovered.

ABSTRACTION IN TAPESTRY Although Wari weavers fashioned cloth, like the earlier Paracas textiles, from both wool and cotton fibers, the resemblance between the two textile styles ends there. While Paracas motifs were embroidered onto the plain woven surface, Wari designs were woven directly into the fabric, the weft threads packed densely over the warp threads in a technique known as *tapestry* (see "Embroidery and Tapestry," Chapter 17, page 485). Some particularly fine pieces have more than two hundred weft threads per inch. Furthermore, unlike the relatively naturalistic individual figures depicted on Paracas mantles, those appearing on Wari textiles are so closely connected and so abstract as to be nearly unintelligible. Most designs, however distorted, derive from the motifs on the Gateway of the Sun at Tiwanaku. The tunic shown here, the so-called *Lima Tapestry* (FIG. **14-24**), for example, is an abstract interpretation of the Tiwanaku staff-bearing attendants. The artist expanded or compressed each figure in a different way and placed them in vertical rows pressed between narrow red bands of plain cloth. Elegant tunics such as this, worn by the elite, must have carried the message of the Tiwanaku staff god to the far reaches of the Andean region.

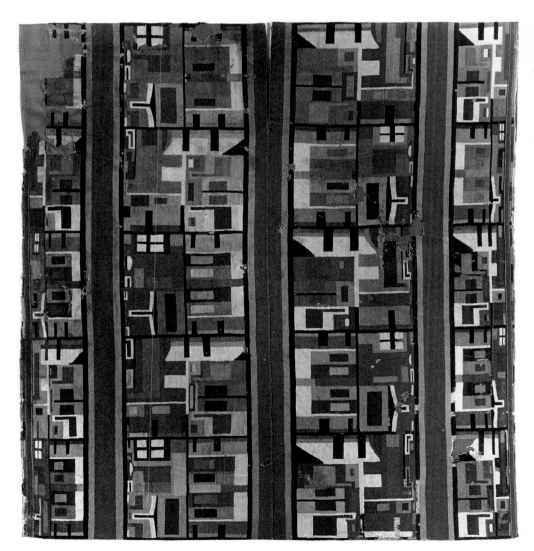

14-24 *Lima Tapestry* (tunic), Wari, from Peru, ca. 500–800. 3′ 3⅜″ × 2′ 11⅜″. National Museum of Archeology, Anthropology, and History of Peru, Lima.

NORTH AMERICA

Bering Strait • Ipiutak

ALASKA

Eskimo (Inuit)

Pacific Ocean

Eskimo (Inuit)

Hudson Bay

CANADA

Woodlands

NORTH AMERICA

MESOAMERICA

SOUTH AMERICA

UNITED STATES

Great Basin — Cliff Palace

ADENA — Cahokia — Serpent Mound

Plains

ANASAZI

Mesa Verde — Taos Pueblo

Colorado R. NAVAJO PUEBLO

HOPI ZUNI

Pueblo Bonito — *Chaco Canyon*

Southwest — Kuaua

MIMBRES

Mississippi R. *Ohio R.* MISSISSIPPIAN

Eastern Woodlands

Atlantic Ocean

Rio Grande

MEXICO

Gulf of Mexico

◇ Archaeological site

| 0 | 500 | 1000 miles |
| 0 | 500 | 1000 kilometers |

1100 B.C.	A.D. 200	500	1000	1150	1500	1600
PREHISTORIC					HISTORIC	

Pipe, Adena
Ohio, ca. 500 B.C.–1 A.D.

Mask, Ipiutak
Point Hope, Alaska, ca. 100

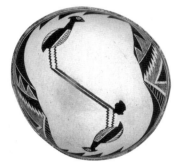

Bowl, Mimbres
New Mexico, ca. 1250

Adena culture, 1100 B.C.–A.D. 200

Earliest Eskimo/Inuit carvings in ivory, 500 B.C.

Mississippian culture dominates eastern North America, 800–1500

Mimbres ceramic masterpieces, ca. 1000–1150

Serpent Mound, Ohio, ca. 1070

Drought forces abandonment of Chaco Canyon, 1200

Mesa Verde abandoned, ca. 1300

Anasazi paint murals on kiva walls, ca. 1300–1500

First European colonies established, 1500–1600

NORTH AMERICA

In many parts of the United States and Canada, "prehistoric" cultures have been discovered that reach back as far as twelve thousand years ago. Most of the surviving art objects, however, come from the past two thousand years. "Historic" cultures, beginning with the earliest date of prolonged contact with Europeans, which varies from the sixteenth to the nineteenth century, have been widely and systematically recorded by anthropologists (see Chapter 30). The materials from these cultures usually reflect profound changes wrought by the impact of alien tools, materials, and values on the native peoples.

Scholars divide the vast and varied territory of North America into cultural regions based on the relative homogeneity of language and social and artistic patterns. Native lifestyles varied widely over the continent, ranging from small bands of migratory hunters to settled—at times even urban—agriculturalists. Among the peoples whose prehistoric existence is documented are the Eskimos, who hunted and fished across the Arctic from Greenland to Siberia, and the maize farmers of the American Southwest, who wrested water from their arid environment and built not only effective irrigation systems but also roads and spectacular cliff dwellings. The vast, temperate Eastern Woodlands—ranging from east-

ern Canada to Florida and from the Atlantic to the Great Plains west of the Mississippi—also were home to farmers. Some of them left behind great earthen mounds that once functioned as their elite residences or burial places.

Eskimo

A MASK OF SEVERAL FACES Eskimo sculpture, while often severely economical in the handling of form, is refined—even elegant—in the placement and precision of both geometric and representational incised designs. A carved ivory burial mask (FIG. **14-25**), datable to ca. A.D. 100, from the Ipiutak site at Point Hope in Alaska is composed of nine carefully shaped parts that are interrelated to produce several faces, both human and animal, as a visual pun. The mask is a confident, subtle composition in shallow relief, a tribute to the artist's imaginative control over the materials. For centuries, the Eskimo also carved hundreds of human and animal figurines, usually in ivory because of the scarcity of wood in most Arctic regions. These figures, as well as intricately carved hunting and fishing implements, reflect a nomadic lifestyle that required the creation of small, portable, and practical objects.

14-25 Burial mask, Ipiutak, from Point Hope, Alaska, ca. 100. Ivory, greatest width $9\frac{1}{2}''$. American Museum of Natural History, New York.

14-26 Pipe, Adena, from a mound in Ohio, ca. 500–1 B.C. Stone, 8"
high. Ohio Historical Society, Columbus.

Woodlands

TWO CARVINGS A MILLENNIUM APART Early
Native American artists also excelled in working stone into a
variety of utilitarian and ceremonial objects. The quite realis-
tic handling of a figural pipe bowl (FIG. **14-26**) from the
Adena culture of Ohio, dated between 500 B.C. and 1 B.C.,
provides an interesting contrast to a much later piece from an-
other culture. The more animated two-dimensional composi-
tion on a shell *gorget* (FIG. **14-27**), or neck pendant, is typical
of the more widespread Mississippian culture. Found at a site
in Tennessee, the shell gorget dates from ca. 1250 to 1300.
The standing pipe figure, although simplified, has naturalistic
joint articulations and musculature, a lively flexed-leg pose,

and an alert facial expression—all combining to suggest
movement. The incised shell gorget depicts a running warrior
wearing an elaborate headdress and carrying a mace in his left
hand and a severed human head in his right. Most Adena and
Mississippian objects come from burial and temple mounds
and are thought to have been gifts to the dead to ensure their
safe arrival and prosperity in the land of the spirits. Other art
objects found in such contexts include fine mica cutouts and
embossed copper cutouts of hands, bodies, snakes, birds,
and other presumably symbolic forms.

CEREMONIAL MOUNDS Both *effigy mounds* (mounds
built in the form of animals or birds) and complex plat-
formed *temple mounds,* some built six thousand years ago,
have been discovered at many sites in the eastern United
States and the Midwest. Such elaborate earthworks exem-
plify the universal practice of creating visually monumental
settings for ceremonial activities. The most impressive of the
temple mounds is Monk's Mound at Cahokia in southern
Illinois, the largest city in North America at one time (ca.
900–1200), with a population of twenty-five thousand and
an area of more than six square miles. Built in stages for three
centuries, Monk's Mound may have served as an elite resi-
dence, a temple, and a burial structure. Each stage was
topped by wooden structures that then were destroyed in
preparation for the building of a new layer. One of the finest
effigy mounds is Serpent Mound (FIG. **14-28**), a twisting
earthwork on a bluff overlooking a creek in Ohio. It mea-
sures nearly a quarter mile from its open jaw, which seems to
clasp an oval-shaped mound in its mouth, to its tightly coiled
tail. Both its date and meaning are controversial (see "Ser-
pent Mound," page 411).

14-27 Incised shell gorget, Mississippian, from Sumner County,
Tennessee, ca. 1250–1300. 4" wide. Museum of the American Indian,
Smithsonian Institution, New York.

ART IN THE NEWS

Serpent Mound

Serpent Mound (FIG. 14-28) is one of the largest and best known of the Woodlands effigy mounds. Rescued from certain destruction at the hands of pot hunters and farmers a century ago (in one of the first efforts at preserving a Native American archeological site), it is today the subject of considerable controversy.

Archeologists long attributed Serpent Mound, first excavated in the 1880s, to the Adena culture, which flourished in the Ohio area for several centuries before the Christian era. New radiocarbon dates taken from the mound, however, indicate that it was built much later and thus by the people known as Mississippians. Unlike most other ancient mounds, this one contained no evidence of burials or temples. Serpents, however, were important in Mississippian iconography, appearing, for example, etched on shell gorgets similar to the one illustrated (FIG. 14-27). Snakes were strongly associated with the earth and the fertility of crops. A stone figurine found at one site, for example, depicts a woman digging her hoe into the back of a large serpentine creature whose tail turns into a vine of gourds.

But another possible meaning for the construction of Serpent Mound has been proposed recently. The new date suggested for it is 1070, not long after the brightest appearance in recorded history of Halley's Comet in 1066. Could Serpent Mound have been built in response to this important astronomical event? It even has been suggested that the serpentine form of the mound replicates the comet itself streaking across the night sky. Whatever its meaning, such a large and elaborate earthwork only could have been built by a large labor force under the firm direction of a powerful elite eager to leave its mark on the landscape forever.

14-28 Serpent Mound, Mississippian, Ohio, late eleventh century. 1200′ long, 20′ wide, 5′ high.

Southwest

Most Native American art media span lengthy periods of time. Detailed chronological sequences of pottery styles are, in fact, the historian's major tool for dating and reconstructing the cultures of the distant past, especially in the Southwest. Many fine specimens of ceramics from the Southwest date from before the Christian era until the present, but pottery became especially fine, and its decoration most impressive, after about 1000.

MIMBRES POTTERY An animated graphic rendering of two cranes creates a dynamic tension between the black figuring and the white ground of a bowl from the Mimbres culture of southwestern New Mexico (FIG. **14-29**). The contrast between the bowl's abstract border designs and the birds creates a similar tension. Thousands of different compositions are known from Mimbres pottery. They range from lively and complex geometric patterns to often whimsical pictures of humans and animals. Almost all are imaginative creations by artists who seem to have been bent on not repeating themselves. Their designs emphasized linear rhythms balanced and controlled within a clearly defined border. Because the potter's wheel was unknown in the Americas, the artists used the coiling method to build countless sophisticated shapes of varied size, always characterized by technical excellence. Although historians have no direct knowledge about the potters' identity, the fact that pottery making was usually women's work in the Southwest during the historic period suggests that the Mimbres potters also may have been women.

Mimbres bowls have been found in burials under house floors, inverted over the head of the deceased and ritually

14-30 Cliff Palace, Anasazi, Mesa Verde National Park, Colorado, ca. 1150–1300.

14-29 Bowl with two cranes and geometric forms, Mimbres, from New Mexico, ca. 1250. Ceramic, black-on-white, diameter approx. 1' ½". Art Institute of Chicago, Chicago (Hugh L. and Mary T. Adams Fund).

"killed" by puncturing a small hole at the base, perhaps to allow the spirits of the deceased to join their ancestors in the sky (viewed as a dome by contemporary Southwestern peoples).

ANASAZI PUEBLOS In the later centuries of the prehistoric era, the Anasazi (Navajo for "enemy ancestors"), northern neighbors of the Mimbres, constructed architectural complexes that reflect masterful building skills and impressive talents of spatial organization. Many ruined *pueblos* (Spanish for "towns") are scattered throughout the Southwest. In Chaco Canyon, New Mexico, a great semicircle of eight hundred rooms reaching to five stepped-back stories was constructed, the largest of several such sites in and around the canyon. Sometime in the late twelfth century, a drought occurred and the Anasazi largely abandoned their open canyon-floor dwelling sites to move farther north to the steep-sided canyons and lusher environment of Mesa Verde in southwestern Colorado. Cliff Palace (FIG. **14-30**) is wedged into a sheltered ledge above a valley floor. It contains about two hundred rectangular rooms (mostly communal dwellings) of carefully laid stone and timber, once plastered inside and out with adobe. The location for Cliff Palace was not accidental — the Anasazi designed it to take advantage of the sun's movements to heat the pueblo and to shade it during the hot summer months.

14-31 Detail of a kiva painting from Kuaua Pueblo (Coronado State Monument), Anasazi, New Mexico, late fifteenth to early sixteenth century. Museum of New Mexico, Santa Fe.

The descendants of the Anasazi built multistoried pueblos of adobe brick, with each story set back from the one beneath it to form broad roof terraces. Some, such as Taos Pueblo in Taos, New Mexico, are still at least partially occupied today.

A NEW MEXICO LIGHTNING MAN Scattered in the foreground of our Cliff Palace photograph are two dozen large circular semisubterranean structures, called *kivas,* which once were roofed over and entered with a ladder through a hole in the flat roof. These chambers were (and remain) the spiritual centers of native Southwest life, male council houses where ritual regalia are stored and private rituals and preparations for public ceremonies take place.

Between 1300 and 1500, the Anasazi decorated their kivas with elaborate mural paintings representing deities associated with agricultural fertility. According to their descendants, the present-day Hopi and Zuñi, the detail of the Kuaua Pueblo mural shown here (FIG. **14-31**) depicts a "lightning man" on the left side. Fish and eagle images (associated with rain) appear on the right side. Seeds, a lightning bolt, and a rainbow stream from the eagle's mouth. All of these figures are associated with the fertility of the earth and the life-giving properties of the seasonal rains, a constant preoccupation of Southwest farmers.

The Anasazi did not disappear but gradually evolved into the various Pueblo peoples who still live in Arizona, New Mexico, Colorado, and Utah. They continue to speak their native languages, to practice deeply rooted rituals, and to make pottery in the traditional manner (see "Native American Artists," Chapter 30, page 953). Today, collectors all over the world highly prize native arts from the Southwest—whether ceramics, jewelry, weaving, or basketry.

AFRICA BEFORE 1800

Ancient Mali Kingdom

Ancient Ghana Kingdom

Modern nations included for reference.

	500 B.C.	A.D. 200		500	800	1000
NIGERIA	NOK				IGBO-UKWU	IFE
MALI AND SIERRA LEONE						DJENNE
SOUTH AFRICA AND ZIMBABWE				LYDENBURG		GREAT ZIMBABWE

Nok head
fifth century B.C.

Lydenburg head
sixth–eighth century

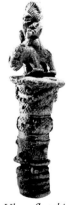

Igbo-Ukwu fly-whisk hilt
ninth–tenth century

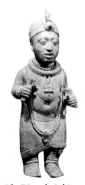

Ife (Yoruba) king
eleventh–twelfth century

First sub-Saharan ceramics, 500 B.C.–A.D. 200

Kingdom of Ghana, sixth–late eleventh century

First copper-alloy castings, 820–1000

SOUTH OF THE SAHARA

EARLY AFRICAN ART

1200	1400	1600	1800
BENIN			
	SAPI		

Djenne Mother and child
eleventh–fourteenth century

Conical tower, Great
Zimbabwe, fifteenth century

Sapi-Portugese saltcellar
fifteenth–sixteenth century

Benin altar of the hand
seventeenth–eighteenth century

Kingdom of Mali, early eleventh–
late fifteenth century

European contact in West and central Africa, ca. 1480–1510

THE ARTS OF AFRICA

GEOGRAPHY AND POPULATION Vastly different topographical and ecological zones characterize Africa. Parched deserts occupy northern and southern regions, high mountains rise in the east, and lush river valleys dot the continent. Three great rivers—the Niger, the Congo (formerly called the Zaire), and the Nile, with their tributaries—support varied agricultural economies and large settled populations. Huge tracts of grassland serve agriculture or provide pasture for the animals of nomadic and semisedentary herding peoples, who reckon wealth by the size of their herds. Fishermen harvest the oceans and rivers, and some relatively small groups still prefer to hunt and gather their foods, even though they (and the herders) know about raising crops in gardens.

Hundreds of distinct ethnic, cultural, and linguistic groups, often, but inaccurately, called "tribes," long have inhabited the enormous African continent. Currently comprising the population of more than fifty-two nations, such groups historically have ranged in size from a few thousand to several million people. Groups of elders often governed smaller groups, while larger populations sometimes have joined with other ethnicities within a centralized state, as in ancient Egypt. Sometimes, as among the Yoruba, a single ethnic group has been divided for centuries into quite autonomous kingdoms.

CORE BELIEFS, ART, AND RITUAL Within this great variety of African peoples, many share a matrix of core beliefs and practices, some dating back to ancient Egypt (see Chapter 3). This matrix includes extreme conservatism in honoring ancestrally established conventions, a profound orientation toward the spiritual in preparation for reward in the afterlife, and a tendency to elevate rulers to divine status. All of these factors have given rise to richly expressive art traditions throughout the continent. Much African sculpture demonstrates a preference for timeless stylized images, often presented without facial expression or movement. Africans also have perpetuated a love for festivals, occasions for presenting symbols of statecraft and religion through the skillful performance of costumed dancers, acrobats, musicians, and masqueraders.

THE RANGE OF AFRICAN ARTS Over the millennia African peoples have created a vast array of visually expressive forms (see "The Role of Art in Africa and the Chronology Problem," page 417). Of numerous types, materials, and technologies, these arts range from prehistoric rock images and ceramic sculptures, made well before Christ's time, to today's cement sculptures and urban murals. Textiles, jewelry, scarification, and painting normally adorn individuals. Nations, religious organizations, and families commission architecture, often finely embellished, while artists also continue to produce pottery, furniture, and shrine objects. The larger men's or women's groups and even whole communities sponsor shrines and their architectural settings. The arts of masquerade and festival incorporate large numbers of objects essential to creating and expressing meaning in these public performances.

ART AND THE AFRICAN WORLDVIEW Africa's visual arts encode ideas central to the ideologies and worldviews of African peoples. Although Islamic peoples in West Africa have been reading and writing Arabic since at least the twelfth century, many sub-Saharan Africans were nonliterate in the Western sense until the past few generations. Among current nonliterate groups, an art object carries a heavier burden of significance, because it replaces rather than supplements written text. Some art refers to or displays information—revealing or concealing it—while in other works the object itself is an ideological instrument, a value with no real equivalent. Art, then, helps define and create culture. It is integral to African life and thought rather than serving only as adornment.

All the hundreds of ethnic groups in Africa, speaking as many mutually unintelligible languages, made visual arts that differ according to economy and lifestyle, the materials available to them, and the specific iconography reflecting their values. Herders emphasize the arts of personal adornment. Early hunters and gatherers made many of the *pictographs* (pictures representing words or ideas) and *petroglyphs* (pictures on rock surfaces) found scattered across the continent. Farming peoples who live in settled communities have always been the major wood and clay sculptors and metalsmiths, and it is the art of these agriculturists that is stressed here.

AFRICA'S EARLIEST ART Thousands of petroglyphs and pictographs found in hundreds of sites across the continent constitute the earliest known African art. Some painted animals from the Apollo 11 Cave in Namibia (see FIG. 1-2) date to perhaps as long ago as twenty-five thousand years, earlier than all but the oldest Paleolithic art of Europe (see Chapter 1). Since humankind apparently originated in Africa, the world's earliest art may yet be discovered there as well. The greatest concentrations of rock art are in now-dry desert regions—the Sahara to the north, the Horn in the east, and the Kalahari to the south—as well as in caves and on rock outcroppings in Namibia and South Africa. Probably because rock artists were more often herders or hunter-gatherers than farmers, these are precisely *not* the areas where most African sculpture is found. Accurately naturalistic renderings on rock surfaces show animals and humans in many different positions and activities, singly or in groups and stationary or in motion. Most of these works date to within the past four to five thousand years or slightly older and provide a rich record of the environment and of human and animal activities.

Although both precise dating and full understanding of meanings are problematic for much rock art, a considerable literature exists that describes, analyzes, and interprets the varied human and animal activities shown, as well as the evidently symbolic, more abstract patterns. Overall meanings probably coincide with those of the later arts (mostly sculpture) of agricultural areas—references to ideas and rituals about the origin, survival, and continuity of human populations.

NIGERIA

Nok Art (500 B.C.–A.D. 200)

TERRACOTTA SCULPTURES Outside Egypt and neighboring ancient Nubia, the earliest African sculpture in the round has been found at several Nigerian archeological

The Role of Art in Africa and the Chronology Problem

It is clear most African peoples make no distinction between "fine" and "applied" art or crafts, as is commonly the case in Europe. Until recently, too, most African peoples had not isolated visual arts into a distinct conceptual category, as suggested by the absence of a word in most African languages that translates accurately into the English word *art*. This realization connects with other issues regarding these arts, such as the importance of contexts to their understanding, the variable viewpoints of commentators, and distinctions between local African interpretations and those of outsiders. And because the arts of sub-Saharan Africa (south of the Sahara Desert) are usually unlabeled, unsigned, and undated, a central problem in organizing the vast array of African artworks is the absence of a secure chronology.

Some African cultures have left written documents that help date their artworks, even when their methods of measuring time differ from those used today. Other cultures, such as the Benin kingdom, preserve complex oral records of past events historians can check against the accounts of early trav-

elers who visited the kingdom and recorded their observations (see "The King's Compound in Benin," Chapter 32, page 987). Where such documentation is fragmentary or unavailable, art historians sometimes try to establish chronology from an object's style, determining what sorts of changes occurred over time to forms of a similar type.

Interpretive techniques such as contextual analyses and scientific techniques such as radiocarbon dating and thermoluminescence may supplement these other kinds of dating. Archeologists use contextual analyses to help date archeological excavations. *Radiocarbon dating* refers to measuring the decay rate of carbon isotopes in organic matter to provide dates for organic materials such as wood, fiber, and ivory. *Thermoluminescence* is a method of dating amounts of radiation found within the clay of ceramic or sculptural forms, as well as in the clay cores from metal castings. Although a comprehensive history of African art remains to be written, important historical information is available for many genres and regions.

sites collectively designated the Nok culture. Named after one of the places where such terracotta sculptures were first discovered, Nok sites date between 500 B.C. and A.D. 200. Since their discovery in 1928 and after the 1940s, many dozens of Nok-style human and animal heads and figures have been found during tin mining operations, as well as in archeological excavations.

A representative fifth-century B.C. Nok terracotta head from a site named Jemaa (FIG. **15-1**) depicts a very expressive face with large pupils and parted lips, as if issuing a sound. The sculptor may have pierced the eyes, mouth, and ear holes to a hollow center to help equalize the clay's heating during the firing process. The swept-back hairstyle with deeply carved grooves and the raised eyebrows, along with the deeply cut triangular eyes, show that the sculptor carved some details of the head while modeling the whole. A proposed earlier artistic tradition of wood carving that has not survived archeologically may explain the lack of any known art tradition leading to the Nok culture's highly sophisticated terracotta sculptures. Perhaps a more centrally organized courtly tradition caused a shift from wood sculpture to the more permanent terracotta medium.

Recently, numerous Nok-style pieces have left Nigeria through an illegal market economy. These works lack source information and the geologic strata data from proper archeological excavation that might shed more light on Nok development (see "Archeology, Art History and the Art Market," Chapter 4, page 81, for a similar case in prehistoric Greece). At a site called Yelwa, northwest of Nok, dated to around the eighth century, a post-Nok style of terracotta sculpture has been found that extends the Nok style's influences into the late

first millenium. Some scholars have noticed stylistic affinities between Nok terracottas and the arts of Ife, Benin, and the more recent pre- and post-colonial sculptures of the Yoruba. Researchers do not yet agree on the function of these objects, but a ritual context is more likely than a simply decorative one.

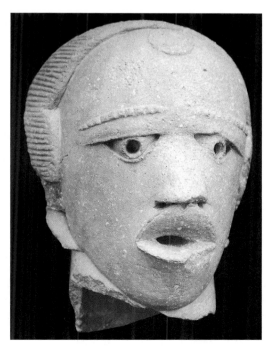

15-1 Nok head, from Jemaa, Nigeria, fifth century B.C. Terracotta, 9 $\frac{13}{16}$″ high. National Museum, Lagos.

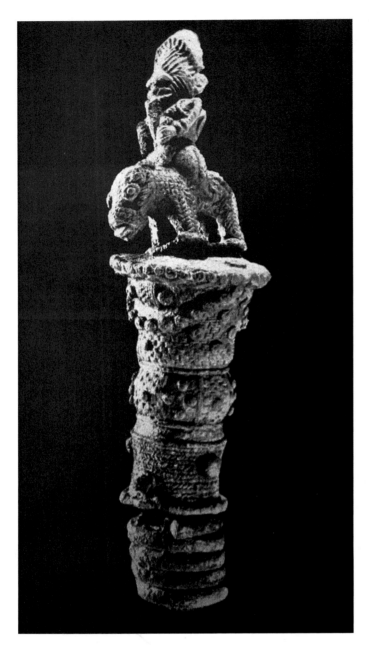

A lost-wax cast bronze equestrian figure fly-whisk hilt from Igbo-Ukwu (FIG. **15-2**) has two distinct parts. This casting method is similar to that used almost fifteen hundred years before in the ancient Mediterranean and in the Near East (see "Hollow-Casting Life-Size Bronze Statues," Chapter 5, page 124). The sculpture's upper section comprises a figure seated on a small horselike animal, and the lower section consists of an elaborately embellished flared handle with beaded and threadlike patterns adorning its surface. This figure is the earliest archeologically documented example of an equestrian figure in sub-Saharan African sculpture. The facial stripes on the human figure probably represent status-oriented marks of leadership.

Ife Art (Eleventh–Fifteenth Centuries)

By the eleventh and twelfth centuries, a very naturalistic style had appeared at Ife in western Nigeria, which long has been considered the cradle of Yoruba culture and civilization, for the Yoruba the place where the gods created the universe. Ife origin stories also account for a line of divine Yoruba rulers extending from the mythical past to the twentieth century.

IMAGES OF DIVINE KINGS An early work, cast in a zinc-brass alloy (FIG. **15-3**), undoubtedly represents a ruler.

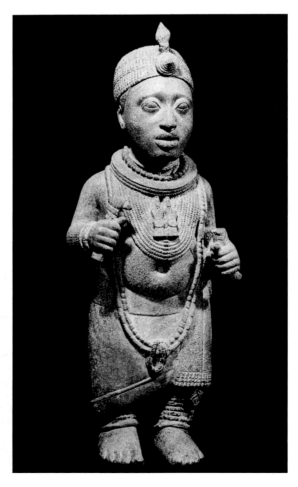

15-2 Equestrian figure on fly-whisk hilt, from Igbo-Ukwu, Nigeria, ninth to tenth century. Copper-alloy bronze, figure $6 \frac{3}{16}''$ high. National Museum, Lagos.

Igbo-Ukwu Art (Ninth–Tenth Centuries)

EARLY BRONZE-CASTING By the ninth century, a West African bronze-casting tradition of great sophistication had developed, as dozens of refined and varied objects excavated near Igbo-Ukwu in southeastern Nigeria indicate. Cast in an extremely intricate style, the copper, bronze, and iron artifacts included basins, bowls, altar stands, staffs, swords, scabbards, knives, and pendants. In the burial of a ruler at a site called Igbo-Richard, the grave goods consisted of numerous prestige objects—copper anklets, armlets, roundels, raised spiral ornaments, a strap, and a fan handle. The tomb also contained such objects as three elephant tusks, a human skull, a beaded armlet, a crown, and a bronze leopard's skull supported on a copper rod. These are the earliest metal castings known from regions south of the Sahara.

15-3 King, from Ife, Nigeria, eleventh to twelfth century. Zinc brass, $1' 6 \frac{1}{2}''$ high. Ife Museum, Ife.

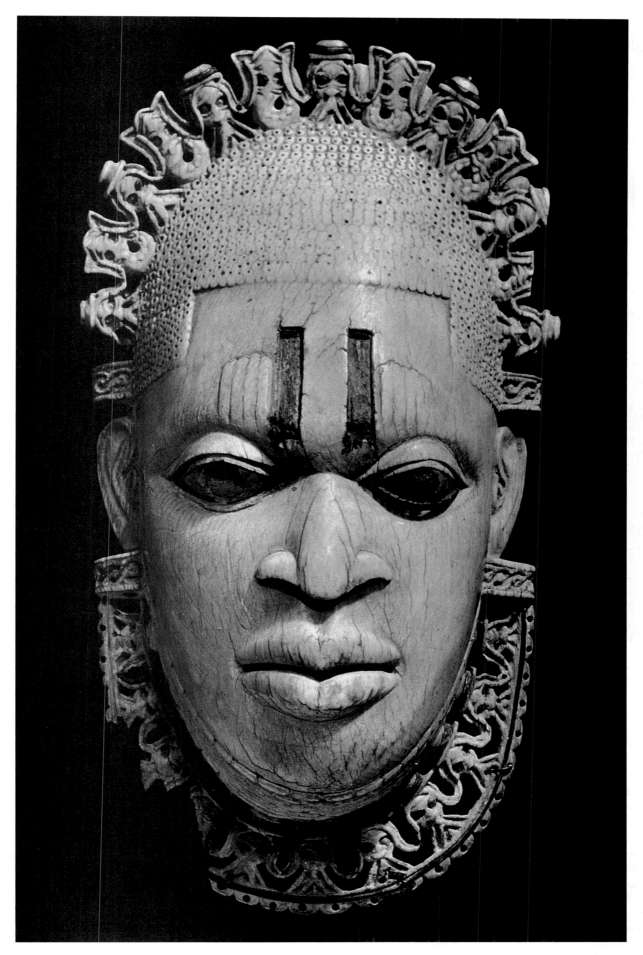

15-4 Ivory belt mask of a Queen Mother, from Benin, Nigeria, mid-sixteenth century. Ivory and iron, 9 $\frac{3}{8}$″ high. Metropolitan Museum of Art, New York (Michael C. Rockefeller Memorial Collection, gift of Nelson A. Rockefeller).

This figure, unlike most later African wood sculpture, shows fleshlike modeling, a kind of idealized naturalism in the torso and head that approaches generalized portraiture. Its proportions are less lifelike, however, than they are ideological. For modern Yoruba, the head is the locus of wisdom, destiny, and the essence of being. Such ideas probably developed some eight hundred years ago but they remain an important part of modern Yoruba culture. The casting is fine, and it accurately records precise details of the heavily beaded costume, crown, and jewelry worn by both ancient and contemporary kings in Ife and other Yoruba city-states. Ife was the source of dozens of accomplished, detailed, and sometimes realistic sculptures of heads, full figures, and animals, principally in terracotta or copper alloys. These and related works from the Yoruba kingdom of Owo, southeast of Ife, undoubtedly served in rituals supporting divine kingship.

Benin Art (Thirteenth–Eighteenth Centuries)

The Benin kingdom was established in the thirteenth century. Though the kingdom no longer exists, Benin City is today the capital of Edo State in Nigeria. By observing current rituals and regalia and talking with elderly specialists who understand the significance of these cultural features, researchers continue to learn about Benin royal art. Numerous historical and ritual ties existed between the divine kings of Ife and those of Benin, and these groups also established mutually beneficial contacts with Portuguese traders in the 1470s. Benin artists have produced many complex, finely cast copper-alloy sculptures, as well as pieces in ivory, wood, ceramic, and wrought-iron. Royalty commissioned (and sometimes still do) cast-metal works and ivory carvings from guilds of highly trained professionals. The hereditary *oba,* or divine king, and his court still use these items, also dispensing them as royal favors to title holders and other chiefs.

THE QUEEN MOTHER In the sixteenth century, the Portuguese served in a military capacity in the army of Benin's Oba Esigie (r. ca. 1504–1550) and helped expand the Benin kingdom. Esigie's mother, Idia, helped him in warfare, and in return he created the title of Iy'oba (Queen Mother) for her and built her a separate palace and court. A mid-sixteenth-century ivory belt mask (FIG. **15-4**), used either to secure a wrapping of clothing or worn as a hip mask, probably represents Idia. The mask also contains symbolic references to Benin's trade and diplomatic relationships with the Portuguese and to the Iy'oba's link to Olokun, god of the sea. Interspersed in the front row of her hairstyle, frontally placed Portuguese heads each wear long hair and a mustache, beard, and helmet. The Benin culture probably associated the Portuguese, with their large ships, powerful weapons, and wealth in metals, with Olokun. Mudfish, which have barbels like catfish, symbolically represented Olokun and, along with other animals prevalent in Benin ritual practices, often served as sacrificial offerings.

A ROYAL ALTAR OF THE HAND Termed an *ikegobo,* a Benin brass casting (FIG. **15-5**), most likely dating from the seventeenth or eighteenth century, comes from an oba's ancestral altar. This work features symmetrical hierarchical compositions centered on the dominant divine king, seen on both the cylinder's top and side. The composition is similar to that of the Benin royal plaque discussed in the Introduction (see FIG. Intro-16). Both use a hierarchy of scale, or the enlarging of elements considered most important. The two images of the Benin king, centrally placed both in the composition on top and directly below on the side, show him as the largest figure. The individuals depicted in the top figure group, cast nearly as freestanding figures, include the king, attendants, and leopards. The lower two sculptural zones, cast in varied levels of low to high relief, emphasize the king's importance by both his size and his positioning, flanked by and centered among his smaller attendants. The casting technique used— the lost-wax method—is still practiced in Benin today and was used elsewhere by cultures in what is now Nigeria some seven hundred years earlier.

At such personal altars, high-ranking officials, including the king, made sacrifices to their own powers of accomplishment—symbolized by the arm and hand. The altar involves power, both in the ritual's anticipated outcome and in the shrine's iconography. The inclusion of leopards on the top and around the base, along with elephant heads and crocodiles (not visible here), symbolizes this power. These animals, common in Benin arts, are also kings in their respective realms. The tame leopards flanking the king on top refer to his dominance over even this king of the wilds and thus indicate his superhuman capacities.

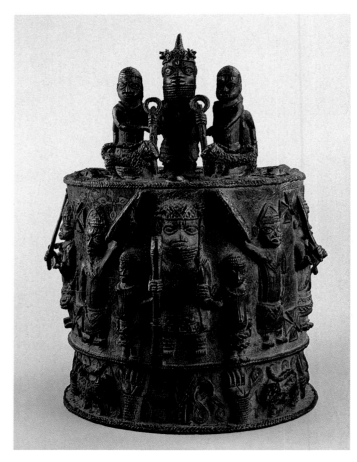

15-5 Altar of the hand, from Benin, Nigeria, seventeenth to eighteenth century(?). Bronze, 1' 5$\frac{1}{2}$" high. British Museum, London.

MALI

Djenne Art (Eleventh–Fifteenth Centuries)

Numerous ceramic (and some copper-alloy) images also have been recovered from tombs at Djenne and other sites in the inland delta of the Niger River, northwest of Nigeria in the modern nation of Mali. The dates of these sculptures fall between 1000 and 1468, roughly contemporary to the preserved artworks from the Yoruba kingdoms of Ife and Owo. This period also overlaps with two of West Africa's most important medieval empires, ancient Ghana (approximately sixth through late eleventh centuries) and Mali (early thirteenth through late fifteenth centuries). The modern nation-states took their names from these empires.

GENDER ROLES IN LIFE AND ART A terracotta statuette of a mother and child from Djenne in the inland delta (FIG. **15-6**) probably attests to gender-specific ideal roles assigned to women and men within ancient Malian societies. Women's roles involved nurturing and domestic activities, while men performed the duties of warrior/hunter and protector. Grave offerings and most likely shrine figures, such fired clay images as this include humans and animals, many in naturalistic poses and others in stiffer, more formal postures. Unfortunately, the vast majority of these terracotta figures have come to light from uncontrolled digging. Therefore, much pertinent contextual information about

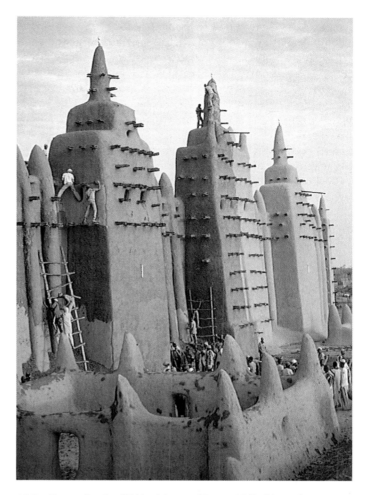

15-7 Eastern facade of Friday Mosque, Djenne, Mali, thirteenth century, rebuilt in 1906–1907.

them has been lost. Their poses, forms, and pairings suggest meanings still found in shrine art forms today among the Dogon and Bamana peoples of Mali (including the gender-specific roles mentioned and ancestral mother/father), who may have historical ties to the earlier Djenne culture (see Chapter 32).

MONUMENTAL ARCHITECTURE Over the past millennium, at least, African peoples have developed countless impressive architectural styles and building types. These range from Ethiopia's twelfth-century stone-cut churches and Mali's adobe-brick mosques from the same period and later to many sculptural and finely painted secular and sacred adobe structures still built across the West African savanna. They also include the impressive palace structures with tall carved posts and lofty thatched roofs of Cameroon kingdoms. Few early buildings survive south of the Sahara, however, because unfired adobe was so often the building material of choice. Unless well maintained, such structures deteriorate rapidly in heavy rains.

ISLAM IN MALI An exceptional surviving monumental structure is the Friday Mosque at Djenne (FIG. **15-7**), first built in the thirteenth century and still in active use. The present structure, reconstructed in 1906–1907, supposedly in the style of the first of two earlier mosques (dating to the thirteenth century) constructed on the site, boasts a strongly vertical emphasis. Three symmetrically balanced adobe towers and tall,

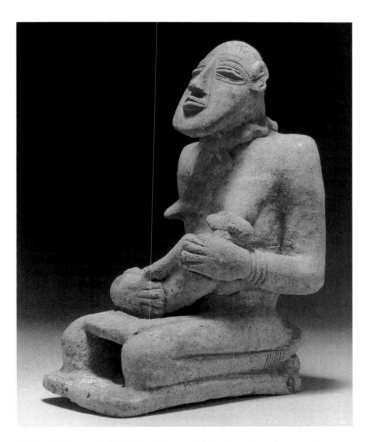

15-6 Mother and child, from Djenne, Mali, eleventh to fourteenth century. Terracotta, 11″ high. University of Iowa Museum of Art, Iowa City (Stanley Collection).

Sapi-Portuguese Ivories
A Hybrid Art Form[1]

Initial contact between Portuguese explorers and traders and West and central African groups occurred in the second half of the fifteenth century. In the first century and a half after contact, ivories became an important African export art destined for elite households and collections in Europe. Three African ethnic groups in three different regions—the Sapi of Sierra Leone, the Bini of Nigeria, and the Kongo of the lower Congo River in the Democratic Republic of the Congo (formerly Zaire)—exported ivory objects. (For information on ivory carving technique, see "Ivory Carving in Antiquity and the Early Middle Ages," Chapter 11, page 322.)

Based on information culled from archival documents, iconographic elements, and stylistic traits, researchers have concluded sculptors made the Sapi-Portuguese ivories from about 1490 to 1530. Nearly one hundred finely crafted objects have survived, including saltcellars, *pyxides* (small boxes used in church ceremonies), spoons, forks, dagger or knife handles, and hunting horns, or *oliphants*. With lids and bases carved with human and animal images in low to high relief, the saltcellars (FIG. 15-9) and pyxides were generally quite elaborate vessels. Some of the figures depicted, although African in countenance, derive their postures or compositional layouts from Christian themes, such as the Virgin and Child, the Crucifixion, or Christ's descent from the cross.

Jewish subjects of Christian significance (for example, Daniel in the lion's den and the Three Hebrews in the fiery furnace; see "Jewish Subjects in Christian Art," Chapter 11, page 305) also appear. African themes depicted include a warrior with shield riding an elephant, an executioner and his victims (FIG. 15-9), a seated man with a pipe, and a man seated on a tripod chair. Secondary male and female figures (most representing Africans) and a host of African animals, such as crocodiles, serpents, and dogs, play prominent roles.

The iconography of most of the known hunting horns features European narrative hunting scenes in low relief. In addition, the carvers commonly presented the coats of arms of ruling families on these horns, as well as Christian religious mottos such as "Hail Mary full of grace" and "Hope in God." Other European motifs include fantastic animals such as unicorns, harpies, and griffins. Many of the high-relief images found on the saltcellars are European in origin, whereas images of rulers and warriors appear African in origin and character. In contrast, most of the narrative imagery carved on the hunting horns seems derived from compositions found on European tapestries and in illustrated books.

[1] E. Bassini and W. Fagg, *Africa and the Renaissance: Art in Ivory* (New York: Center for African Art, 1988).

slender engaged columns combine to create majestic rhythms across the mosque's eastern front. This facade also features protruding beams that are partly structural and practical and partly decorative. The beams serve as perches for workers (visible in FIG. 15–7) undertaking the essential recoating of sacred clay on the exterior that occurs during an annual festival. Although this mosque is larger and grander in scale than the area's civic and domestic architecture, many of its stately features duplicate those elsewhere in these urban environments. In bygone centuries, the great Sudanic empires, such as ancient Ghana and Mali, now known best in oral traditions and from archeological excavations, embraced this architectural style.

SIERRA LEONE

Sapi Art (Fifteenth – Sixteenth Centuries)

During the fifteenth and sixteenth centuries, the Sapi people in Sierra Leone, on the Atlantic coast of West Africa, created stone figures *(nomoli)* that may have served as objects of worship in ancestral memorial shrines. The Sapi were likely ancestors of some of the modern peoples of Guinea and Sierra Leone, whose sculpture still displays stylistic affinities with the earlier group's art.

A SAPI WARRIOR Carved of serpentine, one example (FIG. **15-8**), probably representing a warrior, is notable for its

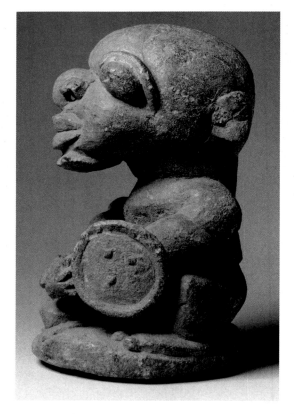

15-8 Sapi warrior, from Sierra Leone, fifteenth century. Serpentine, $7\frac{1}{2}''$ high. Historisches Museum, Bern.

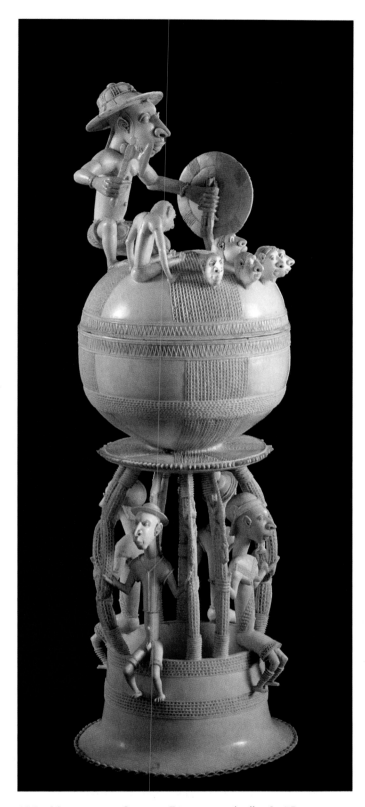

15-9 MASTER OF THE SYMBOLIC EXECUTION, saltcellar, Sapi-Portuguese, from Sierra Leone, fifteenth to sixteenth century. Ivory, 1′ 4 $\frac{7}{8}$″ high. Museo Nazionale Preistorico e Etnografico Luigi Pigorini, Rome.

SAPI ART FOR EUROPEAN PATRONS During the late fifteenth and early sixteenth centuries, Sapi artists also created numerous skillfully crafted ivory objects for export to the wealthy classes of Europe. These items included delicate spoons and forks, *oliphants* (hunting horns), and elaborate saltcellars (containers for salt and spices). Most of these objects have been preserved in royal collections, where scholars study them today as unique hybrid objects of both African and European culture from a period of early contact and trade between the two peoples (see "Sapi-Portuguese Ivories: A Hybrid Art Form," page 422).

One saltcellar (FIG. **15-9**), standing just more than sixteen inches high, depicts an extraordinary execution scene. A kneeling figure with a shield in one hand holds an axe in the other hand over another sitting figure about to lose his head. On the ground before the executioner, six severed heads (five visible here) grimly testify to the executioner's power. A double zigzag line marks the division of the globular container's lid from the vessel below. This entire form rests on a circular platform held up by slender rods adorned with crocodile images. Two male and two female figures sit between these rods. The men wear European-style pants, and the women wear skirts, but the women have elaborate raised scarification patterns on their upper chests. The details and proportions of the heads and the scarification patterns on the female figures recall stylistic traits found on Sapi memorial figures from the same period.

Scholars have identified at least three artists' workshops active during the period from about 1500 to 1540, and they attribute about twenty-two saltcellars, or fragments thereof, to several artists in one of these workshops. The creator of this masterpiece is known as MASTER OF THE SYMBOLIC EXECUTION.

SOUTH AFRICA

Examining three art forms from two artistic traditions in southern Africa—specifically, in South Africa and Zimbabwe—enables comparison with the West African traditions just detailed. As noted previously, South African caves and rock outcroppings contain numerous examples of early rock art, but additional art forms also developed in South Africa and other southern African areas.

Lydenburg Art (Sixth–Eighth Centuries)

SOUTH AFRICA'S OLDEST SCULPTURES A terracotta head from Lydenburg (FIG. **15-10**) is one of seven recovered from that site and dated from the sixth to the eighth centuries, making it among the oldest sculptures so far discovered in southern Africa. The head (reconstructed from fragments) has a humanlike form, although its jarlike shape differs markedly from the sculptural form of the earlier Nok-style head from Jemaa (FIG. 15-1). Here, the artist created the eyes, ears, nose, and mouth by placing thin clay fillets over the head shape. The same method produced the raised scarification marks on the forehead and between the eyes and the ears. Incised marks define the neck's horizontal bands and some parts of the hair on the side and back of the head. Small clay points placed in a curving row along the front hairline create a raised coiffure effect. A small animal-like shape sits atop the head, although it is impossible to identify its species. Perhaps these heads originally served a ritual or commemorative function.

disproportionately large head with bulbous eyes, nose, and lips. The figure wears a circular war shield on his left arm and holds a smaller figure (its head missing) standing before him. The size differential and placement of these two figures imply a power relationship of superior (warrior/chief) versus inferior (vanquished or victim).

15-10 Head, from Lydenburg, South Africa, sixth to eighth century. Terracotta, 1′ 2 15/16″ high. South African Museum, Cape Town.

ZIMBABWE

Great Zimbabwe Art (Eleventh–Fifteenth Centuries)

RUINS OF A LOST EMPIRE Perhaps the most famous southern African architecture is a complex of stone ruins at a major political center called Great Zimbabwe. At a site first occupied in the eleventh century, the still-standing walled enclosures date from about the late thirteenth century to the middle of the fifteenth century, when the Great Zimbabwe empire had a wide trade network. Finds of trade beads and pottery from Persia, the Near East, and China, along with copper and gold objects, show this was a prosperous trade center well before Europeans began their coastal voyaging in the late fifteenth century. Most archeologists and historians agree that the rulers at Great Zimbabwe and other nearby royal towns were ancestors of Zimbabwe's present Shona-speaking peoples.

Based on ethnographic information gathered from Portuguese accounts of the sixteenth to the early nineteenth centuries and from more recent studies of Shona customs, many scholars have tried to interpret the meanings of the buildings and artifacts found at Great Zimbabwe. Most agree the complex was a royal residence with special areas for the king (the royal hill complex), his wives and nobles, including an open

15-11 Conical tower, Great Zimbabwe, Zimbabwe, fifteenth century.

court for ceremonial gatherings. At the zenith of the empire's power, as many as eighteen thousand people may have lived in the area surrounding Great Zimbabwe, with most of the commoners living outside the enclosed structures reserved for royalty. Although actual habitations are gone, the remaining enclosures are unusual for their size and the excellence of their stonework. Some perimeter walls reach thirty feet high. One of these, known as the Great Enclosure, houses one large and several small conical stone towerlike structures (FIG. **15-11**). Scholars often have interpreted these symbolically as masculine (large) and feminine (small) forms, but their precise significance is unknown.

SOAPSTONE SCULPTURES OF BIRDS Explorations at Great Zimbabwe have yielded eight soapstone monoliths. Seven came from the royal hill complex and probably were set up as part of ritual shrines to the ancestors. The eighth soapstone bird monolith (FIG. **15-12**), found in an area now considered the ruler's first wife's ancestral shrine, stands several feet tall. Scholars have interpreted the seated bird on top as symbolizing the first wife's ancestors. (Ancestral spirits among the Shona take the form of birds, especially eagles, and are thought to communicate between the sky and the earth.) The crocodile on the front of the monolith may represent the wife's elder male ancestors, while the circles beneath the bird are called the "eyes of the crocodile" in Shona belief and represent, symbolically, elder female ancestors. The double- and single-chevron motifs represent young male and young female ancestors, respectively. The bird may represent some form of bird of prey, such as an eagle, although this and other bird sculptures from the site have feet with five humanlike toes, rather than an eagle's three-toed talons. The eagle and the crocodile may have symbolized previous rulers who would have acted as messengers between the living and the dead, as well as between the sky and the earth.

The art forms discussed in this chapter, usually made of durable materials such as fired terracotta, ivory, and cast metal (bronze or one of several copper alloys) have survived for many centuries. The complexity of many of these art forms suggests use in elite contexts such as kingship and courtly traditions. As noted, similarities with continuing and related historical traditions, such as those of the Ife-Yoruba and early Benin or contemporary Benin practices, have provided some insight into the possible meanings of these prehistoric and early historic art forms. The basis for understanding many of the art forms of later African art in sub-Saharan Africa (see Chapter 32) is firsthand study of African art traditions, which are more varied in terms of royal and nonroyal groups. The art forms also include a wider range of artistic materials and techniques, including wood carving, weaving, accumulative sculpture, and oil painting.

15-12 Bird with crocodile image on top of stone monolith, from Great Zimbabwe, Zimbabwe, fifteenth century. Soapstone, bird image 1′ 2 ½″ high. Great Zimbabwe Site Museum, Great Zimbabwe.

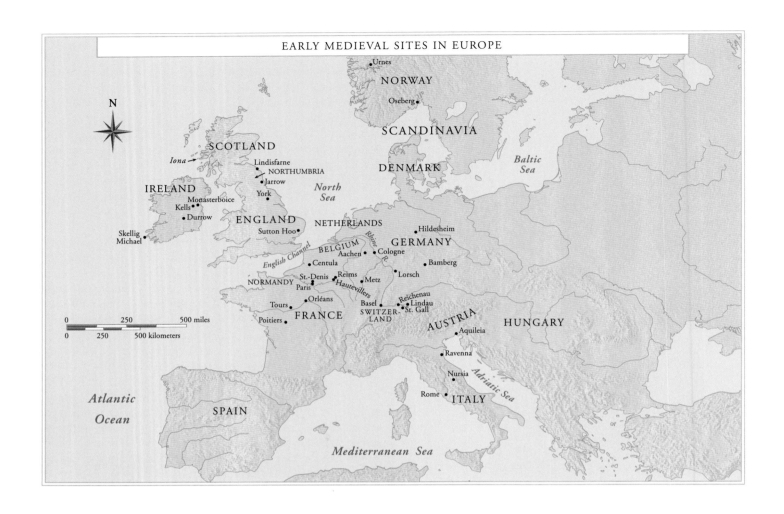

EARLY MEDIEVAL SITES IN EUROPE

	476	768	
FRANCE AND GERMANY	MEROVINGIAN		CAROLINGIAN
NORTHERN EUROPE		HIBERNO-SAXON PERIOD IN THE BRITISH ISLES, VIKING PERIOD IN SCANDINAVIA	

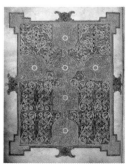

Sutton Hoo purse cover
ca. 625

Lindisfarne Gospels
ca. 698–721

Charlemagne(?)
early ninth century

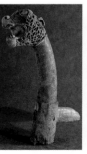

Animal-head post
Oseberg ship
ca. 825

Lindau Gospels, ca. 870

End of Western Roman Empire, 476

Anglo-Saxons take over Roman Britain, ca. 480

Franks in Gaul (Merovingian dynasty), 482–768

Saint Benedict establishes Benedictine
Rule for monasteries, 529

Muslims defeat Visigoths in Spain, 711

Charles Martel defeats Muslims at Poitiers, 732

Charlemagne, r. 768–814, crowned
emperor in Rome, 800

Viking raids begin in Britain, 793

Louis the Pious, r. 814–840

Charles the Bald, r. 840–875

Cluniac order
founded, 910

16

EUROPE AFTER THE
FALL OF ROME

EARLY MEDIEVAL ART IN THE WEST

	936		1000	1024	1050
	OTTONIAN				

High Cross of Muiredach, 923

*Saint Pantaleon
Cologne, 966–980*

*Gospel Book of Otto III
997–1000*

*Bronze doors, Saint Michael's
Hildesheim, 1015*

*Stave church, Urnes
ca. 1050–1070*

Otto I, r. 936–973, crowned
emperor in Rome, 962

Otto II, r. 973–983; marries Byzantine princess Theophanu, 972

Otto III, r. 983–1002

Hugh Capet, king of France, r. 987–996

Bernward, bishop of Hildesheim, 993–1022

Henry II, r. 1002–1024, last Ottonian emperor

Edward the Confessor,
Anglo-Saxon king of
England, r. 1042–1066

MEDIEVAL EUROPE

THE ERA "IN BETWEEN" Historians once referred to the thousand years (roughly 400 to 1400) between the dying Roman Empire's adoption of Christianity as its official religion and the rebirth (Renaissance) of interest in classical antiquity as the Dark Ages. For centuries people thought this long "interval"—between the ancient and what then was perceived as the beginning of the modern European world—was rough and uncivilized, barbarous in manners, superstitious in religion, and crude and primitive artistically. They viewed these centuries—the "Middle Ages"—as simply a blank between (in the middle of) two great civilizations.

As already shown, this judgment is far off the mark with respect to the Byzantine Empire, whose rulers always considered themselves heirs of the Roman Empire and whose artists not only created works of the highest quality but also frequently looked to the Greco-Roman tradition for inspiration. The equally negative assessment of the Middle Ages in western Europe also has been discredited. No longer do art historians consider this period a dark age devoid of invention, an era when—by classical and Renaissance standards—artists created only unsophisticated and inferior works. Historians and art historians now see these centuries with different eyes, perceiving their innovation and greatness. But the powerful force of tradition dictates that scholars continue to use the unfortunately negative term *Middle Ages* and its corresponding adjective *medieval*.

THE MEDIEVAL FUSION Art historians date the early Middle Ages from about 500 to 1000—half a millennium of important artistic production. Early medieval civilization in western Europe represents a fusion of Christianity, the Greco-Roman heritage, and the vibrant yet very different culture of the Celtic-Germanic "barbarians," as the Greeks and Romans called the peoples who lived beyond the classical world's frontiers. Some of these so-called barbarians had, in fact, risen to prominent positions within the Roman army and government during the later Roman Empire. Others established their own areas of rule in western Europe, sometimes with Rome's approval, sometimes in opposition to imperial authority. In time these non-Romans merged with the citizens of the former Roman provinces and slowly developed political and social institutions that continued into modern times. Over the centuries a new order gradually replaced what had been the Roman Empire, resulting eventually in the foundation of today's European nations.

This period of momentous, if slow, change was characterized by countless struggles for power, not only among competing armies but also between secular and sacred authorities. The conflict between church and state is one of the distinguishing features of medieval European history and sets the West sharply apart from the Byzantine and Islamic worlds. In the West the Christian Church not only possessed extensive properties but also early on assumed major governmental responsibilities. Frequently, secular and ecclesiastical authorities found themselves in open opposition. Toward the end of the early medieval period, both sides resolved these conflicts to a large extent by recognizing the other's claim to authority in different spheres, but the tension between the two reverberates even today.

THE ART OF THE WARRIOR LORDS

As Rome's power waned in late antiquity, competition for political authority and armed conflicts became commonplace among "barbarian" groups—Huns, Vandals, Franks, Goths, and others. Once one group established itself in Italy or in one of Rome's European provinces, another often pressed in behind and compelled it to move on. The Visigoths, for example, who at one time controlled part of Italy and formed a kingdom in what is today southern France, were forced southward into Spain under pressure from the Franks, who had crossed the lower Rhine River and established themselves firmly in France, Switzerland, the Netherlands, and parts of Germany. The Ostrogoths moved from Pannonia (at the junction of modern Hungary, Austria, and the former Yugoslavia) to Italy. Under Theodoric, they established their kingdom there, only to have it fall less than a century later to the Lombards, the last of the early Germanic powers to occupy land within the limits of the old Roman Empire (see Chapter 12). In the North, Anglo-Saxons controlled what had been Roman Britain. Celts inhabited Ireland, never colonized by the Romans. In Scandinavia the great seafaring Vikings held sway.

ART AND STATUS Art historians do not know the full range of art and architecture these "barbarian" peoples produced. What has survived is not truly representative and consists almost exclusively of small "status symbols"—weapons and items of personal adornment such as bracelets, pendants, and belt buckles archeologists have discovered in lavish furnished graves. Scholars long ignored these "minor arts" because of their small scale, seeming utilitarian nature, and abstract ornament, and because the people who made them rejected the classical idea that the representation of organic nature should be the focus of artistic endeavor. These early medieval objects gradually have been reevaluated during the past century and are now recognized as highly sophisticated masterpieces, both technically and stylistically. Produced by artists of the highest caliber, these treasures enhanced the prestige of those who owned them and testified to the stature of those who were buried with them. In the great early (possibly seventh-century) Anglo-Saxon epic *Beowulf,* the hero is cremated and his ashes placed in a huge tumulus overlooking the sea. As an everlasting tribute to Beowulf's greatness, his people "buried rings and brooches in the barrow, all those adornments that brave men had brought out from the hoard after Beowulf died. They bequeathed the gleaming gold, treasure of men, to the earth."[1]

A FRANKISH LORD'S COSTLY PIN Most characteristic, perhaps, of the prestige adornments was the *fibula,* a decorative pin the Romans (and the Etruscans before them) favored (see FIG. 9-1). Produced in quantity by almost all the Celtic-Germanic groups, it usually was used to fasten garments. Fibulae are made of bronze, silver, or gold and often are decorated profusely, sometimes with inlaid precious or semiprecious stones. The fibula we illustrate (FIG. **16-1**) was found in France and dates to the sixth or seventh century. It once must have been the proud possession of a wealthy Frankish lord. The pin resembles, in its general form, the roughly contemporary but plain fibulae used to fasten the outer garments of some of the attendants flanking the Byzantine emperor Jus-

Cloisonné

One of the preferred methods of decoration in early medieval art was *cloisonné,* the richest of the luxury arts favored by the kings and warrior lords who often were called "treasure givers" in medieval poetry. This technique was employed in a masterly fashion by the artist or artists responsible for the Sutton Hoo purse cover (FIG. 16-2). First, small metal strips or *cloisons* (French for "partitions"), usually of gold, are soldered edge-up to a metal background. A glass paste (subse-quently fired to give it the look of sparkling jewels) or semi-precious stones, such as garnets, or pieces of colored glass are placed in the compartments thus formed. The edges of the cloisons remain visible on the surface and are an important part of the design. The technique is a cross between mosaic (see "Mosaics," Chapter 11, page 314) and stained glass (see "Stained-Glass Windows," Chapter 18, page 500) but was employed only on a miniature scale.

tinian in the apse mosaic of San Vitale in Ravenna (see FIG. 12-10). (Note how much more elaborate is the emperor's clasp. In Rome, New Rome, and early medieval Europe alike, these fibulae were emblems of office and of prestige.)

The Frankish fibula's entire surface is covered with decorative patterns adjusted carefully to the basic shape of the object they adorn. They thus describe and amplify its form and structure, becoming an organic part of the object itself. Often zoomorphic elements were so successfully integrated into this type of highly disciplined, abstract decorative design that they became almost unrecognizable. One must examine a fibula carefully to discover that it contains a zoomorphic form. In our example (FIG. 16-1), a fish may be discerned just below the center of the fibula.

A KING'S FINAL VOYAGE The *Beowulf* saga also recounts the funeral of the warrior lord Scyld, who was laid to rest in a ship set adrift in the North Sea overflowing with arms and armor and costly adornments:

> They laid their dear lord, the giver of rings, deep within the ship by the mast in majesty; many treasures and adornments from far and wide were gathered there. I have never heard of a ship equipped more handsomely with weapons and war-gear, swords and corselets; on his breast lay countless treasures that were to travel far with him into the waves' domain."[2]

In 1939, a treasure-laden ship was discovered in a burial mound at Sutton Hoo in Suffolk, England. Although unique, it epitomizes the early medieval tradition of burying great lords with rich furnishings, as recorded in *Beowulf.* Among the many precious finds were a gold belt buckle, ten silver bowls, a silver plate with the imperial stamp of the Byzantine emperor Anastasius I (r. 491–518), and forty gold coins (to pay the forty oarsmen who would row the deceased across the sea on his final voyage). Also placed in the ship were two silver spoons inscribed "Saulos" and "Paulos," Saint Paul's names in Greek before and after his baptism. They may allude to a conversion to Christianity. Historians have associated the site with the East Anglian king Raedwald, who was baptized a Christian before his death in 625 but who never fully abandoned pagan polytheism.

Most extraordinary of all the Sutton Hoo finds is a purse cover (FIG. **16-2**) decorated with cloisonné-enamel plaques (see "Cloisonné," above). Four symmetrically arranged groups of figures are in the lower row. The end groups consist of a man standing between two beasts. He faces front, and they appear in profile. This heraldic type of grouping has a venerable heritage in the ancient world (see FIG. 2-10). The two center groups represent eagles attacking ducks. The animal figures are cunningly adjusted to each other. For example, the convex beaks of the eagles fit against the concave beaks of the ducks. The two figures fit together so

16-1 Frankish looped fibula, sixth to seventh century. Silver gilt worked in filigree, with inlays of garnets and other stones, 4″ long. Musée des Antiquités Nationales, Saint-Germain-en-Laye.

16-2 Purse cover, from the Sutton Hoo ship burial in Suffolk, England, ca. 625. Gold, glass, and enamel cloisonné with garnets and emeralds, $7\frac{1}{2}''$ long. British Museum, London.

snugly that they seem at first to be a single dense abstract design. This is true also of the man-animals motif. Above these figures are three geometric designs. The outer ones are clear and linear in style. In the central design, an interlace pattern, the interlacements turn into writhing animal figures. Elaborate interlace patterns are characteristic of many times and places, notably in the art of the Islamic world (Chapter 13). But the combination of interlace with animal figures was uncommon outside the realm of the early medieval warlords. In fact, metalcraft with a vocabulary of interlace patterns and other motifs beautifully integrated with the animal form was, without doubt, *the* art of the early Middle Ages in the West. Interest in it was so great that the colorful effects of jewelry designs were imitated in the painted decorations of manuscripts, in stone sculpture, in the masonry of churches, and in sculpture in wood, an especially important medium of Viking art.

THE PIRATES OF THE NORTH In 793 the pagan traders and pirates known as Vikings (named after the *viks*—coves or "trading places"—of the Norwegian shoreline) set sail from Scandinavia and landed in the British Isles. They destroyed the Christian monastic community on Lindisfarne Island off the Northumbrian (northeastern) coast of England (see later discussion). Shortly after, these *Norsemen* (North men) attacked the monastery at Jarrow in England as well as that on Iona Island, off the west coast of Scotland. From this time until the mid-eleventh century, the Vikings were the terror of western Europe. From their great ships they seasonally

harried and plundered the coasts, harbors, and river settlements of the West. Their fast, seaworthy longboats took them on wide-ranging voyages, from Ireland eastward to Russia and westward to Iceland and Greenland and even, briefly, to Newfoundland in North America, long before Columbus arrived in the "New World."

The Vikings were not intent merely on a hit-and-run strategy of destruction but on colonizing the lands they occupied by conquest. Their exceptional talent for organization and administration, as well as for war, enabled them to take and govern large territories in Ireland, England, and France, as well as in the Baltic regions and Russia. For a while, in the early eleventh century, the whole of England was part of a Danish empire. When Vikings settled in northern France in the early tenth century, their territory came to be called Normandy—home of the Norsemen who became *Normans*. (Later, a Norman duke, William the Conqueror, sailed across the English Channel and invaded and became the master of Anglo-Saxon England; see FIG. 17-40.)

TWO WOMEN BURIED IN A VIKING SHIP The art of the Viking sea rovers was early associated with ships—with wood and the carving of it. Striking examples of Viking wood carving were found in a royal ship buried near Oseberg, Norway. The ship, which was covered by a mound like the earlier Anglo-Saxon royal burial at Sutton Hoo, was more than seventy feet long. It once must have carried many precious objects, but robbers removed them long before its modern discovery. When the vessel was found, it contained

16-3 Animal-head post, from the Oseberg, Norway, ship burial, ca. 825. Wood, approx. 5″ high. Vikingskipshuset Museum, Oslo.

little more than the remains of two women, but the size of the burial and the lavishly carved wooden ornament of the sleek ship attest to the importance of those laid to rest there.

We illustrate a wooden animal-head post (FIG. **16-3**) from the Oseberg ship that, like the other animal forms in the carved bands that follow the prow's gracefully curving lines, expresses the dynamic energy of the nothern sea rovers. This head combines in one composition the image of a roaring beast with protruding eyes and flaring nostrils and the deftly carved, controlled, and contained pattern of tightly interwoven animals that writhe, gripping and snapping, in serpentine fashion. The Oseberg animal head is a powerfully expressive example of the union of two fundamental motifs of the art of the warrior lords on the former Roman Empire's northern frontiers—the animal form and the interlace pattern.

MONSTERS WRITHING ON A CHURCH By the eleventh century, much of Scandinavia had become Christian, but the Viking artistic traditions persisted. Nowhere is this more evident than in the decoration of the portal (FIG. **16-4**) of the stave church (*staves* are wedge-shaped timbers placed vertically) at Urnes in Norway. The portal is almost all that is preserved of a mid-eleventh-century wooden church whose staves were incorporated in the walls of a twelfth-century church. The doorjambs and the connecting lintel are masterpieces of the wood-carver's art. Gracefully elongated mon-

strous animal forms intertwine with flexible plant stalks and tendrils in spiraling rhythm. The effect of natural growth is astonishing. Yet, the elaboration of the forms is so intricate and refined that the animal-interlace art of design seems to have reached its limits of inventiveness. The Urnes style was the culmination of three centuries (the eighth to the eleventh) of Viking art. During the whole period, the art of the Norsemen interacted closely with Hiberno-Saxon art.

HIBERNO-SAXON ART

THE CONVERSION OF THE BRITISH ISLES
In 432 Saint Patrick established a church in Ireland and began the Christianization of the Celts on that remote island that had never known Roman rule. The newly converted Celts, although nominally subject to the popes of Rome, quickly developed a form of monastic organization that differed from the Church of Rome in its liturgical practices and even in its calendar of holidays. The relative independence of the Irish churches was due in part to the isolation of its monasteries, which often were situated in inaccessible and inhospitable places such as Skellig Michael. There, on a craggy hillside overlooking the sea, sixth-century Irish monks and their successors lived in bare beehive-shaped stone cells far from the rest of the world's temptations and distractions.

Before long, Irish monks, filled with missionary zeal, set up monastic establishments in Britain and Scotland. In 563 Saint Columba founded an important monastery on the Scottish

16-4 Wood-carved portal of the stave church at Urnes, Norway, ca. 1050–1070.

island of Iona, where he successfully converted the native Picts to Christianity. The monastery at Lindisfarne off the northern coast of Britain was established by Iona monks in 635. From these and other later foundations, which became great centers of learning for both Scotland and England, Irish and Anglo-Saxon missionaries journeyed through Europe, establishing great monasteries in Italy, Switzerland, Germany, and France.

HIBERNO-SAXON BOOKS A style art historians designate as *Hiberno-Saxon* (Hibernia was the ancient name of Ireland), or sometimes as *Insular* to denote the Irish-English islands where it was produced, flourished within the monasteries of the British Isles. Its most distinctive products were the illuminated manuscripts of the Christian Church (see "Medieval Books," page 434). Liturgical books became an important vehicle of miniature art and a principal medium for the exchange of stylistic ideas between the northern and the Mediterranean worlds. In an age of general illiteracy, books were scarce. For those who could read, books were jealously guarded treasures, most of them housed in the libraries and *scriptoria* (writing studios) of monasteries or major churches. The illuminated books described here survived the depredations of the ninth-century Viking invaders. They are the most important extant monuments of the brilliant culture that flourished in Ireland and Northumbria during the seventh and eighth centuries.

Among the earliest Hiberno-Saxon illuminated manuscripts is the *Book of Durrow,* a Gospel book probably written and decorated in the monastic scriptorium at Iona. (In the late Middle Ages it was housed in Durrow, Ireland—hence its modern nickname.) The Durrow Gospels already display one of the most characteristic features of Insular book illumination: full pages devoted neither to text nor to illustration but to pure embellishment. Interspersed between the Durrow text pages are so-called *carpet pages,* resembling textiles, made up of decorative panels of abstract and zoomorphic forms. The *Book of Durrow* also contains pages where the initial letters of an important passage of sacred text are enormously enlarged and transformed into elaborate decorative patterns. Examples of Hiberno-Saxon carpet pages (FIG. 16-6) and initial pages (FIG. 16-7) will be examined later. It is important to note at the outset that this type of manuscript decoration had no precedent in classical art.

A CHECKERBOARD-CLOAKED EVANGELIST In the *Book of Durrow* each of the four Gospel books has a carpet page facing a page dedicated to the symbol of the Evangelist who wrote that Gospel, framed by an elaborate interlace border. The symbol of Saint Matthew (FIG. **16-5**) is a man (more commonly represented later as winged), but the only human parts the artist, a seventh-century monk, chose to render are a schematic frontal head and two profile feet. The rest of the "body" is enveloped by a checkerboard cloak of yellow, red, and green squares filled with intricate abstract designs and outlined in dark brown or black. The man lacks arms and more resembles a warrior lord's cloisonné-enameled belt buckle, brooch, or purse ornament than a human figure. The Durrow artist was interested in ornamental pattern, not in reproducing physical reality. The *Book of Durrow* weds the ab-

straction of the native arts of personal adornment with classical and Early Christian pictorial imagery. The vehicle for the transmission of those Mediterranean forms was the illustrated book itself, brought to the North by Christian missionaries and deposited and reverently copied in the northern monastic scriptoria.

CARPETS AND CROSSES An excellent example of the marriage between Christian imagery and the animal-interlace style of the North is the cross-inscribed carpet page (FIG. **16-6**) of the *Lindisfarne Gospels.* The book, produced in the Northumbrian monastery on Lindisfarne Island, contains several ornamental pages and exemplifies Hiberno-Saxon art at its best. According to a later *colophon* (an inscription, usually on the last page, providing information regarding a book's manufacture), Eadfrith, Bishop of Lindisfarne between 698 and his death in 721, wrote the *Lindisfarne Gospels* "for God and Saint Cuthbert." Cuthbert's relics (see "Pilgrimages and the Cult of Relics," Chapter 17, page 457) recently had been deposited in the Lindisfarne church.

The Lindisfarne ornamental page's patterning and detail are much more intricate and compact than the *Book of Durrow*'s. Serpentine interlacements of fantastic animals devour each other, curling over and returning on their writhing, elastic shapes. The rhythm of expanding and contracting forms produces a most vivid effect of motion and change. But it is

16-5 Man (symbol of Saint Matthew), folio 21 verso of the *Book of Durrow,* probably from Iona, Scotland, ca. 660–680. Ink and tempera on parchment, $9\frac{5}{8}'' \times 6\frac{1}{8}''$. Trinity College Library, Dublin.

16-6 Cross and carpet page, folio 26 verso of the *Lindisfarne Gospels,* from Northumbria, England, ca. 698–721. Tempera on vellum, 1′ 1½″ × 9¼″. British Library, London.

Medieval Books

The central role books played in the medieval Christian Church led to the development of a large number of specialized types for priests, monks and nuns, and laypersons.

The primary sacred text came to be called the Bible ("the Book"), consisting of the Old Testament of the Jews, originally written in Hebrew, and the Christian New Testament, written in Greek. In the late fourth century, Saint Jerome produced the canonical Latin, or *Vulgate* (vulgar, or common tongue), version of the Bible, which incorporates forty-six Old and twenty-seven New Testament books. Before the invention of the printing press in the fifteenth century, all books were written by hand ("manuscripts," from the Latin *manu scriptus*). Bibles were extremely difficult to produce, and few early medieval monasteries possessed a complete Bible. Instead, several biblical books often were gathered and published in discrete volumes.

The *Pentateuch* contains the first five books of the Old Testament, beginning with the Creation of Adam and Eve (Genesis). The *Gospels* ("good news") are the New Testament works of the Four Evangelists (Saints Matthew, Mark, Luke, and John) and tell the story of the life of Christ (see "The Life of Jesus in Art," Chapter 11, pages 308–309). Medieval Gospel books often contained *canon tables,* a concordance, or matching, of the corresponding passages of the four Gospels as compiled by Eusebius of Caesarea in the fourth century. *Psalters* contained the one hundred fifty psalms of King David, written in Hebrew and translated into both Greek and Latin.

Other types of books also were frequently employed in the Christian liturgy. The *lectionary* contains passages from the Gospels reordered to appear in the sequence they were read during the celebration of Mass throughout the liturgical year. *Breviaries* include the texts required for the daily recitations of monks. *Sacramentaries* were used by priests and incorporate the prayers they recited during Mass. *Benedictionals* contain bishops' blessings.

In the later Middle Ages religious books were developed for the private devotions of the laity, patterned after monks' readers. The most popular were *Books of Hours,* so called because they contain the prayers to be read at specified times of the day.

Many other types of books were written and copied in the Middle Ages—theological treatises, secular texts on history and science, and even some classics of Greco-Roman literature—but these were less frequently illustrated than the various sacred texts.

held in check by the design's regularity and by the dominating motif of the inscribed cross. The cross stabilizes the rhythms of the serpentines and, perhaps by contrast with its heavy immobility, seems to heighten the effect of motion. The illuminator placed the motifs in detailed symmetries, with inversions, reversals, and repetitions that must be studied closely to appreciate not so much their variety as their mazelike complexity. The zoomorphic forms intermingle with clusters and knots of line, and the whole design vibrates with the energy that also permeates Viking art (FIGS. 16-3 and 16-4). The color is rich yet cool. The entire spectrum is embraced, but in hues of low intensity. The painter so adroitly adjusted shape and color that a smooth and perfectly even surface was achieved. The page is the product of a master familiar with long-established conventions, yet neither the discipline nor the convention stiffens the supple lines that tirelessly and endlessly thread and convolute their way through the design.

ILLUMINATING THE WORD The greatest achievement of Hiberno-Saxon art in the eyes of almost all modern observers is the *Book of Kells* (FIG. 16-7), the most elaborately decorated of the Insular Gospel books. Medieval commentators shared this high opinion, and one wrote in the *Annals of Ulster* for the year 1003 that this "great Gospel [is] the chief relic of the western world." The *Book of Kells* (named after the monastery in southern Ireland that owned it) was written and decorated either at Iona or a closely related Irish monastery. Fortunately, it survived the Viking raids of the early ninth century. The manuscript probably was created for display on a church altar. From an early date it was housed in an elaborate metalwork box, befitting a greatly revered "relic." The *Book of Kells* boasts an unprecedented number of full-page illumina-

16-7 Chi-rho-iota page, folio 34 recto of the *Book of Kells,* probably from Iona, Scotland, late eighth or early ninth century. Tempera on vellum, 1′ 1″ × 9½″. Trinity College Library, Dublin.

16-8 Saint Matthew, folio 25 verso of the *Lindisfarne Gospels,* from Northumbria, England, ca. 698–721. Tempera on vellum, 1′ 1½″ × 9¼″. British Library, London.

16-9 The scribe Ezra, folio 5 recto of the *Codex Amiatinus,* from Jarrow, England, ca. 689–716. Tempera on vellum, 1′ 8″ × 1′ 1½″. Biblioteca Medicea-Laurenziana, Florence.

tions, including carpet pages, evangelist symbols, portrayals of the Virgin Mary and of Christ, New Testament narrative scenes, canon tables, and several instances of monumentalized and embellished words from the Bible.

The page we reproduce (FIG. 16-7) opens the account of the nativity of Jesus in the Gospel of Saint Matthew. The initial letters of Christ in Greek (**XPI**, *chi-rho-iota)* occupy nearly the entire page, although two words—*autem* (abbreviated simply as *h)* and *generatio* ("Now this is how the birth of Christ came about")—appear at the lower right. The illuminator transformed the holy words into extraordinarily intricate abstract designs that recall Celtic and Anglo-Saxon metalwork. Close observation reveals that the cloisonné-like interlace is not purely abstract pattern. The letter *rho,* for example, ends in a male head, and animals are at its base to the left of *h generatio.* Half-figures look out at viewers to the left of *chi;* another head is at the very top of that letter; and so forth.

When the priest Giraldus Cambrensis visited Ireland in 1185, he described a manuscript he saw that, if not the *Book of Kells* itself, must have been very much like it:

Fine craftsmanship is all about you, but you might not notice it. Look more keenly at it and you . . . will make out intricacies, so delicate and subtle, so exact and compact, so full of knots and links, with colors so fresh and vivid, that you might say that all this was the work of an angel, and not of a man. For my part, the oftener I see the book, the more carefully I study it, the more I am lost in ever fresh amazement, and I see more and more wonders in the book.[3]

SOUTHERN MOTIFS IN THE NORTH The three Hiberno-Saxon books examined here display the illuminators' pure joy in working on small, infinitely complex, and painstaking projects. The same may be said of the precious objects fashioned by Hiberno-Saxon goldsmiths and jewelers. Even when the illuminators depicted human figures, as in the Matthew symbol of the *Book of Durrow* (FIG. 16-5), the artists' models were generally the abstract designs of buckles and pins, not the world about them or imported works in the classical tradition. But exceptions exist. In some Insular manuscripts it is clear the northern artists copied imported Mediterranean books. This is evident at once when the author portrait of Saint Matthew from the *Lindisfarne Gospels* (FIG. **16-8**) is compared with the contemporary full-page portrayal of the scribe Ezra from the *Codex Amiatinus* (FIG. **16-9**). Both were "copied" from similar books Christian missionaries brought from Italy to England—but with markedly divergent results.

The figure of Ezra and the architectural environment of the *Codex Amiatinus* are closely linked with the pictorial illusionism of late antiquity. The color, although applied here and there in flat planes, is blended smoothly to model the figure and to provide gradual transitions from light to dark. By contrast, the Hiberno-Saxon artist of the Lindisfarne Matthew apparently knew nothing of the illusionistic pictorial technique nor, for that matter, of the representation of the human figure. Although the illuminator carefully copied the pose, the Insular artist interpreted the form in terms of line exclusively,

"abstracting" the classical model's unfamiliar tonal scheme into a patterned figure. The Lindisfarne Matthew resembles the pictures of kings, queens, and jacks in a modern deck of playing cards. The soft folds of drapery in the *Codex Amiatinus* Ezra became, in the Hiberno-Saxon manuscript, a series of sharp, regularly spaced, curving lines. The artist used no modeling. No variations occur in light and shade. The Lindisfarne painter converted the strange Mediterranean forms into a familiar linear idiom. The illuminator studied a tonal *picture* and made of it a linear *pattern.* The result, however, is not an inferior imitation of a southern prototype but a vivid new vision of the Evangelist, unencumbered by distracting details such as the bookcase and the scattered writing instruments on the floor present in the *Codex Amiatinus* picture.

SACRED AUTHORITY IN ART The medieval artist did not go to nature for models but to a prototype—another image, a statue, or a picture in a book. Each copy might be one in a long line of copies, and, in some cases, art historians can trace these copies back to a lost original, inferring its former existence. The medieval practice of copying pictures is closely related to the copying of books, especially sacred books such as the Scriptures and the books used in the liturgy. The medieval scribe or illuminator (before the thirteenth century, most often a monk) could have reasoned that just as the text of a holy book must be copied faithfully if the copy also is to be holy, so must the pictures be rendered faithfully. Of course, in the process of copying, mistakes were made. Although scholars seek to purge books of these textual "corruptions," "mistakes" in the copying of pictures yield new pictorial styles or represent the merging of different styles, as in the *Codex Amiatinus* and the *Lindisfarne Gospels.*

In any event, the style of medieval images, whether in sculpture or in painting, was the result of copying from sources thought to have sacred authority, not from studying natural models. Artists could not, of course, draw Christ or the saints "from life." Thus, they learned what was true from authorities who declared the truth—the Scriptures and the fathers of the Christian Church—and painted "true" images from authoritative images. In the early Middle Ages a pictorial tradition for representing many sacred figures and biblical narratives already had been codified. To deviate from iconographical conventions and investigate "nature" on one's own was unthinkable. It would have meant questioning God's truth as revealed and interpreted.

SCULPTURE ON A GRAND SCALE The preserved art of the early Middle Ages is, as has been noted, confined almost exclusively to small and portable works. The high crosses of the British Isles, erected between the eighth and tenth centuries, are exceptional by their mass and scale—and by the very fact of their survival. These majestic monuments, some seventeen feet in height or taller, preside over burial grounds adjoining the ruins of monasteries at sites widely distributed throughout the Irish countryside, and in some instances also in England. Freestanding and unattached to any architectural fabric, the high crosses have the imposing unity, weight, and presence of both building and statue—architecture and sculpture combined.

The *High Cross of Muiredach* at Monasterboice, Ireland (FIG. **16-10**), though a late representative of the type (dated by inscription to 923), can serve as standard for the form. The

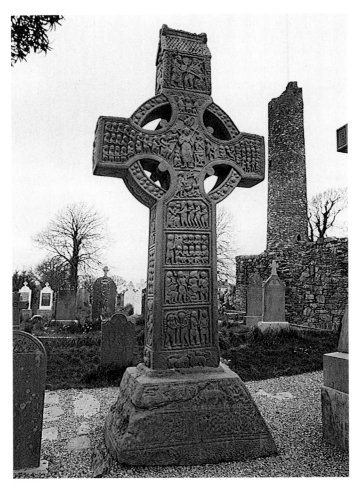

16-10 *High Cross of Muiredach,* Monasterboice, County Louth, Ireland, 923. Approx. 16′ high.

cross element crowns a four-sided stone shaft, which rises from a base with sloping sides. The concave arms of the cross are looped by four arcs that form a circle. The arms expand into squared terminals (compare FIG. 16-6). The circle intersecting the cross identifies the type as Celtic. The early high crosses bear abstract designs, especially the familiar interlace pattern. But the later ones have figured panels, with scenes from the life of Christ or, occasionally, events from the life of some Celtic saint. In addition, fantastic animals sometimes are portrayed. At the center of the Muiredach cross's transom, the risen Christ stands as judge of the world, the hope of the neighboring dead. Below him the souls of the dead are being weighed. Later, the sculptors of twelfth-century church portals (see FIG. 17-25) took up this theme with extraordinary force.

CAROLINGIAN ART

ROME RISES AGAIN On Christmas day of the year 800, Pope Leo III crowned Charles the Great (Charlemagne), King of the Franks since 768, as emperor of Rome (r. 800–814). In time Charlemagne came to be seen as the first Holy (that is, Christian) Roman Emperor, a title his successors in the West did not formally adopt until the twelfth century. The setting for Charlemagne's coronation,

fittingly, was Saint Peter's basilica in Rome (see FIG. 11-7), built by Constantine, the first Roman emperor to embrace Christianity. Born in 742, when northern Europe was still in chaos, Charlemagne consolidated the Frankish kingdom his father and grandfather bequeathed him and defeated the Lombards in Italy. He thus united Europe and laid claim to reviving the ancient Roman Empire's glory. He gave his name (Carolus Magnus in Latin) to an entire era, the *Carolingian* period.

Charlemagne's official seal bore the words *renovatio imperii Romani* (renewal of the Roman Empire). The "Carolingian Renaissance" was a remarkable historical phenomenon, an energetic, brilliant emulation of Early Christian Rome's art, culture, and political ideals. Charlemagne's (Holy) Roman Empire, waxing and waning for a thousand years and with many hiatuses, existed in central Europe until Napoleon destroyed it in 1806.

IMPERIAL IMAGERY REVIVED When Charlemagne returned home from his coronation in Rome, he ordered the transfer of an equestrian statue of the Ostrogothic king Theodoric from Ravenna to the Carolingian palace complex at Aachen. That portrait is lost, as is the grand gilded bronze statue of the Byzantine emperor Justinian that once crowned a column in Constantinople (see "The Emperors of 'New Rome,'" Chapter 12, page 327). But in the early Middle Ages both statues stood as reminders of ancient Rome's glory and of the pretensions and aspirations of the medieval successors of the pagan Roman emperors. The portrait of Theodoric may have been the inspiration for an early ninth-century bronze statuette of a Carolingian emperor on horseback (FIG. **16-11**). Charlemagne greatly admired Theodoric, the first Germanic ruler of Rome. Many have identified the small bronze figure as Charlemagne himself, although others think it portrays his grandson, Charles the Bald.

The ultimate model for the statuette was the equestrian portrait of Marcus Aurelius (see FIG. 10-59) in Rome. In the Middle Ages, it mistakenly was thought to represent Constantine, the first Christian emperor, another revered predecessor of Charlemagne and his Carolingian successors. The medieval sculptor portrayed the ninth-century emperor, like Marcus Aurelius, as overly large so that he, not the horse, is the center of attention. But unlike the Roman emperor, the Carolingian monarch sits rigidly upright. Quiet dignity replaces the torsion of Marcus Aurelius's body and the bold gesture of his right arm. Charlemagne (or Charles the Bald) is on parade, wearing imperial robes rather than a general's cloak, although his sheathed sword is visible. On his head is the imperial crown, and in his outstretched left hand he holds a globe, symbol of world dominion. The portrait proclaimed the *renovatio* of the Roman Empire's power and trappings and set the tone for much of Carolingian art.

The Art of the Book

CHARLEMAGNE'S BOOKS Charlemagne was a sincere admirer of learning, the arts, and classical culture (see "The Revival of Learning at Charlemagne's Court," page 440). He, his successors, and the scholars under their patronage placed a very high value on books, both sacred and secular, importing

many and producing far more. Today four to five times as many Carolingian books exist than Latin books from all of Roman antiquity. One of these is the famous *Coronation Gospels* (also known as the *Gospel Book of Charlemagne*). An old (and probably inaccurate) legend says the book was found on Charlemagne's knees when, in the year 1000, Otto III had the emperor's tomb opened. The text is written in handsome gold letters on purple vellum.

The major full-page illuminations show the four Gospel authors at work. The page we reproduce (FIG. **16-12**) depicts Saint Matthew. Such author portraits were common in medieval books and two earlier examples in the *Lindisfarne Gospels* and the *Codex Amiatinus* (FIGS. 16-8 and 16-9) have already been discussed. The theme originated in ancient book illustrations, and similar representations of seated philosophers or poets writing or reading abound in ancient art (see FIGS. 10-72 and 11-4). The Carolingian painter's technique is of the same antiquity—deft, illusionistic brushwork that easily and accurately defines the massive drapery folds wrapped around the body beneath. Color, not line, was used to create shapes. The cross-legged chair, the lectern, and the saint's toga are familiar Roman accessories. The landscape background is classicizing and the frame is filled with the kind of acanthus leaves found in Roman temple capitals and friezes (see FIG. 10-30). The whole composition seems utterly out of place

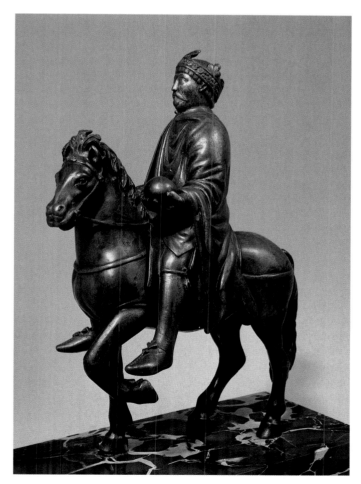

16-11 Equestrian portrait of Charlemagne(?), from Metz, Germany, early ninth century. Bronze, originally gilt, $9\frac{1}{2}$" high. Louvre, Paris.

16-12 Saint Matthew, folio 15 recto of the *Coronation Gospels (Gospel Book of Charlemagne)*, from Aachen, Germany, ca. 800–810. Ink and tempera on vellum, $1' \frac{3}{4}'' \times 10''$. Schatzkammer, Kunsthistorisches Museum, Vienna.

delity to bodily structure to concentrate on the saint's act of writing. Instead, Matthew's face, hands, inkhorn, pen, and book are the focus of the composition. This presentation contrasts strongly with the settled pose of the Saint Matthew of the *Coronation Gospels* with its even stress so that no part of the composition starts out at viewers to seize their attention.

The native power of expression is unmistakable in the *Ebbo Gospels* and became one of the important distinguishing traits of late medieval art. Just as the painter of the *Lindisfarne Gospels* Matthew (FIG. 16-8) transformed his model into something original and strong, translating the classicizing manner of a southern manuscript into his own Hiberno-Saxon idiom, so the *Ebbo Gospels* artist translated his classical prototype into a new Carolingian vernacular. This master painter brilliantly merged classical illusionism and the North's linear tradition.

ACTING OUT THE PSALMS The Carolingians also revived narrative illustration, so richly developed in Early Christian and Byzantine art, and produced many fully illuminated books (even some large Bibles). One of the most extraordinary and enjoyable of all medieval manuscripts is the *Utrecht Psalter* (book of psalms). The text reproduces the Psalms of David in three columns of Latin capital letters emulating the script and page organization of long out-of-fashion ancient books. The artist illustrated each psalm with a pen-

in the North in the ninth century. If a Frank, rather than an Italian or a Byzantine, painted the Saint Matthew and the other Evangelist portraits of the *Coronation Gospels*, the northern artist accomplished an amazing feat of approximation. Almost nothing is known in the Hiberno-Saxon or Frankish West that could have prepared the way for such a classicizing portrayal of Saint Matthew.

AN IMPASSIONED EVANGELIST The style evident in the *Coronation Gospels* was by no means the only one that appeared suddenly in the Carolingian world. A wide variety of styles from late antique prototypes were distributed through the court schools and the monasteries. This must have been a bewildering array for the natives, who attempted to appropriate them by copying them as accurately as possible. Another Saint Matthew (FIG. **16-13**), in a gospel book made for Archbishop Ebbo of Reims, France, may be an interpretation of a prototype very similar to the one the *Coronation Gospels* master used. It resembles it in pose and in brushwork technique, but there the resemblance stops. The *Ebbo Gospels* illuminator replaced the classical calm and solidity of the *Coronation Gospels* with an energy that amounts to frenzy, and the frail saint almost leaps under its impulse. His hair stands on end, his eyes open wide, the folds of his drapery writhe and vibrate, the landscape behind him rears up alive. The painter even set the page's leaf border in motion. Matthew appears to take down in frantic haste what his inspiration (the tiny angel in the upper-right corner) dictates. The artist forsook all fi-

16-13 Saint Matthew, folio 18 verso of the *Ebbo Gospels (Gospel Book of Archbishop Ebbo of Reims)*, from Hautvillers (near Reims), France, ca. 816–835. Ink and tempera on vellum, $10\frac{1}{4}'' \times 8\frac{3}{4}''$. Bibliothèque Municipale, Épernay.

and-ink drawing stretching across the page's entire width. Our example (FIG. **16-14**) depicts figures acting out—literally and with a refreshing sense of humor—Psalm 43, in which the psalmist laments the plight of the oppressed Israelites. Where the text says, "Thou hast made us like sheep for slaughter," the artist drew some slain sheep fallen to the ground in front of a walled city reminiscent of cities on the Column of Trajan in Rome (see FIG. 10-42) and in Early Christian mosaics and manuscripts (see FIG. 11-19). At the left, the faithful grovel on the ground before a temple because the psalm reads "our belly cleaveth unto the earth." The artist's response to "Arise, why sleepest thou, O Lord" was to depict the Lord, flanked by six pleading angels, reclining in a canopied bed overlooking the slaughter below.

The style shows a vivid animation of much the same kind as the Saint Matthew of the *Ebbo Gospels,* and the *Utrecht Psalter* may have been produced in the same "school of Reims." As in the *Ebbo Gospels,* even the earth heaves up around the figures. The bodies are tense, shoulders hunched, heads thrust forward. The rapid, sketchy techniques used to render the figures convey the same nervous vitality as the Evangelists in the *Ebbo Gospels.* From details of the figures, their dress, and accessories, some scholars have argued that the artist followed one or more manuscripts compiled four hundred years before. If the *Utrecht Psalter* is not a copy, it certainly was designed to evoke earlier artworks and to appear "ancient." The interest in simple human emotions and actions and the variety and descriptiveness of gesture, however, are essentially medieval characteristics. Candid observation of human behavior, often in unguarded moments, lent both truth and charm to the art of the Middle Ages.

BEJEWELED BOOKS OF GOLD AND IVORY

The taste for sumptuously wrought and portable objects, shown previously in the art of the early medieval warrior lords, persisted under Charlemagne and his successors. They commissioned numerous works employing costly materials. One of the most luxurious is the psalter belonging to Charles the Bald (r. 840–877), grandson of Charlemagne and patron of the royal abbey of Saint-Denis near Paris, where the work was produced. The book's front cover (FIG. **16-15**) reveals the mastery of both metal- and ivorycraft during the Carolingian era. At the center is an ivory panel that, in shape and size if not subject, recalls late antique diptychs (see FIG. 11-22). It is set within a silver-gilt, filigreed frame inlaid with gems. The panel illustrates verses from Psalm 57:

> Oh God, in the shadow of thy wings will I make my refuge. . . . My soul is among lions; and I lie even among them that are set on fire, even the sons of men, whose teeth are spears and arrows, and their tongues a sharp sword. . . . They have prepared a net for my steps; they have digged a pit before me, into the midst thereof they are fallen themselves.

As in the earlier *Utrecht Psalter,* which, in fact, it directly copies, the narrative composition closely follows the text. Beginning at the top, the panel shows the psalmist in the Lord's lap, flanked by lions. On the next level are men armed to the teeth, and at the bottom, men are digging the pit and falling into it. The style of the carved figures—note the quick, nervous movements and exaggerated gestures—is also derived from the *Utrecht Psalter* illustrations. The cover of the *Psalter of Charles the Bald* is a model of the faithful reproduction of a prototype and exhibits the dependence of much medieval

16-14 Psalm 43, detail of folio 25 recto of the *Utrecht Psalter,* from Hautvillers (near Reims), France, ca. 820–835. Ink on vellum, full page, $1' 1'' \times 9\frac{7}{8}''$. University Library, Utrecht.

ART AND SOCIETY

The Revival of Learning at Charlemagne's Court

To make his empire as splendid as Rome's, Charlemagne invited to his court at Aachen the best minds and the finest artisans of western Europe and the Byzantine East. Among them were Theodulf of Orléans, Paulinus of Aquileia, and Alcuin, master of the cathedral school at York, the center of Northumbrian learning. Alcuin brought Anglo-Saxon scholarship into the Carolingian setting, a major stimulus of its cultural reawakening.

Charlemagne himself, according to Einhard, his biographer, could read and speak Latin fluently, in addition to Frankish, his native tongue. He also could understand Greek, and he studied rhetoric and mathematics with the learned men he gathered around him. But he never learned to write properly—that was a task best left to professional scribes. In fact, one of Charlemagne's dearest projects was the recovery of the true text of the Bible, which, through centuries of miscopying by ignorant scribes, had become quite corrupt. Various scholars undertook the great project at the emperor's behest, but Alcuin of York's revision of the Bible, prepared at the new monastery at Tours, became the most widely used.

Charlemagne's scribes also were responsible for the development of a new, more compact, and more easily written and legible version of Latin script called *Caroline minuscle*. The letters on this page are descended from the alphabet Carolingian scribes perfected. Later generations also owe to Charlemagne's patronage the restoration and copying of important classical texts. The earliest known manuscripts of many Greek and Roman authors are Carolingian in date.

sculpture, small or large scale, on pictorial sources. In general, manuscript illumination provided the prototypes for medieval ivory- and metalwork.

More monumental in its conception is the golden cover of the *Lindau Gospels* (FIG. **16-16**), also fashioned in one of the workshops of Charles the Bald's court. Surrounded by pearls and jewels (raised on golden claw feet so that they can catch and reflect the light even more brilliantly and protect the delicate metal relief from denting), a youthful Christ in the Early Christian tradition is shown nailed to the cross. The statuesque open-eyed figure, rendered in *repoussé* (hammered or pressed relief), brings to mind the beardless unsuffering

16-15 Psalm 57, front cover of the *Psalter of Charles the Bald*, from Saint-Denis, France, ca. 865. Ivory panel set in silver-gilt frame with filigree work and precious stones; panel $5\frac{1}{2}'' \times 5\frac{1}{4}''$, entire cover $9\frac{1}{2}'' \times 7\frac{3}{4}''$. Bibliothèque Nationale, Paris.

16-16 Crucifixion, front cover of the *Lindau Gospels,* ca. 870. Gold, precious stones, and pearls, $1'\ 1\frac{3}{8}'' \times 10\frac{3}{8}''$. Pierpont Morgan Library, New York.

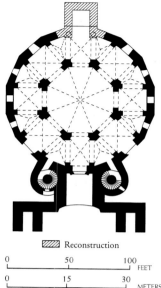

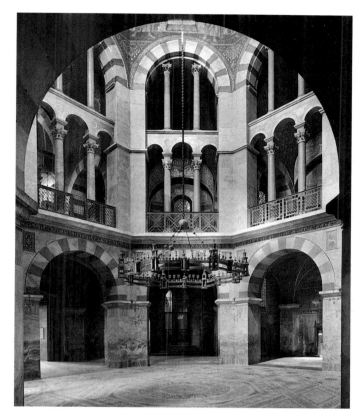

16-18 ODO OF METZ, interior of the Palatine Chapel of Charlemagne, Aachen, Germany, 792–805.

Reconstruction

FEET
0 50 100

METERS
0 15 30

16-17 ODO OF METZ, restored plan of the Palatine Chapel of Charlemagne, Aachen, Germany, 792–805.

Christ of the fifth-century ivory casket from Italy in the British Museum (see FIG. 11-21). By contrast, the four angels and the personifications of the Moon and the Sun above and the crouching figures of the Virgin Mary and Saint John (and two other figures of uncertain identity) in the quadrants below display the vivacity and nervous energy of the *Utrecht Psalter* figures. This single eclectic work displays the classical and native stylistic poles of Carolingian art side by side. But at the core the translated figural style of the south prevails, in keeping with the tastes and aspirations of the Frankish emperors who brought about the "Carolingian Renaissance."

Architecture

In his eagerness to reestablish the imperial past, Charlemagne also encouraged the revival of Roman building techniques. In architecture, as in sculpture and painting, innovations made in the reinterpretation of earlier Roman Christian sources became fundamental to the subsequent development of northern European architecture. For his models, Charlemagne went to Rome and Ravenna. One was the former heart of the Roman Empire, which he wanted to revive. The other was the long-term western outpost of Byzantine might and splendor, which he wanted to emulate in his own capital at Aachen, a site chosen because of its renowned hot springs.

AACHEN: THE RAVENNA OF THE NORTH
Charlemagne often visited Ravenna, and, as already noted, he once brought an equestrian statue of Theodoric from there to display in his palace complex at Aachen, where it served as a model for Carolingian equestrian portraits (FIG. 16-11). Charlemagne also imported *porphyry* (purple marble) columns from Ravenna to adorn his Palatine Chapel, and historians long have thought he chose one of Ravenna's churches as the model for the new structure. The Aachen chapel's plan (FIG. **16-17**) resembles San Vitale's (see FIG. 12-7), and a direct relationship very likely exists between the two, although the de-

sign and construction of Charlemagne's chapel was entrusted to a Frankish builder, ODO OF METZ. (Odo was the first architect north of the Alps whose name is known.)

A comparison between the northern building, the first vaulted structure of the Middle Ages in the West, and its southern counterpart is instructive. The Aachen plan is simpler. San Vitale's apselike extensions reaching from the central octagon into the ambulatory were omitted, so the two main units stand in greater independence of each other. This solution may lack the subtle sophistication of the Byzantine building, but the Palatine Chapel gains geometric clarity. A view of the interior of the Palatine Chapel (FIG. **16-18**) shows that the "floating" quality of San Vitale (see FIG. 12-8) was converted into blunt massiveness and stiffened into solid geometric form.

Odo's conversion of a complex and subtle Byzantine prototype into a building that expresses robust strength and clear structural articulation foreshadowed the architecture of the eleventh and twelfth centuries and the style called Romanesque (see Chapter 17). So, too, did his treatment of the Palatine Chapel's exterior, where two cylindrical towers with spiral staircases flank the entrance portal. This was a first step toward the great dual-tower facades of churches in the West from the tenth century to the present. Above the portal, Charlemagne could appear in a large framing arch and be seen by those gathered in the atrium in front of the chapel (only part of the atrium is included in our plan). Directly behind that second-story arch was Charlemagne's marble throne. From there he could peer down at the altar in the apse. This was in every sense a royal chapel. Charlemagne's son, Louis the Pious (r. 814–840), was crowned there when he succeeded his father as emperor.

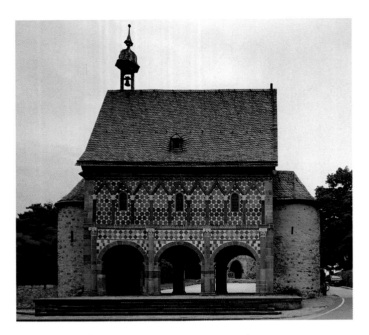

16-19 *Torhalle* (gatehouse), Lorsch, Germany, ninth century.

A MONASTIC TRIUMPHAL GATEWAY The Carolingian evocation of the Roman past is illustrated by a remarkable survival from the ninth century, the *Torhalle* (FIG. **16-19**), or gatehouse, of the Lorsch Monastery in Germany. The gate is difficult to date because it is unique. Long thought to be from Charlemagne's time, it recently has been placed later in the century. Built as a freestanding structure in the atrium of the monastic church, the Lorsch *Torhalle* is a distant relative of the Arch of Constantine (see FIG. 10-76). But it follows more closely the design of Roman city gates, with its second-story windows and flanking towers (which also recall the arrangement of the Palatine Chapel's facade at Aachen). Also inspired by Roman architecture are the fairly close copies of Composite capitals and the framing of the arcuated passageways by engaged columns. The decorative treatment of the flat wall surfaces with colored inlays of cream and pink stone imitated Roman *opus reticulatum,* a method of facing concrete walls with lozenge-shaped bricks or stones to achieve a netlike ornamental surface pattern. However, the columns support a decorative *stringcourse* (raised horizontal *molding,* or band) instead of a full entablature, and the second level was treated in a manner without parallel in classical

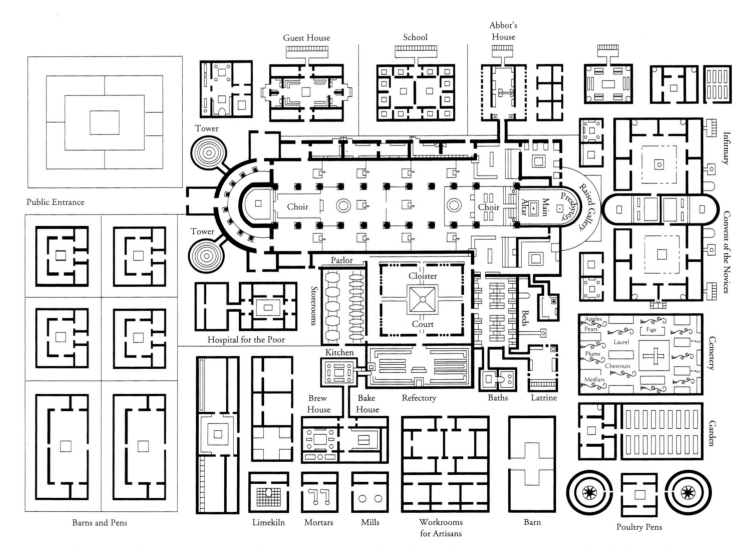

16-20 Schematic plan for a monastery at Saint Gall, Switzerland, ca. 819. (Redrawn after a ninth-century manuscript; original in red ink on parchment, 2′ 4″ × 3′ 8⅛″. Stiftsbibliothek, Saint Gall.)

Medieval Monasteries and Benedictine Rule

Monastic foundations appeared in the West beginning in Early Christian times. The monks who established monasteries also made the rules that governed them. The most significant of these monks was Benedict of Nursia (Saint Benedict), who founded the Benedictine Order in 529. By the ninth century, the "Rule" Benedict gave *(Regula Sancti Benedicti)* had become standard for all Western monastic establishments, in part because Charlemagne had encouraged its adoption throughout the Frankish territories.

Saint Benedict believed that the corruption of the clergy that accompanied the Christian Church's increasing worldliness was rooted in the lack of firm organization and regulation. Neglect of the commandments of God and of the Church was due, as he saw it, to idleness and venality, which in turn tempted the clergy to loose living. The cure for this was communal association in an *abbey* under the absolute rule of an *abbot* the monks elected (or an *abbess* the nuns chose), who would see to it that each hour of the day was spent in useful work and in sacred reading. The emphasis was on work and study and not on meditation and austerity. This is of great historical significance. Since antiquity, manual labor had been considered disgraceful, the business of the lowborn or of slaves. Benedict raised it to the dignity of religion. The core idea of what many people today call the "work ethic" found early expression here as an essential feature of the spiritual life. By thus exalting the virtue of manual labor, Benedict not only rescued it from its age-old association with slavery, but also recognized it as the way to self-sufficiency for the entire religious community.

While some of Saint Benedict's followers emphasized spiritual "work" over manual labor, others, most notably the Cistercians (see "Saint Bernard of Clairvaux on Cloister Sculpture," Chapter 17, page 470), put his teachings about the value of physical work into practice. These monks reached into their surroundings and helped reduce the vast areas of daunting wilderness of early medieval Europe. They cleared dense forest teeming with wolves, bear, and wild boar; drained swamps; cultivated wastelands; and built roads, bridges, and dams, as well as monastic churches and their associated living and service quarters. An ideal monastery (FIG. 16-20) provided all the facilities necessary for the conduct of daily life—a mill, bakery, infirmary, vegetable garden, and even a brewery—so that the monks felt no need to wander outside its protective walls.

Such religious communities were centrally important to the revival of learning. The clergy, who were also often scribes and scholars, had a monopoly on the skills of reading and writing in an age of almost universal illiteracy. The monastic libraries and scriptoria, where books were read, copied, illuminated, and bound with ornamented covers, became centers of study. These were almost the sole repositories of what remained of the literary culture of the Greco-Roman world and early Christianity. The Benedictine Rule's requirements of manual labor and sacred reading were expanded to include writing and copying books, studying music for chanting the day's offices, and—of great significance—teaching. The monasteries were the schools of the early Middle Ages, as well as self-sufficient communities and production centers.

architecture. Pseudo-Ionic pilasters carry a zigzag of ornamental moldings, and the opus reticulatum was converted into a decorative pattern of hexagons and triangles that form star shapes. Finally, the steeply pitched timber roof that shelters a chapel dedicated to Saint Michael unmistakably stamps this gatehouse as a northern building. Still, the source of inspiration is clear, and if the final product no longer closely resembles the original, it is due to the fact it is not a copy but a free and fanciful interpretation of its model.

THE IDEAL MONASTERY The Carolingian monastery at Lorsch is not preserved, but scholars have learned much about the design of monastic communities at this time, thanks to a fascinating contemporary document, the ideal plan (FIG. **16-20**) for a monastery at Saint Gall in Switzerland. About 819, a schematic plan for a Benedictine community (see "Medieval Monasteries and Benedictine Rule," above) was drawn for Haito, the abbot of Reichenau and bishop of Basel, and sent to the abbot of Saint Gall. The plan provided a coherent arrangement of all the buildings of a monastic community and was intended as a guide in the rebuilding of the Saint Gall monastery. The design's fundamental purpose was to sep-

arate the monks from the laity, who also inhabited the community. Variations of the scheme may be seen in later monasteries all across western Europe.

Near the center, dominating everything, was the church with its *cloister,* a colonnaded courtyard (compare FIG. 17-24) not unlike the Early Christian atrium but situated to the side of the church rather than in front of its main portal. Reserved for the monks alone, the cloister provided the peace and quiet necessary for contemplation and was regarded as a kind of earthly paradise removed from the world at large. Around the cloister were grouped the most essential buildings: dormitory, refectory, kitchen, and storage rooms. Other structures, including an infirmary, school, guest house, bakery, brewery, and workshops, were grouped around this central core of church and cloister.

Haito invited the abbot of Saint Gall to adapt the plan as he saw fit, and the Saint Gall builders did not, in fact, follow the Reichenau model exactly. Nonetheless, if the abbot had wished, Haito's plan *could* have served as a practical guide for the Saint Gall masons because it was laid out on a *module* (standard unit) of two and one-half feet. Parts or multiples of this module were used consistently throughout the plan. For

example, the nave's width, indicated on the plan as forty feet, was equal to sixteen modules; the length of each monk's bed to two and one-half modules; and the width of paths in the vegetable garden to one and a quarter modules. This systematic building up of the plan from a prescribed module reflects the medieval mind's eagerness to explain the Christian faith in terms of an orderly, rationalistic philosophy built on carefully distinguished propositions and well-planned arguments. It also parallels the Carolingian invention of that most convenient device, the division of books into chapters and subchapters.

THE BASILICAN CHURCH TRANSFORMED The models that carried the greatest authority for Charlemagne and his builders were those from the Christian phase of the late Roman Empire. The widespread adoption of the Early Christian basilica, at Saint Gall and elsewhere, rather than the domed central plan of Byzantine churches, was crucial to the subsequent development of Western church architecture. Unfortunately, no Carolingian basilica has survived in anything approaching its original form. Nevertheless, it is possible to reconstruct the appearance of some of them with fair accuracy. Several of these structures appear to have followed their Early Christian models quite closely. But in other instances Carolingian builders subjected the basilica plan to some very significant modifications, converting it into a much more complex form. The monastery church at Saint Gall (FIG. 16-20), for example, was essentially a three-aisled basilica, but it had features not found in any Early Christian church. Most obvious is the addition of a second apse on the west end of the building, perhaps to accommodate additional altars and relics (see "Pilgrimages and the Cult of Relics," Chapter 17, page 457). Whatever its purpose, this feature remained a characteristic regional element of German churches until the eleventh century.

Not quite as evident but much more important to the subsequent development of church architecture in the North was the presence of a transept at Saint Gall, a very rare feature, but one that characterized the two greatest Early Christian basilicas in Rome, Saint Peter's (see FIG. 11-7) and Saint Paul's. The Saint Gall transept is as wide as the nave on the plan and was probably the same height. Early Christian builders had not been concerned with proportional relationships. They assembled the various portions of their buildings only in accordance with the dictates of liturgical needs. On the Saint Gall plan, however, the various parts of the building are related to one another by a geometric scheme that ties them together into a tight and cohesive unit. Equalizing the widths of nave and transept automatically makes the area where they cross (the *crossing*) a square. Most Carolingian churches shared this feature. But Haito's planner also used the crossing square as the unit of measurement for the remainder of the church plan. The transept arms are equal to one crossing square, the distance between transept and apse is one crossing square, and the nave is four and one-half crossing squares long. The fact the aisles are half as wide as the nave integrates all parts of the church in a rational, lucid, and extremely orderly plan.

THE MULTIPLICATION OF TOWERS Old drawings of the now-destroyed church of Saint-Riquier at Centula

in northeastern France provide a good idea of what major Carolingian basilicas looked like. A monastery church like that of Saint Gall, Saint-Riquier was built toward the very end of the eighth century. It predated the Saint Gall plan by approximately twenty years. Our drawing (FIG. **16-21**) shows a feature not indicated on the plan for Saint Gall—multiple towers. The Saint Gall plan shows only two towers, both cylindrical and on the west side of the church, as at the Palatine Chapel at Aachen (FIG. 16-17), but they stand apart from the church facade. If a tower existed above the crossing, the silhouette of Saint Gall would have shown three towers rising above the nave. Saint-Riquier had six towers (not all are shown in the illustration) built directly onto or rising from the building proper. As large, vertical, cylindrical masses, these towers rose above the horizontal roofline, balancing one another in two groups of three at each end of the basilican nave. Round stair towers on the basilica's west end provided access to the upper stories of the so-called *westwork* (entrance structure) and to the big spired tower that balanced the spired tower above the eastern crossing. On the second floor, the towered westwork contained a complete chapel flanked by aisles—a small upper church available for parish services. The

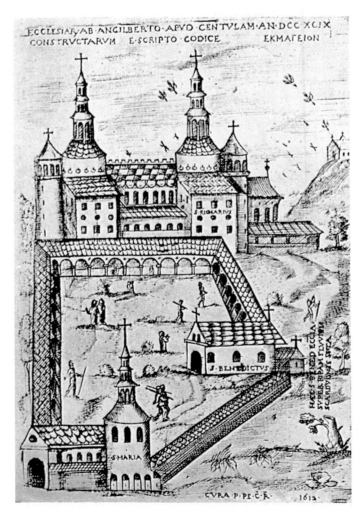

16-21 Drawing of the monastery church of Saint-Riquier, Centula, France, ca. 800. (Engraving made in 1612 after a now-destroyed eleventh-century miniature.)

building's main floor was reserved for the clergy's use. As at Aachen, a gallery opened onto the main nave, and from it, on occasion, the emperor and his entourage could watch and participate in the service below. The Saint-Riquier design, particularly the silhouette with its multiple towers, was highly influential, especially in Germany.

OTTONIAN ART

IN THE AFTERMATH OF CHARLEMAGNE Charlemagne was buried in the Palatine Chapel at Aachen. His empire survived him by less than thirty years. When his son Louis the Pious died in 840, the Carolingian Empire was divided among Louis's sons, Charles the Bald, Lothair, and Louis the German. After bloody conflicts among the brothers, a treaty was signed in 843 partitioning the Frankish lands into western, central, and eastern areas, very roughly foreshadowing the later nations of France and Germany and a third realm corresponding to a long strip of land stretching from the Netherlands and Belgium to Rome. Intensified Viking incursions in the West helped bring about the collapse of the Carolingians and the suspension of their great cultural effort. The empire's breakup into weak kingdoms, ineffectual against the invasions, brought a time of darkness and confusion to Europe. The Viking scourge in the West was complemented by the invasions of the Magyars in the East and by the plundering and piracy of the Saracen (Muslim) corsairs in the Mediterranean.

Only in the mid-tenth century did the eastern part of the former empire consolidate under the rule of a new Saxon line of German emperors called, after the names of the three most illustrious family members, the *Ottonians*. The first Otto (r. 936–973) was crowned emperor in Rome by the pope in 962, assuming the title Charlemagne's weak successors held during most of the previous century. The three Ottos made headway against the invaders from the East, remained free from Viking depredations, and not only preserved but also enriched the Carolingian period's culture and tradition. The Christian Church, which had become corrupt and disorganized, recovered in the tenth century under the influence of a great monastic reform encouraged and sanctioned by the Ottonians, who also cemented ties with Italy and the papacy. When the last of the Ottonian line, Henry II, died in the early eleventh century, the pagan marauders had become Christianized and settled, and the monastic reforms had been highly successful. Several signs pointed to a cultural renewal destined soon to produce greater monuments than had been known in the West since ancient Rome.

Architecture

TOWERING OTTONIAN SPIRES Ottonian architects followed the course of their Carolingian predecessors. In fact, the westwork of the Benedictine abbey church of Saint Pantaleon (FIG. **16-22**) at Cologne, Germany, gives an idea of the former facades of Saint-Riquier and other Carolingian churches. Begun in 966 and consecrated in 980, Saint Pantaleon was the burial site of Archbishop Bruno, brother of Otto I. It is distinguished by its towering westwork, where

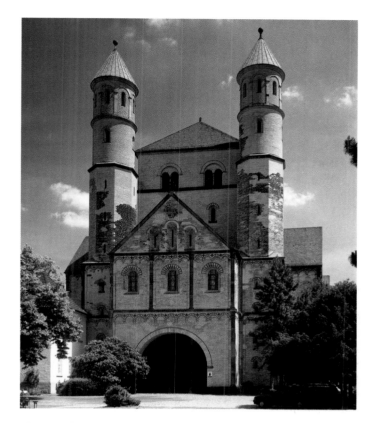

16-22 Abbey church of Saint Pantaleon, Cologne, Germany, 966–980.

two tall cylindrical spires capped by cones rise from polygonal bases and frame a less-lofty, broad, quadrilateral crossing tower. The centerpiece is a three-story entrance facade with a large arcuated portal below three rounded windows framed by pilasters, all crowned by a pediment-like upper story pierced by another set of three smaller windows. The arrangement recalls that of the Lorsch *Torhalle* (FIG. 16-19) and echoes, more distantly, the series of superimposesd arches of varying size of the Roman Pont-du-Gard (see FIG. 10-31). The pattern is repeated, in variant form, on the ends of the transept arms (not shown). The framing of the various design elements by stringcourses and pilasters creates a linear geometric grid that complements the interplay of cylinders, cubes, polygons, and pyramids of the westwork as a whole.

AN OTTONIAN BISHOP IN ROME One of the great patrons of Ottonian art and architecture was Bishop Bernward of Hildesheim, Germany. He was the tutor of Otto III (r. 983–1002) and builder of the abbey church of Saint Michael's at Hildesheim. Bernward, who made Hildesheim a center of learning, not only was skilled in affairs of state but also was an eager scholar, a lover of the arts, and, according to Thangmar of Heidelberg, his biographer, an expert craftsman and bronze caster. In 1001, he traveled to Rome as the guest of Otto III. During this stay, Bernward studied at first hand the monuments of the empire the Carolingian and Ottonian emperors had been seeking to revive.

Bernward's Saint Michael's and its sculptured decoration in precious bronze are widely acknowledged as Ottonian

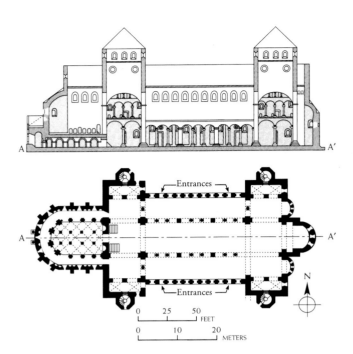

16-23 Longitudinal section *(top)* and plan *(bottom)* of the abbey church of Saint Michael's, Hildesheim, Germany, 1001–1031.

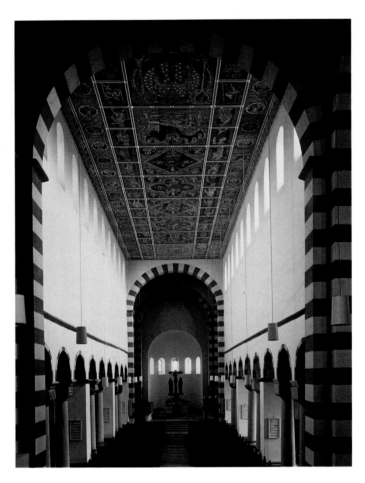

16-24 Restored nave of Saint Michael's, Hildesheim, Germany, 1001–1031.

masterpieces. Constructed between 1001 and 1031, the church has a double-transept plan, tower groupings, and a westwork similar to Saint Pantaleon's, as well as massive walls pierced only occasionally by arcuated windows. The plan and section of Saint Michael's (FIG. **16-23**) clearly show how the two transepts create eastern and western centers of gravity. The nave merely seems to be a hall that connects them. Lateral entrances leading into the aisles from the north and south additionally make for an almost complete loss of the traditional basilican orientation toward the east. Some ancient Roman basilicas, such as the Basilica Ulpia in Trajan's Forum (see FIG. 10-41), also had two apses and were entered from the side, and Bernward probably was familiar with this variant basilican plan.

At Hildesheim, as in the plan of the monastery at Saint Gall (FIG. 16-20), the builders adopted a modular approach. The crossing squares, for example, were used as the basis for the nave's dimensions—three crossing squares long and one square wide. This fact was emphasized visually by the placement of heavy piers at the corners of each square. These piers alternate with pairs of columns as wall supports to form what is called an *alternate-support system*. It became a standard element of many Romanesque churches in northern Europe.

A view of Saint Michael's interior (FIG. **16-24**) shows the rhythm of the alternating light and heavy wall supports. It shows, as well, that this rhythm is not reflected in the upper nave walls—that, in fact, it was not carried farther than the actual supports, unlike later basilicas. Although the nave's proportions had changed from those of earlier churches (it is much taller in relation to its width than a Roman basilica), it retained the continuous and unbroken appearance of its Early Christian predecessors.

Sculpture

BIBLICAL STORIES ON COLOSSAL DOORS In 1001, when Bishop Bernward was in Rome visiting the young Otto III, he resided in Otto's palace on the Aventine hill in the neighborhood of Santa Sabina (see FIG. 11-8), an Early Christian church renowned for its carved wooden doors. Those doors, decorated with episodes from both the Old and New Testaments, may have inspired the remarkable bronze doors the bishop had cast for his new church in Germany. The colossal doors (FIG. **16-25**) for Saint Michael's, dated by inscription to 1015, are more than sixteen feet tall. Each was cast in a single piece with the figural sculpture, a technological tour-de-force of lost-wax casting (see "Hollow-Casting Life-Size Bronze Statues," Chapter 5, page 124). Carolingian sculpture, like most sculpture since late antiquity, consisted primarily of small-scale art executed in ivory and precious metals, so the sixteen individual panels of the Hildesheim doors may be compared to the covers of earlier Carolingian and Ottonian books (FIGS. 16-15 and 16-16). But Bernward's doors are more public than any book cover, although they were situated at the entrance to the church from the cloister, where only the monks could pass through them. The prominent placement of narrative reliefs on the Saint Michael's portal anticipated the reinstatement of large-scale sculpture in the Romanesque period (see "The Romanesque Portal," Chapter 17, page 471).

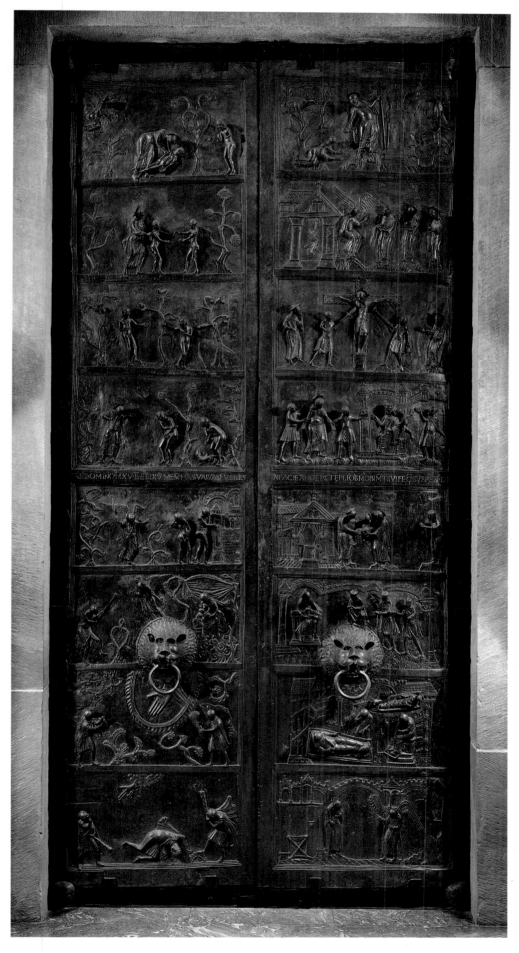

16-25 Doors with relief panels (Genesis, left door; life of Christ, right door), commissioned by Bishop Bernward for Saint Michael's, Hildesheim, Germany, 1015. Bronze, 16′ 6″ high. Saint Michael's, Hildesheim.

The left-door panels illustrate highlights from the biblical Book of Genesis, beginning with the creation of Adam (at the top) and ending with the murder of Adam and Eve's son Abel by his brother Cain (at the bottom). The right door recounts the life of Christ (reading from the bottom up), starting with the Annunciation and terminating with the appearance to Mary Magdalene of Christ after the Resurrection. Together, the doors tell the story of Original Sin and ultimate redemption, showing the expulsion from the Garden of Eden and the path back to Paradise through the Christian Church. As in Early Christian times, the Old Testament was interpreted as prefiguring the New Testament (see "Jewish Subjects in Christian Art," Chapter 11, page 305). The panel depicting the Fall of Adam and Eve, for example, is juxtaposed with the Crucifixion on the other door. Eve nursing the infant Cain is opposite Mary with the Christ Child in her lap.

The composition of many of the scenes on the doors derives from Carolingian manuscript illumination, and the style of the figures has an expressive strength that brings to mind the illustrations in the *Utrecht Psalter* (FIG. 16-14). For example, in the fourth panel from the top on the left door, God, portrayed as a man, accuses Adam and Eve after their fall from grace. As he lays on them the curse of mortality, the primal condemnation, he jabs his finger at them with the force of his whole body. The force is concentrated in the gesture, which becomes the psychic focus of the whole composition. The frightened pair crouch, not only to hide their shame but also to escape the lightning bolt of divine wrath. Each passes the blame — Adam pointing backward to Eve and Eve pointing downward to the deceitful serpent. The starkly flat setting throws the gestures and attitudes of rage, accusation, guilt, and fear into relief. The story was presented with simplicity, but with great emotional impact. The artist had a flair for anecdotal detail. Adam and Eve both struggle to point with one arm while attempting to shield their bodies from sight with the other. With an instinct for expressive pose and gesture, the sculptor brilliantly communicated their newfound embarrassment at their nakedness and their unconvincing denials of wrongdoing.

AN OTTONIAN TRIUMPHAL COLUMN The great doors of Saint Michael's were not the only large-scale masterpieces of bronze-casting Bernward commissioned. Within the church stood a bronze spiral column (FIG. **16-26**) that is preserved intact, save for its later capital and missing surmounting cross. It probably was begun sometime after the doors were set in place and completed before the bishop's death in 1022. The seven spiral bands of relief tell the story of Jesus' life in twenty-four scenes, beginning with his baptism and concluding with his entry into Jerusalem. These are the missing episodes from the story told on the church's doors.

The narrative reads from bottom to top, exactly as on the Column of Trajan in Rome (see FIG. 10-42). That ancient monument was unmistakably the model for the Hildesheim column, even though the Ottonian narrative unfolds from right to left instead of from left to right. Once again, a monument in Rome provided the inspiration for the Ottonian artists working under Bernward's direction. Both the doors and the column of Saint Michael's lend credence to the Ottonian emperors' claim to be the heirs to Charlemagne's *renovatio imperii Romani*.

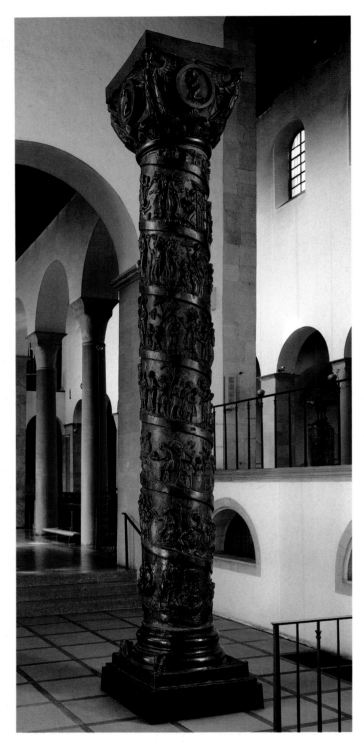

16-26 Column with reliefs illustrating the life of Christ, commissioned by Bishop Bernward for Saint Michael's, Hildesheim, Germany, ca. 1015–1022. Bronze, 12′ 6″ tall. Saint Michael's, Hildesheim.

SUFFERING ON A MONUMENTAL SCALE Nowhere was the revival of interest in monumental sculpture more evident than in the Crucifix (FIG. **16-27**) Archbishop Gero commissioned and presented to Cologne Cathedral in 970. Carved in oak and then painted and gilded, the six-foot-tall image of Christ nailed to the cross is both statue and *reliquary* (a shrine for sacred relics). A com-

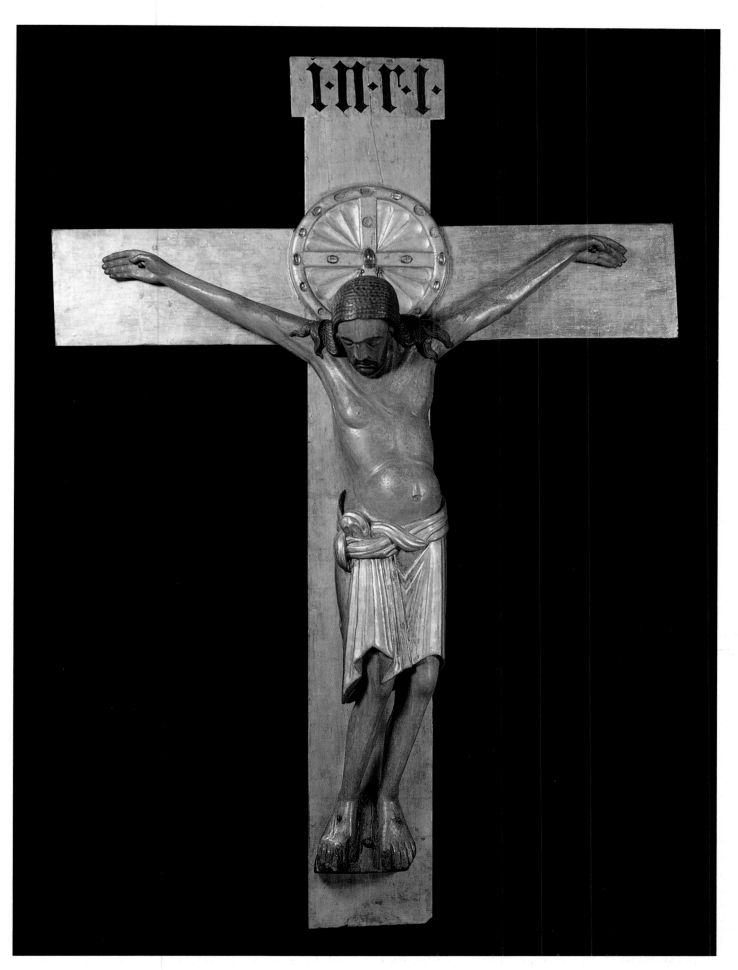

16-27 Crucifix commissioned by Archbishop Gero for Cologne Cathedral, Germany, ca. 970. Painted wood, height of figure 6′ 2″. Cathedral, Cologne.

16-28 *Annunciation to the Shepherds,* folio in the *Lectionary of Henry II,* from Reichenau, Germany, 1002–1014. Tempera on vellum, approx. 1′ 5″ × 1′ 1″. Bayerische Staatsbibliothek, Munich.

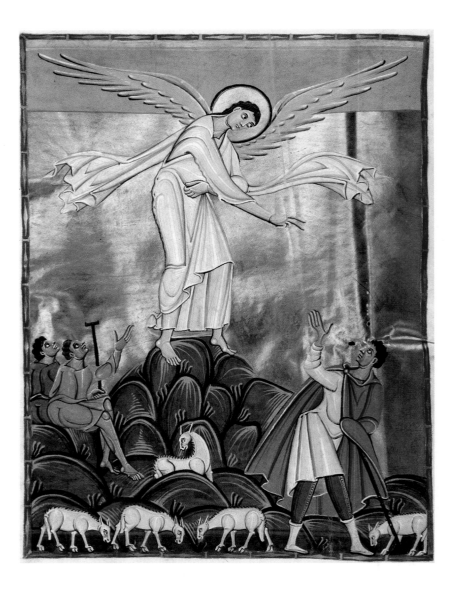

partment in the back of the head held the Host. This was a dramatically different conception of the crucified Savior than that on the cover of the *Lindau Gospels* (FIG. 16-16), which revived the Early Christian image of the youthful Christ triumphant over death. The bearded Christ of the Gero Crucifix is more akin to Byzantine representations of the suffering Jesus (see FIG. 12-20), but the Ottonian work's emotional power is greater still. The sculptor depicted Christ as an all-too-human martyr. Blood streaks down his forehead from the (missing) crown of thorns. His eyelids are closed, and his face is contorted in pain. Christ's body sags under its own weight. The muscles are stretched to the limit—those of his right shoulder and chest seem almost to rip apart. The halo behind Christ's head may foretell his subsequent Resurrection, but all the worshiper senses is his pain. Gero's Crucifix is the most powerful characterization of intense agony of the early Middle Ages.

The Art of the Book

A ROYAL LECTIONARY Ottonian artists carried on the Carolingian tradition of producing sumptuous books for the clergy and royalty alike. One of the finest is the *Lectionary of Henry II,* the cousin of Otto III who succeeded him as em-

peror (r. 1002–1024). The book was his gift to Bamberg Cathedral. We reproduce the full-page illumination of the Annunciation of Christ's birth to the shepherds (FIG. **16-28**). The angel has just alighted on a hill, his wings still beating, and the wind of his landing agitates his draperies. Although the angel is a far cry from the dynamic marble *Nike of Samothrace* (see FIG. 5-82) of Hellenistic times, the framed panel still incorporates much that was at the heart of the classical tradition, including the rocky landscape setting with grazing animals, common also in Early Christian art (see FIG. 11-15). The golden background betrays, however, knowledge of Byzantine book illumination and mosaic decoration. (Otto II, r. 973–983, had taken as his bride the Byzantine princess Theophanu, who ruled as regent from 983 to 991, while Otto III was still a minor.) The angel looms immense above the startled and terrified shepherds, filling the golden sky, and bends on them a fierce and menacing glance as he extends his hand in the gesture of authority and instruction. Emphasized more than the message itself are the power and majesty of God's authority. The artist portrayed it here with the same emotional impact as the electric force of God's violent pointing in the Hildesheim doors.

The draperies, rendered in a hard, firm line, and the planes, partitioned in sharp, often heavily modeled shapes

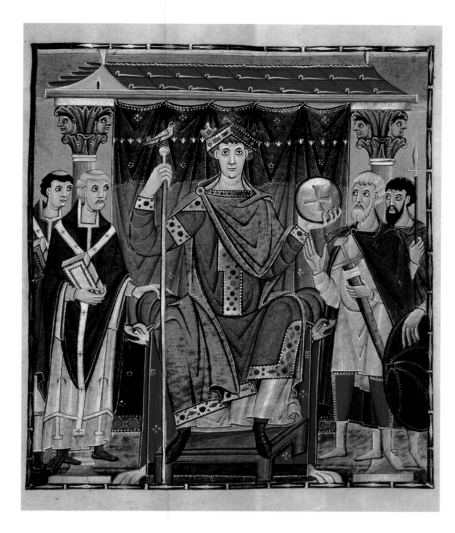

16-29 Otto III enthroned, folio 24 recto of the *Gospel Book of Otto III,* from Trier, Germany, 997–1000. Tempera on vellum, 1' 1"× 9 3/8". Bayerische Staatsbibliothek, Munich.

epitomize the painter's sureness of touch. But the Ottonian figures have lost the old realism, inherited from late antiquity, of the Carolingian *Coronation Gospels* (FIG. 16-12) and move with an abrupt hinged jerkiness that is not "according to nature" but nevertheless possesses a sharp and descriptive expressiveness.

THE IMPERIAL IDEAL IN EUROPE A picture from the *Gospel Book of Otto III,* representing the emperor himself (FIG. **16-29**), sums up much of what went before and points to what was to come. Of the three Ottos, Otto III dreamed the most of a revived Christian Roman Empire; indeed, it was his life's obsession. His mother was a Byzantine princess, and he was keenly aware of his descent from both Eastern and Western imperial lines. He moved his court, with its Byzantine ceremonial, to Rome and there set up theatrically the symbols and trappings of Roman imperialism. Otto's romantic dream of imperial unity for Europe never materialized. He died prematurely, at age twenty-one, and, at his own request, was buried beside Charlemagne at Aachen.

The illuminator represented the emperor enthroned, holding the scepter and cross-inscribed orb that represent his universal authority, conforming to a Christian imperial iconographic tradition that went back to Constantine (see FIG. 10-82). He is flanked by the clergy and the barons (the Christian Church and the state), both aligned in his support.

On the facing page (not illustrated), classicizing female personifications of Slavinia, Germany, Gaul, and Rome—the provinces of the Ottonian Empire—bring tribute to the young emperor. Stylistically remote from Byzantine art, the picture still has a clear political resemblance to the Justinianic mosaic in San Vitale (see FIG. 12-10).

The vestigial ideal of a Christian Roman Empire—awakened in the Frankish Charlemagne and preserved for a while by his Ottonian successors—gave partial unity to western Europe in the ninth, tenth, and early eleventh centuries. To this extent, ancient Rome lived on to the millennium, culminating in the frustrated ambition of Otto III. But native princes in England, France, Spain, Italy, and eastern Europe aspired to a sovereignty outside the imperial Carolingian and Ottonian domination. Staking their claims, they vied in the medieval power contests that led eventually to the formation of the modern states of Europe. The Romanesque period that followed, in fact, denied the imperial spirit that had prevailed for centuries—but not the notion of Western Christendom. A new age was about to begin, and Rome—an august memory—ceased to be the deciding influence. Europe found unity, rather, in a common religious heritage and a missionary zeal. By the year 1000, even remote Iceland had adopted Christianity. The next task for the kings and church leaders of Europe was to take up the banner of Christ and attempt to wrest control of the Holy Land from the Muslims.

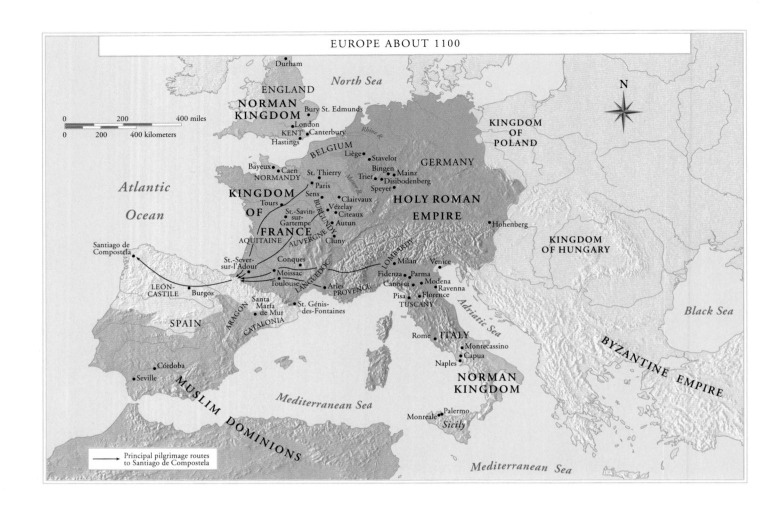

EUROPE ABOUT 1100

Durham
North Sea
ENGLAND
NORMAN
KINGDOM
Bury St. Edmunds
London
KENT • Canterbury
Hastings
KINGDOM
OF
POLAND
N
BELGIUM
Liège • Stavelot
Rhine R.
Bayeux • Caen
NORMANDY
St. Thierry
Bingen
Trier • Disibodenberg
Mainz
GERMANY
Paris
Speyer
Atlantic
Sens
Clairvaux
HOLY ROMAN
Ocean
KINGDOM
OF
FRANCE
Tours
St.-Savin-
sur-
Gartempe
Vézelay
Citeaux
Autun
BURGUNDY
EMPIRE
AQUITAINE
AUVERGNE
Cluny
Hohenberg
Santiago de
Compostela
St.-Sever-
sur-l'Adour
Conques
Milan
LOMBARDY
Venice
KINGDOM
OF
HUNGARY
Moissac
LANGUEDOC
Fidenza
Parma
Canossa • Modena
Toulouse
Arles
Pisa • Florence
Ravenna
LEÓN-
CASTILE • Burgos
Santa
María
de Mur
St. Génis-
des-Fontaines
PROVENCE
TUSCANY
Black Sea
Adriatic Sea
BYZANTINE EMPIRE
SPAIN
ARAGON
CATALONIA
Rome • ITALY
Córdoba
Montecassino
Capua
Seville
MUSLIM DOMINIONS
Naples
NORMAN
KINGDOM
Mediterranean Sea
Monreale • Palermo
Sicily
Mediterranean Sea

0 200 400 miles
0 200 400 kilometers

→ Principal pilgrimage routes
to Santiago de Compostela

1050 — 1075 — 1100

Baptistery
Florence, dedicated 1059

Bayeux Tapestry
ca. 1070–1080

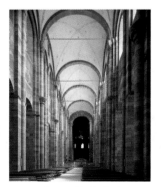

Speyer Cathedral
Vaults, ca. 1082–1106

Bernardus Gelduinus
Christ in Majesty
Saint-Sernin, Toulouse
ca. 1096

Rainer of Huy
Baptismal font
Liège, 1107–1118

Hugh of Semur, 1024–1109

Countess Matilda of
Canossa, 1046–1115

Norman conquest of southern Italy and Sicily, 1060–1101

Norman conquest of England (Battle of Hastings), 1066

Final separation of Latin (Roman) Church from the
Byzantine (Greek Orthodox) Church, 1051–1054

Pope Gregory VII (1073–1085) asserts spiritual
supremacy of papacy over kings and emperors, 1077

Saint Bernard of Clairvaux, ca. 1090–1153

Pope Urban II preaches the
First Crusade, 1095

Hildegard of Bingen, 1098–1179

Cistercian Order founded, 1098

Crusaders capture Jerusalem, 1099

17

THE AGE OF PILGRIMS AND CRUSADERS

ROMANESQUE ART

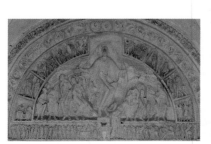

La Madeleine
Vézelay, 1120–1132

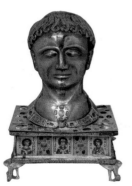

Reliquary of Saint Alexander
Stavelot, 1145

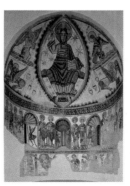

Santa María de Mur
mid-twelfth century

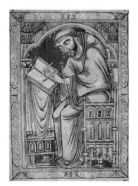

Eadwine Psalter
ca. 1160–1170

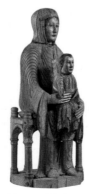

Morgan Madonna
ca. 1150–1200

Foundation of the Knights Templar, 1118

Eleanor of Aquitaine, 1122–1204

King Louis VII of France, r. 1137–1180

Gervase of Canterbury, 1141–1210

Quran translated into Latin, 1143

Second Crusade, 1147

Frederick Barbarossa, Holy
Roman Emperor, r. 1152–1190

King Henry II Plantagenet
of England, r. 1154–1189

King Philip Augustus of
France, r. 1180–1223

King Richard the Lionheart
of England, r. 1189–1199

Third Crusade, 1190

ROMANESQUE EUROPE

The Romanesque era is the first since Archaic and Classical Greece to take its name from an artistic style rather than from politics or geography. Unlike Carolingian and Ottonian art, named for emperors, or Hiberno-Saxon art, a regional term, Romanesque is a title art historians invented to describe an artistic phenomenon. *Romanesque* means "Romanlike" and first was applied in the early nineteenth century to describe European architecture of the late eleventh and the twelfth centuries. Scholars noted that certain architectural elements of this period, principally barrel and groin vaults based on the round arch, resembled those of ancient Roman architecture. Thus, the word distinguished Romanesque buildings from earlier medieval timber-roofed structures, as well as from later Gothic churches with vaults resting on pointed arches. Researchers in other fields quickly borrowed the term. Today "Romanesque" broadly designates the history and culture of western Europe between about 1050 and 1200.

FEUDALISM AND THE RISE OF TOWNS The political, social, and economic system that governed early medieval society in much of Europe is called *feudalism*. The northern warrior lords of the early Middle Ages eventually settled down and established themselves as landholding barons. The barons, or *liege lords,* granted tenure of some of their land to *vassals*. The vassals swore allegiance to their liege and rendered him military service in return for the land and the promise of protection. Vassals could, in turn, allot parts of their *fief* to others and become lesser lords with vassals beholden to them. Peasants sustained all by their work. They tilled the soil to gain a place to live and food to eat. Some accumulated enough wealth to buy their freedom. Most remained subservient to their lords, tied to the land.

The feudal system reflected the agricultural basis of early medieval society. The focus of life was the *manor,* or estate, of the individual feudal lord. But in the Romanesque period, a sharp increase in trade, fostered in part by traveling pilgrims and Crusaders (discussed later), encouraged the growth of towns and cities. The independence the towns so proudly cherished depended on their charters. *Charters* were public documents feudal lords granted, enumerating the communities' rights, privileges, immunities, and exemptions beyond the feudal obligations they owed the lords. A community could win independence by purchasing outright a charter. Many of the new Romanesque towns rose on the sites of ancient Roman colonies, which were restored to busy urban life after centuries of relative stagnation. Often located on navigable rivers, the towns were naturally the nuclei of networks of maritime and overland commerce. Merchants, traders, moneylenders, artisans, and free peasants populated them.

ARCHITECTURE

THE "WHITE ROBE OF THE CHURCH" The new Romanesque towns were also centers of ecclesiastical influence. Their bishops and archbishops built towers, gates, and walls, as well as churches. The immense building enterprise that raised thousands of churches in western Europe in the eleventh and twelfth centuries was not, however, due solely to the revival of urban life. It also reflected the widely felt relief and thanksgiving that the conclusion of the first Christian millennium in the year 1000 did not bring an end to the world, as many had feared. In the Romanesque age, the construction of churches became almost an obsession. Raoul Glaber (ca. 985–ca. 1046), a monk who witnessed the coming of the new millennium, noted the beginning of it:

> [After the] year of the millennium, which is now about three years past, there occurred, throughout the world, especially in Italy and Gaul, a rebuilding of church basilicas. Notwithstanding, the greater number were already well established and not in the least in need, nevertheless each Christian people strove against the others to erect nobler ones. It was as if the whole earth, having cast off the old by shaking itself were clothing itself everywhere in the white robe of the church.[1]

Great building efforts were provoked not only by the needs of growing cities, the pilgrimages, and the Crusades but also by the fact invading armies had destroyed many churches (notably in Italy and France). Architects of the time seemed to see their fundamental challenge in terms of providing a building that would have space for the circulation of its congregations and visitors and that would be solid, fireproof, well lighted, and acoustically suitable. These requirements, of course, are the necessities of any great civic or religious architecture. But, in this case, fireproofing must have been foremost in the builders' minds. Wooden-roofed churches were especially susceptible to fire, whether caused by nature or by humans (see "The Burning of Canterbury Cathedral," page 455). In the ninth and tenth centuries, these churches had burned fiercely and totally when marauders from the north, east, and south set them aflame.

The new churches had to be covered with cut stone, because the technology of concrete construction had been lost long before. The structural problems that arose from this need for a solid masonry were to help determine the "look" of Romanesque architecture throughout most of Europe. Nonetheless, regional differences abound, and some Romanesque churches, especially in Italy, retained the wooden roofs of their Early Christian predecessors long after stone vaulting had become commonplace elsewhere. Whatever their differences, all the buildings manifested a new widely shared method of architectural thinking, a new logic of design and construction. To a certain extent, Romanesque architecture can be compared to the Romance languages of Europe, which vary regionally but have a common core in Latin, the language of the Romans.

Southern France

One of the first regions to have a distinctive Romanesque architecture was southern France, the heart of ancient Gaul. This is not surprising, for of all the Roman Empire's European provinces, Gaul was the most profoundly Romanized. Visitors to the area today can go to almost any town and view both Roman remains (see FIGS. 10-30 and 10-31) and Romanesque buildings. In fact, the modern name of the French region that is the core of what once was Roman Gaul is *Provence* ("the [Roman] Province").

WRITTEN SOURCES

The Burning of Canterbury Cathedral

The perils of wooden construction are well documented by the chroniclers of medieval ecclesiastical history. In some cases, churches burned over and over again in the course of a single century and repeatedly had to be extensively repaired or completely rebuilt. In September 1174, for example, Canterbury Cathedral, which had been dedicated only forty-four years earlier, burned to the ground because its builders had not used the stone vaults employed at Durham (FIG. 17-12) and elsewhere in England and France. A vivid eyewitness account is preserved in the *Chronica* of Gervase of Canterbury (1141–1210), who entered the monastery at Canterbury in 1163 and wrote a history of the archbishopric from 1100 to 1199:

> During an extraordinarily violent south wind, a fire broke out before the gate of the church, and outside the walls of the monastery, by which three cottages were half destroyed. From thence, while the citizens were assembling and subduing the fire, cinders and sparks carried aloft by the high wind, were deposited upon the church, and being driven by the fury of the wind between the joints of the lead, remained there amongst the half rotten planks, and shortly glowing with increased heat, set fire to the rotten rafters; from these the fire was communicated to the larger beams and their braces, no one yet perceiving or helping. For the well-painted ceiling below, and the sheet-lead covering above, concealed between them the fire that had

arisen within. . . . But beams and braces burning, the flames arose to the slopes of the roof; and the sheets of lead yielded to the increasing heat and began to melt. Thus the raging wind, finding a freer entrance, increased the fury of the fire. . . . And now that the fire had loosened the beams from the pegs that bound them together, the half-burnt timbers fell into the choir below upon the seats of the monks; the seats, consisting of a great mass of woodwork, caught fire, and thus the mischief grew worse and worse. And it was marvellous, though sad, to behold how that glorious choir itself fed and assisted the fire that was destroying it. For the flames multiplied by this mass of timber, and extending upwards full fifteen cubits [about twenty-five feet], scorched and burnt the walls, and more especially injured the columns of the church. . . . In this manner the house of God, hitherto delightful as a paradise of pleasures, was now made a despicable heap of ashes, reduced to a dreary wilderness.[1]

After the fire, the Canterbury monks summoned a master builder from Sens, a French city seventy-five miles southeast of Paris, to supervise the construction of their new church. Gervase reports that the first task WILLIAM OF SENS tackled was "the procuring of stone from beyond the sea."

[1]Quoted in Elizabeth G. Holt, *A Documentary History of Art* (New York: Doubleday Anchor Books, 1957), 1: 52–54.

A NEW CHURCH FOR FRENCH PILGRIMS

Around 1070, the counts of Toulouse, principal sponsors of the Crusades, began construction of a great new church in honor of the city's first bishop, Saint Saturninus (Saint Sernin in French), who was martyred in the middle of the third century. Toulouse was an important stop on the pilgrimage road through southwestern France to Santiago de Compostela in northwestern Spain. The grand scale of Saint-Sernin at Toulouse (FIGS. **17-1** to **17-3**) reflects the popularity of pilgrimages and of the cult of relics, which brought big crowds even to relatively isolated places (see "Pilgrimages and the Cult of Relics," page 457). Large congregations were common at the shrines along the great pilgrimage routes, and Saint-Sernin was designed to accommodate them. The twelfth-century exterior of the church is still largely intact, although the two towers of the western facade were never completed and the prominent crossing tower is largely Gothic and later. A complex interplay of rectangular, polygonal, and rounded forms enlivens the basic basilica-with-transept plan. The composition recalls but goes beyond earlier Carolingian and Ottonian experiments in the arrangement of geometric volumes on church exteriors (see FIGS. 16-21 and 16-22).

Saint-Sernin's plan (FIG. 17-2) closely resembles those of the churches of Saint James at Santiago de Compostela and Saint Martin at Tours and exemplifies what has come to be called the "pilgrimage type." At Toulouse one clearly can see how the builders provided additional space for curious pil-

grims, worshipers, and liturgical processions alike. They increased the length of the nave, doubled the side aisles, extended the aisles around the eastern end to make an ambulatory, and attached a series of *radiating chapels* (for the display of relics) opening directly onto the ambulatory and the transept. In addition, upper galleries, or *tribunes*, over the inner aisle and opening onto the nave (FIG. 17-3), accommodated overflow crowds on special occasions.

The Saint-Sernin design is also extremely regular and geometrically precise. The crossing square, flanked by massive piers and marked off by heavy arches, served as the module for the entire church. Each nave bay, for example, measures exactly one-half of a crossing square, and each aisle bay measures exactly one-quarter. The architect employed similar simple ratios throughout the building. The first suggestion of such a planning scheme in medieval Europe was the Saint Gall monastery plan (see FIG. 16-20), almost three centuries earlier. The Toulouse solution was a crisply rational and highly refined realization of the germ of an idea first seen in Carolingian architecture. This approach to design became increasingly common in the Romanesque period.

FIGHTING FIRE WITH STONE VAULTS

The builders of Saint-Sernin also sought to protect the great church from the ravages of fire. To this end, they placed a semicircular stone barrel vault below the timber-roofed loft. The long cut-stone nave vault at Saint-Sernin (FIG. 17-3) put

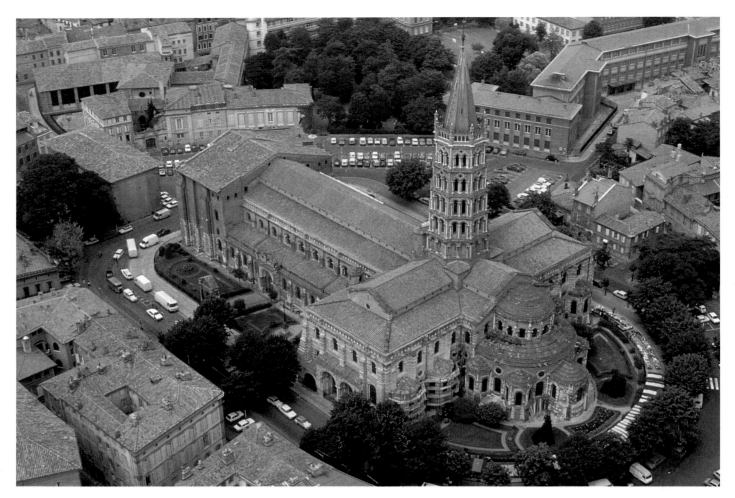

17-1 Aerial view (from the southeast) of Saint-Sernin, Toulouse, France, ca. 1070–1120.

constant pressure along the supporting masonry's entire length. In most churches where the nave is flanked by side aisles, the nave ceiling rests on arcades and the vaults over the aisles transfer the main thrust to the thick outer walls. In larger churches like Saint-Sernin, the second-story tribunes and their vaults (groin vaults at Toulouse) are an integral part of the structure, buttressing the higher vaulting over the nave.

The builders of Saint-Sernin were concerned with more than just buttressing their fireproof nave vault. They also

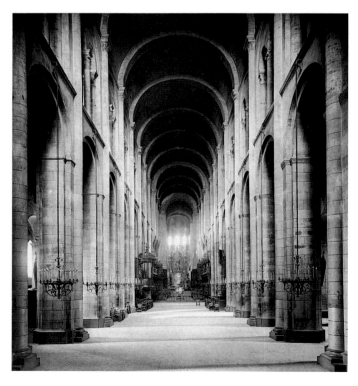

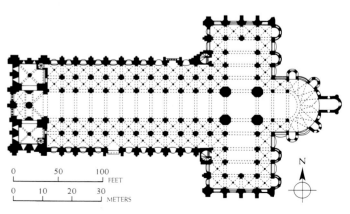

17-2 Plan of Saint-Sernin, Toulouse, France, ca. 1070–1120 (after Kenneth John Conant).

17-3 Interior of Saint-Sernin, Toulouse, France, ca. 1070–1120.

Pilgrimages and the Cult of Relics

The cult of relics was not new in the Romanesque era. For centuries Christians had traveled to sacred shrines housing the body parts of, or objects associated with, the holy family or the saints. The faithful believed such relics—bones, clothing, instruments of martyrdom, and the like—had the power to heal body and soul. As related earlier, for example, in the seventh century the relics of Saint Apollinaris were deposited in a sixth-century church at Ravenna, and, as a result, the church was rededicated and named Sant'Apollinare Nuovo (see FIG. 11-16). But the veneration of relics reached a high point in the eleventh and twelfth centuries.

In Romanesque times, pilgrimage was the most conspicuous feature of public devotion, proclaiming the pilgrim's faith in the veneration of saints and hope for their special favor. The major shrines—Saint Peter's and Saint Paul's in Rome and the Church of the Holy Sepulcher in Jerusalem—drew pilgrims from all over Europe. The visitors braved, for salvation's sake, bad roads and hostile wildernesses infested with robbers who preyed on innocent travelers. The journeys could take more than a year to complete—when they were successful. People often undertook pilgrimage as an act of repentance or as a last resort in their search for a cure for some physical disability. Hardship and austerity were means for increasing pilgrims' chances for the remission of sin or of disease. The distance and peril of the pilgrimage were measures of pilgrims' sincerity of repentance or of the reward they sought.

For those with less time or money than required for a pilgrimage to Rome or Jerusalem, holy destinations could be found closer to home. In France, for example, the church at Vézelay housed the bones of Mary Magdalene. Saint Foy's remains were enshrined at Conques, Lazarus's at Autun, Saint Martin's at Tours, and Saint Saturninus's at Toulouse. Each of these great shrines was also an important way station en route to the most venerated shrine in the West, Santiago de Compostela in northwestern Spain, where the tomb of the apostle Saint James had been discovered in the ninth century.

Hordes of pilgrims paying homage to saints placed a great burden on the churches that stored their relics, but they also provided significant revenues, making possible the erection of ever grander and more luxuriously appointed structures. The popularity of pilgrimages led to changes in church design, necessitating longer and wider naves and aisles, transepts and ambulatories with additional chapels, and second-story galleries (FIGS. 17-2 and 17-3). Pilgrim traffic also established the routes that later became the major avenues of European commerce and communication.

carefully coordinated the vault's design with that of the nave arcade below and with the modular plan of the building as a whole. Our view of the interior (FIG. 17-3) shows that the geometric floor plan (FIG. 17-2) is fully reflected in the nave walls, where the piers marking the corners of the bays are embellished with engaged half-columns. Architectural historians refer to piers with columns or pilasters attached to their rectangular cores as *compound piers*. At Saint-Sernin the engaged columns rise from the bottom of the compound piers to the vault's *springing* (the lowest stone of an arch) and continue across the nave as *transverse arches*.

Ever since Early Christian times, basilican interiors had been framed by long flat walls between arcades and clerestories that enclosed a single horizontal unbroken volume of space (compare FIGS. 11-8 and 16-24). In Saint-Sernin the nave's appearance is radically different. It seems to be composed of numerous identical vertical volumes of space placed one behind the other, marching down the building's length in orderly procession. This segmentation of Saint-Sernin's interior space corresponds to and renders visually the plan's geometric organization. It also is reflected in the building's exterior walls (FIG. 17-1), where buttresses frame each bay. The result is a structure with all of its parts integrated to a degree unknown in earlier Christian architecture. The new scheme, with repeated units decorated and separated by moldings, had a long future in later church architecture in the West.

AN EARTHLY DWELLING PLACE FOR ANGELS
Even grander than Saint-Sernin was the church Abbot Hugh of Semur built in Cluny at the end of the eleventh century. In 909 William, Duke of Aquitaine, had donated land near Roman Cluniacum to a community of reform-minded Benedictine monks under Berno of Baume's leadership. Since William had waived his feudal rights to the land, the abbot of Cluny was subject only to the pope in Rome, a unique privilege. Berno founded a new order at Cluny in strict adherence to the rules of Saint Benedict (see "Medieval Monasteries and Benedictine Rule," Chapter 16, page 443). Under Berno's successors, the Cluniac monks became famous for their scholarship, music, and art. Their influence and wealth grew rapidly, and they built a series of ever more elaborate monastic churches at Cluny.

The church Hugh of Semur commissioned was the third on the site. Begun in 1088, it is called Cluny III by art historians. The building is, unfortunately, largely destroyed today. During the French Revolution it ceased to function as a church. In the nineteenth century it was dismantled so that its building stones could be reused. At the time of its erection, Cluny III was the largest church in Europe, and its contemporaries considered it a place worthy for angels to dwell if they lived on earth. The church had an innovative and influential design, with five aisles, a barrel-vaulted nave, and radiating chapels, as at Saint-Sernin, but with a three-story nave elevation (arcade-tribune-clerestory) and slightly pointed nave vaults. With a nave more than five

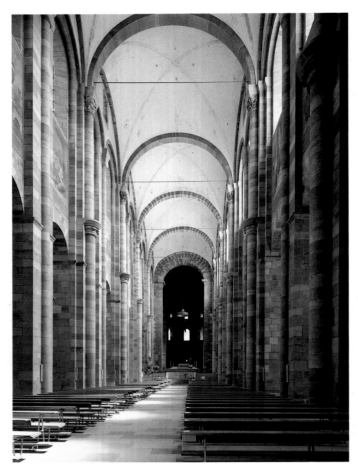

17-4 Interior of Speyer Cathedral, Speyer, Germany, begun 1030; nave vaults, ca. 1082–1106.

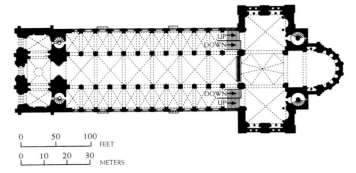

17-5 Plan of Speyer Cathedral, Speyer, Germany, begun 1030.

hundred feet long and more than one hundred feet high (both dimensions are about fifty percent greater than at Saint-Sernin), it epitomized the grandiose scale of the new stone-vaulted Romanesque churches.

Germany and Lombardy

A PROBLEM SOLVED: GROIN VAULTS The barrel-vaulted naves of Cluny III and Saint-Sernin covered vast spaces and were relatively fireproof. But the barrel vaults failed in one critical requirement—lighting. Due to the great outward thrust the continuous semicircular vaults exerted, a clerestory was difficult to construct. (The designers of Saint-Sernin did not even attempt to introduce a clerestory, although their counterparts at Cluny III succeeded.) A more complex and efficient type of vaulting was needed. Structurally, the central problem of Romanesque architecture was the need to develop a masonry vault system that admitted light.

Among the numerous experimental solutions ingenious Romanesque builders devised to alleviate the problem of inadequate lighting, the groin vault turned out to be the most efficient and flexible. The groin vault had been used widely by Roman builders, who saw that its concentration of thrusts at four supporting points permitted clerestory windows (see "The Roman Architectural Revolution: Concrete Construction," Chapter 10, page 249, and FIGS. 10-68 and 10-79). The

great Roman vaults were made possible by the use of concrete, which could be poured into forms, where it solidified into a homogeneous mass. But, as noted earlier, the technique of mixing concrete did not survive into the Middle Ages. And the technical problems of building groin vaults of cut stone and heavy rubble, which had very little cohesive quality, limited their use to the covering of small areas, such as the individual bays of Saint-Sernin's aisles and galleries. But during the eleventh century, masons, using ashlar blocks joined by mortar, developed a groin vault of monumental dimensions.

A DARING GERMAN EXPERIMENT Speyer Cathedral (FIGS. 17-4 and 17-5) in the German Rhineland is an early example of groin vaults used over a nave. The church was begun in 1030 and was the burial place of the Holy Roman Emperors until the beginning of the twelfth century. Like all cathedrals, Speyer was also the seat (*cathedra* in Latin) of the powerful local bishop. In its earliest form, Speyer Cathedral was a timber-roofed structure. When the emperor Henry IV rebuilt it between 1082 and 1106, his masons covered the nave with groin vaults, which made possible the insertion of a small clerestory window above each pair of tribune arches. Scholars disagree about where the first comprehensive use of groin vaulting occurred in Romanesque times, and nationalistic concerns sometimes color the debate. We will not argue here for the precedence of any one region. But no one doubts that the large groin vaults covering the nave of Speyer Cathedral (FIG. 17-4) represent one of the most daring and successful vaulting enterprises of the time. The nave is forty-five feet wide, and the crowns of the vaults are one hundred seven feet high.

Although the cathedral's plan (FIG. 17-5) has some irregularities and was not worked out as neatly and precisely as Saint-Sernin's plan, the builders' intention to employ a modular scheme is quite clear. They used the crossing, covered by an octagonal dome, as the module for the arrangement of the building's east end. Because the nave bays are not square, the use of the crossing as a measurement unit is not as obvious. In fact, every third wall support in the nave marks off an area the size of the crossing. The aisles are half the width of the nave, and each groin-vaulted nave bay corresponds to two aisle bays.

Also in contrast to Saint-Sernin, Speyer Cathedral's nave exhibits an alternate-support system, as in the Ottonian church of Saint Michael's at Hildesheim (see FIG. 16-24). At Speyer, however, the alternation continues all the way up into the vaults (FIG. 17-4), with the nave's more richly molded compound piers marking the corners of the groin vaults. The resultant bay arrangement, with a large unit in the nave

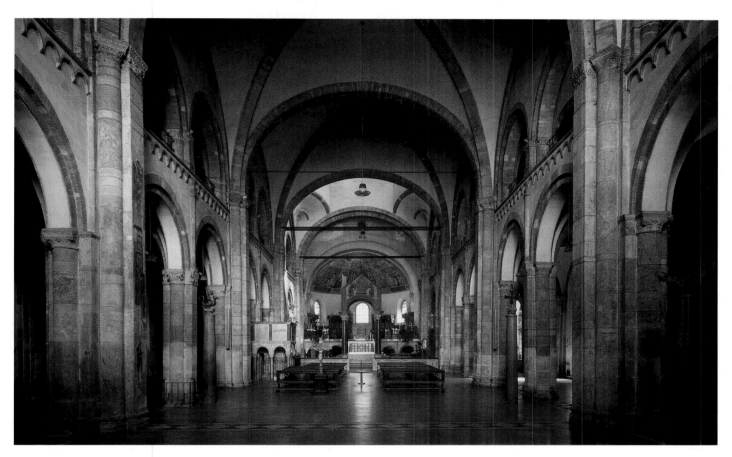

17-6 Interior of Sant'Ambrogio, Milan, Italy, late eleventh to early twelfth century.

flanked by two small units in each aisle, became almost standard in northern Romanesque architecture. Speyer's interior shows the same striving for height and the same compartmentalized effect seen in Saint-Sernin. By virtue of the alternate-support system, the Speyer nave's rhythm is a little more complex. Because each compartment is individually vaulted, the effect of a sequence of vertical spatial blocks is even more convincing.

INNOVATIVE RIB VAULTING IN LOMBARDY

Ever since Charlemagne crushed the Lombards in 773, German kings held sway over Lombardy, and the Rhineland and northern Italy cross-fertilized each other artistically. No agreement exists as to which source of artistic influence was dominant in the Romanesque age, the northern or the southern. The question, no doubt, will remain the subject of controversy until the construction date of Sant'Ambrogio in Milan (FIGS. **17-6** to **17-8**) can be established unequivocally. The church, erected in honor of Saint Ambrose, Milan's first bishop (d. 397), is the central monument of Lombard Romanesque architecture.

Whether or not it was a prototype for Speyer Cathedral, Sant'Ambrogio remains a remarkable building. It has an atrium in the Early Christian tradition (one of the last to be built), a two-story narthex pierced by arches on both levels, two bell towers *(campaniles)* joined to the building, and, over the nave's east end, an octagonal tower that recalls the crossing towers of German churches. Of the facade bell towers, the shorter one dates back to the tenth century, while the taller north campanile is a twelfth-century addition.

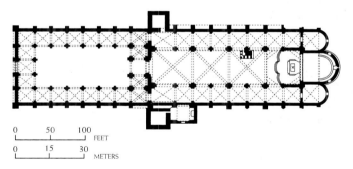

17-7 Plan of Sant'Ambrogio, Milan, Italy, late eleventh to early twelfth century.

In plan (FIG. 17-7), Sant'Ambrogio is three aisled and without a transept. The modular scheme was applied with greater consistency and precision than at Speyer. Each bay consists of a full square in the nave flanked by two small squares in each aisle, all covered with groin vaults. The main vaults are slightly domical, rising higher than the transverse arches (FIG. 17-6). An octagonal dome covers the last bay, its windows providing the major light source (the building lacks a clerestory) for the otherwise rather dark interior. The emphatic alternate-support system perfectly reflects the plan's geometric regularity. The lightest pier moldings are interrupted at the gallery level, and the heavier ones rise to support the main vaults. At Sant'Ambrogio, the compound piers even continue into the ponderous vaults, which have supporting

17-8 Aerial view of Sant'Ambrogio, Milan, Italy, late eleventh to early twelfth century.

17-9 West facade of Saint-Étienne, Caen, France, begun 1067.

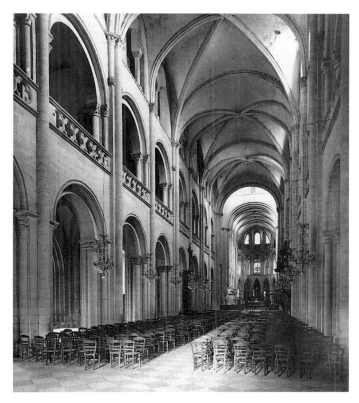

17-10 Interior of Saint-Étienne, Caen, France, vaulted ca. 1115–1120.

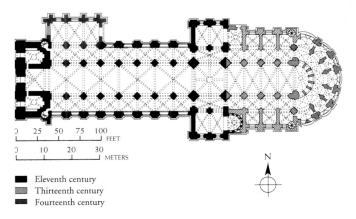

Eleventh century
Thirteenth century
Fourteenth century

17-11 Plan of Saint-Étienne, Caen, France.

arches, or *ribs,* along their groins. This is one of the first instances of rib vaulting, a salient characteristic of mature Romanesque and of later Gothic architecture (see "The Gothic Rib Vault," Chapter 18, page 494).

As noted earlier, regional differences characterize Romanesque architecture. This can be seen clearly by comparing the proportions of Sant'Ambrogio with those of both Speyer Cathedral and Saint-Sernin at Toulouse. The Milanese building does not aspire to the soaring height of the northern churches. Save for the later of the two towers (FIG. 17-8), Sant'Ambrogio's proportions are low and broad and remain close to those of Early Christian basilicas. Italian architects, with their firm roots in the venerable Early Christian style, never accepted the verticality found in northern architecture, not even during the Gothic period.

Normandy and England

After their conversion to Christianity in the early tenth century, the Vikings settled on the northern coast of France in present-day Normandy (see Chapter 16). Almost at once, they proved themselves not only aggressive warriors but also skilled administrators and builders, active in Sicily (see FIG. 12-24) as well as in northern Europe. With astounding rapidity, they absorbed the lessons to be learned from Ottonian architecture and went on to develop a distinctive Romanesque architectural style that became the major source of French Gothic architecture.

A CHURCH FOR ENGLAND'S CONQUEROR Most critics consider the abbey church of Saint-Étienne (Saint Stephen; FIGS. **17-9** to **17-11**) at Caen the masterpiece

of Norman Romanesque architecture. It was begun by William of Normandy (William the Conqueror; see page 484) in 1067 and must have advanced rapidly, as he was buried there in 1087. Saint-Étienne's west facade (FIG. 17-9) is a striking design rooted in the tradition of Carolingian and Ottonian westworks, but it displays the increased rationalism of Romanesque architecture. Four large buttresses divide the facade into three bays that correspond to the nave and aisles. Above the buttresses, the towers also display a triple division and a progressively greater piercing of their walls from lower to upper stages. (The culminating spires are a Gothic addition.) The tripartite division is employed throughout the facade, both vertically and horizontally, organizing it into a close-knit, well-integrated design that reflects the careful and methodical planning of the entire structure.

The original design of Saint-Étienne called for a wooden roof, as originally at Speyer Cathedral. But from the beginning, the French church's nave walls (FIG. 17-10) were built with an alternating rhythm of compound piers with simple engaged half-columns and piers with half-columns attached to pilasters. The decision to employ an alternate-support system must have been motivated by aesthetic rather than structural concerns. When groin vaults were introduced around 1115, the varied nave piers proved an ideal match. The alternating compound piers soar all the way to the vaults' springing. Their branching ribs divide the large square-vault compartments into six sections, making a *sexpartite vault* (FIG. 17-11). These vaults rise high enough to provide room for an efficient clerestory. The resulting three-story elevation, with its large arched openings, provides more light to the interior. It also makes the nave appear even taller than it actually is. As in the Milanese church of Sant'Ambrogio (FIG. 17-8), the

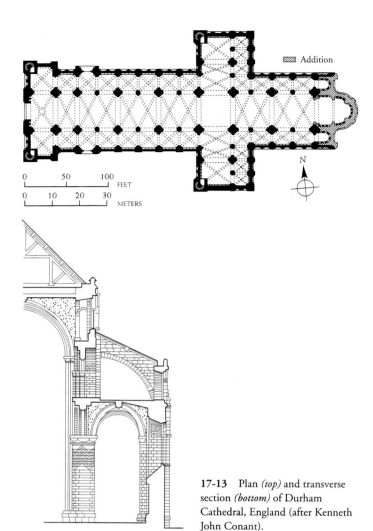

17-13 Plan *(top)* and transverse section *(bottom)* of Durham Cathedral, England (after Kenneth John Conant).

Norman building has rib vaults. The diagonal and transverse ribs compose a structural skeleton that partially supports the still fairly massive paneling between them. But despite the heavy masonry, the large windows and reduced interior wall surface give Saint-Étienne's nave a light and airy quality that is unusual in the Romanesque period.

ROMANESQUE ON THE SCOTTISH BORDER William of Normandy's conquest of Anglo-Saxon England in 1066 began a new epoch in English history. In architecture, it signaled the importation of French Romanesque building and design methods. Durham Cathedral (FIGS. **17-12** and **17-13**) sits majestically on a cliff overlooking the Wear River in northern England. It was begun around 1093, in the generation following the Norman conquest, and is the centerpiece of a monastery, cathedral, and fortified-castle complex on the Scottish frontier. The church's vaulted interior (FIG. 17-12), which predates that of the remodeled Saint-Étienne at Caen, retains its original severe Romanesque appearance. Ambitious in scale, its four-hundred-foot length compares favorably with that of Speyer, the great imperial cathedral. But unlike Speyer and Saint-Étienne, this building was conceived from the very beginning as a vaulted structure. Consequently, the pattern of the ribs of the nave's groin vaults is reflected in the design of the arcade below. Each seven-part nave vault covers two bays. Large simple pillars ornamented with abstract de-

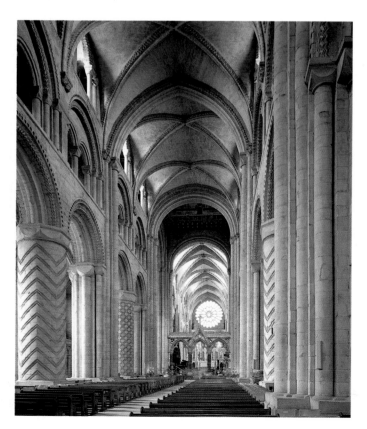

17-12 Interior of Durham Cathedral, England, begun ca. 1093.

signs (diamond, chevron, and cable patterns, all originally painted) alternate with compound piers that carry the transverse arches of the vaults. The pier-vault relationship scarcely could be more visible or the building's structural rationale better expressed.

The Durham nave's bold surface patterning is a reminder that the raising of imposing stone edifices such as the Romanesque churches of England and Normandy required more than just the talents of master designers. A corps of expert masons had to transform rough stone blocks into the precise shapes necessary for their specific place in the church's fabric. Although thousands of simple quadrangular ashlar blocks make up the great walls of these buildings, much more complex shapes also needed to be produced in large numbers. To cover the nave and aisles, the stonecutters had to carve blocks with concave faces to conform to the vault's curve. Also required were blocks with projecting moldings for the ribs, blocks with convex surfaces for the pillars or with multiple profiles for the compound piers, and so forth. It was an immense undertaking, and it is no wonder that medieval building campaigns often lasted for decades.

Durham Cathedral's plan (FIG. 17-13, top) is typically English with its long, slender proportions. It does not employ the modular scheme with the same care and logic seen at Caen. But in other ways this English church is even more innovative than the French church. It is the earliest example known of a ribbed groin vault placed over a three-story nave. And in the nave's western parts, completed before 1130, rib vaults were combined with slightly pointed arches, bringing together for the first time two of the key elements that deter-

mined the structural evolution of Gothic architecture. Also of great significance is the way the nave vaults are buttressed. Our longitudinal section (FIG. 17-13, bottom) reveals that simple *quadrant arches* (arches whose curve extends for one quarter of a circle's circumference) were used in place of groin vaults in the tribune. The structural descendants of the Durham quadrant arches are the flying buttresses that epitomize the mature Gothic solution to church construction (see "The Gothic Cathederal," Chapter 18, page 498).

Tuscany

South of the Lombard region, Italy retained its ancient traditions and, for the most part, produced Romanesque architecture that was structurally less experimental than that of Lombardy. The buildings of Tuscany, along with those of Rome itself, adhered closely to the traditions of the Early Christian basilica. They underscore that diversity is the rule, not the exception, in Romanesque Europe.

A CATHEDRAL WITH UNSTABLE TOWER The cathedral complex at Pisa (FIG. **17-14**) dramatically testifies to the prosperity that busy maritime city enjoyed. The cathedral, its freestanding bell tower, and the baptistery, where infants and converts were initiated into the Christian community, present a rare opportunity to study a coherent group of three Romanesque buildings. Save for the upper portion of the baptistery, with its remodeled Gothic exterior, the three structures are stylistically homogeneous.

Construction of Pisa Cathedral began first—in 1063, the same year work began on Saint Mark's in Venice (see FIGS.

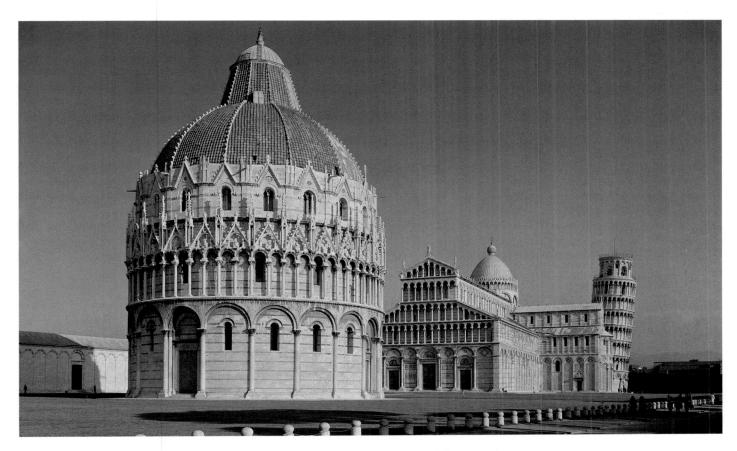

17-14 Cathedral complex, Pisa, Italy; cathedral begun 1063; baptistery begun 1153; campanile begun 1174.

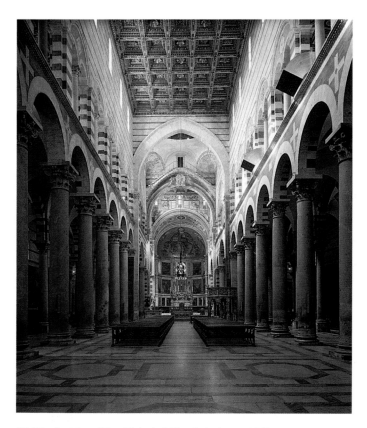

17-15 Interior of Pisa Cathedral, Pisa, Italy, begun 1063.

12-21 and 12-22), another maritime power. The Pisan project was funded by the spoils of a naval victory over the Muslims off Palermo in Sicily in 1062. The cathedral is large, five aisled, and one of the most impressive and majestic of all Romanesque churches. The Pisans, according to a document of the time, wanted their bishop's church not only to be a monument to the glory of God but also one that would bring credit to the city. At first glance, Pisa Cathedral resembles an Early Christian basilica. But the broadly projecting transept, the crossing dome, and the facade's multiple arcade galleries soon distinguish it as Romanesque. So too does the rich marble *incrustation* (wall decoration consisting of bright panels of different colors, as in the Pantheon's interior, FIG. 10-50).

The interior (FIG. **17-15**) also at first suggests the basilica, with its timber rather than vaulted ceiling (originally the rafters were exposed, as in Early Christian basilicas) and nave arcade of reused Roman columns in unbroken procession. Above the colonnade is a continuous horizontal molding, on which the gallery arcades rest. The gallery, of course, is not a basilican feature, but it is a familiar trait of churches north of the Alps. It is ultimately of Byzantine origin. Other divergences from the basilica form include the relatively great verticality of the interior and, at the crossing, the markedly unclassical pointed arch. The pointed arch probably was inspired by Islamic architecture. The striped walls of alternating dark green and cream-colored marble provide a luxurious polychromy that became a hallmark of Tuscan Romanesque and Gothic buildings.

The cathedral's campanile, detached in the standard Italian fashion, is the famous Leaning Tower of Pisa (FIG. 17-14). The tilted vertical axis is the result of a settling foundation. It began to "lean" even while under construction and now in-

clines some twenty-one perilous feet out of plumb at the top. Round, like the bell towers of Sant'Apollinare in Classe and other Ravenna churches, it is much more elaborate. Its stages are marked by graceful arcaded galleries that repeat the cathedral's facade motif and effectively relate the tower to its mother building.

A ROMANESQUE BAPTISTERY IN FLORENCE Florence is always associated with the Renaissance of the fifteenth and sixteenth centuries, but it was already an important independent city-state in the Romanesque period. The gem of Florentine Romanesque architecture is the Baptistery of San Giovanni (Saint John; FIG. **17-16**). Dedicated to the city's patron saint by Pope Nicholas II in 1059, it was constructed during the succeeding century. Like Pisa's baptistery (FIG. 17-14), which it predates, Florence's baptistery faces that city's great cathedral. These freestanding Italian baptisteries are unusual and reflect the great significance the Florentines and Pisans attached to baptisms. On the day of a newborn child's annointment, the citizenry gathered in the baptistery to welcome a new member into their community. The Tuscan baptisteries therefore were important civic, as well as religious, structures. Some of the most renowned artists of the late Middle Ages and the Renaissance were employed to provide the Florentine and Pisan baptisteries with pulpits (see FIG. 19-2), bronze doors (see FIGS. 21-1, 21-2 , and 21-4), and mosaics.

The simple and serene classicism of San Giovanni's design places it in a direct line of descent from ancient Roman architecture—from the Pantheon (see FIG. 10-48) and imperial mausoleums such as Diocletian's (see FIG. 10-75) to the Early Christian Santa Costanza (see FIG. 11-9), the Byzantine San Vitale (see FIG. 12-6), and other central-plan structures, pagan

17-16 Baptistery of San Giovanni, Florence, Italy, dedicated 1059.

or Christian, including Charlemagne's Palatine Chapel at Aachen (FIG. 16-18). A distinctive Tuscan Romanesque feature is the marble incrustation that patterns the walls. These simple oblong and arcuated shapes not only outline the paneled surfaces but also assert the building's structural lines and its elevation levels. The corner piers accentuating the octagon's apexes are boldly striped in the Pisan fashion (FIG. 17-15).

In plan, San Giovanni is a domed octagon, enwrapped on the exterior by a graceful arcade, three arches to a bay. It has three entrances, one each on the north, south, and east sides. On the west side an oblong sanctuary replaces the original semicircular apse. The domical vault is some ninety feet in diameter, its construction a feat remarkable for its time.

OLD AND NEW IN A FLORENTINE BASILICA

Contemporaneous with the baptistery and stylistically affiliated with it is another Florentine building, the Benedictine abbey church of San Miniato al Monte (FIG. **17-17**). It sits, as its name implies, on a hillside overlooking the Arno River and the heart of Florence. The body of the church was completed by 1090, the gable-crowned facade during the twelfth and early thirteenth centuries. Even more than Pisa Cathedral, the structure recalls the Early Christian basilica in plan and elevation, although its elaborate geometric incrustation makes for a rich ornamental effect foreign to the earlier buildings. Though at first glance the lowest level much resembles the patterning of Florence's baptistery, the arcades and panels do not reflect the building's structure. The facade's upper levels, of much later date than the lowest level, are filled capriciously with geometrical shapes that have a purely ornamental function.

San Miniato has a quite Romanesque interior (FIG. **17-18**), despite its strong ties with the design of Early Christian basilicas. Although the church is timber roofed, as are most Tuscan Romanesque churches, the nave is divided into three equal

17-18 Interior of San Miniato al Monte, Florence, Italy, 1062 and twelfth century.

compartments by *diaphragm arches*. The arches rise from compound piers and brace the rather high, thin walls. They also provide firebreaks beneath the wooden roof and compartmentalize the basilican interior in the manner so popular with most Romanesque builders. The compound piers alternate with pairs of simple columns with Roman-revival Composite capitals.

SCULPTURE

Architectural Sculpture

MONUMENTAL STONE SCULPTURE REVIVED Stone sculpture, with some notable exceptions, such as the great crosses of the British Isles (see FIG. 16-10), almost had disappeared from the art of western Europe during the early Middle Ages. The revival of the technique is one of the hallmarks of the Romanesque age—and one of the reasons the period is aptly named. The inspiration for monumental stone sculpture no doubt came, at least in part, from the abundant remains of ancient stone statues and reliefs throughout Rome's northwestern provinces. As one would expect, the individual motifs and compositions Romanesque sculptors employed often originated in Carolingian and Ottonian ivory carving, metalwork, and manuscript illumination. But ancient sculptures throughout France, Italy, Germany, and Spain provided a powerful spur to the imaginations of patrons and artists alike.

The reemergence of monumental stone sculpture in western Europe coincided with the introduction of stone vaulting in Romanesque churches. But it is important to remember

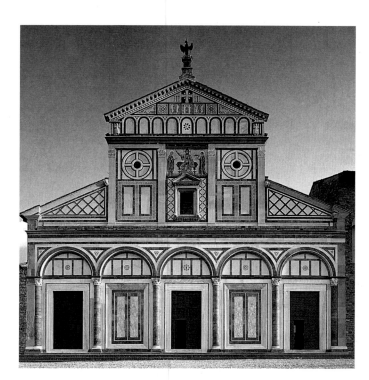

17-17 West facade of San Miniato al Monte, Florence, Italy, 1062 and twelfth century.

17-19 Christ in Majesty *(Maiestas Domini)* with apostles, lintel over doorway, Saint-Génis-des-Fontaines, France, 1019–1020. Marble, approx. 2′ × 7′.

that stone-walled churches and monumental westworks had been built for centuries, even if the structures bore timber ceilings and roofs. The addition of stone vaults to basilican churches is not in itself an explanation for the resurgence of stonecarving in the Romanesque period. The answer lies, rather, in the changing role of many churches in Western Christendom. In the early Middle Ages, most churches served small monastic communities, and the worshipers were primarily or exclusively clergy. These buildings were not devoid of decoration, but it took the form of *interior* mosaics or frescoes. With the rise of cities and towns in the Romanesque period, churches, especially those on the major pilgrimage routes, increasingly served the lay public. To reach this new, largely illiterate audience and to draw a wider population into their places of worship, church officials decided to display Christian symbols and stories on the *exteriors* of their buildings. Stone was the most suitable durable medium for such exterior decorative programs.

Even though the Romanesque church grew out of the Roman basilican type, the towering west facades and broad transepts of Romanesque churches had no parallels in ancient basilicas or temples. Romanesque sculptors may have derived ideas and compositional patterns from surviving Roman sculptures, but they had to develop their own attitudes toward the placement of sculpture on their churches.

CHRIST IN MAJESTY OVER A PORTAL A very early, securely datable, example of Romanesque architectural sculpture is the carved lintel (FIG. **17-19**) over the doorway to the church of Saint-Génis-des-Fontaines, in the extreme south of France near the Spanish border. Dated 1019–1020 by inscription, the lintel depicts Christ enthroned in a lobed *mandorla* ("glory") supported by angels and flanked by apostles. To the left and right of Christ are inscribed the first and last letters of the Greek alphabet, a reference to his role as Last Judge: "I am the Alpha and the Omega, the First and the Last, the Beginning and the End" (Rev. 21:6). The Saint-Génis lintel is the earliest of many reliefs on Romanesque church facades depicting or alluding to Judgment Day and the separation of those who will be saved (the Christian faithful who frequent the churches) from those who will be damned.

The six apostles on the Saint-Génis lintel stand in an arcade of horseshoe arches of the type familiar in Islamic Spain (see FIG. 13-12). The general framework, however, is typical of Roman sarcophagi (see FIG. 10-62), and a late antique or Early Christian sarcophagus in France may have been one of the relief's prototypes. But if the models were ancient, the sculptor translated those sources into a new, distinctively Romanesque idiom. The result is what one might expect of an artisan unfamiliar with the classical figural style who was asked to revive the forgotten art of monumental stone relief sculpture.

A SHRINE FOR SAINT SATURNINUS Also precisely dated is a group of seven marble slabs, representing angels, apostles, and Christ, made for the great pilgrimage church of Saint-Sernin at Toulouse (see FIGS. 17-1 to 17-3). An inscription on a marble altar, part of the group, states that the reliefs date to the year 1096 and that the artist was a certain BERNARDUS GELDUINUS. Today the plaques are affixed to the ambulatory wall. Their original location is uncertain. Some scholars have suggested that they once formed part of a shrine dedicated to Saint Saturninus that stood in the crypt of the grand structure. Others believe the reliefs once decorated a choir screen or an exterior portal.

The sculptured figures are twice the height of those at Saint-Génis but still well under life-size. We illustrate the centerpiece of the group, the figure of Christ in Majesty (FIG. **17-20**). Christ sits in a mandorla, his right hand raised in blessing, his left hand resting on an open book inscribed with the words *Pax vobis* ("peace be unto you"). The signs of the Four Evangelists occupy the slab's corners. Above are the eagle of Saint John and the angel of Saint Matthew. Below are the ox of Saint Luke and the lion of Saint Mark. Art historians debate the sources of Gelduinus's style, but one easily can imagine such a composition used for a Carolingian or Ottonian work in metal or ivory, perhaps a book cover. The polished marble has the gloss of both materials, and the sharply incised lines and the ornamentation of Christ's aureole are characteristic of pre-Romanesque metalwork.

GENESIS ON AN ITALIAN CHURCH Some fifteen years later, around 1110, another sculptor carved one of the first fully developed narrative reliefs in Romanesque art. The facade of Modena Cathedral in northern Italy has a frieze that extends on two levels across three of its bays. It represents

17-20 BERNARDUS GELDUINUS, Christ in Majesty, relief in the ambulatory of Saint-Sernin, Toulouse, France, ca. 1096. Marble, 4′ 2″ high.

scenes from Genesis set against an architectural backdrop. As at Saint-Génis-des-Fontaines (FIG. 17-19), the framing device is derived from late Roman and Early Christian sarcophagi. The segment shown (FIG. **17-21**) illustrates the creation and temptation of Adam and Eve (Gen. 2, 3:1–8), the theme employed almost exactly a century earlier on Bishop Bernward's bronze doors to Saint Michael's at Hildesheim (see FIG. 16-25). At Modena, as at Hildesheim, the faithful enter the house of the Lord with a reminder of Original Sin and the suggestion that the only path to salvation is through the Christian Church.

On the Modena frieze, Christ is at the far left, framed by a mandorla held up by angels—a variation on both the motifs and the themes of the lintel at Saint-Génis-des-Fontaines and the reliefs of Saint-Sernin. The creation of Adam, then Eve, and the serpent's temptation of Eve are to the right. Although the figures appear in an architectural frame, as at Saint-Génis, they break through the arcade's constriction to make for a more continuous narrative. Like the Toulouse Christ, they are not linear patterns but high reliefs. Some parts at Modena are almost entirely in the round. The frieze is the work of a master craftsman whose name, WILIGELMO, is given in an inscription on another relief on the facade. There he boasts, "Among sculptors, your work shines forth, Wiligelmo." The inscription is also an indication of the pride of Wiligelmo's patrons in obtaining the services of such an accomplished sculptor for their city's cathedral.

THE SECOND COMING AT MOISSAC At Modena, the frieze recounts the beginning of the human race. Some twenty-five years later, a portal at Moissac in southwestern France announces its end. The abbey of Saint-Pierre at Moissac joined the Cluniac order in 1047 and was an important stop along the pilgrimage route to the tomb of Saint James at Santiago de Compostela. The monks, enriched by the gifts of pilgrims and noble benefactors, adorned their church and its cloister with one of the most extensive series of sculptures of the Romanesque age.

17-21 WILIGELMO, creation and temptation of Adam and Eve, frieze on the west facade, Modena Cathedral, Modena, Italy, ca. 1110. Marble, approx. 3′ high.

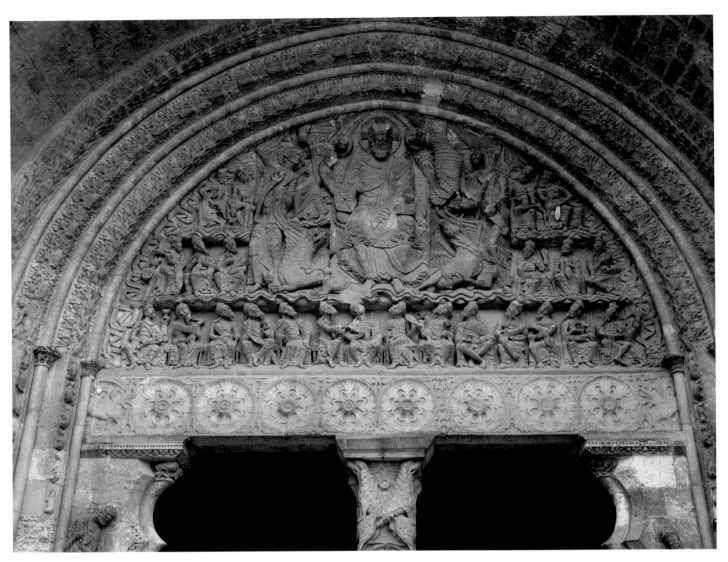

17-22 Christ in Majesty with angels and the Twenty-Four Elders, tympanum of the south portal of Saint-Pierre, Moissac, France, ca. 1115–1135. Marble, approx. 16′ 6″ wide at base.

The vast tympanum that crowns the south portal (see "The Romanesque Portal," page 471) of Saint-Pierre (FIG. **17-22**) depicts the Second Coming of Christ as King and Judge of the world in its last days, a theme already alluded to at Saint-Génis-des-Fontaines (FIG. 17-19). As befits his majesty, the enthroned Christ is at the center, reflecting a compositional rule followed since Early Christian times. The signs of the Four Evangelists flank him. On his right side are the angel and lion, and on his left side are the eagle and ox. To one side of each pair of signs is an attendant angel holding scrolls to record human deeds for judgment. The figures of crowned musicians, which complete the design, are the Twenty-Four Elders who accompany Christ as the kings of this world and make music in his praise. Each turns to face him, much as would the courtiers of a Romanesque monarch in attendance on their lord. Two courses of wavy lines symbolizing the clouds of Heaven divide the Elders into three tiers.

As many variations exist within the general style of Romanesque sculpture as within Romanesque architecture, and the figures of the Moissac tympanum contrast sharply with those of the reliefs previously examined. The extremely elongated bodies of the recording angels, the cross-legged dancing pose of Saint Matthew's angel, and the jerky, hinged movement of the Elders' heads are characteristic of the nameless Moissac master's style of representing the human figure. The zigzag and dovetail lines of the draperies, the bandlike folds of the torsos, the bending back of the hands against the body, and the wide cheekbones are also common features of this distinctive style.

A PROPHET AND LIONS ON A TRUMEAU Below the Moissac tympanum are a richly decorated trumeau and elaborate door jambs with scalloped contours (FIG. 17-22), the latter another Romanesque borrowing from Islamic architecture (see FIG. 13-13). On the trumeau's right face is a prophet (FIG. **17-23**) identified by some as Jeremiah, by others as Isaiah. Whoever the prophet is, he displays the scroll where his prophetic vision is written. His position below the apparition of Christ as the apocalyptic Judge is yet another instance of the pairing of Old and New Testament themes. This is in keeping with an iconographic tradition established in Early Christian times (see "Jewish Subjects in Christian Art," Chapter 11, page 305).

The prophet's figure is very tall and thin, in the manner of the tympanum angels, and, like Matthew's angel, he executes

folds ultimately derive from manuscript illumination and here play gracefully around the elegant figure. The long, serpentine locks of hair and beard frame an arresting image of the dreaming mystic. The prophet seems entranced by his vision of what is to come, the light of ordinary day unseen by his wide eyes. His expression is slightly melancholy—at once pensive and wistful. For people of the Middle Ages, two alternative callings were available. One calling was to *vita activa* (the active life). The other was to *vita contemplativa* (the religious life of contemplation), the pursuit of the vision of God. The sculptor of the Moissac prophet captured the very image of the vita contemplativa, a most appropriate theme for a monastic church.

Six roaring interlaced lions fill the trumeau's outer face (FIGS. 17-22 and 17-23). The animal world was never far from the medieval artist's instinct and imagination and was certainly not far from the medieval mind in general. Kings and barons often were associated with animals thought to be the most fiercely courageous—for example, Richard the Lionheart, Henry the Lion, and Henry the Bear. Lions were the church's ideal protectors. In the Middle Ages, people believed lions slept with their eyes open. But the idea of placing fearsome images at the gateways to important places had a very ancient origin. The lions and composite monsters that guarded the palaces of Assyrian and Mycenaean kings (see FIGS. 2-18, 2-21, and 4-20), the watchful sphinx in front of Khafre's pyramid (see FIG. 3-11), and the panthers and leopards in Greek temple pediments (see FIG. 5-15) and Etruscan tombs (see FIG. 9-8) are the ancestors of the interlaced lions at Moissac.

THE CLOISTER IN MONASTIC LIFE Before the great sculptures were put in place on Moissac's south portal, facing the town square and the public at large, the church's cloister (FIG. **17-24**) was decorated for the monks alone to see. *Cloister* (from the Latin word *claustrum,* an enclosed place) connotes being shut away from the world. Architecturally, the medieval church cloister expresses the seclusion of the spiritual life, the vita contemplativa. It provided the monks (and nuns) with a foretaste of Paradise. They walked in the cloister in contemplation, reading their devotions, praying and meditating in an atmosphere of calm serenity, each withdrawn into the private world where the soul communes only with God. The physical silence of the cloister is one with the silence that the more austere monastic communities required of their members. The monastery cloisters of the twelfth century are monuments to the vitality, popularity, and influence of monasticism at its peak.

At Moissac a timber-roofed walkway supported by piers and columns surrounds the cloister *garth* (garden) on four sides. Moissac's is the earliest surviving cloister with an extensive sculpture program. It consists of large figural reliefs on the piers and historiated (ornamented with figures) capitals on the columns. The pier reliefs portray the Twelve Apostles and the first Cluniac abbot of Moissac, Durandus (1047–1072), who was buried in the cloister. The seventy-six capitals alternately crown single and paired column shafts. They are variously decorated, some with abstract patterns, many with biblical scenes or the lives of saints, others with fantastic monsters of all sorts—basilisks, griffins, lizards, gargoyles, and more. Such sculptures were controversial at the time. Saint Bernard of Clairvaux, for example, complained that this kind of imagery

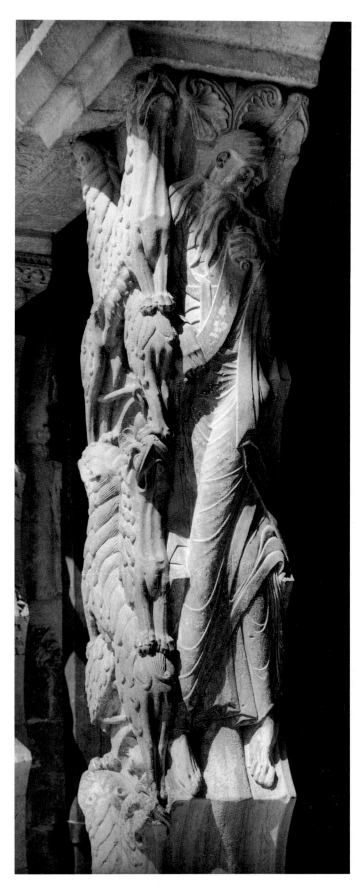

17-23 Lions and Old Testament prophet (Jeremiah or Isaiah?), from the trumeau of the south portal of Saint-Pierre, Moissac, France, ca. 1115–1130. Marble, approx. life-size.

a cross-legged step. The body's animation reveals the passionate nature of the soul within. The flowing lines of the drapery

WRITTEN SOURCES

Saint Bernard of Clairvaux on Cloister Sculpture

The most influential theologian of the Romanesque era was Saint Bernard of Clairvaux (ca. 1090–1153). A Cistercian monk and abbot of the monastery he founded at Clairvaux in northern Burgundy, he embodied not only the reforming spirit of the Cistercian order but also the new religious fervor awakening in the West.

The Cistercians (so called from the Latin name for Cîteaux, France, their place of origin) were Benedictine monks who split from the older Benedictine monasticism of Cluny, which they felt had become rich and worldly. They returned to the strict observance of the Rule of Saint Benedict (see "Medieval Monasteries and Benedictine Rule," Chapter 16, page 443), changing the color of their habits from Cluniac Benedictine black to unbleached white. These so-called White Monks emphasized productive manual labor, and their systematic farming techniques stimulated the agricultural transformation of Europe. Under Bernard's leadership, they expanded rapidly. When he died in 1153, the Cistercian order had three hundred fifty abbeys. By the end of the twelfth century, five hundred thirty had been established.

Saint Bernard's impassioned eloquence made him a European celebrity and drew him into Europe's stormy politics. He intervened in high ecclesiastical and secular matters, defended and sheltered embattled popes, counseled kings, denounced heretics, and preached Crusades against the Muslims—all in defense of papal Christianity and spiritual values.

Saint Bernard's opposition to the profusion of sculpture in the Romanesque churches of his day was legendary. An excerpt from a letter he wrote in 1127 to William, abbot of Saint-Thierry, contains a tirade against the rich outfitting of churches in general and the sculptural adornment of monastic cloisters in particular:

> I say naught of the vast height of your churches, their immoderate length, their superfluous breadth, the costly polishings, the curious carvings and paintings which attract the worshipper's gaze and hinder his attention. . . . Let this pass, however: say that this is done for God's honour. . . . But in the cloister, under the eyes of the Brethren who read there, what profit is there in those ridiculous monsters, in that marvellous and deformed comeliness, that comely deformity? To what purpose are those unclean apes, those fierce lions, those monstrous centaurs, those half-men, those striped tigers, those fighting knights, those hunters winding their horns? Many bodies are there seen under one head, or again, many heads to a single body. Here is a four-footed beast with a serpent's tail; there, a fish with a beast's head. Here again the forepart of a horse trails half a goat behind it, or a horned beast bears the hinder quarters of a horse. In short, so many and so marvellous are [the sculpted figures] that we are more tempted to read in the marble than in our books, and to spend the whole day in wondering at these things rather than in meditating the law of God. For God's sake, if men are not ashamed of these follies, why at least do they not shrink from the expense?[1]

[1]Quoted in Elizabeth G. Holt, *A Documentary History of Art* (New York: Doubleday Anchor Books, 1957), 1: 19, 21.

17-24 Cloister of Saint-Pierre, Moissac, France, ca. 1100–1115. Marble, piers approx. 6' high.

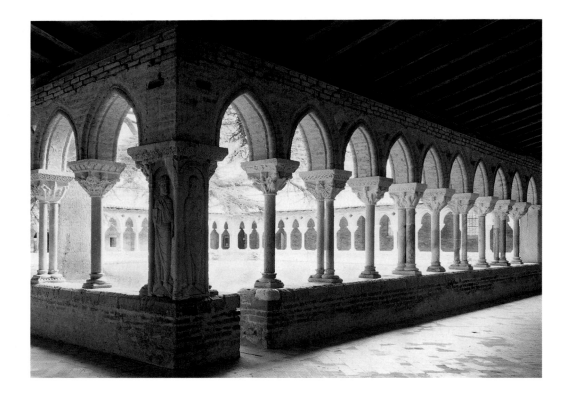

The Romanesque Portal

One of the most significant and distinctive features of Romanesque art is the revival of monumental sculpture in stone. Because of the Second Commandment's prohibition of graven images, large-scale carved Old and New Testament figures (and later saints) were almost unknown in Christian art before the Romanesque period. But in the late eleventh and early twelfth centuries, rich ensembles of figural reliefs began to appear again, although freestanding statuary, still associated with pagan idol worship, remained very rare.

Although sculpture in a variety of materials adorned different areas of Romanesque churches, it was most often found in the grand stone portals through which the faithful had to pass. Theologians undoubtedly dictated the subjects of the Romanesque portals. Church authorities felt it was just as important to have the right subjects carved in the correct places as to have the right arguments correctly arranged in a theological treatise. Sculpture had been employed in church doorways before. For example, carved wooden doors greeted Early Christian worshipers as they entered Santa Sabina in Rome. And Ottonian bronze doors decorated with Old and New Testament scenes marked the entrance to Saint Michael's at Hildesheim (FIG. 16-25). But these were exceptions. And in the Romanesque era (and during the Gothic period that followed), sculpture usually appeared in the area *around,* rather than *on,* the doors.

Our diagram shows the parts of church portals that Romanesque sculptors regularly decorated with figural reliefs:

- *Tympanum* (FIGS. 17-22, 17-25, and 17-26), the prominent semicircular *lunette* above the doorway proper, comparable in importance to the triangular pediment of a Greco-Roman temple

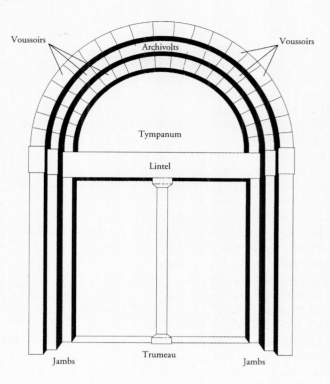

- *Voussoirs* (FIG. 17-26), the wedge-shaped blocks that together form the *archivolts* of the arch framing the tympanum
- *Lintel* (FIG. 17-19), the horizontal beam above the doorway
- *Trumeau* (FIG. 17-23), the center post supporting the lintel in the middle of the doorway
- *Jambs* (FIG. 17-27), the side posts of the doorway

distracted the monks from their devotions (see "Saint Bernard of Clairvaux on Cloister Sculpture," page 470).

JUDGMENT DAY AT AUTUN The relatives of the monsters of the Moissac capitals appear as the demons of Hell in the tympanum of the Burgundian cathedral of Saint-Lazare (Saint Lazarus) at Autun (FIG. **17-25**). The Cluniac bishop Étienne de Bage had the cathedral built, and it was consecrated in 1132. At Moissac (FIG. 17-22), the faithful saw the apparition of the Divine Judge before he summoned humankind to Judgment. At Autun, the Judgment is in progress, announced by four trumpet-blowing angels.

In the tympanum's center, far larger than any other figure, is Christ, enthroned in a mandorla angels support, dispassionately presiding over the separation of the Blessed from the Damned. At the left, an obliging angel boosts one of the Blessed into the heavenly city. Below, the souls of the dead line up to await their fate. Two of the men at the left end of the lintel carry bags emblazoned with a cross and a shell.

These are the symbols of pilgrims to Jerusalem and Santiago de Compostela. Those who had made the difficult journey would be judged favorably. To their right, three small figures beg an angel to intercede on their behalf. The angel responds by pointing to the Judge above. On the right side are those who will be condemned to Hell (see FIG. Intro-6). One poor soul is plucked from the earth by giant hands. Directly above, in the tympanum, is one of the most unforgettable renditions of the weighing of souls in the history of art (compare the much earlier representation of this theme in Egypt, FIG. 3-39). Angels and devils contest at the scales, each trying to manipulate the balance for or against a soul. Hideous demons guffaw and roar. Their gaunt, lined bodies, with legs ending in sharp claws, writhe and bend like long, loathsome insects. A devil, leaning from the dragon mouth of Hell, drags souls in, while, above him, a howling demon crams souls headfirst into a furnace. The resources of the Romanesque imagination, heated by a fearful faith, provided an appalling scene.

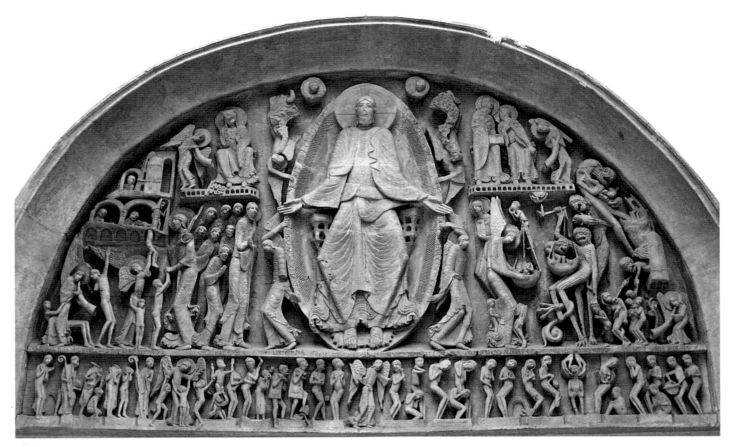

17-25 GISLEBERTUS, Last Judgment (plaster cast), west tympanum of Saint-Lazare, Autun, France, ca. 1120–1135. Marble, approx. 21′ wide at base.

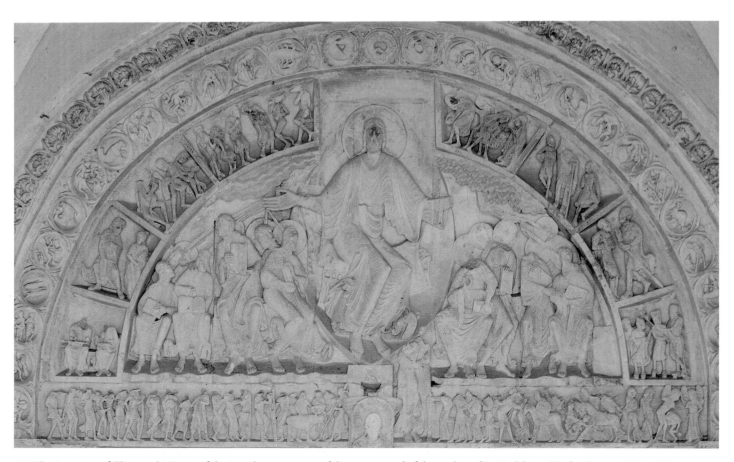

17-26 Ascension of Christ and Mission of the Apostles, tympanum of the center portal of the narthex of La Madeleine, Vézelay, France, 1120–1132.

The Crusades

Between 1095, when Pope Urban II called for an assault on the Holy Land at the Council of Clermont, and 1190, Christians launched three great Crusades from France. The *Crusades* ("taking of the Cross") were mass armed pilgrimages, whose stated purpose was to wrest the Christian shrines of the Holy Land from Muslim control. Crusaders and pilgrims were bound by similar vows. They hoped not only to atone for sins and win salvation but also to glorify God and extend the Christian Church's power. The joint action of the papacy and the barons—mostly French—in this type of holy war strengthened papal authority over the long run and created an image of Christian solidarity.

The joining of religious and secular forces in the Crusades was symbolically embodied in the Christian warrior, the fighting priest, or the priestly fighter. From the early medieval warrior evolved the Christian knight, who fought for the honor of God rather than in defense of his chieftain. The first and most typical of the crusading knights were the Knights Templar. After the Christian conquest of Jerusalem in 1099, they stationed themselves next to the Dome of the Rock (see FIG. 13-1) near the site of Solomon's Temple, the source of their name. Their mission was to protect pilgrims visiting the recovered Christian shrines. Formally founded in 1118, the Knights Templar order was blessed by Saint Bernard, who gave them a rule of organization based on that of his own Cistercians. Saint Bernard justified their militancy by declaring that "the knight of Christ" is "glorified in slaying the infidel . . . because thereby Christ is glorified" and the Christian knight then wins salvation. Saint Bernard saw the Crusades as part of the general reform of the Church and as the defense of the supremacy of Christendom. He himself preached the Second Crusade in 1147.

The Crusaders achieved little in the East. They established a few unstable kingdoms and princely states in Syria and the Holy Land, which the Muslims later overthrew and assimilated. But in western Europe, the Crusades' impact was much greater. They increased the power and prestige of the towns. Many communities purchased their charters from the barons when the barons needed to finance their campaigns. A middle class of merchants and artisans arose to rival the power of the feudal lords and the great monasteries. Italian maritime towns such as Pisa thrived on the commercial opportunities presented by the transportation of Crusaders overseas. The Crusades also widened the provincial West's cultural perspectives, bringing into view more civilized peoples and more exotic and opulent ways of life than anything the medieval West had yet known. And the direct exposure to the art and architecture of Byzantium and Islam had a profound impact on the character of Romanesque buildings, sculptures, reliquaries, mural paintings, and illuminated manuscripts.

One can appreciate the terror the Autun tympanum must have inspired in the believers who passed beneath it as they entered the cathedral. Even those who could not read could, in the words of Saint Bernard of Clairvaux, "read in the marble." For the literate, the Autun clergy composed explicit written warnings to reinforce the pictorial message, and had the words engraved in Latin on the tympanum. For example, beneath the weighing of souls, the inscription reads "May this terror terrify those whom earthly error binds, for the horror of these images here in this manner truly depicts what will be."[2] A second prominent inscription, directly beneath the feet of Christ, names GISLEBERTUS as the sculptor. It has been suggested that Gislebertus placed his signature on the tympanum not to advertise his own fame but as a kind of request to spectators to admire his good work and to pray for his salvation on Judgment Day. But pride in individual accomplishment was also a factor in the increasing number of artists' signatures in Romanesque times, as witnessed by Wiligelmo's boast at Modena.

VÉZELAY AND THE CRUSADES　Another large tympanum (FIG. 17-26), this one at the church of La Madeleine (Mary Magdalene) at Vézelay, not far from Autun, depicts the Ascension of Christ and the Mission of the Apostles. As related in Acts 1:4–9, Christ foretold that the Twelve Apostles would receive the power of the Holy Spirit and become the witnesses of the truth of the Gospels throughout the world. The light rays emanating from Christ's hands represent the instilling of the Holy Spirit in the apostles (Acts 2:1–42) at the Pentecost (the seventh Sunday after Easter). The apostles, holding the Gospel books, receive their spiritual assignment, to preach the Gospel to all nations.

The world's heathen, the objects of the apostles' mission, appear on the lintel below and in eight compartments around the tympanum. The portrayals of the yet-to-be-converted constitute a medieval anthropological encyclopedia. Present are the legendary giant-eared Panotii of India, Pygmies (who require ladders to mount horses), and a host of other races, some characterized by a dog's head, others by a pig's snout, and still others by flaming hair. The assembly of agitated figures also includes hunchbacks, mutes, blind men, and lame men. Humanity, still suffering, awaits the salvation to come. The whole world is electrified by the promise of the ascended Christ, whose great figure, seeming to whirl in a vortex of spiritual energy, looms above human misery and deformity. Again, as at Autun, as worshipers enter the church, the tympanum emphatically establishes the greatness of God and the littleness of human beings.

Stylistically, the Vézelay tympanum figures are similar to those of the Moissac and Autun tympanums. Abrupt and jerky movement (strongly exaggerated at Vézelay), rapid play of line, windblown drapery hems, elongation, angularity, and

17-27 Portal on the west facade of Saint-Trophîme, Arles, France, second third of the twelfth century.

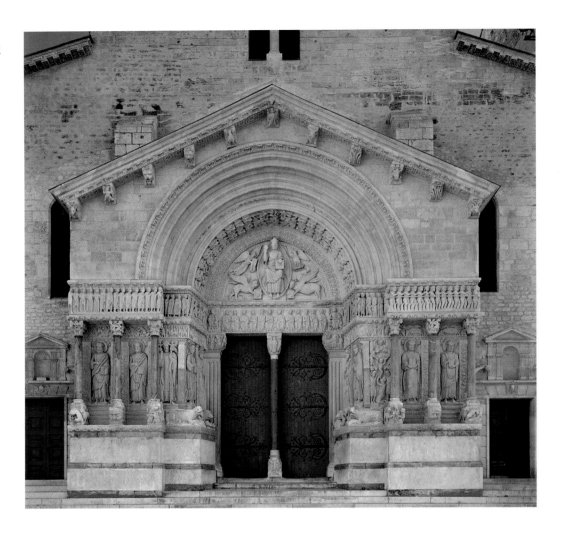

agitated poses, gestures, and silhouettes characterize this French Romanesque style. The Vézelay Christ figure is a splendid essay in calligraphic theme and variation. The drapery lines shoot out in rays, break into quick zigzag rhythms, and spin into whorls, wonderfully conveying the spiritual light and energy that flow from Christ over and into the animated apostles.

The Mission of the Apostles theme was an ideal choice for this tympanum. Vézelay is more closely associated with the Crusades (see "The Crusades," page 473) than any other church in Europe. Pope Urban II had intended to preach the launching of the First Crusade at Vézelay in 1095, twenty to thirty years before the tympanum was carved. In 1147, Saint Bernard of Clairvaux called for the Second Crusade at Vézelay, and King Louis VII of France took up the cross there. In 1190, it was from Vézelay that King Richard the Lionheart of England and King Philip Augustus of France set out on the Third Crusade. The spirit of the Crusades determined in part the iconography of the Vézelay tympanum. The Crusades were a kind of "second mission of the apostles" to convert the infidel.

ROMANESQUE PORTALS AND ROMAN ARCHES

In Provence, rich in the remains of Roman art and architecture, some Romanesque facades seem to have been inspired by Roman triumphal arches. This is the case at the mid-twelfth-century church of Saint-Trophîme at Arles, ancient Arelate, an important Roman colony Julius Caesar founded. Saint

Trophimus was an early bishop in Roman Gaul. For the church's western entrance (FIG. **17-27**), a projecting portal resembling a Roman arch was "attached" to the building's otherwise simple facade. The frieze above the freestanding columns recalls the sculptured fronts of late antique sarcophagi, which are also plentiful in the area. The figures in high relief between the columns emulate classical statuary.

The subject matter is, however, strictly Christian and thematically related to other Romanesque portals already examined here. The tympanum shows Christ surrounded by the signs of the Four Evangelists. On the lintel, directly below him, the Twelve Apostles appear at the center of a continuous frieze depicting the Last Judgment. The outermost parts of the frieze represent the Saved (on Christ's right) and the Damned in the flames of Hell (on his left). Below, in the jambs and the front bays of the portals, stand grave figures of saints draped in classical garb. The sculptor gave pride of place to Saint Trophimus, the third figure from the left. Across the doorway is a depiction of the stoning of Saint Stephen, whose relics were housed at Arles. It is the only narrative relief on the facade's lower part.

The quiet stances of the saints of Saint-Trophîme contrast with the spinning, twisting, and dancing figures seen at Moissac, Autun, and Vézelay. The Arles draperies, modeled on ancient stone sculpture rather than medieval manuscripts and metalwork, are also less agitated and show nothing of the dexterous linear play of the earlier portals. But the statuesque treatment of the figures on the Arles jambs has parallels in French Gothic art.

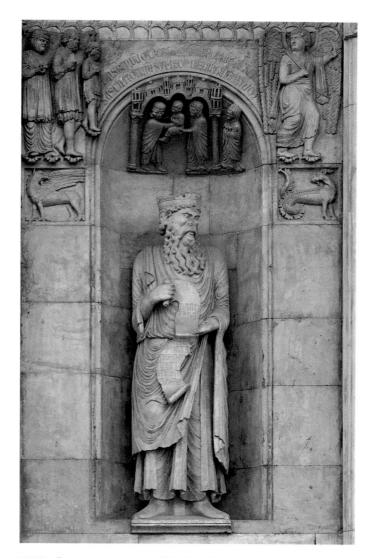

17-28 BENEDETTO ANTELAMI, King David, statue in a niche on the west facade of Fidenza Cathedral, Fidenza, Italy, ca. 1180–1190. Marble, approx. life-size.

In fact, in the north of France, near Paris, sculptors already had begun to adorn church portals with jamb figures that approximated freestanding statuary (see FIGS. 18-5 and 18-6).

THE REVIVAL OF STATUARY IN ITALY The reawakening of interest in stone sculpture in the round also may be seen in northern Italy, where the sculptor BENEDETTO ANTELAMI was active in the last quarter of the twelfth century. Several reliefs by his hand exist, including Parma Cathedral's pulpit and the portals of that city's baptistery. But his most unusual works are the monumental marble statues of two Old Testament figures he carved for Fidenza Cathedral's west facade. Antelami's King David (FIG. **17-28**) seems confined within his niche. His elbows are kept close to his body, and his stance is stiff, lacking any hint of the contrapposto that is classical statuary's hallmark. Yet the sculptor's conception of this prophet is undeniably rooted in Greco-Roman art. One need only compare the Fidenza David with the prophet on the Moissac trumeau (FIG. 17-23), who also displays an unfurled scroll, to see how much the Italian sculptor freed his figure from its architectural setting. Antelami's classical approach to portray-

ing biblical figures in stone was not immediately emulated. But the idea of placing freestanding statues in niches would be taken up again in Italy by Early Renaissance sculptors (see FIGS. 21-6 and 21-8).

Metalwork and Wood Sculpture

BRONZEWORKING IN BELGIUM Another Romanesque sculptor whose name is known is RAINER OF HUY, a bronzeworker from the Meuse River valley in Belgium, an area renowned for its metalwork. In 1118 he masterfully cast in a single piece the baptismal font (FIG. **17-29**) for Notre-Dame-des-Fonts in Liège (today it is in Saint-Barthélémy). The bronze basin rests on the foreparts of twelve oxen, a reference to the "molten sea . . . on twelve oxen" cast in bronze for King Solomon's temple (1 Kings 7:23–25). The Old Testament story was thought to prefigure Christ's baptism (the twelve oxen were equated with the Twelve Apostles), which is the central scene on Rainer's font.

The style is classicizing. The figures are softly rounded, with idealized bodies and faces and heavy clinging drapery. One figure (at the left in our photo) even turns his back to observers. The three-quarter view from the rear was a popular motif in classical art. Some of Rainer's figures, including even Christ, are naked. In Romanesque art, the classical spirit lived on both north and south of the Alps.

Rainer of Huy joins the Italian Benedetto Antelami; Bernardus Gelduinus, who carved the Saint-Sernin sculptures (FIG. 17-20); Wiligelmo, sculptor of the Modena frieze (FIG. 17-21); and Gislebertus of Autun (FIG. 17-25) in the small but growing company of Romanesque artists who signed their works or whose names were recorded. In the twelfth century, artists, illuminators as well as sculptors, increasingly began to identify themselves. (The works of the manuscript painters Stephanus Garsia, FIG. 17-35; Master Hugo, FIG. 17-38; and Eadwine the

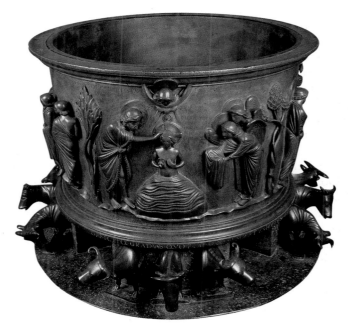

17-29 RAINER OF HUY, Baptism of Christ, baptismal font from Notre-Dame-des-Fonts, Liège, Belgium, 1107–1118. Bronze, 2' 1" high. Saint-Barthélémy, Liège.

Scribe, FIG. 17-39 will be introduced soon.) Although most medieval artists remained anonymous, the contrast of the Romanesque period with the early Middle Ages is striking.

THE THRONE OF WISDOM Despite the widespread use of stone relief sculptures to adorn Romanesque church portals, resistance to the creation of statues in the round—in any material—continued. The avoidance of anything that might be construed as an idol was still the rule, in keeping with the Second Commandment. Two centuries after Archbishop Gero commissioned a monumental wooden image of the crucified Christ for Cologne Cathedral (see FIG. 16-27), freestanding statues of Christ, the Virgin Mary, and the saints were still quite rare. The veneration of relics, however, brought with it a demand for small-scale images of the holy family and saints for placing on the chapel altars of the churches along the pilgrimage roads. Reliquaries in the form of saints (or parts of saints), tabletop crucifixes, and small wooden devotional images began to be produced in great numbers.

One of the most popular types, a specialty of France's Auvergne workshops, was a wooden statuette depicting the Virgin Mary with the Christ Child in her lap. The *Morgan Madonna* (FIG. **17-30**), so named because it once belonged to the financier and prolific collector J. Pierpont Morgan, is an excellent example. The type—known as the Throne of Wisdom, *sedes sapientiae*—is a western European freestanding version of the Byzantine Theotokos theme popular in icons and mosaics (see FIGS. 12-15 and 12-16). Christ, God incarnate, holds a Bible in his left hand and raises his right arm in blessing (both hands are broken off). He is the embodiment of the divine wisdom contained in the Holy Scriptures. His mother, seated on a wooden chair, is in turn the Throne of Wisdom because her lap is the Christ Child's throne. As in Byzantine art, familiar to many Romanesque painters and sculptors, both Mother and Child sit rigidly upright and are strictly frontal emotionless figures. But the intimate scale, the gesture of benediction, the once-bright coloring of the garments, and the soft modeling of the Virgin's face make the group seem much less remote than its counterparts in Byzantium.

A SAINTED POPE'S SILVER RELIQUARY Far more costly, but also created for private devotional purposes, is the reliquary of Saint Alexander (FIG. **17-31**), made in 1145 for Abbot Wibald of Stavelot in Belgium to house the hallowed pope's relics. The idealized head, which resembles portraits of youthful Roman emperors such as Augustus (see FIG. Intro-10) and Constantine (see FIG. 10-78), is almost life-size and was fashioned in beaten (repoussé) silver with bronze gilding for the hair. The saint wears a collar of jewels and enamel plaques around his neck. Enamels and gems also adorn the box on which the head is mounted. The reliquary rests on four bronze dragons—mythical animals of the kind that populated Romanesque cloister capitals. Not surprisingly, Saint Bernard of Clairvaux was as critical of church furnishings such as the Alexander reliquary as he was of Romanesque sculpture:

> [Men's] eyes are feasted with relics cased in gold, and their pursestrings are loosed. They are shown a most comely image of some saint, whom they think all the more saintly that he is the more

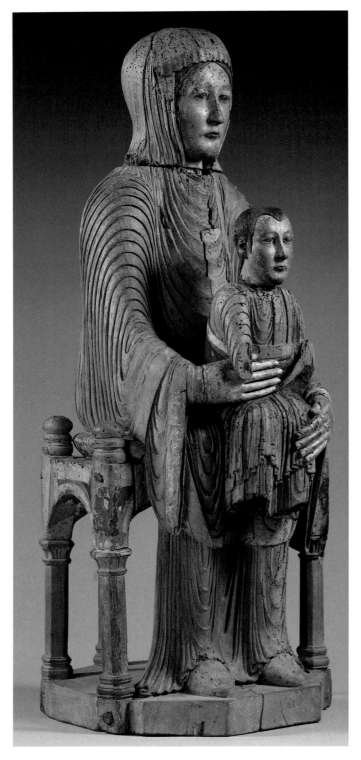

17-30 Virgin and Child *(Morgan Madonna)*, from Auvergne, France, second half of twelfth century. Painted wood, 2′ 7″ high. Metropolitan Museum of Art, New York (gift of J. Pierpont Morgan, 1916).

gaudily painted. Men run to kiss him, and are invited to give; there is more admiration for his comeliness than veneration for his sanctity. . . . O vanity of vanities, yet no more vain than insane! The church . . . clothes her stones in gold and leaves her sons naked; the rich man's eye is fed at the expense of the indigent. The curious find delight here, yet the needy find no relief.[3]

The central plaque on the front of the Stavelot reliquary depicts Pope Alexander. Saints Eventius and Theodolus flank

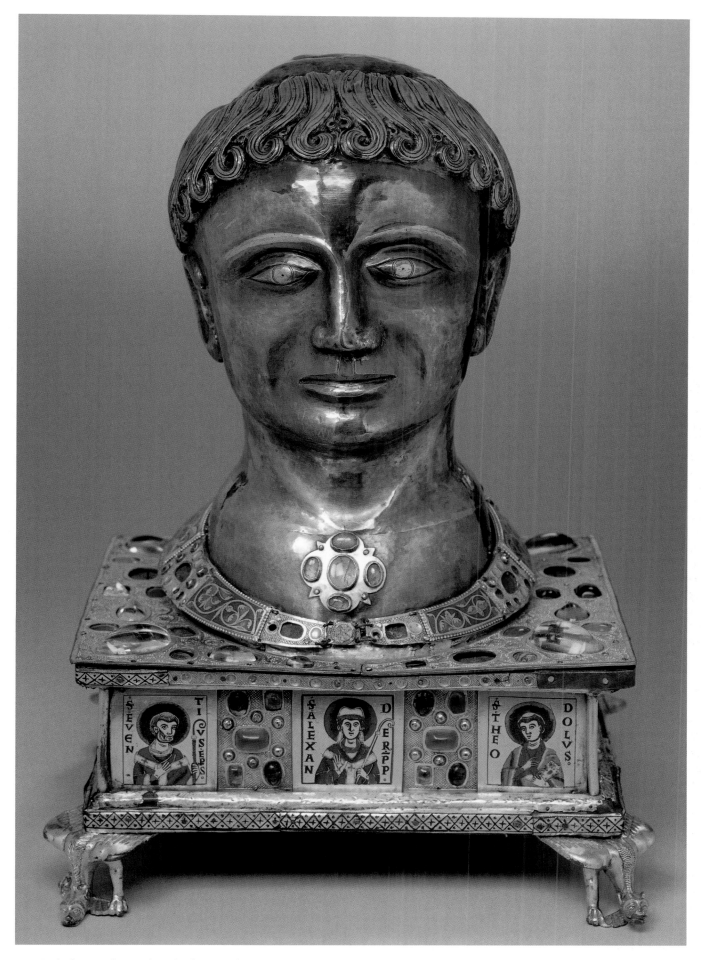

17-31 Head reliquary of Saint Alexander, from Stavelot Abbey, Belgium, 1145. Silver repoussé (partly gilt), gilt bronze, gems, pearls, and enamel, approx. 1′ 5½″ high. Musées Royaux, Brussels.

him. The nine plaques on the other three sides represent female allegorical figures—Wisdom, Piety, and Humility among them. Although a local artist produced these enamels in the Meuse River region, the models were surely Byzantine (compare FIG. 12-25). Saint Alexander's reliquary underscores the multiple sources of Romanesque art, as well as its stylistic diversity. Not since antiquity had people journeyed as extensively as they did in the Romanesque period, and artists regularly saw works of wide geographic origin. Abbot Wibald himself epitomizes the well-traveled twelfth-century clergyman. He was abbot of Montecassino in southern Italy, took part in the Second Crusade, and was sent by Frederick Barbarossa (Holy Roman Emperor, r. 1152–1190) to Constantinople to arrange Frederick's wedding to the niece of the Byzantine emperor Manuel Comnenus.

PAINTING

Unlike the practices of placing vaults over naves and aisles, and decorating building facades with monumental stone reliefs, the art of painting did not need to be "revived" in the Romanesque period. Illuminated manuscripts had been produced in large numbers in the early Middle Ages, and even the Roman tradition of mural painting had never died, especially in Italy. But the quantity of preserved frescoes and illustrated books from the Romanesque era is unprecedented. As with architecture and sculpture, Romanesque painting exhibits considerable regional and stylistic diversity. We discuss here a representative sample of Romanesque paintings from several regions in different media and formats.

Mural Painting

PAINTING IN CHRISTIAN SPAIN In the eighth century, Muslim armies from North Africa defeated the Visigoths and occupied almost all of the Iberian Peninsula (Spain and Portugal), bringing with them both the Islamic faith and Islamic art (see Chapter 13). But in northern Spain, the Muslim conquerors never completely controlled many areas, and Christianity and Christian art still flourished. In fact, Catalonia in northeastern Spain has more Romanesque mural paintings today than anywhere else.

One of the most impressive is the fresco (FIG. **17-32**) that once filled the apse of Santa María de Mur, a monastery church not far from Lérida. (The fresco was detached from the church, and the apse has been reconstructed in the Museum of Fine Arts in Boston.) The formality, symmetry, and placement of the figures is Byzantine—compare the sixth-century apse of Saint Catherine's at Mount Sinai in Egypt (see FIG. 12-13) and the late-twelfth-century apse of the basilica at Monreale (see FIG. 12-24). But the Spanish artist rejected Byzantine mosaic in favor of direct painting on plaster-coated walls. And the iconographic scheme in the semidome of the apse is more closely tied to those of the Romanesque church portals of France (FIGS. 17-22 and 17-27).

In the Santa María de Mur fresco, Christ in a star-strewn mandorla is flanked by the signs of the Four Evangelists—the Apocalypse theme that so fascinated the Romanesque imagination. Seven lamps, or candlesticks, between Christ and the Evangelist signs symbolize the seven Christian communities

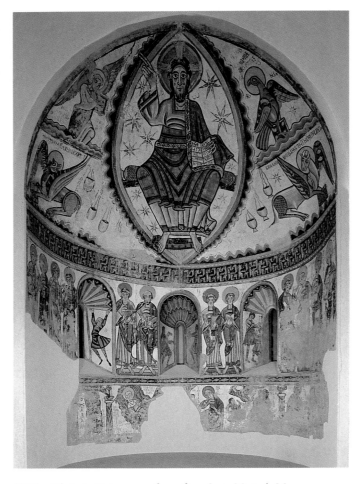

17-32 Christ in Majesty, apse fresco from Santa María de Mur, near Lérida, Spain, mid-twelfth century. 22′ × 24′. Museum of Fine Arts, Boston.

where Saint John addressed his revelation (the Apocalypse) at the beginning of his book (Rev. 1:4, 12, 20). Below stand apostles, paired off in formal frontality, much like the saints on the facade of Saint-Trophîme at Arles (FIG. 17-27), as well as in the apse at Monreale (see FIG. 12-24). The principal figures are rendered—as at Moissac (FIG. 17-22) and elsewhere in Romanesque art—with partitioning of the drapery into volumes, here and there made tubular by local shading. The painter stiffened the irregular shapes of actual cloth into geometric patterns. The effect overall is one of simple, strong, and even blunt directness of statement, reinforced by harsh, bright color, appropriate for a powerful icon.

ITALIAN MURALS AND BYZANTINE MODELS The tradition of decorating church apses with imposing images of Christ and saints is a venerable one, going back to Early Christian art. So, too, is the idea of illustrating episodes from the Old and New Testaments above the nave arcade of basilican churches, as at Santa Maria Maggiore (see FIG. 11-13) and Sant'Apollinare Nuovo (see FIG. 11-17). An extensive series of framed scenes from Christ's life—in fresco rather than mosaic—appears along both sides of the nave of Sant'Angelo in Formis, near Capua in southern Italy. (Frescoes also adorn the apse, where Christ sits on a jeweled throne with the dove of the Holy Spirit above him and the symbols of the Four Evangelists at his side.)

Abbot Desiderius (later Pope Victor III) of Montecassino, the great monastery Saint Benedict founded in the sixth cen-

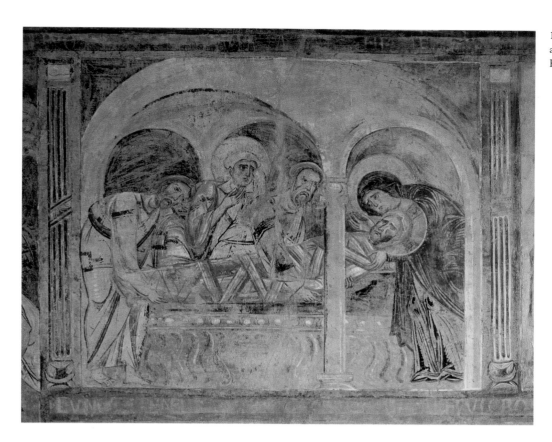

17-33 Entombment of Christ, fresco above the nave arcade, Sant'Angelo in Formis, near Capua, Italy, ca. 1085.

tury, began Sant'Angelo in Formis in 1072. The nave frescoes date to around 1085. Our detail (FIG. **17-33**) shows the panel illustrating the entombment of Christ, with Mary cradling the head of her dead son as Joseph of Arimathea and Nicodemus lower him into his coffin. The weeping Saint John the Evangelist (with nimbus) watches. The fully modeled figures, the three-dimensional architectural setting, and the natural blue sky provide a sharp contrast with the Catalonian mural. But a comparison with the painted lamentation scene in Saint Pantaleimon in Macedonia (see FIG. 12-27) underscores that the Italian painter used Byzantine artworks as models. For the church at Montecassino, Desiderius imported artisans from Constantinople and instructed them to train his monks in mosaic and other arts. Sant'Angelo in Formis displays the work of these Italian pupils of Desiderius's Greek masters.

THE OLD TESTAMENT ON A BARREL VAULT
The Santa María de Mur and Sant'Angelo in Formis frescoes easily could be moved to an Early Christian basilica, where they would find ready homes in the apse and nave. But the murals of the Benedictine abbey church of Saint-Savin-sur-Gartempe were inconceivable before the mastering of stone vaulting in the Romanesque period. A continuous barrel vault supported by columns painted to appear like grained marble covers the nave (FIG. **17-34**) of the French church. The structure lacks both tribune gallery and clerestory, but the absence of a direct light source did not deter the monks from commissioning paintings (not true frescoes) to decorate the ceiling's entire surface. Since the side aisles rise to the nave vault's level, more light than usual reaches the nave from the aisle windows.

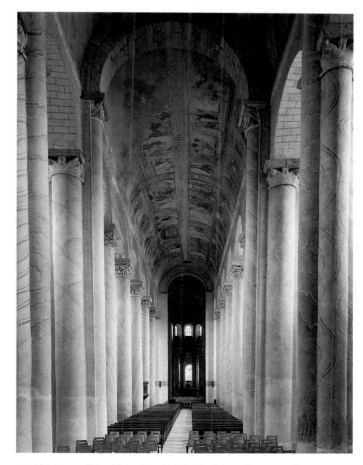

17-34 Nave of the abbey church, Saint-Savin-sur-Gartempe, France. Painted barrel vault, ca. 1100.

The subjects were all drawn from the Pentateuch, the opening five books of the Old Testament, in contrast to the New Testament themes of Sant'Angelo in Formis. They also bear little resemblance stylistically to the Byzantine-inspired murals of the Capuan and Catalonian churches. The elongated, agitated cross-legged figures of the Saint-Savin paintings are northern both in spirit and in form. They have stylistic affinities both to the reliefs of southern French portals and to some of the illuminated manuscripts discussed next.

Manuscript Illumination

THE APOCALYPSE ON TWO PAINTED FOLIOS

The apocalyptic vision of the Second Coming of Christ, recorded in the Book of Revelation and carved on the great tympanum at Moissac (FIG. 17-22), is also the subject of a double-page illumination of the third quarter of the eleventh century. The *Apocalypse of Saint-Sever* (FIG. **17-35**) contains the commentaries on the Apocalypse written by Beatus of Liébana, an eighth-century Spanish monk. The theme of the Second Coming was of such interest that numerous manuscripts of Beatus's commentary were copied and illustrated in the Romanesque era. With the exception of this book, all were produced in Spain. The monastery at Saint-Sever-sur-

l'Adour, in southwestern France near Moissac and Toulouse, is about sixty-five miles from the Spanish border. It does not seem to have had its own scriptorium. STEPHANUS GARSIA, the painter of the great vision of the Second Coming in the *Apocalypse of Saint-Sever*, therefore must have been employed especially for this manuscript.

Stephanus's two-folio painting is significant not only as a masterpiece of the illuminator's art but also as a pictorial relative of the Moissac tympanum. Such manuscript pages probably served as prototypes for the Moissac sculptor. The characters in the drama are essentially the same. Only the composition is different. In both cases, the artist strictly followed the New Testament account of the vision of Saint John (Rev. 4:6–8, 5:8–9). Christ, enthroned in a sapphire aura, appears amid the signs of the Four Evangelists, whose bodies are full of eyes and who are borne aloft by numerous wings. The crowned and music-making Twenty-Four Elders offer their golden cups of incense and their stringed viols. Flights of angels frame the great circle of the apparition. The color is intense and vivid. The agile figures were fluently drawn. The artist depicted the seated figures in a kind of bird's-eye perspective. Their bodies overlap, and some of them are seen from behind. Within a context of visionary abstraction, these deft touches of realism are noteworthy, but the characteristic patternings of Romanesque figural art still contain them.

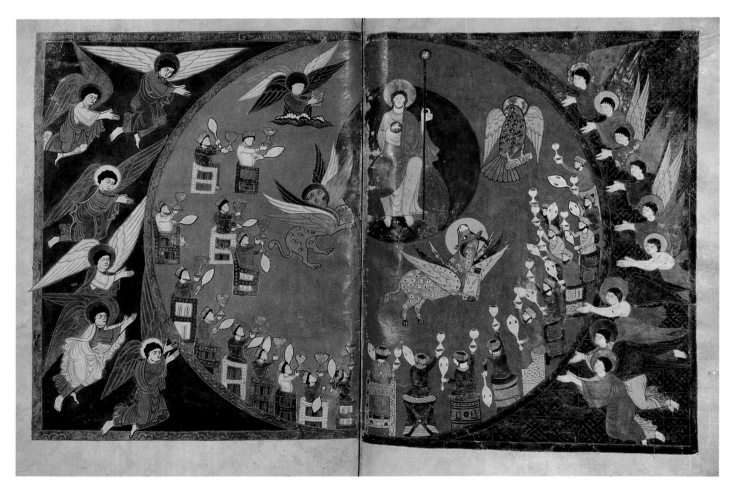

17-35 STEPHANUS GARSIA, enthroned Christ with signs of the Four Evangelists and the Twenty-Four Elders, folios 121 verso and 122 recto of the *Apocalypse of Saint-Sever,* from Saint-Sever-sur-l'Adour, France, ca. 1050–1070. Ink and tempera on vellum, approx. 1′ 2½″ × 1′ 10″. Bibliothèque Nationale, Paris.

nying text. Hildegard immediately sets down what has been revealed to her on a wax tablet resting on her left knee. Nearby, the monk Volmar, Hildegard's confessor, copies into a book all she has written. Here, in a singularly dramatic context, is a picture of the essential nature of ancient and medieval book manufacture—individual scribes copying and recopying texts by hand. In the early Middle Ages and during the Romanesque era, these scribes were almost exclusively monks and nuns working in the sheltered scriptoria of isolated religious communities.

A KNIGHT BATTLES DRAGONS One of the major Romanesque scriptoria was at the abbey of Cîteaux, France, home of the Cistercian order. Just before Saint Bernard joined the monastery in 1112, the monks completed work on an illuminated copy of Saint Gregory's *Moralia in Job*. It is a splendid example of Cistercian illumination before Bernard's passionate opposition to figural art led in 1134 to a ban on elaborate paintings in manuscripts. After 1134, not only were full-page illustrations prohibited but also even initial letters had to be nonfigurative and of a single color.

The historiated initial we reproduce (FIG. **17-37**) clearly would have been in violation of Saint Bernard's ban if it had not been painted before his prohibitions took effect. A knight (thought by some to be Saint George in contemporary garb), his squire, and two roaring dragons form an intricate letter *R*, the initial letter of the salutation *Reverentissimo*. This page is the

17-36 The vision of Hildegard of Bingen, detail of a facsimile of a lost folio in the *Scivias* by Hildegard of Bingen, from Trier or Bingen, Germany, ca. 1050–1079. Formerly in Hessische Landesbibliothek, Wiesbaden.

THE DIVINE VISIONS OF A GERMAN NUN
An unusual portrait of a visionary, rather than a vision, was the opening page of the *Scivias (Know the Ways [Scite vias] of God)* of Hildegard of Bingen. Hildegard was a German nun and eventually the abbess of the convent at Disibodenberg in the Rhineland (see "Romanesque Countesses, Queens, and Nuns," page 482). The manuscript, lost in 1945, is known today only through a facsimile. The original probably was written and illuminated at the monastery of Saint Matthias at Trier between 1150 and Hildegard's death in 1179, but it is possible the book was produced at Bingen under Hildegard's supervision. The *Scivias* contains a record of Hildegard's vision in the year 1141 of the divine order of the cosmos and of humankind's place in it. The vision came to her as a fiery light from the open vault of heaven that poured into her brain.

On one page of the Trier manuscript (FIG. **17-36**), Hildegard sits within the monastery walls, with her feet resting on a footstool, in much the same way the Evangelists of the *Coronation* and *Ebbo Gospels* (see FIGS. 16-12 and 16-13) were portrayed. This Romanesque page is a link in a chain of author portraits that goes back to classical antiquity. The painter showed Hildegard experiencing her divine vision by depicting five long tongues of fire emanating from above and entering her brain, just as she describes the experience in the accompa-

17-37 Initial *R* with knight fighting a dragon, from the *Moralia in Job*, from Cîteaux, France, ca. 1115–1125. Ink and tempera on vellum, 1' 1¾" × 9¼". Bibliothèque Municipale, Dijon.

Romanesque Countesses, Queens, and Nuns

Romanesque Europe was still a man's world, but women could and did have power and influence. Countess Matilda of Canossa (1046–1115), who ruled Tuscany after 1069, was sole heiress of vast holdings in northern Italy. She was a key figure in the political struggle between the popes and the German emperors who controlled Lombardy. With unflagging resolution she defended Pope Gregory's reforms and at her death willed most of her lands to the papacy.

More famous and more powerful was Eleanor of Aquitaine (1122–1204), wife of Henry II of England. She married Henry after her marriage to Louis VII, king of France, was annulled. She was queen of France for fifteen years and queen of England for thirty-five years. During that time she bore three daughters and five sons. Two became kings—Richard I (Lionheart) and John. She prompted her sons to rebel against their father, so Henry imprisoned her. Released at Henry's death, she lived on as dowager queen, managing England's government and King John's holdings in France.

Of quite different stamp was Hildegard of Bingen (1098–1179), the most prominent nun of the twelfth century and one of the greatest religious figures of the Middle Ages. Hildegard was born into an aristocratic family that owned large estates in the German Rhineland. At a very early age she began to have visions. When she was eight, her parents placed her in the Benedictine *double monastery* (for monks *and* nuns) at Disibodenberg. She became a nun at fifteen. In 1141, God instructed Hildegard in a vision to disclose her visions to the world. Before then she had revealed them only to close confidants at the monastery. One of these was the monk Volmar, and Hildegard chose to dictate her visions to him (FIG. 17-36) for posterity. No less a figure than Saint Bernard of Clairvaux certified in 1147 that her visions were authentic. Archbishop Heinrich of Mainz joined him in endorsing Hildegard. In 1148, the Cistercian pope Eugenius III formally authorized Hildegard "in the name of Christ and Saint Peter to publish all that she had learned from the Holy Spirit." At this time Hildegard became the abbess of a new convent built for her near Bingen. As reports of Hildegard's visions spread, kings, popes, barons, and prelates sought her counsel. All of them were attracted by her spiritual insight into the truth of the mysteries of the Christian faith.

In addition to her visionary works—the most important is the *Scivias* (FIG. 17-36)—Hildegard also wrote two scientific treatises. *Physica* is a study of the natural world, and *Causae et curae (Causes and Cures)* is a medical encyclopedia. Hildegard also composed the music and wrote the lyrics of seventy-seven songs published under the title *Symphonia*, and still performed today.

Hildegard was the most famous of all Romanesque nuns, but she was by no means the only learned woman of her age. A younger contemporary, the abbess Herrad (d. 1195) of Hohenberg, Austria, was also the author of an important medieval encyclopedia. Herrad's *Hortus deliciarum (Garden of Delights)* is a history of the world intended for instructing the nuns under her supervision, but it was more widely published.

opening of Gregory's letter to "the very reverent" Leandro, Bishop of Seville. The knight is a slender regal figure who raises his shield and sword against the dragons while the squire, crouching beneath him, runs a lance through one of the monsters. One can gauge Saint Bernard's reaction to this kind of illumination from his tirade against the monstrous creatures and "fighting knights" of contemporary cloister capitals (see "Saint Bernard of Clairvaux on Cloister Sculpture," page 470).

Ornamented initials go back to the Hiberno-Saxon period (see FIG. 16-7), but here the artist translated the theme into Romanesque terms. This page may be a reliable picture of a medieval baron's costume. The typically Romanesque banding of the torso and partitioning of the folds (especially the servant's skirts) are evident, but the master painter deftly avoided stiffness and angularity. The partitioning actually accentuates the knight's verticality and elegance and the thrusting action of his servant. The flowing sleeves add a spirited flourish to the swordsman's gesture. The knight, handsomely garbed, cavalierly wears no armor and aims a single stroke with proud disdain.

MOSES IN AN ENGLISH BIBLE An illumination of exceedingly refined execution is the frontispiece (FIG. **17-38**) to the Book of Deuteronomy from the *Bury Bible*. The page exemplifies the sumptuous illustration common to the large Bibles produced in wealthy Romanesque abbeys not subject to the Cistercian ban. Such costly books were not only used by the monks in their studies and devotions but also lent prestige to monasteries that could afford them (see "Medieval Books," Chapter 16, page 434). MASTER HUGO, also a sculptor and metalworker, produced this volume at the Bury Saint Edmunds abbey in England around 1135. Hugo seems not to have been a monk but a secular artist, like Stephanus Garsia (FIG. 17-35), whom the abbey hired. Hugo and Stephanus were two of a growing number of professional artists and artisans who depended for their livelihood on commissions from well-endowed monasteries. They resided in the towns and traveled frequently to find work. These artists were still the exception, however, and the typical Romanesque scribes and illuminators continued to be monks and nuns working anonymously in the service of God. The Benedictine Rule, for example, specified that "craftsmen in the monastery . . . should pursue their crafts with all humility after the abbot has given permission."

Our page of the *Bury Bible* (FIG. 17-38) shows two scenes from Deuteronomy enframed by symmetrical leaf motifs in softly glowing harmonized colors. The upper register depicts

17-38 MASTER HUGO, Moses expounding the Law, folio 94 recto of the *Bury Bible,* from Bury Saint Edmunds, England, ca. 1135. Ink and tempera on vellum, approx. 1′ 8″ × 1′ 2″. Corpus Christi College, Cambridge.

Moses and Aaron proclaiming the law to the Israelites. Master Hugo represented Moses with horns, consistent with Saint Jerome's translation of the Hebrew word that also means "rays" (compare Michelangelo's similar conception of the Hebrew prophet, FIG. 22-10). The lower panel portrays Moses pointing out the clean and unclean beasts. The gestures are slow and gentle and have quiet dignity. The figures of Moses and Aaron seem to glide. This presentation is quite different from the abrupt emphasis and spastic movement seen in earlier Romanesque paintings. Here, as the patterning softens, the movements of the figures appear more integrated and smooth. Yet the patterning remains in the multiple divisions of the draped limbs, the lightly shaded volumes connected with sinuous lines and ladderlike folds. Hugo still thought of the drapery and body as somehow the same. The frame has a quite definite limiting function, and the painter carefully fit the figures within it.

THE "PRINCE OF SCRIBES" The last page of the *Eadwine Psalter* (FIG. **17-39**) presents a rare picture of a Romanesque artist at work. The book is the masterpiece of an English monk known as EADWINE THE SCRIBE. It contains

one hundred sixty-six illustrations, and many are variations of those in the Carolingian *Utrecht Psalter* (see FIG. 16-14). The "portrait" of Eadwine—it is probably a generic type and not a specific likeness—also has models in the past. It is in the long tradition of author portraits in ancient and medieval manuscripts (see FIGS. 16-8, 16-9, 16-12, 16-13, and 17-36), although the true author of the *Eadwine Psalter* is King David. The image of Eadwine is noteworthy because it represents a living man, a priestly scribe, not one of the Four Evangelists or another sacred person. Carolingian and Ottonian manuscripts included portraits of living men (FIG. 16-29), but those portraits were of reigning emperors, whose right to appear in sacred books was God given, just as Justinian and Theodora and their court had the right to be depicted in San Vitale's sanctuary (see FIGS. 12-10 and 12-11). Here, the inclusion of the scribe's own portrait sanctified his work. Eadwine exaggerated his importance by likening his image to that of an Evangelist writing his gospel and by including an inscription within the inner frame that identifies him and proclaims that he is a "prince among scribes." He declares that, due to the excellence of his work, his fame will endure forever and that he can offer his book as an acceptable gift to God. Eadwine, like other Romanesque sculptors and painters who signed their works, may have been concerned for his fame, but these artists, whether monks or laity, were not yet aware of the concepts of fine art and fine artist. To them, their work existed not for its own sake but for God's.

17-39 EADWINE THE SCRIBE(?), Eadwine the scribe at work, folio 283 verso of the *Eadwine Psalter,* ca. 1160–1170. Ink and tempera on vellum. Trinity College, Cambridge.

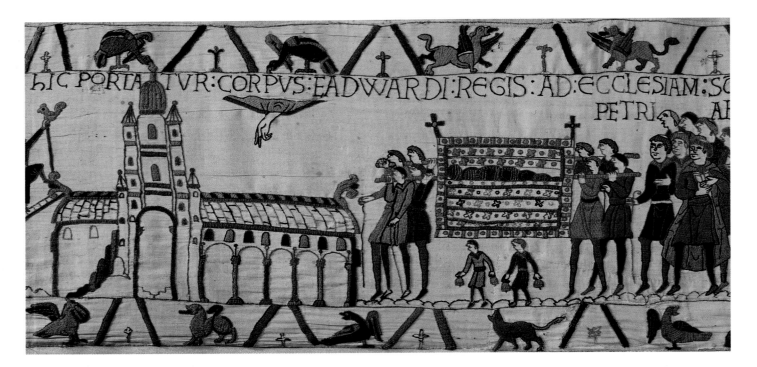

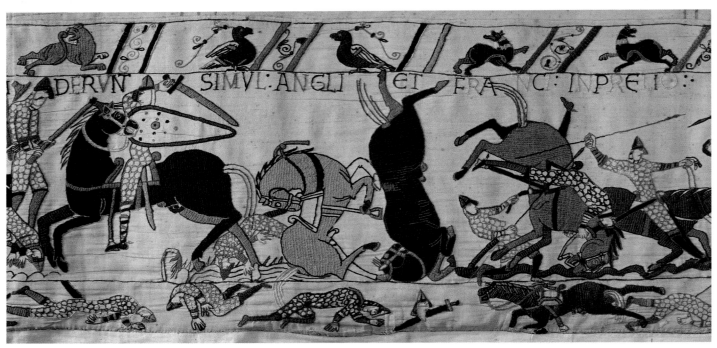

17-40 Funeral procession to Westminster Abbey *(top)* and the Battle of Hastings *(bottom)*, details of the *Bayeux Tapestry*, from Bayeux Cathedral, Bayeux, France, ca. 1070–1080. Embroidered wool on linen, 1′ 8″ high (entire length of fabric 229′ 8″). Centre Guillaume le Conquérant, Bayeux.

The Eadwine portrait's style is related to that of the *Bury Bible,* but, although the patterning is still firm (notably in the cowl and the thigh), the drapery falls more softly and follows the movements of the body beneath it. Here, the arbitrariness of many Romanesque painted and sculpted garments yielded slightly, but clearly, to the requirements of more naturalistic representation. The Romanesque artist's instinct for decorating the surface remained, as is apparent in the gown's whorls and spirals. But, significantly, these were painted in very

lightly so that they would not conflict with the functional lines that contain them.

THE CONQUEST OF ENGLAND This account of Romanesque painting concludes with a work that is *not* a painting. Nor is the so-called *Bayeux Tapestry* (FIG. 17-40) a woven tapestry. It is, instead, an embroidered fabric made of wool sewn on linen (see "Embroidery and Tapestry," page 485). But the *Bayeux Tapestry* is closely related to Romanesque

Embroidery and Tapestry

The most famous embroidery of the Middle Ages is, ironically, known as the *Bayeux Tapestry* (FIG. 17-40). Embroidery and tapestry are related, but different, means of decorating textiles. *Tapestry* designs are woven on a loom as part of the fabric. *Embroidery* patterns are sewn with threads.

The needleworkers who fashioned the *Bayeux Tapestry* were either Norman or English women. They employed eight colors of dyed wool—two varieties of blue, three shades of green, yellow, buff, and terracotta red—and two kinds of stitches. In *stem stitching*, short overlapping strands of thread form jagged lines. *Laid-and-couched work* creates solid blocks of color. In the latter technique, the needleworker first lays down a series of parallel and then a series of cross stitches. Finally, the stitcher tacks down the cross-hatched threads using couching (knotting). On the *Bayeux Tapestry,* the natural linen color was left exposed for the background, human flesh, building walls, and other "colorless" design elements. Stem stitches define the contours of figures and buildings and delineate interior details, such as facial features, body armor, and roof tiles. Laid-and-couched work was employed for clothing, animal bodies, and other solid areas.

manuscript illumination. Its borders are populated by the kinds of real and imaginary animals found in contemporaneous books, and its pictures are often accompanied by an explanatory Latin text sewn in thread.

Some twenty inches high and about two hundred thirty feet long, the *Bayeux Tapestry* is a continuous, friezelike, pictorial narrative of a crucial moment in England's history and of the events that led up to it. The Norman defeat of the Anglo-Saxons at Hastings in 1066 brought England under the control of the Normans, uniting all of England and much of France under one rule. The dukes of Normandy became the kings of England. Commissioned by Bishop Odo, the half brother of the conquering Duke William, the embroidery may have been sewn by women at the Norman court. Many art historians, however, believe it was the work of English stitchers in Kent, where Odo was earl after the Norman conquest. Odo donated the work to Bayeux Cathedral (hence its nickname), but it is uncertain whether it was originally intended for display in the church's nave, where the theme would have been a curious choice.

The circumstances leading to the Norman invasion of England are well documented. In 1066, Edward the Confessor, the Anglo-Saxon king of England, died. The Normans believed Edward had recognized William of Normandy as his rightful heir. But the crown went to Harold, earl of Wessex, the king's Anglo-Saxon brother-in-law, who had sworn an oath of allegiance to William. The betrayed Normans, descendants of the seafaring Vikings, boarded their ships, crossed the English Channel, and crushed Harold's forces.

We illustrate two episodes of the epic tale as represented in the *Bayeux Tapestry.* The first detail (FIG. 17-40, top) depicts King Edward's funeral procession. The hand of God points the way to the church where he was buried—Westminster Abbey, consecrated on December 28, 1065, just a few days before Edward's death. The church was one of the first Romanesque buildings erected in England, and the embroiderers took pains to record its main features, including the imposing crossing tower and the long nave with tribune gallery. Here William was crowned king of England on Christmas Day, 1066. (The coronation of every English monarch since then also has occurred in Westminster Abbey.)

The second detail (FIG. 17-40, bottom) shows the Battle of Hastings in progress. The Norman cavalry cuts down the English defenders. The lower border is filled with the dead and wounded, although the upper register continues the animal motifs of the rest of the embroidery. The Romanesque artist co-opted some of the characteristic motifs of Greco-Roman battle scenes. Note, for example, the horses with twisted necks and contorted bodies (compare FIG. 5-69). But the artists translated the figures into the Romanesque manner. Linear patterning and flat color replaced three-dimensional volume and modeling in light and dark hues.

The *Bayeux Tapestry* is unique in Romanesque art in that it depicts an event in full detail at a time shortly after it occurred, recalling the historical narratives of ancient Roman art. The Norman embroidery often has been likened to the scroll-like frieze of the Column of Trajan (see FIG. 10-42). Like the account on the Column of Trajan, the story told on the *Bayeux Tapestry* is the conqueror's version of history, a proclamation of national pride. And as on Trajan's Column, the narrative is not confined to battlefield successes; it is a complete chronicle of events. Included are the preparations for war, with scenes depicting the felling and splitting of trees for ship construction; the loading of equipment onto the vessels; the cooking and serving of meals; and so forth. In this respect, the *Bayeux Tapestry* is the most *Roman*-esque of all Romanesque artworks.

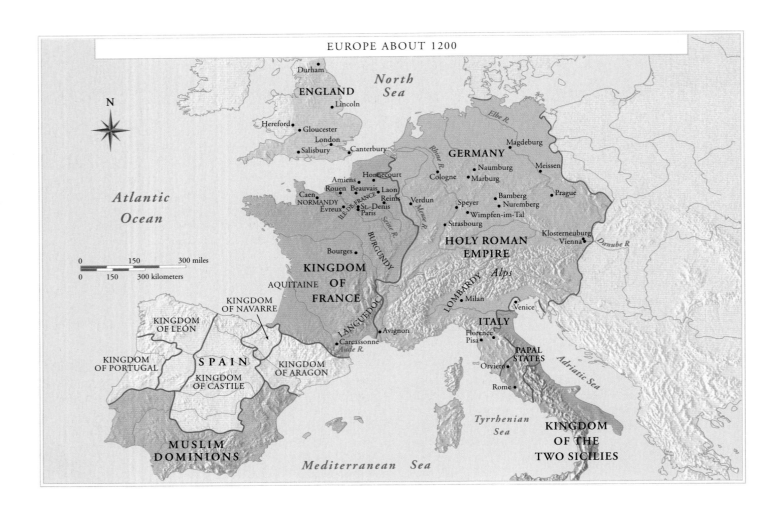

EUROPE ABOUT 1200

North Sea

Atlantic Ocean

ENGLAND
Durham
Lincoln
Hereford • Gloucester
London
Salisbury • Canterbury

GERMANY
Magdeburg
Naumburg • Meissen
Cologne • Marburg
Amiens • Honnecourt
Rouen Beauvais • Laon
Caen • Reims
NORMANDY ILE-DE-FRANCE St.-Denis
Evreux Paris
Verdun
Bamberg • Prague
Speyer • Nuremberg
Wimpfen-im-Tal
Strasbourg

HOLY ROMAN EMPIRE
Klosterneuburg
Vienna
Danube R.

KINGDOM OF FRANCE
Bourges
AQUITAINE
BURGUNDY
Alps
LOMBARDY
Milan
Venice

LANGUEDOC
Carcassonne • Avignon
Aude R.

ITALY
Florence
Pisa
Orvieto

PAPAL STATES
Adriatic Sea

Rome

SPAIN
KINGDOM OF LEÓN
KINGDOM OF NAVARRE
KINGDOM OF PORTUGAL
KINGDOM OF CASTILE
KINGDOM OF ARAGON

MUSLIM DOMINIONS

Mediterranean Sea

Tyrrhenian Sea

KINGDOM OF THE TWO SICILIES

Elbe R.
Rhine R.
Meuse R.
Seine R.

0 150 300 miles
0 150 300 kilometers

1140	1194	1220
EARLY GOTHIC	HIGH GOTHIC	

*Abbey church
Saint-Denis, 1140–1144*

*Nicholas of Verdun
Shrine of the Three Kings
Cologne Cathedral, begun ca. 1190*

*Amiens Cathedral
begun ca. 1220*

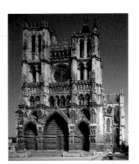

*Moralized Bible of
Blanche of Castile, 1226–1234*

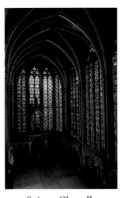

*Sainte-Chapelle
Paris, 1243–1248*

Peter Abelard, 1079–1142

Suger, Abbot of Saint-Denis, 1122–1151

King Louis VII of France, r. 1137–1180

Second Crusade, 1147–1149

Frederick Barbarossa, Holy Roman Emperor, r. 1152–1190

Crétien de Troyes, fl. ca. 1160–1190

King Philip Augustus of France, r. 1180–1223

Saint Francis of Assisi, 1182–1226

University of Paris founded, ca. 1200

Capture of Constantinople by Latins (Fourth Crusade), 1204

King John of England signs Magna Carta, 1215

Frederick II, Holy Roman Emperor, r. 1220–1250

Romance of the Rose, Part I, ca. 1225–1235

Saint Thomas Aquinas, 1225–1274

King Louis IX (Saint Louis) of France, r. 1226–1270

Blanche of Castile, regent of France, 1226–1234

18

THE AGE OF THE GREAT CATHEDRALS

GOTHIC ART

1250	1300	1500
	LATE GOTHIC	

Ekkehard and Uta
Naumburg Cathedral
ca. 1249–1255

Master Honoré
Breviary of Philippe
le Bel, 1296

Virgin of Jeanne
d'Évreux, 1339

Milan Cathedral
begun 1386

House of Jacques Coeur
Bourges, 1443–1451

Chapel of Henry VII
London, 1503–1519

Treaty of Paris between Louis IX and Henry III of England, 1259

Byzantines retake Constantinople, 1261

Dante Alighieri, 1265–1321

Marco Polo in China, 1271–1292

Romance of the Rose, Part II, ca. 1275–1280

King Philippe le Bel of France, r. 1285–1314

Pope Boniface VIII canonizes Louis IX, 1297

King Edward II of England, r. 1307–1327

King Charles IV of France, r. 1322–1328

Hundred Years' War between France and England, 1337–1453

Geoffrey Chaucer, ca. 1343–1400

Black Death first sweeps over Europe, 1347–1350

Great Schism, 1378–1417

Fall of Constantinople to the Ottoman Turks, 1453

King Henry VII of England, r. 1471–1509

GOTHIC EUROPE

GOTHS AND "GOTHIC" In the mid-sixteenth century, Giorgio Vasari, the "father of art history" (see "Giorgio Vasari on Raphael," Chapter 22, page 654), used "Gothic" as a term of ridicule to describe late medieval art and architecture. For him, Gothic art was "monstrous and barbarous," invented by the Goths.[1] Vasari and other admirers of Greco-Roman art believed those uncouth warriors were responsible not only for Rome's downfall but also for the destruction of the classical style in art and architecture. In the thirteenth and fourteenth centuries, however, when the Gothic style was the rage in most of Europe, especially north of the Alps, contemporary commentators considered Gothic buildings *opus modernum* (modern work) or *opus francigenum* (French work). They recognized that the great cathedrals towering over their towns displayed an exciting and new building and decoration style —and that the style originated in France. People regarded their new cathedrals not as distortions of the classical style but as images of the City of God, the Heavenly Jerusalem, which they were privileged to build on earth.

The Gothic style first appeared in northern France around 1140. In southern France (see FIG. 17-27) and elsewhere in Europe the Romanesque style still flourished. But by the thirteenth century, the opus modernum of the region around Paris had spread throughout western Europe, and in the next century further still. The Cathedral of Saint Vitus in Prague (Czech Republic), for example, begun in 1344, closely emulated French Gothic architecture.

Although it became an internationally acclaimed style, Gothic art was, nonetheless, a regional phenomenon. To the east and south of Europe, the Islamic and Byzantine styles still held sway. And many regional variants existed within European Gothic, just as distinct regional styles characterized the Romanesque period. Gothic began and ended at different dates in different places. When the banker Jacques Coeur built his home in Bourges (FIG. 18-30) in the Gothic style in the mid-fifteenth century, classicism already reigned supreme in Italy. While the Gothic church of Saint-Maclou (FIG. 18-28) was under construction in Rouen in the early years of the sixteenth century, Michelangelo was painting the ceiling of the Sistine Chapel in Rome.

TURMOIL AND CHANGE The Gothic period was a time of not only great prosperity but also turmoil in Europe. In 1337, the Hundred Years' War began, shattering the peace between France and England. In the fourteenth century, a great plague, the Black Death, swept over western Europe and killed at least a quarter of its people. From 1378 to 1417, opposing popes resided in Rome and in Avignon in southern France during the political-religious crisis known as the Great Schism (see Chapter 19).

Above all, the Gothic age was a time of profound change in European society. The centers of both intellectual and religious life shifted definitively from monasteries to cities. In these urban areas, prosperous merchants made their homes, universities run by professional guilds of scholars formed, minstrels sang of chivalrous knights and beautiful maidens at

18-1 Ambulatory and radiating chapels, abbey church, Saint-Denis, France, 1140–1144.

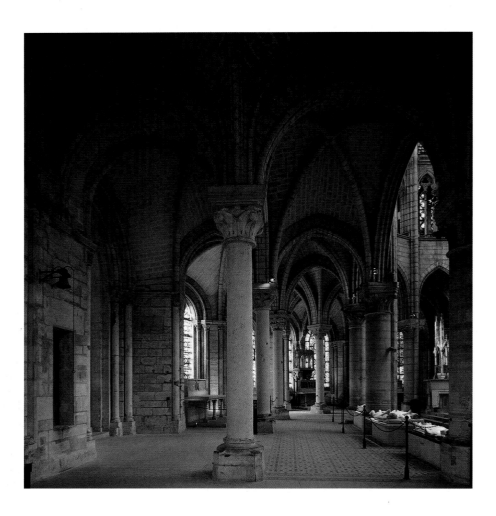

Abbot Suger and the Rebuilding of Saint-Denis

Abbot Suger of Saint-Denis (1081–1151) rose from humble parentage to become the right-hand man of both Louis VI (r. 1108–1137) and Louis VII (r. 1137–1180). When the latter, accompanied by his queen, Eleanor of Aquitaine, left to join the Second Crusade (1147–1149), Suger served as regent of France. From his youth, Suger wrote, he had dreamed of the possibility of embellishing the church in which French monarchs had been buried since the ninth century. In 1122, he became abbot of Saint-Denis and within fifteen years began rebuilding the monastery founded in the Merovingian age. In Suger's time, the French kings' power, except for scattered holdings, extended over an area not much larger than the Île-de-France, the region centered on Paris. But the kings had pretensions to rule all of France. Suger aimed to increase both the prestige of his abbey and of the monarchy by rebuilding France's royal church in grand fashion.

Suger wrote three detailed treatises about his activities as abbot of Saint-Denis. He recorded that he summoned masons and artists from many regions to help design and construct his new church. And in one important passage he described the special qualities of the new choir (FIGS. 18-1 to 18-3) dedicated in 1144:

> [I]t was cunningly provided that—through the upper columns and central arches which were to be placed upon the lower ones built in the crypt—the central nave of the old [Carolingian church] should be equalized, by means of geometrical and arithmetical instruments, with the central nave of the new addition; and, likewise, that the dimensions of the old side-aisles should be equalized with the dimensions of the new side-aisles, except for that elegant and praiseworthy extension in [the form of] a circular string of chapels, by virtue of

which the whole [church] would shine with the wonderful and uninterrupted light of most sacred windows, pervading the interior beauty.[1]

The abbot's brief discussion of the new choir's design is key to the understanding of Early Gothic architecture. But he wrote at much greater length about his church's glorious golden and gem-studded furnishings. Here, for example, is Suger's description of the *altar frontal* (hanging in front of the altar) in the choir:

> Into this panel, which stands in front of [Saint Denis's] most sacred body, we have put . . . about forty-two marks of gold [and] a multifarious wealth of precious gems, hyacinths, rubies, sapphires, emeralds and topazes, and also an array of different large pearls.[2]

The costly furnishings and the light-filled space caused Suger to "delight in the beauty of the house of God" and "called [him] away from external cares." The new church made him feel as if he was "dwelling . . . in some strange region of the universe which neither exists entirely in the slime of the earth nor entirely in the purity of Heaven." In Suger's eyes, then, his splendid new church, permeated with *lux nova* (new light) and outfitted with gold and precious gems, was a waystation on the road to Paradise, which "transported [him] from this inferior to that higher world."[3]

[1] Erwin Panofsky, trans., *Abbot Suger on the Abbey Church of Saint-Denis and Its Art Treasures,* 2nd ed. (Princeton, N.J.: Princeton University Press, 1979), 101.

[2] Ibid., 55.

[3] Ibid., 65.

royal "courts of love," and bishops erected great new cathedrals reaching to the sky. Although the papacy was at the height of its power and knights throughout Europe still gathered to wage Crusades against the Muslims, modern Europe's independent secular nations were beginning to take shape. Foremost among them was France.

FRENCH GOTHIC

Architecture and Architectural Decoration

THE BIRTH OF GOTHIC ARCHITECTURE On June 11, 1144, King Louis VII of France, Queen Eleanor of Aquitaine, royal court members, and a host of distinguished clergy, including five archbishops, converged on the Benedictine abbey church of Saint-Denis for the dedication of its new choir (FIG. **18-1**). Saint Dionysius (Denis in French) was the apostle who brought Christianity to Gaul and who died a

martyr's death there in the third century. The church, just a few miles north of Paris, housed the saint's tomb and those of the French kings, as well as the crimson military banner said to have belonged to Charlemagne. The Carolingian basilica was France's royal church, the very symbol of the monarchy (just as Speyer Cathedral, FIGS. 17-4 and 17-5, was the burial place of the German rulers of the Holy Roman Empire). But the old building had been in disrepair and had become too small to accommodate the growing number of pilgrims. Its abbot, Suger, also had believed it was of insufficient grandeur to serve as the official church of the French kings (see "Abbot Suger and the Rebuilding of Saint-Denis," above). Thus, Suger began to rebuild the church in 1135 by erecting a new west facade with sculptured portals. In 1140, work began on the east end. Suger died before he could remodel the nave but he attended the 1144 choir dedication.

Because the French considered the old church a relic in its own right, the new choir had to conform to the dimensions of the crypt below it. Nevertheless, the elevation and plan

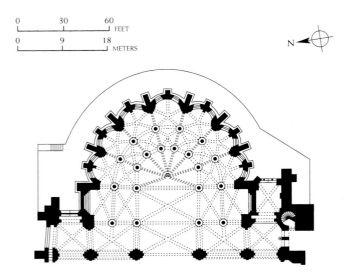

18-2 Plan of the choir, abbey church, Saint-Denis, France, 1140–1144 (after Sumner Crosby).

18-3 Vaults of the ambulatory and radiating chapels of the choir, abbey church, Saint-Denis, France, 1140–1144.

(FIG. **18-2**) of Suger's choir represented a sharp break from past practice. The choir of 1140–1144 is the birthplace of Gothic architecture. Innovative rib vaults resting on pointed arches (see "The Gothic Rib Vault," page 494) cover the ambulatory and chapels (FIG. **18-3**). These pioneering, exceptionally light, vaults spring from slender columns in the ambulatory and from the thin masonry walls framing the chapels. Because of the vaults' lightness, the walls between the chapels were eliminated and the outer walls opened up and filled with stained-glass windows (see "Stained-Glass Windows," page 500). Suger and his contemporaries marveled at the "wonderful and uninterrupted light" that poured in through the "most sacred windows." The abbot called the colored light *lux nova*, "new light." The polychrome rays coming through the windows shine on the walls and columns, almost dissolving them. Both the new type of vaulting and the use of stained glass became hallmarks of the French Gothic style in architecture.

ROYAL PORTALS FILLED WITH SCULPTURE
Saint-Denis is the key monument of Early Gothic art and architecture. Gothic sculpture, as well as architecture and stained glass, made its first appearance at Saint-Denis. Little of the sculpture of the abbey church's west facade survived the French Revolution, although much of the structure is intact. The west facade consists of a double-tower westwork as at Saint-Étienne at Caen (see FIG. 17-9) and has massive walls in the Romanesque tradition. A restored large central *rose window* (a circular stained-glass window) punctuates the facade's upper story, a new feature that became standard in French Gothic architecture. For the three portals, Suger imported sculptors to carry on the rich heritage of Romanesque Burgundy. But at Saint-Denis, statues of Old Testament kings, queens, and prophets attached to columns screened the jambs of all three doorways.

This innovative treatment of the portals of Suger's church appeared immediately afterward at the Cathedral of Notre Dame ("Our Lady," that is, the Virgin Mary) at Chartres, also in the Île-de-France. Work on the west facade, the "Royal Portal" (FIGS. **18-4** and **18-5**), began around 1145. (The Royal Portal is so named because of the statue columns of

kings and queens flanking its three doorways.) The lower parts of the massive west towers at Chartres and the portals between them are all that survived of a cathedral begun in 1134 and destroyed by fire in 1194 before it had been completed. Reconstruction of the cathedral began immediately, but in the High Gothic style (discussed later). The west portals, however, constitute the most complete and impressive surviving ensemble of Early Gothic sculpture. Thierry of Chartres, chancellor of the School of Chartres from 1141 until his death ten years later, may have conceived the complex iconographical program. The right-portal archivolts, for example, depict the seven female Liberal Arts and their male champions. The figures represent the core of medieval learning and symbolize human knowledge, which Thierry and others believed led to true faith.

The sculptures of the west facade (FIG. 18-5) proclaim the majesty and power of Christ. To unite the three doorways iconographically and visually, the sculptors carved episodes from Christ's life on the capitals, which form a kind of frieze linking one entrance to the next. In the right-portal tympanum, Christ appears in the lap of his Virgin Mother, while scenes of his birth and early life fill the lintel below. The tympanum's theme and composition recall Byzantine representations of the Theotokos (see FIGS. 12-15 and 12-16), as well as the Romanesque Throne of Wisdom (see FIG. 17-30). But

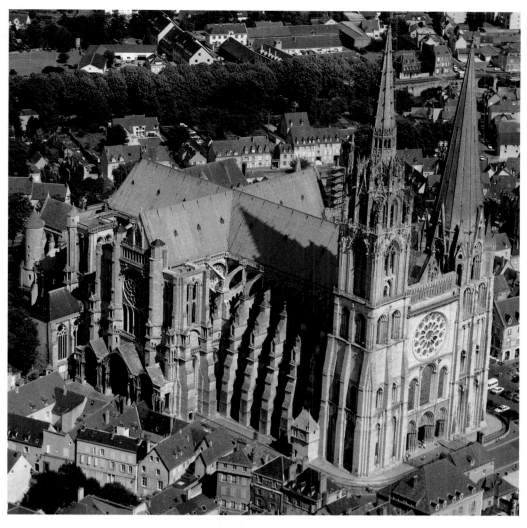

18-4 Aerial view from the northwest of Chartres Cathedral, Chartres, France, begun 1134; rebuilt after 1194.

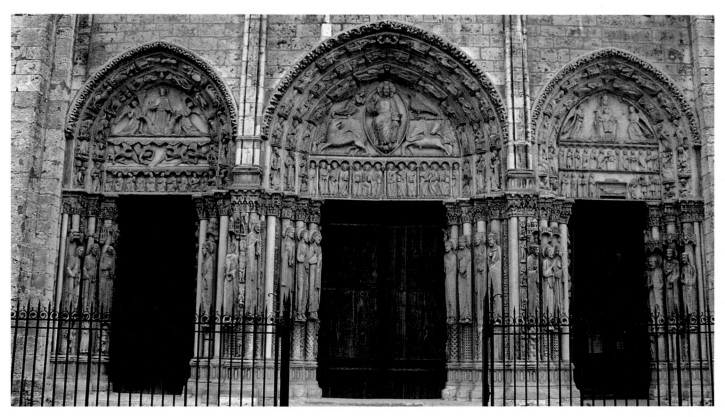

18-5 Royal Portal, west facade, Chartres Cathedral, Chartres, France, ca. 1145–1155.

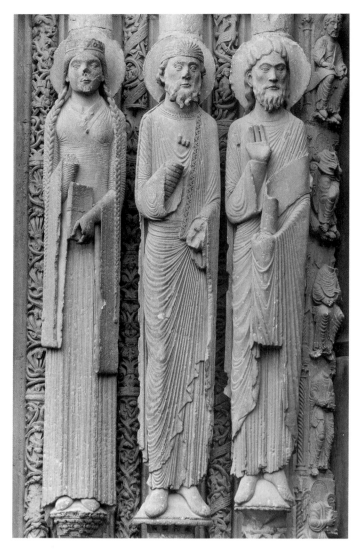

18-6 Old Testament queen and two kings, jamb statues, central doorway of Royal Portal, Chartres Cathedral, Chartres, France, ca. 1145–1155.

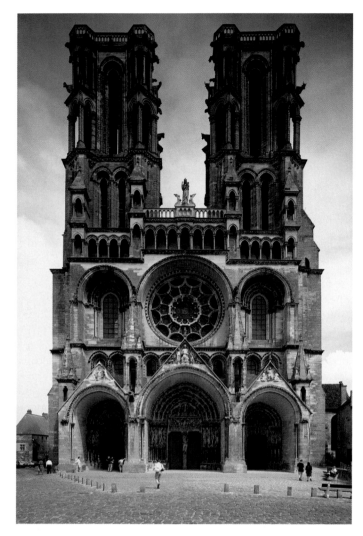

18-7 West facade of Laon Cathedral, Laon, France, begun ca. 1190.

Mary's prominence on the Chartres facade has no parallel in the decoration of Romanesque church portals. At Chartres the designers gave her a central role in the sculptural program, a position she maintained throughout the Gothic period. The cult of the Virgin Mary reached a high point in the Gothic age. As the Mother of Christ, she stood compassionately between the Last Judge and the horrors of Hell, interceding for all her faithful. Worshipers in the later twelfth and thirteenth centuries sang hymns to her, put her image everywhere, and dedicated great cathedrals to her. Soldiers carried the Virgin's image into battle on banners, and her name joined Saint Denis's as part of the French king's battle cry. Mary became the spiritual lady of chivalry, and the Christian knight dedicated his life to her. The severity of Romanesque themes stressing the Last Judgment yielded to the gentleness of Gothic art, where Mary is the kindly Queen of Heaven.

Christ's Ascension into Heaven appears in the tympanum of the left portal. All around, in the archivolts, are the signs of the zodiac and scenes representing the various labors of the months of the year. They are symbols of the cosmic and earthly worlds. The Second Coming is the central tympanum's subject. The signs of the Four Evangelists, the Twenty-

Four Elders of the Apocalypse, and the Twelve Apostles appear around Christ or on the lintel. The Second Coming—in essence, the Last Judgment theme—was still of central importance, as it was in Romanesque portals. But at Early Gothic Chartres the theme became a symbol of salvation rather than damnation.

THE EARLY GOTHIC STATUE-COLUMN Statues of Old Testament kings and queens (FIG. **18-6**) decorate the jambs flanking each doorway of the Royal Portal. They are the royal ancestors of Christ and, both figuratively and literally, support the New Testament figures above the doorways. They wear twelfth-century clothes, and medieval observers also regarded them as images of the kings and queens of France, symbols of secular as well as of biblical authority. (This was the motivation for vandalizing the comparable figures at Saint-Denis during the French Revolution.)

Seen from a distance, the statue-columns appear to be little more than vertical decorative accents within the larger designs of the portals and facade (FIG. 18-5). The figures stand rigidly upright with their elbows held close against their hips. The linear folds of their garments—the Romanesque style's heritage, along with the elongated proportions—generally echo the vertical lines of the columns behind them. (In this respect,

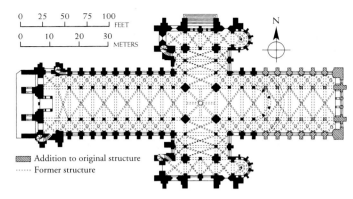

Addition to original structure
Former structure

18-8 Plan of Laon Cathedral, Laon, France, ca. 1160–1205; choir extended after 1210 (after Ernst Gall).

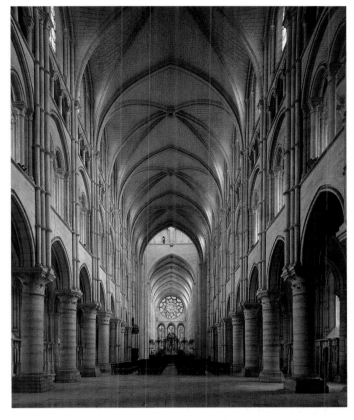

18-9 Nave of Laon Cathedral (view facing east), Laon, France, begun ca. 1190.

Gothic jamb statues differ significantly from classical caryatids; see FIG. 5-52. The Gothic figures are *attached* to columns. The classical statues *replaced* the columns.) And yet, within and despite this architectural straitjacket, the statues display the first signs of a new naturalism. They stand out from the plane of the wall. The sculptors conceived and treated the statues as three-dimensional volumes, so the figures "move" into the space of observers. The new naturalism is noticeable particularly in the statues' heads, where kindly human faces replace the masklike features of most Romanesque figures. At Chartres, a personalization of appearance began that was transformed first into idealized portraits of the perfect Christian and finally, by 1400, into the portraiture of specific individuals. The Royal Portal statues' heads announced an era of artistic concern with personality and individuality.

ROMANESQUE AND GOTHIC AT LAON As noted, Suger completed only the new choir and narthex of Saint-Denis in the twelfth century. Laon Cathedral (FIGS. **18-7** to

18-9), however, provides a fairly complete view of Early Gothic church architecture of the second half of the century. Begun about 1160 and finished shortly after 1200, this building retained many Romanesque features but combined them with the Gothic rib vault resting on pointed arches.

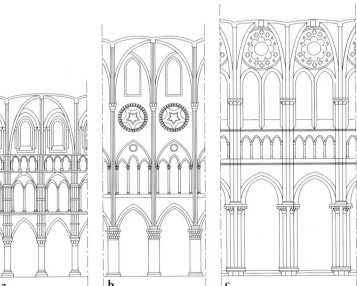

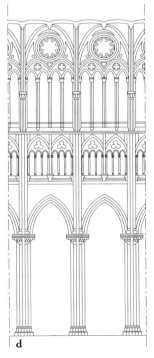

18-10 Nave elevations of four French Gothic cathedrals at the same scale (after Louis Grodecki): *(a)* Laon, *(b)* Paris, *(c)* Chartres, *(d)* Amiens.

a b c d

The Gothic Rib Vault

The ancestors of the Gothic rib vault are the Romanesque vaults found at Caen (see FIG. 17-10), Durham (see FIG. 17-12), and elsewhere. The rib vault's distinguishing feature is its crossed, or diagonal, arches under its groins, as seen in the Saint-Denis choir (FIG. 18-3; compare FIG. 18-20). These arches form the *armature,* or skeletal framework for constructing the vault. Gothic vaults generally have more thinly vaulted webs, or *severies,* between the arches than Romanesque vaults have. But the chief difference between Romanesque and Gothic rib vaults is the pointed arch, an integral part of the Gothic skeletal armature. Pointed arches were first widely used in Sasanian architecture (see FIG. 2-28), and Islamic builders later adopted them. French Romanesque architects (for example, at Cluny III; see Chapter 17, page 457) borrowed the form from Muslim Spain and passed it to their Gothic successors. Pointed arches allowed Gothic builders to make the crowns of all the vault's arches approximately the same level, regardless of the space to be vaulted. The Romanesque architects could not achieve this with their semicircular arches.

Our diagrams illustrate this key difference. In diagram *a,* the rectangle *ABCD* is an oblong nave bay to be vaulted. *AC* and *DB* are the diagonal ribs; *AB* and *DC,* the transverse arches; and *AD* and *BC,* the nave arcade's arches. If the architect uses semicircular arches (*AFB, BJC,* and *DHC*),

their radii and, therefore, their heights (*EF, IJ,* and *GH*), will be different, because the height of a semicircular arch is determined by its width. The result will be a vault (diagram *b*) with higher transverse arches (*DHC*) than the arcade's arches (*CJB*). The vault's crown (*F*) will be still higher. If the archi-tect uses pointed arches, the points (and hence the ribs) can have the same heights (*IK* and *GL* in diagram *a*). The result will be a Gothic rib vault (diagram *c*), where the points of the arches (*L* and K) are at the same level as the vault's crown (*F*).

A major advantage of the Gothic vault is its flexibility, which permits the vaulting of compartments of varying shapes, as may be seen in the Saint-Denis choir plan (FIG. 18-2). Pointed arches also channel the weight of the vaults more directly downward than do semicircular arches. The vaults, therefore, require less buttressing to hold them in place, in turn permitting the opening up of the walls beneath the arches with large windows. Because pointed arches also lead the eye upward, they make the vaults appear taller than they actually are. In our diagrams, the crown (*F*) of both the Romanesque (diagram *b*) and Gothic (diagram *c*) vaults is the same height from the pavement, but the Gothic vault seems taller. Both the physical and visual properties of rib vaults with pointed arches aided Gothic architects in their quest for soaring height in church interiors.

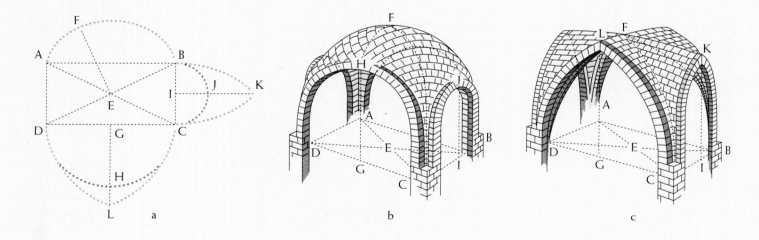

Among the plan's Romanesque features are the nave bays with their large six-part rib vaults, flanked by two small groin-vaulted squares in each aisle (FIG. 18-8). The vaulting system (except for the pointed arches), as well as the vaulted gallery above the aisles, derived from Norman Romanesque churches such as Saint-Étienne at Caen (see FIG. 17-10), which enjoyed great prestige in northern France throughout the twelfth century. A new feature found in the Laon interior, however, is

the *triforium,* the band of arcades below the clerestory (FIG. 18-9) occupying the space corresponding to the exterior strip of wall that the sloping timber roof above the galleries covers. The triforium has no practical function. Its introduction expressed a growing desire to break up and eliminate all continuous wall surfaces. The insertion of the triforium into the Romanesque three-story nave-wall elevation produced the characteristic four-story Early Gothic interior elevation (FIG. 18-9):

nave arcade, vaulted gallery, triforium, and clerestory with single *lancets* (tall, narrow windows ending in pointed arches). FIG. **18-10** compares the Laon nave elevation with those of later Gothic cathedrals.

The Laon architect also employed the alternate-support system of Caen and other Romanesque churches, but more subtly. The nave arcade does not reflect the alternation (although the builders added colonnettes to a few of the columns as work progressed). Rather, the distinction begins above the nave piers, where bundles of three and five shafts alternate in framing the aisle bays. The Laon architect moved away from the compartmentalized effect of Romanesque interiors, which tends to make visitors pause as they advance from unit to unit. Gothic builders aimed, even if rather timidly at Laon, to create a unified interior space that sweeps uninterruptedly from west to east. The level crowns of the successive nave vaults, made possible by pointed arches, enhance this longitudinal continuity (FIG. 18-9).

Laon Cathedral's west facade (FIG. 18-7) signals an even more pronounced departure from the Romanesque style still lingering at Saint-Denis and the Chartres Royal Portal. Typically Gothic are the huge central rose window, the deep porches in front of the doorways, and the open structure of the towers. (The statues of oxen on the towers refer to the local legend that oxen miraculously appeared to haul stones for an earlier church on the site.) A comparison of the facades of Laon Cathedral and Saint-Étienne at Caen (see FIG. 17-9) reveals a much deeper penetration of the wall mass in the later building. At Laon, as in Gothic architecture generally, the operating principle was to reduce sheer mass and replace it with intricately framed voids.

A NEW CATHEDRAL RISES IN PARIS About 1130, Louis VI moved his official residence to Paris, spurring much commercial activity and a great building boom. Paris soon became the leading city of France, indeed of all northern Europe (see "Paris: The Intellectual Capital of Gothic Europe," page 496), making a new cathedral a necessity. Notre-Dame of Paris (FIG. **18-11**) occupies a picturesque site on an island in the Seine River called the Île-de-la-Cité. The Gothic church replaced a large five-aisled Merovingian basilica and has a complicated building history. The choir and transept were completed by 1182; the nave, by ca. 1225; and the facade not until ca. 1250–1260. Sexpartite vaults covered the

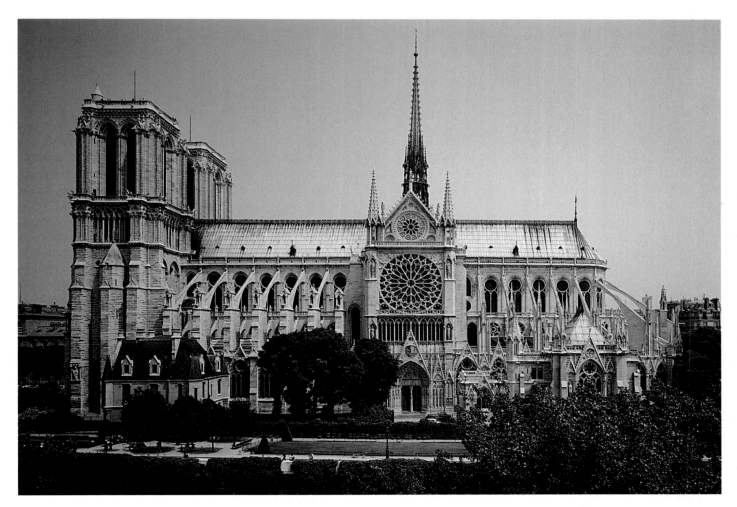

18-11 Notre-Dame (view from the south), Paris, France, begun 1163; nave and flying buttresses, ca. 1180–1200; remodeled after 1225.

Paris
The Intellectual Capital of Gothic Europe

A few years before the formal consecration of the altar of Notre-Dame in Paris (FIG. 18-11), Philip II (Philip Augustus, r. 1180–1223) succeeded to the throne. Philip brought the barons under his control and expanded the royal domains to include Normandy in the north and most of Languedoc in the south, laying the foundations for the modern nation of France. Renowned as "the maker of Paris," he gave the city its walls, paved its streets, and built the palace of the Louvre (now one of the world's great museums) to house the royal family. Although Rome remained the religious center of western Christendom, Paris became its intellectual capital. The University of Paris attracted the best minds from all over Europe. Virtually every thinker of note in the Gothic world at some point studied or taught at Paris.

Even in the Romanesque period, Paris was a learning center. Its Cathedral School professors were known as Schoolmen and the philosophy they developed as Scholasticism. The greatest of the early Schoolmen was Peter Abelard (1079–1142), a champion of logical reasoning. Abelard and his contemporaries had been introduced to the writings of the Greek philosopher Aristotle through the Arabic scholars of Islamic Spain. Abelard applied Aristotle's system of rational inquiry to the interpretation of religious belief. Until the twelfth century, truth had been considered the exclusive property of divine revelation as given in the Holy Scriptures. But the Schoolmen, using Aristotle's method, sought to demonstrate that reason alone could lead to certain truths. Their goal was to prove the central articles of Christian faith by argument *(disputatio)*. In Scholastic argument, a possibility is stated, an authoritative view is cited in objection, the positions are reconciled, and, finally, a reply is given to each of the rejected original arguments.

One of Abelard's greatest critics was Saint Bernard of Clairvaux (see "Saint Bernard of Clairvaux on Cloister Sculpture," Chapter 17, page 470), who believed Scholasticism was equivalent to questioning Christian dogma. Although Bernard succeeded in 1140 in having the Church officially condemn Abelard's doctrines, the Schoolmen's philosophy developed systematically until it became the dominant Western philosophy of the late Middle Ages. By the thirteenth century, the Schoolmen of Paris already had organized as a professional guild of master scholars, separate from the numerous Church schools the bishop of Paris oversaw. The Parisian guild's structure served as the model for many other European universities.

The greatest exponent of Abelard's Scholasticism was Thomas Aquinas (1225–1274), an Italian monk who became a saint. Aquinas settled in Paris in 1244. There, the German theologian Albertus Magnus instructed him in Aristotelean philosophy. Aquinas went on to become an influential teacher at the University of Paris. His most famous work, the *Summa Theologica* (left unfinished at his death), is a model of the Scholastic approach to knowledge. Aquinas divided his treatise into books, the books into questions, the questions into articles, each article into objections with contradictions and responses, and, finally, answers to the objections. He set forth five ways to prove the existence of God by rational argument. Aquinas's work remains the foundation of contemporary Catholic teaching.

The earliest manifestations of the Gothic spirit in art and architecture—the sculpted portals and vaulted choir of Suger's Saint-Denis (FIG. 18-1)—are contemporary with the first stages of Scholastic philosophy. Both also originated in Paris and its environs. Many art historians have noted the parallels between them, how the logical thrust and counterthrust of Gothic construction, the geometric relationships of building parts, and the systematic organization of the iconographical programs of Gothic church portals coincide with Scholastic principles and methods. Although no documents exist linking the scholars, builders, and sculptors, Gothic art and architecture shared with Scholasticism an insistence on systematic design and procedure. They both sought stable, coherent, consistent, and structurally intelligible solutions.

nave, as at Laon. The original elevation (the builders modified the design as work progressed) had four stories, but the scheme (FIG. 18-10*b*) differed from Laon's (FIG. 18-10*a*). In place of the triforium over the gallery, stained glass *oculi* (singular *oculus*, a small round window) opened up the wall below the clerestory lancets. As a result, of the four stories, two were filled by windows, further reducing the masonry area. (This four-story nave elevation can be seen in only one bay in FIG. 18-11, immediately to the right of the south transept, and partially hidden by it.)

THE FINAL GOTHIC INGREDIENT To hold the much thinner—and taller (compare FIGS. 18-10*a* and 18-10*b*)—walls of Notre-Dame in place, the unknown architect introduced *flying buttresses,* exterior arches that spring from the lower roofs over the aisles and ambulatory (FIG. 18-11) and counter the outward thrust of the nave vaults. Flying buttresses seem to have been employed as early as 1150 in a few smaller churches, but at Notre-Dame in Paris they circle a great urban cathedral. The internal quadrant arches the roofs at Durham conceal (see FIG. 17-13), also employed at Laon, perform a similar function and may be regarded as precedents for exposed Gothic flying buttresses. The combination of precisely positioned flying buttresses and rib vaults with pointed arches was the ideal solution to the problem of constructing towering naves with huge windows filled with stained glass. The flying buttresses, like slender extended fingers holding up the walls, also are important elements contributing to the distinctive "look" of Gothic cathedrals (see "The Gothic Cathedral," page 498).

CHARTRES AFTER THE GREAT FIRE The fire of 1194 was not the first to destroy parts of Chartres Cathedral, but it was especially devastating. Churches burned frequently in the Middle Ages (see "The Burning of Canterbury Cathedral," Chapter 17, page 455), and church officials often had to raise money suddenly for new building campaigns. In contrast to monastic churches, which usually were small and completed fairly quickly, the building histories of urban cathedrals often extended over decades and sometimes over centuries. Their financing depended largely on collections and public contributions (not always voluntary), and a lack of funds often interrupted building programs. Unforeseen events, such as wars, famines, or plagues, or friction between the town and the cathedral authorities would stop construction, which then might not resume for years. At Reims (FIG. 18-23), the clergy offered *indulgences* (pardons for sins committed) to those who helped underwrite the enormous cost of erecting the cathedral. The rebuilding of Chartres Cathedral after 1194 took a relatively short twenty-seven years, but at one point the townspeople revolted against the prospect of a heavier tax burden. They stormed the bishop's residence and drove him into exile for four years.

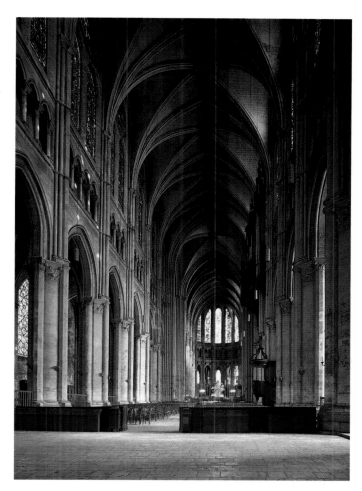

18-13 Nave of Chartres Cathedral (view facing east), Chartres, France, begun 1194.

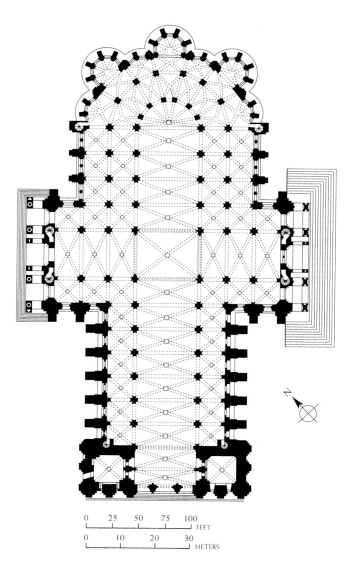

0 25 50 75 100
 FEET
0 10 20 30
 METERS

18-12 Plan of Chartres Cathedral, Chartres, France, as rebuilt after 1194 (after Paul Frankl).

Architectural historians usually consider the new Chartres Cathedral the first High Gothic building—the first to have been planned from the beginning with flying buttresses. The mid-twelfth-century facade left standing to the west (FIGS. 18-4 and 18-5) and the masonry of the crypt to the east determined the new structure's overall dimensions. The crypt housed the most precious relic of Chartres—the mantle of the Virgin, which miraculously survived the fire. For piety and economy, the builders used the crypt for the new structure's foundation. The earlier forms did not limit the plan (FIG. **18-12**), however, which reveals a new kind of organization. Rectangular nave bays replaced the square bays with six-part vaults and the alternate-support system, still present in Early Gothic churches such as Laon Cathedral (FIG. 18-8). The new system, where a rectangular unit in the nave, defined by its own vault, was flanked by a single square in each aisle rather than two, as before, became the High Gothic norm. A change in vault design and the abandonment of the alternate-support system usually accompanied this new bay arrangement. The High Gothic vault, which covered a relatively smaller area and therefore was braced more easily than its Early Gothic predecessor, had only four parts. The visual effect of these changes was to unify the interior (FIG. **18-13**). The High Gothic architect aligned identical units so that viewers saw them in too rapid a sequence to perceive them as individual volumes of space. The nave became a vast, continuous hall.

The Gothic Cathedral

The great cathedrals erected throughout Europe in the later twelfth and thirteenth centuries are the enduring symbols of the Gothic age. These towering structures are eloquent testimonies to the extraordinary skill of the architects, engineers, carpenters, masons, sculptors, glassworkers, and metalsmiths who constructed and decorated the buildings.

Most of the architectural components of Gothic cathedrals appeared in earlier structures, but the way Gothic architects combined these elements made these buildings unique expressions of medieval faith. The key ingredients of the Gothic "recipe" were rib vaults with pointed arches, flying buttresses, and huge colored-glass windows (see "Stained-Glass Windows," page 500). Our "exploded" view of a typical Gothic cathedral illustrates how these and other important Gothic architectural devices worked together.

THE VOCABULARY OF GOTHIC ARCHITECTURE

1. *Flying buttresses:* Masonry struts that transfer the thrust of the nave vaults across the roofs of the side aisles and ambulatory to a tall pier rising above the church's exterior wall. Compare the cross-section of Bourges Cathedral (see FIG. Intro-19).

2. *Pinnacle:* A sharply pointed ornament capping the piers or flying buttresses; also used on cathedral facades

3. *Vaulting web (Severy):* The masonry blocks that fill the area between the ribs of a groin vault

4. *Diagonal rib:* In plan, one of the ribs that form the X of a groin vault. In the diagrams of rib vaults on page 494, the diagonal ribs are the lines *AC* and *DB*.

5. *Transverse rib:* A rib that crosses the nave or aisle at a ninety-degree angle (lines *AB* and *DC* in the diagrams on page 494)

6. *Springing:* The lowest stone of an arch; in Gothic vaulting, the lowest stone of a diagonal or transverse rib

7. *Clerestory:* The windows below the vaults that form the nave elevation's uppermost level. By using flying buttresses and rib vaults on pointed arches, Gothic architects could build huge clerestory win-

dows and fill them with stained glass held in place by ornamental stonework called *tracery.*

8. *Triforium:* The intermediate story in a standard High Gothic three-story nave elevation consisting of arcades, usually blind (FIGS. 18-9 and 18-13) but occasionally filled with stained glass (see FIG. Intro-2)

9. *Nave arcade:* The series of arches supported by piers separating the nave from the side aisles

10. *Compound pier with shafts (responds):* Also called the *cluster pier,* a pier with a group, or cluster, of attached shafts, or *responds,* extending to the springing of the vaults

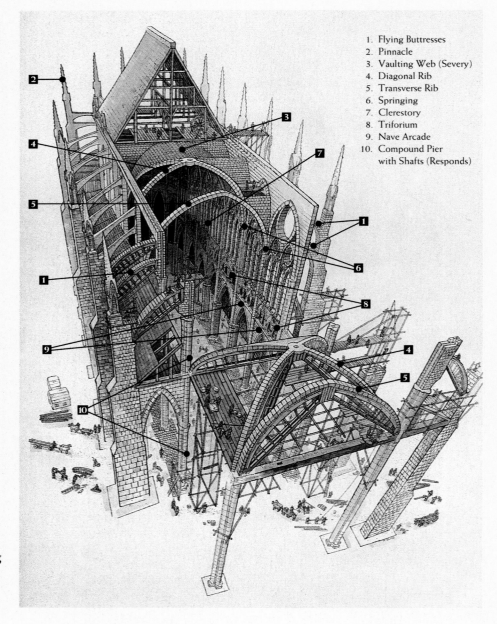

1. Flying Buttresses
2. Pinnacle
3. Vaulting Web (Severy)
4. Diagonal Rib
5. Transverse Rib
6. Springing
7. Clerestory
8. Triforium
9. Nave Arcade
10. Compound Pier with Shafts (Responds)

A new nave-wall elevation, which admitted more light to the nave through greatly enlarged clerestory windows, enhanced the organic, "flowing" quality of the High Gothic interior. Flying buttresses made it possible to eliminate the tribune gallery above the aisle, which had partially braced Romanesque and Early Gothic naves (compare FIG. 18-10*c* with FIGS. 18-10*a* and 18-10*b*). The High Gothic tripartite nave elevation, consisting of arcade, triforium, and clerestory, emphasized the large clerestory windows. Those at Chartres are almost as high as the main arcade and consist of double lancets crowned by a single oculus. The strategic placement of flying buttresses permitted the construction of nave walls whose voids dominated so that heavy masonry played a minor role.

Despite the vastly increased size of the clerestory windows, the Chartres nave is relatively dark (FIG. 18-13). The explanation for this seeming contradiction is that light-muffling colored glass fills the windows. These windows were not meant to illuminate the interior with bright sunlight but to trans-form natural light into Suger's mystical *lux nova* (see "Stained-Glass Windows," page 500). Chartres retains almost the full complement of its original stained glass, which, although it has a dimming effect, transforms the interior's character in dramatic fashion. Gothic churches that have lost their original stained-glass windows give a false impression of what their architects intended.

THE VIRGIN'S BEAUTIFUL WINDOW One Chartres window that survived the fire of 1194 and that the builders subsequently reused in the High Gothic cathedral is the tall single lancet the French call *Notre Dame de la Belle Verrière* (Our Lady of the Beautiful Window, FIG. **18-14**). The central section, depicting the Virgin Mary enthroned with the Christ Child in her lap, dates to ca. 1170 and has a red background. The framing angels seen against a blue ground were added when the window was reinstalled in the thirteenth-century choir. The artist represented Mary as the beautiful, young, rather worldly, Queen of Heaven, haloed, crowned,

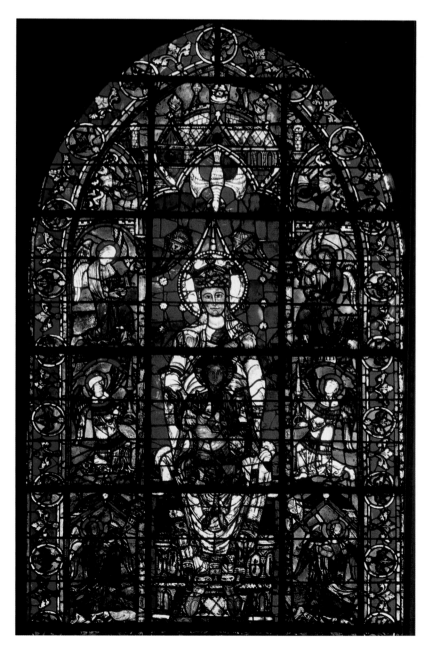

18-14 Virgin and Child and angels *(Notre Dame de la Belle Verrière)*, window in the choir of Chartres Cathedral, Chartres, France, ca. 1170, with thirteenth-century side panels. Stained glass, 16′ × 7′ 8″.

MATERIALS AND TECHNIQUES

Stained-Glass Windows

Stained glass is almost synonymous with Gothic architecture. No other age produced windows of such rich color and beauty. The art of making colored glass is, however, very old. Egyptian artists excelled at fashioning colorful glass vessels and other objects for both home and tomb. Archeologists also have uncovered thousands of colored-glass artifacts at hundreds of sites throughout the classical world.

But if the technology of manufacturing colored glass was ancient, how artists used stained glass in the Gothic period was new. Stained-glass windows were not just installed to introduce color and religious iconography into church interiors. That could have been—and was much earlier—done with both mural paintings and mosaics, often with magnificent effect. But stained-glass windows differ from those earlier techniques in one all-important respect. They do not conceal walls; they replace them. And they transmit rather than reflect light, filtering and transforming the natural sunlight as it enters the building. Abbot Suger called this colored light *lux nova* (see "Abbot Suger and the Rebuilding of Saint-Denis," page 489). Hugh of Saint-Victor (1096–1142), a prominent Parisian theologian who died while Suger's Saint-Denis was under construction, also commented on the special mystical quality of stained-glass windows. "Stained-glass windows," he wrote, "are the Holy Scriptures . . . and since their brilliance lets the splendor of the True Light pass into the church, they enlighten those inside."[1]

As early as the fourth century, architects used colored glass for church windows. Perfection of the technique came gradually. The stained-glass windows in the Saint-Denis choir (FIG. 18-1) show already a high degree of skill. According to Suger, they were "painted by the exquisite hands of many masters from different regions," proving that the art was known widely at that time.[2]

The manufacture of stained-glass windows was labor intensive and costly. First, the master designer drew the exact composition of the planned window on a wooden panel, indicating all the linear details and noting the colors for each section.

Glassblowers provided flat sheets of glass of different colors to *glaziers* (glassworkers), who cut the windowpanes to the required size and shape with special iron shears. Glaziers produced an even greater range of colors by *flashing* (fusing one layer of colored glass to another). Purple, for example, resulted from the fusing of red and blue (compare the color triangle, FIG. Intro-11). Next, painters added details such as faces, hands, hair, and clothing in enamel by tracing the master design on the wood panel through the colored glass. Then they heated the painted glass to fuse the enamel to the surface. The glaziers then *leaded* the various fragments of glass; that is, they joined them by strips of lead called *cames*. The leading not only held the (usually quite small) pieces together but also separated the colors to heighten the design's effect as a whole. The distinctive character of Gothic stained-glass windows is largely the result of this combination of fine linear details with broad flat expanses of color framed by black lead. Finally, the glassworkers strengthened the completed window with an armature of iron bands, which in the twelfth century formed a grid over the whole design (FIG. 18-14). In the thirteenth century, the bands followed the outlines of the medallions and of the surrounding areas (FIGS. 18-15 and 18-26).

The form of the stone window frames into which the glass was set also evolved throughout the Gothic era. Early rose windows, such as the one on Chartres Cathedral's west facade (FIG. 18-4), have stained glass held in place by *plate tracery*. The glass fills only the "punched holes" in the heavy ornamental stonework. *Bar tracery* (FIG. 18-15), a later development, is much more slender. The stained-glass windows fill almost the entire opening, and the stonework is unobtrusive, more like delicate leading than masonry wall.

[1]Hugh of Saint-Victor, *Seculum de mysteriis ecclesiae*, Sermo II.

[2]Erwin Panofsky, trans., *Abbot Suger on the Abbey Church of Saint-Denis and Its Art Treasures*, 2nd ed. (Princeton, N.J.: Princeton University Press, 1979), 73.

and accompanied by the Holy Spirit dove. The frontal composition is traditional. Comparing this Virgin and Child with the Theotokos and Child of Hagia Sophia (see FIG. 12-16) highlights not only the Byzantine image's greater severity and aloofness but also the sharp difference between the light-reflecting mosaic medium and Gothic light-transmitting stained glass. Byzantine and Gothic architects used light to transform the material world into the spiritual, but in opposite ways. In Gothic architecture, light was transmitted through a kind of diffracting screen of stone-set glass. In Byzantine architecture, light was reflected from myriad glass tesserae set into the thick masonry wall.

A QUEEN'S GIFT TO CHARTRES Chartres's thirteenth-century Gothic windows are even more spectacular than the *Belle Verrière* because they were designed from the outset to fill entire walls, thanks to the introduction of flying buttresses. The immense rose window (approximately forty-three feet in diameter) and tall lancets of Chartres Cathedral's north transept (FIGS. 18-4 and **18-15**) were the gift of the Queen of France, Blanche of Castile, around 1220. (The royal motifs of yellow castles on a red ground and yellow *fleurs-de-lis*—three-petaled iris flowers—on a blue ground fill the small lancets in the rose window's lower spandrels.) The enthroned Virgin and Child is again the central motif (Chartres,

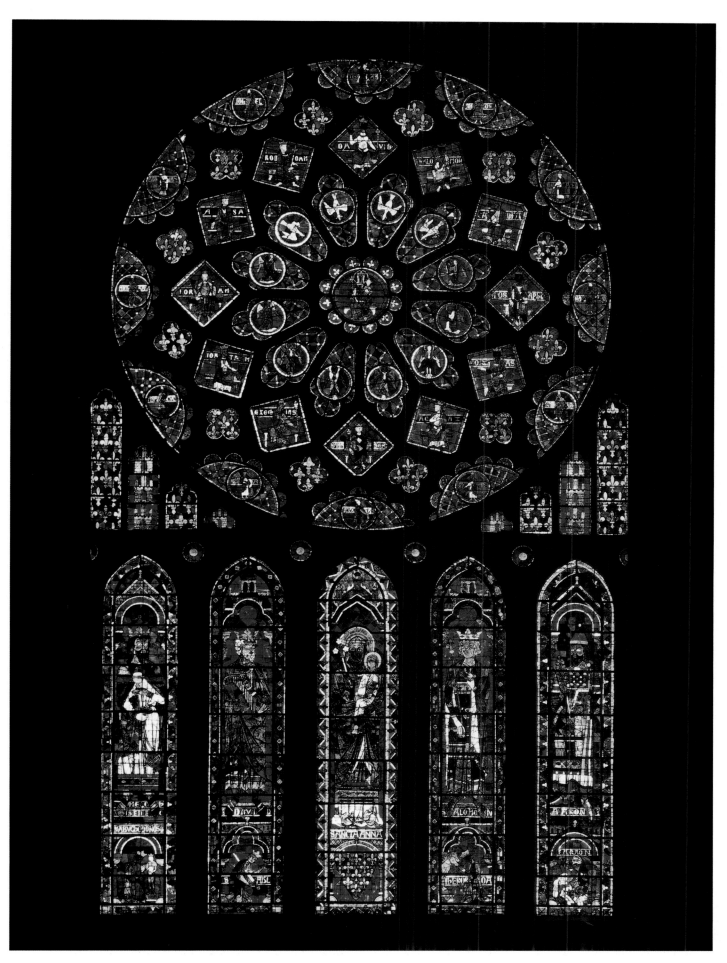

18-15 Rose window and lancets, north transept, Chartres Cathedral, Chartres, France, ca. 1220. Stained glass, rose window approx. 43′ in diameter.

as noted, was dedicated to the Virgin and housed her tunic), but the scale is much reduced. Mary appears in the roundel at the center of the rose, which resembles a gem-studded book cover or cloisonné brooch. Below, in the lancets, are Saint Anne and four Old Testament prophets, supporting the New Testament figures above, as on the Royal Portal. Many Gothic stained-glass windows also present narrative scenes, and their iconographical programs are sometimes as complex as those of the sculpted church portals.

The rose and lancets change in hue and intensity with the hours, turning solid architecture into a floating vision of the celestial heavens. Almost the entire mass of wall opens up into stained glass, which is held in place by an intricate stone armature of stone *bar tracery* that almost has the strength of steel. Here, the Gothic passion for light led to a most daring and successful attempt to subtract all superfluous material bulk just short of destabilizing the structure in order to transform hard substance into insubstantial, luminous color. That this vast, complex fabric of stone-set glass has maintained its structural integrity for almost eight hundred years attests to the Gothic builders' engineering genius.

18-17 Saint Theodore, jamb statue, Porch of the Martyrs (left doorway), south transept, Chartres Cathedral, Chartres, France, ca. 1230.

18-16 Saints Martin, Jerome, and Gregory, jamb statues, Porch of the Confessors (right doorway), south transept, Chartres Cathedral, Chartres, France, ca. 1220–1230.

ANOTHER "CLASSICAL REVOLUTION" The sculptures adorning the portals of the two new Chartres transepts erected after the 1194 fire are also prime examples of the new High Gothic spirit. As at Laon (FIG. 18-7) and Paris (FIG. 18-11), the transept portals project more forcefully from the church than do the Early Gothic portals of its west facade (compare FIGS. 18-4 and 18-5). Similarly, the statues of saints on the portal jambs are more independent from the architectural framework. Three figures from the Porch of the Confessors in the south transept (FIG. **18-16**) reveal the great changes Gothic sculpture underwent since the Royal Portal statues of the mid-twelfth century. These changes recall in many ways the revolutionary developments in ancient Greek sculpture during the transition from the Archaic to the Classical style (see Chapter 5). The Chartres transept statues we illustrate date from 1220 to 1230 and represent Saints Martin, Jerome, and Gregory. Although they are still attached to columns, the architectural setting does not determine their poses as much as it did on the west portals (FIG. 18-6). The saints communicate quietly with one another, like waiting dignitaries. They turn slightly toward and away from each other, breaking the rigid vertical lines that, on the Royal Portal, fix the figures immovably. The drapery folds are not stiff and shallow vertical accents, as on the west facade. The fabric falls and laps over the bodies in soft, if still regular, folds.

The treatment of the faces is even more remarkable. The sculptor gave the figures individualized features and distinctive personalities and clothed them in the period's liturgical costumes. Saint Martin is a tall, intense priest with gaunt features (compare the spiritually moved but not particularized face of the Moissac prophet in FIG. 17-23). Saint Jerome appears as a kindly, practical administrator-scholar, holding his copy of the Scriptures. At the right, the introspective Saint Gregory seems lost in thought as he listens to the Holy Ghost dove on his shoulder. Thus, the sculptor did not contrast the three men simply in terms of their poses, gestures, and attributes but, most particularly and emphatically, as persons. Personality, revealed in human faces, makes the real difference.

The south-transept figure of Saint Theodore (FIG. **18-17**), the martyred warrior on the Porch of the Martyrs, presents an even sharper contrast with Early Gothic jamb statues. The sculptor portrayed Theodore as the ideal Christian knight and clothed him in the cloak and chain-mail armor of Gothic Crusaders. The handsome long-haired youth holds his spear firmly in his right hand and rests his left hand on his shield. He turns his head to the left and swings out his hip to the right. The body's resulting torsion and pronounced sway call to mind Classical Greek statuary, especially the contrapposto stance of Polykleitos's *Spear Bearer* (see FIG. 5-38). It is not inappropriate to speak of the changes that occurred in thirteenth-century Gothic sculpture as a second "Classical revolution."

THE QUEST FOR HEIGHT AT AMIENS Chartres Cathedral was one of the most influential buildings in the history of architecture. Its builders set a pattern that many other Gothic architects followed, even if they refined the details. Construction of Amiens Cathedral (FIGS. **18-18** to **18-21**) began in 1220, while work was still in progress at Chartres. The architects were ROBERT DE LUZARCHES, THOMAS DE CORMONT, and RENAUD DE CORMONT. The builders finished the nave by 1236 and the radiating

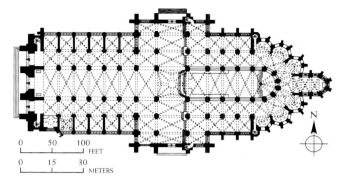

18-18 ROBERT DE LUZARCHES, THOMAS DE CORMONT, and RENAUD DE CORMONT, plan of Amiens Cathedral, Amiens, France, 1220–1288 (after Paul Frankl).

chapels by 1247, but work on the choir continued until almost 1270. The Amiens plan (FIG. 18-18) and elevation (FIGS. 18-10*d* and 18-19) derived from the High Gothic formula established at Chartres. But Amiens Cathedral's proportions are even more elegant, and the number and complexity of the lancet windows in both its clerestory and triforium are even greater. The whole design reflects the builders' confident use of the complete High Gothic structural vocabulary: the rectangular-bay system, the four-part rib vault, and a buttressing system that permitted almost complete dissolution of heavy masses and thick weight-bearing walls. At

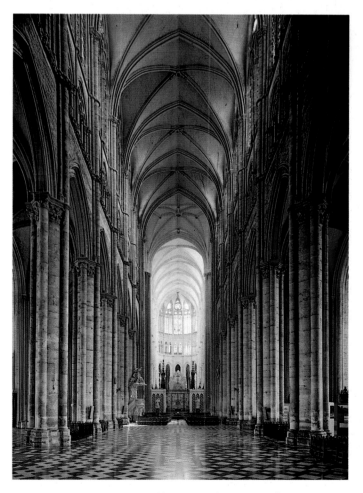

18-19 ROBERT DE LUZARCHES, THOMAS DE CORMONT, and RENAUD DE CORMONT, nave of Amiens Cathedral (view facing east), France, begun 1220.

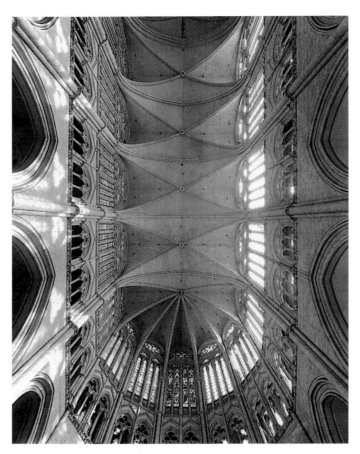

Amiens, the concept of a self-sustaining skeletal architecture reached full maturity. What remained as walls was stretched like a skin between the piers and seems to serve no purpose other than to provide a weather screen for the interior (FIG. 18-20).

Amiens Cathedral is one of the most impressive examples of the French Gothic obsession with constructing ever taller cathedrals. With their new skeletal frames of stone, French builders attempted goals almost beyond limit, pushing with ever more slender supports to new heights. The nave vaults at Laon rise to a height of about eighty feet; at Paris, to one hundred seven feet; and at Chartres, to one hundred eighteen feet. Those at Amiens are one hundred forty-four feet above the floor. The tense, strong lines of the Amiens vault ribs converge to the colonnettes and speed down the shell-like walls to the compound piers. Almost every part of the superstructure has its corresponding element below. The only exception is the *wall rib* (at the junction of the vault and the wall). The overall effect is of effortless strength, of a buoyant lightness one normally does not associate with stone architecture. Viewed directly from below, the choir vaults (FIG. 18-20) seem like a canopy, tentlike and suspended from bundled masts. The light flooding in from the clerestory makes the vaults seem even more insubstantial. The effect recalls another great building, one utterly different from Amiens but where light also plays a defining role: Hagia Sophia in Constantinople (see FIG. 12-5). Once again, not only did the architects reduce the building's physical mass by structural ingenuity and daring, but also light dematerializes further what remains. If Hagia Sophia is the

18-20 ROBERT DE LUZARCHES, THOMAS DE CORMONT, and RENAUD DE CORMONT, choir vaults of Amiens Cathedral, Amiens, France, begun 1220.

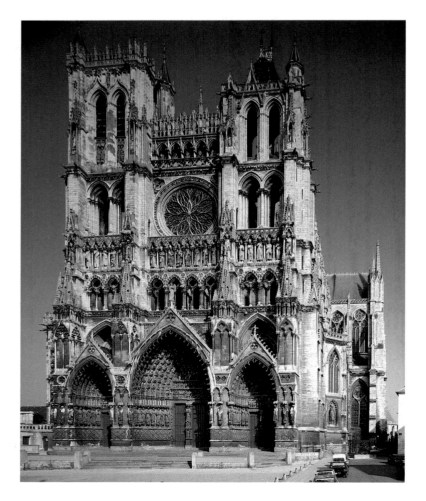

18-21 ROBERT DE LUZARCHES, THOMAS DE CORMONT, and RENAUD DE CORMONT, west facade of Amiens Cathedral, Amiens, France, begun 1220.

perfect expression of Byzantine spirituality in architecture, Amiens, with its soaring vaults and giant windows admitting divine colored light, is its Gothic counterpart.

Work began on the Amiens west facade (FIG. 18-21) at the same time as the nave (1220). Its lower parts seem to reflect the influence of Laon Cathedral (FIG. 18-7) in the spacing of the funnel-like and gable-covered portals. But the Amiens designer punctured the facade's upper parts to an even greater degree than did the Laon architect. The deep piercing of walls and towers at Amiens seems to have left few continuous surfaces for decoration, but the ones that remained were covered with a network of colonnettes, arches, pinnacles, rosettes, and other decorative stonework that visually screens and nearly dissolves the structure's solid core. Sculpture also extends to the areas above the portals, especially the band of statues (the so-called "kings' gallery") running the full width of the facade directly below the rose window (with fifteenth-century tracery). The uneven towers were later additions. The shorter one dates from the fourteenth century, the taller one from the fifteenth century.

CHRIST, THE BEAUTIFUL GOD The most prominent statue on the Amiens facade is of Christ (the *Beau Dieu*, or Beautiful God) on the central doorway's trumeau (FIG. **18-22**). The sculptor fully modeled Christ's figure, enveloping his body with massive drapery folds cascading from his waist. The statue stands freely and is as independent of its architectural setting as any Gothic facade statue ever was. Nonetheless, the sculptor still placed an architectural canopy over the figure's head. It is in the latest Gothic style, mimicking the east end of a thirteenth-century cathedral with a series of radiating chapels pierced by elegant lancet windows. Above the canopy is the great central tympanum with the representation of Christ as Last Judge (FIG. 18-21). But the *Beau Dieu* is a handsome, kindly figure who does not strike terror into sinners. Instead he blesses those who enter the church and tramples a lion and a dragon symbolizing the evil forces in the world. This image of Christ gives humankind hope in salvation. The *Beau Dieu* epitomizes the bearded, benevolent image of Christ that replaced the youthful Early Christian Christ (see FIG. 11-6) and the stern Byzantine Pantocrator (see FIG. 12-24) as the preferred representation of the Savior in later European art. The figure's quiet grace and grandeur also sharply contrast with the emotional intensity of the twisting Romanesque prophet carved in relief on the Moissac trumeau (see FIG. 17-23).

GLASS REPLACES STONE AT REIMS Construction of Reims Cathedral (FIG. **18-23**) began only a few years after work commenced at Amiens. The Reims designers carried the High Gothic style of the Amiens west facade still further, both architecturally and sculpturally. The two facades, although similar, display some significant differences. The kings' gallery of statues at Reims is *above* the great rose window, and the figures stand in taller and more ornate frames. In fact, the architect "stretched" every detail of the facade. The openings in the towers and those to the left and right of the rose window are taller, narrower, and more intricately decorated, and they more closely resemble the elegant lancets of the clerestory within. A pointed arch also frames the rose window itself, and the pinnacles over the portals are taller and more elaborate than those at Amiens. Most striking, however,

18-22 Christ *(Beau Dieu)*, trumeau statue of central doorway, west facade, Amiens Cathedral, Amiens, France, ca. 1220–1235.

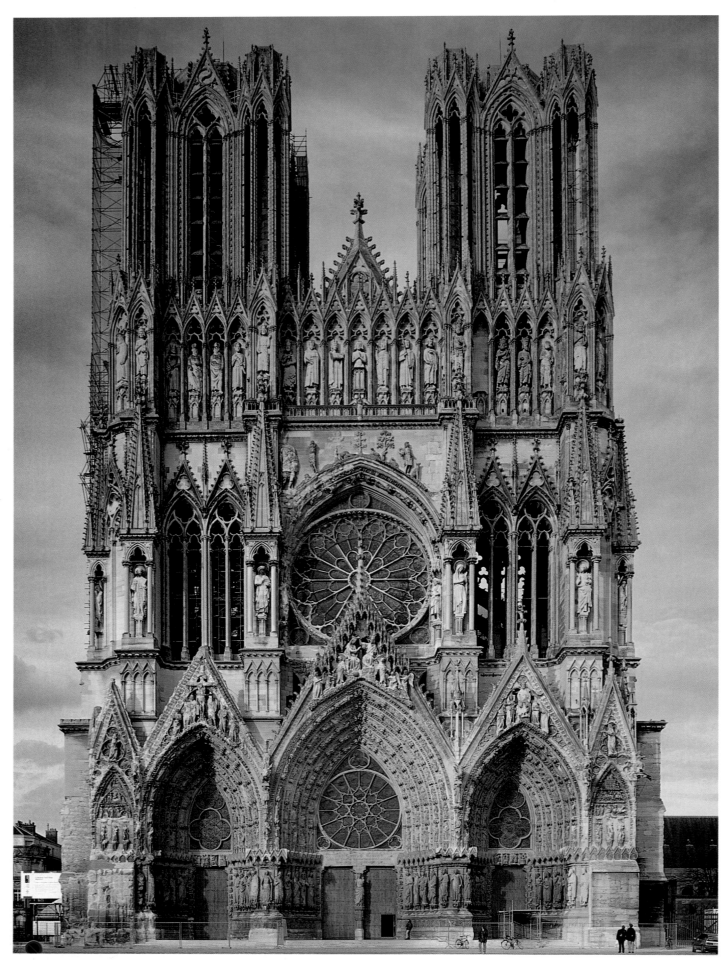

18-23 West facade of Reims Cathedral, Reims, France, ca. 1225–1290.

portraits. The youthful Mary, for example, resembles the women of the Antonine dynasty, especially Faustina the Younger, Marcus Aurelius's wife. Whatever the sculptor's source, the statues are astonishing approximations of the classical naturalistic style. The Reims master even incorporated the Greek contrapposto posture, going far beyond the stance of the Chartres Saint Theodore (FIG. 18-17). At Reims, the swaying of the hips is much more pronounced. The right legs bend, and the knees press through the rippling folds of the garments. The sculptor also set the figures' arms in motion. Not only do Mary and Elizabeth turn their faces toward each other, but they converse through gestures. In the Reims Visitation group, the formerly isolated Gothic jamb statue became part of a narrative group.

A RADIANT ROYAL CHAPEL If the stained-glass windows inserted into the portal tympanums of Reims Cathedral exemplify the wall-dissolving High Gothic architectural style, Sainte-Chapelle in Paris (FIG. **18-25**) shows this principle applied to a whole building. Louis IX built

18-24 Visitation, jamb statues of central doorway, west facade, Reims Cathedral, Reims, France, ca. 1230.

is the architect's treatment of the tympanums over the doorways, replacing the stone relief sculpture of earlier facades with stained-glass windows. The contrast with Romanesque heavy masonry construction (see FIG. 17-9) is extreme. But the rapid transformation of the Gothic facade since the twelfth-century designs of Saint-Denis and Chartres (FIG. 18-4) and even Laon (FIG. 18-7) is no less noteworthy.

STATUES BEGIN TO CONVERSE At Reims the fully ripened Gothic style also can be seen in sculpture. At first glance, the jamb statues of the west portals of Reims Cathedral (FIG. **18-24**) appear to be completely detached from their architectural background. The designer shrank the supporting columns into insignificance so that they in no way restrict the free and easy movements of the full-bodied figures. (Compare the Reims statue-columns with those of the Royal Portal of Chartres, FIG. 18-6, where the background columns occupy a volume equal to the figures' volume.) The two Reims jamb statues we illustrate portray Saint Elizabeth visiting the Virgin Mary before the birth of Jesus. They are two of a series of statues celebrating Mary's life and are further testimony to the Virgin's central role in Gothic iconography.

The sculptor of the Visitation group reveals a classicizing bent startlingly unlike anything seen since Roman times. The artist probably studied actual classical statuary in France. Although art historians have been unable to pinpoint specific models, the heads of both women look like ancient Roman

18-25 Sainte-Chapelle, Paris, France, 1243–1248.

18-26 Interior of the upper chapel, Sainte-Chapelle, Paris, France, 1243–1248.

mous windows (FIG. 18-26) filter the light and fill the interior with an unearthly rose-violet atmosphere. Approximately forty-nine feet high and fifteen feet wide, they were the largest designed up to their time.

THE VIRGIN AS QUEEN The "court style" of Saint Louis was not confined to architecture. Indeed, the elegance and delicacy displayed in Sainte-Chapelle's design permeated the pictorial arts as well. By the early fourteenth century, a mannered elegance that marks Late Gothic art in general had replaced the monumental and solemn sculptural style of the High Gothic portals. Perhaps the best example of the late French court style in sculpture is the statue nicknamed the *Virgin of Paris* (FIG. **18-27**) because of its location in the Parisian Cathedral of Notre-Dame. The sculptor portrayed Mary as a very worldly queen, decked out in royal garments and wearing a heavy gem-encrusted crown. The Christ Child is equally richly attired and is very much the infant prince in the arms of his young mother. The tender, anecdotal characterization of mother and son represents a further humanization of the portrayal of religious figures in Gothic sculpture.

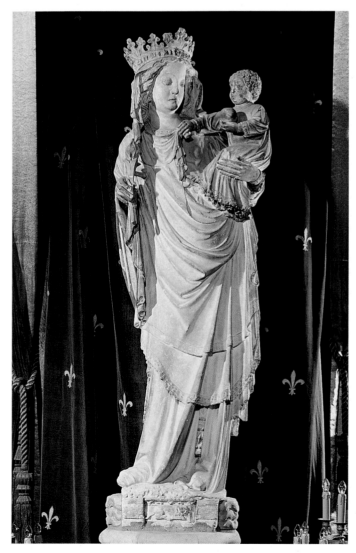

18-27 Virgin and Child *(Virgin of Paris)*, Notre-Dame, Paris, France, early fourteenth century.

Sainte-Chapelle, joined to the royal palace, as a repository for the crown of thorns and other relics of Christ's Passion he had purchased in 1239 from his cousin Baldwin II, the Latin emperor of Constantinople. The building's resemblance to an intricately carved reliquary is intentional (compare FIG. 18-55). The structure is a prime example of the so-called *Rayonnant* (radiant) style of the High Gothic age, which dominated the second half of the century. It was associated with the royal Parisian court of Saint Louis (see "Louis IX: The Saintly King," page 509). In Sainte-Chapelle, the dissolution of walls and the reduction of the bulk of the supports were carried to the point that some six thousand four hundred fifty square feet of stained glass make up more than three-quarters of the structure (FIG. **18-26**). The supporting elements were reduced so much that they are hardly more than large *mullions,* or vertical bars. The emphasis is on the extreme slenderness of the architectural forms and on linearity in general. Although the chapel was heavily restored during the nineteenth century (after damage from the French Revolution), it has retained most of its original thirteenth-century stained glass. Sainte-Chapelle's enor-

Louis IX
The Saintly King

The royal patron behind the Parisian "court style" of Gothic art and architecture was King Louis IX (1215–1270; r. 1226–1270), grandson of Philip Augustus. Louis inherited the throne when he was only twelve years old, so until he reached adulthood six years later, his mother, Blanche of Castile, granddaughter of Eleanor of Aquitaine (see "Romanesque Countesses, Queens, and Nuns," Chapter 17, page 482), served as France's regent.

The French regarded Louis as the ideal king, and in 1297, twenty-seven years after his death, Pope Boniface VIII declared him a saint. In his own time, Louis was revered for his piety, justice, truthfulness, and charity. His alms giving and his donations to religious foundations were extravagant. He especially favored the *mendicant* (begging) orders, the Dominicans and Franciscans (see "Mendicant Orders and Confraternities," Chapter 19, page 537). He admired their poverty, piety, and self-sacrificing disregard of material things.

Louis launched two unsuccessful Crusades, the Seventh (1248–1254, when, in her son's absence, Blanche was again French regent) and the Eighth (1270). He died in Tunisia during the latter. As a crusading knight who lost his life in the service of the Church, Louis personified the chivalric virtues of courage, loyalty, and self-sacrifice. Saint Louis united in his person the best qualities of the Christian knight, the benevolent monarch, and the holy man. He became the model of medieval Christian kingship.

Louis's political accomplishments were also noteworthy. He subdued the unruly French barons, so between 1243 and 1314 no one seriously challenged the crown. He negotiated a treaty with Henry III, king of France's traditional enemy, England. Such was his reputation for integrity and just dealing that he served as arbiter in at least a dozen international disputes. So successful was he as peacekeeper that despite civil wars through most of the thirteenth century, international peace prevailed. Under Saint Louis, medieval France was at its most prosperous, and its art and architecture were admired and imitated throughout Europe.

The playful interaction of an adult and an infant in the *Virgin of Paris* may be compared with the similarly composed statuary group of Hermes and the infant Dionysos (see FIG. 5-62) by the Greek sculptor Praxiteles. Indeed, the exaggerated swaying S curve of the Virgin's body superficially resembles the shallow S curve Praxiteles introduced in the fourth century B.C. But unlike its Late Classical predecessor, the Late Gothic S curve was not organic (derived from within figures), nor was it a rational, if pleasing, organization of human anatomical parts. Rather, the Gothic curve was an artificial form imposed on figures, a decorative device that produced the desired effect of elegance but that had nothing to do with figure structure. In fact, in our example, the body is quite lost behind the heavy drapery, which, deeply cut and hollowed, almost denies the figure a solid existence. The ornamental line the sculptor created with the flexible fabric is analogous to the complex, restless tracery of the Late Gothic style in architecture, which dominated northern Europe in the fourteenth and fifteenth centuries.

A FLAMBOYANT CHURCH IN NORMANDY The change from Rayonnant architecture to the Late Gothic, or *Flamboyant,* style (named for the flamelike appearance of its pointed bar tracery), occurred in the fourteenth century. The style reached its florid maturity nearly a century later. This period was a difficult one for the French monarchy. Long wars against England and the duchy of Burgundy sapped its economic and cultural strength, and building projects in the royal domain either ceased or never began. Architects accepted the new style most enthusiastically in regions outside the Île-de-France.

Normandy is particularly rich in Flamboyant architecture, and the church of Saint-Maclou (FIG. **18-28**) in Rouen, its capital, is a masterpiece of the Flamboyant style. The church is tiny (only about seventy-five feet high and one hundred eighty feet long) compared to the great Gothic cathedrals. Its facade presents a sharp contrast with the High Gothic style of the thirteenth century (compare FIGS. 18-21 and 18-23). The five portals (two of them blind) bend outward in an arc. Ornate gables crown the doorways, pierced through and filled with wiry, "flickering" Flamboyant tracery made up of curves and countercurves that form brittle decorative webs and mask the building's structure. The transparency of the pinnacles over the doorways permits visitors to see the central rose window and the flying buttresses, even though they are set well back from the facade. The overlapping of all features, pierced as they are, confuses the structural lines and produces a bewildering complexity of views that is the hallmark of the Flamboyant style.

A DOUBLY FORTIFIED TOWN The Gothic age was truly "the age of the great cathedrals," but people, of course, also needed and built secular structures such as town halls, palaces, and private residences. In an age of frequent warfare, the feudal barons often constructed fortified castles in places enemies could not easily access. Sometimes thick defensive wall circuits or *ramparts* enclosed entire towns. In time, however, purely defensive wars became obsolete due to the invention of artillery and improvements in siege craft. The fortress

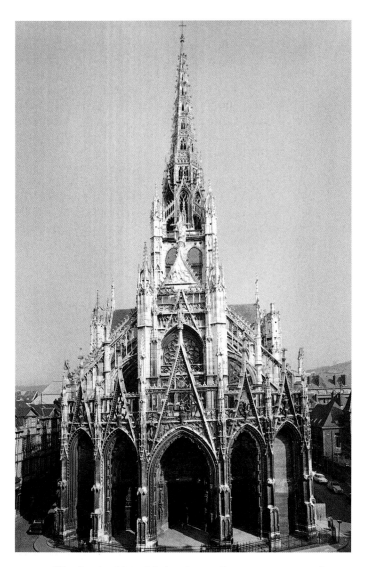

18-28 West facade of Saint-Maclou, Rouen, France, ca. 1500–1514.

era gradually passed, and throughout Europe once-mighty ramparts fell into ruin.

One of the most famous Gothic fortified towns is Carcassonne (FIG. 18-29) in Languedoc in southern France. It was the regional center of resistance to the northern forces of royal France. Built on a hill bounded by the Aude River, Carcassonne had been fortified since Roman times. It had Visigothic walls dating from the sixth century, but in the twelfth century masons reinforced them with bastions and towers. The double ring of walls discouraged any attacking force. *Crenellations* (notches) in the *battlements* (low screen walls) protected guards patrolling the stone ring surrounding the town. Carcassonne might be made to surrender but could not easily be taken by storm.

Within the town's double walls was a fortified castle (FIG. 18-29, left) with a massive attached *keep,* a secure tower that could serve as a place of last refuge. Balancing that center of secular power was the bishop's seat, the Cathedral of Saint-Nazaire (FIG. 18-29, right). The small church, built between 1269 and 1329, may have been the work of an architect brought in from northern France. In any case, Saint-Nazaire's builders were certainly familiar with the latest developments in architecture in the Île-de-France. Today, Carcassonne provides a rare glimpse of what was once a familiar sight in Gothic France: a tightly contained complex of castle, cathedral, and town within towered walls.

A PROSPEROUS MERCHANT'S HOME In the late Middle Ages, a new class of wealthy merchants rose to prominence throughout Europe. Although their fortunes may not have equaled those of the hereditary royalty, their power and influence were still enormous. One such figure was the French trader and financier Jacques Coeur (1395–1456), whose astonishing career illustrates how wealth and power could be won and lost by enterprising private citizens. Coeur had banking houses in every city of France and many abroad.

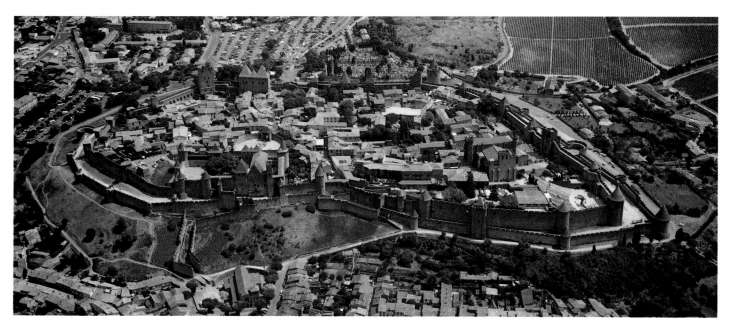

18-29 Aerial view of the fortified town of Carcassonne, France. Bastions and towers, twelfth–thirteenth centuries, restored by EUGÈNE VIOLLET-LE-DUC in the nineteenth century.

The broad facade's focus is a tall central section with a very steep pyramidal roof, a spire-capped tower with Flamboyant tracery, a large pointed-arch stained-glass window, and two doorways (one for pedestrians and the larger one for horses and carriages). The elegant canopied niche beneath the great window once housed a royal equestrian statue. A comparable statue of Coeur on horseback dominated the facade opening onto the interior courtyard. An unusual feature of the external facade is the pair of false windows with life-size relief sculptures of a male and a female servant looking down upon passersby in the street. Jacques Coeur's house is not only a splendid example of Late Gothic architecture but also a monumental symbol of the period's new secular spirit—an expression of the triumph of city culture, of capital accumulation, and of the desire for worldly convenience and proud display.

Book Illumination and Luxury Arts

Paris's claim as the intellectual center of Gothic Europe (see "Paris: The Intellectual Capital of Gothic Europe," page 496) did not rest solely on the stature of its university faculty and on the reputation of its architects, masons, sculptors, and stained-glass makers. The city was also a renowned center for the production of fine books. The famous Florentine poet Dante Alighieri (1265–1321), in fact, referred to Paris in his *Divine Comedy* of ca. 1310–1320 as the city famed for the art of illumination.[2] Indeed, the Gothic period is when book manufacture shifted from monks and nuns toiling for God's glory in scriptoria shut off from the world to urban workshops. Owned and staffed by laypersons who sold their products to the royal family, scholars, and prosperous merchants, these for-profit secular businesses, concentrated in Paris, were the forerunners of modern publishing houses.

THE ART OF GEOMETRY One of the most intriguing Parisian manuscripts preserved today was not, however, produced for sale. It is the personal sketchbook compiled by VILLARD DE HONNECOURT, an early thirteenth-century master mason. Its pages contain details of buildings, plans of choirs with radiating chapels, church towers, lifting devices, a sawmill, stained-glass windows, and other subjects of obvious interest to architects and masons. But also sprinkled liberally throughout the pages are drawings depicting religious and worldly figures, as well as animals, some realistic and others purely fantastic.

On the page we illustrate (FIG. **18-31**), Villard demonstrated the value of the *ars de geometria* (art of geometry) to artists. He showed that both natural forms and buildings are based on simple geometric shapes such as the square, circle, and triangle. Even where he claimed to have drawn his animals from nature, he composed his figures around a skeleton not of bones but of abstract geometric forms. Geometry was, in Villard's words, "strong help in drawing figures."

But geometry played a symbolic as well as a practical role in Gothic art and architecture. Gothic artists, architects, and theologians alike thought the triangle, for example, embodied the idea of the Trinity of God the Father, Christ, and the

18-30 House of Jacques Coeur, Bourges, France, 1443–1451.

He employed more than three hundred agents and competed with the great trading republics of Italy. His merchant ships filled the Mediterranean. With the papacy's permission, he traded widely with the Muslims of Egypt and the Middle East and gained concessions there that benefited French commerce for centuries. He was financial adviser to King Charles VII of France and a friend of Pope Nicholas V. The animosity of hundreds of his highborn debtors and competitors eventually led to Coeur's downfall. His enemies framed him on an absurd charge of having poisoned Agnes Sorel, the king's mistress, and he was imprisoned. His vast wealth and property were confiscated and distributed among the king's people. Coeur escaped from prison and made his way to Rome, where the pope warmly received him. He died of fever while leading a fleet of papal war galleys in the eastern Mediterranean.

Jacques Coeur's great town house (FIG. **18-30**), built between 1443 and 1451 in his native city of Bourges, still stands. It is the best preserved example of Late Gothic domestic architecture. The house's plan is irregular, with the units arranged around an open courtyard. The service areas (maintenance shops and storage, servants' quarters, baths) occupy the ground level. The upper stories house the great hall and auxiliary rooms used for offices and family living rooms.

18-31 VILLARD DE HONNECOURT, figures based on geometric shapes, folio 18 verso of a sketchbook, from Paris, ca. 1220–1235. Ink on vellum, $9\frac{1}{4}'' \times 6''$. Bibliothèque Nationale, Paris.

Holy Spirit. The circle, which has neither a beginning nor an end, symbolized the eternity of the one God. When Gothic architects based their designs on the art of geometry, building their forms out of abstract shapes laden with symbolic meaning, they believed they were working according to the divinely established laws of nature.

GOD AS ARCHITECT OF THE WORLD A vivid illustration of this concept appears as the frontispiece (FIG. **18-32**) of a moralized Bible produced in Paris during the 1220s. *Moralized Bibles* are heavily illustrated, each page pairing Old and New Testament episodes with illustrations explaining their moral significance. The page we show does not conform to this formula because it is the introduction to all that follows. God appears as the architect of the world, shaping the universe with the aid of a compass. Within the perfect circle already created are the spherical sun and moon and the unformed matter that will become the earth once God applies the same geometric principles to it. In contrast to the biblical account of Creation, where God made the world by sheer force of will and a simple "Let there be . . ." command, the Gothic artist portrayed God as an industrious architect, creating the universe with some of the same tools mortal builders used.

A BIBLE FIT FOR A QUEEN Not surprisingly, most of the finest Gothic books known today belonged to the French monarchy. Saint Louis in particular was an avid collector of both secular and religious books. The library he and his royal predecessors and successors formed was vast and eventually formed the core of France's national library, the Bibliothèque Nationale. One of the books the royal family commissioned is a moralized Bible now in the collection of New York's Pierpont Morgan Library. Louis's mother, Blanche of Castile, ordered the Bible during her regency (1226–1234) for her teenage son. The dedication page (FIG. **18-33**) has a costly gold background and depicts Blanche and Louis enthroned beneath triple-lobed arches and miniature cityscapes. The latter can be compared to the architectural canopies above the heads of contemporaneous French portal statues (FIG. 18-22). Below, in similar architectural frames, are a monk and a scribe. The older clergyman dictates a sacred text to his young apprentice. The scribe already has divided his page into two columns of four roundels each, a format often used for the paired illustrations of moralized Bibles. The inspirations for such designs were probably the roundels of Gothic stained-glass windows (compare the borders of the *Belle Verrière* window at Chartres, FIG. 18-14, and the windows of Louis's own, later, Sainte-Chapelle, FIG. 18-26).

18-32 God as architect of the world, folio 1 verso of a moralized Bible, from Paris, ca. 1220–1230. Ink, tempera, and gold leaf on vellum, $1' 1\frac{1}{2}'' \times 8\frac{1}{4}''$. Österreichische Nationalbibliothek, Vienna.

18-33 Blanche of Castile, Louis IX, and two monks, dedication page (folio 8 recto) of a moralized Bible, from Paris, France, 1226–1234. Ink, tempera, and gold leaf on vellum, 1′ 3″ × 10½″. Pierpont Morgan Library, New York.

18-34 Abraham and the three angels, folio 7 verso of the *Psalter of Saint Louis,* from Paris, France, 1253–1270. Ink, tempera, and gold leaf on vellum, $5'' \times 3\frac{1}{2}''$. Bibliothèque Nationale, Paris.

The picture of Gothic book production on the dedication page of Blanche of Castile's moralized Bible is a very abbreviated one. The manufacturing process used in the workshops of thirteenth-century Paris involved many steps and numerous specialized artists, scribes, and assistants of varying skill levels. The Benedictine abbot Johannes Trithemius (1462–1516) described the way books were made in late medieval Europe in his treatise *In Praise of Scribes:*

If you do not know how to write, you still can assist the scribes in various ways. One of you can correct what another has written. Another can add the rubrics [headings] to the corrected text. A third can add initials and signs of division. Still another can arrange the leaves and attach the binding. Another of you can prepare the covers, the leather, the buckles and clasps. All sorts of assistance can be offered the scribe to help him pursue his work without interruption. He needs many things which can be prepared by others: parchment cut, flattened and ruled for script, ready ink and pens. You will always find something with which to help the scribe.[3]

The preparation of the illuminated pages also involved several hands. Some artists, for example, specialized in painting borders or initials. Only the workshop head or one of the most advanced assistants would paint the main figural scenes. Given this division of labor and the assembly-line nature of Gothic book production, it is astonishing how uniform the style is on a single page, as well as from page to page, in most illuminated manuscripts.

STAINED GLASS AND A ROYAL PSALTER The golden background of Blanche's Bible is unusual and has no parallel in Gothic windows. But the radiance of stained glass probably inspired the glowing color of other thirteenth-century Parisian illuminated manuscripts. In some cases, masters in the same urban workshop produced both glass and books. Many art historians believe that the *Psalter of Saint Louis* (FIG. **18-34**) is one of several books produced in Paris for Saint Louis by artists associated with those who made the

18-35 Master Honoré, *David anointed by Samuel and battle of David and Goliath,* folio 7 verso of the *Breviary of Philippe le Bel,* from Paris, France, 1296. Ink and tempera on vellum, $7\frac{7}{8}'' \times 4\frac{7}{8}''$. Bibliothèque Nationale, Paris.

stained glass for his Sainte-Chapelle. Certainly, the painted architectural setting in Saint Louis's psalter reflects the pierced screenlike lightness and transparency of royal buildings such as Sainte-Chapelle. The painted figures also express the same aristocratic elegance as the Rayonnant "court style" of architecture royal Paris favored. The intense colors, especially the blues, emulate glass. The borders resemble glass partitioned by leading. And the gables, pierced by rose windows with bar tracery, are standard Rayonnant architectural features.

The page from the *Psalter of Saint Louis* shown here (FIG. 18-34) represents Abraham and the three angels. Christians believed the Old Testament story prefigured the Christian Trinity (see "Jewish Subjects in Christian Art," Chapter 11, page 305), and the subject was also popular in Byzantine art (see FIGS. 12-8 and 12-34). The Gothic artist included two episodes on the same page, separated by the tree of Mamre mentioned in the Bible. At the left, Abraham greets the three angels. In the other scene, he entertains them while his wife

Sarah peers at them from a tent. The figures' delicate features and the linear wavy strands of their hair have parallels in Blanche of Castile's moralized Bible, as well as in Parisian stained glass. The elegant proportions, facial expressions, theatrical gestures, and swaying poses are characteristic of the Parisian court style admired throughout Europe. A later example of this mannered style in sculpture, complete with the exaggerated contrapposto of the angel in the left foreground, is the *Virgin of Paris* (FIG. 18-27), already discussed.

A FRENCH KING'S PRAYER BOOK As in the Romanesque period, some Gothic manuscript illuminators signed their work. The names of others appear in royal accounts of payments made and similar official documents. One of the artists who produced books for the French court was Master Honoré, whose Parisian workshop was on the street known today as rue Boutebrie. Honoré illuminated a *breviary* (a book of selected prayers and psalms) for Philippe le Bel (Philip the Fair, r. 1285–1314) in 1296. The page we illustrate (FIG. **18-35**) features two Old Testament scenes involving David. In the upper panel, Samuel anoints the youthful David. Below, while King Saul looks on, David prepares to hurl his slingshot at his most famous opponent, the giant Goliath (who already touches the wound on his forehead!). And then, in a classic example of continuous narration, David slays Goliath with his sword.

Master Honoré's linear treatment of hair, his figures' delicate hands and gestures, and their elegant swaying postures are typical of Parisian painting of the time. But this painter was much more interested than most of his colleagues in giving his figures sculptural volume and showing the play of light on their bodies. Honoré, however, was not concerned with locating his figures in space. The Goliath panel in the *Breviary of Philippe le Bel* has a textilelike decorative background, and the feet of Honoré's figures frequently overlap the border. Compared to his contemporaries, Master Honoré pioneered naturalism in figure painting. But he still approached the art of book illumination as a decorator of two-dimensional pages. He did not embrace the classical notion that a painting should be an illusionistic window into a three-dimensional world.

JEAN PUCELLE AND ITALY David and Saul also are the subjects of a miniature painting at the top left of an elaborately decorated text page in the *Belleville Breviary* (FIG. **18-36**). Jean Pucelle of Paris illuminated it around 1325. He went far beyond Honoré and other French artists by placing his fully modeled figures in three-dimensional architectural settings rendered in convincing perspective. For example, Pucelle painted Saul as a weighty figure seated on a throne seen in a three-quarter view, and he meticulously depicted the receding coffers of the barrel vault over the young David's head. Such "stage sets" already had become commonplace in Italian painting, and Pucelle seems to have visited Italy and studied Duccio's work in Siena (see Chapter 19). Pucelle's (or one of his assistant's) renditions of plants, a bird, butterflies, a dragonfly, a fish, a snail, and a monkey also reveal a keen interest in and close observation of the natural world. Nonetheless, in the *Belleville Breviary* the text still dominates the figures, and the artist (and his patron) delighted in ornamental flourishes, fancy initial letters, and abstract pattern. In that respect, comparisons to monu-

18-36 JEAN PUCELLE, *David before Saul*, folio 24 verso of the *Belleville Breviary*, from Paris, France, ca. 1325. Ink and tempera on vellum, $9\frac{1}{2}''$ × $6\frac{3}{4}''$. Bibliothèque Nationale, Paris.

mental panel paintings are inappropriate. Pucelle's breviary remains firmly in the tradition of book illumination.

The *Belleville Breviary* is of special interest because Pucelle's and some of his assistants' names appear at the end of the book, in a memorandum recording the payment they received for their work. Inscriptions in other Gothic illuminated books regularly state the production costs—the prices paid for materials, especially gold, and for the execution of initials, figures, flowery script, and other embellishments. By this time, illuminators were professional guild members, and their personal reputation, like modern "brand names," guaranteed the quality of their work. Though the cost of materials was still the major factor determining a book's price, individual skill and reputation increasingly decided the value of the illuminator's services. The centuries-old monopoly of the Christian Church in bookmaking had ended.

A VIRGIN AND CHILD FOR SAINT-DENIS

The royal family also patronized goldsmiths, silversmiths, and other artists specializing in the production of luxury works in metal and enamel for churches, palaces, and private homes. Especially popular among the wealthy were statuettes of sacred figures purchased either for their private devotion or as gifts to the churches they frequented. The Virgin Mary was a favored subject, reflecting her new prominence in the iconography of Gothic portal sculpture.

Perhaps the finest of these costly statuettes is the large (more than two feet tall) silver-gilt figurine known as the *Virgin of Jeanne d'Evreux* (FIG. **18-37**). The queen, wife of Charles IV (r. 1322–1328), donated the image of the Virgin and Child to the royal abbey church of Saint-Denis in 1339. Mary stands on a rectangular base decorated with enamel scenes of Christ's Passion. (Some art historians think the enamels are Jean Pucelle's work.) But no hint of grief appears in the beautiful young Mary's face. The Christ Child, also without a care in the world, playfully reaches for his mother. The elegant proportions of the two figures, Mary's swaying posture, the heavy drapery folds, and the intimate human characterization of the

18-37 *Virgin of Jeanne d'Evreux,* from the abbey church of Saint-Denis, France, 1339. Silver gilt and enamel, $2' 3\frac{1}{2}''$ high. Louvre, Paris.

holy figures are also features of the roughly contemporary *Virgin of Paris* (FIG. 18-27). The monumental-stone sculptor and the royal silversmith working at small scale approached the representation of the Virgin and Child in a similar fashion.

In the *Virgin of Jeanne d'Evreux,* as in the *Virgin of Paris,* Mary appears not only as the Mother of Christ but as the Queen of Heaven. The Saint-Denis Mary also originally had a crown on her head, and the scepter she holds is in the form of the *fleur-de-lis,* the French monarchy's floral emblem. The statuette also served as a reliquary. The Virgin's scepter contained hairs believed to come from Mary's head.

THE CASTLE OF LOVE Gothic artists produced luxurious objects for secular, as well as religious, contexts. Sometimes they decorated these costly pieces with stories of courtly love inspired by the romantic literature of the day, such as the famous story of Lancelot and Queen Guinevere, wife of King Arthur of Camelot. The French poet Chrétien de Troyes recorded their famous affair in the late twelfth century.

One of the most interesting objects of this type is a woman's jewelry box adorned with ivory relief panels, now in the Walters Art Gallery in Baltimore. The theme of the panel illustrated here (FIG. **18-38**) is related to the *Romance of the Rose* by Guillaume de Lorris, written ca. 1225–1235 and completed by Jean de Meung between 1275 and 1280. At the left the sculptor carved the allegory of the siege of the Castle of Love. Gothic knights attempt to capture love's fortress by shooting flowers from their bows and hurling baskets of roses over the walls from catapults. Among the castle's defenders is Cupid, who aims his arrow at one of the knights while a comrade scales the walls on a ladder. The scene in the lid's two central sections shows two knights jousting on horseback, ac-companied by the sound of blaring trumpets. Several maidens look down on the contest from a balcony and cheer the knights on. A youth in the crowd holds a hunting falcon. The sport was a favorite pastime of the leisure class in the late Middle Ages. At the right, the victorious knight receives his prize (a bouquet of roses) from a chastely dressed maiden on horseback. The scenes on the casket's sides include the famous medieval allegory of female virtue, the legend of the *unicorn,* a white horse with a single ivory horn. Only a virgin could attract the rare animal, and any woman who could do so thereby also demonstrated her moral purity. Religious themes may have monopolized artistic production for churches in the Gothic age, but secular themes figured prominently in private contexts. Unfortunately, very few examples of the latter survive. The Baltimore casket is one of the best.

GOTHIC OUTSIDE OF FRANCE

In 1269, the prior (deputy abbot) of the church of Saint Peter at Wimpfen-im-Tal in the German Rhineland hired "a very experienced architect who had recently come from the city of Paris" to rebuild his monastery church.[4] The architect reconstructed the church *opere francigeno* (in the French manner)—that is, in the Gothic style of the Île-de-France. The spread of the Parisian Gothic style had begun even earlier, but in the second half of the thirteenth century the new style became dominant throughout western Europe. European architecture did not, however, turn Gothic all at once nor in a uniform way. Almost everywhere, patrons and builders modified the "court style" of the Île-de-France according to local preferences. Be-

18-38 The Castle of Love and knights jousting, lid of a jewelry casket, from Paris, France, ca. 1330–1350. Ivory and iron, $4\frac{1}{2}'' \times 9\frac{3}{4}''$. Walters Art Gallery, Baltimore.

18-39 Salisbury Cathedral (view from the southwest), Salisbury, England, 1220–1258; west facade completed 1265; spire ca. 1320–1330.

cause the old Romanesque traditions lingered on in many places, each area, marrying its local Romanesque design to the new style, developed its own brand of Gothic architecture.

England

HORIZONTALITY AND COLOR AT SALISBURY

Salisbury Cathedral (FIG. 18-39) embodies the essential characteristics of English Gothic architecture. Begun in 1220, the same year work started on Amiens Cathedral (FIGS. 18-18 to 18-21), Salisbury Cathedral was mostly completed in about forty years. The two cathedrals are, therefore, almost exactly contemporary, and the differences between them are very instructive. Although Salisbury's facade has lancet windows and blind arcades with pointed arches and statuary, it presents a striking contrast to French designs (compare Amiens, FIG. 18-21, and Reims, FIG. 18-23). The English facade is a wide and squat screen in front of the nave. Not only is the soaring height of the French facades absent, but also the English facade is wider than the building behind it. Its design does not correspond to the three-part division of the interior (nave and two aisles). Also different is the emphasis on the great crossing tower (added ca. 1320–1330), which dominates the silhouette. Salisbury's height is modest compared with that of

Amiens and Reims. And because height is not a decisive factor in the English building, the architect used the flying buttress sparingly and as a rigid prop, rather than as an integral part of the vaulting system within the church. In short, the English builders adopted some of the superficial motifs of French Gothic architecture but did not embrace its structural logic or emphasis on height.

Equally distinctive is the long rectilinear plan (FIG. 18-40), with its double transept and flat eastern end. The latter

0 25 50 75 100 FEET
0 10 20 30 METERS

N

18-40 Plan of Salisbury Cathedral, Salisbury, England, 1220–1258.

18-41 Nave of Salisbury Cathedral (view facing east), Salisbury, England, 1220–1258.

feature was characteristic of Cistercian churches and had been favored in England since Romanesque times. The interior (FIG. **18-41**), although Gothic in its three-story elevation, pointed arches, four-part rib vaults, and compound piers, conspicuously departs from the French Gothic style. The pier colonnettes stop at the springing of the nave arches and do not connect with the vault ribs (compare FIGS. 18-19 and 18-20). Instead, the vault ribs rise from corbels in the triforium, producing a strong horizontal emphasis. The rich color contrast between the light stone of the walls and vaults and the dark Purbeck marble used for the triforium moldings and corbels, compound pier responds, and other details underscores this horizontality. Once again, however, the French Gothic style's impact is clearly visible in the decorative details, especially the tracery of the triforium. Nonetheless, visitors to Salisbury could not mistake the English cathedral for a French one.

FROM DECORATED TO PERPENDICULAR Early on, English architecture found its native language in the elaboration of architectural pattern for its own sake (compare the decorative patterning of the Romanesque piers of Durham Cathedral, FIG. 17-12). Structural logic, expressed in the building fabric, was secondary. The pier, wall, and vault elements, still relatively simple at Salisbury, became increasingly complex and decorative in the fourteenth century. Architectural historians usually call the English Gothic architectural style of that period the Decorated Style. The choir of Gloucester Cathedral (FIG. **18-42**), remodeled about a century after Salisbury, illustrates the transition from the Deco-

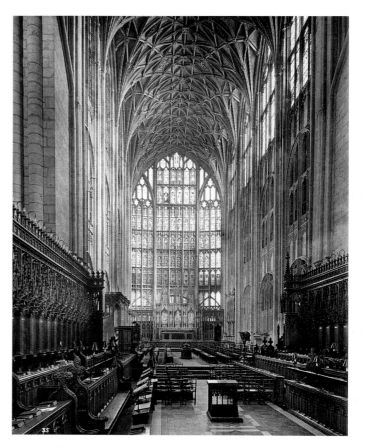

18-42 Choir of Gloucester Cathedral (view facing east), Gloucester, England, 1332–1357.

rated to the last English Gothic style, the Perpendicular Style. The newer style took its name from the pronounced verticality of its decorative details, in contrast to the horizontal emphasis of Salisbury and early English Gothic.

A single enormous window divided into tiers of small windows of like shape and proportion fills the characteristically flat east end of Gloucester Cathedral. At the top, two slender lancets flank a wider central section that also ends in a pointed arch. The design has much in common with the screen facade of Salisbury, but the proportions are different. Vertical, as opposed to horizontal, lines dominate. In the choir wall, the architect also erased Salisbury's strong horizontal accents, as the vertical wall elements lift directly from the floor to the vaulting, unifying the walls with the vaults in the French manner. The vault ribs, which designers had begun to multiply soon after Salisbury, are at Gloucester a dense thicket of entirely ornamental strands that serve no structural purpose. The choir, in fact, is not covered by rib vaults at all but by a continuous Romanesque barrel vault with applied Gothic ornament. In the Gloucester choir the taste for decorative surfaces triumphed over structural "honesty."

"FAN VAULTS" IN A KING'S CHAPEL The decorative and structure-disguising qualities of the Perpendicular Style became even more pronounced in its late phases. A primary example is the early sixteenth-century ceiling of the Chapel of Henry VII (FIG. **18-43**) adjoining Westminster Abbey in London. In this chapel, the earlier linear play of ribs became a kind of architectural embroidery, pulled into

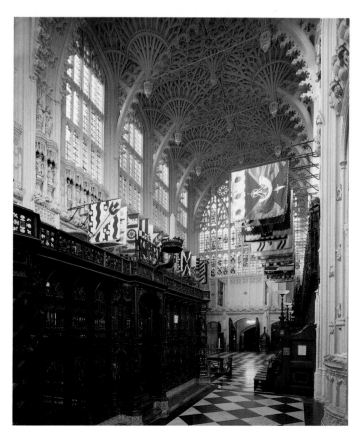

18-43 Chapel of Henry VII, Westminster Abbey, London, England, 1503–1519.

uniquely English "fan vault" shapes with large hanging *pendants* resembling stalactites. The vault looks like something organic that hardened in the process of melting. Intricate tracery recalling lace overwhelms the cones hanging from the ceiling. The chapel represents the dissolution of structural Gothic into decorative fancy. The architect released the Gothic style's original lines from their function and multiplied them into uninhibited architectural virtuosity and theatrics. The Perpendicular Style in this structure well expresses the precious, even dainty, lifestyle codified in the dying etiquette of chivalry at the end of the Middle Ages. A contemporaneous phenomenon in France was the Flamboyant Style seen in churches such as Saint-Maclou at Rouen (FIG. 18-28).

ROYALTY ENTOMBED IN CHURCHES Behind the wooden screen in Henry VII's chapel is the king's tomb in the form of a large stone coffin with sculptured portraits of Henry and his queen, Elizabeth of York, lying on their backs. This type of tomb is a familiar feature of the churches of Late Gothic England—indeed, of Late Gothic Europe. Though not strictly part of the architectural fabric, as are tombs set into niches in the church walls, freestanding tombs with recumbent images of the deceased are permanent and immovable units of church furniture. They preserve both the remains and the memory of the person entombed and testify to the deceased's piety as well as prominence.

Services for the dead were a vital part of the Christian liturgy. The Christian hope for salvation in the hereafter prompted the dying faithful to request masses sung, sometimes in perpetuity, for the eternal repose of their souls. Toward that end, the highborn and wealthy endowed whole chapels for the chanting of masses *(chantries)*, as well as made rich bequests of treasure and property to the Church. Many also required that their tombs be placed as near as possible to the choir or at some other important location in the church, if not in a chapel especially designed and endowed to house it, such as Henry's chapel at Westminster Abbey. Freestanding tombs, accessible to church visitors, had a moral as well as a sepulchral and memorial purpose. The silent image of the deceased, cold and still, was a solemn reminder of human mortality, all the more effective because the remains of the person depicted were housed directly below the portrait. A tomb of an illustrious person could bring distinction, pilgrims, and patronage to the church in which it was placed. Canterbury Cathedral, for example, became one of the most revered shrines in Europe because the martyred saint Thomas à Becket (d. 1170) was buried in its crypt.

A very elaborate example of a freestanding tomb is that of Edward II (r. 1307–1327), installed in Gloucester Cathedral several years after the king's murder in 1327 (FIG. **18-44**). Edward's successor, his son Edward III, paid for the memorial to his father, who reposes in regal robes with his crown on his head. The sculptor portrayed the dead king as an idealized Christlike figure (compare FIG. 18-22). On each side of Edward's head is an attentive angel tenderly touching his hair. At his feet is a guardian lion, emblem also of the king's strength and valor. An intricate Perpendicular Gothic canopy encases the coffin, forming a kind of miniature chapel protecting the deceased. It is a fine example of the English manner with its forest of delicate alabaster and Purbeck marble gables, buttresses, and pinnacles. A distinctive feature is the use

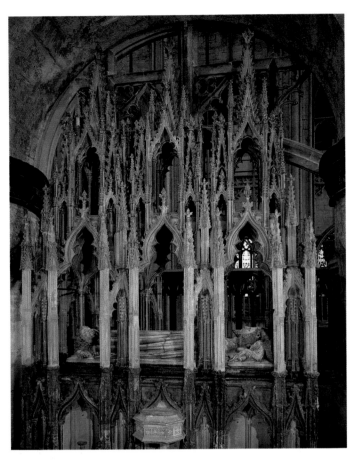

18-44 Tomb of Edward II, Gloucester Cathedral, Gloucester, England, ca. 1330–1335.

of *ogee arches* (arches made up of two double-curved lines meeting at a point), a characteristic Late Gothic form. Art historians often have compared tombs like Edward's to reliquaries. Indeed, the shrinelike frame and the church setting transform the deceased into a kind of saintly relic worthy of veneration.

A GOTHIC VIEW OF THE WORLD We conclude our survey of Gothic England with a monument of a very different kind—a large vellum map of the world (FIG. **18-45**) displayed in Hereford Cathedral. This *mappamundi* ("cloth of the world" in Latin) is probably the work of RICHARD DE BELLO, a priest attached to Lincoln Cathedral from 1264 to 1283. It is the finest thirteenth-century example of the art of mapmaking, which had its roots in antiquity, especially in the imperially commissioned geographic surveys of the then-known world. In fact, at the bottom left of the Hereford map is a picture of the Roman emperor Augustus handing a document to three surveyors and instructing them to "Go into the whole world and report back to the Senate on each continent."

The orientation of the Hereford map and of many other medieval maps is unlike that of most modern maps. North is at the left and east at the top. The explanation is that Christians believed that on Judgment Day Christ would rise in the east, like the sun. At the gabled top of the Hereford map, Christ appears as the enthroned Last Judge of humankind. An angel leads the Saved to Paradise on the left (Christ's right), while grotesque demons pull the Damned into the mouth of Hell. This iconographical theme recalls the tympanum of the

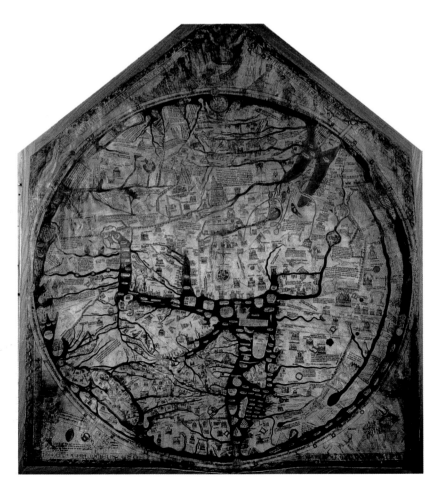

18-45 RICHARD DE BELLO(?), *Mappamundi* (world map) of Henry III, ca. 1277–1289. Tempera on vellum, approx. 5′ 2″ × 4′ 4″. Hereford Cathedral, Hereford, England.

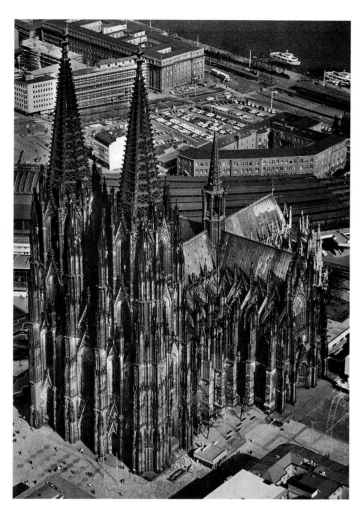

18-46 GERHARD OF COLOGNE, Cologne Cathedral (aerial view from the southwest), Cologne, Germany, begun 1248; nave, facade, and towers completed 1880.

Romanesque church of Saint-Lazare at Autun (see FIG. 17-25). A distinctive Gothic element is the presence of the Virgin Mary below Christ, interceding with her son on behalf of those who prayed to her.

At the world's exact center is Jerusalem, not because medieval mapmakers believed the earth was a flat disk with Jerusalem at its center but because of the central importance of the holy city in medieval thought. Jerusalem appears as a circular walled city accompanied by a picture of Christ on the cross. As was the norm, the Hereford artist characterized most of the world's famous places by their chief buildings. Crete's major feature, for example, is a circular maze, the legendary labyrinth of the Minoan palace at Knossos (see FIGS. 4-3 and 4-4). Babylon's Tower of Babel (see "Babylon: City of Wonders," Chapter 2, page 37) is a multistory fortress with crenellated battlements of the kind found at Carcassonne (FIG. 18-29). Alexandria's lighthouse, one of the Seven Wonders of the ancient world, stands at the Nile River's mouth in Egypt. In some places, the mapmaker provided pictures of the monstrous races that were said to inhabit the far corners of the earth, just as the sculptor of the Vézelay tympanum (see FIG. 17-26) did in the previous century. The Gothic artist also answered the question of what a traveler would find beyond the oceans that bounded the continents — MORS (death).

Germany

THE SOARING VAULTS OF COLOGNE The architecture of Germany remained conservatively Romanesque well into the thirteenth century. In many German churches, the only Gothic feature was the rib vault, buttressed solely by the heavy masonry of the walls. By mid-century, though, the French Gothic style began to make a profound impact. An outstanding example is Cologne Cathedral (FIGS. 18-46 and 18-47). Begun in 1248 under the direction of GERHARD OF COLOGNE, the cathedral was not completed until more than six hundred years later, making it one of the longest building projects on record. Work halted entirely from the mid-sixteenth to the mid-nineteenth century, when the fourteenth-century design for the facade was unexpectedly found. Gothic Revival architects then completed the building according to the Gothic plans, adding the nave, towers, and facade to the east end that had stood alone for several centuries. The Gothic/Gothic Revival structure is the largest cathedral in northern Europe and boasts a giant (four hundred seventy-two feet long) nave with two aisles on each side.

The one hundred fifty-foot-high fourteenth-century choir (FIG. 18-47) is a skillful variation of the Amiens Cathedral choir (FIGS. 18-19 and 18-20) design, with double lancets in the triforium and tall, slender single windows in the clerestory above and choir arcade below. Completed four decades after Gerhard's death, but according to his plans, the choir expresses the Gothic quest for height even more emphatically than many French Gothic buildings. Despite the cathedral's seeming lack of

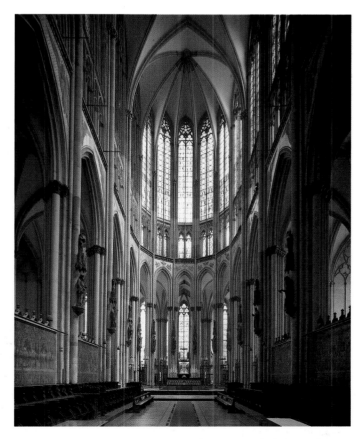

18-47 GERHARD OF COLOGNE, Choir of Cologne Cathedral (view facing east), Cologne, Germany, completed 1322.

18-48 Saint Elizabeth (view from the southeast), Marburg, Germany, 1235-1283.

the standard for their counterparts abroad. In the German Rhineland, then still ruled by the successors of the Carolingian and Ottonian emperors, work began in 1176 on a new cathedral for Strasbourg, today a French city. The apse, choir, and transepts were in place by around 1240. Stylistically, these sections of the new church are Romanesque. But the reliefs of the two south-transept portals are fully Gothic and reveal the impact of contemporary French sculpture, especially that of Reims.

We illustrate the left tympanum, where the theme is the death of the Virgin Mary (FIG. **18-50**). A comparison of the Strasbourg Mary on her deathbed with the Mary of the Reims Visitation group (FIG. 18-24) suggests that the German master had studied the recently installed French jamb statues. The Twelve Apostles gather around the Virgin, forming an arc of mourners well suited to the semicircular frame. At the center Christ receives his mother's soul (the doll-like figure he holds in his left hand). Mary Magdalene, wringing her hands in grief, crouches beside the deathbed. The sorrowing figures express emotion in varying degrees of intensity, from serene resignation to gesturing agitation. The sculptor organized the group by dramatic pose and gesture but also by the rippling flow of deeply incised drapery that passes among them like a rhythmic electric pulse. The sculptor's objective was to imbue the sacred figures with human emotions and to stir emo-tional responses in observers. In Gothic France, as already noted, art became increasingly humanized and natural.

substance, the structure's stability was proven effectively during World War II, when the city of Cologne suffered from extremely heavy aerial bombardments. The church survived the war by virtue of its Gothic skeletal design. Once the first few bomb blasts had blown out all of its windows, subsequent explosions had no adverse effects, and the skeleton remained intact and structurally sound.

A LIGHT-FILLED HALL CHURCH A different type of design, also probably of French origin but developed especially in Germany, is the *Hallenkirche,* or hall church. The term applies to buildings with aisles the same height as the nave. Hall churches, consequently, have no gallery, triforium, or clerestory. An early example of this type is the church of Saint Elizabeth at Marburg (FIGS. **18-48** and **18-49**), built between 1235 and 1283. It incorporates French-inspired rib vaults with pointed arches and tall lancet windows. The facade has two spire-capped towers in the French manner but no tracery arcades or portal sculpture. Because the aisles provide much of the bracing for the nave vaults, the German building's exterior is without the dramatic parade of flying buttresses that typically circles French Gothic churches. But the interior, lighted by double rows of tall windows in the aisle walls, is more unified and free flowing, less narrow and divided, and more brightly illuminated than the interiors of French and English Gothic churches.

HIGH DRAMA IN A GERMAN TYMPANUM Like French Gothic architects, French sculptors also often set

18-49 Interior of Saint Elizabeth (view facing west), Marburg, Germany, 1235–1283.

18-50 Death of the Virgin, tympanum of left doorway, south transept, Strasbourg Cathedral, Strasbourg, France, ca. 1230.

In Gothic Germany artists carried this humanizing trend even further by emphasizing passionate drama. Heightened emotionalism (or *expressionism*) proved an important ingredient of German art in succeeding centuries and even in the modern era.

"PORTRAITS" OF LONG-DEAD DONORS The Strasbourg style, with its feverish emotionalism, was particularly appropriate for narrating dramatic events in relief. The sculptor entrusted with the decoration of the west choir of Naumburg Cathedral faced a very different challenge. The task was to carve statues of the twelve benefactors of the original eleventh-century church on the occasion of a new fundraising campaign. The Strasbourg portal's vivid gestures and agitated faces contrast with the Naumburg statues' quiet solemnity. Two of the figures stand out from the group because of their exceptional quality. They represent the margrave (German military governor) Ekkehard II of Meissen and his wife Uta (FIG. **18-51**). The statues are attached to columns and stand beneath architectural canopies, following the pattern of French Gothic portal statuary. Their location indoors accounts for the preservation of much of the original paint. Ekkehard and Uta give an idea of how the facade and transept sculptures of the French cathedrals once looked.

The period costumes and the individualized features and personalities of the margrave and his wife give the impression they sat for their own portraits, although the subjects lived well before

the sculptor's time. Ekkehard, the intense and somewhat stout knight, contrasts with the beautiful and aloof Uta. With a wonderfully graceful gesture, she draws the collar of her gown partly across her face while she gathers up a soft fold of drapery with a jeweled, delicate hand. The sculptor understood that the drapery and the body it enfolds are distinct. The artist subtly revealed the shape of Uta's right arm beneath her cloak and rendered the fall of drapery folds with an accuracy that indicates the use of a model. The two statues are arresting images of real people, even if they bear the names of aristocrats the artist never met. By the mid-thirteenth century, life-size images not only of sacred but also of secular personages had found their way into churches.

EQUESTRIAN STATUARY REVIVED Somewhat earlier in date than the Naumburg "portraits" is the equestrian statue known as the *Bamberg Rider* (FIG. **18-52**). For centuries this statue has been mounted against a pier in Bamberg Cathedral beneath an architectural canopy that frames the rider's body but not his horse. Scholars debate whether or not the statue was made for this location or moved there, perhaps from the church's exterior. A similar equestrian statue of the same period stood in the market square of Magdeburg, Germany. Both statues revive the imagery of ancient Rome (see FIG. 10-59) and of the Carolingian Empire (see FIG. 16-11).

Like Ekkehard and Uta, the *Bamberg Rider* seems to be a true portrait. Some believe it represents a German emperor, perhaps Frederick II (r. 1220–1250), who was a benefactor of

18-51 Ekkehard and Uta, statues in the west choir, Naumburg Cathedral, Naumburg, Germany, ca. 1249–1255. Painted limestone, approx. 6′ 2″ high.

Bamberg Cathedral. The many other identifications include Saint George and one of the three magi, but a historical personality is most likely the subject. The presence of a Holy Roman Emperor in the cathedral would have underscored the unity of church and state in thirteenth-century Germany. The artist carefully described the rider's costume, the high saddle, and the horse's trappings. The proportions of horse and rider are correct, although the sculptor did not quite understand the animal's anatomy, so its shape is rather stiffly schematic.

The rider turns toward the observer, as if presiding at a review of troops. The stirring and turning of this figure seem to reflect the same impatience with subordination to architecture found in the Reims portal statues (FIG. 18-24).

GRIEVING FOR AN EMACIATED CHRIST The confident thirteenth-century figures at Naumburg and Bamberg stand in marked contrast to a haunting fourteenth-century German image of the Virgin Mary holding the dead Christ in her lap (FIG. **18-53**). The widespread troubles of the fourteenth century—war, plague, famine, and social strife—brought on an ever more acute awareness of suffering. This found its way readily into religious art. The Dance of Death, Christ as the Man of Sorrow, and the Seven Sorrows of the Virgin Mary became favorite themes. A fevered and fearful piety sought comfort and reassurance in the reflection that Christ and the Virgin Mother shared humanity's woes. To represent this, artists emphasized the traits of human suffering in powerful, expressive exaggeration. In the illustrated carved and painted wood group (called a *Pietà*, "pity" or "compassion" in Italian), the sculptor portrayed Christ as a stunted, distorted human wreck, stiffened in death and covered with streams of blood gushing from a huge wound. The Virgin Mother, who cradles him like a child in her lap, is the very image of maternal anguish, her oversized face twisted in an expression of unbearable grief.

18-52 Equestrian portrait *(Bamberg Rider)*, statue in the east choir, Bamberg Cathedral, Germany, ca. 1235–1240. Sandstone, 7′ 9″ high.

18-53 Virgin with the Dead Christ (*Röttgen Pietà*), from the Rhineland, Germany, ca. 1300–1325. Painted wood, 2′ 10½″ high. Rheinisches Landemuseum, Bonn.

This statue expresses nothing of the serenity of Romanesque and earlier Gothic depictions of Mary (see FIGS. 17-30 and 18-5, right tympanum). Nor does the *Röttgen Pietà* (named after a collector) have anything in common with the aloof, iconic images of the Theotokos with the infant Jesus in her lap common in Byzantine art (see FIGS. 12-15 and 12-16). Here the artist forcibly confronts the devout with an appalling icon of agony, death, and sorrow that humanizes, to the point of heresy, the sacred personages. The work calls out to the horrified believer, "What is your suffering compared to this?"

The humanizing of religious themes and religious images accelerated steadily from the twelfth century. By the fourteenth century, art addressed the private person (often in a private place) in a direct appeal to the emotions. The expression of feeling accompanied the representation of the human body's motion. As the figures of the church portals began to "move" on their columns, then within their niches, and then became free-standing, their details became more outwardly related to the human audience as expressions of recognizable human emotions.

GOLD AND ENAMEL FOR THE CHURCH

When Abbot Suger wanted to install a magnificent crucifix in the new Gothic choir of Saint-Denis, he selected artists from Germany's Meuse River valley for the job. The Mosan region long had been famous for the quality of its metalworkers and enamelers (see FIGS. 17-29 and 17-31) so Suger's choice is not surprising. The Saint-Denis crucifix is lost, but Suger described it in one of his treatises on the building and adorning of the royal abbey church. The cross stood on a sumptuous base decorated with sixty-eight enamel scenes pairing Old and New Testament episodes. Costly furnishings such as this crucifix were key ingredients in Suger's plan to make his new church an earthly introduction to the splendors of Paradise (see "Abbot Suger and the Rebuilding of Saint-Denis," page 489).

The leading Mosan artist of the late twelfth and early thirteenth centuries was NICHOLAS OF VERDUN. In 1181 he completed work on a gilded-copper and enamel *ambo* (a pulpit for biblical readings) for the Benedictine abbey church at Klosterneuburg, near Vienna in Austria. After a fire damaged the pulpit in 1330, the church hired artists to convert the pulpit into an altarpiece. The pulpit's sides became the wings of a triptych. The fourteenth-century artists also added six scenes to Nicholas's original forty-five.

We illustrate the *Klosterneuburg Altar* in its final form (FIG. **18-54**), with its fifty-one enamels set into trefoil-arched niches framed by explanatory inscriptions. The central row of enamels depicts New Testament episodes, beginning with the Annunciation, and bears the label *sub gracia,* or the world "under grace," that is, after the coming of Christ. The upper and lower registers contain Old Testament scenes labeled, respectively, *ante legem,* "before the law" Moses received on Mount Sinai, and *sub lege,* "under the law" of the Ten Commandments. In this scheme, prophetic Old Testament events appear above and below the New Testament episodes they prefigure. This organization was unlikely to have been Nicholas's invention. Provost Wernher of Klosterneuburg or another church official probably formulated the iconographical program, consistent with a long tradition going back to the earliest Christian art (see "Jewish Subjects in Christian Art," Chapter 11, page 305).

On the *Klosterneuburg Altar,* the angel's Annunciation to Mary of the coming birth of Jesus, for example, is framed above and below by enamels of angels announcing the births of Isaac and Samson. In the central section of the triptych the Old Testament counterpart of Christ's Crucifixion is Abraham's sacrifice of Isaac, a parallelism already established in Early Christian times in both art (see FIG. 11-5) and literature. Nicholas of Verdun's gold figures stand out vividly from the blue enamel background. The biblical actors make lively gestures and wear garments that are almost overwhelmed by the complex linear patterns of their folds.

ENSHRINING THE MAGI'S RELICS Sculptured versions of the Klosterneuburg figures appear on the *Shrine of the Three Kings* (FIG. **18-55**) in Cologne Cathedral. Nicholas of Verdun probably began work on the huge (more than six feet long and almost as tall) reliquary in 1190. Philip von Heinsberg, archbishop of Cologne from 1167 to 1191, commissioned the shrine to contain relics of the three magi. The Holy Roman Emperor Frederick Barbarossa acquired them in the conquest of

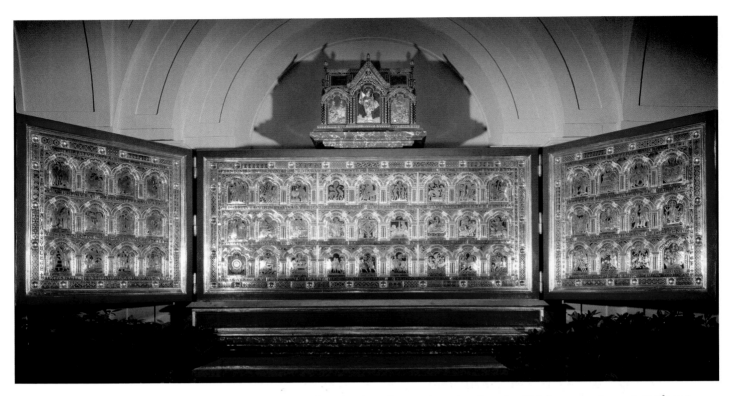

18-54 NICHOLAS OF VERDUN, the *Klosterneuburg Altar,* from the abbey church at Klosterneuburg, Austria, 1181. Gilded copper and enamel, 3′ 6¾″ high. Stiftsmuseum, Klosterneuburg.

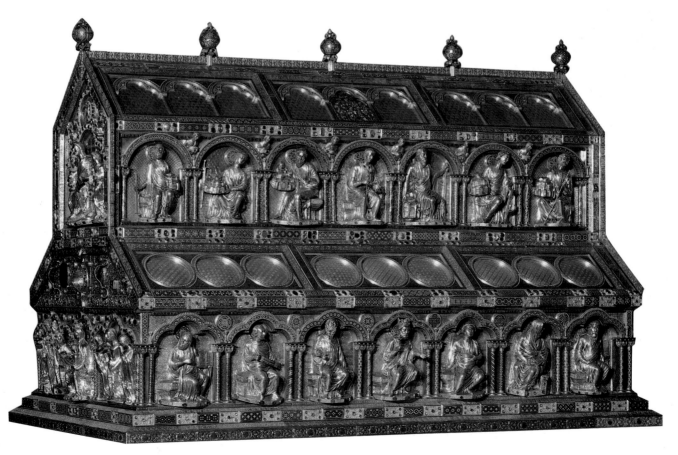

18-55 NICHOLAS OF VERDUN, *Shrine of the Three Kings,* from Cologne Cathedral, Cologne, Germany, begun ca. 1190. Silver, bronze, enamel, and gemstones, 5′ 8″ × 6′ × 3′ 8″. Cathedral Treasury, Cologne.

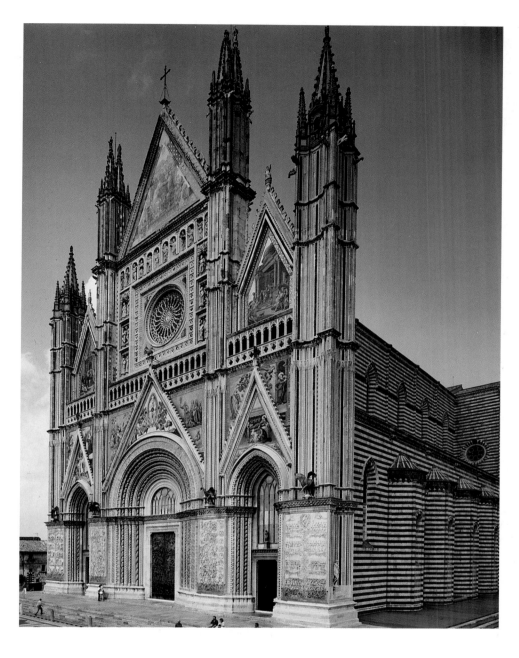

18-56 LORENZO MAITANI, west facade of Orvieto Cathedral, Orvieto, Italy, begun 1310.

Milan in 1164 and donated them to the German cathedral. Possession of the magi's relics gave the Cologne archbishops the right to crown German kings. Nicholas's reliquary, made of silver and bronze with ornamentation in enamel and gemstones, is one of the most luxurious ever fashioned, especially considering its size. The shape resembles that of a basilican church. Repoussé figures of the Virgin Mary, the three magi, Old Testament prophets, and New Testament apostles in arcuated frames are variations of those on the Klosterneuburg pulpit. The deep channels and tight bunches of the drapery folds are hallmarks of Nicholas's style. A similar figural style appeared a half century later in Strasbourg Cathedral's Death of the Virgin tympanum (FIG. 18-50).

Nicholas of Verdun's *Klosterneuburg Altar* and his *Shrine of the Three Kings,* together with Suger's treatises on the furnishings of Saint-Denis, are welcome reminders of how magnificently outfitted medieval church interiors were. The so-called "minor arts" played a defining role in creating a special otherworldly atmosphere for Christian ritual. These Gothic examples continued

a tradition that dates back to the Roman emperor Constantine and the first imperial patronage of Christianity (see "Constantine's Gifts to the Churches of Rome," Chapter 11, page 311).

Italy

GOTHIC AND NON-GOTHIC AT ORVIETO
Nowhere is the regional diversity of Gothic architecture more evident than in Italy. In the Romanesque period, as already discussed, Italian architects stood apart from developments north of the Alps. Many Italian Romanesque churches more closely resemble Early Christian basilicas than contemporary buildings in France, Germany, or England. Similarly, few Italian architects accepted the northern Gothic style. Some architectural historians even have questioned whether it is proper to speak of late medieval Italian buildings as Gothic structures.

The west facade of Orvieto Cathedral (FIG. **18-56**) is typical of late medieval architecture in Italy. Designed in the early fourteenth century by LORENZO MAITANI, an architect from

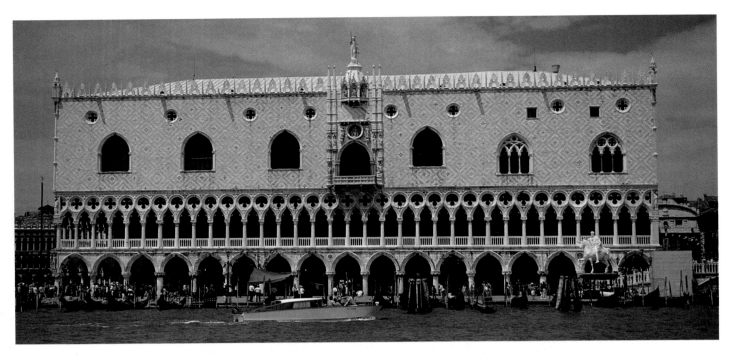

18-57 Doge's Palace, Venice, Italy, begun ca. 1340–1345; expanded and remodeled, 1424–1438.

nearby Siena, the Orvieto facade imitates some elements of the French Gothic architectural vocabulary. French influence is especially noticeable in the pointed gables over the three doorways, in the rose window in the upper zone framed by statues in niches, and in the four large pinnacles that divide the facade into three bays. The outer pinnacles serve as miniature substitutes for the big northern European west-front towers. Maitani's facade is, however, merely a Gothic overlay masking a marble-revetted structure in the Tuscan Early Christian–inspired Romanesque tradition, as our three-quarter view of the cathedral reveals. The Orvieto facade resembles a great altar screen, its single plane covered with carefully placed carved and painted ornament. In principle, Orvieto belongs with Florence's San Miniato al Monte (see FIG. 17-17) or Pisa Cathedral (see FIG. 17-14), rather than with Amiens (FIG. 18-21) or Reims (FIG. 18-23) Cathedrals. Inside, Orvieto Cathedral has a timber-roofed nave with a two-story elevation (columnar arcade and clerestory). Both the triumphal arch framing the apse and the nave arcade's arches are round as opposed to pointed.

THE EARLY CHRISTIAN TRADITION Timber beams rather than lofty stone vaults also cover the nave and aisles of the church of Santa Croce (Holy Cross) in Florence (see FIG. Intro-3), begun in 1295. Although Santa Croce's one hundred twenty-four-foot-high nave is taller than those of Laon (FIG. 18-9) and Chartres (FIG. 18-13) Cathedrals in France, the Florentine church's interior closely resembles an Italian Early Christian basilica. The only immediately recognizable Gothic feature is the pointed arches of the nave arcade and side aisles.

The city churches of Italy, as elsewhere in Gothic Europe, were just as much monuments of civic pride as they were sites of religious ritual. To undertake the construction of great

buildings, a city had to be rich with thriving commerce. The profusion of large churches during the period attests to the prosperity of those who built and maintained them, as well as to the general revival of Italy's economy in the thirteenth and fourteenth centuries (see Chapter 19).

A GOTHIC PALACE ON A LAGOON One of the wealthiest cities of late medieval Italy—and of Europe—was Venice, renowned for its streets of water. Situated on a lagoon on the northeastern coast of Italy, Venice was secure from land attack and could rely on a powerful navy for protection against invasion from the sea. Internally, Venice was a tight corporation of ruling families who, for centuries, provided stable rule and fostered economic growth. The Venetian republic's seat of government was the Doge's (Duke's) Palace (FIG. **18-57**). Begun around 1340–1345 and significantly remodeled after 1424, it was the most ornate public building in medieval Italy. In a stately march, the first level's short and heavy columns support rather severe pointed arches that look strong enough to carry the weight of the upper structure. Their rhythm is doubled in the upper arcades, where more-slender columns carry ogee arches, which terminate in flame-like tips between medallions pierced with quatrefoils. Each story is taller than the one beneath it, the topmost as high as the two lower arcades combined. Yet the building does not look top-heavy. This is due in part to the complete absence of articulation in the top story and in part to the walls' delicate patterning, in cream- and rose-colored marbles, which somehow makes them appear paper thin. The Doge's Palace is the monumental representative of a delightful and charming variant of Late Gothic architecture. Colorful, decorative, light and airy in appearance, and not overloaded, the Venetian Gothic is ideally suited to Venice, which floats between water and air.

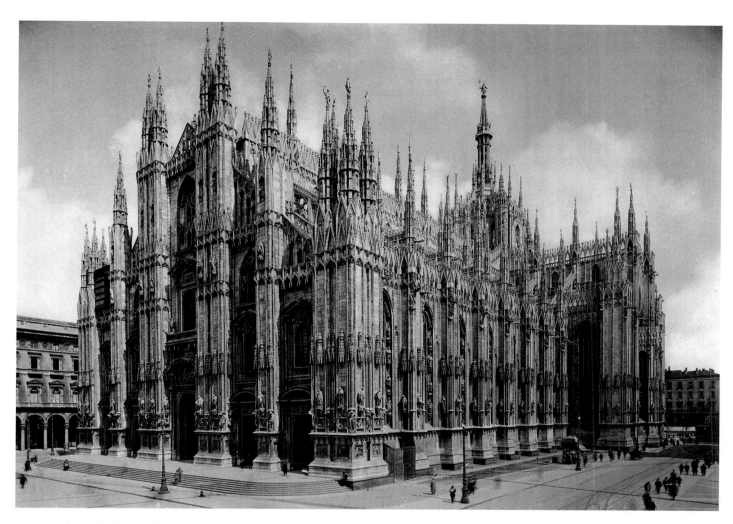

18-58 Milan Cathedral (view from the southwest), Milan, Italy, begun 1386.

MILAN'S ECLECTIC CATHEDRAL Since Romanesque times, northern European influences had been felt more strongly in Lombardy than in the rest of Italy. When Milan's citizens decided to build their own cathedral (FIG. 18-58) in 1386, they invited experts not only from Italy but also from France, Germany, and England. These masters argued among themselves and with the city council, and no single architect ever played a dominant role. The result of this attempt at "architecture by committee" was, not surprisingly, a compromise. The building's proportions, particularly the nave's, became Italian (that is, wide in relation to

height), and the surface decorations and details remained Gothic. Clearly derived from France are the cathedral's multitude of pinnacles and the elaborate tracery on the facade, flank, and transept. But even before the building was half finished, the new classical style of the Italian Renaissance had been well launched (see Chapter 21), and the Gothic design had become outdated. Thus, Milan Cathedral's elaborate facade represents a confused mixture of Late Gothic and classicizing Renaissance elements. With its pediment-capped rectilinear portals amid Gothic pinnacles, the cathedral stands as a symbol of the waning of the Gothic style.

NOTES

Chapter 2

1. Françoise Tallon, trans., *The Royal City of Susa,* by Prudence O. Harper et al. (New York: Metropolitan Museum of Art, 1992), 132.

Chapter 3

1. Herodotus, *Histories,* 2.35.

2. We follow the chronology proposed by John Baines and Jaromír Malék in *Atlas of Ancient Egypt* (Oxford: Oxford University Press, 1980), 36–37, and the division of kingdoms favored by, among others, Mark Lehner, *The Complete Pyramids* (New York: Thames and Hudson, 1997), 8–9, and David P. Silverman, ed., *Ancient Egypt* (New York: Oxford University Press, 1997), 20–39.

Chapter 4

1. Homer, *Iliad,* II. 466–649.

Chapter 5

1. Thucydides, *Peloponnesian War,* II.40–41.

2. Aristotle, *Politics,* I.2.15.

3. Ibid., VII. 11.1.

4. Plutarch, *Life of Pericles,* 12.

5. Pliny, *Natural History,* 34.74.

6. Ibid., 36.20.

7. Lucian, *Amores,* 13–14; *Imagines,* 6.

8. Plutarch, *Moralia,* 335A–B. Translated by J. J. Pollitt, *The Art of Ancient Greece: Sources and Documents* (New York: Cambridge University Press, 1990), 99.

9. Pliny, *Natural History,* 35.110.

10. Diodorus Siculus, *History,* XVII.117.4.

Chapter 7

1. Michael Sullivan, *The Birth of Landscape Painting in China* (Berkeley: University of California Press, 1962), 103.

2. Ibid., 105.

Chapter 10

1. J. J. Pollitt, *The Art of Rome, c. 753 B.C.–A.D. 337: Sources and Documents* (New York: Cambridge University Press, 1983), 170.

2. Livy, *History of Rome,* XXV.40.1–3.

3. Pollitt, 32.

4. Recorded by the Venerable Bede, the great English scholar, monk, and saint, who died in 735; translated by Lord Byron in *Childe Harold's Pilgrimage* (1817) IV.145.

5. Juvenal *Satires* III. 225, 232.

Chapter 12

1. Cyril Mango, trans., *The Art of the Byzantine Empire, 312–1453: Sources and Documents* (Englewood Cliffs, N.J.: Prentice-Hall, 1972), 85–86.

2. Ibid., 74.

3. Ibid., 83, 86.

4. Colm Luibheid, trans., *Pseudo-Dionysius: The Complete Works* (New York: Mahwah, 1987), 68ff.

5. Mango, 75.

6. Nina G. Garsoïan, "Later Byzantium," in *The Columbia History of the World,* ed. John A. Garraty and Peter Gay (New York: Harper and Row, 1972), 453.

7. Ibid., 460.

Chapter 16

1. Kevin Crossley-Holland, trans., *Beowulf* (New York: Farrar, Straus & Giroux, 1968), 119.

2. Ibid., 33.

3. Françoise Henry, *The Book of Kells* (New York: Alfred A. Knopf, 1974), 165.

Chapter 17

1. Quoted in Elizabeth G. Holt, *A Documentary History of Art* (New York: Doubleday Anchor Books, 1957), 1: 18.

2. Translated by Calvin B. Kendall, *The Allegory of the Church. Romanesque Portals and Their Verse Inscriptions* (Toronto: University of Toronto Press, 1998), 207.

3. Holt, 1: 20.

Chapter 18

1. Giorgio Vasari, *Introduzione alle tre arti del disegno* (1550), ch. 3. Paul Frankl, *The Gothic: Literary Sources and Interpretation through Eight Centuries* (Princeton, N.J.: Princeton University Press, 1960), 290–91, 859–60.

2. Dante, *Divine Comedy,* Purgatory, XI.81.

3. Roland Behrendt, trans., *Johannes Trithemius, In Praise of Scribes: De Laude Scriptorum* (Lawrence, Kansas: Coronado Press, 1974), 71.

4. Frankl, 55.

Chapter 19

1. Robert Gottfried, *The Black Death: Natural and Human Disaster in Medieval Europe* (New York: Free Press, 1985), xiii.

Chapter 20

1. Henry Dussart, ed., *Fragments inédits de Romboudt de Doppere: Chronique brugeoise de 1491 à 1498,* (Bruges, Belgium: L. de Plancke, 1892), 49.

2. Johan A. Huizinga, *The Waning of the Middle Ages,* (1924; reprint, New York: St. Martin's Press, 1988), 156.

Chapter 21

1. Elizabeth Gilmore Holt, ed., *Literary Sources of Art History* (Princeton, N.J.: Princeton University Press, 1947), 87–88.

2. Giorgio Vasari, *Lives of the Painters, Sculptors and Architects,* trans. Gaston du C. de Vere (New York: Alfred A. Knopf, 1996), 1:304.

3. Holt, *Literary Sources,* 90–91.

4. Vasari, 1:318

5. H.W. Janson, *The Sculpture of Donatello* (Princeton, N.J.: Princeton University Press, 1965), 154.

Chapter 22

1. Da Vinci to Ludovico Sforza, ca. 1480–81, *Literary Sources of Art History,* ed. Elizabeth Gilmore Holt (Princeton: Princeton University Press, 1947), 170.

2. Anthony Blunt, *Artistic Theory in Italy, 1450–1600* (London: Oxford University Press, 1964), 34.

3. Heinrich Wölfflin, *Classic Art: An Introduction to the Italian Renaissance,* 4th ed. (Ithaca, N.Y.: Cornell University Press, 1980), 27.

4. Erwin Panofsky, "Artist, Scientist, Genius," in *The Renaissance,* ed. Wallace K. Ferguson (New York: Harper & Row, 1962), 147

5. Bruce Boucher, *Andrea Palladio: The Architect in His Time* (New York: Abbeville Press, 1998), 229.

6. Holt, *Literary Sources,* 240.

7. James M. Saslow, *The Poetry of Michelangelo: An Annotated Translation* (New Haven, Conn.: Yale University Press, 1991), 195.

8. Ibid., 239.

9. Ibid., 407.

10. Vasari, 2: 736.

11. Robert J. Clements, *Michelangelo's Theory of Art* (New York: New York University Press, 1961), 320.

12. Francesco Valcanover, "An Introduction to Titian," in *Titian Prince of Painters* (Venice: Marsilio Editori, S.p.A., 1990), 23–24.

13. Vasari, 1: 860.

14. Holt, *Literary Sources,* 229.

Chapter 23

1. Jackson J. Spielvogel, *Western Civilization Since 1300,* 3rd ed., (Minneapolis: West Publishing Company, 1997), 465.

2. Wolfgang Stechow, *Northern Renaissance Art 1400–1600: Sources and Documents* (Evanston, Ill.: Northwestern University Press, 1989), 111.

3. Ibid., 118.

4. Ibid., 123.

5. Vasari, 2: 863.

Chapter 24

1. Wolfgang Stechow, *Rubens and the Classical Tradition* (Cambridge: Harvard University Press, 1968), 26.

2. David G. Wilkins, Bernard Schultz, and Katheryn M. Linduff, *Art Past, Art Present,* 3rd ed. (New York: Harry N. Abrams, 1997), 365.

3. Bob Haak, *The Golden Age: Dutch Painters of the Seventeenth Century* (New York: Abrams, 1984), 75.

4. Ibid., 450.

5. Robert Goldwater and Marco Treves (eds.), *Artists on Art,* 3rd ed. (New York: Pantheon Books, 1958), 155.

6. Ibid., 155.

7. Ibid., 151–153.

8. Jonathan Brown, *Kings and Connoisseurs: Collecting Art in Seventeenth-Century Europe* (Princeton, N.J.: Princeton University Press, 1995), 207.

9. Goldwater and Treves (eds.), 157.

Chapter 25

1. Milo Beach, *The Imperial Image* (Washington, D.C.: Freer Gallery of Art, Smithsonian Institution, 1981), 169.

2. Vidya Dehejia et al., *Devi: The Great Goddess* (Washington, D.C.: The Arthur M. Sackler Gallery, Smithsonian Institution, in association with Mapin Publishing, Ahmedabad and Prestel Verlag, Munich, 1999), 260.

3. *Kamol Tassananchalee: 39 Years Retrospective* (Bangkok: National Gallery, 1999), 29.

Chapter 28

1. Thomas A. Bailey, *The American Pageant: A History of the Republic,* 2nd ed. (Boston: D.C. Heath and Company, 1961), 280.

2. *The Indispensable Rousseau,* compiled and presented by John Hope Mason (London: Quartet Books, 1979), 39.

3. Voltaire to Rousseau, 30 August 1755, *The Collected Writings of Rousseau,* Vol. 3, eds. Roger D. Masters and Christopher Kelly (Hanover, N.H.: University Press of New England, 1992), 102.

4. Elizabeth Gilmore Holt, *Literary Sources of Art History* (Princeton: Princeton University Press, 1947), 532.

5. Robert Goldwater and Marco Treves, *Artists on Art,* 3rd ed. (New York: Random House, 1958), 206.

6. Ibid., 205.

7. Ibid., 205.

8. Alexander Pope, *Epistles to Several Persons (Moral Essays),* ed. F. W. Bateson (London and New Haven: Metheun & Co. Ltd. and Yale University Press, 1961), 155.

9. Edgar Allen Poe, "To Helen" (1831).

10. Marcus Whiffen and Fredrick Koeper, *American Architecture 1607–1976* (Cambridge, MA: The MIT Press, 1981), 130.

11. Goldwater and Treves, 218.

12. Ibid., 216.

13. Gwyn A. Williams, *Goya and the Impossible Revolution* (London: Allen Lane, 1976), 175–77.

14. Walter Pach, trans., *Journal of Eugène Delacroix* (New York: Crown Publishers, 1948), 511.

15. Théophile Gautier, *Histoire de Romantisme* (Paris: Charpentier, 1874), 204.

16. Delacroix to Auguste Jal, 4 June 1832, *Art in Theory 1815–1900: An Anthology of Changing Ideas,* eds. Charles Harrison and Paul Wood with Jason Gaiger (Oxford: Blackwell Publishers Ltd., 1998), 88.

17. Théophile Silvestre, *Les Artistes Français-I: Romantiques* (Paris: Les Éditions G. Crès and C-ie, 1926). 75.

18. H. Borsch-Supan, *Caspar David Friedrich* (New York: Brazillier, 1974), 7.

19. Harrison and Wood with Gaiger, 54.

20. Brian Lukacher, "Nature Historicized: Constable, Turner, and Romantic Landscape Painting," in *Nineteenth Century Art: A Critical History,* ed. Stephen F. Eisenman (New York: Thames and Hudson, 1994), 121.

21. John W. McCoubrey, *American Art 1700–1960: Sources and Documents* (Englewood Cliffs, N.J.: Prentice-Hall, 1965), 98.

22. *The New York Weekly Tribune,* 30 September 1865.

23. Nikolai Cikovsky Jr. and Franklin Kelly, *Winslow Homer* (Washington, D.C.: National Gallery of Art, 1995), 26.

24. Holt, *Literary Sources,* 547, 548.

25. Nicholas Pevsner, *An Outline of European Architecture* (Baltimore, Md.: Penguin, 1960), 627.

26. Letter from Delaroche to François Arao, in Helmut Gernsheim, *Creative Photography* (New York: Bonanza Books, 1962), 24.

27. Naomi Rosenblum, *A World History of Photography* (New York: Abbeville Press, 1984), 69.

Chapter 29

1. Clement Greenberg, "Modernist Painting," *Art & Literature,* no. 4 (spring 1965): 193.

2. Ibid., 194.

3. Linda Nochlin, *Realism and Tradition in Art 1848–1900* (Englewood Cliffs, N.J.: Prentice-Hall, Inc., 1966), 39, 38, 42.

4. Goldwater and Treves, 295–97.

5. Comment by French critic Enault in Linda Nochlin, *The Nature of Realism* (New York: Penguin Books, 1971), 34.

6. Nochlin, *Realism and Tradition in Art,* 42.

7. In George Heard Hamilton, *Manet and His Critics* (New Haven, Conn.: Yale University Press, 1954), 45.

8. Stephen F. Eisenman, *Nineteenth Century Art: A Critical History* (London: Thames and Hudson, 1994), 242.

9. "On the Heroism of Modern Life" (the closing section of Baudelaire's *Salon of 1846,* published as a brochure in Paris in 1846).

10. Lloyd Goodrich, *Thomas Eakins, His Life and Work* (New York: Whitney Museum of American Art, 1933), 51–52.

11. In Kenneth MacGowan, *Behind the Screen* (New York: A Dell Book, Delta, 1965), 49.

12. In Robert A. Sobieszak, *Masterpieces of Photography from the George Eastman House Collection* (Rochester: International Museum of Photography, 1985), 214.

13. Linda Nochlin, *Realism* (Harmondsworth, England: Penguin Books, 1971), 28.

14. Linda Nochlin, *Impressionism and Post-Impressionism 1874–1904* (Englewood Cliffs, N J : Prentice Hall, 1966), 35.

15. Roy McMullan, *Degas: His Life, Times, and Work* (Boston: Houghton Mifflin Company, 1984), 293.

16. John McCoubrey, *American Art 1700–1960: Sources and Documents* (Englewood Cliffs, N.J.: Prentice Hall, 1965), 184.

17. Laurie Schneider Adams, *A History of Western Art,* 2nd ed. (Madison, Wis.: Brown & Benchmark, 1997), 443.

18. Goldwater and Treves, 322.

19. Van Gogh to Theo van Gogh, 3 September 1888, *Van Gogh: A Self-Portrait, Letters Revealing His Life as a Painter,* selected by W. H. Auden (New York: Dutton, 1963), 319.

20. Van Gogh to Theo van Gogh, 11 August 1888, *Van Gogh: A Self-Portrait, Letters Revealing His Life as a Painter,* 313.

21. Van Gogh to Theo van Gogh, 11 August 1888, *Van Gogh: A Self-Portrait, Letters Revealing His Life as a Painter,* 321.

22. Van Gogh to Theo van Gogh, September 1888, *The Complete Letters of Vincent van Gogh,* ed. J. van Gogh–Bonger and W. V. van Gogh (Greenwich, Conn.: 1979), 3: no. 534.

23. Van Gogh to Theo van Gogh, 8 September 1888, *Van Gogh: A Self-Portrait, Letters Revealing His Life as a Painter,* selected by W. H. Auden (New York: Dutton, 1963), 320.

24. Van Gogh to Theo van Gogh, 16 July 1888, ibid., 299.

25. Belinda Thompson, ed. *Gauguin by Himself* (Boston: Little, Brown and Company, 1993), 270–71.

26. Herschel B. Chipp, *Theories of Modern Art* (Berkeley: University of California Press, 1968), 72.

27. Maurice Denis, "The Influence of Paul Gauguin," in *Theories of Modern Art,* 103.

28. Goldwater and Treves, 375.

29. Ibid., 378.

30. Richard W. Murphy, *The World of Cézanne 1839–1906* (New York: Time-Life Books, 1968), 70.

31. Goldwater and Treves, 363.

32. Cézanne to Émile Bernard, 15 April 1904, *Theories of Modern Art,* 19.

33. Goldwater and Treves, eds., 361.

34. George Heard Hamilton, *Painting and Sculpture in Europe 1880–1940,* 6th ed. (New Haven: Yale University Press, 1993), 124.

35. V. Frisch and J.T. Shipley, *Auguste Rodin,* (New York: Stokes, 1939), 203.

36. Eileen Boris, *Art and Labor: Ruskin, Morris, and the Craftsman Ideal in America* (Philadelphia: Temple University Press, 1986), 7.

37. Siegfried Giedion, *Space, Time, and Architecture* (Cambridge, Mass.: Harvard University Press, 1965), 282.

Chapter 30

1. Alfred M. Tozzer, ed., *Landa's Relación de las cosas de Yucatán: A Translation* (Landa's account of the things of Yucatán), (Cambridge: Peabody Museum Papers, 1941; reprint, New York: Kraus Reprint Corporation, 1966), 18:169.

2. Bernal Díaz del Castillo, *The Discovery and Conquest of Mexico,* trans. A. P. Maudslay (New York: Farrar, Straus, Giroux, 1956), 218–19.

Chapter 31

1. This iconographical explanation courtesy of Meteorolgical Service of New Zealand Limited, Kelburn, Wellington.

Chapter 33

1. Benito Mussolini, "The Doctrine of Fascism," in *Italian Fascisms from Pareto to Gentile,* ed. Adrian Lyttleton, trans. Douglas Parmée (London: Cape, 1973), 42.

2. Herwarth Walden, "Kunst und Leben," *Der Sturm* (1919), 10: 2.

3. John Elderfield, *The "Wild Beasts": Fauvism and Its Affinities* (New York: Museum of Modern Art, 1976), 29.

4. John Russell and the editors of Time-Life Books, *The World of Matisse 1869–1954* (New York: Time-Life Books, 1969), 98.

5. Peter Selz, *German Expressionist Painting* (Berkeley: University of California Press, 1957), 95.

6. Chipp, 182.

7. Frederick S. Levine, *The Apocalyptic Vision: The Art of Franz Marc as German Expressionism* (New York: Harper & Row, 1979), 57.

8. Sam Hunter and John Jacobus, *Modern Art,* 3rd ed. (New York: Harry N. Abrams, 1992), 121.

9. Roland Penrose, *Picasso: His Life and Work,* rev. ed. (New York: Harper & Row, 1971), 122.

10. Hamilton, *Painting and Sculpture,* 246.

11. Edward Fry, ed., *Cubism* (London: Thames & Hudson, 1966), 112–13, 116.

12. Hamilton, *Painting and Sculpture,* 238.

13. Michael Hoog, *R. Delaunay* (New York: Crown, 1976), 49.

14. Françoise Gilot and Carlton Lake, *Life With Picasso* (New York: McGraw-Hill, 1964), 77.

15. From the *Initial Manifesto of Futurism,* first published 20 February 1909.

16. Ibid.

17. Umberto Boccioni, et al. "Futurist Painting: Technical Manifesto," *Poesia,* April 10, 1910.

18. Hans Richter, *Dada: Art and Anti-Art* (London: Thames & Hudson, 1961), 25.

19. Robert Short, *Dada and Surrealism* (London: Octopus Books, 1980), 18.

20. Robert Motherwell, ed., *The Dada Painters and Poets: An Anthology,* 2nd ed. (Cambridge, Mass.: Belknap Press of Harvard University, 1989).

21. Richter, 64–65.

22. Ibid., 57.

23. Arturo Schwarz, *The Complete Works of Marcel Duchamp* (London: Thames & Hudson, 1965), 466.

24. Charles C. Eldredge, "The Arrival of European Modernism," *Art in America* 61 (July-August 1973), 35.

25. Dorothy Norman, *Alfred Stieglitz: An American Seer* (Millerton, N.Y.: Aperture, 1973).

26. Ibid., 161.

27. Ibid., 9–10, 161.

28. Gail Stavitsky, "Reordering Reality: Precisionist Directions in American Art, 1915–1941," in *Precisionism in America 1915–1941: Reordering Reality* (New York: Harry N. Abrams, 1994), 12.

29. Carol Troyen and Erica E. Hirshler, *Charles Sheeler: Paintings and Drawings* (Boston: Museum of Fine Arts, 1987), 116.

30. Miles Orvell, "Inspired by Science and the Modern: Precisionism and American Culture," in *Precisionism in America,* 54.

31. Karen Tsujimoto, *Images of America: Precisionist Painting and Modern Photography* (Seattle: University of Washington Press, 1982), 70.

32. Matthias Eberle, *World War I and the Weimar Artists: Dix, Grosz, Beckmann, Schlemmer* (New Haven: Yale University Press, 1985), 65.

33. Ibid., 54.

34. Ibid., 22.

35. Ibid., 42.

36. William S. Rubin, *Dada, Surrealism, and Their Heritage* (New York: Museum of Modern Art, 1968), 64.

37. Hamilton, *Painting and Sculpture,* 392.

38. Richter, 155.

39. Ibid., 159.

40. Rubin, *Dada, Surrealism, and Their Heritage,* 111.

41. Hunter and Jacobus, 179.

42. William S. Rubin, *Miró in the Collection of the Museum of Modern Art* (New York: Museum of Modern Art, 1973), 32.

43. Chipp, 182–86.

44. Ibid., 341, 345.

45. Robert L. Herbert, ed., *Modern Artists on Art* (Englewood Cliffs, N.J.: Prentice Hall, 1965), 140–41, 145–46.

46. Chipp, 328, 334, 336.

47. Ibid., 332, 335.

48. Camilla Gray, *The Russian Experiment in Art 1863–1922* (New York: Harry N. Abrams, 1970), 216.

49. Ibid., 232–33.

50. Kenneth Frampton, *A Critical History of Modern Architecture* (London: Thames & Hudson, 1985), 142.

51. Ibid., 147.

52. Chipp, 349, and Michel Seuphor, *Piet Mondrian: Life and Work* (New York: Harry N. Abrams, 1956), 177.

53. Hamilton, *Painting and Sculpture,* 319.

54. Chipp, 349.

55. Ibid., 350.

56. Hans L. Jaffeé, comp., *De Stijl* (New York: Harry N. Abrams, 1971), 185–188.

57. Piet Mondrian, "Dialogue on the New Plastic," in *Art in Theory 1900–1990: An Anthology of Changing Ideas,* eds. Charles Harrison and Paul Wood (Oxford: Blackwell Publishers Ltd., 1992), 285.

58. Walter Gropius, from *The Manifesto of the Bauhaus,* April 1919.

59. Ibid.

60. Ibid.

61. László Moholy-Nagy, *Vision in Motion* (Chicago: Paul Theobald, 1969), 268.

62. Hamilton, *Painting and Sculpture,* 345.

63. Ibid.

64. *Josef Albers: Homage to the Square* (New York: Museum of Modern Art, 1964), n.p.

65. John Willett, *Art and Politics in the Weimar Period: The New Sobriety, 1917–1933,* (New York: Da Capo Press, 1978), 119.

66. Wayne Craven, *American Art: History and Culture* (Madison, Wis.: Brown and Benchmark, 1994), 403.

67. Vincent Scully, Jr., *Frank Lloyd Wright* (New York: George Braziller, Inc., 1960), 18.

68. Edgar Kauffmann, ed., *Frank Lloyd Wright, An American Architect* (New York: Horizon, 1955), 205, 208.

69. Philip Johnson, *Mies van der Rohe,* rev. ed. (New York: Museum of Modern Art, 1954), 200–201.

70. Hamilton, *Painting and Sculpture,* 462.

71. H. H. Arnason and Marla F. Prather, *History of Modern Art,* 4th ed. (Upper Saddle River, N.J.: Prentice Hall, 1998), 180.

72. Barbara Hepworth, *A Pictorial Autobiography* (London: The Tate Gallery, 1978), 9, 53.

73. Herbert, 139.

74. Herbert, 140–141, 145–146.

75. Herbert, 143.

76. Frances K. Pohl, *Ben Shahn: New Deal Artist in a Cold War Climate, 1947–1954* (Austin, Tex: University of Texas Press, 1989), 159.

77. Pablo Picasso, "Statement to Simone Téry," in *Art in Theory 1900–1990: An Anthology of Changing Ideas,* eds. Charles Harrison and Paul Wood (Oxford: Blackwell Publishers Ltd., 1992), 640.

78. Roland Penrose, *Picasso: His Life and Work,* rev. ed. (New York: Harper and Row, 1973), 311n.

79. Milton Meltzer, *Dorothea Lange: A Photographer's Life* (New York: Farrar, Strauss, Giroux, 1978), 133, 220.

80. Henry Louis Gates Jr., "New Negroes, Migration, and Cultural Exchange," in *Jacob Lawrence: The Migration Series,* ed. Elizabeth Hutton Turner (Washington, D.C.: The Phillips Collection, 1993), 20.

81. James M. Dennis, *Grant Wood: A Study in American Art and Culture* (Columbia, Mo.: University of Missouri Press, 1986), 143.

82. Wanda M. Corn, *Grant Wood: The Regionalist Vision* (New Haven: Yale University Press, 1983), 131.

83. Corn, Grant Wood, 131.

84. Matthew Baigell, *A Concise History of American Painting and Sculpture* (New York: Harper & Row, 1984), 264.

85. Vivian Endicott Barnett, "Banned German Art: Reception and Institutional Support of Modern German Art in the United States, 1933–45," in *Exiles + Emigrés: The Flight of European Artists from Hitler,* by Stephanie Barron (Los Angeles: Los Angeles County Museum of Art, 1997), 283.

Chapter 34

1. Clement Greenberg, "Toward a Newer Laocoon," *Partisan Review* 7, no. 4 (July/August 1940): 305.

2. Clement Greenberg, "Sculpture in Our Time," *Arts Magazine* 32, no. 9 (June 1956): 22.

3. Dawn Ades and Andrew Forge, *Francis Bacon* (London: Thames & Hudson, 1985), 8; and David Sylvester, *The Brutality of Fact: Interviews with Francis Bacon,* 3rd ed. (London: Thames & Hudson, 1987), 182.

4. Marcus Rothko and Adolph Gottlieb, in "The Realm of Art: A New Platform and Other Matters: 'Globalism' Pops into View," by Edward Alden Jewell, *New York Times,* 13 June 1943, x9.

5. Jackson Pollock, "My Painting," *Possibilities* 1 (Winter 1947), 79.

6. "Jackson Pollack: Is He the Greatest Living Painter in the United States?" *Life,* vol. 27 (August 8, 1949), 42–44.

7. Harold Rosenberg, *The Tradition of the New* (New York: Horizon Press, 1959), 25.

8. Thomas Hess, *Barnett Newman* (New York: Walker and Company, 1969), 51.

9. John P. O'Neill, ed., *Barnett Newman: Selected Writings and Interviews* (New York: Knopf, 1990), 108.

10. Mark Rothko, quoted in Sidney Janis, *Abstract and Surrealist Art in America* (New York: Reynal & Hitchcock, 1944), 118. Rothko and Gottlieb, in "The Realm of Art: A New Platform and Other Matters: 'Globalism' Pops into View," x9.

11. In Selden Rodman, *Conversations with Artists* (New York: Devin-Adair, 1957), 93–94.

12. Clement Greenberg, "Recentness of Sculpture," in *Minimal Art: A Critical Anthology,* ed. Gregory Battcock (New York: E. P. Dutton, 1968), 183–84.

13. Maya Lin, in *National Geographic* 167, no. 5 (May 1985): 557.

14. Lucy Lippard, *Eva Hesse* (New York: New York University Press, 1976), 165.

15. Ibid., 56.

16. Ibid., 56.

17. John Gordon, *Louise Nevelson* (New York: Frederick A. Praeger, 1967), 12.

18. Deborah Wye, *Louise Bourgeois* (New York: Museum of Modern Art, 1982), 22.

19. Ibid., 25.

20. Ibid., 22, 25, 27.

21. H. H. Arnason, *History of Modern Art,* 3rd ed., (Englewood Cliffs, N.J.: Prentice Hall, 1986), 472.

22. Barbara Haskell, *Blam! The Explosion of Pop, Minimalism, and Performance 1958–1964* (New York: Whitney Museum of American Art), 53.

23. Caroline Tisdall, *Joseph Beuys* (New York: Thames and Hudson, 1979), 6.

24. "Joseph Kosuth: Art as Idea as Idea," in *Artwords: Discourse on the 60s and 70s,* ed. Jeanne Siegel (Ann Arbor, Mich.: UMI Research Press, 1985), 225.

25. Ibid., 221.

26. Daniel Wheeler, *Art Since Mid-Century: 1945 to the Present* (Englewood Cliffs, N.J.: Prentice-Hall, 1991).247.

27. Richard Francis, *Jasper Johns* (New York: Abbeville Press, 1984), 21.

28. Ibid., 9.

29. John Cage, *Silence* (Middletown, Conn.: Wesleyan University Press, 1961), 101.

30. Christine Lindey, *Superrealist Painting and Sculpture* (London: Orbis, 1980), 50.

31. Ibid., 130.

32. Nancy Holt, ed., *The Writings of Robert Smithson* (New York: New York University Press, 1975), 111.

33. Calvin Tomkins, "The Art World: Tilted Arc," *New Yorker,* 20 May 1985, 100.

34. Peter Blake, *Frank Lloyd Wright* (Hammondsworth, England: Penguin Books, 1960), 115.

35. Robert Venturi, *Complexity and Contradiction in Architecture,* 2nd ed. (New York: Museum of Modern Art, 1977), 16.

36. Fredric Jameson, "Postmodernism and Consumer Society," in *The Anti-Aesthetic: Essays on Postmodern Culture,* ed. Hal Foster (Port Townsend, Wash.: Bay Press, 1983), 113.

37. Grace Glueck, "Susan Rothenberg: New Outlook for a Visionary Artist," *New York Times Magazine,* 22 July 1984, 20.

38. *Walker Art Center: Painting and Sculpture from the Collection* (Minneapolis: Walker Art Center, 1990), 435.

39. Gerald Marzorati, "Sandro Chia: The Last Hero," *Artnews* 82, no. 4 (April 1983): 60.

40. Susanna Torruella Leval, "Recapturing History: The (Un)official Story in Contemporary Latin American Art," *Art Journal* 51, no. 4 (Winter 1992): 74.

41. Ibid.

42. *Corporal Politics* (Cambridge: MIT List Visual Arts Center, 1993), 46.

43. Kobena Mercer, "Black Hair/Style Politics," in *Out There: Marginalization and Contemporary Culture,* ed. Russell Ferguson, Martha Gever, Trinh T. Minh-ha, and Cornel West (New York: New Museum of Contemporary Art, 1990), 248–49.

44. Ibid., 249.

45. Brooke Kamin Rapaport, "Melvin Edwards: Lynch Fragments," *Art in America* 81, no. 3 (March 1993): 62.

46. Ibid.

47. Jaune Quick-to-See Smith and Harmony Hammond, *Women of Sweetgrass: Cedar and Sage* (New York: American Indian Center, 1984), 97.

48. Richard Marshall and Robert Mapplethorpe, *50 New York Artists* (San Francisco: Chronicle Books, 1986), 448–49.

49. Mary Jane Jacob, *Magdalena Abakanowicz* (New York: Abbeville, 1982), 94.

50. Douglas Crimp, "Appropriating Appropriation," in *Image Scavengers: Photography* (Philadelphia: Institute of Contemporary Art, 1982), 30.

PRONUNCIATION GUIDE TO ARTISTS' NAMES

KEY
ŭ **a**b**u**t, k**i**tt**e**n a c**o**t, c**a**rt ā b**a**ke ă b**a**ck au **ou**t
ch **ch**in e l**e**ss ē **ea**sy g **g**ift ĭ tr**i**p ī l**i**fe
j **j**oke k̲ ki**ck** ⁿ French vi**n** ng si**ng** o fl**aw** ō b**oa**t
ö b**i(r)**d oi **coi**n u f**oo**t ū l**oo**t ü f**ew**
y **yo**yo zh vi**si**on

Artist's Name	Phonetic Pronunciation
Abakanowicz, Magdalena	a-ba-kan-'o-wits, mag-dŭ-'lā-nŭ
Achilles Painter	ŭ-'kil-ēz
Aertsen, Pieter	'art-sen, 'pē-tŭr
Alberti, Leon Battista	ăl-'ber-tē, lā-'ōn bat-'tēs-ta
Alexandros of Antioch-on-the-Meander	ă-lig-'zăn-dros *of* 'ăn-tē-ak *on the* mē-'ăn-dŭr
Altdorfer, Albrecht	'alt-dor-fŭr, 'al-brek̲t
Andokides Painter	ăn-'do-kŭ-dēz
Andrea del Castagno	an-'drā-ŭ del ka-'stan-yō
Angas, George French	'ăng-gŭs
Angelico, Fra	an-'jel-li-kō, fra
Anguissola, Sofonisba	ang-gwēs-'sō-lŭ, sō-fō-'nēz-bŭ
Antelami, Benedetto	an-te-'la-mē, be-ne-'det-tō
Anthemius of Tralles	ăn-'thē-mē-ŭs *of* trăl-ēz
Apollodorus of Damascus	ŭ-pal-ŭ-'dor-ŭs *of* dŭ-'măs-kŭs
Archipenko, Aleksandr	ar-ki-'peng-kō, al-ik-'san-dŭr
Arnolfo di Cambio	ar-'nol-fō dē 'kam-byō
Arp, Jean	arp, zhaⁿ
Asam, Egid Quirin	'az–am, ā-'gēt kvē-'rēn
Athanadoros	ŭ-thă-nŭ-'dor-ŭs
Balla, Giacomo	'bal–la, 'ja-kō-mō
Barlach, Ernst	'bar-lak̲, ernst
Barye, Antoine-Louis	ba-'rē, aⁿ-'twan lwē
Beckmann, Max	'bek-man, maks
Behnisch, Günter	'ben-ish, 'gun-tŭr
Bellini, Giovanni	bel-'lē-nē, jō-'van-nē
Berlinghieri, Bonaventura	ber-ling-'gye-rē, bo-na-ven-'tū-ra
Bernini, Gianlorenzo	ber-'nē-nē, jan-lo-'ren-zō
Beuys, Joseph	bois, 'yō-zef
Bichitr	bēch-'hēt(-r)
Bierstadt, Albert	'bēr-shtat
Boccioni, Umberto	bōt-'chō-nē, ūm-'ber-tō
Boffrand, Germain	bo-'fraⁿ, zher-'măⁿ
Bonheur, Rosa	bon-'ur, 'rō-zŭ
Borromini, Francesco	bor-rō-'mē-nē, fran-'ches-kō
Bosch, Hieronymous	bash (*or* bosh), hŭ-'ran-ŭ-mus
Botticelli, Sandro	bot-ti-'chel-ē, 'san-drō
Boucher, François	bū-'shā, fraⁿ-'swa
Bouguereau, William	bū-gŭ-'rō, wēl-'yam
Bourgeois, Louise	bor-'zhwa
Bouts, Dirk	bauts, dirk
Bramante, Donato d'Angelo	bra-'man-tā, do-'na-tō 'dan-je-lō
Brancusi, Constantin	brăn-'kū-zē, kon-stan-'tēn
Braque, Georges	brak, zhorzh
Breuer, Marcel	'broi-ŭr, mar-'sel
Broederlam, Melchior	'brū-dŭr-lam, 'mel-kyor
Bronzino, Agnolo	bron-'zē-nō, 'anʸ-o-lō
Bruegel the Elder, Pieter	'broi-gŭl, 'pē-tŭr
Brunelleschi, Filippo	brūn-ŭ-'les-kē, fē-'lēp-pō
Burgee, John	'bŭr-jē
Caillebotte, Gustave	ka-y(ŭ)-'bot, gū-'stav
Callot, Jacques	ka-'lō, 'zhak

Artist's Name	Phonetic Pronunciation
Campin, Robert	kaⁿ-'peⁿ, rō-'ber
Canaletto, Antonio	ka-na-'let-tō, an-'tōn-yō
Canova, Antonio	ka-'nō-va, an-'tōn-yō
Caradosso, Christoforo Foppa	kar-ŭ-'dos-sō, krē-'sto-fo-rō, 'fop-pa
Caravaggio	kar-ŭ-'vad-jō,
Carpeaux, Jean-Baptiste	kar-'pō, zhaⁿ bap-'tēst
Carracci, Annibale	ka-'rat-chē, an-'nē-bŭ-lā
Cassatt, Mary	kŭ-'sat
Cavallini, Pietro	ka-va-'lē-nē, 'pye-trō
Celer	'ke-lŭr
Cellini, Benvenuto	chel-'lē-nē, ben-vŭ-'nū-tō
Cézanne, Paul	sā-'zan, pōl
Chagall, Marc	shŭ-'gal, mark
Chardin, Jean-Baptiste-Siméon	shar-'dăⁿ, zhaⁿ bap'tēst si-mā-'ōⁿ
Chia, Sandro	'kē-ŭ, 'san-drō
Chirico, Giorgio de	'kēr-i-kō, 'jor-jō de
Chong Son	chung son
Christo	'kris-tō
Christus, Petrus	'kris-tŭs, 'pet-rŭs
Cimabue	chē-ma-'bū-ā
Clodion	klō-dē-'oⁿ
Clouet, Jean	klū-'ā, zhaⁿ
Cormont, Renaud de	kor-'moⁿ, rŭ-'nō dŭ
Cormont, Thomas de	kor-'moⁿ, tō-'ma dŭ
Corot, Jean-Baptiste-Camille	ko-'rō, zhaⁿ bap'tēst kŭ-'mēl
Correggio, Antonio Allegri da	kor-'red-jō, an-'tō-nē-ō al-leg-rē da
Courbet, Gustave	kur-'bā, gū-'stav
Coypel, Antoine	kwa-'pel, aⁿ-'twan
Cranach the Elder, Lucas	'kran-ak̲, 'lū-kŭs
Cuvilliés, François de	kyū-vē-'yā, fraⁿ-'swa dŭ
Cuyp, Aelbert	koip, 'el-bŭrt
Daddi, Bernardo	'dad-dē, ber-'nar-dō
Daedalus	'dī-dŭ-lŭs
Daguerre, Louis-Jacques-Mandé	da-'ger, lū-'ē zhak maⁿ-'dā
Dai Jin	dī jin
Dali, Salvador	'da-lē (*or* da-'lē) sal-vŭ-'dor
Daoji	dau-jē
Daphnis of Miletos	'dăf-nis *of* mī-'lē-tŭs
Daumier, Honoré	dō-'myā, o-nor-'ā
David, Jacques-Louis	da-'vēd, zhak lū-'ē
De Kooning, Willem	dŭ 'kū-ning, 'wil-ŭm
Degas, Edgar	dŭ-'ga, ed-'gar
Delacroix, Eugène	del-ŭ-'k(r)wa, ö-'zhen
Delaunay, Robert	dŭ-lō-'nā, rō-'ber
Della Robbia, Andrea	'del-la 'rō-bē-ŭ, an-'drā-ŭ
Della Robbia, Giovanni	'del-la 'rō-bē-ŭ, jō-'van-nē
Della Robbia, Girolamo	'del-la 'rō-bē-ŭ, jē-ro-'lam-ō
Della Robbia, Luca	'del-la 'rō-bē-ŭ, 'lū-ka
Demuth, Charles	dŭ-'mūth
Derain, André	dŭ-'răⁿ, an-'drā
Donatello	do-nŭ-'tel-lō
Dong Qichang	dong chō-chang
Dubuffet, Jean	'dū-bŭ-fā, zhaⁿ
Duccio di Buoninsegna	'dūt-chō dē bwo-nin-'sā-nya
Duchamp, Marcel	dū – 'shaⁿ, mar-'sel
Dürer, Albrecht	'dü-rŭr, 'al-brek̲t
Durieu, Eugène	dūr-'yü, ö-'zhen
Eadwine the Scribe	ā-'ad-wŭn
Eakins, Thomas	'ā-kŭnz
Eiffel, Alexandre-Gustave	e-'fel, 'al-ek-san-drŭ gū-'stav
El Greco	el 'gre-kō (*or* 'grā-kō)

Artist's Name	Phonetic Pronunciation	Artist's Name	Phonetic Pronunciation
Epigonos	e-ˈpig-o-nos	Horta, Victor	ˈhor-tŭ, ˈvēk-tor
Ergotimos	er-ˈgo-ti-mos	Houdon, Jean-Antoine	ŭ-ˈdoⁿ, zhaⁿ aⁿ-ˈtwan
Ernst, Max	ernst, maks	Huang Binhong	hwang bēn-hung
Eulalios	yū-ˈlā-lē-os	Huang Gongwang	hwang gon-wang
Euphronios	yū-ˈfrō-nē-os	Iaia of Cyzicus	ī-ˈī-a of ˈsiz-ĭ-kŭs
Euthymides	yū-ˈthim-ŭ-dēz	Iktinos	ik-ˈtēn-os
Exekias	ek-ˈzēk-ē-ŭs	Imhotep	im-ˈhō-tep
Eyck, Jan van	ˈīk, yan văn	Ingres, Jean-Auguste Dominique	ˈăⁿ(ng)grŭ, zhaⁿ o-ˈgŭst do-mi-ˈnēk
Fouquet, Jean	fū-ˈkā, zhaⁿ		
Fragonard, Jean-Honoré	frăg-ŭ-ˈnar, zhaⁿ o-no-ˈrā	Isidorus of Miletus	iz-ŭ-ˈdor-ŭs of mī-ˈlē-tŭs
Frankenthaler, Helen	ˈfrăng-kŭn-tha-lŭr	Jeanne-Claude	zhăn-klod
Friedrich, Caspar David	ˈfrēd-ri<u>k</u>, ˈkas-par ˈdav-it	Jones, Inigo	jōnz, ˈin-ŭ-gō
Fuseli, Henry	ˈfüs-lē (or ˈfū-z(ŭ)-lē), ˈhen-rē	Jouvin, Hippolyte	zhū-ˈvăⁿ, ēp-po-ˈlēt
Gabo, Naum	ˈgab-ō, ˈna-ūm	Juvara, Filippo	yū-ˈvar-a, fē-ˈlēp-pō
Gaddi, Taddeo	ˈgad-dē, ˈtad-dā-ō	Kahlo, Frida	ˈka-lō, ˈfrē-da
Garnier, J.L. Charles	gar-ˈnyā, sharl	Kalf, Willem	kalf, ˈvil-ŭm
Garsia, Stephanus	gar-ˈsē-ŭ, ˈstef-an-ŭs	Kallikrates	kal-ˈē-krŭ-tēz
Gaudí, Antonio	gau-ˈdē, an-ˈtōn-ē-ō	Kallimachos	kŭ-ˈlim-ŭ-kŭs
Gauguin, Paul	gō-ˈgăⁿ, pōl	Kandinsky, Vassily	kăn-ˈdin(t)-skē, vŭs-ˈēl-ē
Gaulli, Giovanni Battista	ˈgaul-lē, jō-ˈvan-nē bat-ˈtēs-ta	Kano Eitoku	ka-no e-ē-tō-kŭ
Gehry, Frank	ˈge-rē	Kano Motonobu	ka-nō mō-tō-nō-bū
Gelduinus, Bernardus	gel-ˈdwē-nŭs, bŭr-ˈnar-dŭs	Kaprow, Allan	ˈkăp-rō
Gentile da Fabriano	jen-ˈtē-lā da fab-rē-ˈan-ō	Käsebier, Gertrude	ˈkāz-ŭ-bēr, ˈger-trūd
Gentileschi, Artemisia	jen-ti-ˈles-kē, art-ŭ-ˈmē-zhŭ	Katsushika Hokusai	kat-sū-shē-kŭ, hō-kū-sī
Gentileschi, Orazio	jen-ti-ˈles-kē, o-ˈrat-syō	Kauffmann, Angelica	ˈkauf-man, an-ˈje-li-kŭ
Gerhard of Cologne	ˈgär-hard	Kei	kā-ē
Géricault, Théodore	zhe-ri-ˈkō, tā-ō-ˈdor	Kenzo Tange	ken-zō tan-ge
Ghiberti, Lorenzo	gi-ˈber-tē, lo-ˈren-zō	Kiefer, Anselm	ˈkē-fŭr, ˈan-selm
Ghirlandaio, Domenico	gir-lŭn-ˈda-yō, do-ˈmen-i-kō	Kimou, Owie	kē-mau, ō-wē-ā
Giacometti, Alberto	ja-ko-ˈmet-tē, ăl-ˈber-tō	Kirchner, Ernst Ludwig	ˈkir<u>k</u>-nŭr, ernst ˈlūd-vig
Giorgione da Castelfranco	jor-ˈjō-nā da kas-tel-ˈfrang-kō	Klee, Paul	klā, pōl
Giotto di Bondone	ˈjot-tō dē bon-ˈdō-nā	Kleitias	ˈklī-tē-ŭs
Giovanni da Bologna	jō-ˈvan-nē da bo-ˈlōn-yŭ	Klimt, Gustav	klimt, ˈgus-taf
Girardon, François	zhē-rar-ˈdon, fran-ˈswa	Kollwitz, Käthe	ˈkol-vits, ˈket-ŭ
Girodet-Trioson, Anne-Louis	zhē-rō-ˈdā trē-ō-ˈzoⁿ, an-lū-ˈē	Kosuth, Joseph	kō-ˈsūth
Gislebertus	gē-zŭl-ˈber-tŭs	Kresilas	ˈkres-ŭ-las
Glykon of Athens	ˈglī-kon of ˈăth-ŭnz	Kwei, Kane	kwī, ka-nā
Gnosis	ˈnō-sŭs	L'Enfant, Pierre	laⁿ-ˈfaⁿ, pyer
Goes, Hugo van der	gōz, ˈhyū-gō văn dŭr	La Tour, Georges de	la ˈtūr, zhorzh dŭ
Gogh, Vincent van	gō, vin-ˈsent văn	Labrouste, Henri	la-ˈbrūst, aⁿ-ˈrē
Golub, Leon	ˈgo-lŭb	Le Brun, Charles	lŭ ˈbrŭⁿ, sharl
González, Julio	ˈgon-sal-ās, ˈhūl-yō	Le Corbusier	lŭ kor-bʸū-zē-ˈā
Gossaert, Jan	ˈgos-art, yan	Le Nôtre, André	lŭ ˈnōtr(ŭ), aⁿ-ˈdrā
Goujon, Jean	gū-ˈzhoⁿ, zhaⁿ	Le Nain, Louis	lŭ ˈnăⁿ, lū-ˈē
Goya y Lucientes, Francisco José de	ˈgoi-yŭ ē lū-ˈsyen-tās, fran-ˈsis-kō hō-ˈsā dā	Le Vau, Louis	lŭ ˈvō, lū-ˈē
		Léger, Fernand	lā-ˈzhā, fer-ˈnaⁿ
Greenough, Horatio	ˈgrē-nō, hŭ-ˈrā-shē-ō	Lehmbruck, Wilhelm	ˈlām-bruk, ˈvil-helm
Greuze, Jean-Baptiste	grŭz (or grōz), zhaⁿ bap-ˈtēst	Lemoine, J.B.	lŭ-ˈmwan
Gropius, Walter	ˈgrō-pē-us, ˈwol-tŭr	Leonardo da Vinci	lē-ŭ-ˈnar-dō da ˈvin-chē
Gros, Antoine-Jean	grō, aⁿ-ˈtwan zhaⁿ	Lescot, Pierre	les-ˈkō, pyer
Grosz, George	grōs	Leyster, Judith	ˈlī-stŭr, ˈyū-dith
Grünewald, Matthias	ˈgrü-nŭ-valt, ma-ˈtē-ŭs	Libon of Elis	ˈlī-bŭn of ˈe-lŭs
Gu Kaizhi	gū kī-tsi	Lichtenstein, Roy	ˈlik-tŭn-stīn
Guarini, Guarino	ˈgwar-ē-nē, ˈgwar-ē-nō	Limbourg, Hennequin	ˈlim-burk, ˈhen-ŭ-kăⁿ
Haacke, Hans	ˈha-kŭ, hans	Limbourg, Herman	ˈlim-burk, ˈher-man
Hadrian	ˈhā-drē-ŭn	Limbourg, Pol	ˈlim-burk, pol
Hagesandros	hăg-ŭ-ˈsăn-dros	Lin, Maya Ying	lin, ˈmī-ŭ yēng
Hals, Frans	hals, frants	Lipchitz, Jacques	ˈlip-shits, zhak
Hamada Shoji	ha-ma-da shō-jē	Lippi, Filippino	ˈlēp-pē, fē-lē-ˈpē-nō
Hardouin-Mansart, Jules	ar-ˈdwăⁿ -man-ˈsar, zhül	Lippi, Fra Filippo	ˈlēp-pē, fē-ˈlēp-pō
Hasegawa Tohaku	has-e-ga-wa tō-ha-ku	Lochner, Stephan	ˈlo<u>k</u>-nŭr, ˈstā-fan
Heda, Willem Claesz	ˈhā-da, ˈvil-ŭm klas	Lorenzetti, Ambrogio	lo-rent-ˈset-tē, am-ˈbrō-jō
Hemessen, Caterina van	ˈhā-me-sŭn, ka-te-ˈrē-na văn	Lorenzetti, Pietro	lo-rent-ˈset-tē, pē-ˈā-trō
Herrera, Juan de	er-ˈrer-a, hwan dā	Lorrain, Claude	lŭ-ˈrăⁿ, klōd
Hippodamos of Miletos	hip-ˈad-ŭ-mŭs of mī-ˈlē-tŭs	Luzarches, Robert de	lu-ˈzarsh, rō-ˈber dŭ
Höch, Hannah	hö<u>k</u>, ˈha-na	Lysippos of Sikyon	lī-ˈsip-os of ˈsik-ē-an
Holbein, Hans the Younger	ˈhōl-bīn, hants	Ma Yuan	ma yū-an
Holzer, Jenny	ˈhōlt-zŭr	Mabuse, Jan	ma-ˈbüz, yan
Honam Koeisu	hō-na-mē kō-et-su	Machuca, Pedro	ma-ˈchū-ka, ˈpā-drō
Honnecourt, Villard de	on-ŭ-ˈkūr, vē-ˈlar (or vē-ˈyar) dŭ	Maderno, Carlo	ma-ˈder-nō, ˈkar-lō
Honthorst, Gerrit van	ˈhont-horst, ˈgher-ŭt van	Magritte, René	ma-ˈgrēt, rŭ-ˈnā

Artist's Name	Phonetic Pronunciation	Artist's Name	Phonetic Pronunciation
Maiano, Giuliano da	′mī-a-nō, jū-lē-′a-nō dā	Pisano, Giovanni	pē-′zan-ō, jō-′van-nē
Maillol, Aristide	mī-′yōl, ar-ŭ-′stēd	Pisano, Nicola	pē-′zan-ō, nē′-ko-la
Maitani, Lorenzo	mī-′ta-nē, lo-′ren-zō	Pissarro, Camille	pŭ-′zar-ō, ka-′mēl (or ka-′mēy)
Malevich, Kazimir	mŭl-′yāv-ich, ′kaz-ē-mēr	Piula, Trigo	pē-ū-la, trē-gō
Manet, Édouard	ma-′nā, ā-′dwar	Pollaiuolo, Antonio	pol-lī-′wō-lō an-′tō-nē-ō
Mansart, François	maⁿ-′sar, fraⁿ-′swa	Pollock, Jackson	′pal-ŭk
Mantegna, Andrea	man-′tān-yŭ, an-′drā-ŭ	Polydoros	pal-i-′dor-os
Maqsud of Kashan	mak-′sūd of ka-′shan	Polyeuktos	pal-i-′yuk-tos
Marc, Franz	mark, frants	Polygnotos of Thasos	pal-ig-′nōt-os of ′thā-sos
Marika, Mawalan	ma-rē-ka, ma-wa-lan	Polykleitos of Argos	pal-i-′klīt-os of ′ar-gos
Martini, Simone	mar-′tē-nē, sē-′mōn-ā	Pontormo, Jacopo da	pon-′tor-mō, ′ya-ko-pō da
Maruyama Okyo	ma-rū-ya-ma ō-kyō	Porta, Giacomo della	′por-ta, ′ja-ko-mō ′del-la
Masaccio	ma-′zat-chō	Poussin, Nicolas	pū-′săⁿ, ni-kō-′la
Masolino da Panicale	ma-sō-′lē-nō da pa-nē-′ka-lā	Pozzo, Fra Andrea	′pot-tsō, fra an-′drā-ŭ
Massys, Quinten	′mat-zīs, ′kwin-tŭn	Praxiteles	prak-′sit-ŭl-ēz
Master Honoré	o-no-′rā	Primaticcio, Francesco	prē-ma-′tēt-chō, fran-′ches-kō
Master of Flemalle	flā-′mal	Pucelle, Jean	pū-′sel, zhaⁿ
Matisse, Henri	ma-′tēs, aⁿ-′rē	Puget, Pierre	pū-′zhā, pyer
Melozzo da Forlì	me-′lot-sō da for-′lē	Pugin, A.W.N.	′pyū-jin
Memling, Hans	′mem-ling, hants	Puvis de Chavannes, Pierre	pü-vē-dŭ-sha-′van, pyer
Memmi, Lippo	′mem-mē, ′lēp-pō	Quarton (or Charonton), Enguerrand	kar-′toⁿ (or sha-roⁿ-′toⁿ), aⁿ-ge-′raⁿ
Mendieta, Ana	men-dē-′e-ta, ′a-na	Quick-to-See-Smith, Jaune	jōn
Michelangelo Buonarroti	mī-kŭ-′lăn-jŭ-lō (or mē-ke-′lan-jŭ-lō) bwo-nar-′rō-tē	Rainer of Huy	rī-nŭr of wē
Michelozzo di Bartolommeo	mē-ke-′lot-tsō dē bar-tō-lōm-′mā-ō	Raphael	ra-fa-′yel (or ′răf-ē-ŭl)
Mies van der Rohe, Ludwig	mēz van dŭ-′rō(-ŭ) ′lud-vik	Rauch, John	rauch
Millais, John Everett	mil-′ā	Rauschenberg, Robert	′rau-shŭn-bŭrg
Millet, Jean-François	mē-′yā (or mi-′lā), zhaⁿ fraⁿ-′swa	Redon, Odilon	rŭ-′doⁿ, ō-di-′loⁿ
Miró, Joan	mi-′rō, zhu-′an	Regnaudin, Thomas	re-nyo-′dăⁿ, to-′ma
Mnesikles	(m-)′nes-i-klēz	Rembrandt van Rijn	′rem-brănt van rīn
Moholy-Nagy, László	mō-′hō-lē ′na-zhē, ′laz-lō	Reni, Guido	′rā-nē, ′gwē-dō
Mondrian, Piet	mon-drē-′an, pēt	Renoir, Pierre-Auguste	ren-′war, pyer-o-′gūst
Monet, Claude	mō-′nā, klōd	Ribera, José (Jusepe) de	rē-′be-ra, hō-′sā (jū-′se-pe) dā
Moreau, Gustave	mo-′rō, gū-′stav	Riemenschneider, Tilman	′rē-mŭn-shnī-dŭr, ′til-man
Morisot, Berthe	mo-rē-′zō, bert	Rietveld, Gerrit	′rēt-velt, ′ger-ŭt
Muhammad ibn al-Zayn	mū-′ha-mad ′ēb(ŭ)n ăl-′zān	Rigaud, Hyacinthe	rē-′gō, ē-ŭ-′seⁿt (or ya-′saⁿt)
Munch, Edvard	mungk, ′ed-vard	Rivera, Diego	ri-′ve-ra, dē-′ā-gō
Muqi	mū-kē	Rodin, Auguste	rō-′dăⁿ(n), o-′gūst
Muybridge, Eadweard	′mī-brij, ′ed-wŭrd	Romano, Giulio	rō-′man-ō, ′jŭl-yō
Nadar	na-′dar	Rossellino, Bernardo	ros-sŭl-′lē-nō, ber-′nar-dō
Nanni di Banco	′nan-nē dē ′bang-kō	Rosso Fiorentino	′ros-sō fyor-ŭn-′tē-nō
Natoire	na-′twar	Rouault, Georges	rū-′ō, zhorzh
Neumann, Balthasar	′noi-man, ′bal-tŭ-zar	Rousseau, Henri	rū-′sō, aⁿ-′rē
Niobid Painter	nī-′ō-bid	Rublyev, Andrei	rū-′blev, ′an-drā
Nolde, Emil	′nol-dŭ, ′ā-mēl	Rude, François	rüd, fraⁿ-′swa
Novios Plautios	′nō-vē-os ′plau-tē-os	Ruisdael, Jacob van	′rīz-dal, ′ya-kob van
Odo of Metz	′ō-dō of mets	Ruysch, Rachel	roish, ra̲k̲-ŭl
Ogata Korin	ō-ga-ta kō-rēn	Saarinen, Eero	′săr-ŭ-nŭn, ′ār-ō
Olbrich, Joseph Maria	′ōl-bri̲k̲, ′yō-zŭf ′ma-rē-a	Saint-Gaudens, Augustus	sānt ′god-ŭnz, ŭ-′gŭs-tŭs
Oldenberg, Claes	′ōl-dŭn-bŭrg, klas	Sangallo the Younger, Antonio da	sang-′gal-lō, an-′tō-nē-ō da
Onesimos	o-′nes-i-mos	Sansovino, Jacopo	san-sō-′vē-nō, ′ya-ko-pō
Oppenheim, Meret	′ap-ŭn-hīm, ′mer-ŭt	Schnabel, Julian	′shna-bŭl
Orcagna, Andrea	or-′kan-ya, an-′drā-ŭ	Schongauer, Martin	′shōn-gau-ŭr, ′mar-tin
Orozco, José Clemente	o-′rōs-kō, hō-′sā kle-′men-tā	Schwitters, Kurt	′shvit-ŭrs, kurt
Paik, Nam June	pīk, nam jūn	Senmut	sen-′mūt
Paionios of Ephesos	pī-′ō-nē-ŭs of ′ef-ŭ-sŭs	Sen No Rikyu	sen nō rē-kyū
Palladio, Andrea	pal-′la-dē-ō, an-′drā-ŭ	Seurat, Georges	sŭ-′ra, zhorzh
Parmigianino	par-mi-ja-′nē-nō	Severini, Gino	se-ve-′rē-nē, ′jē-nō
Patinir, Joachim	pa-ti-′nēr, ′yō-a-k̲ēm	Severus	se-′vēr-ŭs
Pentewa, Otto	pen-′te-wa	Signorelli, Luca	sē-nyo-′rel-lē, ′lū-ka
Perrault, Claude	pŭ-′rō, klōd	Siloé, Gil de	sē-lō-′ā, hēl dā
Perugino	per-ŭ-′jē-nō	Sinan the Great	sŭ-′nan
Phiale Painter	fē-′a-lā	Sitani, Mele	si-ta-nē, mā-lā
Phidias	′fid-ē-ŭs	Skopas of Paros	′skō-pŭs of ′păr-os
Philoxenos of Eretria	fŭ-′lak-sŭ-nos of er-′e-trē-ŭ	Sluter, Claus	′slū-tŭr, klaus
Piano, Renzo	pē-′a-nō, ′ren-zō	Song Huizong	song hwā-tsong
Picasso, Pablo	pi-′kas-ō, ′pab-lō	Soufflot, Jacques-Germain	sū-′flō, zhak zher-′meⁿ
Piero della Francesca	′pyer-ō ′del-lŭ fran-′ches-ka	Steen, Jan	stān, yan
Pietro da Cortona	′pyā-trō da kor-′tō-na	Stieglitz, Alfred	′stēg-lits
Piranesi, Giovanni Battista	pē-ra-′nā-zē jō-′van-nē bat-′tēs-ta	Stölzl, Gunta	′shtö(l)-tsŭl, ′gun-ta
Pisano, Andrea	pē-′zan-ō, an-′drā-ŭ	Stoss, Veit	shtōs, vēt

Artist's Name	Phonetic Pronunciation	Artist's Name	Phonetic Pronunciation
Sulayman	′sū-lā-man	Venturi, Robert	ven-′tū-rē
Sultan-Muhammad	sŭl-′tan (or ′sŭl-tan)-mū-′ha-mad	Vermeer, Jan	vŭr-′mēr, yan
Suzuki Harunobu	sū-zū-kē ha-rū-nō-bū	Veronese, Paolo	ver-ŭ-′nā-zā, ′pau-lō
Takahashi Yuichi	ta-ka-ha-shē yū-ē-chē	Verrocchio, Andrea del	vŭr-′rok-kyō, an-′drā-ŭ del
Tanner, Henry Ossawa	ō-′sa-wa	Vigée-Lebrun, Élisabeth Louise	vē-zhā-lŭ-′brönⁿ, ā-lē-za-′bet lŭ-′ēz
Tassananchalee, Kamol	tas-san-anch-′ha-lē, ka-′mol	Vignola, Giacomo da	vē-′nyō-lŭ, ′ja-kō-mō da
Tatlin, Vladimir	′tat-lin, ′vla-di-mir	Vignon, Pierre	vin-′yonⁿ, pyer
Te Pehi Kupe	tā pā-hē kū-pā	Vitruvius	vŭ-′trū-vē-ŭs
Te Whanau-a-Apanui	tā wa-naū-a-a-pa-nū-ē	Vulca of Veii	′vŭl-ka of ′vā-ē
Ter Brugghen, Hendrick	tŭr ′brū-gŭn, ′hen-drik	Wang Wei	wang wā
Theodoros of Phokaia	thē-o-′dor-os of ′fō-kā-ŭ	Warhol, Andy	′wor-hol
Theotokópoulous, Doménikos	thā-o-to-′ko-pū-los, dō-′mā-nē-kŭs	Watteau, Antoine	wa-′tō, aⁿ-′twan
Thutmose	′thŭt-mōs-e	Weyden, Rogier van der	′vī-dŭn, ′ra-jŭr van dŭr
Tiepolo, Giambattista	tē-′ā-pŭ-lō, jam-bat-′tēs-ta	Wiligelmo	vē-lē-′gel-mō
Tinguely, Jean	′tăⁿ-glŭ, zhaⁿ	William of Sens	saⁿ
Tintoretto	tin-tŭ-′ret-tō	Witz, Konrad	vits, ′kon-rat
Titian	′tish-ŭn	Wodiczko, Krzysztof	vō-′dētsh-kō, (k-)′shish-tof
Toledo, Juan Bautista de	tō-′lā-dō, hwan bau-′tēs-ta dā	Wojnarowicz, David	voi-na-′rō-vich
Tori Busshi	tō-rē bū-shē	Wolgemut, Michel	′vōl-gŭ-mūt, ′mik-ŭl
Tosa Mitsunobu	tō-sa mēt-sun-ō-bu	Wright of Derby, Joseph	rīt of ′dar-bē
Toulouse-Lautrec, Henri de	tū-′lūz-lō-′trek, aⁿ-′rē dŭ	Wu Zhen	ū jŭn
Tournachon, Gaspar-Félix	tŭr-na-′shoⁿ, ga-′spar ′fā-lēks	Xia Gui	shya gwā
Toyo Sesshu	tō-yō ses-shu,	Xu Bing	shū bing
Uccello, Paolo	ūt-′chel-lō, ′pau-lō	Yan Liben	yan lē-bŭn
Utzon, Joern	′ut-zōn, ′yor-(ŭ)n	Yi Chae-Gwan	yē chī-gwan
Van Bruggen, Coosje	van ′brū-gŭn, ′kōs-zhŭ	Yokoyama Taikan	yō-kō-ya-ma ta-ē-kan
Van Dyck, Anthony	văn ′dīk, ′an-tŭ-nē	Yosa Buson	yō-sa bus-ōn
Vanbrugh, John	văn-′brū	Zhou Jichang	jō jē-chang
Vecelli, Tiziano	ve-′chel-ē, tēts-′ya-nō	Zong Bing	tsong bing
Velázquez, Diego	ve-′las-kez, dē-′ā-gō	Zurbarán, Francisco de	zur-ba-′ran, fran-′sis-kō dā

GLOSSARY

*Italicized terms in definitions are defined elsewhere in the glossary. A pronunciation guide is now
included for a select number of technical terms and uses the key provided on page 538.*

abacus—(ă-ba-ˈkŭs) The uppermost portion of the *capital* of a *column,* usually a thin slab.

Abakans—(a-baˈkanz) Abstract woven hangings suggesting organic spaces as well as giant pieces of clothing made by Magdalena Abakanowicz.

abstract—In painting and sculpture, emphasizing a derived, essential character that has only a stylized or symbolic visual reference to objects in nature.

Abstract Expressionism—Also known as the New York School. The first major American avant-garde movement, Abstract Expressionism emerged in New York City in the 1940s. The artists produced abstract paintings that expressed their state of mind and were intended to strike emotional chords in viewers. The movement developed along two lines: *Gestural Abstraction* and *Chromatic Abstraction.*

acropolis—(a-ˈkra-pŭ-lŭs) Literally, the "high city." In Greek architecture, usually the site of the city's most important temple(s).

Action Painting—Also called *Gestural Abstraction.* The kind of *Abstract Expressionism* practiced by Jackson Pollock, in which the emphasis was on the creation process, the artist's gesture in making art. Pollock stood on his canvases, pouring liquid paint in linear webs, thereby literally immersing himself in the painting during its creation.

additive—A kind of sculpture technique in which materials, e. g., clay, are built up or "added" to create form.

addorsed—Set back-to-back, especially as in heraldic design.

adobe—(a-ˈdō-bē) The clay used to make a kind of sun-dried mud brick of the same name; a building made of such brick.

aerial perspective—See *perspective.*

aesthetic properties of works of art—The visual and tactile features of an object: form, shape, line, color, mass, and volume.

aesthetics—The branch of philosophy devoted to theories about the nature of art and artistic expression. Also referring to such theories.

agora—(a-go-ˈra) An open square or space used for public meetings or business in ancient Greek cities.

aisle—The portion of a church flanking the *nave* and separated from it by a row of *columns* or *piers.*

akua ba (pl. **akua mma**)—Small wooden fertility figures carved by Asante men in Ghana (West Africa).

alabaster—A variety of gypsum or calcite of dense, fine texture, usually white, but also red, yellow, gray, and sometimes banded.

altarpiece—A panel, painted or sculpted, sit-

uated above and behind an altar. See also *retable.*

alternate-support system—In medieval church architecture, the use of alternating wall supports in the *nave,* usually *piers* and *columns* or *compound piers* of alternating form.

amalaka—(a-ma-ˈla-ka) In Hindu temple design, the large flat disk with ribbed edges surmounting the beehive-shaped tower.

amalau—(a-ma-la-ū) In the Caroline Islands of Micronesia, a spirit house that served as a communal religious structure for both men and women.

Amazonomachy—(ă-mŭ-zon-ˈa-mŭ-kē) In Greek mythology, the legendary battle between the Greeks and Amazons.

ambulatory—(ˈăm-byŭ-lŭ-to-rē) A covered walkway, outdoors (as in a *cloister*) or indoors; especially the passageway around the *apse* and the *choir* of a church.

amphiprostyle—(ăm-fi-ˈpro-stīl) The style of Greek building in which the *colonnade* was placed across both the front and back, but not along the sides.

amphitheater—Literally, a double theater. A Roman building type resembling two Greek theaters put together. The Roman *amphitheater* featured a continuous elliptical *cavea* around a central *arena.*

amphora—(ˈăm-fŭ-ra) A two-handled jar used for general storage purposes, usually to hold wine or oil.

amulet—An object worn to ward off evil or to aid the wearer.

Analytic Cubism—The first phase of *Cubism,* developed jointly by Pablo Picasso and Georges Braque, in which the artists analyzed form from every possible vantage point to combine the various views into one pictorial whole.

anamorphic image—(ăn-ŭ-ˈmor-fik) A distorted image that must be viewed by some special means (such as a mirror) to be recognized.

andron—Dining room in a Greek house.

aniconic—(ăn-ī-ˈkan-ik) Non-image representation.

animal style—A generic term for the characteristic ornamentation of artifacts worn and carried by nomadic peoples who, for almost two millennia (B.C. into A.D.) migrated between China and western Europe. The style is characterized by use of phantasms, like the dragon.

antae—(ˈăn-tī) The molded projecting ends of the walls forming the *pronaos* or *opisthodomos* of an ancient Greek temple.

apadana—(ă-pa-ˈda-na) The great audience hall in ancient Persian palaces.

apotheosis—(ŭ-path-ē-ˈō-sŭs) Elevated to the rank of gods or the ascent to heaven.

apotropaic—(ap-a-trō-ˈpā-ik) Capable of warding off evil.

apse—(ăps) A recess, usually singular and semi-circular, in the wall of a Roman *basilica* or at the east end of a Christian church.

arabesque—(ă-rŭ-ˈbesk) Literally, "Arablike." A flowing, intricate pattern derived from stylized organic motifs, usually floral, often arranged in symmetrical *palmette* designs; generally, an Islamic decorative motif.

arcade—A series of *arches* supported by *piers* or *columns.*

Arcadian (adj.)—In Renaissance and later art, depictions of an idyllic place of rural peace and simplicity. Derived from "Arcadia," an ancient district of the central Peloponnesus in southern Greece.

arch—A curved structural member that spans an opening and is generally composed of wedge-shaped blocks (*voussoirs*) that transmit the downward pressure laterally. A diaphragm arch is a transverse, wall-bearing arch that divides a *vault* or a ceiling into compartments, providing a kind of firebreak. See also *thrust.*

architrave—(ˈar-kŭ-trāv) The *lintel* or lowest division of the *entablature;* sometimes called the epistyle.

archivolt—One of a series of concentric bands on a *Romanesque* or a *Gothic* arch.

arcuated—Of *arch-column* construction.

arena—In a Roman *amphitheater,* the central area where bloody gladiatorial combats and other boisterous events took place.

arhat—(ˈar-hat) Also *bodhisattva.* A *Buddhist* holy person who has achieved enlightenment and *nirvana* by suppression of all desire for earthly things

Arianism—An early Christian movement, condemned by the Church as heretical, that denied the equality of the three aspects of the *Trinity* (Father, Son, and Holy Spirit).

armature—(ˈar-mŭ-chŭr) The crossed, or diagonal, arches that form the skeletal framework of a *Gothic* rib vault. In sculpture, the framework for a clay form.

arras—(ˈar-ŭs) A kind of tapestry originating in Arras, a town in northeastern France.

arrises—(ŭ-ˈrēz-sŭz) In *Doric* columns, the raised edges of the *fluting.* See also *fillets.*

Art Brut—(ar brū) A term coined by artist Jean Dubuffet to characterize art that is genuine, untaught, coarse, even brutish.

Art Deco—Descended from *Art Nouveau,* this movement of the 1920s and 1930s sought to upgrade industrial design in competition with "fine art" and to work new materials into decorative patterns that could

be either machined or hand-crafted. Characterized by "streamlined" design, elongated and symmetrical.

Art Nouveau — (ar nū-'vō) A late nineteenth-/ early twentieth-century art movement whose proponents tried to synthesize all the arts in an effort to create art based on natural forms that could be mass-produced by technologies of the industrial age.

asceticism — Self-discipline and self-denial.

ashlar masonry — ('ăsh-lar) Carefully cut and regularly shaped blocks of stone used in construction, fitted together without mortar.

assemblage — (a-sem-'blazh) A three-dimensional composition made of various materials such as *found objects*, paper, wood, and cloth. See also *collage*.

atlantid — (ăt-'lăn-tid) A male figure that functions as a supporting *column*. See also *caryatid*.

atlatl — ('ăt(-ŭ)-lăt(-ŭ)l) Spear thrower.

atmospheric or aerial perspective — See *perspective*.

atrium (pl. **atria**) — The court of a Roman house that is partly open to the sky. Also the open, colonnaded court in front of and attached to a Christian *basilica*.

attic — In architectural terminology, the uppermost story.

attribution — Assignment of a work to a maker or makers. Based on *documentary evidence* (e.g., signatures and dates on works and/or artist's own writings) and *internal evidence* (stylistic and iconographical analysis).

automatism — In painting, the process of yielding oneself to instinctive motions of the hands after establishing a set of conditions (such as size of paper or medium) within which a work is to be carried out.

avant-garde — ('ă-va^n gard) Literally, the advance guard in a platoon. Late-nineteenth- and twentieth-century artists who emphasized innovation and challenged established convention in their work. Also used as an adjective.

avatar — A manifestation of a deity incarnated in some visible form in which the deity performs a sacred function on earth. In Hinduism, an incarnation of a god.

avlu — A courtyard forming a summer extension of the *mosque* and surrounded by porticoes formed by domed squares.

axial plan — See *plan*.

backstrap loom — A simple loom used by Andean weavers and others since ancient times.

bai — (ba-ē) Elaborately painted men's ceremonial clubhouses on Belau in the Caroline Islands of Micronesia.

baldacchino — (bal-da-'kē-nō) A canopy on columns, frequently built over an altar. See also *ciborium*.

balustrade — ('băl-us-trād) A row of vase-like supports surmounted by a railing.

baptistery — ('băp-tus-trē) In Christian architecture, the building used for baptism, usually situated next to a church.

bar tracery — See *tracery*.

barays — The large reservoirs laid out around Cambodian *wats* that served as means of transportation as well as irrigation. The reservoirs were connected by a network of canals.

Baroque — A blanket designation for the art of the period 1600 to 1750.

barrel or **tunnel vault** — See *vault*.

bas-relief — ('ba rŭ-'lēf) See *relief*.

base — In ancient Greek architecture, the lowest part of *Ionic* and *Corinthian* columns.

basilica — (bu-'sil-ŭ-kŭ) In Roman architecture, a public building for assemblies (especially tribunals), rectangular in plan with an entrance usually on a long side. In Christian architecture, a church somewhat resembling the Roman basilica, usually entered from one end and with an *apse* at the other, creating an axial *plan*.

Bauhaus — ('bau-haus) A school of architecture in Germany in the 1920s under the aegis of Walter Gropius, who emphasized the unity of art, architecture, and design. The Bauhaus trained students in a wide range of both arts and crafts, and was eventually closed by the National Socialists in 1933.

beehive tomb — In Mycenaean architecture, a beehive-shaped tomb covered by an earthen mound and constructed as a *corbeled vault*. See *tholos*.

ben-ben — ('ben-ben) A pyramidal stone; a *fetish* of the Egyptian god Re.

bevel — See *chamfer*.

bhakti — In *Buddhist* thought, the adoration of a personalized deity (*bodhisattva*) as a means of achieving unity with it; love felt by the devotee for the deity. In Hinduism, the devout, selfless direction of all tasks and activities of life to the service of one god.

bi — (bē) In ancient China, jade disks carved as ritual objects for burial with the dead. They were often decorated with piercework carving extending entirely through the object.

bilingual vases — Experimental Greek vases produced for a short time in the late sixth century B.C.; one side featured decoration in *red-figure technique*, the other *black-figure technique*.

black-figure technique — In early Greek pottery, the silhouetting of dark figures against a light background of natural, reddish clay, with linear details incised through the silhouettes.

blind arcade (wall arcade) — An *arcade* having no actual openings, applied as decoration to a wall surface.

block statue — In ancient Egyptian sculpture, a cubic stone image with simplified body parts.

bo nun amuin — Composite imaginary animal masks created by Baule people of Côte d'Ivoire (West Africa). Representing the spirit power of the bush, these sacred and secret masks served a policing function in traditional Baule society.

bodhisattva — (bod-hē-sat-va) In *Buddhist* thought, one of the host of divinities provided to the *Buddha* to help him save humanity. A potential *Buddha*. See also *bhakti*.

bombé — Outwardly bowed.

bottega — (bōt-'tā-gŭ) A shop; the studio-shop of an Italian artist.

breviary — (brē-vē-e-rē) A Christian religious book of selected daily prayers and psalms.

brocade prints — Japanese *woodblock* prints in which the pictures are printed (not hand painted) in many colors.

Buddha (adj. **Buddhist**) — The supreme enlightened being of Buddhism; an embodiment of divine wisdom and virtue.

Buddha triad — A group of three statues with a central *Buddha* flanked on each side by a *bodhisattva*.

burin — ('byū-rin) A pointed tool used for *engraving* or *incising*.

buttress — ('bŭt-trŭs) An exterior masonry structure that opposes the lateral thrust of an *arch* or a *vault*. A pier buttress is a solid mass of masonry; a flying buttress consists typically of an inclined member carried on an arch or a series of arches and a solid buttress to which it transmits lateral *thrust*.

bwoom — A mythical ancestor mask of the Kuba people of the Democratic Republic of Congo.

Byzantium (adj. **Byzantine**) — (biz-'an-te-um/ 'biz-un-tēn) The Christian Eastern Roman Empire, which lasted until 1453, when Constantinople was captured by the Ottoman Turks.

caduceus — (ka-'d(y)ū-sē-ŭs) In ancient Greek mythology, a magical rod entwined with serpents carried by Hermes (Roman, Mercury), the messenger of the gods.

caldarium — (kal-'dă-rē-ŭm) The hot-bath section of a Roman bathing establishment.

caliph(s) — (kā-lef *or* kal-ŭf) *Muslim* rulers, regarded as successors of Muhammad.

calligraphy — Handwriting or penmanship, especially elegant or "beautiful" writing as a decorative art. In Chinese writing, the brushing of characters in different styles.

calotype — ('kă-lŭ-tip) A photographic process in which a positive image is made by shining light through a negative image onto a sheet of sensitized paper.

camera lucida — ('kă-mŭ-rŭ lū-'sē-dŭ) A device in which a small lens projects the image of an object downward onto a sheet of paper. Literally, "lighted room."

camera obscura — ('kă-mŭ-rŭ ŭb-'skyū-rŭ) An ancestor of the modern camera in which a tiny pinhole, acting as a lens, projects an image on a screen, the wall of a room, or the ground-glass wall of a box; used by artists in the seventeenth, eighteenth, and early nineteenth centuries as an aid in drawing from nature. Literally, "dark room."

campaniform — Bell-shaped.

campanile — (kam-pa-'nē-lă) A bell tower of a church, usually, but not always, free-standing.

canon—Rule, e.g., of proportion. The ancient Greeks considered beauty to be a matter of "correct" proportion and sought a canon of proportion, in music and for the human figure.

canon law—The law system of the Roman Catholic church, as opposed to civil or secular law.

canonization—In the Roman Catholic church, the process by which a revered deceased person is declared a *saint* by the pope.

canopic jars—(kǎ-'nō-pik *jars*) In ancient Egypt, containers in which the organs of the deceased were placed for later burial with the mummy.

capital—The uppermost member of a *column,* serving as a transition from the *shaft* to the *lintel.* The form of the capital varies with the *order.*

Capitolium—(kǎ-pi-'tō-lē-ǔm) An ancient Roman temple honoring the divinities Jupiter, Juno, and Minerva.

cardo—('kar-dō) The north–south street in a Roman town, intersecting the *decumanus* at right angles

Caroline minuscule—The alphabet that *Carolingian* scribes perfected, from which our modern alphabet was developed.

Carolingian (adj.)— (kǎ-rō-'lin-jǔn) Pertaining to the empire of Charlemagne and his successors.

carpet pages—In early *medieval* manuscripts, decorative pages resembling textiles.

cartoon—In painting, a full-size preliminary drawing from which a painting is made.

caryatid—(kǎ-rē-ǎt-id) A female figure that functions as a supporting *column.* See also *atlantid.*

castrum—(kǎs-trǔm) A Roman military encampment, famed for the precision with which it was planned and laid out.

catacombs—(kǎt-ǔ-kōmz) Subterranean networks of galleries and chambers designed as cemeteries for the burial of the dead.

catafalque—(kǎt-ǔ-fǎlk) The framework that supports and surrounds a deceased person's body on a bier.

cathedra—(ku-thē-drǔ) Literally, the seat of the bishop, from which the word *cathedral* is derived.

cavea—(kǎ-vē-ǔ) The seating area in ancient Greek and Roman theaters and *amphitheaters.* Literally, a hollow place or cavity.

celadon—(sel-ǔ-dan) A Chinese–Korean pottery glaze, fired in an oxygen-deprived kiln to a characteristic gray–green or pale blue color.

cella—('se-lǔ) The chamber (Greek—*naos*) at the center of an ancient temple; in a classical temple, the room in which the cult statue usually stood.

celt—(selt) In *pre-Columbian* Mexico, Olmec ax-shaped form made of polished jade; generally a prehistoric metal or stone implement shaped like a chisel or ax head.

cement—See *concrete.*

centaur—In ancient Greek mythology, a fantastical creature, with the front or top half of a human and the back or bottom half of a horse.

centauromachy—(sen-to-'ra-mǔ-kē) In ancient Greek mythology, the battle between the Greeks and *centaurs.*

central plan—See *plan.*

cestrum—('kes-trǔm) A small spatula used in *encaustic* painting.

chaitya—(tshī-'tyǔ) An Indian rock-cut temple hall having a votive *stupa* at one end.

chakra—The wheel that sometimes marks the Buddha's feet as a supernatural sign; one of the *lakshanas* of the Buddha.

chakravartin—In India, the ideal king, the Universal Lord who ruled through goodness.

chamfer—('cham-fǔr) The surface formed by cutting off a corner of a board or post; a bevel.

Chan—See *Zen.*

chancel—The elevated area at the altar end of a church reserved for the priest and choir.

Charuns—Etruscan death demons.

chatra—('cha-tra) See *yasti.*

chevet—The east, or apsidal, end of a *Gothic* church, including *choir, ambulatory,* and radiating chapels.

chi-rho-iota—(kī-rō-ī-'ō-tǔ) The three initial letters of Christ's name in Greek (XPI), which came to serve as a monogram for Christ.

chiaroscuro—(kē-ǎ-rō-'skū-rō) In drawing or painting, the treatment and use of light and dark, especially the gradations of light that produce the effect of *modeling.*

chicha—Fermented maize beer consumed on numerous ceremonial and non-ceremonial occasions in the Andes.

chigi—(chē-gē) The crosspiece at the gables of Japanese shrine architecture.

chimera—(kī-mer-ǔ) A monster of Greek invention with the head and body of a lion and the tail of a serpent. A second head, that of a goat, grows out of one side of the body.

chiton—('kī-tan) A Greek tunic, the essential (and often only) garment of both men and women, the other being the *himation,* or *mantle.*

choir—The space reserved for the clergy in the church, usually east of the *transept* but, in some instances, extending into the *nave.*

Christogram—(kris-tō-grǎm) See *chi-rho-iota.*

Chromatic Abstraction—A kind of *Abstract Expressionism* that focused on the emotional resonance of color, as exemplified by the work of Barnett Newman and Mark Rothko.

chryselephantine—(kris-el-ǔ-'fǎn-tīn) Fashioned of gold and ivory.

ciborium—(su-'bor-ē-ǔm) A canopy, often freestanding and supported by four columns, erected over an altar; also, a covered cup used in the sacraments of the Christian church. See *baldacchino.*

circumambulation—In *Buddhist* worship, walking around the *stupa* in a clockwise direction.

cire perdue—(sēr per-'dū) See *lost-wax process.*

cista—('sis-tǔ) An Etruscan cylindrical container made of sheet bronze with cast handles and feet, often with elaborately engraved bodies, used for women's toilet articles.

city-state—An independent, self-governing city that rules the surrounding countryside.

clerestory—('klēr-sto-rē) The *fenestrated* part of a building that rises above the roofs of the other parts. In Roman *basilicas* and medieval churches, the windows that form the *nave's* uppermost level below the timber ceiling or the *vaults.*

cloison—(kloi-zǔn) Literally, a partition. A cell made of metal wire or a narrow metal strip soldered edge-up to a metal base to hold enamel or other decorative materials.

cloisonné—(kloi-zǔ-nā) A process of enameling employing *cloisons.*

cloister—A monastery courtyard, usually with covered walks or *ambulatories* along its sides.

cluster pier—See *compound pier.*

codex (pl. **codices**)—(kō-deks/kō-dǔ-sēz) Separate pages of *vellum* or *parchment* bound together at one side and having a cover; the predecessor of the modern book. The *codex* superseded the *rotulus.* In *pre-Columbian Mesoamerica,* a painted and inscribed book on long sheets of bark paper or deerskin coated with fine white plaster and folded into accordion-like pleats.

coffer—A sunken panel, often ornamental, in a *soffit,* a *vault,* or a ceiling.

collage—(kō-'lazh) A composition made by combining on a flat surface various materials such as newspaper, wallpaper, printed text and illustrations, photographs, and cloth. See also *photomontage.*

colonnades—A series or row of *columns,* usually spanned by *lintels.*

colonnette—A small *column.*

colophon—('ka-lǔ-fan) An inscription, usually on the last page, giving information about a book's manufacture. In Chinese painting, written texts on attached pieces of paper or silk.

color—See *primary, secondary,* and *complementary colors.* The value or tonality of a color is the degree of its lightness or darkness. The intensity or saturation of a color is its purity, its brightness or dullness.

color field painters—A variant of *Post-Painterly Abstraction* whose artists sought to reduce painting to its physical essence by pouring diluted paint onto unprimed canvas, allowing these pigments to soak into the fabric. Examples include the work of Helen Frankenthaler and Morris Louis.

colorito—(ko-lo-'rē-tō) Literally, "colored" or "painted." A term used to describe the applicationof paint, characteristic of sixteenth-century Venetian art. It is distin-

guished from *disegno*, which emphasizes careful design preparation based on preliminary drawing.

column—A vertical, weight-carrying architectural member, circular in cross-*section* and consisting of a base (sometimes omitted), a *shaft*, and a *capital*.

complementary colors—Those pairs of colors, such as red and green, that together embrace the entire spectrum. The complement of one of the three *primary colors* is a mixture of the other two. In pigments, they produce a neutral gray when mixed in the right proportions.

Composite capital—A capital with an ornate combination of *Ionic* volutes and *Corinthian* acanthus leaves that became popular in Roman times.

composite view—See *twisted perspective*.

composition—The way in which an artist organizes *forms* in an art work, either by placing shapes on a flat surface or arranging forms in space.

compound pier—A *pier* with a group, or cluster, of attached *shafts*, or *responds*, especially characteristic of *Gothic* architecture.

computer imaging—A medium developed during the 1960s and 1970s that uses computer programs and electronic light to make designs and images on the surface of a computer or television screen.

conceptual approach to representation—See *descriptive approach to representation*.

Conceptual Art—An American avant-garde art trend of the 1960s that asserted that the "artfulness" of art lay in the artist's idea, rather than its final expression. A major proponent was Joseph Kosuth.

conch—(kank) Semi-circular half-dome.

concrete—A building material invented by the Romans and consisting of various proportions of lime mortar, volcanic sand, water, and small stones. From the Latin *caementa*, from which the English "cement" is derived.

condottiere—(kon-da-'tyer-ē) A professional military leader employed by the Italian city-states in the early Renaissance.

confraternities—(kon-frŭ-'tŭr-nŭ-tēz) In late medieval Europe, organizations founded by laypeople who dedicated themselves to strict religious observances.

connoisseur—(kan-ŭ-'sūr) An expert on works of art and the individual styles of artists.

Constructivism—A movement in art formulated by Naum Gabo, who built up his sculptures piece by piece in space instead of carving or modeling them in the traditional way. In this way the sculptor worked with "volume of mass" and "volume of space" as different materials.

contextuality—The causal relationships among artists, art work, and the society or culture that conditions them.

continuous narration—In painting or sculpture, the convention of the same figure appearing more than once in the same space at different stages in a story.

contour line—In art, a continuous line defining an object's outer shape.

contrapposto—(kon-trŭ-'pas-tō) The disposition of the human figure in which one part is turned in opposition to another part (usually hips and legs one way, shoulders and chest another), creating a counter-positioning of the body about its central axis. Sometimes called weight shift because the weight of the body tends to be thrown to one foot, creating tension on one side and relaxation on the other.

corbel—('kor-bŭl) A projecting wall member used as a support for some element in the superstructure. Also, courses of stone or brick in which each course projects beyond the one beneath it. Two such structures, meeting at the topmost course, create a corbeled arch.

corbel tables—Horizontal projections resting on *corbels*.

corbeled arch—See *corbel*.

corbeled vault—A *vault* formed by the piling of stone blocks in horizontal courses, cantilevered inward until the two walls meet in a pointed arch. No mortar is used, and the vault is held in place only by the weight of the blocks themselves, with smaller stones used as wedges.

Corinthian capital—A more ornate form than *Doric* or *Ionic*; it consists of a double row of acanthus leaves from which tendrils and flowers grow, wrapped around a bell-shaped *echinus*. Although this *capital* form is often cited as the distinguishing feature of the Corinthian *order*, there is, strictly speaking, no Corinthian order, but only this style of capital used in the *Ionic* order.

cornice—The projecting, crowning member of the *entablature* framing the *pediment*; also, any crowning projection.

Cosmati—(kos-'ma-tē) A group of twelfth- to fourteenth-century craftsmen who worked in marble and mosaic, creating work (known as **Cosmato work**) characterized by inlays of gold and precious or semi-precious stones and finely cut marble in geometric patterns.

crenellation—(kren-ŭ-'lā-shŭn) Notches or indentations, usually with respect to tops of walls, as in battlements.

cromlech—('krom-lek) A circle of *monoliths*. Also called henge.

cross vault—See *vault*

crossing—The space in a *cruciform* church formed by the intersection of the *nave* and the *transept*.

crossing square—The area in a church formed by the intersection (*crossing*) of a *nave* and a *transept* of equal width, often used as a standard measurement of interior proportion.

cruciform—Cross-shaped.

Crusades—In *medieval* Europe, armed pilgrimages aimed at recapturing the Holy Land from the Muslims.

crypt—A vaulted space under part of a building, wholly or partly underground; in *medieval* churches, normally the portion under an *apse* or a *chevet*.

cubiculum (pl. **cubicula**)—(kū-'bik-yū-lŭm) A small cubicle or bedroom that opened onto the *atrium* of a Roman house. Also, a chamber in an Early Christian catacomb that served as a mortuary chapel.

Cubism—An early twentieth-century art movement that rejected naturalistic depictions, preferring compositions of shapes and forms "abstracted" from the conventionally perceived world. See also *Analytic Cubism* and *Synthetic Cubism*.

cuerda seca—('kwer-dŭ 'sā-kŭ) A type of polychrome tilework used in decorating Islamic buildings.

cuirass—('kwēr-ăs) A breastplate. In Roman art, the emblem of a military officer.

cultural constructs—In the reconstruction of the context of a work of art, experts consult the evidence of religion, science, technology, language, philosophy, and the arts to discover the thought patterns common to artists and their audiences.

culture—The collective characteristics by which a community identifies itself and by which it expects to be recognized and respected.

cunei—('kū-nē-ī) In ancient Greek theaters, wedge-shaped sections of stone benches separated by stairs.

cuneiform—(kyū-'nā-ŭ-form) Literally, "wedge-shaped." A system of writing used in ancient Mesopotamia, in which wedge-shaped characters were produced by pressing a stylus into a soft clay tablet, which was then baked or otherwise allowed to harden.

cupola—('kū-pō-lŭ) An exterior architectural feature composed of *drums* with shallow caps; a dome.

cutaway—An architectural drawing that combines an exterior view with an interior view of part of a building.

Cycladic art—(sik-'lăd-ik) The pre-Greek art of the Cycladic Islands.

Cyclopean—(sī-klō-'pē-ŭn) Gigantic, vast and rough, massive. Cyclopean masonry is a method of stone construction using large, irregular blocks without mortar. The huge unhewn and roughly cut blocks of stone were used to construct Bronze Age fortifications such as Tiryns and other *Mycenaean* sites.

cylinder seal—A cylindrical piece of stone usually about an inch or so in height, decorated with a design in *intaglio* (incised), so that a raised pattern was left when the seal was rolled over soft clay. In the ancient Near East documents, storage jars, and other important possessions were signed, sealed, and identified in this way.

Dada—('da-da) An art movement that reflected a revulsion against the absurdity and horror of World War I. Dada rejected all art, modern or traditional, as well as the

civilization that had produced it, to create an art of the absurd. Foremost among the Dadaists was Marcel Duchamp.

Daedalic—Refers to a Greek *Orientalizing* style of the seventh century B.C. named after the legendary Daedalus. Characteristic of the style is the triangular flat-topped head framed by long strands of hair that form complementary triangles to that of the face.

daguerreotype—(da-'ger-ō-tip) A photograph made by an early method on a plate of chemically treated metal; developed by Louis J. M. Daguerre.

damnatio memoriae—The Roman decree condemning those who ran afoul of the Senate. Those who suffered damnatio memoriae had their memorials demolished and their names erased from public inscriptions.

darshan—In Hindu worship, seeing images of the divinity and being seen by the divinity.

De Stijl—(du stēl) Dutch for "the style." An early twentieth-century art movement (and magazine) founded by Piet Mondrian and Theo van Doesburg, whose members promoted utopian ideals and developed a simplified geometric style.

deceptive cadence—In a horizontal scroll, the "false ending," which arrests the viewer's gaze by appearing to be the end of a narrative sequence, but which actually sets the stage for a culminating figure or scene.

deconstruction—An analytical strategy developed in the late twentieth century according to which all cultural "constructs" (art, architecture, literature) are "texts." People can read these texts in a variety of ways, but they cannot arrive at fixed or uniform meanings. Any interpretation can be valid, and readings differ from time to time, place to place, and person to person. For those employing this approach, deconstruction means destabilizing established meanings and interpretations while encouraging subjectivity and individual differences.

Deconstructivist architecture—Using *deconstruction* as an analytical strategy, Deconstructionist architects attempt to disorient observers by disrupting the conventional categories of architecture. The haphazard presentation of volumes, masses, planes, lighting, etc. challenges viewers' assumptions about form as it relates to function.

découpage—(de-kū-'pazh) A technique of decoration in which letters or images are cut out of paper or some such material and then pasted onto a surface.

decumanus—The east–west street in a Roman town, intersecting the *cardo* at right angles.

decursio—The ritual circling of a Roman funerary pyre.

demos—The Greek word meaning "the people," from which *democracy* is derived.

demotic—Late Egyptian writing.

denarius—The standard Roman silver coin from which the word *penny* ultimately derives.

descriptive approach to representation—In artistic representation, that which is "known" about an object is represented. To represent a human profile "descriptively" would require the artist to depict both eyes rather than just one.

dharma—In Buddhism, moral law based on the *Buddha's* teaching.

di sotto in sù—(dē 'sot-tō in 'sū) A technique of representing perspective in ceiling painting. Literally, "from below upwards."

diagonal rib—See *rib*.

diaphragm arch—See *arch*.

diorite—('dì-ŭ-rīt) An extremely hard stone used in Mesopotamian and Egyptian art.

dipteral—('dip-tŭr-ŭl) The term used to describe the architectural feature of double *colonnades* around Greek temples. See also *peripteral*.

diptych—('dip-tik) A two-paneled painting or *altarpiece;* also, an ancient Roman, Early Christian, or Byzantine hinged writing tablet, often of ivory and carved on the external sides.

disegno—(dē-'zā-nyō) In Italian, "drawing" and "design." Renaissance artists considered drawing to be the external physical manifestation (*disegno esterno*) of an internal intellectual idea of design (*disegno interno*).

documentary evidence—In *attributions* of works of art, this consists of contracts, signatures, and dates on works as well as the artist's own writings.

doges—(dōzh) Rulers of *medieval* Venice and Genoa.

dolmen—Several large stones (*megaliths*) capped with a covering slab, erected in prehistoric times.

dome—A hemispheric *vault;* theoretically, an *arch* rotated on its vertical axis.

domus—('dō-mŭs) A Roman private house.

Doric—('dor-ik) One of the two systems (or *orders*) evolved for articulating the three units of the elevation of an ancient Greek temple—the platform, the *colonnade,* and the superstructure (*entablature*). The Doric order is characterized by, e.g., capitals with funnel-shaped *echinuses,* columns without bases, and a frieze of *triglyphs* and *metopes*. See also *Ionic*.

dotaku—(do-ta-kū) Ancient Japanese bronze ceremonial bells, usually featuring raised decoration.

dromos—The passage leading to a *beehive tomb*.

drum—The circular wall that supports a *dome;* also, one of the cylindrical stones of which a non-monolithic *shaft* of a *column* is made.

dry fresco—See *fresco*.

dry-joining—Fitting stone blocks together without mortar.

dry point—An engraving in which the design, instead of being cut into the plate with a *burin,* is scratched into the surface with a hard steel "pencil." See also *engraving, etching, intaglio*.

dukha—The *Buddha's* insight that life is pain.

earthenware—Pottery made of clay that is fired at low temperatures and that is slightly porous.

eaves—The lower part of a roof that overhangs the wall.

echinus—(ŭ-'kīn-ŭs) In architecture, the convex element of a *capital* directly below the *abacus*.

écorché—A figure painted or sculptured to show the muscles of the body as if without skin.

effigy mounds—Ceremonial mounds built in the shape of animals or birds by *pre-Columbian* Native American cultures.

elevation—In drawing and architecture, a geometric projection of a building on a plane perpendicular to the horizon; a vertical projection. A head-on view of an external or internal wall, showing its features and often other elements that would be visible beyond or before the wall.

emblema—(em-'blā-mŭ) The central section or motif of a *mosaic*.

embrasure—A *splayed* opening in a wall that enframes a doorway or a window.

embroidery—The technique of sewing threads onto a finished ground to form contrasting designs.

encaustic—(en-'kos-tik) A painting technique in which pigment is mixed with wax and applied to the surface while hot.

engaged column—A half-round *column* attached to a wall. See also *pilaster*.

engraving—The process of *incising* a design in hard material, often a metal plate (usually copper); also, the print or impression made from such a plate. See also *dry point, etching, intaglio*.

entablature—(in-'tăb-lŭ-chŭr) The part of a building above the *columns* and below the roof. The entablature has three parts: *architrave* or *epistyle, frieze,* and *pediment*.

entasis—('en-tŭ-sŭs) A convex tapering (an apparent swelling) in the *shaft* of a *column*.

Environmental or **Earth Art**—An American art form that emerged in the 1960s. Often using the land itself as their material, Environmental artists constructed monuments of great scale and minimal form. Permanent or impermanent, these works transform some section of the environment, calling attention both to the land itself and to the hand of the artist.

epistyle—('ep-ŭ-stil) See *architrave*.

escutcheon—(ŭ-'skŭt-chŭn) An emblem bearing a coat of arms.

esthetic properties of works of art—The visual and tactile features of an object: form, shape, line, color, mass, and volume.

etching—A kind of *engraving* in which the design is incised in a layer of wax or varnish

on a metal plate. The parts of the plate left exposed are then **etched** (slightly eaten away) by the acid in which the plate is immersed after incising. See also *dry point, engraving, intaglio.*

ethnocentrism—The tendency to explain and to judge artifacts from the perspective of one's own culture and to the detriment of other cultures.

Eucharist—('yū-ku-rist) In Christianity, the partaking of the bread and wine, which believers hold to be either Christ himself or symbolic of him.

ewer—A large pitcher.

exedra—(ek-'sē-drŭ) Recessed area, usually semi-circular.

exemplum virtutis—Example or model of virtue.

existentialism—A philosophy asserting the absurdity of human existence and the impossibility of achieving certitude.

Expressionism—Twentieth-century *modernist* art that is the result of the artist's unique inner or personal vision and that often has an emotional dimension. Expressionism contrasts with art focused on visually describing the empirical world. It is characterized by bold, vigorous brushwork, emphatic line, and bright color. Two important groups of early twentieth-century German *expressionists* were Die Brücke, in Dresden, and Der Blaue Reiter, in Munich.

extrados—(ek-'stra-das) The upper or outer surface of an arch. See *intrados.*

facade—(fŭ-'sad) Usually, the front of a building; also, the other sides when they are emphasized architecturally.

faïence—(fa-'an(t)s or fī-'aⁿs) Earthenware or pottery, especially with highly colored design (from Faenza, Italy, a site of manufacture for such ware). Glazed earthenware.

fan vault—See *vault*

fasciae—('făsh-ē-ī) In the Classical Greek *Ionic order,* the three horizontal bands that make up the *architrave.*

fauces—('fo-sēz) Literally, the throat of the house. In a Roman house, the narrow foyer leading to the *atrium.*

Fauvism—('fō-viz-ŭm) From the French word *fauves,* literally, "wild beasts." An early twentieth-century art movement led by Henri Matisse, for whom color became the formal element most responsible for pictorial coherence and the primary conveyor of meaning. The Fauves intensified color with startling contrasts of vermilion and emerald green and of cerulean blue and vivid orange, held together by sweeping brushstrokes and bold patterns.

femmage—(fem-'azh) A kind of feminist sewn collage made by Miriam Schapiro in which she assembles fabrics, quilts, buttons, sequins, lace trim, and rickrack to explore hidden metaphors for womanhood, using techniques historically associated with women's crafts (techniques and media not elevated to the status of fine art).

fenestration—('fen-ŭ-strā-shŭn) The arrangement of the windows of a building.

fengshui—(fŭng-shwā) A Chinese notion of "wind and water," the breath of life, which is scattered by wind and must be stopped by water; thus the forces of wind and water must be adjusted for in the orientation of Chinese architecture.

fête galante—(fet ga-'laⁿ) A type of *Rococo* painting depicting the outdoor amusements of upper-class society.

fetish—('fet-ish) An object believed to possess magical powers, especially one capable of bringing to fruition its owner's plans; sometimes regarded as the abode of a supernatural power or spirit.

feudalism—The *medieval* political, social and economic system held together by the relationship of a liege-lord and vassal.

fibula—('fib-yū-lŭ) A decorative pin, usually used to fasten garments.

figura serpentinata—(fii-'gū-ra ser-pen-ti-'na-ta) In Renaissance art, a contortion or twisting of the body in contrary directions, especially characteristic of the sculpture and paintings of Michelangelo and the Mannerists.

fillets—('fil-ŭts) The flat ridges of *Ionic fluting.* See also *arrises.*

fin de siècle—(fă ⁿ-dŭ-sē-'ek-lŭ) Literally, the end of the century. A period in western cultural history from the end of the nineteenth century until just before World War I, when decadence and indulgence masked anxiety about an uncertain future.

First Style—The earliest style of Roman mural painting. Also called the masonry style, because the aim of the artist was to imitate, using painted stucco relief, the appearance of costly marble panels.

Flamboyant style—A Late *Gothic* style of architecture superseding the *Rayonnant* style and named for the flamelike appearance of its pointed bar *tracery.*

flashing—In making stained-glass windows, fusing one layer of colored glass to another to produce a greater range of colors.

flute or **fluting**—Vertical channeling, roughly semicircular in cross-*section* and used principally on *columns* and *pilasters.*

Fluxus—A group of American, European, and Japanese artists of the 1960s who created *Performance Art.* Their performances focused on single actions, such as turning a light on and off or watching falling snow, and were more theatrical than *Happenings.*

flying buttress—See *buttress.*

folio—A page of a manuscript or book.

foreshortening—(for-'shor-tŭ-ning) The use of *perspective* to represent in art the apparent visual contraction of an object that extends back in space at an angle to the perpendicular plane of sight.

form—In art, an object's shape and structure, either in two dimensions (a figure painted on a surface) or in three dimensions (such as a statue).

formalism—Strict adherence to, or dependence on, stylized shapes and methods of composition. An emphasis on an artwork's visual elements rather than its subject.

forum—The public square of an ancient Roman city.

found objects—Images, materials, or objects as found in the everyday environment that are appropriated into works of art.

Fourth Style—In Roman mural painting, the Fourth Style marks a return to architectural illusionism, but the architectural vistas of the Fourth Style are irrational fantasies.

freedmen—In ancient and *medieval* society, the class of men and women who had been freed from servitude, as opposed to having been born free.

freestanding sculpture—See *sculpture in the round.*

fresco—('fres-kō) Painting on lime plaster, either dry (dry fresco or fresco secco) or wet (true or buon fresco). In the latter method, the pigments are mixed with water and become chemically bound to the freshly laid lime plaster. Also, a painting executed in either method.

fresco secco—('fres-kō 'sek-ō) See *fresco.*

fret or **meander**—An ornament, usually in bands but also covering broad surfaces, consisting of interlocking geometric motifs. An ornamental pattern of contiguous straight lines joined usually at right angles.

frieze—(frēz) The part of the *entablature* between the *architrave* and the *cornice;* also, any sculptured or ornamented band in a building, on furniture, etc.

frigidarium—(fri-jŭ-'dă-rē-ŭm) The cold-bath section of a Roman bathing establishment.

frottage—(frō-'tazh) A process of rubbing a crayon or other medium across paper placed over surfaces with a strong and evocative texture pattern to combine patterns.

Futurism—An early-twentieth century movement involving a militant group of Italian poets, painters, and sculptors. These artists published numerous manifestoes declaring revolution in art against all traditional tastes, values, and styles and championing the modern age of steel and speed and the cleansing virtues of violence and war.

gable—See *pediment.*

garbha griha—('garb-ha 'grē-ha) Literally, "womb chamber." In Hindu temples, this is the *cella,* the inner sanctum, for the cult image or symbol, the holiest of places in the temple.

genetrix—A legendary founding clan mother.

genii—Guardian spirits.

genre—('zhaⁿ-rŭ) A style or category of art; also, a kind of painting realistically depicting scenes from everyday life.

gesso—('jes-sō) Plaster mixed with a binding

material and used for *reliefs* and as a *ground* for painting.

Gestural Abstraction—Also known as *Action Painting*. A kind of abstract painting in which the gesture, or act of painting, is seen as the subject of art. Its most renowned proponent was Jackson Pollock. See also *Abstract Expressionism*.

gigantomachy—(jī-gŭn-'ta-mŭ-kē) In ancient Greek mythology, the battle between gods and giants.

gishes—Medicine canes belonging to *Yei*.

glaze—A vitreous coating applied to pottery to seal and decorate the surface; it may be colored, transparent, or opaque, and glossy or *matte*. In oil painting, a thin, transparent, or semitransparent layer put over a color to alter it slightly.

glazed brick—Bricks painted and then kiln fired to fuse the color with the baked clay.

glory—See *nimbus*.

Golden Mean—Also known as the Golden Rule or Golden Section, a system of measuring in which units used to construct designs are subdivided into two parts in such a way that the longer subdivision is related to the length of the whole unit in the same proportion as the shorter subdivision is related to the longer subdivision. The *esthetic* appeal of these proportions has led artists of varying periods and cultures to employ them in determining basic dimensions.

gong—In ancient China, covered vessels, often in animal forms, holding wine, water, grain, or meat for sacrificial rites.

gopuras—('gō-pū-rŭz) The massive, ornamented entrance gateway towers of South Indian temple compounds.

gorget—('gor-jŭt) Throat armor or a neck pendant.

gorgon—In ancient Greek mythology, a hideous female demon with snake hair. Medusa, the most famous gorgon, was capable of turning anyone who gazed at her into stone.

Gospels—The four New Testament books that relate the life and teachings of Jesus.

Gothic—Originally a derogatory term named after the Goths, used to describe the history, culture, and art of *medieval* western Europe in the twelfth to fourteeth centuries.

gouache—A painting technique employing pigments ground in water.

granulation—A decorative technique in which tiny metal balls, granules, are fused to a metal surface.

graver—A cutting tool used by engravers and sculptors.

Greek cross—A cross in which all the arms are the same length.

grisaille—(grŭ-'zīy) A monochrome painting done mainly in neutral grays to simulate sculpture.

groin—The edge formed by the intersection of two *vaults*.

groin or **cross vault**—Formed by the intersection at right angles of two barrel vaults

of equal size. Lighter in appearance than the barrel vault, the groin vault requires less *buttressing*. See *vault*.

ground—A coating applied to a canvas or some other surface to prepare that surface for painting; also, background.

ground line—In paintings and reliefs, a painted or carved base line on which figures appear to stand.

guilloche—(gē-'yōsh) An architectural ornament that imitates braided ribbon or that consists of interlaced, curving bands.

Hallenkirche—('hal-ŭn-kēr-kŭ) A hall church. A type of *Gothic* design much favored in Germany in which the *aisles* rise to the same height as the *nave*.

handscroll—In Asian art, a horizontal painted scroll that is unrolled to the left and often used to present illustrated religious texts or landscapes.

haniwa—(ha-nē-wa) Sculptured fired pottery cylinders, modeled in human, animal, or other forms and placed around early (archaic) Japanese burial mounds.

Happenings—Loosely structured performances initiated in the 1960s, whose creators were trying to suggest the dynamic and confusing qualities of everyday life; most shared qualities of unexpectedness, variety, and wonder.

hard-edge painting—A variant of *Post-Painterly Abstraction* that rigidly excluded all reference to gesture, and incorporated smooth knife-edge geometric forms to express the notion that the meaning of painting should be its form and nothing else. Ellsworth Kelly is an example.

harihara—A Hindu religious statue divided vertically into a Shiva half and a Vishnu half.

harmika—(har-'mē-ka) In *Buddhist* architecture, a stone fence or railing that encloses an area surmounting the dome of a *stupa* that represents one of the Buddhist heavens; from the center, arises the *yasti*.

hatching—A technique used in drawing, engraving, etc., in which fine lines are cut or drawn close together to achieve an effect of shading.

Hejira—See *Hijra*.

Helladic art—(hŭ-'lăd-ik *art*) The pre-Greek art of the Greek mainland (Hellas).

Hellenes (adj. **Hellenic**)—The name the ancient Greeks called themselves as the people of Hellas, to distinguish themselves from people who did not speak Greek.

Hellenistic—The term given to the culture that developed after the death of Alexander the Great in 323 B.C. and lasted almost three centuries, until the Roman conquest of Egypt in 31 B.C.

herm—A bust on a quadrangular pillar.

Hiberno-Saxon—('hi-ber-no 'sak-sŭn) An art style that flourished in the monasteries of the British Isles in the early *Middle Ages*. Also called Insular.

hierarchy of scale—An artistic convention

in which greater size indicates greater importance.

hieratic—(hī-ŭ-'rā-tik) A method of representation fixed by religious principles and ideas.

hieroglyphic—(hī-rō-'glif-ik) A system of writing using symbols or pictures.

high relief—See *relief*.

Hijra (Hejira)—The flight of Muhammad from Mecca to Medina in A.D. 622, the year from which Islam dates its beginnings.

himation—(hī-'mā-shŭn) An ancient Greek *mantle* worn by men and women over the tunic and draped in various ways.

Hippodamian plan—A city plan devised by Hippodamos of Miletos ca. 466 B.C., in which a strict grid was imposed upon a site, regardless of the terrain, so that all streets would meet at right angles. A *Hippodamian plan* also called for separate quarters for public, private, and religious functions, so that such a city was logically as well as regularly planned.

hiragana—(hē-ra-ga-na) A sound-based writing system developed in Japan from Chinese characters; it came to be the primary script for Japanese court poetry.

historiated—Ornamented with representations, such as plants, animals, or human figures, that have a narrative—as distinct from a purely decorative—function. Historiated initial letters were a popular form of manuscript decoration in the *Middle Ages*.

Holy Spirit—In Christianity, the third "person" of the *Trinity* (with the Father and the Son), often symbolized by a dove.

horror vacui—Literally, "fear of empty space," a technique of design in which an entire surface is covered with pattern.

hue—The name of a *color*. See *primary colors, secondary colors,* and *complementary colors*.

humanism—In the Renaissance, an emphasis on education and on expanding knowledge (especially of classical antiquity), the exploration of individual potential and a desire to excel, and a commitment to civic responsibility and moral duty.

hydria—('hī-drē-ŭ) An ancient Greek three-handled water pitcher.

hypaethral—(hīp-'ēth-rŭl) A building having no pediment or roof, open to the sky.

hypostyle hall—('hī-pŭ-stīl *hall*) In Egyptian architecture, a hall with a roof supported by columns. Also, in Islamic architecture, a *mosque* prayer hall with its roof supported by numerous columns.

icon—A portrait or image; especially in the Eastern Christian churches, a panel with a painting of sacred personages that are objects of veneration. In the visual arts, a painting, a piece of sculpture, or even a building regarded as an object of veneration.

iconoclasm—(ī-'kan-'ŭ-klăz(-ŭ)m) The destruction of images. In *Byzantium* the period from 726 to 843 when there was an

imperial ban on images. The destroyers of images were known as iconoclasts, while those who opposed such a ban were known as iconophiles or iconodules.

iconography—(ī-kŭn-'a-grŭ-fē) Literally, the "writing of images." The term refers both to the content, or subject, of an art work and to the study of content in art. It also includes the study of the symbolic, often religious, meaning of objects, persons, or events depicted in works of art.

iconostasis—(ī-kŭ-'nas-tŭ-sŭs) The large icon-bearing chancel screen that shuts off the sanctuary of a *Byzantine* church from the rest of the church. In the Eastern Christian churches, a screen or a partition, with doors and many *tiers* of *icons,* separating the sanctuary from the main body of the church.

idealization—The representation of things according to a preconception of ideal form or type; a kind of *esthetic* distortion to produce idealized forms. See also *realism.*

ideogram—('ī-dē-ŭ-gram *or* 'id-ē-ŭ-gram) A simple, picturelike sign filled with implicit meaning.

ikegobo—(ē-kā-gō-bō) The Benin (West African) altar of the hand or arm, symbolizing the Benin king's powers of accomplishment.

illumination—Decoration with drawings (usually in gold, silver, and bright colors), especially of *medieval* manuscript pages.

imagines (sing. **imago**)—(i-'ma-gi-nes) In ancient Rome, wax portraits of ancestors.

imam—(i-'mam or i-'mäm) In Islam, the leader of collective worship.

impasto—(im-'pas-tō) A style of painting in which the pigment is applied thickly or in heavy lumps, as in many paintings by Jean Dubuffet or Anselm Kiefer.

imperator—(im-pŭ-'ra-tŭr) A Latin term meaning "commander in chief," from which the word *emperor* is derived.

impluvium—(im-'plū-vē-ŭm) In a Roman house, the basin located in the *atrium* that collected rainwater.

impost block—A stone with the shape of a truncated, inverted pyramid, placed between a *capital* and the *arch* that springs from it.

Impressionism—A late nineteenth-century art movement that sought to capture a fleeting moment by conveying the illusiveness and impermanence of images and conditions.

in antis—In ancient Greek architecture, between the *antae.*

in situ—(in sŭ-'tū) In place; in the original position.

incise—(in-'sīz) To cut into a surface with a sharp instrument; also, a method of decoration, especially on metal and pottery.

incrustation—Wall decoration consisting of bright panels of different colors.

india ink—A soot-based ink used in China for both writing and drawing.

inscriptions—Texts written on the same surface as the picture (such as in Chinese

paintings) or *incised* in stone (such as in ancient art). See also *colophon.*

installation—A *postmodernist* artwork creating an artistic environment in a room or gallery.

insula—('in-sū-lū) In Roman architecture, a multistory apartment house, usually made of brick-faced *concrete;* also refers to an entire city block.

Insular—See *Hiberno-Saxon.*

intaglio—(in-'ta-lē-ō) A graphic technique in which the design is *incised,* or scratched, on a metal plate, either manually (*engraving, dry point*) or chemically (*etching*). The incised lines of the design take the ink, making this the reverse of the *woodcut* technique.

intarsia—(in-'tar-sē-ŭ) Inlay work, primarily in wood and sometimes in mother-of-pearl, marble, etc.

interaxial—The distance between the center of one column drum and the center of the next.

intercolumniation—(in-ter-kŭ-lūm-ne-'a-shŭn) The space or the system of spacing between *columns* in a *colonnade.*

internal evidence—In *attributions* of works of art, what can be learned by stylistic and iconographical analysis, in comparison with other works, and by analysis of the physical properties of the medium itself.

International Style—A style of fourteenth- and fifteenth-century painting begun by Simone Martini, who adapted the French *Gothic* manner to Sienese art fused with influences from the North. This style appealed to the aristocracy because of its brilliant color, lavish costume, intricate ornament, and themes involving splendid processions of knights and ladies. Also a style of twentieth-century architecture associated with Le Corbusier, whose elegance of design came to influence the look of modern office buildings and skyscrapers.

intrados—('in-trŭ-das) The underside of an *arch* or a *vault.* See *extrados.*

Ionic—(ī-'an-ik) One of the two systems (or *orders*) evolved for articulating the three units of the elevation of a Greek temple, the platform, the *colonnade,* and the superstructure (*entablature*). The Ionic order is characterized by, e.g., *volutes, capitals, columns* with *bases,* and an uninterrupted *frieze.*

iron-wire lines—In ancient Chinese painting, thin brush lines suggesting tensile strength.

iwan—('ē-wan) In Islamic architecture, a vaulted rectangular recess opening onto a courtyard.

jamb—In architecture, the side posts of a doorway.

jataka—Tales of the past lives of, or a scriptural account of, the *Buddha.* See also *sutra.*

jihad—(ji-'had) In Islam, holy war, death in which assures a faithful *Muslim* of the reward of Paradise.

jina—The Sanskrit word for "saint"; root

word for the English word "Jainism", the religion founded by Mahavira.

jipae—Among the Asmat of western New Guinea, special rites during which celebrants wear dramatic woven fiber basketry costumes to appease the spirit of a dead ancestor.

jomon—(jo-mon) A type of Japanese decorative technique characterized by rope-like markings. *Jomon* means "rope decoration."

ka—(ka) In ancient Egypt, immortal human substance; the concept approximates the Western idea of the soul.

Kaaba—('ka-ba) From the Arabic word for "cube." A small cubical building in Mecca, the *Muslim* world's symbolic center.

Kachina—(ku-'chē-nu) An art form of Native Americans of the Southwest, the Kachina doll represents benevolent supernatural spirits (kachinas) living in mountains and water sources.

kami—Shinto deities or spirits, believed in Japan to exist in nature (mountains, waterfalls) and in charismatic people.

kaolin—('kā-ŭ-lin) A fine white clay used in making *porcelain.*

karma—In Vedic religions, the ethical consequence of a person's life, which determine his or her fate.

keep—A fortified tower in a castle that served as a place of last refuge.

ketos—('ke-tos) Greek for sea dragon.

key or **meander**—See *fret.*

keystone—The central, uppermost *voussoir* in an *arch.*

khutba—An *imam's* speech, including both a sermon and a profession of allegiance by the *Muslim* community to its leader, that takes place near the *qibla* wall.

Kinetic Art—A kind of moving art. Closely related to *Op Art* in its concern with the perception of motion by visual stimulus, it was a logical step to present objects that actually moved. Characteristic of the work of Alexander Calder and the *Constructivists.*

kiva—('kē-vū) A large circular underground structure that is the spiritual and ceremonial center of Pueblo Indian life.

kondo—(kon-do) Literally, "golden hall." In a Japanese Buddhist temple complex, the building housing the main sculptural icons.

Koran—See *Quran.*

kore (pl. **korai**)—('kor-ā/'kor-ī) Greek for "young woman."

kouros (pl. **kouroi**)—('kūr-os/'kūr-oi) Greek for "young man."

krater—An ancient Greek wide-mouthed bowl for mixing wine and water.

kufic—('kū-fŭk) An early form of the Arabic alphabet.

kylix—An ancient Greek shallow drinking cup with two handles and a stem.

labret—('lā-brŭt) A lip plug.

lacquer—('lăk-ŭr) In Chinese art, a varnish-like substance made from the sap of the Asiatic sumac, used to decorate wood and

other organic materials. It is often colored with mineral pigments, cures to great hardness, and has a lustrous surface.

lakshana(s)—(laksh-'ha-na) Distinguishing marks of the *Buddha*. They include the *urna* and *ushnisha*.

lalita—(la-'lē-ta) In Hindu art, the dance pose of the god Shiva, in which his multiple arms swing rhythmically in an arc.

lamassu—(la-'ma-sū) In Assyrian art, guardians in the form of man-headed winged bulls.

lancet—('lăn-sŭt) In *Gothic* architecture, tall narrow window ending in pointed arch.

landscape—A picture showing natural scenery, without narrative content.

lapis lazuli—('lă-pŭs 'lă-zhyŭ-lē) A rich, ultramarine, semiprecious stone used for carving and as a source for pigment.

lectionary—('lek-shŭn-er-ē) A book containing passages from the *Gospels*, arranged in the sequence that they were to be read during the celebration of religious services, including the *Mass*, throughout the year.

lekythos—('lek-ē-thos) A flask containing perfumed oil; lekythoi were often placed in Greek graves as offerings to the deceased.

letterpress—The technique of printing with movable type invented in Germany in the fifteenth century.

lierne—(lē-'ŭrn) A short *rib* that runs from one main rib of a *vault* to another.

linear perspective—See *perspective*.

linga—In Hindu art, the depiction of Shiva as a phallus or cosmic pillar.

lintel—('lin-tŭl) A beam used to span an opening.

literati—In China, talented amateur painters and scholars from the landed gentry whose work reached maturity during the Yuan Dynasty (A.D. 1279–1368).

loculi—('lak-yū-lē) Openings in the walls of *catacombs* to receive the dead.

loggia—('lo-jū) A gallery with an open *arcade* or a *colonnade* on one or both sides.

logogram—('la-gŭ-gram) One of the thousands of characters in the Chinese writing system, corresponding to one meaningful language unit. See also *pictograph*.

longitudinal plan—See *plan*.

lost-wax process (cire perdue)—A bronze-casting method in which a figure is modeled in wax and covered with clay; the whole is fired, melting away the wax and hardening the clay, which then becomes a mold for molten metal.

lotiform capital—A capital in the form of a lotus petal.

low relief—See *relief*.

lunette—(lū-'net) A semi-circular area (with the flat side down) in a wall over a door, a niche, or a window.

madrasa—(mŭ-'dra-sŭ) An Islamic theological college adjoining and often containing a *mosque*.

maebyong—(mī-byŭng) A Korean vase similar to the Chinese *meiping*.

maestà—(mī-ŭ-'sta) A depiction of the Virgin Mary as the Queen of Heaven enthroned in majesty amid choruses of angels and saints.

magi—('mă-jī) The wise men from the East who present gifts to the infant Jesus.

Mahathat—Literally, "Great Relic."

malanggan—(ma-lang-gan) A type of New Ireland (Papua New Guinea) polychrome sculpture, noted for its bewildering intricacy, created by generous use of openwork and sliverlike projections and by overpainting in minute geometric patterns that further subdivide the image, resulting in a splintered or fragmented and airy effect.

mana—('ma-na) A Polynesian concept expressing spiritual power.

mandapa—(man-'da-pa) An often-pillared, Hindu assembly hall, part of a temple.

mandorla—(măn-'dor-lŭ) An almond-shaped *nimbus,* or *glory,* surrounding the figure of Christ or other sacred figure.

Mannerism—A style of later Renaissance art that emphasized "artifice," contrived imagery not derived directly from nature. Such artworks showed a self-conscious stylization involving complexity, caprice, fantasy, and polish. Mannerist architecture tended to flout the classical rules of order, stability, and symmetry, sometimes to the point of parody.

mantle—A sleeveless, protective outer garment or cloak. See *himation*.

maqsura—(mak-'sū-ra) In some *mosques,* a screened area in front of the *mihrab* that was reserved for a ruler.

marga—The path proposed by the *Buddha* as a way to stop desire.

masjid-i jami—('măs-jid-ē-'ja-mē) The "Friday *mosque,*" large enough to accommodate an Islamic community's entire population for the Friday noonday prayer.

Masonry Style—See *First Style*.

masquerade—Among some African groups, a ritualized drama performed by several masked dancers, embodying ancestors or nature spirits.

Mass—The Catholic and *Orthodox* ritual in which believers understand that Christ's redeeming sacrifice on the cross is repeated when the priest consecrates the bread and wine in the *Eucharist*.

mastaba—(ma-'sta-ba) Arabic for "bench." An ancient Egyptian rectangular brick or stone structure with sloping sides erected over a subterranean tomb chamber connected with the outside by a shaft.

matte (also **mat**)—In painting, pottery, and photography, a dull finish.

mausoleum—A central-plan, domed structure, built as a memorial.

meander or **key**—See *fret*.

medieval—See *Middle Ages*.

medium—The substance or agency in which an artist works; also, in painting, the vehicle (usually liquid) that carries the pigment.

megalith (adj., **megalithic**)—('me-gŭ-lith/ me-gŭ-'lith-ik) Literally, "great stone"; a large, roughly hewn stone used in the construction of monumental prehistoric structures. See also *cromlech, dolmen, menhir*.

megaron—('meg-ŭ-ron) The large reception hall of the king in a Mycenaean palace, fronted by an open, two-columned porch.

meiping—(mă-ping) A Chinese vase of a high-shouldered shape; the *sgrafitto* technique was used in decorating such vases.

memento mori—(mi-'ment-ō 'mo-rē) A reminder of human mortality, usually represented by a skull.

mendicants—In *medieval* Europe, friars belonging to the Franciscan and Dominican orders, who renounced all worldly goods, lived by contributions of laypeople (the word *mendicant* literally means "beggar"), and devoted themselves to preaching, teaching, and doing good works.

menhir—('men-hir) A prehistoric *monolith,* uncut or roughly cut, standing singly or with others in rows or circles.

menorah—(mŭ-no-rŭ) The seven-branched candelabrum used in Jewish religious practices.

Mesoamerica—The region that comprises Mexico, Guatemala, Belize, Honduras, and the Pacific coast of El Salvador.

Mesolithic—(mez-ō-'lith-ik) The "middle" prehistoric period, between the *Paleolithic* and the *Neolithic* ages.

Messiah—(mŭ-'si-ŭ) The savior of the Jews prophesized in the Old Testament. Christians believe that Jesus of Nazareth was the Messiah.

metates—(mŭ-'ta-tāz) Ceremonial grinding stones, perhaps used as thrones in northern South America and various Central American regions.

metope—('met-ŭ-pē) The panel between the *triglyphs* in a *Doric frieze,* often sculptured in *relief*.

Mexica—The name used by a group of initially migratory invaders from northern Mexico to identify themselves; settling on an island in Lake Texcoco in central Mexico, they are known today as the Aztecs.

Middle Ages (adj. **medieval**)—In European history, the period of roughly a thousand years (ca. A.D. 400–1400) from the end of the Western Roman Empire to the Renaissance.

mihrab—(mi-'rab) A semi-circular niche set into the *qibla* wall of an Islamic *mosque*.

minaret—('min-ŭ-ret) A distinctive feature of Islamic *mosque* architecture, a tower from which the *muezzin* calls the faithful to worship.

minbar—('min-bar) In a *mosque,* the pulpit on which an *imam* stands.

miniatures—Small individual paintings intended by Indian painters to be held in the hand and viewed by one or two individuals at one time.

Minimalism (Minimal Art)—An American

predominantly sculptural trend of the 1960s whose works consist of a severe reduction of form to single, homogeneous units called "primary structures." Examples include the sculpture of Tony Smith and Donald Judd.

Minoan art—(Mŭ-ʹnō-ŭn *art*) The pre-Greek art of Crete, named after the legendary King Minos of Knossos.

mobile—(ʹmō-bēl) A sculpture with moving parts.

modeling—The shaping or fashioning of three-dimensional forms in a soft material, such as clay; also, the gradations of light and shade reflected from the surfaces of matter in space, or the illusion of such gradations produced by alterations of value in a drawing, painting, or print.

modern—In art, styles that break with traditional forms and techniques.

Modernism—A movement in Western art that developed in the second half of the nineteenth century and sought to capture the images and sensibilities of the age. Modernist art goes beyond simply dealing with the present and involves the artist's critical examination of the premises of art itself. After World War II modernism increasingly became identified with a strict *formalism.*

module—A basic unit of which the dimensions of the major parts of a work are multiples. The principle is used in sculpture and other art forms, but it is most often employed in architecture, where the module may be the dimensions of an important part of a building, such as a *column,* or simply some commonly accepted unit of measurement (the centimeter or the inch, or, as with Le Corbusier, the average dimensions of the human figure).

molding—In architecture, a continuous, narrow surface (projecting or recessed, plain or ornamented) designed to break up a surface, to accent, or to decorate.

mondop—In Thai architecture, brick buildings adjacent to stupas that enclose *Buddha* images.

monochromatic—(ma-nō-krō-ʹmăt-ŭk) Consisting of a single color.

monolith—A column that is all in one piece (not composed of *drums*); a large, single block or piece of stone used in *megalithic* structures.

Monophysitism—(mŭ-ʹnaf-ŭ-sit-iz-ŭm) An early Christian movement, condemned by the Church as heretical, that denied the duality of Jesus Christ's divine and human natures.

monumental—In art criticism, any work of art of grandeur and simplicity, regardless of its size.

moralized Bible—Gothic heavily illustrated Bibles, each page pairing Old and New Testament episodes with *illuminations* explaining their moral significance.

mortise-and-tenon system—(ʹmor-tŭs- *and*-ʹten-ŭn) See *tenon.*

mosaic—(mō-ʹzā-ŭk) Patterns or pictures made by embedding small pieces of stone or glass (*tesserae*) in cement on surfaces such as walls and floors; also, the technique of making such works.

mosaic tilework—An Islamic decorative technique in which large ceramic panels are fired, cut into smaller pieces, and set in plaster.

moschophoros—The Greek word for "calf-bearer."

moshaambwooy—A mask representing a primordial nature spirit, a mythical ancestor, of the Kuba people of the Democratic Republic of Congo. It serves social control functions and embodies the king's supernatural and political powers.

mosque—(mask) An Islamic religious building. From the Arabic word *masjid,* meaning a place for bowing down.

mudra—(ʹmŭ-drŭ, *or* ʹmŭ-drŭ) A stylized and symbolic hand gesture of mystical significance, usually in representations of the *Buddha* and of Hindu deities.

muezzin—(myŭ-ʹez-ŭn) In Islam, the crier who calls the faithful to worship.

muhaqqaq—(mū-ha-ʹkak) A style of Islamic calligraphy.

mullah—(ʹmŭ-lŭ) An Islamic teacher.

mullion—(ʹmŭl-yŭn) A vertical member that divides a window or that separates one window from another.

mummification—A technique used by ancient Egyptians to preserve human bodies so that they may serve as the eternal home of the immortal *ka.*

muqarna(s)—(mū-ʹkar-na) Stucco decorations of Islamic buildings in which "stalactite"-like forms break a structure's solidity.

mural—A wall painting; a *fresco* is a type of mural medium and technique.

Muslim—A believer in Islam.

Mycenaean—(mī-sŭ-ʹnē-ŭn) The late phase of *Helladic* art, named after the site of Mycenae.

Nabis—The Hebrew word for prophet. A group of *Symbolist* painters influenced by Paul Gauguin.

Nang-yai—(nang-yī) Thai term for shadow puppets cut from large pieces of leather and held above the heads of performers by two sticks tied to a wood frame.

naos—(ʹnā-os) See *cella.*

narrative composition—Elements in a work of art arranged in such a manner as to tell a story.

narthex—(ʹnar-theks) A porch or vestibule of a church, generally *colonnaded* or *arcaded* and preceding the *nave.*

natatio—(na-ʹta-tē-ō) In Roman baths, the swimming pool.

Naturalism—The doctrine that art should adhere as closely as possible to the appearance of the natural world. *Naturalism,* with varying degrees of fidelity to appearance, recurs in the history of Western art.

nave—The part of a church between the chief entrance and the *choir,* demarcated from *aisles* by *piers* or *columns.*

nave arcade—In *basilica* architecture, the series of *arches* supported by *piers* separating the *nave* from the side *aisles.*

ndop—((n)dap) A male figure commemorating a living or dead king, carved by the Kuba people of the Democratic Republic of Congo.

necking—A groove at the bottom of the ancient Greek *Doric capital* between the *echinus* and the *flutes* that masks the junction of *capital* and *shaft.*

necropolis—(nŭ-ʹkrop-ŭ-lŭs) A large burial area or cemetery; literally, a city of the dead.

nemes—In ancient Egyptian statuary, the linen headdress worn by the pharaoh, with the uraeus cobra of kingship on the front.

nenfro—See *tufa.*

Neo-Expressionism—A postmodern art movement that emerged in the 1970s and that reflects the artists' interest in earlier art, notably German *Expressionism* and *Abstract Expressionism.*

Neolithic—(Nē-ō-ʹlith-ik) The "new" Stone Age, approximately 7000–3000 B.C.

Neoplasticism—A theory of art developed by Piet Mondrian to create a pure plastic art comprised of the simplest, least subjective, elements, *primary colors,* primary values, and primary directions (horizontal and vertical).

Neue Sachlichkeit (New Objectivity)—(ʹnoi-ŭ ʹsak-lik-kīt) An art movement that grew directly out of the World War I experiences of a group of German artists who sought to show the horrors of the war and its effects.

ngady amwaash—A female mythical ancestor mask of the Kuba people in the Democratic Republic of Congo, used in reenacting creation stories that also reinforce basic social values.

niello—(nē-ʹel-ō) A black metallic alloy used to fill incised designs in decorating metal objects.

nihonga—(nē-hong-ga) A nineteenth-century Japanese painting style that incorporated some Western techniques in basically Japanese-style painting, as opposed to "yoga" (Western painting).

nimbus—A halo, aureole, or *glory* appearing around the head of a holy figure to signify divinity.

nirvana—In Buddhism and Hinduism, a blissful state brought about by absorption of the individual soul or consciousness into the supreme spirit. Also called moksha.

nkisi nduda—A traditional Kongo power figure.

nkisi n'kondi—((n)kē-sē (n)kan-dē) A power figure carved by the Kongo people of the Democratic Republic of Congo. Such images embodied spirits believed to heal and give life or capable of inflicting harm or death.

nomoli—(ʹna-ma-lī) Stone figures created by the Sapi people on the Atlantic coast of West Africa in the fifteenth and sixteenth centuries.

nymphs—In classical mythology, female divinities of springs, caves, and woods.

octafoliate—Eight-leafed design.

oculus (pl., **oculi**)—(a-kyū-lus/a-kyū-lē) The round central opening or "eye" of a dome. Also, small round windows in *Gothic* cathedrals.

ogee arch—(ō-'jē) A Late *Gothic* arch made up of two double-curving lines meeting at a point.

ogive (adj., **ogival**)—(ō-'jī-vŭl) The diagonal *rib* of a *Gothic vault*; a *pointed*, or Gothic, *arch*.

oliphants—('al-ŭ-fŭnts) Ivory hunting horns carved by Sapi (West African) artists for European patrons in the late fifteenth and early sixteenth centuries.

one-point perspective—See *perspective*.

opisthodomos—(o-pis-'thad-ŭ-mŭs) In Greek architecture, a porch at the rear, set against the blank back wall of the *cella*.

Optical or **Op Art**—A kind of painting style in which precisely drafted patterns directly, even uncomfortably, affect visual perception.

optical approach to representation—In artistic representation, only that which is actually "seen" is represented, rather than what is "known" (e.g., a human profile depicted optically would reveal only one eye, whereas a profile depicted "descriptively" would feature two eyes). See *descriptive approach to representation*.

opus reticulatum—('ō-pŭs rŭ-tik-ŭ-'lat-ŭm) A method of facing concrete walls with lozenge-shaped bricks or stones to achieve a netlike ornamental surface pattern.

orant—('or-ănt) In Early Christian art, a figure represented with hands raised in prayer.

orbiculum—(or-'bik-yū-lŭm) A disc-like opening in a *pediment*.

orchestra—In ancient Greek theaters, the circular piece of earth with a hard and level surface on which the ancient rites took place. Literally, a dancing place.

order—In classical architecture a style represented by a characteristic design of the *columns* and *entablature*. See also *superimposed order*.

Orientalizing—The early phase of Archaic Greek art, so named because of the adoption of forms and motifs from the ancient Near East and Egypt.

orrery—A special technological model to demonstrate the theory that the universe operates like a gigantic clockwork mechanism.

Orthodox—The trinitarian Christian doctrine established in *Byzantium*.

orthogonal—(or-'thag-ŭn-ŭl) A line imagined to be behind and perpendicular to the picture plane; the *orthogonals* in a painting appear to recede toward a vanishing point on the horizon.

orthogonal plan—The imposition of a strict grid plan upon a site, regardless of the terrain, so that all streets meet at right angles. See also *Hippodamian plan*.

Ottonian (adj.)—Pertaining to the empire of Otto I and his successors.

overglaze decoration—In *porcelain* decoration, the techniques of applying paint colors over the *glaze* after the work has been fired. The overglaze colors, or enamels, fuse to the glazed surface in a second firing at a much lower temperature than the main firing. See also *underglaze decoration*.

pagan—A person who worships many gods.

pagoda—(pŭ-'gō-dŭ) A Chinese tower, usually associated with a temple, having a multiplicity of winged eaves; thought to be derived from the Indian *stupa*.

pala—In Christian churches, an altarpiece, or panel placed behind and over the altar.

Paleolithic—(pā-lē-ō-'lith-ik) The "old" Stone Age, during which humankind produced the first art objects beginning ca. 30,000 B.C.

palestra—An ancient Greek and Roman exercise area, usually framed by a *colonnade*, often found in bathing establishments.

palette—In ancient Egypt, a slate slab used for ceremonial purposes, as in the *Palette of King Narmer*. A thin board with a thumb hole at one end on which an artist lays and mixes colors; any surface so used. Also, the colors or kinds of colors characteristically used by an artist.

palmette—A conventional, decorative ornament of ancient origin composed of radiating petals springing from a cuplike base.

Pantocrator—(pan-'tak-rŭ-tŭr) In Christian art, the image of Christ as ruler and judge of heaven and earth.

papyrus—(pŭ-'pī-rŭs) A plant native to Egypt and adjacent lands used to make paperlike writing material; also, the material or any writing on it.

parapet—A low, protective wall along the edge of a balcony or roof.

parchment—Lambskin prepared as a surface for painting or writing, one of the materials which comprised the leaves of a *codex*.

parekklesion—(pă-rŭ-'klē-zŭ-an) The side chapel in a *Byzantine* church.

parinirvana—Reclining images of the *Buddha*, often viewed as representing his death.

parterres—(par-'tārz) Raised flower beds in Chinese gardens.

passage grave—A burial chamber entered through a long, tunnel-like passage.

pastels—Chalk-like crayons made of ground color pigments mixed with water and a binding medium. They lend themselves to quick execution and sketching and offer a wide range of colors and subtle variations of tone, suitable for rendering nuances of value.

patricians—Freeborn landowners of the Roman Republic.

pebble mosaics—Mosaics made of irregularly shaped stones of various colors.

pectoral—An ornament worn on the chest.

pediment—In classical architecture, the triangular space (gable) at the end of a building, formed by the ends of the sloping roof above the *colonnade*; also, an ornamental feature having this shape.

pendentive—A concave, triangular piece of masonry (a triangular section of a hemisphere), four of which provide the transition from a square area to the circular base of a covering *dome*. Although they appear to be hanging (pendant) from the dome, they in fact support it.

peplos—('pep-los) A simple long woolen belted garment worn by ancient Greek women that gives the female figure a columnar appearance.

Performance Art—An American avant-garde art trend of the 1960s that made time an integral element of art. It produced works in which movements, gestures, and sounds of persons communicating with an audience replace physical object. Documentary photographs are generally the only evidence remaining after these events. See also *Happenings*.

peripteral colonnade—(pŭ-'rip-tŭr-ŭl) A colonnade or *peristyle*. See also *dipteral*.

peristyle—('per-rŭ-stīl) In ancient Greek architecture, a *colonnade* all around the *cella* and its porch(es).

Perpendicular style—The last English *Gothic* style, also known as Tudor, characterized by a strong vertical emphasis and dense thickets of ornamental vault ribs that serve entirely decorative functions.

persistence of vision—Retention in the brain for a fraction of a second of whatever the eye has seen; it causes a rapid succession of images to merge one into the next, producing the illusion of continuous change and motion in media such as cinema.

personification—Abstract ideas codified in bodily form.

perspective—A formula for projecting an illusion of the three-dimensional world onto a two-dimensional surface. In linear (single vanishing point) perspective, the most common type, all parallel lines or lines of projection seem to converge on one, two, or three points located with reference to the eye level of the viewer (the horizon line of the picture), known as vanishing points, and associated objects are rendered smaller the farther from the viewer they are intended to seem. Atmospheric, or aerial, perspective creates the illusion of distance by the greater diminution of color intensity, the shift in color toward an almost neutral blue, and the blurring of contours as the intended distance between eye and object increases.

petroglyphs—('pet-rō-glif) *Engravings* or *incisings* in rock.

petuntse—(pŭ-'tŭnt-se) A type of feldspar, ground for mixing with clay in *porcelain*.

photomontage—(fō-tō-mon-'taj) A compo-

sition made by fitting together pictures or parts of pictures, especially photographs. See also *collage.*

Photorealists—See *Superrealism.*

physical music—A kind of video narrative made by Nam June Paik which comprises in quick succession fragmented sequences of a variety of media: dance, advertising, poetry, street scenes, etc.

pictograph—('pik-tō-grăf) A picture, usually stylized, that represents an idea; also, writing using such means; also painting on rock. See also *hieroglyphic.*

Pictorial style—An early style of photography in which photographers desired to achieve effects of painting, using centered figures, framing devices, and soft focus. Gertrude Käsebier was a noted proponent of this style of photography.

pier—A vertical, freestanding masonry support.

pier buttress—See *buttress.*

pietà—(pē-a-'ta) A painted or sculpted representation of the Virgin Mary mourning over the body of Christ.

pietra serena—(pē-'et-rŭ sŭ-'ā-nŭ) Literally, "serene stone," a type of gray stone used for its harmonious appearance when contrasted with stucco or other smooth finish in architecture.

pilaster—A flat, rectangular, vertical member projecting from a wall of which it forms a part. It usually has a *base* and a *capital* and is often *fluted.*

pillar—Usually a weight-carrying member, such as a *pier* or a *column;* sometimes an isolated, freestanding structure used for commemorative purposes.

pinakotheke—(pin-a-kō-thē-kē) The Greek word for "picture gallery."

pinnacle—In *Gothic* churches, a sharply pointed ornament capping the piers or flying buttresses; also used on church *facades.*

pittura metafisica—(pēt-'tū-ra me-ta-'fē-sē-ka) Literally, metaphysical painting. Exemplified by the work of Giorgio de Chirico, a precursor of *Surrealism.*

plan—The horizontal arrangement of the parts of a building or of the buildings and streets of a city or town, or a drawing or a diagram showing such an arrangement as a horizontal *section.* In an axial plan, the parts of a building are organized longitudinally, or along a given axis; in a central plan, the parts radiate from a central point.

plate tracery—See *tracery.*

plebeian—(pli-'be-ŭn) In the Roman Republic, the social class that included small farmers, merchants, and freed slaves.

plein-air—('plen-ār) An approach to painting much favored by the *Impressionists,* in which artists sketch outdoors to achieve a quick impression of light, air and color. The sketches were then taken to the studio for reworking into more finished works of art.

plinth—The lowest member of a *base;* also a square slab at the base of a *column.*

poesia—(pō-e-zē-ŭ) A term describing "poetic" art, notably Venetian Renaissance paintings, which emphasize the lyrical and sensual.

pointed arch—See *ogive.*

pointillism—('poin-tŭ-liz-ŭm) A system of painting that focused on color analysis, devised by the nineteenth-century French painter Georges Seurat. The artist separates color into its component parts and then applies the component colors to the canvas in tiny dots (points). The image only becomes comprehensible from a distance, when the viewer's eyes blend the pigment dots.

polis (pl. **poleis**)—Independent city-states in ancient Greece.

polychrome—('pa-lē-krōm) Done in several colors.

polyptych—An *altarpiece* made up of more than three sections.

pontifex maximus—A Latin term meaning "chief priest" of the state religion.

Pop Art—A term coined by British art critic Lawrence Alloway to refer to art, first appearing in the 1950s, that incorporated elements from popular culture, such as images from motion pictures, television, advertising, billboards, commodities, etc.

porcelains—Extremely fine, hard white ceramics. Unlike stoneware, porcelain is made from a fine white clay called *kaolin* mixed with ground *petuntse,* a type of feldspar. True porcelain is translucent and rings when struck.

porphyry—('por-fŭ-rē) Purple marble.

portico—('por-tŭ-kō) A porch with a roof supported by *columns;* an entrance porch.

post-and-lintel system—A *trabeated* system of construction in which two posts support a *lintel.*

Post-Painterly Abstraction—An American art movement that developed out of *Abstract Expressionism,* yet manifests a radically different sensibility. While Abstract Expressionist art conveys a feeling of passion and visceral intensity, a cool, detached rationality emphasizing tighter pictorial control characterizes *Post-Painterly Abstraction.* See also *color field painting* and *hard-edge painting.*

Postmodernism—A reaction against *Modernist* formalism, which is seen as elitist. Far more encompassing and accepting than the more rigid confines of modernist practice, postmodernism offers something for everyone by accommodating a wide range of styles, subjects, and formats, from traditional easel painting to *installation* and from abstraction to illusionistic scenes.

pottery—Objects (usually vessels) made of clay and hardened by firing.

prasada—In Hindu worship, food that becomes sacred by first being given to a god.

Precisionists—A group of American painters, active in the 1920s and 1930s, whose work concentrated on portraying manmade environments in a clear and concise manner to express the beauty of perfect and precise machine forms. Charles Sheeler is an example.

pre-Columbian (adj.)—The cultures that flourished in the Western Hemisphere before European contact and conquest.

predella—(prŭ-'del-lŭ) The narrow ledge on which an *altarpiece* rests on an altar.

prefiguration—In Early Christian art, the depiction of Old Testament persons and events as prophetic forerunners of Christ and New Testament events.

Pre-Raphaelite Brotherhood—A group of nineteenth-century artists, including John Everett Millais, who refused to be limited to contemporary scenes and chose instead to represent fictional, historical, and fanciful subjects using *realist* techniques.

primary colors—The colors—red, yellow, and blue—from which all other colors may be derived. *Secondary colors* result from mixing pairs of primaries.

Productivism—An art movement that emerged in the Soviet Union after the Revolution, whose members believed that artists must direct art toward creating products for the new society.

pronaos—('pro-nā-os) The space, or porch, in front of the *cella* or *naos* of an ancient Greek temple.

propylaion (pl. **propylaia**)—A gateway building leading to an open court preceding an ancient Greek or Roman temple. The monumental entrance to the Acropolis in Athens.

proscenium—(prō-'sē-nē-ŭm) The part of the stage in front of the curtain. The stage of an ancient Greek or Roman theater.

prostyle—('prō-stīl) A style of ancient Greek temple in which the *columns* stand in front of the *naos* and extend its full width.

provenance—('prō-vŭ-naⁿs) Origin or source.

psalter—('sol-tŭr) A book containing the Psalms of the Bible.

pseudoperipteral—(sŭ-dō-pŭ-'rip-tŭr-ŭl) In Roman architecture, a *pseudoperipteral* temple has a series of engaged columns all around the sides and back of the *cella* to give the appearance of a *peripteral colonnade.*

pueblo—('pwe-blō) Communal multistoried dwellings made of stone or *adobe* brick by the Native Americans of the Southwest; with cap. also used to reference various groups that occupied such dwellings.

purlins—('pŭr-lin) Horizontal beams in a roof structure, parallel to the *ridgepoles,* resting on the main rafters and giving support to the secondary rafters.

putto (pl. **putti**)—('pū-tō/'pū-ti) A cherubic young boy, a favorite subject in Italian painting and sculpture.

pylon—The simple and massive gateway, with sloping walls, of an Egyptian temple.

pyxides—('pik-sŭ-dēz) Small ivory boxes used in church ceremonies; crafted by Sapi (West African) artists for European patrons in the late fifteenth and early sixteenth centuries.

qibla—('kē-blŭ) In the *Muslim* religion, the direction (towards Mecca) the faithful turn when praying.

quadrant arches—Arches whose curve extends for one quarter of a circle's circumference.

quadrant vault—Half-barrel vaults. See *vault*.

quadro riportato—('kwa-drō re-por-'ta-tō) A ceiling design in which painted scenes are arranged in panels resembling framed pictures transferred to the surface of a shallow, curved *vault*.

quatrefoil—A shape or plan in which the parts assume the form of a cloverleaf.

quipu—('kē-pū) Andean record-keeping device made of fibers in which numerous knotted strings hung from a main cord recorded by position and color numbers and categories of things.

quoins—(kwoin) The large, sometimes *rusticated,* usually slightly projecting stones that often form the corners of the exterior walls of masonry buildings.

Quran—(ko-'ran) Also spelled **Koran**. Islam's sacred book, composed of *surahs* (chapters) divided into verses.

radiating chapels—In *medieval* churches, chapels for the display of *relics* that opened directly onto the *ambulatory* and the *transept.*

radiocarbon dating—Method of measuring the decay rate of carbon isotopes in organic matter to provide dates for organic materials such as wood and fiber.

raffia cloth—('răf-ē-ŭ *cloth*) Textiles made from the raffia palm by the Kuba peoples of the Democratic Republic of Congo. Elaborate geometric patterns are created by embroidery and by cut-pile stitching (producing a velvet-like surface by pulling short raffia strands through plain raffia cloth and scraping the tuft ends to spread them out).

raking cornice—The *cornice* on the sloping sides of a *pediment.*

ratha—('rat-ha) Small, freestanding Hindu temple carved from a huge boulder (found in Mahabalipuram, India).

Rayonnant—(rā-yō-'nan) The "radiant" style of *Gothic* architecture, dominant in the second half of the thirteenth century and associated with the French royal court of Louis IX at Paris.

realism—The representation of things according to their appearance in visible nature (without *idealization*).

Realism—A movement that emerged in mid-nineteenth-century France. Realist artists represented the subject matter of everyday life (especially that which up until then had been considered inappropriate for depiction) in a realistic mode.

red-figure technique—In later Greek pottery, the silhouetting of red figures against a black background, with painted linear details; the reverse of the *black-figure technique.*

refectory—(rŭ-'fek-tŭ-rē) The dining hall of a Christian monastery.

Regionalism—A twentieth-century American movement that rejected avant-garde art and portrayed American rural life in a clearly readable, realist style. Major regionalists include Grant Wood and Thomas Hart Benton.

register—One of a series of superimposed bands in a pictorial narrative, or the particular levels on which motifs are placed.

relics—In Christianity, the body parts, clothing, or objects associated with a saint or with Christ himself.

relief—In sculpture, figures projecting from a background of which they are part. The degree of relief is designated high, low (*bas*), sunken (hollow), or *intaglio*. In the last, the artist cuts the design into the surface so that the image's highest projecting parts are no higher than the surface itself. See also *repoussé.*

relieving triangle—In a *corbeled arch,* the opening above the lintel that serves to lighten the weight to be carried by the *lintel* itself.

relievo—(rē-'lyā-vō) *Relief.*

reliquary—('rel-ŭ-kwe-rē) A container for keeping *relics.*

renovatio imperii Romani—Literally, "renewal of the Roman Empire," as claimed by Charlemagne, the first *Carolingian* emperor.

repoussé—(rŭ-pū-'sā) Formed in *relief* by beating a metal plate from the back, leaving the impression on the face. The metal is hammered into a hollow mold of wood or some other pliable material and finished with a *graver.* See also *relief.*

respond—An engaged *column, pilaster,* or similar element that either projects from a *compound pier* or some other supporting device or is bonded to a wall and carries one end of an *arch.*

retables—(rē-'tā-bŭlz) An architectural screen or wall above and behind an altar, usually containing painting, sculpture, carving, or other decorations. See also *altarpiece.*

revetment—(rŭ-'vet-mŭnt) In architecture, an exteral covering or facing.

rhyton—An ancient ceremonial drinking vessel, sometimes in the form of the head of an animal, a person or a mythological creature.

rib—A relatively slender, molded masonry *arch* that projects from a surface. In *Gothic* architecture, the ribs form the framework of the *vaulting.* A diagonal rib is one of the ribs that form the X of a *groin vault.* A transverse rib crosses the nave or aisle at a ninety-degree angle.

rib vault—*Vaults* in which the diagonal and transverse *ribs* compose a structural skeleton that partially supports the still fairly massive paneling between them.

ridgepole—The beam running the length of a building below the peak of the gabled roof.

Rococo—(rō-kō-'kō) A style, primarily of interior design, that appeared in France around 1700. Interiors were designed as total works of art with elegant furniture, small sculpture, ornamental mirrors and easel paintings, and tapestry complementing architecture, reliefs, and wall painting.

Romanesque—(rō-mŭ-'nesk) Literally, "Roman-like." A term used to describe the history, culture, and art of *medieval* western Europe from about 1050 to about 1200.

Romanticism—A Western cultural phenomenon, beginning around 1750 and ending about 1850, that gave precedence to feeling and imagination over reason and thought. More narrowly, the art movement that flourished from about 1800 to 1840.

roof comb—The elaborately sculpted vertical projection surmounting a Maya temple-pyramid.

rose window—A circular stained glass window.

Rosetta Stone—An Egyptian artifact that gave scholars a key to deciphering *hieroglyphic* writing.

rotulus—('rat-yū-lŭs) The long manuscript scroll used by Egyptians, Greeks, Etruscans, and Romans; predecessor of the *codex.*

roundel—See *tondo.*

rusticate—To give a rustic appearance by roughening the surfaces and beveling the edges of stone blocks to emphasize the joints between them. A technique popular during the Renaissance, especially for stone courses at the ground-floor level.

sacra conversazione—('sa-kra kno-ver-sa-tsē-o-nā) Literally, "holy conversation," a style of *altarpiece* painting popular after the middle of the fifteenth century, in which saints from different epochs are joined in a unified space and seem to be conversing either with each other or with the audience.

saint—From the Latin word *sanctus,* meaning "made holy by God." Persons who suffered and died for their Christian faith or who merited reverence for their Christian devotion while alive. In the Roman Catholic church, a worthy deceased Catholic who is *canonized* by the pope.

samsara—In Hindu belief, the rebirth of the soul into a succession of lives.

samurai—('sam-ŭ-rī) Medieval Japanese warriors.

sarcophagus (pl. **sarcophagi**)—(sar-'kof-ŭ-gŭs/sar-'kof-ŭ-gī) A coffin, usually of stone. From the Latin, "consumer of flesh."

sarsen—('sar-sŭn) A form of sandstone used for the *megaliths* at Stonehenge.

satyr—A male follower of the ancient Greek god Dionysos, represented as part human, part goat.

saz—(săz) An Ottoman Turkish design of sinuous curved leaves and blossoms.

scarification—Decorative markings made with scars on the human body.

school—A chronological and stylistic classification of works of art with a stipulation of place.

scriptoria—(skrip-'tor-ē-ŭ) The writing studios of monasteries and churches in early *medieval* Europe.

sculpture in the round—Freestanding figures, carved or modeled in three dimensions.

Second Style—In Roman mural painting, from ca. 80 to ca. 15 B.C. the aim was to dissolve the confining walls of a room and replace them with the illusion of a three-dimensional world constructed in the artist's imagination.

secondary colors—Orange, green, and purple, obtained by mixing pairs of *primary colors* (red, yellow, blue).

section—In architecture, a diagram or representation of a part of a structure or building along an imaginary plane that passes through it vertically. Drawings showing a theoretical slice across a structure's width are lateral sections. Those cutting through a building's length are longitudinal sections. See also *elevation* and *cutaway.*

senate—Literally, a council of elders. The legislative body in Roman constitutional government.

serdab—(sŭ(r)-'dab) A small concealed chamber in an Egyptian tomb (*mastaba*) for the statue of the deceased.

serpentine (line)—The "S" curve, which was regarded by Hogarth as the line of beauty.

Severe Style—The earliest phase of Classical Greek sculpture.

severies (vaulting web)—('sev-u-rēz) In *Gothic* architecture, the masonry blocks that fill the area between the *ribs* of a *groin vault.*

sexpartite vaults—Vaults whose *ribs* spring from compound *piers.* The branching ribs divide the large rectangular vault compartment into six sections. See *vault.*

sfumato—(sfū-'ma-tō) A smokelike haziness that subtly softens outlines in painting; particularly applied to the painting of Leonardo and Correggio.

sgrafitto—(skraf-'fē-tō) A Chinese ceramic technique in which the design is incised through a colored *slip.*

shaft—The part of a *column* between the *capital* and the *base.*

shakti—In Hinduism, the female power of the deity Devi (or Goddess), which animates the matter of the cosmos.

shaman—('sha-mŭn) Among Native Americans, a medicine man thought to have direct contact with supernatural powers, which he uses to help people.

Shiites—Muslims who believe that only direct descendants of the Prophet Muhammad are qualified for the highest political and religious leadership.

shogun—In feudal Japan, a military governor who managed the country on behalf of a figurehead emperor.

silverpoint—A *stylus* made of silver, used in drawing in the fourteenth and fifteenth centuries because of the fine line it produced and the sharp point it maintained.

single vanishing point perspective—See *perspective.*

siren—In ancient Greek mythology, a creature that was part bird, part woman.

skene—('skā-nā) In ancient Greek theaters, the scene building that housed dressing rooms for the actors and also formed a backdrop for the plays.

skenographia—(skā-no-gra-'fē-u) The Greek term for *perspective,* literally, "scene painting," which employed linear, or single vanishing point, perspective to create the illusion of depth.

skiagraphia—(skē-u-gra-'fē-u) The Greek term for shading, literally "shadow painting," said to have been invented by Apollodoros, an Athenian painter of the fifth century B.C.

slip—A mixture of fine clay and water used in ceramic decoration.

soak stain—A technique of painting pioneered by Helen Frankenthaler in which the artist drenches the fabric of raw canvas with fluid paint to achieve flowing, lyrical, painterly effects.

socle—('sak-ŭl) A molded projection at the bottom of a wall or a *pier,* or beneath a pedestal or a *column base.*

soffit—The underside of an architectural member such as an *arch, lintel, cornice,* or stairway. See also *intrados.*

space—The bounded or boundless container of collections of objects.

spandrel—('spăn-drŭl) The roughly triangular space enclosed by the curves of adjacent *arches* and a horizontal member connecting their vertexes; also, the space enclosed by the curve of an *arch* and an enclosing right angle. The area between the arch proper and the framing *columns* and *entablature.*

sphinx—(sfengks) A mythical Egyptian beast with the body of a lion and the head of a human.

splay—A large *bevel* or *chamfer.*

splayed—An opening (as in a wall) that is cut away diagonally so that the outer edges are farther apart than the inner edges. See also *embrasure.*

springing—The lowest stone of an *arch,* resting on the *impost block.* In *Gothic* vaulting, the lowest stone of a diagonal or transverse *rib.*

squinch—(skwinch) An architectural device used as a transition from a square to a polygonal or circular base for a *dome.* It may be composed of *lintels, corbels,* or *arches.*

stanze—('stan-zā) The Italian word for "rooms."

statue column—See *atlantid* or *caryatid.*

stave—A wedge-shaped timber; vertically placed *staves* embellish the architectural features of the building.

stele—('stē-lē) A carved stone slab used to mark graves and to commemorate historical events.

stigmata—In Christian art, the wounds that Christ received at his crucifixion that miraculously appear on the body of a saint.

still life—A picture depicting an arrangement of objects.

stoa—('sto-ŭ) In ancient Greek architecture, an open building with a roof supported by a row of *columns* parallel to the back wall. A covered *colonnade.*

stonewear—Pottery fired at high temperatures producing a stonelike hardness and density.

strategos—An ancient Greek general.

strigil—A scraper, used by ancient Greek athletes to scrape oil from their bodies after exercising.

stringcourse—A raised horizontal *molding,* or band in masonry, ornamental but usually reflecting interior structure.

stucco—('stŭk-kō) Fine plaster or cement used as a coating for walls or for decoration.

stupa—('stū-pŭ) A large, mound-shaped *Buddhist* shrine.

stylobate—('stī-lŭ-bāt) The uppermost course of the platform of a classical temple, which supports the *columns.*

stylus—('stī-lŭs) A needlelike tool used in *engraving* and *incising.*

subtractive—A kind of sculpture technique in which materials are taken away from the original mass, i.e., carving.

sultan—A Muslim ruler.

sunken relief—In sculpture, *reliefs* created by chiseling below the stone's surface, rather than cutting back the stone around the figures to make them project from the surface.

Sunna—Collections of the Prophet Muhammad's moral sayings and descriptions of his deeds.

Sunnites—Muslims who recognize the legitimacy of the first *caliphs,* who were rulers who had been followers of Muhammad but were not directly descended from him.

superimposed orders—*Orders* of architecture that are placed one above another in an *arcaded* or *colonnaded* building, usually in the following sequence: *Doric* (the first story), *Ionic,* and *Corinthian.* Superimposed orders are found in later Greek architecture and were used widely by Roman and Renaissance builders.

superimposition—The nesting of earlier structures within later ones, a common *Mesoamerican* building trait.

Superrealism—A school of painting and sculpture of the 1960s and 1970s which emphasized making images of persons and things with scrupulous, photographic fidelity to optical fact. The Superrealist painters were also called Photorealists because many used photographs as sources for their imagery.

Suprematism—A type of art formulated by Kazimir Malevich to convey his belief that the supreme reality in the world is pure feeling, which attaches to no object and thus calls for new, nonobjective forms in

art—shapes not related to objects in the visible world.

surahs—Chapters of the *Quran* (Koran), divided into verses.

Surrealism—A successor to *Dada, Surrealism* incorporated the improvisational nature of its predecessor into its exploration of the ways to express in art the world of dreams and the unconscious. Biomorphic Surrealists such as Joan Miro produced largely abstract compositions. Naturalistic Surrealists, notably Salvador Dalí, presented recognizable scenes transformed into a dream or nightmare image.

sutra—('sū-trŭ) In Buddhism, an account of a sermon by or a dialogue involving the *Buddha*. A scriptural account of the Buddha. See also *jataka.*

Symbolists—In the late nineteenth century, a group of artists and poets who shared a view that the artist was not an imitator of nature but a creator who transformed the facts of nature into a symbol of the inner experience of that fact.

symmetria—(sim-ŭ-'trē-ŭ) Commensurability of parts. Polykleitos's treatise on his *canon* of proportions summarized the principle of symmetria.

Synthetic Cubism—In 1912 *Cubism* entered a new phase during which the style no longer relied on a decipherable relation to the visible world. In this new phase, called *Synthetic Cubism,* paintings and drawings were constructed from objects and shapes cut from paper or other materials to represent parts of a subject in order to play visual games with variations on illusion and reality.

taberna—(ta-'ber-na) In Roman architecture, a single-room shop covered by a barrel *vault.*

tapa—(ta-pa) Polynesian decorative bark cloth.

tapestry—A weaving technique in which the *weft* threads are packed densely over the *warp* threads so that the designs are woven directly into the fabric.

tapu—(ta-'pŭ) A Polynesian concept, the counterpart to *mana,* and creating with mana a dynamic opposition of forces dominating social and religious practices.

tarashikomi—(ta-ra-shi-ko-mē) In Japanese art, a painting technique involving the dropping of ink and pigments onto surfaces still wet with previously applied ink and pigments.

tatami—(ta-ta-mē) The traditional woven straw mat used for floor covering in Japanese architecture.

tattoo—A Polynesian word for the permanent decoration of human bodies.

technique—The processes that artists employ to create *form,* as well as the distinctive, personal ways in which they handle their materials and tools.

tell—In Near Eastern archeology, a hill or a mound, usually an ancient site of habitation.

tempera—('tem-pŭ-rŭ) A technique of painting using pigment mixed with egg yolk, glue or casein; also the *medium* itself.

temple mounds—Complex platformed earthworks built by *pre-Columbian* North Americans.

templon—('tem-plan) The columnar screen separating the sanctuary from the main body of a *Byzantine* church.

tenebrism—('ten-ŭ-briz(-ŭ)m) Painting in the "dark manner," using violent contrasts of light and dark, as in the work of Caravaggio.

tenon—A projection on the end of a piece of wood that is inserted into a corresponding hole (mortise) in another piece of wood to form a joint.

tenoned—Attached by stone pegs.

tepidarium—(tep-ŭ-'dă-rē-ŭm) The warm bath section of a Roman bathing establishment.

terracotta—(te-rŭ-'ko-tŭ) Hard-baked clay, used for sculpture and as a building material. It may be *glazed* or painted.

tesserae—('tes-ŭ-rē) Tiny stones or pieces of glass cut to desired shape and size to use in *mosaics* to create design and composition.

tetrarchy—(tet-rark-ē) Rule by four. A type of Roman government established in the late third century A.D. by Diocletian in an attempt to share power with potential rivals.

texture—The quality of a surface (rough, smooth, hard, soft, shiny, dull) as revealed by light. In represented texture, a painter depicts an object as having a certain texture even though the paint is the actual texture.

theatron—In ancient Greek theaters, the slope overlooking the *orchestra* on which the spectators sat. Literally, the place for seeing.

Theotokos—(thē-'ō-tō-kos) In Greek, "bearer of God." In Christian art, an image of the Virgin Mary, the mother of Jesus.

thermoluminescence—A method of dating amounts of radiation found within the clay of ceramic or sculptural forms, as well as in the clay cores from metal castings.

Third Style—In Roman mural painting, the style in which delicate linear fantasies were sketched on predominantly *monochromatic* backgrounds.

tholos (pl. **tholoi**)—('thō-los/'thō-loi) A circular structure, generally in classical style; also, in Aegean architecture, a circular beehive-shaped tomb.

thrust—The outward force exerted by an *arch* or a *vault* that must be counterbalanced by *buttresses.*

tier—A series of architectural rows, layers, or ranks arranged above or behind one another.

togu na—(tō-gū na) The "head" and most important part of the Dogon (Mali, West Africa) anthropomorphized village. Literally, "house of words," *togu na* is the men's house where deliberations vital to community welfare take place.

tokonoma—(to-ko-no-ma) A shallow alcove in a Japanese teahouse which is used for a single adornment, e.g., a painting or stylized flower arrangement.

tondo—('ton-dō) A circular painting or *relief* sculpture.

Torah—The scroll containing the Pentateuch, the first five books of the Hebrew Scriptures.

torana—('to-ra-na) Gateway in the stone fence around a *stupa,* located at the cardinal points of the compass.

torque—(tork) The neck band worn by Gauls.

trabeated—('tra-bē-āt-ŭd) Of *post-and-lintel* construction. Literally, "beamed" construction.

tracery—Ornamental stonework for holding stained glass in place, characteristic of *Gothic* cathedrals. In plate tracery the glass fills only the "punched holes" in the heavy ornamental stonework. In bar tracery the stained-glass windows fill almost the entire opening and the stonework is unobtrusive.

transept—('trăn-sept) The part of a *cruciform* church with an axis that crosses the main axis at right angles.

transverse rib—See *rib.*

treasuries—In ancient Greece, small buildings set up for the safe storage of *votive offerings.*

trefoil—A cloverlike ornament or symbol with stylized leaves in groups of three.

tribune—In *Romanesque* church architecture, galleries built over the inner *aisles.*

triclinium—(tri-'klin-ē-um) The dining room of a Roman house.

trident—The three-pronged pitchfork associated with the ancient Greek sea god Poseidon (Roman, Neptune).

triforium—(tri-'for-ē-ŭm) The bank of *arcades* below the *clerestory* that occupies the space corresponding to the exterior strip of wall covered by the sloping timber roof above the galleries. In a *Gothic* cathedral, the *blind arcaded* gallery below the *clerestory;* occasionally the arcades are filled with stained glass.

triglyph—('tri-glif) A projecting, grooved member of a *Doric frieze* that alternates with *metopes.*

trilithons—('tri-lith-onz) A pair of *monoliths* topped with a *lintel;* found in *megalithic* structures.

triptych—('trip-tik) A three-paneled painting or *altarpiece.*

triumphal arch—In Roman architecture, freestanding *arches* commemorating important events such as military victories.

trompe l'œil—(troⁿp 'loi) A form of illusionistic painting that attempts to represent an object as existing in three dimensions at the surface of the painting; literally, "fools the eye."

true fresco—See *fresco.*

trumeau—(trū-'mō) In architecture, the *pillar* or center post supporting the *lintel* in the middle of the doorway.

tubicen—('tū-bŭ-sŭn) The Latin word for "trumpeter."

Tudor—See *perpendicular style.*

tufa—('tū-fŭ) A porous rock formed from deposits of springs.

tumulus (pl. **tumuli**)— ('tū-myū-lus/ 'tū-myū-li) Burial mound; in Etruscan architecture, tumuli cover one or more subterranean multichambered tombs cut out of the local *tufa*. Also characteristic of the Japanese Kofun period of the third and fourth centuries where they signal the rise of grand political leaders.

tunnel vaults—See *vaults.*

Tuscan column—Also known as Etruscan *column*. Resemble ancient Greek *Doric* columns, but made of wood, unfluted, and with *bases*. They were spaced more widely than were Greek columns.

Tusci—The ancient people who inhabited Etruria and gave their name to modern-day Tuscany.

twining—A nonloom technique in which the weaver twists two threads around each other to form the finished cloth.

twisted perspective—A convention of representation in which part of a figure is seen in profile and another part of the same figure frontally. Not strictly *optical* (organized from the perspective of a fixed viewpoint), but *descriptive.*

tympanum—('tim-pŭ-nŭm) The space enclosed by a *lintel* and an *arch* over a doorway.

ubosoth—(ū-bō-soth) The ordination hall of a *Buddhist* temple in Thailand.

ukiyo-e—(ū-kē-yō-ā) A style of Japanese *genre* painting ("pictures of the floating world") that influenced nineteenth-century Western art.

underglaze decoration—In *porcelain* decoration, the application of mineral colors to the surface before the main firing, followed by an application of clear *glaze*. See also *overglaze decoration.*

urna—('ŭr-nŭ) A whorl of hair, represented as a dot, between the brows of the *Buddha;* one of the *lakshanas* of the Buddha.

ushabtis—(ū-'shăb-te) In ancient Egypt, figurines placed in a tomb to act as the deceased's servants in the afterlife.

ushnisha—(ūsh-'nesh-ha) The knot of hair on the top of the *Buddha's* head; one of the *lakshanas* of the Buddha.

value—See *color.*

vanitas—('va-nē-tas) A term describing paintings that include references to death.

vault—A masonry roof or ceiling constructed on the *arch* principle. A *barrel* or tunnel vault, semicylindrical in cross-*section* is, in effect, a deep arch or an uninterrupted series of arches, one behind the other, over an oblong space. A quadrant vault is a half-*barrel* vault. A *groin* or cross vault is formed at the point at which two barrel vaults intersect at right angles. In a ribbed vault, there is a framework of *ribs* or arches under the intersections of the vaulting sections. A sexpartite vault is a rib vault with six panels. A fan vault is a development of *lierne* vaulting characteristic of English Perpendicular *Gothic*, in which radiating ribs form a fan-like pattern.

veda—('vād-u) The Sanskrit word for "knowledge."

veduta—(ve-'dū-ta) Type of naturalistic landscape and cityscape painting popular in eighteenth-century Venice. Literally, "view" painting.

velarium—(ve-'lar-ē-ŭm) In a Roman *amphitheater*, the cloth awning that could be rolled down from the top of the *cavea* to shield spectators from sun or rain.

vellum—Calfskin prepared as a surface for writing or painting, one of the materials which comprised the leaves of a *codex.*

veristic—(ver-'is-tik) True to natural appearance.

vestibule—See *portico.*

vihan—In Thai architecture, halls with walls and roof of brick, stucco, wood, and ceramic tiles that stand in front of monastery stupas.

vihara—(vē-'ha-ra) A *Buddhist* monastery, often cut into a hill.

volute—A spiral, scroll-like form characteristic of the ancient Greek *Ionic* and the Roman *Composite capital.*

votive offering—A gift of gratitude to a deity.

voussoir—(vū-'swar) A wedge-shaped block used in the construction of a true *arch*. The central voussoir, which sets the arch, is the *keystone.*

wabi—(wa-bē) A sixteenth-century Japanese art style characterized by refined rusticity.

wall rib—The *rib* at the junction of the *vault* and the wall.

warp—The vertical threads of a loom or cloth.

wat—(wat) A *Buddhist* monastery in Cambodia.

weft—The horizontal threads of a loom or cloth.

weight shift—See *contrapposto.*

westwork—The *facade* and towers at the western end of a *medieval* church, principally in Germany.

wet fresco—See *fresco.*

white-ground technique—An ancient Greek vase painting technique in which the pot was first covered with a *slip* of very fine white clay, over which black *glaze* was used to outline figures, and diluted brown, purple, red, and white were used to color them.

woodcut or **woodblock**—A wooden block on the surface of which those parts not intended to print are cut away to a slight depth, leaving the design raised; also, the printed impression made with such a block.

yaksha/yakshi—(yak-shū/yak-shē) Lesser local male and female *Buddhist* and Hindu divinities. Yakshas, the male equivalent of yakshis, are often represented as corpulent, powerful males. Yakshis are goddesses associated with fertility and vegetation.

yamato-e—(ya-ma-tō-ā) Also known as native-style painting, a purely Japanese style of sophisticated and depersonalized painting created for the Fujiwara nobility.

yang—In Chinese cosmology, the principle of active masculine energy, which permeates the universe in varying proportions with *ying*, the principle of passive feminine energy.

yasti—('yas-tē) In *Buddhist* architecture, the mast or pole that arises from the dome of the *stupa* and its *harmika* and symbolizes the axis of the universe; it is adorned with a series of *chatras* (stone disks) assigned various meanings.

Yei—Holy people portrayed in Navajo sand paintings.

ying—See *yang.*

yoga—See *nihonga.*

Zen—A *Buddhist* sect and its doctrine, emphasizing enlightenment through intuition and introspection rather than the study of scripture. In Chinese, Chan.

ziggurat—('zig-ŭ-rot) A monumental platform for a temple, built in ancient Mesopotamia.

zullah—Shaded area along the central court of Mohammad's house in Medina.

BIBLIOGRAPHY

This list of books is intended to be comprehensive enough to satisfy the reading interests of the beginning art history student and general reader, as well as those of more advanced readers who wish to become acquainted with fields other than their own. The resources listed range from works that are valuable primarily for their reproductions to those that are scholarly surveys of schools and periods. No entries for periodical articles appear, but some of the major periodicals that publish art-historical scholarship in English are noted.

SELECTED PERIODICALS

The following list is by no means exhaustive. Students wishing to pursue research in journals should contact their instructor, their college or university's reference librarian, or the online catalog for additional titles.

African Arts
American Indian Art
American Journal of Archaeology
Archaeology
Archives of Asian Art
Ars Orientalis
The Art Bulletin
Art History
The Art Journal
The Burlington Magazine
Journal of the Society of Architectural Historians
Journal of the Warburg and Courtauld Institutes
Latin American Antiquity

GENERAL STUDIES

Arntzen, Etta, and Robert Rainwater. *Guide to the Literature of Art History.* Chicago: American Library Association, 1981.

Bator, Paul M. *The International Trade in Art.* Chicago: University of Chicago Press, 1988.

Baxandall, Michael. *Patterns of Intention: On the Historical Explanation of Pictures.* New Haven: Yale University Press, 1985.

Bindman, David, ed. *The Thames & Hudson Encyclopedia of British Art.* London: Thames & Hudson, 1988.

Broude, Norma, and Mary D. Garrard, eds. *The Expanding Discourse: Feminism and Art History.* New York: Harper Collins, 1992.

————. *Feminism and Art History: Questioning the Litany.* New York: Harper & Row, 1982.

Bryson, Norman. *Vision and Painting: The Logic of the Gaze.* New Haven: Yale University Press, 1983.

Bryson, Norman, et al. *Visual Theory: Painting and Interpretation.* New York: Cambridge University Press, 1991.

Cahn, Walter. *Masterpieces: Chapters on the History of an Idea.* Princeton: Princeton University Press, 1979.

Chadwick, Whitney. *Women, Art, and Society.* New York: Thames & Hudson, 1990.

Cheetham, Mark A., Michael Ann Holly, and Keith Moxey, eds. *The Subjects of Art History: Historical Objects in Contemporary Perspective.* New York: Cambridge University Press, 1998.

Chilvers, Ian, and Harold Osborne, eds. *The Oxford Dictionary of Art.* Rev. ed. New York: Oxford University Press, 1997.

Cummings, P., *Dictionary of Contemporary American Artists.* 6th ed. New York: St. Martin's Press, 1994.

Derrida, Jacques. *The Truth in Painting.* Chicago: University of Chicago Press, 1987.

Deepwell, K., ed. *New Feminist Art.* Manchester: Manchester University Press, 1994.

Encyclopedia of World Art. 15 vols. New York: Publisher's Guild, 1959–1968. Supplementary vols. 16, 1983; 17, 1987.

Fielding, Mantle. *Dictionary of American Painters, Sculptors, and Engravers.* 2nd rev. and enl. ed. Poughkeepsie: Apollo, 1986.

Fleming, John, Hugh Honour, and Nikolaus Pevsner. *Penguin Dictionary of Architecture.* 4th ed. New York: Penguin, 1991.

Freedberg, David. *The Power of Images: Studies in the History and Theory of Response.* Chicago: University of Chicago Press, 1985.

Giedion, Siegfried. *Space, Time and Architecture: The Growth of a New Tradition.* 5th ed. Cambridge: Harvard University Press, 1982.

Gombrich, Ernst Hans Josef. *Art and Illusion.* 5th ed. London: Phaidon, 1977.

Haggar, Reginald G. *A Dictionary of Art Terms: Architecture, Sculpture, Painting, and the Graphic Arts.* Poole: New Orchard Editions, 1984.

Hall, James. *Dictionary of Subjects and Symbols in Art.* 2nd rev. ed. London: J. Murray, 1979.

Harris, Anne Sutherland, and Linda Nochlin. *Women Artists: 1550–1950.* Los Angeles: Los Angeles County Museum of Art; New York: Knopf, 1977.

Hauser, Arnold. *The Sociology of Art.* Chicago: University of Chicago Press, 1982.

Hind, Arthur M. *A History of Engraving and Etching from the Fifteenth Century to the Year 1914.* 3rd rev. ed. New York: Dover, 1963.

Holt, Elizabeth G., ed. *A Documentary History of Art.* 2nd ed. 2 vols. Princeton: Princeton University Press, 1981.

Hults, Linda C. *The Print in the Western World: An Introductory History.* Madison: University of Wisconsin Press, 1996.

Kostof, Spiro. *A History of Architecture: Settings and Rituals.* 2nd ed. Oxford: Oxford University Press, 1995.

Kronenberger, Louis. *Atlantic Brief Lives: A Biographical Companion to the Arts.* Boston: Little, Brown, 1971.

Kultermann, Udo. *The History of Art History.* New York: Abaris, 1993.

Lucie-Smith, Edward. *The Thames & Hudson Dictionary of Art Terms.* London: Thames & Hudson, 1984.

Murray, Peter, and Linda Murray. *A Dictionary of Art and Artists.* 5th ed. New York: Penguin, 1988.

Myers, Bernard Samuel, ed. *Encyclopedia of Painting: Painters and Painting of the World from Prehistoric Times to the Present Day.* 4th rev. ed. New York: Crown, 1979.

Myers, Bernard S., and Myers, Shirley D., eds. *Dictionary of 20th-Century Art.* New York: McGraw-Hill, 1974.

Osborne, Harold, ed. *The Oxford Companion to 20th Century Art.* New York: Oxford University Press, 1981.

Parker, Rozsika, and Griselda Pollock. *Old Mistresses: Women, Art, and Ideology.* London: Routledge & Kegan Paul, 1981.

Penny, Nicholas. *The Materials of Sculpture.* New Haven: Yale University Press, 1993.

Pevsner, Nikolaus. *A History of Building Types.* London: Thames & Hudson, 1987. Reprint of 1979 ed.

————. *An Outline of European Architecture.* 8th ed. Baltimore: Penguin, 1974.

————. *The Buildings of England.* 46 vols. Harmondsworth: Penguin, 1951–1974.

Pickover, C., ed. *Visions of the Future: Art, Technology and Computing in the Twenty-First Century.* New York: St. Martin's Press, 1994.

Pierce, James Smith. *From Abacus to Zeus: A Handbook of Art History.* Rev. 5th ed. Upper Saddle River: 1998.

Pierson, William H., Jr., and Martha Davidson. eds. *Arts of the United States, A Pictorial Survey.* 1960. Reprint. Athens: University of Georgia Press, 1975.

Placzek, Adolf K., ed. *Macmillan Encyclopedia of Architects.* 4 vols. New York: Macmillan, 1982.

Podro, Michael. *The Critical Historians of Art.* New Haven: Yale University Press, 1982.

Pollock, Griselda. *Vision and Difference: Femininity, Feminism and Histories of Art.* London: Routledge, 1988.

Preziosi, Donald, ed. *The Art of Art History: A Critical Anthology.* New York: Oxford University Press, 1998.

Read, Herbert, and Nikos Stangos. eds. *The Thames & Hudson Dictionary of Art and Artists.* Rev. ed. London: Thames & Hudson, 1988.

Reid, Jane D. *The Oxford Guide to Classical Mythology in the Arts 1300–1990s.* 2 vols. New York: Oxford University Press, 1993.

Roth, Leland M. *Understanding Architecture: Its Elements, History, and Meaning.* New York: Harper & Row, 1993.

Rosenblum, Naomi. *A World History of Photography.* New York: Abbeville, 1984.

Rubenstein, Charlotte Streifer. *American Women Artists from Early Indian Times to the Present.* Boston: G. K. Hall/Avon Books, 1982.

Slatkin, Wendy. *Women Artists in History: From Antiquity to the 20th Century.* 2nd ed. Englewood Cliffs: Prentice-Hall, 1985.

Smith, Alistair, ed. *The Larousse Dictionary of Painters.* New York: Larousse, 1981.

Smith, G. E. Kidder. *The Architecture of the United States: An Illustrated Guide to Buildings Open to the Public.* 3 vols. Garden City: Doubleday/Anchor, 1981.

Stangos, Nikos. *The Thames & Hudson Dictionary of Art and Artists.* Rev. ed. New York: Thames & Hudson, 1994.

Steer, John, and Antony White. *Atlas of Western Art History: Artists, Sites and Monuments from Ancient Greece to the Modern Age.* New York: Facts on File, 1994.

Stratton, Arthur. *The Orders of Architecture: Greek, Roman and Renaissance.* London: Studio, 1986.

Sutton, Ian. *Western Architecture: From Ancient Greece to the Present.* New York: Thames & Hudson, 1999.

Trachtenberg, Marvin, and Isabelle Hyman. *Architecture, from Prehistory to Post-Modernism.* New York: Abrams, 1986.

Tufts, Eleanor. *American Women Artists, Past and Present, A Selected Bibliographic Guide.* New York: Garland Publishers, 1984.

————. *Our Hidden Heritage, Five Centuries of Women Artists.* London: Paddington Press, 1974.

Turner, Jane, ed. *The Dictionary of Art.* 34 vols. New York: Grove Dictionaries, 1996.

Van Pelt, R., and C. Westfall. *Architectural Principles in the Age of Historicism.* New Haven: Yale University Press, 1991.

Waterhouse, Ellis. *The Dictionary of British 18th Century Painters in Oils and Crayons.* Woodbridge, England: Antique Collectors' Club, 1981.

Wilkins, David G. *Art Past, Art Present.* New York: Abrams, 1994.

Wittkower, Rudolf. *Sculpture Processes and Principles.* New York: Harper & Row, 1977.

Wölfflin, Heinrich. *The Sense of Form in Art.* New York: Chelsea, 1958.

Young, William, ed. *A Dictionary of American Artists, Sculptors, and Engravers.* Cambridge: W. Young, 1968.

ANCIENT ART, GENERAL

Boardman, John, ed. *The Oxford History of Classical Art.* New York: Oxford University Press, 1997.

Clayton, Peter A., and Martin J. Price, eds. *The Seven Wonders of the Ancient World.* New York: Routledge, 1988.

Connolly, Peter, and Hazel Dodge. *The Ancient City. Life in Classical Athens and Rome.* New York: Oxford Unversity Press, 1998.

Davies, W. Vivian, and Louise Schofield, eds. *Egypt, the Aegean and the Levant. Interconnections in the Second Millennium BC.* London: British Museum Press, 1995.

De Grummond, Nancy Thomson, ed. *An Encyclopedia of the History of Classical Archaeology.* 2 vols. Westport: Greenwood, 1996.

Dunbabin, Katherine. *Mosaics of the Greek and Roman World.* New York: Cambridge University Press, 1999.

Kampen, Natalie B. ed., *Sexuality in Ancient Art.* New York: Cambridge University Press, 1996.

Lexicon Iconographicum Mythologiae Classicae. Zurich: Artemis, 1981–.

Ling, Roger. *Ancient Mosaics.* Princeton: Princeton University Press: 1998.

Lloyd, Seton, and Hans Wolfgang Muller. *Ancient Architecture: Mesopotamia, Egypt, Crete.* New York: Electa/Rizzoli, 1980.

Oliphant, Margaret. *The Atlas of the Ancient World: Charting the Great Civilizations of the Past.* New York: Simon & Schuster, 1992.

Onians, John. *Classical Art and the Cultures of Greece and Rome.* New Haven: Yale University Press, 1999.

Renfrew, Colin, and Bahn, Paul G.. *Archaeology: Theories, Methods, and Practices.* London: Thames & Hudson, 1991.

Saggs, H. W. F. *Civilization before Greece and Rome.* New Haven: Yale University Press, 1989.

Stillwell, Richard, et al., eds. *The Princeton Encyclopedia of Classical Sites.* Princeton: Princeton University Press, 1976.

Ward-Perkins, John B. *Cities of Ancient Greece and Italy: Planning in Classical Antiquity.* Rev. ed. New York: Braziller, 1987.

Wolf, Walther. *The Origins of Western Art: Egypt, Mesopotamia, the Aegean.* New York: Universe, 1989.

CHAPTER 1
THE BIRTH OF ART:
AFRICA, EUROPE, AND THE NEAR
EAST IN THE STONE AGE

Bahn, Paul G. *The Cambridge Illustrated History of Prehistoric Art.* New York: Cambridge University Press, 1998.

Bahn, Paul G., and Jean Vertut. *Journey through the Ice Age.* Berkeley: University of California Press, 1997.

Beltrán, Antonio, ed. *The Cave of Altamira.* New York: Harry N. Abrams, 1999.

Breuil, Henri. *Four Hundred Centuries of Cave Art.* New York: Hacker, 1979. Reprint of 1952 ed.

Burl, Aubrey. *Great Stone Circles.* New Haven: Yale University Press, 1999.

Chauvet, Jean-Marie, et al. *Dawn of Art: The Chauvet Cave.* New York: Abrams, 1996.

Chippindale, Christopher. *Stonehenge Complete.* New York: Thames & Hudson, 1994.

Cunliffe, Barry, ed. *The Oxford Illustrated Prehistory of Europe.* New York: Oxford University Press, 1994.

Graziosi, Paolo. *Paleolithic Art.* New York: McGraw-Hill, 1960.

Kenyon, Kathleen M. *Digging Up Jericho.* New York: Praeger, 1974.

Leroi-Gourhan, André. *The Dawn of European Art: An Introduction to Paleolithic Cave Painting.* Cambridge: Cambridge University Press, 1982.

———. *Treasures of Prehistoric Art.* New York: Abrams, 1967.

Marshack, Alexander. *The Roots of Civilization: The Cognitive Beginnings of Man's First Art, Symbol and Notation.* 2nd ed. Wakefield: Moyer Bell, 1991.

Mellaart, James. *Çatal Hüyük: A Neolithic Town in Anatolia.* New York: McGraw-Hill, 1967.

———. *The Neolithic of the Near East.* New York: Scribner, 1975.

Piggott, Stuart. *Ancient Europe.* Chicago: Aldine, 1966.

Pfeiffer, John E. *The Creative Explosion: An Inquiry into the Origins of Art and Religion.* New York: Harper & Row, 1982.

Renfrew, Colin, ed. *British Prehistory: A New Outline.* London: Noyes Press, 1975.

Ruspoli, Mario. *The Cave of Lascaux. The Final Photographs.* New York: Abrams, 1987.

Sandars, Nancy K. *Prehistoric Art in Europe.* 2nd ed. New Haven: Yale University Press, 1985.

Scarre, Chris. *Exploring Prehistoric Europe.* New York: Oxford University Press, 1998.

Sieveking, Ann. *The Cave Artists.* London: Thames & Hudson, 1979.

Trump, David H. *The Prehistory of the Mediterranean.* New Haven: Yale University Press, 1980.

Ucko, Peter J., and Andrée Rosenfeld. *Palaeolithic Cave Art.* New York: McGraw-Hill, 1967.

Wainwright, Geoffrey. *The Henge Monuments: Ceremony and Society in Prehistoric Britain.* London: Thames & Hudson, 1990.

CHAPTER 2
THE RISE OF CIVILIZATION: THE
ART OF THE ANCIENT NEAR EAST

Akurgal, Ekrem. *Art of the Hittites.* New York: Abrams, 1962.

Amiet, Pierre. *Art of the Ancient Near East.* New York: Abrams, 1980.

Collon, Dominique. *Ancient Near Eastern Art.* Berkeley: University of California Press, 1995.

———. *First Impressions. Cylinder Seals in the Ancient Near East.* 2nd ed. London: British Museum, 1993.

———. *Near Eastern Seals.* Berkeley: University of California Press, 1990.

Crawford, Harriet. *Sumer and the Sumerians.* New York: Cambridge University Press, 1991.

Curtis, John E. *Ancient Persia.* Cambridge: Harvard University Press, 1990.

Curtis, John E., and Julian E. Reade. *Art and Empire. Treasures from Assyria in the British Museum.* New York: Metropolitan Museum of Art, 1995.

Frankfort, Henri. *The Art and Architecture of the Ancient Orient.* 5th ed. New Haven: Yale University Press, 1996.

Ghirshman, Roman. *The Arts of Ancient Iran: From Its Origins to the Time of Alexander the Great.* New York: Golden Press, 1964.

———. *Persian Art, the Parthian and Sassanian Dynasties, 249 B.C.–A.D. 651.* New York: Golden Press, 1962.

Harper, Prudence O., et al. *The Royal City of Susa. Ancient Near Eastern Treasures in the Louvre.* New York: Metropolitan Museum of Art, 1992.

Kramer, Samuel N. *The Sumerians: Their History, Culture, and Character.* Chicago: University of Chicago Press, 1971.

Lloyd, Seton. *The Archaeology of Mesopotamia: From the Old Stone Age to the Persian Conquest.* London: Thames & Hudson, 1984.

———. *The Art of the Ancient Near East.* New York: Oxford University Press, 1969.

Macqueen, James G. *The Hittites and Their Contemporaries in Asia Minor.* rev. ed. New York: Thames & Hudson, 1986.

Meyers, Eric M. ed. *The Oxford Encyclopedia of Archaeology in the Near East.* New York: Oxford University Press, 1997.

Moortgat, Anton. *The Art of Ancient Mesopotamia.* New York: Phaidon, 1969.

Oates, Joan. *Babylon.* Rev. ed. London: Thames & Hudson. 1986.

Oppenheim, A. Leo. *Ancient Mesopotamia.* Rev. ed. Chicago: University of Chicago Press, 1977.

Parrot, André. *The Arts of Assyria.* New York: Golden Press, 1961.

———. *Sumer: The Dawn of Art.* New York: Golden Press, 1961.

Porada, Edith. *Man and Images in the Ancient Near East.* Wakefield: Moyer Bell, 1995.

Porada, Edith, and Robert H. Dyson. *The Art of Ancient Iran: Pre-Islamic Cultures.* Rev. ed. New York: Greystone, 1969.

Postgate, J. Nicholas. *Early Mesopotamia: Society and Economy at the Dawn of History.* London: Routledge, 1992.

———. *The First Empires.* Oxford: Elsevier-Phaidon, 1977.

Reade, Julian E. *Assyrian Sculpture.* Cambridge: Harvard University Press, 1999.

———. *Mesopotamia.* Cambridge: Harvard University Press, 1991.

Roaf, Michael. *Cultural Atlas of Mesopotamia and the Ancient Near East.* New York: Facts on File, 1990.

Russell, John M. *Sennacherib's Palace without Rival at Nineveh.* Chicago: University of Chicago Press, 1991.

Saggs, H. W. F. *Babylonians.* London, British Museum, 1995.

Sasson, Jack M., ed. *Civilizations of the Ancient Near East.* New York: Scribner, 1995.

Snell, Daniel C. *Life in the Ancient Near East. 3100–332 B.C.* New Haven: Yale University Press, 1997.

Strommenger, Eva, and Hirmer, Max. *5000 Years of the Art of Mesopotamia.* New York: Abrams, 1964.

Zettler, Richard L., and Lee Horne. *Treasures from the Royal Tombs of Ur.* Philadelphia: University of Pennsylvania Museum of Archaeology and Anthropology, 1998.

CHAPTER 3
PHARAOHS AND THE AFTERLIFE:
THE ART OF ANCIENT EGYPT

Aldred, Cyril. *The Egyptians.* London: Thames & Hudson, 1987.

Arnold, Dieter. *Building in Egypt, Pharaonic Stone Masonry.* New York: Oxford University Press, 1991.

Arnold, Dorothea. *The Royal Women of Amarna.* New York: Metropolitan Museum of Art, 1996.

———. *When the Pyramids Were Built. Egyptian Art of the Old Kingdom.* New York: Rizzoli, 1999.

Arnold, Dorothea, et al. *Egyptian Art in the Age of the Pyramids.* New York: Harry N. Abrams, 1999.

Badawy, Alexander. *A History of Egyptian Architecture.* 3 vols. Berkeley: University of California Press, 1954–1968.

Baines, John, and Jaromír Málek. *Atlas of Ancient Egypt.* New York: Facts on File, 1980.

Bard, Kathryn A. ed. *Encyclopedia of the Archaeology of Ancient Egypt.* London: Routledge, 1999.

Bianchi, Robert S. *Cleopatra's Egypt: Age of the Ptolemies.* Brooklyn: Brooklyn Museum, 1988.

———. *Splendors of Ancient Egypt from the Egyptian Museum, Cairo.* London: Booth-Clibborn, 1996.

Bietak, Manfred. *Avaris, the Capital of the Hyksos.* London: British Museum Press, 1996.

Capel, Anne K., and Glenn E. Markoe, eds. *Mistress of the House, Mistress of Heaven: Women in Ancient Egypt.* New York: Hudson Hills, 1996.

D'Auria, Sue, Peter Lacovara, and Catharine H. Roehrig. *Mummies and Magic. The Funerary Arts of Ancient Egypt.* Boston: Museum of Fine Arts, 1988.

Davis, Whitney. *The Canonical Tradition in Ancient Egyptian Art.* New York: Cambridge University Press, 1989.

Grimal, Nicholas. *A History of Ancient Egypt.* Oxford: Blackwell, 1992.

Ikram, Salima, and Dodson, Aidan. *The Mummy in Ancient Egypt: Equipping the Dead for Eternity.* New York: Thames & Hudson, 1998.

Kozloff, Arielle P., and Betsy M. Bryan. *Egypt's Dazzling Sun: Amenhotep III and His World.* Cleveland: Cleveland Museum of Art, 1992.

Lange, Kurt, and Max Hirmer. *Egypt: Architecture, Sculpture and Painting in Three Thousand Years.* 4th ed. London: Phaidon, 1968.

Lehner, Mark. *The Complete Pyramids. Solving the Ancient Mysteries.* New York: Thames & Hudson, 1997.

Mahdy, Christine, ed. *The World of the Pharaohs: A Complete Guide to Ancient Egypt.* London: Thames & Hudson, 1990.

Málek, Jaromír. *Egyptian Art.* London: Phaidon, 1999.

Málek, Jaromír, ed., *Egypt. Ancient Culture, Modern Land.* Norman: University of Oklahoma Press, 1993.

Redford, Donald B. *Akhenaton, the Heretic King.* Princeton: Princeton University Press, 1984.

Reeves, C. Nicholas. *The Complete Tutankhamun: The King, the Tomb, the Royal Treasure.* London: Thames & Hudson, 1990.

Robins, Gay. *The Art of Ancient Egypt.* Cambridge: Harvard University Press, 1997.

———. *Egyptian Painting and Relief.* Aylesbury: Shire Publications, 1986.

———. *Proportion and Style in Ancient Egyptian Art.* Austin: University of Texas Press, 1994.

———. *Women in Ancient Egypt.* London: British Museum, 1993.

Romer, John. *Valley of the Kings. Exploring the Tombs of the Pharaohs.* New York: Holt, 1994.

Russmann, Edna R. *Egyptian Sculpture. Cairo and Luxor.* Austin: University of Texas Press, 1989.

Schulz, Regina, and Matthias Seidel, eds. *Egypt. The World of the Pharaohs.* Cologne: Körnemann, 1999.

Schäfer, Heinrich. *Principles of Egyptian Art*. Rev. ed. Oxford: Clarendon, 1986.

Shafer, Byron E., ed. *Temples of Ancient Egypt*. Ithaca: Cornell University Press, 1997.

Shaw, Ian, and Paul Nicholson. *The Dictionary of Ancient Egypt*. London: British Museum, 1995.

Silverman, David P., ed. *Ancient Egypt*. New York: Oxford University Press, 1997.

Smith, William Stevenson, and William Kelly Simpson. *The Art and Architecture of Ancient Egypt*. Rev. ed. New Haven: Yale University Press, 1998.

Trigger, Bruce G., et al., *Ancient Egypt. A Social History*. Cambridge: Cambridge University Press, 1983.

Weeks, Kent R. *The Lost Tomb*. New York: William Morrow, 1998.

Wildung, Dietrich. *Egypt. From Prehistory to the Romans*. Cologne: Taschen, 1997.

CHAPTER 4
MINOS AND THE HEROES OF HOMER: THE ART OF THE PREHISTORIC AEGEAN

Barber, R. L. N. *The Cyclades in the Bronze Age*. Iowa City: University of Iowa Press, 1987.

Betancourt, Philip P. *A History of Minoan Pottery*. Princeton: Princeton University Press, 1965.

Cadogan, Gerald. *Palaces of Minoan Crete*. London: Methuen, 1980.

Chadwick, John. *The Mycenaean World*. New York: Cambridge University Press, 1976.

Cottrell, Arthur. *The Minoan World*. New York: Scribner, 1980.

Demargne, Pierre. *The Birth of Greek Art*. New York: Golden Press, 1964.

Dickinson, Oliver P. T. K. *The Aegean Bronze Age*. New York: Cambridge University Press, 1994.

Doumas, Christos. *Thera, Pompeii of the Ancient Aegean: Excavations at Akrotiri, 1967–1979*. New York: Thames & Hudson, 1983.

———. *The Wall-paintings of Thera*. Athens: Thera Foundation, 1992.

Fitton, J. Lesley. *Cycladic Art*. Cambridge: Harvard University Press, 1989.

Getz-Preziosi, Patricia. *Sculptors of the Cyclades. Individual and Tradition in the Third Millennium B.C.* Ann Arbor: University of Michigan Press, 1987.

Graham, James W. *The Palaces of Crete*. Princeton: Princeton University Press, 1962.

Hampe, Roland, and Erika Simon. *The Birth of Greek Art. From the Mycenaean to the Archaic Period*. New York: Oxford University Press, 1981.

Higgins, Reynold. *Minoan and Mycenaean Art*. Rev. ed. New York: Thames & Hudson, 1997.

Hood, Sinclair. *The Arts in Prehistoric Greece*. New Haven: Yale University Press, 1978.

Immerwahr, Sarah A. *Aegean Painting in the Bronze Age*. University Park: Pennsylvania State University Press, 1990.

McDonald, William A., and Carol G. Thomas. *Progress into the Past: The Rediscovery of Mycenaean Civilization*. 2nd ed. Bloomington: Indiana University Press, 1990.

Marinatos, Nanno. *Art and Religion in Thera: Reconstructing a Bronze Age Society*. Athens: Mathioulakis, 1984.

Marinatos, Spyridon, and Max Hirmer. *Crete and Mycenae*. London: Thames & Hudson, 1960.

Morgan, Lyvia. *The Miniature Wall Paintings of Thera: A Study in Aegean Culture and Iconography*. New York: Cambridge University Press, 1988.

Pendlebury, John. *The Archeology of Crete*. London: Methuen, 1967.

Preziosi, Donald, and Louise A. Hitchcock, *Aegean Art and Architecture*. New York: Oxford University Press, 1999.

Taylour, Lord William. *The Mycenaeans*. London: Thames & Hudson, 1990.

Vermeule, Emily. *Greece in the Bronze Age*. Chicago: University of Chicago Press, 1972.

Wace, Alan. *Mycenae, an Archeological History and Guide*. New York: Biblo & Tannen, 1964.

Warren, Peter. *The Aegean Civilisations from Ancient Crete to Mycenae*. 2nd ed. Oxford: Elsevier-Phaidon, 1989.

CHAPTER 5
GODS, HEROES, AND ATHLETES: THE ART OF ANCIENT GREECE

Arias, Paolo. *A History of One Thousand Years of Greek Vase Painting*. New York: Abrams, 1962.

Ashmole, Bernard. *Architect and Sculptor in Classical Greece*. New York: New York University Press, 1972.

Berve, Helmut, Gottfried Gruben, and Max Hirmer. *Greek Temples, Theatres, and Shrines*. New York: Abrams, 1963.

Biers, William. *The Archaeology of Greece: An Introduction*. 2nd ed. Ithaca: Cornell University Press, 1996.

Boardman, John. *Athenian Black Figure Vases*. Rev. ed. New York: Thames & Hudson, 1985.

———. *Athenian Red Figure Vases: The Archaic Period*. New York: Thames & Hudson, 1988.

———. *Athenian Red Figure Vases: The Classical Period*. New York: Thames & Hudson, 1989.

———. *Early Greek Vase Painting, 11th–6th Centuries B.C.* New York: Thames & Hudson, 1998.

———. *Greek Sculpture: The Archaic Period*. Rev. ed. New York: Thames & Hudson, 1985.

———. *Greek Sculpture: The Classical Period*. New York: Thames & Hudson, 1987.

———. *Greek Sculpture: The Late Classical Period and Sculpture in Colonies and Overseas*. New York: Thames & Hudson, 1995.

———. *The Parthenon and Its Sculpture*. Austin: University of Texas Press, 1985.

Carpenter, Thomas H. *Art and Myth in Ancient Greece*. New York: Thames & Hudson, 1991.

Charbonneaux, Jean, Roland Martin, and François Villard. *Archaic Greek Art*. New York: Braziller, 1971.

———. *Classical Greek Art*. New York: Braziller, 1972.

———. *Hellenistic Art*. New York: Braziller, 1973.

Coldstream, J. Nicholas. *Geometric Greece*. New York: St. Martin's, 1977.

Coulton, J. J. *Ancient Greek Architects at Work*. Ithaca: Cornell University Press, 1982.

Fullerton, Mark D. *Greek Art*. New York: Cambridge University Press, 2000.

Haynes, Denys E. L. *The Technique of Greek Bronze Statuary*. Mainz: von Zabern, 1992.

Houser, Caroline. *Greek Monumental Bronze Sculpture*. New York: Vendome, 1983.

Hurwit, Jeffrey M. *The Art and Culture of Early Greece, 1100–480 B.C.* Ithaca: Cornell University Press, 1985.

———. *The Athenian Acropolis: History, Mythology, and Archaeology from the Neolithic Era to the Present*. New York: Cambridge University Press, 1999.

Jenkins, Ian. *The Parthenon Frieze*. Austin: University of Texas Press, 1994.

Langlotz, Ernst, and Max Hirmer. *The Art of Magna Graecia. Greek Art in Southern Italy and Sicily*. New York: Abrams, 1965.

Lawrence, Arnold W., and R. A. Tomlinson. *Greek Architecture*. Rev. ed. New Haven: Yale University Press, 1996.

Martin, Roland. *Greek Architecture: Architecture of Crete, Greece, and the Greek World*. New York: Electa/Rizzoli, 1988.

Mattusch, Carol C. *Classical Bronzes. The Art and Craft of Greek and Roman Statuary*. Ithaca: Cornell University Press, 1996.

———. *Greek Bronze Statuary from the Beginnings through the Fifth Century B.C.* Ithaca: Cornell University Press, 1988.

Morris, Sarah P. *Daidalos and the Origins of Greek Art*. Princeton: Princeton University Press, 1992.

Osborne, Robin. *Archaic and Classical Greek Art*. New York: Oxford University Press, 1998.

Palagia, Olga. *The Pediments of the Parthenon*. Leiden: E. J. Brill, 1993.

Palagia, Olga, and J. J. Pollitt, *Personal Styles in Greek Sculpture*. New York: Cambridge University Press, 1996.

Pedley, John Griffiths. *Greek Art and Archaeology*. 2nd ed. Upper Saddle River: Prentice Hall, 1998.

Pollitt, Jerome J. *Art and Experience in Classical Greece*. New York: Cambridge University Press, 1972.

———. *Art in the Hellenistic Age*. New York: Cambridge University Press, 1986.

———. *The Art of Ancient Greece: Sources and Documents*. 2nd ed. New York: Cambridge University Press, 1990.

Pugliese Carratelli, G. *The Greek World: Art and Civilization in Magna Graecia and Sicily*. New York: Rizzoli, 1996.

Reeder, Ellen D., ed. *Pandora. Women in Classical Greece*. Baltimore: Walters Art Gallery, 1995.

Rhodes, Robin F. *Architecture and Meaning on the Athenian Acropolis*. New York: Cambridge University Press, 1995.

Richter, Gisela M. *The Portraits of the Greeks*. Rev. ed. by R. R. R. Smith. Ithaca: Cornell University Press, 1984.

Ridgway, Brunilde S. *The Archaic Style in Greek Sculpture*. 2nd ed. Chicago: Ares, 1993.

———. *Fifth Century Styles in Greek Sculpture*. Princeton: Princeton University Press, 1981.

———. *Fourth-century Styles in Greek Sculpture*. Madison: University of Wisconsin Press, 1997.

———. *Prayers in Stone. Greek Architectural Sculpture*. Berkeley: University of California Press, 1999.

———. *Roman Copies of Greek Sculpture: The Problem of the Originals*. Ann Arbor: University of Michigan Press, 1984.

———. *Hellenistic Sculpture I: The Styles of ca. 331–200 B.C.* Madison: University of Wisconsin Press, 1990.

———. *The Severe Style in Greek Sculpture*. Princeton: Princeton University Press, 1970.

Robertson, Martin. *The Art of Vase-Painting in Classical Athens*. New York: Cambridge University Press, 1992.

———. *A History of Greek Art*. 2 vols. Rev. ed. New York: Cambridge University Press, 1986.

———. *A Shorter History of Greek Art*. New York: Cambridge University Press, 1981.

Rolley, Claude. *Greek Bronzes*. London: Sotheby's, 1986.

Shapiro, H. Alan. *Art and Cult in Athens under the Tyrants*. Mainz: von Zabern, 1989.

———. *Myth into Art. Poet and Painter in Classical Greece*. New York: Routledge, 1994.

Smith, R. R. R. *Hellenistic Sculpture*. New York: Thames & Hudson, 1991.

Spivey, Nigel. *Greek Art*. London: Phaidon, 1997.

Stansbury-O'Donnell, *Pictorial Narrative in Ancient Greek Art*. New York: Cambridge University Press, 1999.

Stewart, Andrew. *Art, Desire, and the Body in Ancient Greece*. New York: Cambridge University Press, 1997.

———. *Greek Sculpture. An Exploration*. 2 vols. New Haven: Yale University Press, 1990.

Wycherley, Richard E. *How the Greeks Built Cities*. New York: Norton, 1976.

CHAPTER 6
PATHS TO ENLIGHTENMENT: THE ANCIENT ART OF SOUTH AND SOUTHEAST ASIA

Asher, Frederick M. *The Art of Eastern India, 300–800*. Minneapolis: University of Minnesota Press, 1980.

Barrett, Douglas E. *Early Chola Bronzes*. Bombay: Bhulabhai Memorial Institute, 1965.

Brown, Robert L. *The Dvaravati Wheels of the Law and the Indianization of South East Asia*. Leiden: E. J. Brill, 1996.

Chihara, Daigoro. *Hindu-Buddhist Architecture in Southeast Asia*. Leiden: E. J. Brill, 1996.

Coomaraswamy, Ananda K. *History of Indian and Indonesian Art*. New York: Dover, 1985.

Craven, Roy C. *Indian Art: A Concise History*. London: Thames & Hudson, 1985.

Dehejia, Vidya. *Early Buddhist Rock Temples*. Ithaca: Cornell University Press, 1972.

Desai, Vishakha N., and Darielle Mason. *Gods, Guardians, and Lovers: Temple Sculptures from North India A.D. 700–1200*. New York: The Asia Society Galleries, 1993.

Frederic, Louis. *Borobudur*. New York: Abbeville Press, 1996.

Gopinatha Rao, T. A. *Elements of Hindu Iconography.* 2nd ed. 4 vols. New York: Paragon, 1968.

Gray, Basil, ed. *The Arts of India.* Ithaca: Cornell University Press, 1981.

Harle, James C. *The Art and Architecture of the Indian Subcontinent.* New Haven: Yale University Press, 1992.

Huntington, Susan L. *The "Pala-Sena" School of Sculpture.* Leiden: E. J. Brill, 1984.

Huntington, Susan L., and John C. Huntington. *The Art of Ancient India: Buddhist, Hindu, Jain.* New York: Weatherhill, 1985.

Jessup, Helen Ibbitson, and Thierry Zephir, eds. *Sculpture of Angkor and Ancient Cambodia: Millenium of Glory.* Washington: National Gallery of Art, 1997.

Kramrisch, Stella. *The Hindu Temple.* 2 vols. Delhi: Motilal Banarsidass, 1991. (Original edition 1946.)

Meister, Michael W., ed. *Encyclopedia of Indian Temple Architecture.* (8 vols.) New Delhi: American Institute of Indian Studies. Philadelphia: University of Pennsylvania Press, 1983–1996.

Rawson, Phillip. *The Art of Southeast Asia.* New York: Thames & Hudson, 1990.

Rowland, Benjamin. *The Art and Architecture of India: Buddhist, Hindu, Jain.* Harmondsworth, England: Penguin, 1977.

Srinivasan, Doris Meth. *Many Heads, Arms and Eyes: Origin, Meaning and Form of Multiplicity in Indian Art.* Leiden: E. J. Brill, 1997.

Williams, Joanna Gottfried. *The Art of Gupta India: Empire and Province.* Princeton: Princeton University Press, 1982.

Zimmer, Heinrich, and Joseph Campbell, eds. *The Art of Indian Asia; Its Mythology and Transformations.* Bollingen Series 39. 2 vols. Princeton: Princeton University Press, 1983.

CHAPTER 7
DAOISM, CONFUCIANISM, AND BUDDHISM: THE ART OF EARLY CHINA AND KOREA

Barnhart, Richard M., et al. *Three Thousand Years of Chinese Painting.* New Haven: Yale University Press; Beijing: Foreign Languages Press, 1997.

Bush, Susan, and Shio-yen Shih. *Early Chinese Texts on Painting.* Cambridge: Harvard University Press, 1985.

Cahill, James. *Chinese Painting.* New York: Rizzoli, 1960.

———. *The Painter's Practice: How Artists Lived and Worked in Traditional China.* New York: Columbia University Press, 1994.

Clunas, Craig. *Art in China.* New York: Oxford University Press, 1997.

Fong, Wen. *Beyond Representation: Chinese Painting and Calligraphy, 8th–14th Century.* Princeton Monographs in Art and Archaeology, 48; New York: Metropolitan Museum of Art; New Haven: Yale University Press, 1992.

———. *The Great Bronze Age of China: An Exhibition from the People's Republic of China.* New York: Metropolitan Museum of Art, 1980.

Li, Chu-tsing, ed. *Artists and Patrons: Some Social and Economic Aspects of Chinese Painting.* Lawrence: Kress Department of Art History in cooperation with Indiana University Press, 1989.

Powers, Martin J. *Art and Political Expression in Early China.* New Haven: Yale University Press, 1991.

Rawson, Jessica. *Ancient China: Art and Archaeology.* New York, Harper & Row, 1980.

Rawson, Jessica, et al. *The British Museum Book of Chinese Art.* New York: Thames & Hudson, 1992.

Sickman, Laurence, and A. C. Soper. *The Art and Architecture of China,* 3rd ed. New Haven: Yale University Press, 1992.

Silbergeld, Jerome. *Chinese Painting Style: Media, Methods, and Principles of Form.* Seattle and London: University of Washington Press, 1982.

Sullivan, Michael. *The Arts of China,* 3rd ed. Berkeley: University of California Press, 1984.

———. *The Birth of Landscape Painting.* Berkeley: University of California Press, 1962.

Thorp, Robert L. *Son of Heaven: Imperial Arts of China.* Seattle: Son of Heaven Press, 1988.

Vainker, S. J. *Chinese Pottery and Porcelain: From Prehistory to the Present.* London: G. Braziller, 1991.

Weidner, Marsha, ed. *Flowering in the Shadows: Women in the History of Chinese and Japanese Painting.* Honolulu: University of Hawaii Press, 1990.

Whitfield, Roger, and A. Farrer. *Caves of the Thousand Buddhas: Chinese Art of the Silk Route.* London: G. Braziller, 1990.

Wu, Hung. *Monumentality in Early Chinese Art.* Stanford: Stanford University Press, 1996.

———. *The Wu Liang Shrine: The Ideology of Early Chinese Pictorial Art.* Stanford: Stanford University Press, 1989.

CHAPTER 8
SACRED STATUES AND SECULAR SCROLLS: THE ART OF EARLY JAPAN

Aikens, C. Melvin, and Takayama Higuchi. *Prehistory of Japan.* New York: Academic Press, 1982.

Akiyama, Terukazu. *Japanese Painting.* Geneva: Skira; New York: Rizzoli, 1977.

Coaldrake, William H. *Architecture and Authority in Japan.* London: Routledge, 1996.

Drexler, Arthur. *The Architecture of Japan.* New York: Museum of Modern Art, 1966.

Elisseeff, Danielle, and Vadime Elisseeff. *Art of Japan.* Trans. I. Mark Paris. New York: Abrams, 1985.

Ienaga, Saburo. *Painting in the Yamato Style.* Trans. John M. Shields. New York: Weatherhill, 1973.

Kidder, J. Edward, Jr. *Japanese Temples: Sculpture, Paintings, Gardens, and Architecture.* Tokyo: Bijutsu Shuppan-sha, n.d.

———. *Masterpieces of Japanese Sculpture.* Tokyo: Bijutsu Shuppan-sha, 1961.

———. *The Art of Japan.* New York: Park Lane, 1985.

Kurata, Bunsaku. *Horyu-ji: Temple of the Exalted Law.* Trans. W. Chie Ishibashi. New York: Japan Society, 1981.

Mason, Penelope. *History of Japanese Art.* New York: Abrams, 1993.

Nishi, Kazuo, and Kazuo Hozumi. *What Is Japanese Architecture?* Trans. H. Mack Horton. New York: Kodansha International, 1985.

Nishikawa, Kyotaro, and Emily Sano. *The Great Age of Japanese Buddhist Sculpture A.D. 600–1300.* Fort Worth: Kimbell Art Museum, 1982.

Noma, Seiroku. *The Arts of Japan.* Translated and adapted by John Rosenfield and Glenn T. Webb. Tokyo: Kodansha International, 1966.

Okudaira, Hideo. *Narrative Picture Scrolls.* Adapted by Elizabeth ten Grotenhuis. New York: Weatherhill, 1973.

Rosenfield, John M., and Elizabeth ten Grotenhuis. *Journey of the Three Jewels.* New York: Asia Society, 1979.

Rosenfield, John M., and Shujiro Shimada. *Traditions of Japanese Art: Selections from the Kimiko and John Powers Collection.* Cambridge: Fogg Art Museum, 1970.

Rosenfield, John. *Japanese Art of the Heian Period, 794–1185.* New York: Asia Society, 1967.

Stanley-Baker, Joan. *Japanese Art.* New York: Thames & Hudson, 1984.

Suzuki, Kakichi. *Early Buddhist Architecture in Japan.* Translated and adapted by Mary Neighbor Parent and Nancy Shatzman Steinhardt. New York: Kodansha International, 1980.

Swann, Peter C. *Concise History of Japanese Art.* New York: Kodansha International, 1979.

Weidner, Marsha, ed. *Flowering in the Shadows: Women in the History of Chinese and Japanese Painting.* Honolulu: University of Hawaii Press, 1990.

CHAPTER 9
ITALY BEFORE THE ROMANS: THE ART OF THE ETRUSCANS

Banti, Luisa. *The Etruscan Cities and Their Culture.* Berkeley: University of California Press, 1973.

Boethius, Axel. *Etruscan and Early Roman Architecture.* 2nd ed. New Haven: Yale University Press, 1978.

Bonfante, Larissa, ed. *Etruscan Life and Afterlife. A Handbook of Etruscan Studies.* Detroit: Wayne State University Press, 1986.

Brendel, Otto J. *Etruscan Art.* 2nd ed. New Haven: Yale University Press, 1995.

Cristofani, Mauro. *The Etruscans: A New Investigation.* London: Orbis, 1979.

Heurgon, Jacques. *Daily Life of the Etruscans.* London: Weidenfeld & Nicolson, 1964.

Pallottino, Massimo. *Etruscan Painting.* Geneva: Skira, 1953.

———. *The Etruscans.* Harmondsworth: Penguin, 1978.

Richardson, Emeline. *The Etruscans: Their Art and Civilization.* Chicago: University of Chicago Press, 1976. Reprint of 1964 ed., with corrections.

Ridgway, David, and Francesca Ridgway, eds. *Italy before the Romans.* New York: Academic Press, 1979.

Spivey, Nigel. *Etruscan Art.* New York: Thames & Hudson, 1997.

Spivey, Nigel, and Simon Stoddart, *Etruscan Italy: An Archaeological History.* London: Batsford, 1990.

Sprenger, Maja, Gilda Bartoloni, and Max Hirmer. *The Etruscans: Their History, Art, and Architecture.* New York: Abrams, 1983.

Steingräber, Stephan, ed. *Etruscan Painting: Catalogue Raisonné of Etruscan Wall Paintings.* New York: Johnson, 1986.

CHAPTER 10
FROM SEVEN HILLS TO THREE CONTINENTS: THE ART OF ANCIENT ROME

Anderson, James C., Jr. *Roman Architecture and Society.* Baltimore: Johns Hopkins University Press, 1997.

Andreae, Bernard. *The Art of Rome.* New York: Abrams, 1977.

Bianchi Bandinelli, Ranuccio. *Rome: The Center of Power. Roman Art to A.D. 200.* New York: Braziller, 1970.

———. *Rome: The Late Empire. Roman Art A.D. 200–400.* New York: Braziller, 1971.

Brendel, Otto J. *Prolegomena to the Study of Roman Art.* New Haven: Yale University Press, 1979.

Claridge, Amanda. *Rome. An Oxford Archaeological Guide.* New York: Oxford University Press, 1998.

Clarke, John R. *The Houses of Roman Italy, 100 B.C.–A.D. 250.* Berkeley: University of California Press, 1991.

Cornell, Tim, and John Matthews. *Atlas of the Roman World.* New York: Facts on File, 1982.

D'Ambra, Eve. *Roman Art.* New York: Cambridge University Press, 1998.

D'Ambra, Eve, ed. *Roman Art in Context.* Englewood Cliffs: Prentice Hall, 1994.

Elsner, Jaś. *Imperial Rome and Christian Triumph.* New York: Oxford University Press, 1998.

Gazda, Elaine K., ed., *Roman Art in the Private Sphere.* Ann Arbor: University of Michigan Press, 1991.

Grant, Michael. *Cities of Vesuvius: Pompeii and Herculaneum.* Harmondsworth: Penguin, 1976.

Hannestad, Niels. *Roman Art and Imperial Policy.* Aarhus: Aarhus University Press, 1986.

Henig, Martin, ed. *A Handbook of Roman Art.* Ithaca: Cornell University Press, 1983.

Jones, Mark Wilson. *Principles of Roman Architecture.* New Haven: Yale University Press, 1999.

Kent, John P. C., and Max Hirmer. *Roman Coins.* New York: Abrams, 1978.

Kleiner, Diana E. E. *Roman Sculpture.* New Haven: Yale University Press, 1992.

Kleiner, Diana E. E., and Susan B. Matheson, eds. *I Claudia. Women in Ancient Rome.* New Haven: Yale University Art Gallery, 1996.

———. *I Claudia II: Women in Roman Art and Society.* New Haven: Yale University Art Gallery, 2000.

Kraus, Theodor. *Pompeii and Herculaneum: The Living Cities of the Dead.* New York: Abrams, 1975.

Ling, Roger. *Roman Painting.* New York: Cambridge University Press, 1991.

L'Orange, Hans Peter. *The Roman Empire: Art Forms and Civic Life.* New York: Rizzoli, 1985.

MacCormack, Sabine G. *Art and Ceremony in Late Antiquity.* Berkeley: University of California Press, 1981.

MacDonald, William L. *The Architecture of the Roman Empire I: An Introductory Study.* Rev. ed. New Haven: Yale University Press, 1982.

————. *The Architecture of the Roman Empire II: An Urban Appraisal.* New Haven: Yale University Press, 1986.

————. *The Pantheon: Design, Meaning, and Progeny.* Cambridge: Harvard University Press, 1976.

McKay, Alexander G. *Houses, Villas, and Palaces in the Roman World.* Ithaca: Cornell University Press, 1975.

Maiuri, Amedeo. *Roman Painting.* Geneva: Skira, 1953.

Nash, Ernest. *Pictorial Dictionary of Ancient Rome.* 2 vols. 2nd ed. New York: Praeger, 1962.

Pollitt, Jerome J. *The Art of Rome, 753 B.C.–A.D. 337.* Rev. ed. New York: Cambridge University Press, 1983.

Ramage, Nancy H., and Andrew Ramage. *Roman Art: Romulus to Constantine.* 2nd ed. Englewood Cliffs: Prentice Hall, 1996.

Richardson, Lawrence, Jr. *A New Topographical Dictionary of Ancient Rome.* Baltimore: Johns Hopkins University Press, 1992.

————. *Pompeii. An Architectural History.* Baltimore: Johns Hopkins University Press, 1988.

Sear, Frank. *Roman Architecture.* Rev. ed. Ithaca: Cornell University Press, 1989.

Stambaugh, John E. *The Ancient Roman City.* Baltimore: Johns Hopkins University Press, 1988.

Strong, Donald, and Roger Ling. *Roman Art.* 2nd ed. New Haven: Yale University Press, 1988.

Toynbee, Jocelyn M. C. *Death and Burial in the Roman World.* London: Thames & Hudson, 1971.

Wallace-Hadrill, Andrew. *Houses and Society in Pompeii and Herculaneum.* Princeton: Princeton University Press, 1994.

Ward-Perkins, John B. *Roman Architecture.* New York: Electa/Rizzoli, 1988.

————. *Roman Imperial Architecture.* 2nd ed. New Haven: Yale University Press, 1981.

Wood, Susan. *Roman Portrait Sculpture A.D. 217–260.* Leiden: E. J. Brill, 1986.

Yegül, Fikret. *Baths and Bathing in Classical Antiquity.* Cambridge, MA: MIT Press, 1992.

Zanker, Paul. *Pompeii: Public and Private Life.* Cambridge: Harvard University Press, 1998.

————. *The Power of Images in the Age of Augustus.* Ann Arbor: University of Michigan Press, 1988.

MEDIEVAL ART, GENERAL

Alexander, Jonathan J. G. *Medieval Illuminators and Their Methods of Work.* New Haven: Yale University Press, 1992.

Andrews, Francis B. *The Mediaeval Builders and Their Methods.* New York: Barnes & Noble, 1993.

Binski, Paul. *Painters (Medieval Craftsmen).* Toronto: University of Toronto Press, 1991.

Calkins, Robert G. *Illuminated Books of the Middle Ages.* Ithaca: Cornell University Press, 1983.

————. *Medieval Architecture in Western Europe: From A.D. 300 to 1500.* New York: Oxford University Press, 1998.

————. *Monuments of Medieval Art.* New York: E. P. Dutton, 1979.

Coldstream, Nicola. *Masons and Sculptors (Medieval Craftsmen).* Toronto: University of Toronto Press, 1991.

Cross, Frank L., and Livingstone, Elizabeth A., eds. *The Oxford Dictionary of the Christian Church.* 3rd ed. New York: Oxford University Press, 1997.

De Hamel, Christopher. *Scribes and Illuminators (Medieval Craftsmen).* Toronto: University of Toronto Press, 1992.

Focillon, Henri. *The Art of the West in the Middle Ages.* 2nd ed. 2 vols. Ithaca: Cornell University Press, 1980. Reprint of 1963 ed.

Lasko, Peter. *Ars Sacra, 800–1200.* 2nd ed. New Haven, Yale University Press, 1994.

Murray, Peter, and Linda Murray. *The Oxford Companion to Christian Art and Architecture.* New York: Oxford University Press, 1996.

Pächt, Otto. *Book Illumination in the Middle Ages: An Introduction.* London: Miller, 1986.

Pelikan, Jaroslav. *Mary through the Centuries: Her Place in the History of Culture.* New Haven: Yale University Press, 1996.

Reilly, Bernard F., et al. *The Art of Medieval Spain, A.D. 500–1200.* New York: Metropolitan Museum of Art, 1993.

Rickert, Margaret. *Painting in Britain: The Middle Ages.* 2nd ed. Harmondsworth: Penguin, 1965.

Ross, Leslie. *Medieval Art. A Topical Dictionary.* Westport: Greenwood, 1996.

Schiller, Gertrud. *Iconography of Christian Art.* 2 vols. Greenwich, CT: New York Graphic Society, 1971–1972.

Snyder, James. *Medieval Art: Painting, Sculpture, Architecture, 4th–14th Century.* New York: Abrams, 1989.

Stokstad, Marilyn. *Medieval Art.* New York: Harper & Row, 1986.

Stoddard, Whitney. *Art and Architecture in Medieval France.* New York: Harper & Row, 1966.

Tasker, Edward G. *Encyclopedia of Medieval Church Art.* London: Batsford, 1993.

Webb, Geoffrey F. *Architecture in Britain: The Middle Ages.* Harmondsworth: Penguin, 1965.

Zarnecki, George. *Art of the Medieval World: Architecture, Sculpture, Painting, the Sacred Arts.* New York: Abrams, 1975.

CHAPTER 11
PAGANS, CHRISTIANS, AND JEWS:
THE ART OF LATE ANTIQUITY

Beckwith, John. *Early Christian and Byzantine Art.* 2nd ed. New Haven: Yale University Press, 1980.

Bowersock, G. W., Peter Brown, and Oleg Grabar, eds. *Late Antiquity. A Guide to the Postclassical World.* Cambridge: Harvard University Press, 1998.

Brown, Peter. *The World of Late Antiquity, A.D. 150–170.* London: Thames & Hudson, 1971.

Elsner, Jaś. *Art and the Roman Viewer: The Transformation of Art from the Pagan World to Christianity.* New York: Cambridge University Press, 1995.

————. *Imperial Rome and Christian Triumph.* New York: Oxford University Press, 1998.

Grabar, André. *The Beginnings of Christian Art, 200–395.* London: Thames & Hudson, 1967.

————. *Christian Iconography.* Princeton: Princeton University Press, 1980.

Gutmann, Joseph. *Sacred Images: Studies in Jewish Art from Antiquity to the Middle Ages.* Northampton: Variorum, 1989.

Hutter, Irmgard. *Early Christian and Byzantine Art.* London: Herbert, 1988.

Janes, Dominic. *God and Gold in Late Antiquity.* New York: Cambridge University Press, 1998.

Kitzinger, Ernst. *Byzantine Art in the Making.* Cambridge: Harvard University Press, 1977.

————. *Early Medieval Art.* 3rd ed. London: British Museum, 1983.

Koch, Guntram. *Early Christian Art and Architecture.* London: SCM Press, 1996.

Krautheimer, Richard. *Rome, Profile of a City: 312–1308.* Princeton: Princeton University Press, 1980.

Krautheimer, Richard, and Slobodan Curcić. *Early Christian and Byzantine Architecture.* 4th rev. ed. New Haven: Yale University Press, 1986.

Lowden, John. *Early Christian and Byzantine Art.* London: Phaidon, 1997.

Lowrie, Walter S. *Art in the Early Church.* New York: Norton, 1969.

Mathews, Thomas, P. *The Clash of Gods: A Reinterpretation of Early Christian Art.* Rev. ed. Princeton: Princeton University Press, 1999.

Milburn, Robert. *Early Christian Art and Architecture.* Berkeley: University of California Press, 1988.

Perkins, Ann Louise. *The Art of Dura-Europos.* Oxford: Clarendon, 1973.

Stevenson, James. *The Catacombs: Rediscovered Monuments of Early Christianity.* London: Thames & Hudson, 1978.

Volbach, Wolfgang. *Early Christian Mosaics, from the Fourth to the Seventh Centuries.* New York: Oxford University Press, 1946.

Volbach, Wolfgang, and Max Hirmer. *Early Christian Art.* New York: Abrams, 1962.

Webster, Leslie, and Michelle Brown, eds. *The Transformation of the Roman World, A.D. 400–900.* Berkeley: University of California Press, 1997.

Weitzmann, Kurt. *Ancient Book Illumination.* Cambridge: Harvard University Press, 1959.

————. *Late Antique and Early Christian Book Illumination.* New York: Braziller, 1977.

Weitzmann, Kurt, ed. *Age of Spirituality. Late Antique and Early Christian Art, Third to Seventh Century.* New York: Metropolitan Museum of Art, 1979.

CHAPTER 12
ROME IN THE EAST:
THE ART OF BYZANTIUM

Beckwith, John. *The Art of Constantinople: An Introduction to Byzantine Art (330–1453).* 2nd ed. New York: Phaidon, 1968.

Borsook, Eve. *Messages in Mosaic: The Royal Programmes of Norman Sicily.* Oxford: Clarendon, 1990.

Cormack, Robin. *Painting the Soul. Icons, Death Masks, and Shrouds.* London: Reaktion, 1997.

————. *Writing in Gold: Byzantine Society and Its Icons.* New York: Oxford University Press, 1985.

Cutler, Anthony. *The Hand of the Master: Craftsmanship, Ivory, and Society in Byzantium (9th–11th Centuries).* Princeton: Princeton University Press, 1994.

Demus, Otto. *Byzantine Art and the West.* New York: New York University Press, 1970.

————. *The Mosaic Decoration of San Marco, Venice.* Chicago: University of Chicago Press, 1990.

Evans, Helen C., and William D. Wixom, eds. *The Glory of Byzantium. Art and Culture of the Middle Byzantine Era A.D. 843–1261.* New York: Metropolitan Museum of Art, 1997.

Grabar, André. *Byzantine Painting.* New York: Rizzoli, 1979.

————. *The Golden Age of Justinian: From the Death of Theodosius to the Rise of Islam.* New York: Odyssey Press, 1967.

Grabar, André, and Manolis Chatzidakis. *Greek Mosaics of the Byzantine Period.* New York: New American Library, 1964.

Lowden, John. *Early Christian and Byzantine Art.* London: Phaidon, 1997.

Maguire, Henry. *Art and Eloquence in Byzantium.* Princeton: Princeton University Press, 1981.

————. *The Icons of Their Bodies: Saints and Their Images in Byzantium.* Princeton: Princeton University Press, 1996.

Mainstone, Rowland J. *Hagia Sophia: Architecture, Structure and Liturgy of Justinian's Great Church.* London: Thames & Hudson, 1988.

Mango, Cyril. *Art of the Byzantine Empire, 312–1453: Sources and Documents.* Toronto: University of Toronto Press, 1986. Reprint of 1972 ed.

————. *Byzantine Architecture.* New York: Electa/Rizzoli, 1985.

————. *Byzantium: The Empire of New Rome.* New York: Scribner's, 1980.

————. *Byzantium and Its Image: History and Culture of the Byzantine Empire and Its Heritage.* London: Variorum, 1984.

Mark, Robert, and Ahmet S. Cakmak, eds. *Hagia Sophia from the Age of Justinian to the Present.* New York: Cambrdige University Press, 1992.

Mathews, Thomas F. *Byzantium from Antiquity to the Renaissance.* New York: Harry N. Abrams, 1998.

Ousterhout, Robert. *Master Builders of Byzantium.* Princeton: Princeton University Press, 2000.

Pelikan, Jaroslav. *Imago Dei: The Byzantine Apologia for Icons.* Princeton: Princeton University Press, 1990.

Rodley, Lyn. *Byzantine Art and Architecture: An Introduction.* New York: Cambridge University Press, 1994.

Von Simson, Otto G. *Sacred Fortress: Byzantine Art and Statecraft in Ravenna.* Princeton: Princeton University Press, 1986.

Walter, Christopher. *Art and Ritual of the Byzantine Church*. London: Variorum, 1982.

Weitzmann, Kurt. *Ancient Book Illumination*. Cambridge: Harvard University Press, 1959.

———. *Art in the Medieval West and Its Contacts with Byzantium*. London: Variorum, 1982.

———. *The Icon*. New York: Dorset, 1987.

———. *Illustrations in Roll and Codex*. Princeton: Princeton University Press, 1970.

CHAPTER 13
MUHAMMAD AND THE MUSLIMS:
ISLAMIC ART

Asher, Catherine B. *Architecture of Mughal India*. New York: Cambridge University Press, 1992.

Aslanapa, Oktay. *Turkish Art and Architecture*. London: Faber & Faber, 1971.

Atil, Esin. *The Age of Sultan Suleyman the Magnificent*. Washington: National Gallery of Art, 1987.

Baker, Patricia L. *Islamic Textiles*. London: British Museum, 1995.

Blair, Sheila S., and Jonathan Bloom. *The Art and Architecture of Islam 1250–1800*. New Haven: Yale University Press, 1994.

Bloom, Jonathan, and Sheila S. Blair. *Islamic Arts*. London: Phaidon, 1997.

Brend, Barbara. *Islamic Art*. Cambridge: Harvard University Press, 1991.

Canby, Sheila. *Persian Painting*. London: British Museum, 1993.

Creswell, Keppel A. C. *A Short Account of Early Muslim Architecture*. Rev. ed. by James W. Allan. Aldershot: Scolar, 1989.

Dodds, Jerrilynn D., ed. *Al-Andalus: The Art of Islamic Spain*. New York: Metropolitan Museum of Art, 1992.

Ettinghausen, Richard. *Arab Painting*. Geneva: Skira, 1977.

———. *From Byzantium to Sassanian Iran and the Islamic World*. Leiden: E. J. Brill, 1972.

Ettinghausen, Richard, and Oleg Grabar. *The Art and Architecture of Islam, 650–1250*. New Haven: Yale University Press, 1992.

Ferrier, Ronald W., ed. *The Arts of Persia*. New Haven: Yale University Press, 1989.

Frishman, Martin, and Hasan-Uddin Khan. *The Mosque: History, Architectural Development and Regional Diversity*. New York: Thames & Hudson, 1994.

Goodwin, Godfrey. *A History of Ottoman Architecture*. 2nd ed. New York: Thames & Hudson, 1987.

Grabar, Oleg. *The Alhambra*. Cambridge: Harvard University Press, 1978.

———. *The Formation of Islamic Art*. Rev. ed. New Haven: Yale University Press, 1987.

Grube, Ernst J. *Architecture of the Islamic World: Its History and Social Meaning*. 2nd ed. New York: Thames & Hudson, 1984.

Hillenbrand, Robert. *Islamic Architecture: Form, Function, Meaning*. Edinburgh: Edinburgh University Press, 1994.

———. *Islamic Art and Architecture*. New York: Thames & Hudson, 1999.

Hoag, John D. *Islamic Architecture*. New York: Electa/Rizzoli, 1977.

Irwin, Robert. *Islamic Art in Context: Art, Architecture, and the Literary World*. New York: Abrams, 1997.

Lings, Martin. *The Qur'anic Art of Calligraphy and Illumination*. London: World of Islam Festival Trust, 1976.

Michell, George, ed. *Architecture of the Islamic World*. New York: Thames & Hudson, 1978.

Porter, Venetia. *Islamic Tiles*. London: British Museum, 1995.

Robinson, Frank. *Atlas of the Islamic World*. Oxford: Equinox, 1982.

Schimmel, Annemarie. *Calligraphy and Islamic Culture*. New York: New York University Press, 1984.

Stierlin, Henri. *Islam I: Early Architecture from Baghdad to Cordoba*. Cologne: Taschen, 1996.

Ward, Rachel M. *Islamic Metalwork*. New York: Thames & Hudson, 1993.

Welch, Anthony. *Calligraphy in the Arts of the Islamic World*. Austin: University of Texas Press, 1979.

CHAPTER 14
FROM ALASKA TO THE ANDES:
THE ARTS OF
ANCIENT AMERICA
Pre-Columbian

Alva, Walter, and Christopher Donnan. *Royal Tombs of Sipán*. Los Angeles: Fowler Museum of Cultural History, 1993.

Benson, Elizabeth P., and Beatriz de la Fuente, eds. *Olmec Art of Ancient Mexico*. Washington: National Gallery of Art, 1996.

Berrin, Kathleen, ed. *The Spirit of Ancient Peru: Treasures from the Museo Arqueologico Rafael Larco Herrera*. San Francisco: The Fine Arts Museums, 1997.

Berrin, Kathleen, and Esther Pasztory, eds. *Teotihuacan: Art from the City of the Gods*. San Francisco: Thames & Hudson/The Fine Arts Museums of San Francisco, 1993.

Boone, Elizabeth, ed. *Andean Art at Dumbarton Oaks*. 2 vols. Washington: Dumbarton Oaks, 1996.

Bruhns, Karen O. *Ancient South America*. New York: Cambridge University Press, 1994.

Burger, Richard. *Chavín and the Origins of Andean Civilization*. New York: Thames & Hudson, 1992.

Coe, Michael D. *Mexico*. 4th ed. New York: Thames & Hudson, 1994.

———. *The Maya*. 6th edition. New York: Thames & Hudson, 1999.

Coe, Michael D., and Justin Kerr. *The Art of the Maya Scribe*. New York: Abrams, 1998.

Donnan, Christopher. *Ceramics of Ancient Peru*. Los Angeles: Fowler Museum of Cultural History, 1992.

Fash, William. *Scribes, Warriors, and Kings: the City of Copan and the Ancient Maya*. New York: Thames & Hudson, 1991.

Hadingham, Evan. *Lines to the Mountain Gods: Nazca and the Mysteries of Peru*. Norman: University of Oklahoma Press, 1988.

Jones, Julie, ed. *The Art of Pre-Columbian Gold: the Jan Mitchell Collection*. New York: Metropolitan Museum of Art, 1985.

Kolata, Alan. *The Tiwanaku: Portrait of an Andean Civilization*. Cambridge: Blackwell, 1993.

Kubler, George. *The Art and Architecture of Ancient America: the Mexican, Maya, and Andean Peoples*. 3rd ed. New Haven: Yale University Press, 1992.

Lapiner, Alan. *Pre-Columbian Art of South America*. New York: Abrams, 1976.

Miller, Mary E. *The Art of Mesoamerica, from Olmec to Aztec*. 2nd ed. New York: Thames & Hudson, 1996.

Miller, Mary E., and Karl Taube. *The Gods and Symbols of Ancient Mexico and the Maya: An Illustrated Dictionary of Mesoamerican Religion*. New York: Thames & Hudson, 1993.

Morris, Craig, and Adriana von Hagen. *The Inka Empire and its Andean Origins*. New York: Abbeville, 1993.

Olmecs. Special edition of *Arqueología Mexicana*. Mexico City: Editorial Raíces, 1998.

Pang, Hilda. *Pre-Columbian Art: Investigations and Insights*. Norman: University of Oklahoma Press, 1992.

Pasztory, Esther. *Pre-Columbian Art*. New York: Cambridge University Press, 1998.

Paul, Anne. *Paracas Ritual Attire. Symbols of Authority in Ancient Peru*. Norman: University of Oklahoma Press, 1990.

Schele, Linda, and Peter Mathews. *The Code of Kings: The Language of Seven Sacred Maya Temples and Tombs*. New York: Scribner, 1998.

Schele, Linda, and Mary E. Miller. *The Blood of Kings: Dynasty and Ritual in Maya Art*. Fort Worth: Kimbell Art Museum, 1986.

Schmidt, Peter, Mercedes de la Garza, and Enrique Nalda, eds. *Maya*. New York: Rizzoli, 1998.

Stone-Miller, Rebecca, ed. *To Weave for the Sun: Andean Textiles in the Museum of Fine Arts, Boston*. Boston: Museum of Fine Arts, 1992.

Stone-Miller, Rebecca. *Art of the Andes from Chavín to Inca*. New York: Thames & Hudson, 1996.

Townsend, Richard F., ed. *Art From Sacred Landscapes*. Chicago: Art Institute of Chicago, 1992.

Townsend, Richard F., ed. *Ancient West Mexico*. Chicago: Art Institute of Chicago, 1998.

Von Hagen, Adriana, and Craig Morris. *The Cities of the Ancient Andes*. New York: Thames & Hudson, 1998.

Weaver, Muriel Porter. *The Aztecs, Mayas, and Their Predecessors*. 3rd ed. San Diego: Academic Press, 1993.

Native American

Berlo, Janet C., and Ruth B. Phillips. *Native North American Art*. New York: Oxford University Press, 1998.

Brody, J. J. and Rina Swentzell. *To Touch the Past: The Painted Pottery of the Mimbres People*. New York: Hudson Hills, 1996.

Brose, David. *Ancient Art of the American Woodland Indians*. New York: Abrams, 1985.

Cordell, Linda S. *Ancient Pueblo Peoples*. Washington: Smithsonian Institution Press, 1994.

Fagan, Brian. *Ancient North America: the Archaeology of a Continent*. 2nd ed. New York: Thames & Hudson, 1995.

Feest, Christian F. *Native Arts of North America*. 2nd ed. New York: Thames & Hudson, 1992.

Fitzhugh, William W. and Aron Crowell, eds. *Crossroads of Continents: Cultures of Siberia and Alaska*. Washington: Smithsonian Institution Press, 1988.

Furst, Peter, and Jill Furst. *North American Indian Art*. New York: Rizzoli, 1982.

Mathews, Zena, and Aldona Jonaitis, eds. *Native North American Art History*. Palo Alto: Peek Publications, 1982.

Nabokov, Peter, and Robert Easton. *Native American Architecture*. New York: Oxford University Press, 1989.

O'Connor, Mallory M. *Lost Cities of the Ancient Southeast*. Gainesville: University Press of Florida, 1995.

Penney, David, and George C. Longfish. *Native American Art*. Hong Kong: Hugh Lauter Levin and Associates, Inc, 1994.

Wardwell, Allen. *Ancient Eskimo Ivories of the Bering Strait*. New York: Rizzoli, 1986.

Whiteford, Andrew H., et al. *I am Here: 2000 Years of Southwest Indian Arts and Crafts*. Santa Fe: Museum of New Mexico Press, 1989.

CHAPTER 15
SOUTH OF THE SAHARA:
EARLY AFRICAN ART

Bassini, Ezio, and William Fagg. *Africa and the Renaissance: Art in Ivory*. New York: Center for African Art, 1988.

Ben-Amos, Paula. *The Art of Benin*. London: Thames & Hudson, 1980.

Bourgeois, Jean-Louis, and Carollee Pelos. *Spectacular Vernacular: The Adobe Tradition*. New York: Aperture, 1989.

Dark, Philip, J. C. *An Introduction to Benin Art and Technology*. Oxford: Clarenden Press,1973.

Eyo, Ekpo, and Frank Willett. *Treasures of Ancient Nigeria*. New York: Knopf, 1980.

Ezra, Kate. *Royal Art of Benin: The Perls Collection in the Metropolitan Museum of Art*. New York: Metropolitan Museum of Art, 1992.

Fagg, Bernard. *Nok Terracottas*. Lagos: Ethnographica, 1977.

Garlake, Peter S. *Great Zimbabwe*. London: Thames & Hudson, 1973.

Gillon, Werner. *A Short History of African Art*. New York: Facts on File Publication, 1984.

Huffman, Thomas N. *Snakes & Crocodiles. Power and Symbolism in Ancient Zimbabwe*. Johannesburg: Witwatersrand University Press, 1996.

Kaplan, Flora Edouwaya S., ed. *Queens, Queen Mothers, Priestesses, and Power. Case Studies in African Gender. Annals of the New York Academy of Sciences*. Vol. 810. New York: 1997, 73–102.

Perani, Judith, and Fred Smith. *The Visual Arts of Africa. Gender, Power, and Life-Cycle Rituals*. Upper Saddle River: Prentice Hall, 1998.

Phillips, Tom, ed. *Africa. The Art of a Continent.* New York: Prestel, 1995.

Phillipson, David W. *African Archaeology.* 2nd ed. Cambridge: Cambridge University Press, 1993.

Prussin, Labelle. *Hatumere: Islamic Design in West Africa.* Berkeley and Los Angeles: University of California Press, 1986.

Schaedler, Karl-Ferdinand, et al. *Earth and Ore: 2500 Years of African Art in Terra-Cotta and Metal.* Munich: Panterra Verlag, 1997.

Shaw, Thurstan. *Unearthing Igbo-Ukwu: Archaeological Discoveries in Eastern Nigeria.* New York: Oxford University Press, 1977.

Willett, Frank. *Ife in the History of West African Sculpture.* New York: McGraw-Hill, 1967.

CHAPTER 16
EUROPE AFTER THE FALL OF ROME: EARLY MEDIEVAL ART IN THE WEST

Alexander, Jonathan J. G. *Insular Manuscripts, Sixth to the Ninth Century.* London: Miller, 1978.

Backhouse, Janet, et al., eds. *The Golden Age of Anglo-Saxon Art, 966–1066.* Bloomington: Indiana University Press, 1984.

Barral i Altet, Xavier. *The Early Middle Ages. From Late Antiquity to A.D. 1000.* Cologne: Taschen, 1997.

Beckwith, John. *Early Medieval Art.* New York: Oxford University Press, 1964.

Collins, Roger. *Early Medieval Europe, 300–1000.* New York: St. Martin's, 1991.

Conant, Kenneth J. *Carolingian and Romanesque Architecture, 800–1200.* 4th ed. New Haven: Yale University Press, 1992.

Davis-Weyer, Caecilia. *Early Medieval Art, 300–1150: Sources and Documents.* Toronto: University of Toronto Press, 1986. Reprint of 1971 ed.

Diebold, William J. *Word and Image. An Introduction to Early Medieval Art.* Boulder: Westview Press, 2000.

Dodwell, Charles R. *Anglo-Saxon Art: A New Perspective.* Ithaca: Cornell University Press, 1982.

———. *The Pictorial Arts of the West, 800–1200.* New Haven: Yale University Press, 1993.

Grabar, André, and Carl Nordenfalk. *Early Medieval Painting from the Fourth to the Eleventh Century.* Lausanne: Skira, 1957.

Henderson, George. *Early Medieval.* New York: Penguin, 1972.

———. *From Durrow to Kells: The Insular Gospel-Books, 650–800.* London: Thames & Hudson, 1987.

Henry, Françoise. *Irish Art during the Viking Invasions, 800–1020 A.D.* Ithaca: Cornell University Press, 1967.

———. *Irish Art in the Early Christian Period, to 800 A.D.* Rev. ed. Ithaca: Cornell University Press, 1965.

Horn, Walter W., and Ernest Born. *The Plan of Saint Gall.* 3 vols. Berkeley: University of California Press, 1979.

Hubert, Jean, et al. *The Carolingian Renaissance.* New York: Braziller, 1970.

———. *Europe of the Invasions.* New York: Braziller, 1969.

Klindt-Jensen, Ole, and David M. Wilson. *Viking Art.* 2nd ed. Minneapolis: University of Minnesota Press, 1980.

Mayr-Harting, Henry. *Ottonian Book Illumination: An Historical Study.* 2 vols. London: Miller, 1991–1993.

Megaw, Ruth, and John Vincent Megaw. *Celtic Art: From Its Beginning to the Book of Kells.* New York: Thames & Hudson, 1989.

Mütherich, Florentine, and Joachim E. Gaehde. *Carolingian Painting.* New York: Braziller, 1976.

Nordenfalk, Carl. *Celtic and Anglo-Saxon Painting: Book Illumination in the British Isles, 600–800.* New York: Braziller, 1977.

Richardson, Hilary, and John Scarry. *An Introduction to Irish High Crosses.* Dublin: Mercier, 1996.

Stalley, Roger. *Early Medieval Architecture.* New York: Oxford University Press, 1999.

Wilson, David M. *Anglo-Saxon Art: From the Seventh Century to the Norman Conquest.* London: Thames & Hudson, 1984.

CHAPTER 17
THE AGE OF PILGRIMS AND CRUSADERS: ROMANESQUE ART

Armi, C. Edson. *Masons and Sculptors in Romanesque Burgundy: The New Aesthetics of Cluny III.* 2 vols. University Park: Pennsylvania State University Press, 1983.

Barral i Altet, Xavier. *The Romanesque. Towns, Cathedrals and Monasteries.* Cologne: Taschen, 1998.

Cahn, Walter. *Romanesque Bible Illumination.* Ithaca, Cornell University Press, 1982.

———. *Romanesque Manuscripts: The Twelfth Century.* 2 vols. London: Miller, 1998.

Clapham, Alfred W. *Romanesque Architecture in Western Europe.* Oxford: Clarendon, 1959.

Conant, Kenneth J. *Carolingian and Romanesque Architecture, 800–1200.* 4th ed. New Haven: Yale University Press, 1992.

Demus, Otto. *Romanesque Mural Painting.* New York: Thames & Hudson, 1970.

Dodwell, Charles R. *The Pictorial Arts of the West, 800–1200.* New Haven: Yale University Press, 1993.

Fergusson, Peter. *Architecture of Solitude: Cistercian Abbeys in Twelfth-Century Europe.* Princeton: Princeton University Press, 1984.

Forsyth, Ilene H. *The Throne of Wisdom: Wood Sculptures of the Madonna in Romanesque France.* Princeton: Princeton University Press, 1972.

Gantner, Joseph, Marcel Pobé, and Jean Roubier. *Romanesque Art in France.* London: Thames & Hudson, 1956.

Grabar, André, and Carl Nordenfalk. *Romanesque Painting.* New York: Skira, 1958.

Grape, Wolfgang. *The Bayeux Tapestry: Monument to a Norman Triumph.* New York: Prestel, 1994.

Hearn, Millard F. *Romanesque Sculpture: The Revival of Monumental Stone Sculpture in the Eleventh and Twelfth Centuries.* Ithaca: Cornell University Press, 1981.

Kahn, Deborah, ed. *The Romanesque Frieze and Its Spectator.* London: Miller, 1992.

Kauffmann, Claus M. *Romanesque Manuscripts, 1066–1190.* Boston: New York Graphic Society, 1975.

Kubach, Hans E. *Romanesque Architecture.* New York: Electa/Rizzoli, 1988.

Kunstler, Gustav, ed. *Romanesque Art in Europe.* London: Thames & Hudson, 1969.

Little, Bryan D. G. *Architecture in Norman Britain.* London: Batsford, 1985.

Male, Émile. *Religious Art in France: The Twelfth Century.* Rev. ed. Princeton: Princeton University Press, 1978.

Nichols, Stephen G. *Romanesque Signs: Early Medieval Narrative and Iconography.* New Haven, Yale University Press, 1983.

Nordenfalk, Carl. *Early Medieval Book Illumination.* New York: Rizzoli, 1988.

Petzold, Andreas. *Romanesque Art.* New York: Abrams, 1995.

Schapiro, Meyer. *Romanesque Art: Selected Papers.* New York: Braziller, 1977.

———. *The Sculpture of Moissac.* New York: Thames & Hudson, 1985.

Swarzenski, Hanns. *Monuments of Romanesque Art: The Art of Church Treasures in North-Western Europe.* 2nd ed. Chicago: University of Chicago Press, 1967.

Tate, Robert B., and Marcus Tate. *The Pilgrim Route to Santiago.* Oxford: Phaidon, 1987.

Toman, Rolf, ed. *Romanesque: Architecture, Sculpture, Painting.* Cologne: Könemann, 1997.

Zarnecki, George. *Romanesque Art.* New York: Universe, 1971.

———. *Studies in Romanesque Sculpture.* London: Dorian, 1979.

Zarnecki, George, et al. *English Romanesque Art, 1066–1200.* London: Weidenfeld & Nicolson, 1984.

CHAPTER 18
THE AGE OF THE GREAT CATHEDRALS: GOTHIC ART

Alexander, Jonathan J. G., and Paul Binski, eds. *Age of Chivalry: Art in Plantagenet England, 1200–1400.* London: Royal Academy, 1987.

Bony, Jean. *The English Decorated Style: Gothic Architecture Transformed, 1250–1350.* Ithaca: Cornell University Press, 1979.

———. *French Gothic Architecture of the Twelfth and Thirteenth Centuries.* Berkeley: University of California Press, 1983.

Branner, Robert. *Manuscript Painting in Paris during the Reign of St. Louis.* Berkeley: University of California Press, 1977.

———. *St. Louis and the Court Style in Gothic Architecture.* London: Zwemmer, 1965.

Branner, Robert, ed. *Chartres Cathedral.* New York: Norton, 1969.

Brown, Sarah, and David O'Connor. *Glass-Painters (Medieval Craftsmen).* Toronto: University of Toronto Press, 1991.

Camille, Michael. *Gothic Art: Glorious Visions.* New York: Abrams, 1996.

———. *The Gothic Idol. Ideology and Image-making in Medieval Art.* New York: Cambridge University Press, 1989.

Courtenay, Lunn T., ed. *The Engineering of Medieval Cathedrals.* Aldershot: Scolar, 1997.

Erlande-Brandenburg, Alain. *Gothic Art.* New York: Abrams, 1989.

Favier, Jean. *The World of Chartres.* New York: Abrams, 1990.

Frankl, Paul. *Gothic Architecture.* Harmondsworth: Penguin, 1962.

———. *The Gothic: Literary Sources and Interpretations during Eight Centuries.* Princeton: Princeton University Press, 1960.

Frisch, Teresa G. *Gothic Art 1140–c. 1450: Sources and Documents.* Toronto: University of Toronto Press, 1987. Reprint of 1971 ed.

Gerson, Paula, ed. *Abbot Suger and Saint-Denis.* New York: Metropolitan Museum of Art, 1986.

Gimpel, Jean. *The Cathedral Builders.* New York: Grove, 1961.

Grodecki, Louis. *Gothic Architecture.* New York: Electa/Rizzoli, 1985.

Grodecki, Louis, and Catherine Brisac. *Gothic Stained Glass, 1200–1300.* Ithaca: Cornell University Press, 1985.

Jantzen, Hans. *High Gothic: The Classic Cathedrals of Chartres, Reims, Amiens.* Princeton: Princeton University Press, 1984.

Male, Émile. *Religious Art in France: The Thirteenth Century.* rev. ed. Princeton: Princeton University Press, 1984.

Martindale, Andrew. *Gothic Art.* New York: Thames & Hudson, 1985.

Nussbaum, Norbert. *German Gothic Church Architecture.* New Haven: Yale University Press, 2000.

Panofsky, Erwin. *Abbot Suger on the Abbey Church of St. Denis and Its Art Treasures.* 2nd ed. Princeton: Princeton University Press, 1979.

———. *Gothic Architecture and Scholasticism.* New York: New American Library, 1985. Reprint of 1951 ed.

Radding, Charles M., and William W. Clark. *Medieval Architecture, Medieval Learning.* New Haven: Yale University Press, 1992.

Sauerländer, Willibald, and Max Hirmer. *Gothic Sculpture in France 1140–1270.* New York: Abrams, 1973.

Simson, Otto G. von. *The Gothic Cathedral: Origins of Gothic Architecture and the Medieval Concept of Order.* 3rd ed. Princeton: Princeton University Press, 1988.

Toman, Rolf, ed. *The Art of Gothic: Architecture, Sculpture, Painting.* Cologne: Könemann, 1999.

Williamson, Paul. *Gothic Sculpture, 1140–1300.* New Haven: Yale University Press, 1995.

Wilson, Christopher. *The Gothic Cathedral: The Architecture of the Great Church, 1130–1530.* London: Thames & Hudson, 1990.

CHAPTER 19
FROM GOTHIC TO RENAISSANCE: THE FOURTEENTH CENTURY IN ITALY

Andrés, Glenn, et al. *The Art of Florence*. 2 vols. New York: Abbeville Press, 1988.

Antal, Frederick. *Florentine Painting and Its Social Background*. London: Keegan Paul, 1948.

Bomford, David. *Art in the Making: Italian Painting before 1400*. London: National Gallery, 1989.

Borsook, Eve, and Fiorelli Superbi Gioffredi. *Italian Altarpieces 1250–1550: Function and Design*. Oxford: Clarendon Press, 1994.

Cennini, Cennino. *The Craftsman's Handbook (Il Libro dell'Arte)*. Trans. Daniel V. Thompson, Jr. New York: Dover, 1954.

Cole, Bruce. *Sienese Painting: From Its Origins to the Fifteenth Century*. New York: HarperCollins, 1987.

Cole, Bruce. *Italian Art, 1250–1550: The Relation of Renaissance Art to Life and Society*. New York: Harper & Row, 1987.

Hills, Paul. *The Light of Early Italian Painting*. New Haven: Yale University Press, 1987.

Meiss, Millard. *Painting in Florence and Siena after the Black Death*. Princeton: Princeton University Press, 1976.

Norman, Diana, ed. *Siena, Florence, and Padua: Art, Society, and Religion 1280–1400*. New Haven: Yale University Press, 1995.

Panofsky, Erwin. *Renaissance and Renascences in Western Art*. New York: HarperCollins, 1972.

Pope-Hennessy, John. *Introduction to Italian Sculpture*. 3rd. ed. 3 vols. New York: Phaidon, 1986.

———. *Italian Gothic Sculpture*. 3rd ed. Oxford: Phaidon, 1986.

Smart, Alastair. *The Dawn of Italian Painting*. Ithaca: Cornell University Press, 1978.

Stubblebine, James. *Assisi and the Rise of Vernacular Art*. New York: Harper & Row, 1985.

White, John. *Art and Architecture in Italy 1250–1400*. 3rd ed. New Haven: Yale University Press, 1993.

CHAPTER 20
OF PIETY, PASSION, AND POLITICS: FIFTEENTH-CENTURY ART IN NORTHERN EUROPE AND SPAIN

Baxendall, M. *The Limewood Sculptors of Renaissance Germany*. New Haven: Yale University Press, 1980.

Blum, Shirley Neilsen. *Early Netherlandish Triptychs: A Study in Patronage*. Berkeley: University of California Press, 1969.

Campbell, Lorne. *The Fifteenth Century Netherlandish Schools*. London: National Gallery Publications, 1998.

Chatelet, Albert. *Early Dutch Painting*. New York: W. S. Konecky, 1988.

Cuttler, Charles P. *Northern Painting from Pucelle to Bruegel*. New York: Holt, Rinehart & Winston, 1968.

Friedlander, Max J. *Early Netherlandish Painting*. 14 vols. New York: Praeger/Phaidon, 1967–1976.

———. *From Van Eyck to Bruegel*. 3rd ed. Ithaca: Cornell University Press, 1981.

Huizinga, Johan. *The Waning of the Middle Ages*. 1924. Reprint. New York: St. Martin's Press, 1988.

Jacobs, Lynn F. *Early Netherlandish Carved Altarpieces, 1380–1550: Medieval Tastes and Mass Marketing*. Cambridge: Cambridge University Press, 1998.

Lane, Barbara G. *The Altar and the Altarpiece: Sacramental Themes in Early Netherlandish Painting*. New York: Harper & Row, 1984.

Meiss, Millard. *French Painting in the Time of Jean de Berry: The Limbourgs and Their Contemporaries*. New York: Braziller, 1974.

Müller, Theodor. *Sculpture in the Netherlands, Germany, France and Spain, 1400–1500*. New Haven: Yale University Press, 1986.

Panofsky, Erwin. *Early Netherlandish Painting: Its Origins and Character*. 2 vols. Cambridge: Harvard University Press, 1966.

Prevenier, Walter, and Wim Blockmans. *The Burgundian Netherlands*. Cambridge: Cambridge University Press, 1986.

Snyder, James. *Northern Renaissance Art: Painting, Sculpture, the Graphic Arts from 1350 to 1575*. New York: Abrams, 1985.

Wolfthal, Diane. *The Beginnings of Netherlandish Canvas Painting, 1400–1530*. New York: Cambridge University Press, 1989.

CHAPTER 21
HUMANISM AND THE ALLURE OF ANTIQUITY: FIFTEENTH-CENTURY ITALIAN ART

Adams, Laurie Schneider. *Key Monuments of the Italian Renaissance*. Denver: Westview Press, 1999.

Alberti, Leon Battista. *On Painting*. Trans. J. B. Spencer, Rev. ed. New Haven: Yale University Press, 1966.

———. *Ten Books on Architecture*. Ed. J. Rykwert. Trans. J. Leoni. London: Tiranti, 1955.

Ames-Lewis, Francis. *Drawing in Early Renaissance Italy*. New Haven: Yale University Press, 1981.

Baxandall, Michael. *Painting and Experience in Fifteenth Century Italy. A Primer in the Social History of Pictorial Style*. 2nd ed. New York: Oxford University Press, 1988.

Beck, James. *Italian Renaissance Painting*. New York: HarperCollins, 1981.

Blunt, Anthony. *Artistic Theory in Italy, 1450–1600*. Oxford: Clarendon Press, 1966.

Bober, Phyllis Pray, and Ruth Rubinstein. *Renaissance Artists and Antique Sculpture: A Handbook of Sources*. Oxford: Oxford University Press, 1986.

Borsook, Eve. *The Mural Painters of Tuscany*. New York: Oxford University Press, 1981.

Burckhardt, Jacob. *The Architecture of the Italian Renaissance*. Chicago: University of Chicago Press, 1987.

———. *The Civilization of the Renaissance in Italy*. 4th ed. 1867. Reprint. London: Phaidon, 1960.

Christiansen, Keith, Laurence B. Kanter, and Carl B. Strehle, eds. *Painting in Renaissance Siena, 1420–1500*. New York: Metropolitan Museum of Art, 1988.

Cole, Alison. *Virtue and Magnificence: Art of the Italian Renaissance Courts*. New York: Harry N. Abrams, 1995.

Cole, Bruce. *Masaccio and the Art of Early Renaissance Florence*. Bloomington: Indiana University Press, 1980.

Dempsey, Charles. *The Portrayal of Love: Botticelli's Primavera and Humanist Culture at the Time of Lorenzo the Magnificent*. Princeton: Princeton University Press, 1992.

Edgerton, Samuel Y., Jr. *The Heritage of Giotto's Geometry: Art and Science on the Eve of the Scientific Revolution*. Ithaca: Cornell University Press, 1991.

———. *The Renaissance Rediscovery of Linear Perspective*. New York: Harper & Row, 1976.

Gilbert, Creighton, ed. *Italian Art 1400–1500: Sources and Documents*. Evanston: Northwestern University Press, 1980.

Goldthwaite, Richard A. *The Building of Renaissance Florence: An Economic and Social History*. Baltimore: Johns Hopkins University Press, 1980.

Gombrich, E. H. *Norm and Form: Studies in the Art of the Renaissance*. 4th ed. Oxford: Phaidon, 1985.

Hall, Marcia B. *Color and Meaning: Practice and Theory in Renaissance Painting*. Cambridge: Cambridge University Press, 1992.

Hartt, Frederick. *History of Italian Renaissance Art: Painting, Sculpture, Architecture*. 4th ed. rev. by David G. Wilkins. Englewood Cliffs: Prentice-Hall, 1994.

Heydenreich, Ludwig H., and Wolfgang Lotz. *Architecture in Italy 1400–1600*. Harmondsworth: Penguin, 1974.

Hollingsworth, Mary. *Patronage in Renaissance Italy: From 1400 to the Early Sixteenth Century*. Baltimore: Johns Hopkins University Press, 1994.

Kemp, Martin. *Behind the Picture: Art and Evidence in the Italian Renaissance*. New Haven: Yale University Press, 1997.

Kempers, Bram. *Painting, Power, and Patronage: The Rise of the Professional Artist in the Italian Renaissance*. London: Penguin, 1992.

Kent, F. W., and Patricia Simons, eds. *Patronage, Art, and Society in Renaissance Italy*. Canberra: Humanities Research Centre & Clarendon Press, 1987.

Lieberman, Ralph. *Renaissance Architecture in Venice*. New York: Abbeville Press, 1982.

McAndrew, John. *Venetian Architecture of the Early Renaissance*. Cambridge: MIT Press, 1980.

Meiss, Millard. *The Painter's Choice, Problems in the Interpretation of Renaissance Art*. New York: HarperCollins, 1977.

Murray, Peter. *The Architecture of the Italian Renaissance*. Rev. ed. New York: Schocken, 1986.

———. *Renaissance Architecture*. New York: Electa/Rizzoli (paperbound), 1985.

Murray, Peter, and Linda Murray. *The Art of the Renaissance*. London: Thames & Hudson, 1985.

Olson, Roberta J. M. *Italian Renaissance Sculpture*. London: Thames & Hudson, 1992.

Panofsky, Erwin. *Renaissance and Renascences in Western Art*. New York: HarperCollins, 1972.

Pater, Walter. *The Renaissance: Studies in Art and Poetry*. Ed. D. L. Hill. Berkeley: University of California Press, 1980.

Pope-Hennessy, John. *An Introduction to Italian Sculpture*. 3rd ed. 3 vols. New York: Phaidon, 1986.

Seymour, Charles. *Sculpture in Italy, 1400–1500*. New Haven: Yale University Press, 1966.

Thomson, David. *Renaissance Architecture: Critics, Patrons, and Luxury*. Manchester: Manchester University Press, 1993.

Turner, A. Richard. *Renaissance Florence: The Invention of a New Art*. New York: Harry N. Abrams, 1997.

Vasari, Giorgio. *The Lives of the Most Eminent Painters, Sculptors and Architects, 1550–1568*. 3 vols. New York: Abrams, 1979.

Wackernagel, Martin. *The World of the Florentine Renaissance Artist: Projects and Patrons, Workshops and Art Market*. Princeton: Princeton University Press, 1981.

Welch, Evelyn. *Art and Society in Italy 1350–1500*. Oxford: Oxford University Press, 1997.

White, John. *The Birth and Rebirth of Pictorial Space*. 3rd ed. Boston: Faber & Faber, 1987.

Wilde, Johannes. *Venetian Art from Bellini to Titian*. Oxford: Clarendon Press, 1981.

Wittkower, Rudolf. *Architectural Principles in the Age of Humanism*. 4th ed. London: Academy, 1988.

CHAPTER 22
BEAUTY, SCIENCE, AND SPIRIT IN ITALIAN ART: THE HIGH RENAISSANCE AND MANNERISM

Blunt, Anthony. *Artistic Theory in Italy, 1450–1600*. London: Oxford University Press, 1975.

Brown, Patricia Fortini. *Art and Life in Renaissance Venice*. New York: Harry N. Abrams, 1997.

Castiglione, Baldassare. *Book of the Courtier*. 1528. Reprint. New York: Viking Penguin, 1976.

Farago, Claire, ed. *Reframing the Renaissance: Visual Culture in Europe and Latin America 1450–1650*. New Haven: Yale University Press, 1995.

Freedberg, Sydney J. *Painting in Italy, 1500–1600*. 3rd ed. New Haven: Yale University Press, 1993.

———. *Painting of the High Renaissance in Rome and Florence*. Rev. ed. New York: Hacker, 1985.

Friedlaender, Walter. *Mannerism and Anti-Mannerism in Italian Painting*. New York: Schocken, 1965.

Goffen, Rona. *Piety and Patronage in Renaissance Venice: Bellini, Titian, and the Franciscans*. New Haven: Yale University Press, 1986.

Haskell, Francis, and Nicholas Penny. *Taste and the Antique: The Lure of Classical Sculpture, 1500–1900*. New Haven: Yale University Press, 1981.

Holt, Elizabeth Gilmore, ed. *A Documentary History of Art*. Vol. 2, *Michelangelo and the Mannerists*. Rev. ed. Princeton: Princeton University Press, 1982.

Humfry, Peter. *Painting in Renaissance Venice.* New Haven: Yale University Press, 1995.

Huse, Norbert, and Wolfgang Wolters. *The Art of Renaissance Venice: Architecture, Sculpture, and Painting.* Chicago: University of Chicago Press, 1990.

Levey, Michael. *High Renaissance.* New York: Viking Penguin, 1978.

Murray, Linda. *The High Renaissance and Mannerism.* New York: Oxford University Press, 1977.

Partner, Peter. *Renaissance Rome, 1500–1559: A Portrait of a Society.* Berkeley: University of California Press, 1977.

Partridge, Loren. *The Art of Renaissance Rome.* New York: Harry N. Abrams, 1996.

Pietrangeli, Carlo, et al. *The Sistine Chapel: The Art, the History, and the Restoration.* New York: Harmony Books, 1986.

Pope-Hennessy, John. *Italian High Renaissance and Baroque Sculpture.* 3rd ed. 3 vols. Oxford: Phaidon, 1986.

Rosand, David. *Painting in Cinquecento Venice: Titian, Veronese, Tintoretto.* New Haven: Yale University Press, 1982.

Shearman, John K. G. *Mannerism.* Baltimore: Penguin, 1978.

———. *Only Connect . . . Art and the Spectator in the Italian Renaissance.* Princeton: Princeton University Press, 1990.

Summers, David. *Michelangelo and the Language of Art.* Princeton: Princeton University Press, 1981.

Venturi, Lionello. *The Sixteenth Century: From Leonardo to El Greco.* New York: Skira, 1956.

Wölfflin, Heinrich. *The Art of the Italian Renaissance.* New York: Schocken, 1963.

———. *Classic Art: An Introduction to the Italian Renaissance.* 4th ed. Oxford: Phaidon, 1980.

CHAPTER 23
THE AGE OF REFORMATION: SIXTEENTH-CENTURY ART IN NORTHERN EUROPE AND SPAIN

Benesch, Otto. *Art of the Renaissance in Northern Europe.* Rev. ed. London: Phaidon, 1965.

———. *German Painting from Dürer to Holbein.* Geneva: Skira, 1966.

Blunt, Anthony. *Art and Architecture in France 1500–1700.* 4th ed. New Haven: Yale University Press, 1982.

Gibson, W. S. *"Mirror of the Earth": The World Landscape in Sixteenth Century Flemish Painting.* Princeton: Princeton University Press, 1989.

Harbison, Craig. *The Mirror of the Artist: Northern Renaissance Art in its Historical Context.* New York: Harry N. Abrams, 1995.

Hitchcock, Henry-Russell. *German Renaissance Architecture.* Princeton: Princeton University Press. 1981.

Landau, David, and Peter Parshall. *The Renaissance Print: 1470–1550.* New Haven: Yale University Press, 1994.

Smith, Jeffrey C. *German Sculpture of the Later Renaissance c. 1520–1580.* Princeton: Princeton University Press, 1993.

Stechow, Wolfgang. *Northern Renaissance Art, 1400–1600: Sources and Documents.* Englewood Cliffs: Prentice-Hall, 1966.

CHAPTER 24
OF POPES, PEASANTS, MONARCHS, AND MERCHANTS: BAROQUE AND ROCOCO ART

Adams, Laurie Schneider. *Key Monuments of the Baroque.* Denver: Westview Press, 1999.

The Age of Caravaggio. New York: Metropolitan Museum of Art, 1985.

Alpers, Svetlana. *The Art of Describing: Dutch Art in the Seventeenth Century.* Chicago: University of Chicago Press, 1984.

———. *Rembrandt's Enterprise: The Studio and the Market.* Chicago: University of Chicago Press, 1988.

Blunt, Anthony. *Art and Architecture in France:*
1500 to 1700. 4th ed. New Haven: Yale University Press, 1988.

Blunt, Anthony, ed. *Baroque and Rococo: Architecture and Decoration.* Cambridge: Harper & Row, 1982.

Brown, Christopher. *Scenes of Everyday Life: Dutch Genre Painting of the Seventeenth Century.* London: Faber & Faber, 1984.

Brown, Jonathan. *The Golden Age of Painting in Spain.* New Haven: Yale University Press, 1991.

———. *Kings and Connoisseurs: Collecting Art in Seventeenth-Century Europe.* Princeton: Princeton University Press, 1994.

Bryson, Norman. *Word and Image: French Painting of the Ancien Régime.* Cambridge: Cambridge University Press, 1981.

Duncan, Carol. *The Pursuit of Pleasure: The Rococo Revival in French Romantic Art.* New York: Garland, 1976.

Enggass, Robert, and Jonathan Brown. *Italy and Spain, 1600–1750: Sources and Documents.* Englewood Cliffs: Prentice Hall, 1970.

Franits, Wayne. *Looking at Seventeenth-Century Dutch Art: Realism Reconsidered.* Cambridge: Cambridge University Press, 1997.

Freedberg, Sydney J. *Circa 1600: A Revolution of Style in Italian Painting.* Cambridge: Harvard University Press, 1983.

Gerson, Horst, and E. H. ter Kuile. *Art and Architecture in Belgium 1600–1800.* Baltimore: Penguin, 1960.

Haak, Bob. *The Golden Age: Dutch Painters of the Seventeenth Century.* New York: Abrams, 1984.

Haskell, Francis. *Patrons and Painters: A Study in the Relations between Italian Art and Society in the Age of the Baroque.* Rev. ed. New Haven: Yale University Press, 1980.

Held, Julius, and Donald Posner. *17th and 18th Century Art: Baroque Painting, Sculpture, Architecture.* New York: Abrams, 1971.

Hempel, Eberhard. *Baroque Art and Architecture in Central Europe.* New York: Viking Penguin, 1977.

Hibbard, Howard. *Carlo Maderno and Roman Architecture, 1580–1630.* London: Zwemmer, 1971.

Hitchcock, Henry Russell. *Rococo Architecture in Southern Germany.* London: Phaidon, 1968.

Howard, Deborah. *The Architectural History of Venice.* London: B. T. Batsford, 1981.

Huyghe, René, ed. *Larousse Encyclopedia of Renaissance and Baroque Art.* See Reference Books.

Kahr, Madlyn Millner. *Dutch Painting in the Seventeenth Century.* New York: Harper & Row, 1978.

Kalnein, Wend, and Michael Levey. *Art and Architecture of the Eighteenth Century in France.* Harmondsworth: Penguin, 1972.

Kitson, Michael. *The Age of Baroque.* London: Hamlyn, 1976.

Krautheimer, Richard. *The Rome of Alexander VII, 1655–1677.* Princeton: Princeton University Press, 1985.

Lagerlöf, Margaretha R. *Ideal Landscape: Annibale Carracci, Nicolas Poussin and Claude Lorrain.* New Haven: Yale University Press, 1990.

Lees-Milne, James. *Baroque in Italy.* New York: Macmillan, 1960.

Levey, Michael. *Painting and Sculpture in France, 1700–1789.* New ed. New Haven: Yale University Press, 1993.

Martin, John R. *Baroque.* New York: Harper & Row, 1977.

Millon, Henry A. *Baroque and Rococo Architecture.* New York: Braziller, 1965.

Montagu, Jennifer. *Roman Baroque Sculpture: The Industry of Art.* New Haven: Yale University Press, 1989.

Muller, Sheila D., ed. *Dutch Art: An Encyclopedia.* New York: Garland Publishers, 1997.

Norberg-Schulz, Christian. *Baroque Architecture.* New York: Rizzoli, 1986.

———. *Late Baroque and Rococo Architecture.* New York: Electa/Rizzoli, 1985.

North, Michael. *Art and Commerce in the Dutch Golden Age.* New Haven: Yale University Press, 1997.

Pope-Hennessy, Sir John. *The Study and Criticism of Italian Sculpture.* New York: Metropolitan Museum, 1981.

Rosenberg, Jakob, Seymour Slive, and E. H. ter Kuile. *Dutch Art and Architecture, 1600–1800.* New Haven: Yale University Press, 1979.

Schama, Simon. *The Embarrassment of Riches: An Interpretation of Dutch Culture in the Golden Age.* Berkeley: University of California Press, 1988.

Stechow, Wolfgang. *Dutch Landscape Painting of the 17th Century.* 3rd ed. Oxford: Phaidon, 1981.

Summerson, Sir John. *Architecture in Britain: 1530–1830.* 7th rev. and enl. ed. New Haven: Yale University Press, 1983.

Varriano, John. *Italian Baroque and Rococo Architecture.* New York: Oxford University Press, 1986.

Waterhouse, Ellis Kirkham. *Baroque Painting in Rome.* London: Phaidon, 1976.

———. *Italian Baroque Painting.* 2nd ed. London: Phaidon, 1969.

———. *Painting in Britain, 1530–1790.* 4th ed. New York: Yale University Press, 1979.

Wittkower, Rudolf. *Art and Architecture in Italy 1600–1750.* 3rd ed. Harmondsworth: Penguin, 1982.

Wölfflin, Heinrich. *Principles of Art History: The Problem of the Development of Style in Later Art.* 7th ed. New York: Dover, 1950.

———. *Renaissance and Baroque.* London: Collins, 1984.

Wright, Christopher. *The French Painters of the 17th Century.* New York: New York Graphic Society, 1986.

BOOKS SPANNING THE FOURTEENTH THROUGH SEVENTEENTH CENTURIES

Campbell, Lorne. *Renaissance Portraits: European Portrait-Painting in the Fourteenth, Fifteenth, and Sixteenth Centuries.* New Haven: Yale University Press, 1990.

Dunkerton, Jill, Susan Foister, Dillian Gordon, and Nicholas Penny. *Giotto to Durer: Early Renaissance Painting in the National Gallery.* New Haven: Yale University Press, 1991.

Gilbert, Creighton. *History of Renaissance Art throughout Europe.* New York: Abrams, 1973.

Haskell, Francis, and Nicholas Penny. *Taste and the Antique: The Lure of Classical Sculpture 1500–1900.* New Haven: Yale University Press, 1981.

Huyghe, René. *Larousse Encyclopedia of Renaissance and Baroque Art.* See Reference Books.

Kemp, Martin. *The Science of Art: Optical Themes in Western Art From Brunelleschi to Seurat.* New Haven: Yale University Press, 1990.

Paoletti, John T,. and Gary M. Radke. *Art in Renaissance Italy.* Upper Saddle River: Prentice Hall, 1997.

CHAPTER 25
RELIGIOUS CHANGE AND COLONIAL RULE: THE LATER ART OF SOUTH AND SOUTHEAST ASIA

Beach, Milo Cleveland. *Mughal and Rajput Painting.* Cambridge: Cambridge University Press, 1992.

———. *The Imperial Image: Paintings for the Mughal Court.* Washington: Freer Gallery of Art, 1981.

Boisselier, Jean. *The Heritage of Thai Sculpture.* New York: Weatherhill, 1975.

Brand, Michael, and Glenn D. Lowry. *Akbar's India: Art from the Mughal City of Victory.* New York: The Asia Society Galleries, 1985.

Brown, Roxanna. *The Ceramics of South-East Asia: Their Dating and Identification.* 2nd ed. Singapore: Oxford University Press, 1988.

Dallapiccola, Anna Libera, ed. *Vijayanagara—City and Empire.* 2 vols. Stuttgart: Steiner Verlag Viesbaden GMBH, 1985.

Dehejia, Vidya, ed. *Devi: The Great Goddess.* Washington: Arthur M. Sackler Gallery, 1999.

Gascoigne, Bamber. *The Great Moghuls.* New York: Harper & Row, 1971.

Girard-Gestan, Maud, et al. *Art of Southeast Asia.* Trans. J. A. Underwood. New York: Harry N. Abrams, 1998.

Gosling, Betty. *Sukhothai: Its History, Culture, and Art.* Singapore: Oxford University Press, 1991.

Goswamy, B. N., and Eberhard Fischer. *Pahari Masters: Court Painters of Northern India.* Zurich: Artibus Asiae Publishers, 1992.

Jacques, Claude, and Michael Freeman. *Angkor: Cities and Temples.* Bangkok: River Books, 1997.

Michell, George. *Architecture and Art of Southern India: Vijayanagara and the Successor States, 1350–1750.* Cambridge: Cambridge University Press, 1995.

Narula, Karen Schur. *Voyage of the Emerald Buddha.* Kuala Lumpur: Oxford University Press, 1994.

Pal, Pratapaditya, ed. *Master Artists of the Imperial Mughal Court.* Bombay: Marg, 1991.

Poshyananda, Apinan. *Modern Art in Thailand: Nineteenth and Twentieth Century.* Singapore: Oxford University Press, 1992.

Stadtner, Donald M. *The Art of Burma: New Studies.* Mumbai: Marg, 1999.

Stevenson, John, and John Guy, eds. *Vietnamese Ceramics: A Separate Tradition.* Chicago: Art Media Resources, 1997.

Welch, Stuart Cary. *India: Art and Culture 1300–1900.* New York: The Metropolitan Museum of Art, 1985.

CHAPTER 26
INCURSION, RESTORATION, AND TRANSFORMATION: THE ART OF LATER CHINA AND KOREA

Andrews, Julia Frances, and Kuiyi Shen. *A Century in Crisis: Modernity and Tradition in the Art of Twentieth-Century China.* New York: Guggenheim Museum; 1998.

Barnhart, Richard M. *Painters of the Great Ming: The Imperial Court and the Zhe School.* Dallas: Dallas Museum of Art, 1993.

Barnhart, Richard M., et al. *Three Thousand Years of Chinese Painting.* New Haven: Yale University Press; Beijing: Foreign Languages Press, 1997.

Cahill, James. *Chinese Painting.* New York: Rizzoli, 1960.

——. *The Painter's Practice: How Artists Lived and Worked in Traditional China.* New York: Columbia University Press, 1994.

Clunas, Craig. *Art in China.* Oxford: Oxford University Press, 1997.

Fong, Wen C., and James C. Y. Watt. *Possessing the Past: Treasures from the National Palace Museum, Taipei.* New York: Metropolitan Museum of Art, 1996.

Lee, Sherman E., and Wai-Kam Ho. *Chinese Art under the Mongols: The Yuan Dynasty (1279–1368).* Cleveland: Cleveland Museum of Art, 1969.

Li, Chu-tsing, ed. *Artists and Patrons: Some Social and Economic Aspects of Chinese Painting.* Lawrence: Kress Department of Art History in cooperation with Indiana University Press, 1989.

Rawson, Jessica, et al. *The British Museum Book of Chinese Art.* New York: Thames & Hudson, 1992.

Sickman, Laurence, and A. C. Soper. *The Art and Architecture of China.* New Haven: Yale University Press, 1992.

Silbergeld, Jerome. *Chinese Painting Style: Media, Methods, and Principles of Form.* Seattle: University of Washington Press, 1982

Sullivan, Michael. *Art and Artists of Twentieth-Century China.* Berkeley: University of California Press, 1996.

——. *The Arts of China,* 3rd ed. Berkeley: University of California Press, 1984.

Thorp, Robert L. *Son of Heaven: Imperial Arts of China.* Seattle: Son of Heaven Press, 1988.

Vainker, S. J. *Chinese Pottery and Porcelain: From Prehistory to the Present.* London: G. Braziller, 1991.

Weidner, Marsha, ed. *Flowering in the Shadows: Women in the History of Chinese and Japanese Painting.* Honolulu: University of Hawaii Press, 1990.

CHAPTER 27
FROM THE SHOGUNS TO THE PRESENT: THE ART OF LATER JAPAN

Akiyama, Terukazu. *Japanese Painting.* Geneva: Skira, New York: Rizzoli, 1977.

Bring, Mitchell and Josse Wayembergh. *Japanese Gardens: Design and Meaning.* New York: McGraw Hill, 1981.

Cahill, James. *Scholar Painters of Japan.* New York: Asia Society, 1972.

Coaldrake, William H. *Architecture and Authority in Japan.* London: Routledge, 1996.

Drexler, Arthur. *The Architecture of Japan.* New York: Museum of Modern Art, 1966.

Edo: Art in Japan 1615–1868. Washington: National Gallery of Art, 1998.

Elisseeff, Danielle, and Vadime Elisseeff. *Art of Japan.* Trans. I. Mark Paris. New York: Abrams, 1985.

Fontein, Jan, and Money L. Hickman. *Zen Painting and Calligraphy.* Greenwich: New York: Graphic Society, 1970.

Guth, Christine. *Art of Edo Japan: The Artist and the City, 1615–1868.* New York: Abrams, 1996.

Hashimoto, Fumio. *Architecture in the Shoin Style.* Trans. and adapted by H. Mack Horton. New York: Kodansha International, 1981.

Hickman, Money L., et al. *Japan's Golden Age: Momoyama.* New Haven: Yale University Press, 1996.

Kawakita Michiaki. *Modern Currents in Japanese Art.* Trans. Charles E. Terry. New York: Weatherhill, 1974.

Kidder, J. Edward, Jr. *The Art of Japan.* New York: Park Lane, 1985.

Kurokawa, Kisho. *New Wave Japanese Architecture.* London: Academy Editions; Berlin: Ernst & Sohn; New York: St. Martin's Press, 1993.

Lane, Richard. *Images from the Floating World: The Japanese Print.* New York: Dorset, 1978.

Lee, Sherman. *Reflections of Reality in Japanese Art.* Cleveland: Cleveland Museum of Art, 1983.

Mason, Penelope. *History of Japanese Art.* New York: Abrams, 1993.

Meech-Pekarik, Julia. *The World of the Meiji Print: Impressions of a New Civilization.* New York: Weatherhill, 1986.

Mizuo, Hiroshi. *Edo Painting: Sotatsu and Korin.* Trans. John M. Shields. New York: Weatherhill, 1972.

Munroe, Alexandra. *Japanese Art after 1945: Scream against the Sky.* New York: Abrams, 1994.

Nishi, Kazuo, and Kazuo Hozumi. *What Is Japanese Architecture?* Trans. H. Mack Horton. New York: Kodansha International, 1985.

Noma, Seiroku. *The Arts of Japan.* Trans. and adapted by John Rosenfield and Glenn T. Webb. Tokyo: Kodansha International, 1966.

Rosenfield, John M., and Elizabeth ten Grotenhuis. *Journey of the Three Jewels.* New York: Asia Society, 1979.

Rosenfield, John M., and Shujiro Shimada. *Traditions of Japanese Art: Selections from the Kimiko and John Powers Collection.* Cambridge: Fogg Art Museum, 1970

Sanford, James H., William R. LaFleur, and Masatoshi Nagatomi. *Flowing Traces: Buddhism in the Literary and Visual Arts of Japan.* Princeton: Princeton University Press, 1992.

Shimizu, Yoshiaki, et al. *Japan: The Shaping of Daimyo Culture, 1185–1868.* Washington: National Gallery of Art, 1988.

Stanley-Baker, Joan. *Japanese Art.* New York: Thames & Hudson, 1984.

Stewart, David B. *The Making of a Modern Japanese Architecture, 1868 to the Present.* New York: Kodansha International, 1988.

Weidner, Marsha, ed. *Flowering in the Shadows: Women in the History of Chinese and Japanese Painting.* Honolulu: University of Hawaii Press, 1990.

Worlds Seen and Imagined: Japanese Screens from the Idemitsu Museum of Art. New York: The Asia Society, 1995.

CHAPTER 28
THE ENLIGHTENMENT AND ITS LEGACY: NEOCLASSICISM THROUGH THE MID-NINETEENTH CENTURY

Bermingham, Ann. *Landscape and Ideology: The English Rustic Tradition, 1740–1850.* Berkeley: University of California Press, 1986.

Boime, A. *Art in the Age of Bonapartism, 1800–1815.* Chicago: University of Chicago Press, 1990.

——. *Art in the Age of Revolution, 1750–1800.* Chicago: University of Chicago Press, 1987.

Braham, Allan. *The Architecture of the French Enlightenment.* Berkeley: University of California Press, 1980.

Brion, Marcel. *Art of the Romantic Era: Romantcism, Classicism, Realism.* New York: Praeger, 1966.

Bryson, Norman. *Tradition and Desire: From David to Delacroix.* New York: Cambridge University Press, 1984.

Burchard, John, and Albert Bush-Brown. *The Architecture of America: A Social and Cultural History.* Boston: Little, Brown/The American Institute of Architects, 1965.

Clark, Kenneth. *The Romantic Rebellion: Romantic versus Classic Art.* New York: Harper & Row, 1973.

Clay, Jean. *Romanticism.* New York: Phaidon, 1981.

Conisbee, Philip. *Painting in Eighteenth-Century France.* Ithaca: Phaidon/Cornell University Press, 1981.

Cooper, Wendy A. *Classical Taste in America, 1800–1840.* Baltimore: Baltimore Museum of Art, 1993.

Crow, Thomas E. *Painters and Public Life in Eighteenth-Century Paris.* New Haven: Yale University Press, 1985.

Davis, Terence. *The Gothick Taste.* Cranbury: Fairleigh Dickinson University Press, 1975.

Eitner, Lorenz. *Neoclassicism and Romanticism, 1750–1850: An Anthology of Sources and Documents.* New York: Harper & Row, 1989.

Gaunt, W. *The Great Century of British Painting: Hogarth to Turner.* New York: Phaidon, 1971.

Herrmann, Luke. *British Landscape Painting of the Eighteenth Century.* New York: Oxford University Press, 1974.

Holt, Elizabeth Gilmore, ed. *From the Classicists to the Impressionists: A Documentary History of Art and Architecture in the Nineteenth Century.* Garden City: Anchor Books/Doubleday, 1966.

Honour, Hugh. *Neo-Classicism.* Harmondsworth: Penguin, 1968.

——. *Romanticism.* New York: Harper & Row, 1979.

Kalnein, Wend Graf, and Michael Levey. *Art and Architecture of the Eighteenth Century in France.* New York: Viking/Pelican, 1973.

Kroeber, Karl. *British Romantic Art.* Berkeley: University of California Press, 1986.

Levey, Michael. *Painting in Eighteenth-Century Venice.* Ithaca: Phaidon/Cornell University Press, 1980.

——. *Rococo to Revolution: Major Trends in Eighteenth-Century Painting.* London: Thames & Hudson, 1966.

Mendelowitz, Daniel M. *A History of American Art.* 2nd ed. New York: Holt, Rinehart & Winston, 1970.

Middleton, Robin, and David Watkin. *Neoclassical and 19th Century Architecture.* 2 vols. New York: Electa/Rizzoli, 1987.

Novotny, Fritz. *Painting and Sculpture in Europe, 1780–1880.* Harmondsworth: Penguin, 1980.

Pierson, William. *American Buildings and Their Architects.* Vol. 1, *The Colonial and Neo-Classical Style.* Garden City: Doubleday, 1970.

Porterfield, Todd. *The Allure of Empire: Art in the Service of French Imperialism 1798–1836.* Princeton: Princeton University Press, 1998.

Rosenblum, Robert. *Transformations in Late Eighteenth Century Art.* Princeton: Princeton University Press, 1970.

Roston, Murray. *Changing Perspectives in Literature*

and the Visual Arts, 1650–1820. Princeton: Princeton University Press, 1990.

Rykwert, Joseph. *The First Moderns: Architects of the Eighteenth Century.* Cambridge: MIT Press, 1983.

Stillman, Damie. *English Neo-classical Architecture.* 2 vols. London: A Zwemmer, 1988.

Vaughn, William. *German Romantic Painting.* New Haven: Yale University Press, 1980.

Wilton, Andrew. *The Swagger Portrait: Grand Manner Portraiture in Britain from Van Dyck to Augustus John 1630–1930.* London: Tate Gallery, 1992.

Wolf, Bryan Jay. *Romantic Revision: Culture and Consciousness in Nineteenth-Century American Painting and Literature.* Chicago: University of Chicago Press, 1986.

CHAPTER 29
THE RISE OF MODERNISM:
THE LATER NINETEENTH CENTURY

Adams, Steven. *The Barbizon School and the Origins of Impressionism.* London: Phaidon, 1994.

Barger, M. Susan, and William B. White. *The Daguerreotype: Nineteenth-Century Technology and Modern Science.* Washington: Smithsonian Institution, 1991.

Baudelaire, Charles. *The Mirror of Art, Critical Studies.* Trans. Jonathan Mayne. Garden City: Doubleday & Co., 1956.

———. *The Painter of Modern Life, and Other Essays.* Trans. and ed. Jonathan Mayne. London: Phaidon, 1964.

Boime, Albert. *The Academy and French Painting in the 19th Century.* London: Phaidon, 1971.

Broude, Norma. *Impressionism: A Feminist Reading.* New York: Rizzoli, 1991.

Clark, Kenneth. *The Gothic Revival: An Essay in the History of Taste.* New York: Humanities Press, 1970.

Clark, T. J. *The Absolute Bourgeois: Artists and Politics in France, 1848–1851.* London: Thames & Hudson, 1973.

———. *Image of the People: Gustave Courbet and the 1848 Revolution.* London: Thames & Hudson, 1973.

———. *The Painting of Modern Life: Paris in the Art of Manet and His Followers.* Princeton: Princeton University Press, 1984.

Duncan, Alastair. *Art Nouveau.* New York: Thames & Hudson, 1994.

Eisenmann, Stephen F. *19th-Century Art: A Critical History.* New York: Thames & Hudson, 1994.

Farwell, Beatrice. *Manet and the Nude: A Study in the Iconology of the Second Empire.* New York: Garland, 1981.

Fried, Michael. *Courbet's Realism.* Chicago: University of Chicago Press, 1982.

———. *Manet's Modernism, or, The Face of Painting in the 1860s.* Chicago: The University of Chicago Press, 1996.

Friedlaender, Walter. *From David to Delacroix.* New York: Schocken Books, 1968.

Gerdts, William H. *American Impressionism.* New York: Abbeville Press, 1984.

Hamilton, George H. *Painting and Sculpture in Europe, 1880–1940.* 6th ed. New Haven: Yale University Press, 1993.

Herbert, Robert L. *Impressionism: Art, Leisure, and Parisian Society.* New Haven: Yale University Press, 1988.

Hilton, Timothy. *The Pre-Raphaelites.* New York: Oxford University Press, 1970.

Holt, Elizabeth B. *From the Classicists to the Impressionists: Art and Architecture in the Nineteenth Century.* Garden City: Doubleday/Anchor, 1966.

Holt, Elizabeth Gilmore, ed. *The Expanding World of Art 1874–1902.* New Haven: Yale University Press, 1988.

Janson, Horst W. *19th-Century Sculpture.* New York: Harry N. Abrams, 1985.

Jensen, Robert. *Marketing Modernism in Fin-de-Siècle Europe.* Princeton: Princeton University Press, 1994.

Klingender, Francis Donald and Elton, Arthur, ed. & rev. *Art and the Industrial Revolution.* London: Evelyn, Adams & MacKay, 1968.

Krell, Alain. *Manet and the Painters of Contemporary Life.* London: Thames & Hudson, 1996.

Leymarie, Jean. *French Painting in the Nineteenth Century.* Geneva: Skira, 1962.

Macaulay, James. *The Gothic Revival, 1745–1845.* Glasgow: Blackie, 1975.

Mainardi, Patricia. *Art and Politics of the Second Empire: The Universal Expositions of 1855 and 1867.* New Haven: Yale University Press, 1987.

———. *The End of the Salon: Art and the State in the Early Third Republic.* Cambridge: Cambridge University Press, 1993.

Middleton, Robin, ed. *The Beaux-Arts and Nineteenth-Century French Architecture.* Cambridge: MIT Press, 1982.

Miller, Angela L. *The Empire of the Eye: Landscape Representation and American Cultural Politics, 1825–1875.* Ithaca: Cornell University Press, 1993.

Needham, Gerald. *19th-Century Realist Art.* New York: Harper & Row, 1988.

Nochlin, Linda. *Impressionism and Post-Impressionism, 1874–1904: Sources and Documents.* Englewood Cliffs: Prentice-Hall, 1966.

———. *Realism and Tradition in Art, 1848–1900: Sources and Documents.* Englewood Cliffs: Prentice-Hall, 1966.

Novak, Barbara. *American Painting of the Nineteenth Century: Realism and the American Experience.* New York: Harper & Row, 1979.

Novotny, Fritz. *Painting and Sculpture in Europe: 1780–1880.* 2nd ed. New Haven: Yale University Press, 1978.

Pevsner, Nikolaus. *Pioneers of Modern Design.* Harmondsworth: Penguin, 1964.

Rewald, John. *The History of Impressionism.* New York: Museum of Modern Art, 1973.

———. *Post-Impressionism: From Van Gogh to Gauguin.* New York: Museum of Modern Art, 1956.

Rosen, Charles, and Henri Zerner. *Romanticism and Realism: The Mythology of Nineteenth-Century Art.* New York: Viking Press, 1984.

Rosenblum, Robert, and Horst W. Janson. *19th Century Art.* New York: Harry N. Abrams, 1984.

Schapiro, Meyer. *Modern Art: 19th & 20th Centuries.* New York: Braziller, 1978.

Schorske, Carl E. *Fin de Siècle Vienna: Politics and Culture.* New York: Alfred Knopf, 1980.

Shiff, Richard. *Cézanne and the End of Impressionism: A Study of the Theory, Technique, and Critical Evaluation of Modern Art.* Chicago: University of Chicago Press, 1984.

Silverman, Debora L. *Art Nouveau in Fin-de-Siècle France: Politics, Psychology, and Style.* Berkeley: University of California Press, 1989.

Sloane, Joseph C. *French Painting Between the Past and the Present: Artists, Critics, and Traditions from 1848 to 1870.* Princeton: Princeton University Press, 1973.

Smith, Paul. *Impressionism: Beneath the Surface.* New York: Harry N. Abrams, 1995.

Sullivan, Louis. *The Autobiography of an Idea.* New York: Dover, 1956.

Van Gogh: A Self Portrait: Letters Revealing His Life as a Painter. Selected by W. H. Auden. New York: E. P. Dutton, 1963.

Weisberg, Gabriel P. *The European Realist Tradition.* Bloomington: Indiana University Press, 1982.

Wilmerding, John, et al. *American Light: The Luminist Movement, 1850–1875: Paintings, Drawings, Photographs.* Washington: National Gallery of Art, 1980.

Wood, Christopher. *The Pre-Raphaelites.* New York: Viking Press, 1981.

CHAPTER 30
BEFORE AND AFTER THE
CONQUISTADORS: NATIVE ARTS OF
THE AMERICAS AFTER 1000
Pre-Columbian

Boone, Elizabeth, ed. *Andean Art at Dumbarton Oaks,* 2 vols., Washington: Dumbarton Oaks, 1996.

Boone, Elizabeth. *The Aztec World.* Washington: Smithsonian Institution Press, 1994.

Bruhns, Karen O. *Ancient South America.* New York: Cambridge University Press, 1994.

Coe, Michael D. *Mexico.* 4th ed. New York: Thames & Hudson, 1994.

———. *The Maya.* 6th ed. New York: Thames & Hudson, 1999.

Coe, Michael D., and Justin Kerr. *The Art of the Maya Scribe.* New York: Abrams, 1998.

Diaz, Gisele, and Alan Rodgers. *The Codex Borgia.* New York: Dover, 1993.

Donnan, Christopher. *Ceramics of Ancient Peru.* Los Angeles: Fowler Museum of Cultural History, 1992.

Gasparini, Graziano, and Luise Margolies. *Inca Architecture.* Bloomington: Indiana University Press, 1980.

Jones, Julie, ed. *The Art of Pre-Columbian Gold: the Jan Mitchell Collection,* New York: Metropolitan Museum of Art, 1985.

Kubler, George. *The Art and Architecture of Ancient America: the Mexican, Maya, and Andean Peoples.* 3rd ed. New Haven: Yale University Press, 1992.

Lapiner, Alan. *Pre-Columbian Art of South America.* New York: Abrams, 1976.

Malpass, Michael A. *Daily Life in the Inca Empire.* Westport: Greenwood Press, 1996.

Matos, Eduardo M. *The Great Temple of the Aztecs: Treasures of Tenochtitlan.* New York: Thames & Hudson, 1988.

Miller, Mary E. *The Art of Mesoamerica, from Olmec to Aztec.* 2nd ed. New York: Thames & Hudson, 1996.

Miller, Mary E., and Karl Taube. *The Gods and Symbols of Ancient Mexico and the Maya: An Illustrated Dictionary of Mesoamerican Religion.* New York: Thames & Hudson, 1993.

Morris, Craig, and Adriana von Hagen. *The Inka Empire and its Andean Origins.* New York: Abbeville, 1993.

Pasztory, Esther. *Aztec Art.* New York: Abrams, 1983.

Plazas, Clemencia, Ana Maria Falchetti, and Armand J. Labbé. *Tribute to the Gods: Treasures of the Museo del Oro.* Santa Ana: Bowers Museum of Cultural Art, 1992.

Townsend, Richard F., ed. *Art From Sacred Landscapes.* Chicago: Art Institute of Chicago, 1992.

Weaver, Muriel Porter. *The Aztecs, Mayas, and Their Predecessors.* 3rd ed. San Diego: Academic Press, 1993.

Native American

Anderson, Richard, and Karen L. Field, eds., *Art in Small-Scale Societies: Contemporary Readings.* Englewood Cliffs: Prentice Hall, 1993.

Berlo, Janet C., ed. *Plains Indian Drawings 1865–1935.* New York: Abrams, 1996.

Berlo, Janet C., and Ruth B. Phillips. *Native North American Art.* New York: Oxford University Press, 1998.

Berlo, Janet C., and Lee Anne Wilson, eds., *Arts of Africa, Oceania, and the Americas: Selected Readings.* Englewood Cliffs: Prentice Hall, 1993.

Feest, Christian F. *Native Arts of North America.* 2nd ed. New York: Thames & Hudson, 1992.

Fienup-Riordan, Ann. *The Living Tradition of Yup'ik Masks.* Seattle: University of Washington Press, 1996.

Fitzhugh, William W., and Aron Crowell, eds. *Crossroads of Continents: Cultures of Siberia and Alaska.* Washington: Smithsonian Institution Press, 1988.

Furst, Peter, and Jill Furst. *North American Indian Art.* New York: Rizzoli, 1982.

Hill, Tom, and Richard W. Hill, Sr., eds. *Creation's Journey: Native American Identity and Belief.* Washington: Smithsonian Institution Press, 1994.

Jonaitis, Aldona. *From the Land of the Totem Poles: The Northwest Coast Indian Art Collection at the American Museum of Natural History.* Seattle: University of Washington Press, 1988.

MacDonald, George. *Haida Art.* Seattle: University of Washington Press, 1996.

Maurer, Evan M. *Visions of the People: a Pictorial History of Plains Indian Life.* Seattle: University of Washington Press, 1992.

Mathews, Zena, and Aldona Jonaitis, eds. *Native*

North American Art History. Palo Alto: Peek Publications, 1982.

Nabokov, Peter, and Robert Easton. *Native American Architecture*. New York: Oxford University Press, 1989.

Penney, David. *Art of the American Indian Frontier*. Seattle: University of Washington Press, 1992.

Penney, David, and George C. Longfish. *Native American Art*. Hong Kong: Hugh Lauter Levin & Associates, Inc., 1994.

Peterson, Susan. *The Living Tradition of Maria Martinez*. Tokyo: Kodansha International, 1977.

Samuel, Cheryl. *The Chilkat Dancing Blanket*. Norman: Unversity of Oklahoma Press, 1982.

Schaafsma, Polly, ed. *Kachinas in the Pueblo World*. Albuquerque: University of New Mexico Press, 1994.

Stewart, Hilary. *Looking at Totem Poles*. Seattle: University of Washington Press, 1993.

Wardwell, Allen. *Tangible Visions: Northwest Coast Indian Shamanism and its Art*. New York: Monacelli Press, 1996.

Washburn, Dorothy. *Living in Balance: The Universe of the Hopi, Zuni, Navajo, and Apache*. Philadelphia: University Museum, 1995.

Whiteford, Andrew H., et al. *I am Here: 2000 Years of Southwest Indian Arts and Crafts*. Santa Fe: Museum of New Mexico Press, 1989.

Wyman, Leland C. *Southwest Indian Drypainting*. Albuquerque: University of New Mexico Press, 1983.

CHAPTER 31
ELDERS, "BIG MEN," CHIEFS, AND KINGS: THE ARTS OF OCEANIA

Barrow, Terence. *The Art of Tahiti and the Neighboring Society, Austral and Cook Islands*. London: Thames & Hudson, 1979.

Berndt, Ronald M. et. al. *Australian Aboriginal Art*. New York: Macmillan, 1964.

Corbin, George A. *Native Arts of North America, Africa, and the South Pacific: An Introduction*. New York: HarperCollins, 1988.

Hanson, Allan, and Louise Hanson, eds. *Art and Identity in Oceania*. Honolulu: University of Hawaii Press, 1990.

Cox, J. Halley, and William H. Davenport. *Hawaiian Sculpture*. Rev. ed. Honolulu: University of Hawaii Press, 1988.

D'Alleva, Anne. *Arts of the Pacific Islands*. New York: Abrams, 1998.

Feldman, Jerome, and Donald H. Rubinstein. *The Art of Micronesia*. Honolulu: University of Hawaii Art Gallery, 1986.

Greub, Suzanne, ed. *Authority and Ornament: Art of the Sepik River, Papua New Guinea*. Basel: Tribal Art Centre, 1985.

Guiart, Jean. *Arts of the South Pacific*. New York: Golden Press, 1963.

Kaeppler, Adrienne L., Christian Kaufmann, and Douglas Newton. *Oceanic Art*. New York: Abrams, 1997.

Kooijman, Simon, *Tapa in Polynesia*. Honolulu: Bernice P. Bishop Museum Bulletin 234, 1972.

Lincoln, Louise, ed. *Assemblage of Spirits: Idea and Image in New Ireland*. New York: Braziller in association with Minneapolis Institute of Arts, 1987.

Mead, Sidney Moko, ed. *Te Maori: Maori Art from New Zealand Collections*. New York: Abrams in association with American Federation of Arts, 1984.

Rockefeller, Michael C. *The Asmat of New Guinea: The Journal of Michael Clark Rockefeller*. Greenwich: New York Graphic Society, 1967.

Schmitz, Carl A. *Oceanic Art: Myth, Man and Image in the South Seas*. New York: Abrams, 1971.

Schneebaum, Tobias. *Embodied Spirits: Ritual Carvings of the Asmat*. Salem: Peabody Museum of Salem, 1990.

Smidt, Dirk, ed. *Asmat Art: Woodcarvings of Southwest New Guinea*. New York: Braziller in association with Rijksmusum voor Volkenkunde, Leiden, 1993.

Sutton, Peter, ed. *Dreamings: The Art of Aboriginal Australia*. New York: Braziller in association with The Asia Society Galleries, 1988.

Thomas, Nicholas. *Oceanic Art*. London: Thames & Hudson, 1995.

CHAPTER 32
EXPLORATION, COLONIZATION, AND INDEPENDENCE: LATER AFRICAN ART

Abiodun, Roland, Henry J. Drewal, and John Pemberton III (eds.). *The Yoruba Artist: New Theoretical Perspectives on African Arts*. Washington: Smithsonian Institution, 1994.

Blier, Suzanne P. *The Royal Arts of Africa*. New York: Abrams, 1998.

Boone, Sylvia A. *Radiance from the Waters. Ideals of Feminine Beauty in Mende Art*. New Haven: Yale University Press, 1986.

Cole, Herbert M., ed. *I Am Not Myself: The Art of African Masquerade*. Los Angeles: Museum of Cultural History, University of California, 1985.

————. *Icons: Ideals and Power in the Art of Africa*. Washington: National Museum of African Art, Smithsonian Institution, 1989.

————. *Mbari, Art and Life among the Oweri Igbo*. Bloomington: Indiana University Press, 1982.

Cole, Herbert M., and Chike C. Aniakor. *Igbo Art. Community and Cosmos*. Los Angeles, Fowler Museum of Cultural History, 1984.

Cole, Herbert M., and Doran H. Ross. *The Arts of Ghana*. Los Angeles: Museum of Cultural History, UCLA, 1977.

Cornet, Joseph. *Art Royal Kuba*. Milan: Edizioni Sipiel, 1982.

Drewal, Henry J., and Margaret T. Drewal. *Gelede: Art and Female Power among the Yoruba*. Bloomington, Indiana University Press, 1983.

Ezra, Kate. *The Art of the Dogon: Selections from the Lester Wunderman Collection*. New York: Metropolitan Museum of Art, 1988.

————. *A Human Ideal in African Art: Bamana Figurative Sculpture*. New York: Metropolitan Museum of Art, 1986.

Fischer, Eberhard, and Hans Himmelheber. *The Arts of the Dan in West Africa*. Trans. Anne Biddle, Zurich: Museum Reitberg, 1984.

Fraser, Douglas F., and Herbert M. Cole, eds. *African Art and Leadership*. Madison: University of Wisconsin Press, 1972.

Geary, Christraud M. *Images from Bamum: German Colonial Photographs at the Court of King Njoya, Cameroon, West Africa, 1902–1915*. Washington: National Museum of African Art, Smithsonian Institution Press, 1988.

————. *Things of the Palace; A Catalogue of the Bamum Palace Museum in Foumban (Cameroon)*. Weisbaden: Franz Steiner Verlag, 1983.

Glaze, Anita J. *Art and Death in a Senufo Village*. Bloomington: Indiana University Press, 1981.

Himmelheber, Hans. trans Eberhard Fischer. *Zaire 1938/39*. Zurich: Museum Reitberg, 1993.

Kasfir, Sidney L. *West African Masks and Cultural Systems*. Tervuren: Musée Royal de l'Afrique Centrale, 1988.

Kennedy, Jean. *New Currents, Ancient Rivers: Contemporary African Artists in a Generation of Change*. Washington: Smithsonian Institution Press, 1992.

Lamp, Frederick. *Art of the Baga. A Drama of Cultural Reinvention*. New York: The Museum for African Art & Prestel, 1996.

McGaffey, Wyatt, and Michael Harris. *Astonishment and Power (Kongo Art)*. Washington: Smithsonian Institution Press, 1993.

McNaughton, Patrick R. *The Mande Blacksmiths: Knowledge, Power, and Art in West Africa*. Bloomington: Indiana University Press, 1988.

Nooter, Mary H. *Secrecy: African Art that Conceals and Reveals*. New York: Museum for African Art, 1993.

Perrois, Louis. trans. Francine Farr. *Ancestral Art of Gabon from the Collections of the Barbier-Mueller Museum*. Geneva: Musée Barbier-Mueller, 1985.

Phillips, Ruth B. *Representing Woman. Sande Masquerades of the Mende of Sierra Leone*. Los Angeles: UCLA Fowler Museum of Cultural History, 1995.

Roy, Christopher D. *Art and Life in Africa: Selections*

from the Stanley Collection. Iowa City: University of Iowa Museum of Art, 1992.

Sieber, Roy, and Roslyn A. Walker. *African Art in the Cycle of Life*. Washington: Smithsonian Institution Press, 1987.

Thompson, Robert F., and Joseph Cornet. *The Four Moments of the Sun: Kongo Art in Two Worlds*. Washington: National Gallery of Art, 1981.

Vansina, Jan. *The Children of Woot. A History of the Kuba Peoples*. Madison: University of Wisconsin Press, 1978.

Vinnicombe, Patricia. *People of the Eland. Rock Paintings of the Drakensberg Bushmen as a Reflection of Their Life and Thought*. Pietermaritzburg: University of Natal Press, 1976.

Vogel, Susan M., ed. *For Spirits and Kings: African Art from the Tishman Collection*. New York: Metropolitan Museum of Art, 1981.

————. ed. *Art/Artifact: African Art in Anthropology Collections*. New York: TeNeues, 1988.

————, et al. *Africa Explores: Twentieth-Century African Art*. New York: TeNeues, 1990.

————. *Baule. African Art. Western Eyes*. New Haven: Yale University Press, 1997.

CHAPTER 33
THE TRIUMPH OF MODERNIST ART: THE EARLY TWENTIETH CENTURY

Antliff, Mark. *Cultural Politics and the Parisian Avant-Garde*. Princeton: Princeton University Press, 1993.

Baigell, Matthew. *The American Scene: American Painting of the 1930s*. New York: Praeger, 1974.

Barr, Alfred H., Jr. *Cubism and Abstract Art: Painting, Sculpture, Constructions, Photography, Architecture, Industrial Arts, Theatre, Films, Posters, Typography*. Cambridge: Belknap, 1986.

————. ed. *Fantastic Art, Dada, Surrealism*. Reprint of 1936 ed. by the Museum of Modern Art. New York: Arno Press, 1969.

Barron, Stephanie, ed. *Degenerate Art: The Fate of the Avant-Garde in Nazi Germany*. Los Angeles: Los Angeles County Museum of Art, 1991.

————. *Exiles + Emigrés: The Flight of European Artists from Hitler*. Los Angeles: Los Angeles County Museum of Art, 1997.

Bayer, Herbert, Walter Gropius, and Ise Gropius. *Bauhaus, 1919–1928*. New York: Museum of Modern Art, 1975.

Bearden, Romare, and Harry Henderson. *A History of African-American Artists from 1792 to the Present*. New York: Pantheon Books, 1993.

Breton, André. *Surrealism and Painting*. New York: Harper & Row, 1972.

Brown, Milton. *Story of the Armory Show: The 1913 Exhibition That Changed American Art*. 2nd ed. New York: Abbeville, 1988.

Campbell, Mary Schmidt, David C. Driskell, David Lewis Levering, and Deborah Willis Ryan. *Harlem Renaissance: Art of Black America*. New York: The Studio Museum, Harlem/Harry N. Abrams, 1987.

Carrá, Massimo, Ewald Rathke, Caroline Tisdall, and Patrick Waldberg. *Metaphysical Art*. New York: Frederick A. Praeger, 1971.

Davidson, Abraham A. *Early American Modernist Painting, 1910–1935*. New York: Harper & Row, 1981.

Eberle, Matthias. *World War I and the Weimar Artists: Dix, Grosz, Beckmann, Schlemmer*. New Haven: Yale University Press, 1985.

Elderfield, John. *The "Wild Beasts": Fauvism and Its Affinities*. New York: The Museum of Modern Art/Oxford University Press, 1976.

Elsen, Albert. *Origins of Modern Sculpture*. New York: Braziller, 1974.

Fer, Briony, David Batchelor, and Paul Wood. *Realism, Rationalism, Surrealism: Art Between the Wars*. New Haven: Yale University Press, 1993.

Frampton, Kenneth. *A Critical History of Modern Architecture*. London: Thames & Hudson, 1985.

Friedman, Mildred, ed. *De Stijl: 1917–1931, Visions of Utopia*. Minneapolis: Walker Art Center/New York: Abbeville Press, 1982.

Fry, Edward, ed. *Cubism.* London: Thames & Hudson, 1966.

Golding, John. *Cubism: A History and an Analysis, 1907–1914.* Cambridge: Belknap, 1988.

Gordon, Donald E. *Expressionism: Art and Idea.* New Haven: Yale University Press, 1987.

Gray, Camilla. *The Russian Experiment in Art: 1863–1922.* New York: Harry N. Abrams, 1970.

Gropius, Walter. *Scope of Total Architecture.* New York: Collier Books, 1962.

Hamilton, George Heard. *Painting and Sculpture in Europe, 1880–1940.* 6th ed. New Haven: Yale University Press, 1993.

Harrison, Charles, Francis Frascina, and Gill Perry. *Primitivism, Cubism, Abstraction: The Early Twentieth Century.* New Haven: Yale University Press, 1993.

Herbert, James D. *Fauve Painting: The Making of Cultural Politics.* New Haven: Yale University Press, 1992.

Hunter, Sam. *American Art of the 20th Century.* New York: Harry N. Abrams, 1972.

Hurlburt, Laurance P. *The Mexican Muralists in the United States.* Albuquerque: University of New Mexico Press, 1989.

Jaffé, Hans L. C. *De Stijl, 1917–1931: The Dutch Contribution to Modern Art.* Cambridge: Belknap, 1986.

Kahnweiler, Daniel H. *The Rise of Cubism.* New York: Wittenborn, Schultz, 1949.

Kandinsky, Wassily. *Concerning the Spiritual in Art.* Trans. M. T. H. Sadler. New York: Dover, 1977.

Krauss, Rosalind. *The Originality of the Avant-Garde and Other Modernist Myths.* Cambridge: MIT Press, 1986.

Kuspit, Donald. *The Cult of the Avant-Garde Artist.* Cambridge: Cambridge University Press, 1993.

Le Corbusier. *The City of Tomorrow,* Cambridge: MIT Press, 1971.

Lloyd, Jill. *German Expressionism: Primitivism and Modernity.* New Haven: Yale University Press, 1991.

Lodder, Christina. *Russian Constructivism.* New Haven: Yale University Press, 1983.

Martin, Marianne W. *Futurist Art and Theory.* Oxford: Clarendon Press, 1968.

Moholy-Nagy, László. *Vision in Motion.* Chicago: Paul Theobald, 1969, first published in 1946.

Mondrian, Pieter Cornelius. *Plastic Art and Pure Plastic Art.* 3rd ed. New York: Wittenborn, Schultz, 1952.

Motherwell, Robert, ed. *The Dada Painters and Poets: An Anthology.* 2nd ed. Boston: G. K. Hall & Co., 1981.

Myers, Bernard S. *The German Expressionists: A Generation in Revolt.* New York: Frederick A. Praeger, 1956.

Osborne, Harold. *The Oxford Companion to Twentieth Century Art.* New York: Oxford University Press, 1981.

Read, Herbert, ed. *Surrealism.* New York: Frederick A. Praeger, 1971.

Richter, Hans. *Dada: Art and Anti-Art.* London: Thames & Hudson, 1961.

Rosenblum, Robert. *Cubism and Twentieth-Century Art.* Rev. ed. New York: Harry N. Abrams, 1984.

Rubin, William S. *Dada and Surrealist Art.* New York: Harry N. Abrams, 1968.

———. *Dada, Surrealism and Their Heritage.* New York: Museum of Modern Art, 1968.

Rubin, William S., ed. *Pablo Picasso: A Retrospective.* New York: Museum of Modern Art/Boston: New York Graphic Society, 1980.

———. *"Primitivism" in 20th-Century Art: Affinity of the Tribal and the Modern.* 2 vols. New York: Museum of Modern Art, 1984.

Selz, Peter. *German Expressionist Painting.* 1957. reprint. Berkeley: University of California Press, 1974.

Silver, Kenneth E. *Esprit de Corps: The Art of the Parisian Avant-Garde and the First World War, 1914–1925.* Princeton: Princeton University Press, 1989.

Steinberg, Leo. *Other Criteria: Confrontations with 20th-Century Art.* New York: Oxford University Press, 1972.

Stott, William. *Documentary Expression and Thirties America.* New York: Oxford University Press, 1973.

Taylor, Brandon. *Avant-Garde and After.* New York: Harry N. Abrams, 1995.

Taylor, Joshua C. *Futurism.* New York: Museum of Modern Art, 1961.

Tisdall, Caroline, and Angelo Bozzolla. *Futurism.* New York: Oxford University Press, 1978.

Tsujimoto, Karen. *Images of America: Precisionist Painting and Modern Photography.* Seattle: University of Washington Press, 1982.

Tucker, William. *Early Modern Sculpture.* New York: Oxford University Press, 1974.

Vogt, Paul. *Expressionism: German Painting, 1905–1920.* New York: Harry N. Abrams, 1980.

Weiss, Jeffrey S. *The Popular Culture of Modern Art: Picasso, Duchamp, and Avant-Gardism.* New Haven: Yale University Press, 1994.

Whitford, Frank. *Bauhaus.* New York: Thames & Hudson, 1984.

Wright, Frank Lloyd; Edgar Kaufmann, ed. *American Architecture.* New York: Horizon, 1955.

CHAPTER 34
THE EMERGENCE OF POSTMODERNISM: THE LATER TWENTIETH CENTURY

Alloway, Lawrence. *American Pop Art.* New York: Whitney Museum of American Art/Macmillan, 1974.

———. *Topics in American Art Since 1945.* New York: W. W. Norton, 1975.

Anfam, David. *Abstract Expressionism.* New York: Thames & Hudson, 1990.

Ashton, Dore. *American Art Since 1945.* New York: Oxford University Press, 1983.

———. *The New York School: A Cultural Reckoning.* Harmondsworth: Penguin, 1979.

Battcock, Gregory, ed. *Idea Art: A Critical Anthology.* New York: E. P. Dutton, 1973.

———. *Minimal Art: A Critical Anthology.* New York: Studio Vista, 1969.

———. *The New Art: A Critical Anthology.* New York: E. P. Dutton, 1973.

———. *New Artists Video: A Critical Anthology.* New York: E. P. Dutton, 1978.

Battcock, Gregory, and Robert Nickas, eds. *The Art of Performance: A Critical Anthology.* New York: E. P. Dutton, 1984.

Beardsley, Richard. *Earthworks and Beyond: Contemporary Art in the Landscape.* New York: Abbeville Press, 1984.

Beardsley, John, and Jane Livingston. *Hispanic Art in the United States: Thirty Contemporary Painters and Sculptors.* Houston: Museum of Fine Arts/New York: Abbeville Press, 1987.

Benthall, Jeremy. *Science and Technology in Art Today.* New York: Frederick A. Praeger, 1972.

Brion, Marcel, Sam Hunter, et al. *Art Since 1945.* New York: Harry N. Abrams, 1958.

Broude, Norma, and Mary D. Garrard. *The Power of Feminist Art: The American Movement of the 1970s, History and Impact.* New York: Abrams, 1994.

Cockcroft, Eva, John Weber, and James Cockcroft. *Toward a People's Art.* New York: E. P. Dutton, 1977.

Cook, Peter. *New Spirit in Architecture.* New York: Rizzoli, 1990.

Cummings, Paul. *Dictionary of Contemporary American Artists.* 3rd ed. New York: St. Martin's Press, 1977.

Ferguson, Russell, ed. *Discourses: Conversations in Postmodern Art and Culture.* Cambridge: MIT Press, 1990.

Frascina, Francis, ed. *Pollock and After: The Critical Debate.* New York: Harper & Row, 1985.

Geldzahler, Henry. *New York Painting and Sculpture, 1940–1970.* New York: E. P. Dutton, 1969.

Guilbaut, Serge. *How New York Stole the Idea of Modern Art.* Chicago: University of Chicago Press, 1983.

Goldberg, Rose Lee. *Performance Art: From Futurism to the Present.* Rev. ed. New York: Abrams, 1988.

Goodman, Cynthia. *Digital Visions: Computers and Art.* New York: Harry N. Abrams, 1987.

Goodyear, Frank H., Jr. *Contemporary American Realism Since 1960.* Boston: New York Graphic Society, 1981.

Green, Jonathan. *American Photography: A Critical History Since 1945 to the Present.* New York: Abrams, 1984.

Greenberg, Clement. *Clement Greenberg, The Collected Essays and Criticism.* Ed. J. O'Brien. 4 vols. Chicago: University of Chicago Press, 1986–93.

Grundberg, Andy. *Photography and Art: Interactions since 1945.* New York: Abbeville, 1987.

Hays, K. Michael, and Carol Burns, eds. *Thinking the Present: Recent American Architecture.* New York: Princeton Architectural, 1990.

Henri, Adrian. *Total Art: Environments, Happenings, and Performance.* New York: Oxford University Press, 1974.

Herbert, Robert L. *Modern Artists on Art.* Englewood Cliffs: Prentice-Hall, 1971.

Hertz, Richard, ed. *Theories of Contemporary Art.* 2nd ed. Englewood Cliffs: Prentice-Hall, 1993.

Hoffman, Katherine. *Explorations: The Visual Arts since 1945.* New York: HarperCollins, 1991.

Hughes, Robert. *The Shock of the New.* New York: Knopf, 1981.

Hunter, Sam. *An American Renaissance: Painting and Sculpture Since 1940.* New York: Abbeville, 1986.

Jacobus, John. *Twentieth-Century Architecture: The Middle Years, 1940–1964.* New York: Frederick A. Praeger, 1966.

Jencks, Charles. *Architecture 2000: Prediction and Methods.* New York: Frederick A. Praeger, 1971.

———. *The Language of Post-Modern Architecture.* 6th ed. New York: Rizzoli, 1991.

———. *What is Post-Modernism?* 3rd rev. ed. London: Academy Editions, 1989.

Johnson, Ellen H. *American Artists on Art: From 1940 to 1980.* New York: Harper & Row, 1980.

Jones, Amelia, ed. *Sexual Politics: Judy Chicago's Dinner Party in Feminist Art History.* Berkeley: University of California Press, 1996.

Kaprow, Allan. *Assemblage, Environments, and Happenings.* New York: Harry N. Abrams, 1966.

Kirby, Michael. *Happenings.* New York: E. P. Dutton, 1966.

Kramer, Hilton. *The Age of the Avant-Garde: An Art Chronicle of 1956–1972.* New York: Farrar, Straus & Giroux, 1973.

Leja, Michael. *Reframing Abstract Expressionism: Subjectivity and Painting in the 1940s.* New Haven: Yale University Press, 1993.

Lewis, Samella S. *African American Art and Artists.* Rev. ed. Berkeley: University of California Press, 1994.

Lippard, Lucy R. *Mixed Blessings: New Art in a Multicultural America.* New York: Pantheon Books, 1990.

———. *Pop Art.* New York: Frederick A. Praeger, 1966.

———, ed. *From the Center: Feminist Essays on Women's Art.* New York: E. P. Dutton, 1976.

———, ed. *Six Years: The Dematerialization of the Art Object from 1966 to 1972.* New York: Frederick A. Praeger, 1973.

Lovejoy, Margot. *Postmodern Currents: Art and Artists in the Age of the Electronic Media.* Ann Arbor: UMI Research Press, 1989.

Lucie-Smith, Edward. *Art Now.* Edison: Wellfleet Press, 1989.

———. *Movements in Art Since 1945.* new rev. ed. New York: Thames & Hudson, 1984.

Marder, Tod A. *The Critical Edge: Controversy in Recent American Architecture.* New Brunswick: Rutgers University Press, 1980.

———. *An International Survey of Recent Painting and Sculpture.* New York: Museum of Modern Art, 1984.

Meyer, Ursula. *Conceptual Art.* New York: E. P. Dutton, 1972.

Mitchell, William J. *The Reconfigured Eye: Visual Truth in the Post-Photographic Era.* Cambridge: MIT Press, 1992.

Norris, Christopher, and Andrew Benjamin. *What Is Deconstruction?* New York: St. Martin's, 1988.

Polcari, Stephen. *Abstract Expressionism and the Modern Experience*. Cambridge: Cambridge University Press, 1991.

Popper, Frank. *Origins and Development of Kinetic Art*. Trans. Stephen Bann. Greenwich: New York Graphic Society, 1968.

Price, Jonathan. *Video Visions: A Medium Discovers Itself*. New York: New American Library, 1977.

Reichardt, Jasia, ed. *Cybernetics, Art & Ideas*. Greenwich: New York Graphics Society, 1971.

Risatti, Howard, ed. *Postmodern Perspectives: Issues in Contemporary Art*. Englewood Cliffs: Prentice-Hall, 1990.

Robbins, Corinne. *The Pluralist Era: American Art, 1968–1981*. New York: Harper & Row, 1984.

Rosen, Randy, and Catherine C. Brawer, eds. *Making Their Mark: Women Artists Move into the Mainstream, 1970–1985*. New York: Abbeville, 1989.

Rosenberg, Harold. *The Tradition of the New*. New York: Horizon Books, 1959.

Russell, John, and Suzi Gablik. *Pop Art Redefined*. New York: Frederick A. Praeger, 1969.

Sandler, Irving. *Art of the Postmodern Era*. New York: HarperCollins, 1996.

———. *The Triumph of American Painting: A History of Abstract Expressionism*. New York: Frederick A. Praeger, 1970.

Sayre, Henry M. *The Object of Performance: The American Avant-Garde since 1970*. Chicago: University of Chicago Press, 1989.

Schneider, Ira, and Beryl Korot. *Video Art: An Anthology*. New York: Harcourt Brace Jovanovich, 1976.

Shapiro, David, and Cecile Shapiro. *Abstract Expressionism: A Critical Record*. New York: Cambridge University Press, 1990.

Smagula, Howard. *Currents: Contemporary Directions in the Visual Arts*. 2nd ed. Englewood Cliffs: Prentice-Hall, 1989.

Sonfist, Alan, ed. *Art in the Landscape: A Critical Anthology of Environmental Art*. New York: E. P. Dutton, 1983.

Sontag, Susan. *On Photography*. New York: Farrar, Strauss & Giroux, 1973.

Stiles, Kristine, and Peter Selz, eds. *Theories and Documents of Contemporary Art: A Sourcebook of Artists' Writings*. Berkeley: University of California Press, 1996.

Tuchman, Maurice. *American Sculpture of the Sixties*. Los Angeles: Los Angeles County Museum of Art, 1967.

Venturi, Robert, Denise Scott-Brown, and Steven Isehour. *Learning from Las Vegas*. Cambridge, MA: MIT Press, 1972.

Waldman, Diane. Collage, *Assemblage, and the Found Object*. New York: Abrams, 1992.

Wallis, Brian, ed. *Art After Modernism: Rethinking Representation*. New York: New Museum of Contemporary Art in association with David R. Godine, 1984.

Wheeler, Daniel. *Art since Mid-Century: 1945 to the Present*. Englewood Cliffs: Prentice-Hall, 1991.

Wood, Paul. *Modernism in Dispute: Art Since the Forties*. New Haven: Yale University Press, 1993.

BOOKS SPANNING THE EIGHTEENTH, NINETEENTH, AND TWENTIETH CENTURIES

Antreasian, Garo, and Clinton Adams. *The Tamarind Book of Lithography: Art and Techniques*. Los Angeles: Tamarind Workshop and New York: Harry N. Abrams, 1971.

Armstrong, John, Wayne Craven, and Norma Feder, et al. *200 Years of American Sculpture*. New York: Whitney Museum of American Art/Boston: David R. Godine, 1976.

Arnason, H. H. *History of Modern Art: Painting, Sculpture, Architecture*. 4th ed. New York: Harry N. Abrams, 1998.

Ashton, Dore. *Twentieth-Century Artists on Art*. New York: Pantheon Books, 1985.

Brown, Milton, Sam Hunter, and John Jacobus. *American Art: Painting, Sculpture, Architecture, Decorative Arts, Photography*. New York: Harry N. Abrams, 1979.

Burnham, Jack. *Beyond Modern Sculpture. The Effects of Science and Technology on the Sculpture of This Century*. New York: Braziller, 1968.

Castelman, Riva. *Prints of the 20th Century: A History*. New York: Oxford University Press, 1985.

Chipp, Herschel B. *Theories of Modern Art*. Berkeley: University of California Press, 1968.

Coke, Van Deren. *The Painter and the Photograph From Delacroix to Warhol*. Rev. and enl. ed. Albuquerque: University of New Mexico Press, 1972.

Craven, Wayne. *American Art: History and Culture*. Madison: Brown & Benchmark, 1994.

Driskell, David C. *Two Centuries of Black American Art*. Los Angeles: Los Angeles County Museum of Art/New York: Alfred A. Knopf, 1976.

Elsen, Albert. *Origins of Modern Sculpture*. New York: Braziller, 1974.

Fine, Sylvia Honig. *Women and Art: A History of Women Painters and Sculptors from the Renaissance to the 20th Century*. Montclair: Alanheld & Schram, 1978.

Flexner, James Thomas. *America's Old Masters*. New York: McGraw-Hill, 1982.

Frascina, Francis, and Charles Harrison, eds. *Modern Art and Modernism: A Critical Anthology*. New York: Harper & Row, 1982.

Giedion, Siegfried. *Space, Time and Architecture: The Growth of a New Tradition*. 4th ed. Cambridge: Harvard University Press, 1965.

Goldwater, Robert, and Marco Treves, eds. *Artists on Art*. 3rd ed. New York: Pantheon, 1958.

Greenough, Sarah, Joel Snyder, David Travis, and Colin Westerbeck. *On the Art of Fixing a Shadow: One Hundred and Fifty Years of Photography*. Washington: The National Gallery of Art/Chicago: The Art Institute of Chicago, 1989.

Hamilton, George Heard. *Nineteenth- and Twentieth-Century Art*. Englewood Cliffs: Prentice-Hall, 1972.

Herbert, Robert L., ed. *Modern Artists on Art*. Englewood Cliffs: Prentice-Hall, 1964.

Hertz, Richard, and Norman M. Klein, eds. *Twentieth-Century Art Theory: Urbanism, Politics, and Mass Culture*. Englewood Cliffs: Prentice-Hall, 1990.

Hitchcock, Henry-Russell. *Architecture: Nineteenth and Twentieth Centuries*. 4th ed. New Haven: Yale University Press, 1977.

Hunter, Sam, and John Jacobus. *Modern Art: Painting, Sculpture, and Architecture*. 3rd ed. New York: Harry N. Abrams, 1992.

Jencks, Charles. *Modern Movements in Architecture*. Garden City: Anchor Press/Doubleday, 1973.

Kaufmann, Edgar, Jr., ed. *The Rise of an American Architecture*. New York: Metropolitan Museum of Art/Frederick A. Praeger, 1970.

Krauss, Rosalind E. *The Originality of the Avant-Garde and Other Modernist Myths*. Cambridge: MIT Press, 1985.

———. *Passages in Modern Sculpture*. Cambridge, MA: MIT Press, 1981.

Licht, Fred. *Sculpture, Nineteenth and Twentieth Centuries*. Greenwich: New York Graphic Society, 1967.

Lynton, Norbert. *The Story of Modern Art*. 2nd ed. Englewood Cliffs: Prentice-Hall, 1989.

McCoubrey, John W. *American Art, 1700–1960: Sources and Documents*. Englewood Cliffs: Prentice-Hall, 1965.

Mason, Jerry, ed. *International Center of Photography Encyclopedia of Photography*. New York: Crown Publishers, 1984.

Newhall, Beaumont. *The History of Photography*. New York: The Museum of Modern Art, 1982.

Peterdi, Gabor. *Printmaking: Methods Old and New*. New York: Macmillan, 1961.

Pierson, William. *American Buildings and Their Architects: Technology and the Picturesque*. Vol. 2. Garden City: Doubleday, 1978.

Read, Herbert. *Concise History of Modern Painting*. 3rd ed. New York: Frederick A. Praeger, 1975.

———. *A Concise History of Modern Sculpture*. Rev. and enl. ed. New York: Frederick A. Praeger, 1964.

Rose, Barbara. *American Art Since 1900*. rev. ed. New York: Frederick A. Praeger, 1975.

Rosenblum, Robert. *Modern Painting and the Northern Romantic Tradition: Friedrich to Rothko*. New York: Harper & Row, 1975.

Ross, John, and Clare Romano. *The Complete Printmaker*. New York: The Free Press, 1972.

Ross, Stephen David, ed. *Art and Its Significance: An Anthology of Aesthetic Theory*. Albany: SUNY Press, 1987.

Russell, John. *The Meanings of Modern Art*. New York: Museum of Modern Art/Thames & Hudson, 1981.

Scully, Vincent. *Modern Architecture*. rev. ed. New York: Braziller, 1974.

Spalding, Francis. *British Art Since 1900*. London: Thames & Hudson, 1986.

Spencer, Harold. *American Art: Readings from the Colonial Era to the Present*. New York: Charles Scribner's Sons, 1980.

Summerson, Sir John. *Architecture in Britain: 1530–1830*. 7th rev. and enl. ed. Baltimore: Penguin, 1983.

Szarkowski, John. *Photography Until Now*. New York: Museum of Modern Art, 1989.

Tuchman, Maurice, and Judi Freeman, eds. *The Spiritual in Art: Abstract Painting, 1890–1985*. Los Angeles: Los Angeles County Art Museum/New York: Abbeville Press, 1986.

Upton, Dell. *Architecture in the United States*. Oxford: Oxford University Press, 1998.

Weaver, Mike. *The Art of Photography: 1839–1989*. New Haven: Yale University Press, 1989.

Whiffen, Marcus, and Frederick Koeper. *American Architecture, 1607–1976*. Cambridge: MIT Press, 1983.

Wilmerding, John. *American Art*. Harmondsworth, England: Penguin, 1976.

Wilson, Simon. *Holbein to Hockney: A History of British Art*. London: The Tate Gallery & The Bodley Head, 1979.

CREDITS

*The authors and publisher are grateful to the proprietors and custodians of various works of art for photographs
of these works and permission to reproduce them in this book. Sources not included in the captions are listed here.*

Introduction—The Solomon R. Guggenheim Foundation, New York, Photo, David Heald: 1; Aerofilms Limited: 2; Scala/Art Resource, New York: 3; Copyright © 2001 The Georgia O'Keefe Foundation/Artist Rights Society (ARS), New York: 4; Copyright © 2001 Ben Shahn/Licensed by VAGA, New York: 5; Copyright © 1981 M. Sarri/Photo Vatican Museums: 7; Photo copyright © Metropolitan Museum of Art: 9; Saskia Ltd Cultural Documentation: 10; Copyright © National Gallery, London: 12; MOA Art Museum, Shizuoka-ken, Japan: 13; Joachim Blauel/Arthothek: 14; Copyright © 1983 Metropolitan Museum of Art: 15; Saskia Ltd Cultural Documentation: 17; Scala: 18.
Chapter 1—Photo: Paul G. Bahn: 1; With permission: Namibia Archaeological Trust: 3; Ulmer Museum/Thomas Stephan: 3; J.M. Arnaud/Musée d'Aquitaine: 5; Jean Dieuzaide: 6; Jean Vertut: 7, 9, 10; Cliché Mario Ruspoli/Copyright © CNMHS, Paris: 8; Hans Hinz: 11; Eurelios/French Ministry of Culture and Communication, Regional Direction for Cultural Affairs-Rhône-Alpes region-Regional department of archaeology: 12; CNMHS/SPADEM: 13; British School of Archaeology in Jerusalem: 14, 15; Arlette Mellaart: 17, 18; Pubbli Aer Foto: 19.
Chapter 2—Staatliche Museen zu Berlin: 1; Erwin Böhm: 3, 27; Hir: 4, 6, 7, 22, 25; Courtesy of The Oriental Institute of the University of Chicago: 5; University of Pennsylvania Museum (Neg.#T4-848c.): 10; Copyright © The British Museum: 11, 23, 24; Saskia Ltd Cultural Documentation: 13; Erwin Böhm: 14; R.M.N.-R.G. Ojeda: 15; R.M.N.-H. Lewandowski: 16; Gir: 17, 28; photo Henri Stierlin: 18; R.M.N.-D. Chenot: 19; Saskia Ltd Cultural Documentation: 21; Klaus Göken, 1992/BPK: 26; Metropolitan Museum of Art, Fletcher Fund, 1965. (65.126) Photo copyright © 1982 By Metropolitan Museum of Art: 29; Sassoon/Robert Harding Picture Library: 30.
Chapter 3—Jürgen Liepe, Berlin: 2; Hir: 5, 6, 7, 12, 17, 27, 32; Carolyn Brown/PRI: 4; Bill Gallery, Stock, Boston: 8; Robert Harding Picture Library: 11, 25, 37, 38; Courtesy, Museum of Fine Arts, Boston. Reproduced with permission. Copyright © 2000 Museum of Fine Arts, Boston. All rights reserved: 13; R.M.N.: 14; Jean Vertut: 16; Foto Marburg/Art Resource, New York: 18, 23, 40; Photography by Egyptian Expedition, The Metropolitan Museum of Art: 19; Wim Swaan: 20; Metropolitan Museum of Art, Rogers Fund, 1929. (29.3.1) Photo by Schecter Lee. Photo copyright © 1986 Metropolitan Museum of Art: 21; John P. Stevens/AA&A: 22; Metropolitan Museum of Art, Purchase, 1890, Levi Hale Willard Bequest (90.35.1): 26; Ronald Sheridan/AA&A: 28; Jürgen Liepe/BPK: 29; Copyright © The British Museum: 30, 31, 39; Margarete Büsing/BPK: 33, 34, 35; Boltin Picture Library: 36.
Chapter 4—Scala: 1; Studio Kontos: 2, 7, 26; Photo by Raymond V. Schoder, Copyright © 1987 by Bolchazy—Carducci Publishers, Inc: 3, 16; Hir: 8, 17, 23, 24; Wim Swaan: 5; Saskia Ltd Cultural Documentation: 6; Nimatallah/Art Resource, New York: 9, 13; photo Henri Stierlin: 10, 22; Hans Hinz: 11; Copyright © Michelle Jones/Ancient Art & Architecture Collection: 12; Alison Franz Collection, American School of Classical Studies at Athens: 14; Leonard von Matt: 15; Erich Lessing/

Art Resource, New York: 20; Archaeological Receipts Fund: 25.
Chapter 5—Metropolitan Museum of Art, Rogers Fund, 1914. (14.130.14) Photo copyright © 1996 Metropolitan Museum of Art: 1; Metropolitan Museum of Art, Gift of J. Pierpont Morgan, 1917. (17.190.2072). Photo copyright © 1996 Metropolitan Museum of Art: 2; Museum of Fine Arts, Boston, Francis Bartlett Collection: 3; Copyright © The British Museum: 4, 45, 46, 48, 52; Alison Frantz: 6; R.M.N.: 7, 57; Metropolitan Museum of Art, Fletcher Fund, 1932. (32.11.1). Photo copyright © 1993 Metropolitan Museum of Art: 8; Saskia Ltd Cultural Documentation: 9, 10, 27, 28, 37, 38, 53, 54, 55, 62, 66, 71, 73, 85; Studio Kontos: 11, 12, 42, 64, 68, 77, 84; Summerfield: 13; Art Resource, New York: 15, 67; Hir: 17, 47, 48; AL: 18; Scala: 18, 34, 50, 56, 86; Photo Vatican Museums 19, 39, 60; R.M.N.-H. Lewandowski: 21; Colorphoto Hans Hinz: 22; Copyright A.C.L., Brussels: 23; photo Henri Stierlin: 24, 49; Canali: 29, 65, 69, 90; photo Paul M.R. Maeyaert: 30, 31, 32; Nimatallah/Art Resource, New York: 33, 36; Erich Lessing/Art Resource, New York: 35; Photo by Raymond V. Schoder, copyright © 1987 by Bolchazy-Carducci Publishers, Inc.: 40; DAI, Athens. Photo: G. Hellner: 48; Copyright © 1981 M. Sarri/Photo Vatican Museums: 58; Archivio I.G.D.A., Milano: 59; Archaeological Receipts Fund: 63; Photo by Raymond V. Schoder, copyright © 1987 by Bolchazy-Carducci Publishers, Inc.: 70; Vanni/AR: 72; BPK: 75, 78, 79; Photo Giovanni Lattanzi: 80; Summerfield Press Ltd.: 81; R.M.N.-G. Biot/C. Jean: 82; R.M.N.-Arnaudet; J. Schormans: 83; Ricciarini/Simion: 86 Ny Carlsberg Glyptotek: 88; Copyright © 1988 T. Okamura/Photo Vatican Museums: 89.
Chapter 6—John C. Huntington: 1, 4, 14, 15, 16; Archaeological Survey of India, Janpath, New Delhi: 2, 3, 7, 9, 11, 17, 18, 19; Robert Harding Picture Library: 5, 8, 27, 31; Douglas Dickins, FRPS: 12; Joseph Szaszfai: 13; Barnaby's Picture Library: 20; Robert L. Brown: 21, 23, 25; David Tokeley/Robert Harding Picture Library: 24; John Stevens/Ancient Art & Architecture Collection: 26; Nancy Tingley: 28; Eliot Elisofon/Life Magazine copyright © Time Inc.: 29; John Gollings Photography: 32, 33, 34; Douglas Dickins, FRPS: 35.
Chapter 7—Cultural Relics Publishing House, Beijing: 1, 3, 5, 12, 14; Asian Art Museum of San Francisco, B60 B1032: 2; Hunan Provincial Museum, Changsha City, China: 6; Chavannes: 7; Asian Art Museum of San Francisco, The Avery Brundage Collection B60 B1034: 8; Copyright © British Museum: 9; Edition d'Art, Paris: 10; Copyright © Laurence G. Liu: 11, 21; Reproduced with permission. Copyright © 2001 Museum of Fine Arts, Boston 31.643. All rights reserved: 16; The New York Public Library, Astor, Lenox and Tilden Foundations: 17; Victoria & Albert Museum, London/Art Resource, New York: 18; National Palace Museum, Taipei, Taiwan, Republic of China: 19; Reproduced with permission. Copyright © 2001 Museum of Fine Arts, Boston 33.364. All rights reserved: 20; Reproduced with permission. Copyright © 2001 Museum of Fine Arts, Boston 95.4. All rights reserved: 23; Reproduced with permission. Copyright © 2001 Museum of Fine Arts, Boston 14.61. All rights reserved: 24; Asian Art Museum of San Francisco, The Avery Brundage Collection B60 P161: 26; Photo copyright © Korea National Tourism Organization: 28, 29.
Chapter 8—Kyoryokukai: 1, 2; Courtesy of Jingu Shicho: 4; Photo: Ogawa Kozo (Askaen): 5, 6, 7, 8, 12; Robert Harding Picture Library: 10; Eisuke Ueda: 13; Reproduced with permission. Copyright © 2001 Museum of Fine Arts, Boston 11.4000. All rights reserved: 14.
Chapter 9—Hir: 1, 8, 9, 14; David Lees: 2; Canali: 3; Copyright © Mike Andrews/Ancient Art & Achitecture Collection Ltd.: 4; Fototeca: 5; Archivio I.G.D.A., Milano: 7; photo Henri Stierlin:

10; Saskia Ltd Cultural Documentation: 11; Soprintendenza Archeologica per l'Etruria Meridionale: 12; AL: 13; German Archaeological Institute, Rome: 15.
Chapter 10—Photo Henri Stierlin: 1, 13, 30, 32, 50, 52; Scala: 2, 12, 15, 17, 23, 51, 58, 78; AL: 5, 35, 38, 39, 45, 55; German Archaeological Institute, Rome: 6,7; The American Numismatic Society, New York: 8; The Whittlesey Foundation/Aristide D. Caratzas, Publisher: 9; Fototeca: 11; Photo Archives Skira, Geneva, Switzerland: 14; Photo copyright © 1986 Metropolitan Museum of Art: 16; Copyright © Biblioteca Apostolica Vaticana: 19; Canali: 20, 21, 24, 41, 56, 74; Madeline Grimoldi: 22; Copyright © M. Sarri/Photo Vatican Museums: 25; Ny Carlsberg Glyptotek: 26; Saskia Ltd Cultural Documentation: 27, 28, 29, 36, 37, 80; Oliver Benn/Tony Stone Images: 31; The Image Bank/Guido Rossi: 34; Photo Alinari: 42; Photo Marcello Bertinetti/White Star: 43; Fototeca: 44; German Archaeological Institute, Rome: 46, 66, 69; Collection of Israel Antiquities Authority. Exhibited & photo copyright © Israel Museum: 47; Pubbli Aer Foto: 48; Art Resource, New York: 53; Ernani Orcorte/UTET: 54; Erich Lessing/Art Resource, New York: 56; Photo Vatican Museums: 57; De Masi/Canali: 59; German Archaeological Institute, Rome: 60, 72, 75; Canali/On license of the Ministero per i Beni Culturali ed Ambientali: 69,: 62; Peter Muscato: 63; BPK: 64; Photo copyright © 1986 Metropolitan Museum of Art: 65; Fototeca: 68; Photo copyright © 1983 Metropolitan Museum of Art: 70; G. Dagli Orti, Paris: 71; Index/Artphoto: 76; Istituto Centrale per il Catalogo e la Documentazione, (ICCD): 77; Rheinisches Landesmuseum: 81; American Numismatic Society, New York: 82; Hir: 82.
Chapter 11—The Jewish Museum, New York/Art Resource, New York: 1; Madeline Grimoldi: 3; Hir: 4, 14, 18, 20; Foto Archivio Fabbrica di San Pietro in Vaticano: 5; Saskia Ltd Cultural Documentation: 6, 8; Scala: 9, 13, 15, 16, 17; Canali: 11; Andre Held: 12; Österreichische Nationalbibliothek, Vienna: 19; Copyright © The British Museum: 21.
Chapter 12—R.M.N.-Chuzevilleh: 1; Hir: 2; Alan Oddie/PhotoEdit, Long Beach, CA: 3; photo Henri Stierlin: 5; Fotocielo, Rome: 6; Canali: 8, 10, 11; Scala: 9, 12, 24; Ronald Sheridan/AA& A: 13; Firenze, Biblioteca Medicea Laurenziana, Ms. Laur. Plut. 1.56, c. 13v Su concessione del Ministero per i beni e le attività culturali E' vietata ogni ulteriore riproduzione con qualsiasi mezzo: 14; Dumbarton Oaks, Washington, D.C.: 16; photo Paul M.R. Maeyaert: 17, 19; Studio Kontos: 20; Sostegni/Fotocielo: 21; Ricciarini/Visconti: 22; Canali/Cameraphoto: 23; Ricciarini, Milano: 25; R.M.N.: 26; Josephine Powell: 27; Sovfoto/Eastfoto: 29, 34; Studio Kontos: 30; Andre Held: 31; Hir: 33; State Historical Cultural Museum "Moscow Kremlin": 35.
Chapter 13—Yoram Lehmann, Jerusalem: 1; Erich Lessing/Art Resource, New York: 2; Aga Khan Visual Archives, MIT: 3; Photo Archives Skira, Geneva, Switzerland: 4; BPK: 6; Staatliche Museen zu Berlin: 7; Roger Wood/Continuum: 8; photo Henri Stierlin: 10, 19, 21, 23, 24, 27; Copyright © E. Simanor/Robert Harding Picture Library: 11; Saskia Ltd Cultural Documentation: 12; MAS: 13; Copyright © Adam Woolfitt/Robert Harding Picture Library: 14; Copyright © Musée Lorrain, Nancy/photo G. Mangin: 15; The State Hermitage Museum: 16; Reproduced by kind permission of the Trustees of the Chester Beatty Library, Dublin: 17; Copyright © C. Rennie/Robert Harding Picture Library: 18; Josephine Powell: 25; Photographer: Daniel McGrath: 28; Collection Prince Sadruddin Aga Khan: 29; Topkapi Palace Museum: 30; R.M.N.: 31.
Chapter 14—Copyright © Justin Kerr: 1, 8, 12; Erich Lessing/Art Resource, New York: 2; Rene Millon, 1973: 4; Lee Boltin: 5; Photo by Hillel Burger: 7, 11; Copyright © Dirk Bakker: 9, 24; Christopher

ILLUSTRATION CREDITS

INDEX

Boldfaced names refer to artists. Pages in italics refer to illustrations.